CONTENTS

The Philosophy of the Visual Arts

The Philosophy of the Visual Arts

Edited by PHILIP ALPERSON

New York Oxford

OXFORD UNIVERSITY PRESS *1992*

Oxford University Press

Oxford New York Toronto
Delhi Bombay Calcutta Madras Karachi
Kuala Lumpur Singapore Hong Kong Tokyo
Nairobi Dar es Salaam Cape Town
Melbourne Auckland

and associated companies in
Berlin Ibadan

Copyright © 1992 by Oxford University Press, Inc.

Published by Oxford University Press
198 Madison Avenue, New York, New York 10016-4314

Library of Congress Cataloging-in-Publication Data
The Philosophy of the visual arts / edited by Philip Alperson.
 ISBN-13 978-0-19-505975-5
p. cm. ISBN-0-19-505975-1
1. Art—Philosophy. I. Alperson, Philip.
N71.P39 1992 701—dc20
90-27421

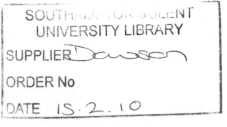
9 8 7 6

Printed in the United States of America
on acid-free paper

Preface

This book is designed to provide a systematic introduction to philosophical problems concerning the visual arts and the institutions that sustain them. Although it is intended for use as a primary text in aesthetics courses whose main orientation is the visual arts, I hope the book will also prove useful in classes on art appreciation, principles of art, art history, and the humanities, where a philosophical approach can enhance one's understanding and appreciation of the visual arts. The book is also directed toward philosophers, artists, critics, and other professionals who wish to examine the philosophical presuppositions and theories that underlie—and at times help determine—the shape and direction of artistic practice.

The Philosophy of the Visual Arts differs from other collections in aesthetics in a number of significant ways. First, the book concentrates on problems associated with the visual arts as a group. The collection opens with an examination of the very notion of "the visual arts." It then investigates philosophical questions raised by various kinds of visual arts. Since painting is usually considered the paradigmatic visual art, the examination of particular kinds of visual art provides a thorough analysis of philosophical questions about painting and the pictorial arts, including questions about form and representation and the relationship between the pictorial arts and other human domains (psychology, religion, politics, and society). The other visual arts are each explored, with emphasis on the philosophical issues raised most clearly by the individual arts.

The focus throughout the book is philosophical. That is, I have sought to include selections that stress conceptual and theoretical issues. Within that context, however, I have deliberately adopted an approach that is both flexible and pluralistic. The collection takes as its subject not only the visual arts as typically conceived (painting, sculpture, and architecture) but also such activities as film and photography (whose status as art forms is frequently debated), as well as arts, objects, events, and practices to which the rubric "visual art" might be applied, such as dance, kitsch, circuses and clowns, the

natural environment, costumery, body beautification, and life itself. The philosophical presuppositions of the traditional grouping, as well as the implications of such an extension, are addressed in several sections of the anthology. The collection also contains a section devoted to the challenge to aesthetic theory presented by contemporary developments in artistic practice, as well as a section on important cultural and social institutions vital to the preservation and historical understanding of the visual arts, including discussions of the functions of museums and art criticism and the nature of art history as an academic discipline. The selections represent both classical and contemporary views and exhibit a range of philosophical styles, approaches, and positions. I have not shied away from including selections by artists, art historians, critics, and other nonphilosophers when this seemed appropriate. It is my conviction that such an inclusion enriches the philosophical and critical examination of our beliefs about the visual arts.

I have generally used the original titles or headings of the selections for this volume. In certain cases I have deviated from this practice for the sake of continuity and cohesiveness of the volume as a whole. The original title for each selection appears in the permission citation.

I would like to thank the many people who helped this volume see the light of day. My research was supported by grants from the President's Research Initiative and the College of Arts and Sciences of the University of Louisville. To both I extend my grateful acknowledgment. I am also indebted to Oxford University Press for its support of this project, and to Peter Ohlin and Henry Krawitz for their editorial assistance. Charles Breslin, Dario Covi, Martin Donougho, Jenefer Robinson, Joe Slavin, Ellen Todd, and the anonymous Oxford reviewers provided insightful suggestions for improving the book. I am grateful to Leo Steinberg and Sheila Schwartz for their expert assistance in editing Professor Steinberg's essay, and to Melissa Horrar for her help in editing the manuscript. I am especially thankful to Cynthia Read for her patience, advice, and constructive comments. I am also indebted to those authors and publishers who have given me permission to reprint the selections contained in this volume. Finally, I thank Mary Hawkesworth for her constant encouragement. This book is dedicated to her.

Louisville, Ky. P. A.
January 1991

Contents

III Painting and the Pictorial Arts: Wider Contexts

a. Psychology

b. Religion

c. Politics and Society

IV Arts of the Camera

I

The Idea of "The Visual Arts"

For most of us it would be difficult to think of a day in our lives which was not touched in some way by the visual arts. We marvel at the magnificence of a building or we are swept away by a painting or a photographic image. We pause to admire a graceful sculpture. We spend an afternoon at the museum. We are transported into the projected world of a movie. Perhaps our eye is caught by a particularly striking typographical design or a photograph in an advertisement. Indeed, a world without such things would scarcely seem human. In that sense we are already familiar with the visual arts. They are a part of our everyday lives and their importance and significance in human affairs seem obvious.

At another level, however, the visual arts remain elusive. It is not easy to say exactly what it is about paintings or sculptures, for example, that attracts us or that accounts for the cultural importance we often ascribe to them. Nor is it immediately clear why we even speak of "the visual arts" as a group. That we do so is not open to dispute. There are magazines, journals, societies, schools, and museums devoted to the production, preservation, appreciation, and study of the visual arts. But what, exactly, do buildings have in common with paintings? Or sculptures with movies? Or, to go a bit further afield, what do these visual arts have in common with other arts such as music, drama, and literature? What is the relationship between the visual arts and such other categories of art as the "fine arts," the "arts of space," and the "arts of time"? Just what do we mean when we speak of the visual arts?

One strategy for arriving at an understanding of the visual arts immediately suggests itself. Whatever else the visual arts are, they seem to be a species of "art." One might therefore try to understand the nature of the visual arts by first developing a clear definition of the term "art." One could then turn to the question of how a specifically visual art is to be distinguished from a nonvisual art. The visual arts would then refer to that class of arts understood as visual in the required sense.

Unfortunately, this strategy is not as straightforward as it at first seems.

"Art" is a notoriously recalcitrant concept. We value works of art for a wide variety of reasons—as manifestations of skill, for example, or as embodiments of particular qualities of form; as means of exercising the imagination or as carriers of expressive, representational, religious, moral, social, political, or historical meaning and force; as personal or domestic adornment or as emblems of wealth, status, privilege, or sophistication. The term *art* resists our efforts to define it in part because of this multiplicity of values.

But the problem is not simply that the term has many definitions reflecting the various interests we might take in works of art. The issue is rather how to come to grips with the practice of art itself. There seems to be no historically secure notion of a system to which the arts might be accommodated or, for that matter, what "the" arts are.[1] This is one reason why the notion of "an art" has such a wide range of application: we speak not only of the visual arts of painting, sculpture, and architecture but also of the arts of poetry, music, theater, and dance, not to mention the medical arts, the art of motorcycle maintenance, and the "gentle" art of making enemies. Moreover, some philosophers have been persuaded by the argument that art is not amenable to a strict definition stating its necessary and sufficient conditions precisely because artists traditionally and continually try to push beyond the boundaries of the styles, genres, and art forms they inherit. This self-transformational character of artistic practice, they argue, means that art is an "open" concept, that in principle cannot be defined.[2] Or perhaps, as has been recently argued, our notions of art and of the arts do, after all, derive from a particular way of thinking about art and the arts, but the implications and limitations of this line of thought generate a set of alternative positions that need to be invoked to account for the diverse ways in which art has come to be understood in specific historical situations.[3] Our thinking about art is further complicated by the fact that we may focus at one moment on questions concerning the artist and the production of art, at another moment on questions concerning works of art, and at another on questions about the relations among these three aspects of the artworld. At the very least, our concept of art seems to be an extremely complex one.

Nevertheless, one line of thinking about art has been especially influential among modern philosophers of art and provides a good beginning for our reflections about the visual arts in particular. The central concept of this view of art is the idea of "the aesthetic." According to one variant of this view deriving from the work of the eighteenth-century philosopher Immanuel Kant, the aesthetic is understood in terms of the concept of *aesthetic interest,* an

1. On this point see Paul O. Kristeller, "The Modern System of the Arts," *Journal of the History of Ideas,* 12 (1951), 465–527, and 13 (1952), 17–46.

2. The classic statement of this position is contained in Morris Weitz's article "The Role of Theory in Aesthetics," *The Journal of Aesthetics and Art Criticism,* 15 (1956), 27–35.

3. For a finely nuanced exposition of this view, see Francis Sparshott's *The Theory of the Arts* (Princeton: Princeton University Press, 1982).

him to this point. The familiar concept of the "fine arts" turns out to be confused and dispensable, for example. Munro also argues that the visual arts may have nonvisual qualities which are aesthetically relevant. And perhaps most surprisingly, Munro argues that the list of arts which might be classified as visual goes well beyond what is sometimes referred to as the trinity of high art: painting, sculpture, and architecture. Indeed, the list of visual arts is indefinitely large. Munro's own partial list includes embalming and mummifying, puppetry, animal breeding, toolmaking, and food preparation. These are all activities from which one might derive aesthetic satisfaction primarily by means of the sense of sight.

But this way of conceptualizing the visual arts comes under attack on several fronts. One might, first of all, question the intelligibility of the notion of the aesthetic attitude, as George Dickie does in his article "The Myth of the Aesthetic Attitude." Dickie allows that the notion of the aesthetic attitude has been historically important in prying philosophers loose from a preoccupation with beauty. But, he argues, if the aesthetic attitude is taken to refer to a special kind of attention, it is a confused notion. The difference between attending to a work "interestedly" (with an ulterior purpose) and "disinterestedly" (without an ulterior purpose) is a motivational or intentional difference, not a perceptual one. One might wish to argue that certain sorts of associations are irrelevancies that distract a viewer from a work, but "distraction is not a special kind of attention," Dickie argues, "it is a kind of inattention." In addition to this conceptual confusion, Dickie contends, the notion of the aesthetic attitude misleads aesthetic theorists in several ways. It incorrectly sets limits on aesthetic relevance and draws incorrect and unfortunate distinctions between appreciation and criticism and between aesthetic value and moral vision.

The conception of the visual arts outlined here might also come under attack on the grounds that one cannot successfully maintain the differentiation of the arts according to the particular senses they address. This is the upshot of the selection by Benedetto Croce, "Intuition, Technique and the Classification of the Arts." Croce distinguishes between two forms of knowledge, intuitive and logical. The former is a knowledge of images obtained through the imagination, the latter a knowledge of concepts obtained through the intellect. Intuition should not be confused with sensation or the perception of the real. Rather, it is an expressive and productive activity: it is "distinguished as *form* from what is felt and suffered, from the flux or wave of sensation, or from psychic matter." Art, Croce contends, is concerned essentially with intuition. This truth holds even in the case of photography, which some would regard as among the most mechanical of the arts. If photography is an art, Croce argues, it is so "to the extent that it transmits the intuition of the photographer, his point of view, the pose and grouping which he has striven to attain."

But, Croce maintains, intuition privileges no sense modality in particular. This means not only that one cannot identify a group of impressions (say,

attitude in which we savor aspects of a thing for its intrinsic merits. We might delight in the lines, colors, and textures of a painting, for example, or the play of surface and planes in a building. According to this view of art, artists are (or should be) concerned with the production of works that facilitate this sort of experience. A work of art just is, in Monroe Beardsley's succinct formulation, "something produced with the intention of giving it the capacity to satisfy the aesthetic interest."[4] Audiences direct (or should direct) their attention to this "aesthetic" aspect of works of art. Art is then understood to refer to that general human domain in which such considerations have a central importance. This approach to art is certainly one assumed by many people in the artworld.

Jerome Stolnitz also defends this approach in his essay "The Aesthetic Attitude," which opens this book. Noting that different cultures and periods have identified different qualities of works of art as "aesthetic," Stolnitz chooses not to define the aesthetic in terms of a particular quality of objects. Instead, he defines it in terms of a certain way of regarding objects, a "disinterested and sympathetic attention to and contemplation of any object of awareness whatever, for its own sake alone." This account of the aesthetic attitude is both exclusive and inclusive. Stolnitz argues that one's aesthetic interest in an object is "disinterested" in the sense that it cannot be directed toward its rarity, monetary value, truth, or any other practical interest or personal need. The aesthetic attitude is rather a sympathetic, active, and discriminating appreciation of the qualities of objects themselves, which allows them to come alive for us in contemplation. This attitude, Stolnitz insists, can be taken toward any object, including concepts, natural objects, products of the imagination, and, of course, works of art, which are especially apt candidates for aesthetic contemplation. Aesthetic experience is thus understood as the experience one has while taking the aesthetic attitude.

Thomas Munro, in his essay "On the Nature of the Visual Arts," shows that this conception of art has important implications for an understanding of the visual arts. After arguing in general for the need to think clearly about the ar' Munro advances a compound definition of art which takes into account se' ways of understanding the term *art*, as certain sets of skill, the products ' skills, a whole domain of human culture, and particular divisions of th' domain which we identify in terms of the particular arts (painting, s' music, and so on). However, Munro then circumscribes the notior identifying a specifically aesthetic definition as "the core concep' an individual art is seen as a "skill in providing stimuli to satis' experience." The visual arts can then be understood as thos' specifically and primarily to the sense of sight.

This is a common enough way of thinking about the is quick to point out several consequences that migh'

4. Monroe C. Beardsley, "An Aesthetic Definition of Art, (New York: Haven Publications, 1983), p. 21.

visual impressions) as inherently aesthetically richer than others, but, more fundamentally, it is a mistake to classify intuitions on the basis of the senses. "The bloom on a cheek, the warmth of a youthful body, the sweetness and freshness of a fruit, the edge of a sharp knife, are not these too, impressions obtainable from a picture? Are they visual?" Croce asks. It is true, Croce acknowledges, that artists develop techniques to externalize their expressions in physical products (metaphorically called *artistic objects* or *works of art*) and that the arts are commonly classified on the basis of these techniques and products. Architecture involves planning and working with materials of construction, we say, sculpture with materials suitable for casting or modeling, painting with techniques of tempera, music with combinations and fusions of tones and sounds, and so on. We classify the arts in ways related to these technical matters when we speak of the arts of hearing, sight, imagination, and so forth. But these divisions rest on empirical and practical matters which, Croce insists, are independent of and posterior to the purely internal, spiritual activity of expression with which the real work of art is to be identified. "All the books dealing with classifications and systems of the arts could be burned without any loss whatever," Croce says bluntly. Similarly, Croce argues, it would be quite pointless to try to determine what the limits of any art might be.

Yet many would argue that the peculiarities of the media of the different arts cannot be written off so easily. Indeed, one might go so far as to argue that the media of the particular arts not only influence their character, they determine their very possibilities and limitations. The classic argument for this viewpoint is that of Gotthold Ephraim Lessing, who (contra Stolnitz) wants to mark out the domain of the aesthetic with reference to a particular quality. The aim of "fine arts," in Lessing's view, is to present beauty, which arises in the harmonious and pleasurable interaction of constituent parts.

In his essay "On the Limits of Painting and Poetry" Lessing compares painting and poetry, with an eye to assessing what each most appropriately represents as subject matter. The visual art of painting is a spatial art, he argues; its signs or means of imitation are figures and colors articulated and coexisting in space. It is therefore best suited for imitating objects whose parts are presented in space in the same way. The true subjects of painting, Lessing says, are bodies with their visible properties. At best, a painting depicts a moment of an action; it can only suggest preceding or subsequent instants of action. Painters are therefore best advised to avoid attempting to capture two (or more) moments of an action by, say, depicting two (or more) of its components simultaneously. A painter's highest calling is to present the beauty of an object, by capturing the harmonious effect of its simultaneously juxtaposed parts.

Words, on the other hand, are presented successively in time. Poetry is therefore best suited to imitating action, whose parts, so to speak, are also consecutively presented. To the extent that poetry does attempt to depict

objects, it should do so only by means of vivid images that do not interfere with the imitative rendering of action. The poet who attempts to be a painter by employing detailed discursive descriptions of objects is doomed to failure. We perceive objects at a glance, and can attend to the elements of the whole in any order. Verbal descriptions, on the other hand, are presented slowly and sequentially. The poet may describe the effects of beauty but must rest content with representing not the physical beauty of objects but rather charm or beauty in motion. (For this reason some commentators question whether Lessing wants to include poetry in the class of fine arts at all.)

It is easy to dismiss Lessing's argument on the grounds that his adherence to a classical theory of art as the imitation of beautiful things (to the point of rejecting the ugly, the shocking, the expressive, and the significant as suitable subject matters for art) is a narrow and historically limited point of view. Lessing is frequently criticized for his efforts to foreclose on the artistic possibilities of the arts he considers in the way he does. On the other hand, Lessing's insistence that each art has its individual character, his emphasis on the material aspects of art, and his concern with the question of the classification of the arts remain compelling to many writers on the arts, and the visual arts in particular. These general issues as well as the other questions raised in this section recur in many of the remaining essays in this book, each of which contributes in its own way to the general question of our understanding of the visual arts.

I

The Aesthetic Attitude

JEROME STOLNITZ

We are defining the realm of the aesthetic in terms of a distinctive kind of "looking." This says nothing about the objects which are apprehended in this way. What they are like, and what characteristics, if any, they have in common with each other, are left open. But this approach is not used by many traditional theories in aesthetics. They do not begin, as we do, by asking, "What is aesthetic experience?" They take "aesthetic" to refer to certain properties which some objects have, by virtue of which they are beautiful, and which others lack. Then the theories set themselves to find out what these properties are specifically. Once these distinguishing characteristics are found, they make up the aesthetic area of experience.

But we are not going about it in this way. Why not? To be genuinely "critical," we must justify our approach. The justification is twofold.

Primarily, traditional attempts to explain the value of art and beauty by means of some distinctive "aesthetic" quality, have proven to be too limited. They have not done justice to the tremendous diversity of works of art and all of the other, very different things which men find interesting to look upon. The property taken to define "aesthetics," notably "harmony,"[1] has been interpreted differently by various thinkers and eras. Generally it is the property of works of art which are found attractive or admirable by people of a certain historical period or a specific culture. It is put forth, however, as the characteristic common to *all* aesthetic objects. Any

object which lacks it is excluded from the area of the aesthetic. Thus art of a particular style or the taste of a particular period is taken to be the model for all aesthetic value. But inevitably, art which is very dissimilar comes to be developed. And for this among other reasons, tastes change ... Then objects are found to be valuable for perception which do *not* possess the properties formerly taken to be "aesthetic." The original explanation of aesthetic value proves to be too circumscribed and narrow, or else it is found to misinterpret the nature of the aesthetic.

It is in order to avoid this crippling narrowness that we shall be defining "aesthetic" in terms of a particular sort of perception. It is extremely important, in beginning this study or any other, not to set too great limitations upon the field of study. At least this should not be done a priori, i.e., before the actual investigation of data has started. If you limit yourself too severely at first, you will very probably overlook facts of great importance. By defining "aesthetic" as perception of an object just for the sake of perceiving it, all objects, of whatever kinds, which men have found occasion to contemplate, are included in the field of study. This includes art of different forms, periods, and styles, and diverse objects and scenes in nature. We can then go on to analyze the structure of these objects and see to what extent there are similarities among them.

This brings us to the second reason for choosing this definition of "aesthetic." ... If we are to under-

From Jerome Stolnitz, *Aesthetics and the Philosophy of Art Criticism*. Boston: Houghton Mifflin Company, 1960, pp. 29–42. Reprinted by permission of Houghton Mifflin Company and the author.

stand what is usually meant by "art" and "beauty," and our experience of them, we must understand the workings of aesthetic perception. We have seen that works of art can be studied and valued in many ways—morally, as a social document, and so on. When we approach the work as a sociologist or moralist, we do not grasp its intrinsic value. To do so we must look at the work without any preoccupation with its origins and consequences. Therefore analysis of such perception is prerequisite to explanation of the *aesthetic* (not the historical, moral, etc.) value of art and the *aesthetic* senses of the term "beauty."

This idea of the uniqueness of aesthetic perception, like all ideas, has its history. Although it is found at scattered places throughout aesthetic theory, it is not until the eighteenth century that it becomes central to the study of aesthetics. After that time the idea gains great currency. Let us see some of the historical causes of this.

Throughout all history and up to the present day, art has been explained and valued in nonaesthetic terms. It has been esteemed for its social utility, or because it inculcates religious beliefs, or because it makes men more moral, or because it is a source of knowledge. In all these cases, you see, art is valued for the consequences to which it gives rise, not for its intrinsic interest. In recent centuries, however, there has been much greater emphasis upon the aesthetic significance of art. One of the chief causes has been the great change in the position of the artist in society. Increasingly he has come to be dissociated from the rest of his society. He is no longer considered one among other craftsmen, as he was in Greek and medieval society. He comes to think of himself as being set apart by his distinctive creative abilities or "genius." Furthermore, his creative activity becomes divorced from other functions of society. The most striking example of this is probably music. Throughout social history music has been the handmaiden of other activities, e.g., work songs, ceremonial music, songs of war. It has been customarily enlisted in the service of religion, where it is used for purposes of worship and celebration. Thus the great German composer Johann Sebastian Bach (1685–1750) said that he wrote music to "sing the praises of God." But increasingly throughout the nineteenth century composers wrote music which was simply to be appreciated for itself. Music which serves no function other than to be heard is therefore a relatively recent development historically. Finally, there are a number of social and cultural forces which isolate the artist even further. For one thing, he is repelled by the ugliness of industrial society, with its squalid mill towns and teeming, dirty cities. At the same time, he rejects the pressures of "mass society" that compel conformity to the values and way of life of the "mass." Such uniformity stifles the individuality which the artist considers so precious. He attempts to express his individuality without restraint, but this aggravates the situation even further. He creates startlingly new and daring works for which there is little or no audience. Art and artistic activity become the object of scorn and derision, or, what is even worse, they are simply ignored. Consider, for example, the attitudes of most people at the present time toward "modern art" and contemporary music. Although more and more people are finding value in such art, its appeal is still very limited. Thus art is forced out of the mainstream of society.

As a result of the causes sketched here, among others, a new conception of art gains prominence: art exists simply to be enjoyed for its own sake. It is valuable in itself, not because it promotes the goals of religion or morality or society generally. The best-known expression of this view is found in the so-called "Art for Art's Sake" movement, which flourished during the last half of the nineteenth century. This movement insisted that the only way to approach art is through aesthetic perception.

Philosophical interest in aesthetic perception thus arises from historical developments in the arts and in society.

But it is one thing to know about the historical origins of an idea and quite another thing to examine the idea itself and test its validity. To this we must now turn. Let us remember that the justification for making aesthetic perception central in our study has thus far been only partially explained. The significance of this concept, like that of the fundamental idea in any field of inquiry, will become clear as we go along. We shall find that the concept of aesthetic perception is enormously useful in solving many of the problems that we meet later on.

Finally, remember that since we shall be talking about a certain kind of human experience, what we say must be true to the facts of this experience. It should describe faithfully the way in which we apprehend literature, music, and painting, and help to explain the value of the experience. Unless it does so, our account will not be accepted by anyone who is philosophically critical.

How We Perceive the World

Aesthetic perception will be explained in terms of the aesthetic *attitude*.

It is the attitude we take which determines how we perceive the world. An attitude is a way of directing and controlling our perception. We never

see or hear everything in our environment indiscriminately. Rather, we "pay attention" to some things, whereas we apprehend others only dimly or hardly at all. Thus attention is *selective*—it concentrates on some features of our surroundings and ignores others. Once we recognize this, we realize the inadequacy of the old notion that human beings are simply passive receptors for any and all external stimuli. Furthermore, what we single out for attention is dictated by the purposes we have at the time. Our actions are generally pointed toward some goal. In order to achieve its goal, the organism watches keenly to learn what in the environment will help and what will be detrimental. Obviously, when individuals have different purposes, they will perceive the world differently, one emphasizing certain things which another will ignore. The Indian scout gives close attention to markings and clues which the person who is simply strolling through the woods will pass over.

Thus an attitude or, as it is sometimes called, a "set," guides our attention in those directions relevant to our purposes. It gives direction to our behavior in still another way. It prepares us to *respond* to what we perceive, to act in a way we think will be most effective for achieving our goals. By the same token, we suppress or inhibit those responses which get in the way of our efforts. A man intent on winning a chess game readies himself to answer his opponent's moves and thinks ahead how best to do this. He also keeps his attention from being diverted by distractions.

Finally, to have an attitude is to be favorably or unfavorably oriented. One can welcome and rejoice in what he sees, or he can be hostile and cold toward it. The Anglophobe is a person whose attitude toward all things British is negative, so that when he meets someone with a British accent or hears "Rule Brittania," we expect him to say something disparaging or cynical. When one's attitude toward a thing is positive, he will try to sustain the object's existence and continue to perceive it; when negative, he will try to destroy it or avert his attention from it.

To sum up, an attitude organizes and directs our awareness of the world. Now the aesthetic attitude is not the attitude which people usually adopt. The attitude which we customarily take can be called the attitude of "practical" perception.

We usually see the things in our world in terms of their usefulness for promoting or hindering our purposes. If ever we put into words our ordinary attitude toward an object, it would take the form of the question, "What can I do with it, and what can it do to me?" I see the pen as something I can write with, I see the oncoming automobile as something

to avoid; I do not concentrate my attention upon the object itself. Rather, it is of concern to me only so far as it can help me to achieve some future goal. Indeed, from the standpont of fulfilling one's purposes, it would be stupid and wasteful to become absorbed in the object itself. The workman who never gets beyond looking at his tools, never gets his job done. Similarly, objects which function as "signs," such as the dinner bell or traffic light, are significant only as guides to future behavior. Thus, when our attitude is "practical," we perceive things only as means to some goal which lies beyond the experience of perceiving them.

Therefore our perception of a thing is usually limited and fragmentary. We see only those of its features which are relevant to our purposes, and as long as it is useful we pay little attention to it. Usually perception is merely a rapid and momentary identification of the kind of thing it is and its uses. Whereas the child has to learn laboriously what things are, what they are called, and what they can be used for, the adult does not. His perception has become economized by habit, so that he can recognize the thing and its usefulness almost at once. If I intend to write, I do not hesitate about picking up the pen rather than a paper clip or the cigarette lighter. It is only the pen's usefulness-for-writing-with, not its distinctive color or shape, that I care about. Is this not true of most of our perception of the "furniture of earth"? "In actual life the normal person really only reads the labels as it were on the objects around him and troubles no further."[2]

If we stop to think about it, it is astonishing how little of the world we really *see*. We "read the labels" on things to know how to act with regard to them, but we hardly see the things themselves. As I have said, it is indispensable to getting on with the "work of the world" that we should do this. However, we should not assume that perception is always habitually "practical," as it probably is in our culture. Other societies differ from our own, in this respect.[3]

But nowhere is perception exclusively "practical." On occasion we pay attention to a thing simply for the sake of enjoying the way it looks or sounds or feels. This is the "aesthetic" attitude of perception. It is found wherever people become interested in a play or a novel or listen closely to a piece of music. It occurs even in the midst of "practical" perception, in "casual truant glances at our surroundings, when the pressing occupations of practical effort either tire us or leave us for a moment to our own devices, as when in the absorbing business of driving at forty or fifty miles an hour along a highway to get to a destination, the tourist on his holiday glances at the trees or the hills or the ocean."[4]

The Aesthetic Attitude

It will forward our discussion of the aesthetic atti-
tude to have a definition of it. But you should
remember that a definition, here or in any other
study, is only a point of departure for further
inquiry. Only the unwary or intellectually lazy stu-
dent will rest content with the words of the defini-
tion alone, without seeing how it helps us to under-
stand our experience and how it can be employed to
carry on the study of aesthetics. With this word of
caution, I will define "the aesthetic attitude" as
"disinterested and sympathetic attention to and
contemplation of any object of awareness whatever,
for its own sake alone." Let us now take up in turn
each of the ideas in this definition and see what they
mean precisely. Since this will be a piecemeal anal-
ysis, the truth of the account must be found in the
total analysis and not in any single part of it.

The first word, "disinterested," is a crucially impor-
tant one. It means that we do not look at the object
out of concern for any ulterior purpose which it
may serve. We are not trying to use or manipulate
the object. There is no purpose governing the expe-
rience other than the purpose of just *having* the
experience. Our interest comes to rest upon the
object alone, so that it is not taken as a sign of some
future event, like the dinner bell, or as a cue to
future activity, like the traffic light.

Many sorts of "interest" are excluded from the
aesthetic. One of them is the interest in owning a
work of art for the sake of pride or prestige. A book
collector, upon seeing an old manuscript, is often
interested only in its rarity or its purchase price, not
its value as a work of literature. (There are some
book collectors who have never *read* the books that
they own!) Another nonaesthetic interest is the
"cognitive," i.e., the interest in gaining knowledge
about an object. A meteorologist is concerned, not
with the visual appearance of a striking cloud for-
mation, but with the causes which led to it. Simi-
larly, the interest which the sociologist or historian
takes in a work of art ... is cognitive. Further,
where the person who perceives the object, the "per-
cipient,"[5] has the purpose of passing judgment upon
it, his attitude is not aesthetic. This should be kept
in mind, for, as we shall see later, the attitude of the
art critic is significantly different from the aesthetic
attitude.

We may say of all these nonaesthetic interests,
and of "practical" perception generally, that the
object is apprehended with an eye to its origins and
consequences, its interrelations with other things.
By contrast, the aesthetic attitude "isolates" the
object and focuses upon it—the "look" of the rocks,
the sound of the ocean, the colors in the painting.

Hence the object is not seen in a fragmentary or
passing manner, as it is in "practical" perception,
e.g., in using a pen for writing. Its whole nature and
character are dwelt upon. One who buys a painting
merely to cover a stain on the wall paper does not
see the painting as a delightful pattern of colors and
forms.

For the aesthetic attitude, things are not to be
classified or studied or judged. They are in them-
selves pleasant or exciting to look at. It should,
then, be clear that being "disinterested" is very far
from being "*un*-interested." Rather, as all of us
know, we can become intensely absorbed in a book
or a moving picture, so that we become much more
"interested" than we usually are in the course of our
"practical" activity.

The word "sympathetic" in the definition of
"aesthetic attitude" refers to the way in which we
prepare ourselves to respond to the object. When we
apprehend an object aesthetically, we do so in order
to relish its individual quality, whether the object be
charming, stirring, vivid, or all of these. If we are to
appreciate it, we must accept the object "on its own
terms." We must make ourselves receptive to the
object and "set" ourselves to accept whatever it may
offer to perception. We must therefore inhibit any
responses which are "un-sympathetic" to the object,
which alienate us from it or are hostile to it. A
devout Mohammedan may not be able to bring
himself to look for very long at a painting of the
Holy Family, because of his animus against the
Christian religion. Closer to home, any of us might
reject a novel because it seems to conflict with our
moral beliefs or our "way of thinking." When we
do so, we should be clear as to what we are doing.
We have *not* read the book aesthetically, for we
have interposed moral or other responses of our
own which are alien to it. This disrupts the aesthetic
attitude. We cannot then say that the novel is *aes-
thetically* bad, for we have not permitted ourselves
to consider it aesthetically. To maintain the aes-
thetic attitude, we must follow the lead of the object
and respond in concert with it.

This is not always easy, for all of us have deep-
seated values as well as prejudices. They may be eth-
ical or religious, or they may involve some bias
against the artist or even against his native country.
(During the First World War, many American sym-
phony orchestras refused to play the works of Ger-
man composers.) The problem is especially acute in
the case of contemporary works of art, which may
treat of disputes and loyalties in which we are
deeply engaged. When they do so, we might remind
ourselves that works of art often lose their topical
significance with the passing of time and then come
to be esteemed as great works of art by later gener-
ations. Milton's sonnet "On the Late Massacre in

Piedmont" is a ringing protest called forth by an event which occurred shortly before the writing of the poem. But the heated questions of religion and politics which enter into it seem very remote to us now. People sometimes remonstrate with a friend who seems to reject offhand works of art of which they are fond, "You don't even give it a chance." To be "sympathetic" in aesthetic experience means to give the object the "chance" to show how it can be interesting to perception.

We come now to the word "attention" in our definition of "aesthetic attitude." As has been pointed out, any attitude whatever directs attention to certain features of the world. But the element of attention must be especially underscored in speaking of aesthetic perception. For, as a former teacher of mine used to say, aesthetic perception is frequently thought to be a "blank, cow-like stare." It is easy to fall into this mistake when we find aesthetic perception described as "just looking," without any activity or practical interest. From this it is inferred that we simply expose ourselves to the work of art and permit it to inundate us in waves of sound or color.

But this is surely a distortion of the facts of experience. When we listen to a rhythmically exciting piece of music which absorbs us with its energy and movement, or when we read a novel which creates great suspense, we give our earnest attention to it to the exclusion of almost everything else in our surroundings. To be "sitting on the edge of the chair" is anything but passive. In taking the aesthetic attitude, we want to make the value of the object come fully alive in our experience. Therefore we focus our attention upon the object and "key up" our capacities of imagination and emotion to respond to it. As a psychologist says of the aesthetic experience, "Appreciation . . . is awareness, alertness, animation."[6] Attention is always a matter of *degree*, and in different instances of aesthetic perception, attention is more or less intense. A color, briefly seen, or a little melody, may be apprehended on the "fringe" of consciousness, whereas a drama will absorb us wholly. But to whatever extent it does so, experience is aesthetic only when an object "holds" our attention.

Furthermore, aesthetic attention is accompanied by activity. This is not the activity of practical experience, which seeks an ulterior goal. Rather it is activity which is either evoked by disinterested perception of the object, or else is required for it. The former includes all muscular, nervous, and "motor" responses such as feelings of tension or rhythmic movement. Contrary to what some snobs would have us believe, there is nothing inherently unaesthetic about tapping one's foot in time to the music. The theory of *empathy* points out that we "feel into" the object our muscular and bodily adjust-

ments. We brace ourselves and our muscles become taut in the face of a sculptured figure which is tall, vigorous, and upright.[7] This does not occur in aesthetic experience alone, and it does not occur in all aesthetic experience, but when it does, it exemplifies the kind of activity which may be aroused in aesthetic perception. The direction of attention itself may not improperly be called "activity." But even overt bodily movement and effort may be required for aesthetic perception. We usually have to walk round all sides of a sculpture, or through a cathedral, before we can appreciate it. We would often reach out and touch sculptured figures if only museum guards would permit us to do so.

But focusing upon the object and "acting" in regard to it is not all that is meant by aesthetic "attention." To savor fully the distinctive value of the object, we must be attentive to its frequently complex and subtle details. Acute awareness of these details is *discrimination*. People often miss a good deal in the experience of art, not only because their attention lapses, but because they fail to "see" all that is of significance in the work. Indeed, their attention frequently lapses for just this reason. They miss the individuality of the work, so that one symphony sounds like any other piece of "long-hair" music, and one lyric poem is indistinguishable from another, and all are equally boring. If you have had the good fortune to study literature with an able teacher, you know how a play or novel can become vital and engaging when you learn to look for details to which you were previously insensitive. But awareness of this kind is not always easily come by. It often requires knowledge about allusions or symbols which occur in the work, repeated experience of the work, and even, sometimes, technical training in the art-form.

As we develop discriminating attention, the work comes alive to us. If we can keep in mind the chief themes in the movement of a symphony, see how they are developed and altered in the course of the movement, and appreciate how they are played off against each other, then there is a great gain in our experience. The experience has greater richness and unity. Without such discrimination it is thin, for the listener responds only to scattered passages or to a patch of striking orchestral color. And it is disorganized, for he is not aware of the structure which binds the work together. His experience may be said to be intermittently and to a limited degree aesthetic, but it is not nearly as rewarding as it might be. Everybody knows how easy it is to start thinking of other things while the music is playing, so that we are really aware of it only now and again. All the more reason, then, why we should develop the capacities for appreciating its richness and profundity. Only so can we keep our experience from

becoming, in Santayana's famous phrase, "a drowsy revery relieved by nervous thrills."[8]

If you now understand how aesthetic attention is alert and vigorous, then it is safe to use a word which has often been applied to aesthetic experience—"contemplation." Otherwise, there is the great danger that this word will suggest an aloof, unexcited gaze which, we have seen, is untrue to the facts of aesthetic experience. Actually, "contemplation" does not so much add something new to our definition as it sums up ideas which we have already discussed. It means that perception is directed to the object in its own right and that the spectator is not concerned to analyze it or to ask questions about it. Also, the word connotes thoroughgoing absorption and interest, as when we speak of being "lost in contemplation." Most things are hardly noticed by us, whereas the object of aesthetic perception stands out from its environment and rivets our interest.

The aesthetic attitude can be adopted toward "any object of awareness whatever." This phrase need not, strictly speaking, be included in our definition. We could understand the aesthetic attitude as the kind of perceptual attention we have been talking about, without adding that "any object whatever" may be its object. But definitions are flexible to an extent. We can choose to include in them even what is not strictly necessary to identify the term being defined. The great and even limitless scope of aesthetic experience is one of the most interesting and important things about it.

The definition permits us to say that any object at all can be apprehended aesthetically, i.e., no object is inherently unaesthetic. But it might be thought odd, or even downright wrong, to say this. There are some objects which are conspicuously attractive, so that they "catch our eye" and draw attention to themselves—a bed of bright and many-colored flowers or a marching song, massive cloud formations, or a noble and stately cathedral. Certainly the same is not true of many, indeed most, other things in the world. Are we to say that a dirty, run-down slum section is to be called "aesthetic"? What about dull, unexciting things like supplies stacked row upon row in a warehouse or, if you please, the telephone directory? Indeed, the word "aesthetic" is often used in everyday speech to distinguish those objects which are delightful to look upon or listen to, from those which are not. As was pointed out at the beginning of this chapter, this is also the view of a good deal of traditional aesthetic theory.

This argument—that some objects do not qualify as "aesthetic"—certainly sounds plausible and convincing. I think that the best way to argue against it is to present evidence that human beings have contemplated disinterestedly objects which are

enormously diverse. Among such objects are some which we might consider wholly uninviting. As was mentioned earlier, men have found perceptual enjoyment in things which people of earlier times or other cultures judged to be unaesthetic. The whole "history of taste" shows how the boundaries of aesthetic experience have been pushed back and have come to include a tremendous variety of things.

The best evidence of this broadening of vision is to be found in the arts. For here we have permanent records of the objects which have aroused aesthetic interest. It can also be found, however, in the appreciation of nature. The subjects chosen from nature for treatment by artists show the expansion of perceptual interest. "Social historians" can often trace changes in the appreciation of nature in other ways, e.g., memoirs and diaries, sites chosen for resort places, and so on. But let us for the moment speak solely of art. If we confine ourselves to the art of the last 150 years, we find an enormous amount of art devoted to the two sorts of objects which "common sense" considers intrinsically unaesthetic, viz., dull, commonplace objects and ugly or grotesque things and events. The poet Wordsworth, at the beginning of the nineteenth century, devoted much of his poetry to "humble and rustic life." One of van Gogh's paintings is of a perfectly prosaic yellow chair, another is of the rude furniture in his bedroom. In our own day, the painter Ben Shahn has chosen as the subject of one of his works city boys playing handball. Instances of the depiction of ugly and macabre themes in recent art are even more obvious. The student may be able to think of some himself. I will cite Géricault's "The Raft of the *Medusa*," the harrowing treatment of a tortured and pathetic figure in Berg's opera *Wozzeck,* and such "realistic" literature as Gorki's *Lower Depths* and Farrell's *Studs Lonigan.*

To be sure, the artist apprehends such subjects with imagination and feeling. And when they emerge in the work of art, he has invested them with vividness and excitement. However, the very fact that his attention has been directed to these subjects shows how far-ranging aesthetic interest can be. Further, his use of them alters and expands the taste of the nonartist. The ordinary man now becomes newly sensitive to the perceptual interest of many different objects and events. Thus appreciation of the grandeur of mountain ranges, which is a relatively recent chapter in the history of taste, was stimulated by such works of art as Haller's poem *Die Alpen.* Less lofty objects and even scenes which are ugly become the objects of aesthetic attention. Here is the testimony of one who is not an artist:

[The] ugliest thing in nature that I can think of at the moment is a certain street of shabby houses

where a street-market is held. If one passes through it, as I sometimes do, early on a Sunday morning, one finds it littered with straw, dirty paper and the other refuse of a market. My normal attitude is one of aversion. I wish to hold myself away from the scene. . . . But I sometimes find that . . . the scene suddenly gets jerked away from *me* and on to the aesthetic plane, so that I can survey it quite impersonally. When this happens, it does seem to me that what I am apprehending looks different; it has a form and coherence which it lacked before, and details are more clearly seen. But . . . it does not seem to me to have ceased to be ugly and to have become beautiful. I can see the ugly aesthetically, but I cannot see it as beautiful.[9]

The student can probably think of things in his own experience—a face, a building, a landscape—which, though not conventionally "pretty" or "attractive," arouse aesthetic interest. Evidence of this kind cannot establish that *all* objects can be aesthetic objects. When such evidence is multiplied, however, it makes this assumption a reasonable one at the outset of aesthetic inquiry.

In keeping with this assumption, the word "awareness" is used in our definition of "aesthetic attitude." I have been using the word "perception" to describe aesthetic apprehension, but its meaning is too narrow. It refers to apprehension of sense-data, e.g., colors or sounds, which are interpreted or "judged" to be of a certain kind. Perception differs from sensation as the experience of an adult differs from that of the newborn infant, for whom the world is a succession of mysterious and unrelated sensory "explosions." In adult experience, we rarely apprehend sense-data without knowing something about them and interrelating them, so that they become meaningful. We see more than a color patch; we see a flag or a warning signal. Perception is the most usual sort of "awareness." But if sensation occurs, it too can be aesthetic.

There is another kind of "awareness" that occurs, though relatively infrequently, in adult experience. This is "intellectual," nonsensuous knowing of "concepts" and "meanings," and their interrelations; such knowing takes place in abstract thinking, such as logic and mathematics. Even if images or "pictures" accompany such thinking, they are only secondary. When the mathematician thinks of the properties of triangles, his thought is not restricted to any particular triangle he may "see in his head" or draw on paper. A man who develops a system of mathematical logic is occupied with logical relationships which are neither sensed nor perceived. Now this kind of apprehension can also be aesthetic. If one's purpose is not, for the moment, problem solving, if he pauses to contemplate disinterestedly the logical structure before him, then his experience is aesthetic. Such experience has been attested to by many mathematicians, and it is evidenced by the use of such words as "elegance" and "grace," borrowed from the realm of the aesthetic, to describe a conceptual system. The poetess Edna St. Vincent Millay says, in a line that has become famous, "Euclid alone has looked on Beauty bare." The great Greek geometrician discerned mathematical properties and relations which had no sensuous "dress" of sound or color.

To take account of such experience as well as sensation, I have used the broad term "awareness" rather than "perception." Anything at all, whether sensed or perceived, whether it is the product of imagination or conceptual thought, can become the object of aesthetic attention.

This completes the analysis of the meaning of "aesthetic attitude," the central concept in our study. "Aesthetic," understood to mean "disinterested and sympathetic attention," marks out the field of our further investigation. All the concepts to be discussed later are defined by reference to this: "aesthetic experience" is the total experience had while this attitude is being taken; "aesthetic object" is the object toward which this attitude is adopted; "aesthetic value" is the value of this experience or of its object. It is therefore imperative that the student understand and think about the meaning of "aesthetic," before going on to further discussions.

Notes

1. "Harmony, we know, has been the accepted synonym for beauty or for the artist's goal through all the ages of a philosophy of art."—Katherine E. Gilbert and Helmut Kuhn, *A History of Aesthetics*, rev. ed. (Indiana University Press, 1953), p. 186.

2. Roger Fry, *Vision and Design* (New York: Brentano's, n.d.), p. 25. Reprinted by permission of Chatto and Windus Ltd.

3. Lester D. Longman, "The Concept of Psychical Distance," *Journal of Aesthetics and Art Criticism*, 6 (1947), 32.

4. D. W. Prall, *Aesthetic Judgment* (New York: Crowell, 1929), p. 31.

5. This is a clumsy and largely outmoded word, but it is more convenient for our purposes than

words of more limited meaning such as "spectator," "observer," "listener," and is accordingly used here and elsewhere in the text.

6. Kate Hevner, "The Aesthetic Experience: A Psychological Description," *Psychological Review,* 44 (1937), 249.

7. Cf. Herbert S. Langfeld, *The Aesthetic Attitude* (New York: Harcourt, Brace, 1920), chaps. 5–6; Vernon Lee, "Empathy," in Melvin Rader, ed., *A Modern Book of Esthetics,* rev. ed. (New York: Holt, 1952), pp. 460–65.

8. George Santayana, *Reason in Art* (New York: Scribner's, 1946), p. 51.

9. E. M. Bartlett, *Types of Aesthetic Judgment* (London: George Allen & Unwin, 1937), pp. 211–12. Italics in original. Reprinted by permission of George Allen & Unwin Ltd.

2

On the Nature of the Visual Arts

THOMAS MUNRO

Persistent Problems and Conflicting Answers

What is art? As a type of human activity and product, what are its main, distinctive characteristics? As a field of phenomena for aesthetics and art history to examine, what does it include? What are the arts, as specific parts of this field, as distinctive pursuits and types of product? How are they related, as to similarities and differences, common and divergent aims and methods? How can they best be grouped and divided for study and teaching?

These and similar questions have been answered in many different ways during the past two hundred years. The arts change, and so do ideas about them. Some old arts, like mosaic and tapestry, have declined. New ones, like the motion picture, have grown extensively. Old arts are combined in new forms, as in the sound film made from "animated" paintings, with synchronized music and speech. New uses are made of old arts, in industry, commerce, and political propaganda. Applied science and machine industry have altered the methods, materials, and products of all the arts. Styles and standards are changed by revivals and exotic importations, such as the present strong influence of oriental and primitive arts. Trends in social organization and theory, in religion, philosophy, and ethics, alter men's views about the functions and values of art and about the relative importance of past artists and their works.

There is no final answer to the question "what are the arts?" or to the question "what should the arts become?" New answers must be made by each generation from the standpoint of its own beliefs and standards of value. These answers, of course, need not and should not be entirely new; but old conceptions must be constantly revised in the light of recent experience, for present situations and uses.

The field of phenomena studied by aesthetics is made up, to a large extent, of the arts and related types of experience. The particular arts are main divisions within this field. A general idea of their nature and interrelations, if correct, can provide the student with a preliminary survey of the field, and help him to direct his special studies within it.

Comparisons between the arts are always a popular subject of discussion between persons of artistic interests. One dogmatic assertion is countered by another ad infinitum, when artists in different fields meet and talk about their respective crafts, the peculiar difficulties and potentialities of each, and what an artist in each field should aim to do. Opinions range from one extreme to the other: from the view that the arts are utterly different, so that no comparison is possible, to the view that all the arts are fundamentally one, and their apparent differences merely superficial. Works in one art are often characterized in terms drawn from another: for example, that a piece of music is "dramatic" or "colorful." A painting is in "a low key" or "a harmony of muted tones." Analogies are drawn

From Thomas Munro, *The Arts and Their Interrelations*, rev. ed. Cleveland: Case Western Reserve University Press, 1967, pp. 3–14, 107–9, 132–36, 547–58. Reprinted with permission of Professor Donald J. Munro.

between line in painting and melody in music; between visual color and musical "tone-color." Bach's fugues are likened to Gothic cathedrals for their complex and rigorous design. But the specialized worker in a given art is usually impatient with such comparisons. He feels that his own craft and its problems are quite different from those of other artists.

Such arguments seldom arrive at any definite conclusion; partly because the persons who engage in them usually lack the patience for clear, systematic study. Artists and students often prefer an endless interchange of excited affirmations and denials, and feel that they are saying something new, profound, and penetrating. They fail to realize how often their thoughts revolve in ancient grooves and circles. Even the meanings of technical terms such as "art," "form," and "harmony" are treated as subjects for personal pronouncement, as in the familiar expression, "this is what it means to me."

Any systematic study of relations between the arts must deal, directly or indirectly, with problems of definition and classification. What is the distinctive, essential nature of painting as an art? Of poetry? Of music? Can the arts be grouped under various headings, such as "space arts" and "time arts," so as to bring out their basic connections and divergences? In the eighteenth and nineteenth centuries, these problems were attacked with enthusiasm, and many elaborate answers were produced. None of them is quite satisfactory in the twentieth century. But no adequate substitutes have been provided.

There has been little concern in recent years with classifications of the arts, by scholars in aesthetics. Some philosophers have condemned all attempts to work them out, as useless and foredoomed to failure. The arts, they say, are too intangible and changing to be defined or classified. There is much to be said for these objections. They provide a valuable warning against the grandiose, unrealistic theorizing which has been done in the past. But that is not the whole story. We shall not be satisfied with the negative conclusion that there is no use in further thinking about the matter.

Many artists and art-lovers have a hearty dislike for all definitions and classifications. All such talk is dull and boring, they say. Let us deal with art itself; with concrete works of art, and the flesh-and-blood artists who make them—not with endless verbal hair-splitting. Again, there is much to be said for this attitude. It is partly a question of personal likes and dislikes. Many persons are impatient with all theoretical studies of art: with all historical scholarship, and all attempts to understand the psychology of art and artists. Such studies, including the whole subject of aesthetics, are not for them. Even

philosophers and aestheticians are often impatient with definition and classification. These are mere preliminaries, they feel; mere verbal ABC's, which any advanced scholar can take for granted. They, too, are anxious to get on to the concrete realities of art.

Unfortunately, one cannot always solve problems by ignoring them, or escape the consequences of ignoring them. In modern aesthetics and art criticism, a great deal of confusion arises from ambiguity in the meaning of basic terms, and from antiquated assumptions about the nature of the arts, which survive from previous centuries because they have never been replaced. However one may wish to come to grips with art itself, and avoid mere verbal issues, one has to use words in writing or talking about art; and there the trouble begins. The most up-to-date writers on ultra-modern art find themselves using the same old terms and concepts, for the lack of better ones. They take it for granted that everyone knows what the "fine arts" are, and what poetry is, never stopping to realize the astonishing variety of ways in which nearly all the basic terms of aesthetics are understood today.

Current criticism of the arts is permeated with traditional assumptions about the proper aims and limits of each art. What kind of effects and values should each one try to achieve? What kinds should it avoid, for fear of trespassing on the field of some other art? Should painting try to tell a story? Should music try to describe a scene? Or is this an encroachment on the field of literature and a confusion of values? Should sculpture employ colors or leave such effects to painting? Can poetry dispense with meaning and rely on the musical effects of word-sounds? Does a combined art, such as opera, preserve the values of all the arts within it and achieve the highest form of art? Or is music at its best when it specializes on its own distinctive effects, as pure music? The answers made to such questions often assume that each art has definite, proper limits, and is at its best when it stays within them. A work of art, old or new, is appraised as good or bad on the basis of such assumptions. We owe them especially to the eighteenth-century philosopher Lessing. Few contemporary critics are acquainted in detail with the "systems of the arts" produced by Kant, Hegel, and their followers; but these ideas still influence current thinking. Unconsciously, one inherits certain conceptions of the arts, produced mainly by German philosophers of a century or two ago. These conceptions one rarely stops to analyze; some of them would appear very dubious in the light of modern knowledge.

Definition and classification can be quite as interesting as any other phase in the general theory of art. They are a necessary part of the effort to think

clearly about the facts of art as we know them, and to summarize our conceptions in an orderly way. Every subject, in progressing out of vague emotionalism and personal impressions toward scientific status, has to work out a set of definitions for its basic terms. It has to describe the main types of phenomena within its field, whether these are triangles, kinds of matter, species of animal life, or kinds of art. It has to investigate how these various types are interrelated; which are included in which; what types are broad and what ones are narrow. In aesthetics, too, such definition and classification are unavoidable, if we are to have clear thinking at all, and gradual advance toward science. As long as we ignore them, our thinking remains inevitably muddled in certain fundamental ways, and our attempts to deal with more advanced problems are impeded.

It is a mistake to think of definition and classification as "mere preliminaries," coming at an early stage in investigation. They come also at the end and in the middle, in fact, all along the line. Those made in the early stages of a subject always have to be revised later on, in the light of increasing knowledge. The ones we make now must be recognized as tentative hypotheses, sure to need further change in a few years' time. But we can summarize in them the results of our latest discoveries up to the present moment, and use them in turn as instruments in further inquiry.

The confusion begins with the basic terms "art" and "arts." The full extent of their ambiguity is not commonly realized. In the first place, the word "art" is applied to certain kinds of skill or technique, and also to the products of these skills—that is, to works of art. It is sometimes applied broadly to all kinds of useful skill, including medicine and agriculture; sometimes restricted to skill in certain media such as painting, or to skills aimed at producing "aesthetic pleasure." (This last term is itself a vague and controversial one.) The word "art" is sometimes used in a laudatory way, to imply high aesthetic quality in the product; sometimes in a neutral, indiscriminate way, as applied to all production and performance in certain fields.

Many of the terms used to classify the arts into various groups, such as "fine and useful arts," "major and minor arts," "decorative arts," and "arts of design," are also very differently understood. For example, music and literature are sometimes classed as fine arts. At other times, that term is restricted to a few visual arts, such as painting and sculpture. Thus our present nomenclature of the arts, though adequate for casual use, is far from being precise or standardized for technical discussion.

We imply a partial classification of the arts whenever we use such a term as "fine arts," "useful arts,"

"theater arts," "graphic arts," or "handicrafts." Several other terms, such as "space and time arts," "plastic arts," "imitative and non-imitative arts" are also used. Inclusive arts such as literature are divided into subclasses such as prose and poetry, drama and fiction. Some arts are closely connected, with much in common—for example, the pictorial arts of drawing, painting, and etching. Others, such as music and sculpture, seem farther apart, and it is harder to see what they have in common, or to group them under a single heading.

The Need for Clear Definitions, as Shown in the Brancusi Case

What constitutes a work of art, and in particular, a piece of sculpture? What qualifies a man to call himself a sculptor? These were no academic questions a few years ago, when United States customs officials pondered whether to admit as art and as sculpture a work by the Rumanian modernist, Constantin Brancusi.[1] The case well illustrates how problems of philosophic theory can take on practical importance, and how the conduct of affairs—here legal and commercial—can be impeded by vague, confused thinking or by the conflicting views of supposed experts. It brings in several different ideas about the nature of art.

The object which aroused this celebrated and often amusing lawsuit was a bronze entitled *Bird in Flight,* which had been purchased by the American artist Edward Steichen. It was entered as a work of art in the form of a sculpture, with the claim that it was therefore entitled to entry free of duty. However, the New York collector of customs assessed it at 40% ad valorem as a manufacture of metal. He had been advised by certain artists, members of the National Academy and National Sculpture Society, that it was not art and not sculpture. When the case, *Brancusi vs. The United States,* was tried in the United States Customs Court, Robert Aitken was the main witness for the government. For the plaintiff, witnesses included Edward Steichen, owner of *Bird in Flight,* Jacob Epstein, Frank Crowninshield, Henry McBride, William H. Fox (Director of the Brooklyn Museum), and Forbes Watson (Editor of *The Arts*). The decision of three judges, rendered by Justice Waite, ruled that the object "is the original production of a professional sculptor and is in fact a piece of sculpture and a work of art," and as such entitled to free entry.

In this decision, which was hailed by *The Arts* as just, liberal, and intelligent, Justice Waite referred to an earlier court decision (1916) on the definition of sculpture. It had been cited by government counsel in the Brancusi case, in support of their conten-

tion that *Bird in Flight* was not sculpture. That earlier decision, which in its turn had referred for authority to both the *Standard Dictionary* and *Century Dictionary,* had said: "Sculpture as an art is that branch of the free fine arts which chisels or carves out of stone or other solid material or models in clay or other plastic substance for subsequent reproduction by carving or casting, imitations of natural objects in their true proportions of length, breadth, and thickness, or of length and breadth only." Justice Waite conceded that, although the piece had been characterized as a bird, "Without the exercise of rather a vivid imagination it bears no resemblance to a bird except, perchance, with such imagination it may be likened to the shape of the body of a bird. It has neither head nor feet nor feathers portrayed in the piece." Accordingly, he believed that "under the earlier decisions this importation would have been rejected as a work of art or, to be more accurate, as a work within the classification of high art."

However, he went on to say that "Under the influence of the modern schools of art the opinion previously held has been modified with reference to what is necessary to constitute art. . . . In the meanwhile there has been developing a so-called new school of art, whose exponents attempt to portray abstract ideas rather than to imitate natural objects. Whether or not we are in sympathy with these newer ideas and the schools which represent them, we think the fact of their existence and their influence upon the art world as recognized by the courts must be considered. The object now under consideration is shown to be for purely ornamental purposes, its use being the same as that of any piece of sculpture of the old masters. It is beautiful and symmetrical in outline, and while some difficulty might be encountered in associating it with a bird, it is nevertheless pleasing to look at and highly ornamental."

In effect, the decision held that the accepted meaning of "sculpture" and of "art" had changed since 1916; that to qualify as such an object no longer had to "imitate natural objects," or even to bear a definite resemblance to any natural object. What, then, did qualify *Bird in Flight* as sculptural art? In the first place, no one contested that it was made from solid material "in clay or other plastic substance for subsequent reproduction by carving or casting." Secondly, it was "for purely ornamental purposes." This was necessary in view of paragraph 1704 of the Tariff Act of 1922, which had stated that "the words 'painting' and 'sculpture' and 'statuary' as used in this paragraph shall not be understood to include any articles of utility." Justice Waite pointed out that certain court decisions had classed "drawings or sketches, designs for

wall paper and textiles" as works of art, "although they were intended for an utilitarian purpose." No one had argued that *Bird in Flight* was useful and therefore disqualified as art. However, it was relevant to describe it as "for purely ornamental purposes." The court also undertook, without fear of the many theoretical difficulties involved, to decide that it was "beautiful," "pleasing," and "highly ornamental." No doubt the more conservative sculptors, called as witnesses for the government, remained unconvinced on this point.

As Forbes Watson, editor of *The Arts,* remarked before the trial, "There is no scientific proof that a work is or is not a work of art. Mr. Brancusi says that Mr. Aitken is not a sculptor and Mr. Aitken says that Mr. Brancusi is not a sculptor. These opinions are equally sincere and equally meaningless—except to those who enjoy the same artistic predilections." Obviously, the words "art" and "sculptor" are being used here with evaluative implications. "Art" is being restricted to products of high aesthetic worth. "Sculptor" does not include anyone who carves, casts, or models, but only those who do so with results considered valuable and meritorious, according to the standards one accepts.

"You cannot prove," continued Watson, "that a work of art is, but you can prove that it is a work of art to someone. If it can be proved that the intention of Brancusi was to create a piece of sculpture and that he was successful to the point of conveying his sculptural idea to others the purpose of the Tariff Act would be met, even if a hundred predisposed academicians should sincerely deny that the work was sculpture." This argument shifts the issue to the more objective, factual questions of (a) the artist's intentions, and (b) the likings and opinions of others. The object is to be regarded as art from the legal standpoint, according to this argument, if the artist intended it to be such, and if other persons (especially experts) regard it as such. Whether or not Brancusi is a sculptor would likewise be decided, not on evaluative grounds, but again on the basis of easily established facts—whether he had studied and practiced sculpture professionally. Watson and others brought evidence to show that *Bird in Flight* and its creator did qualify on these grounds. The judges were impressed by it, for Justice Waite's decision stressed the points that (a) Brancusi had been shown to be a professional sculptor of established reputation, (b) the work was original, (c) some, though not all, of the "persons competent to judge upon that subject" regarded it as art and sculpture. It was not expressly stated that beauty or aesthetic value is a matter of individual taste, or that anything is good art if a considerable number of reputable experts like it; but this was the general tone of the prevailing arguments. There was a strong

desire, at the same time, to put aside the whole question of values—not to decide how good the object and its maker were, but to establish new, non-evaluative definitions of art and sculpture.[2] According to these, anyone would be a sculptor who had received professional training in sculptural techniques and was practicing them professionally. Anything would be a work of art which was intended as such by a professional artist, and regarded as such by experts of established reputation in the field.

Among other things, the Brancusi case illustrates the fact that art today is not a remote and trivial affair, of penniless Bohemians in garrets. The making and selling of "art goods" is an industry, or a group of industries, running into vast annual sums. Copyrights of the stories, tunes, and jingles used in radio and advertising, rights to motion picture scenarios, phonograph records and popular color-print reproductions, run into figures of frequent legal dispute, with sharp legal talent on both sides. Questions of the nature and interrelation of the arts are no longer allowed to remain in the placid backwaters of philosophy, but are dragged into court and marketplace, with impatient calls for some definite ruling on the meaning of terms.

Classification of the Arts for Practical Purposes

Far from being a merely theoretical problem, the way in which arts are defined and classified—whether rightly or wrongly—affects the practical organization and conduct of the arts themselves. It is bound up with educational administration, and helps to determine how the arts shall be taught; what shall be the curricula of art academies, music institutes, and liberal arts colleges. Within each of these schools, separate departments and courses are usually set up, such as "Fine Arts," "Industrial Arts," "Musical Arts," and the like; each implying a partial classification and a theory—often not clearly realized—on what a certain group should cover. The training of prospective artists and scholars in all these fields is correspondingly specialized, and their subsequent outlook is influenced. New schools and faculties are organized, researches are planned and published, technical journals are edited, books on the arts are classified in libraries and publishers' lists.

Artists in various mediums, teachers and scholars, museum officials, band themselves into professional organizations, and sometimes into craft unions, on the basis of current distinctions among the arts. Whenever a government census bureau or a labor union works out a list of occupations in the field of art, it has to classify the arts. It divides them into occupational groups, such as architects, musicians, and graphic artists (including draughtsmen, lithographers, etc.), along with garment designers, scene painters, and others. Playwrights and musicians organize themselves into leagues of authors, composers, and performers. For legal and administrative reasons involving large sums of money, the definition of a certain art or type of artist and his services or products must be made as clear and true to fact as possible. Admission to certain craft unions, such as the motion picture photographers', is greatly sought after; hence the question of what consistutes an artist in these fields is no matter of idle hair-splitting.

Library science has dealt directly and systematically with the problem of classifying books on the arts. It has evolved not one but several systems of headings and subheadings, with the aim of arranging books and filing cards so that librarians can easily decide where to put a new book, and so that readers can easily find it.

Art museums face the problem of classifying many different products under convenient headings, such as paintings, prints, textiles; classical art, oriental art, and decorative arts. Original works of art, photographs, lantern slides, record cards, and the like must be somehow grouped and subdivided for arrangement into galleries or filing cabinets, and for the assignment of specially trained personnel to care for them. Such an arrangement must not be merely arbitrary or casual; it must somehow express the nature of the facts themselves, so that people can find a thing where it ought to be. It must sometimes be adapted to the various ways in which the objects are to be used. For example, lantern slides will be used by artists who wish to find examples of a certain medium or technique such as enamelling, or various portrayals of a certain subject, such as birds or trees. Some teachers wish to select materials on a chronological basis; others on a geographical basis, or on one of abstract types such as classic and romantic. In such a context as this, verbal systems of classification emerge out of practical experience, becoming more extensive and precise as needs determine. They usually begin with traditional terminology, but change and augment it as time goes on.

Such practical systems of classification usually have the merit of close touch with concrete phenomena. They are functional, and seldom rigid or artificial. They are flexible, adaptable to change, so that new arts or branches of art can be admitted. We shall consider them in more detail later on. However, all of them have limitations and difficulties of their own. None is perfect or adaptable to all uses. Hence the need remains for aesthetics to compare and criticize them from a broader, philosophi-

cal standpoint, and to survey the whole problem without restriction to any one special use.

All of these practical modes of organization have been thought out and directed, to a large extent, in terms of traditional names and classifications. The distinctions made therein, as we shall see, are sometimes false and misleading. By imposing arbitrary, sharp distinctions between certain arts in theory, they help to place wide gulfs between them as actual careers and courses of study. For example, music, painting, and literature are so widely separated on the higher levels of education that it is hard for a student to see their interrelations or to study them in close combination. The artist's range of creative work is narrowed by the traditional belief that each art has certain necessary "limits" beyond which he cannot go without violating aesthetic laws. Thus the tremendous modern pressure toward specialization is aggravated by excessively compartmental theories of the arts.

Educators whose minds do not comfortably dwell in such tight compartments protest, calling for "integration" and "orientation." As one phase of this reaction, there has been a new emphasis in recent years on the active interrelation of the arts. Should visual art be taught as a separate subject or somehow "integrated" with history, literature, music, and other subjects? What is its own proper content of history, appreciation, and technical skills? Specialists in a certain art sometimes object strongly to so-called integration, and with some reason, on the ground that it tends to lose or overwhelm the essentials of that particular art, through subordinating it unduly to some other subject. Thus teachers of painting and art appreciation rightly object when their part in a school curriculum is relegated to the making of posters on safety or hygiene for "social studies" and other school activities. But what are the essentials of painting as a fine art, in technique and appreciation? How are they related to the various practical uses which society, in school and out, now requires of its artists? Can painting, literature, music, and acting be harmoniously merged in theater art "projects," as a way to study the history of a certain period?

Such educational questions raise anew the problem of how the arts are and should be interrelated; what are the main concerns of each, and how they can best cooperate. They call for a thorough reconsideration of inherited concepts, in the light of present needs and artistic tendencies.

To be sure, neither artists nor teachers are bound to follow past aesthetic theories or use traditional concepts. Consciously, they often strive to be original. Sometimes they work out new conceptions, which aesthetics itself later adopts. Few artists, and

not many educators, have ever read a book on the classification of the arts, or would feel bound by its conclusions if they did. But it is not easy to escape from the grooves of thought and action marked out by past authorities. It is not easy for an individual worker to establish a new terminology, a new set of theoretical distinctions in a complex field, or to make others understand them. The terms and meanings which have been stamped with authority by such a philosopher as Aristotle sift down through innumerable cultural channels to help determine, unconsciously, the attitudes and mental processes of modern artists, writers, and teachers. Conservative writers and university professors cling to venerable concepts and resist innovations. In spite of all this, basic concepts do change, in fields where active theoretical progress is going on, as in psychology and the social sciences. Interest and active discussion, on the part of those concerned with aesthetic theory, can gradually sharpen up our traditional and somewhat obsolete terminology. . . .

A Revised Definition of Art

As we have seen, it is impossible and undesirable to reduce the many meanings of art to a single, brief, formula. After the most confusing senses have been put aside, to be called by other names, there still remains a group of closely related, alternative senses which are mutually consistent and supplementary. All are useful in different connections, to emphasize different aspects of approximately the same phenomena. All the definitions are drawn from current usage; no entirely new meanings are proposed. The reason for most of the wordings will be apparent from the foregoing discussion; for others, it will be explained in later chapters.

In the first definition, or group of definitions, art refers to certain related types of skill; in the second to a type of product; in the third, to an area of social culture; in the fourth, to a division of this area. Definition *1a* expresses on the whole the consumers's point of view; *1b*, that of the artist or producer; *1c*, a sociological interest in various types of occupation.

1. a. Art is skill in making or doing that which is used or intended as a stimulus to satisfactory aesthetic experience, often along with other ends or functions; especially in such a way that the perceived stimulus, the meanings it suggests, or both, are felt as beautiful, pleasant, interesting, emotionally moving, or otherwise valuable as objects of direct experience, in addition to any instrumental values they may have.

b. Art is skill in expressing and communicating past emotional and other experience, individual and social, in a perceptible medium.

c. Especially, that phase in such skill or activity which is concerned with designing, composing, or performing with personal interpretation, as distinguished from routine execution or mechanical reproduction.

2. Also, a product of such skill, or products collectively; works of art. Broadly, this includes every product of the arts commonly recognized as having an aesthetic function, such as architecture and music, whether or not that particular product is considered to be beautiful or otherwise meritorious.

3. Art, as a main division of human culture and a group of social phenomena, includes all skills, activities, and product covered by the above definition. As such, it is comparable in extent to religion and science; but these divisions overlap in part.

4. An art, such as music, is a particular division of the total field of art, comprising certain distinctive kinds of skill, activity, medium, or product. Especially, a division regarded as comparatively large, important, or distinctive; others being often classed as branches or subdivisions of an art.

The core conception, favored by contemporary scientific usage, is in *1a*. Where brevity is needed, it can be reduced to the following: *Art is skill in providing stimuli to satisfactory aesthetic experience.* However, in making it so brief, one loses several important distinctions, which help to avoid misunderstanding and to convey the special implications of the word in current usage.

"Making or doing" covers performing, as of sounds or gestures; also the manufacture of lasting objects such as statues. It includes designing or planning as well as final execution, when this is formulated in observable sketches, musical scores, or verbal directions. Later on, we shall see why the term "art" is sometimes restricted to the designing or composing phase.

"Used or intended as. . . ." This puts the definition in behavioristic, objective terms. To qualify as art, the product does not need to *be* beautiful or aesthetically satisfying; only to be used or adapted for an aesthetic function, by the producer or consumer. It is not even required that the object be *intended* as beautiful or pleasant; room is left for other types of aesthetic function and for products which fulfill aesthetic functions unintentionally.

"Along with other ends or functions. . . ." This avoids saying that aesthetic experience is the sole or

even the most important function of art. Ordinarily, art has other functions also; but it is unnecessary to specify them in the definition. The aesthetic function is emphasized because it differentiates art from the more purely utilitarian and scientific skills.

"Expressing and communicating" is of course intended to recognize the conception of art advanced by Tolstoy and others. Instead of "feeling" or "emotion," the broader term "experience" is used. It covers not only feeling and emotion, but also perception, cognition, conation, beliefs and attitudes toward the world, etc., all of which are communicated in art. But art is recognized as especially concerned with emotional experience.

"Stimulate" is used in a psychological sense. It does not imply that the percipient is passive in relation to the work of art or the artist. The work of art is a stimulus and an object of apperception, helping to arouse psychosomatic responses in the percipient, and receiving some share of his attention. Through light-waves, sound-waves, or other physical means, it stimulates his sense-organs, nervous system, and related mental apparatus to certain kinds of activity, whose nature is determined also by his character, conditioning, attitudes, present moods and anticipations.

A work of art, such as a picture or symphony, is an arrangement of stimuli in space, time, or both, consisting of lines, color-areas, etc., in visual art, or of sounds in auditory art. It is called an "aesthetic object," which implies that it can become the object of attention and interested contemplation. Natural forms or objects, such as sunsets and flowers, can also become aesthetic objects; but in art we deal with man-made products. All aesthetic stimuli must be presented first to one or more sense-organs, in order to arouse later responses of interpretive, imaginative, cognitive, emotional, or other nature. The emphasis here on appeal to the senses (as in music and visual decoration) and to the imagination (as in literature) helps to distinguish art from science and other fields.

Art does not always stimulate perception and imagination to an equal degree, but it tends to stimulate both to some extent. A novel is addressed through the eyes to the imagination; a sonata is addressed more directly to sense perception. There is little if any perception without some experience of suggested images. . . .

Fine Arts and Visual Arts

Both "art" and "fine art" are sometimes used in a narrow sense, excluding music and poetry. As the *Oxford Dictionary* says of "fine art," it is "often

applied in a more restricted sense to the arts of design, as painting, sculpture, and architecture." The term "art" alone can also be used in this sense, according to the *Oxford:* "The application of skill to the arts of imitation and design, Painting, Engraving, Sculpture, Architecture; the skillful production of the beautiful in visible forms." This we have called the "visual aesthetic" sense of "art" and "fine art."

The term "art" alone is popular in this sense because of its brevity, as in "art school," "art museum," and "art history." College art departments like it because it puts their subject at the head of alphabetical lists. However, we have found it unwise to use "art" alone in this narrow sense, at least in technical discussion. In popular usage, it does no great harm, and the context usually shows what is meant.

Shall we use "fine art," then, with this extension? There are numerous college departments and professors of "fine arts." The term has a pleasantly genteel and superior sound.

We have already noted the peculiar historical changes which led up to this conception. Whereas the visual arts were largely excluded from the select Greek list of "arts of the Muses," as being too manual, they came in time not only to secure admission as fine arts, but (like the camel in the tent) to push out the original occupants. Now, music and literature must endure the slight disparagement of hearing another group of arts call itself "*the* fine arts."

So honorific a title is not likely to be abandoned without a struggle by any college faculty or museum which has once adopted it. The arts excluded are not complaining violently. Nevertheless, the situation operates to confuse still further the mix-up in terminology which we have been attempting to correct in this chapter. The restriction of the concept of "fine art" to a few visual arts is a historical accident. Its literal implications are not taken seriously. Even the most ardent admirer of painting, sculpture, and architecture would hardly maintain that they are actually finer, more beautiful, noble, or pleasant in general than music and poetry. Indeed, architecture involves to a conspicuous degree the trait of utility; hence its theoretical right to be considered "fine" at all has always needed some adroit defending.

The concept of "fine art" in this narrow, visual sense involves the same difficulties which it has in the broader sense. Is it to be considered as antithetical to the "useful arts," and if so to which ones? If architecture is to be included, what right have we to keep out furniture, pottery, and textiles? Is "fine arts" really intended to mean "major fine arts"? In any case, to omit them is to imply a disparagement of pottery and the rest, as necessarily less great and

fine. Admirers of Greek and Chinese vases have a right to protest, when they see the inferior quality of many paintings and statues.

Gladstone, the liberal statesman, is quoted by the *Oxford* as summing up the situation in 1869: "By the term Art, I understand the production of beauty in material forms palpable; whether asociated with industrial purposes or not." By "material" and "palpable," he shuts out music and poetry; but he does let in the useful arts.

As we have seen, fine art is often defined so as to exclude the so-called minor useful arts. However, many authoritative sources now include them without argument under the general heading of "fine art." "The Institute of Fine Arts," a part of New York University, gives no general definition of the term "fine" in its *Announcement of Lectures.* But it does include a course on "Furniture and the Decorative Arts," and one on "Chinese Minor Arts," including pottery, mirrors, and belt buckles. By implication, these are all "fine arts." But music is a separate heading in the University *Bulletin,*[3] and literature is also separated under the usual linguistic headings. This illustrates how questions of general definition or intension are sometimes passed over, while the actual meaning of a term is determined by the extension given it. To include belt buckles under "fine arts" implies a certain conception of fine arts, whether explicitly stated or not.

The advisable solution here is to use the term "visual arts" instead of "fine arts," in the sense under discussion. This term is coming into technical use in aesthetics,[4] and should be generally adopted as a substitute for "fine arts." It should also be used instead of "art" alone when "visual art" is meant, as in college catalogues. To restrict the term "art" to visual arts involves an undesirably sharp separation from music and literature. It is preferable to use "art" in a more generic sense, as including all aesthetic skills; then to subdivide it into "visual arts," "musical arts," etc. Dudley and Faricy, in their treatise on *The Humanities,* have chapters on "The Mediums of the Visual Arts," "The Elements of the Visual Arts," and "Plan in the Visual Arts." The visual arts here are made coordinate with music, literature, and the "combined arts" (dance, theater, opera, cinema, radio and phonograph).

The term "visual arts" was not quite specific enough when "arts" was used in its old, broad, technical sense; for visual arts would then include purely utilitarian buildings, tools, and machines. They are as visible as pictures and statues, though not necessarily made to be seen. But if we understand that art means *aesthetic art,* then "visual art" is by definition restricted to products having some aesthetic function. Their visibility is no mere incidental, but an essential characteristic; power to attract and

interest through the eyes is one of their principal aims. There is need for a term which definitely groups them together, as apart from music and literature. They are taught and written about as a group, in art schools, art histories, and courses on art appreciation. When it becomes necessary to contrast them with other aesthetic arts, such as music and literature, an explicit prefix is needed. "Fine arts" is not the best possible term, because of its other current meanings. "Visual arts" is fairly neutral and objective.

One advantage of calling them "visual" rather than "fine" is that it avoids the old contrast with "useful." There is no theoretical difficulty in including chairs or belt buckles as visual art. The whole basis of classification is shifted from the difficult and controversial one of "useful or not useful" to a more objective, psychological one: that of *which sense is primarily addressed.*

The term "fine arts," like the term "beauty," has become so loaded with confusing associations that it is difficult to use in any technical sense. One must keep repeating the sense intended, to avoid misunderstanding. In such cases, it is often best to avoid the term entirely, if a less ambiguous substitute can be found. This course is recommended now. For its broad aesthetic sense, one can use "art" alone; for its visual aesthetic sense, the term "visual arts" is suggested. For the sense opposed to "useful arts," one may speak of "less utilitarian" or "more purely aesthetic" arts; but even this relative antithesis, as we have seen, involves many controversial points.

Questions arise also in the meaning of "visual arts." What arts are or should be covered by it? Literature is visual in some ways: it is often read with the eyes, and it suggests visual images. Music also can suggest visual images, and is read from printed scores. But such visible means of recording and presenting are not usually considered integral, necessary factors in a work of musical or literary art. Are dance, theater, and film visual arts? To some extent, but they are also auditory, when they involve music. This is usually covered by calling them "combined," "mixed," or "audio-visual" arts.

To group certain arts as "visual" does not imply that this is their only, or necessarily their most important characteristic in all respects. It is not necessarily the only way in which they are presented to the senses. In some arts called "visual," there is also an intentional appeal to the senses of touch and hearing. Clothing is required to be pleasant to the touch; furniture must give us a kinesthetic effect of balance and security; clocks are heard. Their classification as visual is a matter of convenience, to facilitate certain lines of investigation. In calling painting or sculpture visual arts, we do not imply that they should restrict themselves to "purely

visual" effects; that they should avoid "story interest" and leave representation to literature. That would be to perpetuate Lessing's erroneous theory of the fixed limits of the arts.[5]

For study and teaching, we often wish to indicate painting, sculpture, architecture, and the "minor useful" arts as a group by themselves, leaving out dance and theater. This group is also vaguely designated as "the arts" or "the fine arts." How should they be called, to distinguish them from dance and theater, which are also visual, at least in part? One way is to call them "static" visual arts, as distinct from "mobile"; or "space arts," as distinct from "time arts." They are also called "arts of design," from the fact that drawing (*disegno* in Italian, and *dessin* in French) is used in them. This also is hardly satisfactory, since drawing is used in dance and theater, as in sketching costume and scene design. The word "design" also has other meanings, some of which apply even to music and literature. . . .

The Visual Arts: A Partial List

A. Introduction: This group of arts is addressed primarily to the sense of sight. Some of their products appeal to other senses also, as in the sound of a clock or the feeling of clothes and furniture; but their visual qualities are ordinarily considered more important from the aesthetic point of view. They are presented mostly as static forms in two dimensions, on flat surfaces, but they often suggest the third dimension. Some involve movement, as in vehicles of transportation, but they do not usually present to the eyes a complex sequence of movements or changes in definite, temporal order. Details must usually be grasped in some sort of temporal succession (not all at once), but the exact order in which they are seen is usually not essential; hence these are not called "time arts." Some other visual or partly visual arts, in which temporal order is emphasized, are listed elsewhere under Arts of Public Performance.

B. Pictorial Arts and Types of Art
 1. Introduction: The word "picture" comes from the Latin word for "painting." But, in its present sense, a picture is not necessarily painted; it can be made in many other ways, such as engraving and photography. Most pictures are representations of objects, persons, scenes, etc., but sometimes the term is applied to a non-representative painting or design, especially when framed and used as a picture. In pictures classed as artistic, an aesthetic effect is emphasized, but much pictorial art has other functions also, such as the

religious and moral. Some pictures are symbolic, and stand for certain things or ideas without looking like them. Some try to express an emotion, mood, or abstract idea. Some pictorial arts are also called "graphic arts," especially drawing. This word comes from the Greek for "writing" (see §C on the non-pictorial graphic arts of writing and printing). The following subheadings are somewhat interchangeable in that those listed under each main heading can be regarded as subdivisions of the others: e.g., under "Painting," Mural, Religious, Figure, etc. . . .

2. Types of Pictorial Art as to Medium and Process: Materials, Instruments, Techniques.
 a. *Painting.*
 - I'. Oil painting.
 - II'. Tempera painting.
 - III'. Watercolor and gouache.
 - IV'. Fresco.
 - V'. Encaustic.
 - VI'. Sand painting.
 b. *Drawing.*
 - I'. Pencil drawing.
 - II'. Pen and ink drawing.
 - III'. Brush drawing; wash drawing.
 - IV'. Crayon and pastel drawing.
 c. *Print-making.*
 - I'. Engraving, hand; on wood, metal, etc.
 - II'. Etching, drypoint, aquatint.
 - III'. Mezzotint.
 - IV'. Lithography.
 - V'. Photo-engraving; half-tone.
 - VI'. Collotype; gelatine processes.
 - VII'. Silkscreen; serigraphy.
 d. *Photography (still).* In black and white; in color. Microphotography; telephotography; X-ray photography.
 e. *Mosaic, pictorial.*
 f. *Wood inlay; intarsia, pictorial.*
 g. *Tapestry; pictorial weaving.*
 h. *Embroidery* and other needlework, lace, etc., pictorial.
 i. *Collage and montage,* pictorial; cut paper pictures; silhouettes.
 j. *Colored lights,* static and pictorial.

3. Types of Pictorial Art as to Nature of Product.
 a. *As to form, size, location:*
 - I'. Mural pictures; on walls and ceilings.
 - II'. Floor pictures, esp. in tiles and mosaics.
 - III'. Easel pictures.
 - IV'. Scroll pictures.
 - V'. Miniature pictures; separately or as manuscript and book illumination.
 - VI'. Vase painting.
 - VII'. Screen painting.
 - VIII'. Various shapes in the above: rectangular, round, triangular, pendentive, irregular.
 b. *As to subject, function, and mode of treatment.*
 - I'. *Figure* pictures: of humans or supernatural and imaginary beings in human or partly human form. Religious, secular, aristocratic, mythological, fantastic, "genre" or everyday subjects. Single figures and groups with or without landscape or architectural backgrounds. Portraits (head, bust, full-length); more or less realistic, individualized. Equestrian and other combinations of humans and animals.
 - II'. *Animal* pictures.
 - III'. *Landscapes* and seascapes.
 - IV'. *Still-life* pictures.
 - V'. *Decorative, semi-abstract, abstract,* and non-objective pictures; non-representative designs.
 - VI'. *Symbolic* pictures; emblems, insignia. These may be abstract designs or representative pictures with an additional, symbolic meaning; allegories. Types of symbolic picture.
 - A'. Religious symbols, such as the Cross, Crescent, and Star of David; symbols of particular gods and saints such as the owl for Minerva, the wheel for St. Catherine.
 - B'. Political symbols: national, city, etc. Flags, seals, coats of arms.
 - C'. Heraldic symbols, of a family or hereditary rank or title. Coats of arms, crests.
 - D'. Commercial symbols; trade marks.
 - E'. Club and association symbols.
 - VII'. *Illustration* (for books, magazines, posters, etc.).
 - VIII'. *Fashion-illustration.*
 - IX'. *Cartooning;* caricaturing.

C. Writing and Printing; Non-Pictorial Graphic Arts.

1. Introduction: These arts are now mainly used as means for the visual presentation of verbal compositions, including literature. Thus literature can become an art of visual presentation. Writing and printing can also be presented tactually, as in Braille type for the blind. Letters and words can also be communicated aurally. Writing and printing can be combined with pictures. They are visual *arts,* rather than mere utilitarian devices for ordinary communication, only when they involve some aesthetic refinement and development, as in calligraphy and artistic typography. This is not necessarily conspicuous or ornamental, however; it can be subordinated to clear communication and easy readability. . . .

2. *Calligraphy and hand lettering;* in cursive or detached characters; manuscript writing.

3. *Typography.*
 a. Type designing.
 b. Printing.
 c. Layout (non-pictorial); page-arrangement.

4. Other kinds of lettering and visual wording, as by carving in stone, by electric lights, etc.

D. Combined Pictorial-Verbal Arts and Types of Art.

1. Picture-writing, primitive and modern; pictographs; hieroglyphics, pictorial symbols. (In primitive culture, preceded the separation of writing from pictures; but still used, as for educational and advertising purposes.)

2. Manuscript and page illumination and illustration; hand painting combined with calligraphy.

3. Printed layouts, pictorial-verbal; page, poster, and cover design, book and magazine illustrations with text. Advertising and other commercial devices.

4. Packaging, as involving printed pictorial-verbal arrangements.

5. Postage stamps, banknotes, and other common types of form, combining pictorial and decorative elements with words, numbers, etc.

6. Maps, charts, pictorial diagrams and displays for explanatory and utilitarian purposes; often combining realistic details with arbitrary symbols.

7. Luminous displays combining pictorial and graphic elements.

E. Sculptural Arts and Types of Art.

1. Introduction: Sculpture is the art of making three-dimensional forms, usually to be seen from the outside, which represent human or animal figures or other natural objects, compose a design of solid shapes and surfaces, and/or suggest feelings or abstract ideas. Some sculpture is representational and realistic; some highly stylized or abstract. . . .

2. Types of Sculpture as to Medium and Process.
 a. Stone sculpture.
 b. Ceramic sculpture; clay, earthenware, porcelain, terra cotta, plaster, etc.
 c. Metal sculpture, in bronze, iron, copper, gold, silver, lead, etc.; casting and other processes.
 d. Glass sculpture.
 e. Ivory and bone sculpture.
 f. Wood sculpture (including totem poles, fetish figures, etc.).
 g. Wax sculpture; soap sculpture.
 h. Gem carving, cameo and intaglio, with effect of sculptural relief.
 i. Paper and papier-mâché sculpture.
 j. Sculpture in plastic and synthetic materials, string, cloth, etc.
 k. Taxidermy; habitat groups; animal figures reconstructed and arranged.
 l. Embalming and mummifying (of human and animal bodies; esp. in ancient Egypt). Use of skulls and dried heads as statues.

3. Types of Sculpture as to Form of Product.
 a. *As to form, size, and function:*
 I'. In the round.
 II'. In relief; low, high; steles, tablets, on walls and monuments.
 III'. Free-standing.
 IV'. Engaged, attached to a building (e.g., as caryatid) or to a piece of furniture or utensil. As architectural ornaments.
 V'. For magical use, as in amulets, fetishes.
 VI'. Mobiles, stables; combined types. Wind-moved; hand-moved; mechanical. String figures.
 VII'. For religious use, as in idols and ikons.
 VIII'. For commemorative monuments, often with architectural bases.
 IX'. As interior ornaments; esp. small reliefs and statuettes.
 X'. For wear, esp. ceremonial and theatrical, such as masks.
 XI'. For theatrical use, as in marionettes and puppets.
 XII'. As emblems, insignia, for identifi-

cation, as in carving heraldic crests.

XIII'. As advertising devices, displays (three-dimensional).

XIV'. Dolls and similar toys involving three-dimensional representation.

XV'. As to size: colossal, heroic; lifesize; small (statuettes, figurines, bibelots, netsukes, toys, etc.). Small reliefs, as in coins, medals, amulets, cameos, sculptural jewelry.

b. *As to subjects represented:*

I'. Figures: human, animal, supernatural, diabolical, fantastic. Equestrian groups; totem poles.

II'. Portraits; busts; full-length portrait statues. Masks, realistic and fantastic.

III'. Sculptured plants, flowers, fruit, and other natural objects.

IV'. Reliefs with scenic, quasi-pictorial backgrounds.

V'. Semi-abstract and non-representative sculpture; constructivist designs.

F. Useful and Decorative Arts and Types of Art; Utilitarian Design; Industrial Design. . . .

1. Introduction: These arts fulfill a great variety of functions which can be broadly classed as useful or practical. They serve as means in many overt activities such as work, war, education, worship, and everyday living. Their products, mostly three-dimensional, are correspondingly varied in form, size, and mode of operation. Those classed as useful *art*, rather than as purely utilitarian devices, pay some attention also to aesthetic qualities: to visual appearance or "eye appeal." Other sense-qualities may also be emphasized, as in the tone of a violin or piano. Most of their products are non-representational, especially in contemporary styles, but some involve carved, painted, or other representational features for ornament. The "functional" or utilitarian aspects are sometimes considered more important; at other times, the aesthetic and decorative.

2. Types of Useful and Decorative Art as to Medium or Material: those using

a. *Hard, inanimate materials, and soft materials which harden. To be carved, molded, hammered, etc.*

I'. Masonry; stonework (decorative).

II'. Ceramics (non-sculptural); earthenware, pottery, porcelain.

III'. Tilework and brickwork, decorative.

IV'. Plasterwork, stucco, cement-work.

V'. Glassware.

VI'. Enameling.

VII'. Lacquerwork.

VIII'. Ivory and bone-carving (non-sculptural).

IX'. Gem-cutting; lapidary art (non-sculptural).

X'. Goldsmithing and silversmithing.

XI'. Jewelry, as including gems and metal settings, costume jewelry of non-precious materials, etc.

XII'. Ironwork and steelwork, decorative.

XIII'. Coppersmithing.

XIV'. Bronze casting, non-sculptural.

XV'. Plastics.

XVI'. Woodcarving (non-sculptural).

XVII'. Cabinet-making; fine and decorative carpentry.

b. *Those using soft and pliable, inanimate materials. To be twisted, woven, tied, knitted, felted, sewed, pasted, etc.*

I'. Basketry.

II'. Cordwork and stringwork, decorative.

III'. Weaving; textiles; rug and tapestry weaving.

IV'. Lace-making.

V'. Knitting and crocheting.

VI'. Needlework, embroidery, appliqué, etc. (esp. non-pictorial).

VII'. Feltwork.

VIII'. Tapa or barkcloth-making.

IX'. Paper-making, decorative.

X'. Paperwork, decorative; products of cut, folded, pasted papers, plain and colored.

XI'. Plastic cloth-making, decorative.

XII'. Leatherwork.

XIII'. Featherwork.

XIV'. Beadwork and quillwork.

XV'. Fur-making; designing and executing garments, rugs, etc., of fur along with other materials.

c. Those using *plants,* and related natural objects (earth, water, stones, etc.). To be cultivated, trained, and arranged into groups and sequences for aesthetic as well as utilitarian purposes.

d. Those using *animals;* animal breeding and husbandry, for aesthetic as well as other qualities; e.g., for shape, coloring,

graceful motion, etc., as in horses, deer, cattle, dogs, cats, goldfish, birds. (Song is also cultivated in some kinds of birds.) Also, in some cases, as pets for friendly disposition, intelligence, watchfulness; for racing, working, etc.; but not classed as "art" if for utilitarian purposes only.

3. Types of Useful Art as to Process or Technique.
 a. Handcrafts.
 b. Machine crafts; mechanized industries.
 c. Partly mechanized; combinations of hand and machine technique.
 d. Large-scale, mass production methods (e.g., specialized work and assembly line, whether by hand or machinery).

4. As to nature of Product; Form and Function.
 a. *Clothing arts;* design and manufacture of garments and accessories for personal wear; also for dolls, marionettes, etc. For ordinary use or for theater, dance, ritual, ceremonial, or other special occasions.
 I'. Tailoring and dressmaking.
 II'. Hat-making; millinery; head-dresses.
 III'. Shoemaking, bootmaking.
 IV'. Glove-making.
 V'. Lingerie, underwear, corsetry, etc.
 VI'. Costume accessories.
 VII'. Masks, adapted for wear.
 b. *Products for war and hunting.*
 I'. Weapons.
 II'. Armor, helmets, etc., for man and horse.
 c. *Tools, utensils, furniture; equipment for home, work, school, church, recreation.*
 I'. Tools and machines for occupational use.
 II'. Utensils, instruments, smaller home and personal accessories such as dishes, cutlery, tableware, desk equipment, watches, writing materials, games, and sports equipment.
 III'. Furniture and fixtures; larger appliances, movable and immovable.
 IV'. Rugs, carpets, linoleum, and other floor coverings.
 V'. Draperies, upholsteries, and other decorative fabrics adapted for use in rooms, trains, vehicles, etc.
 VI'. Wallpapers and other wall-coverings.
 VII'. Book-manufacture, including

folding and sewing pages, binding, etc.
 VIII'. Toymaking, including dolls and children's games, utensils for play, small copies of products used by adults, etc.
 IX'. Food-preparation, visual aspects of; shape, color, texture of foods, esp. ornamental cakes, candies, desserts.
 X'. Consumable and disposable products, made with attention to visual and other aesthetic qualities: soaps, paper handkerchiefs and napkins, etc.
 d. *Interior design and decoration.* Room composition. The art of planning and arranging furniture and other objects within a room or group of rooms, so as to achieve a satisfactory appearance as well as convenience, health and comfort, efficiency, or other desired qualities.
 I'. *Selection and arrangement* of furniture, fixtures, appliances, wall-coverings, floor-coverings, lamps, pictures, utensils, house-plants, etc., in relation to the architectural setting and to particular needs and ways of living.
 II'. *Table setting and decoration;* selection and arrangement of tableware, cloths, flowers, etc., especially for the service of meals.
 e. *Displays* (of solid objects in three-dimensional space). *Decorative and educational displays:* in museums, schools, libraries, etc. *Commercial* displays: for merchandising, advertising, etc. Arrangements of objects (esp. for sale) in or out of doors; in shops, store windows, exhibit areas; with appropriate backgrounds, lighting; sometimes sound effects.
 f. *Stage and scene design;* large representations of rooms, outdoor scenes, etc.; built, painted, lighted, and equipped for dramatic presentation.
 g. *Dioramas, peep-shows, small-scale model rooms and house interiors,* built in three dimensions. Solid objects and figures arranged in deep space, often so as to be seen from a certain point of view.
 h. *Building arts; architecture, civil engineering.* . . .
 I'. *Civil and military architecture* (the latter including castles, forts, and fortifications).

II′. *Religious architecture:* designing and building temples, churches, baptistries, pagodas, stupas, mosques, shrines, monasteries, etc. Altars, pulpits, fonts, sarcophagi, and other interior fixtures are on the borderline between architecture and furniture.

III′. *Secular architecture:* designing and building dwelling-houses, palaces, arches and complex monuments, hotels, apartments, theaters, office buildings, schools, railway stations, libraries, laboratories, hospitals, factories, warehouses, stores, shopping centers, etc.

IV′. *Other types of building,* often involving architecture and engineering: bridges, dams, highways, piers, harbors, aqueducts, viaducts, lighthouses, airplane fields and hangars, amusement parks and expositions.

i. *Landscape and garden arts.* Arts involving the cultivation and arrangement of plants and other natural objects such as rocks, water, etc., and of planted areas out of doors, with or without accessory products such as small buildings, statuary, garden furniture, lighting, etc.

I′. *Landscape architecture:* the art of arranging plants and other objects and cultivated areas in a certain region, perhaps with alterations in ground-level, bodies of water, etc., so as to produce a satisfactory visual effect from various points of view and also to serve other uses.

II′. *Water-designing:* fountains, cascades, pools; usually in relation to architecture and gardens.

III′. *Gardening:* as an art, the arrangement, planting, and care of flowering and other plants for their appearance, scent, or other aesthetic qualities as well as for their useful functions.

IV′. *Horticulture:* the science and art of growing plants, including flowers, trees, fruit, and other ornamental plants; including applied genetics, breeding and cultivating plants for better appearance, hardiness, and other desired qualities.

V′. *Topiary art;* ornamental clipping and training of plants.

VI′. *Flower arrangements;* set pieces, bouquets, wreaths, garlands.

VII′. *Arrangements* of driftwood, shells, and other natural objects.

VIII′. *Tray landscapes* (esp. Japanese).

j. *Community designing; town, city, and regional planning.* The art of planning and arranging the form of an inhabited area so as to provide the best possible means to social and industrial living: especially as to health, safety, comfort, education and cultural advantages, efficient work and transportation, recreation and travel, family and neighborhood relations. Special care is taken with zoning industrial, commercial, and residential centers, safe and speedy traffic, public buildings and utilities. Relation of buildings, roads, and parks to natural topography, climate and resources is considered. Visual appearance can be planned with respect to all scenes and vistas within or near it, especially the main or central, inclusive ones. Community designing involves architecture, civil engineering, landscape architecture, and many other arts and applied sciences. . . .

I′. *Civil and town planning; urbanism.* Community planning and designing in the case of large or small cities, towns and villages.

II′. *Regional planning and designing; geo-architecture.* Community and environmental planning in the case of large areas, which may include many towns and villages with intervening farms or vacant land, parks, highways, bridges, waterways and waterfronts, dams, irrigation, etc.

k. *Transportation; vehicle design,* for appearance, outside and inside, as well as for comfort, safety, speed, quiet operation, etc. Large, complex vehicles can be regarded as mobile architecture.

I′. *Land transportation:*

A′. *Saddles, harness,* etc., for riding on animals.

B′. *Litters; sedan chairs, human power.*

C′. *Sleds and sledges; without wheels; human or animal power.*

D'. *Chariots; animal power.*
E'. *Carriages, carts, wagons; human and animal power.*
F'. *Bicycles, tricycles, motorcycles.*
G'. *Railroad trains; steam, petroleum, electricity;* cars for sleeping, dining, etc., comparable to hotel rooms.
H'. *Automobiles:* steam, petroleum, electricity.
I'. *Trailers,* built and equipped as dwellings, offices, etc.
II'. *Water transportation; surface and submarine:*
 A'. *Canoes, rowboats, gondolas, galleys* (human power).
 B'. *Sailboats and sailships* (wind-power).
 C'. *Automotive ships, boats, and submarines.* (Steam, petroleum, electricity, atomic energy.) Passenger ships as complex, floating hotels.
 D'. *Combined types.*
III'. *Air and space transportation:*
 A'. *Balloons;* lighter than air; some automotive, dirigible.
 B'. *Airplanes; heavier than air.* Gliders. Automotive planes; propeller type; jet and rocket types.

Notes

1. Details of the case are given in *The Arts* for June and December 1928 (13, no. 5, 327; and 14, no. 6, 337).

2. The argument over what is and what is not sculpture goes merrily on. For example, see the article on Alexander Calder's "mobiles" in the *Art Digest,* 22, no. 6 (Dec. 1947), 17, entitled "It May Not Be Sculpture—But It's Vital." The French aesthetician E. Souriau prefers to call abstract, non-representative sculpture a kind of architecture (*La Correspondance des arts,* Paris, 1947).

3. Vol. 45, no. 26, May 25, 1945. The Graduate School of Arts and Sciences lists several groups of subjects, among which "Fine Arts and Music" are bracketed as Group VI.

4. For example, R. M. Ogden uses "visual art" as one of three major fields of art, along with music and poetry (*The Psychology of Art,* New York, 1938, p. 26). Blunt also speaks of "the visual arts" becoming liberal (op. cit., p. 53). Cf. *The Visual Arts in General Education,* report of a committee of the Progressive Education Association (New York: Appleton-Century, 1940).

5. Cf. G. Boas, "Classification of the Arts and Criticism," *Journal of Aesthetics,* June 1947, p. 270.

3

The Myth of the Aesthetic Attitude

GEORGE DICKIE

Some recent articles[1] have suggested the unsatisfactoriness of the notion of the aesthetic attitude and it is now time for a fresh look at that encrusted article of faith. This conception has been valuable to aesthetics and criticism in helping wean them from a sole concern with beauty and related notions.[2] However, I shall argue that the aesthetic attitude is a myth and while, as G. Ryle has said, "Myths often do a lot of theoretical good while they are still new,"[3] this particular one is no longer useful and in fact misleads aesthetic theory.

There is a range of theories which differ according to how strongly the aesthetic attitude is characterized. This variation is reflected in the language the theories employ. The strongest variety is Edward Bullough's theory of psychical distance, recently defended by Sheila Dawson.[4] The central technical term of this theory is "distance" used as a verb to denote an action which either constitutes or is necessary for the aesthetic attitude. These theorists use such sentences as "He distanced (or failed to distance) the play." The second variety is widely held but has been defended most vigorously in recent years by Jerome Stolnitz and Eliseo Vivas. The *central* technical term of this variety is "disinterested"[5] used either as an adverb or as an adjective. This weaker theory speaks not of a special kind of action (distancing) but of an ordinary kind of action (attending) done in a certain way (disinterestedly). These first two versions are perhaps not as different as my classification suggests. However, the language of the two is different enough to jus-

tify separate discussions. My discussion of this second variety will for the most part make use of Jerome Stolnitz' book[6] which is a thorough, consistent, and large-scale version of the attitude theory. The weakest version of the attitude theory can be found in Vincent Tomas' statement "If looking at a picture and attending closely to how it looks is not really to be in the aesthetic attitude, then what on earth is?"[7] In the following I shall be concerned with the notion of *aesthetic* attitude and this notion may have little or no connection with the ordinary notion of an *attitude*.

I

Psychical distance, according to Bullough, is a psychological process by virtue of which a person *puts* some object (be it a painting, a play, or a dangerous fog at sea) "out of gear" with the practical interests of the self. Miss Dawson maintains that it is "the beauty of the phenomenon, which captures our attention, puts us out of gear with practical life, and forces us, if we are receptive, to view it on the level of aesthetic consciousness."[8]

Later she maintains that some persons (critics, actors, members of an orchestra, and the like) "distance deliberately."[9] Miss Dawson, following Bullough, discusses cases in which people are unable to bring off an act of distancing or are incapable of being induced into a state of being distanced. She uses Bullough's example of the jealous ("under-dis-

From *American Philosophical Quarterly*, 1 (1964), 56–65. Reprinted with permission of American Philosophical Quarterly and the author.

tanced") husband at a performance of *Othello* who is unable to keep his attention on the play because he keeps thinking of his own wife's suspicious behavior. On the other hand, if "we are mainly concerned with the technical details of its [the play's] presentation, then we are said to be over-distanced."[10] There is, then, a species of action—distancing—which may be deliberately done and which initiates a state of consciousness—being distanced.

The question is: Are there actions denoted by "to distance" or states of consciousness denoted by "being distanced"? When the curtain goes up, when we walk up to a painting, or when we look at a sunset are we ever induced into a state of being distanced either by being struck by the beauty of the object or by pulling off an act of distancing? I do not recall committing any such special actions or of being induced into any special state, and I have no reason to suspect that I am atypical in this respect. The distance-theorist may perhaps ask, "But are you not usually oblivious to noises and sights other than those of the play or to the marks on the wall around the painting?" The answer is of course— "Yes." But if "to distance" and "being distanced" simply mean that one's attention is focused, what is the point of introducing new technical terms and speaking as if these terms refer to special kinds of acts and states of consciousness? The distance-theorist might argue further, "But surely you put the play (painting, sunset) 'out of gear' with your practical interests?" This question seems to me to be a very odd way of asking (by employing the technical metaphor "out of gear") if I attended to the play rather than thought about my wife or wondered how they managed to move the scenery about. Why not ask me straight out if I paid attention? Thus, when Miss Dawson says that the jealous husband under-distanced *Othello* and that the person with a consuming interest in techniques of stagecraft over-distanced the play, these are just technical and misleading ways of describing two different cases of inattention. In both cases something is being attended to, but in neither case is it the action of the play. To introduce the technical terms "distance," "under-distance," and "over-distance" does nothing but send us chasing after phantom acts and states of consciousness.

Miss Dawson's commitment to the theory of distance (as a kind of mental insulation material necessary for a work of art if it is to be enjoyed aesthetically) leads her to draw a conclusion so curious as to throw suspicion on the theory.

One remembers the horrible loss of distance in *Peter Pan*—the moment when Peter says "Do you believe in fairies? . . . If you believe, clap your hands!" the moment when most children would like to slink out of the theatre and not a few cry—not because Tinkerbell may die, but because the magic is gone. What, after all, should we feel like if Lear were to leave Cordelia, come to the front of the stage and say, "All the grown-ups who think that she loves me, shout 'Yes'."[11]

It is hard to believe that the responses of any children could be as theory-bound as those Miss Dawson describes. In fact, Peter Pan's request for applause is a dramatic high point to which children respond enthusiastically. The playwright gives the children a momentary chance to become actors in the play. The children do not at that moment lose or snap out of a state of being distanced because they never had or were in any such thing to begin with. The comparison of Peter Pan's appeal to the hypothetical one by Lear is pointless. *Peter Pan* is a magical play in which almost anything can happen, but *King Lear* is a play of a different kind. There are, by the way, many plays in which an actor directly addresses the audience (*Our Town, The Marriage Broker, A Taste of Honey,* for example) without causing the play to be less valuable. Such plays are unusual, but what is unusual is not necessarily bad; there is no point in trying to lay down rules to which every play must conform independently of the kind of play it is.

It is perhaps worth noting that Susanne Langer reports the reaction she had as a child to this scene in *Peter Pan*.[12] As she remembers it, Peter Pan's appeal shattered the illusion and caused her acute misery. However, she reports that all the other children clapped and laughed and enjoyed themselves.

II

The second way of conceiving of the aesthetic attitude—as the ordinary action of attending done in a certain way (disinterestedly)—is illustrated by the work of Jerome Stolnitz and Eliseo Vivas. Stolnitz defines "aesthetic attitude" as "disinterested and sympathetic attention to and contemplation of any object of awareness whatever, for its own sake alone."[13] Stolnitz defines the main terms of his definition: "disinterested" means "no concern for any ulterior purpose";[14] "sympathetic" means "accept the object on its own terms to appreciate it";[15] and "contemplation" means "perception directed toward the object in its own right and the spectator is not concerned to analyze it or ask questions about it."[16]

The notion of disinterestedness, which Stolnitz has elsewhere shown[17] to be seminal for modern aesthetic theory, is the key term here. Thus, it is nec-

essary to be clear about the nature of disinterested attention to the various arts. It can make sense to speak, for example, of listening disinterestedly to music only if it makes sense to speak of listening interestedly to music. It would make no sense to speak of walking *fast* unless walking could be done *slowly*. Using Stolnitz' definition of "disinterestedness," the two situations would have to be described as "listening with no ulterior purpose" (disinterestedly) and "listening with an ulterior purpose" (interestedly). Note that what initially appears to be a perceptual distinction—listening in a certain way (interestedly or disinterestedly)—turns out to be a motivational or an intentional distinction—listening for or with a certain purpose. Suppose Jones listens to a piece of music for the purpose of being able to analyze and describe it on an examination the next day and Smith listens to the same music with no such ulterior purpose. There is certainly a difference between the motives and intentions of the two men: Jones has an ulterior purpose and Smith does not, but this does not mean Jones's *listening* differs from Smith's. It is possible that both men enjoy the music or that both be bored. The attention of either or both may flag and so on. It is important to note that a person's motive or intention is different from his action (Jones's listening to the music, for example). There is only one way to *listen* to (to attend to) music, although the listening may be more or less attentive and there may be a variety of motives, intentions, and reasons for doing so and a variety of ways of being distracted from the music.

In order to avoid a common mistake of aestheticians—drawing a conclusion about one kind of art and assuming it holds for all the arts—the question of disinterested attention must be considered for arts other than music. How would one look at a painting disinterestedly or interestedly? An example of alleged interested viewing might be the case in which a painting reminds Jones of his grandfather and Jones proceeds to muse about or to regale a companion with tales of his grandfather's pioneer exploits. Such incidents would be characterized by attitude-theorists as examples of using a work of art as a vehicle for associations and so on, i.e., cases of interested attention. But Jones is not looking at (attending to) the painting at all, although he may be facing it with his eyes open. Jones is now musing or attending to the story he is telling, although he had to look at the painting at first to notice that it resembled his grandfather. Jones is not now looking at the painting interestedly, since he is not now looking at (attending to) the painting. Jones's thinking or telling a story about his grandfather is no more a part of the painting than his speculating about the artist's intentions is and, hence, his musing, telling, speculating, and so on cannot properly

be described as attending to the painting interestedly. What attitude-aestheticians are calling attention to is the occurrence of irrelevant associations which distract the viewer from the painting or whatever. But distraction is not a special kind of attention, it is a kind of inattention.

Consider now disinterestedness and plays. I shall make use of some interesting examples offered by J. O. Urmson,[18] but I am not claiming that Urmson is an attitude-theorist. Urmson never speaks in his article of aesthetic attitude but rather of aesthetic satisfaction. In addition to aesthetic satisfaction, Urmson mentions economic, moral, personal, and intellectual satisfactions. I think the attitude-theorist would consider these last four kinds of satisfaction as "ulterior purposes" and, hence, cases of interested attention. Urmson considers the case of a man in the audience of a play who is delighted.[19] It is discovered that his delight is *solely* the result of the fact that there is a full house—the man is the impresario of the production. Urmson is right in calling *this* impresario's satisfaction economic rather than aesthetic, although there is a certain oddness about the example as it finds the impresario sitting *in the audience*. However, my concern is not with Urmson's examples as such but with the attitude theory. This impresario is certainly an interested party in the fullest sense of the word, but is his behavior an instance of interested attention as distinct from the supposed disinterested attention of the average citizen who sits beside him? In the situation as described by Urmson it would not make any sense to say that the impresario is attending to the play at all, since his *sole* concern at the moment is the till. If he can be said to be attending to anything (rather than just thinking about it) it is the size of the house. I do not mean to suggest that an impresario could not attend to his play if he found himself taking up a seat in a full house; I am challenging the sense of disinterested attention. As an example of personal satisfaction Urmson mentions the spectator whose daughter is in the play. Intellectual satisfaction involves the solution of technical problems of plays and moral satisfaction the consideration of the effects of the play on the viewer's conduct. All three of these candidates which the attitude-theorist would propose as cases of interested attention turn out to be just different ways of being distracted from the play and, hence, not cases of interested attention to the play. Of course, there is no reason to think that in any of these cases the distraction or inattention must be total, although it could be. In fact, such inattentions often occur but are so fleeting that nothing of the play, music, or whatever is missed or lost.

The example of a playwright watching a rehearsal or an out-of-town performance with a

view to rewriting the script has been suggested to me as a case in which a spectator is certainly attending to the play (unlike our impresario) and attending in an interested manner. This case is unlike those just discussed but is similar to the earlier case of Jones (not Smith) listening to a particular piece of music. Our playwright—like Jones, who was to be examined on the music—has ulterior motives. Furthermore, the playwright, unlike an ordinary spectator, can change the script after the performance or during a rehearsal. But how is our playwright's *attention* (as distinguished from his motives and intentions) different from that of an ordinary viewer? The playwright might enjoy or be bored by the performance as any spectator might be. The playwright's attention might even flag. In short, the kinds of things which may happen to the playwright's attention are no different from those that may happen to an ordinary spectator, although the two may have quite different motives and intentions.

For the discussion of disinterested-interested reading of literature it is appropriate to turn to the arguments of Eliseo Vivas whose work is largely concerned with literature. Vivas remarks that "By approaching a poem in a nonaesthetic mode it may function as history, as social criticism, as diagnostic evidence of the author's neuroses, and in an indefinite number of other ways."[20] Vivas further notes that according to Plato "the Greeks used Homer as an authority on war and almost anything under the sun," and that a certain poem "can be read as erotic poetry or as an account of a mystical experience."[21] The difference between reading a poem *as* history or whatever (reading it nonaesthetically) and reading it aesthetically depends on how *we* approach or read it. A poem "does not come self-labelled,"[22] but presumably is a poem only when it is read in a certain way—when it is an object of aesthetic experience. For Vivas, being an aesthetic object means being the object of the aesthetic attitude. He defines the aesthetic experience as "an experience of rapt attention which involves the intransitive apprehension of an object's immanent meanings and values in their full presentational immediacy."[23] Vivas maintains that his definition "helps me understand better what I can and what I cannot do when I read *The Brothers* [*Karamazov*]" and his definition "forces us to acknowledge that *The Brothers Karamazov* can hardly be read as art...."[24] This acknowledgment means that we probably cannot intransitively apprehend *The Brothers* because of its size and complexity.

"Intransitive" is the key term here and Vivas' meaning must be made clear. A number of passages reveal his meaning but perhaps the following is the best. "Having once seen a hockey game in slow motion, I am prepared to testify that it was an object of pure intransitive experience [attention]— for I was not *interested* in which team won the game and no external factors mingled with my interest in the beautiful rhythmic flow of the slow-moving men."[25] It appears that Vivas' "intransitive attention" has the same meaning as Stolnitz' "disinterested attention," namely, "attending with no ulterior purpose."[26] Thus, the question to ask is "How does one attend to (read) a poem or any literary work transitively?" One can certainly attend to (read) a poem for a variety of different purposes and because of a variety of different reasons, but can one attend to a poem transitively? I do not think so, but let us consider the examples Vivas offers. He mentions "a type of reader" who uses a poem or parts of a poem as a spring-board for "loose, uncontrolled, relaxed day-dreaming, wool-gathering rambles, free from the contextual control" of the poem.[27] But surely it would be wrong to say such musing is a case of transitively attending to a poem, since it is clearly a case of not attending to a poem. Another supposed way of attending to a poem transitively is by approaching it "as diagnostic evidence of the author's neuroses." Vivas is right if he means that there is no critical point in doing this since it does not throw light on the poem. But this is a case of *using* information gleaned from a poem to make inferences about its author rather than attending to a poem. If anything can be said to be attended to here it is the author's neuroses (at least they are being thought about). This kind of case is perhaps best thought of as a rather special way of getting distracted from a poem. Of course, such "biographical" distractions might be insignificant and momentary enough so as scarcely to distract attention from the poem (a flash of insight or understanding about the poet). On the other hand, such distractions may turn into dissertations and whole careers. Such an interest may lead a reader to concentrate his attention (when he does read a poem) on certain "informational" aspects of a poem and to ignore the remaining aspects. As deplorable as such a sustained practice may be, it is at best a case of attending to certain features of a poem and ignoring others.

Another way that poetry may allegedly be read transitively is by reading it as history. This case is different from the two preceding ones since poetry often *contains* history (makes historical statements or at least references) but does not (usually) contain statements about the author's neuroses and so on nor does it contain statements about what a reader's free associations are about (otherwise we would not call them "*free* associations"). Reading a poem as history suggests that we are attending to (thinking about) historical events by way of attending to a

poem—the poem is a time-telescope. Consider the following two sets of lines:

In fourteen hundred and ninety-two
 Columbus sailed the ocean blue.

Or like stout Cortex when with eagle eyes
 He star'd at the Pacific—and all his men
Look'd at each other with a wild surmise—
 Silent, upon a peak in Darien.

Someone might read both of these raptly and not know that they make historical references (inaccurately in one case)—might this be a case of intransitive attention? How would the above reading differ—so far as attention is concerned—from the case of a reader who recognized the historical content of the poetic lines? The two readings do not differ as far as attention is concerned. History is a part of these sets of poetic lines and the two readings differ in that the first fails to take account of an aspect of the poetic lines (its historical content) and the second does not fail to do so. Perhaps by "reading as history" Vivas means "reading *simply* as history." But even this meaning does not mark out a special kind of attention but rather means that only a single aspect of a poem is being noticed and that its rhyme, meter, and so on are ignored. Reading a poem as social criticism can be analyzed in a fashion similar to reading as history. Some poems simply are or contain social criticism, and a complete reading must not fail to notice this fact.

The above cases of alleged interested attending can be sorted out in the following way. Jones listening to the music and our playwright watching the rehearsal are both attending with ulterior motives to a work of art, but there is no reason to suppose that the attention of either is different in kind from that of an ordinary spectator. The reader who reads a poem as history is simply attending to an aspect of a poem. On the other hand, the remaining cases—Jones beside the painting telling of his grandfather, the gloating impresario, daydreaming while "reading" a poem, and so on—are simply cases of not attending to the work of art.

In general, I conclude that "disinterestedness" or "intransitiveness" cannot properly be used to refer to a special kind of attention. "Disinterestedness" is a term which is used to make clear that an action has certain kinds of motives. Hence, we speak of disinterested findings (of boards of inquiry), disinterested verdicts (of judges and juries), and so on. Attending to an object, of course, has its motives but the attending itself is not interested or disinterested according to whether its motives are of the kind which motivate interested or disinterested action (as findings and verdicts might), although the attending may be more or less close.

I have argued that the second way of conceiving the aesthetic attitude is also a myth, or at least that its main content—disinterested attention—is; but I must now try to establish that the view misleads aesthetic theory. I shall argue that the attitude-theorist is incorrect about (1) the way in which he wishes to set the limits of aesthetic relevance; (2) the relation of the critic to a work of art; and (3) the relation of morality to aesthetic value.

Since I shall make use of the treatment of aesthetic relevance in Jerome Stolnitz' book, let me make clear that I am not necessarily denying the relevance of the specific items he cites but disagreeing with his criterion of relevance. His criterion of relevance is derived from his definition of "aesthetic attitude" and is set forth at the very beginning of his book. This procedure leads Monroe Beardsley in his review of the book to remark that Stolnitz' discussion is premature.[28] Beardsley suggests "that relevance cannot be satisfactorily discussed until after a careful treatment of the several arts, their dimensions and capacities."[29]

First, what is meant by "aesthetic relevance"? Stolnitz defines the problem by asking the question: "Is it ever 'relevant' to the aesthetic experience to have thoughts or images or bits of knowledge which are not present within the object itself?"[30] Stolnitz begins by summarizing Bullough's experiment and discussion of single colors and associations.[31] Some associations absorb the spectator's attention and distract him from the color and some associations "fuse" with the color. Associations of the latter kind are aesthetic and the former are not. Stolnitz draws the following conclusion about associations:

If the aesthetic experience is as we have described it, then whether an association is aesthetic depends on whether it is compatible with the attitude of "disinterested attention." If the association re-enforces the focusing of attention upon the object, by "fusing" with the object and thereby giving it added "life and significance," it is genuinely aesthetic. If, however, it arrogates attention to itself and away from the object, it undermines the aesthetic attitude.[32]

It is not clear how something could *fuse* with a single color, but "fusion" is one of those words in aesthetics which is rarely defined. Stolnitz then makes use of a more fruitful example, one from I. A. Richards' *Practical Criticism*.[33] He cites the responses of students to the poem which begins:

Between the erect and solemn trees
I will go down upon my knees;
I shall not find this day
So meet a place to pray.

The image of a rugby forward running arose in the mind of one student-reader on reading the third verse of this poem. A cathedral was suggested to a second reader of the poem. The cathedral image "is congruous with both the verbal meaning of the poem and the emotions and mood which it expresses. It does not divert attention away from the poem."[34] The rugby image is presumably incongruous and diverts attention from the poem.

It is a confusion to take compatibility with disinterested attention as a criterion of relevance. If, as I have tried to show, *disinterested attention* is a confused notion, then it will not do as a satisfactory criterion. Also, when Stolnitz comes to show why the cathedral image is, and the rugby image is not relevant, the criterion he actually uses is *congruousness with the meaning of the poem*, which is quite independent of the notion of disinterestedness. The problem is perhaps best described as the problem of relevance to a poem, or more generally, to a work of art, rather than aesthetic relevance.

A second way in which the attitude theory misleads aesthetics is its contention that a critic's relationship to a work of art is different in kind from the relationship of other persons to the work. H. S. Langfeld in an early statement of this view wrote that we may "slip from the attitude of aesthetic enjoyment to the attitude of the critic." He characterizes the critical attitude as "intellectually occupied in coldly estimating ... merits" and the aesthetic attitude as responding "emotionally to" a work of art.[35] At the beginning of his book in the discussion of the aesthetic attitude, Stolnitz declares that if a percipient of a work of art "has the purpose of passing judgment upon it, his attitude is not aesthetic."[36] He develops this line at a later stage of his book, arguing that appreciation (perceiving with the aesthetic attitude) and criticism (seeking for reasons to support an evaluation of a work) are (1) distinct and (2) "psychologically opposed to each other."[37] The critical attitude is questioning, analytical, probing for strengths and weakness, and so on. The aesthetic attitude is just the opposite: "It commits our allegiance to the object freely and unquestioningly"; "the spectator 'surrenders' himself to the work of art."[38] "Just because the two attitudes are inimical, whenever criticism obtrudes, it reduces aesthetic interest."[39] Stolnitz does not, of course, argue that criticism is unimportant for appreciation. He maintains criticism plays an important and necessary role in preparing a person to appreciate the nuances, detail, form, and so on of works of art. We are quite right, he says, thus to read and listen perceptively and acutely, but he questions, "Does this mean that we must analyze, measure in terms of value-criteria, etc., *during* the supposedly aesthetic experience?"[40] His answer is

"No" and he maintains that criticism must occur "*prior* to the aesthetic encounter,"[41] or it will interfere with appreciation.

How does Stolnitz know that criticism will always interfere with appreciation? His conclusion sounds like one based upon the observations of actual cases, but I do not think it is. I believe it is a logical consequence of his definition of aesthetic attitude in terms of disinterested attention (no ulterior purpose). According to his view, to appreciate an object aesthetically one has to perceive it with no ulterior purpose. But the critic has an ulterior purpose—to analyze and evaluate the object he perceives—hence, in so far as a person functions as a critic he cannot function as an appreciator. But here, as previously, Stolnitz confuses a perceptual distinction with a motivational one. If it were possible to *attend* disinterestedly or interestedly, then perhaps the critic (as percipient) would differ from other percipients. But if my earlier argument about attending is correct, the critic differs from other percipients only in his motives and intentions and not in the way in which he attends to a work of art.

Of course, it might just be a fact that the search for reasons is incompatible with the appreciation of art, but I do not think it is. Several years ago I participated in a series of panel discussions of films. During the showing of each film we were to discuss, I had to take note of various aspects of the film (actor's performance, dramatic development, organization of the screen-plane and screen-space at given moments, and so on) in order later to discuss the films. I believe that this practice not only helped educate me to appreciate subsequent films but that it enhanced the appreciation of the films I was analyzing. I noticed and was able to appreciate things about the films I was watching which ordinarily out of laziness I would not have noticed. I see no reason why the same should not be the case with the professional critic or any critical percipient. If many professional critics seem to appreciate so few works, it is not because they are critics, but perhaps because the percentage of good works of art is fairly small and they suffer from a kind of combat fatigue.

I am unable to see any significant difference between "perceptively and acutely" attending to a work of art (which Stolnitz holds enhances appreciation) and searching for reasons, so far as the experience of a work of art is concerned. If I attend perceptively and acutely, I will have certain standards and/or paradigms in mind (not necessarily consciously) and will be keenly aware of the elements and relations in the work and will evaluate them to some degree. Stolnitz writes as if criticism takes place and then is over and done with, but the search for and finding of reasons (noticing this fits in with that, and so on) is continuous in practiced appreci-

ators. A practiced viewer does not even have to be looking for a reason, he may just notice a line or an area in a painting, for example, and the line or area becomes a reason why he thinks the painting better or worse. A person may be a critic (not necessarily a good one) without meaning to be or without even realizing it.

There is one final line worth pursuing. Stolnitz' remarks suggest that one reason he thinks criticism and appreciation incompatible is that they compete with one another for time (this would be especially bad in the cases of performed works). But seeking and finding reasons (criticism) does not compete for time with appreciation. First, to seek for a reason means to be ready and able to notice something and to be thus ready and able as one attends does not compete for time with the attending. In fact, I should suppose that seeking for reasons would tend to focus attention more securely on the work of art. Second, finding a reason is an achievement, like winning a race. (It takes time to run a race but not to win it.) Consider the finding of the following reasons. How much time does it take to "see" that a note is off key (or on key)? How long does it take to notice that an actor mispronounces a word (or does it right)? How much time does it take to realize that a character's action does not fit his already established personality? (One is struck by it.) How long does it take to apprehend that a happy ending is out of place? It does not take time to find any of these reasons or reasons in general. Finding a reason is like coming to understand—it is done in a flash. I do not mean to suggest that one cannot be mistaken in finding a reason. What may appear to be a fault or a merit (a found reason) in the middle of a performance (or during one look at a painting and so forth) may turn out to be just the opposite when seen from the perspective of the whole performance (or other looks at the painting).

A third way in which the attitude theory misleads aesthetic theory is its contention that aesthetic value is always independent of morality. This view is perhaps not peculiar to the attitude theory, but it is a logical consequence of the attitude approach. Two quotations from attitude-theorists will establish the drift of their view of morality and aesthetic value.

We are either concerned with the beauty of the object or with some other value of the same. Just as soon, for example, as ethical considerations occur to our mind, our attitude shifts.[42]
Any of us might reject a novel because it seems to conflict with our moral beliefs. . . . When we do so . . . we have *not* read the book aesthetically, for we have interposed moral . . . responses of our own which are alien to it. This disrupts the aes-

thetic attitude. We cannot then say that the novel is *aesthetically* bad, for we have not permitted ourselves to consider it aesthetically. To maintain the aesthetic attitude, we must follow the lead of the object and respond in concert with it.[43]

This conception of the aesthetic attitude functions to hold the moral aspects and the *aesthetic* aspects of the work of art firmly apart. Presumably, although it is difficult to see one's way clearly here, the moral aspects of a work of art cannot be an object of aesthetic attention because aesthetic attention is by definition disinterested and the moral aspects are somehow practical (interested). I suspect that there are a number of confusions involved in the assumption of the incompatibility of aesthetic attention and the moral aspects of art, but I shall not attempt to make these clear, since the root of the assumption—disinterested attention—is a confused notion. Some way other than in terms of the aesthetic attitude, then, is needed to discuss the relation of morality and aesthetic value.

David Pole in a recent article[44] has argued that the moral vision which a work of art may embody is *aesthetically* significant. It should perhaps be remarked at this point that not all works of art embody a moral vision and perhaps some kinds of art (music, for example) cannot embody a moral vision, but certainly some novels, some poems, and some films and plays do. I assume it is unnecessary to show how novels and so on have this moral aspect. Pole notes the curious fact that while so many critics approach works of art in "overtly moralistic terms," it is a "philosophical commonplace . . . that the ethical and the aesthetic modes . . . form different categories."[45] I suspect that many philosophers would simply say that these critics are confused about their roles. But Pole assumes that philosophical theory "should take notice of practice"[46] and surely he is right. In agreeing with Pole's assumption I should like to reserve the right to argue in specific cases that a critic may be misguided. This right is especially necessary in a field such as aesthetics because the language and practice of critics is so often burdened with ancient theory. Perhaps *all* moralistic criticism is wrong but philosophers should not rule it out of order at the very beginning by use of a definition.

Pole thinks that the moral vision presented by a particular work of art will be either true or false (perhaps a mixture of true and false might occur). If a work has a false moral vision, then something "is lacking within the work itself. But to say that is to say that the [work] is internally incoherent; some particular aspect must jar with what—on the strength of the rest—we claim a right to demand.

And here the moral fault that we have found will count as an aesthetic fault too."[47] Pole is trying to show that the assessment of the moral vision of a work of art is just a special case of coherence or incoherence, and since everyone would agree that coherence is an aesthetic category, the assessment of the moral vision is an aesthetic assessment.

I think Pole's conclusion is correct but take exception to some of his arguments. First, I am uncertain whether it is proper to speak of a moral vision being true or false, and would want to make a more modest claim—that a moral vision can be judged to be acceptable or unacceptable. (I am not claiming Pole is wrong and my claim is not inconsistent with his.) Second, I do not see that a false (or unacceptable) moral vision makes a work incoherent. I should suppose that to say a work is coherent or incoherent is to speak about how its parts fit together and this involves no reference to something outside the work as the work's truth or falsity does.

In any event, it seems to me that a faulty moral vision can be shown to be an aesthetic fault independently of Pole's consideration of truth and coherence. As Pole's argument implies, a work's moral vision is a *part* of the work. Thus, any statement—descriptive or evaluative—about the work's moral vision is a statement about the *work;* and any statement about a *work* is a critical statement and, hence, falls within the aesthetic domain. To judge a moral vision to be morally unacceptable is to judge it defective and this amounts to saying that the work of art has a defective part. (Of course, a judgment of the acceptability of a moral vision may be wrong, as a judgment of an action sometimes is, but this fallibility does not make any difference.) Thus, a work's moral vision may be an aesthetic merit or defect just as a work's degree of unity is a merit or defect. But what justifies saying that a moral vision is a part of a work of art? Perhaps "part" is not quite the right word but it serves to make the point clear enough. A novel's moral vision is an essential part of the novel and if it were removed (I am not sure how such surgery could be carried out) the novel would be greatly changed. Anyway, a novel's moral vision is not like its covers or binding. However, someone might still argue that even though a work's moral vision is defective and the moral vision is part of the work, that this defect is not an *aesthetic* defect. How is "aesthetic" being used here? It is being used to segregate certain aspects or parts of works of art such as formal and stylistic aspects from such aspects as a work's moral vision. But it seems to me that the separation is only nominal. "Aesthetic" has been selected as a name for a certain sub-set of characteristics of works of art. I certainly cannot object to such a stipulation, since an under-

lying aim of this essay is to suggest the vacuousness of the term "aesthetic." My concern at this point is simply to insist that a work's moral vision is a part of the work and that, therefore, a critic can legitimately describe and evaluate it. I would *call* any defect or merit which a critic can legitimately point out an aesthetic defect or merit, but what we call it does not matter.

It would, of course, be a mistake to judge a work solely on the basis of its moral vision (it is only one part). The fact that some critics have judged works of art in this way is perhaps as much responsible as the theory of aesthetic attitude for the attempts to separate morality from the aesthetic. In fact, such criticism is no doubt at least partly responsible for the rise of the notion of the aesthetic attitude.

If the foregoing arguments are correct, the second way of conceiving the aesthetic attitude misleads aesthetic theory in at least three ways.

III

In answer to a hypothetical question about what is seen in viewing a portrait with the aesthetic attitude, Tomas in part responds "If looking at a picture and attending closely to how it looks is not really to be in the aesthetic attitude, then what on earth is?"[48] I shall take this sentence as formulating the weakest version of the aesthetic attitude. (I am ignoring Tomas' distinction between appearance and reality. See footnote 7. My remarks, thus, are not a critique of Tomas' argument; I am simply using one of his sentences.) First, this sentence speaks only of "looking at a picture," but "listening to a piece of music," "watching and listening to a play," and so on could be added easily enough. After thus expanding the sentence, it can be contracted into the general form: "Being in the aesthetic attitude is attending closely to a work of art (or a natural object)."

But the aesthetic attitude ("the hallmark of modern aesthetics") in this formulation is a great let-down—it no longer seems to say anything significant. Nevertheless, this does seem to be all that is left after the aesthetic attitude has been purged of *distancing* and *disinterestedness*. The only which prevents the aesthetic attitude from collapsing into simple attention is the qualification *closely*. One may, I suppose, attend to a work of art more or less closely, but this fact does not seem to signify anything very important. When "being in the aesthetic attitude" is equated with "attending (closely)," the equation neither involves any mythical element nor could it possibly mislead aesthetic theory. But if the definition has no vices, it seems to have no virtues either. When the aesthetic attitude

finally turns out to be simply attending (closely), the final version should perhaps not be called "the weakest" but rather "the vacuous version" of the aesthetic attitude.

Stolnitz is no doubt historically correct that the notion of the aesthetic attitude has played an important role in the freeing of aesthetic theory from an overweening concern with beauty. It is easy to see how the slogan, "Anything can become an object of the aesthetic attitude," could help accomplish this liberation. It is worth noting, however, that the same goal could have been (and perhaps to

some extent was) realized by simply noting that works of art are often ugly or contain ugliness, or have features which are difficult to include within beauty. No doubt, in more recent times people have been encouraged *to take an aesthetic attitude toward a painting* as a way of lowering their prejudices, say, against abstract and nonobjective art. So if the notion of aesthetic attitude has turned out to have no theoretical value for aesthetics, it has had practical value for the appreciation of art in a way similar to that of Clive Bell's suspect notion of significant form.

Notes

I wish to thank both Monroe C. Beardsley and Jerome Stolnitz who read earlier drafts of this paper and made many helpful comments.

1. See Marshall Cohen, "Appearance and the Aesthetic Attitude," *Journal of Philosophy,* 56 (1959), 926; and Joseph Margolis, "Aesthetic Perception," *Journal of Aesthetics and Art Criticism,* 19 (1960), 211. Margolis gives an argument, but it is so compact as to be at best only suggestive.

2. Jerome Stolnitz, "Some Questions Concerning Aesthetic Perception," *Philosophy and Phenomenological Research,* 22 (1961), 69.

3. *The Concept of Mind* (London, 1949), p. 23.

4. "'Distancing' as an Aesthetic Principle," *Australasian Journal of Philosophy,* 39 (1961), 155–74.

5. "Disinterested" is Stolnitz' term. Vivas uses "intransitive."

6. *Aesthetics and Philosophy of Art Criticism* (Boston, 1960), p. 510.

7. "Aesthetic Vision," *The Philosophical Review,* 68 (1959), 63. I shall ignore Tomas' attempt to distinguish between appearance and reality since it seems to confuse rather than clarify aesthetic theory. See F. Sibley, "Aesthetics and the Looks of Things," *Journal of Philosophy,* 56 (1959), 905–15; M. Cohen, op. cit., pp. 915–26; and J. Stolnitz, "Some Questions Concerning Aesthetic Perception," op. cit., pp. 69–87. Tomas discusses only visual art and the aesthetic attitude, but his remarks could be generalized into a comprehensive theory.

8. Dawson, op. cit., p. 158.

9. Ibid., pp. 159–60.

10. Ibid., p. 159.

11. Ibid., p. 168.

12. *Feeling and Form* (New York, 1953), p. 318.

13. Aesthetics and Philosophy of Art Criticism, pp. 34–35.

14. Ibid., p. 35.

15. Ibid., p. 36.

16. Ibid., p. 38.

17. "On the Origins of 'Aesthetic Disinterestedness'," *The Journal of Aesthetics and Art Criticism,* 20 (1961), pp. 131–43.

18. "What Makes a Situation Aesthetic?" in *Philosophy Looks at the Arts,* Joseph Margolis, ed., (New York, 1962). Reprinted from *Proceedings of the Aristotelian Society, Supplementary Volume* 31 (1957), pp. 75–92.

19. Ibid., p. 15.

20. "Contextualism Reconsidered," *The Journal of Aesthetics and Art Criticism,* 18 (1959), pp. 224–25.

21. Ibid., p. 225.

22. Loc. cit.

23. Ibid., p. 227.

24. Ibid., p. 237.

25. Ibid., p. 228. (Italics mine.)

26. Vivas' remark about the improbability of being able to read *The Brothers Karamazov* as art suggests that "intransitive attention" may sometimes mean for him "that which can be attended to at one time" or "that which can be held before the mind at one time." However, this second possible meaning is not one which is relevant here.

27. Vivas, op. cit., p. 231.

28. *The Journal of Philosophy*, 57 (1960), p. 624.

29. Loc. cit.

30. Op. cit., p. 53.

31. Ibid., p. 54.

32. Ibid., pp. 54–55.

33. Ibid., pp. 55–56.

34. Ibid., p. 56.

35. *The Aesthetic Attitude* (New York, 1920), p. 79.

36. Op. cit., p. 35.

37. Ibid., p. 377.

38. Ibid., pp. 377–78.

39. Ibid., p. 379.

40. Ibid., p. 380.

41. Loc. cit.

42. H. S. Langfeld, op. cit., p. 73.

43. J. Stolnitz, op. cit., p. 36.

44. "Morality and the Assessment of Literature," *Philosophy*, 37 (1962), pp. 193–207.

45. Ibid., p. 193.

46. Loc. cit.

47. Ibid., p. 206.

48. Tomas, op. cit., p. 63.

4

Intuition, Technique and the Classification of the Arts

BENEDETTO CROCE

Intuition and Expression

Knowledge has two forms: it is either *intuitive* knowledge or *logical* knowledge; knowledge obtained through the *imagination* or knowledge obtained through the *intellect;* knowledge of the *individual* or knowledge of the *universal;* of *individual things* or of the *relations* between them: it is, in fact, productive either of *images* or of *concepts.*

In ordinary life, constant appeal is made to intuitive knowledge. It is said that we cannot give definitions of certain truths; that they are not demonstrable by syllogisms; that they must be learnt intuitively. The politician finds fault with the abstract reasoner, who possesses no lively intuition of actual conditions; the educational theorist insists upon the necessity of developing the intuitive faculty in the pupil before everything else; the critic in judging a work of art makes it a point of honour to set aside theory and abstractions, and to judge it by direct intuition; the practical man professes to live rather by intuition than by reason.

But this ample acknowledgment granted to intuitive knowledge in ordinary life, does not correspond to an equal and adequate acknowledgment in the field of theory and of philosophy. There exists a very ancient science of intellectual knowledge, admitted by all without discussion, namely, Logic; but a science of intuitive knowledge is timidly and with difficulty asserted by but a few. Logical knowledge has appropriated the lion's share; and if she

does not slay and devour her companion outright, yet yields to her but grudgingly the humble place of maid-servant or doorkeeper.—What can intuitive knowledge be without the light of intellectual knowledge? It is a servant without a master; and though a master find a servant useful, the master is a necessity to the servant, since he enables him to gain his livelihood. Intuition is blind; intellect lends her eyes.

Now, the first point to be firmly fixed in the mind is that intuitive knowledge has no need of a master, nor to lean upon any one; she does not need to borrow the eyes of others, for she has excellent eyes of her own. Doubtless it is possible to find concepts mingled with intuitions. But in many other intuitions there is no trace of such a mixture, which proves that it is not necessary. The impression of a moonlight scene by a painter; the outline of a country drawn by a cartographer; a musical motive, tender or energetic; the words of a sighing lyric, or those with which we ask, command, and lament in ordinary life, may well all be intuitive facts without a shadow of intellectual relation. But, think what one may of these instances, and admitting further the contention that the greater part of the intuitions of civilized man are impregnated with concepts, there yet remains to be observed something more important and more conclusive. Those concepts which are found mingled and fused with the intuitions are no longer concepts, in so far as they are really mingled and fused, for they have lost all inde-

From Benedetto Croce, *Aesthetic,* revised edition, trans. Douglas Ainslie. New York: Farrar, Straus & Giroux, Inc., 1922, 1972, pp. 1–21, 111–17. Reprinted with permission of Farrar, Straus & Giroux, Inc.

pendence and autonomy. They have been concepts, but have now become simple elements of intuition. The philosophical maxims placed in the mouth of a personage of tragedy or of comedy, perform there the function, not of concepts, but of characteristics of such personage; in the same way as the red in a painted face does not there represent the red colour of the physicists, but is a characteristic element of the portrait. The whole is that which determines the quality of the parts. A work of art may be full of philosophical concepts; it may contain them in greater abundance and they may there be even more profound than in a philosophical dissertation, which in its turn may be rich to overflowing with descriptions and intuitions. But notwithstanding all these concepts the total effect of the work of art is an intuition; and notwithstanding all those intuitions, the total effect of the philosophical dissertation is a concept. The *Promessi Sposi* contains copious ethical observations and distinctions, but does not for that reason lose as a whole its character of simple story or intuition. In like manner the anecdotes and satirical effusions to be found in the works of a philosopher like Schopenhauer do not deprive those works of their character of intellectual treatises. The difference between a scientific work and a work of art, that is, between an intellectual fact and an intuitive fact, lies in the difference of the total effect aimed at by their respective authors. This it is that determines and rules over the several parts of each not these parts separated and considered abstractly in themselves.

But to admit the independence of intuition as regards concept does not suffice to give a true and precise idea of intuition. Another error arises among those who recognize this, or who at any rate do not explicitly make intuition dependent upon the intellect, to obscure and confuse the real nature of intuition. By intuition is frequently understood *perception*, or the knowledge of actual reality, the apprehension of something as *real*.

Certainly perception is intuition: the perceptions of the room in which I am writing, of the ink-bottle and paper that are before me, of the pen I am using, of the objects that I touch and make use of as instruments of my person, which, if it write, therefore exists;—these are all intuitions. But the image that is now passing through my brain of a me writing in another room, in another town, with different paper, pen and ink, is also an intuition. This means that the distinction between reality and non-reality is extraneous, secondary, to the true nature of intuition. If we imagine a human mind having intuitions for the first time, it would seem that it could have intuitions of actual reality only, that is to say, that it could have perceptions of nothing but the real. But since knowledge of reality is based upon

the distinction between real images and unreal images, and since this distinction does not at the first moment exist, these intuitions would in truth not be intuitions either of the real or of the unreal, not perceptions, but pure intuitions. Where all is real, nothing is real. The child, with its difficulty of distinguishing true from false, history from fable, which are all one to childhood, can furnish us with a sort of very vague and only remotely approximate idea of this ingenuous state. Intuition is the undifferentiated unity of the perception of the real and of the simple image of the possible. In our intuitions we do not oppose ourselves as empirical beings to external reality, but we simply objectify our impressions, whatever they be.

Those, therefore, who look upon intuition as sensation formed and arranged simply according to the categories of space and time, would seem to approximate more nearly to the truth. Space and time (they say) are the forms of intuition; to have an intuition is to place it in space and in temporal sequence. Intuitive activity would then consist in this double and concurrent function of spatiality and temporality. But for these two categories must be repeated what was said of intellectual distinctions, when found mingled with intuitions. We have intuitions without space and without time: the colour of a sky, the colour of a feeling, a cry of pain and an effort of will, objectified in consciousness: these are intuitions which we possess, and with their making space and time have nothing to do. In some intuitions, spatiality may be found without temporality, in others, vice versa; and even where both are found, they are perceived by later reflexion: they can be fused with the intuition in like manner with all its other elements: that is, they are in it *materialiter* and not *formaliter*, as ingredients and not as arrangement. Who, without an act of reflexion which for a moment breaks in upon his contemplation, can think of space while looking at a drawing or a view? Who is conscious of temporal sequence while listening to a story or a piece of music without breaking into it with a similar act of reflexion? What intuition reveals in a work of art is not space and time, but *character, individual physiognomy*. The view here maintained is confirmed in several quarters of modern philosophy. Space and time, far from being simple and primitive functions, are nowadays conceived as intellectual constructions of great complexity. And further, even in some of those who do not altogether deny to space and time the quality of formative principles, categories and functions, one observes an effort to unite them and to regard them in a different manner from that in which these categories are generally conceived. Some limit intuition to the sole category of spatiality, maintaining that even time can only be intuited

in terms of space. Others abandon the three dimensions of space as not philosophically necessary, and conceive the function of spatiality as void of all particular spatial determination. But what could such a spatial function be, a simple arrangement that should arrange even time? It represents, surely, all that criticism and refutation have left standing—the bare demand for the affirmation of some intuitive activity in general. And is not this activity truly determined, when one single function is attributed to it, not spatializing nor temporalizing, but characterizing? Or rather, when it is conceived as itself a category or function which gives us knowledge of things in their concreteness and individuality?

Having thus freed intuitive knowledge from any suggestion of intellectualism and from every later and external addition, we must now explain it and determine its limits from another side and defend it from a different kind of invasion and confusion. On the hither side of the lower limit is sensation, formless matter, which the spirit can never apprehend in itself as simple matter. This it can only possess with form and in form, but postulates the notion of it as a mere limit. Matter, in its abstraction, is mechanism, passivity; it is what the spirit of man suffers, but does not produce. Without it no human knowledge or activity is possible; but mere matter produces animality, whatever is brutal and impulsive in man, not the spiritual dominion, which is humanity. How often we strive to understand clearly what is passing within us! We do catch a glimpse of something, but this does not appear to the mind as objectified and formed. It is in such moments as these that we best perceive the profound difference between matter and form. These are not two acts of ours, opposed to one another; but the one is outside us and assaults and sweeps us off our feet, while the other inside us tends to absorb and identify itself with that which is outside. Matter, clothed and conquered by form, produces concrete form. It is the matter, the content, which differentiates one of our intuitions from another: the form is constant: it is spiritual activity, while matter is changeable. Without matter spiritual activity would not forsake its abstractness to become concrete and real activity, this or that spiritual content, this or that definite intuition.

It is a curious fact, characteristic of our times, that this very form, this very activity of the spirit, which is essentially ourselves, is so often ignored or denied. Some confound the spiritual activity of man with the metaphorical and mythological activity of what is called nature, which is mechanism and has no resemblance to human activity, save when we imagine, with Æsop, that "arbores loquuntur non tantum ferae." Some affirm that they have never observed in themselves this "miraculous" activity,

as though there were no difference, or only one of quantity, between sweating and thinking, feeling cold and the energy of the will. Others, certainly with greater reason, would unify activity and mechanism in a more general concept, though they are specifically distinct. Let us, however, refrain for the moment from examining if such a final unification be possible, and in what sense, but admitting that the attempt may be made, it is clear that to unify two concepts in a third implies to begin with the admission of a difference between the two first. Here it is this difference that concerns us and we set it in relief.

Intuition has sometimes been confused with simple sensation. But since this confusion ends by being offensive to common sense, it has more frequently been attenuated or concealed with a phraseology apparently designed at once to confuse and to distinguish them. Thus, it has been asserted that intuition is sensation, but not so much simple sensation as *association* of sensations. Here a double meaning is concealed in the word "association." Association is understood, either as memory, mnemonic association, conscious recollection, and in that case the claim to unite in memory elements which are not intuited, distinguished, possessed in some way by the spirit and produced by consciousness, seems inconceivable: or it is understood as association of unconscious elements, in which case we remain in the world of sensation and of nature. But if with certain associationists we speak of an association which is neither memory nor flux of sensations, but a *productive* association (formative, constructive, distinguishing); then our contention is admitted and only its name is denied to it. For productive association is no longer association in the sense of the sensationalists, but *synthesis,* that is to say, spiritual activity. Synthesis may be called association; but with the concept of productivity is already posited the distinction between passivity and activity, between sensation and intuition.

Other psychologists are disposed to distinguish from sensation something which is sensation no longer, but is not yet intellectual concept: the *representation* or *image.* What is the difference between their representation or image and our intuitive knowledge? Everything and nothing: for "representation" is a very equivocal word. If by representation be understood something cut off and standing out from the psychic basis of the sensations, then representation is intuition. If, on the other hand, it be conceived as complex sensation we are back once more in crude sensation, which does not vary in quality according to its richness or poverty, or according to whether the organism in which it appears is rudimentary or highly developed and full of traces of past sensations. Nor is the ambiguity remedied by defining representation as a psy-

chic product of secondary degree in relation to sensation, defined as occupying the first place. What does secondary degree mean here? Does it mean a qualitative, formal difference? If so, representation is an elaboration of sensation and therefore intuition. Or does it mean greater complexity and complication, a quantitative, material difference? In that case intuition is once more confused with simple sensation.

And yet there is a sure method of distinguishing true intuition, true representation, from that which is inferior to it: the spiritual fact from the mechanical, passive, natural fact. Every true intuition or representation is also *expression*. That which does not objectify itself in expression is not intuition or representation, but sensation and mere natural fact. The spirit only intuits in making, forming, expressing. He who separates intuition from expression never succeeds in reuniting them.

Intuitive activity *possesses intuitions to the extent that it expresses them.* Should this proposition sound paradoxical, that is partly because, as a general rule, a too restricted meaning is given to the word "expression." It is generally restricted to what are called verbal expressions alone. But there exist also non-verbal expressions, such as those of line, colour and sound, and to all of these must be extended our affirmation, which embraces therefore every sort of manifestation of the man, as orator, musician, painter, or anything else. But be it pictorial, or verbal, or musical, or in whatever other form it appear, to no intuition can expression in one of its forms be wanting; it is, in fact, an inseparable part of intuition. How can we really possess an intuition of a geometrical figure, unless we possess so accurate an image of it as to be able to trace it immediately upon paper or on the blackboard? How can we really have an intuition of the contour of a region, for example of the island of Sicily, if we are not able to draw it as it is in all its meanderings? Every one can experience the internal illumination which follows upon his success in formulating to himself his impressions and feelings, but only so far as he is able to formulate them. Feelings or impressions, then, pass by means of words from the obscure region of the soul into the clarity of the contemplative spirit. It is impossible to distinguish intuition from expression in this cognitive process. The one appears with the other at the same instant, because they are not two, but one.

The principal reason which makes our view appear paradoxical as we maintain it, is the illusion or prejudice that we possess a more complete intuition of reality than we really do. One often hears people say that they have many great thoughts in their minds, but that they are not able to express them. But if they really had them, they would have coined them into just so many beautiful, sounding words, and thus have expressed them. If these thoughts seem to vanish or to become few and meagre in the act of expressing them, the reason is that they did not exist or really were few and meagre. People think that all of us ordinary men imagine and intuit countries, figures and scenes like painters, and bodies like sculptors; save that painters and sculptors know how to paint and carve such images, while we bear them unexpressed in our souls. They believe that any one could have imagined a Madonna of Raphael; but that Raphael was Raphael owing to his technical ability in putting the Madonna upon canvas. Nothing can be more false than this view. The world which as a rule we intuit is a small thing. It consists of little expressions, which gradually become greater and wider with the increasing spiritual concentration of certain moments. They are the words we say to ourselves, our silent judgments: "Here is a man, here is a horse, this is heavy, this is sharp, this pleases me," etc. It is a medley of light and colour, with no greater pictorial value than would be expressed by a haphazard splash of colours, from among which one could barely make out a few special, distinctive traits. This and nothing else is what we possess in our ordinary life; this is the basis of our ordinary action. It is the index of a book. The labels tied to things (it has been said) take the place of the things themselves. This index and these labels (themselves expressions) suffice for small needs and small actions. From time to time we pass from the index to the book, from the label to the thing, or from the slight to the greater intuitions, and from these to the greatest and most lofty. This passage is sometimes far from easy. It has been observed by those who have best studied the psychology of artists that when, after having given a rapid glance at any one, they attempt to obtain a real intuition of him, in order, for example, to paint his portrait, then this ordinary vision, that seemed so precise, so lively, reveals itself as little better than nothing. What remains is found to be at the most some superficial trait, which would not even suffice for a caricature. The person to be painted stands before the artist like a world to discover. Michael Angelo said, "One paints, not with the hands, but with the brain." Leonardo shocked the prior of the Convent of the Graces by standing for days together gazing at the "Last Supper," without touching it with the brush. He remarked of this attitude: "The minds of men of lofty genius are most active in invention when they are doing the least external work." The painter is a painter, because he sees what others only feel or catch a glimpse of, but do not see. We think we see a smile, but in reality we have only a vague impression of it, we do not perceive all the characteristic traits of which it is the sum, as the painter discovers them after he has worked upon them and is thus

able to fix them on the canvas. We do not intuitively possess more even of our intimate friend, who is with us every day and at all hours, than at most certain traits of physiognomy which enable us to distinguish him from others. The illusion is less easy as regards musical expression; because it would seem strange to every one to say that the composer had added or attached notes to a motive which was already in the mind of him who is not the composer; as if Beethoven's Ninth Symphony were not his own intuition and his intuition the Ninth Symphony. Now, just as one who is deluded as to the amount of his material wealth is confuted by arithmetic, which states its exact amount, so he who nourishes delusions as to the wealth of his own thoughts and images is brought back to reality, when he is obliged to cross the *Pons Asinorum* of expression. Let us say to the former, count; to the latter, speak; or, here is a pencil, draw, express yourself.

Each of us, as a matter of fact, has in him a little of the poet, of the sculptor, of the musician, of the painter, of the prose writer: but how little, as compared with those who bear those names, just because they possess the most universal dispositions and energies of human nature in so lofty a degree! How little too does a painter possess of the intuitions of a poet! And how little does one painter possess those of another painter! Nevertheless, that little is all our actual patrimony of intuitions or representations. Beyond these are only impressions, sensations, feelings, impulses, emotions, or whatever else one may term what still falls short of the spirit and is not assimilated by man; something postulated for the convenience of exposition, while actually non-existent, since to exist also is a fact of the spirit.

We may thus add this to the various verbal descriptions of intuition, noted at the beginning: intuitive knowledge is expressive knowledge. Independent and autonomous in respect to intellectual function; indifferent to later empirical discriminations, to reality and to unreality, to formations and apperceptions of space and time, which are also later: intuition or representation is distinguished as *form* from what is felt and suffered, from the flux or wave of sensation, or from psychic matter; and this form, this taking possession, is expression. To intuit is to express; and nothing else (nothing more, but nothing less) than *to express*.

Intuition and Art

Before proceeding further, it may be well to draw certain consequences from what has been established and to add some explanations.

We have frankly identified intuitive or expressive knowledge with the æsthetic or artistic fact, taking works of art as examples of intuitive knowledge and attributing to them the characteristics of intuition, and vice versa. But our identification is combated by a view held even by many philosophers, who consider art to be an intuition of an altogether special sort. "Let us admit" (they say) "that art is intuition; but intuition is not always art: artistic intuition is a distinct species differing from intuition in general by something *more*."

But no one has ever been able to indicate of what this something more consists. It has sometimes been thought that art is not a simple intuition, but an intuition of an intuition, in the same way as the concept of science has been defined, not as the ordinary concept, but as the concept of a concept. Thus man would attain to art by objectifying, not his sensations, as happens with ordinary intuition, but intuition itself. But this process of raising to a second power does not exist; and the comparison of it with the ordinary and scientific concept does not prove what is intended, for the good reason that it is not true that the scientific concept is the concept of a concept. If this comparison proves anything, it proves just the opposite. The ordinary concept, if it be really a concept and not a simple representation, is a perfect concept, however poor and limited. Science substitutes concepts for representations; for those concepts that are poor and limited it substitutes others, larger and more comprehensive; it is ever discovering new relations. But its method does not differ from that by which is formed the smallest universal in the brain of the humblest of men. What is generally called *par excellence* art collects intuitions that are wider and more complex than those which we generally experience, but these intuitions are always of sensations and impressions.

Art is expression of impressions, not expression of expression.

For the same reason, it cannot be asserted that the intuition, which is generally called artistic, differs from ordinary intuition as intensive intuition. This would be the case if it were to operate differently on the same matter. But since the artistic function is extended to wider fields, yet does not differ in method from ordinary intuition, the difference between them is not intensive but extensive. The intuition of the simplest popular love-song, which says the same thing, or very nearly, as any declaration of love that issues at every moment from the lips of thousands of ordinary men, may be intensively perfect in its poor simplicity, although it be extensively so much more limited than the complex intuition of a love-song by Leopardi.

The whole difference, then, is quantitative, and as such is indifferent to philosophy, *scientia qualitatum*. Certain men have a greater aptitude, a more

frequent inclination fully to express certain complex states of the soul. These men are known in ordinary language as artists. Some very complicated and difficult expressions are not often achieved, and these are called works of art. The limits of the expression-intuitions that are called art, as opposed to those that are vulgarly called non-art, are empirical and impossible to define. If an epigram be art, why not a simple word? If a story, why not the news-jottings of the journalist? If a landscape, why not a topographical sketch? The teacher of philosophy in Molière's comedy was right: "whenever we speak, we create prose." But there will always be scholars like Monsieur Jourdain, astonished at having spoken prose for forty years without knowing it, who will have difficulty in persuading themselves that when they call their servant John to bring their slippers, they have spoken nothing less than— prose.

We must hold firmly to our identification, because among the principal reasons which have prevented Æsthetic, the science of art, from revealing the true nature of art, its real roots in human nature, has been its separation from the general spiritual life, the having made of it a sort of special function or aristocratic club. No one is astonished when he learns from physiology that every cell is an organism and every organism a cell or synthesis of cells. No one is astonished at finding in a lofty mountain the same chemical elements that compose a small stone fragment. There is not one physiology of small animals and one of large animals; nor is there a special chemical theory of stones as distinct from mountains. In the same way, there is not a science of lesser intuition as distinct from a science of greater intuition, nor one of ordinary intuition as distinct from artistic intuition. There is but one Æsthetic, the science of intuitive or expressive knowledge, which is the æsthetic or artistic fact. And this Æsthetic is the true analogue of Logic, which includes, as facts of the same nature, the formation of the smallest and most ordinary concept and the most complicated scientific and philosophical system.

Nor can we admit that the word genius or artistic genius, as distinct from the non-genius of the ordinary man, possesses more than a quantitative signification. Great artists are said to reveal us to ourselves. But how could this be possible, unless there were identity of nature between their imagination and ours, and unless the difference were only one of quantity? It were better to change poeta nascitur into homo nascitur poeta: some men are born great poets, some small. The cult of the genius with all its attendant superstitions has arisen from this quantitative difference having been taken as a difference of quality. It has been forgotten that genius is not

something that has fallen from heaven, but humanity itself. The man of genius who poses or is represented as remote from humanity finds his punishment in becoming or appearing somewhat ridiculous. Examples of this are the genius of the romantic period and the superman of our time.

But it is well to note here, that those who claim unconsciousness as the chief quality of an artistic genius, hurl him from an eminence far above humanity to a position far below it. Intuitive or artistic genius, like every form of human activity, is always conscious; otherwise it would be blind mechanism. The only thing that can be wanting to artistic genius is the reflective consciousness, the superadded consciousness of the historian or critic, which is not essential to it.

The relation between matter and form, or between content and form, as is generally said, is one of the most disputed questions in Æsthetic. Does the æsthetic fact consist of content alone, or of form alone, or of both together? This question has taken on various meanings, which we shall mention, each in its place. But when these words are taken as signifying what we have above defined, and matter is understood as emotionality not æsthetically elaborated, or impressions, and form as intellectual activity and expression, then our view cannot be in doubt. We must, that is to say, reject both the thesis that makes the æsthetic fact to consist of the content alone (that is, the simple impressions) and the thesis which makes it to consist of a junction between form and content, that is, of impressions plus expressions. In the æsthetic fact, expressive activity is not added to the fact of the impressions, but these latter are formed and elaborated by it. The impressions reappear as it were in expression, like water put into a filter, which reappears the same and yet different on the other side. The æsthetic fact, therefore, is form, and nothing but form.

From this was inferred not that the content is something superfluous (it is, on the contrary, the necessary point of departure for the expressive fact); but that there is no passage from the qualities of the content to those of the form. It has sometimes been thought that the content, in order to be æsthetic, that is to say, transformable into form, should possess some determined or determinable qualities. But were that so, then form and content, expression and impression, would be the same thing. It is true that the content is that which is convertible into form, but it has no determinable qualities until this transformation takes place. We know nothing about it. It does not become æsthetic content before, but only after it has been actually transformed. The æsthetic content has also been defined as the interesting. That is not an untrue statement; it is merely void of

meaning. Interesting to what? To the expressive activity? Certainly the expressive activity would not have raised the content to the dignity of form, had it not been interested in it. Being interested is precisely the raising of the content to the dignity of form. But the word "interesting" has also been employed in another and an illegitimate sense, which we shall explain further on.

The proposition that art is *imitation of nature* has also several meanings. Sometimes truths have been expressed or at least shadowed forth in these words, sometimes errors have been promulgated. More frequently, no definite thought has been expressed at all. One of the scientifically legitimate meanings occurs when "imitation" is understood as representation or intuition of nature, a form of knowledge. And when the phrase is used with this intention, and in order to emphasize the spiritual character of the process, another proposition becomes legitimate also: namely, that art is the *idealization* or *idealizing* imitation of nature. But if by imitation of nature be understood that art gives mechanical reproductions, more or less perfect duplicates of natural objects, in the presence of which is renewed the same tumult of impressions as that caused by natural objects, then the proposition is evidently false. The coloured waxen effigies that imitate the life, before which we stand astonished in the museums where such things are shown, do not give æsthetic intuitions. Illusion and hallucination have nothing to do with the calm domain of artistic intuition. But on the other hand if an artist paint the interior of a wax-work museum, or if an actor give a burlesque portrait of a man-statue on the stage, we have work of the spirit and artistic intuition. Finally, if photography have in it anything artistic, it will be to the extent that it transmits the intuition of the photographer, his point of view, the pose and grouping which he has striven to attain. And if photography be not quite an art, that is precisely because the element of nature in it remains more or less unconquered and ineradicable. Do we ever, indeed, feel complete satisfaction before even the best of photographs? Would not an artist vary and touch up more or little, remove or add something to all of them?

The statements repeated so often, that art is not knowledge, that it does not tell the truth, that it does not belong to the world of theory, but to the world of feeling, and so forth, arise from the failure to realize exactly the theoretic character of simple intuition. This simple intuition is quite distinct from intellectual knowledge, as it is distinct from perception of the real; and the statements quoted above arise from the belief that only intellectual cognition is knowledge. We have seen that intuition is knowledge, free from concepts and more simple than the so-called perception of the real. Therefore art is knowledge, form; it does not belong to the world of feeling or to psychic matter. The reason why so many æstheticians have so often insisted that art is *appearance (Schein)*, is precisely that they have felt the necessity of distinguishing it from the more complex fact of perception, by maintaining its pure intuitiveness. And if for the same reason it has been claimed that art is *feeling* the reason is the same. For if the concept as content of art, and historical reality as such, be excluded from the sphere of art, there remains no other content than reality apprehended in all its ingenuousness and immediacy in the vital impulse, in its *feeling*, that is to say again, pure intuition.

The theory of the *æsthetic senses* has also arisen from the failure to establish, or from having lost to view, the character of expression as distinct from impression, of form as distinct from matter.

This theory can be reduced to the error just indicated of wishing to find a passage from the qualities of the content to those of the form. To ask, in fact, what the æsthetic senses are, implies asking what sensible impressions are able to enter into æsthetic expressions, and which must of necessity do so. To this we must at once reply, that all impressions can enter into æsthetic expressions or formations, but that none are bound to do so of necessity. Dante raised to the dignity of form not only the "sweet colour of the oriental sapphire" (visual impressions), but also tactual or thermic impressions, such as the "dense air" and the "fresh rivulets" which "parch the more" the throat of the thirsty. The belief that a picture yields only visual impressions is a curious illusion. The bloom on a cheek, the warmth of a youthful body, the sweetness and freshness of a fruit, the edge of a sharp knife, are not these, too, impressions obtainable from a picture? Are they visual? What would a picture mean to an imaginary man, lacking all or many of his senses, who should in an instant acquire the organ of sight alone? The picture we are looking at and believe we see only with our eyes would seem to his eyes to be little more than an artist's paint-smeared palette.

Some who hold firmly to the æsthetic character of certain groups of impressions (for example, the visual and auditive), and exclude others, are nevertheless ready to admit that if visual and auditive impressions enter *directly* into the æsthetic fact, those of the other senses also enter into it, but only as *associated*. But this distinction is altogether arbitrary. Æsthetic expression is synthesis, in which it is impossible to distinguish direct and indirect. All impressions are placed by it on a level, in so far as they are æstheticized. A man who absorbs the subject of a picture or poem does not have it before him as a series of impressions, some of which have pre-

rogatives and precedence over the others. He knows nothing as to what has happened prior to having absorbed it, just as, on the other hand, distinctions made after reflexion have nothing whatever to do with art as such.

The theory of the æsthetic senses has also been presented in another way; as an attempt to establish what physiological organs are necessary for the æsthetic fact. The physiological organ or apparatus is nothing but a group of cells, constituted and disposed in a particular manner; that is to say, it is a merely physical and natural fact or concept. But expression does not know physiological facts. Expression has its point of departure in the impressions, and the physiological path by which these have found their way to the mind is to it altogether indifferent. One way or another comes to the same thing: it suffices that they should be impressions.

It is true that the want of given organs, that is, of certain groups of cells, prevents the formation of certain impressions (when these are not otherwise obtained through a kind of organic compensation). The man born blind cannot intuit and express light. But the impressions are not conditioned solely by the organ, but also by the stimuli which operate upon the organ. One who has never had the impression of the sea will never be able to express it, in the same way as one who has never had the impression of the life of high society or of the political arena will never express either. This, however, does not prove the dependence of the expressive function on the stimulus or on the organ. It merely repeats what we know already: expression presupposes impression, and particular expressions particular impressions. For the rest, every impression excludes other impressions during the moment in which it dominates; and so does every expression.

Another corollary of the conception of expression as activity is the *indivisibility* of the work of art. Every expression is a single expression. Activity is a fusion of the impressions in an organic whole. A desire to express this has always prompted the affirmation that the work of art should have *unity*, or, what amounts to the same thing, *unity in variety*. Expression is a synthesis of the various, or multiple, in the one.

The fact that we divide a work of art into parts, a poem into scenes, episodes, similes, sentences, or a picture into single figures and objects, background, foreground, etc., may seem opposed to this affirmation. But such division annihilates the work, as dividing the organism into heart, brain, nerves, muscles and so on, turns the living being into a corpse. It is true that there exist organisms in which division gives rise to other living beings, but in such a case we must conclude, maintaining the analogy between the organism and the work of art, that in

the latter case too there are numerous germs of life each ready to grow, in a moment, into a single complete expression.

It may be said that expression sometimes arises from other expressions. There are simple and there are *compound* expressions. One must surely admit some difference between the *eureka,* with which Archimedes expressed all his joy at his discovery, and the expressive act (indeed all the five acts) of a regular tragedy.—Not in the least: expression always arises directly from impressions. He who conceives a tragedy puts into a crucible a great quantity, so to say, of impressions: expressions themselves, conceived on other occasions, are fused together with the new in a single mass, in the same way as we can cast into a melting furnace formless pieces of bronze and choicest statuettes. Those choicest statuettes must be melted just like the pieces of bronze, before there can be a new statue. The old expressions must descend again to the level of impressions, in order to be synthesized in a new single expression.

By elaborating his impressions, man *frees* himself from them. By objectifying them, he removes them from him and makes himself their superior. The liberating and purifying function of art is another aspect and another formula of its character as activity. Activity is the deliverer, just because it drives away passivity.

This also explains why it is usual to attribute to artists both the maximum of sensibility or *passion,* and the maximum of insensibility or Olympian *serenity.* The two characters are compatible, for they do not refer to the same object. The sensibility or passion relates to the rich material which the artist absorbs into his psychic organism; the insensibility or serenity to the form with which he subdues and dominates the tumult of the sensations and passions.

The Activity of Externalization. Technique and the Theory of the Arts

The fact of the production of physical beauty implies, as has already been remarked, a vigilant will, which persists in not allowing certain visions, intuitions or representations to be lost. Such a will must be able to act with the utmost rapidity and as it were instinctively, and may also need long and laborious deliberations. In any case, thus and thus only does the practical activity enter into relations with the æsthetic, that is to say, no longer as its simple accompaniment, but as a really distinct moment of it. We cannot will or not will our æsthetic vision: we can however will or not will to externalize it, or rather, to preserve and communicate to others, or not, the externalization produced.

This volitional fact of externalization is preceded by a complex of various kinds of knowledge. These are known as *technique,* like all knowledge which precedes a practical activity. Thus we talk of an *artistic technique* in the same metaphorical and elliptic manner that we talk of the physically beautiful, that is to say (in more precise language), *knowledge at the service of the practical activity directed to producing stimuli to aesthetic reproduction.* In place of employing so lengthy a phrase, we shall here avail ourselves of ordinary terminology, whose meaning we now understand.

The possibility of this technical knowledge, at the service of artistic reproduction, is what has led minds astray to imagine the existence of an æsthetic technique of internal expression, which is tantamount to saying, a doctrine of the *means of internal expression,* a thing that is altogether inconceivable. And we know well the reason of its inconceivability; expression, considered in itself, is a primary theoretic activity, and as such precedes practice and intellectual knowledge which illumines practice and is independent alike of both. It aids for its part to illumine practice, but is not illuminated by it. Expression does not possess *means,* because it has not an *end;* it has intuitions of things, but it does not will and is therefore unanalysable into the abstract components of volition, means and end. Sometimes a certain writer is said to have invented a new technique of fiction or of drama, or a painter is said to have discovered a new technique of distributing light. The word is used here at hazard; because the so-called *new technique* is really *that romance itself, or that new picture* itself and nothing else. The distribution of light belongs to the vision of the picture itself; as the technique of a dramatist is his dramatic conception itself. On other occasions, the word "technique" is used to designate certain merits or defects in a work that is a failure; and it is euphemistically said that the conception is bad but the technique good, or that the conception is good but the technique bad.

On the other hand, when we talk of the different ways of painting in oils, or of etching, or of sculpturing in alabaster, then the word "technique" is in its place; but in such a case the adjective "artistic" is used metaphorically. And if a dramatic technique in the æsthetic sense be impossible, a theatrical technique of processes of externalization of certain particular æsthetic works is not impossible. When, for instance, women were introduced on the stage in Italy in the second half of the sixteenth century, in place of men dressed as women, this was a true and real discovery in theatrical technique; such too was the perfecting in the following century of machines for the rapid changing of scenery by the impresarios of Venice.

The collection of technical knowledge at the service of artists desirous of externalizing their expressions, can be divided into groups, which may be entitled *theories of the arts.* Thus arises a theory of Architecture, comprising mechanical laws, information relating to the weight or resistance of the materials of construction or of fortification, manuals relating to the method of mixing lime or stucco; a theory of Sculpture, containing advice as to the instruments to be used for sculpturing the various sorts of stone, for obtaining a successful mixture of bronze, for working with the chisel, for the accurate casting of the clay or plaster model, for keeping clay damp; a theory of Painting, on the various techniques of tempera, of oil-painting, of water-colour, of pastel, on the proportions of the human body, on the laws of perspective; a theory of Oratory, with precepts as to the method of producing, of exercising and of strengthening the voice, of attitude in impersonation and gesture; a theory of Music, on the combinations and fusions of tones and sounds; and so on. Such collections of precepts abound in all literatures. And since it is impossible to say what is useful and what useless to know, books of this sort become very often a sort of encyclopædias or *catalogues of desiderata.* Vitruvius, in his treatise on Architecture, claims for the architect a knowledge of letters, of drawing, of geometry, of arithmetic, of optic, of history, of natural and moral philosophy, of jurisprudence, of medicine, of astrology, of music, and so on. Everything is worth knowing: learn the art and have done with it.

It should be evident that such empirical collections are not reducible to science. They are composed of notions, taken from various sciences and disciplines, and their philosophical and scientific principles are to be found in the latter. To propose to construct a scientific theory of the different arts would be to wish to reduce to the single and homogeneous what is by nature multiple and heterogeneous; to wish to destroy the existence as a collection of what was put together precisely to form a collection. Were we to try to give scientific form to the manuals of the architect, the painter, or the musician, it is clear that nothing would remain in our hands but the general principles of Mechanics, Optics, or Acoustics. And if we were to extract and isolate what may be scattered among them of properly artistic observations, to make of them a scientific system, then the sphere of the individual art would be abandoned and that of Æsthetic entered, for Æsthetic is always general Æsthetic, or rather it cannot be divided into general and special. This last case (that is, the attempt to furnish a technique which ends in composing an Æsthetic) arises when men possessing strong scientific instincts and a natural tendency to philosophy set themselves to work to produce such theories and technical manuals. But the confusion between Physics and Æsthetic

has attained to its highest degree, when æsthetic theories of particular arts are imagined, to answer such questions as: What are the *limits* of each art? What can be represented with colours, and what with sounds? What with simple monochromatic lines and what with touches of various colours? What with tones, and what with metres and rhythms? What are the limits between the figurative and the auditive arts, between painting and sculpture, poetry and music?

This, translated into scientific language, is tantamount to asking: What is the connexion between Acoustics and æsthetic expression? What between the latter and Optics?—and the like. Now, if *there is no passage* from the physical fact to the æsthetic, how could there be from the æsthetic to particular groups of physical facts, such as the phenomena of Optics or of Acoustics?

The so-called *arts* have no æsthetic limits, because, in order to have them, they would need to have also æsthetic existence in their particularity; and we have demonstrated the altogether empirical genesis of those partitions. Consequently, any attempt at an æsthetic classification of the arts is absurd. If they be without limits, they are not exactly determinable, and consequently cannot be philosophically classified. All the books dealing with classifications and systems of the arts could be burned without any loss whatever. (We say this with the utmost respect to the writers who have expended their labours upon them.)

The impossibility of such systematizations finds something like a proof in the strange attempts made to carry it out. The first and most common partition is that into arts of *hearing, sight,* and *imagination;* as if eyes, ears, and imagination were on the same level and could be deduced from the same logical variable as *fundamentum divisionis.* Others have proposed the division into arts of *space* and arts of *time,* arts of *rest* and *movement;* as if the concepts of space, time, rest and motion could determine special æsthetic forms and possess anything in common with art as such. Finally, others have amused themselves by dividing them into *classic* and *romantic,* or into *oriental, classic,* and *romantic,* thereby conferring the value of scientific concepts upon simple historical denominations, or falling into those rhetorical partitions of expressive forms, already criticized above; or into arts *that can only be seen from one side,* like painting, and arts *that can be seen from all sides,* like sculpture—and similar extravagances, which hold good neither in heaven nor on earth.

The theory of the limits of the arts was perhaps at the time when it was put forward a beneficial critical reaction against those who believed in the possibility of remodelling one expression into another, as the *Iliad* or *Paradise Lost* into a series of paintings, and indeed held a poem to be of greater or lesser value according as it could or could not be translated into pictures by a painter. But if the rebellion were reasonable and resulted in victory, this does not mean that the arguments employed and the systems constructed for the purpose were sound.

Another theory which is a corollary to that of the arts and their limits, falls with them; that of the *union of the arts.* Given particular arts, distinct and limited, it was asked: Which is the most *powerful?* Do we not obtain *more powerful* effects by *uniting* several? We know nothing of this: we know only that in each particular case certain given artistic intuitions have need of definite physical means for their reproduction and other artistic intuitions of other means. We can obtain the effect of certain plays by simply reading them; others need declamation and scenic display: there are some artistic intuitions which need for their full externalization words, song, musical instruments, colours, statuary, architecture, actors; while others are quite complete in a slight outline made with the pen, or a few strokes of the pencil. But it is false to suppose that declamation and scenic effects and all the other things together that we have mentioned are *more powerful* than a simple reading or a simple outline of pen or pencil; because each of those facts or groups of facts has, so to say, a different purpose, and the power of the means cannot be compared when the purposes are different.

Finally, it is only from the point of view of a clear and rigorous distinction between the true and proper æsthetic activity and the practical activity of externalization that we can solve the complicated and confused questions as to the relations between *art and utility* and *art and morality.*

We have demonstrated above that art as art is independent both of utility and of morality, as also of all practical value. Without this independence, it would not be possible to speak of an intrinsic value of art, nor indeed to conceive an æsthetic science, which demands the autonomy of the æsthetic fact as its necessary condition.

But it would be erroneous to maintain that this independence of the vision or intuition or *internal expression* of the artist should be simply extended to the practical activity of externalization and communication which may or may not follow the æsthetic fact. If by art be understood the externalization of art, then utility and morality have a perfect right to enter into it; that is to say, the right to be master in one's own house.

Indeed we do not externalize and fix all the many expressions and intuitions which we form in our spirit; we do not declare our every thought in a loud voice, or write it down, or print, or draw, or paint, or expose it to the public. We *select* from the crowd

of intuitions which are formed or at least sketched within us; and the selection is ruled by the criteria of the economic disposition of life and of its moral direction. Therefore, when we have fixed an intuition, we have still to decide whether or no we should communicate it to others, and to whom, and when, and how; all which deliberations come equally under the utilitarian and ethical criterion.

Thus we find the concepts of *selection,* of the *interesting,* of *morality,* of an *educational end,* of *popularity,* etc., to some extent justified, although these can in no way be justified when imposed upon art as art, and we have ourselves rejected them in pure Æsthetic. Error always contains an element of truth. He who formulated those erroneous æsthetic propositions in reality had his eye on practical facts, which attach themselves externally to the æsthetic fact and belong to economic and moral life.

It is well to advocate yet greater freedom in making known the means of æsthetic reproduction; we are of the same opinion, and leave projects for legislation and for legal action against immoral art, to hypocrites, to the ingenuous and to wasters of time. But the proclamation of this freedom, and the fixing of its limits, how wide soever they be, is always the task of morality. And it would in any case be out of place to invoke that highest principle, that *fundamentum æsthetices,* which is the independence of art, to deduce from it the guiltlessness of the artist who calculates like an immoral speculator upon the unhealthy tastes of his readers in the externalization of his imaginings, or the freedom of hawkers to sell obscene statuettes in the public squares. This last case is the affair of the police, as the first must be brought before the tribunal of the moral consciousness. The æsthetic judgement on the work of art has nothing to do with the morality of the artist as a practical man, or with the provisions to be taken that the things of art may not be diverted to evil ends alien to her nature, which is pure theoretic contemplation.

5

On the Limits of Painting and Poetry

GOTTHOLD EPHRAIM LESSING

I shall attempt now to derive the matter from its first principles.

I reason thus: if it is true that in its imitations painting uses completely different means or signs than does poetry, namely figures and colors in space rather than articulated sounds in time, and if these signs must indisputably bear a suitable relation to the thing signified, then signs existing in space can express only objects whose wholes or parts coexist, while signs that follow one another can express only objects whose wholes or parts are consecutive.

Objects or parts of objects which exist in space are called bodies. Accordingly, bodies with their visible properties are the true subjects of painting.

Objects or parts of objects which follow one another are called actions. Accordingly, actions are the true subjects of poetry.

However, bodies do not exist in space only, but also in time. They persist in time, and in each moment of their duration they may assume a different appearance or stand in a different combination. Each of these momentary appearances and combinations is the result of a preceding one and can be the cause of a subsequent one, which means that it can be, as it were, the center of an action. Consequently, painting too can imitate actions, but only by suggestion through bodies.

On the other hand, actions cannot exist independently, but must be joined to certain beings or things. Insofar as these beings or things are bodies,

or are treated as such, poetry also depicts bodies, but only by suggestion through actions.

Painting can use only a single moment of an action in its coexisting compositions and must therefore choose the one which is most suggestive and from which the preceding and succeeding actions are most easily comprehensible.

Similarly, poetry in its progressive imitations can use only one single property of a body. It must therefore choose that one which awakens the most vivid image of the body, looked at from the point of view under which poetry can best use it. From this comes the rule concerning the harmony of descriptive adjectives and economy in description of physical objects.

I should put little faith in this dry chain of reasoning did I not find it completely confirmed by the procedure of Homer, or rather if it had not been just this procedure that led me to my conclusions. Only on these principles can the grand style of the Greek be defined and explained, and only thus can the proper position be assigned to the opposite style of so many modern poets, who attempt to rival the painter at a point where they must necessarily be surpassed by him.

I find that Homer represents nothing but progressive actions. He depicts bodies and single objects only when they contribute toward these actions, and then only by a single trait. No wonder, then, that where Homer paints, the artist finds little or

From Gotthold Ephraim Lessing, *Laocoön*, trans. E. A. McCormick., Indianapolis: Bobbs-Merrill Company, 1962, pp. 78–79, 85–86, 91–93, 104, 111–12, 121–22, 126–28, 137.

nothing to do himself; and no wonder that his harvest can be found only where the story assembles a number of beautiful bodies in beautiful positions and in a setting favorable to art, however sparingly the poet himself may paint these bodies, these positions, and this setting. . . .

But the objection will be raised that the symbols of poetry are not only successive but are also arbitrary; and, as arbitrary symbols, they are of course able to represent bodies as they exist in space. Examples of this might be taken from Homer himself. We need only to recall his shield of Achilles to have the most decisive instance of how discursively and yet at the same time poetically a single object may be described by presenting its coexistent parts.

I shall reply to this twofold objection. I call it twofold because a correct deduction must hold good even without examples; and, conversely, an example from Homer is of importance to me even when I am unable to justify it by means of deduction.

It is true that since the symbols of speech are arbitrary, the parts of a body may, through speech, be made to follow one another just as readily as they exist side by side in nature. But this is a peculiarity of speech and its signs in general and not as they serve the aims of poetry. The poet does not want merely to be intelligible, nor is he content—as is the prose writer—with simply presenting his image clearly and concisely. He wants rather to make the ideas he awakens in us so vivid that at that moment we believe that we feel the real impressions which the objects of these ideas would produce on us. In this moment of illusion we should cease to be conscious of the means which the poet uses for this purpose, that is, his words. This was the substance of the definition of a poetical painting given above. But the poet is always supposed to paint, and we shall now see how far bodies with their coexistent parts adapt themselves to this painting.

How do we arrive at a clear conception of an object in space? We first look at its parts singly, then the combination of parts, and finally the totality. Our senses perform these various operations with such astonishing rapidity that they seem to us to be but one single operation, and this rapidity is absolutely necessary if we are to receive an impression of the whole, which is nothing more than the result of the conceptions of the parts and of their combination. Now let us assume that the poet takes us from one part of the object to the other in the best possible order; let us assume that he knows how to make the combination of these parts ever so clear to us; how much time would he use in doing this? That which the eye takes in at a single glance he counts out to us with perceptible slowness, and it often happens that when we arrive at the end of his description we have already forgotten the first features. And yet we are supposed to form a notion of the whole from these features. To the eye, parts once seen remain continually present; it can run over them again and again. For the ear, however, the parts once heard are lost unless they remain in the memory. And even if they do remain there, what trouble and effort it costs to renew all their impressions in the same order and with the same vividness; to review them in the mind all at once with only moderate rapidity, to arrive at an approximate idea of the whole! . . .

And yet should Homer himself have lapsed into this lifeless description of material objects? I do hope that there are but few passages which one can find to support this; and I feel certain that these few passages are of such a nature as to confirm the rule to which they seem to be the exception.

It remains true that succession of time is the province of the poet just as space is that of the painter.

It is an intrusion of the painter into the domain of the poet, which good taste can never sanction, when the painter combines in one and the same picture two points necessarily separate in time, as does Fra Mazzuoli when he introduces the rape of the Sabine women[1] and the reconciliation effected by them between their husbands and relations, or as Titian does when he presents the entire history of the prodigal son, his dissolute life, his misery, and his repentance.

It is an intrusion of the poet into the domain of the painter and a squandering of much imagination to no purpose when, in order to give the reader an idea of the whole, the poet enumerates one by one several parts or things which I must necessarily survey at one glance in nature if they are to give the effect of a whole.

But as two equitable and friendly neighbors do not permit the one to take unbecoming liberties in the heart of the other's domain, yet on their extreme frontiers practice a mutual forbearance by which both sides make peaceful compensation for those slight aggressions which, in haste and from force of circumstance, the one finds himself compelled to make on the other's privilege: so also with painting and poetry.

To support this I will not cite the fact that in great historical paintings the single moment is always somewhat extended, and that perhaps there is not a single work comprising a wealth of figures in which each one of them is in exactly that motion and position it should be in at the moment of the main action; some are represented in the attitude of a somewhat earlier, others in that of a somewhat later moment. This is a liberty which the master must justify by certain refinements in the arrangement—in the way he uses his figures and places them closer to or more distant from the main

action—which permits them to take a more or less momentary part in what is going on. I shall merely make use of a remark made by Mengs concerning Raphael's drapery. "In his paintings," he says, "there is a reason for every fold, whether it be because of its own weight or because of the movement of the limbs. Sometimes we can tell from them how they were before, and Raphael even tried to attach significance to this. We can see from the folds whether an arm or a leg was in a backward or forward position prior to its movement; whether the limb had moved or is moving from contraction to extension, or whether it had been extended and is now contracted."[2] It is indisputable that in this case the artist is combining two different moments into one. For since that part of the drapery which lies on the foot immediately follows it in its forward motion—unless the drapery be of very stiff material and hence entirely unsuitable for painting—there is no moment in which the garment can form any other fold whatsoever except that which the actual position of the limb requires. However, if it is permitted to form a different fold, then the drapery is represented at the moment preceding and the limb at the following. Nevertheless, who would be so particular with the artist who finds it advantageous to show us these two moments at the same time? Who would not praise him rather for having had the understanding and the courage to commit such a minor error for the sake of obtaining greater perfection of expression? . . .

But I shall not allow the particular justification of either poet or painter to be based on the above-mentioned analogy of the two friendly neighbors. A mere analogy neither proves nor justifies anything. The following consideration must be their real justification: just as in the painter's art two different moments border so closely on one another that we can, without hesitation, accept them as one, so in the poet's work do the several features representing the various parts and properties in space follow one another in such rapid succession that we believe we hear them all at once. . . .

What I have said about material objects generally is doubly true of beautiful material objects. The beauty of an object arises from the harmonious effect of its various parts, which the eye is able to take in at one glance. It demands, therefore, that these parts lie in juxtaposition; and since things whose parts are in juxtaposition are the proper subject of painting, it follows that painting and painting alone can imitate material beauty.

Because the poet is able to show the elements of beauty in succession only, he abstains entirely from the depiction of physical beauty as such. He feels that these elements, when placed in succession, are unable to achieve the effect that they produce in close union; that the concentrating glance which we try to cast back on the parts after they have been enumerated fails to produce the effect of a harmonious image; that it lies beyond the power of human imagination to picture to oneself what the composite effect of this mouth, this nose, and these eyes will be unless we can recall a similar composition of such parts from nature or art.

In this respect, also, Homer is the best model of all. He says that Nireus was beautiful,[3] Achilles still more beautiful, and that Helen possessed a godlike beauty. But nowhere does he enter into a detailed description of these beauties. And yet the entire poem is based on the beauty of Helen. How a modern poet would have reveled in a description of it!. . . .

We might ask whether poetry does not lose too much when we take from her all depictions of physical beauty? But who would do this? If we dissuade her from taking one particular way to attain such pictures, and from following confusedly the footsteps of a sister art without ever reaching the same goal, do we thereby exclude her from every other path where art in turn must see poetry take the lead?

The same Homer, who so assiduously refrains from detailed descriptions of physical beauties, and from whom we scarcely learn in passing that Helen had white arms[4] and beautiful hair,[5] nevertheless knows how to convey to us an idea of her beauty which far surpasses anything art is able to accomplish toward that end. Let us recall the passage where Helen steps before an assembly of Trojan elders. The venerable old men see her, and one says to the other:

Οὐ νέμεσις Τρῶας και ἐϋκνήμιδας ʼΑχαιοὺς
τοιῇδ᾽ ἀμφὶ γυναικὶ πολὺν χρόνον ἄλγεα
πάσχειν·
αἰνῶς ἀθανάτῃσι θεῇς εἰς ὧπα ἔοικεν.[6]

What can convey a more vivid idea of beauty than to let cold old age acknowledge that she is indeed worth the war which had cost so much blood and so many tears?

What Homer could not describe in all its various parts he makes us recognize by its effect. Paint for us, you poets, the pleasure, the affection, the love and delight which beauty brings, and you have painted beauty itself. . . .

Another way in which poetry can draw even with art in the description of physical beauty is by changing beauty into charm. Charm is beauty in motion and for that reason less suitable to the painter than to the poet. The painter can only suggest motion, because in reality his figures are motionless. As a result, charm with him becomes a grimace. But in poetry it remains what it is, a tran-

sitory beauty that we desire to see again and again. It comes and goes; and since we can generally recall a movement more readily and more vividly than mere forms or colors, charm will in the same proportion be more impressive than beauty. . . .

The harmonious interaction of many parts which produces beauty can be destroyed by a single unfitting part, without, however, making the object ugly. Ugliness demands also a number of unsuitable parts, which we must be able to take in at one glance if we are to feel the opposite effect of that which beauty produces.

According to this, then, ugliness by its very nature could not be a subject of poetry; and yet Homer has depicted Thersites as being extremely ugly, and this ugliness is described according to its contiguous parts. Why was he able to do with ugliness what he so wisely abstained from attempting to do with beauty? Is not the effect of ugliness destroyed by the successive enumeration of its elements just as much as the effect of beauty is destroyed through a similar enumeration?

Of course it is; but in this very fact lies Homer's justification. The poet's use of ugliness becomes possible for the very reason that in his description it is reduced to a less offensive manifestation of physical imperfection and ceases, as it were, to be ugly in its effect. Hence, what the poet cannot use by itself, he uses as an ingredient to produce and heighten certain mixed feelings with which he must entertain us in the absence of purely agreeable ones.

These mixed feelings are those of the ridiculous and the terrible.

Homer makes Thersites ugly in order to make him ridiculous; but it is not merely through his ugliness that he becomes so, for ugliness is an imperfection, and to create the ridiculous we need a contrast of perfections and imperfections.[7] This is the explanation given by my friend, to which I should like to add that such contrasts should not be too glaring or sharp, and that, to continue in the language of the artist, they should be of a kind that can be blended into one another. . . .

Such is the manner in which the poet makes use of physical ugliness. What use can the painter make of it?

Painting, as an imitative skill, can express ugliness; painting as a fine art refuses to do so. As a skill, it may take all visible objects as its subjects; as an art, it restricts itself only to those visible objects which awaken our pleasure.

But do not even unpleasant feelings become pleasing in imitation? No, not all. A perceptive critic[8] has already noted this fact about disgust. "Representations of fear," he says, "of melancholy, terror, compassion, etc., can arouse our dislike only insofar as we believe the evil to be real. Hence, these feelings can be transformed into pleasant ones by

recalling that it is an artificial illusion. But whether or not we believe the object to be real, the disagreeable sensation of disgust results, by virtue of the law of our imagination, from the mere mental image. Is the fact that the artistic imitation is ever so recognizable sufficient to reconcile the offended sensibilities? Our dislike did not arise from the supposition that the evil was real, but from the mere mental image of it, which is indeed real. Feelings of disgust are therefore always real and never imitations."[9]

This also applies to the ugliness of forms. Ugliness offends our eyes, contradicts the taste we have for order and harmony, and awakens aversion irrespective of the actual existence of the object in which we perceive it. We do not care to see Thersites either in reality or in a picture; and if the picture is less displeasing, it is not because his physical ugliness ceases being ugly in imitation, but because we are able to disregard this ugliness and derive all our pleasure from the painter's art. But even this pleasure is constantly interrupted by the thought that art has been put to such a bad use, and this consideration will seldom fail to bring about a feeling of contempt for the artist.

Aristotle has found another reason why things which we see with displeasure in nature afford us pleasure when they are most faithfully represented.[10] He calls it the general thirst for knowledge in men. We are pleased when we can learn from the imitation, τί ἕκαστον, what a thing is, or when we can deduce from it, ὅτι οὗτος ἐκεῖνος, that it is this or that thing. But we are unable to infer anything from this in favor of the representation of ugliness. The pleasure which arises from the stilling of our thirst for knowledge is a momentary one, and merely incidental to the object through which it is satisfied. Displeasure, on the other hand, which accompanies our contemplation of ugliness, is permanent, and inherent in the object that awakens it. How is it possible, then, for the former to counterbalance this latter? Still less can the slightly pleasing interest that we feel on noticing the similarity overcome the unpleasant effect of ugliness. The more closely I compare the ugly imitation with its ugly original, the more I expose myself to this effect, so that the pleasure of comparing soon vanishes, leaving behind nothing but the disagreeable impression of a twofold ugliness. To judge from the examples which Aristotle gives, it would seem that he had no intention if including bodily ugliness in those displeasing objects which can afford pleasure in imitation. These examples are ferocious beasts and corpses. Ferocious beasts incite terror, even though they may not be ugly, and it is this terror rather than their ugliness which is transformed into a feeling of pleasure in their imitations. So it is, too, with corpses: it is the keener feeling of pity, the terrifying thought of our own destruction, that makes a real

corpse repulsive to us; but in imitation this pity loses its keenness through our awareness that it is a deceit, and the addition of soothing circumstances can either divert our thoughts from this fatal recollection or, by uniting itself inseparably with it, cause us to believe that we can see in it something more desirable than terrible.

Physical ugliness cannot in itself be a subject for painting as a fine art, because the feeling that it arouses is not only displeasing, but does not even belong to that class of unpleasant sensations which in imitation are turned into pleasant ones. Now it remains to be seen whether it cannot be useful to painting as an ingredient for strengthening other sensations, just as it is useful to poetry.

May painting make use of ugly forms to attain the ridiculous and the terrible?

I will not venture to answer with an unequivocal "no." It is undeniable that harmless ugliness can become ridiculous in painting too; particularly when an affectation of charm and dignity is combined with it. It is just as incontestable that harmful ugliness excites horror in a painting just as in nature, and that the ridiculous and the terrible, which are in themselves mixed sensations, attain in imitation a new degree of attractiveness and pleasure.

I must point out, however, that in spite of this, painting and poetry are not in exactly the same position. In poetry, as I have already noted, ugliness of form loses its repulsive effect almost entirely by the change from coexistence to the consecutive. From this point of view it ceases to be ugliness, as it were, and can therefore combine even more intimately with other qualities to produce a new and special effect. In painting, on the other hand, ugliness exerts all its force at one time and hence has an effect almost as strong as in nature itself. Harmless ugliness consequently cannot remain ridiculous for long; the unpleasant sensation gains the upper hand, and what was at first comical becomes in course of time merely disgusting. It is the same with harmful ugliness; the element of terror is gradually lost and the deformity is left behind alone and unchanged. . . .

I come now to disgusting objects in painting. Even if it were an indisputable fact that there is, properly speaking, no such thing as an object disgusting to the sight—which painting as a fine art would naturally renounce—disgusting objects would still have to be avoided because the association of ideas renders them disgusting to the sight also. In a painting of the burial of Christ, Pordenone pictures one of the bystanders holding his nose. Richardson objects to this on the ground that Christ has not been dead long enough for his body to have begun to putrefy.[11] But in the case of the resurrection of Lazarus he believes that the painter might be allowed to depict some of the bystanders in such an attitude, because the story expressly states that his body had already begun to smell. To my mind this representation would be unthinkable here, too, for not only does actual stench, but even the very idea of it, awaken a feeling of disgust. We avoid places that stink, even when we have a cold. But painting, it may be objected, does not want the disgusting for its own sake; just as is true of poetry, it needs it to intensify the ridiculous and the terrible. At its own peril! But what I have said about the ugly in this respect applies all the more to the disgusting. It loses incomparably less of its effect in an imitation which is meant for the eye than in one which is meant for the ear. Consequently, it will blend less closely with elements of the ridiculous and the terrible in the former than in the latter instance, for as soon as our surprise is over and our first eager look satisfied, the disgusting becomes a separate thing again and appears before us in its own crude form.

Notes

1. Described in the *Aeneid* VIII. 635ff.

2. *Gedanken über die Schönheit und über den Geschmack in der Malerei*, p. 69.

3. In the *Iliad* II. 673, Homer describes Nireus as "the most beautiful man that came up before Troy."

4. Iliad III. 121.

5. Ibid., III. 329.

6. "Surely there is no blame on Trojans and strong-greaved Achaians
if for long time they suffer hardship for a woman like this one.
Terrible is the likeness of her face to immortal goddesses."
(*Iliad* III. 156–58, tr. Lattimore)

7. *Philosophische Schriften des Herrn Moses Mendelsohn*, II, 23.

8. Moses Mendelsson.

9. *Briefe, die neueste Litteratur betreffend*, V, 102.

10. *De Poetica*, chap. 4.

11. Richardson, *De la Peinture*, I, 74.

Painting and the Pictorial Arts
Form and the Representation of the
Visible World

Ask someone to name a work of art off the top of his or her head and there is a good chance the response will be the name of a painting (most likely the *Mona Lisa*, *The Last Supper*, or perhaps *The Last Judgment*). The earliest known examples of visual art belong to the category of painting and in the minds of many, painting is the paradigmatic visual art, if not the paradigm of art itself. Painting is therefore an appropriate place to begin an inquiry into the nature of the particular visual arts. If you ask further what is remarkable about, say, the *Mona Lisa*, there is a good chance that your respondent will say something about the way in which the artist has rendered the subject matter of the painting, perhaps commenting on how Leonardo has managed to capture that enigmatic smile. This is all to say that the art of painting is often and quite naturally appreciated in terms of its capacity to represent the visible world. In this chapter, we look into the matter of representation in painting and other two-dimensional pictorial arts of the hand, such as drawing, print-making, and tapestry.[1]

But what exactly is involved in the pictorial representation of the visible world? And why, if at all, should we consider the pictorial imitation of the world to be of value? These questions are as old as philosophical reflection about the arts, but they continue to exercise contemporary philosophers of art. The basic terms of the inquiry into the nature of pictorial representation were set by Plato, particularly in his philosophical dialogue, *Republic*. When Plato says that the painter, in effect, holds a mirror up to reality, he provides a commanding metaphor for the idea of pictorial representation. Representational paintings, like mirrors, do seem to copy reality. Like mirrors, paintings have an uncanny capacity to capture the likeness of whatever they reflect, and it does seem that we frequently admire and take pleasure in paintings precisely to the extent that they resemble what they represent. On the other hand, we also know that what we see in the mirror is not the

1. Pictorial arts which involve the mediation of a camera or similar device are discussed in Part IV.

real thing. It is *only* an image. It is at this point that Plato's assessment of the value of representational painting differs sharply from the common view. Given his metaphysical views about the nature of reality, Plato is deeply troubled by the fact that paintings are capable of providing what he regards as compelling deceptions, leading their viewers away from the intelligible world of Forms toward the sensible world of appearance. As representations of the world of appearance, paintings are, in Plato's classic formulation, at the third remove from the essential nature of things. Plato is also suspicious of the painters themselves, accusing them of plying their crafts in the absence of true understanding, appealing rather to mere sensation. Painting, therefore, is worse than useless, it is positively corruptive.

Whether the painter's representation of the visible world is simply a matter of copying what he or she sees, however, is a hotly debated psychological and philosophical problem, as is the question of whether there are particular modes of representation (such as single-point perspective) which more closely correspond to the way the visual system works and which are waiting to be discovered, so to speak, by visual artists. E. H. Gombrich takes on these questions in "Truth and the Stereotype: An Illusion Theory of Representation," taken from his famous study, *Art and Illusion: A Study in the Psychology of Pictorial Representation*. Gombrich attacks the copy theory of artistic representation by posing an intriguing question the copy theory seems to leave unanswered: "Why is it that different ages and different nations have represented the visible world in such different ways?" This is what Gombrich calls the "riddle of style." According to Gombrich the copy theory, in tying the notion of representation to the idea of faithful resemblance, either ignores the question of style or treats style as if it were the result of a special activity somehow distinguishable from representation itself. In either case, the copy theory cannot account for the fact that the history of representative art is in large part a history of its styles.

One of the main difficulties with the copy theory, Gombrich argues, is that it rests on what he calls the "myth of the innocent eye," the idea that seeing is a matter of passively registering raw visual data. According to one widely held version of the copy theory, the painter produces a convincing representation by transcribing, so to speak, the image reflected on his or her retina. But the problem of illusion in art is not adequately handled with so static a model, Gombrich argues. Vision is an active process of scanning for motifs which will fit into a familiar schema. Seeing is heavily conditioned by habits and expectations. The representational artist "begins not with his visual impression but with his idea or concept," proceeding through "the rhythms of schema and correction." The artist, Gombrich tells us, will "tend to see what he paints rather than to paint what he sees." Style, then, is not something superadded to the process of representation. Different artistic styles are something like different artistic languages of representation, languages we must learn to read if we are to understand them correctly. The history of styles is the history of the evolution of these languages.

The connection between representation and language is carried further in the hands of Nelson Goodman. Goodman joins Gombrich in attacking the copy theory and the view that representation depends on resemblance, pointing out that we mean quite different things by the terms *representation* and *resemblance*. Goodman goes on to argue that resemblance is neither a necessary nor a sufficient condition for representation to occur. The copy theory also founders in its adherence to the "myth of the given," the notion that something is immediately presented to consciousness, before it has been elaborated by inference or interpretation, waiting to be copied. But, Goodman, remarks, "the object before me is a man, a swarm of atoms, a complex of cells, a fiddler, a friend, a fool, and much more. If none of these constitutes the object as it is, what else might? If all are ways the object is, then none is *the* way the object is."

Goodman takes issue with Gombrich on two key points, however. First, Gombrich presses the idea of the relativity of vision and representation just so far, retaining a place of privilege for the laws of perspective as a criterion of representational fidelity. Goodman will have none of this. Goodman also takes Gombrich to task on a more fundamental point, Gombrich's view that what constitutes realism of representation is the achievement of a successful illusion. Goodman writes, "In looking at the most realistic picture, I seldom suppose that I can literally reach into the distance, slice the tomato, or beat the drum." Goodman argues that representation is best understood on the model of linguistic denotation, a view which, among other things, enables him to account for the pictorial representation of fictional persons, places, and things, a class of subjects which proves awkward for resemblance-based theories to handle. Different representational styles are understood precisely as different "languages" or symbol systems to whose conventions we have become habituated. Realistic representation, on Goodman's view, is not a matter of "any constant or absolute relationship between a picture and its object but of a relationship between the system of representation employed in the picture and the standard system."

Kendall Walton, however, in "Looking at Pictures and Looking at Things," argues that such a view does not do justice to the difference between pictorial and verbal "languages." We must be able to explain the sense we have that pictorial representations are in some sense more natural and less conventional than verbal representations, Walton argues, as well as the sense that pictures may rely on resemblance in a way that words do not. Walton's solution is to resurrect the notion of resemblance, but with a difference: "Rather than asking about resemblances between pictures and the things they picture, we should consider resemblances between *looking* at pictures and *looking* at things."

Pictures, on Walton's view, are props in visual games of make-believe in which the picture and the visual actions of the viewer generate a fictional world. Viewers actually look at the pictures before them, but they "imagine themselves to be seeing things of the kind represented," says Walton. What makes pictures better props in *visual* games of make-believe than, say, verbal

descriptions, is the fact that looking at pictures is more analogous to looking at things than (say) reading descriptions about things. In both cases of looking, the viewer uses his or her eyes, derives information about visual features in a characteristically visual order, there is a certain openendedness to the act of looking, certain things are relatively easy to discriminate, other things more difficult, and so on. Resemblance can therefore play a role in pictorial representation. Different styles, in Walton's view, are not to be construed as constituting different systems but rather as allowing or encouraging different kinds of visual games of make-believe.

Stephanie Ross directs our attention to another aspect of pictorial representation, the problem of caricature. To speak of a caricature is to bring to mind the idea of the exaggeration of a characteristic trait, but since all depictions might be said to exaggerate traits in one way or another, that suggestion does not take us very far in understanding caricature. What exactly makes a David Levine representation of, say, Queen Victoria a caricature and what makes the caricature so effective? Ross, in her article "Caricature," rejects the idea that caricature can be understood in terms of capturing "relevant information," or "essential" or "distinctive" features of a representation. Nor is understanding a caricature a matter of imaginatively transforming the caricature back into a more standard realistic portrait.

Caricature, Ross argues, involves instead a certain kind of reciprocity not unlike the reciprocity of a metaphor which provides us with a new way of (metaphorically) seeing something. In both cases, we see the image in terms of the reality to which it refers, and we see the reality in terms of the caricature. What Levine's caricature of Victoria does is "invite us to see her (more correctly, her pictures) in light of the caricature by seeing her as the caricature depicts her." But this alone would not suffice to account for caricatures, since portraits might be said to function in the same way. Indeed, caricature and portraiture are close relatives. What distinguishes a portrait from a caricature, Ross argues, is a particular practice of looking. We regard caricatures in the light of various utilitarian functions. The distortions of caricature are primarily means to the topical ends of humor, satire, psychological and political commentary, and so forth, whereas the values of portraits are equally visual and aesthetic.

But speaking of the aesthetic value of portraits brings us back to the fundamental question about pictorial representation raised by Plato in *Republic:* what is the value of pictorial representation? Clive Bell, like Plato, is critical of representational painting, though for rather different reasons. In the article "The Aesthetic Hypothesis: Significant Form and Aesthetic Emotion," Clive Bell argues for a strict separation between aesthetic and representational value in art. Bell argues that a work is a work of art if and only if it is capable of arousing the "aesthetic emotion" in suitably sensitive people. Bell describes the emotion rather eloquently: "For a moment we are shut off from human interests; our anticipations and memories are arrested; we are lifted above the

stream of life. The pure mathematician rapt in his studies knows a state of mind which I take to be similar, if not identical."

But the objective quality of works of art which evokes the aesthetic emotion cannot be tied to representation, since representational and nonrepresentational works alike are known to stir the aesthetic emotion. The essential quality of works of visual art is what Bell calls "significant form," which he describes as certain relations and combinations of lines, colors, and visual forms. In fact, Bell argues, not only is representation in painting irrelevant to its aesthetic value, the appeal to the common emotions of life through pictorial representation is frequently harmful, serving to draw audience and artist alike away from the world of "pure aesthetic ecstasy." Bell disparages what he calls mere "descriptive painting" and remarks caustically that "if in the artist an inclination to play upon the emotions of life is often the sign of a flickering inspiration, in the spectator a tendency to seek, behind form, the emotions of life is a sign of defective sensibility always."

6

A Copy Theory of Representation

PLATO

How Representation in Art Is Related to Truth

Readers who take this chapter as stating, for its own sake, an aesthetic theory of the nature of art are surprised and shocked: the point of view seems as perverse, and even stupid, as Tolstoy's in What is Art? *The main object of attack, however, is the claim, currently made by sophists and professional reciters of the Homeric poems,[1] that Homer in particular, and in a less degree the tragedians, were masters of all technical knowledge, from wagon-building or chariot-driving to strategy, and also moral and religious guides to the conduct of life.[2] As such, the poet becomes the rival of the philosopher as conceived by Plato, and the study of poetry an alternative to the severe intellectual training of the Academy. If wisdom is to be gained only through knowledge of the real world of Forms disclosed by Dialectic, the claim that the poet can educate mankind to virtue must be as hollow as the pretence that the artist knows all about shoemaking because he can paint a life-like picture of a shoemaker. How much knowledge of ultimate values does the poet need in order to paint in words his pictures of human life?*

The painter is taken first by way of illustration. A picture of a bed is a two-dimensional representation of the appearance of a solid object seen at a certain angle. The object itself is only a particular bed, which, as a part of the material world, is not a wholly real thing, since it comes into being and perishes and is perpetually changing; it belongs to the realm of
Becoming *characterized in Chapter XIX. This actual bed, however, is nearer to reality than the picture, because it is one of many embodiments of the essential nature common to all beds. Beds can be made of wood or iron or canvas and may vary indefinitely in size, shape, colour, etc. But they cannot be called beds at all unless they serve the purpose of a bed, a thing designed to be slept on. This purpose, however hard to define, may be called the essence or Form of Bed, and in Plato's view it is the unique and unvarying reality which must be, however imperfectly, embodied in any bed, and is in one sense the meaning of the word 'Bed.' (Plato speaks here of this essential Bed as 'in the nature of things,' i.e. in the real world of Forms, and as made by a god, though the Forms are elsewhere described as not made by anyone, but eternal, and there is a difficulty in supposing eternal Forms of the products of human workmanship. These points, however, need not be pressed. The bed was perhaps chosen for illustrative purposes because beds are obviously made by a practical craftsman, whom Plato wishes to contrast with the fine artist, whereas the maker of natural objects, the divine Demiurge of the* **Timaeus,** *is a mythical figure who could not be introduced without a long explanation.) The upshot is that the artist's picture of a bed is at two removes from the essential Form. It is only as it were a mirror-image of a sensible thing, which itself is only one embodiment (with many accidental features) of the real Form, the object of knowledge.*

Poetry is like a picture in words, a representation

From Plato, *The Republic of Plato*, trans. Francis M. Cornford. London: Oxford University Press, 1941, Book X, pp. 321–40. Reprinted with permission of Oxford University Press. The introductions are the comments of Professor Cornford.

of life. However skilfully executed, it is no evidence that the poet really possessed the knowledge required for the right conduct of actual life. This knowledge is not to be gained by studying his portraits of heroic characters, any more than we can learn how to drive a chariot or conduct a campaign from his descriptions of a chariot-race or of the Trojan war. Socrates' examination of the poets had convinced him that they worked, not with conscious intelligence, but from inspiration, like seers and oracle-mongers who do not understand the meaning of the fine language they use (**Apology**, 22 B).

In this chapter **mimesis** *has a wider sense than dramatic impersonation: the nearest English word is 'representation,' applicable to many forms of fine art. The usual rendering 'imitation' is misleading. We do not say that Garrick, still less that Shakespeare, imitated the character of Hamlet; or that Raphael imitated Julius II; or that the Passion music imitates religious emotion. In all these cases* **mimesis** *would be used. The substantive* **mimetes** *can be rendered in this context by 'artist.' On the other hand,* **mimesis** *does also mean 'imitation,' and this encourages the suggestion that tragic acting is on a level with mimicry and that fine art in general is no more than a copying of external appearances. The view that a work of art is an image or likeness* (**eikon**) *of some original, or holds a mirror up to nature, became prominent towards the end of the fifth century together with the realistic drama of Euripides and the illusionistic painting of Zeuxis. Plato's attack adopts this theory. The art which claims to be 'realistic' is, in his view, as far as possible from reality. See T. B. L. Webster, 'Greek Theories of Art and Literature down to 400 B.C.' Classical Quarterly, 33 (1939), 166.*

□ □ □

Indeed, I continued, our commonwealth has many features which make me think it was based on very sound principles, especially our rule not on any account to admit the poetry of dramatic representation.[3] Now that we have distinguished the several parts of the soul, it seems to me clearer than ever that such poetry must be firmly excluded.

What makes you say so?

Between ourselves—for you will not denounce me to the tragedians and the other dramatists—poetry of that sort seems to be injurious to minds which do not possess the antidote in a knowledge of its real nature.

What have you in mind?

I must speak out, in spite of a certain affection and reverence I have had from a child for Homer, who seems to have been the original master and guide of all this imposing company of tragic poets.[4]

However, no man must be honoured above the truth; so, as I say, I must speak my mind.

Do, by all means.

Listen then, or rather let me ask you a question. Can you tell me what is meant by representation in general? I have no very clear notion myself.

So you expect me to have one!

Why not? It is not always the keenest eye that is the first to see something.

True; but when you are there I should not be very desirous to tell what I saw, however plainly. You must use your own eyes.

Well then, shall we proceed as usual and begin by assuming the existence of a single essential nature or Form for every set of things which we call by the same name? Do you understand?

I do.

Then let us take any set of things you choose. For instance there are any number of beds or of tables, but only two Forms, one of Bed and one of Table.

Yes.

And we are in the habit of saying that the craftsman, when he makes the beds or tables we use or whatever it may be, has before his mind the Form[5] of one or other of these pieces of furniture. The Form itself is, of course, not the work of any craftsman. How could it be?

It could not.

Now what name would you give to a craftsman who can produce all the things made by every sort of workman?

He would need to have very remarkable powers!

Wait a moment, and you will have even better reason to say so. For, besides producing any kind of artificial thing, this same craftsman can create all plants and animals, himself included, and earth and sky and gods and the heavenly bodies and all the things under the earth in Hades.

That sounds like a miraculous feat of virtuosity.

Are you incredulous? Tell me, do you think there could be no such craftsman at all, or that there might be someone who could create all these things in one sense, though not in another?[6] Do you not see that you could do it yourself, in a way?

In what way, I should like to know.

There is no difficulty; in fact there are several ways in which the thing can be done quite quickly. The quickest perhaps would be to take a mirror and turn it round in all directions. In a very short time you could produce sun and stars and earth and yourself and all the other animals and plants and lifeless objects which we mentioned just now.

Yes, in appearance, but not the actual things.

Quite so; you are helping out my argument. My notion is that a painter is a craftsman of that kind. You may say that the things he produces are not

real; but there is a sense in which he too does produce a bed.

Yes, the appearance of one.

And what of the carpenter? Were you not saying just now that he only makes a particular bed, not what we call the Form or essential nature of Bed?

Yes, I was.

If so, what he makes is not the reality, but only something that resembles it. It would not be right to call the work of a carpenter or of any other handicraftsman a perfectly real thing, would it?

Not in the view of people accustomed to thinking on these lines.[7]

We must not be surprised, then, if even an actual bed is a somewhat shadowy thing as compared with reality.

True.

Now shall we make use of this example to throw light on our question as to the true nature of this artist who represents things? We have here three sorts of bed: one which exists in the nature of things and which, I imagine, we could only describe as a product of divine workmanship; another made by the carpenter; and a third by the painter. So the three kinds of bed belong respectively to the domains of these three: painter, carpenter, and god.

Yes.

Now the god made only one ideal or essential Bed, whether by choice or because he was under some necessity not to make more than one; at any rate two or more were not created, nor could they possibly come into being.

Why not?

Because, if he made even so many as two, then once more a single ideal Bed would make its appearance, whose character those two would share; and that one, not the two, would be the essential Bed. Knowing this, the god, wishing to be the real maker of a real Bed, not a particular manufacturer of one particular bed, created one which is essentially unique.

So it appears.

Shall we call him, then, the author of the true nature of Bed, or something of that sort?

Certainly he deserves the name, since all his works constitute the real nature of things.

And we may call the carpenter the manufacturer of a bed?

Yes.

Can we say the same of the painter?

Certainly not.

Then what is he, with reference to a bed?

I think it would be fairest to describe him as the artist who represents the things which the other two make.

Very well, said I; so the work of the artist is at the third remove from the essential nature of the thing?

Exactly.

The tragic poet, too, is an artist who represents things; so this will apply to him: he and all other artists are, as it were, third in succession from the throne of truth.[8]

Just so.

We are in agreement, then, about the artist. But now tell me about our painter: which do you think he is trying to represent—the reality that exists in the nature of things, or the products of the craftsman?

The products of the craftsman.

As they are, or as they appear? You have still to draw that distinction.[9]

How do you mean?

I mean: you may look at a bed or any other object from straight in front or slantwise or at any angle. Is there then any difference in the bed itself, or does it merely look different?

It only looks different.

Well, that is the point. Does painting aim at reproducing any actual object as it is, or the appearance of it as it looks? In other words, is it a representation of the truth or of a semblance?

Of a semblance.

The art of representation, then, is a long way from reality; and apparently the reason why there is nothing it cannot reproduce is that it grasps only a small part of any object, and that only an image. Your painter, for example, will paint us a shoemaker, a carpenter, or other workman, without understanding any one of their crafts,[10] and yet, if he were a good painter, he might deceive a child or a simple-minded person into thinking his picture was a real carpenter, if he showed it them at some distance.

No doubt.

But I think there is one view we should take in all such cases. Whenever someone announces that he has met with a person who is master of every trade and knows more about every subject than any specialist, we should reply that he is a simple fellow who has apparently fallen in with some illusionist and been tricked into thinking him omniscient, because of his own inability to discriminate between knowledge and ignorance and the representation of appearances.

Quite true.

Then it is now time to consider the tragic poets and their master, Homer, because we are sometimes told that they understand not only all technical matters but also all about human conduct, good or bad, and about religion; for, to write well, a good poet, so they say, must know his subject; otherwise

he could not write about it. We must ask whether these people have not been deluded by meeting with artists who can represent appearances, and in contemplating the poets' work have failed to see that it is at the third remove from reality, nothing more than semblances, easy to produce with no knowledge of the truth. Or is there something in what they say? Have the good poets a real mastery of the matters on which the public thinks they discourse so well?

It is a question we ought to look into.

Well then, if a man were able actually to do the things he represents as well as to produce images of them, do you believe he would seriously give himself up to making these images and take that as a completely satisfying object in life? I should imagine that, if he had a real understanding of the actions he represents, he would far sooner devote himself to performing them in fact. The memorials he would try to leave after him would be noble deeds, and he would be more eager to be the hero whose praises are sung than the poet who sings them.

Yes, I agree; he would do more good in that way and win a greater name.

Here is a question, then, that we may fairly put to Homer or to any other poet. We will leave out of account all mere matters of technical skill: we will not ask them to explain, for instance, why it is that, if they have a knowledge of medicine and not merely the art of reproducing the way physicians talk, there is no record of any poet, ancient or modern, curing patients and bequeathing his knowledge to a school of medicine, as Asclepius did. But when Homer undertakes to tell us about matters of the highest importance, such as the conduct of war, statesmanship, or education, we have a right to inquire into his competence. 'Dear Homer,' we shall say, 'we have defined the artist as one who produces images at the third remove from reality. If your knowledge of all that concerns human excellence was really such as to raise you above him to the second rank, and you could tell what courses of conduct will make men better or worse as individuals or as citizens, can you name any country which was better governed thanks to your efforts? Many states, great and small, have owed much to a good lawgiver, such as Lycurgus at Sparta, Charondas in Italy and Sicily, and our own Solon. Can you tell us of any that acknowledges a like debt to you?'

I should say not, Glaucon replied. The most devout admirers of Homer make no such claim.

Well, do we hear of any war in Homer's day being won under his command or thanks to his advice?

No.

Or of a number of ingenious inventions and technical contrivances, which would show that he was a man of practical ability like Thales of Miletus or Anacharsis the Scythian?[11]

Nothing of the sort.

Well, if there is no mention of public services, do we hear of Homer in his own lifetime presiding, like Pythagoras, over a band of intimate disciples who loved him for the inspiration of his society and handed down a Homeric way of life, like the way of life which the Pythagoreans called after their founder and which to this day distinguishes them from the rest of the world?

No; on the contrary, Homer's friend with the absurd name, Creophylus,[12] would look even more absurd when considered as a product of the poet's training, if the story is true that he completely neglected Homer during his lifetime.

Yes, so they say. But what do you think, Glaucon? If Homer had really possessed the knowledge qualifying him to educate people and make them better men, instead of merely giving us a poetical representation of such matters, would he not have attracted a host of disciples to love and revere him? After all, any number of private teachers like Protagoras of Abdera and Prodicus of Ceos[13] have succeeded in convincing their contemporaries that they will never be fit to manage affairs of state or their own households unless these masters superintend their education; and for this wisdom they are so passionately admired that their pupils are all but ready to carry them about on their shoulders. Can we suppose that Homer's contemporaries, or Hesiod's, would have left them to wander about reciting their poems, if they had really been capable of helping their hearers to be better men? Surely they would sooner have parted with their money and tried to make the poets settle down at home; or failing that, they would have danced attendance on them wherever they went, until they had learnt from them all they could.

I believe you are quite right, Socrates.

We may conclude, then, that all poetry, from Homer onwards, consists in representing a semblance of its subject, whatever it may be, including any kind of human excellence, with no grasp of the reality. We were speaking just now of the painter who can produce what looks like a shoemaker to the spectator who, being as ignorant of shoemaking as he is himself, judges only by form and colour. In the same way the poet, knowing nothing more than how to represent appearances, can paint in words his picture of any craftsman so as to impress an audience which is equally ignorant and judges only by the form of expression; the inherent charm of metre, rhythm, and musical setting is enough to make them think he has discoursed admirably about generalship or shoemaking or any other technical subject. Strip what the poet has to say of its

poetical colouring, and I think you must have seen what it comes to in plain prose. It is like a face which was never really handsome, when it has lost the fresh bloom of youth.

Quite so.

Here is a further point, then. The artist, we say, this maker of images, knows nothing of the reality, but only the appearance. But that is only half the story. An artist can paint a bit and bridle, while the smith and the leather-worker can make them. Does the painter understand the proper form which bit and bridle ought to have? Is it not rather true that not even the craftsmen who make them know that, but only the horseman who understands their use?[14]

Quite true.

May we not say generally that there are three arts concerned with any object—the art of using it, the art of making it, and the art of representing it?

Yes.

And that the excellence or beauty or rightness of any implement or living creature or action has reference to the use for which it is made or designed by nature?[15]

Yes.

It follows, then, that the user must know most about the performance of the thing he uses and must report on its good or bad points to the maker. The flute-player, for example, will tell the instrument-maker how well his flutes serve the player's purpose, and the other will submit to be instructed about how they should be made. So the man who uses any implement will speak of its merits and defects with knowledge, whereas the maker will take his word and possess no more than a correct belief, which he is obliged to obtain by listening to the man who knows.

Quite so.

But what of the artist? Has he either knowledge or correct belief? Does he know from direct experience of the subjects he portrays whether his representations are good and right or not? Has he even gained a correct belief by being obliged to listen to someone who does know and can tell him how they ought to be represented?

No, he has neither.

If the artist, then, has neither knowledge nor even a correct belief about the soundness of his work, what becomes of the poet's wisdom in respect of the subjects of his poetry?

It will not amount to much.

And yet he will go on with his work, without knowing in what way any of his representations is sound or unsound. He must, apparently, be reproducing only what pleases the taste or wins the approval of the ignorant multitude.[16]

Yes, what else can he do?

We seem, then, so far to be pretty well agreed that the artist knows nothing worth mentioning about the subjects he represents, and that art is a form of play, not to be taken seriously. This description, moreover, applies above all to tragic poetry, whether in epic or dramatic form.

Exactly.[17]

Dramatic Poetry Appeals to the Emotions, Not to the Reason

The psychological objections to poetry in this and the following chapter are based on the earlier division of the soul into three parts, and apply especially to the drama and the element of dramatic impersonation in epic poetry. The appeal of dramatic poetry is not to the reason but to a lower part, the emotions, which, like the senses, are subject to illusions. As optical and other such illusions can be corrected by the calculating and reflective part (logistikon) which ascertains the true facts by measurement, so illusory exaggerations of feeling should be corrected by reflection. But the dramatist is concerned rather to rouse sympathetic emotion than to check its excesses, and while we enter into the joys or sorrows of a hero on the stage, the reason is held in abeyance. Thus drama is as far removed as visual art from true reality and from wisdom.

□ □ □

But now look here, said I; the content of this poetical representation is something at the third remove from reality, is it not?

Yes.

On what part of our human nature, then, does it produce its effect?

What sort of part do you mean?

Let me explain by an analogy. An object seen at a distance does not, of course, look the same size as when it is close at hand; a straight stick looks bent when part of it is under water; and the same thing appears concave or convex to an eye misled by colours. Every sort of confusion like these is to be found in our minds; and it is this weakness in our nature that is exploited, with a quite magical effect, by many tricks of illusion, like scene-painting and conjuring.

True.

But satisfactory means have been found for dispelling these illusions by measuring, counting, and weighing. We are no longer at the mercy of apparent differences of size and quantity and weight; the faculty which has done the counting and measuring or weighing takes control instead. And this can only be the work of the calculating or reasoning element in the soul.

True.

And when this faculty has done its measuring and announced that one quantity is greater than, or equal to, another, we often find that there is an appearance which contradicts it. Now, as we have said, it is impossible for the same part of the soul to hold two contradictory beliefs at the same time. Hence the part which agrees with the measurements must be a different part from the one which goes against them; and its confidence in measurement and calculation is a proof of its being the highest part; the other which contradicts it must be an inferior one.

It must.

This, then, was the conclusion I had in view when I said that paintings and works of art in general are far removed from reality, and that the element in our nature which is accessible to art and responds to its advances is equally far from wisdom. The offspring of a connexion thus formed on no true or sound basis must be as inferior as the parents. This will be true not only of visual art, but of art addressed to the ear, poetry as we call it.

Naturally.

Then, instead of trusting merely to the analogy from painting, let us directly consider that part of the mind to which the dramatic element in poetry[18] appeals, and see how much claim it has to serious worth. We can put the question in this way. Drama, we say, represents the acts and fortunes of human beings. It is wholly concerned with what they do, voluntarily or against their will, and how they fare, with the consequences which they regard as happy or otherwise, and with their feelings of joy and sorrow in all these experiences. That is all, is it not?

Yes.

And in all these experiences has a man an undivided mind? Is there not an internal conflict which sets him at odds with himself in his conduct, much as we were saying that the conflict of visual impressions leads him to make contradictory judgements? However, I need not ask that question; for, now I come to think of it, we have already agreed[19] that innumerable conflicts of this sort are constantly occurring in the mind. But there is a further point to be considered now. We have said[20] that a man of high character will bear any stroke of fortune, such as the loss of a son or of anything else he holds dear, with more equanimity than most people. We may now ask: will he feel no pain, or is that impossible? Will he not rather observe due measure in his grief?

Yes, that is nearer the truth.

Now tell me: will he be more likely to struggle with his grief and resist it when he is under the eyes of his fellows or when he is alone?

He will be far more restrained in the presence of others.

Yes; when he is by himself he will not be ashamed to do and say much that he would not like anyone to see or hear.

Quite so.

What encourages him to resist his grief is the lawful authority of reason, while the impulse to give way comes from the feeling itself; and, as we said, the presence of contradictory impulses proves that two distinct elements in his nature must be involved. One of them is law-abiding, prepared to listen to the authority which declares that it is best to bear misfortune as quietly as possible without resentment, for several reasons: it is never certain that misfortune may not be a blessing; nothing is gained by chafing at it; nothing human is matter for great concern; and, finally, grief hinders us from calling in the help we most urgently need. By this I mean reflection on what has happened, letting reason decide on the best move in the game of life that the fall of the dice permits. Instead of behaving like a child who goes on shrieking after a fall and hugging the wounded part, we should accustom the mind to set itself at once to raise up the fallen and cure the hurt, banishing lamentation with a healing touch.

Certainly that is the right way to deal with misfortune.

And if, as we think, the part of us which is ready to act upon these reflections is the highest, that other part which impels us to dwell upon our sufferings and can never have enough of grieving over them is unreasonable, craven, and faint-hearted.

Yes.

Now this fretful temper gives scope for a great diversity of dramatic representation; whereas the calm and wise character in its unvarying constancy is not easy to represent, nor when represented is it readily understood, especially by a promiscuous gathering in a theatre, since it is foreign to their own habit of mind. Obviously, then, this steadfast disposition does not naturally attract the dramatic poet, and his skill is not designed to find favour with it. If he is to have a popular success, he must address himself to the fretful type with its rich variety of material for representation.

Obviously.

We have, then, a fair case against the poet and we may set him down as the counterpart of the painter, whom he resembles in two ways: his creations are poor things by the standard of truth and reality, and his appeal is not to the highest part of the soul, but to one which is equally inferior. So we shall be justified in not admitting him into a well-ordered commonwealth, because he stimulates and strengthens an element which threatens to undermine the reason. As a country may be given over into the power of its worst citizens while the better sort are ruined, so, we shall say, the dramatic poet sets up a vicious

form of government in the individual soul: he gratifies that senseless part which cannot distinguish great and small, but regards the same things as now one, now the other; and he is an image-maker whose images are phantoms far removed from reality.

Quite true.

The Effect of Dramatic Poetry on Character

A further psychological objection is that dramatic poetry, tragic or comic, by encouraging the sympathetic indulgence of emotions which we are ashamed to give way to in our own lives, undermines the character. If poetry cannot be defended from this charge, it must be restricted to celebrating the praises of the gods and of good men.

◻ ◻ ◻

But, I continued, the heaviest count in our indictment is still to come. Dramatic poetry has a most formidable power of corrupting even men of high character, with a few exceptions.

Formidable indeed, if it can do that.

Let me put the case for you to judge. When we listen to some hero in Homer or on the tragic stage moaning over his sorrows in a long tirade, or to a chorus beating their breasts as they chant a lament, you know how the best of us enjoy giving ourselves up to follow the performance with eager sympathy. The more a poet can move our feelings in this way, the better we think him. And yet when the sorrow is our own, we pride ourselves on being able to bear it quietly like a man, condemning the behaviour we admired in the theatre as womanish. Can it be right that the spectacle of a man behaving as one would scorn and blush to behave oneself should be admired and enjoyed, instead of filling us with disgust?

No, it really does not seem reasonable.

It does not, if you reflect that the poet ministers to the satisfaction of that very part of our nature whose instinctive hunger to have its fill of tears and lamentations is forcibly restrained in the case of our own misfortunes. Meanwhile the noblest part of us, insufficiently schooled by reason or habit, has relaxed its watch over these querulous feelings, with the excuse that the sufferings we are contemplating are not our own and it is no shame to us to admire and pity a man with some pretensions to a noble character, though his grief may be excessive. The enjoyment itself seems a clear gain, which we cannot bring ourselves to forfeit by disdaining the whole poem. Few, I believe, are capable of reflecting that to enter into another's feelings must have an effect on our own: the emotions of pity our sympathy has strengthened will not be easy to restrain when we are suffering ourselves.

That is very true.

Does not the same principle apply to humour as well as to pathos? You are doing the same thing if, in listening at a comic performance or in ordinary life to buffooneries which you would be ashamed to indulge in yourself, you thoroughly enjoy them instead of being disgusted with their ribaldry. There is in you an impulse to play the clown, which you have held in restraint from a reasonable fear of being set down as a buffoon; but now you have given it rein, and by encouraging its impudence at the theatre you may be unconsciously carried away into playing the comedian in your private life. Similar effects are produced by poetic representation of love and anger and all those desires and feelings of pleasure or pain which accompany our every action. It waters the growth of passions which should be allowed to wither away and sets them up in control, although the goodness and happiness of our lives depend on their being held in subjection.

I cannot but agree with you.

If so, Glaucon, when you meet with admirers of Homer who tell you that he has been the educator of Hellas and that on questions of human conduct and culture he deserves to be constantly studied as a guide by whom to regulate your whole life, it is well to give a friendly hearing to such people, as entirely well-meaning according to their lights, and you may acknowledge Homer to be the first and greatest of the tragic poets; but you must be quite sure that we can admit into our commonwealth only the poetry which celebrates the praises of the gods and of good men. If you go further and admit the honeyed muse in epic or in lyric verse, then pleasure and pain will usurp the sovereignty of law and of the principles always recognized by common consent as the best.

Quite true.

So now, since we have recurred to the subject of poetry, let this be our defence: it stands to reason that we could not but banish such an influence from our commonwealth. But, lest poetry should convict us of being harsh and unmannerly, let us tell her further that there is a long-standing quarrel between poetry and philosophy. There are countless tokens of this old antagonism, such as the lines which speak of 'the cur which at his master yelps,' or 'one mighty in the vain talk of fools' or 'the throng of all-too-sapient heads,' or 'subtle thinkers all in rags.'[21] None the less, be it declared that, if the dramatic poetry whose end is to give pleasure can show good reason why it should exist in a well-governed society, we for our part should welcome it back, being ourselves conscious of its charm; only it would be a sin to betray what we believe to be the truth. You too, my

friend, must have felt this charm, above all when poetry speaks through Homer's lips.

I have indeed.

It is fair, then, that before returning from exile poetry should publish her defence in lyric verse or some other measure; and I suppose we should allow her champions who love poetry but are not poets to plead for her in prose, that she is no mere source of pleasure but a benefit to society and to human life. We shall listen favourably; for we shall clearly be the gainers, if that can be proved.

Undoubtedly.

But if it cannot, then we must take a lesson from the lover who renounces at any cost a passion which he finds is doing him no good. The love for poetry of this kind, bred in us by our own much admired institutions, will make us kindly disposed to believe in her genuine worth; but so long as she cannot make good her defence we shall, as we listen, rehearse to ourselves the reasons we have just given, as a counter-charm to save us from relapsing into a passion which most people have never outgrown. We shall reiterate that such poetry has no serious claim to be valued as an apprehension of truth. One who lends an ear to it should rather beware of endangering the order established in his soul, and would do well to accept the view of poetry which we have expressed.

I entirely agree.

Yes, Glaucon; for much is at stake, more than most people suppose: it is a choice between becoming a good man or a bad; and poetry, no more than wealth or power or honours, should tempt us to be careless of justice and virtue.

Your argument has convinced me, as I think it would anyone else.

Notes

1. Such as Ion in Plato's dialogue of that name.

2. In Xenophon's *Symposium*, iii. 5, Niceratus says his father made him learn all Homer by heart in order that he might become a good man.

3. At 398 A. . . . Plato seemed to exclude all dramatic poetry because this contains no narrative but involves the impersonation (*mimesis*) of all types of character, good or bad; whereas epic, for instance, can limit speeches in character to the representation of virtuous or heroic types. He will now argue that all poetry and other forms of art are essentially *mimesis*. The meaning of the word is obviously enlarged where he speaks just below of 'representation in general.'

4. The plots of Greek tragedy were normally stories borrowed from epic poetry. Hence Homer was spoken of as the first tragic poet.

5. 'Form' does not mean 'shape,' but the essential properties which constitute what the thing, by definition, is.

6. The divine Demiurge of the creation-myth in the *Timaeus* is pictured as fashioning the whole visible world after the likeness of the eternal Forms, which he does not create but uses as models. He is thus the maker of natural objects, corresponding to the carpenter who makes artificial objects; and both, as makers of actual things, are superior to the painter or poet, who makes all things only 'in a way,' by creating mere semblances like images in a mirror.

7. Familiar with the Platonic doctrine, as opposed to current materialism, which regards the beds we sleep on as real things and the Platonic Form as a mere 'abstraction' or notion existing only in our minds.

8. Jowett and Campbell quote from Dante Virgil's description of human art as the 'grandchild of God,' since art is said to copy nature, and nature is the child of God: *si che vostr' arte a Dio quasi è nipote*, Inferno xi. 105.

9. The distinction is needed to exclude another possible sense of *mimesis*, the production of a complete replica.

10. Knowledge of carpentry is the essence of the carpenter, what makes him a carpenter. The painter could not reproduce this knowledge in his picture, even if he possessed it himself. This may sound absurd as an objection to art, but Plato is thinking rather of the application to the poet, for whom it was claimed that he both possessed technical and moral knowledge and reproduced it in his work.

11. Thales (early sixth cent.) made a fortune out of a corner in oil-mills when his knowledge of the stars enabled him to predict a large olive harvest, thus proving that wise men could be rich if they chose (Aristotle, *Politics*, i. II). Anacharsis was said to have invented the anchor and the potter's wheel (Diog. Laert. i. 105).

12. Creophylus' name is supposed to be derived from two words meaning 'flesh' and 'tribe.' He is said to have been an epic poet from Chios.

13. Two of the most famous Sophists of the fifth century. Plato's *Protagoras* gives a vivid picture of them on a visit to a rich patron at Athens.

14. In the *Parmenides* (127 A) Plato's half-brother Antiphon, who had transferred his interest from philosophy to horses, is discovered instructing a smith about making a bit. Ancient craftsmen were far less specialized than ours. A blacksmith and a cobbler to-day might need instructions from a jockey.

15. This recalls the association of a thing's peculiar excellence or 'virtue' with its function, 352 D. . . .

16. Living in the world of appearances, the poet reproduces only 'the many conventional notions of the mass of mankind about what is beautiful or honourable or just' (479 D). . . .

17. It should now be clear that this chapter is not concerned with aesthetic criticism, but with extravagant claims for the poets as moral teachers. It may leave the impression that Plato has been irritated by some contemporary controversy, and is overstating his case with a slightly malicious delight in paradox. . . . He speaks of all this Part as a 'defence' of his earlier exclusion of poetry.

18. That ἡ τῆς ποιήσεως μιμητική is here once more restricted to drama and the dramatic element in other poetry is clear from the definition of its content as 'the acts and fortunes of human beings' (πράττειν means both 'to act' and 'to fare' well or ill).

19. In the analysis of the conflict of motives at 439 c ff. . . .

20. At 387 D. . . .

21. The source of these poetical attacks on philosophy is unknown. The earliest philosophers to denounce Homer and Hesiod had been Xenophanes and Heraclitus, about the beginning of the fifth century.

7

Truth and the Stereotype
An Illusion Theory of Representation

E. H. GOMBRICH

The illustration in front of the reader should explain much more quickly than I could in words what is here meant by the "riddle of style." Alain's cartoon neatly sums up a problem which has haunted the minds of art historians for many generations. Why is it that different ages and different nations have represented the visible world in such different ways? Will the paintings we accept as true to life look as unconvincing to future generations as Egyptian paintings look to us? Is everything concerned with art entirely subjective, or are there objective standards in such matters? If there are, if the methods taught in the life class today result in more faithful imitations of nature than the conventions adopted by the Egyptians, why did the Egyptians fail to adopt them? Is it possible, as our cartoonist hints, that they perceived nature in a different way? Would not such a variability of artistic vision also help us to explain the bewildering images created by contemporary artists?

These are questions which concern the history of art. But their answers cannot be found by historical methods alone. The art historian has done his work when he has described the changes that have taken place. He is concerned with the differences in style between one school of art and another, and he has refined his methods of description in order to group, organize, and identify the works of art which have survived from the past. Glancing through the variety of illustrations we find in this book, we all react,

to a major or minor extent, as he does in his studies: we take in the subject of a picture together with its style; we see a Chinese landscape here and a Dutch landscape there, a Greek head and a seventeenth-century portrait. We have come to take such classifications so much for granted that we have almost stopped asking why it is so easy to tell whether a tree was painted by a Chinese or by a Dutch master. If art were only, or mainly, an expression of personal vision, there could be no history of art. We could have no reason to assume, as we do, that there must be a family likeness between pictures of trees produced in proximity. We could not count on the fact that the boys in Alain's life class would produce a typical Egyptian figure. Even less could we hope to detect whether an Egyptian figure was indeed made three thousand years ago or forged yesterday. The art historian's trade rests on the conviction once formulated by Wölfflin, that "not everything is possible in every period." To explain this curious fact is not the art historian's duty, but whose business is it?

There was a time when the methods of representation were the proper concern of the art critic. Accustomed as he was to judging contemporary works first of all by standards of representational accuracy, he had no doubt that this skill had progressed from rude beginnings to the perfection of illusion. Egyptian art adopted childish methods

From E. H. Gombrich, *Art and Illusion: A Study in the Psychology of Pictorial Representation.* Bollingen Series 35, Vol. 5. Princeton: Princeton University Press, 1960, pp. 3–7, 63–70, 73–74, 77–79, 81–90, 97–101, 297–99. Copyright © Trustees of National Gallery of Art. Reprinted with permission of Princeton University Press.

Drawing by Alain; © 1955, 1983 The New Yorker Magazine, Inc.

because Egyptian artists knew no better. Their conventions could perhaps be excused, but they could not be condoned. It is one of the permanent gains we owe to the great artistic revolution which has swept across Europe in the first half of the twentieth century that we are rid of this type of aesthetics. The first prejudice teachers of art appreciation usually try to combat is the belief that artistic excellence is identical with photographic accuracy. The picture post card or pin-up girl has become the conventional foil against which the student learns to see the creative achievement of the great masters. Aesthetics, in other words, has surrendered its claim to be concerned with the problem of convincing representation, the problem of illusion in art. In certain respects this is indeed a liberation, and nobody would wish to revert to the old confusion. But since neither the art historian nor the critic still wishes to occupy himself with this perennial problem, it has become orphaned and neglected. The impression has grown up that illusion, being artistically irrelevant, must also be psychologically very simple.

We do not have to turn to art to show that this view is erroneous. Any psychology textbook will provide us with baffling examples that show the complexity of the issues involved. Take the simple trick drawing which has reached the philosophical seminar from the pages of the humorous weekly *Die Fliegenden Blätter*. We can see the picture as either a rabbit or a duck. It is easy to discover both readings. It is less easy to describe what happens when we switch from one interpretation to the other. Clearly we do not have the illusion that we are confronted with a "real" duck or rabbit. The shape on the paper resembles neither animal very closely. And yet there is no doubt that the shape transforms itself in some subtle way when the duck's beak becomes the rabbit's ears and brings an otherwise neglected spot into prominence as the rabbit's mouth. I say "neglected," but does it enter our experience at all when we switch back reading "duck"? To answer this question, we are compelled to look for what is "really there," to see the shape apart from its interpretation, and this, we soon discover,

Rabbit or duck? Reproduced from *Die Fliegenden Blätter* in Norma V. Scheidemann, *Experiments in General Psychology* (enlarged edn., Chicago, 1939), p. 67, fig. 21. Traditional.

is not really possible. True, we can switch from one reading to another with increasing rapidity; we will also "remember" the rabbit while we see the duck, but the more closely we watch ourselves, the more certainly we will discover that we cannot experience alternative readings at the same time. Illusion, we will find, is hard to describe or analyze, for though we may be intellectually aware of the fact that any given experience *must* be an illusion, we cannot, strictly speaking, watch ourselves having an illusion.

If the reader finds this assertion a little puzzling, there is always an instrument of illusion close at hand to verify it: the bathroom mirror. I specify the bathroom because the experiment I urge the reader to make succeeds best if the mirror is a little clouded by steam. It is a fascinating exercise in illusionist representation to trace one's own head on the surface of the mirror and to clear the area enclosed by the outline. For only when we have actually done this do we realize how small the image is which gives us the illusion of seeing ourselves "face to face." To be exact, it must be precisely half the size of our head. I do not want to trouble the reader with geometrical proof of this fact, though basically it is simple: since the mirror will always appear to be halfway between me and my reflection, the size on its surface will be one half of the apparent size. But however cogently this fact can be demonstrated with the help of similar triangles, the assertion is usually met with frank incredulity. And despite all geometry, I, too, would stubbornly contend that I really see my head (natural size) when I shave and that the size on the mirror surface is the phantom. I cannot have my cake and eat it. I cannot make use of an illusion and watch it.

Works of art are not mirrors, but they share with mirrors that elusive magic of transformation which is so hard to put into words. A master of introspection, Kenneth Clark, has recently described to us most vividly how even he was defeated when he

attempted to "stalk" an illusion. Looking at a great Velázquez, he wanted to observe what went on when the brush strokes and dabs of pigment on the canvas transformed themselves into a vision of transfigured reality as he stepped back. But try as he might, stepping backward and forward, he could never hold both visions at the same time, and therefore the answer to his problem of how it was done always seemed to elude him. In Kenneth Clark's example, the issues of aesthetics and of psychology are subtly intertwined; in the examples of the psychology textbooks, they are obviously not. In this book I have often found it convenient to isolate the discussion of visual effects from the discussion of works of art. I realize this may sometimes lead to an impression of irreverence; I hope the opposite is the truth.

Representation need not be art, but it is none the less mysterious for that. I well remember that the power and magic of image making was first revealed to me, not by Velázquez, but by a simple drawing game I found in my primer. A little rhyme explained how you could first draw a circle to represent a loaf of bread (for loaves were round in my native Vienna); a curve added on top would turn the loaf into a shopping bag; two little squiggles on its handle would make it shrink into a purse; and now by adding a tail, here was a cat. What intrigued me, as I learned the trick, was the power of metamorphosis: the tail destroyed the purse and created the cat; you cannot see the one without obliterating the other. Far as we are from completely understanding this process, how can we hope to approach Velázquez? . . .

The schematism by which our understanding deals with the phenomenal world . . . is a skill so deeply hidden in the human soul that we shall hardly guess the secret trick that Nature here employs.
Immanuel Kant, Kritik der reinen Vernunft

How to draw a cat.

In his charming autobiography, the German illustrator Ludwig Richter relates how he and his friends, all young art students in Rome in the 1820's, visited the famous beauty spot of Tivoli and sat down to draw. They looked with surprise, but hardly with approval, at a group of French artists who approached the place with enormous baggage, carrying large quantities of paint which they applied to the canvas with big, coarse brushes. The Germans, perhaps roused by this self-confident artiness, were determined on the opposite approach. They selected the hardest, best-pointed pencils, which could render the motif firmly and minutely to its finest detail, and each bent down over his small piece of paper, trying to transcribe what he saw with the utmost fidelity. "We fell in love with every blade of grass, every tiny twig, and refused to let anything escape us. Every one tried to render the motif as objectively as possible."

Nevertheless, when they then compared the fruits of their efforts in the evening, their transcripts differed to a surprising extent. The mood, the color, even the outline of the motif had undergone a subtle transformation in each of them. Richter goes on to describe how these different versions reflected the different dispositions of the four friends, for instance, how the melancholy painter had straightened the exuberant contours and emphasized the blue tinges. We might say he gives an illustration of the famous definition by Emile Zola, who called a work of art "a corner of nature seen through a temperament."

It is precisely because we are interested in this definition that we must probe it a little further. The "temperament" or "personality" of the artist, his selective preferences, may be one of the reasons for the transformation which the motif undergoes under the artist's hands, but there must be others— everything, in fact, which we bundle together into the word "style," the style of the period and the style of the artist. When this transformation is very noticeable we say the motif has been greatly "stylized," and the corollary to this observation is that those who happen to be interested in the motif, for one reason or another, must learn to discount the

style. This is part of that natural adjustment, the change in what I called "mental set," which we all perform quite automatically when looking at old illustrations. We can "read" the Bayeux tapestry without reflecting on its countless "deviations from reality." We are not tempted for a moment to think the trees at Hastings in 1066 looked like palmettes and the ground at that time consisted of scrolls. It is an extreme example, but it brings out the all-important fact that the word "stylized" somehow tends to beg the question. It implies there was a special activity by which the artist transformed the trees, much as the Victorian designer was taught to study the forms of flowers before he turned them into patterns. It was a practice which chimed in well with ideas of Victorian architecture, when railways and factories were built first and then adorned with the marks of a style. It was not the practice of earlier times.

The very point of Richter's story, after all, is that style rules even where the artist wishes to reproduce nature faithfully, and trying to analyze these limits to objectivity may help us get nearer to the riddle of style. One of these limits . . . is indicated in Richter's story by the contrast between coarse brush and fine pencil. The artist, clearly, can render only what his tool and his medium are capable of rendering. His technique restricts his freedom of choice. The features and relationships the pencil picks out will differ from those the brush can indicate. Sitting in front of his motif, pencil in hand, the artist will, therefore, look out for those aspects which can be rendered in lines—as we say in a pardonable abbreviation, he will tend to see his motif in terms of lines, while, brush in hand, he sees it in terms of masses.

The question of why style should impose similar limitations is less easily answered, least of all when we do not know whether the artist's intentions were the same as those of Richter and his friends.

. . . Take the image on the artist's retina. It sounds scientific enough, but actually there never was *one* such image which we could single out for comparison with either photograph or painting. What there was was an endless succession of innu-

Hastings. From the Bayeux Tapestry, c. 1080. Cathedral, Bayeux. Bildarchiv Foto Martburg.

merable images as the painter scanned the landscape in front of him, and these images sent a complex pattern of impulses through the optic nerves to his brain. Even the artist knew nothing of these events, and we know even less. How far the picture that formed in his mind corresponded to or deviated from the photograph it is even less profitable to ask. What we do know is that these artists went out into nature to look for material for a picture and their artistic wisdom led them to organize the elements of the landscape into works of art of marvelous complexity that bear as much relationship to a surveyor's record as a poem bears to a police report.

Does this mean, then, that we are altogether on a useless quest? That artistic truth differs so much from prosaic truth that the question of objectivity must never be asked? I do not think so. We must only be a little more circumspect in our formulation of the question. . . .

Logicians tell us—and they are not people to be easily gainsaid—that the terms "true" and "false" can only be applied to statements, propositions. And whatever may be the usage of critical parlance, a picture is never a statement in that sense of the term. It can no more be true or false than a state-

ment can be blue or green. Much confusion has been caused in aesthetics by disregarding this simple fact. It is an understandable confusion because in our culture pictures are usually labeled, and labels, or captions, can be understood as abbreviated statements. When it is said "the camera cannot lie," this confusion is apparent. Propaganda in wartime often made use of photographs falsely labeled to accuse or exculpate one of the warring parties. Even in scientific illustrations it is the caption which determines the truth of the picture. In a cause célèbre of the last century, the embryo of a pig, labeled as a human embryo to prove a theory of evolution, brought about the downfall of a great reputation. Without much reflection, we can all expand into statements the laconic captions we find in museums and books. When we read the name "Ludwig Richter" under a landscape painting, we know we are thus informed that he painted it and can begin arguing whether this information is true or false. When we read "Tivoli," we infer the picture is to be taken as a view of that spot, and we can again agree or disagree with the label. How and when we agree, in such a case, will largely depend on what we want to know about the object represented. The Bayeux

Michel Wolgemut: Woodcuts from the "Nuremberg Chronicle," from Hartmann Schedel, *Weltchronik* (Nuremberg, 1493).

tapestry, for instance, tells us there was a battle at Hastings. It does not tell us what Hastings "looked like."

Now the historian knows that the information pictures were expected to provide differed widely in different periods. Not only were images scarce in the past, but so were the public's opportunities to check their captions. How many people ever saw their ruler in the flesh at sufficiently close quarters to recognize his likeness? How many traveled widely enough to tell one city from another? It is hardly surprising, therefore, that pictures of people and places changed their captions with sovereign disregard for truth. The print sold on the market as a portrait of a king would be altered to represent his successor or enemy.

There is a famous example of this indifference to truthful captions in one of the most ambitious publishing projects of the early printing press, Hartmann Schedel's so-called "Nuremberg Chronicle" with woodcuts by Dürer's teacher Wolgemut. What an opportunity such a volume should give the historian to see what the world was like at the time of Columbus! But as we turn the pages of this big folio, we find the same woodcut of a medieval city recurring with different captions as Damascus, Ferrara, Milan, and Mantua. Unless we are prepared to believe these cities were as indistinguishable from one another as their suburbs may be today, we must conclude that neither the publisher nor the public minded whether the captions told the truth. All they were expected to do was to bring home to the reader that these names stood for cities.

These varying standards of illustration and documentation are of interest to the historian of representation precisely because he can soberly test the information supplied by picture and caption without becoming entangled too soon in problems of aesthetics. Where it is a question of information imparted by the image, the comparison with the correctly labeled photograph should be of obvious value. Three topographical prints representing various approaches to the perfect picture post card should suffice to exemplify the results of such an analysis.

The first shows a view of Rome from a German sixteenth-century newssheet reporting a catastrophic flood when the Tiber burst its banks. Where in Rome could the artist have seen such a timber structure, a castle with black-and-white walls, and a steep roof such as might be found in Nuremberg? Is this also a view of a German town with a misleading caption? Strangely enough, it is not. The artist, whoever he was, must have made some effort to portray the scene, for this curious building turns out to be the Castel Sant' Angelo in Rome, which guards the bridge across the Tiber. A comparison with a photograph shows that it does embody quite a number of features which belong or belonged to the castle: the angel on the roof that gives it its name, the main round bulk, founded on Hadrian's mausoleum, and the outworks with the bastions that we know were there.

I am fond of this coarse woodcut because its very crudeness allows us to study the mechanism of portrayal as in a slow-motion picture. There is no ques-

Castel Sant' Angelo, Rome. Anonymous: 1557, woodcut. Wick Collection, Zentralbibliothek, Zurich.

Castel Sant' Angelo, Anonymous: c. 1540, pen and ink. Private collection, Warburg Institute, London.

tion here of the artist's having deviated from the motif in order to express his mood or his aesthetic preferences. It is doubtful, in fact, whether the designer of the woodcut ever saw Rome. He probably adapted a view of the city in order to illustrate the sensational news. He knew the Castel Sant' Angelo to be a castle, and so he selected from the drawer of his mental stereotypes the appropriate cliché for a castle—a German *Burg* with its timber structure and high-pitched roof. But he did not simply repeat his stereotype—he adapted it to its particular function by embodying certain distinctive features which he knew belonged to that particular building in Rome. He supplies some information

over and above the fact that there is a castle by a bridge. . . .

I do not want to be misunderstood here. I do not want to prove by these examples that all representation must be inaccurate or that all visual documents before the advent of photography must be misleading. Clearly, if we had pointed out to the artist his mistake, he could have further modified his scheme and rounded the windows. My point is rather that such matching will always be a step-by-step process—how long it takes and how hard it is will depend on the choice of the initial schema to be adapted to the task of serving as a portrait. I believe that in this respect these humble documents do

Modern photograph. Alinari, Art Resource, N.Y.

indeed tell us a lot about the procedure of any artist who wants to make a truthful record of an individual form. He begins not with his visual impression but with his idea or concept: the German artist with his concept of a castle that he applies as well as he can to that individual castle. . . .

The individual visual information, those distinctive features I have mentioned, are entered, as it were, upon a preexisting blank or formulary. And, as often happens with blanks, if they have no provisions for certain kinds of information we consider essential, it is just too bad for the information.

The comparison, by the way, between the formularies of administration and the artist's stereotypes is not my invention. In medieval parlance there was one word for both, a *simile,* or pattern, that is applied to individual incidents in law no less than in pictorial art.

And just as the lawyer or the statistician could plead that he could never get hold of the individual case without some sort of framework provided by his forms or blanks, so the artist could argue that it makes no sense to look at a motif unless one has learned how to classify and catch it within the network of a schematic form. This, at least, is the conclusion to which psychologists have come who knew nothing of our historical series but who set out to investigate the procedure anyone adopts when copying what is called a "nonsense figure," an inkblot, let us say, or an irregular patch. By and large, it appears, the procedure is always the same. The draftsman tries first to classify the blot and fit it into some sort of familiar schema—he will say, for instance, that it is triangular or that it looks like a fish. Having selected such a schema to fit the form approximately, he will proceed to adjust it, noticing for instance that the triangle is rounded at the top, or that the fish ends in a pigtail. Copying, we learn from these experiments, proceeds through the rhythms of schema and correction. The schema is not the product of a process of "abstraction," of a tendency to "simplify"; it represents the first approximate, loose category which is gradually tightened to fit the form it is to reproduce. . . .

Not only must we surprise the artist when he is confronted with an unfamiliar task that he cannot easily adjust to his means; we must also know that his aim was in fact portrayal. Given these conditions, we may do without the actual comparison between photograph and representation that was our starting point. For, after all, nature is sufficiently uniform to allow us to judge the information value of a picture even when we have never seen the specimen portrayed. The beginnings of illustrated reportage, therefore, provide another test case where we need have no doubt about the will and can, consequently, concentrate on the skill. . . .

Villard de Honnecourt: Lion and Porcupine, c. 1235, pen and ink. Bibliothèque Nationale, Paris (Cod. fr. 19093)

A . . . famous example comes from the period when medieval art was at its height, from the volume of plans and drawings by the Gothic master builder, Villard de Honnecourt, which tells us so much about the practice and outlook of the men who created the French cathedrals. Among the many architectural, religious, and symbolic drawings of striking skill and beauty to be found in this volume, there is a curiously stiff picture of a lion, seen *en face.* To us, it looks like an ornamental or heraldic image, but Villard's caption tells us that he regarded it in a different light: *"Et sacies bien,"* he says, *"qu'il fu contrefais al vif."* "Know well that it is drawn from life." These words obviously had a very different meaning for Villard than they have for us. He can have meant only that he had drawn his schema in the presence of a real lion. How much of his visual observation he allowed to enter into the formula is a different matter.

. . . The fate of exotic creatures in the illustrated books of the last few centuries before the advent of photography is as instructive as it is amusing. When Dürer published his famous woodcut of a rhinoc-

Dürer: Rhinoceros. 1515, woodcut. Print
Collection, Miriam & Ira D. Wallace Division of Art,
Prints and Photographs, New York Public Library,
Astor, Lenox and Tilden Foundations.

eros, he had to rely on secondhand evidence which
he filled in from his own imagination, colored, no
doubt, by what he had learned of the most famous
of exotic beasts, the dragon with its armored body.
Yet it has been shown that this half-invented crea-
ture served as a model for all renderings of the rhi-
noceros, even in natural-history books, up to the
eighteenth century. When, in 1790, James Bruce
published a drawing of the beast in his *Travels to
Discover the Source of the Nile,* he proudly showed
that he was aware of this fact:

The animal represented in this drawing is a
native of Tcherkin, near Ras el Feel . . . and this
is the first drawing of the rhinoceros with a dou-

ble horn that has ever yet been presented to the
public. The first figure of the Asiatic rhinoceros,
the species having but one horn, was painted by
Albert Durer, from the life. . . . It was wonder-
fully ill-executed in all its parts, and was the ori-
gin of all the monstrous forms under which that
animal has been painted, ever since. . . . Several
modern philosophers have made amends for this
in our days; Mr. Parsons, Mr. Edwards, and the
Count de Buffon, have given good figures of it
from life; they have indeed some faults, owing
chiefly to preconceived prejudices and inatten-
tion. . . . This . . . is the first that has been pub-
lished with two horns, it is designed from the life,
and is an African.

If proof were needed that the difference between
the medieval draftsman and his eighteenth-century
descendant is only one of degree, it could be found
here. For the illustration, presented with such flour-
ishes of trumpets, is surely not free from "precon-
ceived prejudices" and the all-pervading memory of
Dürer's woodcut. We do not know exactly what
species of rhinoceros the artist saw at Ras el Feel,
and the comparison of his picture with a photo-
graph taken in Africa may not, therefore, be quite
fair. But I am told that none of the species known
to zoologists corresponds to the engraving claimed
to be drawn *al vif!*

The story repeats itself whenever a rare specimen
is introduced into Europe. Even the elephants that
populate the paintings of the sixteenth and seven-
teenth centuries have been shown to stem from a
very few archetypes and to embody all their curious
features, despite the fact that information about ele-
phants was not particularly hard to come by.

These examples demonstrate, in somewhat gro-

Rhinoceros of Africa. 1789, engraving. From Beckingham
(ed.), *Bruce's Travels to Discover the Source of the Nile*
(Edinburgh, 1964).

AFRICAN RHINOCEROS. Courtesy of Emil
Schulthess.

tesque magnification, a tendency which the student of art has learned to reckon with. The familiar will always remain the likely starting point for the rendering of the unfamiliar; an existing representation will always exert its spell over the artist even while he strives to record the truth. Thus it was remarked by ancient critics that several famous artists of antiquity had made a strange mistake in the portrayal of horses: they had represented them with eyelashes on the lower lid, a feature which belongs to the human eye but not to that of the horse. A German ophthalmologist who studied the eyes of Dürer's portraits, which to the layman appear to be such triumphs of painstaking accuracy, reports somewhat similar mistakes. Apparently not even Dürer knew what eyes "really look like."

This should not give us cause for surprise, for the greatest of all the visual explorers, Leonardo himself, has been shown to have made mistakes in his anatomical drawings. Apparently he drew features of the human heart which Galen made him expect but which he cannot have seen.

The study of pathology is meant to increase our understanding of health. The sway of schemata did not prevent the emergence of an art of scientific illustration that sometimes succeeds in packing more correct visual information into the image than even a photograph contains. But the diagrammatic maps of muscles in our illustrated anatomies are not "transcripts" of things seen but the work of trained observers who build up the picture of a specimen that has been revealed to them in years of patient study.

Now in this sphere of scientific illustration it obviously makes sense to say that [ancient Egyptian artists or] Villard himself could not have done what the modern illustrator can do. They lacked the relevant schemata, their starting point was too far removed from their motif, and their style was too rigid to allow a sufficiently supple adjustment. For so much certainly emerges from a study of portrayal in art: you cannot create a faithful image out of nothing. You must have learned the trick if only from other pictures you have seen.

In our culture, where pictures exist in such profusion, it is difficult to demonstrate this basic fact. There are freshmen in art schools who have facility in the objective rendering of motifs that would appear to belie this assumption. But those who have given art classes in other cultural settings tell a different story. James Cheng, who taught painting to a group of Chinese trained in different conventions, once told me of a sketching expedition he made with his students to a famous beauty spot, one of Peking's old city gates. The task baffled them. In the end, one of the students asked to be given at least a picture post card of the building so that they would have something to copy. It is stories such as these, stories of breakdowns, that explain why art has a history and artists need a style adapted to a task.

I cannot illustrate this revealing incident. But luck allows us to study the next stage, as it were—the adjustment of the traditional vocabulary of Chinese art to the unfamiliar task of topographical portrayal in the Western sense. For some decades Chiang Yee, a Chinese writer and painter of great gifts and charm, has delighted us with contemplative records of the Silent Traveller, books in which he tells of his encounters with scenes and people of the English and Irish countryside and elsewhere. I take an illustration from the volume on the English Lakeland.

It is a view of Derwentwater. Here we have crossed the line that separates documentation from art. Mr. Chiang Yee certainly enjoys the adaptation of the Chinese idiom to a new purpose; he wants us to see the English scenery for once "through Chinese eyes." But it is precisely for this reason that it is so instructive to compare his view with a typical "picturesque" rendering from the Romantic period. We see how the relatively rigid vocabulary of the Chinese tradition acts as a selective screen which admits only the features for which schemata exist. The artist will be attracted by motifs which can be rendered in his idiom. As he scans the landscape, the sights which can be matched successfully with the schemata he has learned ot handle will leap forward as centers of attention. The style, like the medium, creates a mental set which makes the artist look for certain aspects in the scene around him that he can render. Painting is an activity, and the artist will therefore tend to see what he paints rather than to paint what he sees.

It is this interaction between style and preference which Nietzsche summed up in his mordant comment on the claims of realism:

"All Nature faithfully"—But by what feint
Can Nature be subuded to art's constraint?
Her smallest fragment is still infinite!
And so he paints but what he likes in it.
What does he like? He likes, what he can paint!

There is more in this observation than just a cool reminder of the limitations of artistic means. We catch a glimpse of the reasons why these limitations will never obtrude themselves within the domain of art itself. Art presupposes mastery, and the greater the artist the more surely will he instinctively avoid a task where his mastery would fail to serve him. The layman may wonder whether Giotto could have painted a view of Fiesole in sunshine, but the historian will suspect that, lacking the means, he would not have wanted to, or rather that he could not have wanted to. We like to assume, somehow,

Chiang Yee: Cows in Derwentwater. 1936, brush and ink. The Fell and Rock Climbing Club of the English Lake District, Kendal Westmorland. From Chiang Yee, *The Silent Traveller* (London, 1937).

Anonymous: Derwentwater, looking toward Borrowdale. 1826, lithograph. From *Ten Lithographic Drawings of Scenery* (London, 1826). Victoria and Albert Museum, London.

that where there is a will there is also a way, but in matters of art the maxim should read that only where there is a way is there also a will. The individual can enrich the ways and means that his culture offers him; he can hardly wish for something that he has never known is possible.

The fact that artists tend to look for motifs for which their style and training equip them explains why the problem of representational skill looks different to the historian of art and to the historian of visual information. The one is concerned with success, the other must also observe the failures. But these failures suggest that we sometimes assume a little rashly that the ability of art to portray the visible world developed, as it were, along a uniform front. We know of specialists in art—of Claude Lorrain, the master of landscape whose figure paintings were poor, of Frans Hals who concentrated almost exclusively on portraits. May not skill as much as will have dictated this type of preference? Is not all naturalism in the art of the past selective?

A somewhat Philistine experiment would suggest that it is. Take the next magazine containing snapshots of crowds and street scenes and walk with it through any art gallery to see how many gestures and types that occur in life can be matched from old paintings. Even Dutch genre paintings that appear to mirror life in all its bustle and variety will turn out to be created from a limited number of types and gestures, much as the apparent realism of the picaresque novel or of Restoration comedy still applies and modifies stock figures which can be traced back for centuries. There is no neutral naturalism. The artist, no less than the writer, needs a vocabulary before he can embark on a "copy" of reality.

Everything points to the conclusion that the phrase the "language of art" is more than a loose metaphor, that even to describe the visible world in images we need a developed system of schemata. This conclusion rather clashes with the traditional distinction, often discussed in the eighteenth century, between spoken words which are conventional signs and painting which uses "natural" signs to "imitate" reality. It is a plausible distinction, but it has led to certain difficulties. If we assume, with this tradition, that natural signs can simply be copied from nature, the history of art represents a complete puzzle. It has become increasingly clear since the late nineteenth century that primitive art and child art use a language of symbols rather than "natural signs." To account for this fact it was postulated that there must be a special kind of art grounded not on seeing but rather on knowledge, an art which operates with "conceptual images." The child—it is argued—does not look at trees; he

is satisfied with the "conceptual" schema of a tree that fails to correspond to any reality since it does not embody the characteristics of, say, birch or beech, let alone those of individual trees. This reliance on construction rather than on imitation was attributed to the peculiar mentality of children and primitives who live in a world of their own.

But we have come to realize that this distinction is unreal. Gustaf Britsch and Rudolf Arnheim have stressed that there is no opposition between the crude map of the world made by a child and the richer map presented in naturalistic images. All art originates in the human mind, in our reactions to the world rather than in the visible world itself, and it is precisely because all art is "conceptual" that all representations are recognizable by their style.

Without some starting point, some initial schema, we could never get hold of the flux of experience. Without categories, we could not sort our impressions. Paradoxically, it has turned out that it matters relatively little what these first categories are. We can always adjust them according to need. Indeed, if the schema remains loose and flexible, such initial vagueness may prove not a hindrance but a help. An entirely fluid system would no longer serve its purpose; it could not register facts because it would lack pigeonholes. But how we arrange the first filing system is not very relevant.

The progress of learning, of adjustment through trial and error, can be compared to the game of "Twenty Questions," where we identify an object through inclusion or exclusion along any network of classes. The traditional initial schema of "animal, vegetable, or mineral" is certainly neither scientific nor very suitable, but it usually serves us well enough to narrow down our concepts by submitting them to the corrective test of "yes" or "no." The example of this parlor game has become popular of late as an illustration of that process of articulation through which we learn to adjust ourselves to the infinite complexity of this world. It indicates, however crudely, the way in which not only organisms but even machines may be said to "learn" by trial and error. Engineers at their thrilling work on what they call "servo mechanisms," that is, self-adjusting machines, have recognized the importance of some kind of "initiative" on the part of the machine. The first move such a machine may make will be, and indeed must be, a random movement, a shot in the dark. Provided a report of success or failure, hit or miss, can be fed back into the machine, it will increasingly avoid the wrong moves and repeat the correct ones. One of the pioneers in this field has recently described this machine rhythm of schema and correction in a striking verbal formula: he calls all learning "an arboriform stratification of guesses about the world." Arboriform, we may take it, here

describes the progressive creation of classes and sub-classes such as might be described in a diagrammatic account of "Twenty Questions."

We seem to have drifted far from the discussion of portrayal. But it is certainly possible to look at a portrait as a schema of a head modified by the distinctive features about which we wish to convey information. The American police sometimes employ draftsmen to aid witnesses in the identification of criminals. They may draw any vague face, a random schema, and let witnesses guide their modifications of selected features simply by saying "yes" or "no" to various suggested standard alterations until the face is sufficiently individualized for a search in the files to be profitable. This account of portrait drawing by remote control may well be over-tidy, but as a parable it may serve its purpose. It reminds us that the starting point of a visual record is not knowledge but a guess conditioned by habit and tradition.

Need we infer from this fact that there is no such thing as an objective likeness? That it makes no sense to ask, for instance, whether Chiang Yee's view of Derwentwater is more or less correct than the nineteenth-century lithograph in which the formulas of classical landscapes were applied to the same task? It is a tempting conclusion and one which recommends itself to the teacher of art appreciation because it brings home to the layman how much of what we call "seeing" is conditioned by habits and expectations. It is all the more important to clarify how far this relativism will take us. I believe it rests on the confusion between pictures, words, and statements which we saw arising the moment truth was ascribed to paintings rather than to captions.

If all art is conceptual, the issue is rather simple. For concepts, like pictures, cannot be true or false. They can only be more or less useful for the formation of descriptions. The words of a language, like pictorial formulas, pick out from the flux of events a few signposts which allow us to give direction to our fellow speakers in that game of "Twenty Questions" in which we are engaged. Where the needs of users are similar, the signposts will tend to correspond. We can mostly find equivalent terms in English, French, German, and Latin, and hence the idea has taken root that concepts exist independently of language as the constituents of "reality." But the English language erects a signpost on the roadfork between "clock" and "watch" where the German has only *"Uhr."* The sentence from the German primer, *"Meine Tante hat eine Uhr,"* leaves us in doubt whether the aunt has a clock or a watch. Either of the two translations may be wrong as a description of a fact. In Swedish, by the way, there is an additional roadfork to distinguish between

aunts who are "father's sisters," those who are "mother's sisters," and those who are just ordinary aunts. If we were to play our game in Swedish we would need additional questions to get at the truth about the timepiece.

This simple example brings out the fact, recently emphasized by Benjamin Lee Whorf, that language does not give name to preexisting things or concepts so much as it articulates the world of our experience. The images of art, we suspect, do the same. But this difference in styles or languages need not stand in the way of correct answers and descriptions. The world may be approached from a different angle and the information given may yet be the same.

From the point of view of information there is surely no difficulty in discussing portrayal. To say of a drawing that it is a correct view of Tivoli does not mean, of course, that Tivoli is bounded by wiry lines. It means that those who understand the notation will derive *no false information* from the drawing—whether it gives the contour in a few lines or picks out "every blade of grass" as Richter's friends wanted to do. The complete portrayal might be the one which gives as much correct information about the spot as we would obtain if we looked at it from the very spot where the artist stood.

Styles, like languages, differ in the sequence of articulation and in the number of questions they allow the artist to ask; and so complex is the information that reaches us from the visible world that no picture will ever embody it all. This is not due to the subjectivity of vision but to its richness. Where the artist has to copy a human product he can, of course, produce a facsimile which is indistinguishable from the original. The forger of banknotes succeeds only too well in effacing his personality and the limitations of a period style.

But what matters to us is that the correct portrait, like the useful map, is an end product on a long road through schema and correction. It is not a faithful record of a visual experience but the faithful construction of a relational model.

Neither the subjectivity of vision nor the sway of conventions need lead us to deny that such a model can be constructed to any required degree of accuracy. What is decisive here is clearly the word "required." The form of a representation cannot be divorced from its purpose and the requirements of the society in which the given visual language gains currency.

. . . There are few more influential discussions on the philosophy of representation than the momentous passage in the *Republic* where Plato introduces the comparison between a painting and a mirror image. It has haunted the philosophy of art ever since. To re-examine his theory of ideas, Plato con-

trasts the painter with the carpenter. The carpenter who makes the couch translates the idea, or concept, of the couch into matter. The painter who represents the carpenter's couch in one of his paintings only copies the appearance of one particular couch. He is thus twice removed from the idea. The metaphysical implications of Plato's condemnation of art need not concern us. It is possible to translate his statement into terminology which does not operate with Platonic ideas. If you telephone a carpenter to order a couch, he must know what the word means, or, to put it somewhat pedantically, what pieces of furniture are subsumed under the concept "couch." A painter who draws the interior of a room need not trouble his head about the names given in the furniture trade to the objects in front of him. He is not concerned with concepts or classes but with particular things.

But it is just because this analysis looks so plausible that we must probe it carefully. Is there really this difference between the carpenter who makes the couch and the painter who imitates it? Surely the difference cannot lie in the medium. Many a couch is designed first and worked out in a blueprint before it is made. In this case, Plato would have to admit the designer into his Ideal State because he, too, imitated the idea of the couch rather than any deceptive reality. But . . . we cannot tell in any particular case whether the design is to serve as an instruction or as an imitation. A series of pictures of couches in a sales catalogue may be a promise that such pieces of furniture will be made to order, or that they have already been made; in an illustrated dictionary of English words they may be an "iconic sign," a device to impart information about the meaning of the term.

The more we think about Plato's famous distinction between making and imitating, the more these border lines become blurred. Plato speaks of the painter who "paints both reins and bit." Unlike the horseman and the harness maker, Plato thought, the painter need have no knowledge of these things. It is a doubtful assertion even in the case of painters. But what about the sculptor who fits a real metal bit to his marble horse, as many a sculptor has done? Or what, for that matter, of a sculptor who represents a figure lying on a couch? Is he not also a maker?

Must it always be true that the sculptor's couch is a representation? If we mean by this term that it must refer to something else, that it is a sign, then this will surely depend on the context. Put a real couch into a shop window and you thereby turn it into a sign. It is true that once this is its only function, you may choose a couch which is not good for anything else. You may also make a cardboard dummy. In other words, there is a smooth and even transition, dependent on function, between what

Plato called "reality" and what he called "appearance." On the stage no less than in the shop window, we can find the real couch side by side with flimsy imitations or furniture painted on a backdrop. Any one of these may become a sign to us if we question it for information about the type of object it stands for. To one person, let us say, the model airplane may be interesting for its reference; to the child, it will be just a toy that really works.

In the world of the child there is no clear distinction between reality and appearance. He can use the most unlikely tools for the most unlikely purposes—a table upside down for a spaceship, a basin for a crash helmet. For the context of the game it will serve its purpose rather well. The basin does not "represent" a crash helmet, it *is* a kind of improvised helmet, and it might even prove useful. There is no rigid division between the phantom and reality, truth and falsehood, at least not where human purpose and human action come into their own. What we call "culture" or "civilization" is based on man's capacity to be a maker, to invent unexpected uses, and to create artificial substitutes.

To us the word "artificial" seems immensely far removed from art. But this was not always so. The works of cunning craftsmen in myth and story include precious toys and intriguing machines, artificial singing birds, and angels blowing real trumpets. And when men turned from the admiration of artifice to the worship of nature, the landscape gardener was called in to make artificial lakes, artificial waterfalls, and even artificial mountains. For the world of man is not only a world of things; it is a world of symbols where the distinction between reality and make-believe is itself unreal. The dignitary who lays the foundation stone will give it three taps with a silver hammer. The hammer is real, but is the blow? In this twilight region of the symbolic, no such questions are asked, and therefore no answers need be given.

When we make a snowman we do not feel, I submit, that we are constructing a phantom of a man. We are simply making a man of snow. We do not say, "Shall we represent a man who is smoking?" but "Shall we give him a pipe?" For the success of the operation, a real pipe may be just as good or better than a symbolic one made of a twig. It is only afterward that we may introduce the idea of reference, of the snowman's representing somebody. We can make him a portrait or a caricature, or we can discover a likeness to someone and elaborate it. But always, I contend, making will come before matching, creation before reference. As likely as not, we will give our snowman a proper name, call him "Jimmie" or "Jeeves," and will be sorry for him when he starts to slump and melt away.

But are we not still matching something when we

make the snowman? Are we not at least modeling our creation after the idea of a man, like Plato's craftsman who copied the idea of the couch? Or, if we reject this metaphysical interpretation, are we not imitating the image of a man we have in our mind? This is the traditional answer, but we have seen in the last chapter that it will not quite do. First of all, it makes the created image into a replica of something nobody has ever seen, the snowman we allegedly carry in our heads before we body it forth. Moreover there was no such preexistent snowman. What happens is rather that we feel tempted to work the snow and balance the shapes till we recognize a man. The pile of snow provides us with the first schema, which we correct until it satisfies our minimum definition. A symbolic man, to be sure, but still a member of the species man, subspecies snowman. What we learn from the study of symbolism, I contend, is precisely that to our minds the limits of these definitions are elastic.

This, once more, is the real issue. For Plato and those who followed him, definitions were something made in heaven. The idea of man, couch, or basin was something fixed eternally with rigid outlines and immutable laws. Most of the tangles into which the philosophy of art and the philosophy of symbolism got themselves can be traced back to this awe-inspiring starting point. For once you accept the argument that there are rigid classes of things, you must also describe their image as a phantom. But a phantom of what? What is the artist's task when he represents a mountain—does he copy a particular mountain, an individual member of the class, as the topographic painter does, or does he, more loftily, copy the universal pattern, the idea of a mountain?

We know this to be an unreal dilemma. It is up to us how we define a mountain. We can make a mountain out of a molehill, or ask our landscape gardener to make one. We can accept the one or the other according to our wish or whim. There is a fallacy in the idea that reality contains such features as mountains and that, looking at one mountain after another, we slowly learn to generalize and to form the abstract idea of mountaineity. We have seen that both philosophy and psychology have revolted against this time-honored view. Neither in thought nor in perception do we learn to generalize. We learn to particularize, to articulate, to make distinction where before there was only an undifferentiated mass.

. . . Whenever we receive a visual impression, we react by docketing it, filing it, grouping it in one way or another, even if the impression is only that of an inkblot or a fingerprint. Roger Fry and the impressionists talked of the difficulty of finding out what things looked like to an unbiased eye because

of what they called the "conceptual habits" necessary to life. But if these habits are necessary to life, the postulate of an unbiased eye demands the impossible. It is the business of the living organism to organize, for where there is life there is not only hope, as the proverb says, but also fears, guesses, expectations which sort and model the incoming messages, testing and transforming and testing again. The innocent eye is a myth. That blind man of Ruskin's who suddenly gains sight does not see the world as a painting by Turner or Monet—even Berkeley knew that he could only experience a smarting chaos which he has to learn to sort out in an arduous apprenticeship. Indeed, some of these unfortunates give up and never learn it at all. For seeing is never just registering. It is the reaction of the whole organism to the patterns of light that stimulate the back of our eyes; in fact, the retina itself has recently been described by J. J. Gibson as an organ that does not react to individual stimuli of light, such as were postulated by Berkeley, but to their relationship, or gradients. We have seen that even newly hatched chickens classify their impressions according to relationships. The whole distinction between sensation and perception, plausible as it was, had to be given up in the face of the evidence from experiments with human beings and animals. Nobody has ever seen a visual sensation, not even the impressionists, however ingenuously they stalked their prey.

We seem to have arrived at an impasse. On the one hand, Roger Fry's and Ruskin's accounts of painting do somehow correspond with the facts. Representation really does seem to advance through the suppression of conceptual knowledge. On the other, no such suppression appears to be possible. It is an impasse which has led to a certain amount of confusion in writing on art. The easiest way out is to deny the traditional reading of the historical facts altogether. If there is no unbiased eye, Roger Fry's account of the discovery of what things look like to such an unbiased eye must be false. The reaction against impressionism which we witnessed in the twentieth century increased the appeal of such a conclusion. Here was another convenient stick with which to beat the Philistine who wanted paintings to look like nature. The demand was nonsense. If all seeing is interpreting, all modes of interpretation could be argued to be equally valid.

I have myself in these pages often stressed the conventional element in many modes of representation. But it is for this very reason that I cannot accept this easy way out of the impasse. For obviously it is also nonsense. Granted . . . that Constable's painting of Wivenhoe Park is not a mere transcript of nature but a transposition of light into paint. It still remains true that it is a closer render-

ing of the motif than is that of the child. I have also attempted to define a little more explicitly what may be meant by such a statement. It means, I suspect, that we can, and almost must, interpret Constable's paintings in terms of a possible visible world; if we accept the truth of the label that the painting represents Wivenhoe Park, we will also be confident that this interpretation will tell us a good many facts about that country seat in 1816 which we would have gathered if we had stood by Constable's side. Of course, both he and we would have seen much more than can be translated into the cryptograms of paint, but to those who can read the code, it would at least give no false information. This formulation, I know, may sound chilling and pedantic, but it has one advantage. It eliminates the "image on Constable's retina" and, indeed, the whole idea of appearances that has proved such a will-o'-the-wisp to aesthetics.

8

Reality Remade
A Denotation Theory of Representation

NELSON GOODMAN

Art is not a copy of the real world. One of the damn things is enough. *

1. Denotation

Whether a picture ought to be a representation or not is a question much less crucial than might appear from current bitter battles among artists, critics, and propagandists. Nevertheless, the nature of representation wants early study in any philosophical examination of the ways symbols function in and out of the arts. That representation is frequent in some arts, such as painting, and infrequent in others, such as music, threatens trouble for a unified aesthetics; and confusion over how pictorial representation as a mode of signification is allied to and distinguished from verbal description on the one hand and, say, facial expression on the other is fatal to any general theory of symbols.

The most naive view of representation might perhaps be put somewhat like this: "*A* represents *B* if and only if *A* appreciably resembles *B*", or "*A* represents *B* to the extent that *A* resembles *B*". Vestiges of this view, with assorted refinements, persist in most writing on representation. Yet more error could hardly be compressed into so short a formula.

Some of the faults are obvious enough. An object resembles itself to the maximum degree but rarely represents itself; resemblance, unlike representation, is reflexive. Again, unlike representation, resemblance is symmetric: *B* is as much like *A* as *A* is like *B*, but while a painting may represent the

Duke of Wellington, the Duke doesn't represent the painting. Furthermore, in many cases neither one of a pair of very like objects represents the other: none of the automobiles off an assembly line is a picture of any of the rest; and a man is not normally a representation of another man, even his twin brother. Plainly, resemblance in any degree is no sufficient condition for representation.[1]

Just what correction to make in the formula is not so obvious. We may attempt less, and prefix the condition "If *A* is a picture, . . .". Of course, if we then construe "picture" as "representation", we resign a large part of the question: namely, what constitutes a representation. But even if we construe "picture" broadly enough to cover all paintings, the formula is wide of the mark in other ways. A Constable painting of Marlborough Castle is more like any other picture than it is like the Castle, yet it represents the Castle and not another picture—not even the closest copy. To add the requirement that *B* must not be a picture would be desperate and futile; for a picture may represent another, and indeed each of the once popular paintings of art galleries represents many others.

The plain fact is that a picture, to represent an object,[2] must be a symbol for it, stand for it, refer to it; and that no degree of resemblance is sufficient to establish the requisite relationship of reference. Nor is resemblance *necessary* for reference; almost any-

* Reported as occurring in an essay on Virginia Woolf. I have been unable to locate the source.

From Nelson Goodman, *Languages of Art*, 2nd edition. Indianapolis: Hackett Publishing Company, 1976, pp. 3–43. Reprinted with permission of Hackett Publishing Company and the author.

thing may stand for almost anything else. A picture that represents—like a passage that describes—an object refers to and, more particularly, *denotes*[3] it. Denotation is the core of representation and is independent of resemblance.

If the relation between a picture and what it represents is thus assimilated to the relation between a predicate and what it applies to, we must examine the characteristics of representation as a special kind of denotation. What does pictorial denotation have in common with, and how does it differ from, verbal or diagrammatic denotation? One not implausible answer is that resemblance, while no sufficient condition for representation, is just the feature that distinguishes representation from denotation of other kinds. Is it perhaps the case that if *A* denotes *B*, then *A* represents *B* just to the extent that *A* resembles *B*? I think even this watered-down and innocuous-looking version of our initial formula betrays a grave misconception of the nature of representation.

2. Imitation

"To make a faithful picture, come as close as possible to copying the object just as it is." This simple-minded injunction baffles me; for the object before me is a man, a swarm of atoms, a complex of cells, a fiddler, a friend, a fool, and much more. If none of these constitute the object as it is, what else might? If all are ways the object is, then none is *the* way the object is.[4] I cannot copy all these at once; and the more nearly I succeeded, the less would the result be a realistic picture.

What I am to copy then, it seems, is one such aspect, one of the ways the object is or looks. But not, of course, any one of these at random—not, for example, the Duke of Wellington as he looks to a drunk through a raindrop. Rather, we may suppose, the way the object looks to the normal eye, at proper range, from a favorable angle, in good light, without instrumentation, unprejudiced by affections or animosities or interests, and unembellished by thought or interpretation. In short, the object is to be copied as seen under aseptic conditions by the free and innocent eye.

The catch here, as Ernst Gombrich insists, is that there is no innocent eye.[5] The eye comes always ancient to its work, obsessed by its own past and by old and new insinuations of the ear, nose, tongue, fingers, heart, and brain. It functions not as an instrument self-powered and alone, but as a dutiful member of a complex and capricious organism. Not only how but what it sees is regulated by need and prejudice.[6] It selects, rejects, organizes, discriminates, associates, classifies, analyzes, constructs. It

does not so much mirror as take and make; and what it takes and makes it sees not bare, as items without attributes, but as things, as food, as people, as enemies, as stars, as weapons. Nothing is seen nakedly or naked.

The myths of the innocent eye and of the absolute given are unholy accomplices. Both derive from and foster the idea of knowing as a processing of raw material received from the senses, and of this raw material as being discoverable either through purification rites or by methodical disinterpretation. But reception and interpretation are not separable operations; they are thoroughly interdependent. The Kantian dictum echoes here: the innocent eye is blind and the virgin mind empty. Moreover, what has been received and what has been done to it cannot be distinguished within the finished product. Content cannot be extracted by peeling off layers of comment.[7]

All the same, an artist may often do well to strive for innocence of eye. The effort sometimes rescues him from the tired patterns of everyday seeing, and results in fresh insight. The opposite effort, to give fullest rein to a personal reading, can be equally tonic—and for the same reason. But the most neutral eye and the most biased are merely sophisticated in different ways. The most ascetic vision and the most prodigal, like the sober portrait and the vitriolic caricature, differ not in how *much* but only in *how* they interpret.

The copy theory of representation, then, is stopped at the start by inability to specify what is to be copied. Not an object the way it is, nor all the ways it is, nor the way it looks to the mindless eye. Moreover, something is wrong with the very notion of copying any of the ways an object is, any aspect of it. For an aspect is not just the object-from-a-given-distance-and-angle-and-in-a-given-light; it is the object as we look upon or conceive it, a version or construal of the object. In representing an object, we do not copy such a construal or interpretation—we *achieve* it.[8]

In other words, nothing is ever represented either shorn of or in the fullness of its properties. A picture never merely represents *x*, but rather represents *x* as a man or represents *x* to be a mountain, or represents *the fact that x is* a melon. What could be meant by copying a fact would be hard to grasp even if there were any such things as facts; to ask me to copy *x* as a soandso is a little like asking me to sell something as a gift; and to speak of copying something to be a man is sheer nonsense. We shall presently have to look further into all this; but we hardly need look further to see how little is representation a matter of imitation.

The case for the relativity of vision and of representation has been so conclusively stated elsewhere

that I am relieved of the need to argue it at any length here. Gombrich, in particular, has amassed overwhelming evidence to show how the way we see and depict depends upon and varies with experience, practice, interests, and attitudes. But on one matter Gombrich and others sometimes seem to me to take a position at odds with such relativity; and I must therefore discuss briefly the question of the conventionality of perspective.

3. Perspective

An artist may choose his means of rendering motion, intensity of light, quality of atmosphere, vibrancy of color, but if he wants to represent space correctly, he must—almost anyone will tell him—obey the laws of perspective. The adoption of perspective during the Renaissance is widely accepted as a long stride forward in realistic depiction. The laws of perspective are supposed to provide absolute standards of fidelity that override differences in style of seeing and picturing. Gombrich derides "the idea that perspective is merely a convention and does not represent the world as it looks", and he declares "One cannot insist enough that the art of perspective aims at a correct equation: It wants the image to appear like the object and the object like the image."[9] And James J. Gibson writes: ". . . it does not seem reasonable to assert that the use of perspective in paintings is merely a convention, to be used or discarded by the painter as he chooses, . . . When the artist transcribes what he sees upon a two-dimensional surface, he uses perspective geometry, of necessity."[10]

Obviously the laws of the behavior of light are no more conventional than any other scientific laws. Now suppose we have a motionless, monochromatic object, reflecting light of medium intensity only. The argument runs[11]:—A picture drawn in correct perspective will, under specified conditions, deliver to the eye a bundle of light rays matching that delivered by the object itself. This matching is a purely objective matter, measurable by instruments. And such matching constitutes fidelity of representation; for since light rays are all that the eye can receive from either picture or object, identity in pattern of light rays must constitute identity of appearance. Of course, the rays yielded by the picture under the specified conditions match not only those yielded by the object in question from a given distance and angle but also those yielded by any of a multitude of other objects from other distances and angles.[12] Identity in pattern of light rays, like resemblance of other kinds, is clearly no sufficient condition for representation. The claim is rather that such identity is a criterion of fidelity, of correct pictorial representation, where denotation is otherwise established.

If at first glance the argument as stated seems simple and persuasive, it becomes less so when we consider the conditions of observation that are prescribed. The picture must be viewed through a peephole, face on, from a certain distance, with one eye closed and the other motionless. The object also must be observed through a peephole, from a given (but not usually the same) angle and distance, and with a single unmoving eye. Otherwise, the light rays will not match.

Under these remarkable conditions, do we not have ultimately faithful representation? Hardly. Under these conditions, what we are looking at tends to disappear rather promptly. Experiment has shown that the eye cannot see normally without moving relative to what it sees[13]; apparently, scanning is necessary for normal vision. The fixed eye is almost as blind as the innocent one. What can the matching of light rays delivered under conditions that make normal vision impossible have to do with fidelity of representation? To measure fidelity in terms of rays directed at a closed eye would be no more absurd. But this objection need not be stressed; perhaps enough eye motion could be allowed for scanning but not for seeing around the object.[14] The basic trouble is that the specified conditions of observation are grossly abnormal. What can be the grounds for taking the matching of light rays delivered under such extraordinary conditions as a measure of fidelity? Under no more artificial conditions, such as the interposition of suitably contrived lenses, a picture far out of perspective could also be made to yield the same pattern of light rays as the object. That with clever enough stage-managing we can wring out of a picture drawn in perspective light rays that match those we can wring out of the object represented is an odd and futile argument for the fidelity of perspective.

Furthermore, the conditions of observation in question are in most cases not the same for picture and object. Both are to be viewed through a peephole with one transfixed eye; but the picture is to be viewed face on at a distance of six feet while the cathedral represented has to be looked at from, say, an angle of $45°$ to its façade and at a distance of two hundred feet. Now not only the light rays received but also the attendant conditions determine what and how we see; as psychologists are fond of saying, there is more to vision than meets the eye. Just as a red light says "stop" on the highway and "port" at sea, so the same stimulus gives rise to different visual experience under different circumstances. Even where both the light rays and the momentary external conditions are the same, the preceding train of visual experience, together with information gath-

ered from all sources, can make a vast difference in what is seen. If not even the former conditions are the same, duplication of light rays is no more likely to result in identical perception than is duplication of the conditions if the light rays differ.

Pictures are normally viewed framed against a background by a person free to walk about and to move his eyes. To paint a picture that will under these conditions deliver the same light rays as the object, viewed under any conditions, would be pointless even if it were possible. Rather, the artist's task in representing an object before him is to decide what light rays, under gallery conditions, will succeed in rendering what he sees. This is not a matter of copying but of conveying. It is more a matter of 'catching a likeness' than of duplicating—in the sense that a likeness lost in a photograph may be caught in a caricature. Translation of a sort, compensating for differences in circumstances, is involved. How this is best carried out depends upon countless and variable factors, not least among them the particular habits of seeing and representing that are ingrained in the viewers. Pictures in perspective, like any others, have to be read; and the ability to read has to be acquired. The eye accustomed solely to Oriental painting does not immediately understand a picture in perspective. Yet with practice one can accommodate smoothly to distorting spectacles or to pictures drawn in warped or even reversed perspective.[15] And even we who are most inured to perspective rendering do not always accept it as faithful representation: the photograph of a man with his feet thrust forward looks distorted, and Pike's Peak dwindles dismally in a snapshot. As the saying goes, there is nothing like a camera to make a molehill out of a mountain.

So far, I have been playing along with the idea that pictorial perspective obeys laws of geometrical optics, and that a picture drawn according to the standard pictorial rules will, under the very abnormal conditions outlined above, deliver a bundle of light rays matching that delivered by the scene portrayed. Only this assumption gives any plausibility at all to the argument from perspective; but the assumption is plainly false. By the pictorial rules, railroad tracks running outward from the eye are drawn converging, but telephone poles (or the edges of a façade) running upward from the eye are drawn parallel. By the 'laws of geometry' the poles should also be drawn converging. But so drawn, they look as wrong as railroad tracks drawn parallel. Thus we have cameras with tilting backs and elevating lens-boards to 'correct distortion'—that is, to make vertical parallels come out parallel in our photographs; we do not likewise try to make the railroad tracks come out parallel. The rules of pictorial perspective no more follow from the laws of optics than would rules calling for drawing the tracks parallel and the poles converging. In diametric contradiction to what Gibson says, the artist who wants to produce a spatial representation that the present-day Western eye will accept as faithful must defy the 'laws of geometry'.

If all this seems quite evident, and neatly clinched by Klee,[16] there is nevertheless impressive weight of authority on the other side,[17] relying on the argument that all parallels in the plane of the façade project geometrically as parallels onto the parallel plane of the picture. The source of unending debate over perspective seems to lie in confusion concerning the pertinent conditions of observation. In [the accompanying] figure, an observer is on ground level with eye at a; at b,c is the façade of a tower atop a building; at d,e is a picture of the tower façade, drawn in standard perspective and to a scale such that at the indicated distances picture and façade subtend equal angles from a. The normal line of vision to the tower is the line a,f; looking much higher or lower

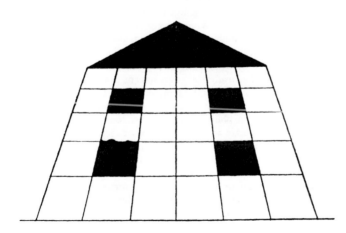

Drawing from Paul Klee's Pädagogisches Skizzenbuches, 2nd American edition, (Munich, 1925: New York, Frederick A. Praeger, Inc., 1953), p. 41.

will leave part of the tower façade out of sight or blurred. Likewise, the normal line of vision to the picture is *a,g*. Now although picture and façade are parallel, the line *a,g* is perpendicular to the picture, so that vertical parallels in the picture will be projected to the eye as parallel, while the line *a,f* is at an angle to the façade so that vertical parallels there will be projected to the eye as converging upward. We might try to make picture and façade deliver matching bundles of light rays to the eye by either (1) moving the picture upward to the position *h,i*, or (2) tilting it to the position *j,k*, or (3) looking at the picture from *a* but at the tower from *m*, some stories up. In the first two cases, since the picture must be also nearer the eye to subtend the same angle, the scale will be wrong for lateral (left–right) dimensions. What is more important, none of these three conditions of observation is anywhere near normal. We do not usually hang pictures far above eye level, or tilt them drastically bottom toward us, or elevate ourselves at will to look squarely at towers.[18] With eye and picture in normal position, the bundle of light rays delivered to the eye by the picture drawn in standard perspective is very different from the bundle delivered by the façade.

This argument by itself is conclusive, but my case does not rest upon it. The more fundamental arguments advanced earlier would apply with full force even had the choice of official rules of perspective

been less whimsical and called for drawing as convergent all parallels receding in any direction. Briefly, the behavior of light sanctions neither our usual nor any other way of rendering space; and perspective provides no absolute or independent standard of fidelity.

4. Sculpture

The troubles with the copy theory are sometimes attributed solely to the impossibility of depicting reality-in-the-round on a flat surface. But imitation is no better gauge of realism in sculpture than in painting. What is to be portrayed in a bronze bust is a mobile, many-faceted, and fluctuating person, encountered in ever changing light and against miscellaneous backgrounds. Duplicating the form of the head at a given instant is unlikely to yield a notably faithful representation. The very fixation of such a momentary phase embalms the person much as a photograph taken at too short an exposure freezes a fountain or stops a racehorse. To portray faithfully is to convey a person known and distilled from a variety of experiences. This elusive conceit is nothing that one can meaningfully try to duplicate or imitate in a static bronze on a pedestal in a museum. The sculptor undertakes, rather, a subtle and intricate problem of translation.

Even where the object represented is something simpler and more stable than a person, duplication seldom coincides with realistic representation. If in a tympanum over a tall Gothic portal, Eve's apple were the same size as a Winesap, it would not look big enough to tempt Adam. The distant or colossal sculpture has also to be *shaped* very differently from what it depicts in order to be realistic, in order to 'look right'. And the ways of making it 'look right' are not reducible to fixed and universal rules; for how an object looks depends not only upon its orientation, distance, and lighting, but upon all we know of it and upon our training, habits, and concerns.

One need hardly go further to see that the basic case against imitation as a test of realism is conclusive for sculpture as well as for painting.

5. Fictions

So far, I have been considering only the representation of a particular person or group or thing or scene; but a picture, like a predicate, may denote severally the members of a given class. A picture accompanying a definition in a dictionary is often such a representation, not denoting uniquely some one eagle, say, or collectively the class of eagles, but distributively eagles in general.

Other representations have neither unique nor multiple denotation. What, for example, do pictures of Pickwick or of a unicorn represent? They do not represent anything; they are representations with null denotation. Yet how can we say that a picture represents Pickwick, or a unicorn, and also say that it does not represent anything? Since there is no Pickwick and no unicorn, what a picture of Pickwick and a picture of a unicorn represent is the same. Yet surely to be a picture of Pickwick and to be a picture of a unicorn are not at all the same.

The simple fact is that much as most pieces of furniture are readily sorted out as desks, chairs, tables, etc., so most pictures are readily sorted out as pictures of Pickwick, of Pegasus, of a unicorn, etc., without reference to anything represented. What tends to mislead us is that such locutions as "picture of" and "represents" have the appearance of mannerly two-place predicates and can sometimes be so interpreted. But "picture of Pickwick" and "represents a unicorn" are better considered unbreakable one-place predicates, or class-terms, like "desk" and "table". We cannot reach inside any of these and quantify over parts of them. From the fact that P is a picture of or represents a unicorn we cannot infer that there is something that P is a picture of or represents. Furthermore, a picture of Pickwick is a picture of a man, even though there is no man it represents.

resents. Saying that a picture represents a soandso is thus highly ambiguous as between saying what the picture denotes and saying what kind of picture it is. Some confusion can be avoided if in the latter case we speak rather of a 'Pickwick-representing-picture' or a 'unicorn-representing-picture' or a 'man-representing-picture' or, for short, of a 'Pickwick-picture' or 'unicorn-picture' or 'man-picture'. Obviously a picture cannot, barring equivocation, both represent Pickwick and represent nothing. But a picture may be of a certain kind—be a Pickwick-picture or a man-picture—without representing anything.[19]

The difference between a man-picture and a picture of a man has a close parallel in the difference between a man-description (or man-term) and a description of (or term for) a man. "Pickwick", "the Duke of Wellington", "the man who conquered Napoleon", "a man", "a fat man", "the man with three heads", are all man-descriptions, but not all describe a man. Some denote a particular man, some denote each of many men, and some denote nothing.[20] And although "Pickwick" and "the three-headed man" and "Pegasus" all have the same null extension, the second differs from the first in being, for example, a many-headed-man-description, while the last differs from the other two in being a winged-horse-description.

The way pictures and descriptions are thus classified into kinds, like most habitual ways of classifying, is far from sharp or stable, and resists codification. Borderlines shift and blur, new categories are always coming into prominence, and the canons of the classification are less clear than the practice. But this is only to say that we may have some trouble in telling whether certain pictures (in common parlance) 'represent a unicorn', or in setting forth rules for deciding in every case whether a picture is a man-picture. Exact and general conditions under which something is a soandso-picture or a soandso-description would indeed be hard to formulate. We can cite examples: Van Gogh's *Postman* is a man-picture; and in English, "a man" is a man-description. And we may note, for instance, that to be a soandso-picture is to be a soandso-picture as a whole, so that a picture containing or contained in a man-picture need not itself be a man-picture. But to attempt much more is to become engulfed in a notorious philosophical morass; and the frustrating, if fascinating, problems involved are no part of our present task. All that directly matters here, I repeat, is that pictures are indeed sorted with varying degrees of ease into man-pictures, unicorn-pictures, Pickwick-pictures, winged-horse-pictures, etc., just as pieces of furniture are sorted into desks, tables, chairs, etc. And this fact is unaffected by the difficulty, in either case, of framing definitions for the

several classes or eliciting a general principle of classification.

The possible objection that we must first understand what a man or a unicorn is in order to know how to apply "man-picture" or "unicorn-picture" seems to me quite perverted. We can learn to apply "corncorb pipe" or "staghorn" without first understanding, or knowing how to apply, "corn" or "cob" or "corncob" or "pipe" or "stag" or "horn" as separate terms. And we can learn, on the basis of samples, to apply "unicorn-picture" not only without ever having seen any unicorns but without ever having seen or heard the word "unicorn" before. Indeed, largely by learning what are unicorn-pictures and unicorn-descriptions do we come to understand the word "unicorn"; and our ability to recognize a staghorn may help us to recognize a stag when we see one. We may begin to understand a term by learning how to apply either the term itself or some larger term containing it. Acquiring any of these skills may aid in acquiring, but does not imply possessing, any of the others. Understanding a term is not a precondition, and may often be a result, of learning how to apply the term and its compounds.[21]

Earlier I said that denotation is a necessary condition for representation, and then encountered representations without denotation. But the explanation is now clear. A picture must denote a man to represent him, but need not denote anything to be a man-representation. Incidentally, the copy theory of representation takes a further beating here; for where a representation does not represent anything there can be no question of resemblance to what it represents.

Use of such examples as Pickwick-pictures and unicorn-pictures may suggest that representations with null denotation are comparatively rare. Quite the contrary; the world of pictures teems with anonymous fictional persons, places, and things. The man in Rembrandt's *Landscape with a Huntsman* is presumably no actual person; he is just the man in Rembrandt's etching. In other words, the etching represents no man but is simply a man-picture, and more particularly a the-man-in-Rembrandt's-*Landscape-with-a-Huntsman*-picture. And even if an actual man be depicted here, his identity matters as little as the artist's blood-type. Furthermore, the information needed to determine what if anything is denoted by a picture is not always accessible. We may, for example, be unable to tell whether a given representation is multiple, like an eagle-picture in the dictionary, or fictive, like a Pickwick-picture. But where we cannot determine whether a picture denotes anything or not, we can only proceed as if it did not—that is, confine ourselves to considering what kind of picture it is. Thus

cases of indeterminate denotation are treated in the same way as cases of null denotation.

But not only where the denotation is null or indeterminate does the classification of a picture need to be considered. For the denotation of a picture no more determines its kind than the kind of picture determines the denotation. Not every man-picture represents a man, and conversely not every picture that represents a man is a man-picture. And in the difference between being and not being a man-picture lies the difference, among pictures that represent a man, between those that do and those that do not represent him as a man.

6. Representation-as

The locution "represents . . . as" has two quite different uses. To say that a picture represents the Duke of Wellington as an infant, or as an adult, or as the victor at Waterloo is often merely to say that the picture represents the Duke at a given time or period—that it represents a certain (long or short, continuous or broken) temporal part or 'time-slice' of him. Here "as . . ." combines with the *noun* "the Duke of Wellington" to form a description of one portion of the whole extended individual.[22] Such a description can always be replaced by another like "the infant Duke of Wellington" or "the Duke of Wellington upon the occasion of his victory at Waterloo". Thus these cases raise no difficulty; all that is being said is that the picture represents the object so described.

The second use is illustrated when we say that a given picture represents Winston Churchill as an infant, where the picture does not represent the infant Churchill but rather represents the adult Churchill as an infant. Here, as well as when we say that other pictures represent the adult Churchill as an adult, the "as . . ." combines with and modifies the *verb*; and we have genuine cases of *representation-as*. Such representation-as wants now to be distinguished from and related to representation.

A picture that represents a man denotes him; a picture that represents a fictional man is a man-picture; and a picture that represents a man as a man is a man-picture denoting him. Thus while the first case concerns only what the picture denotes, and the second only what kind of picture it is, the third concerns both the denotation and the classification.

More accurate formulation takes some care. What a picture is said to represent may be denoted by the picture as a whole or by a part of it. Likewise, a picture may be a soandso-picture as a whole or merely through containing a soandso-picture.[23] Consider an ordinary portrait of the Duke and Duchess of Wellington. The picture (as a whole)

denotes the couple, and (in part) denotes the Duke. Furthermore, it is (as a whole) a two-person-picture, and (in part) a man-picture. The picture represents the Duke and Duchess as two persons, and represents the Duke as a man. But although it represents the Duke, and is a two-person-picture, it obviously does not represent the Duke as two persons; and although it represents two persons and is a man-picture, it does not represent the two as a man. For the picture neither is nor contains any picture that as a whole both represents the Duke and is a two-man-picture, or that as a whole both represents two persons and is a man-picture.

In general, then, an object k is represented as a soandso by a picture p if and only if p is or contains a picture that as a whole both represents k and is a soandso-picture.[24] Many of the modifiers that have had to be included here may, however, be omitted as understood in what follows; for example, "is or contains a picture that as a whole both represents Churchill and is an adult-picture" may be shortened to "is an adult-picture representing Churchill".

Everyday usage is often careless about the distinction between representation and representation-as. Cases have already been cited where in saying that a picture represents a soandso we mean not that it denotes a soandso but that it is a soandso-picture. In other cases, we may mean both. If I tell you I have a picture of a certain black horse, and then I produce a snapshot in which he has come out a light speck in the distance, you can hardly convict me of lying; but you may well feel that I misled you. You understandably took me to mean a picture of the black horse as such; and you therefore expected the picture not only to denote the horse in question but to be a black-horse-picture. Not inconceivably, saying a picture represents the black horse might on other occasions mean that it represents the horse as black (i.e., that it is a black-thing-picture representing the horse) or that it represents the black thing in question as a horse (i.e., that it is a horse-picture representing the black thing).

The ambiguities of ordinary use do not end there. To say that the adult Churchill is represented as an infant (or as an adult) is to say that the picture in question is an infant-picture (or an adult-picture). But to say that Pickwick is represented as a clown (or as Don Quixote) cannot mean that the picture is a clown-picture (or Don-Quixote-picture) representing Pickwick; for there is no Pickwick. Rather, what is being said is that the picture belongs to a certain rather narrow class of pictures that may be described as Pickwick-as-clown-pictures (or Pickwick-as-Don-Quixote-pictures).

Distinctions obscured in much informal discourse thus need to be carefully marked for our purposes here. Being a matter of monadic classification,

representation-as differs drastically from dyadic denotative representation. If a picture represents k as a (or the) soandso, then it denotes k and is a soandso-picture. If k is identical with h, the picture also denotes and represents h. And if k is a suchand-such, the picture also represents a (or the) suchand-such, but not necessarily *as* a (or the) suchandsuch. To represent the first Duke of Wellington is to represent Arthur Wellesley and also to represent a soldier, but not necessarily to represent him *as* as soldier; for some pictures of him are civilian-pictures.

Representations, then, are pictures that function in somewhat the same way as descriptions.[25] Just as objects are classified by means of, or under, various verbal labels, so also are objects classified by or under various pictorial labels. And the labels themselves, verbal or pictorial, are in turn classified under labels, verbal or nonverbal. Objects are classified under "desk", "table", etc., and also under pictures representing them. Descriptions are classified under "desk-description", "centaur-description", "Cicero-name", etc.; and pictures under "desk-picture", "Pickwick-picture", etc. The labeling of labels does not depend upon what they are labels for. Some, like "unicorn", apply to nothing; and as we have noted, not all pictures of soldiers are soldier-pictures. Thus with a picture as with any other label, there are always two questions: what it represents (or describes) and the sort of representation (or description) it is. The first question asks what objects, if any, it applies to as a label; and the second asks about which among certain labels apply to it. In representing, a picture at once picks out a class of objects and belongs to a certain class or classes of pictures.[26]

7. Invention

If representing is a matter of classifying objects rather than of imitating them, of characterizing rather than copying, it is not a matter of passive reporting. The object does not sit as a docile model with its attributes neatly separated and thrust out for us to admire and portray. It is one of countless objects, and may be grouped with any selection of them; and for every such grouping there is an attribute of the object. To admit all classifications on equal footing amounts to making no classification at all. Classification involves preferment; and application of a label (pictorial, verbal, etc.) as often *effects* as it records a classification. The 'natural' kinds are simply those we are in the habit of picking out for and by labeling. Moreover, the object itself is not ready-made but results from a way of taking the world. The making of a picture commonly participates in making what is to be pictured. The

object and its aspects depend upon organization; and labels of all sorts are tools of organization.

Representation and description thus involve and are often involved in organization. A label associates together such objects as it applies to, and is associated with the other labels of a kind or kinds. Less directly, it associates its referents with these other labels and with their referents, and so on. Not all these associations have equal force; their strength varies with their directness, with the specificity of the classifications in question, and with the firmness of foothold these classifications and labelings have secured. But in all these ways a representation or description, by virtue of how it classifies and is classified, may make or mark connections, analyze objects, and organize the world.

Representation or description is apt, effective, illuminating, subtle, intriguing, to the extent that the artist or writer grasps fresh and significant relationships and devises means for making them manifest. Discourse or depiction that marks off familiar units and sorts them into standard sets under well-worn labels may sometimes be serviceable even if humdrum. The marking off of new elements or classes, or of familiar ones by labels of new kinds or by new combinations of old labels, may provide new insight. Gombrich stresses Constable's metaphor: "Painting is a science . . . of which pictures are but the experiments."[27] In representation, the artist must make use of old habits when he wants to elicit novel objects and connections. If his picture is recognized as almost but not quite referring to the commonplace furniture of the everyday world, or if it calls for and yet resists assignment to a usual kind of picture, it may bring out neglected likenesses and differences, force unaccustomed associations, and in some measure remake our world. And if the point of the picture is not only successfully made but is also well-taken, if the realignments it directly and indirectly effects are interesting and important, the picture—like a crucial experiment—makes a genuine contribution to knowledge. To a complaint that his portrait of Gertrude Stein did not look like her, Picasso is said to have answered, "No matter; it will."

In sum, effective representation and description require invention. They are creative. They inform each other; and they form, relate, and distinguish objects. That nature imitates art is too timid a dictum. Nature is a product of art and discourse.

8. Realism

This leaves unanswered the minor question what constitutes realism of representation. Surely not, in view of the foregoing, any sort of resemblance to reality. Yet we do in fact compare representations with respect to their realism or naturalism or fidelity. If resemblance is not the criterion, what is?

One popular answer is that the test of fidelity is deception, that a picture is realistic just to the extent that it is a successful illusion, leading the viewer to suppose that it is, or has the characteristics of, what it represents. The proposed measure of realism, in other words, is the probability of confusing the representation with the represented. This is some improvement over the copy theory; for what counts here is not how closely the picture duplicates an object but how far the picture and object, under conditions of observation appropriate to each, give rise to the same responses and expectations. Furthermore, the theory is not immediately confounded by the fact that fictive representations differ in degree of realism; for even though there are no centaurs, a realistic picture might deceive me into taking it for a centaur.

Yet there are difficulties. What deceives depends upon what is observed, and what is observed varies with interests and habits. If the probability of confusion is 1, we no longer have representation—we have identity. Moreover, the probability seldom rises noticeably above zero for even the most guileful trompe-l'œil painting seen under ordinary gallery conditions. For seeing a picture as a picture precludes mistaking it for anything else; and the appropriate conditions of observation (e.g., framed, against a uniform background, etc.) are calculated to defeat deception. Deception enlists such mischief as a suggestive setting, or a peephole that occludes frame and background. And deception under such nonstandard conditions is no test of realism; for with enough staging, even the most unrealistic picture can deceive. Deception counts less as a measure of realism than as evidence of magicianship, and is a highly atypical mishap. In looking at the most realistic picture, I seldom suppose that I can literally reach into the distance, slice the tomato, or beat the drum. Rather, I recognize the images as signs for the objects and characteristics represented—signs that work instantly and unequivocally without being confused with what they denote. Of course, sometimes where deception does occur—say by a painted window in a mural—we may indeed call the picture realistic; but such cases provide no basis for the usual ordering of pictures in general as more or less realistic.

Thoughts along these lines have led to the suggestion that the most realistic picture is the one that provides the greatest amount of pertinent information. But this hypothesis can be quickly and completely refuted. Consider a realistic picture, painted in ordinary perspective and normal color, and a second picture just like the first except that the perspective is reversed and each color is replaced by its complementary. The second picture, appropriately

interpreted, yields exactly the same information as the first. And any number of other drastic but information-preserving transformations are possible. Obviously, realistic and unrealistic pictures may be equally informative; informational yield is no test of realism.

So far, we have not needed to distinguish between fidelity and realism. The criteria considered earlier have been as unsatisfactory for the one as for the other. But we can no longer equate them. The two pictures just described are equally correct, equally faithful to what they represent, provide the same and hence equally true information; yet they are not equally realistic or literal. For a picture to be faithful is simply for the object represented to have the properties that the picture in effect ascribes to it. But such fidelity or correctness or truth is not a sufficient condition for literalism or realism.

The alert absolutist will argue that for the second picture but not the first we need a key, Rather, the difference is that for the first the key is ready at hand. For proper reading of the second picture, we have to discover rules of interpretation and apply them deliberately. Reading of the first is by virtually automatic habit; practice has rendered the symbols so transparent that we are not aware of any effort, of any alternatives, or of making any interpretation at all.[28] Just here, I think, lies the touchstone of realism: not in quantity of information but in how easily it issues. And this depends upon how stereotyped the mode of representation is, upon how commonplace the labels and their uses have become.

Realism is relative, determined by the system of representation standard for a given culture or person at a given time. Newer or older or alien systems are accounted artificial or unskilled. For a Fifth-Dynasty Egyptian the straightforward way of representing something is not the same as for an eighteenth-century Japanese; and neither way is the same as for an early twentieth-century Englishman. Each would to some extent have to learn how to read a picture in either of the other styles. This relativity is obscured by our tendency to omit specifying a frame of reference when it is our own. "Realism" thus often comes to be used as the name for a particular style or system of representation. Just as on this planet we usually think of objects as fixed if they are at a constant position in relation to the earth, so in this period and place we usually think of paintings as literal or realistic if they are in a traditional[29] European style of representation. But such egocentric ellipsis must not tempt us to infer that these objects (or any others) are absolutely fixed, or that such pictures (or any others) are absolutely realistic.

Shifts in standard can occur rather rapidly. The very effectiveness that may attend judicious departure from a traditional system of representation sometimes inclines us at least temporarily to install the newer mode as standard. We then speak of an artist's having achieved a new degree of realism, or having found new means for the realistic rendering of (say) light or motion. What happens here is something like the 'discovery' that not the earth but the sun is 'really fixed'. Advantages of a new frame of reference, partly because of their novelty, encourage its enthronement on some occasions in place of the customary frame. Nevertheless, whether an object is 'really fixed' or a picture is realistic depends at any time entirely upon what frame or mode is then standard. Realism is a matter not of any constant or absolute relationship between a picture and its object, but of a relationship between the system of representation employed in the picture and the standard system. Most of the time, of course, the traditional system is taken as standard; and the literal or realistic or naturalistic system of representation is simply the customary one.

Realistic representation, in brief, depends not upon imitation or illusion or information but upon inculcation. Almost any picture may represent almost anything; that is, given picture and object there is usually a system of representation, a plan of correlation, under which the picture represents the object.[30] How correct the picture is under that system depends upon how accurate is the information about the object that is obtained by reading the picture according to that system. But how literal or realistic the picture is depends upon how standard the system is. If representation is a matter of choice and correctness a matter of information, realism is a matter of habit.

Our addiction, in the face of overwhelming counterevidence, to thinking of resemblance as the measure of realism is easily understood in these terms. Representational customs, which govern realism, also tend to generate resemblance. That a picture looks like nature often means only that it looks the way nature is usually painted. Again, what will deceive me into supposing that an object of a given kind is before me depends upon what I have noticed about such objects, and this in turn is affected by the way I am used to seeing them depicted. Resemblance and deceptiveness, far from being constant and independent sources and criteria of representational practice are in some degree products of it.[31]

9. Depiction and Description

Throughout, I have stressed the analogy between pictorial representation and verbal description because it seems to me both corrective and suggestive. Reference to an object is a necessary condition for depiction or description of it, but no degree of resemblance is a necessary or sufficient condition

for either. Both depiction and description partici-
pate in the formation and characterization of the
world; and they interact with each other and with
perception and knowledge. They are ways of clas-
sifying by means of labels having singular or multi-
ple or null reference. The labels, pictorial or verbal,
are themselves classified into kinds; and the inter-
pretation of fictive labels, and of depiction-*as* and
description-*as,* is in terms of such kinds. Applica-
tion and classification of a label are relative to a
system[32]; and there are countless alternative systems
of representation and description. Such systems are
the products of stipulation and habituation in vary-
ing proportions. The choice among systems is free;
but given a system, the question whether a newly
encountered object is a desk or a unicorn-picture or
is represented by a certain painting is a question of
the propriety, under that system, of projecting the
predicate "desk" or the predicate "unicorn-pic-
ture" or the painting over the thing in question, and
the decision both is guided by and guides usage for
that system.[33]

The temptation is to call a system of depiction a
language; but here I stop short. The question what
distinguishes representational from linguistic sys-
tems needs close examination. One might suppose
that the criterion of realism can be made to serve
here, too; that symbols grade from the most realistic
depictions through less and less realistic ones to
descriptions. This is surely not the case; the measure
of realism is habituation, but descriptions do not
become depictions by habituation. The most com-
monplace nouns of English have not become pic-
tures.

To say that depiction is by pictures while descrip-
tion is by passages is not only to beg a good part of
the question but also to overlook the fact that deno-
tation by a picture does not always constitute depic-
tion; for example, if pictures in a commandeered
museum are used by a briefing officer to stand for

enemy emplacements, the pictures do not thereby
represent these emplacements. To represent, a pic-
ture must function as a pictorial symbol; that is,
function in a system such that what is denoted
depends solely upon the pictorial properties of the
symbol. The pictorial properties might be roughly
delimited by a loose recursive specification.[34] An ele-
mentary pictorial characterization states what
color a picture has at a given place on its face. Other
pictorial characterizations in effect combine many
such elementary ones by conjunction, alternation,
quantification, etc. Thus a pictorial characteriza-
tion may name the colors at several places, or state
that the color at one place lies within a certain
range, or state that the colors at two places are com-
plementary, and so on. Briefly, a pictorial charac-
terization says more or less completely and more or
less specifically what colors the picture has at what
places. And the properties correctly ascribed to a
picture by pictorial characterization are its pictorial
properties.

All this, though, is much too special. The formula
can easily be broadened a little but resists general-
ization. Sculptures with denotation dependent
upon such sculptural properties as shape do repre-
sent, but words with denotation dependent upon
such verbal properties as spelling do not. We have
not yet captured the crucial difference between pic-
torial and verbal properties, between nonlinguistic
and linguistic symbols or systems, that makes the
difference between representation in general and
description.

What we have done so far is to subsume represen-
tation with description under denotation. Repre-
sentation is thus disengaged from perverted ideas of
it as an idiosyncratic physical process like mirror-
ing, and is recognized as a symbolic relationship
that is relative and variable. Furthermore, represen-
tation is thus contrasted with nondenotative modes
of reference. . . .

Notes

1. What I am considering here is pictorial representation, or depiction, and the comparable rep-
resentation that may occur in other arts. Natural objects may represent in the same way: witness the
man in the moon and the sheep-dog in the clouds. Some writers use "representation" as the general
term for all varieties of what I call symbolization or reference, and use "symbolic" for the verbal and
other nonpictorial signs I call nonrepresentational. "Represent" and its derivatives have many other
uses, and while I shall mention some of these later, others do not concern us here at all. Among the
latter, for example, are the uses according to which an ambassador represents a nation and makes
representations to a foreign government.

2. I use "object" indifferently for anything a picture represents, whether an apple or a battle. A
quirk of language makes a represented object a subject.

3. Not until the next chapter will denotation be distinguished from other varieties of reference.

4. In "The Way the World Is", *Review of Metaphysics,* 14 (1960), pp. 48–56, I have argued that
the world is as many ways as it can be truly described, seen, pictured, etc., and that there is no such

thing as *the* way the world is. Ryle takes a somewhat similar position (*Dilemmas* [Cambridge, England: Cambridge University Press, 1954], pp. 75–77) in comparing the relation between a table as a perceived solid object and the table as a swarm of atoms with the relation between a college library according to the catalogue and according to the accountant. Some have proposed that the way the world is could be arrived at by conjoining all the several ways. This overlooks the fact that conjunction itself is peculiar to certain systems; for example, we cannot conjoin a paragraph and a picture. And any attempted combination of all the ways would be itself only one—and a peculiarly indigestible one—of the ways the world is. But what is *the world* that is in so many ways? To speak of ways the world is, or ways of describing or picturing the world, is to speak of world-descriptions or world-pictures, and does not imply there is a unique thing—or indeed anything—that is described or pictured. Of course, none of this implies, either, that nothing is described or pictured. See further section 5 and note 19 below.

5. In *Art and Illusion* (New York: Pantheon Books, 1960), pp. 297–98 and elsewhere. On the general matter of the relativity of vision, see also such works as R. L. Gregory, *Eye and Brain* (New York: McGraw-Hill Book Co., 1966), and Marshall H. Segall, Donald Campbell, and Melville J. Herskovits, *The Influence of Culture on Visual Perception* (Indianapolis and New York: The Bobbs-Merrill Co., Inc., 1966).

6. For samples of psychological investigation of this point, see Jerome S. Bruner's "On Perceptual Readiness", *Psychological Review*, 64 (1957), pp. 123–52, and other articles there cited; also William P. Brown, "Conceptions of Perceptual Defense", *British Journal of Psychology Monograph Supplement 35* (Cambridge, England: Cambridge University Press, 1961).

7. On the emptiness of the notion of epistemological primacy and the futility of the search for the absolute given, see my *Structure of Appearance* (2nd edition; Indianapolis and New York: The Bobbs-Merrill Co., Inc., 1966—hereinafter referred to as *SA*), pp. 132–45, and "Sense and Certainty", *Philosophical Review*, 61 (1952), pp. 160–67.

8. And this is no less true when the instrument we use is a camera rather than a pen or brush. The choice and handling of the instrument participate in the construal. A photographer's work, like a painter's, can evince a personal style. Concerning the 'corrections' provided for in some cameras, see section 3 below.

9. *Art and Illusion*, pp. 254 and 257.

10. From "Pictures, Perspective, and Perception", *Daedalus* (Winter 1960), p. 227. Gibson does not appear to have explicitly retracted these statements, though his interesting recent book, *The Senses Considered as Perceptual Systems* (Boston: Houghton Mifflin Co., 1966), deals at length with related problems.

11. Substantially this argument has, of course, been advanced by many other writers. For an interesting discussion see D. Gioseffi, *Prospettiva Artificialis* (Trieste: Università degli studi di Trieste, Istituto di Storia dell'Arte Antica e Moderna, 1957), and a long review of the same by M. H. Pirenne in *The Art Bulletin*, 41 (1959), pp. 213–17. I am indebted to Professor Meyer Schapiro for this reference.

12. Cf. Gombrich's discussion of 'gates' in *Art and Illusion*, pp. 250–51.

13. See L. A. Riggs, F. Ratliff, J. C. Cornsweet, and T. Cornsweet, "The Disappearance of Steadily Fixated Visual Objects", *Journal of the Optical Society of America*, 43 (1953), pp. 495–501. More recently, the drastic and rapid changes in perception that occur during fixation have been investigated in detail by R. M. Pritchard, W. Heron, and D. O. Hebb in "Visual Perception Approached by the Method of Stabilized Images", *Canadian Journal of Psychology*, 14 (1960), pp. 67–77. According to this article, the image tends to regenerate, sometimes transformed into meaningful units not initially present.

14. But note that owing to the protuberance of the cornea, the eye when rotated, even with the head fixed, can often see slightly around the sides of an object.

15. Adaptation to spectacles of various kinds has been the subject of extensive experimentation. See, for example, J. E. Hochberg, "Effects of Gestalt Revolution: The Cornell Symposium on Perception", *Psychological Review*, 64 (1959), pp. 74–75; J. G. Taylor, *The Behavioral Basis of Perception* (New Haven: Yale University Press, 1962), pp. 166–85; and Irvin Rock, *The Nature of Perceptual Adaptation* (New York: Basic Books, Inc., 1966). Anyone can readily verify for himself how easy it is to learn to read pictures drawn in reversed or otherwise transformed perspective. Reversed perspective often occurs in Oriental, Byzantine, and mediaeval art; sometimes standard and reversed perspective are even used in different parts of one picture—see, for example, Leonid Ouspensky and Vladimir Lossky, *The Meaning of Icons* (Boston: Boston Book and Art Shop, 1952), p. 42 (note 1),

p. 200. Concerning the fact that one has to learn to read pictures in standard perspective, Melville J. Herskovits writes in *Man and His Works* (New York: Alfred A. Knopf, 1948), p. 381: "More than one ethnographer has reported the experience of showing a clear photograph of a house, a person, a familiar landscape to people living in a culture innocent of any knowledge of photography, and to have the picture held at all possible angles, or turned over for an inspection of its blank back, as the native tried to interpret this meaningless arrangement of varying shades of grey on a piece of paper. For even the clearest photograph is only an interpretation of what the camera sees."

16. As Klee remarks, the drawing looks quite normal if taken as representing a floor but awry as representing a façade, even though in the two cases parallels in the object represented recede equally from the eye.

17. Indeed, this is the orthodox position, taken not only by Pirenne, Gibson, and Gombrich, but by most writers on the subject. Some exceptions, besides Klee, are Erwin Panofsky, "Die Perspektive als 'Symbolische Form'", *Vorträge der Bibliothek Warburg* (1924–1925), pp. 258ff; Rudolf Arnheim, *Art and Visual Perception* (Berkeley: University of California Press, 1954), e.g., pp. 92ff, 226ff, and elsewhere; and in an earlier day, one Arthur Parsey, who was taken to task for his heterodox views by Augustus de Morgan in *Budget of Paradoxes* (London, 1872), pp. 176–77. I am indebted to Mr. P. T. Geach for this last reference. Interesting discussions of perspective will be found in *The Birth and Rebirth of Pictorial Space,* by John White (New York: Thomas Yoseloff, 1958), Chapters 8 and 13.

18. The optimal way of seeing the tower façade may be by looking straight at it from *m*; but then the optimal way of seeing the railroad tracks would be by looking down on them directly above the midpoint of their length.

19. The substance of this and the following two paragraphs is contained in my paper, "On Likeness of Meaning", *Analysis,* 1 (1949), pp. 1–7, and discussed further in the sequel, "On Some Differences about Meaning", *Analysis,* 13 (1953), pp. 90–96. See also the parallel treatment of the problem of statements 'about fictive entities' in "About", *Mind,* 70 (1961), esp. pp. 18–22. In a series of papers from 1939 on (many of them reworked and republished in *From a Logical Point of View* [Cambridge: Harvard University Press, 1953]), W. V. Quine had sharpened the distinction between syncategorematic and other expressions, and had shown that careful observance of this distinction could dispel many philosophical problems.

I use the device of hyphenation (e.g., in "man-picture") as an aid in technical discourse only, not as a reform of everyday usage, where the context normally prevents confusion and where the impetus to fallacious existential inference is less compulsive, if not less consequential, than in philosophy. In what follows, "man-picture" will always be an abbreviation for the longer and more usual "picture representing a man", taken as an unbreakable one-place predicate that need not apply to all or only to pictures that represent an actual man. The same general principle will govern use of all compounds of the form "—picture". Thus, for example, I shall not use "Churchill-picture" as an abbreviation for "picture painted by Churchill" or for "picture belonging to Churchill". Note, furthermore, that a square-picture is not necessarily a square picture but a square-representing-picture.

20. Strictly, we should speak here of utterance and inscriptions; for different instances of the same term may differ in denotation. Indeed, classifying replicas together to constitute terms is only one, and a far from simple, way of classifying utterances and inscriptions into kinds. See further *SA,* pp. 359–63, and also Chapter 4 in *Languages of Art.*

21. To know how to apply all compounds of a term would entail knowing how to apply at least some compounds of all other terms in the language. We normally say we understand a term when we know reasonably well how to apply it and enough of its more usual compounds. If for a given "——picture" compound we are in doubt about how to apply it in a rather high percentage of cases, this is also true of the correlative "represents as a ——" predicate. Of course, understanding a term is not exclusively a matter of knowing how to apply it and its compounds; such other factors enter as knowing what inferences can be drawn from and to statements containing the term.

22. I am indebted to Mr. H. P. Grice and Mr. J. O. Urmson for comments leading to clarification of this point. Sometimes, the portion in question may be marked off along other than temporal lines. On the notion of a temporal part, see *SA,* pp. 127–29.

23. The contained picture may, nevertheless, denote given objects and be a soandso-picture *as a result* of its incorporation in the context of the containing picture, just as "triangle" through occurrence in "triangle and drums" may denote given musical instruments and be a musical-instrument-description.

24. This covers cases where k is represented as a soandso by either a whole picture or part of it. As remarked in the latter part of note 19 above, there are restrictions upon the admissible replacements for "soandso" in this definitional schema; an old or square picture or one belonging to Churchill does not thereby represent him as old or square or self-possessed.

25. The reader will already have noticed that "description" in the present text is not confined to what are called definite descriptions in logic but covers all predicates from proper names through purple passages, whether with singular, multiple, or null denotation.

26. The picture does not denote the class picked out, but denotes the no or one or several members of that class. A picture of course belongs to countless classes, but only certain of these (e.g., the class of square-pictures, the class of Churchill-pictures) and not others (e.g., the class of square pictures, the class of pictures belonging to Churchill) have to do with what the picture represents-as.

27. From Constable's fourth lecture at the Royal Institution in 1836; see C. R. Leslie, *Memoirs of the Life of John Constable,* ed. Jonathan Mayne (London: Phaidon Press, 1951), p. 323.

28. Cf. Descartes, *Meditations on the First Philosophy,* trans. E. S. Haldane and G. R. T. Ross (New York: Dover Publications, Inc., 1955), vol. 1, p. 155; also Berkeley, "Essay Towards a New Theory of Vision", in *Works on Vision,* ed. C. M. Turbayne (New York: The Bobbs-Merrill Co., Inc., 1963), p. 42.

29. Or conventional; but "conventional" is a dangerously ambiguous term: witness the contrast between "very conventional" (as "very ordinary") and "highly conventional" or "highly conventionalized" (as "very artificial").

30. Indeed, there are usually many such systems. A picture that under one (unfamiliar) system is a correct but highly unrealistic representation of an object may under another (the standard) system be a realistic but very incorrect representation of the same object. Only if accurate information is yielded under the standard system will the picture represent the object both correctly and literally.

31. Neither here nor elsewhere have I argued that there is no constant relation of resemblance; judgments of similarity in selected and familiar respects are, even though rough and fallible, as objective and categorical as any that are made in describing the world. But judgments of complex overall resemblance are another matter. In the first place, they depend upon the aspects or factors in terms of which the objects in question are compared; and this depends heavily on conceptual and perceptual habit. In the second place, even with these factors determined, similarities along the several axes are not immediately commensurate, and the degree of total resemblance will depend upon how the several factors are weighted. Normally, for example, nearness in geographical location has little to do with our judgment of resemblance among buildings but much to do with our judgment of resemblance among building lots. The assessment of total resemblance is subject to influences galore, and our representational customs are not least among these. In sum, I have sought to show that insofar as resemblance is a constant and objective relation, resemblance between a picture and what it represents does not coincide with realism: and that insofar as resemblance does coincide with realism, the criteria of resemblance vary with changes in representational practice.

32. To anticipate fuller explanation in *Languages of Art,* a symbol system (not necessarily formal) embraces both the symbols and their interpretation, and a language is a symbol system of a particular kind. A formal system is couched in a language and has stated primitives and routes of derivation.

33. On the interaction between specific judgment and general policy, see my *Fact, Fiction, and Forecast* (2nd edition; Indianapolis and New York: The Bobbs-Merrill Co., Inc., 1965—hereinafter referred to as *FFF*), pp. 63–64. The propriety of projecting a predicate might be said to depend upon what similarities there are among the objects in question; but with equal truth, similarities among the objects might be said to depend upon what predicates are projected (cf. note 31 above, and *FFF*, pp. 82, 96–99, 119–20). Concerning the relationship between the 'language theory' of pictures outlined above and the much discussed 'picture theory' of language, see "The Way the World Is" (cited in note 4 above), pp. 55–56.

34. The specification that follows has many shortcomings, among them the absence of provision for the often three-dimensional nature of picture surfaces. But while a rough distinction between pictorial and other properties is useful here . . . nothing very vital rests on its precise formulation.

9

Looking at Pictures and Looking at Things

KENDALL L. WALTON

One way to "represent" something is to make a picture of it. Another is to describe it or refer to it in words. Pictures are *visual* representations; words are *verbal* ones. But this difference is elusive. We *look* at words as well as pictures; representations of both kinds are for the eyes. How is pictorial representation more *visual* than verbal representation?

It is often said that pictorial representation is somehow "natural," whereas verbal representation is merely conventional. Traditional accounts of this naturalness speak of resemblances between pictures and what they picture; some even postulate illusions. A picture of a dog looks like a dog, it is said; but the word "dog" means dog only because there happens to be a rule or agreement or convention, in the English language, to that effect. This may seem to accommodate the idea that pictures are visual in a way that words are not.[1]

But resemblance theories of depiction, the most obvious formulations of them at least, have run into serious difficulties. It has been widely recognised that conventions of one sort or another have much to do with depiction, as well as verbal languages. One cannot help being impressed by the variety of pictorial styles, by the many *different* ways there are of picturing a dog or a person or a building. Some have urged that these differences amount to mere differences of "convention," that we have many different pictorial "languages" and that the choice among them is to some extent arbitrary. If this is so, how is it that pictorial representation differs from verbal representation by being "natural" rather

than conventional? And what becomes of the idea that pictures rely on resemblance in a way that words do not?

I am interested not only in the nature of depiction and how depictions differ from descriptions, but also in differences among pictorial styles, especially differences of "realism." *Realism* is a monster with many heads, which desperately need to be untangled from each other. Resemblance theorists have a quick if crude way of accounting for one sort of realism, at least. Similarity has degrees, they point out, and some kinds of pictures look more like what they portray than others do. Realistic pictures are supposedly ones which look *very much* like what they portray, or ones which present especially convincing illusions.

But if we are to understand picturing in terms of conventions rather than resemblance or illusion, if we regard different pictorial styles as different "languages" and resist the idea that some are more "right" or more "natural" than others, assimilating differences between Renaissance perspective painting and Impressionism and Cubism to those between English and German and Swahili, one may wonder whether there will be any room for realism. Calling a dog a "dog" is not a more or less realistic way of referring to it than is calling it a "hund." If Cubism simply amounts to a system of conventions, a language, different from that used by Vermeer, for instance, how is Vermeer's way of portraying things any more realistic than a cubist one?[2]

Most disputes about the role of resemblance in

From Andrew Harrison (ed.), *Philosophy and the Visual Arts*. Dordrecht: D. Reidel Publishing Company, 1987, pp. 277–300. Revised for this book and reprinted with permission of Kluwer Academic Publishers and the author. The material in this essay is incorporated in Kendall L. Walton, *Mimesis as Make-Believe: On the Foundations of the Pepret sintational Arts*. Cambridge: Harvard University Press, 1990.

depiction and pictorial realism have been mis-guided, in my opinion. Theorists have looked for resemblances in the wrong place. Rather than ask-ing about resemblances between pictures and the things they picture, we should consider resem-blances between *looking* at pictures and *looking* at things. The significant similarities are to be found between the acts of perception, not between the things perceived. It is these which illuminate the sense in which depiction is more "natural" and less arbitrary than verbal representation, and which are linked to pictorial "realism," in some important senses of this extraordinarily slippery term.

To begin, I will sketch, very briefly, what I think pictures are.[3]

Pictures are props in games of make-believe. They function in many ways as dolls, hobby horses, and toy trucks do. (There are important differences too, but I will focus on the similarities now.) We can speak of the *world* of a game of dolls—in which the participants bathe and dress babies, rock them to sleep, etc. Likewise, there are worlds (fictional worlds) associated with the games viewers play with paintings.

Propositions which are "true in the world of a game" are, I will say, *"fictional."* Some fictional truths in a game of dolls are generated by the props alone, by the dolls; others are generated by the par-ticipants, or by the props and participants together. It is fictional that there is a baby in a crib, if there is a doll in a toy crib, and it is fictional that Heidi is dressing a baby when Heidi puts doll clothes on the doll. In the game which a viewer plays with Mein-dert Hobbema's *The Water Mill with the Great Red Roof* it is fictional that there is a mill with a red roof. This fictional truth is generated by the prop itself, but others depend on the viewer and what he does in front of the painting. It is fictional that the viewer sees a mill with a red roof, and perhaps that he notices a peasant in the shadows of a doorway.

The world of the appreciator's game is distinct from the world of the work he is appreciating, though the two are closely related. The appreciator does not belong to the world of the work (unless it happens to be a portrait of him), but he does belong to the world of his game. Roughly, the world of the work contains only fictional truths generated by the work itself. The work of the appreciator's game contains fictional truths generated both by the work and by the appreciator, and also by the two in com-bination.

Novels and stories are props in games of make-believe also. What distinguishes pictures is the fact that they are props in *visual* games, reasonably rich and vivid visual games. (It is *this* that makes depic-tion a visual medium, unlike the novel, even though we use our eyes in both cases.) There are many

visual actions which, fictionally, the spectator may perform. Fictionally the viewer of *The Water Mill with the Great Red Roof* sees a mill. It may also be fictional that he notices the woman in the doorway, that he looks for squirrels in the trees, that he exam-ines the wood for worm holes, that he gazes casually toward the fields in the distance, and so on. A rela-tively rich visual game is one which allows the spec-tator fictionally to perform a large variety of visual actions.

Fictional truths about the viewer's visual activi-ties are generated by his actual visual actions, by his actually looking at the picture in various ways. What makes it fictional that he notices a woman in the doorway is the fact that, in looking at the paint-ing, he really notices that it is fictional that there is a woman in the doorway.

Moreover, it is fictional *(de re)* of his lookings at the paintings, that *they* are acts of looking at a mill and its surroundings. His noticing that fictionally there is a woman in the doorway not only makes it fictional that he notices a woman in a doorway; it makes it fictional that his noticing this fact about the painting is itself an act of noticing a woman in a doorway.

I have not explained what it is for something to be fictional, to be "true-in-a-picture," or "true-in-the-world-of-a-game." For now, let me say only that there is a very close connection between what is fictional and what appreciators *imagine* to be the case. The viewer imagines that there is a mill with a red roof; he imagines himself to be seeing a mill; and he imagines his act of looking at the canvas to be an act of looking at a mill. The vividness of a visual game of make-believe is connected with the vivacity with which spectators imagine the propo-sitions which are fictional in the game.

My claim is that *all* representational pictures bring the viewer into a fiction, a game of make-believe, together with the people and objects which are depicted. Certain art historians—Alois Riegl and Michael Fried, for example—have taken pains to emphasize differences in the extent to which dif-ferent works invite the viewer in or recognise him.[4] Certainly there are such differences. Perhaps they have to do with the degree of vivacity with which the viewer imagines himself to be in the presence of the subjects, or the extent to which he is encouraged to elaborate in imagination on his relationships to the subjects. My point now is a more basic one which concerns pictorial representation in general. It can be brought out by contrasting pictures with novels. Spectators of all pictures imagine themselves to be seeing things of the kind represented, in a way in which readers of novels do not.

Here is an objection: We can play whatever game of make-believe we like with a given prop. We could choose to play visual games with verbal texts. But

surely this wouldn't transform the texts into pictures.

The answer is that we are *not* free to play any game we wish with a given prop. It would be awkward to say the least to play visual games with texts as props, and next to impossible to use them for visual games of any significant richness and vivacity.

Some things are much better suited to serve as props in games of certain kinds than others are. A tree makes a fine make-believe mast on a pirate ship. A tunnel or a watermelon would make a terrible one. A game of pirates in which to crawl through a tunnel, or to eat a watermelon is fictionally to climb a mast, is unlikely to be very rich or vivid. (What would count as fictionally swaying with the mast in the wind, or fictionally grabbing a spar to keep from falling, or fictionally scanning the horizon for merchant vessels?)

Pictures make much better props in visual games of make-believe than verbal descriptions would (given their respective semantic characteristics). This is because looking at pictures is analogous to looking at things, in ways in which looking at verbal descriptions is not.

The analogies in question do not hold equally for all kinds of pictures. Because of these differences, the visual games in which painted canvases of various kinds are props vary in richness and vividness, and in other important respects. This will allow us to distinguish between pictures which are more and less "realistic." It will also help to illuminate differences among pictorial styles which are not naturally described as differences in realism.

In what ways is looking at a picture like looking at things? I do not mean to compare the visual sensations or phenomenological experiences which viewers of pictures and observers of things enjoy. (It is not obvious how this comparison could be separated from a comparison between the visual characteristics of pictures and the visual characteristics of things. Both, it seems, would amount to comparing *how pictures look* with *how things look*.) The comparison I am interested in is between the process of investigating the "world of a picture" by inspecting the picture and the process of investigating the real world by looking at it, between visual examinations of people and landscapes in pictures and visual examinations of actual people and landscapes.

Consider a spectator examining Hobbema's *The Water Mill with the Great Red Roof,* and also a person looking at an actual scene of the kind this painting portrays, a red roofed mill near a cluster of large trees, with ducks in a pond in front of the mill and several peasants in the background. (Let us suppose that the second person is situated at a place corresponding to the point of view of the painting, i.e., that he is standing on the left bank of the river some 200 yards downstream from the mill.) What I want to compare is the process by which the viewer of the painting ascertains that fictionally there is a red roofed mill near a cluster of large trees, ducks in a pond, and so on, with the process by which the observer of the actual scene ascertains that there is actually a red roofed mill near a cluster of large trees, and ducks in a pond, etc.

Several points of analogy are obvious. The investigations are both visual ones; we use our eyes in both cases. And the two investigations yield similar kinds of information—information about visual characteristics of the world of the picture in the one case, and visual characteristics of the real world in the other. The spectator of the painting discovers the redness of the mill's roof, the size and approximate number of trees, the presence of peasants, ducks, etc., in the picture-world; the observer of the actual scene is likely to discern similar features of the real world. (More precisely, the viewer of the painting ascertains the *fictionality* of propositions whose *truth* the observer of the actual mill and its surroundings might well ascertain.) Neither viewer is very likely to learn the marital status of the (fictional or actual) peasants, or their taste in wine, or the names of their siblings, although conceivably either might draw inferences about such matters from facial characteristics or other more obviously visual information.

A third analogy is a correspondence in the *order* in which the two observers acquire their information. A quick glance at the painting may reveal that fictionally the mill has a red roof and that there is a peasant carrying a long tool silhouetted against the bright fields. A later and longer look will reveal that the tool is a hoe and that there is a woman hidden in a dark doorway. Perhaps only after a careful and extended examination of the picture will we discover knots in the wood of the mill, subtleties of the woman's facial expression, or warts on her hand. The sequence is "realistic." The person observing the actual mill (from the point of view and in the circumstances in question) is likely to notice the red roof before noticing that the peasant's tool is a hoe, and only after that pick out knots in the wood or warts on the woman's hands.

Already we are beginning to see why it is so natural for the viewer of the painting, as he notices that fictionally there is a mill with a red roof, a woman hidden in the shadows of the doorway, knots in the wood, and so on, to imagine that he is looking at an actual mill and observing that it has a red roof, that there is a woman in the doorway, etc.

How unique are these three points of analogy?

Suppose one reads a story about a red roofed mill. The reader uses his eyes, of course, to learn about the fictional mill. But much of the information he acquires about it may not be visual information. The story might tell us that the peasant was born in Haarlem and has three children, that one of her children is asleep inside the building, that she is thinking about the price of grain. And it may neglect to specify the color of the mill's roof or to mention the trees surrounding it. If it does concentrate on visual features of the scene, this information may be presented in an unlikely order. The reader might learn first of a wart on the woman's hand and only much later of the mill's prominent red roof.

Consider the opening passage from Faulkner's *The Bear*:

> There was a man and a dog too this time. Two beasts, counting Old Ben, the bear, and two men, counting Boon Hogganbeck, in whom some of the same blood ran which ran in Sam Fathers, even though Boon's was a plebeian strain of it and only Sam and Old Ben and the mongrel Lion were taintless and incorruptible.
>
> He was sixteen. For six years now he had been a man's hunter. For six years now he had heard the best of all talking. It was of the wilderness, the big woods, bigger and older than any recorded document. . . .

This passage is more visual than many in literature. Nevertheless, it is as awkward and strained to imagine one's reading it to be an instance of looking at a scene of the kind described as it is to imagine of one's crawling through a tunnel that it is an action of climbing the mast of a pirate ship. (Of course one can easily imagine, *while* reading the passage, that one is watching a party of hunters. But this is a very different matter.)

Although most stories and novels are such that reading them is not much like looking at things, in the ways we have so far considered, there can be exceptions. It is possible for a story to provide only visual information about a scene and to present it in a sequence in which an observer of the scene might actually learn it. An author might "write from life"; he might sit in front of a mill and simply record what he observes over his typewriter as he observes it. The works of Alain Robbe-Grillet come to mind. Here is the opening of his *Jealousy:*

> Now the shadow of the column—the column which supports the southwest corner of the roof—divides the corresponding corner of the veranda into two equal parts. This veranda is a wide, covered gallery surrounding the house on three sides. Since its width is the same for the central portion as for the sides, the line of shadow cast by the column extends precisely to the corner of the house; but it stops there, for only the veranda flagstones are reached by the sun, which is still too high in the sky. The wooden walls of the house—that is, its front and west gable-end—are still protected from the sun by the roof (common to the house proper and the terrace). So at this moment the shadow of the outer edge of the roof coincides exactly with the right angle formed by the terrace and the two vertical surfaces of the corner of the house.
>
> Now A . . . has come into the bedroom by the inside door opening onto the central hallway. . . .[5]

Investigating the world of *this* story by reading it will be much like learning about an actual mill by looking at it, in the respects I have mentioned so far.

But there are other correspondences between looking at pictures and looking at the world which are much more difficult to duplicate in a verbal medium.

Some have to do with why it is that we make discoveries in the order that we do. It is because the red roof in the painting is more obvious, more striking visually, than the knot in the wood that it is likely to be noticed first. This might well be true of the actual scene, of course. But if, in reading a story, one learns that fictionally a mill has a red roof before learning fictional truths about a knot in the wood, one does so because of the order in which the sentences of the story occur, not because the red roof springs from the pages and forces itself on our attention. Detecting the knot does not require a closer examination of the text than detecting the red roof does. One just reads the sentences as they come.

Also, of course, the viewer of the painting, like the spectator of life, has some choice about what he looks at when. If a story is read in the normal manner, from the beginning to the end, the reader makes no similar decisions; the order of his discoveries is determined by the author.

We see, again, how it is much easier to imagine one's examination of the picture to be an examination of a real mill than to imagine this of one's reading of a story, even a story "written from life" in the manner of Robbe-Grillet. Being struck by the prominent red patch on the canvas from which one learns that fictionally the mill has a red roof, is much more naturally imagined to be an instance of being struck by the red roof of a (real) mill, than is methodically reading on in a story. Searching deliberately for marks on the canvas which would por-

tray squirrels in the trees is more naturally imagined to be looking deliberately for (actual) squirrels, than is perusing sentences in a text in the order the *author* chose, even if, as it happens, one learns thereby that fictionally there are squirrels in trees.

There is a certain openendedness to the task of visually investigating our (real-world) surroundings. There seems always more to be learned about things by examining them more closely or more carefully. Likewise, one can continue more or less indefinitely discovering fictional truths in Hobbema's painting: details about the grain of the wood, the expressions on the peasants' faces, the precise dimensions of the building and the pond in front of it. But there is a definite limit to what fictional truths can be learned from a description (though one may always continue reflecting on and digesting what he has learned). One can *finish* reading a novel, but there is no such thing as completing the task of examining a painting or that of visually investigating the real world. One does not stop to *contemplate* a text, as one does a picture. One simply reads each sentence, and goes on to the next, and the next until one comes to the end.

This point is not as clear cut as it may first appear. There are limits to how closely we can look at a picture, and to our powers of discrimination. These can be extended by the use of magnifying glasses and microscopes, in theory indefinitely, perhaps. But the "information" in pictures often runs out even before optical instruments come into play. The image dissolves into blobs of paint or black dots, and it becomes clear that closer looks will not reveal anything more about the fictional world.[6] (This happens sooner for pictures of some kinds—tapestries, mosaics—than for others.) It is significant that approximately when we see that the information is running out we no longer see the picture as a picture, we no longer see a mill or a bowl of fruit or a person in it. As long as one examines a picture in a *normal* manner, seeing it as a picture, one does not exhaust the fictional truths which it generates. No ordinary examination of Hobbema's painting will reveal all of the fictional truths that can be extracted from it; there is always more to be found. In this respect looking at the picture *in the usual manner* is like looking at life.

The openendedness of the task of "reading" pictures is related to the fact that the experience of *seeing as* or *seeing in*—the experience, for instance, of seeing a red-roofed mill in a design—is not a momentary occurrence but a continuous state. One continues to see a mill in a picture for a period of short or long duration. But there seems to be no comparable continuous state connected with

descriptions. Does one see an inscription of the word "elephant" as meaning elephant for thirty seconds, or for five minutes? It may be true throughout a period of thirty seconds or five minutes that one takes this word token to have that meaning, but doing so is not a *perceptual* state and need not involve seeing the inscription throughout the period. One does perceptually recognize the word and grasp its meaning, but this is a momentary occurrence (or possibly two momentary occurrences), not a continuous state, even if the recognition or grasping comes only with difficulty. My point is not that the state of seeing a picture as a man is one of constantly discovering new fictional truths. Rather it is the constant *possibility* of making new discoveries which sustains the state.

The openendedness of examinations of pictures is connected with Goodman's claim that pictures necessarily belong to "dense" symbol systems. I don't think Goodman is right about this. A system of mosaics, for instance, might fail to be dense but be pictorial nonetheless. But pictorial systems do tend to be dense *"up to a point"* at least, a point which is frequently beyond the limits of discrimination when pictures are examined in the normal manner. And this fact contributes to the openendedness of pictorial investigations.

The important point is that we can now see *why* pictorial systems are dense, insofar as they are. Density contributes to a significant analogy between visual investigations of picture worlds and visual investigations of the real world, and so to the ease with which the former are imagined to be the latter.

Another significant analogy between examining the world of a picture and examining, visually, the real world concerns what is easy to ascertain and what difficult, and what mistakes the investigator is susceptible to.[7] In these respects also examinations of both of these kinds contrast sharply with readers' investigations of the worlds of verbal representations.

In estimating the height of a tree by looking at it, small errors are more likely than large ones. It is easier to mistake an 85 foot tall tree for an 85.0001 foot tree, than for one which is merely 35 feet tall. This holds for picture-trees as well as for real ones. Smaller mistakes in estimating the height of trees in Hobbema's painting are more likely than larger ones.

The reverse is often true for trees in stories. The numerals "3" and "8" are readily mistaken for each other. An inattentive reader might easily take an 85 foot tall (fictional) tree to be merely 35 feet high. This enormous mistake is much *more* likely than many smaller ones. The reader is not very likely to

suppose that the tree in the story is 85.0001 feet high rather than a mere 85 feet high, since "85" and "85.0001" are easily distinguishable.

It is relatively easy to confuse a *house* in a story with a *horse* or a *hearse*, a *cat* with a *cot*, a *madam* with a *madman*, *intellectuality* with *ineffectuality*, *taxis* with *taxes*, and so on. But when we examine either the real world by looking at it, or picture worlds, houses are more apt to be mistaken for barns or woodsheds than for hearses or horses, cats are harder to distinguish from puppies than from cots, etc.

The mistakes perceivers are susceptible to correspond to similarities among things themselves. Things which are hard to discriminate perceptually are things which really are similar to each other in some respect. An 85 foot tree resembles one which is 85.0001 feet more closely than it does a 35 foot tree. Houses are more like barns and woodsheds than like horses or hearses. In fact, the degree of similarity explains the likelihood of confusion. It is *because* 85 and 85.0001 foot trees are very similar that they are difficult to distinguish.

So there are substantial correlations between difficulty of discrimination, when we look at the real world, and similarities among things. In *this* sense we can be said to perceive things as they really are. Pictorial representations largely preserve these correlations.

But descriptions scramble the real similarity relations. Houses are not much like horses or hearses. The difficulty of distinguishing a house from a horse in a story has nothing to do with similarities between the house and horses; it is due to similarities between the *words* used to describe them. So we think of the words as getting between us and what we are reading about, in a way in which pictorial representations do not. The words block our view of the objects. No wonder that it is so much easier to imagine, vividly, of one's investigation of a picture that it is a visual examination of the world, than to imagine this of one's reading of a story.

We now have the tools to understand a couple of possible representational systems mentioned by Richard Wollheim:

. . . we could imagine a painting of a landscape in which, say, the colours were reversed so that every object—tree, river, rocks—was depicted in the complementary of its real colour: or we could imagine, could we not?, an even more radical reconstruction of the scene, in which it was first fragmented into various sections and these sections were then totally rearranged without respect for the look of the landscape, according to a formula? And in both cases it seems as though

there is nothing in the . . . view [that representation is a kind of code or convention] that could relieve us from classifying such pictures as representations. Yet ordinarily we should not be willing to concede that this is what they were, since it is only by means of an inference, or as the result of a 'derivation', that we are able to go from the drawing to what it is said to depict. There is no longer any question of seeing the latter in the former. We have now not a picture that we look at, but a puzzle that we unravel.[8]

I agree that if "reading" a representation is an inferential process of the kind described, if one must first ascertain the relevant features of the representation and then figure out, according to a formula, what fictional truths are generated, the representation is not functioning as a picture for us. Normally the viewer of Hobbema's mill-scape just looks and sees that fictionally there is a mill with a red roof near a grove of trees. If we could not do this more or less automatically, if we had to invoke explicitly the relevant rules of perspective and so forth, the canvas would not be a picture for us.

The reason, I would add, is that the process of figuring out on the basis of features of the two-dimensional pattern and with the aid of a formula, that fictionally there is a red-roofed mill, etc., can hardly be imagined vividly to be an instance of looking (at the real world) and noticing a red-roofed mill, etc.

What about Wollheim's examples? Is it *impossible* that the representation with its colors reversed, or the systematically scrambled one, should be *pictures*? I suspect that with sufficient practice we could become so familiar with these systems and so adept at "reading" representations in them, that we wouldn't have to figure out what fictional truths are generated, but could just look and see. If we did Wollheim, apparently, would be willing to call the representations pictures.

But I am suspicious. The ability to read representations automatically is clearly not sufficient for their being pictures; we read words automatically, after all.

Consider a scrambled system whereby the parts of pictures in some normal system are rearranged according to the following schema:

Normal				Scrambled		
1	2	3		6	4	2
4	5	6		5	3	1

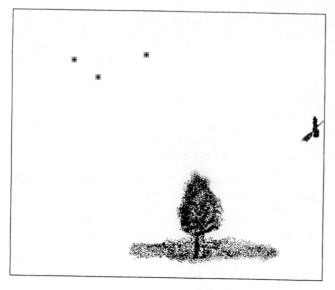

FIGURE 1a. Normal; witch on right.

Figure 1b (minus the rectangles) is the scrambled version of the normal picture, 1a. Understood in their own systems, they generate the same fictional truths—the "world of the picture" is the same in both cases. Each depicts a tree in the center of the scene and a witch on the far right. Since the Scrambled System is foreign to us, we have to do some calculating to figure out what is going on in Figure 1b. We understand 1a much more readily.

But suppose that after long experience with both representational systems we develop the ability to "read" pictures of both kinds automatically. There still will be important differences in the processes of investigating them. The scrambling drastically alters the ease or difficulty with which various fictional truths are ascertained, even for observers equally fluent in the two systems. A viewer practiced in reading pictures in the Scrambled System could presumably tell at a glance that the witch in 1b is not near the centre of the scene, not above the tree, but is far to one side or the other. (If she were in the centre her portrayal on the picture surface

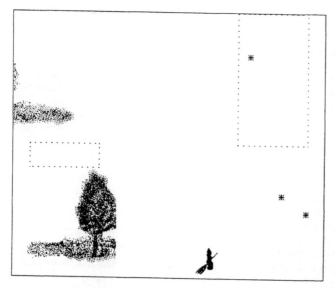

FIGURE 1b. Scrambled; witch on right.

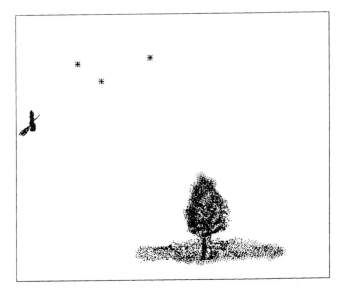

FIGURE 2a. Normal; witch on left.

would be in one of the two rectangular areas indi-cated in Figure 1b, and it obviously is not.) But it is not so easy even for the practiced viewer to tell *which* side of the scene she is on, whether she is far to the left or far to the right—whether she is com-ing or going. In 1b she is on the right. In Figure 2b she is on the left. These two pictures are not readily distinguishable.

Contrast the ordinary unserambled versions of these pictures: Figures 1a and 2a. In 2a the witch is approaching on the far left; 1a shows her far to the

right on her way to other mischief. It is easy to tell which is which.

Examining the worlds of ordinary pictures like these is clearly more like looking at the real world than is examining the worlds of the scrambled ones, even for a viewer thoroughly fluent in the Scram-bled System. When in real life would one notice quickly that a witch is *either* far to the right or far to the left, and not be able to tell which without looking much more closely?

I do not suggest that the scrambled pictures are

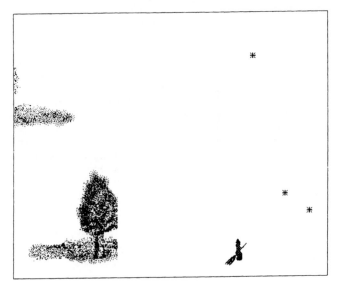

FIGURE 2b. Scrambled; witch on left.

not pictures. Looking at them is, in many *other* respects, like looking at the world, and they do function as props in visual games of make-believe which are *reasonably* rich and vivid. Certainly each of their six segments qualifies as a picture. Nevertheless, the differences between them and their unscrambled cousins are important. We might characterize them as differences in degrees of 'realism'.

(Incidentally, the scrambled system has every right to be regarded as *dense,* in Goodman's sense, both syntactically and semantically, if the unscrambled one is, and is just as replete. Goodman's account of pictures fails to distinguish between them.)[9]

Wollheim's scrambled system is not just an academic exercise. Various artists have employed what amount to scramblings in their work, most obviously the Cubists,[10] although the principles on which their scramblings are based are typically very unsystematic and much more complex than those employed in our artifical example. Often viewers have to divine the system by which the pieces are arranged from the picture itself. Flashbacks and flash-forwards in film have similar consequences.

We see more clearly now how serious a mistake it is to regard Cubism, for instance, as just a *different* system from others, one with different conventions which we must get used to. It is a system which affects substantially the nature of the visual games in which the works function as props, quite apart from our familiarity with it. The difference I have described bears out the familiar characterization of Cubism as a more intellectual, less visual pictorial style, compared to earlier ones.[11]

We are now in a position to assess the significance of many other features of pictorial styles. In general, I suggest that we look at the nature of the visual games of make-believe works in various styles allow or encourage. (When the games encouraged by certain pictures are reasonably described as richer or more vivid than those encouraged by others we may comfortably speak of differences of "realism." But there are important variations among visual games which are not easily characterised in terms of richness or vividness. Our understanding of manners of depiction should go beyond explaining judgments of realism.)

Consider what I will call the *Sloppy Style* of depiction. Figure 3 is in this style. It would be uncharitable and a little boorish to insist that the walls of the house-in-the-picture are crooked and don't quite reach the ground, and that the structure is listing dangerously to one side. True, the lines of the sketch are not straight and don't connect with

FIGURE 3. House in sloppy style.

each other as they would in a precise architectural drawing. But this *is* Sloppy Style, after all, and lines in Sloppy Style are *expected* to be sloppy. Their sloppiness is not to be read into the fictional world portrayed, but to be accepted as inevitable in that style regardless of what is being portrayed. It is reasonable to allow that fictionally the house is a normal one with normally straight walls which do connect with the ground, etc., notwithstanding the sloppiness of the portrayal.

How does this picture differ from a precise architectural drawing? Neither portrays a house as about to fall down. But there are important differences between the visual games of make-believe we can play with the two drawings. The person who looks at either of them fictionally looks at a house. But nothing which the viewer of the Sloppy Style sketch might do is easily imagined to be looking carefully to see just how straight the walls are. One will not, fictionally, examine the house closely to see how well made it is. For once we see that it is in Sloppy Style, we realize that further investigation of the lines of the drawing will not reveal fictional truths about details of the house's construction. The person who looks at a more precise drawing of a house, however, might very well fictionally engage in a close scrutiny of the house's construction. A more precise drawing will probably admit of visual games of make-believe which are richer in some respects than ones we might play with the Sloppy Style sketch.

Paul Klee's *Mountains in Winter* is of an opposite kind. Here the lines are straight, but the mountains aren't. We can reasonably take for granted, I sug-

gest, that fictionally the mountains are rough and ragged, as befits all self-respecting mountains. We might call this *Smooth Style*.

Similar observations can be made about the idealized shapes of Cubist works. Is it fictional that a person has an angular head, if the picture uses angular shapes to portray it? Not if the angularity is thought of as being simply a feature of the style, whatever is being portrayed. Picasso's *Portrait of Daniel Henry Kahnweiler* (1910) does not portray Kahnweiler as exotically deformed. But our visual game of make-believe is severely limited in certain ways. There will be no such thing as fictionally gazing fondly at the gentle curve of his brow, or fictionally being slightly intimidated by his aggressive, prominent chin.

Let's consider a more involved example. Some pictures portray very explicitly the play of light on the surfaces of objects, rendering shadows and reflections in great detail. Vermeer's works do, and so do many photographs. Other pictures concentrate on the shapes, positions, colors, and textures of objects, while ignoring how light is reflected from them. These include outline drawings and assorted ancient, "primitive," and twentieth century works. Vermeer's *Girl Reading Letter Near Window* (1657) will serve as an example of the first kind. The second kind of picture is illustrated by Matisse's *The Red Room* (1911), in which the solid, homogeneously coloured table cloth and wall are portrayed by solid coloured, homogeneous stretches of canvas, ignoring shadows, differing angles of the incidence of light on different parts of the table cloth, etc.

What exactly does this difference amount to? Shall we say that the Vermeer contains "information" of certain kinds which the Matisse lacks? Perhaps, but this difference is not as great as might first appear. It would probably not be fair to say that whereas the Vermeer generates fictional truths about the play of light, the Matisse does not. It is clear that the main illumination in the Matisse comes from the large window on the left. (The window is open, it is large, and since the scene is a daytime one we shouldn't expect there to be any other significant sources of illumination.) So it is reasonable to infer, for example, that (fictionally) the vase casts a shadow on the table in the direction away from the window. The fact that Matisse did not use a darker patch of paint to portray the shadow, as Vermeer would have, can be construed as a characteristic of the style in which his picture is painted, which does not indicate the absence of a shadow in the depicted scene.[12] (This is not to deny the aesthetic importance of the absence of explicitly portrayed shadows and reflections, however; this feature of the work's style contributes significantly, even profoundly, to the expressive character of the painting. But neither the supposition that it is fictional that there are no shadows nor the supposition that it is not fictional that there are shadows is required to explain the contribution. It can be understood to derive from the truncation of spectators' games of make-believe, which I will describe shortly.)

The Red Room does, then, generate some fictional truths about the play of light. It does not generate as detailed or specific ones as we find in the Vermeer, to be sure; the Vermeer contains *more* "information" about the light and shadow than the Matisse does. But a more interesting and important difference betwen the two works has to do not with what fictional truths are generated, but with the manner in which they are generated, and the effect that *that* has on our visual games of make-believe.

It is only by virtue of generating fictional truths about the position of the window, the position and shapes of the vase and other objects on the table, etc., that the Matisse generates fictional truths about shadows and reflections. Fictionally there is a shadow *because* it is fictional that there is a vase on the table, a window on the left, etc. The Vermeer generates such fictional truths more directly.

Fictional truths about the positions and shapes of objects are in some cases generated more directly in the Matisse than in the Vermeer. Vermeer uses reflections and shadows to indicate the folds of the draperies, for instance, and also textures of surfaces. It is fictional that the draperies fall in such-and-such manner because it is fictional that light is reflected from various parts of them in a certain way.

In short, there are certain relations of dependency among the fictional truths generated by these works, and the dependencies run in opposite directions in the two cases. In the Matisse, fictional truths about the play of light depend on fictional truths about three-dimensional objects. In the Vermeer fictional truths about three-dimensional objects depend, to a considerable extent, on fictional truths about the play of light.[13]

There is a corresponding difference in how we learn fictional truths of the two kinds. Fictional truths about the play of light enable the spectator of the Vermeer to ascertain fictional truths about the spatial configuration of objects. But the viewer of the Matisse must base such judgments on other things—most obviously on lines in the painting indicating the edges of objects. Our access to the world of the Vermeer corresponds more closely to the access perceivers have to the real world. In real life reflections and shadows have a lot to do with

our judgments of spatial properties of three-dimensional objects. It is easily understood that, fictionally, we perceive the topography of the drapes by perceiving the patterns of light and shadow on them.

But one might reasonably allow that it is fictional, in our game with the Matisse as well, that our perception of the attitudes of objects are dependent on our perception of light and shade. This fictional truth derives from a general principle to the effect that a fictional world is to be regarded as normal, as similar to the real one, in the absence of explicit indications to the contrary.

The difference that does obtain between the two pictures comes out most dramatically when the observer investigates the perceptual cues underlying his perception of fictional truths about three-dimensional objects. The viewer of the Vermeer inevitably imagines himself to be probing the grounds of his judgments about objects of the kind represented. Fictionally, he notices that certain reflections and shadows are important cues. But the viewer of the Matisse who embarks on similar reflections is soon forced out of the game of make-believe. It may be fictional that shadows and reflections serve him as cues, but nothing he does is naturally imagined to be investigating and discovering these cues. Examining the *actual* cues underlying his awareness of *fictional* truths about three-dimensional objects is not, for these cues do not include fictional truths about light and shadow.

The visual games one plays with the Matisse are thus attenuated, in a way in which the visual games one plays with the Vermeer are not.

Often in real life we pay no attention to shadows and reflections; we concentrate on the spatial configuration of three-dimensional objects, not even noticing the perceptual cues on which our judgments of these matters are based. In contemplating the Vermeer we may also fail to notice fictional truths about the play of light which serve as cues for our perception of fictional truths about three-dimensional objects. When this is so, is our experience no different from that of the viewer of Matisse's painting? In both cases we simply look and see that, fictionally, objects are arranged in certain ways, thereby fictionally looking at objects and seeing how they are arranged; the mechanics of the process by which we tell, it may seem, are not part of the experience.

I believe that a vague realization of the possibility of, fictionally, probing the cues underlying one's perceptions of three-dimensional objects is present in one's experience of the Vermeer and significantly colors it, even if one pays no attention to the portrayal of light and shadow. This realisation, the realisation of the potential richness of his visual game of make-believe, is an important part of what makes so vivid the viewer's imaginings, of his viewings, that they are observations of the real world.

Many other aspects of pictorial representations can, I believe, be illuminated by examining spectators' visual games of make-believe. It would be interesting to look at various kinds of perspective in this light; at pictures which do and ones which do not conform to what Gombrich calls the eye-witness principle in its negative aspect: "[T]he artist must not include in his image anything the eye-witness could not have seen *from a particular point at a particular moment*";[14] at pictures in which foreground and background are in equally sharp focus, in contrast to ones in which one or the other is blurred; at the use in film of slow motion, wide screens, bird's eye views, etc.; at depictions of things which we don't or can't see in real life for one reason or another: microscopic organisms, foetuses in the womb, drops of falling water frozen in a photograph, patterns of thermal or ultraviolet radiation, sounds and smells, etc. The significance of these various features of representational styles can be traced, in large measure, to the consequences they have for viewers' perceptual games of make-believe.

Notes

1. An alternative suggested by Richard Wollheim and others, is based on the idea that we see a picture of a dog as a dog, or that we see a dog in it. This requires an explanation of what seeing as or seeing in amounts to. I would suggest that the relevant notion of seeing as or seeing in is to be understood in terms of visual games of make-believe.

2. There are intimations in Panofsky of the view that differences of pictorial styles are mere differences of convention. According to Michael Podro, Panofsky's paper. 'Die Perspektive als "Symbolische Form"',

Takes the perspective construction developed in the Renaissance and argues . . . that it has no unique authority as a way of organising the depiction of spatial relations, that it is simply part of one particular culture and has the same status as other modes of spatial depiction

developed within other cultures. [Michael Podro, *The Critical Historians of Art* (New Haven: Yale University Press, 1982), p. 186.]

Nelson Goodman denies realism any place at all in pictures or pictorial styles themselves. Realism, he claims, is just a matter of habituation, of how familiar we happen to be with the conventions of a given pictorial symbol system. Pictures which we judge more realistic than others are merely ones in symbol systems which we have learned to 'read' more fluently. [Nelson Goodman, *Languages of Art* (Indianapolis: Bobbs-Merrill; Sussex: Harvester, 1963), p. 34-39.]

3. I develop my account of depiction more thoroughly in *Mimesis as Make-Believe: On the Foundations of the Representational Arts* (Cambridge: Harvard University Press, 1990).

4. See Alois Riegl, *Holländisches Gruppenporträt* (1902); and Podro's discussion of it in *The Critical Historians of Art*, pp. 81-95; also Michael Fried, *Absorption and Theatricality: Painting and Beholder in the Age of Diderot* (Berkeley: University of California Press, 1980).

5. Alain Robbe-Grillet, *Two Novels by Robbe-Grillet: Jealousy and in the Labyrinth*, trans. Richard Howard (New York: Grove Press Inc., 1965).

6. In some cases we can see the blobs before seeing the limit approaching. But the reverse is not likely.

7. I consider this point more thoroughly in "Transparent Pictures: On the Nature of Photographic Realism," *Critical Inquiry* (December 1984).

8. Richard Wollheim, "On Drawing an Object," in *On Art and Mind* (Cambridge: Harvard University Press, 1974), p. 25.

9. The scrambled system differs however from the ordinary one with respect to what Kent Bach calls 'continuous correlation', and what Elliott Sober calls 'perspicuity', cf. Bach, "Part of What a Picture is?," *British Journal of Aesthetics* (1970), and Sober, *Simplicity* (Oxford: The University Press, 1975).

10. "[Picasso] presents us here [in Desmoiselles d'Agignon] with a female form dismembered and reassembled in a way that allows us to see the back and front at the same time, a device that became a keystone of Cubism". [Roland Penrose, 'In Praise of Illusion', in R. L. Gregory and E. H. Gombrich, *Illusion in Nature and Art* (London: Duckworth, 1973), pp. 248-49.]

11. "[Cubism] is the art of painting new structures out of elements borrowed not from the reality of sight, but from the reality of insight". [Guillaume Apollinaire, The Cubist Painters: *Aesthetic Meditations*, trans. Lionel Abel (New York: 1949).]

12. There is room for doubt about this construal of the Matisse. But many ordinary line drawings are obviously to be construed in this way, it seems to me, and they can serve to illustrate my point. It is fictional, in many line drawings, that there are shadows and reflections, even if the drawing does not explicitly portray them.

13. Which work is thought to correspond best to the way the world is may depend on one's metaphysical theory. A phenomenalist might pick the Vermeer; a materialist the Matisse. My present concern is with how pictures relate not to how the world is or is thought to be, but to how we perceive it.

14. E. H. Gombrich, "Standards of Truth: The Arrested Image and the Moving Eye," *Critical Inquiry*, vol. 7, no. 2 (Winter 1980), 246. (My emphasis.)

IO

Caricature

STEPHANIE ROSS

That caricature succeeds at all seems paradoxical. That its dictum is "less is more" seems more puzzling still. In this [chapter] I hope to investigate how caricature transforms exaggeration, distortion, and falsification into vehicles for succinct comment and easy identification. I shall examine and discard several views of how caricature functions, and conclude by arguing that correctly identifying a caricature is no more, and no less, paradoxical than correctly identifying any of the everyday objects that clutter our world.

The formula "caricature highlights essential features" is a natural first attempt at explaining caricature. But the notion of essential features proves incoherent. On one reading, we all have the same essential features—two eyes, two ears, one nose, one mouth, . . . Clearly this is of no use. Our essential features must be those that are distinctive and set us apart from others. Yet no feature or set of features can entail or demand a particular identification. Two eyes sketched on a sheet of newsprint won't identify anyone. Nor will two eyes set in a blank face. Any number of people can have eyes of the same shape, color, and size. Distinctive features are distinctive only when viewed as part of a face, seen in the context of surrounding features. Thus essential features reduces to the empty fact that what is distinctive about a person's face is his face. One further point. Even if we could isolate certain aspects of a person's face in virtue of which he is easily identified, these aspects aren't permanent and invariant in the sense connoted by the term "essen-

tial," for faces are seen differently by different people. Consider how variously a person is perceived by his lover, by a photographer, by an orthodontist.

We might try to preserve the less pernicious aspects of the previous thesis by claiming that caricature succeeds by communicating the relevant information.[1] This is little improvement over physiognomic essentialism. If the relevant information is simply construed as the appearance of a person's face, we gain no useful insight into the art of caricature. If relevant information consists in distinctive features, the problems raised above recur. Finally, "relevant information" is even more prey to relativism than the notion of essential features.

Any explanation of caricature that focuses on what caricature captures will succumb to similar criticisms unless it can also account for how the capture is effected. We might take up this challenge with the following definition: Caricature highlights selected aspects of a person's appearance by exaggerating faithful representations along certain parameters. Thus caricatured strong jaws are stronger and caricatured long noses longer, caricatured weak chins are weaker and caricatured beady eyes beadier. Unfortunately, this proves more a restatement than a solution of our original paradox. There is no computation by which the exaggeration can be reversed to recover a subject's 'actual' appearance. Thus our definition simply repeats the puzzle—caricature effects easy identification through false description.

Let us consider these claims in more detail. They

From *The Monist*, 58 (1974), pp. 285–93. Reprinted with permission of *The Monist* and the author.

acknowledge the subtleties of exaggeration when used as a tool for caricature. That is, the tools of caricature are not hyperbole and understatement, but rather overemphasis and underemphasis, over/understatement and under/overstatement.[2] This makes perfect sense. If a caricaturist uniformly exaggerated *every* feature of his subject's face, he would simply end up with a very large (or very small) drawing. Instead, his exaggeration is selective. Some features are highlighted, others played down, others eliminated altogether. Then of what use is the exaggerated description? How can it aid identification if not derived from reality in a rule-governed way?

The short answer here is that locating and reversing exaggeration is not important in identifying caricatures. The process of recognition does not turn on any mental imaginings which transform the caricature into a realistic portrait. Identification proceeds directly from caricature to subject. Not only does introspection fail to yield any inner computations, but there is no standard realistic representation which might be their goal. Reading caricature cannot be explained by appeal to reading portraits, for this is no less puzzling.

Gombrich advances a thesis admirably divorced from any mention of essential features or standard or truthful representations. He claims: "All artistic discoveries are discoveries not of likenesses but of equivalences which enable us to see reality in terms of an image and an image in terms of reality. And this equivalence never rests on the likeness of elements so much as on the identity of responses to certain relationships . . . these identities do not depend on the imitation of individual features so much as on configuration of clues."[8] All of Gombrich's negative comments are valid. His positive theory is not so airtight. First, he grounds the equivalence between a caricature and its subject in audience response. What counts as caricature, although rooted in practice, is not a statistical question. Debate here is not settled by opinion polls. A caricature seen by no one but its artist would nevertheless be a caricature; so would a caricature so poor that none of its viewers correctly identified its subject. Second, Gombrich's formulae fail to distinguish caricature from other forms of representation. And third, when Gombrich briefly attempts to explain the means by which caricature captures its subjects he reverts to the hapless notion of "concentrating all required information into one arrested image".[4]

We have discovered many ways not to talk of caricature. The possibility of framing a definition in terms of necessary and sufficient conditions seems increasingly remote. Let us begin anew and try to find a way of saying what caricature is and how it

Drawing by David Levine. Reprinted with permission from *The New York Review of Books*. Copyright © 1972 The New York Review.

works without falling into the pitfalls exposed above. Consider David Levine's caricature of C. P. Snow as an eggheaded Humpty Dumpty sitting atop a computer. In what critical respects does it differ from (1) an oil portrait of Lord Snow (2) a photograph of him (3) a photograph of him taken through a fish-eye lens (4) a drawing of an egg (5) an accurate and detailed verbal description of Lord Snow (6) a verbal description which greatly exaggerates his resemblance to a heavily jowled egg and alludes to the story of Humpty Dumpty?

Let us dispense with (5) and (6) first. Certainly Levine's caricature is nonlinguistic. Thus with example (5) it shares only the fact of referring to Lord Snow. Does it share with example (6) the label "caricature"? Pictures can caricature both styles

and individuals; perhaps paragraphs can only parody styles. Both Levine's drawing and example (6) refer to Lord Snow, exaggerate his rotundity, and emphasize his resemblance to an egg. Yet although they accomplish the same tasks, their differences are significant. This is best expressed by stipulating that the vehicle of the paragraph is metaphor, that of the picture caricature. I shall return to this point later.

The distinctions between Levine's caricature and examples (1) through (3) can be effectively stated if we keep in mind the lessons learned from the earlier definitions of caricature. The temptation there was to claim that caricature lights on the important features of a face and distorts them in a way that heightens recognition. Unfortunately this proved unsayable. We erred in referring the caricatures back to their subject's faces. This automatically required appeal to (1) essential and important features, and (2) true, actual, or undistorted representations and appearances. We had a much more appropriate standard of comparison already at hand. A caricature is best contrasted not with a face but with already existing modes of representing that face. Our canons of realistic representation are relative and variable. Nevertheless we can correctly judge where various representations belong in the continuum. Thus the caricature of Lord Snow and examples (1) through (3) are *all* C. P. Snow-representations. Those representations which are also caricatures are among those judged less realistic than the others.

Part of our paradox is now resolved. Correctly identifying the subject of a caricature is no more and no less a problem than correctly identifying the subject of a painting or photograph. The difference in medium among our examples—oil, pen and ink, light-sensitive paper—is incidental. The important difference is their degree of realism. Yet clearly this is not sufficient to distinguish caricature, for example (3) is a distorted representation of Lord Snow. A fish-eye photograph differs from a caricature in that it is mechanically and regularly distorted. Such a photograph is interesting in its own right, but it imparts no information particularly relevant to Lord Snow. Any person photographed through a fish-eye lens would look similarly splayed. Caricatures are those among less realistic representations which are purposefully distorted, distorted so as to give new insight into, new vision of, the face they represent.

Discussion of example (4) is relevant here. A drawing of an egg would, if reference to Lord Snow were established, be a perfectly legitimate caricature of him. Such a representation offers us a new and striking visual parallel. Its effect is much like that of metaphor as discussed in *Languages of Art*. At work here is a certain reciprocity. Not only does the world determine how we see pictures, but pictures can determine how we see the world. Gombrich makes this point explicitly, but elaborates it in an unfortunate direction with talk of relevant information and audience response. To repeat his words: "All artistic discoveries are discoveries not of likenesses but of equivalences which enable us to see reality in terms of image and an image in terms of reality."[5] Of caricature in particular, he remarks " ... it offers a visual interpretation of a physiognomy which we can never forget and which the victim will always carry around with him like a man bewitched."[6] Some caricatures in particular bear out this thesis, those whose 'message' can be captured linguistically through a simple simile. Thus we can talk of Nixon represented *as* a bomb, C. P. Snow *as* an egg and *as* Humpty Dumpty, Louis Philippe *as* a pear,[7] Beckett *as* a buzzard. Although the great majority of caricatures cannot be succinctly summed up in a simile, they can nevertheless be understood on this model. Consider Levine's chipmunklike caricature of Queen Victoria. It does not invite us to see the Queen as any particular animal, fruit, or vegetable. But it does invite us to see her (more correctly, her pictures) in light of the caricature by seeing her as the caricature depicts her.

Drawing by David Levine. Reprinted with permission from *The New York Review of Books*. Copyright © 1972 The New York Review.

Accepting Gombrich's formula, we can carve the following niche for caricature in the continuum of pictorial representations: Caricatures are those representations of people which are judged to be less realistic and which demand we see reality (which includes people *and* pictures) in terms of them. This accords with Goodman in that realistic pictures are those conventionally or habitually judged realistic, and borrows from Gombrich to effect the further explanation that these are just those pictures we can see in terms of the world rather than seeing the world in terms of them.

This account of caricature is not sufficiently discriminating. It fails to distinguish Levine's Queen Victoria from portraits by Goya, Matisse, Picasso. Consider Goya's portrait of the Spanish royal family, or Picasso's portrait of Gertrude Stein. These canvases overstep the traditional bounds of realism; they prompt us to see their subjects in new terms. They thus inhabit the niche we set aside for caricature. Although we lack necessary and sufficient conditions which will prevent such encroachment, we can for each case explain why the painting in question is not a caricature. The explanation lies in the details of practice. Caricature is a multiple art; it is topical. It is more often to be found in newspapers and magazines than in museums and galleries. This all hints at caricature's utilitarian function. Caricature is primarily a vehicle for humor, for satire, or simply for reference. Its distortions are means to these ends. They aid identification and visually convey meaning, message, and metaphor. This distinguishes caricature from such works as Picasso's portrait of Vollard, where the distortion stems from a theory of art and vision and affects not only physiognomy but all objects, even all spaces. It also distinguishes caricature from Goya's portrait, where visual and aesthetic values are equally as important as the psychological and political comments made through them. Caricature and portraiture lie in a continuum but they do not collapse into one another. But crudely, their difference in purpose is evidenced in a difference in practice, a difference in the way they are received, a difference in the way they are explained. We regard caricatures differently from portraits, we talk about them differently. This difference is not erased by our lack of necessary and sufficient conditions which pick out all and only all caricatures.

We have offered as preliminary solution to the problem of caricature an explanation which situates caricature within the larger continuum of representation. Metaphor was explained through metaphorical talk of new ways of seeing; caricature is explained through literal talk of new ways of seeing. Some explanation of seeing itself now seems required. No simple explanation is forthcoming. Recognizing a caricature was claimed to be no more paradoxical than recognizing a realistic portrait. I now claim (and Gombrich's thesis supports me) that recognizing a realistic portrait is no more paradoxical than recognizing any among the myriad objects that clutter our world. Yet how we accomplish this *is* paradoxical, or at least puzzling, astounding, bewildering. Consider desks for a moment. I have seen many desks in my life. I am writing at one now. I was first introduced to desks through ostensive definition. My mother had a dark, delicate, ornate desk with claw feet and elaborate brass handles; my father's was blonde, spare, and modern. From these I learned to apply the word "desk" to many pieces of furniture, some resembling tables or shelves more than those first desks I was acquainted with. I have learned to project the predicate "desk" without ever acquiring a set of necessary and sufficient conditions to aid me. And, no such set of conditions could be framed. A fallen tree could be my desk if I'm out in the wilds; a desk could be a dining room table in a student apartment. The only definition adequate to capture all and only all desks would be an endless, and therefore impossible, enumeration of cases.

There is a point to this outpouring of autobiography. We can all project an absolutely enormous number of predicates. Given this basis, we can outline some of the formal features of caricature recognition by acknowledging the complexity of projection required. First, I must be able to correctly judge which pictures do and which do not belong to the class of caricatures. That is, I must be able to project the predicate "caricature". Projection is also involved in correctly identifying and reading caricatures. Since I can often identify caricatures of subjects I have never before seen caricatured, I must be relying on additional information. My entire record of previous correct caricature identifications is relevant here. So too are my past correct picture and photo identifications, my acquaintance with cartoons, with realistic line drawings, with faces, with face descriptions, with metaphors, with myths . . . in short, with almost everything. Once we acknowledge the complexity of the projection class involved, we wean ourselves from the belief that caricature identification is a paradoxical leap from features emphasized in a drawing to the person (face) they mirror and exaggerate. It is a useful exercise to explain caricature recognition on the model of metaphor. Caricature is to realistic art as metaphor is to literal expression. Both involve new ways of seeing; both inhabit a continuum with literal ways of depicting reality; neither is circumscribable by necessary and sufficient conditions; neither turns on resemblance or likeness (although there are standards of appropriateness for both). Both caricature and metaphor are vehicles for conciseness, novelty, and economy of expression. Neither is paradoxical; both are wondrous.

Notes

1. E. H. Gombrich, *Art and Illusion* (Princeton: Princeton University Press, 1969), p. 345.
2. Nelson Goodman, *Languages of Art: An Approach to a Theory of Symbols* (Indianapolis: Bobbs-Merrill Co., 1968), p. 82.
3. Gombrich, p. 345.
4. Ibid.
5. Ibid.
6. Ibid., p. 344.
7. Ibid.

The Aesthetic Hypothesis:
Significant Form and Aesthetic Emotion

CLIVE BELL

It is improbable that more nonsense has been written about aesthetics than about anything else: the literature of the subject is not large enough for that. It is certain, however, that about no subject with which I am acquainted has so little been said that is at all to the purpose. The explanation is discoverable. He who would elaborate a plausible theory of aesthetics must possess two qualities—artistic sensibility and a turn for clear thinking. Without sensibility a man can have no aesthetic experience, and, obviously, theories not based on broad and deep aesthetic experience are worthless. Only those for whom art is a constant source of passionate emotion can possess the data from which profitable theories may be deduced; but to deduce profitable theories even from accurate data involves a certain amount of brain-work, and, unfortunately, robust intellects and delicate sensibilities are not inseparable. As often as not, the hardest thinkers have had no aesthetic experience whatever. I have a friend blessed with an intellect as keen as a drill, who, though he takes an interest in aesthetics, has never during a life of almost forty years been guilty of an aesthetic emotion. So, having no faculty for distinguishing a work of art from a handsaw, he is apt to rear up a pyramid of irrefragable argument on the hypothesis that a handsaw is a work of art. This defect robs his perspicuous and subtle reasoning of much of its value; for it has ever been a maxim that faultless logic can win but little credit for conclusions that are based on premises notoriously false.

Every cloud, however, has its silver lining, and this insensibility, though unlucky in that it makes my friend incapable of choosing a sound basis for his argument, mercifully blinds him to the absurdity of his conclusions while leaving him in full enjoyment of his masterly dialectic. People who set out from the hypothesis that Sir Edwin Landseer was the finest painter that ever lived will feel no uneasiness about an aesthetic which proves that Giotto was the worst. So, my friend, when he arrives very logically at the conclusion that a work of art should be small or round or smooth, or that to appreciate fully a picture you should pace smartly before it or set it spinning like a top, cannot guess why I ask him whether he has lately been to Cambridge, a place he sometimes visits.

On the other hand, people who respond immediately and surely to works of art, though, in my judgment, more enviable than men of massive intellect but slight sensibility, are often quite as incapable of talking sense about aesthetics. Their heads are not always very clear. They possess the data on which any system must be based; but, generally, they want the power that draws correct inferences from true data. Having received aesthetic emotions from works of art, they are in a position to seek out the quality common to all that have moved them, but, in fact, they do nothing of the sort. I do not blame them. Why should they bother to examine their feelings when for them to feel is enough? Why should they stop to think when they are not very

From Clive Bell, *Art*. London: Chatto & Windus, 1914, pp. 3–37. Reprinted with permission of Chatto & Windus and the Estate of Clive Bell.

good at thinking? Why should they hunt for a common quality in all objects that move them in a particular way when they can linger over the many delicious and peculiar charms of each as it comes? So, if they write criticism and call it aesthetics, if they imagine that they are talking about Art when they are talking about particular works of art or even about the technique of painting, if, loving particular works they find tedious the consideration of art in general, perhaps they have chosen the better part. If they are not curious about the nature of their emotion, nor about the quality common to all objects that provoke it, they have my sympathy, and, as what they say is often charming and suggestive, my admiration too. Only let no one suppose that what they write and talk is aesthetics; it is criticism, or just "shop."

The starting-point for all systems of aesthetics must be the personal experience of a peculiar emotion. The objects that provoke this emotion we call works of art. All sensitive people agree that there is a peculiar emotion provoked by works of art. I do not mean, of course, that all works provoke the same emotion. On the contrary, every work produces a different emotion. But all these emotions are recognisably the same in kind; so far, at any rate, the best opinion is on my side. That there is a particular kind of emotion provoked by works of visual art, and that this emotion is provoked by every kind of visual art, by pictures, sculptures, buildings, pots, carvings, textiles, etc., etc., is not disputed, I think, by anyone capable of feeling it. This emotion is called the aesthetic emotion; and if we can discover some quality common and peculiar to all the objects that provoke it, we shall have solved what I take to be the central problem of aesthetics. We shall have discovered the essential quality in a work of art, the quality that distinguishes works of art from all other classes of objects.

For either all works of visual art have some common quality, or when we speak of "works of art" we gibber. Everyone speaks of "art," making a mental classification by which he distinguishes the class "works of art" from all other classes. What is the justification of this classification? What is the quality common and peculiar to all members of this class? Whatever it be, no doubt it is often found in company with other qualities; but they are adventitious—it is essential. There must be some one quality without which a work of art cannot exist; possessing which, in the least degree, no work is altogether worthless. What is this quality? What quality is shared by all objects that provoke our aesthetic emotions? What quality is common to Sta. Sophia and the windows at Chartres, Mexican sculpture, a Persian bowl, Chinese carpets, Giotto's frescoes at Padua, and the masterpieces of Poussin,

Piero della Francesca, and Cézanne? Only one answer seems possible—significant form. In each, lines and colours combined in a particular way, certain forms and relations of forms, stir our aesthetic emotions. These relations and combinations of lines and colours, these aesthetically moving forms, I call "Significant Form"; and "Significant Form" is the one quality common to all works of visual art.

At this point it may be objected that I am making aesthetics a purely subjective business, since my only data are personal experiences of a particular emotion. It will be said that the objects that provoke this emotion vary with each individual, and that therefore a system of aesthetics can have no objective validity. It must be replied that any system of aesthetics which pretends to be based on some objective truth is so palpably ridiculous as not to be worth discussing. We have no other means of recognising a work of art than our feeling for it. The objects that provoke aesthetic emotion vary with each individual. Aesthetic judgments are, as the saying goes, matters of taste; and about tastes, as everyone is proud to admit, there is no disputing. A good critic may be able to make me see in a picture that had left me cold things that I had overlooked, till at last, receiving the aesthetic emotion, I recognise it as a work of art. To be continually pointing out those parts, the sum, or rather the combination, of which unite to produce significant form, is the function of criticism. But it is useless for a critic to tell me that something is a work of art; he must make me feel it for myself. This he can do only by making me see; he must get at my emotions through my eyes. Unless he can make me see something that moves me, he cannot force my emotions. I have no right to consider anything a work of art to which I cannot react emotionally; and I have no right to look for the essential quality in anything that I have not *felt* to be a work of art. The critic can affect my aesthetic theories only by affecting my aesthetic experience. All systems of aesthetics must be based on personal experience—that is to say, they must be subjective.

Yet, though all aesthetic theories must be based on aesthetic judgments, and ultimately all aesthetic judgments must be matters of personal taste, it would be rash to assert that no theory of aesthetics can have general validity. For, though A, B, C, D are the works that move me, and A, D, E, F the works that move you, it may well be that x is the only quality believed by either of us to be common to all the works in his list. We may all agree about aesthetics, and yet differ about particular works of art. We may differ as to the presence or absence of the quality x. My immediate object will be to show that significant form is the only quality common and peculiar to all the works of visual art that move me;

and I will ask those whose aesthetic experience does not tally with mine to see whether this quality is not also, in their judgment, common to all works that move them, and whether they can discover any other quality of which the same can be said.

Also at this point a query arises, irrelevant indeed, but hardly to be suppressed: "Why are we so profoundly moved by forms related in a particular way?" The question is extremely interesting, but irrelevant to aesthetics. In pure aesthetics we have only to consider our emotion and its object: for the purposes of aesthetics we have no right, neither is there any necessity, to pry behind the object into the state of mind of him who made it. Later, I shall attempt to answer the question; for by so doing I may be able to develop my theory of the relation of art to life. I shall not, however, be under the delusion that I am rounding off my theory of aesthetics. For a discussion of aesthetics, it need be agreed only that forms arranged and combined according to certain unknown and mysterious laws do move us in a particular way, and that it is the business of an artist so to combine and arrange them that they shall move us. These moving combinations and arrangements I have called, for the sake of convenience and for a reason that will appear later, "Significant Form."

A third interruption has to be met. "Are you forgetting about colour?" someone inquires. Certainly not; my term "significant form" included combinations of lines and of colours. The distinction between form and colour is an unreal one; you cannot conceive a colourless line or a colourless space; neither can you conceive a formless relation of colours. In a black and white drawing the spaces are all white and all are bounded by black lines; in most oil paintings the spaces are multi-coloured and so are the boundaries; you cannot imagine a boundary line without any content, or a content without a boundary line. Therefore, when I speak of significant form, I mean a combination of lines and colours (counting white and black as colours) that moves me aesthetically.

Some people may be surprised at my not having called this "beauty." Of course, to those who define beauty as "combinations of lines and colours that provoke aesthetic emotion," I willingly concede the right of substituting their word for mine. But most of us, however strict we may be, are apt to apply the epithet "beautiful" to objects that do not provoke that peculiar emotion produced by works of art. Everyone, I suspect, has called a butterfly or a flower beautiful. Does anyone feel the same kind of emotion for a butterfly or a flower that he feels for a cathedral or a picture? Surely, it is not what I call an aesthetic emotion that most of us feel, generally, for natural beauty. I shall suggest, later, that some people may, occasionally, see in nature what we see in art, and feel for her an aesthetic emotion; but I am satisfied that, as a rule, most people feel a very different kind of emotion for birds and flowers and the wings of butterflies from that which they feel for pictures, pots, temples and statues. Why these beautiful things do not move us as works of art move is another, and not an aesthetic, question. For our immediate purpose we have to discover only what quality is common to objects that do move us as works of art. In the last part of this chapter, when I try to answer the question—"Why are we so profoundly moved by some combinations of lines and colours?" I shall hope to offer an acceptable explanation of why we are less profoundly moved by others.

Since we call a quality that does not raise the characteristic aesthetic emotion "Beauty," it would be misleading to call by the same name the quality that does. To make "beauty" the object of the aesthetic emotion, we must give to the word an over-strict and unfamiliar definition. Everyone sometimes uses "beauty" in an unaesthetic sense; most people habitually do so. To everyone, except perhaps here and there an occasional aesthete, the commonest sense of the word is unaesthetic. Of its grosser abuse, patent in our chatter about "beautiful huntin'" and "beautiful shootin'," I need not take account; it would be open to the precious to reply that they never do so abuse it. Besides, here there is no danger of confusion between the aesthetic and the non-aesthetic use; but when we speak of a beautiful woman there is. When an ordinary man speaks of a beautiful woman he certainly does not mean only that she moves him aesthetically; but when an artist calls a withered old hag beautiful he may sometimes mean what he means when he calls a battered torso beautiful. The ordinary man, if he be also a man of taste, will call the battered torso beautiful, but he will not call a withered hag beautiful because, in the matter of women, it is not to the aesthetic quality that the hag may possess, but to some other quality that he assigns the epithet. Indeed, most of us never dream of going for aesthetic emotions to human beings, from whom we ask something very different. This "something," when we find it in a young woman, we are apt to call "beauty." We live in a nice age. With the man-in-the-street "beautiful" is more often than not synonymous with "desirable"; the word does not necessarily connote any aesthetic reaction whatever, and I am tempted to believe that in the minds of many the sexual flavour of the word is stronger than the aesthetic. I have noticed a consistency in those to whom the most beautiful thing in the world is a beautiful woman, and the next most beautiful thing a picture of one. The confusion between aes-

thetic and sensual beauty is not in their case so great as might be supposed. Perhaps there is none; for perhaps they have never had an aesthetic emotion to confuse with their other emotions. The art that they call "beautiful" is generally closely related to the women. A beautiful picture is a photograph of a pretty girl; beautiful music, the music that provokes emotions similar to those provoked by young ladies in musical farces; and beautiful poetry, the poetry that recalls the same emotions felt, twenty years earlier, for the rector's daughter. Clearly the word "beauty" is used to connote the objects of quite distinguishable emotions, and that is a reason for not employing a term which would land me inevitably in confusions and misunderstandings with my readers.

On the other hand, with those who judge it more exact to call these combinations and arrangements of form that provoke our aesthetic emotions, not "significant form," but "significant relations of form," and then try to make the best of two worlds, the aesthetic and the metaphysical, by calling these relations "rhythm," I have no quarrel whatever. Having made it clear that by "significant form" I mean arrangements and combinations that move us in a particular way, I willingly join hands with those who prefer to give a different name to the same thing.

The hypothesis that significant form is the essential quality in a work of art has at least one merit denied to many more famous and more striking— it does help to explain things. We are all familiar with pictures that interest us and excite our admiration, but do not move us as works of art. To this class belongs what I call "Descriptive Painting"— that is, painting in which forms are used not as objects of emotion, but as means of suggesting emotion or conveying information. Portraits of psychological and historical value, topographical works, pictures that tell stories and suggest situations, illustrations of all sorts, belong to this class. That we all recognise the distinction is clear, for who has not said that such and such a drawing was excellent as illustration, but as a work of art worthless? Of course many descriptive pictures possess, amongst other qualities, formal significance, and are therefore works of art: but many more do not. They interest us; they may move us too in a hundred different ways, but they do not move us aesthetically. According to my hypothesis they are not works of art. They leave untouched our aesthetic emotions because it is not their forms but the ideas or information suggested or conveyed by their forms that affect us.

Few pictures are better known or liked than Frith's "Paddington Station"; certainly I should be the last to grudge it its popularity. Many a weary forty minutes have I whiled away disentangling its fascinating incidents and forging for each an imaginary past and an improbable future. But certain though it is that Frith's masterpiece, or engravings of it, have provided thousands with half-hours of curious and fanciful pleasure, it is not less certain that no one has experienced before it one half-second of aesthetic rapture—and this although the picture contains several pretty passages of colour, and is by no means badly painted. "Paddington Station" is not a work of art; it is an interesting and amusing document. In it line and colour are used to recount anecdotes, suggest ideas, and indicate the manners and customs of an age: they are not used to provoke aesthetic emotion. Forms and the relations of forms were for Frith not objects of emotion, but means of suggesting emotion and conveying ideas.

The ideas and information conveyed by "Paddington Station" are so amusing and so well presented that the picture has considerable value and is well worth preserving. But, with the perfection of photographic processes and of the cinematograph, pictures of this sort are becoming otiose. Who doubts that one of those *Daily Mirror* photographers in collaboration with a *Daily Mail* reporter can tell us far more about "London day by day" than any Royal Academician? For an account of manners and fashions we shall go, in future, to photographs, supported by a little bright journalism, rather than to descriptive painting. Had the imperial academicians of Nero, instead of manufacturing incredibly loathsome imitations of the antique, recorded in fresco and mosaic the manners and fashions of their day, their stuff, though artistic rubbish, would now be an historical gold-mine. If only they had been Friths instead of being Alma Tademas! But photography has made impossible any such transmutation of modern rubbish. Therefore it must be confessed that pictures in the Frith tradition are grown superfluous; they merely waste the hours of able men who might be more profitably employed in works of a wider beneficence. Still, they are not unpleasant, which is more than can be said for that kind of descriptive painting of which "The Doctor" is the most flagrant example. Of course "The Doctor" is not a work of art. In it form is not used as an object of emotion, but as a means of suggesting emotions. This alone suffices to make it nugatory; it is worse than nugatory because the emotion it suggests is false. What it suggests is not pity and admiration but a sense of complacency in our own pitifulness and generosity. It is sentimental. Art is above morals, or, rather, all art is moral because, as I hope to show presently, works of art are immediate means to good. Once we have judged a thing a work of art, we have judged it ethically of the first importance and put it beyond the reach of the mor-

alist. But descriptive pictures which are not works of art, and, therefore, are not necessarily means to good states of mind, are proper objects of the ethical philosopher's attention. Not being a work of art, "The Doctor" has none of the immense ethical value possessed by all objects that provoke aesthetic ecstasy; and the state of mind to which it is a means, as illustration, appears to me undesirable.

The works of those enterprising young men, the Italian Futurists, are notable examples of descriptive painting. Like the Royal Academicians, they use form, not to provoke aesthetic emotions, but to convey information and ideas. Indeed, the published theories of the Futurists prove that their pictures ought to have nothing whatever to do with art. Their social and political theories are respectable, but I would suggest to young Italian painters that it is possible to become a Futurist in thought and action and yet remain an artist, if one has the luck to be born one. To associate art with politics is always a mistake. Futurist pictures are descriptive because they aim at presenting in line and colour the chaos of the mind at a particular moment; their forms are not intended to promote aesthetic emotion but to convey information. These forms, by the way, whatever may be the nature of the ideas they suggest, are themselves anything but revolutionary. In such Futurist pictures as I have seen—perhaps I should except some by Severini—the drawing, whenever it becomes representative as it frequently does, is found to be in that soft and common convention brought into fashion by Besnard some thirty years ago, and much affected by Beaux-Art students ever since. As works of art, the Futurist pictures are negligible; but they are not to be judged as works of art. A good Futurist picture would succeed as a good piece of psychology succeeds; it would reveal, through line and colour, the complexities of an interesting state of mind. If Futurist pictures seem to fail, we must seek an explanation, not in a lack of artistic qualities that they never were intended to possess, but rather in the minds the states of which they are intended to reveal.

Most people who care much about art find that of the work that moves them most the greater part is what scholars call "Primitive." Of course there are bad primitives. For instance, I remember going, full of enthusiasm, to see one of the earliest Romanesque churches in Poitiers (Notre-Dame-la-Grande), and finding it as ill-proportioned, over-decorated, coarse, fat and heavy as any better class building by one of those highly civilised architects who flourished a thousand years earlier or eight hundred later. But such exceptions are rare. As a rule primitive art is good—and here again my hypothesis is helpful—for, as a rule, it is also free from descriptive qualities. In primitive art you will find no accurate representation; you will find only significant form. Yet no other art moves us so profoundly. Whether we consider Sumerian sculpture or pre-dynastic Egyptian art, or archaic Greek, or the Wei and T'ang masterpieces,[1] or those early Japanese works of which I had the luck to see a few superb examples (especially two wooden Bodhisattvas) at the Shepherd's Bush Exhibition in 1910, or whether, coming nearer home, we consider the primitive Byzantine art of the sixth century and its primitive developments amongst the Western barbarians, or, turning far afield, we consider that mysterious and majestic art that flourished in Central and South America before the coming of the white men, in every case we observe three common characteristics—absence of representation, absence of technical swagger, sublimely impressive form. Nor is it hard to discover the connection between these three. Formal significance loses itself in preoccupation with exact representation and ostentatious cunning.[2]

Naturally, it is said that if there is little representation and less saltimbancery in primitive art, that is because the primitives were unable to catch a likeness or cut intellectual capers. The contention is beside the point. There is truth in it, no doubt, though, were I a critic whose reputation depended on a power of impressing the public with a semblance of knowledge, I should be more cautious about urging it than such people generally are. For to suppose that the Byzantine masters wanted skill, or could not have created an illusion had they wished to do so, seems to imply ignorance of the amazingly dexterous realism of the notoriously bad works of that age. Very often, I fear, the misrepresentation of the primitives must be attributed to what the critics call, "wilful distortion." Be that as it may, the point is that, either from want of skill or want of will, primitives neither create illusions, nor make display of extravagant accomplishment, but concentrate their energies on the one thing needful—the creation of form. Thus have they created the finest works of art that we possess.

Let no one imagine that representation is bad in itself; a realistic form may be as significant, in its place as part of the design, as an abstract. But if a representative form has value, it is as form, not as representation. The representative element in a work of art may or may not be harmful; always it is irrelevant. For, to appreciate a work of art we need bring with us nothing from life, no knowledge of its ideas and affairs, no familiarity with its emotions. Art transports us from the world of man's activity to a world of aesthetic exaltation. For a moment we are shut off from human interests; our anticipations and memories are arrested; we are lifted above the stream of life. The pure mathema-

tician rapt in his studies knows a state of mind which I take to be similar, if not identical. He feels an emotion for his speculations which arises from no perceived relation between them and the lives of men, but springs, inhuman or super-human, from the heart of an abstract science. I wonder, sometimes, whether the appreciators of art and of mathematical solutions are not even more closely allied. Before we feel an aesthetic emotion for a combination of forms, do we not perceive intellectually the rightness and necessity of the combination? If we do, it would explain the fact that passing rapidly through a room we recognise a picture to be good, although we cannot say that it has provoked much emotion. We seem to have recognised intellectually the rightness of its forms without staying to fix our attention, and collect, as it were, their emotional significance. If this were so, it would be permissible to inquire whether it was the forms themselves or our perception of their rightness and necessity that caused aesthetic emotion. But I do not think I need linger to discuss the matter here. I have been inquiring why certain combinations of forms move us; I should not have travelled by other roads had I enquired, instead, why certain combinations are perceived to be right and necessary, and why our perception of their rightness and necessity is moving. What I have to say is this: the rapt philosopher, and he who contemplates a work of art, inhabit a world with an intense and peculiar significance of its own; that significance is unrelated to the significance of life. In this world the emotions of life find no place. It is a world with emotions of its own.

To appreciate a work of art we need bring with us nothing but a sense of form and colour and a knowledge of three-dimensional space. That bit of knowledge, I admit, is essential to the appreciation of many great works, since many of the most moving forms ever created are in three dimensions. To see a cube or a rhomboid as a flat pattern is to lower its significance, and a sense of three-dimensional space is essential to the full appreciation of most architectual forms. Pictures which would be insignificant if we saw them as flat patterns are profoundly moving because, in fact, we see them as related planes. If the representation of three-dimensional space is to be called "representation," then I agree that there is one kind of representation which is not irrelevant. Also, I agree that along with our feeling for line and colour we must bring with us our knowledge of space if we are to make the most of every kind of form. Nevertheless, there are magnificent designs to an appreciation of which this knowledge is not necessary: so, though it is not irrelevant to the appreciation of some works of art it is not essential to the appreciation of all. What we must say is that the representation of three-dimensional space is neither irrelevant nor essential to all art, and that every other sort of representation is irrelevant.

That there is an irrelevant representative or descriptive element in many great works of art is not in the least surprising. Why it is not surprising I shall try to show elsewhere. Representation is not of necessity baneful, and highly realistic forms may be extremely significant. Very often, however, representation is a sign of weakness in an artist. A painter too feeble to create forms that provoke more than a little aesthetic emotion will try to eke that little out by suggesting the emotions of life. To evoke the emotions of life he must use representation. Thus a man will paint an execution, and, fearing to miss with his first barrel of significant form, will try to hit with his second by raising an emotion of fear or pity. But if in the artist an inclination to play upon the emotions of life is often the sign of a flickering inspiration, in the spectator a tendency to seek, behind form, the emotions of life is a sign of defective sensibility always. It means that his aesthetic emotions are weak or, at any rate, imperfect. Before a work of art people who feel little or no emotion for pure form find themselves at a loss. They are deaf men at a concert. They know that they are in the presence of something great, but they lack the power of apprehending it. They know that they ought to feel for it a tremendous emotion, but it happens that the particular kind of emotion it can raise is one that they can feel hardly or not at all. And so they read into the forms of the work those facts and ideas for which they are capable of feeling emotion, and feel for them the emotions that they can feel—the ordinary emotions of life. When confronted by a picture, instinctively they refer back its forms to the world from which they came. They treat created form as though it were imitated form, a picture as though it were a photograph. Instead of going out on the stream of art into a new world of aesthetic experience, they turn a sharp corner and come straight home to the world of human interests. For them the significance of a work of art depends on what they bring to it; no new thing is added to their lives, only the old material is stirred. A good work of visual art carries a person who is capable of appreciating it out of life into ecstasy: to use art as a means to the emotions of life is to use a telescope for reading the news. You will notice that people who cannot feel pure aesthetic emotions remember pictures by their subjects; whereas people who can, as often as not, have no idea what the subject of a picture is. They have never noticed the representative element, and so when they discuss pictures they talk about the shapes of forms and the relations and quantities of colours. Often they can tell by the quality of a single line whether or no a man is a good artist. They are concerned only with lines and colours, their relations and quantities and

qualities; but from these they win an emotion more profound and far more sublime than any that can be given by the description of facts and ideas.

This last sentence has a very confident ring—over-confident, some may think. Perhaps I shall be able to justify it, and make my meaning clearer too, if I give an account of my own feelings about music. I am not really musical. I do not understand music well. I find musical form exceedingly difficult to apprehend, and I am sure that the profounder subtleties of harmony and rhythm more often than not escape me. The form of a musical composition must be simple indeed if I am to grasp it honestly. My opinion about music is not worth having. Yet, sometimes, at a concert, though my appreciation of the music is limited and humble, it is pure. Sometimes, though I have a poor understanding, I have a clean palate. Consequently, when I am feeling bright and clear and intent, at the beginning of a concert for instance, when something that I can grasp is being played, I get from music that pure aesthetic emotion that I get from visual art. It is less intense, and the rapture is evanescent; I understand music too ill for music to transport me far into the world of pure aesthetic ecstasy. But at moments I do appreciate music as pure musical form, as sounds combined according to the laws of a mysterious necessity, as pure art with a tremendous significance of its own and no relation whatever to the significance of life; and in those moments I lose myself in that infinitely sublime state of mind to which pure visual form transports me. How inferior is my normal state of mind at a concert. Tired or perplexed, I let slip my sense of form, my aesthetic emotion collapses, and I begin weaving into the harmonies, that I cannot grasp, the ideas of life. Incapable of feeling the austere emotions of art, I begin to read into the musical forms human emotions of terror and mystery, love and hate, and spend the minutes, pleasantly enough, in a world of turbid and inferior feeling. At such times, were the grossest pieces of onomatopoeic representation—the song of a bird, the galloping of horses, the cries of children, or the laughing of demons—to be introduced into the symphony, I should not be offended. Very likely I should be pleased; they would afford new points of departure for new trains of romantic feeling or heroic thought. I know very well what has happened. I have been using art as a means to the emotions of life and reading into it the ideas of life. I have been cutting blocks with a razor. I have tumbled from the superb peaks of aesthetic exaltation to the snug foothills of warm humanity. It is a jolly country. No one need be ashamed of enjoying himself there. Only no one who has ever been on the heights can help feeling a little crestfallen in the cosy valleys. And let no one imagine, because he has made merry in the warm tilth and quaint nooks of romance, that he can even guess at the austere and thrilling raptures of those who have climbed the cold, white peaks of art.

About music most people are as willing to be humble as I am. If they cannot grasp musical form and win from it a pure aesthetic emotion, they confess that they understand music imperfectly or not at all. They recognise quite clearly that there is a difference between the feeling of the musician for pure music and that of the cheerful concert-goer for what music suggests. The latter enjoys his own emotions, as he has every right to do, and recognises their inferiority. Unfortunately, people are apt to be less modest about their powers of appreciating visual art. Everyone is inclined to believe that out of pictures, at any rate, he can get all that there is to be got; everyone is ready to cry "humbug" and "impostor" at those who say that more can be had. The good faith of people who feel pure aesthetic emotions is called in question by those who have never felt anything of the sort. It is the prevalence of the representative element, I suppose, that makes the man in the street so sure that he knows a good picture when he sees one. For I have noticed that in matters of architecture, pottery, textiles, etc., ignorance and ineptitude are more willing to defer to the opinions of those who have been blest with peculiar sensibility. It is a pity that cultivated and intelligent men and women cannot be induced to believe that a great gift of aesthetic appreciation is at least as rare in visual as in musical art. A comparison of my own experience in both has enabled me to discriminate very clearly between pure and impure appreciation. Is it too much to ask that others should be as honest about their feelings for pictures as I have been about mine for music? For I am certain that most of those who visit galleries do feel very much what I feel at concerts. They have their moments of pure ecstasy; but the moments are short and unsure. Soon they fall back into the world of human interests and feel emotions, good no doubt, but inferior. I do not dream of saying that what they get from art is bad or nugatory; I say that they do not get the best that art can give. I do not say that they cannot understand art; rather I say that they cannot understand the state of mind of those who understand it best. I do not say that art means nothing or little to them; I say they miss its full significance. I do not suggest for one moment that their appreciation of art is a thing to be ashamed of; the majority of the charming and intelligent people with whom I am acquainted appreciate visual art impurely; and, by the way, the appreciation of almost all great writers has been impure. But provided that there be some fraction of pure aesthetic emotion, even a mixed and minor appreciation of art is, I am sure, one of the most valuable things in the world—so valuable, indeed, that in my giddier moments I have been

tempted to believe that art might prove the world's salvation.

Yet, though the echoes and shadows of art enrich the life of the plains, her spirit dwells on the mountains. To him who woos, but woos impurely, she returns enriched what is brought. Like the sun, she warms the good seed in good soil and causes it to bring forth good fruit. But only to the perfect lover does she give a new strange gift—a gift beyond all price. Imperfect lovers bring to art and take away the ideas and emotions of their own age and civilisation. In twelfth-century Europe a man might have been greatly moved by a Romanesque church and found nothing in a T'ang picture. To a man of a later age, Greek sculpture meant much and Mexican nothing, for only to the former could he bring a crowd of associated ideas to be the objects of familiar emotions. But the perfect lover, he who can feel the profound significance of form, is raised above the accidents of time and place. To him the problems of archaeology, history, and hagiography are impertinent. If the forms of a work are significant its provenance is irrelevant. Before the grandeur of those Sumerian figures in the Louvre he is carried on the same flood of emotion to the same aesthetic ecstasy as, more than four thousand years ago, the Chaldean lover was carried. It is the mark of great art that its appeal is universal and eternal.[3] Significant form stands charged with the power to provoke aesthetic emotion in anyone capable of feeling it. The ideas of men go buzz and die like gnats; men change their institutions and their customs as they change their coats; the intellectual triumphs of one age are the follies of another; only great art remains stable and unobscure. Great art remains stable and unobscure because the feelings that it awakens are independent of time and place, because its kingdom is not of this world. To those who have and hold a sense of the significance of form what does it matter whether the forms that move them were created in Paris the day before yesterday or in Babylon fifty centuries ago? The forms of art are inexhaustible; but all lead by the same road of aesthetic emotion to the same world of aesthetic ecstasy.

Notes

1. The existence of the Ku K'ai-chih makes it clear that the art of this period (fifth to eighth centuries), was a typical primitive movement. To call the great vital art of the Liang, Chen, Wei, and Tang dynasties a development out of the exquisitely refined and exhausted art of the Han decadence—from which Ku K'ai-chih is a delicate straggler—is to call Romanesque sculpture a development out of Praxiteles. Between the two something has happened to refill the stream of art. What had happened in China was the spiritual and emotional revolution that followed the onset of Buddhism.

2. This is not to say that exact representation is bad in itself. It is indifferent. A perfectly represented form may be significant, only it is fatal to sacrifice significance to representation. The quarrel between significance and illusion seems to be as old as art itself, and I have little doubt that what makes most palaeolithic art so bad is a preoccupation with exact representation. Evidently palaeolithic draughtsmen had no sense of the significance of form. Their art resembles that of the more capable and sincere Royal Academicians: it is a little higher than that of Sir Edward Poynter and a little lower than that of the late Lord Leighton. That this is no paradox let the cave-drawings of Altamira, or such works as the sketches of horses found at Bruniquel and now in the British Museum, bear witness. If the ivory head of a girl from the Grotte du Pape, Brassempouy (Musée St. Germain) and the ivory torso found at the same place (Collection St. Crie), be, indeed, palaeolithic, then there were good palaeolithic artists who created and did not imitate form. Neolithic art is, of course, a very different matter.

3. Mr. Roger Fry permits me to make use of an interesting story that will illustrate my view. When Mr. Okakura, the Government editor of The Temple Treasures of Japan, first came to Europe, he found no difficulty in appreciating the pictures of those who from want of will or want of skill did not create illusions but concentrated their energies on the creation of form. He understood immediately the Byzantine masters and the French and Italian Primitives. In the Renaissance painters, on the other hand, with their descriptive preoccupations, their literary and anecdotic interests, he could see nothing but vulgarity and muddle. The universal and essential quality of art, significant form, was missing, or rather had dwindled to a shallow stream, overlaid and hidden beneath weeds, so the universal response, aesthetic emotion, was not evoked. It was not till he came on to Henri Matisse that he again found himself in the familiar world of pure art. Similarly, sensitive Europeans who respond immediately to the significant forms of great Oriental art, are left cold by the trivial pieces of anecdote and social criticism so lovingly cherished by Chinese dilettanti. It would be easy to multiply instances did not decency forbid the labouring of so obvious a truth.

III

Painting and the Pictorial Arts
Wider Contexts

The representation in painting and other pictures of people, objects, and events raises many perplexing philosophical problems, several of which are discussed in the preceding section of this book. Clearly, however, the cultural significance of paintings and other works of visual art goes beyond what the eye can directly descry. The pictorial arts in particular have long been valued for meanings that are expressed or symbolized by the images they present. Whether we think of the dramatic Paleolithic cave paintings created seventeen thousand years ago in the Hall of the Bulls in Lascaux or of Picasso's *Guernica* done in this century, the pictorial arts have been regularly regarded as central documents in the social, political, psychological, religious, and spiritual history of human beings. The next four chapters explore a range of questions pertaining to this wider range of significance.

In this chapter, the painter Wassily Kandinsky and the philosopher Monroe Beardsley address general questions concerning the expressive and symbolic meaning of the pictorial arts. Kandinsky, in his article, "Concerning the Spiritual in Art," is concerned with the expressive potential of painting. He advances an expressionist view of art similar, in many ways, to that put forward by Leo Tolstoy in his book *What Is Art?* (1898). Kandinsky grants that art can serve pictorial aims by trying to imitate nature and probe the expressive features of natural forms. However, the highest calling of art, as he sees it, is as a form of expressive communication. The artist is impelled to embody in a work of art an emotion he or she has felt. The work in turn evokes a similar emotion in the observer. The work thus consists of two elements, the inner (the emotion of the artist) and the outer (the material form of the work). A beautiful work, Kandinsky says, is "the consequence of an harmonious cooperation of the inner and the outer."

Kandinsky supports his argument with numerous examples of the expressive effects ("internal resonances") of color and form (both abstract and representational), including an extended discussion ("not based on any exact science") of feelings evoked by simple colors. It is in virtue of this expressive

capacity of art that works of art are able to express, not only the emotions of individual artists, but the spirit of an age. A work of art may thus evince personal and societal expression, but, Kandinsky asserts, the artist must always follow what he calls the "principle of internal necessity": artistic choice must rest on "the purposive vibration of the human soul."

Beardsley tackles the question of symbolism in the visual arts. He is not so much concerned to discuss symbolism in the art historian's sense of iconography) as emblematic meanings conventionally attached to particular images (e.g., the dove that refers symbolically to the Holy Ghost). Rather, he is interested in the basic principles according to which pictures symbolize sets of properties or characteristics such as faith, hope, charity, courage, or wisdom.

Taking the example of the bald eagle, which appears on the Great Seal of the United States, Beardsley argues that three conditions may enter into the making of a symbol. There may be a *natural* basis, which establishes a connection in nature between the symbol and a certain property or set of qualities (e.g., the connection between an eagle and strength). There may be an actual or believed *conventional* basis, which stipulates a connection between the symbol and what is symbolized (e.g., the decision in 1872 to let the eagle stand for the United States). And there may be a *vital* basis, a history of actions and events, which establishes the symbolic connection in a culture (e.g., the use of the eagle on the Great Seal and on dollar bills). Beardsley argues that only the vital basis is essential but that the vital basis of a symbol is generally established through the force of either or both of the other two bases.

Beardsley then proposes certain principles of interpretation based on this analysis. In general, interpretation is (or ought to be) a matter of deciphering the conventional and natural bases of the image in question. In the case of an image with little or no conventional symbolic basis, we may follow the "Principle of Prominence" to decide whether it has symbolic meaning at all: the picture must draw attention to some feature of the image to secure the natural basis for symbolic meaning. To decide among competing symbolic meanings for a given symbol, we resort to the "Principle of Symbol-Congruence," that is, we consider the symbol in the context of the rest of the work. Finally, we must remember what Beardsley might have called the "Principle of Prudence": we should resist the temptation to read definite meaning into symbols which are simply ambiguous.

12

Concerning the Spiritual in Art

WASSILY KANDINSKY

Every work of art is the child of its time; often it is the mother of our emotions. It follows that each period of culture produces an art of its own, which cannot be repeated. Efforts to revive the art principles of the past at best produce works of art that resemble a stillborn child. For example, it is impossible for us to live and feel as did the ancient Greeks. For this reason those who follow Greek principles in sculpture reach only a similarity of form, while the work remains for all time without a soul. Such imitation resembles the antics of apes: externally a monkey resembles a human being; he will sit holding a book in front of his nose, turning over the pages with a thoughtful air, but his actions have no real significance.

But among the forms of art there is another kind of external similarity, which is founded on a fundamental necessity. When there is, as sometimes happens, a similarity of inner direction in an entire moral and spiritual milieu, a similarity of ideals, at first closely pursued but later lost to sight, a similarity of "inner mood" between one period and another, the logical consequence will be a revival of the external forms which served to express those insights in the earlier age. This may account partially for our sympathy and affinity with and our comprehension of the work of primitives. Like ourselves, these pure artists sought to express only inner[1] and essential feelings in their works; in this process they ignored as a matter of course the fortuitous.

This great point of inner contact is, in spite of its considerable importance, only one point. Only just now awakening after years of materialism, our soul is infected with the despair born of unbelief, of lack of purpose and aim. The nightmare of materialism, which turned life into an evil, senseless game, is not yet passed; it still darkens the awakening soul. Only a feeble light glimmers, a tiny point in an immense circle of darkness. This light is but a presentiment; and the mind, seeing it, trembles in doubt over whether the light is a dream and the surrounding darkness indeed reality. This doubt and the oppression of materialism separate us sharply from primitives. Our soul rings cracked when we sound it, like a precious vase, dug out of the earth, which has a flaw. For this reason, the primitive phase through which we are now passing, in its present derivative form, must be short-lived.

The two kinds of resemblance between the forms of art of today and of the past can be easily recognized as diametrically opposed. The first, since it is external, has no future. The second, being internal, contains the seed of the future, After a period of materialist temptation, to which the soul almost succumbed, and which it was able to shake off, the soul is emerging, refined by struggle and suffering. Cruder emotions, like fear, joy and grief, which belonged to this time of trial, will no longer attract the artist. He will attempt to arouse more refined emotions, as yet unnamed. Just as he will live a complicated and subtle life, so his work will give to those

From Wassily Kandinsky, *Concerning the Spiritual in Art*. New York: George Wittenborn, Inc., 1947, pp. 23–27, 43–64, 67–71. Reprinted with permission of Wittenborn Art Books, Inc.

observers capable of feeling them emotions subtle beyond words.

The observer of today is seldom capable of feeling such vibrations. He seeks instead an imitation of nature with a practical function (for example, a portrait, in the ordinary sense) or an intuition of nature involving a certain interpretation (e.g., "impressionist" painting) or an inner feeling expressed by nature's forms (as we say, a picture of "mood"[2]). When they are true works of art, such forms fulfil their purposes and nourish the spirit. Though this remark applies to the first case, it applies more strongly to the third, in which the spectator hears an answering chord in himself. Such emotional chords cannot be superficial or without value; the feeling of such a picture can indeed deepen and purify the feeling of the spectator. The spirit at least is preserved from coarseness: such pictures tune it up, as a tuning fork does the strings of a musical instrument. But the subtilization and extension of this chord in time and space remained limited, and the potential power of art is not exhausted by it.

Imagine a building, large or small, divided into rooms; each room is covered with canvases of various sizes, perhaps thousands of them. They represent bits of nature in color—animals in sunlight or shadow, or drinking, standing in water, or lying on grass; close by, a "Crucifixion," by a painter who does not believe in Christ; then flowers, and human figures, sitting, standing, or walking, and often naked; there are many naked women foreshortened from behind; apples and silver dishes; a portrait of Mister So-and-So; sunsets; a lady in pink; a flying duck; a portrait of Lady X; flying geese; a lady in white; some cattle in shadow, flecked by brilliant sunlight; a portrait of Ambassador Y; a lady in green. All this is carefully reproduced in a book with the name of the artist and the name of the picture. Book in hand, people go from wall to wall, turning pages, reading names. Then they depart, neither richer nor poorer, again absorbed by their affairs, which have nothing to do with art. Why did they come? In every painting a whole life is mysteriously enclosed, a whole life of tortures, doubts, of hours of enthusiasm and inspiration.

What is the direction of that life? What is the cry of the artist's soul, if the soul was involved in the creation? "To send light into the darkness of men's hearts—such is the obligation of the artist," said Schumann. "A painter is a man who can draw and paint everything," said Tolstoi.

Of these two definitions we must choose the second, if we think of the exhibition just described. With more or less skill, virtuosity and vigor, objects are created on a canvas, "painted" either roughly or smoothly. To bring the whole into harmony on the canvas is what leads to a work of art. With cold eye and indifferent mind the public regards the work. Connoisseurs admire "technique," as one might admire a tight-rope walker, or enjoy the "painting quality," as one might enjoy a cake. But hungry souls go hungry away.

The public ambles through the rooms, saying "nice" or "interesting." Those who could speak have said nothing; those who could hear have heard nothing. This condition is called "art for art's sake." This annihilation of internal vibrations that constitute the life of the colors, this dwindling away of artistic force, is called "art for art's sake."

The artist seeks material rewards for his facility, inventiveness and sensitivity. His purpose becomes the satisfaction of ambition and greediness. In place of an intensive cooperation among artists, there is a battle for goods. There is excessive competition, over-production. Hatred, partisanship, cliques, jealousy, intrigues are the natural consequences of an aimless, materialist art.[3]

The public turns away from artists who have higher ideals, who find purpose in an art without purpose.

"Comprehension" is educating the spectator to the point of view of the artist. It has been said that art is the child of its time. But such an art can only repeat artistically what is already clearly realized by the contemporary. Since it is not germinative, but only a child of the age, and unable to become a mother of the future, it is a castrated art. It is transitory; it dies morally the moment the atmosphere that nourished it alters.

There is another art capable of further developments, which also springs from contemporary feeling. Not only is it simultaneously its echo and mirror but it possesses also an awakening prophetic power which can have far-reaching and profound effect.

The spiritual life to which art belongs, and of which it is one of the mightiest agents, is a complex but definite movement above and beyond, which can be translated into simplicity. This movement is that of cognition. Although it may take different forms, it holds basically to the same internal meaning and purpose.

The causes of the necessity to move forward and upward—through sweat, suffering, evil and torments—are obscure. When a stage has been reached at which obstacles have been cleared from the way, a hidden, malevolent hand scatters new obstacles. The path often seems blocked or destroyed. But someone always comes to the rescue—someone like ourselves in everything, but with a secretly implanted power of "vision."

He sees and points out. This high gift (often a heavy burden) at times he would gladly relinquish. But he cannot. Scorned and disliked, he drags the

heavy weight of resisting humanity forward and upward.

Sometimes, after his body has vanished from the earth, men try by every means to recreate it in marble, iron, bronze, or stone, and on an enormous scale. As though there were any intrinsic value in the bodily existence of such divine martyrs and servants of humanity, who despised the flesh but wanted only to serve the spirit. But raising marble is evidence that a number of men have reached the point where the one they would now honor formerly stood alone.

Movement

The life of the spirit may be graphically represented as a large acute-angled triangle, divided horizontally into unequal parts, with the narrowest segment uppermost. The lower the segment, the greater it is in breadth, depth and area.

The whole triangle moves slowly, almost invisibly forward and upward. Where the apex was today, the second segment will be tomorrow; what today can be understood only by the apex, is tomorrow the thought and feeling of the second segment.[4]

At the apex of the highest segment often stands one man. His joyful vision is the measure of his inner sorrow. Even those who are nearest to him in sympathy do not understand. Angrily they abuse him as a charlatan or madman. So in his lifetime Beethoven stood, solitary and insulted.[5] How long will it be before a larger segment of the triangle reaches the spot where he once stood? Despite memorials, are there really many who have risen to his level?[6]

There are artists in each segment of the triangle. He who can see beyond the limits of his own segment is a prophet and helps the advance. But those who are near-sighted, or who retard the movement for base reasons, are fully understood and acclaimed. The larger the segment (i.e., the lower it lies in the triangle), the greater the number of people capable of understanding the artist. Every segment hungers, consciously or unconsciously, for adequate spiritual satisfactions. These are offered by artists, and for such satisfactions the segment below will tomorrow stretch out eager hands.

.

The Effect of Color

If you let your eye stray over a palette of colors, you experience two things. In the first place you receive a *purely physical effect,* namely, the eye itself is enchanted by the beauty and other qualities of color. You experience satisfaction and delight, like a gourmet savoring a delicacy. Or the eye is stimu-

lated as the tongue is titillated by a spicy dish. But then it grows calm and cool, like a finger after touching ice. These are physical sensations, limited in duration. They are superficial, too, and leave no lasting impression behind if the soul remains closed. Just as we feel at the touch of ice a sensation of cold, forgotten as soon as the finger becomes warm again, so the physical action of color is forgotten as soon as the eye turns away. On the other hand, as the physical coldness of ice, upon penetrating more deeply, arouses more complex feelings, and indeed a whole chain of psychological experiences, so may also the superficial impression of color develop into an experience.

On the average man, only impressions caused by familiar objects will be superficial. A first encounter with any new phenomenon exercises immediately an impression on the soul. This is the experience of the child discovering the world; every object is new to him. He sees a light, wishes to hold it, burns his finger and feels henceforth a proper respect for flame. But later he learns that light has a friendly side as well, that it drives away the darkness, makes the day longer, is essential to warmth and cooking, and affords a cheerful spectacle. From the accumulation of these experiences comes a knowledge of light, indelibly fixed in his mind. The strong, intensive interest disappears, and the visual attraction of flame is balanced against indifference to it. In this way the whole world becomes gradually disenchanted. The human being realizes that trees give shade, that horses run fast and automobiles still faster, that dogs bite, that the moon is distant, that the figure seen in a mirror is not real.

Only with higher development does the circle of experience of different beings and objects grow wider. Only in the highest development do they acquire an internal meaning and an inner resonance. It is the same with color, which makes a momentary and superficial impression on a soul whose sensibility is slightly developed. But even this simplest effect varies in quality. The eye is strongly attracted by light, clear colors, and still more strongly by colors that are warm as well as clear; vermilion stimulates like flame, which has always fascinated human beings. Keen lemon-yellow hurts the eye as does a prolonged and shrill bugle note the ear, and one turns away for relief to blue or green.

But to a more sensitive soul the effect of colors is deeper and intensely moving. And so we come to the second result of looking at colors: *their psychological effect.* They produce a correspondent spiritual vibration, and it is only as a step towards this spiritual vibration that the physical impression is of importance.

Whether the psychological effect of color is direct, as these last few lines imply, or whether it is the outcome of association, is open to question. The

soul being one with the body, it may well be possible that a psychological tremor generates a corresponding one through *association*. For example, red may cause a sensation analogous to that caused by flame, because red is the color of flame. A warm red will prove exciting, another shade of red will cause pain or disgust through association with running blood. In these cases color awakens a corresponding physical sensation, which undoubtedly works poignantly upon the soul.

If this were always the case, it would be easy to define by association the physical effects of color, not only upon the eye but the other senses. One might say that bright yellow looks sour, because it recalls the taste of a lemon.

But such definitions are not universal. There are several correlations between taste and color which refuse to be classified. A Dresden doctor reported that one of his patients, whom he designated as an "exceptionally sensitive person," could not eat a certain sauce without tasting "blue," i.e., without "seeing blue."[7] It would be possible to suggest, by way of explanation, that in highly sensitive people the approach to the soul is so direct, the soul itself so impressionable, that any impression of taste communicates itself immediately to the soul, and thence to the other organs of sense (in this case, the eyes). This would imply an echo or reverberation, such as occurs sometimes in musical instruments which, without being touched, sound in harmony with an instrument that is being played. Men of sensitivity are like good, much-played violins which vibrate at each touch of the bow.

But sight has been known to harmonize not only with the sense of taste but with the other senses. Many colors have been described as rough or prickly, others as smooth and velvety, so that one feels inclined to stroke them (e.g., dark ultramarine, chromoxide green, and madder-lake). Even the distinction between warm and cool colors is based upon this discrimination. Some colors appear soft (madder-lake), others hard (cobalt green, blue-green oxide), so that fresh from the tube they seem to be "dry."

The expression "perfumed colors" is frequently met with.

The sound of colors is so definite that it would be hard to find anyone who would express bright yellow with bass notes, or dark lake with the treble.[8] The explanation in terms of association will not satisfy us, in many important cases. Those who have heard of chromotherapy know that colored light can influence the whole body. Attempts have been made with different colors to treat various nervous ailments. Red light stimulates and excites the heart, while blue light can cause temporary paralysis. If the effect of such action can be observed in animals

and plants, as it has, then the association theory proves inadequate. In any event one must admit that the subject is at present unexplored, but that it is unquestionable that color can exercise enormous influence upon the body as a physical organism.

The theory of association is no more satisfactory in the psychological sphere. Generally speaking, color directly influences the soul. Color is the keyboard, the eyes are the hammers, the soul is the piano with many strings. The artist is the hand that plays, touching one key or another purposively, to cause vibrations in the soul.

It is evident therefore that color harmony must rest ultimately on purposive playing upon the human soul; this is one of the guiding principles of internal necessity.

The Language of Form and Color

The man that hath no music in himself,
Nor is not moved with concord of sweet
 sounds,
Is fit for treasons, stratagems, and spoils;
The motions of his spirit are dull as night,
And his affections dark as Erebus:
Let no such man be trusted. Mark the music.
 The Merchant of Venice, Act V, Sc. 1.

Musical sound acts directly on the soul and finds an echo there, since music is innate in man.

"Everyone knows that yellow, orange, and red suggest ideas of 'joy and plenty'" (Delacroix).[9]

The above quotations show the deep relations among the arts, and especially between music and painting. Goethe said that painting must consider this relation its ground, and by this prophetic remark he foretold the position of painting today. Painting stands, in fact, at the first stage of the road by which it will, according to its own possibilities, grow in the abstract sense and arrive finally at painterly *composition*.

For this ideal of composition, painting has two means at its disposal:

1. Color.
2. Form.

Form can stand alone, as a representation of an object ("real" or not), or as an abstract limit to a space or a surface.

Color cannot stand alone; it cannot dispense with boundaries of some kind. An unlimited expanse of red can only be seen in the mind; when the word red is heard, the color is evoked without definite boundaries; if they are necessary, they have to be imagined deliberately. But red as is seen abstractly and not materially arouses both a precise and an unprecise impression on the soul, which has a purely internal

physical sound.[10] This red has also no independent transition to warmth or cold; the same must be imagined as subtleties of the red tone. Therefore, I call this spiritual seeing "unprecise." However, it is at the same time "precise" since the inner sound remains without incidental tendencies to warm and cold, etc. This inner sound is similar to the sound of a trumpet or an instrument which one can imagine one hears when the world "trumpet" is pronounced. This sound is not detailed; it is imagined without the variations that occur depending upon whether the trumpet is sounded in the open air, in a closed room, alone or with other instruments, if played by a postilion, a huntsman, a soldier or a professional.

But when red is presented concretely (as in painting), it must possess (1) some definite shade of the innumerable shades of red that exist and (2) a limited surface, divided off from other colors which are unconditionally there; this may under no circumstance be avoided, and by this means, through delimitation and proximity, the subject characteristics change, i.e., receive an objective sheath, here the objective "accompanying sound."

The inevitable relation between color and form brings us to the question of the influences of form on color. Form alone, even though abstract and geometrical, has its internal resonance, a spiritual entity whose properties are identical with the form. A triangle (without consideration of its being acute or obtuse or equilateral) is such an entity, with its particular spiritual perfume. In relation to other forms this perfume may be somewhat modified, but it remains in intrinsic quality the same, as the scent of the rose cannot be mistaken for that of the violet. The case is similar with a circle, a square or any conceivable geometrical figure.[11] As above, with red, we have a subjective substance in an objective sheath.

The mutual relation of form and color now becomes clear. A yellow triangle, a blue circle, a green square, or a green triangle, a yellow circle, a blue square: all these are differently acting entities.

It is evident that certain colors can be emphasized or dulled in value by certain forms. Generally speaking, sharp colors are well suited to sharp forms (e.g., yellow in the triangle), and soft, deep colors by round forms (e.g., blue in the circle). But it must be remembered that an unsuitable combination of form and color is not necessarily discordant, but may with manipulation show fresh harmonic possibilities.

Since the number of colors and forms in infinite, their combinations also are infinite, and, simultaneously, their effect. This material is inexhaustible.

Form, in the narrow sense, is the boundary between one surface and another: that is its external meaning. But it has also an internal significance, of varying intensity,[12] and properly speaking *form is the external expression of inner meaning*. To use again the metaphor of the piano, and substituting form for color, the artist is the hand which, by playing this or that key (i.e., form), purposely vibrates the human soul in this or that way. *It is evident that form harmony must rest only on the purposive vibration of the human soul. This principle has been designated here as the principle of internal necessity.*

The two aspects of form define its two aims. The external boundary is purposive only when it realizes expressively the meaning of form.[13] The external aspect of form, i.e., the boundary, may assume different shapes; but it will never overstep two external limits:

(1) Either a form aims at delimiting a concrete object two-dimensionally,

(2) Or a form remains abstract, a purely abstract entity. Such abstract entities, which have life in themselves, are a square, a circle, a triangle, a rhombus, a trapezoid, etc., many of them so complicated as to have no mathematical formula. All these forms are of equal rank in the abstract realm.

Between these two boundaries lie the innumerable forms in which both elements exist, with a preponderance of either the abstract or the concrete. These forms are at present largely the treasure from which the artist draws all the component elements of his creations. Purely abstract forms are in the reach of few artists at present; they are too indefinite for the artist. It seems to him that to limit himself to the indefinite would be to lose possibilities, to exclude the human and therefore to weaken expression.

Nevertheless, there are artists who even today experience abstract form as something quite precise and use it to the exclusion of any other means. This seeming stripping bare becomes an inner enrichment.

On the other hand, there exists no purely material form. A material object cannot be absolutely reproduced. For better or worse the artist depends on *his eye, his hand,* which in this case are perhaps more artistic than his soul that would confine itself to photographic aims. But the discriminating artists who cannot be content with an inventory of material objects seek to express objects by what was once called "idealization," and later "stylization," and which in the future will again be called something else.[14]

The impossibility and, in art, the purposelessness of copying an object, the desire to make the object express itself, are the beginning of leading the artist away from "literary" color to artistic, i.e., pictorial aims. And this brings us to the question of composition.

The purely pictorial composition has in regard to form two aims:

1. The composition of the whole picture.

2. The creation of the various forms which, by standing in different relations to each other, serve the composition of the whole.[15] Many objects (concrete, abstract and purely abstract) have to be considered in the light of the whole, and so arranged as to suit this whole. Singly they will have little meaning, being of importance only so far as they help the general effect. These single objects must be fashioned in one way only; this, not because their internal meaning demands that particular means, but because they must serve as material for the whole. Here we have defined the first problem, which is the composition of the whole canvas.[16]

Thus the element of the abstract is creeping into art, although yesterday it was derided and ignored for mundane ideals. Its gradual advance and eventual success is natural enough, for as representational form falls into the background, the abstract gains.

But residual organic forms possess, nevertheless, an internal sound of their own, which may be similar to that of their abstract parallel (thus producing a simple combination of the two elements) or different (in which case the combination may be complex and possibly discordant). However diminished in importance organic forms may be, their internal sound will always be heard; for this reason the choice of natural objects in painting is an important one. The spiritual accord of naturalism with the abstract may strengthen the appeal of the latter (either by concord or counterpoint), or may be disturbing to it. The subject may possess only a casual sound, which would not effect an essential change in the fundamental harmony if the subject were replaced.

Let us suppose a rhomboidal composition, made up of human figures. The artist asks himself: Are these human figures absolutely necessary to the composition, or could they be replaced by other organic forms, without affecting the fundamental harmony of the whole? If the answer is in the affirmative, we have a case in which the materialistic appeal not only does not help the abstract but damages it directly. An indifferent sound in the object weakens the sound of the abstract. This is not only logical but an actual artistic fact. Therefore, in this case another object should be found which is more suitable to the inner sound of the abstract (either through similarity or contrast), or this entire form should, generally speaking, remain a purely abstract form.

Once more the metaphor of the piano applies: for "color" or "form" substitute "object." Every object (whether a natural form or man-made) has its own

life and therefore its own potency; we are continually being affected by spiritual potency. Many results will remain in the "subconscious" (where they continue to be alive and creative). Many rise to the "super-conscious." Man can free himself from many of these by shutting his soul to them. Nature, that is to say, the ever changing surroundings of men, sets in vibration the strings of the piano (the soul) by manipulation of the keys (various objects with their specific potentialities).

The effects we receive, which often appear chaotic, consist of three elements: the action of the color of the object, of its form, and of the object per se, independent of either color or form.

At this point the individuality of the artist asserts itself and makes use of these three elements. Here too the purposive prevails. *It is clear, therefore, that the choice of an object (i.e., one of the elements of form) must be decided by a purposive vibration in the human soul; therefore, the choice of the object also originates from the principle of internal necessity.*

The freer the abstract form, the purer and more primitive the vibration. Therefore, in any composition where corporeal form seems superfluous it may be replaced by abstract or semi-abstract form. In each case this translation should be guided by our feeling. The more an artist uses these semi-abstract or abstract forms, the deeper and more confidently will he advance into the sphere of the abstract. And after him will follow those who look at his pictures, who will in turn gradually acquire familiarity with the language of abstract art.

Must we then altogether abandon representation and work solely in abstraction? The problem of harmonizing the appeal of the concrete and the abstract answers this question. Just as each spoken word rouses an internal vibration, so does every object represented. To deprive oneself of this possibility of causing a vibration would be reducing one's arsenal of means of expression: anyhow, that is the case today. But besides this, there is another one which art can always offer to any question beginning with "must": There is no "must" in art, because art is always free.

With regard to the second problem of composition, the creation of the forms which are to compose the whole, it must be remembered that the same form with the same relations will always have the same internal appeal. Only the relations constantly vary. The result is that: (1) Ideal harmony alters according to its relation with other forms; (2) Even in similar relations, a slight approach to or withdrawal from other forms may affect the structure.[17] Nothing is absolute. Form composition is relative, depending on (1) alterations in the relations of one form to another, and (2) alterations in each individ-

ual form, down to the very smallest. Every form is as sensitive as smoke, the slightest wind will fundamentally alter it. This extreme mobility makes it perhaps easier to obtain similar harmonies from the use of different forms than from a repetition of the same one: apart from the fact that, of course, an exact repetition can never be produced. So long as we are susceptible mainly to the appeal of a whole composition, this fact is of theoretical importance. But when we become more sensitive, by a constant use of abstract forms (which have no material interpretation), it will become of great practical significance. On the one hand, the difficulties of art will increase, but at the same time the wealth of forms of expression will also increase in quality and quantity. Simultaneously the problem of distortion in drawing disappears and is replaced by the problem of how far the internal structure of a particular form is veiled or bared. This changed point of view will lead further and to greater enrichment of the media of expression because veiling is of enormous power in art. The combining of the veiled and bared will form a new possibility of *leitmotivs* in form composition.

Without such development as this, form composition is impossible. To anyone who cannot experience the internal structure of form (whether natural or abstract), composition must be meaningless and arbitrary. Apparently aimless alterations in arrangement make art seem a senseless game of forms. Here we find the same criterion and principle which thus far we have encountered everywhere as the only purely artistic one free from the unessential, *the principle of inner necessity*.

If, for example, features of the face or parts of the body are changed or distorted for artistic reasons, one encounters not only the purely pictorial question but also that of anatomy, which hampers the pictorial intention and imposes upon it the consideration of unimportant details. In our case, however, the unessential disappears automatically and only the essential remains, the artistic aim. These seemingly arbitrary but, in reality, well-reasoned alterations in form are one of the sources of an infinite number of artistic creations.

The flexibility of each form, its internal, organic variation, its direction (motion) in the picture, the relative weight of concrete or of abstract forms and their combination; further, the concord or discord of the various elements of a pictorial structure, the handling of groups, the combination of the hidden and the stripped bare, the use of rhythmical or unrhythmical, of geometrical or non-geometrical forms, their contiguity or separation—all these things are the elements of structure in drawing.

But as long as color is excluded, such structure is confined to black and white. Color itself offers con-

trapuntal possibilities and, when combined with design, may lead to the great pictorial counterpoint, where also painting achieves composition, and where pure art is in the service of the divine. The same infallible guide will carry it to the great heights, *the principle of internal necessity.*

Inner necessity originates from three elements: (1) Every artist, as a creator, has something in him which demands expression (this is the element of personality). (2) Every artist, as the child of his time, is impelled to express the spirit of his age (this is the element of style)—dictated by the period and particular country to which the artist belongs (it is doubtful how long the latter distinction will continue). (3) Every artist, as a servant of art, has to help the cause of art (this is the quintessence of art, which is constant in all ages and among all nationalities).

A full understanding of the first two elements is necessary for a realization of the third. But he who realizes this will recognize that a rudely carved Indian column is an expression of the spirit that actuates any advance-guard work.

There has been in the past, and there is now, much talk of "personality" in art. Talk of the coming "style" is more frequent each day. But in spite of their importance now, these questions will lose their edge under the perspective of time.

Only the third element—that of quintessential art—will remain forever. Time, far from diminishing its importance, increases it. An Egyptian carving moves us more deeply today than it did its contemporaries; for they judged it with the restrictive knowledge of period and personality. But we can judge it as an expression of an eternal art.

Similarly, the greater the part played in a modern work of art by the elements of style and personality, the better will it be appreciated by people today; but a modern work of art which is full of the third element will fail to reach the contemporary soul. Sometimes centuries have to pass before the third element is understood. But the artist in whose work this third element predominates is the great artist.

These three mystical necessities are the constituent elements of a work of art, which interpenetrate and constitute unity of the work. Nevertheless, the first two elements include what belongs to time and space, while in the pure and eternal artistry, which is beyond time and space, this forms a relatively non-transparent shell. The process in the development in art consists of the separation of its quintessence from the style of the time and the element of personality. Thus, these two elements are not only a cooperative but also a hindering force. The personality and the style of the time create in every epoch many precise forms, which in spite of apparent major differences are so organically related that

they can be designated as one single form: their inner sound is finally but one major chord. These two elements are of a subjective nature. The entire epoch desires to reflect itself, to express artistically its life. Likewise, the artist wishes to express himself and chooses only forms which are sympathetic to his inner self. Thus, gradually is formed the style of an epoch, i.e., a certain external and subjective form. The pure and eternal art is, however, the objective element which becomes comprehensible with the help of the subjective.

The inevitable desire for expression of the *objective* is the impulse here defined as "internal necessity." This impulse is the lever or spring driving the artist forward. Because the spirit progresses, today's internal laws of harmony are tomorrow's external laws, which in their further application live only through this necessity which has become external. It is clear, therefore, that the inner spirit of art uses the external form of any particular period as a stepping-stone to further development.

In short, the effect of internal necessity and the development of art is an ever advancing expression of the eternal and objective in terms of the historical and subjective.

Because the objective is forever exchanging the subjective expression of today for that of the morrow, each new extension of liberty in the use of external form is hailed as final and supreme. At present we say that an artist may use any form, so long as he draws on forms that exist in nature. But this limitation, like all its predecessors, is temporary. From the point of view of inner need, no limitation can be made. The artist may use any form which his expression demands; his inner impulse must find suitable external form.

Thus one sees finally (and this is of utmost importance for today or any time) that to seek for personality and "style," for nationality, to achieve this deliberately, is not only impossible but comparatively unimportant. The general relationship of those works of art which through the centuries are not weakened but always more and more strengthened, does not lie in the "external" but in the deep roots of mystical inner content. Therefore, the following of schools, the searching for the "mode," the desire for principles in a work and the insistence upon certain media of expression of a period can only be misleading and must bring misunderstanding, obscurity and silence.

The artist must ignore distinctions between "recognized" or "unrecognized" conventions of form, the transitory knowledge and demands of this particular age. He must watch his own inner life and hearken to the demands of internal necessity. Then he may safely employ means sanctioned or forbidden by his contemporaries. This is the only way to express the mystical necessity. All means are sacred which are called for by internal necessity. All means are sinful which are not drawn from inner necessity.

It is impossible to theorize about this ideal. In real art, theory does not precede practice but follows it. Everything is at first a matter of feeling. Even though the general structure may be formulated theoretically, there is still an additional something which constitutes the soul of creation. Any theoretical scheme will be lacking in the essential of creation—the internal desire for expression—which cannot be formulated. Despite the most accurate weights and balances to be had, a purely deductive weighing can never suffice. True proportions cannot be calculated, nor true scales be found ready-made.[18] Proportions and scales are not outside the artist but within him; they are what we may call a feeling for boundaries, artistic tact—qualities which are innate and which may be raised by enthusiasm to genius. In this sense we may understand the possibility of a general base to painting, as envisaged by Goethe. Such a grammar of painting is at present a matter of conjecture, and, should it ever be achieved, it will be not so much according to physical laws (which have often been tried and which the cubists try today), as according to the laws of internal necessity, which is of the soul.

Inner necessity is the basis of both small and great problems in painting. Today we are seeking the road which is to lead us away from the external[19] to the internal basis. The spirit, like the body, can be strengthened and developed by frequent exercise: just as the body, if neglected, grows weak and finally impotent, so the spirit perishes if untended. The innate feeling of the artist is the biblical talent which must not be buried in the earth. And for this reason it is necessary for the artist to know the starting-point for the exercise of his spirit.

The starting-point is the study of color and its effects on men.

There is no need to deal with the profound and refined complexities of color; we should consider at first only the direct use of simple colors.

To begin with, let us test the effect upon ourselves of *individual* colors, and make a chart, which will simplify the whole question.

Two great divisions of color immediately occur to the mind: warm and cool; light and dark. Thus it becomes evident that each color may have four principal notes: either (1) warm, and therefore either light or dark; or (2) cold, and either light or dark.

Generally speaking, warmth or coolness in a color means an approach to yellow or to blue. This

distinction occurs on one level, so to speak: i.e., the color preserves its basic quality, but this quality is, now more, now less, earthy. It represents a horizontal movement, the warm colors approaching the spectator, the cool ones retreating from him.

The colors that cause in another color a horizontal movement while they are themselves affected by it have another movement of their own, which acts with a violent, separative force. This is therefore the first great antithesis in internal value, and the inclination of the color to cool or warm is of tremendous importance.

The second great antithesis is between white and black; i.e., the inclination to light or dark caused by the two tones. These tones have, too, a peculiar movement to and from the spectator, but in a more rigid form.[20]

Yellow and blue have another movement which affects the first antithesis—an eccentric and concentric movement. If two circles are drawn and painted respectively yellow and blue, a brief contemplation will reveal in the yellow a spreading movement out from the center, and a noticeable approach to the spectator. The blue, on the other hand, moves into itself, like a snail retreating into its shell, and draws away from the spectator. The eye feels stung by the first circle while it is absorbed into the second.

In the case of light and dark colors movement is emphasized. That of the yellow increases with an admixture of white, i.e., as it becomes lighter. That of the blue increases with an admixture of black, i.e., as it becomes darker. This fact has a greater importance if we note that yellow inclines to the light (white) to such an extent that there can be no very dark yellow. The relationship between white and yellow is as close as between black and blue, for blue can be so dark as to border on black. Besides this physical relation, there is also a spiritual one (between yellow and white on one side, and blue and black on the other), which marks a strong separation between the two pairs.

An attempt to make yellow colder produces a greenish tint and checks both the horizontal and eccentric movement. The color becomes sickly and unreal, like an energetic man who has been checked in the use of his energy by external circumstances. The blue by its contrary movement acts as a brake on the yellow and is hindered in its own movement, and, if more blue is added, the contrary movements cancel each other and complete immobility ensues. The result is *green*. Similarly white, when mixed with black, loses permanence, and the result is gray, which is spiritually similar to green.

But while yellow and blue are potentially active in green, though temporarily paralyzed, in gray there is no possibility of movement because gray consists of colors that have no motive power, one representing static resistance, the other non-resistant immobility (like an endless wall or a bottomless pit).

Because the component colors of green are active and have a movement of their own, it is possible, even theoretically, on the basis of this movement, to determine (or anticipate) their spiritual effect.

We reach the same results by proceeding experimentally in having colors act upon us. The first movement of yellow, that of straining toward the spectator (which can be increased by intensifying the yellow), and the second movement, that of overrunning the boundaries, having a material parallel in that human energy which attacks every obstacle blindly and goes forth aimlessly in all directions.

If steadily gazed at in any geometrical form, yellow has a disturbing influence; it pricks, upsets people, and reveals its true character, which is brash and importunate.[21] The intensification of yellow increases the painful shrillness of its note, like that of a shrill bugle.[22]

Yellow is the typical earthly color. It never acquires much depth. When cooled by blue, it assumes, as I have said before, a sickly tone. If we were to compare it with human states of mind, it might be said to represent not the depressive, but the manic aspect of madness. The madman attacks people and disperses his force in all directions, aimlessly, until it is completely gone. To use another metaphor, we are reminded of the last prodigal expansion of summer in the glaring autumn foliage, whose calming blue component rises to the sky.

Depth is found in blue, first in its physical movements (1) of retreat from the spectator, (2) of turning in upon its own center. It affects us likewise mentally in any geometrical form. The deeper its tone, the more intense and characteristic the effect. We feel a call to the infinite, a desire for purity and transcendence.

Blue is the typical heavenly color,[23] the ultimate feeling it creates is one of rest.[24] When it sinks almost to black, it echoes a grief that is hardly human.[25] It becomes an infinite engrossment in solemn moods. As it grows lighter it becomes more indifferent and affects us in a remote and neutral fashion, like a high, cerulean sky. The lighter it grows, the more it loses resonance, until it reaches complete quiescence, in other words, white. In music a light blue is like a flute, a darker blue a 'cello; a still darker the marvelous double bass; and the darkest blue of all—an organ.

Yellow easily becomes acute and is incapable of great depth. Conversely, blue resists pointing up and heightening. A well-balanced mixture of blue and yellow produces green; the horizontal move-

First pair of antitheses **a and b** (internal structure acting on the spirit)

a. **warm** **cold** = **First antithesis**
 yellow **blue**

Two movements:

 (I) *horizontal*

Towards the spectator (bodily) ⟵⟨⟨ ⟩⟩⟶ Away from the spectator (spiritual)

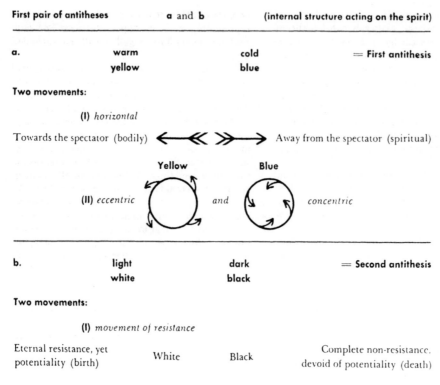

 (II) *eccentric* *and* *concentric*

b. **light** **dark** = **Second antithesis**
 white **black**

Two movements:

 (I) *movement of resistance*

Eternal resistance, yet Complete non-resistance,
potentiality (birth) White Black devoid of potentiality (death)

 (II) *eccentric and concentric, as in the case of yellow and blue, but more rigid*

ments cancel each other, and so do movements from and towards the center. Calm ensues. This is a fact recognized not only by oculists, but by the world. Absolute green is the most restful color, lacking any undertone of joy, grief or passion. On exhausted men this restfulness has a beneficial effect, but after a time it becomes tedious. Pictures painted in shades of green bear this out. As a picture painted in yellow always radiates spiritual warmth, or as one in blue has apparently a cooling effect, so green is only boring. Yellow and blue have an active effect corresponding to man's participation in continuous and perhaps eternal cosmic motion, whereas green represents the passive principle. This contrasts with the active warmth of yellow or the active coolness of blue. In the hierarchy of colors green represents the social middle class, self-satisfied, immovable, narrow.[26] It is the color of summer, when nature is quiescent after the perturbations of spring.

Any preponderance in the absolute green of yellow or blue introduces a corresponding activity and changes the inner appeal. The green keeps its char-

acteristic equanimity and restfulness, the former increasing with the inclination to lightness, the latter with the inclination to depth. In music, absolute green is represented by the placid, middle notes of a violin.

Black and white have already been discussed in general terms. Speaking more particularly, white, although often considered as *no color* (a theory due largely to the impressionists, who saw no white in nature[27]), is a symbol of a world from which all colors as material attributes have disappeared. This world is too far above us for its structure to touch our souls. There comes a great silence which materially represented is like a cold, indestructible wall going on into the infinite. White, therefore, acts upon our psyche as a great, absolute silence, like the pauses in music that temporarily break the melody. It is not a dead silence, but one pregnant with possibilities. White has the appeal of the nothingness that is before birth, of the world in the ice age.

On the other hand, the ground-note of black is a silence with no possibilities. In music it is repre-

sented by one of those profound and final pauses, after which any continuation of the melody seems the dawn of another world: the circle is closed. Black is something burnt out, like the ashes of a funeral pyre, something motionless like a corpse. The silence of black is the silence of death. Outwardly black is the most toneless color of all, a kind of neutral background against which the minutest shades of other colors stand forth clearly. It also differs in this from white, in conjunction with which nearly every color becomes blurred, dissolves and leaves only a faint resonance.[28]

White is not without reason taken to symbolize joy and spotless purity, and black, grief and death. A blend of black and white produces gray, which, as has been said, is silent and motionless, being composed of two inactive colors, its restfulness having none of the potential activity of green. The immobility of gray is desolate. The darker the gray the more preponderant becomes this feeling of desolation and strangulation. When it is made lighter, the color seems to breathe again, as if invested with new hope. A similar gray is produced by an optical mixture of green and red, a spiritual blend of passivity and glowing warmth.[29]

The unbounded warmth of *red* has not the irresponsible appeal of yellow, but rings inwardly with a determined and powerful intensity. It glows in itself, maturely, and does not distribute its vigor aimlessly.

The varied powers of red are very striking. By a skilful use of it in its different shades, its fundamental tone may be made warm or cool.[30]

Light warm red has a certain similarity to medium yellow, alike in texture and appeal, and gives a feeling of strength, vigor, determination, triumph. In music, it is a sound of trumpets, strong, harsh and ringing.

Vermilion is a red with a feeling of sharpness, like flowing steel which can be cooled by water. Vermilion is quenched by blue, for it can bear no mixture with a cold color: more accurately speaking, such a mixture produces what is called a muddy color, scorned by the painters of today. But mud as a material object has its own internal appeal, and therefore to avoid it in painting is as unjust and narrow as was yesterday's cry for pure color. At the call of internal necessity that which is outwardly foul may be inwardly pure, and vice versa.

These two shades of red are similar to yellow, except that they reach out less toward the spectator. The glow of red is within itself. For this reason it is a color more beloved than yellow, being frequently used in primitive and traditional decoration and also in peasant costumes, because in the open air the harmony of red and green is very charming. Taken by itself this red is material and, like yellow, has no very deep appeal. It is dangerous to seek to deepen red by an admixture of black, for black quenches the glow or at least reduces it.

There remains brown, unemotional, disinclined to movement. An intermixture of red is outwardly barely audible, but there does ring out a powerful inner harmony. Skilful blending can produce an inner appeal of extraordinary, indescribable beauty. The vermilion now rings like a great trumpet or thunders like a drum.

Cool red (madder-lake), like any other fundamentally cool color, can be deepened, especially by an intermixture of azure. The character of the color changes; the inward glow increases, the active element gradually disappears. But this active element is never so wholly absent as in deep green. There always remains a hint of renewed vigor somewhere out of sight, waiting for a certain moment in order to burst forth afresh. In this lies the great difference between a deepened red and a deepened blue, because in red there is always a trace of the material. Corresponding in music are the passionate, middle tones of a 'cello. A cool, light red contains a very distinct bodily or material element, but it is always pure, like the fresh beauty of a young girl's face. The singing notes of a violin exactly express this in music.[31]

Warm red, intensified by a kindred yellow, is *orange*. This blend brings red almost to the point of spreading out towards the spectator. But the element of red is always sufficiently strong to keep the color from flippancy. Orange is like a man convinced of his own powers. Its note is that of a church-bell (the Angelus bell), a strong contralto voice, or the *largo* of an old violin.

Just as orange is red brought nearer to humanity by yellow, so violet is red withdrawn from humanity by blue. But the red in violet must be cool, for spiritual need does not allow of a mixture of warm red with cold blue.

Violet is therefore both in the physical and spiritual sense a cooled red. It has a morbid, extinct quality, like slag. It is worn by old women, and in China it is the garb of mourning. In music it is an English horn, or the deep notes of woodwinds (e.g., a bassoon).[32]

The last two colors, which result from mixing red with yellow or blue, are rather unstable. We are reminded of a tight-rope walker who has to balance himself continuously. Where does orange start, and either red or yellow cease? Where is the border-line dividing violet from red or blue, and when does it become lilac?[33] Orange and violet are the fourth and last pair of antitheses of the primitive colors. They stand to each other in the same relation as the third

Second pair of antitheses **c** and **d** (physical appeal of complementary colors)

c. **Red** **Green** = **Third antithesis (of the spiritually extinguished first antithesis)**

Two movements:

Movement within itself = Potentiality of motion

= Immovability

Red

Eccentric and concentric movements are entirely absent.

Optical blend = Gray

Mechanical blend of white and black = Gray

d. **Orange** **Violet** = **Fourth antithesis**

Arise out of the first antithesis from:

1. Active element of the yellow in red = Orange

2. Passive element of the blue in red = Violet

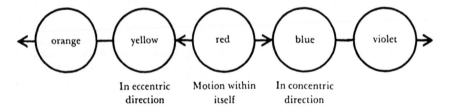

 In eccentric Motion within In concentric
 direction itself direction

antithesis—green and red—, i.e., as complementary colors.

As in a great circle, a serpent biting its own tail (the symbol of eternity, of something without end), appear the six colors that make up the three main antitheses. And to right and left stand the two great possibilities of silence—death and birth.

It is clear that all I have said of these simple colors is very provisional and general, and so are the feelings (joy, grief, etc.) which have been quoted as parallels to the colors. For these feelings are only material expressions of the soul. Shades of color, like those of sound, are of a much finer texture and awaken in the soul emotions too fine to be expressed in prose. Certainly each tone will find some proba-

ble expression in words, but there will always be something left over, which the word fails to express and which yet is not supererogatory but the very kernel of its existence. For this reason words are, and will always remain, hints, mere suggestions of colors. In this impossibility of expressing color in words, with the consequent need for some other mode of expression, lies the possibility of a monumental art. . . .

Theory

Because of the very nature of modern structure, there has never been a time when it was more difficult than it is today to formulate a complete theory[34] or to construct a pictorial foundation. All

attempts to do so have the same result—that cited in the case of Leonardo and his system of little spoons. However, it would be rash to say that there are no principles in painting comparable to a foundation, or that such principles would inevitably lead to academicism. Music has a grammar which, although modified from time to time, is of continual help and value and may be used as a kind of dictionary.

Painting today is in a different position. The emancipation from dependence on nature is only just beginning. If until now color and form were used as inner agents, it was mainly done subconsciously. The subordination of composition to geometrical form is no new idea (cf. the art of the Persians). Construction on a purely spiritual basis is a slow business, and at first seemingly blind and unmethodical. The artist must train not only his eye but also his soul, so that it can weigh colors in its own scale and thus become a determinant in artistic creation. If we begin at once to break the bonds that bind us to nature and to devote ourselves purely to combination of pure color and independent form, we shall produce works which are mere geometric decoration, resembling something like a necktie or a carpet. Beauty of form and color is no sufficient aim by itself, despite the assertions of pure aesthetes or even of naturalists obsessed with the idea of "beauty." It is because our painting is still at an elementary stage that we are so little able to be moved by wholly autonomous color and form composition. The nerve vibrations are there (as we feel when confronted by applied art), but they get no further than the nerves because the corresponding vibrations of the spirit which they call forth are weak. When we remember, however, that spiritual experience is quickening, that positive science, the firmest basis of human thought, is tottering, that dissolution of matter is imminent, we have reason to hope that the hour of pure composition is not far away. The first stage has arrived.

It must not be thought that decoration is lifeless. It has its inner being, but one which either is no longer comprehensible to us, as in the case of old decorative art, or seems illogical, a world in which full-grown men and embryos play equal roles, in which beings deprived of limbs are on a level with noses and toes and navels living isolated from their own vitality. The jumble is like that of a kaleidoscope,[35] where material accident reigns, not spirit. Despite their lack of plan and drawing these ornaments have distinct effects on us: an Oriental ornament is something intrinsically different from a Swedish, Negro or ancient Greek ornament. It is not for nothing that there is a general custom of describing samples of material as gay, sober, lively, etc., just as music is described as *allegro, serioso,* etc.

Probably conventional ornament had its beginning in nature. (Modern designers still borrow their motifs from the countryside.) But when we assert that external nature is the source of all art, we must remember that, in patterning, natural objects are used as symbols, almost as though they were mere hieroglyphics. For this reason they gradually lose meaning for us, until we can no longer decipher their inner value. For example we can endure a design of Chinese dragons, which in their ornamental form retain precise corporeal features, in our dining- or bed-rooms, and are no more disturbed by it than by a runner embroidered with daisies.

It is possible that towards the close of our dawning epoch a new ornamental language will develop, but it is not likely to be founded on geometrical form. At the present time any attempt to force such ornament into being would be as useless as pulling a small bud open so as to make a full-blown flower. In general nowadays we are still by and large bound to external nature and must find our *forms* in her. (Purely abstract paintings are still rare.) The only question is, how are we to do it? In other words, how far may we go in altering her forms and colors?

We may go as far as the artist is able to carry his emotion; and once more we see how immense is the need for cultivating this emotion. A few examples will make the meaning of this clearer.

A warm red tone (acting as an irritant in isolation) will materially alter in internal value when it is no longer isolated as an abstract tone, but is applied as an element of some other object and combined with natural form. Combining red with various natural forms will also cause different spiritual effects, all of which will harmonize with that of the original isolated red. Suppose we combine red with the sky, flowers, a garment, a face, a horse, a tree.

A red sky suggests to us sunset, or fire, and has a consequent effect upon us—either of splendor or menace. Much depends now on the way in which other objects are treated in connection with this red sky. If the treatment is faithful to nature, but all the same harmonious, the "naturalistic" appeal of the sky is strengthened. If, however, the other objects are treated in a way which is more abstract, they tend to lessen, if not to destroy, the naturalistic appeal of the sky. Much the same applies to the use of red in a human face. In this case red can be employed to suggest a spiritual commotion, or a special lighting of the model, with a force that only an extremely abstract treatment of the rest of the picture can subdue.

A red garment is quite a different matter, for it can in fact be of any color. Red will, however, best supply the needs of pure artistry, for only here can it be used without any association with material aims. The artist has to consider not only the value

of the red cloak by itself, but also its relation with the figure wearing it and, further, the relation of the figure to the whole picture. Suppose the picture to be sad, and the red-cloaked figure to be the central point on which the sadness is concentrated—either from its central position, or from its features, attitude, color, and so on. The red will provide a felt acute discord, emphasizing the gloom of the picture, especially of the main figure. The use of a color in itself sad would weaken the dramatic effect of the whole.[36] This is the principle of antithesis already defined. The dramatic element here originates only from the inclusion of red in the entire sad composition, because red, once entirely isolated, which falls upon the calm surface of the soul, cannot normally have a sad effect.[37]

The case of a red tree is different. The fundamental value of red remains in any event, but an association with "autumn" enters. The color combines easily in this association; there is not the dramatic clash that exists in the case of the red cloak.

The red horse provides further variation. The word itself puts us into another atmosphere. The improbability of a red horse demands an "unreal" world. Otherwise this combination of color and form may impress one as a curiosity—a superficial and non-artistic appeal—or as a clumsily understood fairytale[38] likewise non-artistic. To set the red horse in naturalistic landscape is to create a discord wanting in appeal and coherence. The need for coherence is essential to harmony—whether it is founded on the convention of discord or of concord. The new harmony demands that the inner plane of a picture should remain one, though the canvas may be divided into many planes and filled with outer discords. Again, the constructive elements of a canvas are to be sought not in externals but in internal necessity.

Spectators are too accustomed to looking for a "meaning" in a picture, i.e., some external relation among its various elements. Our materialist age has produced a kind of spectator, a "connoisseur," who is not content to place himself in front of a picture and let it speak for itself. He does not search for the internal feeling of the picture directly for himself, he worries himself into looking for "closeness to nature," or "temperament," or "handling," or "tonality," or "perspective," and so on. His eye does not probe the external expression to arrive at the internal significance. In a conversation with an interesting person, we endeavor to get at his fundamental ideas and feelings. We do not bother about the words he uses, nor his spelling, nor the breath necessary for speaking, nor the movements of his tongue and lips, nor the psychological effect on our brain, nor the physical sound in our ear, nor the physiological effect on our nerves. We realize that these things, though interesting and important, are not the problem. The meaning and ideas are what concerns us. We should have the same attitude when confronted with a work of art if we are to absorb its abstract effect. If this attitude ever becomes general, the artist will be able to dispense with natural forms and colors and to use purely artistic means.

Contrasts such as a red garment in an otherwise somber composition may be freely used, but must always be held to the same spiritual level. Yet the existence of such a level does not solve all color problems. "Unnaturalistic" objects may have a "literary" appeal in a picture; the composition may have the effect of a fairytale. The spectator is in an atmosphere which does not disturb him because he accepts it as imaginary; he tries to follow the "story," remaining relatively indifferent to the various effects of color. In any event the pure internal working of color is no longer possible: the external idea is dominant. Besides, when the spectator imagines he is in fairyland, he becomes automatically immune to strong internal vibrations. So the artist's effort miscarries. We must find, therefore a form which excludes a fairytale effect[39] and which does not hinder pure color action. To this end, form, movement, color, natural and imaginary objects must be divorced from any narrative intent. Then movement, though seemingly unmotivated, becomes pure and intrinsic.

Notes

1. A work of art consists of two elements, the inner and the outer.

The inner is the emotion in the soul of the artist; this emotion has the capacity to evoke a similar emotion in the observer.

Being connected with the body, the soul is affected through the medium of the senses—the felt. Emotions are aroused and stirred by what is sensed. Thus the sensed is the bridge, i.e., the physical relation, between the immaterial (which is the artist's emotion) and the material, which results in the production of a work of art. And again, what is sensed is the bridge from the material (the artist and his work) to the immaterial (the emotion in the soul of the observer).

The sequence is: emotion (in the artist) → the sensed → the art-work → the sensed → emotion (in the observer).

The two emotions will be like and equivalent to the extent that the work of art is successful. In this respect painting is in no way different from a song: each is a communication. The successful singer arouses in listeners his emotions; the successful painter should do no less.

The inner element, i.e., emotion, must exist; otherwise the work of art is a sham. The inner element determines the form of the work of art.

In order that the inner element, which at first exists only as an emotion, may develop into a work of art, the second element, i.e., the outer, is used as an embodiment. Emotion is always seeking means of expression, a material form, a form that is able to stir the senses. The determining and vital element is the inner one, which controls the outer form, just as an idea in the mind determines the words we use, and not vice versa. The determination of the form of a work of art is therefore determined by the irresistible inner force: this is the only unchanging law in art. A beautiful work is the consequence of an harmonious cooperation of the inner and the outer; i.e., a painting is an intellectual organism which, like every other material organism, consists of many parts. (*This explanation by Kandinsky of the relation between internal and external, or inner and outer, is a slightly revised version of a translation by Arthur Jerome Eddy of part of an article by Kandinsky which appeared in* Der Sturm, *Berlin, 1913; cf.* Cubists and Post-Impressionists, *A. C. McClurg, Chicago, 1914, pp. 119-20.*)

2. Alas, this word, which in the past was used to describe the poetical aspirations of an artist's soul has been misused and finally ridiculed. Was there ever a great word that the crowd did not try immediately to desecrate?

3. A few exceptions do not affect the truth of this sad and ominous picture; even the exceptions are chiefly believers in the doctrine of art for art's sake. They serve, therefore, a higher ideal, but one which is ultimately a useless waste of their strength. External beauty is one element in a spiritual milieu. But beyond this positive fact (that what is beautiful is good) lies the weakness of a talent not used to the full (*talent* in the biblical sense).

4. This "today" and "tomorrow" correspond to the biblical "days" of Creation.

5. Weber, composer of "Der Freischütz," said of Beethoven's Seventh Symphony: "The extravagances of genius have reached the limit; Beethoven is now ripe for an asylum." On the opening phrase, a reiterated "E," the Abbé Stadler said to his neighbor: "That same old 'E' again; he's run out of ideas, the bore." (*Beethoven* by August Göllerich, p. 1 in the series, *Die Musik,* ed. by R. Strauss.)

6. Many of our monuments are melancholy answers to the question.

7. Freudenberg, "Spaltung der Persönlichkeit (*Übersinnliche Welt,* 1908, no. 2, p. 64–65). The author also discusses hearing color, and says that no rules can be laid down. But see L. Shanejeff in *Musik,* no. 9, Moscow, 1911, where the imminent possibility of laying down a law is clear.

8. Much theory and practice have been devoted to this question. People have thought to paint in counterpoint. Also, unmusical children have been successfully helped to play the piano by quoting a parallel in color (e.g., of flowers). Mme A. Sacharjin-Unkowsky has worked along these lines for several years and has evolved a method of "so describing sounds by natural colors, and colors by natural sounds, that color could be heard and sound seen." The system has proved successful for several years both in the inventor's own school and the Conservatoire at St. Petersburg. Finally Scriabin, on more spiritual lines, has paralleled sounds and colors in a chart not unlike that of Mme Unkowsky. In "Prometheus" he has given convincing proof of his theories. (His chart appeared in *Musik,* no. 9, Moscow, 1911.)

9. Cf. Paul Signac: *D'Eugène Delacroix au Neo-Impressionisme.* Also compare an interesting article by K. Shettler: "Notizen über die Farbe" (*Decorativ Kunst,* February 1901).

10. A similar result is shown in the example given later of the tree: in that, however, the material part of the idea takes up comparatively great space.

11. An important part is played by the direction in which the triangle stands (e.g., movement). This is of great importance in painting.

12. It is never literally true that a form is meaningless and "says nothing." Every form in the world says something. But its message often fails to reach us; as when what is said is not interesting in itself or is not said in the proper place.

13. The phrase "expressively" must be clearly understood. Form often is most expressive when subdued. It is often most expressive when reticent, perhaps only a stroke, a mere hint of external meaning.

1 4. The function of idealization was to beautify the organic form, to make it ideal, whereby it easily resulted in schematically dulling its inner personal note. "Stylization," developing from impressionist foundation, had, as its first aim, not the beautifying of the organic form, but a strong characterization through an omission of incidental details. The resulting harmony had an entirely personal character but with a prevailing external expression. The coming treatment and change of the organic form aims at baring or uncovering inner harmony. The organic form here no longer serves as direct object but is only an element of the divine language, which needs human expression because it is directed from man to man.

1 5. The general composition will naturally include little compositions which may be antagonistic to each other, though helping—perhaps by their very antagonism—the harmony of the whole. These little compositions have themselves subdivisions of varied inner shades.

1 6. A good example is Cézanne's "Bathers," which is built in the form of a triangle (the mystical triangle). Such geometrical composition is an old principle, which was abandoned because academic usage had made it lifeless. But Cézanne has given it new life by emphasizing pictorial-compositional elements. He does not use the triangle to harmonize his groups, but as a final artistic aim. Here is the geometrical form which is simultaneously the means to the composition in painting; stress is laid on purely artistic aims with strong accompaniment of the abstract. He distorts the human figure justifiably. Not only must the whole figure follow the lines of the triangle, but each limb is driven upward, as it were, becoming ever lighter and more expansive.

1 7. This is what we mean when we speak of "movement." For example, an upright triangle is more steadfast and quiet than one set obliquely on the surface.

1 8. The many-sided genius of Leonardo devised a system of little spoons with which different colors were to be used, thus creating a kind of mechanical harmony. One of his pupils, after trying in vain to use this system, in despair asked one of his colleagues how the master himself used the invention. The colleague replied: "The master never uses it at all" (Merejkowksi, *The Romance of Leonardo da Vinci*).

1 9. The term "external," here used, must not be confused with the term "material" used previously. I am using the former to mean "external necessity," which never goes beyond conventional limits, nor produces other than conventional beauty. "Internal necessity" knows no such limits and often produces results conventionally considered "ugly." But "ugly" itself is a conventional term, and only means "spiritually unsympathetic," being applied to some expression of internal necessity either outgrown or not yet attained. But everything which adequately expresses internal necessity is beautiful, and will sooner or later be recognized as such.

2 0. All these statements are the results of empirical feeling, and are not based on any exact science.

2 1. E.g., the effect of the yellow mail boxes in Bavaria. It is also worth noting that the sour-tasting lemon and shrill-singing canary are both yellow.

2 2. A parallel between color and music can only be relative. Just as a violin can give various shades of tone, so yellow has shades, which can be expressed by various instruments. But in making such parallels, I am assuming in each case a pure, moderate tone of color or sound, unvaried by vibration or dampers, etc.

2 3. ". . . The halos are golden for emperors and prophets (i.e., for mortals), and sky-blue for symbolic figures (i.e., spiritual beings) . . ." (Kondakoff, *Histoire de l'Art Byzantine considérée principalement dans les miniatures*, vol. 2, p. 382, Paris, 1886–91).

2 4. Supernatural rest, not the earthly contentment of green. The way to the supernatural lies through the natural. And we mortals passing from the earthly yellow to the heavenly blue must pass through green.

2 5. Yet different from violet, for which see later.

2 6. With regard to this much-praised "equilibrium" we are reminded of the words of Christ: "Ye are neither hot nor cold."

2 7. Van Gogh, in his letters, asks whether he may not paint a white wall dead white. This question offers no difficulty to the non-representational artist, who is concerned only with the inner harmony of color. But to the impressionist-realist it appears a bold liberty to take. To him it seemed as outrageous as his own change from brown shadows to blue seemed to his contemporaries. (Cf. the famous example of "green sky and blue grass.") Van Gogh's question marks a transition from impressionism to an art of spiritual harmony, as the coming of the blue shadow marked a transition from academicism to impressionism (see *The Letters of Vincent van Gogh*).

28. E.g., vermilion rings dull and muddy against white, but against black with clear strength. Light yellow against white is weak, against black pure and brilliant.

29. Gray = immobility and rest. Delacroix sought to express rest by a mixture of green and red (see Signac, sup. cit.).

30. Of course, every color can be to some extent varied between warm and cool, but no color has so extensive a scale of varieties as red.

31. The pure, joyous, consecutive sounds of sleigh-bells are called in Russian "raspberry jingling." The color raspberry juice is close to the above-mentioned light, cool red.

32. Among artists, the question, "How do you do?" is sometimes jokingly answered, "Deep violet," meaning "not very well."

33. Violet tends to merge into lilac. Where does one end and the other begin?

34. Attempts have been made. Once more emphasis must be laid on the parallel with music. For example, see *Tendances Nouvelles,* no. 35, for the remarks of Henri Ravel: "The laws of harmony are the same for painting and music."

35. This jumble has its own well-defined existence, but in a different sphere.

36. Once more it is wise to emphasize the necessary inadequacy of these examples. Rules cannot be laid down, the variations are so endless; a single line can alter the composition of a picture.

37. Terms like "sad" and "joyful" are only clumsy equivalents for the delicate spiritual vibrations of the new harmony. They must be read as necessarily inadequate.

38. If a fairytale is not completely realized, it results in something like a moving-picture version of fairyland.

39. The struggle with the fairytale atmosphere resembles the struggle with nature. How easily, and often quite against his will, does *nature* infiltrate into an artist's composition? It is easier to depict her than to oust her.

13

Symbolism

MONROE C. BEARDSLEY

To most of us a painting is a "picture." The first thing we are likely to notice about a visual design is that it shows the latest model Chevrolet, a plaid shirt, a bottle of whiskey, or a pretty girl. In fact, it takes a certain effort to think of a design *as a* design—as a bounded collection of lines, shapes, and colors—even though it is the lines, shapes, and colors that do the picturing. We see through them, so to speak. But a picture is two things at once: it is a design, and it is a picture *of* something. In other words, it presents something to the eye for direct inspection, and it represents something that exists, or might exist, outside the picture frame.

It is this second aspect of the design that we are after when we ask questions like: What does it portray? What is it about? What does it mean? Or, elliptically, what *is* it? Often, of course, these questions do not arise, for we can see the answer at once. But [sometimes we are puzzled]. . . . What is the significance of the empty charger on the floor in Dürer's *Last Supper*?. . . Who or what is the Colossus in Goya's aquatint? To answer questions like these is to *interpret* the design. And a large part of interpretation consists in saying what the design represents, or to put it in what we shall count as synonymous terms, saying what its subject is.

It is this dual aspect of visual design that confronts us with our next array of puzzles. What is the connection between what is represented and what is presented? Which of these, if either, is more important? Painters themselves differ rather deeply

on these questions, and critics quite as much. Meanwhile the ordinary citizen who wants to know what he can expect of visual art, what to look for and be content with, is confounded worst of all. And this is a pity. For in pining after what he cannot have, he may miss what is really of supreme worth.

The notorious twentieth-century example of misunderstanding of art was the public reaction to the New York Armory show of 1913, which first brought various modern movements to the United States. The most upsetting picture there was Marcel Duchamp's *Nude Descending a Staircase* (1912, Arsenberg Collection, Philadelphia Museum of Art), which had a kind of descending movement of overlapping cubist forms: it was called "a hurricane in a shingle factory," "a collection of saddlebags," and other impolite things. We should not say that its detractors failed to grasp what the painter *intended;* they failed to see what he had *done,* because they approached it with mistaken assumptions and expectations.

But one need not go back that far; every year brings a new *cause célèbre* involving violent differences of opinion over "modern" art. The word itself has taken on such negative connotations in many quarters that the Boston Institute in 1948 changed "Modern" in its name to "Contemporary." Early in 1955 the Budget Committee of the Nebraska state legislature burst into protests at a mural painting by Kenneth Evett that had been installed in the rotunda of the capitol at Lincoln a few months

From Monroe C. Beardsley, *Aesthetics: Problems in the Philosophy of Criticism,* 2nd edition. Indianapolis: Hackett Publishing Company, 1981, pp. 267–69, 288–93. Reprinted with permission of Hackett Publishing Company.

Albrecht Dürer, *The Last Supper,* 1523. Print Collection, Miriam & Ira D. Wallace Division of Art, Prints and Photographs, New York Public Library, Astor, Lenox and Tilden Foundations.

before. It is a strong, simple design with four figures, representing a craftsman, a cattleman, complete with large bull, a miner, and a builder.

"That square bull gets me," said a state senator. "The figures appear to have been drawn with a T-square." Two years earlier, one of the many reasons advanced against the murals by Anton Refregier in the lobby of the Rincon Annex Post Office in San Francisco, which were attacked by veterans' organizations and which the House of Representatives in Washington voted should be removed, was "Our ancestors did not have rectangular heads."

What should be our judgment of such reasons as these? First of all, are they relevant to the question whether a mural is good or bad art, or is its goodness or badness quite independent of its distortions of bull and man? If they are relevant, in what way are they relevant—is it, in other words, a conclusive objection to these murals that they involve a misrepresentation of nature, or is it just one of the factors to be taken into account in judging them? Of course, the ordinary citizen does not need to care

what a final judgment would be; but he is interested to know whether he should go to see them or give them a wide berth, whether he ought to try to understand them even if they repel him by their strangeness, and especially whether his taxpayer's money ought to be spent on them. Here is a place, surely, where a careful and thorough consideration of an aesthetic problem cannot but be of practical value. . . .

. . . Few terms of criticism in any of the arts are less tractable than the term "symbol," but part of what requires interpretation in some works of visual art is their symbolic meaning. I am unable to offer a succinct and adequate definition of "symbol," but it is worth some effort to clarify it as far as may be done briefly.

I think that what we are after is a sense of "symbol" stricter and more useful than one of its familiar senses. In Renaissance painting, the emblems of the saints and of other Biblical persons, which serve to identify them, are often called "symbols": the dove that denotes the Holy Ghost, the four apocalyptic

Francisco Goya, *The Colossus*.
Kupferstichkabinett, Berlin.

beasts of the Book of Revelation that denote the four gospels, Minerva's owl, St. Catherine's spiked wheel, and St. Lucy's eyes, often held forth on a plate. But though there is a kind of reference in these examples, it is a fairly limited one-to-one correspondence, not very different from having the saints wear lapel-cards with their names, like people at a convention. Of course the objects serve to remind us of their forms of martyrdom, but they are not much more than tokens. They are symbols, if you like, but not in the central and full sense.

For an example of symbolism nearer to the sense we are tracking down, we may consider the eye and pyramid on the Great Seal of the United States (see the back of a dollar bill). They are said to symbolize material strength and duration and the spiritual welfare that is above the material, as the eye is above the pyramid; and the thirteen olive leaves on the branch held in the right claw of the eagle and the thirteen arrows held in its left claw symbolize

the nation's power in peace and in war. Or, it would sometimes be said that in a painting of, say, a man behind the barbed wire of a concentration camp there is symbolized the barbarity of totalitarianism or man's inhumanity to man.

One preliminary distinction will simplify matters. There can be symbolism in a painting of a cross—or of a skull, a mirror, or a balance. But when we say the painting is symbolic, this can be regarded as an elliptical statement, which is expanded to two: (1) the painting represents a cross, and (2) the cross symbolizes Christianity. In other words, it is objects (the bald eagle, the cross, the flag) or patterns (the red cross, the red star, the fleur-de-lis, the swastika) that symbolize something; a painting is symbolic when it represents or suggests such an object or contains such a pattern. This distinction is a help. For it may be hard enough to discover what we mean when we say, for example, that the Cup is a Christian symbol, but if we do know what

we mean by that, then we will know what we mean when we say that Dürer's *Last Supper,* is symbolic, for that just means it is a picture of, among other things, the Cup.

Though, for convenience, we shall confine our attention to symbolic objects, it perhaps ought to be noted that actions, too, can be symbolic. And not only the ritual actions of devotion—the bended knee, the elevation of the Host—but certain common actions. . . . Whatever account we give of symbolic objects should be framed in such a way that it can be readily extended to symbolic acts.

If it is, then, an object or pattern or act that does the symbolizing, what is symbolized is always a set of properties or characteristics: faith, hope, charity, courage, wisdom, chastity, decay. A symbolic object can denote a particular thing, but denoting is not symbolizing. The Great Seal denotes the United States, but what it symbolizes are certain characteristics that the United States has or is thought to have or ought to have.

But what makes an object symbolic? How does it come to take on symbolic meaning? These questions have not been satisfactorily answered, but there are some things we can say with reasonable confidence, and they are important. Consider the bald eagle. Three things, at least, seem to be involved in making it a symbol. First, there is a natural similarity in some respects between the eagle and the nation and national qualities it stands for. The eagle is strong, fiercely independent, and has a certain magnificence of form and size; it is possible, at least, to hope that the nation itself has these qualities. Let us call these similarities, actual or believed, the *natural basis* of the symbolism. Second, the bald eagle did not acquire its symbolic function by chance; there had to be a *decision* at some point—namely in 1872—to let it stand for the United States. In other words, there was a kind of agreement or stipulation: let us call this the *conventional basis* of the symbolism. But third, the eagle might have languished on his eminence, or remained a mere token or indication of the nation. A check is a substitute for cash, and stands for the availability of that cash, but it is not a symbol of the cash in any but a pallid sense. In the full sense of the term, it took some *history* for the eagle to become a symbol: it had to be used on the Great Seal and dollar bills, to appear in connection with political gatherings, to acquire the capacity to evoke patriotic emotions, pride and joy. It entered into certain activities, and reproductions of it came to take on some measures of sanctity, so to speak, in themselves. Let us call this the *vital basis* of the symbolism.

Now, many symbols have all three bases, but the third, the *vital,* seems to be the essential or defining one. An object or pattern does not become a symbol in the full sense until it enters into human activities so that it is perceived not as a bare sign of something, but as having valuable qualities in itself, in virtue of its symbolic function. The flag, though a symbol, is protected by rules: it must not be thrown on the floor, and people who see their flag trampled underfoot feel as though the flag were insulted: some of their feelings about the nation have been transferred to the flag itself.

The general principle that I want to propose for consideration, though without supporting it by an adequate array of instances, is this: to acquire a vital basis and become symbolic, an object must have a conventional basis if the natural basis is slight or altogether lacking, but it may acquire a vital basis without a conventional basis if its natural basis is considerable and prominent. This principle I want to illustrate briefly.

The flag, as a symbol of the nation, has a little natural basis for its symbolism: it is not arbitrary that red connects with valor through the color of blood, white with purity and innocence, and blue with the overarching justice of the sky—not to mention the numerical correspondence of the stars and stripes to the states and colonies. The flag has also its conventional basis: it was deliberately chosen. And the vital basis is the sum of human activities that Americans have entered into, in which the flag has played a functional role: wars, parades, rallies, meetings, presidential inaugurations. The cross as a symbol of Christianity has a conventional basis, but little natural basis: there isn't a similarity between the shape of the cross and what it stands for. Its vital basis is the history of Christianity, and of Christian ritual, in which the cross is itself sacred and an object of veneration.

These are examples of symbols with little or no natural basis, but a conventional basis: the red star and the red cross would be other examples. But there is another class of symbols that have no conventional basis, and do not need one. These include various natural objects that have been an important part of the life of man, objects on whose behavior he has often been intent because of what it meant for his safety, security, and well-being: sun, moon, mountain, river, fire. It was not necessary for people to agree to let the sun be a symbol of life, when it shines on a cornfield, or of death, when it shines on a desert; its warmth is the warmth of life, it hotness is the hotness of a fevered death, and its importance for the life of man ensures that these cannot be overlooked.

In the symbolic patterns used by Indian tribes— the lizard pattern that means contentment, or the broken arrow that means peace—there is a conventional element, but it comes in at a different place. The designs are conventional; they are much sim-

plified pictures of lizards or the sun or spiders, and it takes a kind of tacit agreement to let these be understood as indicating those objects—they are not quite representational, though they are suggestive. However, once it is agreed to let the pattern stand for the sun, what the *sun* symbolizes has a natural basis. And I want to say the same sort of thing for barbed wire. The barbed wire does not stand for totalitarianism because anyone willed it to; there is a natural basis for the symbolism; a totalitarian state is *like* barbed wire in certain ways. And there is, of course, a considerable vital basis.

How, then, do we know what is symbolized in a painting? And where disagreements arise, in what way are they settled? These are the main questions we have been leading up to. As has been noted, it is too easy to reply that we must look for evidence of what the painter intended to symbolize. Even so brief an analysis of symbolism as we have conducted shows that what a painter can symbolize is not subject to his will: no matter what he says, he cannot paint a carrot and make it symbolize the Revolt of the Masses, or a corkscrew the innocence of childhood; and if he tells us that his painting of a black circle on a white background symbolizes the eternal vigilance of divine providence presiding over the aspiring spirit of man, we shall have to reply in a paraphrase of Alice's skeptical words to Humpty Dumpty.

I think what we do in interpreting the symbolism in a painting is first to see whether it contains any symbols with a primarily conventional basis, and second whether it contains any symbols with a primarily natural basis. The first is a study of iconology. To know what the cross or the barbed wire symbolizes, we study not the intention of the painter, but the history of Christianity and of modern governments. To know that in Titian's painting commonly called *Sacred and Profane Love*[1] (ca. 1510, Galleria Borghese, Rome) the nude woman is sacred, and the clothed one profane—instead of the other way about, as we might at first suppose—we have, of course, to consider that the painting was painted before the rise of Puritanism, and in the context of Neoplatonism. It is Neoplatonism that gives us the correct conventional basis of these symbols. The symbols have also a natural basis, of course, but without knowing the conventions, we would find the painting almost as obscure as Bellini's *Earthly Paradise* (ca. 1490?, Uffizi Gallery, Florence) or Rembrandt's etching, *The Phoenix* (1658, Hind 295).

It will always be more difficult to agree, and to be sure we know what we are doing, when we interpret those symbols that have no conventional basis, for there is no dictionary of them, no set of rules for decoding them. Here I think it is of considerable importance to separate two questions: how do we know that an object depicted by the painting is a symbol at all? And how do we know what it symbolizes?

The answer to the first question seems to be that we use, often without explicit formulation, a methodological principle of a rather special sort. If the objects in the painting belong together, in the sense that in the normal course of events we would expect to find them in the same vicinity, we are not forced to seek any symbolic significance in them. But if an object stands out in some way, in contrast to its setting, or is brought into focus by the design, then we are invited to dwell on it and treat it as a symbol. In Italian Renaissance paintings—for example, Bellini—you sometimes see the branches of trees lopped off, so that they appear bare. Barren trees are a natural symbol of death and unfruitfulness; they can also symbolize damnation, as perhaps does the tree in the *Netherlandish Proverbs* of Pieter Brueghel the Elder (1559, Kaiser Friedrich Museum, Berlin). But are the Bellini trees symbolic? It is ordinarily regarded as relevant to answering this question to point out that Italian peasants cut off the branches of trees as fodder for their livestock. In other words, there is nothing especially out of the way, or improbable, in their appearance in this landscape, so there is no call to interpret them symbolically.

Let us call this the *Principle of Prominence*: an object that is not already a recognized conventional symbol becomes a natural symbol in a painting only if its presence is in some way unusual or striking. Goya's *Colossus* is an excellent example. There he sits, enormous, on the edge of the world, towering over the plain; there is no explanation of his coming or going, he is just a giant out of place. We can hardly refrain from reading him as a powerful symbol. . . .

The answer to the second question seems to be that we first consider the range of potential symbolic meaning of the objects as they have figured in the life of man. The moon is cool, changeable, remote; the act of sowing is fruitful, chancy, patient, hopeful, humble toward nature and God. But we then seen which of these potential symbolic meanings can be fitted into a coherent whole with the other objects in the painting, including their potential meanings, if any. This is the *Principle of Symbol-Congruence*. . . . [Regarding] the Goya, the symbolic significance of giants is [neither] clear [nor] fixed. There is something fearful and yet attracting about this creature who towers over the houses at his feet; he does not actually menace us, as he turns to fix us with a shadowed stare, but he is evidently a potential destructive force. He is like something lurking in our own unconscious, an

embodied id. But his meaning has never been fully read, probably not even by Goya.

In the Goya we have reason to think there is symbolism, even if we cannot interpret it. But of course, as everywhere in our inquiries, we encounter borderline cases. For symbolism easily shades off into nothing, and where objects are barely suggested, or their symbolic potentialities loose and uncontrolled by the context, it will always be possible to supply, by free association, freewheeling symbolic meanings. But they will be largely subjective and private, and our time might better be occupied in other ways.

Note

1. According to Panofsky, *Studies in Iconology* (New York: Oxford University Press, 1939), p. 152, which see on Neoplatonic symbolism, the correct title is *The Twin Venuses* and they are opposed as the eternal Form of Beauty and the force that creates the ephemeral beauties of the world.

a. *Psychology*

If we construe psychology to mean the scientific study of the nature, functions, and phenomena of the human mind, including issues concerning human intention and motivation, it is clear that psychological questions will bear on virtually every aspect of painting and the pictorial arts. Questions about the perception of artistic form and pictorial representation are addressed in part II of this volume, but many other sorts of psychological issues relate to the production, understanding, evaluation, and cultural placement of the pictorial arts. We might say, speaking very broadly, that there are two complementary aspects of the question of the relation between psychology and the pictorial arts. First, it is possible that psychology might enrich our understanding of the pictorial arts and, second, it is possible that these arts might illuminate if not validate particular psychological hypotheses or theories.

Consider the case of psychology and painting. Psychologists have in fact generated theories about the creation of paintings, not only through their empirical investigations of what is often called "the creative process" but also in their characterizations of individual painters and painters in general as instantiations of various psychological "types." Psychological theories are also sometimes invoked to support critical comments about the psychology "in" paintings, often through claims about psychological states of human beings depicted in the works themselves. In addition, psychologists study what is sometimes called audience or viewer psychology, that is, the psychological processes involved in the perception, understanding, and judgment of pictorial works of art. Psychologists have also frequently appealed to paintings and works of pictorial art to elucidate and support particular psychological theories.

The selections in this part illustrate these connections from three different psychological perspectives. In his article "Art and Thought," the gestalt psychologist Rudolf Arnheim explores aspects of what he calls visual thinking. Arnheim argues that one way in which children make sense of the world is through the creation of visual images. A child may, for example, engage in a

kind of problem-solving, establishing in his or her drawings, "categories," "concepts," and functional relationships which make the child's world intelligible. Through the creation of visual images, the child may also develop and refine other cognitive operations such as the ability to apply an insight learned in one situation to a new or larger context (generalization) or to understand part–whole relationships (interaction). A child may also, through the creation of visual images, manifest or come to grips with inner problems and pleasures, the portrayal of which is important working material for many types of art therapy.

But visual thinking is not a matter of interest solely for the developmental psychologist. Arnheim argues that these processes continue to assert themselves at the very highest levels of visual creativity in works of visual art. Rembrandt, Arnheim argues, portrays his understanding of central theological tenets in the compositional aspects of his painting *Christ at Emmaus,* as does Vermeer in his *Woman Weighing Gold.* Nonrepresentational works of art may function in a similar manner, serving to express basic human "patterns of forces," as in Henry Moore' sculpture *Two Forms,* which, Arnheim says, expresses protection and concern. "A work of art," Arnheim writes, "is an interplay of vision and thought."

The best known psychoanalytic attempt to explore the connection between psychology and painting is Sigmund Freud's famous case study, *Leonardo da Vinci and a Memory of His Childhood,* a selection from which is included in this section. There Freud invokes psychoanalytic principles to explain not only enigmatic features of Leonardo's life and career but also the subject matter of several of his most celebrated paintings. What was it, Freud asks, that drew Leonardo to painting? Why did Leonardo, a man who was acknowledged by his contemporaries to be a master among painters, begin painting less and less, eventually giving up painting completely in favor of scientific investigation? How could this painter, one of the greatest scientific minds in the history of Western civilization, have committed the obvious mistake of using oil colors in *The Last Supper,* which would have difficulty adhering to the wall and would lead to the premature decay of the work? What prompted Leonardo to return to painting later in life? Why did Leonardo—despite his fascination with human physiology—seem willfully to avoid the depiction of human genitalia in his drawings and commit uncharacteristic mistakes in the few instances where he did depict them? And what is the significance of the captivating smile that appears on the face of the *Mona Lisa* as well as on the faces of many other figures in Leonardo's later work?

The answer to all these questions, Freud argues, is to be found in Leonardo's psychosexual history, especially in certain developments in Leonardo's earliest childhood. Freud takes his cue from one of the few personal observations in Leonardo's own papers, in which Leonardo describes a strange childhood memory according to which, in Freud's translation, "while I was in my cradle a

vulture came down to me, and opened my mouth with its tail, and struck me many times with its tail against my lips." Building on this fragment (which Freud takes to be an adult fantasy rather than an actual childhood memory), Freud advances a complex and fascinating explanation involving Leonardo's reminiscence of the pleasure of being suckled at his mother's breast, the absence of Leonardo's father in early childhood, Leonardo's memory of his mother's "tender seductions," his erotic attachment to his mother and his resulting homosexuality, Leonardo's attempts to deal with a frustrating period of "infantile sexual research," and his felt rivalry with his father. According to Freud, Leonardo's craving for knowledge—as manifested in his scientific inquires, his activities as a painter, and the content of the paintings themselves—are to be understood in terms of the sublimation of unconscious and essentially sexual instinctual forces.

Herbert Read also seeks to establish a connection between art and the unconscious, this time from the standpoint of Jungian psychology. Read follows Jung in distinguishing between works of art which are personal, deliberate constructions and works which are suprapersonal, symbolic, and more or less unconscious expressions of primordial images which Jung calls *archetypes*. Both types of art have a formal side involving the organization of constituent material elements, but in works of the second sort the artist functions as a "channel" through which profound, prototypical human experiences are represented and transformed by means of nondiscursive symbolic forms. Read applies this theory to several works of contemporary art: Picasso's etching *Minotauromachy,* his painting *Guernica,* and the reclining figures of the sculptor Henry Moore. Such art, Read asserts, "gives concrete existence to what is numinous, what is beyond the limits of rational discourse: it brings the dynamics of subjective experience to a point of rest in the concrete object. . . . The forms of art are only significant in so far as they are archetypal, and in that sense predetermined; and only vital in so far as they are *trans*formed by the sensibility of the artist and in that sense free."

Psychological approaches such as these are widespread in the art world. It is also important to remember, however, that psychological theories of art need to be carefully scrutinized from a philosophical view, a task which Douglas Morgan undertakes in "Psychology and Art Today: A Summary and Critique." There is a crucial question to be raised, for example, about the epistemological status of "the unconscious" in the context of a scientific theory. One might ask, "If the unconscious is *really* unconscious, how is it that we can know anything about it?" Morgan does not pose the question in this bald a fashion, but he nevertheless insists that psychological theories which rest on the postulation of unconscious entities be required to indicate "at least in principle what kind of evidence will be accepted (when and if we can get it) as confirmatory, and what kind as disconfirmatory." Morgan worries about the "suspiciously ad hoc" nature of certain gestalt hypotheses. He raises some

tough questions about quantitatively oriented "experimental" approaches to
the psychology of art. Morgan also questions just how far psychological
approaches take us in understanding normative judgments about works of art.
On the other hand, it would be a mistake for philosophers to dismiss the
contributions of psychologists out of hand. As Morgan observes, psychologists
have made permanent contributions to our understanding of organizational
factors in art perception and the role of empathy, play and psychical distance
in our appreciation of the arts as well as directing our attention to aspects of
art production and appreciation which may lie below the surface of
consciousness.

14

Art and Thought

RUDOLF ARNHEIM

Thinking calls for images, and images contain thought. Therefore, the visual arts are a home-ground of visual thinking. This needs to be shown now by a few examples.

To treat art as a form of visual thinking may seem unduly one-sided. Art fulfills other functions, which are often considered primary. It creates beauty, perfection, harmony, order. It makes things visible that are invisible or inaccessible or born of fantasy. It gives vent to pleasure or discontent. None of this is denied here; but in order to fulfill such functions a great deal of visual thinking must be done. The creation of beauty poses problems of selection and organization. Similarly, to make an object visible means to grasp its essential traits; one can depict neither a state of peace nor a foreign landscape nor a god without working out its character in terms offered by the image. And when Paul Klee writes in his diary: "I create *pour ne pas pleurer;* that is the first and last reason," it is evident that Klee's drawings and paintings could serve so great an artist and so intelligent a human being as an alternate to weeping only by clarifying for him what there was to weep about and how one could live with, and in spite of, this state of affairs.

Inversely, some of the objectives attributed to art are means of making visual thinking possible. Beauty, perfection, harmony, order do serve to give a sense of well-being by presenting a world conge-nial to human needs; but they are also indispensable conditions for making a cognitive statement clear, coherent, comprehensible. Aesthetic beauty is the isomorphic correspondence between what is said and how it is said.

Thinking in Children's Drawings

If one wishes to trace visual thinking in the images of art, one must look for well-structured shapes and relations, which characterize concepts and their applications. They are readily found in work done at early levels of mental development, for example, in the drawings of children. This is so because the young mind operates with elementary forms, which are easily distinguished from the complexity of the objects they depict. To be sure, children often give only rough approximations of the shapes and spa-tial relations they intend to depict. They may lack skill or have not actively explored the advantages of well-defined patterns. Also, children draw, and paint and model not only for the reasons that inter-est us here particularly. They like to exert and exer-cise their muscles, rhythmically or wildly; they like to see something appear where nothing was before, especially if it stimulates the senses by strong color or a flurry of shapes; they also like to defile, to attack, to destroy. They imitate what they see else-where. All this leaves its traces and keeps a child's picture from being always a neat record of his thought.

Yet we need not look far for demonstrations of our contention. Figure 1 is the picture of a horse-

From Rudolf Arnheim, *Visual Thinking*. Berkeley: University of California Press, 1969, pp. 254–73. Reprinted with per-mission of the Regents of the University of California and the author.

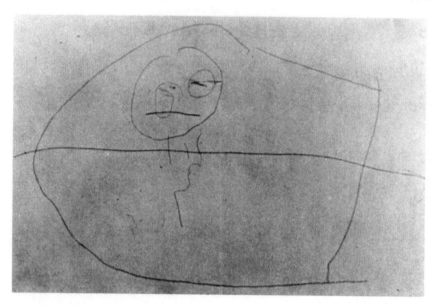

FIGURE 1.

back rider drawn by a girl of three years and nine months. It shows the horse as a large oval and a horizontal line representing "what the man sits on." The drawing is surely primitive when it is compared with the complexity of the objects it depicts. What matters more, however, is that instead of showing a mechanical, though clumsy adherence to the model the drawing testifies to a mind freely discovering relevant structural features of the subject and finding adequate shapes for them in the medium of lines on flat paper. The horse is not characterized as such but is abstracted to the level of an unspecific mount, a base sustaining the rudimentary man. One thing serves as a foil for the other, which it encloses. But this relation is too loose: it lets the little man float in the oval. In order to give him a pedestal on which he can solidly perch, the child introduces the baseline—which is not a picture of the horse's back, but is support in the abstract, although completely visual.

The child's statement, then, consists of visual concepts, which are demanded by direct experience but depict the subject abstractly by some relevant features of shape, relation, and function. The drawing derives its form more directly from the "pure shapes" of very generic visual concepts than from the particular appearance of horse and rider. It shows thereby what matters to the child about the theme of the mounted gentleman: he is enthroned, surrounded, supported. And although the picture is so highly conceptual, it springs entirely from intense observation of the sensory world and interprets the character of the model without straying in any way from the realm of the visible.

Occasionally, a visual concept jells into a precise, almost stereotyped shape, repeated with little variation in spite of diverse applications. Figure 2 reproduces drawings of a six-year-old girl in which the Valentine heart shape is used to portray noses, brooches, a party dress, arms, wings(?), decorations of the crown, etc. The device, although somewhat conventional, displays all the traits and functions of a concept. It is simply structured, easily grasped. It serves to make understandable a number of different objects which resemble it sufficiently to be subsumed under it. This subsumption creates a common category of noses, brooches, arms, etc. It establishes a bit of order in a world of complexity.

The selection and assignment of visual concepts involves the kind of problem solving of which I spoke earlier as the intelligence of perception. To perceive an object means to find sufficiently simple, graspable form in it. The same is true for the representational concepts needed for picture-making. They derive from the character of the medium (drawing, painting, modeling) and interact with the perceptual concepts. The solutions of the problem show much ingenuity. Even in young children, they greatly vary from person to person. One may have seen thousands of children's drawings, but one never ceases to be struck by the inexhaustible originality of ever new solutions to the problem of how to draw a human figure or an animal, with a few simple lines.

Thinking requires more than the formation and assignment of concepts. It calls for the unraveling of relations, for the disclosure of elusive structure. Image-making serves to make sense of the world.

FIGURE 2.

Figure 3 shows a balloon salesman drawn by a seven-to-eight-year-old. In his natural habitat a balloon man is a confusing spectacle. Pummeled from all sides by his unruly merchandise, he makes his way through crowds, moving his limbs as he bends down to a child, detaches a balloon, takes the money. The basic structure governing the man and his wares is by no means easy to see. A great deal of active exploring, involving more than the sense of sight, is necessary before the principle of the matter

FIGURE 3.

is understood. Genuine thinking is also needed to find the best equivalent of this principle in the medium of two-dimensional drawing. In the child's picture all confusion has vanished. The spatial arrangement elucidates the functional order. The man is shown as the central agent by being placed in the center. What happens to the left and to the right of this middle axis is treated symmetrically because no functional difference is intended between what the left and what the right are doing. The strings issue from the controlling hands as a family of evenly distributed radii. The balloons are circularly arranged around the central figure, indicating that they are homotypic, i.e., that they have the same place in the functional whole. The back-

ground is empty, devoid of distracting accessories. The total composition of the picture is devoted to clarification. It is not a rendering of any particular view of the scene the child actually saw but instead the clearest possible visual representation of a hier-archic setup. It is the final accomplishment of a long process of perceptual puzzling and wrestling by which the child's thinking found order in the observed disorder.

At higher levels of mental development the com-positional patterns become more complex, and so do the configurations of forces discerned in the draftsman's world and interpreted in his pictures. The divers in Figure 4 were drawn by a somewhat older, Egyptian child. Again one must bear in mind

FIGURE 4.

what the child is likely to have seen of such scenes. Only then can one appreciate the freedom with which the data of experience are transformed into an independent visual interpretation, executed with the resources of the two-dimensional medium. In actual life one can watch the divers leave their boats and disappear in the water. An underwater film may show them descending, going about their business, rising again. But all these views are partial. The drawing does better. It presents a vertical continuum, the unbroken relation between what happens above in the boats and below in the depths, one coherent event showing all functions and connections of the total process. Although entirely unrealistic, this view offers simple and directly pertinent instruction. In the universe of the flat picture space its visual logic is immediately convincing and appropriate.

The boats surround and support their crews two-dimensionally without hiding them partly from sight as they do "in reality." The men holding the ropes are treated as rows of equals because they are homotypic, equal in function. The steersmen, who have a different job, are distinguished in shape and color. The ropes are clearly traceable connections; they do not interfere with each other, except in one case, where the crossing is demanded by overriding needs of spatial distribution. The even, blue foil of the water sets off the other colors, which serve clearly to distinguish the men and the boats. The irregular placement of the divers shows that they float in unlimited space, as against the more static arrangement of the men in the boats. The figures of the divers explain with the utmost clarity their holding on to the ropes, the attachment of weights and baskets, etc.

I am describing these drawings as though they were diagrams of instruction, like maps or other informational material, because my task demands just that. At the same time, of course, a beautiful drawing has qualities of art. It tells not only about diving; it also conveys the "sense," the live experience of the event. This effect is obtained by the aesthetic qualities of balance, order, and expression, the dominant regiment in the boats above, the swarming of the red figures below, the freedom of their floating and the weightiness of their bodies. However, all this is by no means alien to the visual lesson worked out and conveyed by the child. Here, as everywhere else in art, "beauty" is not an added decoration, a mere bonus for the beholder, but an integral part of the statement. Every aspect of the picture, informational or evocative, is in perfect fit with what the child understood, felt, and tells.

The situations elucidated by visual thinking never concern the outer world alone. As the child grasps the characteristics of the diving situation, he

also finds and clarifies in them elements of his own experience: being suspended, "dependent" (in the literal and figurative meaning of the word), immersed into forbidding darkness, but safely held from above, exposed to adventure and duty, in company and yet alone. After all, it must be this sort of affinity that makes a person take a cognitive interest in what goes on outside his own business and that makes him want to hold and clarify it.

Personal Problems Worked Out

This personal involvement can be much more explicit. Figure 5 shows two drawings done at an interval of eight weeks by a seven-year-old girl whose family had just moved to the United States. Having been at a very strict European school, she felt lost in the more informal setting of the American public school; she came home crying: "Nobody tells me what I should do anymore!" During those early weeks of distress, she drew the first picture. She portrayed herself twice, as the center figure in the top row and the one on the right underneath. She is surrounded by three females with wildly outward-streaming "American" hair: her older sister, who liked the American school, a college student who gave her violin lessons and whose unladylike slacks shocked her, and Nancy, another American girl. In the midst of these cheerfully smiling figures, she presented herself, melancholy and weeping, with pathetically reduced hair, armless or locked in her protective jump rope.

The second drawing [Fig. 6] was done when she had begun to make friends with her schoolmates in particular and America more in general. The discrepancy among the figures has vanished. They are all alike and smiling. A compromise hair style displays good grooming but also a pert flourish, and in three out of four instances the rope is no longer permitted to confine the beaming head. The child could not make these drawings without pinpointing the causes of her trouble. She observed in her environment the manifestations of painful exclusion and shocking license and later the cheerful solution. For these various themes she discovered the striking pictorial formulae. By doing all this, she made the various aspects of her worries and pleasures tangible and comprehensible. She diagnosed and shaped her problem, aided by her sense of sight.

The working out of personal problems is evident in drawings and painting done by patients in art therapy. Case studies, such as those published by Margaret Naumburg, offer examples of how the work in its early stages may depict the raw threat of "free-floating anxiety," often poorly defined, and how with increasing elaboration there emerge also

FIGURE 5.

indications of the causes to which the threat is due. Toward the end, the hostile power is sometimes seen as properly reduced, put in its place, explained by its context. As a rule, the art work is only a part of the patient's guided effort to rid himself of his troubles. There is psychotherapy, there is the mental wrestling going on day and night, and to some extent the drawings and paintings are only a reflection of these struggles and their results. Evidently, however, the fight is waged also within the art itself. The effort to visualize and thereby to define the powers which the patient vaguely faces and to discover the correct relations between them means more than rendering observations on paper. It means to work out the problem by making it portrayable.

Often the pictures and sculptures of adult patients do not fulfill their task as completely as do the children's drawings shown above. The children are amateurs like the adults. But with their unspoiled sense of form they can still put all aspects of shape and color totally to the service of the intended meaning. In this sense, their work is like that of the accomplished artist. In the average adult of our civilization, however, the sense of form fades, rather than keeping up with the increasing complexity of the mind. His art work may contain elements of authentic expression—a woman hugging

FIGURE 6.

a child, a monster glaring in the darkness—but otherwise he mainly tells a story as best he can, without conveying its intrinsic meaning through the arrangement of the shapes and colors themselves. To the eye, such drawings can be confusing, misleading, and weak although they convey their message ideographically, by picture language.

Is it permissible to infer from what is known about imagery that such art work will have its full impact only if the perceptual pattern reflects the constellation of forces that underlies the theme of the picture? I am tempted to suggest that this is so. The direct perceptual evidence, which is the mind's most persuasive source of knowledge, must display itself in the overall composition and in the organization of detail if the message of the picture is to act with full therapeutic strength. Otherwise the insight derived from the art work might be expected to remain partial and indirect. This means that ideally art therapy should also be art education, geared to guiding the person not only to the clarification of subject matter but to that of its visual representation. Only when the picture speaks clearly to the eye, can it expect to do its best for the mind. In this sense one can say that Margaret Naumburg's "scribble" technique, which encourages patients to "create spontaneous free-swinging forms in curves and zigzag lines upon a large sheet of paper," liberates not only the flow of unconscious content but can also help to recuperate the spontaneous sense of form from perceptually inanimate, constrained picture-making.

Cognitive Operations

Genuine art work requires organization which involves many, and perhaps all of the cognitive operations known from theoretical thinking. I will give a few examples. Commonly in philosophical, scientific, or practical situations, a problem is solved first in a narrow, local range, which calls for modifications when the situation is to be treated in a larger context. Here is an elementary illustration of such restricted thinking in drawing. Young children often place the chimney obliquely rather than vertically on the roof (Fig. 7). The practice makes good sense if one views it not just negatively as wrong but positively as a local solution of a spatial problem. The chimney rests on a slanted roof, and in relation to this slant it is placed perpendicularly. This is indeed the only proper placement as long as the problem is limited to its narrowest range. Only in the broader framework of the total scene is the roof revealed as being slanted, that is, divergent from the basic framework of space. The roof is not the firm platform it appears to be in the narrow view. Therefore, in order to obtain the stable position which the child intended to give to the chimney by placing it at right angles to the roof, the chimney must confirm to the vertical of the larger space. This creates an awkward, wrong-looking relation between the two neighbors, chimney and roof—a relation justified only when seen in the broader context.

Another basic cognitive problem is that of interaction: At an early level of thought, things are considered as self-contained entities. There may not be any relation between them. Just as young children will play next to each other but not with each other, so the figures in their drawings float in space, unconcerned with each other. When relation is depicted, it does not indicate at first that the partners are modified by it. In the very primitive drawing of Fig. 8a the oval-shaped horse does not acknowledge the presence of the rider nor does the human figure seem to be modified by the function of riding. Only the spatial placement tells that the relation between the two is something more than independent coexistence. At a next step the partners sacrifice some of their integrity in the interest of the interaction. In Fig. 8a and 8d, the legs are omitted in order to solidify the interface between figure and support visually. But the partners do not yet invade each other. Figures 8b and 8e show a different solution. The partners are left unimpaired but they interpenetrate. They form a closer visual unity but are unaffected by it. Each is shaped the way it would be by itself, without the presence of the other. This creates areas that belong to both

FIGURE 7.

FIGURE 8.

partners and may be interpreted wrongly as show-ing transparency. Instead they are unacknowledged coincidences. But the double occupancy creates visual rivalry, and this conflict spurs the need for a more unified treatment of the problem.

The clown on the elephant (Fig. 8c) has assumed the profile position in deference to his mount. In addition, however, he has given up one leg. To accept this sacrifice as legitimate requires a much stronger modification of early thought than did the mere omission of the legs in Figs. 8a and 8d. In early drawings, children easily ignore limbs; but to acknowledge their presence and to agree to the amputation nevertheless calls for a more radical departure from the primary image of the human fig-ure. The child faces here, in a perceptually tangible and relatively neutral situation, the often painful problem of interaction: the part must be modified in the interest of the whole; and the particular form and behavior of the part is understandable only through its function in the whole. As a cognitive problem, interaction poses difficulties at all levels of theoretical thinking; as a problem of interpersonal relations, many people never truly succeed in solv-ing it.

In the two more advanced drawings of a seated figure (Figs. 8f and 8g) interaction leads to internal modification of the body. The rigid primary figure of the earlier drawings is now recognized as mobile in its joints or bendable. A reference to language may illustrate how universally characteristic of human though this difference is. The so-called iso-lation method of language forms sentences by the stringing together of words which remain unmod-ified within themselves. The connections between the words are expressed either by the mere sequence, as in Chinese, or by auxiliary words such as prepositions, e.g., the indication of the possessive case by the English *of* or the Japanese *no*. The inflec-tive method, on the other hand, modifies nouns, verbs, and other elements to make the interaction between the components of a statement explicitly visible. This method prevails in Latin and German. The terms *inflection* and *declension* derive etymo-logically from *bending*. Although Sapir warns against the temptation of considering inflective lan-guages as "higher" than the isolating ones, a devel-opment from rigid to flexible word shape can be observed, for example, in children; and Schlauch mentions that the inflected Indo-European lan-guage "may have developed out of an earlier stage in which root words and particles were loosely strung together as independent and semi-indepen-dent elements."

Characteristic of thought processes quite in gen-eral are also the confused or "ugly" transitional forms that come about when a person abandons a well-structured conception in order to proceed to a higher, more complex and more adequate one. It is a reaction to the sort of risk a mountain climber takes when he lets go of a safe position in order to get to a more advanced place. Figure 9 shows sche-matically three ways of representing a house, typi-cally found in children's drawings. Figure 9a, clearly defined and unimpeachable in itself, fails to indicate three-dimensionality and therefore tends to look unsatisfactory when demands become more exacting. Figure 9b is a new clear-cut solution, as perfect as the first but with some differentiation of front and side views. Figure 9c illustrates one of the many intermediate forms of disorientation by which the draftsman gropes for the more complex solution of the problem, following vague hunches, applying structural features inconsequently, and making tentative stabs in this or that direction.

The resulting disorder, though perhaps unap-pealing in itself, gives evidence of the searching mind in action. The exploration is goal-directed

FIGURE 9.

and productive and therefore necessary and educationally welcome. It must be distinguished from the very different kind of confusion that results when the sense of form is interfered with by misguided teaching or other disturbances. This difference between productive and unproductive confusion can be observed in other areas of human learning as well.

The simple shapes and color schemes found in the early drawings of children become more complex in all their aspects. Originally they reflect the perceptual order which the human mind establishes at an early age by straightening out the distortions of projection, accidental aspects, overlapping, etc. However, as the mind grows subtler, it becomes capable of incorporating the intricacies of perceptual appearance, thereby obtaining a richer image of

reality, which suits the more differentiated thinking of the developed mind. This greater complexity shows up in the art work of older children.

In the early drawings, the geometrical elements—circle, straight line, oval, rectangle—are presented explicitly, although rarely in perfect execution. They combine to form human figures, animals, trees but retain their own shapes. A circle, an oval, four straight lines, properly connected, make a primitive figure. Soon, however, these independent units tend to fuse into more complex shapes. Figure 10, a "prehistoric animal" drawn by a not quite five-year-old boy, is an impressive example. In order to perceive such a pattern, the mind employs its usual procedure of organizing it in terms of simpler elements, which are suggested by the approximations actually given. They, as well as the skeleton

FIGURE 10.

that combines them structurally, are not spelled out by the drawing but potentially contained in it and discovered by the beholder. The effort of visual thinking needed to read such a pattern is correspondingly greater and subtler.

Abstract Patterns in Visual Art

From these beginnings, an unbroken development leads to the accomplishments of great art. Perceptually, a mature work reflects a highly differentiated sense of form, capable of organizing the various components of the image in a comprehensive compositional order. But the intelligence of the artist is apparent not only in the structure of the formal pattern but equally in the depth of the meaning conveyed by this pattern. In Rembrandt's *Christ at Emmaus*, the religious substance symbolized by the

Bible story is presented through the interaction of two compositional groupings. One of them is centered in the figure of Christ, which is placed symmetrically between the two disciples. This triangular arrangement is heightened by the equally symmetrical architecture of the background and by the light radiating from the center. It shows the traditional hierarchy of religious pictures, culminating in the divine figure. However, this pattern is not allowed to occupy the center of the canvas. The group of figures is shifted somewhat to the left, leaving room for a second apex, created by the head of the servant boy. The second triangle is steeper and more dramatic also by its lack of symmetry. The head of Christ is no longer dominant but fitted into the sloping edge. Rembrandt's thinking strikingly envisages, in the basic form of the painting, the Protestant version of the New Testament. The humility of the Son of God is expressed composi-

Rembrandt, *Christ at Emmaus* (1648).

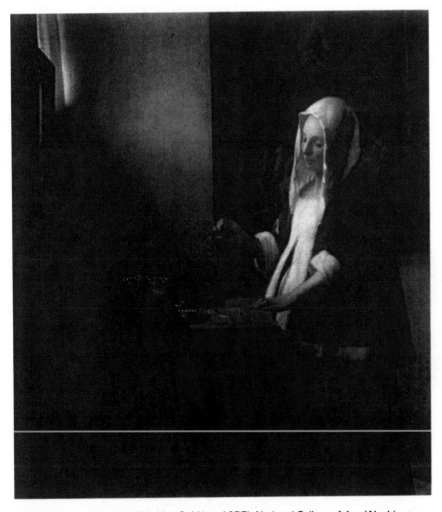

Jan Vermeer, *A Woman Weighing Gold* (ca. 1657). National Gallery of Art. Washington, D.C. Widener Collection.

tionally not only in the slight deviation of the head from the central axis of the otherwise symmetrical pyramid of the body; Christ appears also as subservient to another hierarchy, which has its high point in the humblest figure of the group, namely, the servant.

Needless to say, this analysis covers only the barest scaffold of Rembrandt's painting. If one wished to do fuller justice to the work of art, one would have to show how the theme is carried out in the detail. What matters here, however, is that the basic compositional scheme, often considered a purely formal device for pleasant arrangement, is in fact the carrier of the central subject. It presents the underlying thought in a highly abstract geometry, without which the realistically told story might have remained a mere anecdote.

The nature of visual thinking in art becomes particularly evident when it is compared with elements of "intellectual" knowledge, which, although legitimate constituents of the work, are imported into the visual statement from the outside. Jan Vermeer's *Woman Weighing Gold* is identified in the guide book as an allegory: "The young woman weighs her worldly goods standing before a painting of the Last Judgment wherein Christ weighs the souls of men." The parallel between the two actions is indispensable for the understanding of the picture. However, this is an intellectual connection, not displayed compositionally. If one knows of the Last Judgment, one can compare the subject matter of the background story with that of the foreground. All the painter does to suggest the relation is to frame the head of the lady in such a way as to place it directly below the figure of Christ. This relation, although close, is unspecific. The intellectual theme, however, is also expressed visually. The most conspicuous feature of the background picture is the dark, rigidly vertical ledge of the frame, which descends in the very center of Vermeer's composition. This powerful shape takes hold of the woman's hand and suspends the hand's movement. By this device the worldly scene of the foreground is arrested, while a light from above, stronger than the mundane glitter of the jewelry, causes the woman's eyes to close. Here again, the basic compositional pattern spells out the deepest and central thought of the work in great directness. The iconographic data

Jean Baptiste Camille Corot, *Mother and Child on the Beach*. Philadelphia Museum of Art.

add only a religious specification to the broader human theme.

The foregoing examples have shown what enables a work of art to be more than an illustration of a particular event or thing or a sample of a kind of event or thing. An abstract pattern of form, or more precisely, of forces is seen embedded in the image. Because of its abstractness, such a pattern is a generality. Through its particular appearance it represents the nature of a kind of thing. I have shown earlier that in principle this is true for all perception; but since the objects of nature and also many artifacts were not made for the purpose of fulfilling this perceptual function, they carry visual form only impurely and approximately. They leave much to the formative power of the observer. Works of visual art, on the other hand, are made exclusively for being perceived, and therefore the artist endeavors to create the strongest, purest, most precise embodiment of the meaning that, consciously or unconsciously, he intends to convey.

The carriers of directly perceivable meaning,

which mimetic art embeds in its representations of physical objects, reveal their abstractness more conspicuously in successful works of non-mimetic modern art. I will try to illustrate this point by comparing Camille Corot's *Mother and Child on the Beach* with Henry Moore's *Two Forms*. In the Corot, just as in the two paintings discussed a moment ago, the basic theme of the work is conveyed by the structural skeleton of the composition. The child, symmetrical and frontal, reposes like a self-contained, independent little monument, whereas the figure of the mother is fitted to a bending and reaching wave shape, expressing protection and concern. Moore's carving, equally complex and subtle, embodies a very similar theme. The smaller of the two units is compact and self-sufficient like Corot's infant, although it also strains noticeably towards its partner. The larger seems wholly engaged in its leaning over the smaller, dominating it, holding it down, protecting, encompassing, receiving it. One can find parallels to human or otherwise natural situations in this work: the relation

Henry Moore, Two Forms (1934).
Collection: The Museum of Modern
Art. Sir Michael Sadler Fund.

of mother and child, spelled out in the Corot, or that of male and female. Such associations rely on the similarity of the inherent patterns of forces, they exemplify the reasons why the work has something to tell that concerns us; but they are no inherent part of the work itself.

Just as a chemist "isolates" a substance from contaminations that distort his view of its nature and effects, so the work of art purifies significant appearance. It presents abstract themes in their generality, but not reduced to diagrams. The variety of direct experience is reflected in highly complex forms. The work of art is an interplay of vision and thought. The individuality of particular existence and the generality of types are united in one image. Percept and concept, animating and enlightening each other, are revealed as two aspects of one and the same experience.

15

Leonardo da Vinci and a Memory of His Childhood

SIGMUND FREUD

I

When psychiatric research, normally content to draw on frailer men for its material, approaches one who is among the greatest of the human race, it is not doing so for the reasons so frequently ascribed to it by laymen. 'To blacken the radiant and drag the sublime into the dust' is no part of its purpose,[1] and there is no satisfaction for it in narrowing the gulf which separates the perfection of the great from the inadequacy of the objects that are its usual concern. But it cannot help finding worthy of understanding everything that can be recognized in those illustrious models, and it believes there is no one so great as to be disgraced by being subject to the laws which govern both normal and pathological activity with equal cogency.

Leonardo da Vinci (1452–1519) was admired even by his contemporaries as one of the greatest men of the Italian renaissance; yet in their time he had already begun to seem an enigma, just as he does to us to-day. . . .

There is, so far as I know, only one place in his scientific notebooks where Leonardo inserts a piece of information about his childhood. In a passage about the flight of vultures he suddenly interrupts himself to pursue a memory from very early years which had sprung to his mind:

'It seems that I was always destined to be so deeply concerned with vultures; for I recall as one of my very earliest memories that while I was in my cradle a vulture came down to me, and opened my mouth with its tail, and struck me many times with its tail against my lips.'[2]

What we have here then is a childhood memory; and certainly one of the strangest sort. It is strange on account of its content and on account of the age to which it is assigned. That a person should be able to retain a memory of his suckling period is perhaps not impossible, but it cannot by any means be regarded as certain. What, however, this memory of Leonardo's asserts—namely that a vulture opened the child's mouth with its tail—sounds so improbable, so fabulous, that another view of it, which at a single stroke puts an end to both difficulties, has more to commend it to our judgement. On this view the scene with the vulture would not be a memory of Leonardo's but a phantasy, which he formed at a later date and transposed to his childhood.

This is often the way in which childhood memories originate. Quite unlike conscious memories from the time of maturity, they are not fixed at the moment of being experienced and afterwards repeated, but are only elicited at a later age when childhood is already past; in the process they are altered and falsified, and are put into the service of later trends, so that generally speaking they cannot be sharply distinguished from phantasies. Their nature is perhaps best illustrated by a comparison with the way in which the writing of history origi-

From Sigmund Freud, *Leonardo da Vinci and A Memory of His Childhood*, trans. Alan Tyson. New York: W. W. Norton & Company, 1964, pp. 13, 32–37, 57, 60–61, 81–84. Reprinted with permission of W. W. Norton & Company.

171

nated among the peoples of antiquity. As long as a nation was small and weak it gave no thought to the writing of its history. Men tilled the soil of their land, fought for their existence against their neighbours, and tried to gain territory from them and to acquire wealth. It was an age of heroes, not of historians. Then came another age, an age of reflection: men felt themselves to be rich and powerful, and now felt a need to learn where they had come from and how they had developed. Historical writing, which had begun to keep a continuous record of the present, now also cast a glance back to the past, gathered traditions and legends, interpreted the traces of antiquity that survived in customs and usages, and in this way created a history of the past. It was inevitable that this early history should have been an expression of present beliefs and wishes rather than a true picture of the past; for many things had been dropped from the nation's memory, while others were distorted, and some remains of the past were given a wrong interpretation in order to fit in with contemporary ideas. Moreover people's motive for writing history was not objective curiosity but a desire to influence their contemporaries, to encourage and inspire them, or to hold a mirror up before them. A man's conscious memory of the events of his maturity is in every way comparable to the first kind of historical writing [which was a chronicle of current events]; while the memories that he has of his chidlhood correspond, as far as their origins and reliabilty are concerned, to the history of a nation's earliest days, which was compiled later and for tendentious reasons.

If, then, Leonardo's story about the vulture that visited him in his cradle is only a phantasy from a later period, one might suppose it could hardly be worth while spending much time on it. One might be satisfied with explaining it on the basis of his inclination, of which he makes no secret, to regard his preoccupation with the flight of birds as preordained by destiny. Yet in underrating this story one would be committing just as great an injustice as if one were carelessly to reject the body of legends, traditions and interpretations found in a nation's early history. In spite of all the distortions and misunderstandings, they still represent the reality of the past: they are what a people forms out of the experience of its early days and under the dominance of motives that were once powerful and still operate to-day; and if it were only possible, by a knowledge of all the forces at work, to undo these distortions, there would be no difficulty in disclosing the historical truth lying behind the legendary material. The same holds good for the childhood memories or phantasies of an individual. What someone thinks he remembers from his childhood is not a matter of indifference; as a rule the residual

memories—which he himself does not understand—cloak priceless pieces of evidence about the most important features in his mental development. As we now possess in the techniques of psycho-analysis excellent methods for helping us to bring this concealed material to light, we may venture to fill in the gap in Leonardo's life story by analysing his childhood phantasy. And if in doing so we remain dissatisifed with the degree of certainty which we achieve, we shall have to console ourselves with the reflection that so many other studies of this great and enigmatic man have met with no better fate.

If we examine with the eyes of a psycho-analyst Leonardo's phantasy of the vulture, it does not appear strange for long. We seem to recall having come across the same sort of thing in many places, for example in dreams; so that we may venture to translate the phantasy from its own special language into words that are generally understood. The translation is then seen to point to an erotic content. A tail, 'coda', is one of the most familiar symbols and substitutive expressions for the male organ, in Italian no less than in other languages; the situation in the phantasy, of a vulture opening the child's mouth and beating about inside it vigorously with its tail, corresponds to the idea of an act of *fellatio,* a sexual act in which the penis is put into the mouth of the person involved. It is strange that this phantasy is so completely passive in character; moreover it resembles certain dreams and phantasies found in women or passive homosexuals (who play the part of the woman in sexual relations).

I hope the reader will restrain himself and not allow a surge of indignation to prevent his following psycho-analysis any further because it leads to an unpardonable aspersion on the memory of a great and pure man the very first time it is applied to his case. Such indignation, it is clear, will never be able to tell us the significance of Leonardo's childhood phantasy; at the same time Leonardo has acknowledged the phantasy in the most unambiguous fashion, and we cannot abandon our expectation—or, if it sounds better, our prejudice—that a phantasy of this kind must have *some* meaning, in the same way as any other psychical creation: a dream, a vision or a delirium. Let us rather therefore give a fair hearing for a while to the work of analysis, which indeed has not yet spoken its last word.

The inclination to take a man's sexual organ into the mouth and suck at it, which in respectable society is considered a loathsome sexual perversion, is nevertheless found with great frequency among women of to-day—and of earlier times as well, as ancient sculptures show— and in the state of being in love it appears completely to lose its repulsive character. Phantasies derived from this inclination are found by doctors even in women who have not

become aware of the possibilities of obtaining sexual satisfaction in this way by reading Krafft-Ebing's *Psychopathia Sexualis* or from other sources of information. Women, it seems, find no difficulty in producing this kind of wishful phantasy spontaneously. Further investigation informs us that this situation, which morality condemns with such severity, may be traced to an origin of the most innocent kind. It only repeats in a different form a situation in which we all once felt comfortable—when we were still in our suckling days *('essendo io in culla')*[3] and took our mother's (or wet-nurse's) nipple into our mouth and sucked at it. The organic impression of this experience—the first source of pleasure in our life–doubtless remains indelibly printed on us; and when at a later date the child becomes familiar with the cow's udder whose function is that of a nipple, but whose shape and position under the belly make it resemble a penis, the preliminary stage has been reached which will later enable him to form the repellent sexual phantasy.

Now we understand why Leonardo assigned the memory of his supposed experience with the vulture to his suckling period. What the phantasy conceals is merely a reminiscence of sucking—or being suckled—at his mother's breast, a scene of human beauty that he, like so many artists, undertook to depict with his brush, in the guise of the mother of God and her child. There is indeed another point which we do not yet understand and which we must not lose sight of: this reminiscence, which has the same importance for both sexes, has been transformed by the man Leonardo into a passive homosexual phantasy. For the time being we shall put aside the question of what there may be to connect homosexuality with sucking at the mother's breast, merely recalling that tradition does in fact represent Leonardo as a man with homosexual feelings. In this connection, it is irrelevant to our purpose whether the charge brought against the young Leonardo was justified or not. What decides whether we describe someone as an invert is not his actual behaviour, but his emotional attitude.

Our interest is next claimed by another unintelligible feature of Leonardo's childhood phantasy. We interpret the phantasy as one of being suckled by his mother, and we find his mother replaced by— a vulture. . . .

We have not yet done with Leonardo's vulture phantasy. In words which only too plainly recall a description of a sexual act ('and struck me many times with its tail against my lips'), Leonardo stresses the intenstiy of the erotic relations between mother and child. From this linking of his mother's (the vulture's) activity with the prominence of the mouth zone it is not difficult to guess that a second

memory is contained in the phantasy. This may be translated: 'My mother pressed innumerable passionate kisses on my mouth.' The phantasy is compounded from the memory of being suckled and being kissed by his mother.

Kindly nature has given the artist the ability to express his most secret mental impulses, which are hidden even from himself, by means of the works that he creates; and these works have a powerful effect on others who are strangers to the artist, and who are themselves unaware of the source of their emotion. Can it be that there is nothing in Leonardo's life work to bear witness to what his memory preserved as the strongest impression of his childhood? One would certainly expect there to be something. Yet if one considers the profound transformations through which an impression in an artist's life has to pass before it is allowed to make its contribution to a work of art, one will be bound to keep any claim to certainty in one's demonstrations within very modest limits; and this is especially so in Leonardo's case.

Anyone who thinks of Leonardo's paintings will be reminded of a remarkable smile, at once fascinating and puzzling, which he conjured up on the lips of his female subjects. It is an unchanging smile, on long, curved lips; it has become a mark of his style and the name 'Leonardesque' has been chosen for it. In the strangely beautiful face of the Florentine Mona Lisa del Giocondo it has produced the most powerful and confusing effect on whoever looks at it. This smile has called for an interpretation, and it has met with many of the most varied kinds, none of which has been satisfactory. . . .

Let us attempt to clarify what is suggested here. It may very well have been that Leonardo was fascinated by Mona Lisa's smile for the reason that it awoke something in him which had for long lain dormant in his mind—probably an old memory. This memory was of sufficient importance for him never to get free of it when it had once been aroused; he was continually forced to give it new expression. Pater's confident assertion that we can see, from childhood, a face like Mona Lisa's defining itself on the fabric of his dreams, seems convincing and deserves to be taken literally. . . .

The aim of our work has been to explain the inhibitions in Leonardo's sexual life and in his artistic activity. With this in view we may be allowed to summarize what we have been able to discover about the course of his psychical development.

We have no information about the circumstances of his heredity; on the other hand we have seen that the accidental conditions of his childhood had a profound and disturbing effect on him. His illegitimate birth deprived him of his father's influence until perhaps his fifth year, and left him open to the

tender seductions of a mother whose only solace he was. After being kissed by her into precocious sexual maturity, he must no doubt have embarked on a phase of infantile sexual activity of which only one single manifestation is definitely attested—the intensity of his infantile sexual researches. The instinct to look and the instinct to know were those most strongly excited by the impressions of his early childhood; the erotogenic zone of the mouth was given an emphasis which it never afterwards surrendered. From his later behaviour in the contrary direction, such as his exaggerated sympathy for animals, we can conclude that there was no lack of strong sadistic traits in this period of his childhood.

A powerful wave of repression brought this childhood excess to an end, and established the dispositions which were to become manifest in the years of puberty. The most obvious result of the transformation was the avoidance of every crudely sensual activity; Leonardo was enabled to live in abstinence and to give the impression of being an asexual human being. When the excitations of puberty came in their flood upon the boy they did not, however, make him ill by forcing him to develop substitutive structures of a costly and harmful kind. Owing to his very early inclination towards sexual curiosity the greater portion of the needs of his sexual instinct could be sublimated into a general urge to know, and thus evaded repression. A much smaller portion of his libido continued to be devoted to sexual aims and represented a stunted adult sexual life. Because his love for his mother had been repressed, this portion was driven to take up a homosexual attitude and manifested itself in ideal love for boys. The fixation on his mother and on the blissful memories of his relations with her continued to be preserved in the unconscious, but for the time being it remained in an inactive state. In this way repression, fixation and sublimation all played their part in disposing of the contributions which the sexual instinct made to Leonardo's mental life.

Leonardo emerges from the obscurity of his boyhood as an artist, a painter and a sculptor, owing to a specific talent which may have been reinforced by the precocious awakening in the first years of childhood of his scopophilic instinct. We should be most glad to give an account of the way in which artistic activity derives from the primal instincts of the mind if it were not just here that our capacities fail us. We must be content to emphasize the fact—which it is hardly any longer possible to doubt—that what an artist creates provides at the same time an outlet for his sexual desire; and in Leonardo's case we can point to the information which comes from Vasari that heads of laughing women and beautiful boys—in other words, representations of his sexual objects—were notable among his first artistic endeavours. In the bloom of his youth Leonardo appears at first to have worked without inhibition. Just as he modelled himself on his father in the outward conduct of his life, so too he passed through a period of masculine creative power and artistic productiveness in Milan, where a kindly fate enabled him to find a father-substitute in the duke Lodovico Moro. But soon we find confirmation of our experience that the almost total repression of a real sexual life does not provide the most favourable conditions for the exercise of sublimated sexual trends. The pattern imposed by sexual life made itself felt. His activity and his ability to form quick decisions began to fail; his tendency towards deliberation and delay was already noticeable as a disturbing element in the 'Last Supper', and by influencing his technique it had a decisive effect on the fate of that great painting. Slowly there occurred in him a process which can only be compared to the regressions in neurotics. The development that turned him into an artist at puberty was overtaken by the process which led him to be an investigator, and which had its determinants in early infancy. The second sublimation of his erotic instinct gave place to the original sublimation for which the way had been prepared on the occasion of the first repression. He became an investigator, at first still in the service of his art, but later independently of it and away from it. With the loss of his patron, the substitute for his father, and with the increasingly sombre colours which his life took on, this regressive shift assumed larger and larger proportions. He became *'impacientissimo al pennello'*,[4] as we are told by a correspondent of the Countess Isabella d'Este, who was extremely eager to possess a painting from his hand. His infantile past had gained control over him. But the research which now took the place of artistic creation seems to have contained some of the features which distinguish the activity of unconscious instincts—insatiability, unyielding rigidity and the lack of an ability to adapt to real circumstances.

At the summit of his life, when he was in his early fifties—a time when in women the sexual characters have already undergone involution and when in men the libido not infrequently makes a further energetic advance—a new transformation came over him. Still deeper layers of the contents of his mind became active once more; but this further regression was to the benefit of his art, which was in the process of becoming stunted. He met the woman who awakened his memory of his mother's happy smile of sensual rapture; and, influenced by this revived memory, he recovered the stimulus that guided him at the beginning of his artistic endeavours, at the time when he modelled the smiling women. He painted the Mona Lisa, the 'St. Anne

with Two Others' and the series of mysterious pic-
tures which are characterized by the enigmatic
smile. With the help of the oldest of all his erotic
impulses he enjoyed the triumph of once more con-
quering the inhibiton in his art. This final develop-
ment is obscured from our eyes in the shadows of
approaching age. Before this his intellect had soared
upwards to the highest realizations of a conception
of the world that left his epoch far behind it.

Notes

1. [Es liebt die Welt, das Strahlende zu schwärzen
 Und das Erhabene in den Staub zu ziehn.
(The world loves to blacken the radiant and drag the sublime into the dust.) From a poem by Schiller,
"Das Mädchen von Orleans", inserted as an extra prologue to the 1801 edition of his play *Die Jung-
frau von Orleans*. The poem is reputed to have been an attack on Voltaire's *La Pucelle*.]

2. 'Questo scriver si distintamente del nibio par che sia mio destino, perchè nella mia prima recor-
datione della mia infantia e' mi parea che, essendo io in culla, che un nibio venissi a me e mi aprissi la
bocca colla sua coda e molte volte mi percuotesse con tal coda dentro alle labbra.' (Codex Atlanticus,
F.65 v., as given by Scognamiglio [1900, 22].) [In the German text Freud quotes Herzfeld's trans-
lation of the Italian original, and our version above is a rendering of the German. There are in fact
two inaccuracies in the German: 'nibio' should be 'kite' not 'vulture' . . . and 'dentro', 'within', is
omitted. This last omission is in fact rectified by Freud himself below.]

3. 'While I was in my cradle.'

4. 'Very impatient of painting.'

16

The Forms of Things Unknown

HERBERT READ

I

Any discussion of the psychology of art must begin with an affirmation that is not always acceptable to the psychologist; or, if acceptable, is often conveniently forgotten. This is the fact that the work of art exists as such, not in virtue of any 'meaning' it expresses, but only in virtue of a particular organization of its constituent material elements. We say that this organization is *formal,* but we are soon aware that any metrical analysis of form, any morphology of art, does not yield up art's secret. Form refers back to measures of area, volume, time-intervals, tones; the appeal of these measures, which is called aesthetic because it operates through perception and sensation, is accepted pragmatically, as an evident fact. There have been various attempts to explain this appeal, beginning with the early Greek philosophers, and they have generally been attempts to relate the measurements of art to the measurements of nature, and to see in the proportions of the crystal, of vegetation, of man himself, the prototypes of the proportions discovered in the work of art. I say *discovered* in the work of art because though the Greek architects and sculptors, like Le Corbusier and others today, began to make conscious use of natural proportions, the significant fact is that these proportions appear without conscious intervention in all those works of art that can be characterized as 'beautiful'. This, perhaps, is no more than an hypothesis which has yet to be

proved, and certainly a few traditional concepts of natural proportion, such as the Golden Section, do not suffice to explain all the phenomena of art. Form, that is to say, is not necessarily so obvious that it can be expressed in a single formula such as the Golden Section; and we must beware of limiting our notions of form to the canons of a particular tradition or culture. Many of my readers will remember a book that was published in Berlin in the 1920s—Professor Karl Blossfeldt's *Urformen der Kunst.*[1] It was a book that at the time was a revelation of the beauty inherent in plant forms, but Professor Blossfeldt had looked on nature with classical eyes, and found everywhere the motifs of Greek or Gothic architecture and decorative art. About the same time the surréalistes in Paris, inspired by Rimbaud, Lautréamont and Freud, began to find beauty in phenomena of a different kind which, in spite of their strangeness, are equally natural—it might be an octopus, a fungus or the proliferations of disease or decay. Basically no doubt all these forms are the same, or relate to one universal system of formal articulation. What is significant is the selection and combination of forms made by the artist. The forms selected by Karl Blossfeldt tell us something about Karl Blossfeldt, just as the forms selected by a surrealist painter like Max Ernst tell us something about Max Ernst.[2] There is 'no hierarchy in the cycle of natural forms', remarks, very truly, another painter of this school, André Masson: 'The royal structure of the human body is no more *beautiful*

From Herbert Read, *The Forms of Things Unknown.* New York: Horizon Press, 1960, pp. 49–75.

than the radiolaria, an oceanic star with solid rays.'[3] The artist, we might say, expresses himself with 'forms already plastic', forms discovered in nature, the signs which, according to Novalis, occur everywhere, and which, in the activity of art, we merely disinter, isolate and recombine.

With what purpose? ... [T]he purpose of a work of art is not necessarily definable in the terms of rational discourse. Art is a form of symbolic discourse, and its elements are not linguistic but, as Conrad Fiedler recognized seventy years ago, perceptual. 'We are not in a realm of abstract thought at all, but in one of 'visual cognition'. The work of art remains in what André Masson has called 'the secret world of analogy.' Masson draws attention to some remarks made by Goethe in a conversation reported by J. Daniel Falk which go immediately to the heart of our problem:

'We talk too much, we should talk less and draw more. As for me, I should like to renounce the word and, like plastic nature, speak only in drawings. This fig-tree, this little serpent, this cocoon lying there under the window and quietly awaiting its future, all these are profound seals; and he who can decipher their true sense, can in the future do without spoken or written language! ... Look, he added, pointing to a multitude of plants and fantastic figures which he had just traced on the paper while talking—here are really bizarre images, really mad, yet they could be twenty times more mad and fantastic and still there the question would arise— if their type did not exist somewhere in nature. In drawing, the soul recounts a part of its essential being and it is precisely the deepest secrets of creation, those which rest basically on drawing and sculpture, that the soul reveals in this way.'[4]

One might find expressions of the same idea in Goethe's writings and he indeed was the first to realize that there are two distinct and uninterchangeable non-linguistic modes of communication, one elaborated by man and of limited scope, the other elaborated by nature, of unlimited scope, both of which man may use in that expressive process which we call art.

Nature, we might say, is a world of plastic forms, evolved or in the process of evolution, and man perceives these forms or carries in his memory images of these forms. Images, totally distinct from words or any signs used in discursive reasoning, assume an autonomous activity, combine by way of analogy or metaphor, and produce an effect in us which may be merely personal or sensational and which, when pleasurable, is called beautiful; or may be supra-personal and will then convey what Goethe calls 'the deepest secrets of creation'; or what Dr. Erich Neumann has called 'die Gefühlsqualität des Numinosen'.[5] I favour this emphasis on the quality of feeling, for it must never be forgotten that in art the way from the personal to the supra-personal lies along the path of sensation. There are no mental aids in art; without sensibility there is no revelation.

Obviously there is, as Dr Jung has recognized, a creative process at work here which involves the artist as a medium, or as a field of operations. The artist is responsible only as the possessor and activator of a releasing mechanism. It therefore becomes very difficult to apply to this process the ordinary laws of causality. I am not referring to the biological difficulty of explaining the sudden emergence of a genius like Michelangelo or Mozart: the science of genetics can juggle with its genes and chromosomes to some purpose in that direction. But given the genius, how explain the Sistine Chapel or *The Marriage of Figaro*? It is not the fact but the quality of genius that calls for explanation, and of this quality genius itself, in its operations, may be in some sense unaware.

Dr Jung has expressed such a view:

'Personal causality has as much and as little to do with the work of art, as the soil with the plant that springs from it. Doubtless we may learn to understand some peculiarities of the plant by becoming familiar with the character of its habitat. And for the botanist this is, of course, an important component of his knowledge. But nobody will maintain that he has thereby recognized all the essentials relating to the plant itself. The personal orientation that is demanded by the problem of personal causality is out of place in the presence of the work of art, just because the work of art is not a human being, but supra-personal. It is a thing and not a personality; hence the personal is no criterion for it.'[6]

Dr Jung has also said, at the beginning of this same essay on 'Poetic Art', that that which constitutes the essential nature of art must always lie outside the province of psychology—'the problem what is art in itself, can never be the object of a psychological, but only of an aesthetic-artistic method of approach'. I am myself an aesthetician, and with this warning in mind I shall disclaim any intention of providing a psychological explanation for phenomena which have been so magisterially excluded from the province of psychology. At the same time it must be observed that it is very difficult to talk about the creative process in art without at the same time giving some information about the thing created, and Jung himself was the first to break his rule—he has made some very important observations about the specific qualities of works of art. He has said, as we have just seen, that art is supra-personal. He goes on to make a distinction between works of art that are deliberate, created by the artist's conscious will and judgment; and works of art that are spontaneous, fully formed before deliv-

ered, for which the artist merely acts as a channel. He says of such a work of art that it is 'a force of nature that effects its purpose, either with tyrannical might, or with that subtle cunning which nature brings to the achievement of her end, quite regardless of the weal or woe of the man who is the vehicle of the creative force'. He distinguishes between symbolic works of art which rarely permit of aesthetic enjoyment and non-symbolic works of art which invite such enjoyment and offer us 'an harmonious vision of fulfilment.' And finally, and this is the point of departure for our present deliberations, he suggests that the creative process is an autonomous complex, a living independent organism implanted, as it were, in the souls of man—'a detached portion of the psyche that leads an independent psychic life withdrawn from the hierarchy of consciousness, and in proportion to its energic value or force, may appear as a mere disturbance of the voluntarily directed process of consciousness, or as a superordinated authority which may take the ego bodily into its service.[7]

The notion of a detached portion of the psyche, capable of independent activity, is difficult to accept, since we are so prejudiced in favour of the unity or integrity of the personality. And yet such an autonomous force is one of the oldest and most persistent ideas in human history. It is the Ancient Greek notion of a *daemon,* which goes back at least as far as Heraclitus; and which was used by Plato specifically to explain the phenomenon of poetic inspiration. Daemons were not always good: they shared, and might even be responsible for, the perversity of mankind. In the Middle Ages they were divided into guardian angels and devils, and the autonomous complexes of modern psychology are equally ambiguous. They may even remain ambiguous, from an ethical point of view, when they emerge into consciousness as works of art. But ethical ambiguity does not affect aesthetic harmony, and it is the source and significance of that harmony which is our present concern.

At the source of all autonomous psychic activities Jung finds a phenomenon which has enjoyed several names and undergone certain transformations as the evidence accumulated. The name which Jung has given to this phenomenon is the *archetype,* a somewhat theological term which may hide, from the uncautious, the essentially materialistic basis of the whole conception, as it took shape in Jung's mind. I think I am right in saying that the term 'archetype' was preceded by the equivalent term 'primordial image', which was more concrete and more directly related to the current terminology of psychology. Indeed, while for the historical description of the archetypes we may have to range over wide fields of myth and fable, as phenomena they

are nevertheless firmly rooted in the physiological structure of the brain. Their functions cannot be revealed by anatomical dissection, any more than the 'engrams' and other hypothetical entities of the modern physiologist. But the brain has evolved—has grown in size and complexity through vast stretches of time—and its structure is related to the experiences of countless generations of the human species. It is Jung's reasonable assumption that the profoundest social experiences of mankind must have left some physiological trace in the structure of the brain; and in particular that some of the earliest experiences of the species, long forgotten in the comparative security of historical times, left the deepest traces.

Archetypes, therefore, must be conceived, as the engrams of the physiologist are conceived, as 'inherited with the structure of the brain'; indeed, they *are* engrams, the lowest layer of these physical impresses, and because they are so primordial, Jung described them as 'the chthonic portion of the mind . . . that portion through which the mind is linked to nature, or in which, at least, its relatedness to the earth and the universe seems most comprehensible'. Jung says specifically, and it is a saying to which I shall return, that the primordial images which proceed from this chthonic level of the brain show most clearly 'the influence of the earth and its laws upon the mind'.[8]

The archetypes, therefore, are a function of the brain, but we are not normally aware of their existence. They are not so much unconscious as *unactivated,* dynamos that do not go into action until charged with some psychic current. When they do go into action, they act in a predetermined way— in the way predetermined by their physical constitution and mechanism. They connect up with mnemonic images, deeply buried memories of racial experience, and as these images emerge into individual consciousness, perhaps transformed on the way, they inevitably revive and represent 'countless typical experiences of our ancestors'.[9]

But there is nothing inevitably aesthetic about such revived images, even if we regard them, not so much as concrete symbols, but rather, as Jung himself has suggested, as 'typical forms of apprehension', as 'regularly recurring ways of apprehension'.[10] Ways and forms of apprehension imply a structural organization of the symbolic content, and what is structural *may* be aesthetic. 'A factor determining the uniformity and regularity of our apprehension'–that is another of Jung's definitions of the archetypes, and it comes very near to the Gestalt definition of the aesthetic factor in perception as 'a disposition to feel the completeness of an experienced event as being right and fit'.[11] The farther modern psychology has probed into the dis-

tinctive quality of the work of art, the more it has tended to recognize the presence of autonomous processes of organization within the nervous system, and to attribute to these processes the formal characteristics that constitute the aesthetic appeal of the work of art. I refer in particular to the approach of a Gestalt psychologist like K. Koffka to the problems of art.[12]

There is an inherent biological necessity in such aesthetic organization of the data of perception. As Susanne Langer has said 'our merest sense-experience is a process of *formulation*. The world that actually meets our senses is not a world of "things", about which we are invited to discover facts as soon as we have codified the necessary logical langue to do so: the world of pure sensation is so complex, so fluid and full, that sheer sensitivity to stimuli would only encounter what William James has called (in a characteristic phrase) "a blooming, buzzing, confusion". Out of this bedlam our sense organs must select certain predominant forms, if they are to make report of *things* and not of mere dissolving sensa. The eye and the ear must have their logic. . . . An object is not a datum, but a form construed by the sensitive and intelligent organ, a form which is at once an experimental individual thing and a symbol for the concept of it, for *this sort of thing*'.[13]

I must quote further from Mrs Langer's book, because apparently without any awareness of Jung's psychology, approaching our problem as a logician and philosopher, she arrives at identical conclusions:

A tendency to organize the sensory field into groups and patterns of sense data, to perceive forms rather than a flux of light-impressions, seems to be inherent in our receptor apparatus just as much as in the higher nervous centres with which we do arithmetic and logic. But this unconscious appreciation of forms is the primitive root of all abstraction, which in turn is the keynote of rationality; so it appears that the conditions for rationality lie deep in our pure animal experience—in our power of perceiving, in the elementary functions of our eyes and ears and fingers. Mental life begins with our mere physiological constitution. A little reflection shows us that, since no experience occurs more than once, so-called "repeated" experiences are really *analogous* occurrences, all fitting a form that was abstracted on the first occasion. *Familiarity* is nothing but the quality of fitting very neatly into a form of previous experience. . . .
No matter what heights the human mind may attain, it can work only with the organs it has and the functions peculiar to them. Eyes that did not see forms could never furnish it with *images;*

ears that did not hear articulated sounds could never open it to *words*. Sense data, in brief, would be useless to a mind whose activity is "through and through a symbolic process", were they not *par excellence* receptacles of meaning. But meaning . . . accrues essentially to forms. Unless the *Gestalt*-psychologists are right in their belief that *Gestaltung* is of the very nature of perception, I do not know how the hiatus between perception and conception, sense-organ and mind-organ, chaotic stimulus and logical response, is ever to be closed and welded. A mind that works primarily with meanings must have organs that supply it primarily with forms.[14]

This is the point: form exists and then a meaning 'creeps into it'.[15] But where do these forms come from—what forms the forms? A form, Susanne Langer says, was abstracted on the first occasion; a separate pattern was segregated from the sensory field, and once imprinted on the cortex, was gradually 'developed' by analogous or identical experiences until it acquired what we call meaning. The form became detachable, as a sign or symbol. According to Jung, as we have seen, by reason of their intensity or their frequent recurrence, certain experiences have left formal imprints on the cellular structure of the brain: they are engrams, and as such heritable.

From the aesthetic point of view there are two possibilities here: (1) that a pattern or form can be organized from sense data in virtue of an inner coherence—that we only see a pattern because it has certain physical characteristics, such as symmetry, balance and rhythm; or (2) that among the forms segregated by this organization of the sensory world, some are merely utilitarian, others aesthetic—a view which implies ideal categories of beauty independent of experience. Personally I do not see how the conception of such ideal categories could arise except on the basis of experience—they are meanings read into forms which have been determined by the physical necessities of animal evolution. What is certain is that the forms into which sensory experience is organized were gradually differentiated into two distinct types: signs or symbols whose meaning remained magical, sensory, unexplained; and signs or symbols whose meaning became conventional, conceptual and discursive. We now reserve the word 'signs', or better still, 'signals',[16] for the latter type of communication, and the whole structure of discursive reasoning and non-aesthetic communication is based on such signals, most generally and effectively in the form of word-syllabic systems.

We are to be concerned only with the first method of communication: non-discursive symbols;

and only with symbols in so far as they exhibit those characteristics, or convey those sensations, which we call aesthetic. We must first ask why some such symbols have aesthetic characteristics, others not.

It would seem that those non-discursive symbols which are devoid of aesthetic appeal must have lost such appeal, for as we have seen, they only became differentiated from the buzzing confusion of sense impressions in virtue of their attractive form, the 'goodness' of their *Gestalt*.

Jung's theory, if I understand it rightly, is that the symbol loses its original force (and I think the implication is that this original force is aesthetic—a point I shall discuss presently) when it becomes too explicit—when the libido, instead of being retained in the image, is squandered in sexuality or any other physical dispersion of the retained energy. In discussing the relativity of the symbol with special reference to *The Shepherd* of Hermas, and also with reference to the symbolism of the Grail, he makes it 'abundantly clear' that it is the repressed libido which evokes a powerful transformation in the unconscious, and endows the symbol with its mysterious efficacy. He even suggests,[17] that an aesthetic form is an essential component of the symbol's efficacy.

I think the necessity for an aesthetic factor is explained by the psychological facts already considered: the symbol only becomes perceptually definite and sensationally effective if it has a good form. Its potency will depend on the relative degree of goodness in the form: the degree of aesthetic appeal depends on the organization of parts into a whole, and on the direct, undifferentiated appeal of the unity achieved by aesthetic organization. In short, we return to the problem of form.

This is not, of course, a problem peculiar to aesthetics. It has been more and more the tendency, during recent years, to reduce science in general to a problem of form, and the contributions to this problem, particularly from physicists and biologists, are of the greatest significance for our study of the aesthetic aspects of symbolic form.[18] Mr Lancelot Law Whyte has dealt with some of the general problems of form,[19] and I have no intention of going over once again the ground he has so adequately surveyed. Admittedly, as we have already noted, there are many analogies between natural forms and aesthetic forms, and perhaps there are no forms conceivable that are not echoes or correspondences of one another. But it would be a poor end to our speculations if all we could prove is that the aesthetic significance of symbolic form lies in its more or less conscious reduplication of natural forms! I am not forgetting that a distinction must be made between natural forms in the widest cosmical sense, and organic forms in the limited biological sense. We

know that there have been whole epochs in the history of art that have renounced organic forms, that have taken refuge in geometrical abstractions; there is even a tendency to such abstraction in our own epoch! But it would seem that the more the human psyche tries to escape from organic forms, the more it finds itself involved in the universal matrix from which these forms emerge.

At this point we might consider a little more closely the distinction between organic forms, such as we find in a shell, a leaf, a flower, or the human body itself; and those proportions, inherent in these forms, but typical also of a range of phenomena far wider than the phenomena of organic life. Not only is form typical of inorganic as well as organic phenomena, as in the geometrical proportions of a crystal, but proportions can be discerned in the operations of the universe itself, the so-called 'harmony of the spheres'; and there is a similar order discernible in the microscopic world of atoms and molecules. The whole universe is 'patterned', and there can be little wonder, therefore, in the fact that the psychic element in life *conforms* to the all-environing physical mould. Dr Jung has compared the archetype to the ancient bed of a river to which the stream of life may return after some indefinitely long period. As an image it is perhaps too irregular: the stream often flows in channels that are of regular proportions, into basins and cascades of an order that we agree to call beautiful. The freedom, which we inevitably associate with the creative activity, can perhaps be explained as an apparently infinite series of variations on a relatively few fixed forms. There is no need to shrink from such an explanation as from an intolerable restriction of the possibilities of art, for what has the art of music, to a naïve apprehension the freest of all forms of art, ever been but such a play with a determinate number of fixed forms?

A philosopher might complain at this point that we are making metaphysical assumptions. How do we 'cognize' form: by what faculty of the mind do we determine its regularity? Are we not involved in a Kantian system of categories? Perhaps: but personally I believe that our argument can proceed on a purely pragmatic level. The forms of beauty relate to the forms of life, to biological forms; and these are determined by the organic process itself—by efficiency, by natural selection, by environment. Form is determined by physical causes, and 'forms mathematically akin may belong to organisms biologically remote'.[20] But forms, in the sense of regular figures, have a limited range of variation—Plato, in the *Timaeus*, argued that in three-dimensional space there are only five absolutely regular solids. 'These solids inter-penetrate; according to Plato, they intersect in such a way that out of their perfect

harmonies in themselves, they produce all the various discords and resolutions which we find in space within the universe.'[21] The main purport of D'Arcy Thompson's great book *On Growth and Form* is to show how the varieties of form in nature can be explained by a few physical causes.

In the same way a limited number of mathematical figures account for the symbolic significance of the forms of art. A modern physicist has recently remarked that 'Numbers and figures, as the emptiest and most primary forms of thought, are the simplest and perhaps the purest vessel into which inexpressible experiences can still be poured. To be sure, mathematical symbols are not the truth, but they exhibit as much of it as can be exhibited and hide the rest. The formal laws of art are the residues of this experience (which are) still present in the consciousness of the present age. All laws of artistic form have a core of the simplest mathematics. Let us but recall the ratios of musical harmony, the meaning of symmetry and regular sequence in all the arts, the pictorial beauty of mathematically simple figures. And it is the very secret of art that the strictest law of form which has apparently nothing to do with content permits it to express things which escape unrestricted speech.'[22]

The causes that determine the varieties of form in art are likewise few—indeed, in so far as we are concerned with composition, i.e., the disposition of forms within three-dimensional space, the physical limitations are the same in art and nature: a fact which was probably known to Greek artists of the classical period, and certainly to Renaissance artists like Leonardo and Piero della Francesca. We are reduced to the conclusion, therefore, that the forms of art, in so far as they are symmetrical, rhythmical and proportionate, have no psychological significance at all—at least, they are not determined psychically, and any psychological or symbolical or analogical significance they have for human consciousness arises in the act of choice and combination. We may, to adopt the terminology of Wölfflin, choose an open rather than a closed form; we may stand a pyramid on its base or on its apex; but always we find ourselves manipulating a few simple forms, which are the predetermined forms of visual order, of visual significance. The psychic content of art has to fit into these predetermined forms, like jelly into a mould. What remains of psychological significance, therefore, is the manipulation and variation of typical forms, and the energy displayed in their manipulation, together with such subjective attributes as colour, texture, and that visual mark of nervous sensibility known as 'facture' or 'handwriting'. All these secondary features in the work of art are in themselves also formal and can be referred to the artist's physical constitution or disposition,

and though such features may indicate the psychological type to which the artist belongs, they are of no wider significance. Collectively they constitute the talents of the artist: they do not explain genius.

The nearer we get to that central mystery of art the more obvious it becomes, as Jung has often remarked, that there is nothing personal about it. The artist is merely a medium, a channel for forces that are impersonal, and though there can be no great art without enabling instruments of sensibility and talent, it is the power and purpose with which those instruments are used that make the difference between the major work of art and those trivial but charming expressions of sentiment which are not merely minor in degree, but also essentially different in kind. The fact that the very gifts that enable major works of art to be created are often used by the same artists for minor effects, or as aesthetic exercises, should not blind us to the radical difference which nevertheless exists between the songs and lyrics of Shakespeare or Goethe, and works like *Lear* and *Faust*. The same difference may exist between a painter's sketches and his finished compositions—between a melody and a symphony. What intervenes, to convert the personal into the supra-personal, to give unity to a diversity of effects, is always in the nature of a myth; and because the word myth has associations which are historical or literary we must speak in our present context of the archetype. The archetype is thus clearly differentiated as the principle that gives significant unity to a diversity of aesthetic perceptions. In itself, as Dr Neumann has said, it may be 'bildnislos, namenlos, gestaltlos', but it takes our images and forms, the fine phenomena of our aesthetic perception, and organizes them to some unconscious purpose, gives them a supra-personal significance.

Myth and archetype must therefore be conceived as unifying forces in art, and not as projections from the artist's own unconscious—much less as constructions of his intellect. One can conceive them as magnetic forces that, to use Dr Neumann's metaphor,[23] induce a pattern into a field of scattered perceptions, impressions, intuitions, feelings: and in my opinion we must assume that the force is induced, or brought into play, by a certain ripeness or maturity in the artist. Only artists with a richness of perception and a readiness of expression realize the formal significance of a particular 'constellation' of events in the phenomenal field. The great intuitions come to minds rendered abnormally alert by constant exercise of their talents—a fact which perhaps explains the psychological similarities that exist between artists and mystics.

In comparing form to a mould into which the artist pours a certain content I have ignored the important fact that it is the artist who discovers the

form—that is to say, the artist's peculiarity is that he possess what Schiller called the *formative instinct (Formtrieb),* and there is an intimate relationship between the pregnancy of the artist's inspiration and the ability to give that inspiration its appropriate form. The form is found by instinct, ready at hand like a glove already shaped by personal use— or, as Goethe expressed it, the form evolves organically—

geprägte Form, die lebend sich entwickelt.

A failure to realize that fact has been responsible for all the lifeless academicism of the schools. Focillon, in *The Life of Forms in Art,* has expressed the same truth with admirable clarity:

> . . . the idea of the artist is form. His emotional life turns likewise to form: tenderness, nostalgia, desire, anger are in him, and so are many other impulses, more fluid, more secret, oftentimes more rich, colourful, and subtle than those of other men, but not necessarily so. He is immersed in the whole of life; he steeps himself in it. He is human, he is not a machine. Because he is a man, I grant him everything. But his special privilege is to imagine, to recollect, to think, and to feel in *forms.* This conception must be extended to its uttermost limit, and it must be extended in two directions. I do not say that form is the allegory or symbol of feeling, but, rather, its innermost activity. Form activates feeling. Let us say, if you like, that art not only clothes sensibility with a form, but that art also awakens form in sensibility. And yet no matter what position we take, it is eventually to form that we must always come. If I were to undertake . . . the establishment of a psychology for the artist, I should have to analyse formal imagination and memory, formal sensibility and intellect; I should have to define all the processes whereby the life of forms in the mind propagates a prodigious animism that, taking natural objects as the point of departure, makes them matters of imagination and memory, of sensibility and intellect—and it would then be seen that these processes are touches, accents, tones, and values. . . . Between nature and man form intervenes. The man in question, the artist, that is, forms this nature; before taking possession of it, he thinks it, sees it, and feels it as form.[24]

What Focillon means by nature is the life-process itself, the underlying dynamics of existence. The whole of our theory of art may therefore be conceived as one that allows for the spontaneous emergence of a psychic energy which, passing through the brain, gives unity to a variety of forms, which forms are in no sense nondescript or arbitrary, but are the typal forms of reality, the forms in which the

universe exists and becomes discretely comprehensible to mind. Art might therefore be described as a crystallization of instincts—as the unifying of all feelings and desires; as a marriage of Heaven and Hell, which was Blake's profound intuition of the process. That psychic Energy which is given form by the archetype, Blake defined as Eternal Delight.

It is a process of crystallization which takes place through the senses; we never celebrate the marriage of Heaven and Hell unless we celebrate it in the flesh, in 'Schaudern', in ecstasy, in a piercing vibration of the nerves, in the 'felix transitus' of consummation. In the next essay, I shall try to come a little nearer to the reality of the process in the analysis of certain specific works of art.

II

We must now try to demonstrate our theory in the evolution of art itself, more particularly in the development of typical artists. I shall confine myself mainly to contemporary art, not only because it is the phase of art best known to me, but also because it offers some opportunity of confirming our theories by the cross-examination of the artists themselves.

But there is another and more important reason for confining ourselves to modern art. Excluding the past fifty years, there has prevailed for centuries a conception of art which identified *reality* with *appearance,* and the whole energy of the artist was devoted to the task of giving the reality of his feelings the illusory mask of appearances. This disparity was already obvious to Schiller, and *Letters on Aesthetic Education* are devoted to an examination of the paradox. Schiller pointed out that although a devotion to semblance (Schein) is required of man for the purposes of social intercourse and the mastery of the objective world, when this need is stilled, an inner freedom develops its limitless possibilities, and we become aware of an energy which is independent of outer things. Then we see that a distinction exists between the reality of things and the semblance of things, and that the latter is the work of man. Feeling, Schiller then notes, that feeds on appearances, no longer takes delight in what it experiences, but on what it does; it evades reality and plays with form, with independent energy and freedom of the heart. In Schiller's view the separation of form from essence, of reality from appearance, was wholly to the good because it left reality at the mercy of the understanding; it left art in ideal freedom, and gave to man the possibility of enjoying pure beauty. The modern artist cannot accept this divorce from reality; rather, he insists on leaving appearance to the philosopher, or the psychologist,

or the photographer, and on being himself the exponent of the inner reality. He has forever finished with an idealism that is based on illusion, and would now master the essence of reality. This means, in our terminology, that he has taken on the job of mastering the unconscious—or, if that seems too ambitious a project, at any rate he will attempt to find some degree of correspondence between the concrete symbols of his art and the subjective reality of his imagination.

I will not stop to discuss whether modern art is unique in this respect—I suspect not, but an investigation of the subject would require a discussion of the precise relation between symbol and sign at different stages of human evolution—for example, for prehistoric man was the bison a symbolic image, as Dr Neumann assumes (he called it 'ein geistig-psychisches Symbolbild'), or was it an eidetic image, a *Scheinbild*, with purely utilitarian connotations?—an open question. But when a modern artist like Picasso paints a bull, there is no longer any question: he is using this animal as a symbol, and as a symbol whose significance can be determined.

Whatever the theoretical justification for the use of such symbols, their predominance in the history of art is inescapable, and Picasso is merely reverting, in this respect, to a predilection which was evident enough in Mycenaean and Minoan art, and is recurrent in the plastic arts, in myth and poetry, throughout the history of western civilization. The bull as a symbol, and the equally archaic symbol of the horse, were embodied in the ritual of the *tauromachia* or bull-fight, a pagan ritual that has maintained, in the hearts of the Spanish people, a hold as strong as the Christian ritual. The art of Picasso, in the course of his development, builds up to the most complete revelation of the unconscious sources and symbolic significance of this same rite. I am referring to his painting called 'Guernica', regarded by some cirtics of art as Picasso's greatest achievement: it is certainly, in scale and execution, his most monumental work.

Let me recall the origins of this painting. On 28th April 1937 the world was shocked to hear that the Basque town of Guernica had been destroyed by bombs dropped by German aeroplanes in the service of General Franco. Picasso began to paint his picture two days later, on 1st May, and worked on it with maniacal intensity until it was finished some weeks later. During the course of the work he declared: 'In the panel on which I am working which I shall call Guernica, and in all my recent works of art, I clearly express my abhorrence of the military caste which has sunk Spain in an ocean of pain and death.'

The motive of the painting is therefore not in doubt. How is that abhorrence expressed?

By symbols—by the traditional symbols of the bull and the horse, with a number of minor symbols in association with them. Before commenting on the use of these symbols in *Guernica*, let us note that two years before the town of Guernica was bombed, before there was any question of expressing abhorrence for a particular deed, Picasso had used virtually all the same symbols in a large etching which he called 'Minotauromachy'.

There is a significant omission in the later picture—the figure of the bearded man who, in 'Minotauromachy', is climbing up a ladder on the left edge of the picture, as if to escape from the scene. It is the archetypal image of the wise man—'the saviour or redeemer' who, as Jung says, 'lies buried and dormant in man's unconscious since the dawn of culture', and who is 'awakened whenever the times are out of joint and a human society committed to a serious error.'[25]

The scene that the Wise Man abandons shows the Minotaur advancing with uplifted arms towards a child who, with a light uplifted in one hand and a bunch of flowers in the other, surveys a horse uprearing, under the threat of the Minotaur, with a woman, apparently dead, stretched on its back. From an opening in the tower-like building in the background, which may be intended as the labyrinth of the Minotaur, two figures in loving embrace, and associated with doves, look down on the scene.

It is a picture so rich in symbolic significance, that one is almost persuaded that Picasso has at some time made a study of Jung and Kerenyi! In addition to the figure of the Wise Man, already mentioned, we have the Minotaur, representing the dark powers of the labyrinthine unconscious; the sacrificial horse, bearing on its back the overpowered libido; and confronting them the divine child, the culture bearer, the bringer of light, the child-hero who fearlessly confronts the powers of darkness, the bearer of higher consciousness.[26] How easily a Jungian interpretation can be given to this picture may be judged from the following passage from Jung's contribution to an *Introduction to a Science of Mythology*:

'It is a striking paradox in all child-myths that the "child" is on the one hand delivered helpless into the power of terrible enemies and in continual danger of extinction, while on the other he possesses powers far exceeding those of ordinary humanity. This is closely related to the psychological fact that though the child may be "insignificant", unknown, "a mere child", he is also divine. From the point of view of the conscious mind we seem to be dealing with an insignificant content that is gifted with no liberating let alone

redeeming character. The conscious mind is caught in its conflict-situation, and the combatant forces seem so overwhelming that the "child", emerging in isolation, appears not to be proportionate to the conscious factors. It is therefore easily overlooked and falls back into the unconscious. At least, this is what we should have to fear if things turned out according to our conscious expectations. Myth, however, emphasizes that it is not so, but that the "child" is endowed with exceeding powers, and despite all dangers, will unexpectedly pull through. The "child" is born out of the womb of the unconscious, begotten out of the depths of human nature, or rather out of living Nature herself. It is a personification of vital forces quite outside the limited range of our conscious mind; of possible ways and means of which our one-sided conscious mind knows nothing; a wholeness which embraces the very depths of Nature. It represents the strongest, the most ineluctable urge in every being, namely the urge to realize itself.'[27]

The 'Minotauromachy' may therefore be regarded as Picasso's affirmation of the grandeur and invincibility of the 'child', a child holding the light of revelation and not at all terrified by the powers of darkness confronting it. An obvious allegory, it might be said, of not great interest because it 'nowhere oversteps the bounds of conscious comprehension',[28] but then this dominant theme by no means exhausts the symbolical significance of the picture. If the dead or unconscious woman represents the libido, why does she carry a sword in her right hand? And what is the significance of the maidens and doves who lovingly look down on the strange scene? All these symbols, no doubt, would yield to rationalistic explanation, but I must be forgiven if I do not dwell on them because what matters, in my present context, is not the interpretation of meaning, but the fact that the artist has employed universal symbols of this kind.[29] Before making any general comment of this process of symbolization I would like to return to 'Guernica'.

We are lucky to possess photographs which show the evolution of this painting in Picasso's studio[30]—not only the various stages in the composition of the canvas itself, but also a considerable number of preliminary sketches of details. This preliminary material shows that the constituent symbols of the painting—the bull, the horse, the woman with a dead child, the light-bearer, the figure representing the sacrificed republic—were present in Picasso's mind from the beginning as discrete phenomena. He began with these symbols—the bull, the horse and the woman bearing a light. In some of the composition studies, pencil sketches on gesso made on 1st

and 2nd May 1937, a Pegasus is introduced, at first perching on the bull's back, but next day emerging from a wound in the horse's flank. But this symbol was quickly discarded, and others were introduced, notably the one of the victim, at first the traditional republican figure with helm and spear. These traditional accessories are gradually discarded, and in general there is a tendency to get away from literary or historical associations and to let the symbols tell by their inner expressive power. The artist is seen, in these preliminary sketches, exploring the expressive tensions of distortion and exaggeration, until he has substituted his own symbols of power, sacrifice, terror, death and resurrection.

As in the 'Minotauromachy', the horse is the sacrificial animal of the Upanishads, where it signifies a renunciation of the universe. 'When the horse is sacrificed,' comments Jung, 'then the world is sacrificed and destroyed, as it were.... The horse signifies the libido, which has passed into the world. We previously saw that the "mother libido" must be sacrificed in order to produce the world; here the world is destroyed by the repeated sacrifice of the same libido, which once belonged to the mother. The horse can, therefore, be substituted as a symbol for this libido, because, as we saw, it had minifold connections with the mother. The sacrifice of the horse can only produce another state of introversion, which is similar to that before the creation of the world.[31]

This is only a casual comparison, but Picasso's use of these symbols is unerringly orthodox, and the question is whether he is orthodox because he is learned in the history of symbolism, or because he allows his symbols to emerge freely from his unconscious. They not only emerge as orthodox symbols, but in significant association: the sacrificial horse with the figure representing the sacrificed republic, the bull with the horse, the light-bearer with the bull, minor symbols like the flower that grows by the side of the broken sword, and the dove of peace that flies above the carnage.

The question could only be settled by a direct approach to the artist, and this I feel too diffident to make—it would be to invite a confession that in the estimation of psychologists would be damaging to the dynamic force of the work of art. It is generally known, however, that Picasso is not a naïve artist: he is a man of culture, who read voraciously. It is not inconceivable, therefore, that the traditional symbols he uses are used with deliberate intention. Such symbols are activated by surface emotions, and not by the unconscious. But as Jung has said,[32] 'a symbol loses its magical power . . . as soon as its dissolubility is recognized. An effective symbol, therefore, must have a nature that is unimpeachable . . . its form must be sufficiently remote from compre-

hension as to frustrate every attempt of the critical intellect to give any satisfactory account of it; and, finally, its aesthetic appearance must have such a convincing appeal that no sort of argument can be raised against it on that score.'

In the past I have praised 'Guernica' as a work of art, and even now I am not going to suggest that it can be dismissed as a work of art merely because its symbols are traditional—that criterion would exclude the best part of all the visual arts ever created by man. But I would maintain that there is a stage in the evolution of symbolism at which the symbols become clichés, and clichés can never be used in a work of art. A dead or exhausted symbol is just as much a cliché as a stale epithet or a hackneyed metaphor. The situation obviously is not improved by beginning with the clichés and then deliberately disguising them. Artistic creation, to the same degree and in the same manner as effective symbolism, implies spontaneity: the artistically valid symbols are those which rise, fully armed by the libido, from the depths of the unconscious.

What redeems this picture, to a degree I would not now venture to determine, is what saves any painting of the past that makes a conscious use of traditional symbolism—any painting making use of the symbols of the Christian faith, or a painting by Poussin making use of the symbols of classical mythology: I mean the fact that every line, every form, every colour, is dominated by the aesthetic sensibility of the artist. What the symbols import into this aesthetic organization is a certain element of collective or traditional significance. A painting of the Madonna may be merely the direct portrait, full of sensuous charm, of a contemporary woman; aesthetically it is never anything else, but the fact that the woman represents the Mother of God imparts into the aesthetic experience a feeling of devotion which is actually a trance-like opening-up of the way to the unconscious, and the woman the artist painted then becomes, not only immediately the Mother of God, but more remotely the representative of still deeper complexes. One way of putting it (it is Jung's way) is that 'humanity came to its gods through accepting the reality of the symbol'; but equally one might say that it was only possible to accept the reality of the symbol because the artist had succeeded in giving it *living form*.

The complex but deliberate symbolism of works like 'Minotauromachy' and 'Guernica' has simplified our task, which is to show the interrelations between the forms of art and the energies of the psyche. I have admitted that to the extent the symbols used by Picasso in these two pictures are deliberate and allegorical, to that extent we may suspect that they have been fished from waters that are relatively shallow; but 'Minotauromachy' and 'Guernica'

occupy a small place in the copious repertory of images created by Picasso throughout his career, most of which resist any attempt at rationalistic explanation. Other images are vital, and their vitality comes, not from any identity with the outward world of visual appearances, but from a fidelity to an inner world where vision is archetypal.

I would like now to turn to the work of another contemporary artist, and one well known to me personally for many years, the sculptor Henry Moore. By comparison with Picasso his work presents a certain unity and consistency of development, together with a drastic limitation of theme. Apart from a few abstract works, in themselves nearly always suggested by natural forms, the work of this sculptor consists almost entirely of representations of the female figure, representations that depart considerably from the phenomenal appearances of that object.

A preference for the human form as a motif for sculpture is characteristic of the art from its prehistoric origins, and although there have been periods, in Greece in the fifth century and in Renaissance Italy, when an integrated humanism found expressions indifferently in the form of either sex, in general the male sculptor has devoted his talent to the female form. We do not know whether the first prehistoric carvings of female figures, evidently fertility charms, were the work of men or women; but it is not important, for surely it does not need any profound theory to account for a male preoccupation with the female form. Apart from normal sexuality, it is quite usual for a man to have a mother-fixation, and there is evidence to suggest that an unusual proportion of artists, poets as well as plastic artists, have this psychic bias. But such psychological tendencies merely explain a preference for a particular subject-matter: the aesthetic interest only begins with the transformation which the mother-symbol undergoes in the process of artistic creation.

In the case of Henry Moore, we can simplify our analysis by confining ourselves to a single pose—the reclining figure. His treatment of this theme begins about 1930 in a tradiitonal manner, though it is the tradition of Mayan (Mexican) sculpture rather than of classical Renaissance sculpture. Moore then felt the need to expel all traditional concepts from his psyche, and to proceed to a complete disintegration of the human form (43*a*: 1934)[33] and then to an abstract reconstruction (51: 1937). From this geometrical basis, he reanimates the form, gives it recognizably organic shape; and then follows a whole series, continuing to the present day, in which the basic elements of the female figure are the theme for an almost countless series of variations, in various materials. These variations can be studied in greater detail in the numerous sketches in which the sculp-

ture makes a preliminary exploration of his form (139, *a, b*; 150*a*; 237).

It would be possible to interpret this development in a purely formal sense. Here is a mass of stone or wood, isolated in space, in dialectical opposition to the space which is its environment, forms weaving and undulating with a life of their own. The aesthetic experience begins with an empathetic response to such a closed world of form—we enter it and fill it and are moved round within it, with sensational reactions which we do not stop to analyse, but which are harmonic and pleasant. But the sculptor himself has told us that 'the humanist organic element will always be for me of fundamental importance in sculpture, giving sculpture its vitality. Each particular carving I make takes on in my mind a human, or occasionally animal, character and personality, and this personality controls its design and formal qualities, and makes me satisfied or dissatisfied with the work as it develops'.[34]

His design, Moore tells us in this passage, is not an intellectual invention: it is not even a direct intuition of form—it is dictated by an inner life, a personality, a daemon, which has entered the block of stone or wood, and imperiously demands a living form.

Moore is here confessing that the creation of a work of art is a genuine, primordial experience—that it is 'the expression of something existent in its own right, but imperfectly known', to repeat Jung's phrase.[35] Moore does not claim to have invented the life of his artistic forms—on the contrary, he asserts that the work of art takes on its own personality, and that this personality controls the design and formal qualities. In other words, Moore confirms Jung's view that 'personal causality has as much and as little to do with the work of art, as the soil with the plant that springs from it. . . . The personal orientation that is demanded by the problem of personal causality is out of place in the presence of the work of art, just because the work of art is not a human being, but essentially supra-personal.'[36]

Jung's further perception, in this essay on 'Poetic Art', that 'the work of art is not merely transmitted or derived—it is a creative reorganization of those very determinants to which a causalistic psychology must always reduce it'; that it is like a plant which is 'not a mere product of the soil; but a living creative process centred in itself, the essence of which has nothing to do with the character of the soil'; that, in short, the work of art 'must be regarded a creative formation, freely making use of every precondition'[37]—all this is fully and precisely illustrated in Moore's sculpture, and confirmed in his personal statements. The work 'has a power over him that he is quite unable to command',[38] and to watch Moore work is to confirm Jung's description

of the poet as one 'who is not identical with the process of creative formation'; who is 'himself conscious of the fact that he stands as it were underneath his work, or at all events beside it, as though he were another person who had fallen within the magic circle of an alien will'.[39]

That being so, it is still permissible to speculate on the significance of the forms proliferated by this dynamic force, using the artist as its channel. In Picasso's two pictures the symbolic figures stand outside the labyrinth itself; and this labyrinth is the archetypal womb, the hollow earth from which all life has emerged.

I might mention, in passing, and without attaching any particular significance to the fact, that Moore's early childhood was dominated by an actual labyrinth, that of the coal-mine. Moore's father was a miner, descending daily into the earth to bring to the surface the substance of fire, which was also the substance of the family's livelihood. It was an enterprise involving danger, and anxiety in the mind of the beloved mother. There are possibilities here of an unconscious association of the labyrinth and the womb.[40] During the war Moore himself descended into the labyrinth, the 'Underground' of the Tube stations, used as bomb shelters, and made a series of drawings which, apart from their immediate interest as records of war, re-emphasize his obsession with the labyrinth. In some of his drawings the figures are seen standing outside a cave or labyrinth, and in many others the figures seem to be embedded in rock.

Moore's reclining figures are not substantial solids, as are the sculptures of the classical tradition, but arched and winding caverns. The female body, its superficial protuberances reduced to insignificance, becomes an exposed womb, an excavated mine, and where one might expect emptiness, there is life—the life of shapes and forms which by their convolutions and transformation of masses and volumes, have created an artistic form. We might say that there is a foetus in this womb, but it is the space of the womb itself, the form defined by its rhythmic outlines. In some of his later figures Moore has actually filled these caverns with separate, foetus-like forms, but they were not necessary to express the significance of his symbols.

The Mayan reclining figure which was the point of departure for Moore's series of reclining figures was a god of fertility, Chac Mool, whose particular function was to ensure an adequate rainfall. Round the head are bands of threaded grain, and across the breast an ornament in the form of a butterfly, emblem of regeneration. The hands meet above the womb or belly, and form a hollow depression, basin-like, destined to contain the human hearts demanded as a sacrifice by this cruel deity.

Such symbolism, elaborated no doubt by priests, in the service of a cult, is precise and interpretable. Moore's symbolism is completely unconscious, and is not dictated by any priesthood, or dedicated to any ritual. Nevertheless, it is not entirely unconnected with the same archetypal pattern as the Chac Mool of Mayan religion. Moore assures me that when he first became familiar with the Mexican reclining figure, he had no knowledge of its ritualistic or archetypal significance—to him it was just a piece of sculpture which attracted him by its formal qualities as a work of art. If we interpret Moore's figures as archetypal images of creation, we are then free to relate them to the same archetypal pattern that prevailed in Yucatan more than 3,000 years ago, not as conscious formal imitations, but as identical expressions of the same archetype. The Mayan sculptor proceeded from image to form—his symbols were pre-determined by his cult. The modern sculptor proceeds from form to image—he discovers (or we discover for him) the significance of his forms *after* he has created them. What we must admire, in the modern artist, is the confidence with which he accepts as a gift from the unconscious, forms of whose significance he is not, at the creative moment, precisely aware.

He has that confidence—and this is really the main consideration—because he knows instinctively that there is an intimate connection between the vitality of art and the deeper significance of form. Form is not merely a play with abstractions, a communication of pleasure by the skilful manipulation of proportions and intervals and other geometrical elements. In that way our nerves, our sensibility, may be stimulated—the tone of our physical existence may be enhanced. But it has always been obvious that there was more in artistic creation than could be accounted for by such a direct chain of causality. The forms of art must refer to something hidden, to something not contained in the circuit of nervous reflexes. The aestheticians of former ages—with a few exceptions like Schiller and Fiedler—have been satisfied with an idealistic explanation: art was significant, not in itself, but because it embodied transcendental *ideas*. That fallacy, which even on a basis of the art of the past, should never have been entertained, has forever been exploded by the creative achievements of modern art, achievements which are neither conceptual nor—in the metaphysical sense—transcendental, but which are nevertheless superreal. Modern art—art such as Picasso's and Moore's—is significant but not significant of any expressible ideas. It gives concrete existence to what is numinous, what is beyond the limits of rational discourse: it brings the dynamics of subjective experience to a point of rest in the concrete object. But it only does this in virtue of a certain imaginative play—*eine psychische Spielerei*. The forms of art are only significant in so far as they are archetypal, and in that sense predetermined; and only vital in so far as they are *trans*formed by the sensibility of the artist and in that sense free. The artist releases these dynamic energies within his own psyche, and his peculiarity, his *virtue,* is that he can direct such forces into matter: can 'realize' them as forms of stone or metal, dimensions of space, measured intervals of time. In this sense the artist has become the alchemist, transmuting the *materia prima* of the unconscious into those 'wondrous stones', the crystal forms of art.

Notes

1. Verlag Ernst Wasmuth, 2nd edition, 1929.

2. Cf. Max Ernst, *Histoire Naturelle* (Paris: Jeanne Bucher, 1926).

3. André Masson, *Anatomy of My Universe,* (New York: Curt Valentin, 1943).

4. Goethes Gespräche, J. D. Falk, June 14, 1809.

5. 'Kunst und Zeit', *Eranos Jahrbuch 1951.* Band XX. 'Mensch und Zeit', Zürich, 1952.

6. "On the Relation of Analytical Psychology to Poetic Art," *Contributions to Analytical Psychology,* 1922, London, 1928, pp. 233–34.

7. Op. cit., p. 238.

8. *Contributions to Analytical Psychology,* London, Kegan Paul, 1928, pp. 118ff.

9. Ibid., p.246.

10. Ibid., p. 281.

11. R. M. Ogden, *Psychology and Education* (New York, 1926), p. 133.

12. Cf. "Problems in the Psychology of Art," *Art: A Bryn Mawr Symposium,* Bryn Mawr, 1940.

13. *Philosophy in a New Key* (Harvard University Press, 1942), p. 89.

14. *Philosophy in a New Key,* pp. 89–90.

15. Cf. Wolfgang Köhler, *Gestalt Psychology,* 1929, p. 208.

16. Cf. Charles Morris, *Signs, Language and Behaviour* (New York: Prentice-Hall, 1946), pp. 23–27 and page 35 above.

17. Cf. *Psychological Types* (London: Kegan Paul, 1938), p. 291.

18. For a general discussion of the subject see the symposium edited by L. L. Whyte, *Aspects of Form*, (London, 1951).

19. *Eranos Jahrbuch 1951*, Band XXI, 'Mensch und Zeit', pp. 253–70: 'Time and the Mind-Body Problem. A changed scientific Conception of Process.'

20. D'Arcy W. Thompson, *On Growth and Form*, 1942, pp. 693–94.

21. Wind, Edgar, "Mathematics and Sensibility," *The Listener*, 47, 1952, p. 705. Cf. the 'Notice' by Albert Rivaud to his translation of the Timaeus, Budé edition, Paris 1925; also F. M. Cornford, *Plato's Cosmology: The Timaeus of Plato* (London, 1937).

22. von Weizsäcker, C. F., *The World View of Physics*, trans. Marjorie Grene (London, Routledge and Kegan Paul, 1952), p. 151.

23. *Eranos Jahrbuch*, 22, 1953.

24. Focillon, Henri, *The Life of Forms in Art*, 2nd edition, trans. by Hogan and Kubler (New York: Wittenborn, Schultz, 1948), p. 47.

25. *Modern Man in Search of a Soul* (London, Kegan Paul, 1936), p. 197.

26. These are Jung's epithets for the divine child. Cf. *Introduction to a Science of Mythology*, C. G. Jung and C. Kerenyi (London, Routledge and Kegan Paul, 1951), p. 122.

27. Op. cit., pp. 123–24.

28. Op. cit., p. 127.

29. In a drawing made two years later, entitled 'The End of a Monster', Picasso shows a sea goddess emerging from the sea to hold up a mirror to the Minotaur, who lies on the beach transfixed by an arrow.

30. They are reproduced in *Guernica*, a volume of illustrations accompanied by a text by Juan Larrea, published by Curt Valentin, New York, 1947.

31. *Psych. of the Unconscious*, pp. 466–67.

32. *Psychological Types*, p. 291.

33. I give references to the illustrations in *Henry Moore: Sculptures and Drawings*, 2nd edition, (London, Lund Humphries, 1949). The reader should also refer to Erich Neumann's recent work, *The Archetypal World of Henry Moore* (New York and London, 1959), where the concepts of analytical psychology are applied to Moore's work in a very comprehensive and illuminating manner.

34. Op. cit., xl, ii.

35. *Modern Man*, pp. 186–87.

36. *Contributions to Analytical Psychology*, p. 233.

37. Ibid., p. 234.

38. Ibid., p. 235.

39. Ibid., p. 236.

40. Neumann (op. cit., p. 65) suggests that in these drawings 'the decisive phenomenon is that, in spite of the mining world of the father in which he grew up, the archetypal cave world of the mother nevertheless managed to assert itself to such effect'. I do not agree that Moore's mining pictures are 'weak', but it is perhaps significant that he himself does not like them.

17

Psychology and Art Today
A Summary and Critique

DOUGLAS N. MORGAN

I

For some 75 years, investigations into the psychology of art have been developing under that name, and for some 2300 years before that time some somewhat similar work was being done under the name of philosophy. I offer here no pseudo-comprehensive synopsis of this vast, rich range of material, but merely a brief summary and methodological criticism of some of the work being done today within the field.[1] After a quick glance at certain psychological insights no longer being avidly pursued,[2] I shall try to classify in three broad groups the work being done now, offering examples of each approach in its application to various works of various arts. In the second part of this chapter, I shall venture certain comments and criticisms—some new and some old—on ways and means by which, perhaps, somewhat more ground may be gained in our understanding of the psychology of the arts.

Following Fechner, who published his *Vorschule der Aesthetik* in 1876, and thereby founded experimental aesthetics, three major directions developed around three central and fertile ideas. The first of these, called "empathy," had grown from Aristotle[3] through Robert Vischer[4] to Lipps[5] and Lee.[6] Its central idea was an interpretaion of the appreciative act in art as a kind of identification: a feeling-into or personification of the object by the spectator. The second central idea gave rise to a theory which stresses certain similarities found between the phenomenon of play and the act of creating or appreciating works of art. It descended from Schiller[7]

through Herbert Spencer[8] to Karl Groos[9] and Konrad Lange.[10] The third of these ideas emerges from a concept of an aesthetically necessary "psychical distance" between spectator and aesthetic object, and finds its fullest statement in the work of Edward Bullough.[11] All three of these ideas: empathy, play, and psychical distance, have materially conditioned our present interpretations of art, but none of them seems to be receiving active attention from a significant number of psychologists now at work, at least in this country and in this language. The ideas appear to have performed their service and been set aside, at least for the time being; they are not in the main stream of the three approaches now being vigorously explored, especially in America, England, and Italy. I am labeling these approaches respectively *psychoanalytic, Gestalt,* and *experimental,* for want of better terms. I now propose to characterize each of these approaches independently, in terms of what we may call its "core idea," to state its specifically aesthetic questions, and to offer examples of its research.[12]

II

No extended or properly qualified epitomization of the core idea of psychoanalysis will be necessary or desirable before this audience; besides, I do not see that a philosopher need rush in where psychologists themselves fear to tread. In broad terms, let it simply

From *The Journal of Aesthetics and Art Criticism,* 9 (1950), 81–96. Reprinted with permission of *The Journal of Aesthetics and Art Criticism.*

be said that the psychoanalytic approach germinates out the fundamental notion that man's behavior can be explained in terms of the working out of a complex of conscious and unconscious personality needs and drives, at least some of which are erotic, and all of which strive toward and often find symbolic expression, as in dreams and in the fine arts.

The most characteristic aesthetic question asked by the psychoanalysts is an inquiry into the personality factors which condition the creation and/or appreciation of works of art. It has developed from the "divine frenzy" of Plato's poet[13] who creates because of an irrational love-force; through the idea-dream-reality identification of Schopenhauer,[14] and the "Dionysiac" voluntarism of Nietzsche;[15] to the comprehensive contributions of Freud and his followers.[16] Today Edmund Bergler[17] has challenged the conventional psychoanalytic theory that the artist expresses through his work his unconscious wishes and fantasies in sublimated, symbolic form; Bergler urges instead that the artist is unconsciously *defending himself against* his own unconscious wishes and fantasies.

The general-theoretical development of this core-idea may be exemplifed in the work of Charles Baudouin[18] and of Harry B. Lee.[19] Baudouin stresses psychoanalytic factors in appreciation, offering an extended example in the analysis of the poetry of Verhaeren; Lee attempts, within a psychoanalytic framework, to describe factors leading up to artistic creation and explaining differential aesthetic responses. He makes frequent and interesting references to his own clinical experience.

Far more work is being done in the direction of detailed, applied interpretations of particular works of art. The attempt seems to be to read the work, in whatever field, symbolically, and to correlate these readings with whatever biographical data may be available, to the end that we understand more fully the personality of the creating artist, and that through this understanding light may be thrown upon the "mystery" of creation in the arts.

In literature, an enormous amount of analysis is being done; we take only a few, fairly random samples as typical. Hamlet has been a favorite subject for psychoanalysis;[20] King Lear was a narcissist;[21] Baudelaire and Poe are said to displace the death-bringing attributes of their fathers onto their mothers, as a result of infantile menstruation traumas.[22] The body images in the limericks of Edward Lear have been used as psychoanalytic data.[23] Charles Kingsley, author of *The Water Babies,* appears to have suffered from a respiratory neurosis, stammering asthma.[24] Lewis Carroll is said[25] to be the romantic, erotic, wish-fulfilling, schizic *alter ego* of the dignified mathematics professor Charles Dodgson. His heroine Alice is a phallus, and her adventures in

Wonderland represent a trip back into the mother's womb.[26]

In music too this fertile idea has been generously applied. Perotti[27] has exhumed Schopenhauer, suggesting that the mysteries of music may be explained in terms of the unconscious. The language of music is held to be a universal language in that the language of the unconscious is equally universal. Max Graf[28] has set boldly about the historical explanation of composition in terms of erotic powers and other impeti to creation; his ultimate conclusion is, unfortunately, somewhat mystical.

Freud himself presents the most extended analysis in painting, in his admittedly speculative but stimulating—*Leonardo da Vinci.* Leonardo's childhood phoenix dream, the loss of his father and consequent intimacy with his mother, the details of his account book and manners with his assistants in the studio: all these and more are brought to bear upon the perennial question of why the Mona Lisa smiles. More recently, an Italian student[29] has done some interesting work in interpreting contemporary painting. He suggests, for example, that surrealism exhibits on a social plane what had hitherto been observed only clinically: a general tendency of the libido to regress from adult genitality to a pregenital phase of undifferentiated cell-activity; there is a consequent increase in forgetting and liberation of aggression tendencies. While psychoanalysts seek to *integrate* the self, surrealists seek its *disintegration.* Whether this hypothesis will prove ultimately satisfactory, I cannot say; but at least it seems to me more enlightening than the mountains of incoherent words which the surrealists themselves have had to utter in their own defense. Wight[30] interprets some of Goya's etchings. Bergler[31] suggests a highly stimulating psychoanalytic interpretation of one of Millais' paintings, in terms of the painter's loving sympathy for the frustrated wife of impotent John Ruskin, and argues for his interpretation in terms of material external evidence.

Even sculpture is coming within the purview of the psychoanalysts. If I may, however, I should like to defer my example for a few moments, when we shall be able to compare the psychoanalytic with the *Gestalt* interpretations of a given series of works.

I I I

The hesitancy expressed earlier about the "core idea" of psychoanalysis hold also in connection with the Gestalt approach. Suppose that we characterize it, quite simply, as the belief that perception (and perhaps other psychological phenomena as well) can be explained in terms of neural factors tending to produce organized, though dynamically changing patterns or segregated groups of units, or

"wholes." The application of these "functional concepts" to aesthetics follows quite clearly. Thinkers in this tradition ask, "What perceptual organizing factors condition the experience of seeing or hearing a work of art?"

We think, of course, of the work of Wertheimer,[32] Köhler,[33] and Koffka[34] in their general elaboration of the Gestalt thesis. The most recent full-scale development in aesthetics seems to be Schaefer-Simmern's study of art education.[35] Gestalt studies of aesthetic perception[36] also appear from time to time.

As has been the case with psychoanalysis, we find here also some extended attempts to apply the psychological categories to particular works of art, and to our experiences of them. Stephen Pepper[37] has given us many interesting working examples of figure-ground, positive-negative space relationships, and of the operation of sensory fusion, closure and sequence principles in actual paintings and works of sculpture. Hans Ruin[38] discusses the works of Monet, Cézanne, Gauguin, Munch, van Gogh and Matisse, suggesting that painters have, in their treatments of color, figure and structure, often anticipated theoretical Gestalt psychologists.

In music, Reymes-King[39] is studying the perceptual relationships of verbal and tonal stimuli and they are simultaneously presented in song. He asks whether any phenomenon analogous to sensory fusion may be bound when stimuli come through different sense organs. Tentatively, he suggests that this is doubtful, but that a distinction among levels of perception may help to explain the differences between our responses to instrumental music and to song.

Even the movies are being studied by the Gestaltists. Rudolf Arnheim[40] examines the relationships between visual and auditory stimuli and the act of perception, suggesting that one weakness in some sound movies (and, by extension, presumably also in television) may be a perceptual competition, and hence distraction, division, and loss of attention.

In summary of the discussion thus far, I should like to present two interpretations of what is essentially the same subject matter: the sculpture of Henry Moore. I choose first the recent analysis of a psychoanalytical critic, Frederick Wight.[41] For brevity I paraphrase.

Moore's figures have no soft parts or textures; he eviscerates his figures, eliminating hollow parts of the body, leaving only the bony structure. His father was a miner. Moore mines into the hollow of the breast, which is the feeding ground of the child. Subconsciously an infant cannibal, he eats away the flesh, feels himself inside his mother in image, regressing to the womb. But this is only the least profound of his subconscious interests. More subtly, he builds his sculpture for eternity. His drawings

and his writings exemplify this need to transcend death. Everything temporal, soft, is wasted away. Nearly all figures are female. Is not the mine the grave? And is Moore not consigning his father to the mine forever, feeling his way *permanently* inside his mother? But death, as Moore presents it, is not revolting; it is almost dignified, after the British manner. The British national church is floored with graves; it is built on the serene acceptance of the dead underfoot; "for the Englishman the easy unrepugnant moldering of the dead exhales a rich philosophic savor." Not a Christian, Moore wants quite simply a particular image, a material and perhaps a national image, to survive.

We now turn to a Gestalt interpretation of the same material, selecting that of Arnheim,[42] and again paraphrasing. The problem of composing the human form has plagued sculptors for centuries; the solid trunk contrasts with the flying appendages. Moore transforms the trunk into a series of ribbons, and thus finds a common denominator for the whole. Plastic forms are dynamic: conic, pyramidal, ovoidal, rather than static cubes and cylinders. Brain-carrying heads are diminished in size; faces are placid; physical-subrational abdomens are emphasized in the characteristic reclining position. The holes, as perceived, are not merely dead and empty intervals but peculiarly substantial, as though they were filled out with denser air, puddles of semi-solid air hollowed out, scooped out by mostly concave surfaces. Principles of three-dimensional figure-ground relationships (concavity making for ground, convexity for figure; enclosed areas tending to be figure, enclosing areas tending to be ground, etc.) apply here also. Instead of pushing shapes out into space, Moore invites space inside his figures, adds to their substance with space. The resulting deliberate figure-ground ambivalence results in a dynamic interplay between two figures in the same work, a lessening of importance of sharp boundaries, and a strong feeling for movement within the work.

Now it is apparent that these two criticisms do not contradict each other; they ask different questions about the aesthetic object, and arrive at different answers. I find both suggestive and interesting, and feel that they may well contribute side by side to our understanding of Moore's work, and of our responses to it.

I V

Finally, we come to our third principal approach to the problems of psychology of art: the approach which is usually labelled "experimental." An apology for the term is in order, since Gestaltists certainly also perform experiments. What I mean to

indicate is the group of investigators sometimes loosely known as "behaviorists." Because I do not wish to limit the discussion to literal Watsonians, if there are any still around, or to "physicalists," I shall define this group as comprising those who distrust as "unscientific" or "merely philosophical" any investigations (including most of those already discussed) which make inferences on any basis other than precise mathematical measurements of behavior, and which make predictions to any other conclusions that those measurable in such precise terms.[43] The most recent experimental attempts at any kind of comprehensiveness in aesthetics seem to be those of Norman C. Meier,[44] who has outlined an elementary general interpretation of aesthetics and suggested an "interlinkage" theory of artistic creation, and of Albert Chandler.[45] The specific applications of experimentalism to aesthetics are too various to classify under one simple heading; let us rather discover the directions of work from particular examples, which I have very roughly classified as aptitude tests, physiological correlations (Wundt's "expression" category), and preference tests (Wundt's "impression"). A few investigations do not fit conveniently under any of these headings, and must be reserved for brief notation later.[46] Our examples, again, are fairly random samples from the vast contemporary literature, and represent only a fraction of the work being done. They are intended as typical, rather than as definitive.

Aptitude testing is fairly well advanced in music and in painting. The famous Seashore tests of pitch and tonal memory are, I understand, in use in schools today. The Tilson-Gretsch test, and others, have since been developed to measure tonal, harmonic and rhythmic discrimination. In painting and the plastic arts we have the McAdory Art Test, the Meier Art Judgment Test, the Knauber Test of Art Ability, and the Lewerenz tests in fundamental abilities of the visual arts. Color discrimination tests, line-drawing aptitude tests, and the like, have multiplied profusely. Perhaps the most difficult theoretical question in this field is whether the testers are testing aptitude or achievement: it is sometimes not easy to distinguish the two on experimental grounds. In either case, the practical value of the work is apparent; if we develop tests to the point where we can examine a youngster young enough, and decide what his prospects for a musical career might be, we ought to be able to make significant recommendations about his education, at least in a negative direction. Theoretical advantages of this work are perhaps not so immediately apparent.

Physiological testing is being done, primarily on subjects exposed to works of art, mainly works of music. Dreher[47] has observed that 33 college students trained in music sweat more when listening to certain pieces of piano music than do 33 students who are not so trained. There is some experimental correlation between physical characteristics of music and moods or feelings reported by listeners: music called "dignified" tends to be slow, low-pitched, and of limited orchestral range; music called "animated" tends to be fast, etc.[48]

Preference tests represent the major part of the work being done by experimental psychologists in aesthetics. Most of the work follows the by now well worn footsteps of Fechner. We take only a few samples from the wide range of literature.

In music, Olson[49] has concluded (by asking 1,000 people whether they prefer "this" to "that") that people prefer full frequency sound ranges over limited frequency ones. Pepinsky[50] modestly suggests that the emotion aroused by instrumental music depends partly on how the instrument is played, and not altogether on the physical characteristics of the tone or instrument.

In the field of painting, C. W. Valentine[51] has identified four distinct "types" of appreciators. From other workers[52] we learn that little boys prefer seascapes to landscapes, while little girls prefer pictures of people. Little children of both sexes like bright pictures. Children like bigger cardboard rectangles than adults do; preferred shapes approach the golden mean.[53] One of Great Britain's leading psychologists of art, R. W. Pickford, selected 45 pictures to include 10 aesthetic qualities. Eighteen judges who were interested in the psychology of art rated the pictures. Intercorrelations between the responses were factorized. The general conclusion was drawn that design, feeling, and rhythm were the "essence of art."[54] One of the most careful of recent experiments was performed by Sister Agnes Raley at Nazarene College.[55] Dissatisfied with speculative theories of humor, she set about psychometrics in this field. Twenty-eight cartoons were grouped into seven rows of four. A Thurston scale was developed, and a rank order preference technique explained to her students. Test retest correlation on the experiment ran .98. Probable error was computed at +.007 . . . a very high realiabilty. Sister Agnes suggests, on the basis of this experiment, that girls below the age of fifteen like different cartoons than do girls of sixteen, seventeen, and eighteen.

Rather less "preference" work has been done with literary or quasi-literary situations. I report only three experimental results. First: people of different ages aesthetically prefer familiar first names (Robert, Jean) over bizarre first names (Hulsey, Minna); children resent outlandish first names.[56] Second: a reader of poetry and prose is better understood if he speaks in a normal voice than he is if he talks through his nose.[57] Third: literary authors'

punctuation habits differ; in poetry, fiction and drama, the use of the colon (counted per thousand marks of punctuation) is declining; punctuation profiles can be constructed, but are probably unreliable indices to total personality.[58]

Three last examples, which do not fit tidily under the headings listed above, will complete our "experimental" list. The first is quite an interesting experiment performed on a group of 100 college students to test the influence of prestige factors in directing affective response.[59] There does seem to be some such influence. Another investigator has shown that some music sounds funny, even without any program or title.[60] And finally, Paul Farnsworth, former president of the Esthetics Division of the A.P.A., among many other contributions to the psychology of music, has demonstrated[61] that there is some correlation among the following factors: the amount of attention certain eminent musicians receive in certain encyclopedias and histories of music (presumably measured in number of lines of type, so as to remain objective); the number of phonograph records of their music; the frequencies with which their names appear on the programs of certain symphony orchestras; and how well grade school, high school and college students say that they like the musicians' music. These materials are in turn correlated with the musicians' birthdays.

V

Broadly, what contributions may each of these various approaches claim to have made to our understanding of the arts? What do its limitations seem at present to be?

We might first note, in an overview of all three positions, that none of them by any means definitely solves the *normative* problem—if there is any such problem—which has worried so many philosophers of art. Some, but not all, psychoanalysts frankly disavow any such interest, admitting that "bad" poems are equally revealing psychoanalytically as "good" ones.[62] The Gestaltists worry about the problem,[63] but I am not yet satisfied that their suggestions will prove ultimately satisfactory. The experimentalists, quite obviously, beg the normative question. This general scientific disinterest in aesthetic norms is, I believe, a healthy sign. A degree of philosophical naïveté is excusable and perhaps even desirable in a scientist; the converse, however, is not true. This whole question of the methodology of value-psychology needs consideration, but is much too extended to discuss here.

It seems, generally, that we owe to the psychoanalysts a broad set of categories, of hypothetical constants, of (charitably) "as if" personality factors analogous to the "as if" constituents of the atom, which seem in some cases to help us partially account for what hitherto had appeared to be the "miracle" of creation. We have been provided with a very schematic picture of a "hidden mechanism" whose workings we are only beginning to understand. Miscellaneous groups of data, hitherto disorganized in our understanding, are brought under these categories and seen to have some kind of a common explanation, however broad. Some sort of "intellectual at-homeness" may be brought about in this way . . . although it may not be exactly the kind of a home of which we may be very proud.

In terms of these categories, certain very general generalizations do seem to be allowable, on an admittedly semi-speculative basis, as, for example, that erotic desires repressed by the censorial superego tend toward external vicarious or sublimated expression by means of art-symbols, analogous to dream-symbols. We find at least a serious attempt to give one kind of explanation of the symbols in art, and to bring together observed facts from various fields into a coherent explanation. There seems to be no reason why such explanations, when developed, may not warrant prediction; and their clinical efficacy seems fairly well established.

Among the many criticisms which have been levelled at the psychoanalytical approach to works of art I shall mention only a few. There are two naive and equally dogmatic rejections of the entire Freudian-Voluntaristic approach. The first of these is the lay rejection of the man in the street: "The whole business sounds cock-eyed. It must be crazy." To be sure, some of the speculative analyses do sound cock-eyed to the layman, but that is neither here nor there. Einstein's hypotheses, watered down to the lay level, sound cock-eyed too. It is a dogmatic and quite clearly extra-empirical demand that every scientific explanation make clear good sense to the man in the street. The question at issue is not whether Freudian interpretations sound farfetched, but whether they are true, interesting and useful.

A second general criticism, less obviously naive but still, I think, dogmatic, amounts to little more than a blanket categorical refusal to grant the honorific title "science" to such enterprises, on grounds that they are not both experimental in a literal sense and quantitative in their data. This is the criticism we used to hear from the extreme behaviorists. Insofar as the dispute is a rather petty quibble over who has a right to the precious word "science," I do not find it enlightening. It is worth pointing out that many disciplines which we do ordinarily call by that name—astronomy, for example—do not feature literal experimentation. Similarly observational rather than literally experimental are all the so-

called historical sciences of man, such as anthropology ... sciences which (like psychoanalysis) take ranges of data and attempt generalizations on the basis of them. Nor is it the case that all of what we commonly call "sciences" constantly engage in statistical correlations: botany furnishes a familiar example.

There are, however, certain other criticisms which may be raised with perhaps somewhat more force. They are not intended as a priori categorical denunciations of a whole field of endeavor, but rather simply as requests. What Baudouin said in the twenties[64] remains true today: "The new doctrine requires criticism; but it is absurd, at this date, to regard psychoanalysis as null and void."

First, it would be helpful if it were possible for the psychoanalysts to clarify in empirical terms the grounding definitions of their categories: id, ego, super-ego, etc. Presumably we should be able to specify (or at least we should like to be able to specify) some sort of operational definitions for them, yet it seems to be exceedingly difficult to do so. We would like to be able to say, "If the painting contains this symbol, we see the artist's ego at work; if it contains that symbol, we see his super-ego." This demand may now be altogether impossible of fulfillment, because of the rich complexity of the subject matter with which the psychoanalyst is dealing. He himself assures us that all of the different factors are represented in our every action. Just exactly how, then (we would like to know) can we recognize the activity of the various personality factors when we meet them? How shall we even work *toward* precise measurement, granting that precision is impossible at the present time?

Furthermore, we are somewhat worried, on reviewing psychoanalytic-aesthetic literature, about an apparent tendency to reify categories, to make theoretical entities into "things out there." We are anxious to keep clearly before us in our analyses that the unconscious is a hypothetical construct, rather than a metaphysical entity; it is to be justified in use, rather than to be intuited as a self-evident criterion and set up as an independent court of authority. We must be careful to use our categories as instruments of generalization *from* facts, rather than as prejudicial definitions of what kind of evidence will be admitted as factual.

And finally, we would like with psychoanalytic-aesthetic hypotheses, as with any other, some suggested pattern of verification. This will entail the presentation of specific predictions about human behavior, and it may be that we do not yet have adequate generalizations on which to base any far-reaching predictions. But at least some of us will be happier when we see the way clear to a confirmation or disconfirmation of the hypotheses in terms of predictions fulfilled or frustrated. It seems fair to charge the proponents of any scientific theory with showing us at least in principle what kind of evidence will be accepted (when and if we can get it) as confirmatory, and what kind as disconfirmatory.

An estimate of the contributions of Gestalt psychology to our understanding of the arts would have to include our debt for several sensitive and enlightening criticisms of particular works of art, and for a set of principles, only now in process of fuller formulation, which seem to have widening application. Many of our actual experiences of familiar works can be enriched by looking for and finding these principles at work in our own perception. And again, we are always grateful for any fertile ideas which help us to organize into intelligible patterns miscellaneous ranges of data, to "make sense out of experience."

The naive criticisms of psychoanalysis in art have also been levelled against Gestaltism. Let our earlier comments apply here too.

A warning may, I think, be reasonably issued to the Gestaltists, analogous to one which is sometimes issued to the psychoanalysts, namely the stark and real possibility that the hypotheses may become so thin, in order to accommodate many various data, that they no longer say very much. It seems that some changes in this direction have taken place during the past twenty years ... qualifications and refinements which rather dangerously broaden the scope. Any broad scientific or philosophical hypothesis runs this risk, of course; in striving for breadth, it becomes thin, just as, in striving for specificity, it becomes narrow.

Hardly anyone today doubts that the Gestalt is a good idea, but it has been suggested that at least some of its principles may already have done their work, have run their courses in art. We find in the arts magnificent textbook examples of fusion, closure, sequence, figure-ground principles, especially so long as we confine our attention to classical architecture and to sculpture. But, as Ehrenzweig points out,[65] the most persuasive Gestalt interpretations hinge quite naturally around those perceptual surfaces and depths in which the eye and the attention are expressly confined. But in much of contemporary painting and poetry, the eye and attention are invited to wander. There seem to be simply no well-defined wholes in perception. Figure and ground blend indistinguishably. The presented surface may as well be seen as all figure, or all ground, or neither, like wallpaper. The Gestaltist can, of course, answer this criticism, but only by digging rather deep for evidence of the principles which he brings to the work of art. In no very clear sense does he find them "there" so to speak in the evidential work of art presented to him. To justify

such "digging," overwhelming prior evidence, of a more direct sort, must warrant the hypothesis as highly probable. There is a suspiciously ad hoc feeling about any such extreme hypothetical extension; quite justifiably, I feel, it weakens our original, fresh faith in the hypothesis.

We come finally to an estimate of the contributions of what we have called the "experimental" approach to aesthetics. Here, I think, we may be most grateful for the aptitude tests, which are doing practical work every day. As for theoretical contributions to our understanding of the fine arts, however, I find myself (with few exceptions)[66] at a loss. Frankly, I don't think we have yet learned very much about art by the kind of experimentation and measurement which has been going on. If pressed, I will admit that I do not expect—unless we alter our approach somewhat—that we will learn a great deal more in this direction, at least within the next three thousand years. Beyond that I do not care to predict. Indirectly, of course, we in aesthetics have benefited materially from experimental psychology. Experiments in perception, learning and emotions have made some important contributions ... but these investigations have, for the most part, been carried on outside the field of psychology of art.[67] Within that field, as practiced by the experimentalists, we have found some models of experimental technique, complete with control groups and probable error computations. We have found examples of highly refined statistical procedures and high-powered correlations; even factor analysis has found its way into this field.[68] And we have come out with fairly suggestive evidence quite strongly indicating that several things which we believed all along to be true are really true.

This latter-day sophisticated behaviorism in aesthetics seems to many of us to be frankly thin, to present results disappointing and even insignificant in proportion to the enormous labors which have been put into it. Why is this?

The naive answer to this question is one which perennially arises in cases of this sort: just because we find our scientific row difficult to hoe, some people deny the possibility of ever hoeing it, and illogically infer that the field is somehow forever "autonomous," "beyond science" in some mysterious sense in which the field of physics is not. "Art," it is argued, "is too pure, too unique, too otherworldly and intuitive to be a subject-matter for such 'atomistic' science."[69] I suppose that psychologists still have to listen to this sort of complaint from time to time, just as philosophers do. But I submit that it is vestigial nineteenth century romanticism and not worth taking seriously within the framework of our present-day lives and works. We cannot prove it false, because of the very nature of the position: it

doesn't say anything explicit enough to be proved true or false. But in attempting a science of art, as in attempting a science of anything else, we must assume it to be false. Since this assumption seems (although admittedly extra-empirical) to be a condition of any knowledge about anything, I am willing to make it cheerfully, and I suggest that we all do so. I do not know of any evidence which could possibly prove our assumption to be mistaken, since it is at least primarily procedural rather than descriptive. The *analysis* of this assumption, by the way, I take to be one of the primary tasks of philosophy.

Three other answers however suggest themselves as possible explanations for our dissatisfaction with the results of experimental-quantitative aesthetics. The first of these points to the empirical fact that our experiences of works of art in appreciation, and artists' experience in creation, are admitted by all hands to be highly complex. A positively enormous number of variables enter into the perceptual situation; many, but not all, of these have been pointed out in philosophical analyses of art. The entire physical and psychological history of the percipient seems to condition his response, often in apparently irrelevant and certainly unexpected ways. A large number of the qualities of the work itself are clearly relevant. The physical and social environment of appreciation obviously plays an important part. The whole "as if" representational world of the visual and literary arts presents special psychological complexities. And all of these variable factors seem to fuse in extraordinarily complicated fashions. It is not at all evident, or perhaps it is even unlikely, that discrete observations gleaned in the sterile atmosphere of the usual psychological laboratory are now legitimate warrant for *any* very interesting or useful generalizations about the aesthetic experience. Responding to an El Greco on a museum wall simply isn't much like comparing cardboard rectangles in a classroom, and it is difficult to see from here how any number of such cardboard comparisons will ever pile up, one on top of another, to give a description of the aesthetic response. In order to get the problem into the laboratory, it has quite naturally been necessary to control the number of variables. It may be that this control has resulted in a fatal over-simplification of the problem.

Note that this is emphatically *not* a retreat into mysticism. I do not believe that these problems of aesthetics—or, for that matter, any real problems of description of any phenomena at all—are forever inevitably beyond the scientist. But I am not encouraged that they are now within the grasp of the quantitative experimentalist in anything closely approximating the rather cavalier attack we find in

the books and journals of the nineteen forties. The counsel is one of caution rather than of surrender. Let us beware of the subleties and complexities, lest we distort the problems into over-simplified caricatures in the name of empirical science.

As a second general observation, I suggest that at least in some cases in which aesthetic behavior patterns have been studied by experimentalists, the experimenters have apparently failed to ask significant and crucial questions *in advance of* experiment. Charles Darwin once remarked that he never heard of anything sillier than a man setting up an experiment without trying to prove or disprove something, just going into the laboratory to perform an experiment for the sake of the experiment. It does look sometimes as if some of these investigators into aesthetics have been willing to settle for just any old correlation between any old sets of behavioral data at all, so long as they are "objective." Small wonder that correlations are found: it is a tautology to say that *any* sets of data will correlate somewhere between − 1.0 and + 1.0. There are indeed behavioral correlations to be found; the trouble is that there are too many of them. In the psychology of art we must imaginatively select in advance of experiment *which* factors, when correlated, will give us interesting and important results. This requires some hard thinking, some imagination, some kind of a *theory*, however tentative, some "exploratory hypothesis" guessed at from earlier work, or from common sense observation, or wherever. *Mere* laboratory observations, however accurately made and acutely correlated, will never give us anything remotely resembling a scientific description of the aesthetic experience. Statistical calisthenics may be a fine exercise for a student of psychology; I expect it is; the études of Czerny are fine exercises for students of piano. But (to borrow a figure) we do not expect to hear Czerny études from the concert platform.

It may be that physics is indeed the proper model for psychology to emulate. But the emulation should be *methodological* rather than *material*. Psychologists of art may of course, but need not, make the rather extravagant assumption that every aesthetically relevant consideration is a space-time event measurable in physiological terms. And, as Köhler pointed out, if we are to take physics as our model, we might well remember that physics went through centuries of qualitative refinement before its quantitative methods became applicable. It is at least possible that our understanding of the psychology of art is still in a stone age, a period of pre-scientific or better "pre-quantitative" discrimination.[70] After all, even physics has occasionally had difficulty with its quantification techniques. I know of no one who would want to maintain seriously that the problems of psychology of art are simpler than those of physics ... except where they have been made simpler by radical surgical excisions of important and relevant complexities. Frank recognition of these complexities is surely a prime duty of the empirical scientist.

This [chapter] has included a summary, classification, and tentative criticism of psychology at work today among the arts. No moral need be drawn, but if one is requested, let it be simply this: we need hard-headed, cautious, clear scientific thinking about the arts; perhaps right now we need it most on the level of fundamental theory developed by trained psychologists who have a love for the arts and a healthy curiosity about what makes them tick.

Notes

1. This paper was read to the Psychology Colloquium of Northwestern University on January 30, 1950. It is intended as one contribution in partial fulfillment of Thomas Munro's reasonable request ("Methods in the Psychology of Art," *Journal of Aesthetics and Art Criticism*, March 1948, p. 226) for "more discussion of aims and methods." In this valuable article, Mr. Munro brings to the attention of American students the important work of Müller-Freienfels(*Psychologie der Kunst*, 3 vols., Leipzig 1923), Sterzinger (*Grundlinien der Kunstpsychologie*, Graz 1938), and Plaut (*Prinzipien und Methoden der Kunstpsychologie*, Berlin, 1935). The reader is referred to these books, and to Munro's article, for a survey of psychological approaches in Germany and Austria to 1935. Chandler's fine book, *Beauty and Human Nature*, (New York and London, 1934) still contains interesting material; its approach is, however, almost wholly restricted to that called "experimental" in this paper. It goes without saying that interested readers will refer to one of the masterpieces in the field by one of its masterworkers, the late Max Dessoir: *Aesthetik und allgemeine Kunstwissenschaft* (Stuttgart, 1923).

2. Except perhaps in France, and there only in an attenuated form. See the June 1949 issue of *Journal of Aesthetics and Art Criticism*. R. Bayer's article, "Method in Aesthetics," in this issue, contains a quasi-critical and quasi-poetic discussion of psychological methodology in aesthetics.

3. 1411b, *34; Rhetoric* III, 2.

4. *Das optische Formgefühl,* Tübingen 1873.

5. *Aesthetik,* Hamburg and Leipzig 1903-1906.

6. With C. Anstruther-Thompson, "Beauty and Ugliness," *Contemporary Review* 1897, pp. 72, 544-69; 669-88.

7. *Letters upon the Aesthetical Education of Man, 1793-94.* More convenient is the 1905 London edition *Essays, Aesthetical and Philosophical,* etc.

8. *The Principles of Psychology* (London, 1870-72).

9. *The Play of Animals* (New York, 1898); *The Play of Man* (New York, 1901).

10. *Das Wesen der Kunst* (Berlin, 1901).

11. Miscellaneous articles in *British Journal of Psychology,* ca. 1913.

12. It should be noted that serious attempts have been made, and are still being made, to organize these various approaches into a unified program which will incorporate also discoveries contributed by anthropological, historical and sociological disciplines. See Munro, op. cit., p. 233.

13. *Phaedrus* 245.

14. See Baudouin, *Psychoanalysis and Aesthetics* trans. Paul, (New York, 1924), p. 29.

15. *Das Geburt der Tragödie* (Leipzig, 1872), available in translation; *The Will to Power, 1878* (New York, 1924).

16. Freud's own chief contributions to aesthetics include *Leonardo da Vinci* (New York, 1916); *Wit and Its Relation to the Unconscious* (New York, 1916); *Dream and Delusion* (New York, 1917); *Totem and Taboo* (New York, 1918). The Jungian approach may be found in "Psychology and Literature," pp. 175-199 in *Modern Man in Search of a Soul* trans. Dell and Baynes (New York, 1934), and in *Contributions to Analytical Psychology* (London and New York, 1928), pp. 225-49.

17. *American Imago,* 1948, p. 200, and elsewhere. *The Writer and Psychoanalysis* (New York, 1950).

18. Op. cit. We might almost take as a text Baudouin's quotation (p. 25) from Wagner's *Meistersinger:* "Poetry is nothing but the interpretation of dreams."

19. "On the Esthetic State of Mind," *Psychiatry* (1947,) 281-306, and elsewhere.

20. See, for only one example, Ernest Jones, *Hamlet* (London, 1947), pp. 7-42.

21. Abenheimer, "On Narcissism, etc.," *British Journal of Medical Psychology* 20 (1945), 322-29.

22. Daly, "The Mother Complex in Literature," *Samiksa* 1 (1947), 157-190. I am grateful to Dr. Edward Weiss of Chicago for his kindness in sharing his personal copy of this journal, and of those cited in notes 27 and 29 below.

23. Reitman, "Lear's Nonsense," *Journal of Clinical Psychopathology and Psychotherapy,* 7 (1946), 64-102.

24. Deutsch, "Artistic Expression and Neurotic Illness," *American Imago* (1947), 64-102.

25. Skinner, "Lewis Carroll's 'Adventures in Wonderland,'" *American Imago* (1947,) 3-31. The earliest article on this subject seems to be that of Schilder, "Psychoanalytic remarks on *Alice in Wonderland* and Lewis Carroll," *Journal of Nervous and Mental Diseases,* 87 (1938), 159-168.

26. Grotjohn, "About the Symbolization of Alice's Adventures in Wonderland," *American Imago* (1947), 32-41.

27. "La Musica, linguaggio dell'inconscio," *Psicoanalisi* (1945), 60-82. He suggests that whereas ordinary verbal language tends to express cold, abstract concepts, music expresses the determinate "charge" *(carica)* of the unconscious.

28. *From Beethoven to Shostakovich; The Psychology of the Composing Process* (New York, 1947).

29. Servadio, "Il Surrealismo: storia, dottrina, valutazione psicoanalitica," *Psicoanalisi* (1946), 77. See also Akin (or Atkin), "Psychological Aspects of Surrealism," *Journal of Clinical Psychopathology and Psychotherapy* (1945), 35-41.

30. "The Revulsions of Goya," *Journal of Aesthetics and Art Criticism* 5, (1946), 1-28.

31. Loc. cit. Schneider also has done psychoanalyses of paintings: see his work on Picasso [*College Art Journal* 6 (1946), 81-95] and on Chagall (ibid., pp. 115-24).

32. *Productive Thinking* (New York and London, 1945).

33. *Gestalt Psychology* (New York, 1947).

34. *Principles of Gestalt Psychology* (New York, 1935). I cite only recent editions.

35. *The Unfolding of the Artistic Activity* (Berkeley, 1948).

36. As, for example, that of Koffka, "Problems on the Psychology of Art," *Bryn Mawr Notes and Monographs* (Bryn Mawr, 1940), 9 . . . cited by Heyl, *New Bearings in Esthetics and Art Criticism* (New Haven, 1943), p. 110n.

37. *Principles of Art Appreciation* (New York, 1949).

38. "La Psychologie Structurale et l'art moderne," *Theoria* (Lund, 1949), 253–75.

39. In an interesting but, so far as I can discover, still unpublished paper read at the 1949 meeting of the Society for Aesthetics in Oberlin, Ohio. It should be noted that my report is from memory; Reymes-King is not to be held responsible for these views.

40. Also from an unpublished paper read at the 1949 meeting (see note 39). Arnheim is not to be held responsible for these views; they are quoted from memory.

41. "Henry Moore: the Reclining Figure," *Journal of Aesthetics and Art Criticism* (1947), 95–105.

42. "The Holes of Henry Moore," *Journal of Aesthetics and Art Criticism* (1948), 29–38.

43. Consider, for example, the attitude expressed by Carl Seashore, *Psychology of Music* (New York, 1938), p. 377.

44. *Art in Human Affairs* (New York and London, 1942).

45. Op. cit. See note 1 above.

46. I here deliberately set aside applied psychology experiments on the use of music in psychotherapy, and in increasing production in factories and chicken coops, the visual appearance of advertising layouts, and the like, since such experimenters generally make no claim to be contributing to our understanding of the arts.

47. "The relationship between verbal reports and galvanic skin responses to music," abstract: *American Psychologist* 3 (1948), 275.

48. Gundlach, "Factors Determining the Characterization of Musical Phrases," 4 (1935), 624–43.

49. "Frequency range preference for speech and music," *Journal of Acoustical Society of America* (1947), 549.

50. "Musical Tone Qualities as a Factor in Expressiveness," *Journal of Acoustical Society of America* (1947), 542. Pepinsky cites no actual experimental evidence; his inclusion in this classification is perhaps open to question.

51. *An Introduction to the Experimental Psychology of Beauty* (London and New York, 1913).

52. Dietrich and Hunnicutt, "Art content preferred by primary grade children," *Elementary School Journal* (1948), 557–59.

53. Shipley, Dattman, Steele, "The influence of size on preferences for rectangular proportion in children and adults," *Journal of Experimental Psychology* (1947), 333.

54. Abstract: "Experiments with pictures," *Advancement of Science*, 5 (1948), 140.

55. Abstract: *American Psychologist*, 1 (1946), 205.

56. Finch, Kilgren, Pratt, "The Relation of First Name Preferences to Age of Judges or to Different Although Overlapping Generations," *Journal of Social Psychology* 20 (1944), 249–64.

57. Glasgow, "The Effects of Nasality on Oral Communication," *Quarterly Journal of Speech* 30 (1944), 337–40.

58. E. L. Thorndike, "The Psychology of Punctuation," *American Journal of Psychology*, 61 (1948), 222–28.

59. Rigg, "Favorable versus Unfavorable Propaganda in the Enjoyment of Music," *Journal of Experimental Psychology* (1948) 78–81.

60. Mull, "A Study of Humor in Music," *American Journal of Psychology*, 62 (October 1949), 560–66.

61. Abstract: "Musical Eminence," *American Psychologist*, 1 (1946), 205.

62. Stekel, *Die Träume der Dichter* (Wiesbaden, 1932), p. 32; quoted by Langer, *Philosophy in a New Key* (Pelican ed., 1948), p. 168.

63. See Köhler's *The Place of Value in the World of Facts* (New York, 1938).

64. Op. cit. p. 20. Baudouin claims (pp. 33–34) that psychoanalysts "have laid the foundations for the psychology of art, of a science of aesthetics which shall be genuinely scientific without thinking itself bound for that reason to approach art as a psychological 'case' or as a 'subject' to be catalogued, without succumbing to the danger of manifesting a sterile erudition, without losing contact with life, and without forfeiting the sense of beauty." Or again (p. 294) "Psychology is no longer (ca. 1922)

content to make use of the methods proper to the physical sciences; it has sought out, and to a large extent has already found, methods proper to itself."

65. "Unconscious Form-Creation in Art," *British Journal of Medical Psychology* (1948), pp. 185–214. Ehrenzweig attributes the basic idea to Herbert Read [*Art in Industry* (London, 1934)], and points out that education both in creation and in appreciation often seems to contradict Gestalt principles: we learn, for example, to see ground, or negative space, as *figure,* as shaped.

66. As sample exceptions, the investigations of Gundlach, Mull, and Rigg, cited above.

67. Buswell, for example [*How People Look at Pictures.* (Chicago 1935)] presents relevant and important data on perception in art. He trained cameras on corneas and mapped out eye movement diagrams, timing fixations. Alschuler and Weiss [*Painting and Personality: A Study of Young Children* (Chicago 1947)] present an intensive and fairly extensive study of the relations between creative expression and personality in children between the ages of two and five.

68. Guilford and Holley, "A factorial approach to the analysis of variations in aesthetic judgments," *Journal of Experimental Psychology* 39 (1949), pp. 208–18, an ingenious methodology applied to choices of designs of playing cards.

69. See Jung, *Modern Man in Search of a Soul* (New York, 1934), p. 177: "Any reaction to stimulus may be causally explained; but the creative act, which is the absolute antithesis of mere reaction will forever elude the human understanding."

70. For examples of psychologists' critiques of psychological experimentations in aesthetics, see Max Dessoir, op cit., pp. 17ff. R. M. Ogden, *The Psychology of Art* (New York, 1938), p. 22, says: "A work of art eludes all efforts to quantify it in terms of a precise formula. 'Aesthetic measure' is a contradiction in terms." He refers, of course, to Birkhoff's *Aesthetic Measure* (Cambridge, 1933). A more moderate, and I suspect, more nearly correct view, is that of Thomas Munro [*Scientific Method in Aesthetics* (New York, 1928), pp. 15–17]: "quantitative measurements . . . when erected into a fetish, as they have been by 'experimental aesthetics' . . . usually lead to premature inferences that have a spacious air of certainty, and the neglecting of more fruitful methods of inquiry. . . . Too rigorous an insistence on absolute reliability and 'objectivity' of data, too impatient a zeal for universally valid generalizations, may be an obstacle in a field where these cannot be attained at once, if ever." See also Jung, *Modern Man,* p. 176.

b. *Religion*

The connections between the pictorial arts and organized religion are venerable
and complex. Whether one thinks of Michelangelo's monumental fresco on the
ceiling of the Sistine Chapel, which incorporates a myriad of Judaic, Christian,
and Greek Creation themes, of Leonardo's famous *The Last Supper,* or of the
thousands of paintings of, say, the crucifixion of Christ, it is hard to
overestimate the importance of religious subject matter in the pictorial arts of
the West. In the virtue of its ability to represent the visible world, the pictorial
arts could, in the words of Pope Gregory the Great, "do for the illiterate what
writing does for those who can read." Paintings in particular have provided a
virtual catalog of religious imagery, from depictions of divine and human
beings associated with particular religions to representations of religious
allegories, stories, doctrine, and symbols. The iconography of religious
paintings and other works of visual art has accordingly been an important
feature of art historical scholarship. But the religious significance of painting is
not confined to the presence of religious subject matter in paintings. The
practice of painting exists in a religious and social context in which the activity
of painting itself has often been thought to have religious significance and in
which the institutions of religion have had a profound influence as both patron
and censor.

The two selections in this section take up the question of the religious
significance of the pictorial arts in provocative ways. Etienne Gilson's essay
"The Religious Significance of Painting" begins with a minimalist definition of
painting ("a plane surface covered with colors assembled in a certain order")
reminiscent of the formalism of Clive Bell. A painting, Gilson tells us, is "the
embodiment of a form in a matter." Its ultimate end is "to achieve a fitting
object of contemplation." Gilson's distinction between painting and what he
calls "picturing" (the art of creating convincing imitative images) has evident
affinities with Bell's distinction between painting as an art and painting as
illustration (what Bell calls "descriptive" painting).

But if Gilson seems to be advancing a formalist position, it is clearly a very

different brand of formalism than that espoused by Bell. After providing an Aristotelian analysis of the ontology of painting, Gilson argues that the most profound religious significance of painting lies not so much in what artists are able to accomplish by imitating visible things as picturemakers but rather in the very process of embodying form in matter, an activity which mirrors the process of creation by means of which God brought everything into existence. The painter's highest religious calling, Gilson argues, is not the representation of religious content but rather the religious creation of beautiful form. Gilson thus offers a view of the religious significance of the productive activity of painting itself, a position that owes much to the thirteenth-century philosopher and theologian St. Thomas Aquinas.

Leo Steinberg's essay "The Sexuality of Christ in Renaissance Art and in Modern Oblivion" is equally intriguing, though for different reasons. Despite its startling title, Steinberg's essay is in some ways quite traditional. Unlike Gilson who concerns himself primarily with the religious significance of form in painting, Steinberg concentrates on the more familiar question of the religious significance of content. In that sense, Steinberg is simply carrying on the kind of iconographical and iconological analysis which has long been a staple of art historical inquiry. Furthermore, Steinberg chooses for his analysis an historically defined body of work familiar to art historians: Christian art of the Renaissance.

What makes Steinberg's analysis immediately controversial is the specific religious question which, he argues, is raised by certain works in this period: the sexuality of Christ. It is precisely because any treatment of this topic is so likely to be dismissed or denounced that Steinberg seeks to establish, first, that the subject exists—that is, that there is a significant body of work in which Renaissance artists can be reasonably construed as grappling with the problem of Christ's sexuality. In the book from which this selection is taken, Steinberg adduces evidence from hundreds of paintings, drawings, and woodcuts which feature what Steinberg calls an *ostentatio genitalium,* a showing forth of the genitals.

However, Steinberg is not content to reproduce pictorial images, since these works would, in any case, stand in need of interpretation. In support of his own view that they do concern the question of Christ's sexuality, Steinberg advances a two-pronged argument. Negatively, he attacks anthropological and naturalistic accounts which seek to explain away the sexual reference of these works, and, positively, he argues that the creation of these works can be explained with reference to the theological context in which they were created. They are to be understood, Steinberg argues, as pictorial explorations of the Christian doctrine of the "humanation of God"—the notion of God's descent into manhood. It is this "incarnational theology," as well as the corollary themes of the eternal become mortal, the exemplary virtue of Christ and the "shame-lessness' of the New Adam, that are probed in these works. Far from betraying a scandalous, scurrilous, or prurient interest in sexuality as such, the

very realism of these works betokens an attitude of celebration and wonder toward the mystery of the incarnation. In Steinberg's words, "the realism of Renaissance painting [is] justified in the faith. The rendering of the incarnate Christ ever more unmistakably flesh and blood is a religious enterprise because it testifies to God's greatest achievement." Indeed, Steinberg argues, Renaissance visual artists were in the unique position of being able to explore pictorially what might well have seemed blasphemous as articulated in a verbal context. If we in the twentieth centruy fail to see these works as "primary texts" and regard them instead as mere naturalistic representations, perhaps it is because religion has ceased to occupy the central place it had for these Renaissance artists and the creation of truly religious works has itself fallen into oblivion.

18

The Religious Significance of Paintings

ETIENNE GILSON

Giorgio Vasari seems to have been one of the first artists to attempt a definition of painting. This definition itself presupposes another one, that of design. By the word "drawing" *(disegno)* Vasari means the art of outlining figures by means of appropriate curves. There is a certain amount of design in every painting, but to paint is something more than merely to make an outline. "A painting is a plane surface—be it a wood panel, a piece of canvas, or a wall—covered with spots of colors disposed around an outline which, because its curves have been well designed, circumscribes the figure."[1]

A similar definition occurs in Hippolyte Taine's classic *Philosophy of Art,*[2] and again, more recently, in a famous article by Maurice Denis. The formula is well known, but it is so often misquoted or misunderstood that it will not be amiss to quote it once more: "Remember that before being a war horse, a nude woman, or telling any story whatever, a painting essentially consists of a plane surface covered with colors assembled in a certain order."[3] Maurice Denis did not know the passage of Taine at the time he himself had written his own definition,[4] but even if he had, the fact would be of little importance. There is no common measure between a casual statement made by a philosopher and the same statement, or a similar one, made by an artist fully aware of the exigencies of his own art.

Although it may seem too obvious to be worth quoting, this was, and it still remains, a highly con-troversial definition. We sometimes find it quoted under this abridged form: "A painting is a plane surface covered with colors assembled in a certain order." But the gist of Denis' definition was that, *before* being the representation of any subject whatever, a painting is made up of colors assembled on a plane surface according to a certain pattern. To say what a thing *essentially* is does not amount to giving an exhaustive description of it.[5] As to Taine, the fact that his definition appears only at the end of his work suggests that it is of secondary importance in his aesthetics.[6] At any rate, it seems difficult to deny that the two notions of color (or of light values)[7] and of order sufficiently determine the nature of painting considered as distinct from pure drawing. Of these two notions, that of order is of especial importance for the ontology of painted works of art, but its definition presupposes a certain understanding of the notion of form, to which we now must turn our attention.

1. Form and Becoming

At this moment of our inquiry, it may prove profitable to ascertain the technical meaning of some terms whose use is unavoidable in the present discussion. These terms are borrowed from the philosophy of Aristotle, and their practical necessity appears from the fact that no aesthetician wholly

From Etienne Gilson, *Painting and Reality*. Bollingen Series 35, vol. 4. Princeton: Princeton University Press, 1957, 1985, pp. 104–13, 260–69, 293–96. Copyright © Trustees of National Gallery of Art. Reprinted with permission of Princeton University Press.

succeeds in doing away with them. Modern phenomenologists, and even existentialists, openly or tacitly return to Aristotle's terminology every time they attempt to describe the relationship between artists and the works created by their art. And no wonder, since the philosophy of Aristotle, in its very essence, is a reflection on the operations in consequence of which things come to be. Now, art is distinct from nature, but, like nature, it is a cause in consequence of which a certain class of beings come to be. It seems therefore advisable to consider a few general notions applicable to becoming under all its forms—that is to say, in the order of nature as well as in the order of art.

Let us come back to the notions defined by Aristotle in connection with the problem of knowing how things come to be. His first remark about it is that, for any conceivable thing, to become is "to come to be from another thing" (*Physics*, I, 7, 189b, 33). The other thing from which it comes to be is called its matter. This notion can point out different objects. Matter can be something very modest in both being and commercial value, such as paper, plaster, or clay. It can also be something exceedingly precious and expensive, such as the gold a goldsmith uses as a matter in making a gold ring. Moreover, a matter can be a very complicated structure, itself the result of long natural preparation or of an elaborate industrial or artistic processing. In order to make things clearer, let us say that matter is both a certain way of being and a certain way of causing something else to be. Apart from absolute prime matter, which has no being of its own, any concrete substance can serve as a matter for the becoming of another being.

Because of the generality of its notion, Aristotle often calls matter a "substratum," that is, the underlying element "from which proceeds that which comes to be" (*Physics* I, 7, 190b, 1–4). Among the five examples quoted by him of the different ways in which things come to be from a certain matter, three are relevant to art: by change of shape, as a statue; by taking away, as the Hermes from the stone; by putting together, as a house. A fourth example of becoming—by addition—is borrowed by Aristotle from living things (things that grow), but he could as well have borrowed it from the art of the painter. In all these cases, a thing comes into existence, starting from something else (its matter) that becomes the thing in question. That from which becoming originates, in which it takes place, and which constitutes the very body of the being at stake is its matter. Such are marble, stone, or bronze in a statue; such also are the colored pigments in a painting.

One of the points stressed by Aristotle in connection with matter is that its notion is not merely negative. Matter is not a simple absence of being. On the contrary, in any process of becoming, that which becomes is often a highly complex entity, as are the germs and seeds in the generation of living beings. The matter from which becoming proceeds is sometimes called its *subject*, in order to stress the positive nature of its entity. At the same time, every generation, or becoming, presupposes the nonbeing of something—that is, the nonbeing of that which is going to be at the term of the process. This notion is really a very simple one: that which already is cannot possibly come to be; in other words, all becoming is the coming to be of something that, at the beginning of the process, is not.

This point led Aristotle to a curious notion, whose meaning appears in full when artistic production is at stake. It is the notion of privation.

Let us suppose a matter, or substratum, that will become the subject of some process of becoming. The very nature of this process will consist in turning the subject at stake into its very contrary. What Aristotle means thereby is this: if we want to obtain a colored surface, the starting point of this process should be a noncolored surface, or, in plain language, a white surface, just as, if we want to turn a man into a musician, he must first be innocent of musical skill at the beginning of the process. Privation then can be conceived as the absence, in a subject matter, of what it is going to possess at the end of the process of becoming. Thus, matter always is a certain thing that is becoming, and because it is always the matter-of-a-substance, it itself nearly is substance; on the contrary, as Aristotle himself expressly says it: "the privation in no sense is" (*Physics*, I, 9, 192a, 3–6).

This negative notion assumes a positive meaning as soon as we ask ourselves: of what is it the privation? For, indeed, this question immediately introduces the notion of a third principle of becoming, which is form. At the origin of any process of becoming, there is the privation—that is, the nonbeing—of a certain form that is coming to be. In other words, to be the cause of a certain becoming is to produce something, not indeed from absolute nothingness, but at least from the nothingness of the very form that is to be produced.

The aesthetic inspiration of Aristotle's philosophy of nature is clearly felt in his remarks on this curious notion of privation. Taken in itself, it first gives an impression of mere verbalism. What can be more commonplace than such a statement: it is contradictory to suppose that something already is that which it is about to become? But this Aristotelian notion is best understood in connection with the remark often made by the Philosopher, that negative as it is, the notion of privation points out the nonbeing of something that ought to be or, in other

words, the absence of something that should be there. In this sense, the becoming of every work of art consists in substituting the presence of a certain form from the privation of that form in a certain matter.

The reason becoming takes place is precisely that, taken in itself, a given matter is neither pure nonbeing nor pure being. Placed, so to speak, betwixt and between, it always is both a substance determined in itself, such as a piece of canvas or masonite, and a possible subject for further determinations, such as the support of a possible painting. Expressed in terms of common experience, this means that in perceiving things, we often perceive, at least as much as what they are, what could be done with them or, in other words, what would become of them if they were used as so much material for the production of new beings.

The awareness of this fact is the probable source of Aristotle's remarkable doctrine concerning the origin of becoming in material substances. Having at his disposal three elements to account for this phenomenon—matter, form, and privation—Aristotle observes that he cannot find its explanation in form, because, being wholly defined in itself, form has nothing to desire; nor can he find its explanation in privation, for the simple reason that, having no entity of its own, privation cannot be the seat of any yearning; there then remains matter as the sole possible source of such desire, and this is what Aristotle finally affirms in a formula justly famous for a brutality verging upon crudity: "The truth is that what desires the form is matter, as the female desires the male and the ugly the beautiful" (*Physics*, I, 9, 192a, 20–25).

It is easy to misunderstand this doctrine and even to make it look ludicrous. There seems to be a naïve anthropomorphism in a position that attributes to matter desire and yearning as if matter were endowed with a soul capable of such emotions. But Aristotle's doctrine is not that simple. It describes a complex experience in which the formal vocation of a certain matter is perceived by such a human mind as that of an artist. More deeply still, it describes a complex reality in which nature itself is unconsciously working after the manner of an artist and obscurely groping its way toward always higher ends. Is it really absurd to conceive of the universe of material things as animated from within by a sort of desire for perfection? Assuredly, this is not a scientific notion, but it has at least the merit of accounting for a fact that contemporary science leaves unexplained, namely, the progressive and quasi-creative character of evolution in general. At any rate, and without entering controversies we can avoid, let us say that, even if Aristotle had been mistaken in conceiving nature as a sort of unconscious

human agent, his philosophy of nature would, for this very reason, provide a fitting interpretation of the genesis of works of art.

Reduced to its essentials, Aristotle's teaching on this point is that there is in matter a craving for any form that can turn its privation into some positive mode of being. Obviously, the fulfillment of this craving cannot be the work of privation, which is nothingness, or of matter, which is the seat of privation; it must therefore be the work of form, whose notion it remains for us to describe.

The word "form" now belongs to everyday language. In its common acceptation, it simply means the visual appearnce of a thing or, in other terms, its figure and its shape. These meanings are correct, but they express less what Aristotle used to call form than its external manifestations. In the sense we shall give it, the word "form" designates the essential nature of a thing or, still more precisely, that nature itself considered as determining the thing in its species and, by the same token, in its figure and in its shape.

We know form much less in itself than by its effects. Every time certain effects are present, we can safely infer that a form is there, as their cause. Among these effects, let us first note a literally universal one: form is that through which each and every being has existence. For instance, wood is a thing of nature; it is a bed only potentially; to turn it into an actual bed, some artisan has to give it the shape of a bed, but as soon as it has been given this shape, the wood in question becomes a bedstead; in short, it is a bed. So the bed exists only through its form (*Physics*, II, 2193a, 30–35).

Aristotle expressed the same notion in different words when he said that, for any substance, or thing, that which "is only potentially a *this*" (for instance, a bed) "only potentially *is*" (*On Coming to Be and Passing Away*, I, 3, 317b, 26). Consequently, in giving actual form to a shapeless matter, we cause it to be actually *this*, we give it actual being.

Our next question then should be: how does form give actual being? It does so by isolating, within matter, a whole that, because it is endowed with determinate size, shape, and position in space, is capable of separate existence. We are here reaching a point where all the notions related to being are given at once as included in every one of them. Let it suffice to list the principal among these notions and to characterize their meaning in a summary way.

Form is that on account of which a certain thing is the very thing that it is. In this sense, as has already been said, form is, for each and every thing, the cause of its being.

By positing a thing as a definite being, form sep-

arates it from all that which it is not. This separative power of the form is easily observed, especially in the art of drawing, in which a few lines suffice to isolate a portion of space from the surrounding ones, and, thereby, to delineate a distinct being: angel, man, or beast. Under the hand of Albrecht Dürer, minor worlds, all complete in themselves, seem miraculously to separate themselves from nothingness and to acquire actual being. On a more abstract level, it can be said that, from the fact that something is that which it is, it becomes distinct from all the rest.

This separative power of the form manifests itself by delineation, if the operation takes place in space; or by definition, if the operation takes place in the order of abstract intellectual knowledge. The very word "definition" reveals the relationship between the two operations of defining and separating. To define is "to mark the limits or boundaries of." The definition of a notion therefore marks the limits, or boundaries, that separate it from other notions. This twofold operation, or, rather, this twofold effect of one and the same operation, is what classical philosophy used to express in saying that form is the *ratio*, or "reason," of the thing. Inasmuch as it is "reason," form is that in any reality which makes it intelligible (*Webster's*, p. 828). This "reason" (*ratio, logos*) can be experienced by sense, as when sight perceives the unity of an arabesque in space, or when hearing perceives the unity of a melodic line in time. In any case, the definition, reason, or intelligible formula of a thing results from its form, whose function it is to gather together a multiplicity of elements and to include them in the unity of a distinct being.

From this point of view, the Greek notion of form entails, as its highest characteristics, totality, wholeness, completion, and perfection. When the privation that was in matter has been replaced with a being fully determined by its form, the process of becoming is completed. For the same reason, this process is said to have reached its "end." Here again, language has its own logic. In the light of its Latin etymology, that is "perfect" which "has all the properties naturally belonging to it." In other words, it is that which has been "perfected." In the light of the Greek etymology of the word, that is perfect which has attained its end. In a remarkable passage of his *Physics* (III, 6, 207a, 12–14), in which he strives to establish that to be unfinished is also to be imperfect, Aristotle remarks: "*Whole* and *complete* are either quite identical or closely akin. Nothing is complete [*teleion*] which has no end [*telos*]; and the end is a limit."

It now remains for us to realize the fact that all this analysis is dominated by the notion of form. For, indeed, the sole function of matter is to be the receiver of some form, to be informed by it, and thus to pave the way for determinations of a still higher type. From the beginning of this process to its end, form is the active energy that, in its effort to fulfill the obscure yearning of matter, quickens it from within and gives rise to fully constituted beings.

To this analysis the ready objection is: what is it about? Is this a description of the generation of natural beings, or is it a description of the production of works of art? It is both. One of the most important lessons we can learn from Aristotle is that, distinct as they are, natural causality and artistic causality are far from being unrelated. Nature works as a determined and unconscious artist, while artists work as free and more or less clearly conscious natures. This philosophy of being is, at one and the same time, a philosophy of nature and a philosophy of art.

To be sure, the philosophers who undertake to deduce from their ontology or their phenomenology some systematic interpretation of the fine arts, or of the various classes of works of art, are usually led to conclusions widely different from those of Aristotle. On the contrary, it is worth noticing that when they undertake to draw a philosophical interpretation of art from the direct observation and analysis of art itself, modern aestheticians, even though they have little use for Aristotle, spontaneously rediscover the fundamental notions of Aristotelian philosophy. If Aristotelian forms were not endowed with a dynamic spontaneity closely similar to life, nothing would happen in the order of nature any more than in that of art. Every time we start talking about matters, forms, and the "life of forms," our mind is simply recapturing ancient intuitions that are as valid today as they ever were. At any rate, there is no reason for deciding a priori that these intuitions are not worth testing in an introduction to the ontology of painting. . . .

2. Pictures and Paintings

In virtue of its own nature, painting is inextricably enmeshed in another art for which there is no name, and for which it is hard to find a name because, so far, it has called itself "painting." Let us tentatively call this second art the art of "picturing"—that is, the art of doing pictures.[8] Why, and how, should it be distinguished from the art of painting?

If there is such an art, its very essence is to represent, or imitate, and whatever can make imitation more nearly perfect can be considered as serving the very end and purpose of this art. Deception is not necessarily its most perfect expression, but there is no ground on which it could be rejected as foreign to the essence of picturing.

Moreover, picturing is an art because it includes all the techniques that are conducive to its own end—namely, to turn out images that represent their models as faithfully as possible. The relationship, in the commonly received interpretation of Plato, between natural beings and their Ideas correctly applies to this conception of picturing as an art.

Picturing even is a "fine art," because it is beyond doubt that skillfully done images are extremely pleasant to see. Children delight in looking at picture books, and grown-up people remain pretty much like children in this respect. But pictures are at least as pleasant to do as they are to see. There is a specific pleasure in hitting the likeness of any given object, especially of human faces, as well as in seeing it. Contrariwise to what is true of the art of painting, comparatively young people, some of them hardly out of childhood, have an innate gift of drawing strikingly successful caricatures, usually profiles, of people around them. They do this not by chance, or in a haphazard way, but deliberately, intelligently, and consistently. Portrait painters without pretensions to genius, landscape painters, still-life painters, and even such recognized geniuses as Giotto, Botticelli, and Veronese—in short, all the masters of classical art—have left us a vast number of painted works, most of which are, at one and the same time, both pictures and paintings. And there is an invidious question that it probably is wiser not to ask. Among the countless visitors to art galleries, how many enjoy the works of Raphael as pictures, how many enjoy them as paintings? Is there any contradiction in imagining a visitor constantly delighted with the lovely images of men, women, landscapes, and still lifes that he sees in an art gallery, and returning home in a state of complete satisfaction, without even suspecting that he has been enjoying paintings as pictures much more than as paintings?

We do not intend to minimize the importance of pictures, or images. On the contrary, if one succeeded in introducing a distinction between pictures and paintings that looks so well founded, pictures would benefit by it as much as paintings. We need a history and an aesthetics of the art of picturing conceived in a spirit of sympathetic objectivity suitable to the importance of the subject.

Images are among the oldest products of the fabricative activity of man. They are inseparable from the magic rituals and from most of the religious cults: image makers have always helped men in imagining deities in which they believed but which they could not see.[9] Images are inseparable from the political life of nations: image makers have always helped human groups in maintaining in their midst the memory of national heroes and their deeds.[10] Images are inseparable from domestic life: image makers have been doing portraits for centuries, and photographers are simply helping painters keep the common memories of family life alive for the members of this primitive social cell. Images are inseparable from sexual life: quite a few of the greatest painters have relied upon the attraction exercised by natural beauty to give at least this pleasure to those who derive little or none at all from the art of painting. But sex appeal naturally leads to advertisement, which, although it makes use of everything that can elicit a response from imagination, feelings, and desires, seldom neglects to enlist the services of this fundamental instinct.

The list could be extended endlessly, the more so as one and the same image can serve, at one and the same time, several different purposes. The most resolutely imitational form of art considers it its duty to embellish reality, and this is so true that the sacred images of national heroes or saints have not always drawn their models from the purest sources. The simplicity of those whom such images help in their piety is so perfect, and certainly so pure, that one probably would do more harm than good by quoting facts in support of these remarks.[11]

This is no place to attempt an anesthetics of imitation, or mimicry, which is one of the most fundamental among the natural instincts of man. Our only point is that, were it to be attempted at all, such a study should be carefully kept apart from that of the art of painting. Their confusion, which is everywhere apparent, never fails to provide hopeless misunderstandings.

When Captain Cocq commissioned Rembrandt to commemorate his company of guards by means of a large canvas, he could have meant either one of two entirely different things. If what he wanted was a real painting to perpetuate the memory of his company, he should have left Rembrandt free to paint what he well pleased. This is what, in fact, Rembrandt did, but Captain Cocq did not like it. What he really had in mind, when he commissioned Rembrandt, was a group of portraits of himself surrounded with his men, more or less like the groups of portraits painted by Frans Hals for the companies of civic guards or for the boards of hospital trustees that wanted to perpetuate the memory of their faces. Captain Cocq could not guess that his name would survive the course of centuries precisely because *The Night Watch* did not seriously attempt to portray him or his guards. Yet this is exactly what did happen, and there would be fewer controversies about public monuments if, before commissioning artists, civic authorities made up their minds on the subject. Let us add that artists, too, should be quite explicit as to the spirit in which they accept a commission.

If an *image* is at stake, then imitation and likeness in representing are of the essence of the work to be done. This imposes such limitations upon the freedom of creative artists, and it grants such facilities to the others, that practically all commemorative monuments and pictures are bound to be, at best, indifferent works of art. But there is nothing to complain about in this fact. If we want a picture accurately to *represent* Joan of Arc liberating Orléans, George Washington crossing the Delaware, or, simply, one of the unknown soldiers of World War No. X, then we can demand a good picture, but we should not expect too good a painting. The reason is that too many details that must be included or excluded in order to obtain a good picture have to be excluded or included in order to do a good painting.

The alternative is to invite the painter to do as beautiful a painting as he possibly can, and to dedicate his work, after the manner of a commemorative stone, to the memory of a great man, a national hero, or some historical event. This time, imitation or representation should be, if not necessarily excluded, at least subordinated to the artistic end the painter aims to achieve. This is what Aristide Maillol rightly did when, as a monument to a great musician, he simply made one more of his beautiful statues and inscribed on the pedestal the simple words "To Claude Debussy." It was that, or else a statue representing Debussy himself, all complete from beard to shoelaces. There may be reasons in favor of either choice, but that a choice has to be made seems to be beyond discussion.

Two additional remarks can be made in favor of this distinction. The first one is that it disposes of the vexing problem recently created by the development of art photography. There is a great deal of truth in the famous saying of Jean Cocteau that "photography has liberated painting." It has liberated painting from the duty it had so long assumed, to imitate the visible appearance of things. But at the same time it was becoming itself, painting has liberated photography from its unsound ambition to be an inferior kind of painting.

To the often-asked question, Is photography an art? the answer to give is, Yes, it can be an art, but because it is an art whose end is to imitate, photography is not a variety of the art of painting. Photography should rather be considered a mechanical variety of the art of picturing. Its immense popularity and the veritable passion sometimes put at the service of its pursuit bear witness to the natural love of man for the making of images. Photography is the draftsmanship of those whom nature has not blessed with the gift of picturing.[12]

The second remark is that, because they are specifically distinct, it is just as wrong to judge paintings from the point of view of pictures as it is to judge pictures from the point of view of painting.

A painting has its own rule, its own justification within itself. A picture has its criterion outside itself, in the external reality it imitates. Several critics have recently made the remark that nonrepresentational art has this major defect, that, being unrelated to any external reality, it has no criterion by which it can be judged. The argument would be valid if the art of painting were the art of picturing. As it is, all judgments and appreciations of paintings founded upon their relation to an external model are irrelevant to painting.[13]

A painting is the embodiment of a form in a matter; the whole being of a picture is determined by the relationship that obtains between the image itself and some external reality. And since their aim and purpose is to represent things as they are, images have a right to be appreciated from the point of view of their success, or failure, in achieving their own end. As compared with a painting, whose ultimate end is to achieve a fitting object of contemplation, images are characterized by their ambition to represent all the objects they include, and to represent these objects with all the details that are compatible with their pictorial representation.

This remark applies not only to the number of the objects represented, but also to their visual appearance from the two points of view of shape and color. In short, a good image represents whatever is supposed to be visible in its object and represents it as exactly as possible as it would be seen if it were an externally given reality. In this sense, art critics are fully justified in judging images by the degree of their success in conveying an impression of reality. It is likewise understandable that, in judging paintings as if these were images, some art critics should condemn in them all deformation of what we take to be the real shape of external objects, all modifications of what we take to be their natural colors. What is justifiable in a painting, taken precisely qua painting, cannot be condoned in an image, whose proper function is to imitate reality.

These superficial differences are the signs of a deeper one. Since its proper end is to represent things, beings, scenes of human life, and, in short, the whole of visible reality, the art of imaging is a particular case of the general function of language. It is a branch of literature. In Odilon Redon's words, "There is a literary idea every time there is no plastic invention."[14] Images always have a meaning, and they are rightly judged by the degree of their success, or failure, in conveying it. Consequently, the choice of the subjects to be represented by an

image is of primary importance. Particularly the natural beauty, or charm, or power of suggestion proper to the objects, beings, or scenes represented by an image is lawfully taken into account in appreciating its artistic value precisely qua image. Images so obviously participate in the nature of their objects that to religious images, for instance, is often attributed a sort of inherent sacredness that really belongs to that which they represent, that is, to their meaning.

Innumerable consequences follow from this simple fact. To sum them up generally, let us say that, whereas images are likely to become more or less faithful historical documents, paintings very seldom serve the same purpose, and, when they do, the result is purely incidental to their nature. Good image makers have rightly been praised for having bequeathed to posterity a faithful picture of their country, its way of life, its people, and even the history of their own generation.[15] All the loves of a nation, all its hatreds, all its ambitions, all the successive images under which it depicts itself to itself can be represented by means of pictures, and when the image maker happens to be, at the same time, an authentic painter, as was the case of Honoré Daumier, it is often difficult to sort out, from among their immense daily production, what belongs to the art of picturing, what belongs to the art of painting, and what, as often happens, belongs to both. With a painter who is nothing but a painter, no such problems arise. From the whole production of Paul Cézanne, what can we infer concerning the history of his country? Derain, Matisse, and many other painters have left us countless paintings among which it would not be easy to find anything of historical significance. Their apples, their landscapes, and their odalisques are just as indifferent to the tragic events that shook their country, in 1870, 1914, and 1939, as the allegories of Botticelli are unconcerned with the local history of Florence during the second half of the fifteenth century. This is but the external symptom of the radical difference between a painting, whose meaning is in itself, and a picture, whose function is to point out something else, as do the words of spoken language and all the systems of written signs used by various nations ever since the beginning of civilization.

The distinction is particularly visible in the case of religious painting. As artists, Christians find themselves confronted with the same problems as other painters. The present situation itself is common to all. Like those of their contemporaries who have understood what this situation means for their art, the creative Christian painters are attempting to achieve plastic purification. In the case of reli-

gious painting, however, the additional difficulty arises that, inasmuch as it may be called upon to teach, or to recall religious realities to the mind and to the heart, representational elements are necessarily included in a large number of its works.

Two answers have been found to the problem. The first one is to substitute for the subject to be represented certain plastic equivalents of its meaning. The difficulty then is for the painter to remain readable without becoming imitational. The usual way to meet this difficulty is to insert, in the plastic form, at least some fragments of representational elements that direct the mind of the onlooker toward the intelligible meaning of the plastic forms at stake. A still more satisfactory compromise is simply to resort to the genre of painting in which art is less hampered by the nonplastic elements of the reality it has to express—namely, still life. Léger has left us, in his stained glasses of the Audincourt church, a remarkable collection of what can be called "religious still lifes." *Crown of Thorns,* by Alfred Manessier, is another religious still life. The formula is excellent, especially from the point of view of the painter.

For, indeed, this does not solve the whole problem. There are cases in which the direct representation of scenes including human figures may be required from the painter. Are we to say that no religious picture can possibly be conceived as a painting? There is no general answer to the problem, but the painting itself, in each particular case, is the answer. If he is asked to do a *Pietà,* it is up to the painter to invent some plastic form in which such a scene can be inscribed. His sketch of it will remain his constant guide during the whole execution. Still, what he has been asked to paint is not a plastic form; it has to be a *Pietà.* His problem then is to work in the plastic form so that, even while imitating a recognizable reality, everything in the work, from its fundamental color scheme to the natural forms it includes, be constantly supported, ordered, and bound together by the unity of the germinal form from which it originates. There is no general recipe for solving such problems. If there is such a recipe, painters, not philosophers, should be consulted about it. . . .

3. The Significance of Modern Painting

If there is such a thing as a divine art, it must be very different from our own. First of all, our own art never creates in the proper sense of the word. It does not create its matter; it does not even properly create its forms. Human art simply assembles the elements of composites that, once made, are possessed

of their own forms for the sole reason that they *are*.[16] Moreover, if one can speak of God as of the supreme Artist, his art is certainly innocent of any groping and of any becoming due to what would be for him the incomplete previsibility of his own works. Unlike the Ideas of Plato, those of Christian theology are one with the very being of the Creator; unlike the Prime Mover of Aristotle, the Christian Creator of the world has Ideas of all things known by him and creatable by his power. For this very reason, nothing that happens can possibly be new in the sight of God. Yet, when all is said and done, the God of the Jews and of the Christians did create the universe, and if this was nothing new in him, it certainly was the beginning of all newness in the created world itself. According to Christian theology, creative power belongs to God alone, and the world of creation owns no parcel of it. But it does not take a divine power to achieve novelty in the communication of existence and in the forming of man-made beings. This is what artists do. It is what modern painting has done in the highest degree, and, be it for this reason only, it deserves the careful consideration of philosophers, even perhaps of theologians.

Metaphysicians and theologians usually say that, since effects resemble their causes, created beings resemble their Creator. Because his very essence is to be the pure act of being, the world created by God is, or exists. Because this existence of the world is due to the efficacy of the divine power acting as a cause, we see all the beings included in God's creation causing, acting, and operating in their diverse ways and according to their different natures. Things, Thomas Aquinas liked to say, imitate God in that they are and in that they are causes. Such are the painters, whose works add to the beauty of the world. Painters are the makers of new visual forms whose proper function is to make intelligibility perceptible to human sight.

This is the most solid ground there is for speaking of a religious art. In a created universe whatever exists is religious because it imitates God in its operations as well as in its being. If what precedes is true, art, too, is religious in its very essence, because to be creative is to imitate, in a finite and analogical way, the divine prerogative, exclusively reserved for HE WHO IS, of making things to be. Now, as has already been seen, to make things be and to make them beautiful are one and the same thing.[17] Each artist, then, while exerting his often anguished effort to add new types of beings to those which make up the world of nature, should be conscious of the resemblance between his finite art and the infinitely perfect efficacy of the divine power. All truly creative art is religious in its own right.

By the same token, the meaning of the words "Christian art" becomes at once apparent. The problem does not arise in connection with picturing conceived as an art distinct from painting properly so called. Some religions exclude images; others do not hesitate to appeal to them as to visual aids in the teaching of religious truth. Christianity has always done so, the more willingly as, upholding the truth of the substantial unity of man, the Church has always associated, in both cult and prayer, the mind of man, his affectivity, and his activity. It seems therefore evident that picturing fulfills in Christian worship an important function, whose proper end is inscribed in its very nature and which cannot possibly reach this end without resorting to imitational art. The subject here is of primary importance, and nothing is more legitimate in it than to do what most creative artists would consider an abomination: to rely upon the subject more than upon the art as a source of emotion. In religious imagery, this is not only legitimate; it is necessarily required by its very end. He to whom a bare wooden cross does not suffice is perhaps not so wholly Christian as he should be; he who sees in a crucifix the thing of beauty it may well be, but nothing else, is not a Christian at all. The art of doing Christian pictures does not exclude the possibility of doing Christian paintings; by itself, however, it necessarily is representational art.[18]

This answer is but indirectly related to the problem of creative Christian art. On the contrary, the fact that all the main moments of human life have a religious significance lies at the very center of the question. Ever since the birth of Our Lord, the birth of every child is a nativity. There is, in a Christian universe made up of created beings, a direct invitation to artists to join in the praise of God by co-operating with his creative power and by increasing, to the extent that man can do so, the sum total of being and beauty in the world. This is the more instantly required when the works to be produced by human art are primarily destined to a specifically religious use. There then is an inner affinity between the intended end and the means to be employed to reach it. Religion can survive without art; it even survives in spite of the fact that its churches have largely become so many temples dedicated to the exhibition of industrialized ugliness and to the veneration of painted nonbeing. But when Christian artists are called upon to celebrate the glory of God by co-operating, in their modest human manner, with the work of creation, it becomes imperative that their own works be things of beauty. Otherwise, these works would not truly be, and the artists themselves would contribute nothing.

Notes

1. Vasari, painter and architect, born at Arezzo in 1511, died in Florence in 1574. His famous book, *The Lives of the Painters, Sculptors and Architects,* is found in an English translation by A. B. Hinds. This edition does not include the *Maniera* of Vasari, often prefixed to the *Lives* as introduction. It exists in a separate translation by Louisa Maclehose, *Vasari on Technique,* ed. G. B. Brown.— Since the definition of painting found in the *Maniera* has been generally overlooked, we beg to quote it in the Italian original: "Ora, avendo di cio [i.e., design] ragionato abbastanza, seguita che noi veggiamo che cose sia la pittura. Ell' è dunque un piano coperto di campi di colori in superficie o di tavola o di muro o di tela, intorno a' lineamenti deiti di sopra, i quali per virtù di un buon disegno di linee girate circondano la figura." "Introduzione alle tre arti," ch. 15, in *Le Opere di Giorgio Vasari,* vol. I, p. 38.

2. "By themselves and apart from their aptitude to imitate, colors as well as lines have a meaning. Our impression varies according to the way they are assembled. A painting is a colored surface on which the various tones and the various degrees of light are distributed with a certain choice; this is its intimate being; the fact that these tones and these degrees of light make up figures, draperies, or architectures is with them an ulterior property that does not prevent their primitive property from having all its importance and all its rights. The value proper to color is therefore enormous, and the decision made about it by painters determines the rest of their work" (vol. 2. 334–35). Taine wrote these words at the end of the second volume of this work, when it was too late for him to do anything with it. In fact, the whole trend of Taine's aesthetic is against it. One cannot help wondering if, when Taine was about to write the last sixteen pages of his *Philosophy of Art,* some charitable painter did not remind him that colors play an important part in painting.

3. Denis, "Définition du néo-traditionnisme," in *Théories,* p. 1. This same definition is restated, with an important addition, p. 27: "Before being a representation of any thing whatever, a painting is a plane surface covered with colors assembled in a certain order, *and for the pleasure of eye.*" This raises the problem of the final cause of the paintings. It will be considered separately in another section of this book.

4. Denis, *Charmes et leçons de l'Italie,* p. 177, n. 1.

5. Denis himself has sometimes abridged his formula: "The fruitful notion of the plane surface covered with colors assembled in a certain order...." ("The influence of Paul Gauguin," *Théories,* pp. 166–71). But some historians have deliberately reduced it to this sole element: "Remember that a picture ... is a plane surface covered with colors assembled in a certain order" (Bernard Dorival, *Les Étapes de la peinture française contemporaine,* vol. 1, p. 110). In this "axiom," the ellipsis stands for all that has been suppressed. Going further still, some critics reproach Denis with having eliminated from the notion of "painting" all that is not color: Charles Lalo, "Classification structurale des beaux-arts" in *Formes de l'art,* p. 20, n. 2. Lalo reduces Denis' definition to the following formula: "Visual perception of two-dimensional forms on a continuous surface." The notion of order has thus been replaced with that of forms. This substitution agrees with Lalo's description of painting as "a technical interpretation of the laws of theoretic optics" (p. 20); but men have painted masterpieces for millenniums without even suspecting the existence of optics and its laws. Denis' definition simply aimed at recovering a clear awareness of the essence of painting conceived precisely as one of the fine arts.

6. "I am now coming to the last element, a capital one, namely, color" (*La Philosophie de l'art,* II, 355). Despite his theories about climate, race, and so on, Taine did not completely overlook the fact that, at the origin of painting, there is an aptitude to feel pleasure at the sight of certain colors.

7. Some painters have practiced a voluntary asceticism with respect to color (see Denis, "Le Renoncement de Carrière," *Théories,* pp. 213–14), but nothing forbids us to call "painting" a preparation in black and white, such as, for instance, those of Seurat.—Black and white can be held to be, in a certain sense, colors. See *Webster's:* "All colors are divisible into two classes; *chromatic colors,* as reds, greens, purples, browns and pinks; *achromatic colors,* including black, white, and the series of grays intermediate between black and white, which differ from each other only in the degree of resemblance to white or difference from black." The notion of achromatic (i.e., colorless) colors appears paradoxical, not to say self-contradictory. But these problems of terminology should not prevent us from acknowledging the fact that light values suffice to constitute a painting.

8. If the principle of this distinction is accepted, usage will find the proper words to express it.

To *illustrate*, or *illustrating*, mainly applies to the kinds of images that accompany, as visual aids, the text of certain books. *Image making* had for a while detained our attention, but Lionel Trilling, whose advice we sought on this question, dissuaded us from using it, for the same reason that one would avoid *imagery*; these two words "too much suggest the poetic process, the process of metaphor." Another noun, *imaging* (from the verb "to image), also had to be eliminated because it "carries some overtones of the discussion of poetry." As far as we can see, *picturing* then remains the only possible candidate. A picture is a graphic representation of something. Trilling: "*Picturing* has to me the great advantage of a certain childish connotation: 'Picturebook,' 'See the pretty picture.' And *picturing* is exactly what a child does."

9. Religious art is imagery to the extent that iconography has something to say about it. Thus understood, art, like nature, is the Bible (i.e., the Book) in which believers see, or read, the object of their religious beliefs. This is important to some religions; for instance, not to Judaism or to Islamism, but very much to Christianity. As subservient to religious instruction, painting has produced unsurpassed masterpieces (the ceiling of the Sistine Chapel); it has also produced countless charming pictures, including all the Madonnas that are more rightly accounted lovely rather than beautiful, because they portray "that kind of woman who is lovable to those who love that kind of woman and in the attitude which is charming to those who are charmed by it" (Eric Gill, *Art-Nonsense*, p. 74); in fine, it has produced, and is still producing, a colossal number of artistically insignificant images, plus quite a few downright ugly ones, whose only justification, if there is one, is to serve the ends of religious instruction. On the contrary, if we forget about iconography, all true works of art are essentially religious, whereas all the works that present themselves as works of art but are not can be said to be (whatever they may represent) areligious. Eric Gill goes further still (pp. 72–73): "The most irreligious modern work is to be found in churches and, on the other hand, the most religious is that of the men of the so-called post-impressionist schools; for these men have dared to proclaim in their work that worship is properly given to that which is beautiful in itself and not to those things which please merely by entertaining us." As an example of "godly" art, Gill quotes that of Matisse (p. 173)— a statement that, made in 1929, was an astounding prophecy.

10. So-called "history painting," in all countries without exception, is largely dedicated to the exploitation of nationalistic passions. As it is now developing in Russia or in Mexico, art is frankly at the service of a class propaganda that in no way differs from the czarist, monarchist, or patriotic propagandas of the recent past. See the pronouncement attributed to Orozco: "A painting is a poem, and nothing else. A poem is made of relationships between forms as other kinds of poems are made of the relationships between words, sounds or ideas." ("Orozco 'Explains,'" *Bulletin of the Museum of Modern Art* 7 (Aug 1940), 4, and *Masters of Modern Art*, p. 156.) Those who look at his *Zapatistas*, or, for the matter, at the paintings of Diego Rivera, will not find their "poems" very different, in inspiration, from those dedicated by Louis David first to the French Revolution, then to Napoleon I.

11. A few indications should suffice for those who are not familiar with the facts in question. Since so-called religious art is still largely derived from the Italian Renaissance, see, in Vasari, how Fra Filippo Lippi selected his model for a picture of Our Lady (*Lives*, II, 4). This model became the unwed mother of Filippino Lippi. Even if the anecdote happened not be true, Vasari's remark would still be worth meditating: "He was so highly esteemed for his abilities that many blameworthy things in his life were covered over by his excellencies" (II, 6; cf. p. 7). There is something humorous in the simplicity with which religious books or magazines (we beg to be excused from quoting titles, years, and pages) hope to feed the piety of religious souls with "reproductions" of the Blessed Virgin by . . . Sodoma. They would certainly not dare to print the name of this painter, as they do, if the purity of their intentions did not keep them miles away from realizing its meaning. See Vasari, III, 289, 292; especially III, 141: "Giovannantonio was a brutal, licentious man whose vices had won him the name of Sodoma, of which he was rather proud."

12. Baudelaire, "The Modern Public and Photography," *The Mirror of Art*, pp. 225–31.

13. See Charles-Pierre Bru, *Esthétique de l'abstraction*, pp. 217–18 Cf., on this problem, the remarks made by Lionel Trilling (*The Opposing Self*, pp. 97–98). The nature of the difficulty appears in full view in the essay of Raoul Ergmann, "The Chances of a Dialogue; Berenson and Malraux," *Diogenes*, 7 (1954), 73–74. Incidentally, the chances of such a dialogue are nil: Berenson would have a great deal of listening to do. Still, the question itself is good (p. 73): "If art may not be subjected to the discipline of representation, what measure of its value can be proposed?" And again (pp. 73–74): In the compositions of Klee and Miró, even if pleasure is felt by the eye, we cannot judge of the "con-

formity [of the work] to a law which is as strict as it is secret." It is a hopeless undertaking to make a critic—who is a writer—understand that what he has to judge is the relationship between his own sensible pleasure and the painting, not the relationship between the painting and some externally given reality. To be sure, there is a secret there, but it is the critic's own secret as much as it is the painter's.

14. A soi-méme. p. 78.

15. This social function performed by the maker of images, so foreign to the activity of the painter, is well expressed in the "Letters to the Editors" In *The Saturday Evening Post* for April 16, 1955. For instance: "Re Norman Rockwell Album (March 12), I doubt if history has or will again portray a complete cycle of a generation of Americans with equal nostalgic emotional power." Again: "The Rockwell covers on your magazine seem as typically American as apple pie and the Dodgers." Again: "Surely no artist of any period has ever bettered Mr. Rockwell in delineating a given subject." However great they are, these merits are entirely foreign to the art of painting.—On the need of an aesthetics of picturing, see the penetrating views of Baudelaire, "On the Essence of Laughter, and, in General, on the Comic in Plastic Arts," *The Mirror of Art*, pp. 133–34. In 1855, Baudelaire was writing: "The task still remains to be done." The sentence remains largely true in 1956.

16. Thomas Aquinas, *Summa theologiae*, I, 45, 5, 1st obj. and answer.

17. The perfect formula is given by Eric Gill (*Beauty Looks After Herself*, p. 66): "Beauty—the word is a stumbling block. Do not let us stumble over it. Beauty is *the Splendour of Being*. The primary constituent of visible Being is Order."

18. In his *Théories,* Denis strongly protested against the excesses of the "expression by the subject" in religious art. In 1896, he did not hesitate to write that, although a masterpiece, it was with Vinci's *Last Supper* that religious painting "entered the way to perdition." If he represents a subject endowed with an emotional value of its own, as was here the case, the painter does not act upon our emotions through his work, but through his subject. The way was then open to Munkácsy, Tissot, "and all that is worse in religious art." From then on, it was going to be the subject alone that, in religious painting, would invite to worship (pp. 41–42). This perhaps is the shortest definition of the art Philistine: "He does not look at the painting; he sees nothing but the subject."

19

The Sexuality of Christ in
Renaissance Art and in Modern Oblivion

LEO STEINBERG

The first necessity is to admit a long-suppressed matter of fact: that Renaissance art, both north and south of the Alps, produced a large body of devotional imagery in which the genitalia of the Christ Child, or of the dead Christ, receive such demonstrative emphasis that one must recognize an *ostentatio genitalium* comparable to the canonic *ostentatio vulnerum*, the showing forth of the wounds. In many hundreds of pious, religious works, from before 1400 to past the mid-16th century, the ostensive unveiling of the Child's sex, or the touching, protecting or presentation of it, is the main action (Fig. 1). And the emphasis recurs in images of the dead Christ, or of the mystical Man of Sorrows. All of which has been tactfully overlooked for half a millennium. Hence my first question—whether the outgoing 20th century is late enough to concede that the subject exists.

My second objective is to propose plausible theological grounds for the genital reference in the works under review. Sooner or later someone is bound to notice what the priest's right hand is doing; to prevent it is not in our power. The question is in what spirit—whether in ribaldry or in reverence, frankly or nervously—the discovery is to be made, and made public.

My third concern is didactic. At the risk of belaboring what is obvious, I must address myself to the many who still habitually mistake pictorial symbols in Renaissance art for descriptive naturalism. To take one example: At the sight of an infant Christ

touching the Virgin's chin, they will admire the charm of a gesture so childlike, playful, affectionate. They are not wrong, but I think they are satisfied with too little. For the seeming artlessness of what I shall call the chin-chuck disguises a ritual form of impressive antiquity. It is first encountered in New Kingdom Egypt as a token of affection or erotic persuasion. In Archaic Greek painting the gesture is given to wooers, and it occurs more than once in the *Iliad* to denote supplication.[1] In Late Antique art, the caress of the chin is allegorized to express the union of Cupid and Psyche, the god of Love espousing the human soul. And the gesture proliferates in medieval art into representations both of profane lovers and of the Madonna and Child. Thus no Christian artist, medieval or Renaissance, would have taken this long-fixed convention for anything but a sign of erotic communion, either carnal or spiritual. By assigning it to the Christ Child, the artist was designating Mary's son as the Heavenly Bridegroom who, having chosen her for his mother, was choosing her for his eternal consort in heaven. The chin-chuck, then, betokens the Infant Spouse (a phrase I take from St. Augustine[2])—whether the action appears naturalized on earth, or enskied (Fig. 2).

In decoding such ostensible genre motifs as the chin-chuck, our charge is to remain undeceived by their verisimilitude. If the depicted gesture was made to look common, imputable to any mother's child, the intent was not to diminish but, on the

From Leo Steinberg, *The Sexuality of Christ in Renaissance Art and in Modern Oblivion*. New York: A Pantheon/October Book, 1983, pp. 1–23, 71–72, 107–8. Reprinted with permission of Pantheon Books and the author.

FIGURE 1. Illumination from the Hours of Philip the Good, *Presentation in the Temple*, 1454–55. The Hague, Koninklijke Bibliotheek, ms. 76, fol. 141v.

contrary, to confirm the mystery of the Incarnation. Lifelikeness posed no threat, because these Renaissance artists regarded the godhead in the person of Jesus as too self-evident to be dimmed by his manhood. What they did not anticipate was the retroactive effect that four centuries of deepening secularism would have on the perception of Renaissance art. They did not foresee that the process of demythologizing Christianity would succeed in profaning our vision of their sacred art; so that now, most modern viewers are content to stop at the demythicized image—a human image drawn to all appearances from the natural world, far afield from the mysteries of the Creed. Could it be that Renaissance artistry, striving for truthful representation, became too competent for its own good? Rapt in the wonder of God's assumed human nature, Renaissance artists will have produced work whose win-

FIGURE 2. Barent van Orley,
Madonna and Child with Angels
(detail), c. 1513. New York, The
Metropolitan Museum of Art,
Bequest of Benjamin Altman.

ning naturalism was rendered in retrospect self-defeating. Wherever, in humanizing their Christ, they dared the most, we now see nothing out of the ordinary; as though the infant Christ or the adult's corpse were mere pretexts for exhibiting common humanity.

Accordingly, at the sight of a dead Christ touching his groin, we are told not to wonder because dying men often do this—as if the alleged frequency of the posture in male human corpses justified its allocation to Christ on sacred monuments. Similarly, a picture such as Veronese's *Sacra Conversazione* (Uffizi)—four amazed saints gathered about a blithe sleeper—elicits the explanation that "it's what baby boys do." And the outrage of Hans Baldung Grien's *Holy Family* woodcut (Fig. 3) is shrugged off on the grounds that "it's what grandmothers do." Perhaps; but how comes it that the only baby in Western art so entertained is the Christ?

The Baldung Grien woodcut shows the Christ Child subjected to genital manipulation. How should this curiosity be perceived? Shall we hurry past it with stifled titters, or condemn it as scandalous? No matter what the response, one feels that St. Anne's gesture, fondling or testing her grandchild's penis, is a liberty without parallel in Christian art. Yet the action is staged in solemnity, and as the central motif of a work that does not seem scurrilous in intention. One remains at a loss for alternatives, wanting an appropriate context. The thing demands explanation, or at least some explaining away.

Explaining away has been tried. Until the 1981 Baldung Grien exhibition in Washington and New Haven, it was the recourse of the foremost Baldung scholar Carl Koch. Koch interpreted St. Anne's gesture in the light of the artist's known interest in folk superstition—witness Baldung's fascination by witches. But, he continued, Baldung displays "even

FIGURE 3. Hans Baldung Grien,
Holy Family, woodcut, 1511.

deeper insight into arcane popular customs believed
to possess magic powers. Thus, under pretext of
representing the pious companionship of the Holy
Family, he dares make the miracle-working spell
pronounced over a child the subject of a woodcut
composition."[3]

This is all we were told. The nature of this sup-
posed spell, whether fecundative or apotropaic, was
not divulged. But Koch's purpose was unmistak-
able: to forestall any suspicion of impudence on Bal-
dung's part. We were urged instead to applaud the
artist's inquiry into secret peasant beliefs, his antic-
ipation of modern anthropological attitudes. In his
woodcut, the grandam's gesture, so far from being
prurient or frivolous, was to be understood as a rec-
ord of Baldung's fieldwork among the folk. Mean-
while, the woodcut's overt Christian subject was

reduced to the role of a cover. Apparently, the ges-
ture portrayed would have been too indelicate to
stage in a peasant setting, visited on some nameless
child; but with the Christ Child anything goes.

An alternative mode of evasion argues the case in
reverse: St. Anne's conduct, we hear, is not an arca-
num discovered in folk superstition, but a silly genre
motif—no further explanation required. We are
asked to recall that the practice of admiring and
handling a male infant's genitals was formerly com-
mon in many cultures, so that Baldung would have
represented no more than a routine occasion in a
typical household. Philippe Ariès actually cites Bal-
dung's woodcut to document what he calls the once
"widespread tradition" of playing with a child's
privy parts.

What is involved here is a misunderstanding of a

critical truth: that naturalistic motifs in religious Renaissance art are never adequately accounted for by their prevalence in life situations. Ordinary experience is no template for automatic transfer to art. There are many things babies do—crawling on all fours, for instance, before they start walking—which no artist, however deeply committed to realism, ever thought of imputing to the Christ Child. For the infant Christ, in Renaissance as in medieval art, is like no other child, whether he sits up to give audience, or rehearses the Crucifixion; whether he hands the keys of the kingdom to Peter, or snatches a makeshift cross from his playmate St. John. He engages in actions, such as eating grapes, or perusing a book, from which common babies desist. And long before normal toddlers learn to put round pegs in round holes, he deftly slips a ring on St. Catherine's finger. In short, the depicted Christ, even in babyhood, is at all times the Incarnation—very man, very God. Therefore, when a Renaissance artist quickens an Infancy scene with naturalistic detail, he is not recording this or that observation, but revealing in the thing observed a newfound compatibility with his subject.

This rule must apply as well to the palpation of the Child's privy parts. The question is not whether such practice was common, but how, whether common or not, it serves to set Mary's son apart from the run of the sons of Eve. Thus we still have to ask what Baldung thought he was doing when he offered the Infant's penis to the grandmother's touch.

I answer, provisionally, that the presentation centers on an ostensive act, a palpable proof—proving nothing less than what the Creed itself puts at the center: God's descent into manhood. And because grandmother Anne guarantees Christ's human lineage, it is she who is tasked with the proving. Observe that while the Child's lower body concedes its humanity, the arms reach for the Virgin, one hand of the Infant Spouse exposing the ear through which the Word entered, the other grasping her chin. Meanwhile, a contemplative Joseph looks on. Book laid aside, he watches the revelation direct, the first man to behold it with understanding.

There is something here that we are expected to take for granted—here as in all religious Renaissance art: that the divinity in the incarnate Word needs no demonstration. For an infant Christ in Renaissance images differs from the earlier Byzantine and medieval Christ Child not only in degree of naturalism, but in theological emphasis. In the imagery of earlier Christianity, the claims for Christ's absolute godhood, and for his parity with the Almighty Father, had to be constantly reaffirmed against unbelief—first against Jewish recalcitrance and pagan skepticism, then against the Arian heresy, finally against Islam. Hence the majesty of the infant Christ and the hieratic posture; and even in the Byzantine type known as the Glykophilousa, the "Madonna of Sweet Love," the Child's ceremonial robe down to the feet. In Otto Demus' words: "The Byzantine image ... always remains an 'image,' a Holy Icon, without any admixture of earthly realism."[4] But for a Western artist nurtured in Catholic orthodoxy—for him the objective was not so much to proclaim the divinity of the babe as to declare the *humanation* of God.[5] And this declaration becomes the set theme of every Renaissance Nativity, Adoration, Holy Family, or Madonna and Child.

I have learned much from John O'Malley's recent book, *Praise and Blame in Renaissance Rome*—a masterly study that deals for the first time with the sermons delivered at the papal court between the years 1450 and 1521. O'Malley quotes this admonition to preachers from a late 15th-centruy author (Brandolini): "Whereas in earlier times men had to search for the truth and dispute about it, in the Christian era men are to enjoy it."[6] The preacher is not to waste words persuading believers to belief. His office is to stir men to gratitude and delight. The sermons, accordingly, dwell on the boon conferred by the Incarnation; to which the Christian's proper response is admiration and praise.

Now, "what man praises most especially in God are his works and deeds." Of these, the first was the act of Creation; but his second great "deed" was his becoming flesh and dwelling on earth. And the sermons affirm that God's first accomplishment was surpassed in the second, since the former had proved corruptible through man's sin, but the latter, which redeems from corruption, is good forever.[7]

"The theology of the Western Church," writes O'Malley, "has generally tended to pinpoint the redemptive act in Christ's death on the cross, or in the conjunction of his suffering, death, and resurrection."[8] The more surprising to hear the Renaissance preachers emphasizing the preeminence of the Incarnation. "That emphasis," O'Malley continues, "wants to view all the subsequent events of Christ's life as articulations of what was already inchoately accomplished in the initial moment of man's restoration, which was the incarnation in the Virgin's womb.... Whatever injury man and the universe had suffered in the Fall was healed ... when the Word assumed flesh."[9]

Shall this insight stop at the work of the preachers? It seems to me—and O'Malley concurs—that the "incarnational theology" which he finds in the Renaissance sermons is immanent in earlier and contemporaneous Renaissance art. So much of this

art is a celebration; so much of it proclaims over and over that godhood has vested itself in the infirmity of the flesh, so as to raise that flesh to the prerogatives of immortality. It celebrates the restoral which the divine power brought off by coming to share man's humanity.

And this supreme feat of God, superior even to the primordial act of Creation, is perpetually manifest in the Incarnation, that is to say, here and now in this armful of babyflesh.[9] The wonder of it, and its constant reaffirmation—this mystery is the stuff of Renaissance art: the humanation of God; the more "superwonderful" (St. Bonaventure's word) the more tangible you can make it.

Thus is the realism of Renaissance painting justified in the faith. The rendering of the incarnate Christ ever more unmistakably flesh and blood is a religious enterprise because it testifies to God's greatest achievement. And this must be the motive that induces a Renaissance artist to include, in his presentation of the Christ Child, even such moments as would normally be excluded by considerations of modesty—such as the exhibition or manipulation of the boy's genitalia. Returning once more to the action in Baldung's woodcut (Fig. 3): if this sort of conduct was routine in Renaissance families, no representation of it would be made, except only in the imagery of the Christ Child, since no other child born of woman needed to have its ordinary humanity brought home and celebrated. Whence it follows that the central action in Baldung's woodcut could be at the same time trite and unique; reflective of vulgar practice and special to Christ. We apprehend the event because it is commonplace; and condone its depiction because it touches Christ. And the same principle holds for the self-touching posture of the corpse following the descent from the cross: the artists who introduced the motif understood it as human; they depicted the gesture because its performance was God's.

The image, then, is both natural and mysterial, each term enabling the other. But this reciprocal franchise is peculiar to the Catholic West, where the growth of a Christward naturalism in painting is traceable from the mid-13th century. Of course, the West held no monopoly on the affirmation of Christ's humanity. Every right-thinking Christian, whether Latin or Greek, artist or otherwise, confessed that the pivotal moment in the history of the race was God's alliance with the human condition. But in celebrating the union of God and man in the Incarnation, Western artists began displacing the emphasis, shifting from the majesty of unapproachable godhead to a being known, loved, and imitable.[10] Where the maker of a Byzantine cult image enthroned the incarnate Word as an imperial Christ, satisfied that the manhood of him was suf-

ficently evident in his filiation from Mary, the art of the West sought to realize that same manhood as the common flesh of humanity. Realism, the more penetrating the better, was consecrated a form of worship.

Yet it remains to ask how a direct demonstration of the incarnate God's human nature justifies a select sexual accent. Christ's manhood, yes, by all means, but why these particular means? Why should there exist even one Christian painting, such as Botticini's *Nativity* tondo in Florence, where angels vent their joy at God's human birth by bestrewing his pudenda with flowers? Two thousand years earlier, Heraclitus had said: "If it were not Dionysus for whom they march in procession and chant the hymn to the phallus, their action would be most shameless."[11] What then is it in the Christian mystery of the Incarnation that could move its Renaissance celebrants to such venial "shamelessness"? The question leads to three theological considerations that bear ineluctably on Christ's sex.

The eternal, by definition, experiences neither death nor generation. If the godhead incarnates itself to suffer a human fate, it takes on the condition of being both deathbound and sexed. The mortality it assumes is correlative with sexuality, since it is by procreation that the race, though consigned to death individually, endures collectively to fulfill the redemptive plan.[12] Therefore, to profess that God once embodied himself in a human nature is to confess that the eternal, there and then, became mortal and sexual. Thus understood, the evidence of Christ's sexual member serves as the pledge of God's humanation.

Other modalities of this pledge come to mind, notably the Christ Child's dependence on nourishment; for the iconic type of the nursing Madonna did not enter the repertory of Christian art because painters saw mothers breastfeed their children, and not merely to display the Madonna's humility, as suggested by Millard Meiss, but to attest once again the truth of the Incarnation. This is why the Virgin gives suck even in formal sessions, as when she sits to St. Luke for her portrait. This is why the nursling is so often depicted turning his face to alert our attention; or, more incongruously, with his mouth engaged and eyes forward, striding toward us; or even *sub specie aeternitatis,* moon-cradled above the clouds, still owning his erstwhile need. The image of the *Maria lactans,* popular since the mid-14th century, assured the believer that the God rooting at Mary's breast had become man indeed; and that she who sustained the God-man in his infirmity had gained infinite credit in heaven. We do not suppose that every painter of a nursing Madonna meditated

the underlying theology—the meaning of the subject was plain: Christ has to eat. His taking food, initially as an infant and lastly again at Emmaus, tendered the living proof that the substance assumed by the Trinity's Second Person, whether aborning or raised from death, was human flesh subject to hunger.

As for the sexual component in the manhood of Christ, it was normally left unspoken, suppressed originally by the ethos of Christian asceticism, ultimately by decorum. In theological writings the matter hardly appears, except, as we shall see, in connection with the Circumcision. The admission of Christ's sex occurs commonly only by indirection or implication. Thus the humanity taken on by the Word in Mary's womb was said to be—in the locution current from St. Augustine to the 17th century—"complete in all the parts of a man."[13] From the preacher or theologian, no further anatomic specification was needed.

But for the makers of images the case stood otherwise. We have to consider that Renaissance artists, committed for the first time since the birth of Christianity to naturalistic modes of representation, were the only group within Christendom whose métier required them to plot every inch of Christ's body. They asked intimate questions that do not well translate into words, at least not without disrespect; whether, for instance, Christ clipped his nails short, or let them grow past the fingertips. The irreverent triviality of such inquisitions verges on blasphemy. But the Renaissance artist who lacked strong conviction on this sort of topic was unfit to fashion the hands of Christ—or his loins. For even if the body were partly draped, a decision had to be made how much to cover; whether to play the drapery down, or send it fluttering like a banner; and whether the loincloth employed, opaque or diaphanous, was to reveal or conceal. Only they, the painters and sculptors, kept all of Christ's body in their mind's eye. And some among them embraced even his sex in their thought—not from licentiousness, but in witness of one "born true God in the entire and perfect nature of true man, complete in his own properties, complete in ours."[14]

My second consideration pertains to the Christ of the Ministry. When they visualized Jesus adult and living, artists did not, as a rule, refer to his sex—except perhaps in the manner chosen at certain times to render Christ's nudity at the Baptism. For the rest, the sexual reference tends to polarize at the mysteries of Incarnation and Passion; that is to say, it occurs either in Infancy scenes or in representations of Christ dead or risen. Here the oeuvre of Andrea del Sarto is paradigmatic. Twice does it summon us to see Christ place his hand in his groin—once as a laughing child, and again, with disturbing likeness, in a drawing for a *Pietà*. The crucified God is one with the frolicking infant; end and beginning agree.

Between these poles lies the earthly career of Jesus of Nazareth. And that he, the Christ of the Ministry, was ever-virgin no sound believer may doubt. "A man entirely virginal," says Tertullian. St. Methodius (3rd century) dubs him Arch-virgin and bridegroom, whose success in preserving the flesh "incorrupt in virginity" is to be viewed as the chief accomplishment of the Incarnation. St. Jerome calls Christ "our virgin Lord,"—"a virgin born of a virgin"; and explains that "Christ and Mary . . . consecrated the pattern of virginity for both sexes." Photius (9th century) urges "those not yet married [to] offer virginity; for nought is so sweet and pleasing to the Ever-Virgin." The doctrine draws scriptural support from the passage in Matthew (19:12), where Christ commends those who have made themselves "eunuchs for the sake of the kingdom of heaven."

Needless to say, this precept was not meant to be taken literally; it was not to be misconstrued as a plea for physical disability or mutilation. Virginity, after all, constitutes a victory over concupiscence only where susceptibility to its power is at least possible. Chastity consists not in impotent abstinence, but in potency under check. In Christological terms: just as Christ's resurrection overcame the death of a mortal body, so did his chastity triumph over the flesh of sin. It was this flesh Christ assumed in becoming man, and to declare him free of its burden, to relieve him of its temptations, is to decarnify the Incarnation itself.[15] It follows that Christ's exemplary virtue and the celebration of his perpetual virginity again presuppose sexuality as a *sine qua non*.

My third consideration concerns Christ in the character of Redeemer. His manhood differs from that of all humankind in one crucial respect, which once again involves the pudenda: he was without sin—not only without sins committed, but exempt from the genetically transmitted stain of Original Sin. Therefore, applied to Christ's body, the word "pudenda" (Italian: *le vergogne;* French: *parties honteuses;* German: *Schamteile*—"shameful parts") is a misnomer. For the word derives from the Latin *pudere*, to feel or cause shame. But shame entered the world as the wages of sin. Before their transgression, Adam and Eve, though naked, were unembarrassed; and were abashed in consequence of their lapse. But is it not the whole merit of Christ, the New Adam, to have regained for man his prelapsarian condition? How then could he who restores human nature to sinlessness be shamed by

the sexual factor in his humanity? And is not this reason enough to render Christ's sexual member, even like the stigmata, an object of *ostentatio?*[16]

Modesty, to be sure, recommends covered loins; and the ensuing conflict provides the tension, the high risk, against which our artists must operate. But if they listened to what the doctrine proclaimed; if even one of them disdained to leave its truth merely worded, wanting it plain to see in paint or marble; if such a one sought to behold Christ in a faultless manhood from which guilt was withdrawn, that is to say, as a nakedness immune to shame; if one such Renaissance artist held his idiom answerable to fundamental Christology so as to rethink the doctrine in the concretion of his own

art; then, surely, conflict—if not within himself then with society—was unavoidable. He would be caught between the demands of decorum, lest the sight of nobly drawn genitalia further inflame the prurience of human nature, and the command, deeply internalized, to honor that special nature whose primal guiltlessness would be disgraced by a "garment of misery."[17]

We are faced with the evidence that serious Renaissance artists obeyed imperatives deeper than modesty—as Michelangelo did in 1514, when he undertook a commission to carve a *Risen Christ* for a Roman church (Fig. 4). The utter nakedness of the statue, complete in all the parts of a man, was thought by many to be reprehensible. It is hardly

FIGURE 4. Michelangelo, *Risen Christ*, marble, 1514–20. Rome, Sta. Maria sopra Minerva.

surprising that every 16th-century copy—whether drawing, woodcut, engraving, bronze replica, or adaptation in marble—represents the figure as aproned; even now the original statue in Sta. Maria sopra Minerva stands disfigured by a brazen breech-clout. But the intended nudity of Michelangelo's figure was neither a licentious conceit, nor a thoughtless truckling to antique precedent. If Michelangelo denuded his *Risen Christ,* he must have sensed a rightness in his decision more compelling than inhibitions of modesty; must have seen that a loincloth would convict these genitalia of being "pudenda," thereby denying the very work of redemption which promised to free human nature from its Adamic contagion of shame.[18]

That Michelangelo conceived his figure of Christ *all'antica* is evident; the common charge that he did so to the detriment of its Christian content does not cut deep enough. We must, I think, credit Michelangelo with the knowledge that Christian teaching makes bodily shame no part of man's pristine nature, but attributes it to the corruption brought on by sin. And would not such Christian knowledge direct him to the ideality of antique sculpture? Where but in ancient art would he have found the pattern of naked perfection untouched by shame, nude bodies untroubled by modesty? Their unabashed freedom conveyed a possibility which Christian teaching reserved only for Christ and for those who would resurrect in Christ's likeness: the possibility of a human nature without human guilt.

Yet the nakedness of Michelangelo's marble differs significantly in one respect from the nudity of antique statues: those ancients continued nude as they had been immemorially; Michelangelo's monumental Christ stood newly denuded. The former are innocent, prelapsarian in the sense that they precede Christian shame; the latter overbears shame in the person of Christ resurrected. I shall be told, perhaps, that the word "prelapsarian" applied to pre-Christian paganism is theologically preposterous; and so it is. But it reflects a cherished persuasion of Renaissance humanists. We find a striking expression of their belief in the *Hieroglyphica* of Pierio Valeriano. Setting out to discuss the ancient symbolism of the human pudenda, Valeriano excuses his subject with the following exordium: "Antiquity, being less vicious, philosophized more plainly and frankly about each and every thing; nor was there at that time anything in the human body which was considered disgraceful [*turpis*] either by sight or name. However, with the development of bad customs, many things had to be declared foul both in deed and in speech. . . ."[19]

Note that Valeriano's periodization consigned the "development of bad customs" to post-antiq-

uity—just as Vasari ascribed the degeneracy of art to the Christian age. The preceding phase was designated "less vicious" *(minus vitiosa),* therefore rightly unencumbered by shame. Christians of a more theological bent would have attributed pagan shamelessness to moral idiocy, postlapsarian ignorance. But neither Valeriano nor Michelangelo saw ignorance shine in the works of the ancients; nor evidence of Original Sin. This is why Michelangelo in his most Christian moments could look to antiquity for the uniform of the blessed. Whatever paganism informed his *Risen Christ* was there as the form of a Christian hope—the eschatological promise of redemption which promised to free human nature sinlessness concretely embodied.

I am inclined to read the same promise in a startling invention of the 15th century that has never yet been described, though it recurs often enough: the motif of the infant Christ, in childlike innocence, earnestly or in play, pulling his dress aside to expose his sex. It was surely the honest charm of the action that earned it a welcome in both Flanders and Florence, and endeared it to artists as diverse as Roger van der Weyden and Antonio Rossellino. In each man's work, the same spirited demonstration: a droll little boy chuckling, lifting his bib, invites us to see—the morosest of iconographers might wish to protect such a frisk from the pall of theology.[20] Yet the subject is Christ. And in making the Child's self-display the crux of a devotional image, the deep-thinking Roger was assuredly meditating his subject and thinking Christ. Nor can I believe even the elegant Rossellino unmindful of his protagonist's character. He too meant Mary's Child for no less than the Incarnation. What these artists relished in the motif was, I submit, its reconcilement of sexual exposure with innocence. For as the first effect of Paradise lost was the punishing shame of the pudenda, so the acceptable sign of restoral is the uncovering of the New Adam, in token of Eden regained.

These, then, are my three initial considerations. The first reminds us that the humanation of God entails, along with mortality, his assumption of sexuality. Here, since the verity of the Incarnation is celebrated, the sex of the newborn is a demonstrative sign.

In the second consideration, touching Christ's adult ministry, sexuality matters in its abeyance. Jesus as exemplar and teacher prevails over concupiscence to consecrate the Christian ideal of chastity. We have no call to be thinking of private parts.

But we do again on the third turn. Delivered from sin and shame, the freedom of Christ's sexual member bespeaks that aboriginal innocence which in Adam was lost. We may say that Michelangelo's

naked Christs—on the cross, dead, or risen—are, like the naked Christ Child, not shameful, but literally and profoundly "shame-less."

The candor of Michelangelo's naked Redeemer consummates a development traceable through two and a half centuries of devotional art. Representative instances run in the hundreds. But I should feel defeated were these works taken as illustrations of texts, or of theological arguments. On the contrary: the pictures set forth what perhaps had never been uttered. They are themselves primary texts, and the truisms I have recited were extrapolated from them as their precondition. To put it another way: it is not that the pictures and sculptures parallel any preformed sexual Christology, but that this wants to be formulated to render the works accessible in their wholeness, with their deep content intact. Were it not for the imagery of Fra Filippo Lippi, Bellini, and Michelangelo, of Roger van der Weyden and Schongauer, of Andrea del Sarto and Veronese, my theological considerations could not and need not have been entertained. Without the austerity of these works, without their grave beauty and religious conviction, no theology involving Christ's sexual member can exist without scandal.

The Incarnation of the Trinity's Second Person is the centrum of Christian orthodoxy. But we are taught that the godhead in Christ, while he dwelled on earth, was effectively hidden—insufficiently manifest for the Devil to recognize, obscured even from Christ's closest disciples (Mark 8:27–30; Matt. 16:13–20), apparent only to a handful of chosen initiates and a few beneficiaries of his miracles.[21] By the testimony of Scripture, the manhood in Christ, though free from ignorance and sin, was otherwise indistinguishable—not because the protagonist of the Gospels assumed a deceptive disguise (like a godling in pagan fable), but because he took real flesh in a woman's womb and endured it till death.

This much Christendom has professed at all times. Not so Christian art. For when a depictive style aims at the other-worldly; when the stuff of which human bodies are formed is attenuated and subtilized; when Christian representations of Christ, dismayed by the grossness of matter, decline to honor the corporeality God chose to assume—then, whatever else such art may be after, the down-to-earth flesh of the bodied Word is not confessed. It is arguable from a stylistic viewpoint—at least in retrospect and from a Renaissance vantage—that the hieratic Christs of Byzantine art are better adapted to Gnostic heresies than to a theology of Incarnation; for, to quote Otto Demus again, "The

Byzantine image . . . always remained a Holy Icon, without any admixture of earthly realism." But for those Western Christians who would revere the Logos in its human presence, it was precisely an "admixture of earthly realism" that was needed to flesh out the icon. And because Renaissance culture not only advanced an incarnational theology (as the Greek Church had also done), but evolved representational modes adequate to its expression, we may take Renaissance art to be the first and last phase of Christian art that can claim full Christian orthodoxy. Renaissance art—including the broad movement begun c. 1260—harnessed the theological impulse and developed the requisite stylistic means to attest the utter carnality of God's humanation in Christ. It became the first Christian art in a thousand years to confront the Incarnation entire, the upper and the lower body together, not excluding even the body's sexual component. Whereat the generations that followed recoiled, so that, by the 18th century, the Circumcision of Christ, once the opening act of the Redemption, had become merely bad taste. When Goethe reports on Guercino's *Circumcision of Christ,* a painting he admired in the artist's birthplace at Cento in mid-October 1786, he speaks of it in the simper of polite conversation: "I forgave the intolerable subject and enjoyed the execution."[22] And a standard modern reference work by Louis Réau explains that the Circumcision dropped out of Christian iconography because of the subject's "indecency."[23] Both authors unwittingly abrogate the special status of the body of Christ—the exemption of Christ's nakedness from the mores of Christendom.

We are left with a cultural paradox: Renaissance artists and preachers were able to make Christian confession only by breaking out of Christian restraints.

Hence the abundant genital emphasis in many of the most cherished creations of Renaissance art, as when the Christ Child, waking or sleeping, fingers his privy parts; more rarely, but unmistakably, when his penis appears erect, demonstrating in the Infant that physiological potency without which the chastity of the man would count for naught; or when the Virgin lays a protective hand on the child's groin, as if to acknowledge and shield his vulnerable humanity.

A like emphasis recurs in hundreds of images of the dead Christ—sometimes by indirection, as when the loincloth of the Crucified is exalted into huge fluttering streamers; or when the deposed body's left hand, in a gesture tensed to a vital grasp, rests on the loincloth. Surely the dead Christ is here visualized in the totality of a promise fulfilled. His Passion completed, he points back to its beginning,

much as his blood may be shown to run from the last wound back to the first—as if to say *consummatum est*. In the joining of first and last, the Passion is brought to perfection.

Whether the hand-on-groin gesture is performed by the corpse or the grieving mother, its sign character is apparent. And a sign it remains in a fifteenth-century Flemish subgroup of the type known as the Trinity, or Throne or Grace. Normally, in these visionary images, the Second Person is posed upright, indicating with the right hand the last wound received. But the works I have in mind differ from the more common type in directing the Father's left hand to the Son's groin (Fig. 5). Like the symbolic "blood hyphen," the two pointing hands span the Alpha and Omega of the Passion, the *ostentatio genitalium* complementing the requisite *ostentatio vulnerum*. We are shown once more that the incarnate Word died as a full-fraught man, triumphant over both sin and death; his sexuality vanquished by chastity, his mortality by Resurrection.

There is something disquieting in these presentations; and this leads me, hesitantly, to a final reflection of the kind I have sought to avoid. It will not have escaped the reader that my discussion has left out of account all psychological considerations; such factors as may operate in the Christological creed itself, and such psychic determinants as may have influenced individual artists. As to the first, I gladly leave it to students of disciplines other than mine. Nor am I inclined to speculate on the inner motives of painters who chose to involve the sexuality of Christ in their iconography. If personal or subconscious drives motivated this or that artist in his approach to the Christ theme, these drives were ultimately subordinated to his conscious grasp of the subject, since the treatment he accorded the subject must be compatible with the liturgical function which the work was to serve—often as a commissioned altarpiece in a place of public worship. And monumental images of the Trinity were certainly destined for altars. Their meaning, as I understand it, was to give visible form to a climactic liturgical moment, the moment of the petition in the rite of the Roman Mass when, at the transubstantiation of the Eucharistic species into the sacramental body of Christ, that body sacrificed is offered to the Father with prayers for its acceptance. The Throne of Grace, as the Apostle called it (Hebrews 4:16), is the idea of the sacrificed Son in his acceptability to the Father. Visualized as the triune godhead enriched by the humanity of the Second Person, it had been a familiar theme since the 12th century.

But what makes the images I am citing rare and psychologically troubling is the Father's intrusive gesture, his unprecedented acknowledgment of the Son's loins (Fig. 5). Nothing in received iconography sanctions it; and common intuition proscribes it. Joyce's Stephen Dedalus speaks of the steadfast bodily shame by which sons and fathers are sundered.[24] He perceived their severance, the distancing of their persons through shame of body, as the way of all flesh. And precisely this shame caves in now before our eyes. Natural distance collapses in this coalition of Persons wherein the divine Father's only-begotten is (as theology has it) a virgin, virginally conceived; enfleshed, sexed, circumcised, sacrificed, and so restored to the Throne of Grace; there symbolizing not only the aboriginal unity of the godhead, but in its more dramatic, more urgent message, a conciliation which stands for the atonement, the being-at-one, of man and God. For this atonement, on which hinges the Christian hope of salvation, Northern Renaissance art found the painfully intimate metaphor of the Father's hand on the groin of the Son; breaching a universal taboo as the fittest symbol of reconcilement. Such a symbol can only have sprung from an artist attuned to the deep undertow of his feelings. And it would not surprise me if its originator turned out to be, once again, Roger van der Weyden. It is perhaps more surprising that a handful of artists understood the metaphor well enough to adopt and to imitate it—before everybody was educated into incomprehension. But this incomprehension—the "oblivion" to which the title of this essay refers—is profound, willed, and sophisticated. It is the price paid by the modern world for its massive historic retreat from the mythical grounds of Christianity.

A few words more. The field I have tried to enter is unmapped, and unsafe, and more far-reaching than appears from my present vantage. Much of what I have said is conjectural and surely due for revision. I can hardly claim, as St. Bernard does in closing his eighty-second sermon on the Song of Songs: "We need have no regrets for anything we have said; it is all supported by unquestioned and absolute truth." But I have risked hypothetical interpretations chiefly to show that, whether one looks with the eye of faith or with a mythographer's cool, the full content of the icons discussed bears looking at without shying. And perhaps from one further motive: to remind the literate among us that there are moments, even in a wordy culture like ours, when images take their life from no preformed program and become primary texts. Treated as illustrations of what is already scripted, they withhold their secrets.

FIGURE 5. Swabian, *Throne of Grace with Saints,* wood sculptures, c. 1510. Boston, Isabella Stewart Gardner Museum.

Notes

1. *Iliad,* I, 501–02; VII, 370–71; X, 454–55.

2. St. Augustine speaks of "His appearance as an Infant Spouse, from his bridal chamber, that is, from the womb of a virgin"; Augustine, Sermon IX, 2 (Ben. 191); *Sermons for Christmas and Epiphany,* trans. T. C. Lawler (Ancient Christian Writers, 15). Westminster, Md., 1952, p. 109. See also Sermon X, 3, pp. 115–16, for the theme of the Infant Spouse, the Virgin's womb as bride chamber, and the Incarnation of the Word "by a marriage which it is impossible to define."

3. Carl Koch in Staatliche Kunsthalle Karlsruhe, *Hans Baldung Grien,* exh. cat., Karlsruhe, 1959, pp. 17 and (summary) 241.

4. Otto Demus, "The Methods of the Byzantine Artist," *The Mint,* no. 2 (1948), p. 69.

5. The English word "humanation," obsolete since it was ousted in the 17th century by "incarnation," deserves a place in the active vocabulary; it has at least some of the force of the German *Menschwerdung.* Meanwhile, the Italians never let go of the word, still singing at Christmastide "Cristo è nato e humanato."

6. O'Malley, *Praise and Blame in Renaissance Rome: Rhetoric, Doctrine and Reform in the Sacred Orators of the Papal Court, c. 1450–1521,* Durham, North Carolina, 1979, p. 70, n. 97, gives the original Latin; on the needlessness of persuading believers to belief, see also his p. 76.

7. Ibid., pp. 138–39.

8. Ibid. The following from St. Bonaventure may serve as a standard traditional formulation: "Man has been freed from death and from the cause of death by the most efficacious means: the merit of the death of Christ" (*Breviloquium,* IV, 9, trans. José de Vinck (The Works of Bonaventure, Vol.

2), Paterson, N. J., 1963, p. 173). The relative ranking of the Resurrection above the miracle of the Incarnation in Eastern theology is explicit in these words of Photius, the 9th-century Patriarch of Constantinople: "Wondrous was the manger at Bethlehem which received my Lord . . . as He had just emerged from a virgin's womb. . . . Yet a far greater miracle does the tomb exhibit; . . . in the latter is accomplished the end and the purpose of God's advent . . ." (Homily X, 1, *The Homilies of Photius, Patriarch of Constantinople,* trans. Cyril Mango, Cambridge, Mass., 1958, pp. 209–10). Clearly, the issue here is not one of essential creed. It is not a question of doctrine, but of choice of rhetorical emphasis.

9. In the words of St. Bernard, "God himself is in this babe, reconciling the world to himself" (*On the Song of Songs,* trans. Kilian Walsh and Irene Edmonds, 4 vols., Kalamazoo, Mich., 1971–80, Sermon II, 8, p. 14).

10. "That he might be known and loved and imitated" is the formula proposed by St. Bonaventure; *Breviloquium,* IV, 3, pp. 144–45.

11. Hermann Diels, *Die Fragmente der Vorsokratiker,* fragment 15.

12. For the conjunction of mortality and fecundity as the defining terms of the human condition, see, for example, St. Gregory as quoted by Bede: "Although God deprived man of immortality for his sin, he did not destroy the human race on that account, but of his merciful goodness left man his ability to continue the race" (Bede, *A History of the English Church and People,* I, 27, 7).

13. "Made up of all the members . . .," writes St. Augustine (*City of God,* XXII, 18). For Leo the Great and the Council of Chalcedon, see n. 14 below. Originally, such expressions had no genital connotation; but they came to serve euphemistically when such reference was intended, as when the Renaissance preacher Cardulus, referring to the circumcised member, speaks of Christ's body as *"omnibus membris expressum"* (*Oratio de circumcisione,* Lucca, Biblioteca Capitolare, cod. 544, II, fol. 89). Here the "all" comes to mean "nothing excluded"—not even what modesty would suppress. The equivalent modern euphemism is the word "altogether" used as a noun (example cited in *Webster's Third International:* swimming in the altogether). Like the word "all," the word "perfect" may, in context, assume a similar sexual connotation. Thus in Boccaccio's *De mulieribus claris,* Marcia, a female artist of antiquity, is said to have faced the choice of either depicting "imperfect" male figures or, if "perfect," violating her virginal modesty. To escape this dilemma, we read, Marcia specialized in painting women, but men "rarely, if ever."

14. *Totus in suis, totus in nostris;* from the *Tome* of Pope Leo the Great (449; see Henry Bettenson, *Documents of the Christian Church,* New York and London, 1947, p. 70). See also the definition of the nature of Christ promulgated at the Council of Chalcedon: "at once complete in Godhead and complete in manhood . . . of one substance with the Father as regards his Godhead . . . of one substance with us as regards his manhood; like us in all respects, apart from sin" (ibid., p. 72).

15. Hebrews 4:15 speaks of Christ as "one tempted in all things like as we are, [yet] without sin." St. Augustine makes the three temptations resisted by Christ the types of all human temptation: lust of the flesh, lust of the eyes, and pride of life.

16. Christ's necessary exemption from genital shame follows from the theological definition of shame as the penalty of Original Sin. As the German Renaissance theologian Conrad Braun explained it to his generation: "Blameless nudity [*sane nuditas*] . . . is that which Adam and Eve had before sin . . . nor were they confounded by that nudity. There was in them no motion of body deserving of shame, nought to be hidden, since nothing in what they felt needed restraining. But after sin, whatever in the disobedience of their members caused shame (whereat they blushed . . .), to the disobedience of sin alone was this imputed. . . . So that man, disobedient to God, would feel his disobedience in his very members" (*De imaginibus . . . adversus Iconoclastas,* in D. *Conradi Bruni opera tria nunc primum aedita,* Mainz, 1548, p. 51; also in Paola Barocchi, ed., *Trattati d'arte del cinquecento,* II, Bari, 1961, p. 601, n. 1). The teaching is, of course, Augustinian. "We are ashamed," wrote St. Augustine, "of that very thing which made those primitive human beings [Adam and Eve] ashamed, when they covered their loins. That is the penalty of sin; that is the plague and mark of sin; that is the temptation and very fuel of sin; that is the law in our members warring against the law of our mind; that is the rebellion against our own very selves, proceeding from our very selves, which by a most righteous retribution is rendered us by our disobedient members. It is this which makes us ashamed, and justly ashamed" (*On Marriage and Concupiscence,* II, 22, in *Anti-Pelagian Writings,* ed. Philip Schaff, Grand Rapids, Mich., 1956, p. 291).

But in the incarnate Word—"whom sin could not defile nor death retain" (St. Leo, *Tome;* Bettenson, *Documents,* p. 70)—flesh did not war against spirit; no bodily member was "disobedient." In

the words of Pope Honorius I, writing in 634 to the Patriarch of Constantinople (Denzinger, *The Sources of Catholic Dogma,* trans. R. J. Deferrari, St. Louis and London, 1957, p. 99): "our nature, not our guilt was assumed by the Godhead." Ergo, no shame.

17. Gregory of Nyssa's term for the fig leaves adopted by our First Parents; see Jean Daniélou, *The Bible and Liturgy,* South Bend, Indiana, 1956, p. 50.

18. The resurrected, both male and female, shall not be ashamed in heaven. This is self-evident to Thomas Aquinas, as it is to Augustine. St. Thomas writes: "Though there be difference of sex there will be no shame in seeing one another, since there will be no lust to invite them to shameful deeds which are the cause of shame" (*Summa theologiae,* Suppl. q. 81, art. 3).

19. Pierio Valeriano, *Hieroglyphica,* ed. Basel, 1567, XXXIV, pp. 245–46—a work first published in 1556, but more than half a century in the making.

20. The sculptor of the masterly terracotta group in the Victoria and Albert Museum, London, is identified as Antonio Rossellino in John Pope-Hennessy, "The Virgin with the Laughing Child" (1957), in *Essays on Italian Sculpture,* London, 1968, pp. 72–77. The author does not remark on the Child's self-exposure and attributes its laughter to the "unreflecting" temper of childhood.

21. Cf. the Gnostic Gospel of Thomas, Saying 91: "They said to him, 'Tell us who You are so that we may believe in You.' He said to them, 'You read the face of the sky and of the earth, but you have not recognized the one who is before you'" (*The Nag Hammadi Library in English,* trans. T. O. Lambdin, New York, 1977, p. 128). As to the hiddenness of Christ's divine nature during the Ministry, the propagandistic trend of the canonic Gospels seems to create somewhat of a problem. The working of the redemptive plan required that the devil be tricked into thinking Jesus mere man, hence deserving of death. But of the demons whom Jesus exorcized, most were sensitive to his other nature. What then made the devil so sluggish? The question was faced by Origen and weakly answered in his Sixth Homily on St. Luke. Replying to the objection that the devils cast out by Jesus knew him to be the Son of God, Origen cites their inferiority in malice to Satan himself, and invokes the rule among men that the worse they are, the less they can know of Christ.

22. "Ich verzieh den unleidlichen Gegenstand und erfreute mich an der Ausführung" (*Italienische Reise*).

23. Louis Réau, *Iconographie de l'art chrétien,* II/II, Paris, 1957, p. 260.

24. *Ulysses,* Episode IX (Random House ed., p. 205): "They are sundered by a bodily shame so steadfast that the criminal annals of the world, stained with all other incests and bestialities, hardly record its breach."

c. *Politics and Society*

Art is a social phenomenon, through and through. Notwithstanding the romantic stereotype of the artist living on the fringe of society, toiling away in a garret, artists are members of society. Their work is typically addressed to and received, understood and validated by other human beings. As a kind of a productive activity, art is influenced by the myriad of economic and power relations in a society. The notion of art itself may be adequately understood only in terms of the institutions, theories, and practices that prevail in a given society (an issue also discussed in parts I, VI, and VII). At the same time, art affects society in profound ways. The pictorial arts in particular have long functioned as a kind of record of political, moral, and social life and values. This is so frequently the case that paintings are often categorized according to the social domain they depict. We might assign a painting to the category of genre painting, for example, insofar as its subject matter is a scene of everyday life.

But to speak of the pictorial arts as *simply* recording social conditions and values is misleading. It would be more accurate to say that the pictorial arts both present and characterize social conditions and beliefs. Jan Steen's seventeenth-century genre painting *The Dissolute Household* does not so much register a domestic scene of card-playing, gluttony, and sloth as condemn it. Similarly, the usual effect of exaggeration in a caricature is not simply to draw attention to a personal trait but to ridicule or satirize the object of the caricature. Portraits often tell us more what people were like than what they looked like. Allegories are frequently idealized commentaries on the events and values they represent symbolically. Even still lifes may have deep ideological significance, serving, for example, to celebrate the notions of ownership and private property, or so it has been argued.[1] Moreover, because the pictorial arts not only capture but also criticize prevailing values, they can influence the attitudes and actions of people in a society. Plato was surely right to draw philosophical attention to the political, social, and moral significance and effects of art.

The selections in this chapter deal with several of these issues in the context

1. See John Berger, *Ways of Seeing* (Harmondsworth: Penguin Books, Ltd., 1972), chap. 5.

of the relationship between women and art. Consider, first, the question of the representation of women in the pictorial arts. The selection by Sir Kenneth Clark, "The Naked and the Nude," lays the groundwork for a way of approaching this topic familiar to students of art history. Clark distinguishes between two ways of describing the unclothed body: as "naked," with its connotations of deprivation and embarrassment, and as "nude," with its image of "a balanced, prosperous and confident body" fit for artistic representation. Considered as an art form, the nude interests us, Clark argues, not for its imitative function, but rather as an effort to perfect the human body. This is clearly seen in classical representations of the nude, which sought to tie representations of the form of ideal human beauty to notions of measurable proportion, pride in the human body, and, ultimately, philosophical idealism. Clark allows that the nude inevitably arouses at least "some vestige of erotic feeling" in the spectator, but the nude is not primarily about sexuality. To the contrary, Clark argues, the nude "takes the most sensual and immediately interesting object, the human body, and puts it out of reach of time and desire; it takes the most purely rational concept of which mankind is capable, mathematical order, and makes it a delight to the senses. . . . The nude remains the most complete example of the transmutation of matter into form." The nude appeals, we might say, not to sensuality but to the sense of order. It is a mark of the civilized.

A very different understanding of the genre of the nude is advanced by John Berger in his article "Ways of Seeing Women." Berger attacks both Clark's characterization of the attitude one is presumed to take toward the nude and his account of the significance of the subject matter of the nude. An image, Berger argues, embodies a way of seeing; it shows "how the subject had once been seen by other people." Treating images as works of art and expressions of the highest and noblest aspects of the humanist spirit, Berger argues, only mystifies the images presented and makes them "unnecessarily remote," thus corroborating the social relations and moral values of the ruling classes.

A case in point is the way in which women are depicted in European oil painting. Berger begins his analysis of this category of art with a bit of social psychology. Men and women, he argues, tend to be seen in different ways. A man's presence evokes in us "the promise of power," whether moral, physical, economic, social, or sexual. We therefore look at a man in terms of what he might do to or for us. Women, on the other hand, tend to be seen (especially by men) in terms of a lack of power, in terms of what can be done to them. Women are treated as sights, as objects to be surveyed, even by other women and by themselves.

Berger contends that this way of seeing women is manifest in the European tradition of the nude. The first European nudes depict the story of Adam and Eve, with Eve typically presented as having caused the fall and as being judged, by Adam, by herself (as she watches her reflection in a mirror, for example), or by the viewer of the painting. The theme of the surveyed woman continues in the motif of the judgment of Paris and in early twentieth-century paintings in

which a common theme is the woman-as-prostitute. The subject of these images of woman is not the society's highest ideals, Berger argues, but rather sexuality after all, understood broadly to include social and psychological relations between men and women. These images are sexually provocative but, ironically, the most important figure in the nude is not the woman represented in the painting but rather the (male) viewer, a fact which, Berger argues, does much to explain the prevalence in the genre of frontal nudity and seductive glances directed at the viewer.

Linda Nochlin, in her article "Why Have There Been No Great Women Artists?" is concerned less with representations of women in paintings than with the social institutions that surround the production of art. Nochlin poses the question why there have been no great women artists, not so much to answer it as to deconstruct it. To be sure, the question has been asked and has received answers ranging from the suggestion that women are incapable of artistic greatness to efforts by art historians to discover great women artists who have been overlooked by the art establishment. But Nochlin's approach is more radical. She attacks the idea of artistic greatness itself, especially as it is assumed to depend on the notion of "genius."

According to the received view, genius is seen as a mysterious power of talent (a "little golden nugget") which sets the great apart from normal mortals. Onto this view is grafted the "observation" that the capacity happens to inhere mainly in men. The trouble with this notion of artistic greatness, Nochlin argues, is that it ignores both the actual, concrete historical conditions that affect the development of artistic potential and the social circumstances according to which artists and their works are enfranchised. Nochlin then identifies several social and institutional conditions (including the refusal, as late as 1893, to allow women to paint nudes at London's Royal Academy) which have militated against the development of artistic ability in women[2] and prevented those excellent works women artists have managed to produce from gaining the recognition they deserve. Nochlin thus joins forces with Berger in pitting the social against the aesthetic.

2. Cf. John Stuart Mill, *The Subjection of Women* (Cambridge: M.I.T. Press, 1970; originally published in 1869), pp. 72–75: "It is in the fine arts, properly so called, that the prima facie evidence of inferior original powers in women at first sight appears the strongest: since opinion (it may be said) does not exclude them from these, but rather encourages them, and their education, instead of passing over this department, is in the affluent classes mainly composed of it. Yet in this line of exertion they have fallen still more short than in many others, of the highest eminence attained by men. This shortcoming, however, needs no other explanation than the familiar fact, more universally true in the fine arts than in anything else; the vast superiority of professional persons over amateurs. Women in the educated classes are almost universally taught more or less of some branch or other of the fine arts, but not that they may gain their living or their social consequence by it. Women artists are all amateurs. The exceptions are only of the kind which confirm the general truth. . . . There are other reasons . . . why women remain behind men, even in the pursuits which are open to both. For one thing, very few women have time for them. . . . Independently of the regular offices of life which devolve upon a woman, she is expected to have her time and faculties always at the disposal of everybody. . . . Is it wonderful, then, if she does not attain the highest eminence in things which require consecutive attention, and the concentration on them of the chief interest of life? Such is philosophy and such, above all, is art, in which, besides the devotion of the thoughts and feelings, the hand also must be kept in constant exercises to attain high skill." I thank Mary Hawkesworth for drawing this passage to my attention.

20

The Naked and the Nude

KENNETH CLARK

The English language, with its elaborate generosity, distinguishes between the naked and the nude. To be naked is to be deprived of our clothes, and the word implies some of the embarrassment most of us feel in that condition. The word "nude," on the other hand, carries, in educated usage, no uncomfortable overtone. The vague image it projects into the mind is not of a huddled and defenseless body, but of a balanced, prosperous, and confident body: the body re-formed. In fact, the word was forced into our vocabulary by critics of the early eighteenth century to persuade the artless islanders that, in countries where painting and sculpture were practiced and valued as they should be, the naked human body was the central subject of art.

For this belief there is a quantity of evidence. In the greatest age of painting, the nude inspired the greatest works; and even when it ceased to be a compulsive subject it held its position as an academic exercise and a demonstration of mastery. Velásquez, living in the prudish and corseted court of Philip IV and admirably incapable of idealization, yet felt bound to paint the *Rokeby Venus* [Fig. 1]. Sir Joshua Reynolds, wholly without the gift of formal draftsmanship, set great store by his *Cymon and Iphigenia*. And in our own century, when we have shaken off one by one those inheritances of Greece which were revived as the Renaissance, discarded the antique armor, forgotten the subjects of mythology, and disputed the doctrine of imitation,

the nude alone has survived. It may have suffered some curious transformations, but it remains our chief link with the classic disciplines. When we wish to prove to the Philistine that our great revolutionaries are really respectable artists in the tradition of European painting, we point to their drawings of the nude. Picasso has often exempted it from that savage metamorphosis which he has inflicted on the visible world and has produced a series of nudes that might have walked unaltered off the back of a Greek mirror, and Henry Moore, searching in stone for the ancient laws of its material and seeming to find there some of these elementary creatures of whose fossilized bones it is composed, yet gives to his constructions the same fundamental character that was invented by the sculptors of the Parthenon in the fifth century before Christ.

These comparisons suggest a short answer to the question, "What is the nude?" It is an art form invented by the Greeks in the fifth century, just as opera is an art form invented in seventeenth-century Italy. The conclusion is certainly too abrupt, but it has the merit of emphasizing that the nude is not the subject of art, but a form of art.

It is widely supposed that the naked human body is in itself an object upon which the eye dwells with pleasure and which we are glad to see depicted. But anyone who has frequented art schools and seen the shapeless, pitiful model that the students are industriously drawing will know this is an illusion. The

From Kenneth Clark, *The Nude: A Study in Ideal Form.* Bollinger Series 35, Vol. 2. (Princeton: Princeton University Press, 1956, 1984), pp. 3–29. Copyright (©) Trustees of National Gallery of Art. Reprinted with permission of Princeton University Press.

FIGURE 1. Velásquez, *Rokeby Venus*. National Gallery, London.

body is not one of those subjects which can be made into art by direct transcription—like a tiger or a snowy landscape. Often in looking at the natural and animal world we joyfully identify ourselves with what we see and from this happy union create a work of art. This is the process students of aesthetics call empathy, and it is at the opposite pole of creative activity to the state of mind that has produced the nude. A mass of naked figures does not move us to empathy, but to disillusion and dismay. We do not wish to imitate; we wish to perfect. We become, in the physical sphere, like Diogenes with his lantern looking for an honest man; and, like him, we may never be rewarded. Photographers of the nude are presumably engaged in this search, with every advantage; and having found a model who pleases them, they are free to pose and light her in conformity with their notions of beauty; finally, they can tone down and accentuate by retouching. But in spite of all their taste and skill, the result is hardly ever satisfactory to those whose eyes have grown accustomed to the harmonious simplifications of antiquity. We are immediately disturbed by wrinkles, pouches, and other small imperfections, which, in the classical scheme, are eliminated. By long habit we do not judge it as a living organism, but as a design; and we discover that the transitions are inconclusive, the outline is faltering. We are bothered because the various parts of the body cannot be perceived as simple units and have no clear relationship to one another. In almost every detail the body is not the shape that art had led us to believe it should be. Yet we can look with pleasure at photographs of trees and animals, where the canon of perfection is less strict. Consciously or unconsciously, photographers have usually recognized that in a photograph of the nude their real object is not to reproduce the naked body, but to imitate some artist's view of what the naked body should be. Rejlander was the most Philistine of the early photographers, but, perhaps without knowing it, he was a contemporary of Courbet [Fig. 2] and with this splendid archetype somewhere in the background he produced one of the finest (as well as one of the first) photographs of the nude [Fig. 3]. He succeeded partly because his unconscious archetype was a realist. The more nearly ideal the model, the more unfortunate the photographs that try to imitate it—as those in the style of Ingres or Whistler prove.

So that although the naked body is no more than the point of departure for a work of art, it is a pretext of great importance. In the history of art, the subjects that men have chosen as nuclei, so to say, of their sense of order have often been in themselves unimportant. For hundreds of years, and over an area stretching from Ireland to China, the most vital expression of order was an imaginary animal biting its own tail. In the Middle Ages drapery took on a life of its own, the same life that had inhabited the

FIGURE 2. Courbet, *La Source*. Réunion des Musées Nationaux.

twisting animal, and became the vital pattern of
Romanesque art. In neither case had the subject any
independent existence. But the human body, as a
nucleus, is rich in associations, and when it is turned
into art these associations are not entirely lost. For
this reason it seldom achieves the concentrated aes-
thetic shock of animal ornament, but it can be made
expressive of a far wider and more civilizing expe-
rience. It is ourselves and arouses memories of all

the things we wish to do with ourselves; and first of
all we wish to perpetuate ourselves.

This is an aspect of the subject so obvious that I
need hardly dwell on it; and yet some wise men have
tried to close their eyes to it. "If the nude," says Pro-
fessor Alexander, "is so treated that it raises in the
spectator ideas or desires appropriate to the mate-
rial subject, it is false art, and bad morals." This
high-minded theory is contrary to experience. In

FIGURE 3. Rejlander, photograph. Gernsheim
Collection, Harry Ransom Humanities Research
Center, The University of Texas at Austin.

the mixture of memories and sensations aroused by
Rubens' *Andromeda* or Renoir's *Bather* are many
that are "appropriate to the material subject." And
since these words of a famous philosopher are often
quoted, it is necessary to labor the obvious and say
that no nude, however abstract, should fail to
arouse in the spectator some vestige of erotic feel-
ing, even though it be only the faintest shadow—
and if it does not do so, it is bad art and false morals.
The desire to grasp and be united with another
human body is so fundamental a part of our nature
that our judgment of what is known as "pure form"
is inevitably influenced by it; and one of the diffi-
culties of the nude as a subject for art is that these
instincts cannot lie hidden, as they do, for example,
in our enjoyment of a piece of pottery, thereby gain-
ing the force of sublimation, but are dragged into
the foreground, where they risk upsetting the unity
of responses from which a work of art derives its
independent life. Even so, the amount of erotic con-
tent a work of art can hold in solution is very high.
The temple sculptures of tenth-century India are an
undisguised exaltation of physical desire; yet they
are great works of art because their eroticism is part
of their whole philosophy.

Apart from biological needs, there are other
branches of human experience of which the naked
body provides a vivid reminder—harmony, energy,
ecstasy, humility, pathos; and when we see the
beautiful results of such embodiments, it must seem
as if the nude as a means of expression is of universal
and eternal value. But this we know historically to
be untrue. It has been limited both in place and in
time. There are naked figures in the paintings of the
Far East; but only by an extension of the term can
they be called nudes. In Japanese prints they are part
of *ukioye*, the passing show of life, which includes,
without comment, certain intimate scenes usually
allowed to pass unrecorded. The idea of offering the
body for its own sake, as a serious subject of contem-
plation, simply did not occur to the Chinese or Jap-
anese mind, and to this day raises a slight barrier of
misunderstanding. In the Gothic North the posi-
tion was fundamentally very similar. It is true that
German painters in the Renaissance, finding that
the naked body was a respected subject in Italy,
adapted it to their needs, and evolved a remarkable
convention of their own. But Dürer's struggles
show how artificial this creation was. His instinc-
tive responses were curiosity and horror, and he had
to draw a great many circles and other diagrams
before he could brace himself to turn the unfortu-
nate body into the nude.

Only in countries touching on the Mediterra-
nean has the nude been at home; and even there its
meaning was often forgotten. The Etruscans, owing
three quarters of their art to Greece, never aban-
doned a type of tomb figure in which the defunct
man displays his stomach with a complacency that
would have shocked a Greek profoundly. Hellenis-
tic and Roman art produced statues and mosaics of
professional athletes who seem satisfied with their
monstrous proportions. More remarkable still, of
course, is the way in which the nude, even in Italy
and Greece, is limited by time. It is the fashion to
speak of Byzantine art as if it were a continuation
of Greek; the nude reminds us that this is one of the
refined excesses of specialization. Between the ner-
eids of late Roman silver and the golden doors of
Ghiberti the nudes in Mediterranean art are few
and insignificant—a piece of modest craftsmanship
like the Ravenna ivory *Apollo and Daphne,* a few
objets de luxe, like the Veroli Casket, with its car-
toon-strip Olympus, and a number of Adams and
Eves whose nakedness seldom shows any memory
of antique form. Yet, during a great part of that mil-
lennium, the masterpieces of Greek art had not yet
been destroyed, and men were surrounded by rep-
resentations of the nude more numerous and, alas,
infinitely more splendid than any that have come
down to us. As late as the tenth century the *Knidian
Aphrodite* of Praxiteles, which had been carried to
Constantinople, it is said, by Theodosius, was

praised by the Emperor Constantine Porphyrogenitus; and a famous bronze copy of it is mentioned by Robert de Clari in his account of the taking of Constantinople by the Crusaders. Moreover, the body itself did not cease to be an object of interest in Byzantium: this we may deduce from the continuation of the race. Athletes performed in the circus; workmen, stripped to the waist, toiled at the building of St. Sophia. There was no want of opportunity for artists. That their patrons did not demand representations of the nude during this period may be explained by a number of reaonable-looking causes—fear of idolatry, the fashion for asceticism, or the influence of Eastern art. But in fact such answers are incomplete. The nude had ceased to be the subject of art almost a century before the official establishment of Christianity. And during the Middle Ages there would have been ample opportunity to introduce it both into profane decoration and into such sacred subjects as show the beginning and the end of our existence.

Why, then, does it never appear? An illuminating answer is to be found in the notebook of the thirteenth-century architect, Villard de Honnecourt. This contains many beautiful drawings of draped figures, some of them showing a high degree of skill. But when Villard draws two nude figures in what he believes to be the antique style the result is painfully ugly. It was impossible for him to adapt the stylistic conventions of Gothic art to a subject that depended on an entirely different system of forms. There can be few more hopeless misunderstandings in art than his attempt to render that refined abstraction, the antique torso, in terms of Gothic loops and pothooks. Moreover, Villard has constructed his figures according to the pointed geometrical scheme of which he himself gives us the key on another page. He evidently felt that the divine element in the human body must be expressed through geometry. Cennino Cennini, the last chronicler of medieval practice, says, "I will not tell you about irrational animals, because I have never learned any of their measurements. Draw them from nature, and in this respect you will achieve a good style." The Gothic artists could draw animals because this involved no intervening abstraction. But they could not draw the nude because it was an idea: an idea that their philosophy of form could not assimilate.

As I have said, in our Diogenes search for physical beauty our instinctive desire is not to imitate but to perfect. This is part of our Greek inheritance, and it was formulated by Aristotle with his usual deceptive simplicity. "Art," he says, "completes what nature cannot bring to a finish. The artist gives us knowledge of nature's unrealized ends." A great many assumptions underlie this statement, the chief

of which is that everything has an ideal form of which the phenomena of experience are more or less corrupted replicas. This beautiful fancy has teased the minds of philosophers and writers on aesthetics for over two thousand years, and although we need not plunge into a sea of speculation, we cannot discuss the nude without considering its practical application, because every time we criticize a figure, saying that a neck is too long, hips are too wide or breasts are too small, we are admitting, in quite concrete terms, the existence of ideal beauty. Critical opinion has varied between two interpretations of the ideal, one unsatisfactory because it is too prosaic, the other because it is too mystical. The former begins with the belief that although no individual body is satisfactory as a whole, the artist can choose the perfect parts from a number of figures and then combine them into a perfect whole. Such, we are told by Pliny, was the procedure of Zeuxis when he constructed his *Aphrodite* out of the five beautiful maidens of Kroton, and the advice reappears in the earliest treatise on painting of the postantique world, Alberti's *Della Pittura*. Dürer went so far as to say that he had "searched through two or three hundred." The argument is repeated again and again for four centuries, never more charmingly than by the French seventeenth-century theorist, Du Fresnoy, whom I shall quote in Mason's translation:

> For tho' our casual glance may sometimes meet
> With charms that strike the soul and seem
> complete,
> Yet if those charms too closely we define,
> Content to copy nature line for line,
> Our end is lost. Not such the master's care,
> Curious he culls the perfect from the fair;
> Judge of his art, thro' beauty's realm he flies,
> Selects, combines, improves, diversifies;
> With nimble step pursues the fleeing throng,
> And clasps each Venus as she glides along.

Naturally, the theory was a popular one with artists: but it satisfies neither logic nor experience. Logically, it simply transfers the problem from the whole to the parts, and we are left asking by what ideal pattern Zeuxis accepted or rejected the arms, necks, bosoms, and so forth of his five maidens. And even admitting that we do find certain individual limbs or features that, for some mysterious reason, seem to us perfectly beautiful, experience shows us that we cannot often recombine them. They are right in their setting, organically, and to abstract them is to deprive them of that rhythmic vitality on which their beauty depends.

To meet this difficulty the classic theorists of art invented what they called "the middle form." They

based this notion on Aristotle's definition of nature, and in the stately language of Sir Joshua Reynolds' *Discourses* it seems to carry some conviction. But what does it amount to, translated into plain speech? Simply that the ideal is composed of the average and the habitual. It is an uninspiring proposition, and we are not surprised that Blake was provoked into replying, "All Forms are Perfect in the Poet's Mind but these are not Abstracted or compounded from Nature, but are from the Imagination." Of course he is right. Beauty is precious and rare, and if it were like a mechanical toy, made up of parts of average size that could be put together at will, we should not value it as we do. But we must admit that Blake's interjection is more a believer's cry of triumph than an argument, and we must ask what meaning can be attached to it. Perhaps the question is best answered in Crocean terms. The ideal is like a myth, in which the finished form can be understood only as the end of a long process of accretion. In the beginning, no doubt, there is the coincidence of widely diffused desires and the personal tastes of a few individuals endowed with the gift of simplifying their visual experiences into easily comprehensible shapes. Once this fusion has taken place, the resulting image, while still in a plastic state, may be enriched or refined upon by succeeding generations. Or, to change the metaphor, it is like a receptacle into which more and more experience can be poured. Then, at a certain point, it is full. It sets. And, partly because it seems to be completely satisfying, partly because the mythopoeic faculty has declined, it is accepted as true. What both Reynolds and Blake meant by ideal beauty was really the diffused memory of that peculiar physical type developed in Greece between the years 480 and 440 B.C., which in varying degrees of intensity and consciousness furnished the mind of Western man with a pattern of perfection from the Renaissance until the present century.

Once more we have returned to Greece, and it is now time to consider some peculiarities of the Greek mind that may have contributed to the formation of this indestructible image.

The most distinctive is the Greek passion for mathematics. In every branch of Hellenic thought we encounter a belief in measurable proportion that, in the last analysis, amounts to a mystical religion; and as early as Pythagoras it had been given the visible form of geometry. All art is founded on faith, and inevitably the Greek faith in harmonious numbers found expression in their painting and sculpture; but precisely how we do not know. The so-called canon of Polykleitos is not recorded, and the rules of proportion that have come down to us through Pliny and other ancient writers are of the most elementary kind. Probably the Greek sculptors

were familiar with a system as subtle and elaborate as that of their architects, but we have scarcely any indication as to what it was. There is, however, one short and obscure statement in Vitruvius that, whatever it meant in antiquity, had a decisive influence on the Renaissance. At the beginning of the third book, in which he sets out to give the rules for sacred edifices, he suddenly announces that these buildings should have the proportions of a man. He gives some indication of correct human proportions and then throws in a statement that man's body is a model of proportion because with arms or legs extended it fits into those "perfect" geometrical forms, the square and the circle. It is impossible to exaggerate what this simple-looking proposition meant to the men of the Renaissance. To them it was far more than a convenient rule: it was the foundation of a whole philosophy. Taken together with the musical scale of Pythagoras, it seemed to offer exactly that link between sensation and order, between an organic and a geometric basis of beauty, which was (and perhaps remains) the philosopher's stone of aesthetics. Hence the many diagrams of figures standing in squares or circles that illustrate the treatises on architecture or aesthetics from the fifteenth to the seventeenth century.

Vitruvian man, as this figure has come to be called, appears earlier than Leonardo da Vinci, but it is in Leonardo's famous drawing in Venice [Fig. 4] that he receives his most masterly exposition; also, on the whole the most correct, for Leonardo makes only two light deviations from Vitruvius, whereas most of the other illustrations follow him very sketchily. This is not one of Leonardo's most attractive drawings, and it must be admitted that the Vitruvian formula does not provide any guarantee of a pleasant-looking body. The most carefully worked-out illustration of all, in the Como Vitruvius of 1521 shows an ungraceful figure with head too small and legs and feet too big [Fig. 5]. Especially troublesome was the question of how the square and the circle, which were to establish the perfect form, should be related to one another. Leonardo, on no authority that I can discover, said that in order to fit into a circle the figure should stretch apart his legs so that he was a fourteenth shorter than if they were together. But this arbitrary solution did not please Cesariano, the editor of the Como Vitruvius, who inscribed the square in the circle, with unfortunate results. We see that from the point of view of strict geometry a gorilla might prove to be more satisfactory than a man.

How little systematic proportion alone can be relied on to produce physical beauty is shown by Dürer's engraving known as the *Nemesis* or *Large Fortune*. It was executed in 1501, and we know that in the preceding year Dürer had been reading

FIGURE 4. Leonardo da Vinci, Vitruvian man. Gallerie dell' Accademia.

Vitruvius. In this figure he has applied Vitruvian principles of measurement down to the last detail: according to Professor Panofsky, even the big toe is operative. He has also taken his subject from a work by Poliziano, the same humanist poet who inspired Botticelli's *Birth of Venus* and Raphael's *Galatea*. But in spite of these precautions he has not achieved the classical ideal. That he did so later was owing to the practice of relating his system to antique figures. It was not his squares and circles that enabled him to master classical proportions, but the fact that he applied them to memories of the *Apollo Belvedere* and the *Medici Venus*—forms "perfected in the poet's mind." And it was from these, in the end, that he derived the beautiful nude figure of Adam in his famous engraving of the *Fall*.

Francis Bacon, as we all know, said, "There is no excellent beauty that hath not some strangeness in the proportion. A man cannot tell whether Apelles

or Albert Dürer were the more trifler; where of the one would make a personage by geometrical proportions: the other by taking the best part out of divers faces to make one excellent." This very intelligent observation is unfair to Dürer, and suggests that Bacon, like the rest of us, had not read his book on human proportions, only looked at the plates. For, after 1507, Dürer abandoned the idea of imposing a geometrical scheme on the body, and set about deducing ideal measurements from nature, with a result, as may be imagined, somewhat different from his analyses of the antique; and in his introduction he forcefully denies the claim that he is providing a standard of absolute perfection. "There lives no man upon earth," he says, "who can give a final judgment upon what the most beautiful shape of a man may be; God only knows that.... 'Good' and 'better' in respect of beauty are not easy to discern, for it would be quite possible to make

FIGURE 5. Cesariano, Vitruvian
man. From the Como Vitruvius,
1521.

two different figures, neither conforming with the other, one stouter, the other thinner, and yet we might scarce be able to judge which of the two excelled in beauty." So the most indefatigable and masterly constructor of ideal proportions abandoned them halfway through his career, and his work, from the *Nemesis* onward, is a proof that the idea of the nude does not depend on analyzable proportions alone. And yet when we look at the splendidly schematized bodies of Greek sculpture, we cannot resist the conviction that some system did exist. Almost every artist or writer on art who has thought seriously about the nude has concluded that it must have some basis of construction that can be stated in terms of measurement; and I myself, when trying to explain why a photograph did not satisfy me, said that I missed the sense of simple units clearly related to one another. Although the artist cannot construct a beautiful nude by mathematical rules, any more than the musician can compose a beautiful fugue, he cannot ignore them. They must be lodged somewhere at the back of his mind or in the movements of his fingers. Ultimately he is as dependent on them as an architect.

Dipendenza: that is the word used by Michelangelo, supreme as a draftsman of the nude and as an architect, to express his sense of the relationship between these two forms of order. And in the pages that follow I often make use of architectural analogies. Like a building, the nude represents a balance between an ideal scheme and functional necessities. The figure artist cannot forget the components of the human body, any more than the architect can fail to support his roof or forget his doors and windows. But the variations of shape and disposition are surprisingly wide. The most striking instance is, of course, the change in proportion between the Greek and the Gothic idea of the female body. One of the few classical canons of proportion of which we can be certain is that which, in a female nude, took the same unit of measurement for the distance between the breasts, the distance from the lower breast to the navel, and again from the navel to the division of the legs. This scheme we shall find carefully maintained in all figures of the classical epoch [Fig. 6] and in most of those which imitated them down to the first century. Contrast a typical Gothic nude of the fifteenth century, the *Eve* in the Vienna gallery attributed to Memlinc [Fig. 7]. The components are—naturally—the same. The basic pattern of the female body is still an oval, surmounted by two spheres; but the oval has grown incredibly long, the spheres have grown distressingly small. If we apply our unit of measurement, the distance

FIGURE 6. Sixteenth-century cast of antique
Aphrodite. Musée National du Château de
Fontainebleau.

FIGURE 7. Memlinc workshop. *Eve.* Vienna.

between the breasts, we find that the navel is exactly
twice as far down the body as it is in the classic
scheme. This increased length of body is made more
noticeable because it is unbroken by an suggestion
of ribs or muscles. The forms are not conceived as
individual blocks, but seem to have been drawn out
of one another as if they were made of some viscous
material. It is usual to speak of this kind of Gothic
nude as "naturalistic," but is Memlinc's *Eve* really
closer to the average (for this is what the word
means) than the antique nude? Such, at all events,
was certainly not the painter's intention. He aimed

at producing a figure that would conform to the ideals of his time, that would be the kind of shape men liked to see; and by some strange interaction of flesh and spirit this long curve of the stomach has become the means by which the body has achieved the ogival rhythm of late Gothic architecture.

A rather less obvious example is provided by Sansovino's *Apollo* on the Loggetta in Venice [Fig. 8]. It is inspired by the *Apollo Belvedere,* but although Sansovino, like all his contemporaries, thought that the antique figure was of unsurpassable beauty, he has allowed himself a fundamental difference in his construction of the body. We may describe this by saying that the antique male nude is like a Greek temple, the flat frame of the chest being carried on the columns of the legs, whereas the Renaissance nude is related to the architectural system that produced the central-domed church; so that instead of the sculptural interest depending on a simple, frontal plane, a number of axes radiate from one center. Not only the elevations but, so to say, the ground plans of these figures would have an obvious relationship to their respective architectures. What we may call the multiple-axis nude continued until the classicistic revival of the eighteenth century. Then, when architects were reviving the Greek-temple form, sculptors once more gave to the male body the flatness and frontality of a frame building. Ultimately the *dipendenza* of architecture and the nude expresses the relationship we all so earnestly desire between that which is perfected by the mind and that which we love. Poussin, writing to his friend Chantelou in 1642, said, "The beautiful girls whom you will have seen in Nîmes will not, I am sure, have delighted your spirit any less than the beautiful columns of Maison Carrée; for the one is no more than an old copy of the other." And the hero of Claudel's *Partage de midi,* when at last he puts his arms round his beloved, utters, as the first pure expression of his bliss, the words "O Colonne!"

So our surmise that the discovery of the nude as a form of art is connected with idealism and faith in measurable proportions seems to be true, but it is only half the truth. What other peculiarities of the Greek mind are involved? One obvious answer is their belief that the body was something to be proud of, and should be kept in perfect trim.

We need not suppose that many Greeks looked like the *Hermes* of Praxiteles, but we can be sure that in fifth-century Attica a majority of the young men had the nimble, well-balanced bodies depicted on the early red-figure vases. On a vase in the British Museum is a scene that will arouse sympathy in most of us, but to the Athenians was ridiculous and shameful—a fat youth in the gymnasium embarrassed by his ungraceful figure, and apparently protesting to a thin one, while two young men of more fortunate development throw the javelin and the discus. Greek literature from Homer and Pindar downward contains many expressions of this physical pride, some of which strike unpleasantly on the Anglo-Saxon ear and trouble the minds of schoolmasters when they are recommending the Greek ideal of fitness. "What do I care for any man?" says the young man Kritobolos in the *Symposium* of Xenophon; "I am beautiful." And no doubt this arrogance was increased by the tradition that in the gymnasium and the sports-ground such young men displayed themselves totally naked.

The Greeks attached great importance to their nakedness. Thucydides, in recording the stages by which they distinguished themselves from the barbarians, gives prominence to the date at which it became the rule in the Olympic games, and we know from vase paintings that the competitors at the Panathenaic festival had been naked ever since the early sixth century. Although the presence or absence of a loincloth does not greatly affect questions of form, and in this study I shall include figures that are lightly draped, psychologically the Greek cult of absolute nakedness is of great importance. It implies the conquest of an inhibition that oppresses all but the most backward people; it is like a denial of original sin. This is not, as is sometimes supposed, simply a part of paganism: for the Romans were shocked by the nakedness of Greek athletes, and Ennius attacked it as a sign of decadence. Needless to say, he was wide of the mark, for the most determined nudists of all were the Spartans, who scandalized even the Athenians by allowing women to compete, lightly clad, in their games. He and subsequent moralists considered the matter in purely physical terms; but, in fact, Greek confidence in the body can be understood only in relation to their philosophy. It expresses above all their sense of human wholeness. Nothing that related to the whole man could be isolated or evaded; and this serious awareness of how much was implied in physical beauty saved them from the two evils of sensuality and aestheticism.

At the same party where Kritobolos brags about his beauty Xenophon describes the youth Autolykos, victor of the Pankration, in whose honor the feast was being given. "Noting the scene," he says, "the first idea to strike the mind is that beauty has about it something regal; and the more so if it chance to be combined (as now in the person of Autolykos) with modesty and self-respect. Even as when a splendid object blazes forth at night, the eyes of men are riveted, so now the beauty of Autolykos drew on him the gaze of all; nor was there one of those onlookers but was stirred to his soul's depth

FIGURE 8. Sansovino. *Apollo*.
Logetta, Venice.

by him who sat there. Some fell into unwonted silence, while the gestures of the rest were equally significant."

This feeling, that the spirit and body are one, which is the most familiar of all Greek characteristics, manifests itself in their gift of giving to abstract ideas a sensuous, tangible, and, for the most part, human form. Their logic is conducted in the form of dialogues between real men. Their gods take visible shape, and on their appearance are usually mistaken for half-familiar human beings—a maidservant, a shepherd, or a distant cousin. Woods, rivers, even echoes are shown in painting as bodily presences, solid as the living protagonists, and often more prominent. Here we reach what I take to be the central point of our subject: "Greek statues," said Blake, in his *Descriptive Catalogue,* "are all of them representations of spiritual existences, of gods immortal, to the mortal, perishing organ of sight; and yet they are embodied and organised in solid marble." The bodies were there, the belief in the gods was there, the love of rational proportion was there. It was the unifying grasp of the Greek imagination that brought them together. And the nude gains its enduring value from the fact that it reconciles several contrary states. It takes the most sensual and immediately interesting object, the human body, and puts it out of reach of time and desire; it takes the most purely rational concept of which mankind is capable, mathematical order, and makes it a delight to the senses; and it takes the vague fears of the unknown and sweetens them by showing that the gods are like men and may be worshiped for their life-giving beauty rather than their death-dealing powers.

To recognize how completely the value of these spiritual existences depends on their nudity, we have only to think of them as they appear, fully clothed, in the Middle Ages or early Renaissance. They have lost all their meaning. When the Graces are represented by three nervous ladies hiding behind a blanket they no longer convey to us the civilizing influence of beauty. When Herakles is a lumbering *Landsknecht* weighed down by fashionable armor, he cannot increase our sense of well-being by his own superabundant strength. Conversely, when nude figures, which had been evolved to express an idea, ceased to do so, and were represented for their physical perfection alone, they soon lost their value. This was the fatal legacy of neoclassicism, and Coleridge, who lived through the period, summed up the situation in some lines he added to the translation of Schiller's *Piccolomini:*

The intelligible powers of ancient poets,
The fair humanities of old religion,
The Power, the Beauty and the Majesty,

That had their haunts in dale or piney
 mountain,
. . . all these have vanished.
They live no longer in the faith of reason.

The academic nudes of the nineteenth century are lifeless because they no longer embodied real human needs and experiences. They were among the hundreds of devalued symbols that encumbered the art and architecture of the utilitarian century.

The nude had flourished most exuberantly during the first hundred years of the classical Renaissance, when the new appetite for antique imagery overlapped the medieval habits of symbolism and personification. It seemed then that there was no concept, however sublime, that could not be expressed by the naked body, and no object of use, however trivial, that would not be the better for having been given human shape. At one end of the scale was Michelangelo's *Last Judgment;* at the other the door knockers, candelabra, or even handles of knives and forks. To the first it might be objected—and frequently was—that nakedness was unbecoming in a representation of Christ and His saints. This was the point put forward by Paolo Veronese when he was tried by the Inquisition for including drunkards and Germans in his picture of the marriage of Cana: to which the chief inquisitor gave his immortal reply, "Do you not know that in these figures by Michelangelo there is nothing that is not spiritual—*non vi è cosa se non de spirito?*" And to the second it might be objected—and frequently is—that the similitude of the naked Venus is not what we need in our hand when we are cutting up our food or knocking at a door, to which Benvenuto Cellini would have replied that since the human body is the most perfect of all forms we cannot see it too often. In between these two extremes was that forest of nude figures, painted or carved, in stucco, bronze, or stone, which filled every vacant space in the architecture of the sixteenth century.

Such an insatiable appetite for the nude is unlikely to recur. It arose from a fusion of beliefs, traditions, and impulses very remote from our age of essence and specialization. Yet even in the new self-governing kingdom of the aesthetic sensation the nude is enthroned. The intensive application of great artists has made it into a sort of pattern for all formal constructions, and it is still a means of affirming the belief in ultimate perfection. "For soule is forme, and doth the bodie make," wrote Spenser in his *Hymne in Honour of Beautie,* echoing the words of the Florentine Neoplatonists, and although in life the evidence for the doctrine is inconclusive, it is perfectly applicable to art. The nude remains the most complete example of the transmutation of matter into form.

Nor are we likely once more to cut ourselves off from the body, as in the ascetic experiment of medieval Christianity. We may no longer worship it, but we have come to terms with it. We are reconciled to the fact that it is our lifelong companion, and since art is concerned with sensory images the scale and rhythm of the body is not easily ignored. Our continuous effort, made in defiance of the pull of gravity, to keep ourselves balanced upright on our legs affects every judgment on design, even our conception of which angle shall be called "right." The rhythm of our breathing and the beat of our hearts are part of the experience by which we measure a work of art. The relation of head to body determines the standard by which we assess all other proportions in nature. The disposition of areas in the torso is related to our most vivid experiences, so that, abstract shapes, the square and the circle, seem to us male and female; and the old endeavor of magical mathematics to square the circle is like the symbol of physical union. The starfish diagrams of Renaissance theorists may be ridiculous, but the Vitruvian principle rules our spirits, and it is no accident that the formalized body of the "perfect man" became the supreme symbol of European belief. Before the *Crucifixion* of Michelangelo we remember that the nude is, after all, the most serious of all subjects in art; and that it was not an advocate of paganism who wrote, "The Word was made flesh, and dwelt among us ... full of grace and truth."

21

Ways of Seeing Women

JOHN BERGER

Seeing comes before words. The child looks and recognizes before it can speak.

But there is also another sense in which seeing comes before words. It is seeing which establishes our place in the surrounding world; we explain that world with words, but words can never undo the fact that we are surrounded by it. The relation between what we see and what we know is never settled. Each evening we *see* the sun set. We *know* that the earth is turning away from it. Yet the knowledge, the explanation, never quite fits the sight. The Surrealist painter Magritte commented on this always-present gap between words and seeing in a painting called *The Key of Dreams*.

The way we see things is affected by what we know or what we believe. In the Middle Ages when men believed in the physical existence of Hell the sight of fire must have meant something different from what it means today. Nevertheless their idea of Hell owed a lot to the sight of fire consuming and the ashes remaining—as well as to their experience of the pain of burns.

When in love, the sight of the beloved has a completeness which no words and no embrace can match: a completeness which only the act of making love can temporarily accommodate.

Yet this seeing which comes before words, and can never be quite covered by them, is not a question of mechanically reacting to stimuli. (It can only be thought of in this way if one isolates the small part of the process which concerns the eye's retina.)

We only see what we look at. To look is an act of choice. As a result of this act, what we see is brought within our reach—though not necessarily within arm's reach. To touch something is to situate oneself in relation to it. (Close your eyes, move round the room and notice how the faculty of touch is like a static, limited form of sight.) We never look at just one thing; we are always looking at the relation between things and ourselves. Our vision is continually active, continually moving, continually holding things in a circle around itself, constituting what is present to us as we are.

Soon after we can see, we are aware that we can also be seen. The eye of the other combines with our own eye to make it fully credible that we are part of the visible world.

If we accept that we can see that hill over there, we propose that from that hill we can be seen. The reciprocal nature of vision is more fundamental than that of spoken dialogue. And often dialogue is an attempt to verbalize this—an attempt to explain how, either metaphorically or literally, 'you see things', and an attempt to discover how 'he sees things'.

In the sense in which we use the word in this [chapter] all images are man-made.

An image is a sight which has been recreated or reproduced. It is an appearance, or a set of appearances, which has been detached from the place and time in which it first made its appearance and preserved—for a few moments or a few centuries.

From John Berger, *Ways of Seeing*. Harmondsworth, Eng.: Penguin Books, Ltd., 1972, pp. 45–64. Reprinted with permission of Penguin Books, Ltd., and the author.

Magritte, *The Key of Dreams*.
Copyright 1990 C. Herscovici/ARS,
New York.

Every image embodies a way of seeing. Even a photograph. For photographs are not, as is often assumed, a mechanical record. Every time we look at a photograph, we are aware, however slightly, of the photographer selecting that sight from an infinity of other possible sights. This is true even in the most casual family snapshot. The photographer's way of seeing is reflected in his choice of subject. The painter's way of seeing is reconstituted by the marks he makes on the canvas or paper. Yet, although every image embodies a way of seeing, our perception or appreciation of an image depends also upon our own way of seeing. (It may be, for example, that Sheila is one figure among twenty; but for our own reasons she is the one we have eyes for.)

Images were first made to conjure up the appearances of something that was absent. Gradually it became evident that an image could outlast what it represented; it then showed how something or somebody had once looked—and thus by implication how the subject had once been seen by other people. Later still the specific vision of the image-maker was also recognized as part of the record. An image became a record of how X had seen Y. This was the result of an increasing consciousness of individuality, accompanying an increasing awareness of history. It would be rash to try to date this last development precisely. But certainly in Europe such consciousness has existed since the beginning of the Renaissance.

No other kind of relic or text from the past can offer such a direct testimony about the world which surrounded other people at other times. In this respect images are more precise and richer than literature. To say this is not to deny the expressive or imaginative quality of art, treating it as mere documentary evidence; the more imaginative the work, the more profoundly it allows us to share the artist's experience of the visible.

Yet when an image is presented as a work of art, the way people look at it is affected by a whole series of learnt assumptions about art. Assumptions concerning:

Beauty
Truth
Genius
Civilization
Form
Status
Taste, etc.

Many of these assumptions no longer accord with the world as it is. (The world-as-it-is is more than pure objective fact, it includes consciousness.) Out of true with the present, these assumptions obscure the past. They mystify rather than clarify. The past is never there waiting to be discovered, to be recognized for exactly what it is. History always constitutes the relation between a present and its past. Consequently fear of the present leads to mystification of the past. The past is not for living in; it is a well of conclusions from which we draw in order to act. Cultural mystification of the past entails a double loss. Works of art are made unnecessarily remote. And the past offers us fewer conclusions to complete in action.

When we 'see' a landscape, we situate ourselves in it. If we 'saw' the art of the past, we would situate ourselves in history. When we are prevented from seeing it, we are being deprived of the history which belongs to us. Who benefits from this deprivation? In the end, the art of the past is being mystified because a privileged minority is striving to invent a history which can retrospectively justify the role of

the ruling classes, and such a justification can no longer make sense in modern terms. And so, inevitably, it mystifies. . . .

According to usage and conventions which are at last being questioned but have by no means been overcome, the social presence of a woman is different in kind from that of a man. A man's presence is dependent upon the promise of power which he embodies. If the promise is large and credible his presence is striking. If it is small or incredible, he is found to have little presence. The promised power may be moral, physical, temperamental, economic, social, sexual—but its object is always exterior to the man. A man's presence suggests what he is capable of doing to you or for you. His presence may be fabricated, in the sense that he pretends to be capable of what he is not. But the pretence is always towards a power which he exercises on others.

By contrast, a woman's presence expresses her own attitude to herself, and defines what can and cannot be done to her. Her presence is manifest in her gestures, voice, opinions, expressions, clothes, chosen surroundings, taste—indeed there is nothing she can do which does not contribute to her presence. Presence for a woman is so intrinsic to her person that men tend to think of it as an almost physical emanation, a kind of heat or smell or aura.

To be born a woman has been to be born, within an allotted and confined space, into the keeping of men. The social presence of women has developed as a result of their ingenuity in living under such tutelage within such a limited space. But this has been at the cost of a woman's self being split into two. A woman must continually watch herself. She is almost continually accompanied by her own image of herself. Whilst she is walking across a room or whilst she is weeping at the death of her father, she can scarcely avoid envisaging herself walking or weeping. From earliest childhood she has been taught and persuaded to survey herself continually.

And so she comes to consider the *surveyor* and the *surveyed* within her as the two constituent yet always distinct elements of her identity as a woman.

She has to survey everything she is and everything she does because how she appears to others, and ultimately how she appears to men, is of crucial importance for what is normally thought of as the success of her life. Her own sense of being in herself is supplanted by a sense of being appreciated as herself by another.

Men survey women before treating them. Consequently how a woman appears to a man can determine how she will be treated. To acquire some control over this process, women must contain it and interiorize it. That part of a woman's self which is the surveyor treats the part which is the surveyed so as to demonstrate to others how her whole self would like to be treated. And this exemplary treatment of herself by herself constitutes her presence. Every woman's presence regulates what is and is not 'permissible' within her presence. Every one of her actions—whatever its direct purpose or motivation—is also read as an indication of how she would like to be treated. If a woman throws a glass on the floor, this is an example of how she treats her own emotion of anger and so of how she would wish it to be treated by others. If a man does the same, his action is only read as an expression of his anger. If a woman makes a good joke this is an example of how she treats the joker in herself and accordingly of how she as a joker-woman would like to be treated by others. Only a man can make a good joke for its own sake.

One might simplify this by saying: *men act* and *women appear*. Men look at women. Women watch themselves being looked at. This determines not only most relations between men and women but also the relation of women to themselves. The surveyor of woman in herself is male: the surveyed female. Thus she turns herself into an object—and most particularly an object of vision: a sight.

In one category of European oil painting women were in the principal, ever-recurring subject. That category is the nude. In the nudes of European painting we can discover some of the criteria and conventions by which women have been seen and judged as sights.

The first nudes in the tradition depicted Adam and Eve. It is worth referring to the story as told in Genesis:

> And when the woman saw that the tree was good for food, and that it was a delight to the eyes, and that the tree was to be desired to make one wise, she took of the fruit thereof and did eat; and she gave also unto her husband with her, and he did eat.

> And the eyes of them both were opened, and they knew that they were naked; and they sewed fig-leaves together and made themselves aprons. . . . And the Lord God called unto the man and said unto him, 'Where are thou?' And he said, 'I heard thy voice in the garden, and I was afraid, because I was naked; and I hid myself. . . . Unto the woman God said, 'I will greatly multiply thy sorrow and thy conception; in sorrow thou shalt bring forth children; and thy desire shall be to thy husband and he shall rule over thee'.

What is striking about this story? They became aware of being naked because, as a result of eating the apple, each saw the other differently. Nakedness was created in the mind of the beholder.

The second striking fact is that the woman is blamed and is punished by being made subservient to the man. In relation to the woman, the man becomes the agent of God.

In the medieval tradition the story was often illustrated, scene following scene, as in a strip cartoon.

During the Renaissance the narrative sequence disappeared, and the single moment depicted became the moment of shame. The couple wear fig-leaves or make a modest gesture with their hands. But now their shame is no so much in relation to one another as to the spectator.

Later the shame becomes a kind of display.

When the tradition of painting became more secular, other themes also offered the opportunity of painting nudes. But in them all there remains the implication that the subject (a woman) is aware of being seen by a spectator.

She is not naked as she is.

She is naked as the spectator sees her.

Often—as with the favourite subject of Susannah and the Elders—this is the actual theme of the picture. We join the Elders to spy on Susannah taking her bath. She looks back at us looking at her.

In another version of the subject by Tintoretto, Susannah is looking at herself in a mirror. Thus she joins the spectators of herself.

The mirror was often used as a symbol of the vanity of woman. The moralizing, however, was mostly hypocritical. You painted a naked woman because you enjoyed looking at her, you put a mirror in her hand and you called the painting *Vanity,* thus morally condemning the woman whose nakedness you had depicted for your own pleasure.

The real function of the mirror was otherwise. It was to make the woman connive in treating herself as, first and foremost, a sight.

Pol de Limbourg, *Fall and Expulsion from Paradise.* Early fifteenth century. Giraudon, Musée Condé, Chantilly.

Mabuse, *Adam and Eve*. Early sixteenth century. National Gallery, London.

The Judgement of Paris was another theme with the same inwritten idea of a man or men looking at naked women.

But a further element is now added. The element of judgement. Paris awards the apple to the woman he finds most beautiful. Thus Beauty becomes competitive. (Today The Judgement of Paris has become the Beauty Contest.) Those who are not judged beautiful are *not beautiful*. Those who are, are given the prize.

The prize is to be owned by a judge—that is to say to be available for him. Charles the Second commissioned a secret painting from Lely. It is a highly typical image of the tradition. Nominally it might be a *Venus and Cupid*. In fact it is a portrait of one of the King's mistresses, Nell Gwynne. It shows her passively looking at the spectator staring at her naked.

This nakedness is not, however, an expression of her own feelings; it is a sign of her submission to the owner's feelings or demands. (The owner of both woman and painting.) The painting, when the King showed it to others, demonstrated this submission and his guests envied him.

It is worth noticing that in other non-European traditions—in Indian art, Persian art, African art, Pre-Columbian art—nakedness is never supine in this way. And if, in these traditions, the theme of a work is sexual attraction, it is likely to show active sexual love as between two people, the woman as active as the man, the actions of each absorbing the other.

Tintoretto, *Susannah and the Elders*. Réunion des Musées Nationaux.

Tintoretto, *Susannah and the Elders.*
Kunsthistorisches Museum, Vienna.

Memling, *Vanity.* Musées de la Ville de Strasbourg.

Cranach, *The Judgement of Paris.* Metropolitan
Museum of Art, New York, Rogers Fund, 1928.

Rubens, *The Judgement of Paris*.
National Gallery, London.

We can now begin to see the difference between nakedness and nudity in the European tradition. In his book on *The Nude* Kenneth Clark maintains that to be naked is simply to be without clothes, whereas the nude is a form of art. According to him, a nude is not the starting point of a painting, but a way of seeing which the painting achieves. To some degree, this is true—although the way of seeing 'a nude' is not necessarily confined to art: there are also nude photographs, nude poses, nude gestures. What is true is that the nude is always conventionalized—and the authority for its conventions derives from a certain tradition of art.

What do these conventions mean? What does a nude signify? It is not sufficient to answer these questions merely in terms of the art-form, for it is quite clear that the nude also relates to lived sexuality.

To be naked is to be oneself.

To be nude is to be seen naked by others and yet not recognized for oneself. A naked body has to be seen as an object in order to become a nude. (The sight of it as an object stimulates the use of it as an object.) Nakedness reveals itself. Nudity is placed on display.

To be naked is to without disguise.

Lely, *Nell Gwynne*. Denys Eyre Bower Bequest, Chiddingstone Castle, Kent, England.

To be on display is to have the surface of one's own skin, the hairs of one's own body, turned into a disguise which, in that situation, can never be discarded. The nude is condemned to never being naked. Nudity is a form of dress.

In the average European oil painting of the nude the principal protagonist is never painted. He is the spectator in front of the picture and he is presumed to be a man. Everything is addressed to him. Everything must appear to be the result of his being there. It is for him that the figures have assumed their nudity. But he, by definition, is a stranger—with his clothes still on.

Consider the *Allegory of Time and Love* by Bronzino. The complicated symbolism which lies behind this painting need not concern us now because it does not affect its sexual appeal—at the first degree. Before it is anything else, this is a painting of sexual provocation.

The painting was sent as a present from the Grand Duke of Florence to the King of France. The boy kneeling on the cushion and kissing the woman is Cupid. She is Venus. But the way her body is arranged has nothing to do with their kissing. Her body is arranged in the way it is, to display it to the man looking at the picture. This picture is made to appeal to *his* sexuality. It has nothing to do with her sexuality. (Here and in the European tradition generally, the convention of not painting the hair on a woman's body helps towards the same end. Hair is associated with sexual power, with passion. The woman's sexual passion needs to be minimized so that the spectator may feel that he has the monopoly of such passion.) Women are there to feed an appetite, not to have any of their own.

Compare the expressions of these two women: one the model for a famous painting by Ingres and the other a model for a photograph in a girlie magazine.

Is not the expression remarkably similar in each case? It is the expression of a woman responding with calculated charm to the man whom she imagines looking at her—although she doesn't know him. She is offering up her femininity as the surveyed.

It is true that sometimes a painting includes a male lover.

But the woman's attention is very rarely directed towards him. Often she looks away from him or she looks out of the picture towards the one who considers himself her true lover—the spectator-owner.

There was a special category of private pornographic paintings (especially in the eighteenth century) in which couples making love make an appearance. But even in front of these it is clear that the spectator-owner will in fantasy oust the other

Bronzino, *Venus, Cupid, Time, and Love.* National Gallery, London.

man, or else identify with him. By contrast the image of the couple in non-European traditions provokes the notion of many couples making love. 'We all have a thousand hands, a thousand feet and will never go alone.'

Almost all post-Renaissance European sexual imagery is frontal—either literally or metaphorically—because the sexual protagonist is the spectator-owner looking at it.

The absurdity of this male flattery reached its peak in the public academic art of the nineteenth century. Men of state, of business, discussed under paintings like this. When one of them felt he had been outwitted, he looked up for consolation. What he saw reminded him that he was a man.

There are a few exceptional nudes in the European tradition of oil painting to which very little of what has been said above applies. Indeed they are no longer nudes; they break the norms of the art-form; they are paintings of loved women, more or less naked. Among the hundreds of thousands of nudes which make up the tradition there are perhaps a hundred of these exceptions. In each case the painter's personal vision of the particular women he is painting is so strong that it makes no allowance for the spectator. The painter's vision binds the woman to him so that they become as inseparable

Ingres, *La Grande Odalisque*. (detail) Louvre.

as couples in stone. The spectator can witness their relationship—but he can do no more: he is forced to recognize himself as the outsider he is. He cannot deceive himself into believing that she is naked for him. He cannot turn her into a nude. The way the painter has painted her includes her will and her intentions in the very structure of the image, in the very expression of her body and her face.

The typical and the exceptional in the tradition can be defined by the simple naked/nude antinomy, but the problem of painting nakedness is not as simple as it might at first appear.

What is the sexual function of nakedness in reality? Clothes encumber contact and movement. But it would seem that nakedness has a positive visual value in its own right: we want to *see* the other

Bouguereau, *Les Oréades*. Giraudon/ Art Resource, New York.

Rembrandt, *Danae*. (detail) Hermitage, Leningrad.

naked: the other delivers to us the sight of them-
selves and we seize upon it—sometimes quite
regardless of whether it is for the first time or the
hundredth. What does this sight of the other mean
to us, how does it, at that instant of total disclosure,
affect our desire?

Their nakedness acts as a confirmation and pro-
vokes a very strong sense of relief. She is a woman
like any other: or he is a man like any other: we are
overwhelmed by the marvellous simplicity of the
familiar sexual mechanism.

We did not, of course, consciously expect this to
be otherwise: unconscious homosexual desires (or
unconscious heterosexual desires if the couple con-
cerned are homosexual) may have led each to half
expect something different. But the 'relief' can be
explained without recourse to the unconscious.

We did not expect them to be otherwise, but the
urgency and complexity of our feelings bred a sense
of uniqueness which the sight of the other, as she is
or as he is, now dispels. They are more like the rest
of their sex than they are different. In this revelation

lies the warm and friendly—as opposed to cold and
impersonal—anonymity of nakedness.

One could express this differently: at the moment
of nakedness first perceived, an element of banality
enters: an element that exists only because we need
it.

Up to that instant the other was more or less mys-
terious. Etiquettes of modesty are not merely puri-
tan or sentimental: it is reasonable to recognize a
loss of mystery. And the explanation of this loss of
mystery may be largely visual. The focus of percep-
tion shifts from eyes, mouth, shoulders, hands—all
of which are capable of such subtleties of expression
that the personality expressed by them is mani-
fold—it shifts from these to the sexual parts, whose
formation suggests an utterly compelling but single
process. The other is reduced or elevated—which-
ever you prefer—to their primary sexual category:
male or female. Our relief is the relief of finding an
unquestionable reality to whose direct demands our
earlier highly complex awareness must now yield.

We need the banality which we find in the first

instant of disclosure because it grounds us in reality. But it does more than that. This reality, by promising the familiar, proverbial mechanism of sex, offers, at the same time, the possibility of the shared subjectivity of sex.

The loss of mystery occurs simultaneously with the offering of the means for creating a shared mystery. The sequence is: subjective–objective–subjective to the power.

We can now understand the difficulty of creating a static image of sexual nakedness. In lived sexual experience nakedness is a process rather than a state. If one moment of that process is isolated, its image will seem banal and its banality, instead of serving as a bridge between two intense imaginative states, will be chilling. This is one reason why expressive photographs of the naked are even rarer than paintings. The easy solution for the photographer is to turn the figure into a nude which, by generalizing both sight and viewer and making sexuality unspecific, turns desire into fantasy.

Let us examine an exceptional painted image of nakedness. It is a painting by Rubens of his young second wife whom he married when he himself was relatively old.

We see her in the act of turning, her fur about to slip off her shoulders. Clearly she will not remain as she is for more than a second. In a superficial sense her image is as instantaneous as a photograph's. But, in a more profound sense, the painting 'contains' time and its experience. It is easy to imagine that a moment ago before she pulled the fur round her shoulders, she was entirely naked. The consecutive stage up to and away from the moment of total disclosure have been transcended. She can belong to any or all of them simultaneously.

Her body confronts us, not as an immediate sight, but as experience—the painter's experience. Why? There are superficial anecdotal reasons: her dishevelled hair, the expression of her eyes directed towards him, the tenderness with which the exaggerated susceptibility of her skin has been painted. But the profound reason is a formal one. Her appearance has been literally re-cast by the painter's subjectivity. Beneath the fur that she holds across herself, the upper part of her body and her legs can never meet. There is a displacement sideways of about nine inches: her thighs, in order to join on to her hips, are at least nine inches too far to the left.

Rubens probably did not plan this: the spectator may not consciously notice it. In itself it is unimportant. What matters is what it permits. It permits the body to become impossibly dynamic. Its coherence is no longer within itself but within the experience of the painter. More precisely, it permits the upper and lower halves of the body to rotate separately, and in opposite directions, round the sexual centre which is hidden: the torso turning to the right, the legs to the left. At the same time this hidden sexual centre is connected by means of the dark fur coat to all the surrounding darkness in the picture, so that she is turning both around and within the dark which has been made a metaphor for her sex.

Apart from the necessity of transcending the single instant and of admitting subjectivity, there is, as we have seen, one further element which is essential

Rubens, *Helene Fourment in a Fur Coat*. Kunsthistorisches Museum, Vienna.

for any great sexual image of the naked. This is the element of banality which must be undisguised but not chilling. It is this which distinguishes between voyeur and lover. Here such banality is to be found in Rubens's compulsive painting of the fat softness of Hélène Fourment's flesh which continually breaks every ideal convention of form and (to him) continually offers the promise of her extraordinary particularity.

The nude in European oil painting is usually presented as an admirable expression of the European humanist spirit. This spirit was inseparable from individualism. And without the development of a highly conscious individualism the exceptions to the tradition (extremely personal images of the naked), would never have been painted. Yet the tradition contained a contradiction which it could not itself resolve. A few individual artists intuitively recognized this and resolved the contradiction in their own terms, but their solutions could never enter the tradition's *cultural* terms.

The contradiction can be stated simply. On the one hand the individualism of the artist, the thinker, the patron, the owner: on the other hand, the person who is the object of their activities—the woman—treated as a thing or an abstraction.

Dürer believed that the ideal nude ought to be constructed by taking the face of one body, the breasts of another, the legs of a third, the shoulders of a fourth, the hands of a fifth—and so on.

The result would glorify Man. But the exercise presumed a remarkable indifference to who any one person really was.

In the art-form of the European nude the painters and spectator–owners were usually men and the persons treated as objects, usually women. This unequal relationship is so deeply embedded in our culture that it still structures the consciousness of many women. They do to themselves what men do to them. They survey, like men, their own femininity.

In modern art the category of the nude has become less important. Artists themselves began to question it. In this, as in may other respects, Manet represented a turning point. If one compares his *Olympia* with Titian's original, one sees a woman, cast in the traditional role, beginning to question that role, somewhat defiantly.

The ideal was broken. But there was little to replace it except the 'realism' of the prostitute—who became the quintessential woman of early avant-garde twentieth-century painting. (Toulouse-Lautrec, Picasso, Rouault, German Expressionism, etc.) In academic painting the tradition continued.

Today the attitudes and values which informed that tradition are expressed through other more widely diffused media—advertising, journalism, television.

But the essential way of seeing women, the essential use to which their images are put, has not changed. Women are depicted in a quite different way from men—not because the feminine is different from the masculine—but because the 'ideal' spectator is always assumed to be male and the image of the woman is designed to flatter him. If you have any doubt that this is so, make the following experiment. Choose from this [chapter] an image of a traditional nude. Transform the woman into a man. Either in your mind's eye or by drawing on the reproduction. Then notice the violence which that transformation does. Not to the image, but to the assumptions of a likely viewer.

22

Why Have There Been No Great Women Artists?

LINDA NOCHLIN

While the recent upsurge of feminist activity in this country has indeed been a liberating one, its force has been chiefly emotional—personal, psychological and subjective—centered, like the other radical movements to which it is related, on the present and its immediate needs, rather than on historical analysis of the basic intellectual issues which the feminist attack on the status quo automatically raises. Like any revolution, however, the feminist one ultimately must come to grips with the intellectual and ideological basis of the various intellectual or scholarly disciplines—history, philosophy, sociology, psychology, etc.—in the same way that it questions the ideologies of present social institutions. If, as John Stuart Mill suggested, we tend to accept whatever is as natural, this is just as true in the realm of academic investigation as it is in our social arrangements. In the former, too, "natural" assumptions must be questioned and the mythic basis of much so-called "fact" brought to light. And it is here that the very position of woman as an acknowledged outsider, the maverick "she" instead of the presumably neutral "one"—in reality the white male-position-accepted-as-natural, or the hidden "he" as the subject of all scholarly predicates—is a decided advantage, rather than merely a hindrance or a subjective distortion.

In the field of art history, the white Western male viewpoint, unconsciously accepted as *the* viewpoint of the art historian, may—and does—prove to be inadequate not merely on moral and ethical grounds, or because it is elitist, but on purely intel-

lectual ones. In revealing the failure of much academic art history, and a great deal of history in general, to take account of the unacknowledged value system, the very *presence* of an intruding subject in historical investigation, the feminist critique at the same time lays bare its conceptual smugness, its meta-historical naïveté. At a moment when all disciplines are becoming more self-conscious, more aware of the nature of their presuppositions as exhibited in the very languages and structures of the various fields of scholarship, such uncritical acceptance of "what is" as "natural" may be intellectually fatal. Just as Mill saw male domination as one of a long series of social injustices that had to be overcome if a truly just social order were to be created, so we may see the unstated domination of white male subjectivity as one in a series of intellectual distortions which must be corrected in order to achieve a more adequate and accurate view of historical situations.

It is the engaged feminist intellect (like John Stuart Mill's) that can pierce through the cultural-ideological limitations of the time and its specific "professionalism" to reveal biases and inadequacies not merely in the dealing with the question of women, but in the very way of formulating the crucial questions of the discipline as a whole.

Thus, the so-called woman question, far from being a minor, peripheral and laughably provincial subissue grafted on to a serious, established discipline, can become a catalyst, an intellectual instrument, probing basic and "natural" assumptions,

From *ARTnews*, 69 (1971), 22–39, 67–71. Reprinted with permission of *ARTnews* and the author.

providing a paradigm for other kinds of internal questioning, and in turn providing links with paradigms established by radical approaches in other fields. Even a simple question like "Why have there been no great women artists?" can, if answered adequately, create a sort of chain reaction, expanding not merely to encompass the accepted assumptions of the single field, but outward to embrace history and the social sciences, or even psychology and literature, and thereby, from the outset, to challenge the assumption that the traditional divisions of intellectual inquiry are still adequate to deal with the meaningful questions of our time, rather than the merely convenient or self-generated ones.

Let us, for example, examine the implications of that perennial question (one can, of course, substitute almost any field of human endeavor, with appropriate changes in phrasing): "Well, if women really *are* equal to men, why have there never been any great women artists (or composers, or mathematicians, or philosophers, or so few of the same)?"

"Why have there been no great women artists?" The question tolls reproachfully in the background of most discussions of the so-called woman problem. But like so many other so-called questions involved in the feminist "controversy," it falsifies the nature of the issue at the same time that it insidiously supplies its own answer: "There are no great women artists because women are incapable of greatness."

The assumptions behind such a question are varied in range and sophistication, running anywhere from "scientifically proved" demonstrations of the inability of human beings with wombs rather than penises to create anything significant, to relatively open-minded wonderment that women, despite so many years of near-equality—and after all, a lot of men have had their disadvantages too—have still not achieved anything of exceptional significance in the visual arts.

The feminist's first reaction is to swallow the bait, hook, line and sinker, and to attempt to answer the question as it is put: i.e., to dig up examples of worthy or insufficiently appreciated women artists throughout history; to rehabilitate rather modest, if interesting and productive careers; to "re-discover" forgotten flower-painters or David-followers and make out a case for them; to demonstrate that Berthe Morisot was really less dependent upon Manet than one had been led to think—in other words, to engage in the normal activity of the specialist scholar who makes a case for the importance of his very own neglected or minor master. . . .

Another attempt to answer the question involves shifting the ground slightly and asserting, as some contemporary feminists do, that there is a different kind of "greatness" for women's art than for men's,

thereby postulating the existence of a distinctive and recognizable feminine style, different both in its formal and its expressive qualities and based on the special character of women's situation and experience.

This, on the surface of it, seems reasonable enough: in general, women's experience and situation in society, and hence as artists, is different from men's, and certainly the art produced by a group of consciously united and purposefully articulate women intent on bodying forth a group consciousness of feminine experience might indeed by stylistically identifiable as feminist, if not feminine, art. Unfortunately, though this remains within the realm of possibility it has so far not occurred. While the members of the Danube School, and followers of Caravaggio, the painters gathered around Gauguin at Pont-Aven, the Blue Rider, or the Cubists may be recognized by certain clearly defined stylistic or expressive qualities, no such common qualities of "femininity" would seem to link the styles of women artists generally, any more than such qualities can be said to link women writers. . . . No subtle essence of femininity would seem to link the work of Artemesia Gentileschi, Mme. Vigée-Lebrun, Angelica Kauffmann, Rosa Bonheur, Berthe Morisot, Suzanne Valadon, Kaethe Kollwitz, Barbara Hepworth, Georgia O'Keeffe, Sophie Taeuber-Arp, Helen Frankenthaler, Bridget Riley, Lee Bontecou or Louise Nevelson, any more than that of Sappho, Marie de France, Jane Austen, Emily Brontë, George Sand, George Eliot, Virginia Woolf, Gertrude Stein, Anaïs Nin, Emily Dickinson, Sylvia Plath and Susan Sontag. In every instance, women artists and writers would seem to be closer to other artists and writers of their own period and outlook than they are to each other.

Women artists are more inward-looking, more delicate and nuanced in their treatment of their medium, it may be asserted. But which of the women artists cited above is more inward-turning than Redon, more subtle and nuanced in the handling of pigment than Corot? Is Fragonard more or less feminine than Mme. Vigée-Lebrun? Or is it not more a question of the whole Rococo style of 18th-century France being "feminine," if judged in terms of a two-valued scale of "masculinity" vs. "femininity"? Certainly, though, if daintiness, delicacy and preciousness are to be counted as earmarks of a feminine style, there is nothing fragile about Rosa Bonheur's *Horse Fair,* nor dainty and introverted about Helen Frankenthaler's giant canvases. If women have turned to scenes of domestic life, or of children, so did Jan Steen, Chardin and the Impressionists—Renoir and Monet as well as Morisot and Cassatt. In any case, the mere choice of a certain realm of subject matter, or the restriction to certain

Mary Cassatt. *The Bath*. 1891. Oil on canvas. Courtesy of The Art Institute of Chicago.

subjects, is not to be equated with a style, much less with some sort of quintessentially feminine style.

The problem lies not so much with the feminists' concept of what femininity is, but rather with their misconception shared with the public at large of what art is: with the naïve idea that art is the direct, personal expression of individual emotional experience, a translation of personal life into visual terms. Art is almost never that, great art never is. The making of art involves a self-consistent language of form, more or less dependent upon, or free from, given temporarily defined conventions, sche-

Marie Laurencin, *Group of Artists.*
1908. Oil on canvas. The Baltimore
Museum of Arts. Bequest of Miss
Etta and Dr. Claribel Cone.

mata or systems of notation, which have to be learned or worked out, either through teaching, apprenticeship or a long period of individual experimentation. The language of art is, more materially, embodied in paint and line on canvas or paper, in stone or clay or plastic or metal—it is neither a sob-story nor a confidential whisper.

The fact of the matter is that there have been no supremely great women artists, as far as we know, although there have been many interesting and very good ones who remain insufficiently investigated or appreciated; nor have there been any great Lithuanian jazz pianists, nor Eskimo tennis players, no matter how much we might wish there had been. That this should be the case is regrettable, but no amount of manipulating the historical or critical evidence will alter the situation; nor will accusations of male-chauvinist distortion of history. The fact, dear sisters, is that there *are* no women equivalents for Michelangelo or Rembrandt, Delacroix or Cézanne, Picasso or Matisse, or even in very recent times, for de Kooning or Warhol, any more than there are black American equivalents for the same. If there actually were large numbers of "hidden" great women artists, or if there really should be different standards for women's art as opposed to men's—and one can't have it both ways—then what are the feminists fighting for? If women have in fact achieved the same status as men in the arts, then the status quo is fine as it is.

But in actuality, as we all know, things as they are and as they have been, in the arts as in a hundred other areas, are stultifying, oppressive and discouraging to all those, women among them, who did not have the good fortune to be born white, preferably middle class and, above all, male. The fault, dear brothers, lies not in our stars, our hormones, our menstrual cycles or our empty internal spaces, but in our institutions and our education—education understood to include everything that happens to us from the moment we enter this world of meaningful symbols, signs and signals. The miracle is, in fact, that given the overwhelming odds against women, or blacks, that so many of both have achieved so much sheer excellence, in those bailiwicks of white masculine prerogative like science, politics or the arts.

It is when one really starts thinking about the implications of "Why have there been no great women artists?" that one begins to realize to what extent our consciousness of how things are in the world has been conditioned—and often falsified—by the way the most important questions are posed. We tend to take it for granted that there really is an East Asian Problem, a Poverty Problem, a Black Problem—and a Woman Problem. But first we must ask ourselves who is formulating these "questions," and then, what purposes such formulations may serve. (We may, of course, refresh our memories with the connotations of the Nazi's "Jewish Problem.") Indeed, in our time of instant communication, "problems" are rapidly formulated to rationalize the bad conscience of those with power: thus the problem posed by Americans in Vietnam and Cambodia is referred to by Americans as "the East Asian Problem," whereas East Asians may view it, more realistically, as "the American Problem"; the so-called Poverty Problem might more directly be viewed as the "Wealth Problem" by denizens of urban ghettos or rural wastelands; the same

irony twists the White Problem into its opposite: A Black Problem; and the same inverse logic turns up in the formulation of our own present state of affairs as the "Woman Problem."

Now the "Woman Problem," like all human problems, so-called (and the very idea of calling anything to do with human beings a "problem" is, of course, a fairly recent one) is not amenable to "solution" at all, since what human problems involve is reinterpretation of the nature of the situation, or a radical alteration of stance or program *on the part of the "problems" themselves*. Thus women and their situation in the arts, as in other realms of endeavor, are not a "problem" to be viewed through the eyes of the dominant male power elite. Instead, *women* must conceive of themselves as potentially, if not actually, equals, and must be willing to look the facts of their situation full in the face, without self-pity; at the same time they must view their situation with that high degree of emotional and intellectual commitment necessary to create a world in which equal achievement will be not only made possible but actively encouraged by social institutions.

It is certainly not realistic to hope that a majority of men, in the arts, or in any other field, will soon see the light and find that it is in their own self-interest to grant complete equality to women, as some feminists optimistically assert, or to maintain that men themselves will soon realize that they are diminished by denying themselves access to traditionally "feminine" realms and emotional reactions. After all, there are few areas that are really "denied" to men, if the level of operations demanded be transcendent, responsible or rewarding enough: men who have a need for "feminine" involvement with babies or children gain status as pediatricians or child psychologists, with a nurse (female) to do the more routine work; those who feel the urge for kitchen creativity may gain fame as master chefs; and, of course, men who yearn to fulfill themselves through what are often termed "feminine" artistic interests can find themselves as painters or sculptors, rather than as volunteer museum aides or part-time ceramists, as their female counterparts so often end up doing; as far as scholarship is concerned, how many men would be willing to change their jobs as teachers and researchers for those of unpaid, part-time research assistants and typists as well as full-time nannies and domestic workers?

Those who have privileges inevitably hold on to them, and hold tight, no matter how marginal the advantage involved, until compelled to bow to superior power of one sort or another.

Thus the question of women's equality—in art as in any other realm—devolves not upon the relative benevolence or ill-will of individual men, nor the self-confidence or abjectness of individual women, but rather on the very nature of our institutional structures themselves and the view of reality which they impose on the human beings who are part of them. As John Stuart Mill pointed out more than a century ago: "Everything which is usual appears natural. The subjection of women to men being a universal custom, any departure from it quite naturally appears unnatural." Most men, despite lip-service to equality, are reluctant to give up this "natural" order of things in which their advantages are so great; for women, the case is further complicated by the fact that, as Mill astutely pointed out, unlike other oppressed groups or castes, men demand of her not only submission but unqualified affection as well; thus women are often weakened by the internalized demands of the male-dominated society itself, as well as by a plethora of material goods and comforts: the middle-class woman has a great deal more to lose than her chains.

The question "Why have there been no great women artists?" is simply the top tenth of an iceberg of misinterpretation and misconception; beneath lies a vast dark bulk of shaky *idées reçues* about the nature of art and its situational concomitants, about the nature of human abilities in general and of human excellence in particular, and the role that the social order plays in all of this. While the "woman problem" as such may be a pseudo-issue, the misconceptions involved in the question "Why have there been no great women artists?" points to major areas of intellectual obfuscation beyond the specific political and ideological issues involved in the subjection of women. Basic to the question are many naïve, distorted, uncritical assumptions about the making of art in general, as well as the making of great art. These assumptions, conscious or unconscious, link together such unlikely superstars as Michelangelo and van Gogh, Raphael and Jackson Pollock under the rubric of "great"—an honorific attested to by the number of scholarly monographs devoted to the artist in question—and the Great Artist is, of course, conceived of as one who has "Genius"; Genius, in turn, is thought of as an atemporal and mysterious power somehow embedded in the person of the Great Artist. Such ideas are related to unquestioned, often unconscious, meta-historical premises that make Hippolyte Taine's race-milieu-moment formulation of the dimensions of historical thought seem a model of sophistication. But these assumptions are intrinsic to a great deal of art-historical writing. It is no accident that the crucial question of the conditions *generally* productive of great art has so rarely been investigated, or that attempts to investigate such general problems have, until fairly recently, been dismissed as unscholarly, too broad, or the province of some

other discipline, like sociology. To encourage a dis-passionate, impersonal, sociological and institution-ally oriented approach would reveal the entire romantic, elitist, individual-glorifying and mono-graph-producing substructure upon which the pro-fession of art history is based, and which has only recently been called into question by a group of younger dissidents. . . .

The fairy tale of the Boy Wonder, discovered by an older artist or discerning patron, usually in the guise of a lowly shepherd boy, has been a stock-in-trade of artistic mythology ever since Vasari immortalized the young Giotto, discovered by the great Cimabue while the lad was guarding his flocks, drawing sheep on a stone; Cimabue, over-come with admiration by the realism of the draw-ing, immediately invited the humble youth to be his pupil. Through some mysterious coincidence, later artists including Beccafumi, Andrea Sansovino, Andrea del Castagno, Mantegna, Zurbarán and Goya were all discovered in similar pastoral circum-stances. Even when the young Great Artist was not fortunate enough to come equipped with a flock of sheep, his talent always seems to have manifested itself very early, and independent of any external encouragement: Filippo Lippi and Poussin, Courbet and Monet are all reported to have drawn carica-tures in the margins of their schoolbooks instead of studying the required subjects—we never, of course, hear about the youths who neglected their studies and scribbled in the margins of their note-books without ever becoming anything more ele-vated than department-store clerks or shoe sales-men. The great Michelangelo himself, according to his biographer and pupil, Vasari, did more drawing than studying as a child. So pronounced was his tal-ent, reports Vasari, that when his master, Ghirlan-daio, absented himself momentarily from his work in Santa Maria Novella, and the young art student took the opportunity to draw "the scaffolding, tres-tles, pots of paint, brushes and the apprentices at their tasks," he did it so skillfully that upon his return the master exclaimed: "This boy knows more than I do."

As is so often the case, such stories, which prob-ably have some truth in them, tend both to reflect and perpetuate the attitudes they subsume. Despite any basis in fact of these myths about the early man-ifestations of Genius, the tenor of the tales is mis-leading. It is no doubt true, for example, that the young Picasso passed all the examinations for entrance to the Barcelona, and later to the Madrid, Academy of Art at the age of 15 in but a single day, a feat of such difficulty that most candidates required a month of preparation. But one would like to find out more about similar precocious qual-ifiers for art academies who then went on to achieve nothing but mediocrity or failure—in whom, of course, art historians are uninterested—or to study in greater detail the role played by Picasso's art-pro-fessor father in the pictorial precocity of his son. What if Picasso had been born a girl? Would Señor Ruiz have paid as much attention or stimulated as much ambition for achievement in a little Pablita?

What is stressed in all these stories is the appar-ently miraculous, non-determined and a-social nature of artistic achievement; this semi-religious conception of the artist's role is elevated to hagiog-raphy in the 19th century, when both art histori-ans, critics and, not least, some of the artists them-selves tended to elevate the making of art into a substitute religion, the last bulwark of Higher Val-ues in a materialistic world. . . .

One would like to ask, for instance, from what social classes artists were most likely to come at dif-ferent periods of art history, from what castes and sub-group. What proportion of painters and sculp-tors, or more specifically, of major painters and sculptors, came from families in which their fathers or other close relatives were painters and sculptors or engaged in related professions? As Nikolaus Pevs-ner points out in his discussion of the French Acad-emy in the 17th and 18th centuries, the transmis-sion of the artistic profession from father to son was considered a matter of course (as it was with the Coypels, the Coustous, the Van Loos, etc.); indeed, sons of academicians were exempted from the cus-tomary fees for lesson. Despite the noteworthy and dramatically satisfying cases of the great father-rejecting *révoltés* of the 19th century, one might be forced to admit that a large proportion of artists, great and not-so-great, in the days when it was nor-mal for sons to follow in their fathers' footsteps, had artist fathers. In the rank of major artists, the names of Holbein and Dürer, Raphael and Bernini, imme-diately spring to mind; even in our own times, one can cite the names of Picasso, Calder, Giacometti and Wyeth as members of artist-families.

As far as the relationship of artistic occupation and social class is concerned, an interesting para-digm for the question "Why have there been no great women artists?" might well be provided by trying to answer the question: "Why have there been no great artists from the aristocracy?" One can scarcely think, before the anti-traditional 19th cen-tury at least, of any artist who sprang from the ranks of any more elevated class than the upper bourgeoisie; even in the 19th century, Degas came from the lower nobility—more like the haute bour-geoisie, in fact—and only Toulouse-Lautrec, meta-morphosed into the ranks of the marginal by acci-dental deformity, could be said to have come from the loftier reaches of the upper classes. While the aristocracy has always provided the lion's share of

the patronage and the audience for art—as, indeed, the aristocracy of wealth does even in our more democratic days—it has contributed little beyond amateurish efforts to the creation of art itself, despite the fact that aristocrats (like many women) have had more than their share of educational advantages, plenty of leisure and, indeed, like women, were often encouraged to dabble in the arts and ever develop into respectable amateurs, like Napoleon III's cousin, the Princess Mathilde, who exhibited at the official Salons, or Queen Victoria, who, with Prince Albert, studied art with no less a figure than Landseer himself. Could it be that the little golden nugget—Genius—is missing from the aristocratic makeup in the same way that it is from the feminine psyche? Or rather, is it not, that the kinds of demands and expectations placed before both aristocrats and women—the amount of time necessarily devoted to social functions, the very kinds of activities demanded—simply made total devotion to professional art production out of the question, indeed unthinkable, both for upper-class males and for women generally, rather than its being a question of genius and talent?

When the right questions are asked about the conditions for producing art, of which the production of great art is a sub-topic, there will no doubt have to be some discussion of the situational concomitants of intelligence and talent generally, not merely of artistic genius. Piaget and others have stressed in their genetic epistemology that in the development of reason and in the unfolding of imagination in young children, intelligence—or, by implication, what we choose to call genius—is a dynamic activity rather than a static essence, and an activity of a subject *in a situation*. As further investigations in the field of child development imply, these abilities, or this intelligence, are built up minutely, step by step, from infancy onward, and the patterns of adaptation–accommodation may be established so early within the subject-in-an-environment that they may indeed *appear* to be innate to the unsophisticated observer. Such investigations imply that, even aside from meta-historical reasons, scholars will have to abandon the notion, consciously articulated or not, of individual genius as innate, and as primary to the creation of art.

The question "Why have there been no great women artists?" has led us to the conclusion, so far, that art is not a free, autonomous activity of a super-endowed individual, "influenced" by previous artists, and, more vaguely and superficially, by "social forces," but rather, that the total situation of art making, both in terms of the development of the art maker and in the nature and quality of the work of art itself, occur in a social situation, are

integral elements of this social structure, and are mediated and determined by specific and definable social institutions, be they art academies, systems of patronage, mythologies of the divine creator, artist as he-man or social outcast.

The Question of the Nude

We can now approach our question from a more reasonable standpoint, since it seems probable that the answer to why there have been no great women artists lies not in the nature of individual genius or the lack of it, but in the nature of given social institutions and what they forbid or encourage in various classes or groups of individuals. Let us first examine such a simple, but critical, issue as availability of the nude model to aspiring women artists, in the period extending from the Renaissance until near the end of the 19th century, a period in which careful and prolonged study of the nude model was essential to the training of every young artist, to the production of any work with pretentions to grandeur, and to the very essence of History Painting, generally accepted as the highest category of art: indeed, it was argued by defenders of traditional painting in the 19th century that there could be no great painting *with* clothed figures, since costume inevitably destroyed both the temporal universality and the classical idealization required by great art. Needless to say, central to the training programs of the academies since their inception late in the 16th and early in the 17th centuries, was life drawing from the nude, generally male, model. In addition, groups of artists and their pupils often met privately for life drawing sessions from the nude model in their studios. In general, it might be added, while individual artists and private academies employed the female model extensively, the female nude was forbidden in almost all public art schools as late as 1850 and after—a state of affairs which Pevsner rightly designates as "hardly believable." Far more believable, unfortunately, was the complete unavailability to the aspiring woman artist of *any* nude models at all, male or female. As late as 1893, "lady" students were not admitted to life drawing at the Royal Academy in London, and even when they were, after that date, the model had to be "partially draped."

A brief survey of representations of life-drawing sessions reveals an all male clientele drawing from the female nude in Rembrandt's studio; men working from male nudes in 18th-century representations of academic instruction in The Hague and Vienna; men working from the seated male nude in Boilly's charming painting of the interior of Hou-

don's studio at the beginning of the 19th century; Mathieu Cochereau's scrupulously veristic *Interior of David's Studio,* exhibited in the Salon of 1814, reveals a group of young men diligently drawing or painting from a male nude model, whose discarded shoes may be seen before the models' stand.

The very plethora of surviving "Academies"—detailed, painstaking studies from the nude studio model—in the youthful *oeuvre* of artists down through the time of Seurat and well into the 20th century, attests to the central importance of this branch of study in the pedagogy and development of the talented beginner. The formal academic program itself normally proceeded, as a matter of course, from copying from drawings and engravings, to drawing from casts of famous works of sculpture, to drawing from the living model. To be deprived of this ultimate state of training meant, in effect, to be deprived of the possibility of creating major art works, unless one were a very ingenious lady indeed, or simply, as most of the women aspiring to be painters ultimately did, to restrict oneself to the "minor" fields of portraiture, genre, landscape or still-life. It is rather as though a medical stu-

dent were denied the opportunity to dissect or even examine the naked human body.

There exist, to my knowledge, no representations of artists drawing from the nude model which include women in any role but that of the nude model itself, an interesting commentary on rules of propriety: i.e., it is all right for a ("low," of course) woman to reveal herself naked-as-an-object for a group of men, but forbidden to a woman to participate in the active study and recording of naked-man-as-an-object, or even of a fellow woman. An amusing example of this taboo on confronting a dressed lady with a naked man is embodied in a group portrait of the members of the Royal Academy in London in 1772, represented by Zoffany as gathered in the life room before two nude male models: all the distinguished members are present with but one noteworthy exception—the single female member, the renowned Angelica Kauffmann, who, for propriety's sake, is merely present in effigy, in the form of a portrait hanging on the wall. . . .

A photograph by Thomas Eakins of about 1885 reveals the students in the Women's Modeling Class

Angelica Kauffmann, *Cornelia Mother of the Gracchi,* detail. 1785. Oil on canvas. The Virginia Museum of Fine Arts, Richmond. The Adolph D. and Wilkins C. Williams Fund.

at the Pennsylvania Academy modeling from a cow (bull? ox? the nether regions are obscure in the photograph), a naked cow to be sure, perhaps a daring liberty when one considers that even piano legs might be concealed beneath pantalettes during this era (the idea of introducing a bovine model into the artist's studio stems from Courbet, who brought a bull into his short-lived studio academy in the 1860s). Only at the very end of the 19th century, in the relatively liberated and open atmosphere of Repin's studio and circle in Russia, are we able to find representations of women art students working uninhibitedly from the nude model—the female model, to be sure—in the company of men. . . .

It also becomes apparent why women were able to compete on far more equal terms with men—and even become innovators—in literature. While art-making traditionally had demanded the learning of specific techniques and skills, in a certain sequence, in an institutional setting outside the home, as well as becoming familiar with a specific vocabulary of iconography and motifs, the same is by no means true for the poet or novelist. Anyone, even a woman, has to learn the language, can learn to read and write, and can commit personal experiences to paper in the privacy of one's room. Naturally this oversimplifies the real difficulties and complexities involved in creating good or great literature, whether by man or woman, but it still gives a clue as to the possibility of the existence of Emily Brontë or an Emily Dickinson, and the lack of their counterparts, at least until quite recently, in the visual arts.

The Lady's Accomplishment

In contrast to the single-mindedness and commitment demanded of a *chef d'école*, we might set the image of the "lady painter" established by 19th-century etiquette books and reinforced by the literature of the times. It is precisely the insistence upon a modest, proficient, self-demeaning level of amateurism as a "suitable accomplishment" for the well-brought-up young woman, who naturally would want to direct her major attention to the welfare of others—family and husband—that militated, and still militates, against any real accomplishment on the part of women. It is this emphasis which transforms serious commitment to frivolous self-indulgence, busy work or occupational therapy, and today, more than ever, in suburban bastions of the feminine mystique, tends to distort the whole notion of what art is and what kind of social role it plays. . . .

In literature, as in life, even if the woman's commitment to art was a serious one, she was expected to drop her career and give up this commitment at the behest of love and marriage: this lesson is, today as in the 19th century, still inculcated in young girls, directly or indirectly, from the moment they are born. Even the determined and successful heroine of Mrs. Craik's mid-19th-century novel about feminine artistic success, *Olive*, a young woman who lives alone, strives for fame and independence and actually supports herself through her art—such unfeminine behavior is at least partly excused by the fact that she is a cripple and automatically considers that marriage is denied to her—even Olive ultimately succumbs to the blandishments of love and marriage. To paraphrase the words of Patricia Thomson in *The Victorian Heroine*, Mrs. Craik, having shot her bolt in the course of her novel, is content, finally, to let her heroine, whose ultimate greatness the reader has never been able to doubt, sink, gently into matrimony. "Of Olive, Mrs. Craik comments imperturbably that her husband's influence is to deprive the Scottish Academy of 'no one knows how many grand pictures.'" Then as now, despite men's greater "tolerance," the choice for women seems always to be marriage or career, i.e., solitude as the price of success or sex and companionship at the price of professional renunciation.

That achievement in the arts, as in any field of endeavor, demands struggle and sacrifice, no one would deny; that this has certainly been true after the middle of the 19th century, when the traditional institutions of artistic support and patronage no longer fulfilled their customary obligations, is undeniable: one has only to think of Delacroix, Courbet, Degas, Van Gogh and Toulouse-Lautrec as examples of great artists who gave up the distractions and obligations of family life, at least in part, so that they could pursue their artistic careers more single-mindedly. Yet none of them was automatically denied the pleasures of sex or companionship on account of this choice. Nor did they ever conceive that they had sacrificed their manhood or their sexual role on account of their singleness and single-mindedness in order to achieve professional fulfillment. But if the artist in question happens to be a woman, 1,000 years of guilt, self-doubt and objecthood have been added to the undeniable difficulties of being an artist in the modern world. . . .

Successes

But what of the small band of heroic women, who, throughout the ages, despite obstacles, have achieved pre-eminence, if not the pinnacles of grandeur of a Michelangelo, a Rembrandt or a Picasso:

Are there any qualities that may be said to have characterized them as a group and as individuals? While we cannot go into such an investigation in depth in this article, we can point to a few striking characteristics of women artists generally: they all, almost without exception, were either the daughters of artist fathers, or, generally later, in the 19th and 20th centuries, had a close personal connection with a stronger or more dominant male artistic personality. Neither of these characteristics is, of course, unusual for men artists, either, as we have indicated above in the case of artist fathers and sons: it is simply true almost without exception for their feminine counterparts, at least until quite recently. From the legendary sculptor, Sabina von Steinbach, in the 13th century, who, according to local tradition, was responsible for South Portal groups on the Cathedral of Strasbourg, down to Rosa Bonheur, the most renowned animal painter of the 19th century, and including such eminent women artists as Marietta Robusti, daughter of Tintoretto, Lavinia Fontana, Artemisia Gentileschi, Elizabeth Chéron, Mme. Vigée-Lebrun and Angelica Kauffmann—all, without exception, were the daughters of artists; in the 19th century, Berthe Morisot was closely associated with Manet, later marrying his brother, and Mary Cassatt based a good deal of her work on the style of her close friend Degas. Precisely the same breaking of traditional bonds and discarding of time-honored practices that permitted men artists to strike out in directions quite different from those of their fathers in the second half of the 19th century enabled women, with additional difficulties, to be sure, to strike out on their own as well. Many of our more recent women artists, like Suzanne Valadon, Paula Modersohn-Becker, Kaethe Kollwitz or Louise Nevelson, have come from non-artistic backgrounds, although many contemporary and near-contemporary women artists have married fellow artists.

It would be interesting to investigate the role of benign, if not outright encouraging, fathers in the formation of women professionals: both Kaethe Kollwitz and Barbara Hepworth, for example, recall the influence of unusually sympathetic and supportive fathers on their artistic pursuits. In the absence of any thoroughgoing investigation, one can only gather impressionistic data about the presence or absence of rebellion against parental authority in women artists, and whether there may be more or less rebellion on the part of women artists than is true in the case of men or vice versa. One thing however is clear: for a woman to opt for a career at all, much less for a career in art, has required a certain amount of unconventionality, both in the past and at present; whether or not the woman artist rebels against or finds strength in the attitude of her family, she must in any case have a good strong streak of rebellion in her to make her way in the world of art at all, rather than submitting to the socially approved role of wife and mother, the only role to which every social institution consigns her automatically. It is only by adopting, however covertly, the "masculine" attributes of single-mindedness, concentration and absorption in ideas and craftsmanship for their own sake, that women have succeeded, and continue to succeed, in the world of art. . . .

The difficulties imposed by demands on the woman artist continue to add to her already difficult enterprise even today. Compare, for example, the noted contemporary, Louise Nevelson, with her combination of utter, "unfeminine" dedication to her work and her conspicuously "feminine" false eyelashes; her admission that she got married at 17 despite her certainty that she couldn't live without creating because "the world said you should get married."

Conclusion

We have tried to deal with one of the perennial questions used to challenge women's demand for true, rather than token, equality, by examining the whole erroneous intellectual substructure upon which the question "Why have there been no great women artists?" is based; by questioning the validity of the formulation of so-called "problems" in general and the "problem" of women specifically, and then, by probing some of the limitations of the discipline of art history itself. Hopefully, by stressing the *institutional*—i.e., the public—rather than the *individual,* or private, preconditions for achievement or the lack of it in the arts, we have provided a paradigm for the investigation of other areas in the field. By examining in some detail a single instance of deprivation or disadvantage—the unavailability of nude models to women art students—we have suggested that it was indeed *institutionally* made impossible for women to achieve artistic excellence, or success, on the same footing as men, *no matter what* the potency of their so-called talent, or genius. The existence of a tiny band of successful, if not great, women artists throughout history does nothing to gainsay this fact, any more than does the existence of a few superstars or token achievers among the members of any minority groups. And while great achievement is rare and difficult at best, it is still rarer and more difficult if, while you work, you must at the same time wrestle with inner demons of self-doubt and guilt and outer

monsters of ridicule or patronizing encouragement, neither of which have any specific connection with the quality of the art work.

What is important is that women face up to the reality of their history and of their present situation, without making excuses or puffing mediocrity. Disadvantage may indeed be an excuse; it is not, however, an intellectual position. Rather, using as a vantage point their situation as underdogs in the realm of grandeur, and outsiders in that of ideology, women can reveal institutional and intellectual weaknesses in general, and, at the same time that they destroy false consciousness, take part in the creation of institutions in which clear thought—and true greatness—are challenges open to anyone, man or woman, courageous enough to take the necessary risk, the leap into the unknown.

IV

Arts of the Camera

In this section we consider what we might call "arts of the camera" by which we mean arts that issue in visual images produced by means of a mechanical or technical device such as a camera. This category includes, among other things, still photography (producing a static image) and cinema (producing a dynamic image) as well as television, video, and laser holography. So understood, the group might also include arts involving the direct manipulation of film, film animation, and certain sorts of computer-generated or computer-assisted art.

It is an interesting philosophical question why this family of arts would be thought to merit special attention. After all, are not the arts of the camera "pictorial" arts in the same sense as painting, drawing, and the other pictorial arts discussed in parts II through III? It is a fact that the arts of the camera include a firmly established tradition of creating representational images, a tradition which could quite reasonably be regarded as central to the practice of these arts. Perhaps that is why we routinely refer to photographs as "pictures" and to films as "moving pictures." Similarly, though it is true that the arts of the camera may be understood to involve the mediation of a mechanical device, one might ask what constitutes a "mechanical device." What is the paintbrush—much less the camera obscura—if not a mechanical device?[1] Painters regularly make technical decisions about their equipment and materials. Conversely, for many photographers who see themselves as working primarily with the effects of light and other forms of radiant energy on suitably sensitized surfaces, the role of a camera may be considerably attenuated, if not in some cases entirely eliminated. Or, again, we may think of arts of the camera as carrying with them the possibility of mechanical reproduction. But is not the same true of etchings and woodcuts?

1. Raymond Williams observes that the root meaning of "mechanical" is not *machine* (which came to acquire the denotation of a complex apparatus of interrelated and moving parts only in the eighteenth century) but the Latin *machina*, which has the sense of any contrivance, especially in non-agricultural productive work. See his *Keywords: A Vocabulary of Culture and Society,* rev. ed. (New York: Oxford University Press, 1985), p. 201.

These are important questions. There is, in fact, considerable overlap between many of the issues which one might discuss with respect to such arts as painting and drawing and questions philosophers have asked about the nature and function of photography, film, and other arts of the camera. One can certainly raise questions about representation and realism in photography or film, for instance, or about the relationship between form and representation, as we have done in the earlier chapters. One can inquire into the expressive capabilities of these arts and their social, political, and religious significance.

Still, questions pertaining to such issues need to be reformulated with care when the focus shifts to the arts of the camera. Also, the advent of photography, cinema, and other arts of the camera have brought several important philosophical issues into special prominence. Consider, for example, André Bazin's article, "The Ontology of the Photographic Image." Bazin presents what might be called the "realist" view of photography by examining both the affinities and the dissimilarities between photography on the one hand and painting and sculpture on the other. Bazin offers a psychological and sociological account of the origin of the latter arts, arguing that they arose out of an appetite for illusion, a desire to duplicate the world (or create an ideal one), perhaps so that we might "have the last word in the argument with death by means of the form that endures." The tendency toward realism in painting helps satisfy this desire.

But painting, Bazin argues, splits its allegiance between the urge toward realism and the aesthetic goal of symbolic expression. Photography and cinema, on the other hand, are preeminently and primarily realistic arts. The photographic arts are "objective" in the sense that "for the first time, an image of the world is formed automatically, without the creative intervention of man." Viewers realize this and credit photographic images with a degree of veracity and verisimilitude that would not have been possible for painting, which will always remain an art of the hand. Photography enchants by virtue of its ability literally to re-present the world. At the same time, it has cut painting loose from the illusionist imperative. Photography, Bazin writes, "is clearly the most important event in the history of plastic arts. Simultaneously a liberation and a fulfillment, it has freed Western painting, once and for all, from its obsession with realism and allowed it to recover its aesthetic autonomy."

Susan Sontag examines some of the social and moral implications of the realistic force of photography in her essay "In Plato's Cave." From its beginnings photography has been used as a means of documentation and surveillance, but Sontag takes pains to argue that photographs are neither accurate nor innocent records of reality. Like paintings, drawings, and written records, photographs are interpretations of the world. But photography, Sontag argues, is not only an attempt to see the world, it is an attempt to have it. "To photograph," she asserts, "is to appropriate the thing photographed. It means putting oneself into a certain relation to the world that feels like knowledge—

and therefore like power. . . . There is an aggression implicit in every use of the camera."

Sontag goes on to detail ways in which photography can affect social and moral actions and conditions. Photography plays a formative role in shaping family relations, in curbing feelings of anxiety among tourists ("It seems positively unnatural to travel for pleasure without taking a camera along. Photographs will offer indisputable evidence that the trip was made, that the program was carried out, that fun was had."), and in creating alternative worlds of fantasy, reverie, and nostalgia. More generally, photography can give us "a sense of situation" in present and past events and, as such, it can influence moral judgment in both beneficial and adverse ways. Pornographic photographs and photographs of wartime atrocities, for example, can sensitize us to dehumanizing and barbarous acts, but as such photographic images are proliferated and lose their initial shock value, they can also deaden our sensitivity to such things. Sontag argues that the realistic force of photography is especially dangerous insofar as it lulls us into a false sense of security about the meaning and truth of visual images. "Photography implies that we know about the world if we accept it as the camera records it. But this is the opposite of understanding, which starts from *not* accepting the world as it looks. . . . The knowledge gained through still photographs will always be some kind of sentimentalism, whether cynical or humanist. It will be a knowledge at bargain prices—a semblance of knowledge, a semblance of wisdom." Whence the title of Sontag's article.

The close association between photography and representational realism is based in large part on a widespread belief about how photographs come into being—namely, through a "mechanical" or "automatic" process. But what exactly is being asserted by this characterization of the photographic process? Joel Snyder and Neil Walsh Allen attack the realist view of photography in "Photography, Vision, and Representation," arguing that such thinking usually rests on one of three models of how photography works, none of which is acceptable.

The least defensible of the three positions is the argument from "automatism," that is, the view that photography involves no human agency whatsoever. This view is simply naive, ignoring the many decisions about technique and subject matter the photographer has to make. The two more plausible accounts of the photographic process are the visual model and the mechanical model, both of which appeal to the operation of presumed natural laws. The visual model of photography likens the photographic process to processes of visual perception. According to this view, photographs show us a scene as we would see it if we had been there. The view gains much of its appeal from the comparison of the relationship between the lens and retina of the eye and the lens and film of the camera. But the analogy between vision and photography breaks down at virtually every point, Walsh and Allen contend, with the result that the model tells us little about either the process of photography or the way we view photographs. The mechanical model fares

little better. This model argues that photographic realism derives from the ability of photography, because of its mechanical origins, to record the scene as it actually is (even if we can not see with the naked eye what the camera records). But this model downplays the extent to which conventions, formulas, and rules of interpretation are involved in the production and understanding of photographs. The truth, Snyder and Allen argue, is that the production and understanding of photographic images is as complex and involves many of the same general procedures, conventions, and habits as the pictorial images of drawing, painting, and other representational visual arts. To reduce philosophical reflection on photography to questions about photography and reality or, further, to questions about how a photograph is made seriously limits our understanding of the practice.

The debate about photographic realism also features in philosophical discussions of film. In "A Realist Theory of Film," Siegfried Kracauer gives a realist account of film that ties film to its roots in photography. Kracauer notes the virtual coincidence of the invention of photography in the mid-nineteenth century with the expressed desire to capture real-life events photographically. The basic properties of film, according to Kracauer, are photographic properties, which he understands as those pertaining to the effort "to record and reveal physical reality." Filmic techniques such as editing, close-up, soft focus, and so on must be subordinated to this basic realist imperative.

Kracauer grants that there are two main tendencies in film-making. The first of these is an orientation toward realism (typified by the work of Lumière) which concentrates on the movement of material phenomena and in which staging is regarded as an instrument to further the faithful reproduction of the real world. The second filmic tendency is a concern with fantasy and form (as exemplified by Méliès), which may involve such nonrealistic elements as dreams, visions, the manipulation of abstract shapes and so on. However, of the two tendencies, the realistic is the more "cinematic," Kracauer insists. This is so, he argues, because the tendency toward realism is more in line with the basic photographic properties of the medium. The formative tendency must therefore always be at the service of the realistic tendency. If we are to apply the term *art* to film, then, it must be with the understanding that the aesthetic value of cinematic art derives from the artful rendering of physical reality. This by no means excludes ideas, beliefs, and values from the realm of filmic subject matter or condemns films to triviality or superficiality. To the contrary, Kracauer argues, the rendering of physical reality is a "gate" through which spiritual concerns are expressed. In an age in which deeply spiritual belief is on the wane and scientific abstraction draws us away from the concrete fullness of the world, the art of film can return us to "the experience of things in their concreteness." By holding the mirror up to nature, the cinema offers us the possibility of redeeming physical reality.

Rudolf Arnheim, writing in 1933, attacks the realist theory of film, seeing such views as a threat to the notion that film is a form of art. In the selection "Film as Art," Arnheim is especially concerned to refute theories that rest on

the idea of the camera as "an automatic recording machine." To counter the
notion that photography is a passive mechanical process, Arnheim endeavors to
show that the perception of film images is different from the perception of
images of reality, thanks to what he calls "the unreality of the film picture":
the reduction of depth, the absence of color (in black and white film), the
delimitation of the visual field, disjunctures of space and time continua, and
other features of the projected film image. These are differences which can be
exploited for artistic purposes. Even the matter of photographing so simple an
object as a cube (let alone mountains or human beings) involves delicate
judgments about correct camera position, lighting, and so on. This is not to say
that every technical development in film enhances its artistic potential.
Arnheim is suspicious of technological innovations such as color photography,
ever larger screens, three-dimensional techniques, and the addition of sound, all
of which, in Arnheim's view, bring film closer to the illusionistic ideal of the
wax museum and hence farther from the artistic potentialities of the medium.
In the right hands, however, film presents a variety of techniques by means of
which it can satisfy the artistic urge "not simply to copy but to originate, to
interpret, to mold."

 A more broadly based analysis of the central features of film is offered by
Francis Sparshott in "Basic Film Aesthetics." Sparshott acknowledges that the
history of film is bound up with the history of its technology. But rather than
adjudicate the dispute between the realists and the nonrealists, Sparshott slices
through it: "just because the means of cinema are so complex, anyone who has
mastered them . . . will naturally use them to convey whatever message or
vision he may wish to convey, whether or not it is 'cinematic' by any plausible
definition. People use their languages to say what they wish to say, not what
the language makes it easy to say. Most theorists of cinema insist that the
outcome of this natural tendency is bound to be a bad film, but one hardly sees
why. Whatever can be done with a medium is among its possibilities and hence
'true to' it in a sense that has yet to be shown to be illegitimate."

 In line with this catholicity of approach, Sparshott proceeds to describe and
analyze a wide range of cinematic features and effects including the "bias of
exposition," film space, the dreamlike quality of film, film time, film motion,
film sound, and film structure. Nor is Sparshott content to treat these features
as if they exist in some sort of phenomenological vacuum. Each of these facets
of film experience is affected by the expectations and cultural baggage we bring
with us into the moviehouse as well as by the commercial and economic
exigencies of movie production and distribution. The film critic must be alive
to all these aspects of the film. But film criticism is no more a mechanical affair
than is film production. "The moral and cultural side of a critique must depend
on the maturity and sensitivity of the critic's social and moral awareness,"
Sparshott asserts. "If you could teach people to be critics, you could teach them
to be human."

23

The Ontology of the Photographic Image

ANDRÉ BAZIN

If the plastic arts were put under psychoanalysis, the practice of embalming the dead might turn out to be a fundamental factor in their creation. The process might reveal that at the origin of painting and sculpture there lies a mummy complex. The religion of ancient Egypt, aimed against death, saw survival as depending on the continued existence of the corporeal body. Thus, by providing a defense against the passage of time it satisfied a basic psychological need in man, for death is but the victory of time. To preserve, artificially, his bodily appearance is to snatch it from the flow of time, to stow it away neatly, so to speak, in the hold of life. It was natural, therefore, to keep up appearances in the face of the reality of death by preserving flesh and bone. The first Egyptian statue, then, was a mummy, tanned and petrified in sodium. But pyramids and labyrinthine corridors offered no certain guarantee against ultimate pillage.

Other forms of insurance were therefore sought. So, near the sarcophagus, alongside the corn that was to feed the dead, the Egyptians placed terra cotta statuettes, as substitute mummies which might replace the bodies if these were destroyed. It is this religious use, then, that lays bare the primordial function of statuary, namely, the preservation of life by a representation of life. Another manifestation of the same kind of thing is the arrow-pierced clay bear to be found in prehistoric caves, a magic identity-substitute for the living animal, that will ensure a successful hunt. The evolution, side by side, of art and civilization has relieved the plastic arts of their magic role. Louis XIV did not have himself embalmed. He was content to survive in his portrait by Le Brun. Civilization cannot, however, entirely cast out the bogy of time. It can only sublimate our concern with it to the level of rational thinking. No one believes any longer in the ontological identity of model and image, but all are agreed that the image helps us to remember the subject and to preserve him from a second spiritual death. Today the making of images no longer shares an anthropocentric, utilitarian purpose. It is no longer a question of survival after death, but of a larger concept, the creation of an ideal world in the likeness of the real, with its own temporal destiny. "How vain a thing is painting" if underneath our fond admiration for its works we do not discern man's primitive need to have the last word in the argument with death by means of the form that endures. If the history of the plastic arts is less a matter of their aesthetic than of their psychology then it will be seen to be essentially the story of resemblance, or, if you will, of realism.

Seen in this sociological perspective photography and cinema would provide a natural explanation for the great spiritual and technical crisis that overtook modern painting around the middle of the last century. André Malraux has described the cinema as the furthermost evolution to date of plastic realism, the beginnings of which were first manifest at the Renaissance and which found its completest expression in baroque painting.

From André Bazin, *What Is Cinema?*, trans. Hugh Gray. Berkeley: University of California Press, 1967, pp. 9–16. Reprinted with permission of the Regents of the University of California.

It is true that painting, the world over, has struck a varied balance between the symbolic and realism. However, in the fifteenth century Western painting began to turn from its age-old concern with spiritual realities expressed in the form proper to it, towards an effort to combine this spiritual expression with as complete an imitation as possible of the outside world.

The decisive moment undoubtedly came with the discovery of the first scientific and already, in a sense, mechanical system of reproduction, namely, perspective: the camera obscura of Da Vinci foreshadowed the camera of Niepce. The artist was now in a position to create the illusion of three-dimensional space within which things appeared to exist as our eyes in reality see them.

Thenceforth painting was torn between two ambitions: one, primarily aesthetic, namely the expression of spiritual reality wherein the symbol transcended its model; the other, purely psychological, namely the duplication of the world outside. The satisfaction of this appetite for illusion merely served to increase it till, bit by bit, it consumed the plastic arts. However, since perspective had only solved the problem of form and not of movement, realism was forced to continue the search for some way of giving dramatic expression to the moment, a kind of psychic fourth dimension that could suggest life in the tortured immobility of baroque art.[1]

The great artists, of course, have always been able to combine the two tendencies. They have allotted to each its proper place in the hierarchy of things, holding reality at their command and molding it at will into the fabric of their art. Nevertheless, the fact remains that we are faced with two essentially different phenomena and these any objective critic must view separately if he is to understand the evolution of the pictorial. The need for illusion has not ceased to trouble the heart of painting since the sixteenth century. It is a purely mental need, of itself nonaesthetic, the origins of which must be sought in the proclivity of the mind towards magic. However, it is a need the pull of which has been strong enough to have seriously upset the equilibrium of the plastic arts.

The quarrel over realism in art stems from a misunderstanding, from a confusion between the aesthetic and the psychological; between true realism, the need that is to give significant expression to the world both concretely and its essence, and the pseudorealism of a deception aimed at fooling the eye (or for that matter the mind); a pseudorealism content in other words with illusory appearances.[2] That is why medieval art never passed through this crisis; simultaneously vividly realistic and highly spiritual, it knew nothing of the drama that came to light as a consequence of technical developments. Perspective was the original sin of Western painting.

It was redeemed from sin by Niepce and Lumière. In achieving the aims of baroque art, photography has freed the plastic arts from their obsession with likeness. Painting was forced, as it turned out, to offer us illusion and this illusion was reckoned sufficient unto art. Photography and the cinema on the other hand are discoveries that satisfy, once and for all and in its very essence, our obsession with realism.

No matter how skillful the painter, his work was always in fee to an inescapable subjectivity. The fact that a human hand intervened cast a shadow of doubt over the image. Again, the essential factor in the transition from the baroque to photography is not the perfecting of a physical process (photography will long remain the inferior of painting in the reproduction of color); rather does it lie in a psychological fact, to wit, in completely satisfying our appetite for illusion by a mechanical reproduction in the making of which man plays no part. The solution is not to be found in the result achieved but in the way of achieving it.[3]

This is why the conflict between style and likeness is a relatively modern phenomenon of which there is no trace before the invention of the sensitized plate. Clearly the fascinating objectivity of Chardin is in no sense that of the photographer. The nineteenth century saw the real beginnings of the crisis of realism of which Picasso is now the mythical central figure and which put to the test at one and the same time the conditions determining the formal existence of the plastic arts and their sociological roots. Freed from the "resemblance complex," the modern painter abandons it to the masses who, henceforth, identify resemblance on the one hand with photography and on the other with the kind of painting which is related to photography.

Originality in photography as distinct from originality in painting lies in the essentially objective character of photography. [Bazin here makes a point of the fact that the lens, the basis of photography, is in French called the "objectif," a nuance that is lost in English.—Tr.] For the first time, between the originating object and its reproduction there intervenes only the instrumentality of a nonliving agent. For the first time an image of the world is formed automatically, without the creative intervention of man. The personality of the photographer enters into the proceedings only in his selection of the object to be photographed and by way of the purpose he has in mind. Although the final result may reflect something of his personality, this does not play the same role as is played by that of the painter. All the arts are based on the presence of

man, only photography derives an advantage from his absence. Photography affects us like a phenomenon in nature, like a flower or a snowflake whose vegetable or earthly origins are an inseparable part of their beauty.

This production by automatic means has radically affected our psychology of the image. The objective nature of photography confers on it a quality of credibility absent from all other picture-making. In spite of any objections our critical spirit may offer, we are forced to accept as real the existence of the object reproduced, actually re-presented, set before us, that is to say, in time and space. Photography enjoys a certain advantage in virtue of this transference of reality from the thing to its reproduction.[4]

A very faithful drawing may actually tell us more about the model but despite the promptings of our critical intelligence it will never have the irrational power of the photograph to bear away our faith.

Besides, painting is, after all, an inferior way of making likenesses, an ersatz of the processes of reproduction. Only a photographic lens can give us the kind of image of the object that is capable of satisfying the deep need man has to substitute for it something more than a mere approximation, a kind of decal or transfer. The photographic image is the object itself, the object freed from the conditions of time and space that govern it. No matter how fuzzy, distorted, or discolored, no matter how lacking in documentary value the image may be, it shares, by virtue of the very process of its becoming, the being of the model of which it is the reproduction; it *is* the model.

Hence the charm of family albums. Those grey or sepia shadows, phantomlike and almost undecipherable, are no longer traditional family portraits but rather the disturbing presence of lives halted at a set moment in their duration, freed from their destiny; not, however, by the prestige of art but by the power of an impassive mechanical process: for photography does not create eternity, as art does, it embalms time, rescuing it simply from its proper corruption.

Viewed in this perspective, the cinema is objectivity in time. The film is no longer content to preserve the object, enshrouded as it were in an instant, as the bodies of insects are preserved intact, out of the distant past, in amber. The film delivers baroque art from its convulsive catalepsy. Now, for the first time, the image of things is likewise the image of their duration, change mummified as it were. Those categories of *resemblance* which determine the species *photographic* image likewise, then, determine the character of its aesthetic as distinct from that of painting.[5]

The aesthetic qualities of photography are to be sought in its power to lay bare the realities. It is not for me to separate off, in the complex fabric of the objective world, here a reflection on a damp sidewalk, there the gesture of a child. Only the impassive lens, stripping its object of all those ways of seeing it, those piled-up preconceptions, that spiritual dust and grime with which my eyes have covered it, is able to present it in all its virginal purity to my attention and consequently to my love. By the power of photography, the natural image of a world that we neither know nor can know, nature at last does more than imitate art: she imitates the artist.

Photography can even surpass art in creative power. The aesthetic world of the painter is of a different kind from that of the world about him. Its boundaries enclose a substantially and essentially different microcosm. The photograph as such and the object in itself share a common being, after the fashion of a fingerprint. Wherefore, photography actually contributes something to the order of natural creation instead of providing a substitute for it. The surrealists had an inkling of this when they looked to the photographic plate to provide them with their monstrosities and for this reason: the surrealist does not consider his aesthetic purpose and the mechanical effect of the image on our imaginations as things apart. For him, the logical distinction between what is imaginary and what is real tends to disappear. Every image is to be seen as an object and every object as an image. Hence photography ranks high in the order of surrealist creativity because it produces an image that is a reality of nature, namely, an hallucination that is also a fact. The fact that surrealist painting combines tricks of visual deception with meticulous attention to detail substantiates this.

So, photography is clearly the most important event in the history of plastic arts. Simultaneously a liberation and a fulfillment, it has freed Western painting, once and for all, from its obsession with realism and allowed it to recover its aesthetic autonomy. Impressionist realism, offering science as an alibi, is at the opposite extreme from eye-deceiving trickery. Only when form ceases to have any imitative value can it be swallowed up in color. So, when form, in the person of Cézanne, once more regains possession of the canvas there is no longer any question of the illusions of the geometry of perspective. The painting, being confronted in the mechanically produced image with a competitor able to reach out beyond baroque resemblance to the very identity of the model, was compelled into the category of object. Henceforth Pascal's condemnation of painting is itself rendered vain since the

photograph allows us on the one hand to admire in reproduction something that our eyes alone could not have taught us to love, and on the other, to admire the painting as a thing in itself whose rela-tion to something in nature has ceased to be the jus-tification for its existence.

On the other hand, of course, cinema is also a lan-guage.

Notes

1. It would be interesting from this point of view to study, in the illustrated magazines of 1890–1910, the rivalry between photographic reporting and the use of drawings. The latter, in particular, satisfied the baroque need for the dramatic. A feeling for the photographic document developed only gradually.

2. Perhaps the Communists, before they attach too much importance to expressionist realism, should stop talking about it in a way more suitable to the eighteenth century, before there were such things as photography or cinema. Maybe it does not really matter if Russian painting is second-rate provided Russia gives us first-rate cinema. Eisenstein is her Tintoretto.

3. There is room, nevertheless, for a study of the psychology of the lesser plastic arts, the molding of death masks for example, which likewise involves a certain automatic process. One might consider photography in this sense as a molding, the taking of an impression, by the manipulation of light.

4. Here one should really examine the psychology of relics and souvenirs which likewise enjoy the advantages of a transfer of reality stemming from the "mummy-complex." Let us merely note in passing that the Holy Shroud of Turin combines the features alike of relic and photograph.

5. I use the term *category* here in the sense attached to it by M. Gouhier in his book on the theater in which he distinguishes between the dramatic and the aesthetic categories. Just as dramatic tension has no artistic value, the perfection of a reproduction is not to be identified with beauty. It constitutes rather the prime matter, so to speak, on which the artistic fact is recorded.

24

In Plato's Cave

SUSAN SONTAG

Humankind lingers unregenerately in Plato's cave, still reveling, its age-old habit, in mere images of the truth. But being educated by photographs is not like being educated by older, more artisanal images. For one thing, there are a great many more images around, claiming our attention. The inventory started in 1839 and since then just about everything has been photographed, or so it seems. This very insatiability of the photographing eye changes the terms of confinement in the cave, our world. In teaching us a new visual code, photographs alter and enlarge our notions of what is worth looking at and what we have a right to observe. They are a grammar and, even more importantly, an ethics of seeing. Finally, the most grandiose result of the photographic enterprise is to give us the sense that we can hold the whole world in our heads—as an anthology of images.

To collect photographs is to collect the world. Movies and television programs light up walls, flicker, and go out; but with still photographs the image is also an object, lightweight, cheap to produce, easy to carry about, accumulate, store. In Godard's *Les Carabiniers* (1963), two sluggish lumpen-peasants are lured into joining the King's Army by the promise that they will be able to loot, rape, kill, or do whatever else they please to the enemy, and get rich. But the suitcase of booty that Michel-Ange and Ulysse triumphantly bring home, years later, to their wives turns out to contain only picture postcards, hundreds of them, of Monuments, Department Stores, Mammals, Wonders of Nature, Methods of Transport, Works of Art, and other classified treasures from around the globe. Godard's gag vividly parodies the equivocal magic of the photographic image. Photographs are perhaps the most mysterious of all the objects that make up, and thicken, the environment we recognize as modern. Photographs really are experience captured, and the camera is the ideal arm of consciousness in its acquisitive mood.

To photograph is to appropriate the thing photographed. It means putting oneself into a certain relation to the world that feels like knowledge—and, therefore, like power. A now notorious first fall into alienation, habituating people to abstract the world into printed words, is supposed to have engendered that surplus of Faustian energy and psychic damage needed to build modern, inorganic societies. But print seems a less treacherous form of leaching out the world, of turning it into a mental object, than photographic images, which now provide most of the knowledge people have about the look of the past and the reach of the present. What is written about a person or an event is frankly an interpretation, as are handmade visual statements, like paintings and drawings. Photographed images do not seem to be statements about the world so much as pieces of it, miniatures of reality that anyone can make or acquire.

Photographs, which fiddle with the scale of the world, themselves get reduced, blown up, cropped,

From Susan Sontag, *On Photography*. New York: Farrar, Straus & Giroux, Inc., 1977, pp. 3-24. Reprinted with permission of Farrar, Straus & Giroux, Inc., and the author.

retouched, doctored, tricked out. They age, plagued by the usual ills of paper objects; they disappear; they become valuable, and get bought and sold; they are reproduced. Photographs, which package the world, seem to invite packaging. They are stuck in albums, framed and set on tables, tacked on walls, projected as slides. Newspapers and magazines feature them; cops alphabetize them; museums exhibit them; publishers compile them.

For many decades the book has been the most influential way of arranging (and usually miniaturizing) photographs, thereby guaranteeing them longevity, if not immortality—photographs are fragile objects, easily torn or mislaid—and a wider public. The photograph in a book is, obviously, the image of an image. But since it is, to begin with, a printed, smooth object, a photograph loses much less of its essential quality when reproduced in a book than a painting does. Still, the book is not a wholly satisfactory scheme for putting groups of photographs into general circulation. The sequence in which the photographs are to be looked at is proposed by the order of pages, but nothing holds readers to the recommended order or indicates the amount of time to be spent on each photograph. Chris Marker's film, *Si j'avais quatre dromadaires* (1966), a brilliantly orchestrated meditation on photographs of all sorts and themes, suggests a subtler and more rigorous way of packaging (and enlarging) still photographs. Both the order and the exact time for looking at each photograph are imposed; and there is a gain in visual legibility and emotional impact. But photographs transcribed in a film cease to be collectable objects, as they still are when served up in books.

Photographs furnish evidence. Something we hear about, but doubt, seems proven when we're shown a photograph of it. In one version of its utility, the camera record incriminates. Starting with their use by the Paris police in the murderous roundup of Communards in June 1871, photographs became a useful tool of modern states in the surveillance and control of their increasingly mobile populations. In another version of its utility, the camera record justifies. A photograph passes for incontrovertible proof that a given thing happened. The picture may distort; but there is always a presumption that something exists, or did exist, which is like what's in the picture. Whatever the limitations (through amateurism) or pretensions (through artistry) of the individual photographer, a photograph—any photograph—seems to have a more innocent, and therefore more accurate, relation to visible reality than do other mimetic objects. Virtuosi of the noble image like Alfred Stieglitz and Paul Strand, composing mighty, unforgettable photographs decade

after decade, still want, first of all, to show something "out there," just like the Polaroid owner for whom photographs are a handy, fast form of notetaking, or the shutterbug with a Brownie who takes snapshots as souvenirs of daily life.

While a painting or a prose description can never be other than a narrowly selective interpretation, a photograph can be treated as a narrowly selective transparency. But despite the presumption of veracity that gives all photographs authority, interest, seductiveness, the work that photographers do is no generic exception to the usually shady commerce between art and truth. Even when photographers are most concerned with mirroring reality, they are still haunted by tacit imperatives of taste and conscience. The immensely gifted members of the Farm Security Administration photographic project of the late 1930s (among them Walker Evans, Dorothea Lange, Ben Shahn, Russell Lee) would take dozens of frontal pictures of one of their sharecropper subjects until satisfied that they had gotten just the right look on film—the precise expression on the subject's face that supported their own notions about poverty, light, dignity, texture, exploitation, and geometry. In deciding how a picture should look, in preferring one exposure to another, photographers are always imposing standards on their subjects. Although there is a sense in which the camera does indeed capture reality, not just interpret it, photographs are as much an interpretation of the world as paintings and drawings are. Those occasions when the taking of photographs is relatively undiscriminating, promiscuous, or self-effacing do not lessen the didacticism of the whole enterprise. This very passivity—and ubiquity—of the photographic record is photography's "message," its aggression.

Images which idealize (like most fashion and animal photography) are no less aggressive than work which makes a virtue of plainness (like class pictures, still lifes of the bleaker sort, and mug shots). There is an aggression implicit in every use of the camera. This is as evident in the 1840s and 1850s, photography's glorious first two decades, as in all the succeeding decades, during which technology made possible an ever increasing spread of that mentality which looks at the world as a set of potential photographs. Even for such early masters as David Octavius Hill and Julia Margaret Cameron who used the camera as a means of getting painterly images, the point of taking photographs was a vast departure from the aims of painters. From its start, photography implied the capture of the largest possible number of subjects. Painting never had so imperial a scope. The subsequent industrialization of camera technology only carried out a promise

inherent in photography from its very beginning: to democratize all experiences by translating them into images.

That age when taking photographs required a cumbersome and expensive contraption—the toy of the clever, the wealthy, and the obsessed—seems remote indeed from the era of sleek pocket cameras that invite anyone to take pictures. The first cameras, made in France and England in the early 1840s, had only inventors and buffs to operate them. Since there were then no professional photographers, there could not be amateurs either, and taking photographs had no clear social use; it was a gratuitous, that is, an artistic activity, though with few pretensions to being an art. It was only with its industrialization that photography came into its own as art. As industrialization provided social uses for the operations of the photographer, so the reaction against these uses reinforced the self-consciousness of photography-as-art.

Recently, photography has become almost as widely practiced an amusement as sex and dancing—which means that, like every mass art form, photography is not practiced by most people as an art. It is mainly a social rite, a defense against anxiety, and a tool of power.

Memorializing the achievements of individuals considered as members of families (as well as of other groups) is the earliest popular use of photography. For at least a century, the wedding photograph has been as much a part of the ceremony as the prescribed verbal formulas. Cameras go with family life. According to a sociological study done in France, most households have a camera, but a household with children is twice as likely to have at least one camera as a household in which there are no children. Not to take pictures of one's children, particularly when they are small, is a sign of parental indifference, just as not turning up for one's graduation picture is a gesture of adolescent rebellion.

Through photographs, each family constructs a portrait-chronicle of itself—a portable kit of images that bears witness to its connectedness. It hardly matters what activities are photographed so long as photographs get taken and are cherished. Photography becomes a rite of family life just when, in the industrializing countries of Europe and America, the very institution of the family starts undergoing radical surgery. As that claustrophobic unit, the nuclear family, was being carved out of a much larger family aggregate, photography came along to memorialize, to restate symbolically, the imperiled continuity and vanishing extendedness of family life. Those ghostly traces, photographs, supply the token presence of the dispersed relatives. A family's photograph album is generally about the extended family—and, often, is all that remains of it.

As photographs give people an imaginary possession of a past that is unreal, they also help people to take possession of space in which they are insecure. Thus, photography develops in tandem with one of the most characteristic of modern activities: tourism. For the first time in history, large numbers of people regularly travel out of their habitual environments for short periods of time. It seems positively unnatural to travel for pleasure without taking a camera along. Photographs will offer indisputable evidence that the trip was made, that the program was carried out, that fun was had. Photographs document sequences of consumption carried on outside the view of family, friends, neighbors. But dependence on the camera, as the device that makes real what one is experiencing, doesn't fade when people travel more. Taking photographs fills the same need for the cosmopolitans accumulating photograph-trophies of their boat trip up the Albert Nile or their fourteen days in China as it does for lower-middle-class vacationers taking snapshots of the Eiffel Tower or Niagara Falls.

A way of certifying experience, taking photographs is also a way of refusing it—by limiting experience to a search for the photogenic, by converting experience into an image, a souvenir. Travel becomes a strategy for accumulating photographs. The very activity of taking pictures is soothing, and assuages general feelings of disorientation that are likely to be exacerbated by travel. Most tourists feel compelled to put the camera between themselves and whatever is remarkable that they encounter. Unsure of other responses, they take a picture. This gives shape to experience: stop, take a photograph, and move on. The method especially appeals to people handicapped by a ruthless work ethic—Germans, Japanese, and Americans. Using a camera appeases the anxiety which the work-driven feel about not working when they are on vacation and supposed to be having fun. They have something to do that is like a friendly imitation of work: they can take pictures.

People robbed of their past seem to make the most fervent picture takers, at home and abroad. Everyone who lives in an industrialized society is obliged gradually to give up the past, but in certain countries, such as the United States and Japan, the break with the past has been particularly traumatic. In the early 1970s, the fable of the brash American tourist of the 1950s and 1960s, rich with dollars and Babbittry, was replaced by the mystery of the group-minded Japanese tourist, newly released from his island prison by the miracle of overvalued

yen, who is generally armed with two cameras, one on each hip.

Photography has become one of the principle devices for experiencing something, for giving an appearance of participation. One full-page ad shows a small group of people standing pressed together, peering out of the photograph, all but one looking stunned, excited, upset. The one who wears a different expression holds a camera to his eye; he seems self-possessed, is almost smiling. While the others are passive, clearly alarmed spectators, having a camera has transformed one person into something active, a voyeur: only he has mastered the situation. What do these people see? We don't know. And it doesn't matter. It is an Event: something worth seeing—and therefore worth photographing. The ad copy, white letters across the dark lower third of the photograph like news coming over a teletype machine, consists of just six words: ". . . Prague . . . Woodstock . . . Vietnam . . . Sapporo . . . Londonderry . . . LEICA." Crushed hopes, youth antics, colonial wars, and winter sports are alike—are equalized by the camera. Taking photographs has set up a chronic voyeuristic relation to the world which levels the meaning of all events.

A photograph is not just the result of an encounter between an event and a photographer; picture-taking is an event in itself, and one with ever more peremptory rights—to interfere with, to invade, or to ignore whatever is going on. Our very sense of situation is now articulated by the camera's interventions. The omnipresence of cameras persuasively suggests that time consists of interesting events, events worth photographing. This, in turn, makes it easy to feel that any event, once underway, and whatever its moral character, should be allowed to complete itself—so that something else can be brought into the world, the photograph. After the event has ended, the picture will still exist, conferring on the event a kind of immortality (and importance) it would never otherwise have enjoyed. While real people are out there killing themselves or other real people, the photographer stays behind his or her camera, creating a tiny element of another world: the image-world that bids to outlast us all.

Photographing is essentially an act of non-intervention. Part of the horror of such memorable coups of contemporary photojournalism as the pictures of a Vietnamese bonze reaching for the gasoline can, of a Bengali guerrilla in the act of bayoneting a trussed-up collaborator, comes from the awareness of how plausible it has become, in situations where the photographer has the choice between a photograph and a life, to choose the photograph. The person who intervenes cannot record; the person who is recording cannot intervene. Dziga Vertov's great film, *Man with a Movie Camera* (1929), gives the ideal image of the photographer as someone in perpetual movement, someone moving through a panorama of disparate events with such agility and speed that any intervention is out of the question. Hitchcock's *Rear Window* (1954) gives the complementary image: the photographer played by James Stewart has an intensified relation to one event, through his camera, precisely because he has a broken leg and is confined to a wheelchair; being temporarily immobilized prevents him from acting on what he sees, and makes it even more important to take pictures. Even if incompatible with intervention in a physical sense, using a camera is still a form of participation. Although the camera is an observation station, the act of photographing is more than passive observing. Like sexual voyeurism, it is a way of at least tacitly, often explicitly, encouraging whatever is going on to keep on happening. To take a picture is to have an interest in things as they are, in the status quo remaining unchanged (at least for as long as it takes to get a "good" picture), to be in complicity with whatever makes a subject interesting, worth photographing—including, when that is the interest, another person's pain or misfortune.

"I always thought of photography as a naughty thing to do—that was one of my favorite things about it," Diane Arbus wrote, "and when I first did it I felt very perverse." Being a professional photographer can be thought of as naughty, to use Arbus's pop word, if the photographer seeks out subjects considered to be disreputable, taboo, marginal. But naughty subjects are harder to find these days. And what exactly is the perverse aspect of picture-taking? If professional photographers often have sexual fantasies when they are behind the camera, perhaps the perversion lies in the fact that these fantasies are both plausible and so inappropriate. In *Blowup* (1966), Antonioni has the fashion photographer hovering convulsively over Verushka's body with his camera clicking. Naughtiness, indeed! In fact, using a camera is not a very good way of getting at someone sexually. Between photographer and subject, there has to be distance. The camera doesn't rape, or even possess, though it may presume, intrude, trespass, distort, exploit, and, at the farthest reach of metaphor, assassinate—all activities that, unlike the sexual push and shove, can be conducted from a distance, and with some detachment.

There is a much stronger sexual fantasy in Michael Powell's extraordinary movie *Peeping Tom* (1960), which is not about a Peeping Tom but about a psychopath who kills women with a weapon concealed in his camera, while photograph-

ing them. Not once does he touch his subjects. He doesn't desire their bodies; he wants their presence in the form of filmed images—those showing them experiencing their own death—which he screens at home for his solitary pleasure. The movie assumes connections between impotence and aggression, professionalized looking and cruelty, which point to the central fantasy connected with the camera. The camera as phallus is, at most, a flimsy variant of the inescapable metaphor that everyone unselfconsciously employs. However hazy our awareness of this fantasy, it is named without subtlety whenever we talk about "loading" and "aiming" a camera, about "shooting" a film.

The old-fashioned camera was clumsier and harder to reload than a brown Bess musket. The modern camera is trying to be a ray gun. One ad reads: "The Yashica Electro-35 GT is the spaceage camera your family will love. Take beautiful pictures day or night. Automatically. Without any nonsense. Just aim, focus and shoot. The GT's computer brain and electronic shutter will do the rest." Like a car, a camera is sold as a predatory weapon—one that's as automated as possible, ready to spring. Popular taste expects an easy, an invisible technology. Manufacturers reassure their customers that taking pictures demands no skill or expert knowledge, that the machine is all-knowing, and responds to the slightest pressure of the will. It's as simple as turning the ignition key or pulling the trigger.

Like guns and cars, cameras are fantasymachines whose use is addictive. However, despite the extravagances of ordinary language and advertising, they are not lethal. In the hyperbole that markets cars like guns, there is at least this much truth: except in wartime, cars kill more people than guns do. The camera/gun does not kill, so the ominous metaphor seems to be all bluff—like a man's fantasy of having a gun, knife, or tool between his legs. Still, there is something predatory in the act of taking a picture. To photograph people is to violate them, by seeing them as they never see themselves, by having knowledge of them they can never have; it turns people into objects that can be symbolically possessed. Just as the camera is a sublimation of the gun, to photograph someone is a sublimated murder—a soft murder, appropriate to a sad, frightened time.

Eventually, people might learn to act out more of their aggressions with cameras and fewer with guns, with the price being an even more imagechoked world. One situation where people are switching from bullets to film is the photographic safari that is replacing the gun safari in East Africa. The hunters have Hasselblads instead of Winchesters; instead of looking through a telescopic sight to aim a rifle, they look through a viewfinder to frame a picture. In end-of-the-century London, Samuel Butler complained that "there is a photographer in every bush, going about like a roaring lion seeking whom he may devour." The photographer is now charging real beasts, beleaguered and too rare to kill. Guns have metamorphosed into cameras in this earnest comedy, the ecology safari, because nature has ceased to be what it always had been—what people needed protection from. Now nature—tamed, endangered, mortal—needs to be protected from people. When we are afraid, we shoot. But when we are nostalgic, we take pictures.

It is a nostalgic time right now, and photographs actively promote nostalgia. Photography is an elegiac art, a twilight art. Most subjects photographed are, just by virtue of being photographed, touched with pathos. An ugly or grotesque subject may be moving because it has been dignified by the attention of the photographer. A beautiful subject can be the object of rueful feelings, because it has aged or decayed or no longer exists. All photographs are *memento mori*. To take a photograph is to participate in another person's (or thing's) mortality, vulnerability, mutability. Precisely by slicing out this moment and freezing it, all photographs testify to time's relentless melt.

Cameras began duplicating the world at that moment when the human landscape started to undergo a vertiginous rate of change: while an untold number of forms of biological and social life are being destroyed in a brief span of time, a device is available to record what is disappearing. The moody, intricately textured Paris of Atget and Brassaï is mostly gone. Like the dead relatives and friends preserved in the family album, whose presence in photographs exorcises some of the anxiety and remorse prompted by their disappearance, so the photographs of neighborhoods now torn down, rural places disfigured and made barren, supply our pocket relation to the past.

A photograph is both a pseudo-presence and a token of absence. Like a wood fire in a room, photographs—especially those of people, of distant landscapes and faraway cities, of the vanished past—are incitements to reverie. The sense of the unattainable that can be evoked by photographs feeds directly into the erotic feelings of those for whom desirability is enhanced by distance. The lover's photograph hidden in a married woman's wallet, the poster photograph of a rock star tacked up over an adolescent's bed, the campaign-button image of a politician's face pinned on a voter's coat, the snapshots of a cabdriver's children clipped to the visor—all such talismanic uses of photographs express a feeling both sentimental and implicitly

magical: they are attempts to contact or lay claim to another reality.

Photographs can abet desire in the most direct, utilitarian way—as when someone collects photographs of anonymous examples of the desirable as an aid to masturbation. The matter is more complex when photographs are used to stimulate the moral impulse. Desire has no history—at least, it is experienced in each instance as all foreground, immediacy. It is aroused by archetypes and is, in that sense, abstract. But moral feelings are embedded in history, whose personae are concrete, whose situations are always specific. Thus, almost opposite rules hold true for the use of the photograph to awaken desire and to awaken conscience. The images that mobilize conscience are always linked to a given historical situation. The more general they are, the less likely they are to be effective.

A photograph that brings news of some unsuspected zone of misery cannot make a dent in public opinion unless there is an appropriate context of feeling and attitude. The photographs Mathew Brady and his colleagues took of the horrors of the battlefields did not make people any less keen to go on with the Civil War. The photographs of ill-clad, skeletal prisoners held at Andersonville inflamed Northern public opinion—against the South. (The effect of the Andersonville photographs must have been partly due to the very novelty, at that time, of seeing photographs.) The political understanding that many Americans came to in the 1960s would allow them, looking at the photographs Dorothea Lange took of Nisei on the West Coast being transported to internment camps in 1942, to recognize their subject for what it was—a crime committed by the government against a large group of American citizens. Few people who saw those photographs in the 1940s could have had so unequivocal a reaction; the grounds for such a judgment were covered over by the pro-war consensus. Photographs cannot create a moral position, but they can reinforce one—and can help build a nascent one.

Photographs may be more memorable than moving images, because they are a neat slice of time, not a flow. Television is a stream of underselected images, each of which cancels its predecessor. Each still photograph is a privileged moment, turned into a slim object that one can keep and look at again. Photographs like the one that made the front page of most newspapers in the world in 1972—a naked South Vietnamese child just sprayed by American napalm, running down a highway toward the camera, her arms open, screaming with pain—probably did more to increase the public revulsion against the war than a hundred hours of televised barbarities.

One would like to imagine that the American public would not have been so unanimous in its acquiescence to the Korean War if it had been confronted with photographic evidence of the devastation of Korea, an ecocide and genocide in some respects even more thorough than those inflicted on Vietnam a decade later. But the supposition is trivial. The public did not see such photographs because there was, ideologically, no space for them. No one brought back photographs of daily life in Pyongyang, to show that the enemy had a human face, as Felix Greene and Marc Riboud brought back photographs of Hanoi. Americans did have access to photographs of the suffering of the Vietnamese (many of which came from military sources and were taken with quite a different use in mind) because journalists felt backed in their efforts to obtain those photographs, the event having been defined by a significant number of people as a savage colonialist war. The Korean War was understood differently—as part of the just struggle of the Free World against the Soviet Union and China—and, given that characterization, photographs of the cruelty of unlimited American firepower would have been irrelevant.

Though an event has come to mean, precisely, something worth photographing, it is still ideology (in the broadest sense) that determines what constitutes an event. There can be no evidence, photographic or otherwise, of an event until the event itself has been named and characterized. And it is never photographic evidence which can construct—more properly, identify—events; the contribution of photography always follows the naming of the event. What determines the possibility of being affected morally by photographs is the existence of a relevant political consciousness. Without a politics, photographs of the slaughter-bench of history will most likely be experienced as, simply, unreal or as a demoralizing emotional blow.

The quality of feeling, including moral outrage, that people can muster in response to photographs of the oppressed, the exploited, the starving, and the massacred also depends on the degree of their familiarity with these images. Don McCullin's photographs of emaciated Biafrans in the early 1970s had less impact for some people than Werner Bischof's photographs of Indian famine victims in the early 1950s because those images had become banal, and the photographs of Tuareg families dying of starvation in the sub-Sahara that appeared in magazines everywhere in 1973 must have seemed to many like an unbearable replay of a now familiar atrocity exhibition.

Photographs shock insofar as they show something novel. Unfortunately, the ante keeps getting raised—partly through the very proliferation of such images of horror. One's first encounter with

the photographic inventory of ultimate horror is a kind of revelation, the prototypically modern revelation: a negative epiphany. For me, it was photographs of Bergen-Belsen and Dachau which I came across by chance in a bookstore in Santa Monica in July 1945. Nothing I have seen—in photographs or in real life—ever cut me as sharply, deeply, instantaneously. Indeed, it seems plausible to me to divide my life into two parts, before I saw those photographs (I was twelve) and after, though it was several years before I understood fully what they were about. What good was served by seeing them? They were only photographs—of an event I had scarcely heard of and could do nothing to affect, of suffering I could hardly imagine and could do nothing to relieve. When I looked at those photographs, something broke. Some limit had been reached, and not only that of horror; I felt irrevocably grieved, wounded, but a part of my feelings started to tighten; something went dead; something is still crying.

To suffer is one thing; another thing is living with the photographed images of suffering, which does not necessarily strengthen conscience and the ability to be compassionate. It can also corrupt them. Once one has seen such images, one has started down the road of seeing more—and more. Images transfix. Images anesthetize. An event known through photographs certainly becomes more real than it would have been if one had never seen the photographs—think of the Vietnam War. (For a counter-example, think of the Gulag Archipelago, of which we have no photographs.) But after repeated exposure to images it also becomes less real.

The same law holds for evil as for pornography. The shock of photographed atrocities wears off with repeated viewings, just as the surprise and bemusement felt the first time one sees a pornographic movie wear off after one sees a few more. The sense of taboo which makes us indignant and sorrowful is not much sturdier than the sense of taboo that regulates the definition of what is obscene. And both have been sorely tried in recent years. The vast photographic catalogue of misery and injustice throughout the world has given everyone a certain familiarity with atrocity, making the horrible seem more ordinary—making it appear familiar, remote ("it's only a photograph"), inevitable. At the time of the first photographs of the Nazi camps, there was nothing banal about these images. After thirty years, a saturation point may have been reached. In these last decades, "concerned" photography has done at least as much to deaden conscience as to arouse it.

The ethical content of photographs is fragile. With the possible exception of photographs of those horrors, like the Nazi camps, that have gained the status of ethical reference points, most photographs do not keep their emotional charge. A photograph of 1900 that was affecting then because of its subject would, today, be more likely to move us because it is a photograph taken in 1900. The particular qualities and intentions of photographs tend to be swallowed up in the generalized pathos of time past. Aesthetic distance seems built into the very experience of looking at photographs, if not right away, then certainly with the passage of time. Time eventually positions most photographs, even the most amateurish, at the level of art.

The industrialization of photography permitted its rapid absorption into rational—that is, bureaucratic—ways of running society. No longer toy images, photographs became part of the general furniture of the environment—touchstones and confirmations of that reductive approach to reality which is considered realistic. Photographs were enrolled in the service of important institutions of control, notably the family and the police, as symbolic objects and as pieces of information. Thus, in the bureaucratic cataloguing of the world, many important documents are not valid unless they have, affixed to them, a photograph-token of the citizen's face.

The "realistic" view of the world compatible with bureaucracy redefines knowledge—as techniques and information. Photographs are valued because they give information. They tell one what there is; they make an inventory. To spies, meteorologists, coroners, archaeologists, and other information professionals, their value is inestimable. But in the situations in which most people use photographs, their value as information is of the same order as fiction. The information that photographs can give starts to seem very important at that moment in cultural history when everyone is thought to have a right to something called news. Photographs were seen as a way of giving information to people who do not take easily to reading. The *Daily News* still calls itself "New York's Picture Newspaper," its bid for populist identity. At the opposite end of the scale, *Le Monde,* a newspaper designed for skilled, well-informed readers, runs no photographs at all. The presumption is that, for such readers, a photograph could only illustrate the analysis contained in an article.

A new sense of the notion of information has been constructed around the photographic image. The photograph is a thin slice of space as well as time. In a world ruled by photographic images, all borders ("framing") seem arbitrary. Anything can be separated, can be made discontinuous, from anything else: all that is necessary is to frame the subject

differently. (Conversely, anything can be made adjacent to anything else.) Photography reinforces a nominalist view of social reality as consisting of small units of an apparently infinite number—as the number of photographs that could be taken of anything is unlimited. Through photographs, the world becomes a series of unrelated, freestanding particles; and history, past and present, a set of anecdotes and *faits divers*. The camera makes reality atomic, manageable, and opaque. It is a view of the world which denies interconnectedness, continuity, but which confers on each moment the character of a mystery. Any photograph has multiple meanings; indeed, to see something in the form of a photograph is to encounter a potential object of fascination. The ultimate wisdom of the photographic image is to say: "There is the surface. Now think—or rather feel, intuit—what is beyond it, what the reality must be like if it looks this way." Photographs, which cannot themselves explain anything, are inexhaustible invitations to deduction, speculation, and fantasy.

Photography implies that we know about the world if we accept it as the camera records it. But this is the opposite of understanding, which starts from *not* accepting the world as it looks. All possibility of understanding is rooted in the ability to say no. Strictly speaking, one never understands anything from a photograph. Of course, photographs fill in blanks in our mental pictures of the present and the past: for example, Jacob Riis's images of New York squalor in the 1880s are sharply instructive to those unaware that urban poverty in late-nineteenth-century America was really that Dickensian. Nevertheless, the camera's rendering of reality must always hide more than it discloses. As Brecht points out, a photograph of the Krupp works reveals virtually nothing about that organization. In contrast to the amorous relation, which is based on how something looks, understanding is based on how it functions. And functioning takes place in time, and must be explained in time. Only that which narrates can make us understand.

The limit of photographic knowledge of the world is that, while it can goad conscience, it can, finally, never be ethical or political knowledge. The knowledge gained through still photographs will always be some kind of sentimentalism, whether cynical or humanist. It will be a knowledge at bargain prices—a semblance of knowledge, a semblance of wisdom; as the act of taking pictures is a semblance of appropriation, a semblance of rape. The very muteness of what is, hypothetically, comprehensible in photographs is what constitutes their attraction and provocativeness. The omnipresence of photographs has an incalculable effect on our ethical sensibility. By furnishing this already crowded world with a duplicate one of images, photography makes us feel that the world is more available than it really is.

Needing to have reality confirmed and experience enhanced by photographs is an aesthetic consumerism to which everyone is now addicted. Industrial societies turn their citizens into image-junkies; it is the most irresistible form of mental pollution. Poignant longings for beauty, for an end to probing below the surface, for a redemption and celebration of the body of the world—all these elements of erotic feeling are affirmed in the pleasure we take in photographs. But other, less liberating feelings are expressed as well. It would not be wrong to speak of people having a *compulsion* to photograph: to turn experience itself into a way of seeing. Ultimately, having an experience becomes identical with taking a photograph of it, and participating in a public event comes more and more to be equivalent to looking at it in photographed form. That most logical of nineteenth-century aesthetes, Mallarmé, said that everything in the world exists in order to end in a book. Today everything exists to end in a photograph.

25

Photography, Vision, and Representation

JOEL SNYDER AND NEIL WALSH ALLEN

I

Is there anything peculiarly "photographic" about photography—something which sets it apart from all other ways of making pictures? If there is, how important is it to our understanding of photographs? Are photographs so unlike other sorts of pictures as to require unique methods of interpretation and standards of evaluation? These questions may sound artificial, made up especially for the purpose of theorizing. But they have in fact been asked and answered not only by critics and photographers but by laymen. Furthermore, for most of this century the majority of critics and laymen alike have tended to answer these questions in the same way: that photographs and paintings differ in an important way and require different methods in interpretation precisely *because* photographs and paintings come into being in different ways. These answers are interesting because, even within the rather restricted classes of critics, photographers, and theorists, they are held in common by a wide variety of people who otherwise disagree strongly with each other—by people who think that photographs are inferior to paintings and people who think they are (in some ways, at least) superior; by people who believe that photographs ought to be "objective" and those who believe they should be "subjective"; by those who believe that it is impossible for photographers to "create" anything and by those who believe that they should at least try.

Our purpose here is not to show that these answers are always, in every case, wrong, or that there is never anything to be gained by differentiating between photography and other visual arts, or that questions about how photographs come into being are never appropriate to any investigation. But we do want to suggest that they are a very small part of the story and that they have been supported by definitions of the "nature" of photography and the way it works which are misleading at the very least, and are more often quite simply wrong. But to appreciate just what it is that modern critics and laymen believe about photography, it might be instructive to go back a step and take a look at a different notion of what photography is all about.

In 1889, Peter Henry Emerson, a physician and one of the finest photographers of his time, set down his prescriptions for photographers in a pamphlet entitled, *Naturalistic Photography for Students of the Art.*[1] Emerson assumes that photographs are first and foremost *pictures*, and that like other pictures they may serve to provide information (the "scientific division") or to provide aesthetic pleasure (the "art division"). The aim of the artistic photographer is not different from the aim of the artist in other media such as oil painting or charcoal; for Emerson, this aim is "naturalistic" representation. By naturalism, Emerson meant the representation of a scene in such a way as to be, as much as possible, identical with the visual impression an observer would get at the actual spot from which the pho-

From *Critical Inquiry*, 2 (1975), pp. 143–69. Reprinted with permission of the University of Chicago Press and the authors.

tograph was made. Thus, much of his argument is devoted to a discussion of the characteristics of human vision, based on the research of Von Helmholtz, and the application of this knowledge to the selection and use of a lens so that its "drawing power" would render a scene with "natural" perspective and with the correct amount of detail, suitably distributed throughout the various planes of the scene. The "students of the art" are warned against an excess amount of definition, which is both untrue to our senses and "artistically false" even though it may be "scientifically true." In addition, one must expose, develop, and print photographs so as to have a "natural" relation among the tones—the student is cautioned to avoid the commercially successful heresy of "pluckiness" or "snap" (contrast), the enemy of artistic truth. These strictures on practice are useless unless the photographer is familiar with the principles of naturalistic art; therefore, Emerson includes a sort of walking tour of the British Museum in one chapter, telling students which exhibits are to be admired and why.

Although Emerson's program of "naturalism" was not universally accepted, the basic notion that photographs were representations, and should be understood and judged as were other kinds of representations, was quite widespread. Thus, in 1907, the critic Charles Caffin writes, "This group of 'advanced photographers' is striving to secure in their prints the same qualities that contribute to the beauty of a picture in any other medium, and ask that their work be judged by the same standard."[2]

But critical opinion was shifting even as Caffin wrote. The consensus of modern critics is that photographs differ from other sorts of representations in a fundamental way and that special theoretical principles and critical standards are necessary to account for them. The philosopher Stanley Cavell expresses this difference in the following way: "So far as photography satisfied a wish, it satisfied a wish not confined to painters, but the human wish, intensifying since the Reformation, to escape subjectivity and metaphysical isolation—a wish for the power to reach this world, having for so long tried, at last hopelessly, to manifest fidelity to another.... Photography overcame subjectivity in a way undreamed of by painting, one which does not so much defeat the act of painting as escape it altogether: by *automatism,* by removing the human agent from the act of reproduction."[3] Photographs are not simply different from other kinds of pictorial representation in certain detailed respects; on the contrary, photographs are not really representations at all. They are the practical realization of the general artistic ideals of objectivity and detachment. The use of a machine to lay down lines and the reliance on the natural laws of refraction and

chemical change to create pictures are viewed as the decisive differences leading the critic André Bazin to proclaim,". . . the essential factor in the transition from the baroque to photography is not the perfecting of a physical process . . . rather does it lie in a psychological fact, to wit, in completely satisfying our appetite for illusion by a mechanical reproduction in the making of which man plays no part. The solution is not to be found in the result achieved but in the way of achieving it."[4] Stated in the most general terms, the modern position is that in photography there are certain necessary connections between a photograph and its "real life" original which simply do not (and perhaps cannot) exist in the "traditional" arts. But just what are these guarantees, and how important are they for our understanding of photographs?

We will examine the way one modern theorist, Rudolf Arnheim, has recently formulated answers to these questions. Arnheim's exposition is interesting for two reasons: First, it is more complete and covers more ground than many other treatments of the subject; second, it is to some extent a recantation of his earlier work, *Film as Art.*[5] This book contained a lengthy discussion of how photography could escape from being "a mere mechanical copy of nature" and thus, in Arnheim's view, claim the stature of a true art:

> The strategy was therefore to describe the differences between the images we obtain when we look at the physical world and the images perceived on the motion picture screen. These differences could then be shown to be a source of artistic expression. In a sense it was a negative approach because it defended the new medium by measuring it according to the standards of the traditional ones. . . . Only secondarily was I concerned with the positive virtues that photography derives precisely from the mechanical quality of its images.[6]

In his recent article, Arnheim bases his argument squarely on the "mechanical" origin of photographic images. "All I have said derives ultimately from the fundamental peculiarity of the photographic medium: the physical objects themselves print their image by means of the optical and chemical action of light" (p. 155). Because of this fundamental peculiarity, photographs have "an authenticity from which painting is barred by birth" (p. 154). In looking at photographs, "we are on vacation from artifice" (p. 157). We expect to find a certain "documentary" value in photographs, and toward this end we ask certain "documentary questions": "Is it authentic?" "Is it correct?" and "Is it true?" (p. 157).

Certain ethical and stylistic consequences follow

from the close connection between photography and "physical reality" or "the facts of the moment." The picture taker is on slippery ethical ground since "the photographer is part of the situation he depicts" and his picture, like the photon in atomic physics "upsets the facts on which it reports" (pp. 152, 151).

Old-time photographers benefited from the slowness of the early photographic processes since they could portray people with an "enviable timelessness" that "transcended the momentary presence of the portrayed objects" (pp. 150, 154).

More modern processes are capable of preserving "the spontaneity of action," although they may exhibit "the incompleteness of the fraction of a second lifted from the context of time" (p. 151). To portray the anxiety of man "in need of a *persona*, concerned with his image," all that the modern documentarian needs is "persons acknowledging the presence of the photographer" (p. 155). Finally, should a photographer develop a hankering for surrealistic effects, he need only pose some naked people in a forest, a living room, or an abandoned cottage: "Here was indubitably real human flesh, but since appearances of nude figures were known only from the visions of painters, the reality of the scene was transfigured into a dream" (p. 154).

Of course, compared with painting, photographs suffer from the same deficiencies that "physical reality" or "the world" itself does. They lack the "formal precision" and "expressive freedom" which the "private visions" of the painter possess. Photographs are tied to the world which is "irrational" and "incompletely defined." By its very nature, photography "limits the creations of the mind by powerful material constraints" (p. 160). But regrettable as these constraints may be "from the point of view of the painter, the composer, or the poet," they are "an enviable privilege" when we consider photography's "function in human society" (p. 160).

Arnheim shies away from what he takes to be the most extreme modern doctrine that the "photographic image is nothing but a faithful copy of the object." He insists that the process of photography injects its own "visual peculiarities" into the final picture, and that the picture must somehow "acquire form at its primary level" in order to communicate "its message" (pp. 155–56). But, oddly enough, the "visual peculiarities" of photographs serve as a sort of rhetorical reassurance; they make their audience aware that it is indeed a photograph they are looking at and not some sort of *trompe l'oeil* painting. In regard to form, a photograph is a compromise between nature and the "formative power" of man, a "compromise" or "coproduction" (pp. 156, 157, 159–60). Just as in Arnheim's theory, human visual perception "organizes and

structures the shapes offered by the optical projections in the eye . . . in a photograph, the shapes are selected, partially transformed, and treated by the picture taker and his optical and chemical equipment" (p. 159). Unlike other kinds of pictures, photographs are not entirely "made and controlled by man" but are "mechanical deposits of light" which reflect, as no other kind of imagery can, the "visual accidents of a world that has not been created for the convenience of the photographer" (p. 158). The very shortcoming of photography—its inability to attain the formal perfection of the other visual arts—is simply the obverse of photography's cardinal virtue—its ability to embody "the manifest presence of authentic physical reality" (p. 159).

Before examining these doctrines closely, it should be emphasized that Arnheim is not advancing anything very new or different here. Siegfried Kracauer and André Bazin, two critics whom Arnheim cites with approval, have advanced rather similar positions, and writers as diverse as Etienne Gilson, R. G. Collingwood, Stanley Cavell, William Ivins, and E. H. Gombrich[7] have all used photography as a benchmark of "pictorial fact" against which to measure more traditional pictorial media.[8] Nor are Arnheim's views confined to a small circle of specialists. Most people, if asked, would no doubt say that, whereas the painter can paint whatever he wants, the photographer must depict "what is there." The painter creates, the photographer "finds" or "captures" or "selects" or "organizes" or "records" his pictures. Needless to say, many photographers would agree with Arnheim as well. Of course, some people think that an intimate connection with physical reality is a very fine thing indeed, and others do not; some believe that photographers should accentuate "visual peculiarities" such as film grain and wide-angle lens distortion, while others are more conservative; some believe that photographers should try to "interpret" the world, and others believe that any "interpretation" is heretical. But these disagreements are minor when one considers the broad areas of agreement within which they arise. For example, even when the director of the Department of Photography at the Museum of Modern Art attempts to show that photographers can produce the kind of "private visions" that Arnheim assigns to the traditional artist, he insists that photography is a "different kind of art," unrelated to traditional types but closely related to perception.[9]

Arnheim describes himself as a "media analyst," not a critic, but despite this disclaimer, we must point out that he makes criticism of photographs difficult if not impossible. And since his views are held by critics and their audience as well, it is not surprising that there is very little intelligent criticism

of photography. We are told that when we look at a photograph we are on "a vacation from artifice"—but *should* we be on vacation? We are told that a photograph is a "coproduction of nature and man"—but is this coproduction along the lines of Michelangelo and a piece of marble, or a geneticist and breeds of corn, or some other sort of coproduction altogether? We are told that it is wrong to look at a photograph as though it were "made and controlled by man"—but what might we discover if we did look at photographs in just that way? In addition, we might ask whether Arnheim's "acknowledged fact" that "the physical objects themselves print their image" is really a fact at all, and whether the photographic process itself really guarantees much of anything about the relation between image and imaged.

It is odd that modern critics who believe that the photographic process should be the starting point for criticism have had very little to say about what the process is, how it works, and what it does and doesn't guarantee. Aside from the simple notion of automatism, two models of how photography works have been used, or at least assumed. One of these, which we will call the "visual" model, stresses the supposed similarity between the camera and the eye as optical systems, and posits that a photograph shows us (or ought to show us) "what we would have seen if we had been there ourselves." The other version of how photography works we will call the "mechanical" model. It stresses the necessary and mechanical connections which exist between what we see in a photograph and what was in front of the camera. According to this model, a photograph may not show us a scene as we ourselves would have seen it, but it is a reliable index of what *was*. Writers on photography have often treated these models as though they were identical, or as though one were contained within the other, but this is not the case, and such assumptions gloss over the basic challenge to any theory which attempts to find the meaning of photographic images by referring to their origins—the challenge of extracting pictorial meaning from the operation of natural laws.

I I

The photographic process consists of the more-or-less permanent recording of an image made by a camera. The use of cameras with lenses for making pictures was first described by Giovanni Battista della Porta in the second edition of his book *Magica Naturalis,* published in 1589. Cameras were used by draughtsmen and painters, including Canaletto and probably Vermeer as an aid in rendering perspective and detail. By the time Niepce, Daguerre, and Fox

Talbot began to try to fix the camera image, cameras had been used by artists for more than 200 years, and the requirements of "traditional" art had already influenced their design; whereas a round lens "naturally" creates a circular image (Fig. 1) which shades off into obscurity around its circumference, the portable *camera obscura* of the early nineteenth century was fitted with a square or rectangular ground glass which showed only the central part of the image made by the lens.

A camera image, especially one seen on the ground glass of a large-format camera, is almost magically lifelike: colors seem "natural" yet intense and every motion in front of the camera is seen in the image as well. It is difficult to find a term describing the relation between what was in front of the camera and the image which does not predetermine the results of any investigation into that relation. We will use the words "characterization" and "character" to describe both individual steps and aspects of the photographic process (a given lens characterizes things in greater or lesser detail than another lens) and also the end result of the process (a photograph is a characterization of something). A characterization may be accurate or inaccurate, may refer to something real or that is conjured up; it may be valuable because it refers to something else or have value as a thing in itself; and, finally, certain kinds of characterizations, such as maps, may be valuable for the most part in only one way, for their accuracy, whereas other kinds of characterizations, such as drawings, may be valuable in many different ways—for their factual content, or as souvenirs, or as art.

A photographer—even a Sunday snapshooter—makes a number of characterizations by his choice of equipment and how he uses it. He may not consider each one in detail on every occasion, and in a simple snapshot camera (and subsequently, in drugstore processing) these characterizations are "built in"—but they are still there. Some of these characterizations determine the amount of detail that will appear in the picture. A lens may be able to resolve very fine detail, or it may be inherently "soft." The lens must be focused on a single plane in front of the camera. Sharp focus will extend behind and in front of this plane to varying degrees, depending on the focal length of the lens, the size of the image area and extent of enlargement in printing, and the size of the lens opening—a phenomenon called "depth of field." The camera must also be placed in a definite position, which will establish a point of view for the image.

The position of the camera effects further characterizations; once again, this holds true whether the position of the camera is carefully planned by the photographer, or whether the camera goes off

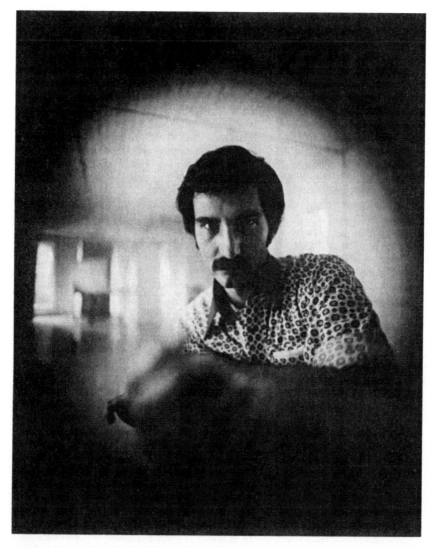

FIGURE 1. Complete image area of photographic lens.

by accident when dropped, or whether the camera is built into a booth and goes off automatically when people feed coins into a slot. The camera position will determine whether one of two objects within the camera's field of view will be to the right or the left, in front of or behind, another object. Together with the choice of lens, the camera position will determine the size and location of individual objects both in relation to the total image area and to each other. Thus, given a man standing in a room, the photographer can characterize the scene so that the man appears to dominate his environment or to be dominated by it.

With these kinds of characterizations in mind, Arnheim's notion that "the physical objects themselves print their image" seems more like a fanciful metaphor than an "acknowledged fact." It is the light reflected by the objects and refracted by the lens which is the agent in the process, not "the physical objects themselves." These "physical objects" do not have a single "image"—"their image"—but, rather, the camera can manipulate the reflected light to create an infinite number of images. An image is simply not a property which things naturally possess in addition to possessing size and weight. The image is a crafted, not a natural, thing.

It is created out of natural material (light), and it is crafted in accordance with, or at least not in contravention of, "natural" laws. This is not surprising. Nor is it surprising that something in the camera's field will be represented in the image; but how it will be represented is neither natural nor necessary.

What we have called the "visual" model of the photographic process is another way of trying to flesh out the bare bones of photography's alleged "intimate involvement" with "physical reality." No doubt this model originated in, and retains its plausibility because of, the supposed resemblance of the human eye with its lens and retina to the camera with its lens and film. But once this resemblance has been stated, the model fails to establish anything further. The notion that a photograph shows us "what we would have seen had we been there ourselves" has to be qualified to the point of absurdity. A photograph shows us "what we would have seen" at a certain moment in time, *from* a certain vantage point *if* we kept our head immobile *and* closed one eye *and if* we saw with the equivalent of a 150-mm or 24-mm lens *and if* we saw things in Agfacolor or in Tri-X developed in D-76 and printed on Kodabromide #3 paper. By the time all the conditions are added up, the original position has been reversed: instead of saying that the camera shows us what our eyes would see, we are now positing the rather unilluminating proposition that, if our vision worked like photography, then we would see things the way a camera does.

The camera-eye analogy is no more helpful for people investigating human vision than it is for the investigator of photographs. The more the supposed analogy is investigated, the more convincing becomes the conclusion that we do not possess, receive, or even "make" *an image* of things when we see—that there is nothing corresponding to a photographic image formed in one place which is then inspected or interpreted. Images are indeed formed on the retina of the eye, but they do not answer functionally to the image at the film plane of a camera. In the living, active eye, there is nothing that can be identified as *the* retinal image, meaning by that a persisting image that is resolved on one definite topographical portion of the retina. Rather, the image is kept in constant involuntary motion: the eyeball moves, the image drifts away from the fovea and is "flicked" back, while the drifting movement itself vibrates at up to 150 cycles per second.[10] Amidst all this motion, is there one privileged image to set beside a photograph for comparison? At the material level (the level at which arguments about photography are usually pitched), the two processes are simply incommensurate. We might, of course, identify the end result of vision—"what we see"—as *the* image. But unless the camera-eye analogy

works at some simpler level, why should we call what we see an "image" at all?[11]

For these reasons, there are great difficulties, not only with theories which equate photography with vision, but also those which equate it with half-digested vision.[12] Similarly, there is little choice between theories which find the artistic merit or value of photographs in their closeness to human perception[13] or in their departure from it.[14] The problem is that all such theories presuppose some standard or baseline of retinal correctness from which "artistic" or "good" photography either ought or ought not to depart—but that standard or baseline does not exist.

If anything, Emerson's conscientious attempt to duplicate characteristics of human vision strikes us today as "impressionistic" or even "arty" rather than as "natural" in any definitive sense of that word (Figs. 2, 3). We are just as likely or even more likely to accept as "natural" a photograph that renders much more detail throughout than Emerson's procedure allows. This variety of standards of optical "truth" is not unique to photography; neither is the difficulty of guaranteeing "natural" relationships between a picture and its real-life original. E. H. Gombrich has dealt with the problems at length.[15] He states that illusionistic images are not those *derived* from nature but, instead, are those which have been so made that under certain conditions they will confirm certain hypotheses which one would formulate, and find confirmed, when looking at the original scene. Thus, given our immobile, one-eyed viewer, it may be possible to construct some sort of representation (by photography, painting, or tracing on a pane of glass) which will show him some of the same shapes, or the same relative brightness values or relative color values that he would perceive "directly" from nature, without representation. But representations suggest to us fewer hypotheses capable of confirmation or refutation. The celebrated rabbit-duck figure always remains ambiguous. There are no additional hypotheses to formulate and test (as we might do when confronted by ambiguous-looking things in real life). We do not, as we might in "real-life" cases, say at the end of careful scrutiny: "Aha—it really is a duck after all, though I can see why I thought at first that it might be a rabbit." Furthermore, representations can be made so as to confirm certain hypotheses (about meaning, relationships, and so on) which we would never think of formulating about their real-life counterparts. Perhaps all this is what Arnheim means when he says that in photography, unlike vision, "the shapes have been selected, partially transformed and treated ..."[16]—but it's hard to find anything specifically "photographic" about that interpretation.

FIGURE 2. P. H. Emerson, "Gathering Water Lilies." Courtesy of The Art Institute of Chicago.

The visual model of the photographic process is of only limited value as a way of describing how we react to photographs (as opposed to "traditional" works of art) as well. Julia Margaret Cameron's photograph of Alice Liddell (Fig. 4) was made by placing the camera considerably below Miss Liddell's eye level. In looking at the photograph, do we really duplicate the camera position in our imagination—do we believe that we are shorter than Miss Liddell, or that we are stooping down or squatting in front of her? Only in a vague and metaphorical sense. The experience is much more like

looking at a painting in many respects. When we look at a painting of a figure that dominates the canvas, depicted from the point of view that Mrs. Cameron used, we do not mentally reconstruct the actual scene in the artist's studio and the peculiarities of the artist's cornea, retina, and optic nerve which allowed him, or forced him, to depict the figure as he did. Instead, our immediate reaction is that we are looking at a proud, haughty person, and on analysis we conclude that the artist used a certain manner of depiction in order to give us that impression. It seems silly not to make the same assumption about Mrs. Cameron.

The problems of photographing "what we see" are substantial, and the solutions only partial, when "what we see" consists of stationary dry goods. When we turn to the problems of photographing things that move or even might move, the visual model breaks down completely. Let's consider how we might photograph horses running a race. We can keep the camera stationary and use a slow shutter speed: the horses will appear as blurs against a stationary background. We can "pan" the camera with the horses and use a somewhat faster shutter speed: the horses will be somewhat sharper and the background blurred. We can use an extremely fast shutter speed and "freeze" the horses against a stationary background. All these methods are commonly used and accepted ways of photographing moving things. But we don't see motion in any of

FIGURE 3. Actual-size detail of "Gathering Water Lillies."

FIGURE 4. Julia Margaret Cameron, ''Pomona'' Alice Liddell). The Royal Photographic
Society, Bath, England.

these ways; we see things move. When Eadweard Muybridge succeeded in "freezing" rapid motion— to settle a bet as to how horses galloped—his results were met with dismay by artists, photographers, and the general public alike as being "unnatural" and "untrue." This was not an expression of doubt in the veracity of Muybridge's results but, instead, a perception that the results lay outside of common visual experience, and outside of the conventions of representation that obtained at the time. People believed that horses might indeed gallop as Muybridge had photographed them, but the proposition could only be confirmed by other photographs, not by direct observation.

If photographic characterizations of motion display a unique character trait of the medium, as Arnheim says,[17] then this trait is that a photograph is a still picture. It is a peculiarity shared with other, traditional media, but not with normal vision. Like other media, photography must resort to conventions to represent motion. Since conventions are multiple, it is no surprise that there are several different ways of representing motion with photography, or that photographers have developed conventions of representation that depart from the prephotographic norms. And these conventions do not necessarily operate in total isolation from our practical, day-to-day experience with things. It is our practical knowledge which helps us interpret a fuzzy patch in a photograph as representing motion, rather than something rendered out-of-focus or even something "naturally" fuzzy (such as fog or lint) rendered in sharp focus. If a photographer wishes to capture (or avoid) the "incompleteness of a fraction of a second," he must do more than use (or eschew) a fast shutter speed. He must also analyze his subject and be aware of the expectations of his audience. Conversely, the slowness of early photographic materials was insufficient by itself to produce an "enviable timelessness" or to depict "the abiding nature of motion." All too often early photographs showed instead the restless nature of enforced immobility, and "natural"-looking portraits were attributed to the photographer's artistry, technical virtuosity, or sometimes to his hypnotic powers over his subjects.

It can be asserted, of course, that while photographs do not always show us a scene as we would have seen it, they are, because of their mechanical origin, an accurate record of the scene as it actually was. Thus, although we did not see blurred horses or a blurred background or horses frozen in mid-stride as we watched the horserace, there is a causal explanation for all of these—they are the inevitable outcome of the facts of the situation. The horses actually did assume a certain posture at a certain

time; the motion of the horses or the camera or both bear a causal relation to the blurs we see in the photograph. This sort of approach would certainly allow us to say that certain photographs are "natural" or "objective" even though it was obvious that they showed things which we never had seen and never were likely to see.

To the extent that the mechanical model holds that a camera is a certain sort of extension or expansion of our normal visual experience along certain lines, it seems quite plausible. For instance, when we see a horse "frozen" in mid-gallop in a photograph, we have no reason to doubt that, at a certain moment, the horse "really" assumed that posture. Here we are simply extending and modifying the notion that the camera is an eye. We are assuming that, if we could see a horse in full detail in a thousandth of a second, he would look like this. But the blurred horse we see in a time exposure is another matter. Here we do not assume that the galloping horse ever "really" became a blur at all. We assume, instead, that the horse "really" galloped and that this galloping plus perhaps the movement of the camera and the peculiarities of the film resulted in the horse being characterized as an equine blur. Thus the photograph is not a substitute for vision, not even a modified or extended form of vision, but simply the inevitable outcome of a certain series of events. No doubt it is this sense of inevitability, this feeling that a photograph is the end result of a series of cause-and-effect operations performed upon "physical reality," that inclines us to impute a special sort of veracity to photographs—an "authenticity from which painting is barred by birth," to use Arnheim's phrase. After all, a photograph can be used to settle matters of fact and establish scientific truth. No matter how great the photographer's range of controls, no matter how labyrinthine the path from scene to image, one can always find mechanical connections between the two. The question is whether these mechanical connections are really important to us when we look at and try to understand the final picture.

Let us consider another equestrian example, one which is universally agreed to be an impartial record of the finish of a horserace (Fig. 5). As the horses near the finish line, the operator of the photofinish camera flicks a switch which starts a motor. The motor pulls film smoothly past a razor-thin vertical slit in a metal plate near the film plane of the camera. No shutter interrupts the light on its way to the film while the camera is running, so the final result will be a single still picture. As long as nothing moves past the finish line, all that is recorded on the moving streak is a vertically patterned blur. But as the nose of the winning horse crosses the finish line,

FIGURE 5. Photofinish. Courtesy of Sportman's Park and Eye-in-the-Sky.

it is recorded, and the process continues as the horse's neck and legs cross, and as all the other horses cross.

This single picture shows the exact order of finish of all the horses in the race. It would be impossible to show this in a conventional, "instantaneous" photograph, since although it might be clear which horse got to the finish line first, the photograph would not show which of two close contenders actually finished second or third. With the photofinish camera, it's all very easy: whatever horse is seen to be to the right of another horse was recorded on the film first and therefore reached the finish line before the other horse. Of course in making the prints to be shown to the crowd, the camera operator has to put in an artificial "finish line" on the nose of whatever horse is in contention, but there is no great deception here, since every point in the photograph is the finish line. Furthermore, the speed with which the film moves past the slit is usually set to correspond roughly with the speed with which the images of the horses will move past the slit; otherwise, the horses might appear greatly elongated or greatly compressed in the final print. Neither compression nor elongation would make much difference in determining which horse finished when, but it might upset the crowd.

Of course, once we know how a photofinish picture is made, it upsets *us*. We are accustomed, when we see five horses occupying five different positions in a photograph to think that we are looking at a picture of five horses that were all in different places at the same time. In a photofinish, we see five horses that were at the same place at different times. When we look at the nose and tail of a single horse in the picture, we are still looking at things which were recorded as they occupied the same place at different times. As we move from left to right across the

picture, we are not looking at distance, but at time. We do not know how far the winning horse was ahead of the place horse at the time he crossed the finish line—all we know is that it took a certain amount of time for the place horse to cross the finish line after the winner.

There is no doubt that the photofinish is an accurate characterization of the finishing order of horses in a race and no doubt that this accuracy derives from the mechanisms of the camera, laws of optics and chemistry, and so on. But the way in which the picture is made has little to do with the way we normally interpret it. The photofinish looks like a snapshot taken at the end of a race, and no amount of knowledge about photofinish cameras can supplant this interpretation with another one. The picture seems "realistic" or "natural" or to display "the manifest presence of authentic physical reality" in spite of the way in which it was made, in spite of the fact that what the photograph actually manifests is far from what we normally take "physical reality" to be. The mechanical relations which guarantee the validity of the photograph as an index of a certain kind of truth have been almost completely severed from the creation of visual likeness.

It might be objected that the photofinish is a special case, or a "trick" photograph. This invites the question why people who bet on horseraces should consent to have their bets settled by trickery. Nor is the photofinish a special case; many kinds of "scientific" photographs display a similar divorce of pictorial content and "the facts of the moment." In infra-red and ultra-violet color photography, visible colors are arbitrarily assigned to invisible bands of the spectrum. In color Schlieren photography used to analyze motions in gases and liquids, colors are arbitrarily assigned to directions, and no surgeon expects to find anything resembling an X-ray when he opens up a body. In all these cases, the picture is valuable as an index of truth only to the extent that the process by which it was made is stated explicitly, and the pictures can be interpreted accurately only by people who have learned how to interpret them. To the uninstructed viewer, red and purple potato plants look equally bizarre; only the expert interpreter, who knows how color infra-red film works, who knows what filter was placed over the lens, and who knows something about potato plants can confidently equate red with health and purple with disease. Even when a scientist uses "conventional" kinds of photograhpy, he is likely to rely on the inclusion of stopwatches or yardsticks or reference patches in the image, rather than on the photographic process pure and simple, to produce pictures which are a reliable guide to the truth.[18] Needless to say, the explicitness that provides guarantees to the scientist is rarely demanded of most photographs we see, and if demanded couldn't be provided, and if provided wouldn't explain much anyway.[19]

Let's consider, for example, two photographs taken with a "normal" lens, given "normal" development, and so on (Figs. 6, 7). They differ only in that one (Fig. 6) was given the "normal" exposure for the figure in sunlight, the other the "normal" exposure for the figure in shade. As indexes of "what was there," they are equally informative; as "mechanical deposits of light," one is as good as the other. Indeed, as "mechanical deposits of light," overexposure and underexposure so extreme as to be utterly featureless would be just as acceptable as the exposures used here. The mechanical model, by explaining everything, ends up explaining nothing. In practice, the mechanical workings of the photographic process must constantly be regulated by a set of rules for making "acceptable" pictures, and simple mechanical procedures must be augmented by additional processes to produce a number of different degrees and kinds of acceptability. By following the rule of thumb "better underexposure than over,"[20] a photographer would produce Figure 6 rather than Figure 7, and by employing any one or a combination of techniques (most of them "non-manipulative"), a photographer could greatly compress the "natural" brightness range of the scene into acceptable, or even pleasing, limits.

III

If "automatism" and both the visual and mechanical models of photography explain so little of how photography works, why are they advanced? At least one reason seems to be that they are not intended as serious descriptions of the photographic process in the first place and are only put forward as "negative" definitions in order to establish what is peculiarly photographic about photography by way of contrast with what is peculiarly "artistic" about art. Thus what is truly significant about a photograph of a horse is not really that the horse himself printed his image, or that the photograph shows us the horse as we ourselves would (or wouldn't) have seen him, or that it establishes something in the way of scientific truth about this horse. What is significant (it seems to be alleged) is that *this* horse wasn't invented by some artist: this is a picture of a *real* horse. This sort of thing is usually more hinted at than stated explicitly, and it seems to encompass a number of different beliefs, some about photography and some about art, some mainly ontological and some mainly aesthetic.

At a simple, literal level, the ontological distinc-

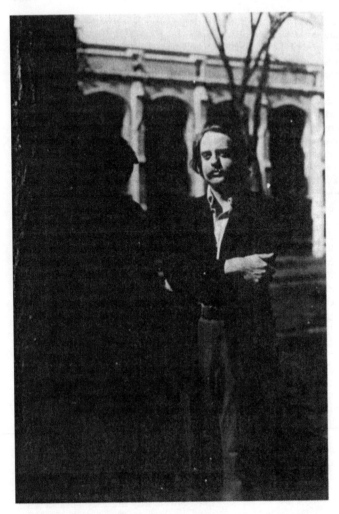

FIGURE 6. Correct exposure for sunlit face.

tion seems rather unpromising. Certainly Holbein *might* have painted the portrait of some imaginary being and called the result "Erasmus"—but we are fairly sure that Erasmus was not a phantasm of Holbein's imagination. Certainly "imaginary" scenes can be created by traditional art, but this does not mean that every painting, or even every good painting, is by definition totally divorced from "physical reality." Nor is it a fact that every photograph is inextricably mired in "the facts of the moment." At the literal level once again, one must first exclude by fiat all sorts of photographic practices in order to make the distinction begin to work. There must be no retouching, no staging, no distortion, no combining of negatives in a single print. "Photography"

must be understood to exclude such (purely "photographic") printing methods as gum-bichromate (which allowed the addition of brush strokes to the emulsion) and bromoil (a classic book on this method includes an illustration with the caption "excess sheep removed").

Of course once a theorist has defined photography as being nonmanipulative, nonimaginative, and noninventive (in a literal sense), and has defined "art" as being manipulative, inventive, and imaginative, the distinction between the two becomes relatively clear.

As far as principles of aesthetics go, John Szarkowski has gone further than many other writers by stating explicitly the theory of art that separates

FIGURE 7. Correct exposure for shaded face.

photography from "handmade" representations: "most of the literature of art history is based on the assumption that the subject exists independent of, and prior to, the picture. This notion suggests that the artist begins with his subject and then does something to it—deforms it somehow, according to some personal sense of style."[21] In the very next sentence, Szarkowski adds that this theory probably doesn't account for the work of any artist in any medium, which makes his assertion that "it is especially irrelevant in the case of photography" somewhat less than definitive. Now it is certainly true that many artists have drawn or painted Crucifixions, Last Suppers, and Horatios and Bridges, and that it is instructive to see how representations of

these set subjects have varied from era to era, and among different artists of the same era. It is, however, equally instructive to compare the ways that William Henry Jackson and Ansel Adams photographed Old Faithful, or the ways Edward Steichen and Walker Evans photographed the Brooklyn Bridge. Of course these are not "preexistent" subjects in quite the way Szarkowski means. But neither were the subjects of Constable's *Wivenhoe Park* or Turner's *Burial at Sea,* or Seurat's *Sunday Afternoon on Grande Jatte Island.* Furthermore, when one does compare two "traditional" renditions of ostensibly the same subject, one is often forced to the same conclusion that Szarkowski takes to be unique to photography: that much of the creative

task of the artist lies in defining just what the subject *is*. When Szarkowski says of a photograph by Harry Callahan that the subject "is not the figure, or the room, or the shape and graphic weight of the light window against the dark ground, but every element within the frame, and their precisely just relationship,"[22] he is hardly revolutionizing the aesthetics of the visual arts.

Now it would be quite correct to point out, à la Gombrich, that there is nothing in photography that corresponds exactly with the schemata used by many artists of other eras as aids in making representations of individual objects. The photographer who knows how to make acceptable pictures of horses might be thrown for a loop if a rhinoceros, instead of Old Dobbin, were to come trotting out of the barn, but it would not be for lack of means of representing rhinos as opposed to horses. However, formulas and standardized procedures of representation are certainly not lacking in photography, especially in those kinds of photography often thought to be simple, straightforward "documents." The passport photograph and the police "mug shot" are each produced by formulas regulating choice of lens, framing, and lighting. The Kodak manual *Clinical Photography*[23] contains 118 pages describing a wide variety of methods of photographing the human body, each method appropriate for the characterization of a separate set of conditions or symptoms. Similar manuals exist to instruct commercial photographers in the methods appropriate for architecture, family groups, silverware, and glassware. In addition, there are the "built-in" formulas of the snapshot camera, designed for "typical" snapshot subjects and to compensate for the amateur's problems with focus,

exposure, framing, and holding still. Some methods of photography and some pieces of photographic equipment are more versatile than others, but there is no single method that will produce acceptable results every time—because the standard of what is "acceptable" varies with the subject to be represented and the audience and purpose for which it is to be represented.

Even in the realm of serious and inventive photography there is no clear-cut break with older traditions of representation. Genres such as portraiture and landscape have been appropriated, expanded, and redefined, and new genres and subgenres have been created. Furthermore, photographers have relied upon conventions and habits of pictorial interpretation (both by confirming conventional expectations and by deliberately frustrating them), have created new conventions of their own, and have borrowed other conventions from the nonvisual arts. Thus to formulate a set of critical principles for photography based on what is purely or uniquely or essentially photographic is as absurd and unprofitable as would be the adoption in its place of standards taken from a mummified canon of nineteenth-century painting.

"Traditional" analyses of photographs may not be theoretically impossible, but are they worthwhile and workable? We will attempt to show that they might be by performing a rather stodgy analysis of a photograph made by a living photographer with a 35-mm camera, first published in *Life* magazine. The picture (Fig. 8) is by Dennis Stock and shows James Dean at the grave of Cal Dean. We will not try to show that this is a great or even a very good photograph, much less to establish that it is better than, or at least as good as, some comparable paint-

FIGURE 8. Dennis Stock, "James Dean at the grave of Cal Dean." Courtesy of The Art Institute of Chicago.

ing or drawing. But we will try to show that it is capable of being analyzed as a picture "made and controlled by man." In addition, we will attempt to determine how the fact that James Dean really existed, and really stood next to Cal's grave, is important to our understanding of the picture. Finally, we will attempt to show that this photograph, and other photographs, lend themselves to a wide *variety* of critical approaches.

Clearly our interest in this picture does not lie strictly in the objects that it portrays but in the relation between those objects which have been characterized by the photographer's choice of lens and point of view. These relations are complex. The two people are carefully balanced in opposition to the tombstone. Dean's younger brother is looking at the tombstone; Dean himself is glancing away. The surroundings are extremely simple, and help to concentrate our attention on the two figures and the grave. Dean himself seems to be a study in ambiguities: he is both consoling his younger brother and being comforted by him; he cannot "face up" to death, yet sees it all around him. We feel that Dean has ceased to view death as an incomprehensible tragedy which happens to other people and sees it instead as a constant threat to himself. Although the scene was recorded instantaneously, there doesn't seem to be anything "fragmentary" about it: it seems quite typical of the contrasting attitudes of a boy and sensitive young man toward death.

We could reconstruct the "actual" scene that took place—the visit to the grave, the five or ten minutes that Dean and his brother spent there—and we can easily see that thousands of photographs *might* have been taken which would not affect us as this one does. For example, instead of this photograph, Stock might have made an exposure at the same moment from a similar point of view which showed much more of the cemetery. This alternate view would present substantially the same "facts" but would considerably weaken the contrasts between Dean and his younger brother. Dean's action at Cal Dean's grave would no longer seem to be a more mature yet also more self-centered reaction than that of his younger brother: he might appear to be more philosophical in relating his great-grandfather's death to the general lot of humanity, or he might simply appear to be a person who gets edgy in graveyards.

There is no doubt that Stock made a number of choices in the course of producing this photograph, but it is difficult to imagine that he calmly evaluated every possible photograph that *might* have been taken and chose this one as the best. Nor is it likely that he hopped about the cemetery, viewfinder glued to his eye, until he "found" this picture and pressed the shutter release, nor even that he was

standing around in the cemetery when suddenly James Dean started looking odd and Stock, with lightning reflexes, vaulted onto the tombstone and "captured" the scene. It seems much more likely to suppose that Stock began with a notion that he would like to photograph Dean in a way which expressed what Stock believed to be Dean's attitude toward death and that he proceeded to set up a situation and choose a point of view and a lens which would create the photograph.

More to the point, we should notice that the kind of visual experience we have when looking at Stock's photograph is never (or very rarely) available to us as we walk about. The reason it is unavailable is not that we rarely happen upon sensitive young men standing in family plots. (This is the complaint of many would-be photographers.) Rather, the sort of experience we have in looking at the photograph is available only through representations, not directly from nature. In other words, if we were to state that Stock's work in making this picture consisted of selecting—of including and excluding—that selection does not operate directly on the scene in front of him. Instead, the principles of inclusion and exclusion are to be found in the final print that Stock has already decided upon as his goal.

Of course Stock did not create his notion of the final print out of thin air, or intuit it from some other-worldly realm. He knew James Dean and knew what sort of objects one was likely to find in cemeteries. He knew what kind of picture he was after: one that would show something of Dean's character from his reaction to his surroundings. He knew how his audience might react to various arrangements of figures with one another, with other objects, and within the space of the overall picture. He also knew what his camera, lens, and film would do under all sorts of circumstances. To this must be added Stock's own sensibility, his ideas of what sorts of pictures were worth making. Considerations of this sort are available to every photographer, although how they are employed in creating photographs seems to vary greatly. Some photographers "previsualize" every detail of the negative and print before tripping the shutter. Others may have a number of nebulous possibilities in mind which take on more specific form as they shoot a number of exposures, and their expectations may take on final form only when they "discover" their picture on a contact sheet.

Perhaps it is this sort of procedure that prompts critics to talk of photography as an "encounter with physical reality" or as a "compromise" or "coproduction." But certainly there is nothing new here: artists have long sought out favorite bits of countryside, hired favorite models, returned time and again

to congenial themes or restricted themselves to one or two genres. The limitations on visual artists, including photographers, are usually self-imposed or imposed by a lack of invention or a lack of representational schemes and programs for translating ideas into pictures. So if we find some fault with Stock's picture, we needn't let him off the hook by saying that Nature hasn't done *her* share, or trying to see things as mechanical deposits of light, or reminding ourselves that, after all, it's only a photograph. We are fully justified in saying that the work itself is flawed, or poorly made, or trivial. If we do find such faults, we might try to show how Stock could have done better, or, if this was the best he could do, we might suggest that he file this picture away with his other unsuccessful efforts.

Does this picture have any special status by virtue of the fact that it was made by a camera rather than by hand? One is tempted to say that it does, that it establishes certain facts about James Dean—that, at the very least, he once stood next to the grave of Cal Dean. But even this minimal statement is not incorrigible. We might be challenged to prove that it was indeed James Dean, not a look-alike, or that this is a real grave, not a stage set, or that Cal and James Dean were related. If we were to establish that everyone and everything is what it seems from external evidence, what *new* facts does the photograph establish? It would seem then to establish the same things about James Dean that would be established about the subject of this picture even if he *weren't* James Dean, or in fact had never existed at all. Of course our knowledge about the real James Dean—that he died young or that he played a character named Cal in *East of Eden*—may add a good deal of poignancy to this photograph. This sort of thing happens all the time, regardless of medium and even regardless of "the facts." Our recognition that it is Christ on the cross, or Marat in the bathtub adds to, or may even transform, our appreciation of pictures and of their subjects—even when we suspect or know that the death scenes in question "didn't really look like that."

The method of analysis we have sketched out here is by no means the only one that might be applied to this picture. We might instead have tried to assign Stock's picture to a genre—say a certain sort of portraiture which we might call "environmental portraiture," that differs both from simple portraiture and from simple depiction of people engaged in daily activities. Or, having noted that some of the effect produced by Stock's picture is due to an interplay between human figures and their environment, we might ask how another photographer, Henri Cartier-Bresson, handles these two elements in ostensibly similar pictures. Here we might conclude that whereas in Cartier-Bresson's work the relation of people to their environment is usually incongruous or in the broad sense humorous, in Stock's photograph the environment serves as an appropriate setting and occasion for human action. In this respect, Stock's photograph seems to be akin to certain kinds of motion pictures in which similar arrangements of people within an environment are found. We might ask why this picture was published in a mass-circulation periodical, how that possible use might have influenced Stock in creating this picture, and what the picture might reveal about the readership of *Life* magazine.

In sum, we may consider the photograph either as something in itself or in its relationship to other things—to its subject matter, or the formal qualities it shares with other pictures, or to the psychological make-up of its creator, or to the conventional expectations of its audience. We may ask specifically photographic questions of it (pertaining, for example, to the use of wide-angle lenses) or we may ask questions that are extremely broad (pertaining, for example, to the representation of "serious" action by agents who are neither better nor worse than average). The ability to investigate this photograph and others in these various ways does not, in and of itself, establish that this is a great or significant photograph or that photography is "as good as" easel painting. Instead, the variety of critical approaches (of which we may think some to be valuable and others to be wrong-headed) provides us with a variety of ways to assess the merit or lack of merit of this and other photographs. Just as important, this variety provides us with a number of ways of defining just what this photograph is, both in itself, and as the cause of a variety of effects and as the effect of a variety of causes.

Even if we are interested in photographs as "documents" rather than as "art," the naive belief that photography lies outside the sphere of other representations can lead to a basic misunderstanding of the "documentary" questions we ought to ask. The documentary value of a photograph is not determined solely by Arnheim's questions of "authenticity," "correctness," and "truth." We can also ask what it means, who made it, for whom was it made, and why it was made in the way it was made. These questions are asked of other "documents," ranging from Minoan warehouse receipts to great works of art. They should be asked of "documentary" photographs and photographs-considered-as-documents as well.

The poverty of photographic criticism is well known. It stands out against the richness of photographic production and invention, the widespread use and enjoyment of photographs, and even the

popularity of photography as a hobby. To end this poverty we do not need more philosophizing about photographs and reality, or yet another (this time *definitive*) definition of "photographic seeing," or

yet another distillation of photography's essence or nature. The tools for making sense of photographs lie at hand, and we can invent more if and when we really need them.

Notes

1. Peter Henry Emerson, *Naturalistic Photography for Students of the Art* (London, 1889; facsimile ed. of 1890 ed., New York, 1972).

2. Charles H. Caffin, *Photography as a Fine Art* (New York, 1901; facsimile ed., Hastings-on-Hudson, N.Y., 1971), p. vii.

3. Stanley Cavell, *The World Viewed* (New York, 1971), pp. 21, 23.

4. André Bazin, *What Is Cinema?* (Los Angeles and Berkeley, 1967), p. 12.

5. Rudolf Arnheim, *Film als Kunst* (Berlin, 1932); *Film as Art* (Los Angeles and Berkeley, 1957).

6. Rudolf Arnheim, "On the Nature of Photography," *Critical Inquiry* 1 (September 1974): 155. Hereafter, page numbers in the text refer to this article.

7. Etienne Gilson, *Painting and Reality* (London, 1957), pp. 242–46; R. G. Collingwood, *The Principles of Art* (New York, 1958), pp. 53–55; Cavell, pp. 16–25; William M. Ivins, Jr., *Prints and Visual Communication* (Cambridge, Mass., 1973), pp. 121–22, 177–78; E. H. Gombrich, *Art and Illusion* (New York, 1960; 2d ed., Princeton, N.J., 1969), pp. 67–73.

8. However, Gilson's opposition is between "picturing" and painting; Collingwood says that by using "tricks" the photographer can escape from "literal representation"; Ivins is more concerned with reproducing pictures than with making originals. But only Gombrich entertains real doubts about the usual reference to photography to settle questions of pictorial fact (pp. 34, 36).

9. John Szarkowski, "Photography—a Different Kind of Art," *New York Times Magazine* (April 13, 1975).

10. Roy M. Pritchard, "Stabilized Images on the Retina," *Scientific American* (June 1961); reprinted in *Perception: Mechanisms and Models,* ed. Richard Held and Whitman Richards (San Francisco, 1972).

11. "Images" may be thought necessary to explain the difference between what I see and what my cat sees. But is such a noun absolutely necessary even in this case? I hear differently from my cat; I also eat differently and walk differently. Must there be entities in these cases also, which take no human or feline form, or are endowed with human or feline properties?

12. Arnheim, "On the Nature of Photography," p. 159.

13. Emerson, p. 114.

14. Arnheim, *Film as Art,* p. 127; Szarkowski, p. 65.

15. Gombrich, pp. 33–62, 87–90.

16. Arnheim, "On the Nature of Photography," p. 159.

17. Ibid., p. 151.

18. Similarly, professional photographers include the standard Kodak Colorguide in their pictures to aid printers in reproducing color. In the absence of such a referent, photofinishers printing amateur color negatives program their printing machines on the assumption that every picture will "average out" to about 18 percent gray. When the assumption is wrong and the results go awry, photofinishers refer to it as "subject failure."

19. Even in criminal proceedings, the police photographer is not questioned about optics or chemistry. He is asked instead whether his photographs give an accurate indication of what the scene looked like—a question that could be asked, and answered, of many "handmade" pictures as well. See also Eastman Kodak Company, *Basic Police Photography* (Rochester, N.Y., 1974).

20. This is a simple modern rule for color reversal film. A more complex modern rule for black and white would be to expose for highlights and develop for shadows. The opposites of these rules have prevailed in other areas.

21. Szarkowski, p. 65.

22. Ibid.

23. Eastman Kodak Company, *Clinical Photography* (Rochester, N.Y., 1974).

26

A Realist Theory of Film

SIEGFRIED KRACAUER

Like the embryo in the womb, photographic film developed from distinctly separate components. Its birth came about from a combination of instantaneous photography, as used by Muybridge and Marey, with the older devices of the magic lantern and the phenakistoscope.[1] Added to this later were the contributions of other nonphotographic elements, such as editing and sound. Nevertheless photography, especially instantaneous photography, has a legitimate claim to top priority among these elements, for it undeniably is and remains the decisive factor in establishing film content. The nature of photography survives in that of film.

Originally, film was expected to bring the evolution of photography to an end—satisfying at last the age-old desire to picture things moving. This desire already accounted for major developments within the photographic medium itself. As far back as 1839, when the first daguerreotypes and talbotypes appeared, admiration mingled with disappointment about their deserted streets and blurred landscapes.[2] And in the 'fifties, long before the innovation of the hand camera, successful attempts were made to photograph subjects in motion.[3] The very impulses which thus led from time exposure to snapshot engendered dreams of a further extension of photography in the same direction—dreams, that is, of film. About 1860, Cook and Bonnelli, who had developed a device called a photobioscope, predicted a "complete revolution of photographic art.... We will see ... landscapes," they

announced, "in which the trees bow to the whims of the wind, and leaves ripple and glitter in the rays of the sun."[4]

Along with the familiar photographic leitmotif of the leaves, such kindred subjects as undulating waves, moving clouds, and changing facial expressions ranked high in early prophecies. All of them conveyed the longing for an instrument which would capture the slightest incidents of the world about us—scenes that often would involve crowds, whose incalculable movements resemble, somehow, those of waves or leaves. In a memorable statement published before the emergence of instantaneous photography, Sir John Herschel not only predicted the basic features of the film camera but assigned to it a task which it has never since disowned: "the vivid and lifelike reproduction and handing down to the latest posterity of any transaction in real life—a battle, a debate, a public solemnity, a pugilistic conflict."[5] Ducos du Hauron and other forerunners also looked forward to what we have come to label newsreels and documentaries—films devoted to the rendering of real-life events.[6] This insistence on recording went hand in hand with the expectation that motion pictures could acquaint us with normally imperceptible or otherwise induplicable movements—flashlike transformations of matter, the slow growth of plants, etc.[7] All in all, it was taken for granted that film would continue along the lines of photography....[8]

From Siegfried Kracauer, *Theory of Film: The Redemption of Physical Reality.* New York: Oxford University Press, 1960, pp. 27–40, 285–88, 291–92, 296–300. Reprinted with permission of Oxford University Press.

Properties of the Medium

The properties of film can be divided into basic and technical properties.

The basic properties are identical with the properties of photography. Film, in other words, is uniquely equipped to record and reveal physical reality and, hence, gravitates toward it.

Now there are different visible worlds. Take a stage performance or a painting: they too are real and can be perceived. But the only reality we are concerned with is actually existing physical reality—the transitory world we live in. (Physical reality will also be called "material reality," or "physical existence," or "actuality," or loosely just "nature." Another fitting term might be "camera-reality." Finally, the term "life" suggests itself as an alternate expression'. . . . The other visible worlds reach into this world without, however, really forming a part of it. A theatrical play, for instance, suggests a universe of its own which would immediately crumble were it related to its real-life environment.

As a reproductive medium, film is of course justified in reproducing memorable ballets, operas, and the like. Yet even assuming that such reproductions try to do justice to the specific requirements of the screen, they basically amount to little more than "canning," and are of no interest to us here. Preservation of performances which lie outside physical reality proper is at best a sideline of a medium so particularly suited to explore that reality. This is not to deny that reproductions, say, of stage production numbers may be put to good cinematic use in certain feature films and film genres.

Of all the technical properties of film the most general and indispensable is editing. It serves to establish a meaningful continuity of shots and is therefore unthinkable in photography. (Photomontage is a graphic art rather than a specifically photographic genre.) Among the more special cinematic techniques are some which have been taken over from photography—e.g., the close-up, soft-focus pictures, the use of negatives, double or multiple exposure, etc. Others, such as the lap-dissolve, slow and quick motion, the reversal of time, certain "special effects," and so forth, are for obvious reasons exclusively peculiar to film.

These scanty hints will suffice. It is not necessary to elaborate on technical matters which have been dealt with in most previous theoretical writings on film.[9] Unlike these, which invariably devote a great deal of space to editing devices, modes of lighting, various effects of the close-up, etc., the present book concerns itself with cinematic techniques only to the extent to which they bear on the nature of film, as defined by its basic properties and their various implications. The interest lies not with editing in itself, regardless of the purposes it serves, but with editing as a means of implementing—or defying, which amounts to the same—such potentialities of the medium as are in accordance with its substantive characteristics. In other words, the task is not to survey all possible methods of editing for their own sake; rather, it is to determine the contributions which editing may make to cinematically significant achievements. Problems of film technique will not be neglected; however, they will be discussed only if issues going beyond technical considerations call for their investigation.

This remark on procedures implies what is fairly obvious anyway: that the basic and technical properties differ substantially from each other. As a rule the former take precedence over the latter in the sense that they are responsible for the cinematic quality of a film. Imagine a film which, in keeping with the basic properties, records interesting aspects of physical reality but does so in a technically imperfect manner; perhaps the lighting is awkward or the editing uninspired. Nevertheless such a film is more specifically a film than one which utilizes brilliantly all the cinematic devices and tricks to produce a statement disregarding camera-reality. Yet this should not lead one to underestimate the influence of the technical properties. It will be seen that in certain cases the knowing use of a variety of techniques may endow otherwise nonrealistic films with a cinematic flavor.

The Two Main Tendencies

If film grows out of photography, the realistic and formative tendencies must be operative in it also. Is it by sheer accident that the two tendencies manifested themselves side by side immediately after the rise of the medium? As if to encompass the whole range of cinematic endeavors at the outset, each went the limit in exhausting its own possibilities. Their prototypes were Lumière, a strict realist, and Méliès, who gave free rein to his artistic imagination. The films they made embody, so to speak, thesis and antithesis in a Hegelian sense.[10]

Lumière and Méliès

Lumière's films contained a true innovation, as compared with the repertoire of the zootropes or Edison's peep boxes:[11] they pictured everyday life after the manner of photographs.[12] Some of his early pictures, such as Baby's Breakfast (Le Déjeuner de bébé) or The Card Players (La Partie d'écarté), testify to the amateur photographer's delight in family idyls and genre scenes.[13] And there was Teasing the

Gardener (L'Arroseur arrosé), which enjoyed immense popularity because it elicited from the flow of everyday life a proper story with a funny climax to boot. A gardener is watering flowers and, as he unsuspectingly proceeds, an impish boy steps on the hose, releasing it at the very moment when his perplexed victim examines the dried-up nozzle. Water squirts out and hits the gardener smack in the face. The denouement is true to style, with the gardener chasing and spanking the boy. This film, the germ cell and archetype of all film comedies to come, represented an imaginative attempt on the part of Lumière to develop photography into a means of story telling.[14] Yet the story was just a real-life incident. And it was precisely its photographic veracity which made Maxim Gorki undergo a shock-like experience. "You think," he wrote about *Teasing the Gardener*, "the spray is going to hit you too, and instinctively shrink back."[15]

On the whole, Lumière seems to have realized that story telling was none of his business; it involved problems with which he apparently did not care to cope. Whatever story-telling films he, or his company, made—some more comedies in the vein of his first one, tiny historical scenes, etc.—are not characteristic of his production.[16] The bulk of his films recorded the world about us for no other purpose than to present it. This is in any case what Mesguich, one of Lumière's "ace" cameramen, felt to be their message. At a time when the talkies were already in full swing he epitomized the work of the master as follows: "As I see it, the Lumière Brothers had established the true domain of the cinema in the right manner. The novel, the theater, suffice for the study of the human heart. The cinema is the dynamism of life, of nature and its manifestations, of the crowd and its eddies. All that asserts itself through movement depends on it. Its lens opens on the world."[17]

Lumière's lens did open on the world in this sense. Take his immortal first reels *Lunch Hour at the Lumière Factory (Sortie des usines Lumière)*, *Arrival of a Train (L'Arrivée d'un train)*, *La Place des Cordeliers a Lyon*:[18] their themes were public places, with throngs of people moving in diverse directions. The crowded streets captured by the stereographic photographs of the late 'fifties thus reappeared on the primitive screen. It was life at its least controllable and most unconscious moments, a jumble of transient, forever dissolving patterns accessible only to the camera. The much-imitated shot of the railway station, with its emphasis on the confusion of arrival and departure, effectively illustrated the fortuity of these patterns; and their fragmentary character was exemplified by the clouds of smoke which leisurely drifted upward. Signifi-

cantly, Lumière used the motif of smoke on several occasions. And he seemed anxious to avoid any personal interference with the given data. Detached records, his shots resembled the imaginary shot of the grandmother which Proust contrasts with the memory image of her.

Contemporaries praised these films for the very qualities which the prophets and forerunners had singled out in their visions of the medium. It was inevitable that, in the comments on Lumière, "the ripple of leaves stirred by the wind" should be referred to enthusiastically. The Paris journalist Henri de Parville, who used the image of the trembling leaves, also identified Lumière's over-all theme as "nature caught in the act."[19] Others pointed to the benefits which science would derive from Lumière's invention.[20] In America his camera-realism defeated Edison's kinetoscope with its staged subjects.[21]

Lumière's hold on the masses was ephemeral. In 1897, not more than two years after he had begun to make films, his popularity subsided. The sensation had worn off; the heyday was over. Lack of interest caused Lumière to reduce his production.[22]

Georges Méliès took over where Lumière left off, renewing and intensifying the medium's waning appeal. This is not to say that he did not occasionally follow the latter's example. In his beginnings he too treated the audience to sightseeing tours; or he dramatized, in the fashion of the period, realistically staged topical events.[23] But his main contribution to the cinema lay in substituting staged illusion for unstaged reality, and contrived plots for everyday incidents.[24]

The two pioneers were aware of the radical differences in their approach. Lumière told Méliès that he considered film nothing more than a "scientific curiosity,"[25] thereby implying that his cinematograph could not possibly serve artistic purposes. In 1897, Méliès on his part published a prospectus which took issue with Lumière: "Messrs. Méliès and Reulos specialize mainly in fantastic or artistic scenes, reproductions of theatrical scenes, etc. . . . thus creating a special genre which differs entirely from the customary views supplied by the cinematograph—street scenes or scenes of everyday life."[26]

Méliès's tremendous success would seem to indicate that he catered to demands left unsatisfied by Lumière's photographic realism. Lumière appealed to the sense of observation, the curiosity about "nature caught in the act"; Méliès ignored the workings of nature out of the artist's delight in sheer fantasy. The train in *Arrival of a Train* is the real thing, whereas its counterpart in Méliès's *An Impossible Voyage (Voyage à travers l'impossible)* is

a toy train as unreal as the scenery through which it is moving. Instead of picturing the random movements of phenomena, Méliès freely interlinked imagined events according to the requirements of his charming fairy-tale plots. Had not media very close to film offered similar gratifications? The artist–photographers preferred what they considered aesthetically attractive compositions to searching explorations of nature. And immediately before the arrival of the motion picture camera, magic lantern performances indulged in the projection of religious themes, Walter Scott novels, and Shakespearean dramas.[27]

Yet even though Méliès did not take advantage of the camera's ability to record and reveal the physical world, he increasingly created his illusions with the aid of techniques peculiar to the medium. Some he found by accident. When taking shot of the Paris Place de l'Opéra, he had to discontinue the shooting because the celluloid strip did not move as it should; the surprising result was a film in which, for no reason at all, a bus abruptly transformed itself into a hearse.[28] True, Lumière also was not disinclined to have a sequence of events unfold in reverse, but Méliès was the first to exploit cinematic devices systematically. Drawing on both photography and the stage, he innovated many techniques which were to play an enormous role in the future—among them the use of masks, multiple exposure, superimposition as a means of summoning ghosts, the lap-dissolve, etc.[29] And through his ingenuity in using these techniques he added a touch of cinema to his playful narratives and magic tricks. Stage traps ceased to be indispensable; sleights-of-hand yielded to incredible metamorphoses which film alone was able to accomplish. Illusion produced in this climate depended on another kind of craftsmanship than the magician's. Méliès's *The Haunted Castle (Le Manoir du diable)* "is conceivable only in the cinema and due to the cinema," says Henri Langlois, one of the best connoisseurs of the primitive era.[30]

Notwithstanding his film sense, however, Méliès still remained the theater director he had been. He used photography in a pre-photographic spirit—for the reproduction of a papier-mâché universe inspired by stage traditions. In one of his greatest films, *A Trip to the Moon (Le Voyage dans la lune)*, the moon harbors a grimacing man in the moon and the stars are bull's-eyes studded with the pretty faces of music hall girls. By the same token, his actors bowed to the audience, as if they performed on the stage. Much as his films differed from the theater on a technical plane, they failed to transcend its scope by incorporating genuinely cinematic subjects. This also explains why Méliès, for all his inventiveness, never thought of moving his camera;[31] the stationary camera perpetuated the spectator's relation to the stage. His ideal spectator was the traditional theatergoer, child or adult. There seems to be some truth in the observation that, as people grow older, they instinctively withdraw to the positions from which they set out to struggle and conquer. In his later years Méliès more and more turned from theatrical film to filmed theater, producing *féeries* which recalled the Paris Châtelet pageants.[32]

The Realistic Tendency

In following the realistic tendency, films go beyond photography in two respects. First, they picture movement itself, not only one or another of its phases. But what kinds of movements do they picture? In the primitive era when the camera was fixed to the ground, it was natural for film makers to concentrate on moving material phenomena; life on the screen was life only if it manifested itself through external, or "objective," motion. As cinematic techniques developed, films increasingly drew on camera mobility and editing devices to deliver their messages. Although their strength still lay in the rendering of movements inaccessible to other media, these movements were no longer necessarily objective. In the technically mature film "subjective" movements—movements, that is, which the spectator is invited to execute—constantly compete with objective ones. The spectator may have to identify himself with a tilting, panning, or traveling camera which insists on bringing motionless as well as moving objects to his attention.[33] Or an appropriate arrangement of shots may rush the audience through vast expanses of time and/or space so as to make it witness, almost simultaneously, events in different periods and places.

Nevertheless the emphasis is now as before on objective movement; the medium seems to be partial to it. As René Clair puts it: "If there is an aesthetics of the cinema . . . it can be summarized in one word: 'movement.' The external movement of the objects perceived by the eye, to which we are today adding the inner movement of the action."[34] The fact that he assigns a dominant role to external movement reflects, on a theoretical plane, a marked feature of his own earlier films—the balletlike evolutions of their characters.

Second, films may seize upon physical reality with all its manifold movements by means of an intermediary procedure which would seem to be less indispensable in photography—staging. In order to narrate an intrigue, the film maker is often obliged to stage not only the action but the surroundings as well. Now this recourse to staging is most certainly legitimate if the staged world is

made to appear as a faithful reproduction of the real one. The important thing is that studio-built settings convey the impression of actuality, so that the spectator feels he is watching events which might have occurred in real life and have been photographed on the spot.[35]

Falling prey to an interesting misconception, Emile Vuillermoz champions, for the sake of "realism," settings which represent reality as seen by a perceptive painter. To his mind they are more real than real-life shots because they impart the essence of what such shots are showing. Yet from the cinematic point of view these allegedly realistic settings are no less stagy than would be, say, a cubist or abstract composition. Instead of staging the given raw material itself, they offer, so to speak, the gist of it. In other words, they suppress the very camera-reality which film aims at incorporating. For this reason, the sensitive moviegoer will feel disturbed by them.[36] (The problems posed by films of fantasy which, as such, show little concern for physical reality will be considered later on.)

Strangely enough, it is entirely possible that a staged real-life event evokes a stronger illusion of reality on the screen than would the original event if it had been captured directly by the camera. The late Ernö Metzner who devised the settings for the studio-made mining disaster in Pabst's *Kameradschaft*—an episode with the ring of stark authenticity—insisted that candid shots of a real mining disaster would hardly have produced the same convincing effect.[37]

One may ask, on the other hand, whether reality can be staged so accurately that the camera-eye will not detect any difference between the original and the copy. Blaise Cendrars touches on this issue in a neat hypothetical experiment. He imagines two film scenes which are completely identical except for the fact that one has been shot on the Mont Blanc (the highest mountain of Europe) while the other was staged in the studio. His contention is that the former has a quality not found in the latter. There are on the mountain, says he, certain "emanations, luminous or otherwise, which have worked on the film and given it a soul."[38] Presumably large parts of our environment, natural or man-made, resist duplication.

The Formative Tendency

The film maker's formative faculties are offered opportunities far exceeding those offered the photographer. The reason is that film extends into dimensions which photography does not cover. These differ from each other according to area and composition. With respect to areas, film makers have never confined themselves to exploring only

physical reality in front of the camera but, from the outset, persistently tried to penetrate the realms of history and fantasy. Remember Méliès. Even the realistic-minded Lumière yielded to the popular demand for historical scenes. As for composition, the two most general types are the story film and the non-story film. The latter can be broken down into the experimental film and the film of fact, which on its part comprises, partially or totally, such subgenres as the film on art, the newsreel, and the documentary proper.

It is easy to see that some of these dimensions are more likely than others to prompt the film maker to express his formative aspirations at the expense of the realistic tendency. As for areas, consider that of fantasy: movie directors have at all times rendered dreams or visions with the aid of settings which are anything but realistic. Thus in *Red Shoes* Moira Shearer dances, in a somnambulistic trance, through fantastic worlds avowedly intended to project her unconscious mind—agglomerates of landscape-like forms, near-abstract shapes, and luscious color schemes which have all the traits of stage imagery. Disengaged creativity thus drifts away from the basic concerns of the medium. Several dimensions of composition favor the same preferences. Most experimental films are not even designed to focus on physical existence; and practically all films following the lines of a theatrical story evolve narratives whose significance overshadows that of the raw material of nature used for their implementation. For the rest, the film maker's formative endeavors may also impinge on his realistic loyalties in dimensions which, because of their emphasis on physical reality, do not normally invite such encroachments; there are enough documentaries with real-life shots which merely serve to illustrate some self-contained oral commentary.

Clashes Between the Two Tendencies

Films which combine two or more dimensions are very frequent; for instance, many a movie featuring an everyday-life incident includes a dream sequence or a documentary passage. Some such combinations may lead to overt clashes between the realistic and formative tendencies. This happens whenever a film maker bent on creating an imaginary universe from freely staged material also feels under an obligation to draw on camera-reality. In his *Hamlet* Laurence Olivier has the cast move about in a studio-built, conspicuously stagy Elsinore, whose labyrinthine architecture seems calculated to reflect Hamlet's unfathomable being. Shut off from our real-life environment, this bizarre structure would spread over the whole of the film were it not for a small, otherwise insignificant scene in which the real ocean out-

side that dream orbit is shown. But no sooner does the photographed ocean appear than the spectator experiences something like a shock. He cannot help recognizing that this little scene is an outright intrusion; that it abruptly introduces an element incompatible with the rest of the imagery. How he then reacts to it depends upon his sensibilities. Those indifferent to the peculiarities of the medium, and therefore unquestioningly accepting the staged Elsinore, are likely to resent the unexpected emergence of crude nature as a letdown, while those more sensitive to the properties of film will in a flash realize the make-believe character of the castle's mythical splendor. Another case in point is Renato Castellani's *Romeo and Juliet*. This attempt to stage Shakespeare in natural surroundings obviously rests upon the belief that camera-reality and the poetic reality of Shakespeare verse can be made to fuse into each other. Yet the dialogue as well as the intrigue establish a universe so remote from the chance world of real Verona streets and ramparts that all the scenes in which the two disparate worlds are seen merging tend to affect one as an unnatural alliance between conflicting forces.

Actually collisions of this kind are by no means the rule. Rather, there is ample evidence to suggest that the two tendencies which sway the medium may be interrelated in various other ways. Since some of these relationships between realistic and formative efforts can be assumed to be aesthetically more gratifying than the rest, the next step is to try to define them.

The Cinematic Approach

It follows from what has been said in the preceding [section] that films may claim aesthetic validity if they build from their basic properties; like photographs, that is, they must record and reveal physical reality. I have [elsewhere] dealt with the possible counterargument that media peculiarities are in general too elusive to serve as a criterion; for obvious reasons it does not apply to the cinematic medium either. Yet another objection suggests itself. One might argue that too exclusive an emphasis on the medium's primary relation to physical reality tends to put film in a strait jacket. This objection finds support in the many existing films which are completely unconcerned about the representation of nature. There is the abstract experimental film. There is an unending succession of "photoplays" or theatrical films which do not picture real-life material for its own sake but use it to build up action after the manner of the stage. And there are the many films of fantasy which neglect the external world in freely composed dreams or visions. The old German expressionist films went

far in this direction; one of their champions, the German art critic Herman G. Scheffauer, even eulogizes expressionism on the screen for its remoteness from photographic life.[39]

Why, then, should these genres be called less "cinematic" than films concentrating on physical existence? The answer is of course that it is the latter alone which afford insight and enjoyment otherwise unattainable. True, in view of all the genres which do not cultivate outer reality and yet are here to stay, this answer sounds somewhat dogmatic. But perhaps it will be found more justifiable in the light of the following two considerations.

First, favorable response to a genre need not depend upon its adequacy to the medium from which it issues. As a matter of fact, many a genre has a hold on the audience because it caters to widespread social and cultural demands; it is and remains popular for reasons which do not involve questions of aesthetic legitimacy. Thus the photoplay has succeeded in perpetuating itself even though most responsible critics are agreed that it goes against the grain of film. Yet the public which feels attracted, for instance, by the screen version of *Death of a Salesman*, likes this version for the very virtues which made the Broadway play a hit and does not in the least care whether or not it has any specifically cinematic merits.

Second, let us for the sake of argument assume that my definition of aesthetic validity is actually one-sided; that it results from a bias for one particular, if important, type of cinematic activities and hence is unlikely to take into account, say, the possibility of hybrid genres or the influence of the medium's nonphotographic components. But this does not necessarily speak against the propriety of that definition. In a strategic interest it is often more advisable to loosen up initial one-sidedness—provided it is well founded—than to start from all too catholic premises and then try to make them specific. The latter alternative runs the risk of blurring differences beween the media because it rarely leads far enough away from the generalities postulated at the outset; its danger is that it tends to entail a confusion of the arts. When Eisenstein, the theoretician, began to stress the similarities between the cinema and the traditional art media, identifying film as their ultimate fulfillment, Eisenstein, the artist, increasingly trespassed the boundaries that separate film from elaborate theatrical spectacles: think of his *Alexander Nevsky* and the operatic aspects of his *Ivan the Terrible*.[40]

In strict analogy to the term "photographic approach" the film maker's approach is called "cinematic" if it acknowledges the basic aesthetic principle. It is evident that the cinematic approach materializes in all films which follow the realistic

tendency. This implies that even films almost devoid of creative aspirations, such as newsreels, scientific or educational films, artless documentaries, etc., are tenable propositions from an aesthetic point of view—presumably more so than films which for all their artistry pay little attention to the given outer world. But as with photographic reportage, newsreels and the like meet only the minimum requirement.

What is of the essence in film no less than photography is the intervention of the film maker's formative energies in all the dimensions which the medium has come to cover. He may feature his impressions of this or that segment of physical existence in documentary fashion, transfer hallucinations and mental images to the screen, indulge in the rendering of rhythmical patterns, narrate a human-interest story, etc. All these creative efforts are in keeping with the cinematic approach as long as they benefit, in some way or other, the medium's substantive concern with our visible world. As in photography, everything depends on the "right" balance between the realistic tendency and the formative tendency; and the two tendencies are well balanced if the latter does not try to overwhelm the former but eventually follows its lead.

The Issue of Art

When calling the cinema an art medium, people usually think of films which resemble the traditional works of art in that they are free creations rather than explorations of nature. These films organize the raw material to which they resort into some self-sufficient composition instead of accepting it as an element in its own right. In other words, their underlying formative impulses are so strong that they defeat the cinematic approach with its concern for camera-reality. Among the film types customarily considered art are, for instance, the above-mentioned German expressionist films of the years after World War I; conceived in a painterly spirit, they seem to implement the formula of Hermann Warm, one of the designers of *The Cabinet of Dr. Caligari* settings, who claimed that "films must be drawings brought to life."[41] Here also belongs many an experimental film; all in all, films of this type are not only intended as autonomous wholes but frequently ignore physical reality or exploit it for purposes alien to photographic veracity. By the same token, there is an inclination to classify as works of art feature films which combine forceful artistic composition with devotion to significant subjects and values. This would apply to a number of adaptations of great stage plays and other literary works.

Yet such a usage of the term "art" in the tradi-

tional sense is misleading. It lends support to the belief that artistic qualities must be attributed precisely to films which neglect the medium's recording obligations in an attempt to rival achievements in the fields of the fine arts, the theater, or literature. In consequence, this usage tends to obscure the aesthetic value of films which are really true to the medium. If the term "art" is reserved for productions like *Hamlet* or *Death of a Salesman*, one will find it difficult indeed to appreciate properly the large amount of creativity that goes into many a documentary capturing material phenomena for their own sake. Take Ivens's *Rain* or Flaherty's *Nanook*, documentaries saturated with formative intentions: like any selective photographer, their creators have all the traits of the imaginative reader and curious explorer; and their readings and discoveries result from full absorption in the given material and significant choices. Add to this that some of the crafts needed in the cinematic process—especially editing—represent tasks with which the photographer is not confronted. And they too lay claim to the film maker's creative powers.

This leads straight to a terminological dilemma. Due to its fixed meaning, the concept of art does not, and cannot, cover truly "cinematic" films— films, that is, which incorporate aspects of physical reality with a view to making us experience them. And yet it is they, not the films reminiscent of traditional art works, which are valid aesthetically. If film is an art at all, it certainly should not be confused with the established arts. There may be some justification in loosely applying this fragile concept to such films as *Nanook*, or *Paisan*, or *Potemkin* which are deeply steeped in camera-life. But in defining them as art, it must always be kept in mind that even the most creative film maker is much less independent of nature in the raw than the painter or poet; that his creativity manifests itself in letting nature in and penetrating it. . . .

What Is the Good of Film Experience?

No doubt a major portion of the material which dazes and thrills the moviegoer consists of sights of the outer world, crude physical spectacles and details. And this emphasis on externals goes hand in hand with a neglect of the things we usually consider essential. In *Pygmalion* the scenes added to the original, scenes which ignored its moral to concentrate on incidental life, prove much more effective than the salient points of the Shavian dialogue, which is drowned in bagatelles; and what the adaptation thus loses in significance is plainly a boon to it from the cinematic viewpoint.[42] The cinema seems to come into its own when it clings to the surface of things.

So one might conclude that films divert the spectator from the core of life. This is why Paul Valéry objects to them. He conceives of the cinema as an "external memory endowed with mechanical perfection." And he blames it for tempting us to assimilate the manners of the phantoms that people the screen: how they are smiling, or killing, or visibly meditating. "What is still left of the meaning of these actions and emotions whose intercourse and monotonous diversity I am seeing? I no longer have the zest for living, for living is no longer anything more than resembling. I know the future by heart."[43] According to Valéry, then, by featuring the outer aspects of inner life, the cinema all but compels us to copy the former and desert the latter. Life exhausts itself in appearances and imitations, thus losing the uniqueness which alone would make it worth while. The inevitable result is boredom.[44] In other words, Valéry insists that, because of its exclusive concern for the exterior world, film prevents us from attending to the things of the mind; that its affinity for material data interferes with our spiritual preoccupations; that inner life, the life of the soul, is smothered by our immersion in the images of outer life on the screen. He, by the way, is not the only writer to argue along these lines. Georges Duhamel complains that the moving pictures no longer permit him to think what he wants to but "substitute themselves for his very thoughts."[45] And more recently Nicola Chiaromonte reproaches photography and film with making us "stare at the world entirely from the outside." Or as he also puts it, "the eye of the camera gives us that extraordinary thing: the world disinfected of consciousness."[46]

This argument would be tenable, however, only if the beliefs, ideas, and values that make up inner life occupied today the same position of authority they occupied in the past and if, as a consequence, they were presently just as self-evident, powerful, and real as are the events of the material world which film impresses upon us. Then indeed we might with justice condemn the cinema for alienating us from the higher objectives within our reach. But are they? But can it really be said that the relations between the inner universe and physical reality remain at all times essentially the same? Actually, they have undergone profound changes in the course of the last three or four centuries. Two such changes are of special interest here: the declining hold of common beliefs on the mind and the steadily increasing prestige of science.

Note that these two interrelated developments—they have already been referred to on an earlier occasion to account for the notion of "life as such"—radically invalidate Valéry's argument. If ideology is disintegrating, the essences of inner life can no longer be had for the asking; accordingly, Valéry's insistence on their primacy sounds hollow. Conversely, if under the impact of science the material components of our world gain momentum, the preference which film shows for them may be more legitimate than he is willing to admit. Perhaps, contrary to what Valéry assumes, there is no short-cut to the evasive contents of inner life whose perennial presence he takes for granted? Perhaps the way to them, if way there is, leads through the experience of surface reality? Perhaps film is a gate rather than a dead end or a mere diversion?

Yet these matters will have to wait. Let me begin at the beginning—modern man's intellectual landscape. . . .

From the nineteenth century on practically all thinkers of consequence, no matter how much they differed in approach and outlook, have agreed that beliefs once widely held—beliefs that were embraced by the whole of the person and that covered life in its wholeness—have been inexorably waning. They not only acknowledge this fact but speak of it with an assurance which is palpably founded on inner experience. It is as if they felt in their very bones the breakdown of binding norms.

Suffice it to select some pertinent views at random. Nietzsche, the Nietzsche of *Human, All Too Human,* claims that religion has had its day and that there "will never again be a horizon of life and culture that is bounded by religion."[47] (The later Nietzsche, though, would try to restore the patient to health by substituting the gospel of the Anti-Christ for abandoned Christianity. But had not Comte too declared religion to be a thing of the past and then made a new one of reason? *Le roi est mort! Vive le roi!*) What Nietzsche sweepingly postulates, Whitehead puts on the record in the manner of a physician consulting the fever chart. "The average curve marks a steady fall in religious tone," he observes within contexts devoted to the decay of religious influence in European civilization.[48] Freud on his part diagnoses the decay as a promising symptom. He calls religion the universal illusion of mankind and, with complete candor, compares it to a childhood neurosis. "According to this conception one might prophesy that the abandoning of religion must take place with the fateful inexorability of a process of growth and that we are just now in the middle of this phase of development."[49] And of course, to Marx religion is nothing but part of the ideological superstructure, destined to cave in when class rule is swept away.

If the impact of religion lessens, that of common beliefs in contiguous secular areas, such as ethics or custom, tends to become weaker also. Many are the thinkers who hold that our cultural traditions in general are on the decline; that there are indeed no

longer any spiritual values and normative principles that would be unquestioningly sanctioned. . . .

The other, less noticed characteristic of our situation can briefly be defined as abstractness—a term denoting the abstract manner in which people of all walks of life perceive the world and themselves. We not only live among the "ruins of ancient beliefs" but live among them with at best a shadowy awareness of things in their fullness. This can be blamed on the enormous impact of science. As the curve of "religious tone" has been falling, that of science has risen steadily. How could it be otherwise? Science is the fountainhead of technological progress, the source of an endless stream of discoveries and inventions that affect everyday life in its remotest recesses and alter it with ever-increasing speed. It is not too much to say that we feel the sway of science at each move we make or, thanks to science, are saved from making. Small wonder that an approach so productive in applications of the first magnitude should leave its imprint on the minds even in provinces not directly subject to its rule. Whether we know it or not, our way of thinking and our whole attitude toward reality are conditioned by the principles from which science proceeds.

Conspicuous among these principles is that of abstraction. Most sciences do not deal with the objects of ordinary experience but abstract from them certain elements which they then process in various ways. Thus the objects are stripped of the qualities which give them "all their poignancy and preciousness" (Dewey).[50] The natural sciences go farthest in this direction. They concentrate on measurable elements or units, preferably material ones; and they isolate them in an effort to discover their regular behavior patterns and relationships, the goal being to establish any such regularity with mathematical precision. If it holds true that units admitting of quantitative treatment are more abstract than units which still preserve traits of the objects from which they are drawn, one might speak of a tendency toward increasing abstractness within the sciences themselves. The social sciences, for instance, whose subject matter would seem to justify, or indeed require, a qualitative appreciation of the given material, tend to neglect qualitative evaluations for quantitative procedures apt to yield testable regularities (which, however, are often entirely irrelevant); in other words, they aim at achieving the status of the exact sciences. And the latter on their part aspire to further mathematization of the traces of reality they involve.

Evidently we can limit our all but compulsive indulgence in abstractions only if we restore to the objects the qualities which, as Dewey says, give them "their poignancy and preciousness." The rem-

edy for the kind of abstractness which befalls minds under the impact of science is experience—the experience of things in their concreteness. Whitehead was the first to see our situation in this light and to comment on it accordingly. He blames contemporary society for favoring the tendency toward abstract thinking and insists that we want concretion—want it in the double sense of the word: "When you understand all about the sun and all about the atmosphere and all about the rotation of the earth, you may still miss the radiance of the sunset. There is no substitute for the direct perception of the concrete achievement of a thing in its actuality. We want concrete fact with a high light thrown on what is relevant to its preciousness."

And how can this demand be met? "What I mean," Whitehead continues, "is art and aesthetic education. It is, however, art in such a general sense that I hardly like to call it by that name. Art is a special example. What we want is to draw out habits of aesthetic apprehension."[51] No doubt Whitehead is right in thus emphasizing the aesthetic character of experience. The perception of "concrete fact" presupposes both detached and intense participation in it; in order to manifest its concreteness, the fact must be perceived in ways similar to those which play a role in the enjoyment and production of art.

Whitehead himself exemplifies this necessity by pointing to the multiple aspects of a factory with "its machinery, its community of operatives, its social service to the general population . . ." etc. Instead of dealing with it merely in terms of economic abstractions, as is the custom, we should learn to appreciate all its values and potentialities. "What we want to train is the habit of apprehending such an organism in its completeness."[53] Perhaps the term "completeness" is not quite adequate. In experiencing an object, we not only broaden our knowledge of its diverse qualities but in a manner of speaking incorporate it into us so that we grasp its being and its dynamics from within—a sort of blood transfusion, as it were. It is two different things to know about the habits and typical reactions of a foreign people and really to experience what makes them tick. (Here, incidentally, lies the problem of the currently fashionable cultural exchanges, with their claim to promote "mutual understanding.") Or take our relations to a city: the geometric pattern of New York streets is a well-known fact, but this fact becomes concrete only if we realize, for instance, that all the cross streets end in the nothingness of the blank sky.

What we want, then, is to touch reality not only with the fingertips but to seize it and shake hands with it. Out of this urge for concretion technicians

often fall into playful animism, lending some motor with which they commune the traits of a whimsical person. Yet there are different realities or dimensions of reality, and our situation is such that not all of these worlds are equally available to us. Which of them will yield to our advances? The answer is, plainly, that we can experience only the reality still at our disposal.

Reality Within Reach

Because of the waning of ideology the world we live in is cluttered with debris, all attempts at new syntheses notwithstanding. There are no wholes in this world; rather, it consists of bits of chance events whose flow substitutes for meaningful continuity. Correspondingly, individual consciousness must be thought of as an aggregate of splinters of beliefs and sundry activities; and since the life of the mind lacks structure, impulses from psychosomatic regions are apt to surge up and fill the interstices. Fragmentized individuals act out their parts in fragmentized reality.

It is the world of Proust, Joyce, Virginia Woolf. Proust's work rests throughout upon the conviction that no man is a whole and that it is impossible to know a man because he himself changes while we try to clarify our original impressions of him.[53] In addition, the modern realistic novel insists on the "disintegration of the continuity of exterior events."[54] Erich Auerbach uses a section of *To the Lighthouse* to illustrate this point: "What takes place here in Virginia Woolf's novel is precisely what was attempted everywhere in works of this kind. . .—that is, to put the emphasis on the random occurrence, to exploit it not in the service of a planned continuity of action but in itself."[55] The inevitable result is that the chance happenings narrated for their own sake do not add up to a whole with a purpose. Or as Auerbach observes, "common to almost all of these novels is haziness, vague indefinability of meaning . . . uninterpretable symbolism."[56] (About the same might be said of any Fellini film—prior to his *Dolce Vita*, that is.)

Now the world portrayed by the modern novel extends from sporadic spiritual notions all the way down to scattered material events. It is a mental continuum which comprises the physical dimension of reality, without, however, exhibiting it separately. But if we want to do away with the prevailing abstractness, we must focus primarily on this material dimension which science has succeeded in disengaging from the rest of the world. For scientific and technological abstractions condition the minds most effectively; and they all refer us to physical phenomena, while at the same time luring us

away from their qualities. Hence the urgency of grasping precisely these given and yet ungiven phenomena in their concreteness. The essential material of "aesthetic apprehension" is the physical world, including all that it may suggest to us. We cannot hope to embrace reality unless we penetrate its lowest layers.

But how can we gain access to these lower depths? One thing is sure, the task of contacting them is greatly facilitated by photography and film, both of which not only isolate physical data but reach their climax in representing it. Lewis Mumford justly emphasizes photography's unique capacity for adequately depicting the "complicated, inter-related aspects of our modern environment."[57] And where photography ends, film, much more inclusive, takes over. Products of science and technology, the two media are our contemporaries in every sense of the word; small wonder that they should have a bearing on preferences and needs arising from our situation. It is again Mumford who establishes a relation between the cinema and one of these needs; he argues that film may fulfill a timely mission in helping us apprehend and appreciate material objects (or "organisms," as he sees fit to call them): "Without any conscious notion of its destination, the motion picture presents us with a world of interpenetrating, counterinfluencing organisms: and it enables us to think about that world with a greater degree of concreteness."[58]

This is not all, however. In recording and exploring physical reality, film exposes to view a world never seen before, a world as elusive as Poe's purloined letter, which cannot be found because it is within everybody's reach. What is meant here is of course not any of those extensions of the everyday world which are being annexed by science but our ordinary physical environment itself. Strange as it may seem, although streets, faces, railway stations, etc., lie before our eyes, they have remained largely invisible so far. Why is this so?

For one thing, it should be remembered that physical nature has been persistently veiled by ideologies relating its manifestations to some total aspect of the universe. (Much as realistic medieval painters indulge in ugliness and horror, the reality they reveal lacks immediateness; it emerges only to be consumed again by arrangements, compositional or otherwise, which are imposed on it from without and reflect such holistic notions as sin, the last judgment, salvation, and the like.) Yet considering the breakdown of traditional values and norms, this explanation of our failure to notice the world around us is no longer convincing. In fact, it makes good sense to conclude that, now that ideology has

disintegrated, material objects are divested of their wraps and veils so that we may appreciate them in their own right. Dewey jumps at this conclusion. He submits that our freedom "from syntheses of the imagination that went contrary to the grain of things"[59] is compensated for by our new awareness of the latter; and he attributes this development not only to the disappearance of false syntheses but to the liberating influence of science as well. Science, says he, "has greatly quickened in a few at least alertness of observations with respect to things of whose existence we were not before even aware."[60]

But Dewey fails to realize that science is a double-edged sword. On the one hand, it alerts us to the world of its concern, as he assumes; on the other, it tends to remove that world from the field of vision—a counterinfluence which he does not mention. The truly decisive reason for the elusiveness of physical reality is the habit of abstract thinking we have acquired under the reign of science and technology. No sooner do we emancipate ourselves from the "ancient beliefs" than we are led to elimi-

nate the qualities of things. So the things continue to recede. And, assuredly, they are all the more elusive since we usually cannot help setting them in the perspective of conventional views and purposes which point beyond their self-contained being. Hence, were it not for the intervention of the film camera, it would cost us an enormous effort to surmount the barriers which separate us from our everyday surroundings.

Film renders visible what we did not, or perhaps even could not, see before its advent. It effectively assists us in discovering the material world with its psychophysical correspondences. We literally redeem this world from its dormant state, its state of virtual nonexistence, by endeavoring to experience it through the camera. And we are free to experience it because we are fragmentized. The cinema can be defined as a medium particularly equipped to promote the redemption of physical reality. Its imagery permits us, for the first time, to take away with us the objects and occurrences that comprise the flow of material life.

Notes

1. Sadoul, *L'Invention du cinéma*, pp. 8, 49ff., 61–81 (about Marey). This book is a "must" for anyone interested in the complex developments that led up to Lumière. For Muybridge, see also Newhall, "Photography and the Development of Kinetic Visualization," *Journal of the Warburg and Courtauld Institutes*, 7 (1944), pp. 42–43. T. Ra., "Motion Pictures," *Encyclopedia Britannica*, 1932, vol. 15, pp. 854–56, offers a short survey of the period.

2. Newhall, op. cit., p. 40.

3. Ibid., p. 40.

4. Sadoul, *L'Invention du cinéma*, p. 38.

5. Herschel, "Instantaneous Photography," *Photographic News*, vol. 4, no. 88 (1860), 13. I am indebted to Mr. Beaumont Newhall for his reference to this quote.

6. Sadoul, *L'Invention du cinéma*, pp. 36–37, 86, 241–42.

7. It was Ducos du Hauron who, as far back as 1864, predicted these developments; see Sadoul, ibid. p. 37.

8. Mr. Georges Sadoul, *L'Invention du cinéma*, p. 298, sagaciously observes that the names given the archaic film cameras offer clues to the then prevailing aspirations. Such names as vitascope, vitagraph, bioscope, and biograph were undoubtedly intended to convey the camera's affinity for "life," while terms like kinetoscope, kinetograph, and cinematograph testified to the concern with movement.

9. See, for instance, Balázs, *Der Geist des Films*; Arnheim, *Film*; Eisenstein, *The Film Sense* and *Film Form*; Pudovkin, *Film Technique and Film Acting*; Rotha, *The Film Till Now*; Spottiswoode, *A Grammar of the Film* and *Basic Film Techniques* (University of California Syllabus Series No. 303); Karel Reisz, *The Technique of Film Editing*, etc.

10. Caveing, "Dialectique du concept du cinéma," *Revue internationale de filmologie* (part I: July–Aug. 1947, no. 1; part II: Oct. 1948, nos. 3–4) applies, in a somewhat highhanded manner, the principles of Hegel's dialectics to the evolution of the cinema. The first dialectic stage, he has it, consists of Lumière's reproduction of reality and its antithesis—complete illusionism, as exemplified by Méliès (see especially part I, pp. 74–78). Similarly, Morin, *Le Cinéma ou l'homme imaginaire*, p. 58, conceives of Méliès's "absolute unreality" as the antithesis, in a Hegelian sense, of Lumière's "absolute realism." See also Sadoul, *Histoire d'un art*, p. 31.

11. Sadoul, *L'Invention du cinéma*, pp. 21–22, 241, 246.

12. Langlois, "Notes sur l'histoire du cinéma," *La Revue du cinéma*, vol. 3, no. 15 (July 1948), 3.

13. Sadoul, op. cit., p. 247.

14. Ibid., pp. 249, 252, 300; and Sadoul, *Histoire d'un art*, p. 21.

15. Gorki, "You Don't Believe Your Eyes," *World Film News*, (March 1938), 16.

16. Bessy and Duca, *Louis Lumière, inventeur*, p. 88. Sadoul, op. cit., pp. 23–24.

17. Quoted by Sadoul, *L'Invention du cinéma*, p. 208. See also, ibid., p. 253.

18. Sadoul, ibid., pp. 242–44, 248. Vardac, *Stage to Screen*, pp. 166–67. Vardac emphasizes that an ever-increasing concern with realism prompted the nineteenth-century stage to make elaborate use of special devices. For instance, Steele MacKaye, a theatrical producer who died shortly before the arrival of the vitascope, invented a "curtain of light" so as to produce such effects as the fade-in, the fade-out, and the dissolve (p. 143).

19. Sadoul, op. cit., p. 246.

20. Bessy and Duca, *Louis Lumière, inventeur*, pp. 49–50. Sadoul, *Histoire d'un art*, p. 23.

21. Sadoul, *L'Invention du cinéma*, pp. 222–24, 227.

22. Sadoul, ibid., p. 332, and Sadoul, *Histoire d'un art*, p. 24.

23. Sadoul, *L'Invention du cinéma*, pp. 322, 328.

24. Ibid. p. 332. Langlois, "Notes sur l'histoire du cinéma," *La Revue du cinéma*, vol. 3, no. 15 (July 1948), 10.

25. Quoted by Bardèche and Brasillach, *The History of Motion Pictures*, p. 10.

26. Sadoul, *L'Invention du cinéma*, p. 332.

27. Ibid., p. 102, 201; esp. 205.

28. Ibid., pp. 324–26.

29. For Méliès's technical innovations, see Sadoul, *Les Pionniers du cinéma*, pp. 52–70.

30. Langlois, "Notes sur l'histoire du cinéma," *La Revue du cinéma*, vol. 3, no. 15 (July 1948), 5.

31. Sadoul, op. cit., pp. 154, 166.

32. Sadoul, *L'Invention du cinéma*, pp. 330–31.

33. Cf. Meyerhoff, *Tonfilm and Wirklichkeit*, pp. 13, 22.

34. Claire, *Réflexion faite*, p. 96; he made this statement in 1924.

35. Ibid., p. 150.

36. Vuillermoz, "Réalisme et expressionisme," *Cinéma (Les cahiers du mois, 16/17)*, 1925, pp. 78–79.

37. See Kracauer, *From Caligari to Hitler*, p. 240.

38. Berge, "Interview de Blaise Cendrars sur le cinéma," *Cinéma (Les cahiers du mois, 16/17)*, 1925, p. 141. For the problems involved in the staging of actuality, see also Mauriac, *L'Amour du cinéma*, p. 36, and Obraszow, "Film und Theater," in *Von der Filmidee zum Drehbuch*, p. 54.

39. Scheffauer, "The Vivifying of Space," *The Freeman*, Nov. 24 and Dec. 1, 1920.

40. Eisenstein, *Film Form*, pp. 181–82.

41. See Kracauer, *From Caligari to Hitler*, p. 68.

42. Arnold Hauser belongs among the few who have seen this. In his *The Philosophy of Art History*, p. 363, he says: "The film is the only art that takes over considerable pieces of reality unaltered; it interprets them, of course, but the interpretation remains a photographic one." His insight notwithstanding, however, Hauser seems to be unaware of the implications of this basic fact.

43. Valéry, "Cinématographe," in L'Herbier, ed., *Intelligence du cinématographe*, p. 35.

44. This verdict notwithstanding, Valéry has a pronounced sense of the flow of material life, as is illustrated, for instance, by his delightful description of Amsterdam streets and canals. Also, he is aware that visible shapes cannot be grasped to the full unless they are stripped of the meanings which commonly serve to identify them; and the idea of seizing upon them for their own sake rather appealed to him. See Valéry, "Le retour de Hollande," in *Variété II*, pp. 25–27.

45. Quoted by Benjamin, "L'oeuvre d'art à l'époque de sa reproduction mécanisée," *Zeitschrift fuer Sozialforschung*, vol. 5, no. 1 (1936), 62, from Duhamel, *Scènes de la vie future*, Paris, 1930.

46. Chiaromonto, "a note on the movies," *instead*, June 1948, no. 4.

47. Nietzsche, *Human, All-Too-Human*, Aphorism no. 234; trans. Helen Zimmern, p. 217.

48. Whitehead, *Science and the Modern World*, p. 187.

49. Freud, *The Future of an Illusion*, trans. W. D. Robson-Scott, pp. 77–78, 96.

50. Dewey, *Art as Experience*, p. 338.

51. Whitehead, *Science and the Modern World*, p. 199.

52. Ibid., p. 200.

53. Proust, *Remembrance of Things Past, passim;* see, for instance, vol. I, pp. 15, 656.

54. Auerbach, *Mimesis,* trans. Willard R. Trask, p. 546.

55. Ibid., p. 552.

56. Ibid., p. 551.

57. Mumford, *Technics and Civilization,* p. 340.

58. Ibid., p. 343.

59. Dewey, *Art as Experience,* p. 340.

60. Ibid., p. 339.

27

Film as Art

RUDOLF ARNHEIM

Film and Reality

Film resembles painting, music, literature, and the dance in this respect—it is a medium that may, but need not, be used to produce artistic results. Colored picture post cards, for instance, are not art and are not intended to be. Neither are a military march, a true confessions story, or a strip tease. And the movies are not necessarily film art.

There are still many educated people who stoutly deny the possibility that film might be art. They say, in effect: "Film cannot be art, for it does nothing but reproduce reality mechanically." Those who defend this point of view are reasoning from the analogy of painting. In painting, the way from reality to the picture lies via the artist's eye and nervous system, his hand and, finally, the brush that puts strokes on canvas. The process is not mechanical as that of photography, in which the light rays reflected from the object are collected by a system of lenses and are then directed onto a sensitive plate where they produce chemical changes. Does this state of affairs justify our denying photography and film a place in the temple of the Muses?

It is worth while to refute thoroughly and systematically the charge that photography and film are only mechanical reproductions and that they therefore have no connection with art—for this is an excellent method of getting to understand the nature of film art.

With this end in view, the basic elements of the film medium will be examined separately and compared with the corresponding characteristics of what we perceive "in reality." It will be seen how fundamentally different the two kinds of image are; and that it is just these differences that provide film with its artistic resources. We shall thus come at the same time to understand the working principles of film art.

The Projection of Solids Upon a Plane Surface

Let us consider the visual reality of some definite object such as a cube. If this cube is standing on a table in front of me, its position determines whether I can realize its shape properly. If I see, for example, merely the four sides of a square, I have no means of knowing that a cube is before me, I see only a square surface. The human eye, and equally the photographic lens, acts from a particular position and from there can take in only such portions of the field of vision as are not hidden by things in front. As the cube is now placed, five of its faces are screened by the sixth, and therefore this last only is visible. But since this face might equally well conceal something quite different—since it might be the base of a pyramid or one side of a sheet of paper, for instance—our view of the cube has not been selected characteristically.

We have, therefore, already established one important principle: If I wish to photograph a cube,

From Rudolf Arnheim, *Film as Art*. Berkeley: University of California Press, 1957, pp. 8–17, 20–21, 154–60. Reprinted with permission of the Regents of the University of California and the author.

it is not enough for me to bring the object within range of my camera. It is rather a question of my position relative to the object, or of where I place it. The aspect chosen above gives very little information as to the shape of the cube. One, however, that reveals three surfaces of the cube and their relation to one another, shows enough to make it fairly unmistakable what the object is supposed to be. Since our field of vision is full of solid objects, but our eye (like the camera) sees this field from only one station point at any given moment, and since the eye can perceive the rays of light that are reflected from the object only by projecting them onto a plane surface—the retina—the reproduction of even a perfectly simple object is not a mechanical process but can be set about well or badly.

The second aspect gives a much truer picture of the cube than the first. The reason for this is that the second shows more than the first—three faces instead of only one. As a rule, however, truth does not depend on quantity. If it were merely a matter of finding which aspect shows the greatest amount of surface, the best point of view could be arrived at by purely mechanical calculation. There is no formula to help one choose the most characteristic aspect: it is a question of feeling. Whether a particular person is "more himself" in profile than full face, whether the palm or the outside of the hand is more expressive, whether a particular mountain is better taken from the north or the west cannot be ascertained mathematically—they are matters of delicate sensibility.

Thus, as a preliminary, people who contemptuously refer to the camera as an automatic recording machine must be made to realize that even in the simplest photographic reproduction of a perfectly simple object, a feeling for its nature is required which is quite beyond any mechanical operation. . . . In artistic photography and film, those aspects that best show the characteristics of a particular object are not by any means always chosen; others are often selected deliberately for the sake of achieving specific effects.

Reduction of Depth

How do our eyes succeed in giving us three-dimensional impressions even though the flat retinae can receive only two-dimensional images? Depth perception relies mainly on the distance between the two eyes, which makes for two slightly different images. The fusion of these two pictures into one image gives the three-dimensional impression. As is well known, the same principle is used in the stereoscope, for which two photographs are taken at once, about the same distance apart as the human

eyes. This process cannot be used for film without recourse to awkward devices, such as colored spectacles, when more than one person is to watch the projection. For a single spectator it would be easy to make a stereoscopic film. It would only mean taking two simultaneous shots of the same incident a couple of inches apart and then showing one of them to each eye. For display to a larger number of spectators, however, the problem of stereoscopic film has not yet been solved satisfactorily—and hence the sense of depth in film pictures is extraordinarily small. The movement of people or objects from front to back makes a certain depth evident—but it is only necessary to glance into a stereoscope, which makes everything stand out most realistically, to recognize how flat the film picture is. This is another example of the fundamental difference between visual reality and film.

The effect of film is neither absolutely two-dimensional nor absolutely three-dimensional, but something between. Film pictures are at once plane and solid. In Ruttmann's film *Berlin* there is a scene of two subway trains passing each other in opposite directions. The shot is taken looking down from above onto the two trains. Anyone watching this scene realizes, first of all, that one train is coming toward him and the other going away from him (three-dimensional image). He will then also see that one is moving from the lower margin of the screen toward the upper and the other from the upper toward the lower (plane image). This second impression results from the projection of the three-dimensional movement onto the screen surface, which, of course, gives different directions of motion.

The obliteration of the three-dimensional impression has as a second result a stronger accentuation of perspective overlapping. In real life or in a stereoscope, overlapping is accepted as due merely to the accidental arrangement of objects, but very marked cuts result from superimpositions in a plane image. If a man is holding up a newspaper so that one corner comes across his face, this corner seems almost to have been cut out of his face, so sharp are the edges. Moreover, when the three-dimensional impression is lost, other phenomena, known to psychologists as the constancies of size and shape, disappear. Physically, the image thrown onto the retina of the eye by any object in the field of vision diminishes in proportion to the square of the distance. If an object a yard distant is moved away another yard, the area of the image on the retina is diminished to one-quarter of that of the first image. Every photographic plate reacts similarly. Hence in a photograph of someone sitting with his feet stretched out far in front of him the subject comes out with enormous feet and much too small a head.

Curiously enough, however, we do not in real life get impressions to accord with the images on the retina. If a man is standing three feet away and another equally tall six feet away, the area of the image of the second does not appear to be only a quarter of that of the first. Nor if a man stretches out his hand toward one does it look disproportionately large. One sees the two men as equal in size and the hand as normal. This phenomenon is known as the constancy of size. It is impossible for most people—excepting those accustomed to drawing and painting, that is, artificially trained—to see according to the image on the retina. This fact, incidentally, is one of the reasons the average person has trouble copying things "correctly." Now an essential for the functioning of the constancy of size is a clear three-dimensional impression; it works excellently in a stereoscope with an ordinary photograph, but hardly at all in a film picture. Thus, in a film picture, if one man is twice as far from the camera as another, the one in front looks very considerably the taller and broader.

It is the same with the constancy of shape. The retinal image of a table top is like the photograph of it; the front edge, being nearer to the spectator, appears much wider than the back; the rectangular surface becomes a trapezoid in the image. As far as the average person is concerned, however, this again does not hold good in practice: he *sees* the surface as rectangular and draws it that way too. Thus the perspective changes taking place in any object that extends in depth are not observed but are compensated unconsciously. That is what is meant by the constancy of form. In a film picture it is hardly operative at all—a table top, especially if it is near the camera, looks very wide in front and very narrow at the back.

These phenomena, as a matter of fact, are due not only to the reduction of three-dimensionality but also to the unreality of the film picture altogether—an unreality due just as much to the absence of color, the delimitation of the screen, and so forth. The result of all this is that sizes and shapes do not appear on the screen in their true proportions but distorted in perspective.

Lighting and the Absence of Color

It is particularly remarkable that the absence of colors, which one would suppose to be a fundamental divergence from nature, should have been noticed so little before the color film called attention to it. The reduction of all colors to black and white, which does not leave even their brightness values untouched (the reds, for instance, may come too dark or too light, depending on the emulsion), very

considerably modifies the picture of the actual world. Yet everyone who goes to see a film accepts the screen world as being true to nature. This is due to the phenomenon of "partial illusion." The spectator experiences no shock at finding a world in which the sky is the same color as a human face; he accepts shades of gray as the red, white, and blue of the flag; black lips as red; white hair as blond. The leaves on a tree are as dark as a woman's mouth. In other words, not only has a multicolored world been transmuted into a black-and-white world, but in the process all color values have changed their relations to one another: similarities present themselves which do not exist in the natural world; things have the same color which in reality stand either in no direct color connection at all with each other or in quite a different one.

The film picture resembles reality insofar as lighting plays a very important role. Lighting, for instance, helps greatly in making the shape of an object clearly recognizable. (The craters on the surface of the moon are practically invisible at full moon because the sun is perpendicular and no shadows are thrown. The sunlight must come from one side for the outlines of the mountains and the valleys to become visible.) Moreover, the background must be of a brightness value that allows the object to stand out from it sufficiently; it must not be patterned by the light in such a way that it prevents a clear survey of the object by making it appear as though certain portions of the background were part of the object or vice versa.

These rules apply, for example, to the difficult art of photographing works of sculpture. Even when nothing but a "mechanical" reproduction is required, difficulties arise which often puzzle both the sculptor and the photographer. From which side is the statue to be taken? From what distance? Shall it be lighted from the front, from behind, from the right or left side? How these problems are solved determines whether the photograph or film shot turns out anything like the real object or whether it looks like something totally different.

Delimitation of the Image and Distance from the Object

Our visual field is limited. Sight is strongest at the center of the retina, clearness of vision decreases toward the edges, and, finally, there is a definite boundary to the range of vision due to the structure of the organ. Thus, if the eyes are fixed upon a particular point, we survey a limited expanse. This fact is, however, of little practical importance. Most people are quite unconscious of it, for the reason that our eyes and heads are mobile and we contin-

ually exercise this power, so that the limitation of our range of vision never obtrudes itself. For this reason, if for no other, it is utterly false for certain theorists, and some practitioners, of the motion picture to assert that the circumscribed picture on the screen is an image of our circumscribed view in real life. That is poor psychology. The limitations of a film picture and the limitations of sight cannot be compared because in the actual range of human vision the limitation simply does not exist. The field of vision is in practice unlimited and infinite. A whole room may be taken as a continuous field of vision, although our eyes cannot survey this room from a single position, for while we are looking at anything our gaze is not fixed but moving. Because our head and eyes move we visualize the entire room as an unbroken whole.

It is otherwise with the film or photograph. For the purpose of this argument we are considering a single shot taken with a fixed camera. . . . The limitations of the picture are felt immediately. The pictured space is visible to a certain extent, but then comes the edge which cuts off what lies beyond. It is a mistake to deplore this restriction as a drawback. . . .

Absence of the Space—Time Continuum

In real life every experience or chain of experiences is enacted for every observer in an uninterrupted spatial and temporal sequence. I may, for example, see two people talking together in a room. I am standing fifteen feet away from them. I can alter the distance between us; but this alteration is not made abruptly. I cannot suddenly be only five feet away; I must move through the intervening space. I can leave the room; but I cannot suddenly be in the street. In order to reach the street I must go out of the room, through the door, down the stairs. And similarly with time. I cannot suddenly see what these two people will be doing ten minutes later. These ten minutes must first pass in their entirety. There are no jerks in time or space in real life. Time and space are continuous.

Not so in film. The period of time that is being photographed may be interrupted at any point. One scene may be immediately followed by another that takes place at a totally different time. And the continuity of space may be broken in the same manner. A moment ago I may have been standing a hundred yards away from a house. Suddenly I am close in front of it. I may have been in Sydney a few moments ago. Immediately afterward I can be in Boston. I have only to join the two strips together. . . .

The Complete Film

The technical development of the motion picture will soon carry the mechanical imitation of nature to an extreme. The addition of sound was the first obvious step in this direction. The introduction of sound film must be considered as the imposition of a technical novelty that did not lie on the path the best film artists were pursuing. They were engaged in working out an explicit and pure style of silent film, using its restrictions to transform the peep show into an art. The introduction of sound film smashed many of the forms that the film artists were using in favor of the inartistic demand for the greatest possible "naturalness" (in the most superficial sense of the word). By sheer good luck, sound film is not only destructive but also offers artistic potentialities of its own. Owing to this accident alone the majority of art-lovers still do not realize the pitfalls in the road pursued by the movie producers. They do not see that the film is on its way to the victory of wax museum ideals over creative art.

The development of the silent film was arrested possibly forever when it had hardly begun to produce good results; but it has left us with a few splendidly mature films. In the future, no doubt, "progress" will be faster. We shall have color films and stereoscopic films, and the artistic potentialities of the sound film will be crushed at an even earlier stage of their development.

What will the color film have to offer when it reaches technical perfection? We know what we shall lose artistically by abandoning the black-and-white film. Will color ever allow us to achieve a similar compositional precision, a similar independence of "reality"?

The masterpieces of painting prove that color provides wider possibilities than black-and-white and at the same time permits of a very exact and genuine style. But can painting and color photography be compared? Whereas the painter has a perfectly free hand with color and form in presenting nature, photography is obliged to record mechanically the light values of physical reality. In achromatic photography the reduction of everything to the gray scale resulted in an art medium that was sufficiently independent and divergent from nature. There is not much likelihood of any such transposition of reality into a qualitatively different range of colors in color film. To be sure, one can eliminate individual colors—one may, for example, cut out all blues, or, vice versa, one may cut out everything except the blues. Probably it is possible also to change one or more color tones qualitatively—for example, give all reds a cast of orange or make all the yellows greenish—or let colors change places

with one another—turn all blues to red and all reds to blue—but all this would be, so to speak, only transposition of reality, mechanical shifts, whose usefulness as a formative medium may be doubted.

Hence there remains only the possibility of controlling the color by clever choice of what is to be photographed. All kinds of fine procedures are conceivable, especially in the montage of colored pictures, but it must not be overlooked that in this way the subjective formative virtues of the camera, which are so distinctive a characteristic of film, will be more and more restricted, and the artistic part of the work will be more and more focused upon what is set up and enacted *before* the camera. The camera is thereby increasingly relegated to the position of a mere mechanical recording machine.

Above all, it is hardly realistic to speculate on the artistic possibilities of the color film without keeping in mind that at the same time we are likely to be presented with the three-dimensional film and the wide screen. Efforts in these directions are in progress. The illusion of reality will thereby have been increased to such a degree that the spectator will not be able to appreciate certain artistic color effects even if they should be feasible technically. It is quite conceivable that by a careful choice and arrangement of objects it might be possible to use the color on the projection surface artistically and harmoniously. But if the film image becomes stereoscopic there is no longer a plane surface within the confines of the screen, and therefore there can be no composition of that surface; what remains will be effects that are also possible on the stage. The increased size of the screen will render any two-dimensional or three-dimensional composition less compelling; and formative devices such as montage and changing camera angles will become unusable if the illusion of reality is so enormously strengthened. Obviously, montage will seem an intolerable accumulation of heterogeneous settings if the illusion of reality is very strong. Obviously also a change in the position of the camera will now be felt as an actual displacement within the space of the picture. The camera will have to become an immobile recording machine, every cut in the film strip will be mutilation. Scenes will have to be taken in their entire length and with a stationary camera, and they will have to be shown as they are. The artistic potentialities of this form of film will be exactly those of the stage. Film will no longer be able in any sense to be considered as a separate art. It will be thrown back to before its first beginnings—for it was with a fixed camera and an uncut strip that film started. The only difference will be that instead of having all before it film will have nothing to look forward to.

This curious development signifies to some extent the climax of that striving after likeness to nature which has hitherto permeated the whole history of the visual arts. Among the strivings that make human beings create faithful images is the primitive desire to get material objects into one's power by creating them afresh. Imitation also permits people to cope with significant experiences; it provides release, and makes for a kind of reciprocity between the self and the world. At the same time a reproduction that is true to nature provides the thrill that by the hand of man an image has been created which is astoundingly like some natural object. Nevertheless, various countertendencies—some of them purely perceptual—have prevented mechanically faithful imitation from being achieved hundreds of years ago. Apart from rare exceptions, only our modern age has succeeded in approaching this dangerous goal. In practice, there has always been the artistic urge not simply to copy but to originate, to interpret, to mold. We may, however, say that aesthetic theory has rarely sanctioned such activities. Even for artists like Leonardo da Vinci the demand for being as true to nature as possible was a matter of course when he talked theory, and Plato's attack on artists, in which he charged them with achieving nothing but reproductions of physical objects, is far from the general attitude.

To this very day some artists cherish this doctrine, and the general public does so to an even greater extent. In painting and sculpture it is only in recent decades that works have been appearing which show that their creators have broken with this principle intellectually and not merely practically. If a man considers that the artist should imitate nature, he may possibly paint like Van Gogh, but certainly not like Paul Klee. We know that the very powerful and widespread rejection of modern art is almost entirely supported by the argument that it is not true to nature. The development of film shows clearly how all-powerful this ideal still is.

Photography and its offspring, film, are art media so near to nature that the general public looks upon them as superior to such old-fashioned and imperfect imitative techniques as drawing and painting. Since on economic grounds film is much more dependent on the general public than any other form of art, the "artistic" preferences of the public sweep everything before them. Some work of good quality can be smuggled in but it does not compensate for the more fundamental defeats of film art. The complete film is the fulfillment of the age-old striving for the complete illusion. The attempt to make the two-dimensional picture as nearly as possible like its solid model succeeds; original and copy

become practically indistinguishable. Thereby all formative potentialities which were based on the differences between model and copy are eliminated and only what is inherent in the original in the way of significant form remains to art.

H. Baer in a remarkable little essay in the *Kunstblatt* has pointed out that color film represents the accomplishment of tendencies which have long been present in graphic art.

"Graphic art (he says)—of which photography is one branch—has always striven after color. The oldest woodcuts, the blockbooks, were finished off by being handpainted. Later, a second, colored, plate was added to the black-and-white—as in Dürer's portrait of 'Ulrich Varnbühler.' A magnificent picture of a knight in armor in black, silver, and gold, exists by Burgmair. In the eighteenth century multicolored etchings were produced. In the nineteenth the lithographs of Daumier and Gavarni are colored in mass production. . . . Color invaded the graphic arts as an increased attraction for the eye. Uncivilized man is not as a rule satisfied with black-and-white. Children, peasants and primitive peoples demand the highest degree of bright coloring. It is the primitives of the great cities who congregate before the film screen. Therefore film calls in the aid of bright colors. It is a fresh stimulus."

In itself, the perfection of the "complete" film need not be a catastrophe—if silent film, sound film, and colored sound film were allowed to exist alongside it. There is no objection to the "complete" film as an alternative to the stage—it might help to take into remote places fine performances of good works, as also of operas, musical comedies, ballets, the dance. Moreover, by its very existence it would probably have an excellent influence on the other—the real—film forms, by forcing them to advance along their own lines. Silent films, for example, would no longer provide dialogue in its titles, because then the absence of the spoken word would be felt as artificial and disturbing. In sound film, too, any vague intermediate form between it and the stage would be avoided. Just as the stage will feel itself obliged by the very existence of film to emphasize its own characteristic—the predominance of dramatic speech—so the "complete" film could relegate the true film forms to their own sphere.

The fact is, however, that whereas aesthetically these categories of film could and should exist along with mechanically complete reproduction, they are inferior to it in the capacity to imitate nature. Therefore the "complete" film is certain to be considered an advance upon the preceding film forms, and will supplant them all.

28

Basic Film Aesthetics

F. E. SPARSHOTT

The basic aesthetics of film as of any other art must be descriptive and analytic, giving an account of the relevant variables and their means of variation. And any such account must be rooted in some notion, however imprecise, of what a work of the art in question is. What, then, is a film? It seems to be characteristic of the art that acceptable definitions need to specify not only the nature of the work itself but also the means essential to its production and its characteristic effects. A sample definition might go like this: "A film is a series of motionless images projected onto a screen so fast as to create in the mind of anyone watching the screen an impression of continuous motion, such images being projected by a light shining through a corresponding series of images arranged on a continuous band of flexible material."[1] Much variation in detail and in emphasis is possible, but no definition can dispense with two important features: a succinct description of at least the basic features of the *mechanism* employed, and an allusion to the creation of an *illusion* of motion. Let us consider these necessary features in turn.

Mechanism

More than any other art, film is technologically determined. Music, dance, drawing, painting, sculpture, poetry, even architecture need for their original and rudimentary forms either no materials or materials lying everywhere at hand, but cinematography cannot begin without laboriously invented and precisely constructed equipment. The history of film is the history of the invention of its means. Aestheticians of the cinema may often be differentiated by how they react to various aspects of its technology: the properties of lenses and emulsions, the conditions of production and display. Thus the most notorious dogmas about how films ought to be made are demands for truth to the supposed tendencies of some aspect of the medium: to the clarity and convincingness of photographic images, or to the impartial receptivity of a film camera to whatever may be put before it, or to the camera's way of reducing whatever is put before it to a homogeneous image, or to the ease with which assorted scraps of film may be so cemented as to suggest a common provenance, and so on. It is characteristic of such dogmas that they fasten on one such aspect and tendency and ignore the rest. All of them ignore one very important factor: just because the means of cinema are so complex, anyone who has mastered them (and, equally rare and difficult, who has regular access to them) will naturally use them to convey whatever message or vision he may wish to convey, whether or not it is "cinematic" by any plausible definition. People use their languages to say what they wish to say, not what the language makes it easy to say. Most theorists of cinema insist that the outcome of this natural tendency is bound to be a bad film, but one hardly sees why. Whatever

From *The Journal of Aesthetic Education*, 5 (1971), pp. 11–34. Reprinted with permission of the University of Illinois Press and the author.

can be done with a medium is among its possibilities and hence "true to" it in a sense that has yet to be shown to be illegitimate. A person may become (or may train himself to be) sensitive to the degree in which films exploit or ignore some possibility of the medium, and then may govern his taste or regulate his critical judgment accordingly, but one does not see why such arbitrary selective systems should be imposed on those who would reject them. It is one thing to show that it is almost impossible to make a good film by photographing a stage performance of a play, by enumerating the probable sources of boredom and irritation; it is quite another to declare that all filmed plays are necessarily nonfilmic and on that account bad films.

Illusion

The second necessary feature of our sample definition was its reference to an illusion. Perhaps alone among the arts, and certainly in a way quite different from any of the other major arts, film is necessarily an art of illusion from the very beginning; and illusion, like technology, serves as a focal point around which aesthetic disputes arrange themselves. On the one hand, it may be taken as an opportunity to be exploited. Both by fabricating the images to be projected and by manipulating the speed and sequence of their projection, films can and do revel in the creation of the most elaborate illusions. On the other hand, illusion may be seen as the temptation to be resisted. The motion on the screen has to be unreal, but can and should faithfully portray a motion that really took place just so in the real world. Both tendencies go back to the earliest days of cinema, in the work of the realist Lumière and the fantasist Méliès. But that does not mean that film-makers have to choose between embracing and eschewing illusion: quite usually, and in the films of at least some acknowledged masters, fantasy is put at the service of realism (e.g., the stone lions in *Potemkin*) or realism at the service of fantasy (e.g., the homecoming in *Ugetsu*).

To speak broadly of "illusion" as we have done is misleading. While the basic illusion of motion is an automatic and unavoidable function of the mechanism of human vision, what I shall call the "secondary illusions" constructed upon it, to the effect that an event or movement of a certain sort is taking place, are not automatic but depend on the filmgoer's knowledge and his ability or willingness to acquiesce in a pretense. Writers on film often mention a scene in which an Indian villager is pursued by a tiger. The pursuit is shown entirely by intercut shots of scared man and slavering beast until, at the very end, pursuer and pursued at last appear

together in a single shot. For Bazin, this saves the scene: previously one had assumed that the propinquity of man and beast was an illusion created by cutting, now one suddenly sees that it was not.[2] For Montagu, it is stupid: the effect was created by the cutting, the concluding two-shot is a banal assertion.[3] And of course on reflection one realizes that either it was a tame tiger or we are being served another trick shot. It seems obvious that different audiences will differ in their susceptibilities to such effects; trying to decide the proprieties (as both writers do) by invoking ultimate principles is surely a waste of time.

The Bias of Exposition

As the example we have just given shows, the secondary illusions of film relate not to what is projected on the screen but to the supposed provenance of the image. No more than when attending a stage play does anyone at the movies feel as if an event were really taking place before his eyes. But why should there be illusions of provenance? The answer seems to lie in the complex relations between cinematography and photography, and the peculiar nature of photographic images themselves. A clue to these relations may be found in the fact that all but one of the demands of "truth to the medium" that we used as examples mentioned some aspect of photography, although our sample definition of a film made no allusion to photography at all.

The images whose successive projection makes a film are most easily produced by photography; but they can be drawn directly on the film stock. A photograph to represent an object is most easily made by aiming a camera at an object of the appropriate kind; but what is photographed may also be a model or a drawing or even another photograph made for the purpose. A photograph of an event or happening is most easily made by finding one and photographing it; but scenes may be enacted and scenery constructed for the purpose. The required succession of images is most easily produced by using a device that will take a lot of photographs in rapid succession and fix them in the right order; but it can be (and in animated cartoons is) drawn or photographed frame by frame. And the obvious way to work the film camera (though not necessarily the easiest; rather it is synchronization that requires care) is to run it at the same speed as you will run your projector; but it can be run faster or slower. Film thus has a bias, quite strong though readily resistible, towards its simplest form, that in which the projector repeats a camera event; and one tends if not on one's guard to assume, wherever nothing in the film suggests the contrary, that what is shown

on the screen represents such a repetition, as if the projector copied a camera that enacted the spectator's eye.

An eye is not a camera, and a photographic image does not show what eyes see. As you look around you, your eye constantly adjusts its iris as brightness changes and alters its focus as depth changes. The parallax effect of the use of two eyes gives everything you see a shifting and unstable character, since everything not focused on at the moment yields a vague doubled image. The eye in nature is therefore restless; in looking at a photograph, all in one plane and with a relatively small range of luminosity, the eye is spared much of its labor. However, though a photographic image is not at all like the visible world, it does have precisely the quality that old theorists used to ascribe to that venerable phantom of optics, the retinal image. A photographic image represents a sort of ideal projection, the way we normalize in imagination what we see. What the invention of photography did was not to reproduce vision but to achieve a dream of ideal vision. A photographic image is not so much a true one as a convincing one. Photographs tend to carry an irresistible sense of authenticity. Looking at a good photograph is not like looking at the photographed thing (this is so far from being the case that Peter Ustinov's famous remark, that he made *Billy Budd* in black-and-white because it was more realistic than color, hardly seems paradoxical); it is like looking at a faithful record.

The basic illusion of movement by itself gives an impression not of reality but of a sort of unattributable vivacity. This becomes evident when one watches an animated cartoon. Verisimilitude adds nothing to the lifelikeness of such films, and the elaborate devices used by Disney in his later years to suggest a third dimension have been abandoned as futile (as well as expensive). The sense of reality elicited by such films is akin to that of painting: we attribute the actions we see neither to the real world nor to the screen image, but to Donald Duck and the cartoon world created for him. It is not the illusion of movement, then, that moves us to attribute what we see to the world of experience; rather it is the photographic character of the image that lends films their characteristic bias of exposition, and to the extent that it is present and uncontradicted by the nature of what is presented encourages us to take what we see as the record of something that took place as we see it taking place. The viewer tends to normalize in this sense his perception of films made in the most diverse ways.

Many theories about how films ought to be made represent attitudes to the bias of exposition just described. The Soviet film-makers of the twenties claimed that the whole art of film lay in exploiting its tendency by the use of montage or associative cutting, joining strips of photographed film in such a way as to synthesize in the spectator's mind an experiential reality that went beyond the images shown.[4] Siegfried Kracauer urged on the contrary that the best use of film is an honest reliance on its capacity to convey authenticity, to preserve and celebrate the sense of reality.[5] His argument was not that a film should actually be a record or chronicle, but that it should celebrate and "redeem," as no other medium can, the radiant actuality of the physical world, eschewing alike fantasies and superimposed formal arrangements. Other critics, noting that film bestows verisimilitude on the deserving and the undeserving alike, urge that film includes among its unique capacities that of making "dreams come true." Only film can *show* the impossible happening and thus make fantasy convincing.[6] In the opposite direction, some exponents of contemporary "underground" film go beyond Kracauer (and beyond Rossellini and the Italian neorealists) in urging that to cut film at all is to falsify: the finished film should consist of all that the camera took in the order it was taken in, and if this means that some shots are out-of-focus, ill-exposed or irrelevant, they will thereby only be truer to the film experience.[7] On this view, a film records not what happened in front of the camera but what happened to the film *in* the camera. And finally, some extremists might urge that the only honest way to make a film is to set a camera up somewhere and let it just run, taking in whatever may happen along.[8] But at that point the urge to honesty would surely defeat itself by suggesting a standard it cannot fulfill. Films are not natural events, and it is pointless to prevaricate about the selective intervention of the film-maker.

Film Space

That the realism of film is that of a graphic record and not that of an illusive actuality is apparent in the peculiar nature of film space, the actual and suggested spatial relations between elements of the film and between film and spectator.[9] Many writers imply that a filmgoer ordinarily feels himself to be in the same relation to the filmed scene as the camera was (or purports to have been). On this basis such trick shots as those showing a room through the flames of a fire in the fireplace are condemned on the ground that the audience know that nobody would be in that position.[10] But this seems to be mistaken. Spectators seem to identify themselves with the camera viewpoint only when some such process as Cinerama is used which makes the screen approximate to the total visual environment. Otherwise,

shots taken looking straight downward do not give one a sense of vertigo (though they may do to persons extremely susceptible in this regard), and even the most rapid changes in camera position do not produce in an experienced filmgoer any sense of nausea or disorientation. If one really accepted a change in camera position as a change in one's personal viewpoint, rapid intercutting between different viewpoints would obviously be intolerable. There is certainly a sense in which one has a feeling of spatial presence at the filmed scene (which is not to be confused with psychological involvement in the action), construing the scene as a three-dimensional space in which one is involved and has a viewpoint. This depth and inclusiveness of cinema space owes much to parallax, the differential motion and occlusion of distant objects as the viewpoint changes. It follows that when, as often happens nowadays, action is interrupted by stop-motion, the whole nature of the space in which the action takes place is instantly transformed (a striking instance is the concluding scene of *The Strawberry Statement*). This little-noted factor is important. Without such a change in spatiality, stop-motion might give the impression that the world had suddenly come to a halt; as it is, it confronts us rather with a transition to a different mode of representation, and hence perhaps a different mode of being.

The more one reflects on one's sense of cinema space, the more it seems to be one peculiar to cinema. The use of a zoom lens increasing the (objective) size of the image does have the effect of bringing the action nearer; but walking towards the screen, though it produces a (subjectively) larger image and does bring the screen nearer, does not bring the action nearer at all. One's sense of spatial involvement in a scene does not depend on one's occupying any particular seat, but only on one's being neither too close nor too far to see the screen properly. Similar considerations apply to all the distortions of space that result from the use of various lenses. The resulting plasticity of space relations is accepted as a narrative device or as an invitation to an imaginary viewpoint, it does not disorient the audience. The use of a deep-focus lens for Miss Havisham's room in *Great Expectations* certainly has a "magnifying" effect, but a curious one: we do not feel that we are in a big room, but that "this is how it must have seemed to Pip." Again, in the scene where the girl runs toward the airplane in *Zabriskie Point* the scale-relations between girl and low horizon are such that for a second or two we accept what we see as an ordinary medium-shot; then we notice that for all her running the girl is not receding much, and realize that it is a typical telephoto shot. But the effect of this realization on me was not to alter my feeling of where I was in relation to the scene, but to change my interpretation of that relation. In fact, a telephoto shot answers to no possible real spatial relationship between spectator and event: there is a viewing angle, but no possible viewpoint. Yet this never disturbs anyone.

Phenomena of the sort we have been mentioning suggest that one's sense of space in film is somehow bracketed or held in suspense: one is aware of one's implied position and accepts it, but is not existentially committed to it. A simple explanation of this is that most of the time one is simultaneously aware of a film (as one is of a painting) both as a two-dimensional arrangement on the screen and as a three-dimensional scene, so that neither aspect dominates the mind except in moments of excitement or disaffection. A subtler explanation is that cinema vision is alienated vision. A man's sense of where he is depends largely on his sense of balance and his muscular senses, and all a filmgoer's sensory cues other than those of vision and hearing relate firmly to the theater and seat in which he sits. In the scene with the epileptic doctor in *Carnet du Bal,* which is taken with a consistently tilted camera, what one sees on the screen insists that one is off balance, but one's body insists that it is not; and the effect on me is the one Duvivier surely intended, a feeling of malaise accompanied by a sense of *vicarious* disorientation on behalf of the protagonist.

Some of the spatial ambiguity of film is shared with still photography. No matter how one moves a photograph around in relation to oneself, it continues to function as a faithful record implying a viewpoint from which it was taken: and there is a sense in which one continues to be "at" this viewpoint no matter what angle the photograph is inspected from. What differentiates film from still photography is not only the sense of vivacity and hence spatial reality that motion imparts, but also the great size and contrasting illumination of the film image in the darkened theater, whereby it comes much closer to dominating the visual sense, and the relatively invariant relation between screen and spectator.[11] The director determines the audience's spatial relation to his films, but what he determines remains an imaginary space; we are within the film's space but not part of its world; we observe from a viewpoint at which we are not situated.

It is the alienation of the visual sense in cinema space that makes possible many of the uses and special effects of film that work against its function as record. Being deprived of so many sensory cues, the spectator loses all sense of absolute scale, so that back-projections and painted backgrounds may wear a convincing air of reality, and the apparent size of any object may be varied by placing it in a

magnified or diminished setting, or simply (as when storms and wrecks are shot using models in tanks) by trading on the spectator's narrative assumptions.

Film and Dream

Unique as it is, the alienated spatiality of film, in which the spectator participates without contact, and which he observes from a viewpoint that contrives to be both definite and equivocal or impossible, presents striking analogies to the space of dreams. Or perhaps, since different people seem to have widely varying dream perceptions, I should limit myself to saying that my own spatial relation to my dream worlds is like nothing in waking reality so much as it is like my relation to film worlds. In my dreams, too, I see from where I am not, and move helplessly in a space whose very nature is inconstant, and may see beside me the being whose perceptions I share. There are indeed many ways in which filmgoing is like dreaming; but the likeness is always qualified. Films are like dreams in involving one in a world whose course one cannot control, but unlike them in that their world does not incorporate the dream of effort and participation. Filmed reality shares with dreamed reality (as nothing else does) its tolerance of limitlessly inconsequent transitions and transformations; but it lacks that curious conceptual continuity of dreams in which what is a raven may become a writing-desk or may simultaneously *be* a writing-desk, and in which one *knows* that what looks like one person is really a quite different person. The conceptual equivalences essayed by film-makers (e.g., Eisenstein's equation of Kerensky with a peacock in *October*), which usually proceed by intercutting shots of the two entities to be equated, seem rather to be the visual equivalent of similes or metaphors than equivalents of the dream carryover, which depends on a dream-interpretation imposed on the dream-percept and not (as must be the case in film) on an interpretation suggested by the percept itself.[12]

The dreamlikeness of film has often been noted. Usually the recognition takes the form of a loose analogy with daydreaming (which is quite different), but Susanne Langer for one has made the formal analogy with dreaming the basis of her account of the nature of film.[13] The analogy must not be pushed too far. A quite fundamental difference between a filmgoer and a dreamer is that the former remains in control of his faculties, capable of sustained and critical attention. A dreamlike inconsequentiality is thus far from typical of film, though it remains among filmic possibilities and the filmgoing public at large acquiesces in a degree of cheer-

ful incoherence (as in *Casino Royale*) that in other arts is acceptable only to the sophisticate.

To the extent that the analogy between film and dream is taken seriously, it seems to invite Freudians to apply their methods of symbolic interpretation with even more confidence than they do to other arts. But they seem not to have accepted the invitation (except in so far as Freudian methodology lies behind the auteur theory of criticism), perhaps because not enough film-makers are safely dead yet. In any case, before we reach that level of interpretation we have to complete our survey of the basic attributes of the film world.

Film Time and Film Reality

The same confusion between an actual event and a convincing record that has made critics write of the camera as a surrogate for the spectator's eye leads them to say that film time is present time, that in watching a film one seems to see things happening *now*, as though one were present not at the film but at the filmed event. But this contention is vulnerable to the same sort of objection that refutes the doctrine of the camera eye. In one sense it is true but trivial: of course what one sees is always here and now, because "here" and "now" are defined by one's presence. In any other sense it is false, or we should not be able to take in our stride the flashbacks and flash-forwards, the accelerations and decelerations, that are part of film's stock in trade. Rather, it is as though we were spectators of the temporality of the films we see. Film time has a quality analogous to that dreamlike floating between participation and observation, between definite and indeterminate relationships, that gives film space its pervasive character. Granted, the fundamental illusion of motion combines with the convincingness of a photographic record to ensure that we ordinarily do read the presented motion as continuous and as taking just as much time to happen as it takes us to observe it; but this supposition is readily defeated by any counterindication. D. W. Griffith, challenged on his early use of spatiotemporal discontinuities, justified himself by appealing to the example of Dickens, and surely he was right to do so.[14] The time of a novel is filmic, as its space is not. Events can be filmed, as they can be narrated, with equal facility in any order, at any speed, with any degree of minuteness. Unlike the novelist, however, the film-maker has no language proper to his medium in which to specify temporal relations. He may use titles, trick dissolves, a narrator's voice, or datable visual clues to establish his temporal relations; but some directors seem to feel that such

devices are clumsy or vulgar, and prefer to trust the public's acumen or simply to leave the relations indeterminate.[15]

The dream-relationships of film space and the narrative nature of film time combine to encourage an ambiguity that may be fruitful or merely irritating. One often does not know whether one is seeing what in the film's terms is real, or only what is passing through the mind of one of the film's characters. This ambiguity becomes acute whenever there is a temporal jump, for time (as Kant observed) is the form of subjectivity. A flash-back may represent a character's memory, or may simply be a narrative device; a flash-forward may stand for a character's premonition, or simply an anticipation by the filmmaker;[16] and, where the temporally displaced scene is recalled or foreseen, it may stand either for the event as it was or would be, or for the way it is (perhaps falsely) conjured up. The status of film events thus becomes equivocal, and such uncertainty may pervade an entire film. Thus in 8½ some scenes are remembered, some dreamed, some imagined, and some belong to the reality of the film's story. There are many scenes whose status is unclear at the time, and some whose status never becomes clear. Does the opening scene of the closed car in the traffic jam show a seizure which makes the cure necessary (as Arnheim seems to think),[17] or is it a dream of a patient already undergoing treatment (as most critics suppose)? Nothing in the version of the film I saw determined either answer. A more striking equivocation occurs in *Easy Rider,* when a brief glimpse of an unexplained roadside fire is identified at the end of the film as the burning of the hero's motorcycle. Was that first glimpse a premonition of the hero's (and if so, just what did he foresee?), or a *memento mori* by the director, or just a pointless interjection to which no meaning can be assigned? In such a self-indulgent piece of hokum, who can say? In general, the tolerability of such unresolved ambiguities is likely to depend partly on the handling of "reality" in the film as a whole, partly on one's confidence in the director's control over his medium, and partly on one's own tolerance of ambiguity. In any case, one must not suppose that such questions as we have just posed need have a single "right" answer (perhaps what the director "meant"). All the director has done is to splice celluloid, and if he has not provided enough clues to determine a reading then no meaning is determined. What the director may have had in mind is not the same as what he put on film, and directors sometimes have nothing at all in mind. The flexibility of film technique is a standing invitation to meaningless trickery, and the complexities of production involve endless risks of inadvertent nonsense.[18]

As the apparent time of the action changes, then, so changes the subjectivity/objectivity rating of what we see; and so too may vary our degree of confidence in our ability to assign a rating. Nor are such ambiguities the prerogative of highbrow excursions like *Last Year at Marienbad.* They occur quite naturally in unsophisticated films. For example, in Jerry Lewis's Jekyll-and-Hyde fantasy *The Nutty Professor* the transformation scene in the laboratory slips onto a plane of witty extravagance quite removed from the surface naturalism of the rest of the film. Are we witnessing the event or a metaphor for the event? Who knows? One could spend a long time figuring out possible meanings for it, but in fact it comes across as just a happy episode and the popcorn-grinding jaws do not miss a beat.

Film Motion

The ambiguities of space and time combine to give film motion an endless complexity that we have no space to explore here. Let us confine our attention to some additional complications. In the earliest movies, each scene was taken with a fixed camera, so that the motion shown took place within a fixed frame and against an unchanging background. A scene in a modern film is likely to be enriched or muddled with three different kinds of camera motion. The camera may be shifted from place to place, turned horizontally or vertically to alter its field of reception, or modified by changing the focal length of its lens so as to take in a greater or smaller area. This third kind of camera shot is often dismissed as the equivalent of a tracking shot, moving the camera viewpoint toward or away from the scene, but it is not; it retains much of the sense of getting a different view from the same position. A camera can also be rotated on its focal axis, or joggled and steadied, but these can be set aside for now as occasional effects.

Even a shot of immobile objects taken with an immobile camera need not be devoid of movement, for there is also movement of light: illumination may change in direction, in intensity, in color, in sharpness. And even when the light remains unchanged, the much-used prints that most audiences see have a sort of constant surface shimmer, a vibrant presence derived from the random stains and lesions hard use imparts, that has a good deal to do with the "film experience" and is exploited by some film-makers in much the same spirit that furniture-makers fake a "distressed finish." The free combinations of all the kinds of film motion can impart to a single scene a plastic, balletic quality, a unique kind of formal beauty that is at once abstract and realistic and has no parallel in any other medium.

The mobility of the frame combines with the camera's typical neglect of natural boundaries to produce a marked contrast between the actions of theater and cinema.[19] The stage world is a closed world; an actor who goes offstage loses all determinate existence for the audience;[20] but the edge of a cinema screen functions like a window frame through which we glimpse part of a world to which we attribute infinite continuity.[21] This sense of infinity adds an implicit freedom of movement to the actual freedom that the camera's mobility affords.

Because film space and time are observed rather than lived, film motion can be speeded up or slowed down within scenes in a way denied to theater, in which events take their proper time. (Conversely, theater has a way of achieving temporal plasticity denied to film, by exploiting the stage-unreality of the offstage world: in theater, but not in film, offstage actions are often performed in the course of a scene in an incongruously short time.) The effects of such variations in time depend on context, in a way that becomes easier to understand when we reflect that motion photography was invented to serve not one realistic purpose but two: not only to observe and record movements, but also to study and examine them. And of course very fast movements are best studied by slowing down their representation, very slow ones by speeding it up. Nature films are quite regularly made at unnatural speeds, accelerating plant growth and decelerating bird flight,[22] and replays of crucial movements in sport are usually in slow motion. In this context of study the spectator has no sense of unreality at all: he feels simply that he is getting a better look. But in narrative contexts things are differnt. Acceleration was early discovered to have a reliably comic effect. But deceleration is more variable, for it may produce an impression of joy, or unreality, or obsessiveness, or solemnity, or inevitability. Its effects often evade description, but directors find them reliable enough for regular use, and they have hardened into more than one cliché. One such is the flash-back reverie, where the slow motion seems to work by suggesting weightlessness and hence ethereality (as in *The Pawnbroker*). Another is the use of weightlessness as a metaphor for lightheartedness (as in many TV commercials). A third is the slow-motion death by shooting (as in *Bonnie and Clyde*), partly an appeal to voyeurism but partly a symbolization of death through the transposition of the action into another key of reality.[23]

One can think of acceleration and deceleration as a sort of preediting, the equivalent of adding or subtracting frames in a film taken at projector speed. It is basic to film that editing can produce an impression of motion by intercutting suitably spaced shots of the same object in different positions (as by successive still photographs). The impression does not depend on the basic illusion of continuity: provided that the mind can supply a possible trajectory, all that is needed is that the object should appear to be the same and that its position in successive shots should appear to be different. But beyond this, the effect of *any* sustainedly rapid cutting is to produce an impression of rapid motion, even if the intercut shots have no common content and one cannot say what (apart from "things") is moving. An intermediate sort of effect produced by editing is a two-dimensional movement of light, where the continuity of light and dark areas in successive shots is enough to entice the mind to complete a *Gestalt;* but this effect is of limited application, in that it draws attention away from the filmed world to the screen surface.

Cinema's repertory of motions both presented and psychologically suggested is so extensive and so essential that one might think that what film shares with still photography is unimportant, and specifically that two-dimensional composition within the frame can play no significant part in film at all. But that would be going too far. Not only does the awareness of the screen and its flat pattern play an essential part in grounding the ambiguous nature of film space, but directors in practice often do envisage their scenes statically. They make sketches for their key scenes beforehand, and use viewfinders to compose a scene before shooting it. A film no less than a play may proceed from tableau to tableau. Nonetheless, the tableau is insidiously misleading in more than one way. The more one reads about films the more clearly one sees how each film is invariably illustrated by a handful of constantly recurring still shots: *Potemkin* comes to be represented by half a dozen stills, *Caligari* by two, *Nosferatu* by one. Most of these are not even frames taken from the actual film, but photographs taken on a still camera before or after shooting. And they are chosen for their pictorial qualities. What I most vividly recall from *Bicycle Thieves* is the mountain of bundled clothing in the pawnshop, but that image would be nothing without the camera's movement and the action of adding one's own bundle to the mountain, and what the stills show me is a pretty, pathetic picture of the hero and his son sitting on the sidewalk. Thus in time one's recollection of what a film was like becomes distorted.[24]

Sound

We have been discussing film in visual terms. But for rather more than half its history film has been fully an art of sound as well as sight in the sense that

the associated sound has been determined by the same celluloid strip that carries the image. The justification of our procedure is that sight remains primary. It is the requirements of the visual image that call for the elaboration of equipment and the circumstances of display that are fundamental to cinema. Film sound has no distinctive qualities in itself, and can be meaningfully discussed only as an adjunct to the visual.

Though a sound track for a film can be made directly at the time of shooting simply by hanging microphones near the action and recording on the film whatever they pick up, this is neither necessary nor usual. The sound track is usually made separately and combined with the visual film later.[25] The resulting complexities for sound film are theoretically immense, though in practice the technology is not intimidating. The use of magnetic tape has made the recording, inventing, blending, splicing and modification of sounds easy and inexpensive as the analogous procedures for visual film can never be.

The fundamental classification of film sounds is that enunciated by Kracauer.[26] A sound may belong to the world of the film (e.g., the dialogue of its characters) or it may be extraneous (e.g., background music or a commentary). In the former case, it may belong to the very scene being shown on the screen or it may not (you may hear what is happening elsewhere from what you see, or be reminded by the sound track of a previous scene; as a marginal case, what you hear may be a sound remembered by one of the characters). If the sound does belong to the scene being shown, its provenance may be on or off camera (as you hear someone talk, you may see him, or the person he is addressing, or someone who overhears him, or an opening door that he fails to notice). Thus sound may (and in a slackly made film often does) merely duplicate or reinforce what is visible, but it may play an independent structural or narrative role, and may affect the interpretation or emotional tone of what is seen. For example, distortions, fadings, and swellings of voices can be used to overcome one of the difficulties of film narrative, that of economically revealing to the audience a state of mind that someone is successfully hiding from those around him. Background music may supply an ironic comment, as when the refueling of aircraft in *Dr. Strangelove* is accompanied by a love song—a Russian film of the silent days would have made the point by intercutting shots of animals mating, and what a bore it would have been. One can even try to use a musical score to supplement narrative deficiencies, or even to contradict the apparent tendency of what is seen to be happening, though such techniques have some notorious fiascos to their credit.

When determinate sound was first introduced,

many film-lovers were opposed to it. In principle, the objection was invalid, for films had never been shown without accompanying (and would-be relevant) sound (a "silent" film shown in silence is a curiosity rather than a significant experience), and in principle the change only guaranteed that from now on the sound would indeed be relevant. But in practice what was feared was the "talking film," in which the sound track merely enabled the audience to hear what they could already see. And the use of sound does indeed make sloppy and mindless filmmaking easier. But sound can be and properly is used not merely to add another dimension to the film experience but to add an extra perspective to the visual experience itself.

As an alternative to the mindless use of attached sound that they dreaded, the Russian theorists of the late twenties proposed that their favorite device of associative or metaphorical montage should be extended to sound: intercut images should form a counterpoint against intercut sounds.[27] This did not happen. For one thing, auditory comprehension has a much slower tempo than visual; for another, sounds tend to blend whereas images contrast. The proposed contrapuntal montage would have been impossibly overloaded, if not unintelligible. What montage requires from sound, it turns out, is not a contrapuntal pattern but a chordal backing for its visual melody, a continuous equivalent for or commentary on the character of the whole episode. In any case, the possibility of using sound effects as commentary on the visual images has made elaborate visual montage an obsolete device. This can be thought of as a catastrophic and uncompensated loss to the art of film, but the matter is open to question. Although Eisenstein and others made the use of associative intercutting into a Marxist aesthetic dogma (inasmuch as the conflict of contrasting shots forms a "dialectic" from which the realist truth is synthesized),[28] others have pointed out that the device endears itself to totalitarian regimes by lending itself to lying propaganda: the associations it creates are entirely irrational.[29] Partly, too, the reliance on cutting was enforced by the use of heavy and inflexible camera equipment. Conversely, the decreasing reliance on editing in scene construction is partly due to the introduction of ever more mobile and flexible equipment, partly to the familiarity of multicamera television procedures, partly to difficulties in synchronizing dialogue, but partly also to the fact that commercial directors tend not to do their own cutting anyway, losing effective control over their films as soon as shooting stops.

Structure

We have been dealing with the materials of film. To make a movie, the materials must somehow be orga-

nized. A film can be made simply by linking images and sounds in abstract rhythmic concatenation (as in McLaren's films), or by loosely arranging them around a theme (as in travelogues). But these straightforward methods, though in some ways they represent an ideal of pure cinema, seem to work well only for quite short films, and (especially since the decline of vaudeville) the staple of film production is the "feature," long enough to give the cash customers their money's worth. There are no theoretical limits to the length of a clearly articulated pattern of imagery, but most abstract films are short. The closest actual approximation to an abstract or purely formal method of organizing images is to associate them with extended musical forms, since the latter constitute long formal sequences of a kind that audiences already know and accept; but Disney's *Fantasia,* though often and lucratively revived, has not aroused emulation and in any case supplemented the musical structure with at least an illusion of parallel narrative form. More usually, coherence is sought through the organization of the subject matter of the imagery: by exploring a problem, or an object, or a place, or a situation, or an event (documentary), or, commonest of all, by constructing a fictitious or historical story. The contrast between documentary and the regular "feature" is not so much that between fact and fiction, for features may be factual and most documentaries have fictional aspects, as between exploratory and narrative methods of organization. The reason for the dominance of the narrative feature lies partly in the flexibility of the film medium, which makes it especially suitable for a free-running narrative whose closest affinities are with novels and biographies, but partly in the assumption that the "mass audience" will associate exploration with instruction and hence with tedium. Now that the mass audience is safely shut away with its TV set things may change: *Woodstock* is a portent. Meanwhile, writers on cinema are bound to assume that the narrative feature remains the norm.

It is from the normal narrative form that the customary description of the articulation of film is derived. In a sense, and from the editor's viewpoint, the unit is the frame, but this does not exist for perception. Aesthetically, a film consists of shots organized into scenes which are themselves articulated into sequences. This structure corresponds, very roughly, to an analysis of activity into movements (shots), actions (scenes), and episodes (sequences).[30] Accordingly, shots cohere into scenes through relevance, each shot being experienced as relevant to expectations aroused earlier in the scene (ideally, I suppose, by the preceding shot). Scenes are divided by jump-cuts or dissolves marking a change of subject; sequences are divided by such more emphatic

punctuation as fade-out and fade-in. But (as with novel and theater) no rules or firm conventions demand such articulation: the determining changes are discontinuities of place, time, participants or activities (in abstract films, changes in the kind of image or movement; in documentaries, changes of aspect or style). The film-maker's use of punctuating devices is merely incidental to these. Actually, the very concept of a "shot" becomes nebulous and archaic as cameras become more mobile: the distinction between scene and shot takes on a vagueness such as infects the distinction between an action and its constituent movements.

The plasticity of camera viewpoint is such that films, like novels and unlike plays, can focus one's attention precisely. Only what is irreducibly relevant to the story need be shown. A raised eyebrow can fill the screen. In theater, perception follows attention: one looks at the relevant part of what is visible on stage and ignores the rest.[31] In film, attention follows perception: whatever is not relevant is either not screened or thrown into shadow or out of focus.[32] Hence, film storytelling can and sometimes does achieve great elegance and economy. Styles change, however. The introduction of the wide screen has made the use of close-ups to isolate relevant detail seem rather blatant, and encourages a more fluid and relaxed style of presentation in which more use is made of the simultaneous presence on the screen of more than one focus for attention.[33]

The focusing habit of the camera and the necessary priority of the visual might make one think that the most filmic and hence the best film story was one in which the *precise* content of each shot set up the story through its dynamic connection with the next. One might further infer from this that tragedy with its overriding architectonic goes against the grain of film, which has a special affinity for such episodic forms as picaresque comedy. There is something in that, but we warned at the start against the facile assumption that the best works in any medium are those which take its most obvious opportunities as procedural rules, and an overly filmic film might have the mechanized aggressiveness of a "well-made play." One could more reasonably infer that the least filmic and hence dullest films would be those in which the dialogue carried the story and the camera just coasted along.[34] And yet that is how most films seem to be made. One can see why. Many films are adapted from literary works, in which the dialogue alone can be borrowed without alteration.[35] But in any case the logistics of making a full-scale film are such that it more or less has to be constructed from a detailed shooting-script.[36] Films are largely *written* before they are shot. But writers are bound to be word-oriented. Besides, dialogue is the only part of

the script that contributes directly to determining the actual quality of the finished film: specifications of visual images cannot include what will differentiate the effective from the flat, the fine from the clumsy. Perhaps most important, to throw responsibility for the story onto the dialogue is to play safe and easy. So long as the actors mouth the lines the story will somehow come through, and the director can content himself with the most perfunctory and generalized camera work. If the story depends on what can be seen, much greater care must be taken over exactly what is shown, and that will add to the shooting time which is the variable on which the cost of a film chiefly depends.

Art, Commerce, and Criticism

Now the cat is out of the bag. Films are traditionally about money, and film as most people know it is commercial film. Film did not begin as high art or as folk art, but as the offspring of technological curiosity and showmanship. It got into the public eye by way of peepshow and vaudeville, and its first exponents did not think of themselves as artists. The structural analogies between film and novel, and the superficial likenesses between film and drama, suggest affiliations that took some time to develop. A glance at the advertisements in your local newspaper should convince you that film has yet to free itself from the hectic world and accent of the fairground.

Though cheap and flexible sound and camera equipment has done much to effect what Andrew Sarris has called "demystifying the medium,"[37] the financial structure of the film industry has still some claim to be considered as part of the technological conditions that we have recognized to be paramount in cinema. The decisive factors here are that the initial costs of making even a cheap film are high, but the printing, distribution, and exhibition costs are low. So the costs can be recovered if enough people are willing to see the film—which they will be able to do only if enough people are willing to show it. Nor is this a consequence of the sickness of western bourgeois society. No one, socialist or capitalist, is going to be allowed to tie up so much of other people's labor and equipment unless there is some reasonable assurance that there will be something to show for it: if not money, then prestige or the approved performance of some supposed social function. By the same token, the complexities of the arrangements for distributing or showing films are almost certain to deprive the director of control over the final condition and destiny of his work.[38] A film critic is seldom commenting on the work of an individual or a cohesive group

so much as on the upshot of a loosely connected series of independent decisions. He may thus succumb to feelings of irrelevance.[39]

There are three plausible lines a critic can take here. One is to confine his attention to noncommercial films. Of course, these are atypical, but the critic can say (as Parker Tyler says[40]) that it is not typical for a film to be a work of art. Most drawings, to take a parallel case, are not works of art but advertisements or sources of technical information or doodles, and no one expects a critic to waste his time on such objects.

A second critical line is to accept that most films, both commercial and "underground," are junk, to be greeted with silence or a dismissive gesture, but that any kind of interest or excellence may turn up in any sort of film. Such a rejection of all commitments to styles and cultural traditions is in the line of twentieth-century critical orthodoxy, but may find it hard to steer between the Scylla of an empty formalistic aestheticism and the Charybdis of a relativism that accepts everything equally because everything succeeds in being what it is.

A third critical line is to accept cinema as a demotic art and devise a critical system appropriate to such an art. George Orwell has shown the way.[41] His exemplary study of Frank Richards devoted itself to describing the "world" depicted or implied by the ensemble of Richard's work, and exploring the repertory of mannerisms which gave that world a facile coherence. Students of Jung and Frye have enlarged this critical armory by showing how to expose the underlying mythical archetypes and patterns in popular fiction. These methods have been applied to Hollywood films in what is misnamed the "auteur theory" of criticism (which is a policy rather than a theory). Whatever a studio does to a film, a strong-minded director can impregnate it indelibly with his own basic textures, his view of human relationships, his favorite narrative devices, and obsessive images. In fact, the measure of a director's stature may be the extent to which he can retain these elements of his own style when working on an uncongenial assignment from his studio. And by comparing a director's different films, which taken in isolation had been thought undistinguished if no worse, one can educe a complex world full of ironies and unexpected insights.[42]

Some auteur critics seem to assume that any director whose work is susceptible to their methods is thereby proved to be an artist, and his films shown to be good films. This is a strange assumption. Critics of other arts are far from supposing that to show that a work is recognizable and typical of its author has any tendency to show that it is a good work.[43] In fact, the analogue in other arts is a form of criticism specifically devised for handling material inca-

pable of yielding anything of interest to a more searching critique. Auteur criticism may work best as a heuristic device: armed with his comparisons and with his trained eye for manners and genres, a critic can show us meaning where we saw none; but when we have been shown we must be able to see for ourselves. In other arts we accept that one may not understand any work by an innovating artist until one has familiarized oneself with his style; but it is strange to have a similar esoteric status claimed for the output of a studio work-horse. The paradox of auteur criticism is that while its methods are devised to handle cinema as a demotic art, it relies on a view of that art which is inaccessible to most of its normal public. How many people are going to get to see a Raoul Walsh festival?

In so far as the normal film is about human affairs, it is susceptible to criticism on the same basis as literary or dramatic works or figurative paintings, in terms of its verisimilitude, psychological richness, moral maturity, social significance, political viability, relations to the divine and the unconscious and so on. The fact that such topics are not specific to film does not make them trivial or irrelevant:[44] on the contrary, most actual serious discussion of films centers on this human side, and so it should. But we need say nothing about such criticism here. In practice we all know what we want to say; in theory the basic moves are familiar from discussions of criticism in the older arts. From this point of view, the art of film criticism would lie in knowledge of and sensitivity to the ways in which such human qualities can be conveyed by such cinematic means as we have been discussing.

The salient feature of film is the enormous range of its specific effects. Film is unique in its capacity for visual recording and analysis, in its ability to convey the unique present reality of things, in its ability to reveal the qualities of lives; but also in its formal freedom, its capacity for realizing fantasy and developing abstract forms. In view of this inexhaustible flexibility of the medium, it is ludicrous to lay down general principles as to what is a good film. Those critics who do so are in most cases obviously fixated on the kind of film that was around when they were first moved by movies. A judicious critic will equip himself with the most exhaustive possible grasp of the variables and variations accessible to film-makers, and note just which of these the director is exploiting and how he is doing it. So much can be done in a film that it requires close attention and knowledge to discern what is actually being done. Technical assessment and appreciation can almost be read off from the roll of specific opportunities opened up by the director's initial options and then seized or missed: take care of the facts and the values will take care of themselves. Beyond that, the moral and cultural side of a critique must depend on the maturity and sensitivity of the critic's social and moral awareness. If you could teach people to be critics, you could teach them to be human.

Notes

1. This definition is adapted from that given by Ivor Montagu, *Film World* (Baltimore: Penguin Books, 1964), p. 16.

2. Cf. André Bazin, *What Is Cinema?* (Berkeley: University of California Press, 1967), pp. 49–50. (Actually Bazin is writing of a different film, *Where No Vultures Fly*, with Africa and lions, but the principle is the same.)

3. Ivor Montagu, op. cit., p. 120. Montagu, as a former colleague both of Hitchcock and of Eisenstein, predictably places a high value on montage and on crude psychological impact; the intellectual Bazin worries about integrity.

4. V. I. Pudovkin, *Film Technique and Film Acting* (New York: Grove, 1960), pp. 23–28.

5. Siegfried Kracauer, *Theory of Film* (New York: Oxford University Press, 1960).

6. See the devastating critique of Kracauer in Pauline Kael, *I Lost It at the Movies* (New York: Bantam Books, 1966), pp. 243–63. Kael conclusively refutes Kracauer's preposterous arguments, but is wrong in thinking that this demolishes their author: Kracauer's strength lay not in his attempted proofs but in his exploration of some of the possibilities of film.

7. See Jonas Mekas in Richard Dyer MacCann, ed. *Film: A Montage of Theories* (New York: Dutton, 1966), p. 338.

8. The inference might be drawn from Warhol's practice in *Empire*, but I am not aware that it actually has.

9. For an analysis of space, time, and motion in films, see Ralph Stephenson and J. R. Debrix, *The Cinema as Art* (Baltimore: Penguin Books, 1965).

10. Ivor Montagu, op. cit., pp. 140–41.

11. Note that in being transferred to the domestic television screen a film loses all three characteristics: size, luminosity, and audience immobility. It becomes an object rather than an experience.

12. The statement in the text requires qualification, in that the metaphorical equations of film do rely either, as in the example given, on stock responses (peacock = pride), or on values explicitly established in the film beforehand. Otherwise, the intended metaphor reduces to a collocation of unrelated images. For example, Michel Sanouillet in *Parking on This Side* used an outspread hand dragged down a blackboard to suggest a teeth-on-edge feeling, because that is how he felt when he raked his fingernails down a blackboard. No doubt anyone would feel the same, but without the director's explanation one could not guess what was intended.

13. Susanne K. Langer, *Feeling and Form* (New York: Scribners, 1953), pp. 411–15.

14. Sergei Eisenstein, *Film Form* (New York: Meridian Books, 1957), p. 205.

15. An example would be Buñuel's *Tristana,* in which a very strong narrative is combined with reticence about time.

16. The terms "flash-back" and "flash-forward" are often used in such a way as to suggest that every film has a normal time from which all sequences assignable to other times are to be regarded as deviations. But why should this be so? The terms are better taken as marking temporal discontinuities rather than displacements.

17. He calls it "the scene of the heart attack in the closed car." Rudolf Arnheim in Gregory Battcock, ed. *The New American Cinema* (New York: Dutton, 1967), p. 63.

18. An example, gleaned from a motel TV in Colorado. A party rides through Indian territory. One rider falls, an arrow deeply embedded beside his spine. Then the Indians attack—but they are all using rifles, not a bow in sight. After the fight we see the wounded man: his arm is in a sling. Who cares to know what history of studio botching lies behind that piece of idiocy?

19. Cf. André Bazin, op. cit., pp. 76–124.

20. This phenomenon provides the theme of Tom Stoppard's play *Rosencrantz and Guildenstern Are Dead.* In theater in the round and participatory theater, reality is reduced to an ambiance created by the action itself; as in oriental theater, an actor ceases to exist as soon as he stops acting.

21. This is only partly true of animated cartoons, in which the artist's sense of graphic composition tends to reinstate the enclosure of his depicted space.

22. "Small birds with quick, incisive movements come through better when filmed at 32 frames and projected at the usual 24. Flight shots should never be taken at less than 32." James Fisher and Roger Tory Peterson, *The World of Birds* (New York: Doubleday, 1964), p. 104.

23. These slow-motion deaths might be compared with the protracted deaths common in opera, with the death of Richard in Olivier's film of *Richard III* and with the death of Mercutio in John Cranko's ballet *Romeo and Juliet.* All these protracted agonies are found ludicrous by some audiences, but it is obvious that artists feel impelled to produce them.

24. How are films recollected? My own experience is that what I retain is always an image, but never a purely pictorial one: it is always an image associated with a high point in the action of the film, yet it is *as* an image that it is recalled. In Nelson's *Oh Dem Watermelons* one shot shows a melon on a green field in the position of a football about to be kicked. The shot is held interminably while the audience awaits the kick, finally laughing helplessly—at last the kick comes, shattering the tension and the melon. But what sticks in my mind is the look of the melon on the sunlit grass.

25. A particularly clear account of the process of integration is given by Ernest Lindgren, *The Art of the Film,* 2d ed. (London: Allen and Unwin, 1963).

26. Siegfried Kracauer, op. cit., pp. 111–14. My version is considerably simplified, and I hope clarified.

27. See the 1928 "Statement" by Eisenstein, Pudovkin, and Alexandrov, in Sergei Eisenstein, op. cit., pp. 257–59.

28. Sergei Eisenstein, op. cit., pp. 45–63.

29. Eric Rhode, *Tower of Babel* (Philadelphia: Chilton, 1967), pp. 51–59. Eisenstein is associated with Leni Riefenstahl and compared unfavorably with Humphrey Jennings, much as one might rebuke Dostoievski for not being like John Gunther.

30. The relation between shot, scene, and sequence has more usually been compared with that between word, sentence and chapter, but this analogy is misleading. A film shot is an iconic sign, a complex ad hoc presentation intelligible through its resemblances; a word is an arbitrary symbol, often if not usually intuited merely as part of a syntactic unit. A whole sentence functions more like a shot than a word does. Cf. Charles Barr, "CinemaScope: Before and After" in Richard Dyer MacCann, ed., op. cit., 318–28.

31. Ralph Stephenson and J. R. Debrix, op. cit., p. 73.

32. "Within the frame the artist collects that which he wishes us to share with him; beyond the frame is placed what he considers of no value to his thought." Josef von Sternberg, *Fun in a Chinese Laundry* (New York: Macmillan, 1965), p. 310. In Noel Coward's *Blithe Spirit* we see the hero wearing a crepe mourning band for each of his two wives, one on each arm. On the visually uncluttered stage, the actor's figure draws our eye and the armbands can be of the usual size without risk of escaping notice. In film, whatever is on screen is saturated with import and the actor's body merges into its setting: the armbands will be invisible unless emphasized. They might have been shown in alternate brief close-ups; in fact, the director (Lean) chose to include both in a single medium-close shot, but made them of exaggerated size.

33. In *Quaxer Fortune,* while a scene in the hero's bedroom is establishing his relations with his family, his attitude to his work is simultaneously shown by the presence of three small pictures of horses. These are not picked out in close-up, but are rendered conspicuous by forming a strong vertical line of contrasting tonality. We are invited to notice them, but we don't have to.

34. This is the theme of Robert Gessner, *The Moving Image* (New York: Dutton, 1968). However, Gessner accepts Eisenstein's view of the function and significance of cutting, and therefore requires a film to be articulated as a complex of conflicts expressed in terms of imagery. This seems an excessively restrictive view.

35. Von Sternberg (op. cit., p. 46) relates how he defended himself against Dreiser for his treatment of the latter's *American Tragedy* by showing that the dialogue Dreiser complained about was actually part of the novel.

36. The reason for this is explained by Ivor Montagu, op. cit., pp. 193–206, and illustrated by Lillian Ross, *Picture* (New York: Rinehart, 1952).

37. Gregory Battcock, ed., op. cit., p. 55.

38. A producer's cooperative seems to be the best safeguard; but unless a cooperative maintains quality control it will lose its market.

39. In any case, the film audiences see may not be the one criticized. One recalls the unpredictable contractions and expansions of *Les Enfants du Paradis.* And a film made for a golden-section screen may be reduced to nonsense by being shown on a wide screen, thus losing about half its area.

40. Parker Tyler, *Sex, Psyche Etcetera in the Film* (New York: Horizon, 1969), pp. 210–21.

41. George Orwell, "Boys' Weeklies," in his *Collection of Essays* (New York: Doubleday, 1954), pp. 284–312.

42. For a succinct and persuasive account of auteur criticism, see Peter Wollen, *Signs and Meaning in the Cinema* (London: Secker and Warburg, 1969), pp. 74–115.

43. Pauline Kael (op. cit., pp. 264–88) has written a penetrating critique of auteur criticism.

44. It has become fashionable among practitioners of the visual arts to apply the term "literary" to all humanistic or nonformal aspects of works of art, thus suggesting that in being a picture *of* something a work is somehow untrue of the visual. This implies that seeing or hearing something happen is an indirect way of reading about it. In fact, of course, scenes convey meaning as naturally and directly as words.

V

Sculpture, Architecture, and Hand-Crafted Objects

The selections in this chapter deal with a group of visual arts whose relationship to each other is more that of a loose family with overlapping features than a tightly defined class. The arts under consideration here are sculpture, architecture, and a large group of arts commonly described as "crafts": ceramics, enameling, jewelry-making, wood-carving, iron-working, leather-working, fashion design, furniture-making, rug-weaving, quilt-making, flower-arranging, calligraphy, and the hand-fashioning of other sorts of objects. These arts are often linked in the institutions of the artworld. They are routinely taught and discussed together in the courses and curricula of departments of art or art history. They are frequent subjects of discussion in the lecture series of museums and community arts associations. Articles on these arts often appear side-by-side in the "arts" sections of newspapers.

It is useful to consider these arts as a group, though as often happens in the case of family members, the differences among members are as intriguing as the resemblances. We might begin thinking of these arts negatively, as visual arts which are *not* devoted primarily to the presentation of two-dimensional images, as are painting and the pictorial arts (discussed in parts II through III) or the arts of the camera (discussed in part IV). This distinction is a helpful start, since we do not normally think of sculpture, architecture, or most crafts as devoted in the first instance to the production of two-dimensional images or pictures.

Having said this, however, we should bear in mind that many crafts such as ceramics, enameling, embroidery, scrimshaw, and tattooing do frequently issue in visual images on (more or less) flat surfaces. Even the question of three-dimensionality may be more a matter of degree than of difference. Low-relief sculpture, for example, though not quite two-dimensional, seems not fully three-dimensional either. Or again, these arts—or certain of them—might have an affinity with each other in that they are able to satisfy, not only an aesthetic interest, but also the demands of a nonaesthetic practical function. Many, if not most, sculptures are decorative or commemorative. Most architectural

works provide space for human habitation, and it is generally assumed that architectural works should be fit for such a purpose. The practical utility of clay vessels, vases, and bowls is obvious. On the other hand, we are all familiar with sculptures that seem to represent or commemorate no particular person, event, or thing. We differentiate mere buildings from works of architecture. We distinguish, among mugs, those fit only for drinking and those suitable for display. Considering these arts as a group, then, we will have to be alive to both their commonalities and their differences.

Let us begin with sculpture. In reflecting on the art of sculpture, three things seem self-evident. First, sculpture seems to be a primarily visual art. We look at sculptures. Indeed, sculpture is usually taken to be one of the three paradigmatic visual arts (along with painting and architecture). Second, sculpture seems to be a three-dimensional art, in the sense that we normally think of the sculptor as creating three-dimensional objects in space. Finally, sculpture has seemed, for much of its history at any rate, to be a representational art. The practice of creating carved figurines representing animals and human beings can be traced back to paleolithic hunters and gatherers, and many of us continue to think of the art of sculpture in terms of the practice of modeling, carving, welding, or otherwise forming three-dimensional representations of objects in the physical world, especially if we have in mind the European sculptural tradition of Pisano, Donatello, Michelangelo, Bernini, and Rodin.

In "The Discovery of Space," Herbert Read critically examines these assumptions. Rather than describe sculpture as a three-dimensional art, Read prefers to characterize it as an art of space. The difference is crucial. Read sees sculpture as primarily addressing our sense of space and, more specifically, what the psychologist William James calls "touch-space," a mode of spatial perception built mainly on tactile values. Painting, Read argues, is an art of "sight-space." Sculpture, he asserts, "is an art of *palpation*—an art that gives satisfaction in the touching and handling of objects."

According to Read's view, the history of sculpture manifests a gradual, if somewhat fitful, evolution toward the ideal of an art of touch-space. Ancient Egyptian sculpture was mostly relief sculpture or sculpture in the round, which was "made to be read" rather than "handled as a three-dimensional object," primarily because Egyptian sculpture was subordinated to architecture and the purposes architectural works served. Greek sculpture achieved a more realistic rendering of the human body in space, but, even when it was not overtly tied to architectural function, it still suffered from the "visual prejudice" that its main end was to provide an object for "visual contemplation from a fixed [usually frontal] point of view." It was not until the Renaissance and the rise of the modern notion of the autonomous (and transportable) objet d'art that sculpture could begin to be emancipated from architectural and "painterly" demands and devote itself to the exploration of the plastic qualities of tactility, volume, and mass, an achievement realized in the modern abstract sculpture of Brancusi, Gabo, Arp, and Moore.

That is not to say that abstract sculpture is necessarily freed from the demands of architectural or other sorts of utility or cultural significance. Tom Wolfe's essay, "The Worship of Art," has an undercurrent of dry, biting humor, but it is humor with a point. Drawing upon a Weberian reading of the social role of religion as involving the rejection of the world and the legitimation of wealth, Wolfe maintains that in contemporary society, "art is the religion of the educated classes." This is especially evident, Wolfe contends, in the case of abstract public sculpture. The very abstraction of contemporary sculpture—its lack of obvious representational or commemorative content— makes contemporary sculpture an ideal object of "spiritually correct" private, corporate and civic investment. Religious practice in this case comes complete with the numinous icon (the nonrepresentational work of sculpture), a learned clerisy (the circle of New York "art experts"), a recognized form of offering or prayer (sponsorship and display of sculptural works in a prominent public place), the promise of salvation through tithing (cultural respectability attendant upon appropriate support of the arts), and an air of mystery befitting the apprehension of religious objects (bafflement at the meaning of the works themselves).[1]

The question of the function of art that is not clearly or primarily representational also arises prominently in connection with architecture. Indeed, architecture, not sculpture, is the usual locus of discussion for philosophical reflection on the general question of the relationship between art and utility. This is probably so because the question of the function of architectural works seems virtually inescapable. Whatever else they might be, buildings are sites for habitation and activity. The seemingly necessary connection between architecture and utility has led many architectural theorists to conceive of architectural excellence *primarily* in terms of function. Functionalism, however, is a protean doctrine. One of the earliest modern versions of functionalism in architecture can be found in the writings of the nineteenth-century American sculptor and essayist, Horatio Greenough, who takes an approach in the selection "Form and Function" that one might describe as "architectural Darwinism" or, perhaps more accurately, "architectural Lamarckism." Greenough draws an analogy between architectural and natural, organic forms, arguing that in both cases the motive forces for the design of a structure are (ideally) the needs imposed on it from without. "The law of adaptation is the fundamental law of nature in all structure," Greenough asserts.

Furthermore, Greenough claims, the adapatation of form to function, whether we find it in the shank of the horse, the war club of the South Sea Islander, or the sailing ships of the nineteenth-century, instinctively excites our admiration. Indeed, Greenough says, beauty may be defined as "the promise of Function." Greenough accordingly counsels architects to avoid the

1. For Wolfe's assessment of the ideology of modern painting and modern architecture, see his books *The Painted Word* (New York: Farrar, Straus & Giroux, 1975) and *From Bauhaus to Our House* (New York: Farrar, Straus & Giroux, 1981), respectively.

"monumental" approach to architectural design, that is, the thoughtless appropriation of architectural forms and ornaments of the past, however much those forms might appeal to "the sympathies, the faith, or the taste of a people." Architects are better advised to follow the fundamental "organic" principle of all building, the "adaptation of the forms and the magnitude of structures to the climate they are exposed to, and the offices for which they are intended." It is that adaptation, Greenough asserts, which gives architectural works their character and expression.

Nelson Goodman is also interested in the question of the meaning of architecture, but his construction of the problem in "How Buildings Mean," is rather different. "A building is a work of art only insofar as it signifies, means, refers, symbolizes in some way," says Goodman, and he proceeds to examine four varieties of architectural reference. *Denotation* is Goodman's term for the application of a symbol to an object, event, or other instance of it. Denotation includes such modes of reference as naming, predication, description, portrayal, and pictorial representation. Architectural works may depict, as in the case of Utzon's famous Sydney Opera House, but in general denotation does not play a prominent role in architectural meaning. Far more common in architectural works is the *exemplification* of properties possessed by the work or of labels that apply to it. In some cases these properties belong literally to the work, as when a building is designed to make visible the sheen of marble or the intersection of planes. In other cases, architecture may exemplify properties which a work metaphorically possesses ("dynamism" or "jazziness," for example), for which Goodman reserves the term *expression*. Finally, architectural works may refer by means of *mediate reference* through a chain of signification, as in the case of the exemplification of keystonelike forms in a Michael Graves building, which refer indirectly to Egyptian or Greek buildings with similar exemplified properties as well as to the properties exemplified and expressed by the buildings themselves. This variety of meaning is what architects and critics usually have in mind when they speak of architectural "allusion." Goodman does not find it necessary to refer to the notion of aesthetic experience in his account of architectural meaning. His focus is rather on the symbolic function of architecture, a concern which he believes is often overlooked by architectural formalists who operate with a "cramped" (i.e., representational) conception of reference. Once this limitation is recognized, Goodman argues, the way is open to understanding how architecture provides insight and contributes to our "continual remaking of a world."

Michael Graves speaks for himself in the essay "A Case for Figurative Architecture." Like Goodman, Graves applies a linguistic model to architecture or, perhaps more precisely, a literary model. Just as one can speak of both figurative and nonfigurative uses of language in literature, so can we identify standard ("internal") and poetic languages in architecture, Graves argues. Graves's understanding of the term *language* is looser than Goodman's, but his observations about recent trends in architecture are well worth considering.

Graves uses the standard/poetic distinction to mark out two general attitudes one might take toward an architectural work. On the one hand, one might attend to the features of a building that are determined in large part by pragmatic, constructional, and technical requirements. On the other hand, one might be responsive to what Graves calls "the figurative, associative and anthropomorphic" meanings of a work. Graves then characterizes the difference between modernist and figurative architecture in terms of their relative emphases on the two types of architectural "language." Modernism in architecture supplants poetic forms in favor of nonfigural, abstract geometries, but in doing so, Graves argues, it effects "the dismemberment of our former cultural language of architecture." If it is argued that modernist architecture, too, has its poetic language, it must be replied that its dominant symbol is the machine, which is itself a symbol of utility. In Graves's view, figurative architecture, with its emphasis on allusiveness and associational meanings, seeks to reestablish a poetic and more humane architectural language "which engages inventions of culture at large . . . for access to our own myths and rituals within the building narrative." Thus Graves, in his own way, makes a case for architectural reference and for a central feature of much postmodern architecture.

The debate about the role of pragmatic and technical considerations in the production and appreciation of architectural works raises the more general question of the relationship between art and craft. The most famous philosophical discussion of this issue occurs in R. G. Collingwood's *The Principles of Art*, from which the selection, "Art and Craft," is taken. Collingwood observes that the classical sense of the world *art* corresponds to what he chooses to designate as *craft*, but in Collingwood's view, art and craft are two quite distinct activities. Collingwood defines *craft* as "the power to produce a preconceived result by means of consciously controlled and directed action." The idea of craft involves, among other things, clear distinctions between means and end, between planning and execution, between raw material and finished product, and between form and matter. A craftperson's technique consists in the specialized skill (or skills) required to achieve a designated end. This analysis helps to explain the operations and goals of such diverse activities as carpentry, cobbling, metallurgy, pottery, weaving, blacksmithing, farming, silviculture, automobile manufacturing, and warfare, all of which have in common the end of producing in the minds of consumers a state of satisfaction by having certain of their demands met.

But this analysis also leads to the conclusion that art cannot be a kind of craft. There is, Collingwood allows, a venerable and persistent tradition, dating back to Plato and Aristotle and continuing in the minds of many today, that identifies art with craft, a position Collingwood calls "the technical theory of art." According to this theory, the artist may be seen as a skilled producer who strives to bring about certain states of mind in his or her audience. Artistic technique, seen as the means by which that end is achieved, is generally

understood to involve the imposition of a preconceived form by the artist on raw material, resulting in the material artifact called a "work of art." In accordance with the technical theory, art is often said to be divisible into two types of crafts, the craft devoted to making what is beautiful (the "fine arts") and the craft devoted to making what is useful (the "useful arts"). But these are all confusions, Collingwood argues. Though an activity might be both art and carft, art is not, in its essence, a kind of craft. There is nothing in art—properly so called—which answers to the basic terms and distinctions that define the activity of craft. Art, in Collingwood's view, is properly understood as the expression of emotion, directed at neither an emotion's betrayal nor its arousal, but rather at its understanding. And this is an activity for which there can be no technique.

Not all philosophers draw such a hard distinction between art and craft, however, or draw it in the same way that Collingwood does. In "The Aesthetic of the Antique," for example, Leon Rosenstein begins by contrasting the ontological status of the art object with that of one particular type of crafted object, the antique. An art object, Rosenstein argues, has a certain sort of existentiality: it sets up its own world of meaning and reality, a world which captivates us by means of a "translucent" quality that calls attention simultaneously to the sensuous and material qualities of the object and to its created world. Antiques, on the other hand, are "world-referent" rather than "world-creating." The antique can be defined as "a primarily handcrafted object of rarity and beauty which, by means of its style and the durability of its materiality, has the capacity to evoke and preserve for us the image of a world now past." The handcraftedness of the antique plays no small role in its world-referent capability. Crafts, Rosenstein argues, "having less (or no) self-subsistent ideational content, and constrained to exist entirely in their own materiality (i.e., opacity), are naturally more disposed to the generation of the past world through the materiality of their media." The antique is thus positioned to preserve, evoke, and affirm a past world as well as to provide pleasure from its own beauty in an age of mechanical reproduction. But that is to say that the antique, like the art object, addresses the faculty of imagination. Both are means by which we transform "actuality into possibility by the imagination's generating a more expansive world than the mere perceptive faculty can provide" (an interest which Rosenstein situates historically in the emergence in the seventeenth and eighteenth century of a greater awareness of the historicality of civilization and of individual historical self-consciousness). Rosenstein thus adopts an overarching view of imaginative aesthetic experience broad enough to encompass traditional objects of fine art as well as the antique considered as a handcrafted object.

In "Use and Contemplation," Octavio Paz presents another perspective on the significance of craft and its relationship to art. Paz's article is as much an essay on modern culture as it is on the specific activity of craft. According to Paz, craft stands as a bulwark against two dehumanizing aspects of modern life,

the "cult of art" and the "cult of usefulness." By the former Paz means the modern habit of regarding works of art as isolated objects fit primarily for contemplation for their own sake. Like Wolfe, Paz casts the role of art in modern society in religious terms: art consecrates and decontextualizes its objects, imparting to them a kind of eternity, that they may be worshipped in the hallowed halls of the museum. But beauty is not a quality circumscribed by the walls of glass display cases. The cult of usefulness is the product of the industrial revolution. Its effects can be seen in the products of technology, "machines and contraptions" which surround us and whose form is dictated solely by function. The result of these two tendencies is an absolute separation of beauty and usefulness: "the religion of art forbids us to regard the useful as beautiful; the worship of usefulness leads us to conceive of beauty not as a presence but as a function."

Craftwork—a pitcher, a glass jug, a wicker basket—returns us to a world in which beauty and usefulness are fused, and in doing so mediates between the two modes of dehumanization. In contrast to the cult of usefulness, with its emphasis on impersonal efficiency, craftwork pleases by asserting the value of imagination, decoration, and caprice. It bears the marks of style and of a human hand, testifying to the community and tradition from which the work emerges. In contrast to the work of art, craftwork is not worshipped for its autonomy and uniqueness but rather valued as an object whose beauty cannot be divorced from everyday uses and ends. The work of craft is thus a physical artifact whose meaning is necessarily human. Paz writes: "A thing that is handmade is a useful object but also one that is beautiful; an object that lasts a long time but also one that slowly ages away and is resigned to so doing; an object that is not unique like the work of art and can be replaced by another object that is similar but not identical. The craftsman's handiwork teaches us to die and hence teaches us to live." In this way handcraft continues a tradition— begun by the Romantic poets—of spiritual rebellion against certain of the values of modern industrial society.

29

The Discovery of Space

HERBERT READ

The peculiarity of sculpture as an art is that it creates a three-dimensional object *in space*. Painting may strive to give, on a two-dimensional plane, the illusion of space, but it is space itself as a perceived quantity that becomes the particular concern of the sculptor. We may say that for the painter space is a luxury; for the sculptor it is a necessity.

A solid object is situated in space; it occupies or displaces a definite amount of space. It becomes an object for us by being differentiated from other objects and by being delimited from the space surrounding it. We have a sensation of the amount of space occupied by the object, which is the *quality* of volume, or *bulk*. If we refer to the *quantity* of matter the object contains, we speak of its *mass*.

We are not born with a notion of the object as a distinct entity, existing and moving in a spatial field; such a notion is built up during the first two years of life by processes of discrimination, association, and selection.[1] Out of the original chaotic experience of vastness (to use William James's phrase) the infant constructs real space, and this construction involves several subordinate processes that are gradually co-ordinated. As a beginning, separate objects have to be discriminated within the total field of vision. In itself this process involves several stages of development: the objects must be arranged in a definite order, and then their relative sizes must be perceived and assessed. At the same time, all the different sensations—of sight, touch, hearing, taste, and the rest—must "coalesce" in the same thing. In this process, one of the sensations

usually will be "held to *be* the thing," while "the other sensations are taken for its more or less accidental *properties*, or modes of appearance."[2] We tend to see the bulk of a tree, for example, but to feel the bulk of a piece of furniture, a tool, or a book. The point to emphasize, for our present purposes, is that space perception is almost entirely acquired by education. We say "almost entirely" because the individual may be conditioned to his environment by certain hereditary biological processes; we are not born into a static or a mechanical world but are insinuated into a continuous process of organic evolution.[3]

When we consider the evolution of sculpture, it is important for us to realize that the kind of coherent space perception that man now possesses is a construction of the intelligence, and that even so, as William James pointed out, "touch-space is one world; sight-space is another world. The two worlds have no essential or intrinsic congruence, and only through the 'association of ideas' do we know what a seen object signifies in terms of touch." James mentions the case of a patient cured of congenital cataracts by surgical aid who said, "It might very well be a *horse*," when a ten-liter bottle was held up a foot from his face. All this goes to show, as James says, that "it needs a subtler sense for analogy than most people have, to discern the *same* spatial aspects and relations" in optical sensations "which previously known tactile and motor experiences have yielded."[4]

I shall suggest in this chapter that sculpture is pri-

From Herbert Read, *The Art of Sculpture*. Bollingen Series 35, vol. 3. (Princeton: Princeton University Press, 1956, 1984), pp. 46–68, 116–17. Reprinted with permission of Princeton University Press.

marily an art of "touch-space"—is and always should have been—whereas painting is primarily an art of "sight-space"; and that in both arts most of the confusion between theory and practice is due to the neglect of this distinction. There may be some ambiguity in the word *primarily,* but though a complexity, or rather a complicity, of sensations is always involved in the creation and appreciation of a work of art, one and only one of these sensations "touches off" the process. This is the sensation I call primary. I think we must set out from the same point as Berkeley, who, in his *Essay Towards a New Theory of Vision,* held that the tangible "feel" of a thing and the "look" of it to the eye are "specifically distinct."[5] It is not necessary to draw Berkeley's metaphysical conclusions from these primitive facts; however, we must remember that the peculiarity of the artist is that he deals with primitive facts, with sensations in their state of innocence. He works on the basis of a direct feeling and not on the basis of concepts, which are secondary intellectual constructions.

There is, perhaps, a mental process of this secondary kind that the phrase "tactile imagination" describes; and Bernard Berenson used the phrase to indicate the particular contribution that Giotto made to the development of the art of painting: ". . . it was of the power to stimulate the tactile consciousness . . . that Giotto was supreme master. This is his everlasting claim to greatness." Berenson dismissed all paintings before Giotto as negligible because "none of these masters had the power to stimulate the tactile imagination, and, consequently, they never painted a figure which has artistic existence. Their works have value, if at all, as highly elaborate, very intelligible symbols, capable, indeed, of communicating something, but losing all higher value the moment the message is delivered."[6]

I cannot so lightly dismiss the pictorial art of the Byzantine period—Mr. Berenson's strictures would apply to its mosaics as well as to its paintings—nor medieval painting in general as represented in wall paintings, stained-glass paintings, and illuminated manuscripts. It has always seemed to me that the evaluation of art according to the number of dimensions it includes is a curiously materialistic procedure. A "*keener* sense of reality," which the introduction of tactile values into painting is supposed to give, is not necessarily an artistic achievement. The intention of the artist might be to give a keener sense of irreality or superreality; and that, indeed, was the intention of the medieval artist. To lend "a higher coefficient of reality to the object represented," another of Mr. Berenson's phrases, is the aim that gradually corrupted the artistic consciousness and led the art of painting into the morasses of academicism and sentimentalism.[7]

For the sculptor, tactile values are not an illusion to be created on a two-dimensional plane: they constitute a reality to be conveyed directly, as existent mass. Sculpture is an art of *palpation*—an art that gives satisfaction in the touching and handling of objects. That, indeed, is the only way in which we can have direct sensation of the three-dimensional shape of an object. It is only as our hands move over an object and trace lines of direction that we get any physical sensation of the difference between a sphere and a square; touch is essential to the perception of subtler contrasts of shape and texture. A genuine sculptor is continually passing his hands over the work in progress, not to test its surface quality, though that may be one purpose, but simply to realize and to assess the shape and volume of the object. Unfortunately visitors to a museum "are requested not to touch the exhibits"—unfortunately, because that request deprives them of one of the essential modes of appreciating sculpture, which is palpation, handling. Admittedly, there is much sculpture in our public galleries that would not yield any pleasure as a result of this approach. If we merely "look at" sculpture, even with our sophisticated vision, which is capable of reading into the visual image the conceptual knowledge we possess from previous experience of three-dimensional objects, still we get merely a two-dimensional impression of a three-dimensional object. We are recommended, in manuals of art appreciation, to walk round a piece of sculpture and to allow all the various points of view to coalesce in our imagination. This difficult feat, if successful, might conceivably give us a ghostlike version of the solid object. Sculpture, again, is often mounted on turntables to save us the trouble of circumambulation. We see an object twisting and twirling in our line of vision, and from that impression of shifting planes and lights we are supposed to derive a sensation of solidity!

. . . [I]n the early stages of the evolution of the art of sculpture, sculptural objects were small and palpable, or if they were on a scale too large to be handled they were not to be detached from a background, a matrix. Prehistoric sculpture takes the form either of small amulets or of relief sculpture such as the *Venus* of Laussel. The two bison modeled out of clay at Tuc d'Audoubert, which are 24.4 and 25.2 inches long, are built up against a projecting rock and are hardly to be considered as detached monuments. A considerable number of prehistoric relief sculptures have been discovered—the great majority representing animals—but sculpture in the round is extremely rare.

If we turn to the sculpture of Egypt we find a similar predominance of relief sculpture, and even when the statues are in the round they are often

supported by a background. There are two possible but not contradictory explanations of this characteristic. In Egypt carved sculpture is historically later than clay modeling, and it was the practice to give support to the early clay figures, not in the modern way by inserting an armature of wire, but by leaning the figure against a vertical strip or sheaf of bamboo. This device, it is argued, was copied by the sculptor in stone. A much more plausible explanation is provided, however, by a consideration of the function of sculpture in Egypt. It was never regarded as a separate and distinct art. From the beginning it was subordinate to architecture, and the nature of the architecture determined the nature and even the technique of the sculpture. A statue of Ateta, from Sakkara,[8] shows the typical architectural setting of a piece of Egyptian sculpture of the Old Kingdom, in a rectangular niche surrounded by designs and inscriptions in low relief. Dr. Murray, in her book on Egyptian sculpture, suggests that in such a rectangular setting the figures could not be too naturalistic but had to follow the vertical and horizontal lines of the architecture as far as these could be echoed in the human figure. If one asks why Egyptian architecture was so rectangular, he is usually referred to the horizontal and vertical lines of the Nile Valley, a landscape unlike any other in the world. "The horizontal line of the top of the cliffs is repeated in the horizontal strata, and again in the flat plain which forms the habitable land of Egypt. In violent contrast to these levels stand the vertical lines of the cliffs, weathered by ages of wind and wind-blown sand into gigantic columns as straight and true as though set there by the hand of man. There are no curves in the Egyptian landscape, no rounded hills, no great peaks to break the level skyline of the cliffs. As Sir Flinders Petrie says: 'In the face of such an overwhelming rectangular framing, any architecture less massive and square than the Egyptian would be hopelessly defeated.' "[9]

One or two considerations, however, throw doubt on this materialistic argument. The Gothic style of architecture, for example, is quite independent of a particular type of landscape—it imposes itself on any landscape—and even in Egypt the theory would be contradicted at a later period by that country's ready assimilation of the Moslem style in architecture, so light and graceful in its general effect. We know that the artistic spirit works by contrast or counterpoint just as naturally as it works by harmony or imitation. Granted a style of architecture and the idea that sculpture should be functionally subordinate to it, then it is obvious that the style and technique of the glyptic art must be subordinate to the style and technique of the architectonic art . . . The conscious will to art, the intention of the artist, and his consciousness of the intention of other artists are the primary determinants of style; style cannot be reduced to an automatic reaction to environment. Environment acts rather as a limiting factor, as a containment of forces that might otherwise be too dispersed. Environment creates ethos, the prevailing spirit of a community, and in the Greek conception of the word, ethos was always strictly localized. Ethos does not explain style, only intensity. It explains, for example, the fact that tragedy is a prevailing form, but it does not explain the form of the tragedy or its poetic style.

The intention behind Egyptian art is functional. The architecture is functional, and so is the subordinate sculpture. There is no room for the play of fantasy, as Worringer has pointed out. This being the situation, the Egyptian sculptor had no desire to isolate the human figure in space, to dissociate it from its niche or socket, for to do so would have served no rational purpose. Space *as such* was not felt by the Egyptians, who were complete strangers to what the Germans call *Raumgefühl*. Their satisfaction with relief sculpture derived from this lack. Relief sculpture is, in fact, the typical art of ancient Egypt, and as Worringer has said, "No stranger, more consistent two-dimensional art has ever existed, but it is just two-dimensional art and no more. We may think of Greek art—how much artistic thinking had to be employed by it before it discovered its ideal relief style, that wonderfully delicate play of balance between surface and depth which even in the most perfect productions still always reflects the hesitations of a never-to-be-overcome tension between surface and depth. The Egyptian relief is from the very first complete in its pure surface character. No unrest born of depth finds its way into it. It is entirely without tension and conflict. The third dimension, the dimension by which we are actually aware of depth, from which all that is more profound in the drama of artistic creation draws its inspiration, is not present at all as a resistant in the artistic consciousness of the Egyptian."[10]

From the point of view I am presenting, we can state that no complete plastic consciousness was possible in Egyptian sculpture, because the form was never isolated in space and was never handled as a three-dimensional object. The technique was one of incision, essentially linear, essentially graphic. Egyptian sculpture was made to be read, like the Egyptian pictorial script. It kept this limited character for three milleniums, into the Ptolemaic period. Only the relatively small bronze or wooden servant statues, votive tomb figures, and folk art in general offer any exception to this rigid limitation of plastic feeling.

In this connection, the German art historian, Alois Riegl, invented the term "space shyness," and

certainly the Egyptians were shy of space. It plays no part in their architecture nor in any of their subordinate arts, and all their arts, as I have previously pointed out, were subordinate to architecture. There are, however, two senses in which we can speak of space shyness: space as a practical necessity, to which we can react on a merely sensational level, and space as a concept, to which we react emotionally and spiritually. Worringer, who defines space as metaphysical consciousness, argues that the Egyptians were not aware of space in this second sense and that they were neutral and indifferent to the very idea. Their space shyness, therefore, was a form of inarticulateness. They were like children who have not yet discovered that space exists, except as a relationship between groups of objects. The same, with some qualifications, is true of the Greeks. "According to Aristotle," observes a modern physicist, C. F. von Weizsäcker, "the world is finite in extent. In its center is the ball-shaped earth, its outer boundary is the sphere of the fixed stars. Outside that sphere there is no thing and hence no place, since every place is the place of some thing. The idea of space as such, existing even if it is not filled by something, was unknown to the Greeks—with the exception of the atomistic school."[11]

In accordance with this essentially practical and limited conception of space, we get the characteristic of Greek sculpture that has been called "the law of frontality," which is really no "law" at all but merely a limitation of sensibility. The development of Greek sculpture is often represented as an age-long struggle with this very problem. "The agile mind of the Greek," writes Dr. Richter, "determined to wrestle with these problems [of modeling and perspective]. Not content with what had been accomplished before him, he was eager to solve new problems, and so he started out on his adventure of representing a human body in all manner of postures, with bones and muscles correctly indicated, in proper relation and in right perspective, both in the round and in relief. To a pioneer in the field it was a formidable task. But with infinite patience the Greek artist accomplished it, and his solution of these problems was like the removal of shackles which had hampered the free development of art for generations. Thenceforward the road was clear. In a century or two we pass from the Apollo of Tenea to the Idolino, from the Nike of Delos to the Nike of Paionios, from the Spartan ancestor relief to the Hegeso stele."[12]

...[F]or reasons that have little to do with any conception of space the Greek sculptor arrived at a completely realistic rendering of the human body image. Yet apart from this narcissistic form of projection, this re-creation of the self, Greek sculpture remained either bound to architecture, as in the Parthenon frieze, or anchored in some way to the earth. The Hegeso stele, mentioned by Dr. Richter, is a case in point. It represents the acme of the Greek sculptor's skill, but the figures, in all their grace and realism, remain prisoners within the architectural framework of the stele. This may be taken as a symbol of all Greek sculpture and indeed of all sculpture down to our own period. Even at the end of the nineteenth century, in 1893, we find the German sculptor Adolf Hildebrand, in his famous treatise on sculpture, exercising all his ingenuity to establish the two-dimensional unity of the relief as a standard for all the plastic arts. He calls it an unchangeable law of art, and he says further that "The thousand-fold judgments and movements of our observation find in this mode of presentation their stability and clearness. It is an essential to all artistic form, be it in a landscape or in the portrayal of a head. In this way the visual content is universally arranged, bound together, and put in repose. Through all figurative art this idea is the same, the one guiding thought. It acts always as a general condition and requirement to which all else is subordinate, in which everything finds a place and a unity."[13]

What we may call the visual prejudice cannot go farther. It is true that Hildebrand is prepared to free relief from its dependence on architecture; but his real object is to eliminate all sense impressions save those given in visual contemplation from a fixed point of view. Such a result can be achieved only by ignoring the palpability of the sculptured object and by confining the senses within a pictorial framework. This sense of imprisonment, of restraint, may become still clearer if we turn abruptly to a consideration of Gothic sculpture. As sculpture it was gradually and profoundly influenced by the Greek ideal of humanism; it also remained, as sculpture, completely subordinated to architecture. Of course, the general architectonic conception had changed. Not only had the medieval architect become aware of space as a separate entity, but also he was fascinated by its metaphysical implications, by the problem of infinite extension. How he managed to suggest in the structure of his building this quality, this metaphysical sensibility, is another story that does not concern us now. When his feeling for space became coherent and conscious, he could no longer tolerate the imprisonment of sculpture in the architectural framework. The sculptured figures were freely accommodated within that framework, but they remain guests at their east in such heavenly mansions. They are "at home" in their niches and seem free to leave if the spirit so moves them. In the mature Gothic style, they perch in the tracery like birds poised for flight. Decoratively, however, they are still a unity with the architecture and contribute

their share to its total lucid effect. Even at Chartres, where the earlier Portail Royal represents a complete subordination of the sculpture to an overriding architectonic purpose, there is no contradiction between the structural and the sculptural functions of the figures. One can hardly say the same of Greek caryatids; the caryatids of the Erechtheum, for example, seem to be imprisoned by the weight they support.

There are other important distinctions to be made between Greek and Gothic sculpture, . . . but none is so striking as this spatial element that was denied to Greek sculpture but in which Gothic sculpture began to stir restlessly. As a chief consequence, the Gothic sculptor was able to express the illusion of movement, a subject I must postpone discussing for the moment. What the Gothic sculptor did not achieve, any more than did the Egyptian or the Greek sculptor, was the complete emancipation of sculpture from architecture, and to this decisive achievement I shall devote the remainder of the present chapter.

We have already noted that for the Greeks there was no concept of "space" but only of "place." "Every body is at a place." Such was their theory of physics, and accordingly they believed, in a literal sense, that every body should have a place. Mental habits that would produce similar effects were characteristic of medieval scholasticism. One of these was the convention of *manifestatio* or clarification, which, according to Professor Panofsky, resulted in just such a subordination of parts to the whole in Gothic architecture.[14] One cannot emphasize too strongly that the *objet d'art,* as a detached and independent *thing,* transportable or movable in space, is foreign to the Greek and Gothic civilizations; it is a peculiarly modern conception, the expression of a new change of human attitude.

The detachment and isolation of the *objet d'art* is a consequence of that growth of a sense and of a philosophy of individualism that has been studied by Burckhardt and others. Conformity to an ideal, to a canon of art, had been characteristic of all previous epochs of art. Even before Descartes based a philosophy on his affirmation *cogito ergo sum,* the artist had dared to say to himself: *creo ergo sum.* The medieval artist might have a particular genius, a unique quality of expressiveness, but his creative achievements did not relate to any idea of his own personality. Rather they were the results of a discovery of some new aspect of God's creation, a revelation of the divine in nature. Man had to situate the divinity within his own breast before he could claim that his originality was the expression of a unique self. Once the artist had reached that conviction, he no longer wished to sink his individual creation into some complex logical structure such

as a cathedral, where his individuality was lost in the collective ideal. He began to set his work on its own isolated pedestal and to invite admiration for this work of art as an expression of his own skill, of his own personality or of his own ideal of beauty.

This parturition was not achieved without difficulty. It involved not merely a secularization of art and a declaration of the independence and separate entity of individual achievements but also an inner reorganization of the work of art thus rendered independent of a supporting background. The first process has been considered in some detail by art historians; I refer in particular to Dr. Frederick Antal's study, *Florentine Painting and Its Social Background.* Antal shows how in the early fifteenth century the leading painters and sculptors gradually won a new social status for themselves so that they ceased to be artisans under the instruction of their patrons and became free artists with what Dr. Antal calls an "upper-middle-class mentality." This secularization of art and the emancipation of the artist were developments that enabled the artist to meet the snobbish requirements of the new burgher class. Artists were required to make not only portraits of the burghers or their wives, but also *cassoni,* bridal caskets, birthday platters, and other such commemorative objects that, though still treated as part of the furniture of the house and not as works of art giving independent aesthetic satisfaction, nevertheless did liberate artists from official and ecclesiastical patronage and allowed them to develop and to express their own personalities in their work. Antal also shows how the particular artists who thus began to separate themselves from the mass of craftsmen "were, characteristically enough, the same whose interests were mainly in scientific and technical questions. What was formerly technical skill was put more and more to the service of scientific innovation based on theoretical knowledge; for it was by establishing a theoretical and scientific foundation for itself that art could obtain greater social recognition, could free itself from the crafts, and so those who practised it could rise from the condition of artisans close to the upper middle class. In this context, pioneering importance attached to the technical and mathematical studies of Brunelleschi, particularly those on perspective. This architect and engineer, who was so deeply interested in technical and mathematical questions and also demonstrated the application of linear perspective to painting, already worked . . . with theoretical scientists. Masaccio, Donatello, Uccello, and Ghiberti directed their interests towards the same subjects: technics, optics, and perspective."[15]

How much they understood of these questions and how scientifically they applied their knowledge to their arts is another question . . . Let us first note,

however, that the curiosity newly awakened in these artists, which was historical as well as scientific, led them to a study of the art of the ancient world and particularly to a study of Greek sculpture. Ghiberti in his *Commentarii* tells us that he began about this time—the mid-fifteenth century—to collect specimens of antique sculpture. The same is true of Donatello, and "Brunelleschi and Donatello were the first artists to go to Rome for the express purpose of studying antique art."[16]

What is significant about this development is that for the first time artists are found contemplating pieces of sculpture—monuments, not amulets—*as detached works of art*, are found collecting them and appreciating them irrespective of the architectural function for which they were originally conceived and executed. There was, however, a time lag between the conception of a free-standing statue and the discovery of an aesthetics appropriate to such sculpture. The fragments from antiquity were, after all, fragments of a sculpture whose aesthetics had already been determined by an architectural function. These sculptors of the early Renaissance did not yet dare to conceive of an emancipated art. Their first independent figures, works like Donatello's *David* of 1408-9, even if not actually executed for an architectural setting, a niche designed by some architect, were nevertheless inspired by antique works that had had such a function. The whole conception of such a figure as this, actually conceived for a setting in the Piazza della Signoria, or of the same sculptor's *Judith and Holofernes*[17] is, to borrow an excellent term from John Summerson, *aedicular*.[18] The statue was thought of not merely as occupying a niche or an architectural frame; it was conceived as an object viewed standing in a niche and therefore always viewed frontally. That we unconsciously acquiesce in the Renaissance attitude toward its sculpture will be discovered by anyone who tries to obtain photographs of these statues taken from any but a frontal point of view.

How difficult escaping from this law of frontality proved to be is illustrated by the story of the commissioning of Michelangelo's *David* of 1501-4, which comes almost a full century later than Donatello's first *David*. We know that Michelangelo carved this colossal statue without any site in mind, because a commission was appointed, after the work had been completed, to decide on a site in Florence; and the commission not being able to agree, the sculptor himself was left to select a site. Even in this case we must assume that all the time Michelangelo conceived his work as erected against an architectural background and as producing its optimal effect from a single point of view. Wölfflin points out that when the original statue was moved from its exposed position by the Palazzo Vecchio

into the shelter of a museum, and a bronze cast was substituted for it, "a most unhappy position was chosen for this, illustrating the present-day lack of a sense of style. The bronze was set up in the middle of a large open space, so that one gets the most monstrous views of the figure before one sees him properly. In its own day, immediately after it was finished, the question of a site for the statue was referred to a committee of artists, whose memorandum still exists: they were unanimous that it must be related to a wall-surface, either in the Loggia dei Lanzi or near the door of the Palazzo della Signoria. The figure requires this, for it is entirely worked in planes to be seen from the front and not from all sides: a central position is most calculated to emphasize its ugly qualities."[19]

Michelangelo was well aware of the unique problems that beset the sculptor in any attempt to realize a three-dimensional object in space. There is, however, little in his recorded statements on the art of sculpture that is theoretical in nature. In answering Benedetto Varchi's famous questionnaire about the relative merits of painting and sculpture, he welcomed Varchi's own view that any superiority was not due to the nature of the art but rather to the judgment and ability of the artist, whatever the medium. He does express the view that "painting should be considered excellent in proportion as it approaches the effect of relief, while relief should be considered bad in proportion as it approaches the effect of painting."[20] From this we may deduce that Michelangelo's ideal in sculpture was to get away from a pictorial or painterly effect, a deduction that is supported by his further distinction, made in the same letter to Varchi, between the sort of sculpture executed by cutting away from the block and the sort executed by building up or modeling, which, Michelangelo says, resembles painting.

The general view of the period is best expressed by Benvenuto Cellini in his answer to Varchi's questionnaire. Sculpture, says Cellini, is seven times as great as any other art based on design, because a statue has eight show-sides and they should be equally good.[21] "A painting is nothing more than one of the eight principal views required of a statue. And this is so because when a worthy artist wants to model a figure—either nude, or draped, or otherwise ... he will take some clay or wax and begin to fashion his graceful figure. I say 'graceful' because beginning from the front view, before making up his mind, he often raises, lowers, pulls forwards and backwards, bends and straightens every limb of the said figure. And once he is satisfied with the front view, he will turn his figure sideways—which is another of the four principal views—and more often than not he will find that his figure looks far less graceful, so that he will be forced to undo that

first fine aspect he had decided upon, in order to make it agree with this new aspect. . . .

"These views are not only eight, but more than forty, because even if the figure be rotated no more than an inch, there will be some muscle showing too much or not enough, so that each single piece of sculpture presents the greatest variety of aspects imaginable. And thus the artist finds himself compelled to do away with the gracefulness that he had achieved in this first view in order to harmonize it will all the others. The difficulty is so great that no figure has ever been known to look right from every direction."[22]

This statement of Cellini's illustrates perfectly the visual prejudice of Renaissance sculpture. . . .

. . . [F]or the present I want to emphasize that it inevitably leads to a painterly conception of sculpture, to a conception of sculpture as a coherence of surfaces rather than as a realization of mass. Michelangelo did, I believe, instinctively reject this illusionist approach to the object in space. We are told that he delighted not only in looking at antique sculptures but also in running his fingers over their subtle surfaces. Still, "over the surface" is not the full palpable grasp of the mass in space, and Michelangelo's sculpture never became in this sense "free." Rodin pointed out that nearly all Michelangelo's figures are conceived not as a self-subsisting harmony or equilibrium of parts balanced against each other in graceful unity but rather as a variant of the console, that is to say, as a projecting bracket that seems to imply the support of the wall behind it. The legs are bent outwards, the thorax curved inwards to give a tense and even tortured attitude that seemed to Rodin to have much in common with the art of the Middle Ages and to reflect a medieval anxiety or torment of the spirit.[23] Whatever the expressive significance of such forms, and I see no reason to question Rodin's interpretation, this technical observation confirms the hypothesis that the free placing of sculpture in space had not been achieved by the end of the sixteenth century, not even by Michelangelo. Again, as in Greece and Egypt, it was only in and through *Kleinplastik,* small objects that can actually be handled, that sculpture became emancipated from all architectonic and utilitarian purposes and conceived as an independent plastic art.

Before developing this thesis that the art of sculpture in its complete aesthetic integrity had to grow from sculpture in miniature, let us glance at the path of decadence that set in after Michelangelo's death. The seeds of that decadence had already been sown by Leonardo. That Leonardo despised the art of sculpture is evident from the terms in which he speaks of it. He cannot hide his disdain of an art that demanded physical strength, that caused, as he said, "much perspiration which mingling with the grit turns into mud." The sculptor's face "is pasted and smeared all over with marble powder, making him look like a baker, and he is covered with minute chips as if emerging from a snowstorm, and his dwelling is dirty and filled with dust and chips of stone. . . . How different is the painter's lot. . . . He is well dressed and handles a light brush dipped in delightful color. He is arrayed in the garments he fancies, and his home is clean and filled with delightful pictures, and he often enjoys the accompaniment of music or the company of men of letters who read to him from various beautiful works to which he can listen without the interference of hammering and other noises."[24]

Leonardo's snobbish prejudice is matched by an intellectual one: "In the first place, sculpture is dependent on certain lights, namely those from above, while a picture carries everywhere with it its own light and shade; light and shade therefore are essential to sculpture. In this respect, the sculptor is aided by the nature of the relief, which produces these of its own accord, but the painter artificially creates them by his art in places where nature would normally do the like. The sculptor cannot render the difference in the varying natures of the colors of objects; painting does not fail to do so in any particular. The lines of perspective of sculptors do not seem in any way true; those of painters may appear to extend a hundred miles beyond the work itself. The effects of aerial perspective are outside the scope of sculptors' work; they can neither represent transparent bodies nor luminous bodies nor angles of reflection nor shining bodies such as mirrors and like things of glittering surface, nor mists, nor dull weather, nor an infinite number of things which I forbear to mention lest they should prove wearisome."[25]

Such an argument is a typical example of the logical fallacy known as *petitio principii.*[26] It assumes that the aims of painting and sculpture are the same and that they are but different means of achieving the same end, which Leonardo gave as the imitation of all the visible works of nature, Berenson's "higher coefficient of reality." Throughout all Leonardo's writings on art, there is the supposition that art is a mirror held up to nature and that the work of art is most praiseworthy that is most like the thing represented. Even when Leonardo admits that the painter may have the duty to represent states of mind, then he must translate these too into observable actions. "A good painter," he says, "is to paint two main things, namely, man and the working of man's mind. The first is easy, the second difficult, for it is to be represented through the gestures and movements of the limbs. And these may best be learned from the dumb, who make them more

clearly than any other sort of men."[27] This recommendation, to resort to the dumb for an adequate expression of states of mind, we may compare with our resort to the blind for an adequate expression of haptic sensations.

The real prejudice underlying Leonardo's approach to art is the visual one, which in itself is closely related to an intellectual prejudice—the desire not just to realize or represent but to understand and to explain the works of nature. It led, in one direction, to the anatomy of the human figure, and I need not remind the reader how much time and industry Leonardo devoted to this scientific study. In the other direction his intellectual prejudice led to the study of perspective, and in that blind alley all sense of the palpable and ponderable qualities of the object were lost.

The theories of perspective developed by Brunelleschi and others in the fifteenth century had an immense effect on all the arts. However beneficial these influences may have been on architecture and painting—and I have my doubts about the effects of their influence on the latter art—in sculpture their effects were disastrous. We do not always realize that the theory of perspective developed in the fifteenth century is a scientific convention; it is merely one way of describing space and has no absolute validity. G. R. Kernodle has shown how the theory was applied to the box-frame of the Renaissance theater, and the painter's frame is just such an arbitrary rectangle through which one sees an imaginary scene disposed in depth.[28] Such was the perspective imposed on the sculptor. Instead of situating his objects in a space to be directly realized by the senses, he was required to imitate the painter to the extent of situating his objects in an illusory frame of reference, perspectival space. This perversion of the primary haptic sensibility is very obvious in the stucco and bronze reliefs of the period. A molded frame serves as a proscenium, the scenery is disposed within architectural "wings," and the "space" is then cut off and contained by an architectural "backcloth." Within this box the figures perform as on an actual stage but frozen in some particular attitude. The sculptor imagined that he had created the illusion of space, but what is "space" in this sense but a space, a "place" in the Greek sense, and essentially a pictorial artiface? The same illusion was aimed at in reliefs less theatrical in their conception, as in Desiderio's *The Young Christ with St. John the Baptist.*

What should be equally evident is that any sculptor who starts out with painterly prejudices tends to approach his three-dimensional task from the same theatrical point of view. He is situating his object in an artifical box, the front of which may be "read off" with purely visual faculties just as we "read off"

a painted picture. The object faces an audience, and as in a piece of scenery on the stage what is *not* seen need not correspond with what *is* seen. . . . The Greek law of frontality—Hildebrand's "unchangeable law of nature"—persisted throughout the entire Renaissance period.

If the artist has succeeded by these means in giving us aesthetic satisfaction, what harm, we may ask, is done? For centuries the Western world has admired this kind of sculpture. Must we now be robbed of our simple pleasures? Of course not; as one kind of sculpture, giving a specific though a limited pleasure, the typical reliefs of the Renassance are justified. The aesthetics of relief sculpture cannot be wholly identified with those of painting. There are problems of texture, of the conveyance of three-dimensional qualities by means of actual light and shade rather than by color and chiaroscuro, that distinguish a carved or modeled relief from a panel painting of the same period. Into his reliefs, such as the *Lamentation* in the Victoria and Albert Museum, and the later panels on the pulpit in San Lorenzo, Donatello put all the expressive power of which a "painterly" art is capable, but the reliefs remain essentially painterly *(malerisch)*. . . . There are other qualities that can be conveyed *only* by the art of sculpture, but by an art of sculpture completely emancipated from painterly prejudices. . . .

I do not wish to establish a hierarchy of the arts based on a quantitative sensational basis. One cannot say that the eye is superior to the ear and that *therefore* Michelangelo is superior to Beethoven, nor that Michelangelo is superior to Giotto because his sensibility for three-dimensional form was more acute or more clearly expressed. Indeed, I have always protested against comparative evaluations of artists or even of works of art, because every authentic aesthetic experience is *sui generis,* unique. We may like oranges better than apples, but we do not assert that therefore oranges *are* better than apples. Doctors may assure us that apples are better for us than oranges, but we do not therefore assert that apples are more beautiful than oranges. We may assert that the figures in the Portail Royal at Chartres are architecturally more appropriate for that particular location than would be the *Three Standing Figures* of Henry Moore, but three figures from Chartres, torn from their context, their architectural setting, would look fragmentary and frustrate in a London park. What we can say . . . is that to each particular co-ordination of the senses corresponds an appropriate art with its aesthetic laws. If we give prominence to vision and subordinate all other sensations to its law of maximum aesthetic effect, then we get one kind of art; if we give prominence to touch and subordinate all other sensations to *its* law of maximum aesthetic effect, then we get

another kind of art. I have not assumed that sculpture is an art of tactile sensation only; I have pointed out that even within the concept of "tactile sensation" we must include those somatic or haptic sensations that take place inwardly. What I have asserted—and nothing in my aesthetic experience has ever weakened my conviction on this point—is that the art of sculpture achieves its maximum and most distinctive effect when the sculptor proceeds almost blindly to the statement of tactile values, values of the palpable, the ponderable, the assessable mass. Integral volume, not apparent to the eye alone, but given by every direct or imaginable sensation of touch and pressure—such is the unique sculptural emotion.

Notes

1. These processes have been observed in great detail by Jean Piaget. Cf. especially *La Construction du réel chez l'enfant* (Neuchâtel and Paris, 1937; trans. Margaret Cook as *The Construction of Reality in the Child*, New York, 1954; as *The Child's Construction of Reality*, London, 1955).

2. William James, *Psychology* (London and New York, 1892), p. 339. In general I am relying on James's treatment of this subject.

3. Piaget (N.Y. ed.), p. 218. Cf. p. 217: "Hence, in the last analysis, it is the functioning of intelligence which explains the construction of space. Space is an organization of movements such as to impress upon the perceptions shapes that are increasingly coherent. The basis of these shapes derives from the very conditions of assimilation that entail the elaboration of groups. But it is the progressive equilibrium of this assimilation with the accommodation of the motor schemata to the diversity of objects which accounts for the formation of sequential structures. Space is therefore the product of an interaction between the organism and the environment in which it is impossible to dissociate the organization of the universe perceived from that of the activity itself."

4. James, p. 349.

5. (Dublin, 1709); reprinted with *Alciphron* (London, 1732), II; and in *Works*, ed. A. C. Fraser (rev. ed., Oxford, 1901), I, 93–210.

6. *The Italian Painters of the Renaissance* (London and New York, 1952), pp. 40–41.

7. Ibid., pp. 41, 42 respectively for the two phrases quoted.

8. Margaret Alice Murray, *Egyptian Sculpture* (London, 1930), pp. 61–62 and pl. xi.

9. Ibid., p. xvii. Worringer regards this explanation as only partly satisfactory. He points out that the stone used in Egyptian architecture was brought from neighboring mountain ranges, and that a tremendous will to work in stone must have been necessary to overcome all the technical obstacles that stood in the way of getting the huge blocks of stone and transporting them into the plains of the valley. "These gigantic blocks had to be brought to the place for which they were destined upon frail rafts and Nile boats. And when they were set up at their destination, they were great strangers upon the thin upper surface of this desert soil exploited by civilization, strangers from the mountains. We cannot admit that any unity grew up between the Egyptian soil and the gigantic stone monuments. Here it is rather the power of absolute contrast which determines the impression received. It was not a natural logic of geology that set these stone giants in their place, but a conscious will to art, following a definite abstract command without any feeling for the physical nature of the land. Egyptian stone architecture is just a deliberate and gigantic denial of the hazardousness and transience in the midst of which the artificial structure of Egyptian culture is placed."—*Egyptian Art*, trans. and ed. Bernard Rackham (London, 1928), p. 38.

10. Ibid., p. 25.

11. C. F. von Weizsäcker, *The History of Nature*, trans. Fred D. Wieck (Chicago and London, 1949), p. 65.

12. Gisela M. A. Richter, *The Sculpture and Sculptors of the Greeks* (New Haven and London, 1930), p. 24.

13. *The Problem of Form in Painting and Sculpture*, trans. and rev. with the author's co-operation by Max Meyer and Robert Morris Green (2nd ed., New York, 1945), p. 83.

14. Erwin Panofsky, *Gothic Architecture and Scholasticism* (The Wimmer Lecture 1948; Latrobe, Penna., 1951). Cf. Robert Grinnell, "The Theoretical Attitude toward Space in the Middle Ages," *Speculum* 21 (April 1946), 141–57; "Franciscan Philosophy and Gothic Art," *Ideological Differences and World Order*, ed. F. S. C. Northrop (New Haven, 1949), pp. 117–36.

15. (London, 1947), p. 376.

16. Ibid., p. 377.

17. Donatello made several *Davids.* The first, in marble, very early in his career, was ordered for the Duomo at Florence in 1408 but was found to be too small. A second, the famour bronze, dates from about thirty years later. Sir Eric Maclagan, in his Norton Lectures for 1927–28 (*Italian Sculpture of the Renaissance,* Cambridge, Mass., 1935), described this bronze as "perhaps the first really free-standing nude since Classical times." The figure illustrated on pl. 84–85 is officially ascribed to Donatello, but on the basis of a convincing stylistic analysis John Pope-Hennessy has recently given it to Antonio Rossellino (*Burlington Magazine,* CI:673 (April 1959), 134–39).

18. Cf. *Heavenly Mansions and Other Essays on Architecture* (London, 1949). I should like to quote the following paragraph from this book (p. 9) as support for my general thesis that the true aesthetic of sculpture was derived from *Kleinplastik:* "It has been satisfactorily shown, by Mâle, Lasteyrie and others, that the re-entry of figure–sculpture into architecture in the Romanesque churches of the 11th century was conditioned by the sculptors' familiarity with metal–work, manuscripts and other objects of art: the technique of architectural sculpture, up to the Gothic revolution in the middle of the 12th century, shows clear evidence of such a derivation. But so far as I know, nobody has developed the corollary of this—namely, that the aedicular architecture of Romanesque churches may have been reinforced or given renewed vitality from the same source."

19. *Classic Art,* trans. Peter and Linda Murray (London and New York, 1952), p. 48.

20. *Literary Sources of Art History,* ed. Elizabeth G. Holt (Princeton, 1947), p. 193.

21. Ibid., pp. 205–06.

22. From "Sopra l'arte del disegno," included in *I trattati dell' oreficeria e della scultura* (Florence, 1857), pp. 217–18; trans. Marco Treves, *Artists on Art,* ed. Robert Goldwater and Marco Treves, 2nd rev. ed. (New York, 1947), pp. 89–90.

23. Auguste Rodin, *Art,* trans. from the French of Paul Gsell by Mrs. Romilly Feden (Boston, 1912), pp. 192–93, 202.

24. Leonardo da Vinci, *The Literary Works,* ed. and trans. J. P. Richter and Irma A. Richter, 2nd rev. ed. (New York and London, 1939), vol. 1, p. 91.

25. *The Notebooks of Leonardo da Vinci,* ed. Edward MacCurdy (London, 1938), vol. 2, p. 229. Cf. American ed. in 1 vol. (Garden City, N.Y., 1941–42), pp. 854f.

26. "Begging the question."

27. *Das Buch der Malerei,* ed. Heinrich Ludwig (Vienna, 1882), p. 216; quoted in *Artists on Art,* p. 52.

28. *From Art to Theater: Form and Convention in the Renaissance* (Chicago, 1944).

30

The Worship of Art
Notes on the New God

TOM WOLFE

Let me tell you about the night the Vatican art show opened at the Metropolitan Museum of Art in New York. The scene was the Temple of Dendur, an enormous architectural mummy, complete with a Lake of the Dead, underneath a glass bell at the rear of the museum. On the stone apron in front of the temple, by the lake, the museum put on a formal dinner for 360 souls, including the wife of the President of the United States, the usual philanthropic dowagers and corporate art patrons, a few catered names, such as Prince Albert of Monaco and Henry Kissinger, and many well-known members of the New York art world. But since this was, after all, an exhibition of the Vatican art collection, it was necessary to include some Roman Catholics. Cardinal Cooke, Vatican emissaries, prominent New York Catholic laymen, Knights of Malta—there they were, devout Christians at a New York art world event. The culturati and the Christians were arranged at the tables like Arapaho beads: one culturatus, one Christian, one culturatus, one Christian, one culturatus, one Christian, one culturatus, one Christian.

Gamely, the guests tried all the conventional New York conversation openers—real estate prices, friends who have been mugged recently, well-known people whose children have been arrested on drug charges, Brits, live-in help, the dishonesty of helipad contractors, everything short of the desperately trite subjects used in the rest of the country, namely the weather and front-wheel drive. Nothing worked. There were dreadful lulls during which there was no sound at all in that antique churchyard except for the pings of hotel silver on earthenware plates echoing off the tombstone facade of the temple.

Shortly before dessert, I happened to be out in the museum's main lobby when two Manhattan art dealers appeared in their tuxedos, shaking their heads.

One said to the other: "Who *are* these *unbelievable people?*"

But of course! It seemed not only *outré* to have these . . . these . . . these . . . these *religious types* at an art event, it seemed sacrilegious. The culturati were being forced to rub shoulders, with heathens. That was the way it hit them. For today art—not religion—is the religion of the educated classes. Today educated people look upon traditional religious ties—Catholic, Episcopal, Presbyterian, Methodist, Baptist, Jewish—as matters of social pedigree. It is only art that they look upon religiously.

When I say that art is the religion of the educated classes, I am careful not to use the word in the merely metaphorical way people do when they say someone is religious about sticking to a diet or training for a sport. I am not using "religion" as a synonym for "enthusiasm." I am referring specifically to what Max Weber identified as the objective functions of a religion: the abnegation or rejection of the world and the legitimation of wealth.

Everyone is familiar with the rejection of the world in the ordinary religious sense. When I

From *Harper's Magazine*, October 1984. Reprinted with permission of *Harper's Magazine*.

worked for the *Washington Post*, I was sent into the hills of West Virginia to do a story about a snake-handling cult—or I should say religion, since a cult is nothing more than a religion whose political influence is nil. The snake-handling religion is based on a passage in Mark in which Jesus, in the Upper Room, tells his disciples that those who believe in him will be able to "handle snakes" and "come to no harm." At the services, sure enough, there is a box or basket full of snakes, poisonous snakes, right before your eyes, and their heads poke out from under the lid and you can see their forked tongues. Snake-handling thrives only in mountain areas where the farmlands are poor and the people scrape by. The message of the preachers usually runs as follows: "Oh, I know that down there in the valley they're driving their shiny cars, yes, and smoking their big cigars, unh hunh, and playing with their fancy women, unh hunh, oh yes. But you wait until the Last Days, when it comes time to kiss the snake. *You* will ascend to the right hand of God and live in His Glory, and they will perish." There you have the religious rejection of the world.

Today there are a few new religions that appeal to educated people—Scientology, Arica, Synanon, and some neo-Hindu, neo-Buddhist, and neo-Christian groups—but their success has been limited. The far more common way to reject the world, in our time, is through art. I'm sure you're familiar with it. You're on the subway during the morning rush hour, in one of those cars that is nothing but a can of meat on wheels, jammed in shank to flank and haunch to paunch and elbow to rib with people who talk to themselves and shout obscenities into the void and click their teeth and roll back their upper lips to reveal their purple gums, and there is nothing you can do about it. You can't budge. Coffee, adrenaline, and rogue hate are squirting through every duct and every vein, and just when you're beginning to wonder how any mortal can possibly stand it, you look around and you see a young woman seated serenely in what seems to be a perfect pink cocoon of peace, untouched, unthreatened, by the growling mob around her. Her eyes are lowered. In her lap, invariably, is a book. If you look closely, you will see that this book is by Rimbaud, or Rilke, or Baudelaire, or Kafka, or Gabriel García Márquez, author of *One Hundred Years of Solitude*. And as soon as you see this vision, you understand the conviction that creates the inviolable aura around her: "I may be forced into this rat race, this squalid human stew, but I do not have to be *of* it. I inhabit a universe that is finer. I can reject all this." You can envision her apartment immediately. There is a mattress on top of a flush door supported by bricks. There's a window curtained in monk's

cloth. There's a hand-thrown pot with a few blue cornflowers in it. There are some Paul Klee and Modigliani prints on the wall and a poster from the Acquavella Galleries' Matisse show. "I don't need your Louis Bourbon bergères and your fabric-covered walls. I reject your whole Parish-Hadley world—through art."

And what about the legitimation of wealth? It wasn't so long ago that Americans of great wealth routinely gave 10 percent of their income to the church. The practice of tithing was a certification of worthiness on earth and an option on heaven. Today the custom is to give the money to the arts. When Mrs. E. Parmalee Prentice, daughter of John D. Rockefeller Sr. and owner of two adjoining mansions on East Fifty-third Street, just off Fifth Avenue, died in 1962, she did not leave these holdings, worth about $5 million, to her church. She left them to the Museum of Modern Art for the building of a new wing. Nobody's eyebrows arched. By 1962, it would have been more remarkable if a bequest of that size had gone to a religion of the old-fashioned sort.

Today it has reached the point where there is a clear-cut hierachy of museum bequests. Best of all is to found a new museum with your name on it, such as the Hirshhorn Museum in Washington, named for Joseph H. Hirschhorn, whose collection of modern art is the core of the museum's holdings. Next best is endowing a new wing, such as the new wing at the Museum of Modern Art. Next best, a big gallery on the first floor with sunlight; next best, other galleries on the first floor. Then you go up to the second floor, with the sunny corner rooms in front the first pick, and the rooms in the rear next best; then upward to the third floor, and the fourth, until there are no more upper floors and you are forced to descend into the cellar. Today it is not unusual to be walking along a basement corridor of a museum and come upon what looks like the door to a utility room with a plaque on it reading: "The E. Runcey Atherwart Belgian Porcelain Cossack Collection."

When the new Metropolitan Opera House was built, there were so many people eager to pour money into it that soon every seat in the orchestra had its own little plaque on the back reading "Sheldon A. Leonard and Family," or whatever. That was nothing more than the twentieth-century version of a traditional religious practice of the seventeenth and eighteenth centuries, when every pew in the front half of the main floor of the church had its own little plaque on the back with the name of the family that had endowed it—and sat in it on Sunday. At the Opera House, when they ran out of seats in the orchestra, they went into the lobbies. People endowed columns. And when I say columns,

I'm not talking about columns with stepped pediments or fluted shafts or Corinthian capitals with acanthus leaves. I'm talking about I-beams, I-beams supporting the upper floors. When they ran out of columns, they moved on to radiator covers and water fountains.

There was a time when well-to-do, educated people in America adorned their parlors with crosses, crucifixes, or Stars of David. These were marks not only of faith but of cultivation. Think of the great homes, built before 1940, with chapels. This was a fashionable as well as devout use of space. Today those chapels are used as picture galleries, libraries, copper kitchens, saunas, or high-tech centers. It is perfectly acceptable to use them for the VCR and the Advent. But it would be in bad taste to use them for prayer. Practically no one who cares about appearing cultivated today would display a cross or Star of David in the living room. It would be . . . *in bad taste*. Today the conventional symbol of devoutness is—but of course!—the Holy Rectangle: the painting. The painting is the religious object we see today in the parlors of the educated classes.

There was a time, not so long ago, when American businesses gave large amounts of money to churches. In the Midwest and much of the South, areas dominated by so-called Dissenting Protestants, if any man wished to attain the eminence of assistant feed-store manager or better, he joined the Presbyterian or the United Brethren or the Lutheran or the Dutch Reformed church in his community. It was a sign of good faith in every sense of the term. It was absolutely necessary. Businesses literally prayed in public.

Today, what American corporation would support a religion? Most would look upon any such thing as sheer madness. So what does a corporation do when the time comes to pray in public? It supports the arts. I don't need to recite figures. Just think of the money raised since the 1950s for the gigantic cultural complexes—Lincoln Center, Kennedy Center, the Chandler Pavillion, the Woodruff Arts Center—that have become *de rigueur* for the modern American metropolis. What are they? Why, they are St. Patrick's, St. Mary's, Washington National, Holy Cross: the American cathedrals of the late twentieth century.

We are talking here about the legitimation of wealth. The worse odor a corporation is in, the more likely it is to support the arts, and the more likely it is to make sure everybody knows it. The energy crisis, to use an antique term from the 1970s, was the greatest bonanza in the Public Broadcasting Service's history. The more loudly they were assailed as exploiters and profiteers, the more earnestly the oil companies poured money into PBS's cultural programming. Every broadcast seemed to end with a discreet notice on the screen saying: "This program was made possible by a grant from Exxon," or perhaps Mobil, or ARCO. The passing of the energy crisis has been bad news for PBS. That resourceful institution would do well to mount an attack on real estate ventures, money-market funds, low-calorie beer, flea collars, antihistamines, videodisc racks, pornographic magazines, or some other prosperous enterprises. One of the pornography *jefes*, Hugh Hefner, has given his Chicago headquarters, known as the Playboy Mansion, worth an estimated $3 million, to the Chicago Art Institute. It is safe to predict that other pornographers will seek—and with some success—to legitimize their wealth by making devout offerings upon the altar of Art. To give the same offerings to a church would make them look like penitent sinners.

As you can imagine, this state of affairs has greatly magnified the influence of the art world. In size, that world has never been anything more than a village. In the United States, fashions in art are determined by no more than 3,000 people, at least 2,950 of whom live in Manhattan. I can't think of a single influential critic today. "The gallery-going public" has never had any influence at all—so we are left with certain dealers, curators, and artists. No longer do they have the servant-like role of catering to or glorifying the client. Their role today is to save him. They have become a form of clergy—or clerisy, to use an old word for secular souls who take on clerical duties.

In this age of the art clerisy, the client is in no position to say what will save him. He is in no position to do anything at all except come forward with the money if he wants salvation and legitimation.

Today large corporations routinely hire curators from the art village to buy art in their behalf. It is not a mere play on words to call these people curates, comparable to the Catholic priests who at one time were attached to wealthy European families to conduct daily masses on their estates. The corporations set limits on the curators' budgets and reserve the right to veto their choices. But they seldom do, since the entire purpose of a corporate art program is legitimation of wealth through a spiritually correct investment in art. The personal tastes of the executives, employees, clients, or customers could scarcely matter less. The corporate curators are chiefly museum functionaries, professors of art, art critics, and dealers, people who have devoted themselves not so much to the history of art as to the theories and fashions that determine prestige within the art world—that village of 3,000 souls—today, in the here and now.

Thus Chase Manhattan Bank hired a curator who was a founding trustee of the scrupulously devout and correct New Museum in New York. IBM hired a curator from the Whitney Museum to direct the art program at its new headquarters in New York. Philip Morris, perhaps the nation's leading corporate patron of the arts, did IBM one better. In its new headquarters in New York, Philip Morris has built a four-story art gallery and turned it over directly to the Whitney. Whatever the Whitney says goes.

For a company to buy works of art simply because they appeal to its executives and its employees is an absolute waste of money, so far as legitimation is concerned. The Ciba-Geigy agricultural chemical company started out collecting works of many styles and artists, then apparently realized the firm was getting no benefit from the collection whatsoever, other than aesthetic pleasure. At this point Ciba-Geigy hired an artist and a Swiss art historian, who began buying only Abstract Expressionist works by artists such as Philip Guston and Adolph Gottlieb. These works were no doubt totally meaningless to the executives, the employees, and the farmers of the world who use agricultural chemicals, and were, therefore, a striking improvement.

If employees go so far as to protest a particular fashionable style, a corporation will usually switch to another one. Corporations are not eager to annoy their workers. But at the same time, to spend money on the sort of realistic or symbolic work employees might actually enjoy would be pointless. The point is to be acclaimed for "support of the arts," a phrase which applies only to the purchase of works certified by the curates of the art village. This was quite openly the aim of the Bank of America when it hired a curator in 1979 and began buying works of art at the rate of 1,000 a year. The bank felt that its corporate image was suffering because it was not among those firms receiving "credit for art support."

The credit must come from the art clerisy. It is for this reason that IBM, for example, has displayed Michael Heizer's *Levitated Mass* at its outdoor plaza at Madison Avenue and Fifty-sixth Street. The piece is a 25-foot-by-16-foot metal tank containing water and a slab of granite. It is meaningless in terms of IBM, its executives, its employees, its customers, and the thousands of people who walk past the plaza every day. Far from being a shortcoming, that is part of *Levitated Mass's* exemplary success as a spiritual object.

It is precisely in this area—public sculpture—that the religion of art currently makes its richest contribution to the human comedy. A hundred years ago there was no confusion about the purpose of public sculpture. It glorified the ideals or triumphs of an entire community by the presentation of familiar figures or symbols, or, alternatively, it glorified the person or group who paid for it. The city where I grew up, Richmond, Virginia, was the capital of the Confederacy during the Civil War. After the war, Robert E. Lee ascended to the status of a saint in the South, and above all in Richmond. In 1888, a six-story-high statue of Lee on his horse was commissioned. In 1890, when it arrived by boat up the James River, the entire city turned out and went down to the harbor. The men of Richmond took off their seersucker jackets and rolled up their sleeves and, by sheer manpower, hauled the prodigious figures of Lee and his horse Traveller up a two-mile slope to the crest of Monument Avenue, where it now rests. Then they stepped back and cheered and wept. Such was the nature of public sculpture a century ago.

Other public sculpture, as I say, was created simply for the glory of whoever paid for the building it stood in front of. My favorite example is the statue of James Buchanan Duke of the American Tobacco Company that stands in the main quadrangle of the Duke University campus. He's leaning debonairly on his walking stick and has a great round belly and a jolly look on his face and a cigar in his left hand. The statue just comes right out and says: "He made a lot of money in tobacco, he gave you this place, he loved smoking, and here he is!"

That, too, was the nature of public sculpture up until World War II. Shortly before the war, the Rockefeller family erected a monument to itself known as Rockefeller Center, a great building complex featuring two major pieces of sculpture (and many smaller sculptures and bas-reliefs). One, at the skating rink, is a gilt statue of Prometheus, rampant, by Paul Manship. The other, on Fifth Avenue, is Lee Lawrie's highly stylized rendition of Atlas supporting the globe. The use of mythological imagery was typical of public sculpture at the time, and the local meaning was clear enough: the Rockefellers and American business were as strong as Atlas and Promethean in their daring.

But what did the Rockefellers commission in the way of public sculpture *after* World War II? The Rockefellers' Number One Chase Manhattan Plaza was the first glass skyscraper on Wall Street. Out front, on a bare Bauhaus-style apron, the so-called plaza, was installed a sculpture by Jean Dubuffet. It is made of concrete and appears to be four toadstools fused into a gelatinous mass with black lines running up the sides. The title is *Group of Four Trees*. Not even *Group of Four Rockefellers*. After all, there *were* four at the time: David, John D. III, Nelson, and Laurance. But the piece has absolutely

nothing to say about the glory or even the existence of the Rockefellers, Wall Street, Chase Manhattan Bank, American business, or the building it stands in front of. Instead, it proclaims the glory of contemporary art. It fulfills the new purpose of public sculpture, which is the legitimation of wealth through the new religion of the educated classes.

Six years after Number One Chase Manhattan Plaza was built, the Marine Midland Bank building went up a block away. It is another glass skyscraper with a mean little Bauhaus-style apron out front, and on this apron was placed a red cube resting on one point by Isamu Noguchi. Through the cube (a rhombohedron, strictly speaking) runs a cylindrical hole. One day I looked through that hole, expecting at the very least that my vision would be led toward the board room, where a man wearing a hard-worsted suit, and with thinning, combed-back hair, would be standing, his forefinger raised, thundering about broker loan rates. Instead what I saw was a woman who appeared to be part of the stenographic pool probing the auditory meatus of her left ear with a Q-Tip. So what is it, this red cube by Noguchi? Why, nothing more than homage to contemporary art, the new form of praying in public. In 1940, the same sculptor, Noguchi, completed a ten ton stainless steel bas-relief for the main entrance of Rockefeller Center's Associated Press building. It shows five heroic figures using the tools of the wire-service employee: the Teletype, the wire-photo machine, the telephone, the camera, and the pad and pencil. It is entitled *News*. Noguchi's sculpture in front of the Marine Midland building is entitled *Rhombohedron*. Even a title suggesting that it had anything to do with American banking would have been a gauche intrusion upon a piece of corporate piety.

No doubt some corporations find it convenient not to have to express what is on their minds, nor to have to make any claims about being Promethean or Atlas-like or noble or even helpful in any way. How much easier it is, surely, to make a devout gesture and install a solemn art icon by Jean Dubuffet or Isamu Noguchi or Henry Moore. Noguchi's solid geometries, lumps, and extruded squiggles, and Moore's hard boluses with holes in them, have become the very emblems of corporate devoutness.

This type of abstract public sculpture is known within the architectural profession, sotto voce, as the Turd in the Plaza school. The term was coined by James Wines, who said, "I don't care if they want to put up these boring glass boxes, but why do they always deposit that little turd in the plaza when they leave?"

We are long since past the age when autocrats made aesthetic decisions based on what *they* wanted to see in public. Today corporations, no less than individuals, turn to the clerisy, saying, in effect. "Please give us whatever we should have to certify the devoutness of our dedication to art."

If people want to place Turds in the Plazas as a form of religious offering or prayer, and they own the plazas, there isn't much anybody else can do about it. But what happens when they use public money, tax money, to do the same thing on plazas owned by the public? At that point you're in for a glorious farce.

The fun began with a competition for the Franklin Delano Roosevelt memorial. In 1955 Congress created a commission, which called in a jury composed of art curates, headed by an orthodox Bauhaus-style architect named Pietro Belluschi. By 1955 this seemed natural enough. In fact, it was a novel step, and an indication of the emerging power of the art clerisy. In the case of the Lincoln Memorial, completed in 1922, Congress appointed a commission, and the commission solicited entries from only two men. Henry Bacon and John Russell Pope, both classicists, and chose Bacon. To make sure that the Jefferson Memorial, completed in 1947, would match the Lincoln Memorial, another congressional commission chose Pope. In the case of the Roosevelt memorial—a project initiated just eight years after the completion of the Jefferson Memorial—neither Congress nor the public could figure out what hit them.

As soon as the idea of building a memorial was announced, every American who had lived through the Depression or World War II could envision Roosevelt's prognathous jaw and his grin with more teeth than a possum and his cigarette holder cocked up at a forty-five-degree angle. So what did they get? The jury selected a design by a devout modernist sculptor named Norman Hoberman: eight rectangular white concrete slabs—some of them as high as 200 feet. That was it: homage not to Franklin Roosevelt but to—of course!—Art. The Roosevelt family and Congress were nonplussed at first and, soon enough, furious. The press named the slabs Instant Stonehenge. Congress asked to see the designs of the other five finalists. But there was nothing to choose from. All five designs were abstract. To this day no Roosevelt memorial has been built, even though the project remains officially alive.

This *opéra bouffe* has been repeated with stunning regularity ever since. Our own period has been especially rich, thanks in no small part to the General Services Administration's Art-in-Architecture program and the Veterans Administration's Art in Public Places program, under which the federal government in effect gives the art clerisy millions of tax dollars for the creation of public sculpture.

In 1976, the city of Hartford decided to reinforce

its reputation as the Athens of lower central midwestern New England by having an important piece of sculpture installed downtown. It followed what is by now the usual procedure, which is to turn the choice over to a panel of "experts" in the field—i.e., the clerisy, in this case, six curators, critics, and academicians, three of them chosen by the National Endowment for the Arts, which put up half the money. So one day in 1978 a man named Carl Andre arrived in Hartford with thirty-six rocks. Not carved stones, not even polished boluses of the Henry Moore sort—rocks. He put them on the ground in a triangle, like bowling pins. Then he presented the city council with a bill for $87,000. Nonplussed and, soon enough, furious, the citizenry hooted and jeered and called the city council members imbeciles while the council members alternately hit the sides of their heads with their hands and made imaginary snowballs. Nevertheless, they approved payment, and the rocks—entitled *Stone Field*—are still there.

One day in 1981, the Civil Service workers in the new Javits Federal Building in Manhattan went outside to the little plaza in front of the building at lunchtime to do the usual, which was to have their tuna puffs and diet Shastas, and there, running through the middle of it, was a wall of black steel twelve feet high and half a city block long. Nonplussed and, soon enough, furious, 1,300 of them drew up a petition asking the GSA to remove it, only to be informed that this was, in fact, a major work of art, entitled *Tilted Arc,* by a famous American sculptor named Richard Serra. Serra did not help things measurably by explaining that he was "redefining the space" for the poor Civil Service lifers and helping to wean them away from the false values "created by advertising and corporations." Was it his fault if "it offends people to have their preconceptions of reality changed"? This seventy-three-ton gesture of homage to contemporary art remains in place.

The public see nothing, absolutely nothing, in these stone fields, tilted arcs, and Instant Stonehenges, because it was never meant to. The public is looking at the arcana of the new religion of the educated classes. At this point one might well ask what the clerisy itself sees in them, a question that would plunge us into doctrines as abstruse as any that engaged the medieval Scholastics. Andre's *Stone Field,* for example, was created to illustrate three devout theories concerning the nature of sculpture. One, a sculpture should not be placed upon that bourgeois device, the pedestal, which seeks to elevate it above the people. (Therefore, the rocks are on the ground.) Two, a sculpture should "express its gravity." (And what expresses gravity better than

rocks lying on the ground?) Three, a sculpture should not be that piece of bourgeois pretentiousness, the "picture in the air" (such as the statues of Lee and Duke); it should force the viewer to confront its "object-ness." (You want object-ness? Take a look at a plain rock! Take a look at thirty-six rocks!)

Public bafflement or opposition is taken as evidence of an object's spiritual worthiness. It means that the public's "preconceptions of reality" have been changed, to use Serra's words. When George Sugarman's sculpture for the plaza of the new federal courthouse in Baltimore was protested by both the building's employees and the judges, Sugarman said: "Isn't controversy part of what modern art is all about?" These are devout incantations of the Turbulence Theorem, which has been an article of faith within the clerisy for the past forty years. It was originally enunciated by the critic Clement Greenberg, who said that all great contemporary art "looks ugly at first." It was expanded upon by the art historian Leo Steinberg, who said that the great artists cause us "to abandon our most cherished values." In short, if a work of art troubles you, it's probably good; if you detest it, it's probably great.

In such a situation, naturally you need expert counsel: i.e., the clerisy. The notion of "the art expert" is now widely accepted. The curators of programs such as Art-in-Architecture and Art in Public Places are contemptuous of the idea that politicians, civic leaders, or any other representative of the public—much less the people themselves—should determine what sculpture is installed in public. The director of the Art-in-Architecture program, Donald Thalacker, once said: "You go to a medical expert for medical advice; you go to a legal expert for advice about the law. . . . Yet when it comes to art, it seems they want the local gas station attendant in on things." This is a lovely piece of nonsense—as anyone who sought to devise a licensing examination for an art expert or, for that matter, an artist, would soon discover. An "art expert" is merely someone who understands and believes in the tastes and values of the tiny art village of New York.

The public is nonplussed and, soon enough, becomes furious—and also uneasy. After all, if understanding such arcana is the hallmark of the educated classes today, and you find yourself absolutely baffled, what does that say about your level of cultivation? Since 1975, attendance at museums of art in the United States has risen from 42 million to 60 million people per year. Why? In 1980 the Hirshhorn Museum did a survey of people who came to the museum over a seven-month period. I find the results fascinating. Thirty-six percent said

they had come to the museum to learn about contemporary art. Thirty-two percent said they had come to learn about a particular contemporary artist. Thirteen percent came on tours. Only 15 percent said they were there for what was once the conventional goal of museumgoers: to enjoy the pictures and sculptures. The conventional goal of museumgoers today is something quite different.

Today they are there to learn—and to see the light. At the Hirshhorn, the people who were interviewed in the survey said such things as: "I know this is great art, and now I feel so unintelligent." And: "After coming to this museum, I now feel so much better about art and so much worse about me."

In other words: "I believe, O Lord, but I am unworthy? Reveal to me Thy mysteries!"

31

Form and Function

HORATIO GREENOUGH

The mind of this country has never been seriously applied to the subject of building. Intently engaged in matters of more pressing importance, we have been content to receive our notions of architecture as we have received the fashion of our garments and the form of our entertainments, from Europe. In our eagerness to appropriate, we have neglected to adapt, to distinguish,—nay, to understand. We have built small Gothic temples of wood and have omitted all ornaments for economy, unmindful that size, material, and ornament are the elements of effect in that style of building. Captivated by the classic symmetry of the Athenian models, we have sought to bring the Parthenon into our streets, to make the temple of Theseus work in our towns. We have shorn them of their lateral colonnades, let them down from their dignified platform, pierced their walls for light, and, instead of the storied relief and the eloquent statue which enriched the frieze and graced the pediment, we have made our chimneytops to peer over the broken profile and tell, by their rising smoke, of the traffic and desecration of the interior. Still the model may be recognized, some of the architectural features are entire; like the captive king, stripped alike of arms and purple and drudging amid the Helots of a capital, the Greek temple, as seen among us, claims pity for its degraded majesty, and attests the barbarian force which has abused its nature and been blind to its qualities.

If we trace architecture from its perfection in the days of Pericles to its manifest decay in the reign of Constantine, we shall find that one of the surest symptoms of decline was the adoption of admired forms and models for purposes not contemplated in their invention. The forum became a temple; the tribunal became a temple; the theater was turned into a church; nay, the column, that organized member, that subordinate part, set up for itself, usurped unity, and was a monument! The great principles of architecture being once abandoned, correctness gave way to novelty, economy and vainglory associated produced meanness and pretension. Sculpture, too, had waned. The degenerate workmen could no longer match the fragments they sought to mingle, nor copy the originals they only hoped to repeat. The moldering remains of better days frowned contempt upon such impotent efforts, till, in the gradual coming of darkness, ignorance became contempt, and insensibility ceased to compare.

We say that the mind of this country has never been seriously applied to architecture. True it is that the commonwealth, with that desire of public magnificence which has ever been a leading feature of democracy, has called from the vasty deep of the past the spirits of the Greek, the Roman, and the Gothic styles; but they would not come when she did call to them! The vast cathedral, with its ever-open portals, towering high above the courts of kings, inviting all men to its cool and fragrant twilight, where the voice of the organ stirs the blood,

From Horatio Greenough, *Form and Function*. Berkeley: University of California Press, 1947, pp. 53–63, 64–66, 71–73. Reprinted with permission of the University of California Press.

and the dim-seen visions of saints and martyrs bleed and die upon the canvas amid the echoes of hymning voices and the clouds of frankincense—this architectural embodying of the divine and blessed words, "Come to me, ye who labor and are heavy laden, and I will give you rest!" demands a sacrifice of what we hold dearest. Its cornerstone must be laid upon the right to judge the claims of the church. The style of Greek architecture, as seen in the Greek temple, demands the aid of sculpture, insists upon every feature of its original organization, loses its harmony if a note be dropped in the execution, and when so modified as to serve for a customhouse or bank, departs from its original beauty and propriety as widely as the crippled gelding of a hackney coach differs from the bounding and neighing wild horse of the desert. Even where, in the fervor of our faith in shapes, we have sternly adhered to the dictum of another age, and have actually succeeded in securing the entire exterior which echoes the forms of Athens, the pile stands a stranger among us, and receives a respect akin to what we should feel for a fellow citizen in the garb of Greece. It is a make-believe. It is not the real thing. We see the marble capitals; we trace the acanthus leaves of a celebrated model—incredulous; it is not a temple.

The number and variety of our experiments in building show the dissatisfaction of the public taste with what has been hitherto achieved; the expense at which they have been made proves how strong is the yearning after excellence; the talents and acquirements of the artists whose services have been engaged in them are such as to convince us that the fault lies in the system, not in the men. Is it possible that out of this chaos order can arise?—that of these conflicting dialects and jargons a language can be born? When shall we have done with experiments? What refuge is there from the absurdities that have successively usurped the name and functions of architecture? Is it not better to go on with consistency and uniformity, in imitation of an admired model, than incur the disgrace of other failures? In answering these questions let us remember with humility that all salutary changes are the work of many and of time; but let us encourage experiment at the risk of license, rather than submit to an iron rule that begins by sacrificing reason, dignity, and comfort. Let us consult nature, and in the assurance that she will disclose a mine richer than was ever dreamed of by the Greeks, in art as well as in philosphy. Let us regard as ingratitude to the author of nature the despondent idleness that sits down while one want is unprovided for, one worthy object unattained.

If, as the first step in our search after the great principles of construction, we but observe the skeletons and skins of animals, through all the varieties of beast and bird, of fish and insect, are we not as forcibly struck by their variety as by their beauty? There is no arbitrary law of proportion, no unbending model of form. There is scarce a part of the animal organization which we do not find elongated or shortened, increased, diminished, or suppressed, as the wants of the genus or species dictate, as their exposure or their work may require. The neck of the swan and that of the eagle, however different in character and proportion, equally charm the eye and satisfy the reason. We approve the length of the same member in grazing animals, its shortness in beasts of prey. The horse's shanks are thin, and we admire them; the greyhound's chest is deep, and we cry, beautiful! It is neither the presence nor the absence of this or that part, or shape, or color, that wins our eye in natural objects; it is the consistency and harmony of the parts juxtaposed, the subordination of details to masses, and of masses to the whole.

The law of adaptation is the fundamental law of nature in all structure. So unflinchingly does she modify a type in accordance with a new position, that some philosophers have declared a variety of appearance to be the object aimed at; so entirely does she limit the modification to the demands of necessity, that adherence to one original plan seems, to limited intelligence, to be carried to the very verge of caprice. The domination of arbitrary rules of taste has produced the very counterpart of the wisdom thus displayed in every object around us; we tie up the camelopard to the rack; we shave the lion, and call him a dog; we strive to bind the unicorn with his band in the furrow, and make him harrow the valleys after us!

When the savage of the South Sea islands shapes his war club, his first thought is of its use. His first efforts pare the long shaft, and mold the convenient handle; then the heavier end takes gradually the edge that cuts, while it retains the weight that stuns. His idler hour divides its surface by lines and curves, or embosses it with figures that have pleased his eye or are linked with his superstition. We admire its effective shape, its Etruscan-like quaintness, its graceful form and subtle outline, yet we neglect the lesson it might teach. If we compare the form of a newly invented machine with the perfected type of the same instrument, we observe, as we trace it through the phases of improvement, how weight is shaken off where strength is less needed, how functions are made to approach without impeding each other, how straight becomes curved, and the curve is straightened, till the straggling and cumbersome machine becomes the compact, effective and beautiful engine.

So instinctive is the perception of organic beauty

in the human eye, that we cannot withhold our admiration even from the organs of destruction. There is majesty in the royal paw of the lion, music in the motion of the brindled tiger; we accord our praise to the sword and the dagger, and shudder our approval of the frightful aptitude of the ghastly guillotine.

Conceiving destruction to be a normal element of the system of nature equally with production, we have used the word beauty in connection with it. We have no objection to exchange it for the word character, as indicating the mere adaptation of forms to functions, and would gladly substitute the actual pretensions of our architecture to the former, could we hope to secure the latter.

Let us now turn to a structure of our own, one which, from its nature and uses, commands us to reject authority, and we shall find the result of the manly use of plain good sense, so like that of taste, and genius too, as scarce to require a distinctive title. Observe a ship at sea! Mark the majestic form of her hull as she rushes through the water, observe the graceful bend of her body, the gentle transition from round to flat, the grasp of her keel, the leap of her bows, the symmetry and rich tracery of her spars and rigging, and those grand wind muscles, her sails. Behold an organization second only to that of an animal, obedient as the horse, swift as the stag, and bearing the burden of a thousand camels from pole to pole! What academy of design, what research of connoisseurship, what imitation of the Greeks produced this marvel of construction? Here is the result of the study of man upon the great deep, where Nature spake of the laws of building, not in the feather and in the flower, but in winds and waves, and he bent all his mind to hear and to obey. Could we carry into our civil architecture the responsibilities that weigh upon our shipbuilding, we should ere long have edifices as superior to the Parthenon, for the purposes that we require, as the *Constitution* or the *Pennsylvania* is to the galley of the Argonauts. Could our blunders on terra firma be put to the same dread test that those of shipbuilders are, little would be now left to say on this subject.

Instead of forcing the functions of every sort of building into one general form, adopting an outward shape for the sake of the eye or of association, without reference to the inner distribution, let us begin from the heart as the nucleus, and work outward. The most convenient size and arrangement of the rooms that are to constitute the building being fixed, the access of the light that may, of the air that must be wanted, being provided for, we have the skeleton of our building. Nay, we have all excepting the dress. The connection and order of parts, juxtaposed for convenience, cannot fail to speak of their relation and uses. As a group of idlers on the quay, if they grasp a rope to haul a vessel to the pier, are united in harmonious action by the cord they seize, as the slowly yielding mass forms a thorough-bass to their livelier movement, so the unflinching adaptation of a building to its position and use gives, as a sure product of that adaptation, character and expression.

What a field of study would be opened by the adoption in civil architecture of those laws of apportionment, distribution, and connection which we have thus hinted at? No longer could the mere tyro huddle together a crowd of ill-arranged, ill-lighted, and stifled rooms and, masking the chaos with the sneaking copy of a Greek façade, usurp the name of architect. If this anatomic connection and proportion has been attained in ships, in machines, and, in spite of false principles, in such buildings as made a departure from it fatal, as in bridges and in scaffolding, why should we fear its immediate use in all construction? As its first result, the bank would have the physiognomy of a bank, the church would be recognized as such, nor would the billiard room and the chapel wear the same uniform of columns and pediment. . . .

The monuments of Egypt and of Greece are sublime as expressions of their power and their feeling. The modern nation that appropriates them displays only wealth in so doing. The possession of means, not accompanied by the sense of propriety or feeling for the true, can do no more for a nation than it can do for an individual. The want of an illustrious ancestry may be compensated, fully compensated; but the purloining of the coat-of-arms of a defunct family is intolerable. That such a monument as we have described should have been erected in London while Chantrey flourished, when Flaxman's fame was cherished by the few, and Baily and Behnes were already known, is an instructive fact. That the illustrator of the Greek poets and of the Lord's Prayer should in the meanwhile have been preparing designs for George the Fourth's silversmiths, is not less so.

The edifices in whose construction the principles of architecture are developed may be classed as organic, formed to meet the wants of their occupants, or monumental, addressed to the sympathies, the faith, or the taste of a people. These two great classes of buildings, embracing almost every variety of structure, though occasionally joined and mixed in the same edifice, have their separate rules, as they have a distinct abstract nature. In the former class the laws of structure and apportionment, depending on definite wants, obey a demonstrable rule. They may be called machines each individual of which must be formed with reference to the abstract type of its species. The individuals of the latter class, bound by no other laws than those of the sentiment

which inspires them, and the sympathies to which they are addressed, occupy the positions and assume the forms best calculated to render their parent feeling. No limits can be put to their variety; their size and richness have always been proportioned to the means of the people who have erected them.

If, from what has been thus far said, it shall have appeared that we regard the Greek masters as aught less than the true apostles of correct taste in building, we have been misunderstood. We believe firmly and fully that they can teach us; but let us learn principles, not copy shapes; let us imitate them like men, and not ape them like monkeys. Remembering what a school of art it was that perfected their system of ornament, let us rather adhere to that system in enriching what we invent than substitute novelty for propriety. After observing the innovations of the ancient Romans, and of the modern Italian masters in this department, we cannot but recur to the Horation precept—

"exemplaria Graeca
Nocturna versate manu, versate diurna!"

To conclude: The fundamental laws of building found at the basis of every style of architecture must be the basis of ours. The adaptation of the forms and magnitude of structures to the climate they are exposed to, and the offices for which they are intended, teaches us to study our own varied wants in these respects. . . .

In the hope that some persons, studious of art, may be curious to see how I develop the formula I have set up, I proceed. When I define Beauty as the promise of Function; Action as the presence of Function; Character as the record of Function, I arbitrarily divide that which is essentially one. I consider the phases through which organized intention passes to completeness, as if they were distinct entities. Beauty, being the promise of function, must be mainly present before the phase of action; but so long as there is yet a promise of function there is beauty, proportioned to its relation with action or with character. There is somewhat of character at the close of the first epoch of the organic life, as there is somewhat of beauty at the commencement of the last, but they are less apparent, and present rather to the reason than to sensuous tests.

If the normal development of organized life be from beauty to action, from action to character, the progress is a progress upward as well as forward; and action will be higher than beauty, even as the summer is higher than the spring; and character will be higher than action, even as autumn is the résumé and result of spring and summer. If this be true, the attempt to prolong the phase of beauty into the epoch of action can only be made through nonperformance; and false beauty or embellishment must be the result.

Why is the promise of function made sensuously pleasing? Because the inchoate organic life needs a care and protection beyond its present means of payment. In order that we may respect instinctive action, which is divine, are our eyes charmed by the aspect of infancy, and our hearts obedient to the command of a visible yet impotent volition.

The sensuous charm of promise is so great that the unripe reason seeks to make life a perennial promise; but promise, in the phase of action, receives a new name—that on nonperformance, and is visited with contempt.

The dignity of character is so great that the unripe reason seeks to mark the phase of action with the sensuous livery of character. The ivy is trained up the green wall, and while the promise is still fresh on every line of the building, its function is invaded by the ambition *to seem* to have lived.

Not to promise forever, or to boast at the outset, not to shine and to seem, but to be and to act, is the glory of any coördination of parts for an object.

32

How Buildings Mean

NELSON GOODMAN

1. Architectural Works

Arthur Schopenhauer ranked the several arts in a hierarchy, with literary and dramatic arts at the top, music soaring in a separate even higher heaven, and architecture sinking to the ground under the weight of beams and bricks and mortar.[1] The governing principle seems to be some measure of spirituality, with architecture ranking lowest by vice of being grossly material.

Nowadays such rankings are taken less seriously. Traditional ideologies and mythologies of the arts are undergoing deconstruction and disvaluation, making way for a neutral comparative study that can reveal a good deal not only about relations among the several arts[2] but also about the kinships and contrasts between the arts, the sciences, and other ways that symbols of various kinds participate in the advancement of the understanding.

In comparing architecture with the other arts, what may first strike us, despite Schopenhauer, is a close affinity with music: architectural and musical works, unlike paintings or plays or novels, are seldom descriptive or representational. With some interesting exceptions, architectural works do not denote—that is, do not describe, recount, depict, or portray. They mean, if at all, in other ways.

On the other hand, an architectural work contrasts with other works of art in scale. A building or park or city[3] is not only bigger spatially and tem-

porally than a musical performance or painting, it is bigger even than we are. We cannot take it all in from a single point of view; we must move around and within it to grasp the whole. Moreover, the architectural work is normally fixed in place. Unlike a painting that may be reframed or rehung or a concerto that may be heard in different halls, the architectural work is firmly set in a physical and cultural environment that alters slowly.

Finally, in architecture as in few other arts, a work usually has a practical function, such as protecting and facilitating certain activities, that is no less important than, and often dominates, its aesthetic function. The relationship between these two functions ranges from interdependence to mutual reinforcement to outright contention, and can be highly complex.

Before considering some consequences of and questions raised by these characteristics of architecture, perhaps we should ask what a work of architectural art is. Plainly, not all buildings are works of art, and what makes the difference is not merit. The question "What is art?" must not be confused with the question "What is good art?" for most works of art are bad. Nor does being a work of art depend upon the maker's or anyone else's intentions but rather upon how the object in question functions. A building is a work of art only insofar as it signifies, means, refers, symbolizes in some way. That may seem less than obvious, for the sheer bulk of an

From Nelson Goodman, "How Buildings Mean," in Nelson Goodman and Catherine Z. Elgin, *Reconceptions in Philosophy and Other Arts and Sciences.* Cambridge and Indianapolis: Hackett Publishing Company, 1988, pp. 31–48. Reprinted with permission of Hackett Publishing Company.

architectural work and its daily dedication to a practical purpose often tend to obscure its symbolic function. Moreover, some formalist writers preach that pure art must be free of all symbolism, must exist and be looked upon solely in and for itself, and that any reference beyond it amounts virtually to pollution. But this contention, as we shall see, rests upon a cramped conception of reference.

Of course, not all symbolic functioning is aesthetic. A scientific treatise signifies abundantly but is not thereby a work of literary art; a painted sign giving directions is not thereby a work of pictorial art. And a building may mean in ways unrelated to being an architectural work—may become through association a symbol for sanctuary, or for a reign of terror, or for graft. Without attempting to characterize in general the features of symbolic function that distinguish works of art, we can proceed to look at some pertinent ways that architectural works as such symbolize.

2. Ways of Meaning

I am neither an architect nor a historian or critic of architecture. My undertaking here is not to evaluate works or to provide canons for evaluation or even to say what is meant by particular works of architecture, but rather to consider how such works may mean, how we determine what they mean, how they work, and why it matters.

The vocabulary of reference and related terms is vast: within a few brief passages from a couple of essays on architecture, we may read of buildings that allude, express, evoke, invoke, comment, quote; that are syntactical, literal, metaphorical, dialectical; that are ambiguous or even contradictory! All these terms and many more, have to do in one way or another with reference and may help us to grasp what a building means. Here I want to outline some distinctions and interrelations among such terms. To begin with, the varieties of reference may be grouped under four headings: "denotation," "exemplification," "expression," and "mediated reference."

Denotation includes naming, predication, narration, description, exposition, and also portrayal and all pictorial representation—indeed, any labeling, any application of a symbol of any kind to an object, event, or other instance of it. "Berlin" and a certain postcard both denote Berlin, and so does "city," even though this word denotes other places as well. "Word" denotes many things, including itself.

Buildings are not texts or pictures and usually do not describe or depict. Yet representation does occur in salient ways in some architectural works, notably in Byzantine churches with mosaic-covered interiors and in Romanesque facades that consist almost entirely of sculpture (Fig. 1). Perhaps even in such cases, we are inclined to say that prominent *parts* of the building represent rather than that the building itself or as a whole represents. As buildings that themselves depict, we may think first of shops that represent a peanut or an ice cream cone or a hot dog, but not all cases are so banal. Jørn Utzon's Opera House (1973) in Sydney is almost as literal a depiction of sailboats, though with a primary concern for form (Fig. 2). In Arland Dirlam's First Baptist Church (1964) in Gloucester, Massachusetts, a traditional peaked roof is modified and accentuated to reflect the forms of sailboats as we approach from the east; and the frame of the nave, made of curved wood beams, is an inverted image of the skeletons of fishing boats often seen under construction in nearby Essex. Again, the weird towers of Antonio Gaudi's church of the Sagrada Familia (Fig. 3), in Barcelona, are revealed as startling representations when we come upon the tapering conical mountains a few miles away at Montserrat.

FIGURE 1. Saint Nicholas Church, Civray, France, twelfth century.

FIGURE 2. Jørn Utzon, Sydney Opera House, 1973.

FIGURE 3. Antonio Gaudí, Sagrada Familia Church, Barcelona, 1882–1930.

Yet since few architectural works depict either as wholes or in part, directly or indirectly, architecture never had to undergo the trauma brought on by the advent of modern abstractionism in painting. In painting, where representation was customary, the absence of representation sometimes left a sense of deprivation and gave rise to both acrid accusations and defiant defenses of meaninglessness; but where representation is not expected, we readily focus upon other kinds of reference. These are no less important in painting or literature—indeed, their presence is a major feature distinguishing literary from nonliterary texts—but they are often somewhat obscured by our concern with what is depicted or described or recounted.

Whether or not a building represents anything, it may exemplify or express certain properties. Such reference runs, not as denotation does, from symbol to what it applies to as label, but in the opposite direction, from symbol to certain labels that apply to it or to properties possessed by it.[4] A commonplace case is a swatch of yellow plaid woolen serving as a sample. The swatch refers not to anything it pictures or describes or otherwise denotes but to its properties of being yellow, plaid, and woolen, or to the words "yellow," "plaid," and "woolen" that denote it. But it does not so exemplify all its properties nor all labels applying to it—not, for instance, its size or shape. The lady who ordered dress mate-

rial 'exactly like the sample' did not want it in two-inch-square pieces with zigzag edges.

Exemplification is one of the major ways that architectural works mean. In formalist architecture it may take precedence over all other ways. According to William H. Jordy, the Dutch architect Gerrit Reitveld (see Fig. 4) "fragmented architecture into primal linear elements (columns, beams, and framing elements for openings) and planes (wall increments) in order to make visible the 'build' of the building."[5] That is, the building is designed to refer effectively to certain characteristics of its structure. In other buildings made of columns, beams, frames, and walls, the structure is not thus exemplified at all, serving only practical and perhaps also other symbolic functions. But exemplifications of structure may accompany, and either take precedence over or be subordinate to, other ways of meaning. For instance, reference to structure is not the primary symbolic function of a church but may play a notable supporting role. Of the Vierzehnheiligen pilgrimage church near Bamberg (Figs. 5, 6), Christian Norberg-Schulz writes:

Analysis shows that two systems have been combined in the layout: a biaxial organism . . . and a conventional Latin cross. As the centre of the biaxial layout does not coincide with the crossing, an exceptionally strong syncopation results. Over the crossing, where traditionally the centre of the church ought to be, the vault is eaten away by the four adjacent baldachins. The space defined by the groundplan is thereby transposed

relative to space defined by the vault and the resulting syncopated interpenetration implies a spatial integration more intimate than ever before in the history of architecture. This dynamic and ambiguous system of main spaces is surrounded by a secondary, outer zone, derived from the traditional aisles of the basilica.[6]

The shape of the church might have been correctly described in many alternative ways—the ground plan as a highly complex polygon, and so on. But, induced by the greater familiarity of oblongs and crosses and by the long preceding history of basilicas and cruciform churches, what comes forth, what is exemplified here, is the structure as derivative from these simpler forms. The vault likewise tells not as a single undulating shell but as a smooth shape interrupted by others. The syncopation and dynamism mentioned depend upon the interrelation not of formal properties that the building merely possesses but of properties it exemplifies.

Not all the properties (or labels) that a building refers to are among those it literally possesses (or that literally apply to it). The vault in the Vierzehnheiligen church is not literally eaten away; the spaces do not actually move; and their organization is not literally but rather metaphorically dynamic. Again, although literally a building blows no brass and beats no drums, some buildings are aptly described as 'jazzy.' A building may express feelings it does not feel, ideas it cannot think or state, activities it cannot perform. That the ascription of certain properties to a building in such cases is meta-

FIGURE 4. Gerritt Reitveld, Schroder House (model), Utrecht, 1924.

FIGURE 5. Balthasar Neumann, Vierzehnheiligen Church, Bamberg, 1743–72.

FIGURE 6. Ground plan, Vierzehnheiligen Church.

phorical does not amount merely to its being literally false, for metaphorical truth is as distinct from metaphorical falsity as is literal truth from literal falsity. A Gothic cathedral that soars and sings does not equally droop and grumble. Although both descriptions are literally false, the former but not the latter is metaphorically true.

Reference by a building to properties possessed either literally or metaphorically is exemplification, but exemplification of metaphorically possessed properties is what we more commonly call "expression". To mark the distinction, I ordinarily use "exemplification" as short for "literal exemplification" and reserve "expression" for the metaphorical cases, although in much writing "expression" is used for cases of both sorts. For instance, we often read of a building's 'expressing' its function, but since a factory has the function of manufacturing, its exemplification of that function is of a property literally possessed. Only if the factory were to exemplify the function of, say, marketing, would it in my terminology be expressing that function. But distinguishing between exemplification and expression matters less than recognizing literal exemplification as an important variety of reference, especially in architecture. A purely formal building that neither

depicts anything nor expresses any feelings or ideas is sometimes held not to function as a symbol at all. Actually, it exemplifies certain of its properties, and only so distinguishes itself from buildings that are not works of art at all.

I stress the role of exemplification, for it is often overlooked or even denied by writers who insist that the supreme virtue of a purely abstract painting or a purely formal architectural work lies in its freedom from all reference to anything else. But such a work is not an inert unmeaning object, nor does it refer solely (if at all) to itself. Like the swatch of cloth, it picks out, points to, *refers to* some of its properties but not others. And most of these exemplified properties are also properties of other things which are thus associated with, and may be indirectly referred to by, the work.

An architectural work may of course both literally exemplify some properties and express others. Of the facade of San Miniato al Monte outside Florence, Rudolph Arnheim writes that it "expresses its character as a self-contained object dependent on ... the earth; but it also symbolizes the human mind's struggle for maintaining its own centered integrity against the interference by outer powers."[7] In my vocabulary the facade *exemplifies* the

first (literal) property and *expresses* the second (metaphorical) one.

3. Ramifications

Representation, exemplification, and expression are elementary varieties of symbolization, but reference by a building to abstruse or complicated ideas sometimes runs along more devious paths, along homogeneous or heterogeneous chains of elementary referential links. For instance, if a church represents sailboats, and sailboats exemplify freedom from earth, and freedom from earth in turn exemplifies spirituality, then the church refers to spirituality via a three-link chain. Parts of a Michael Graves building may exemplify keystonelike and other forms depicted or exemplified by Egyptian or Greek architecture and, thus, indirectly refer to such buildings and in turn to properties these exemplify and express.[8] Such indirect or mediate reference is often termed "allusion," as when 'The Five' architects are described as making "allusions to ancient and Renaissance classicism" and as being "attracted by Le Corbusier's witty introduction of collage allusion into his buildings."[9] And when Robert Venturi writes of 'contradiction' in architecture, he is not supposing that a building can actually assert a self-contradictory sentence, but is speaking of exemplification by a building of forms that give rise when juxtaposed, because they are also severally exemplified in architecture of contrasting kinds (for example, classical and baroque), to expectations that contravene each other.[10] The 'contradiction' thus arises from indirect reference.

Not all chains consisting of referential links conduct reference from one end to the other. The name of the name of the rose is not the name of the rose; and "Gaudí's famous church in Barcelona" refers to a certain building, not to the mountains that that building refers to. On the other hand, a symbol that refers via a chain may also refer directly to the same thing; and sometimes where reference via a given chain becomes common, short-circuiting occurs. For instance, if a building alludes to Greek temples that in turn exemplify classical proportions that it does not itself possess, it may come to express these proportions directly. Moreover, reference by a work via a chain is seldom unique; a building may reach symbolically to the same referent along several routes. The reader will find his own examples.

Sometimes other relationships a building may stand in—for instance, to effects or causes of it—are mistaken for reference. What an architectural work means cannot in general be identified either with thoughts it inspires and feelings it arouses or with circumstances responsible for its existence or design. Although "evocation" is sometimes used almost interchangeably with "allusion" or "expression", it should be distinguished from them; for while some works allude to or express feelings they evoke, not all do. A building of an earlier era does not always express the nostalgia it evokes, nor does a skyscraper in a New England town always refer to the fury, however widespread and lasting, it may arouse. Equally, allusion and all other reference must be distinguished from causation. Even if in some cases "an epoch is inscribed in its monuments [so] architecture is not neutral[;] it expresses political, social, economic, and cultural 'finalities'"[11] still, an architectural work does not always refer to economic or social or psychological or other factors or ideas that brought about its construction or affected its design.

Even when a building does mean, that may have nothing to do with its architecture. A building of any design may come to stand for some of its causes or effects, or for some historical event that occurred in it or on its site, or for its designated use; any abattoir may symbolize slaughter, and any mausoleum, death; and a costly county courthouse may symbolize extravagance. To mean in such a way is not thereby to function as an architectural work.

4. Architectural Judgment

So much for some of the ways that architectural works as such do mean and some they do not. But when does a work actually mean as such? Some writing about architecture may give the impression that prose is as prominent an ingredient in architecture as steel and stone and cement. Does a work mean just whatever anyone says it means, or is there a difference between right and wrong statements about how and what it means?

On one view, correct interpretation is unique; there are no alternatives, and rightness is tested by accord with the artist's intentions. Obviously, drastic adjustments in this are needed to accommodate works that fail to realize the artist's intentions or that exceed or diverge from them: not only the road to hell is paved with unfulfilled intentions, and great works are often full of unintended realizations. Moreover, we are seldom utterly at a loss to interpret a prehistoric or other work when virtually nothing is known of the artist or his intentions. But the main fault I find in this view lies in its absolutism rather than in the particular test of rightness specified. A work of art typically means in varied and contrasting and shifting ways and is open to many equally good and enlightening interpretations.

At the opposite extreme from such absolutism is a radical relativism that takes any interpretation to

be as right or wrong as any other. Everything goes if anything does. All interpretations are extraneous to the work, and the critic's function is to strip them off. A work means whatever it may be said to mean—or, in other words, it does not mean at all. No difference between rightness and wrongness of interpretation is recognized. So stated, this view obviously involves a gross oversimplification. More than any other art, architecture makes us aware that interpretation cannot be so easily distinguished from the work. A painting can be presented all at once—though our perception of it involves synthesizing the results of scanning—but a building has to be put together from a heterogeneous assortment of visual and kinesthetic experiences: from views at different distances and angles, from walks through the interior, from climbing stairs and straining necks, from photographs, miniature models, sketches, plans, and from actual use. Such construction of the work as known is itself of the same sort as interpretation and will be affected by our ideas about the building and by what it and its parts mean or are coming to mean. The same altar may be a central pivot or an incidental deviation. A mosque will not have the same structure for a Muslim, a Christian, an atheist. Stripping off or ripping out *all* construals (that is, all interpretation and construction) does not leave a work cleansed of all encrustation but demolishes it.

The resolute deconstructionist will not flinch at this. He will dismiss unconstrued works as will-o-the-wisps and treat interpretation not as *of* anything but as mere storytelling. He is thus released from any stereotyped conception of a work and from the hampering and hopeless search for the single right interpretation. A heady freedom replaces oppressive obligation. But the freedom is bought at the price of inconsequence. Whatever may be said counts as a right interpretation of any work.

Thus both the absolutist's view that a work is and means what the architect intended and the extreme relativist's view that a work is and means whatever anyone happens to say have serious shortcomings. A third view that might be called constructive relativism takes deconstruction as a prelude to *recon*struction and insists on recognition that among the many construals of a work some—even some that conflict with one another—are right while others are wrong. Consideration of what constitutes the difference thus becomes obligatory.

This question is formidable; for a work may be right or wrong in many different ways, and rightness reaches far beyond truth which pertains to verbal statements only. Obviously, no full and final answer to this question will be forthcoming. Not only is any search for a ready and conclusive test of rightness (for a key, no less, to all knowledge!) pat-

ently absurd, but even a pat and satisfying definition can hardly be expected. The particular determination of which works are right and which wrong is no more the philosopher's responsibility than is the determination of which statements are true in a particular science or of what are the facts of life. Those who are most concerned must apply and constantly develop their own procedures and sensibilities. The philosopher is no expert in all fields or, indeed, in any. His role is to study particular judgments made and general principles proposed on the basis of them and examine how tensions between particular judgments and general principles are resolved—sometimes by altering a principle, sometimes by changing a judgment. All I can offer here are some reflections on the *nature* of rightness and on factors affecting our tentative decisions concerning what versions are right or more nearly right than others.

Judgments of rightness of a building as a work of architecture (of how well it works as a work of art) are often in terms of some sort of good fit—fit of the parts together and of the whole to context and background. What constitutes such fit is not fixed but evolves. As illustrated in the case of 'contradiction' in architecture, drastic changes in standards of fit start from and are effected against some concepts and expectations that give way slowly. *Entrenchment* established by habit is centrally involved in the determination of rightness and is, indeed, the basis that makes innovation possible. In Venturi's words, "Order must exist before it can be broken."[12]

As an example of the judgment of rightness in terms of fit, consider Julia Trilling's discussion of Charles Garnier's Opéra in Paris (Fig. 7):

> Even Haussmann didn't always get the proportions right. The Garnier opera house, while indisputably monumental itself, doesn't really work to complete the Avenue de l'Opéra. It is too wide for its site, spilling over the sides of the frame defined by the buildings adjoining the avenue. In the case of the Place de la Bastille, the correct site for the new opera house would not be the designated one, on the old railway yards, but adjacent to it on the canal that completes Haussmann's Boulevard Richard-Lenoir.[13]

What is being discussed here is not physical fit; there is no complaint of blocked access or light or of intrusion into the public way. The fit in question is of exemplified forms to each other and into the form exemplified by the whole. It thus depends upon what the components and the whole signify in one way or another—in this case, primarily by exemplification. In other cases, fit may depend upon what is expressed or denoted or referred to via

FIGURE 7. Charles Garnier, Opera House, avenue de l'Opéra, Paris, 1861–74.

complex chains. And I am not suggesting that all rightness is a matter of fit.

To summarize briefly, I have tried to suggest some of the ways buildings may mean and ways that their meaning is involved in factors that affect judgment of their effective functioning as works of art. I have not tried to say how to determine what and how particular buildings mean, for we have no general rules for this any more than for determining what a text means or a drawing depicts; but I have tried to give some examples of the kinds of meaning involved. As for the further question, why it matters how and when a building means, I think that a work of architecture, or any other art, works as such to the extent that it enters into the way we see, feel, perceive, conceive, comprehend in general. A visit to an exhibition of paintings may transform our vision, and I have argued elsewhere that excellence of a work is a matter of enlightenment rather than of pleasure. A building, more than most works, alters our environments physically; but moreover, as a work of art it may through various avenues of meaning, inform and reorganize our entire experience. Like other works of art—and like scientific theories, too—it can give new insight, advance understanding, participate in our continual remaking of a world.

Notes

Laurie Olin and John Whiteman have given valuable help with the literature of architecture.

1. See Bryan Magee, *The Philosophy of Schopenhauer* (Oxford: Oxford University Press, 1983), pp. 176–78.

2. A recent contribution is *Das Laokoon-Projekt,* ed. Gunter Gebauer (Stuttgart: J. V. Metzler, 1984); see especially Gebauer's own essay, "Symbolstrukturen und die Grenzen der Kunst, Zu Lessings Kritik der Darstellungsfähigkeit künstlerischer Symbole," pp. 137–65.

3. Hereafter I shall ordinarily use "building" as the generic term for all such cases.

4. I shall speak indifferently of properties or labels as being exemplified. For a discussion of this matter, see Nelson Goodman, *Languages of Art,* 2nd ed. (Indianapolis: Hackett Publishing Company, 1976), pp. 54–57.

5. William H. Jordy, "Aedicular Modern: The Architecture of Michael Graves," *New Criterion* 2 (October 1983), 46.

6. Christian Norberg-Schulz, *Meaning in Western Architecture* (New York: Praeger, 1975), p. 311.

7. Rudolph Arnheim, "The Symbolism of Centric and Linear Composition," *Perspecta 20* (1983), 142.

8. Although a link in an ordinary chain is nondirectional, one element in a referential link may refer to but not be referred to by the other. Where one element exemplifies the other, however, reference runs in both directions, for the exemplified element denotes what exemplifies it.

9. Jordy, "Aedicular Modern," p. 45.

10. See Robert Venturi, *Complexity and Contradiction in Architecture* (Garden City, N.Y.: Doubleday, 1966).

11. François Mitterand, quoted in Julia Trilling, "Architecture as Politics," *Atlantic Monthly* (October 1983), 35.

12. Venturi, *Complexity and Contradiction in Architecture*, p. 46.

13. Trilling, "Architecture as Politics," pp. 33–34.

33

A Case for Figurative Architecture

MICHAEL GRAVES

A standard form and a poetic form exist in any language or in any art. Although analogies drawn between one cultural form and another prove somewhat difficult, they nevertheless allow associations that would otherwise be impossible. Literature is the cultural form which most obviously takes advantage of standard and poetic usages, and so may stand as a model for architectural dialogue. In literature, the standard, accessible, simple ranges of daily use are expressed in conversational or prose forms, while the poetic attitudes of language are used to test, deny, and at times, to further support standard language. It seems that standard language and poetic language have a reciprocal responsibility to stand as separate and equal strands of the greater literary form and to reinforce each other by their similarity and diversity. Through this relationship of tension, each form is held in check and plays on the other for its strength.

When applying this distinction of language to architecture, it could be said that the standard form of building is its common or internal language. The term internal language does not imply in this case that it is non-accessible, but rather that it is intrinsic to building in its most basic form—determined by pragmatic, constructional, and technical requirements. In contrast, the poetic form of architecture is responsive to issues external to the building, and incorporates the three dimensional expression of the myths and rituals of society. Poetic forms in architecture are sensitive to the figurative, associative, and anthropomorphic attitudes of a culture. If one's goal is to build with only utility in mind, then it is enough to be conscious of technical criteria alone. However, once aware of and responsive to the possible cultural influences on building, it is important that society's patterns of ritual be registered in the architecture. Could these two attitudes, one technical and utilitarian and the other cultural and symbolic, be thought of as architecture's standard and poetic languages?

Without doubt, the inevitable overlap of these two systems of thought can cause this argument to become somewhat equivocal. However, the salient tendencies of each attitude may be distinguished and reasonably discussed. This is said with some critical knowledge of the recent past. It could be maintained that dominant aspects of modern architecture were formulated without this debate about standard and poetic language, or internal and external manifestations of architectural culture. The Modern Movement based itself largely on technical expression—internal language—and the metaphor of the machine dominated its building form. In its rejection of the human or anthropomorphic representation of previous architecture, the Modern Movement undermined the poetic form in favor of nonfigural, abstract geometries. These abstract geometrics might in part have been derived from the simple internal forms of machines themselves. Coin-

Michael Graves, "A Case for Figurative Architecture," in Karen Vogel Wheeler, Peter Arnell, and Ted Bickford, eds, *Michael Graves: Buildings and Projects, 1966–81.* New York: Rizzoli International Publications, 1982, pp. 11–13. Reprinted with permission of the author.

cident with machine metaphors in buildings, architecture in the first half of this century also embraced aesthetic abstraction in general. This has contributed to our interest in purposeful ambiguity, the possibility of double readings within compositions.

While any architectural language, to be built, will always exist within the technical realm, it is important to keep the technical expression parallel to an equal and complementary expression of ritual and symbol. It could be argued that the Modern Movement did this, that as well as its internal language, it expressed the symbol of the machine, and therefore practiced cultural symbolism. But in this case, the machine is retroactive, for the machine itself is a utility. So this symbol is not an external allusion, but rather a second, internalized reading. A significant architecture must incorporate both internal and external expressions. The external language, which engages inventions of culture at large, is rooted in a figurative, associational and anthropomorphic attitude.

We assume that in any construct, architectural or otherwise, technique, the art of making something, will always play a role. However, it should also be said that the components of architecture have not only derived from pragmatic necessity, but also evolved from symbolic sources. Architectural elements are recognized for their symbolic aspect and used metaphorically by other disciplines. A novelist, for example, will stand his character next to a window and use the window as a frame through which we read or understand the character's attitude and position.

In architecture, however, where they are attendant to physical structure, basic elements are more frequently taken for granted. In this context, the elements can become so familiar that they are not missed when they are eliminated or when they are used in a slang version. For instance, if we imagine ourselves standing adjacent to a window, we expect the window sill to be somehow coincident with the waist of our body. We also expect, or might reasonably ask, that its frame help us make sense not only of the landscape beyond, but also of our own position relative to the geometry of the window and to the building as a whole. In modern architecture, however, these expectations are seldom met, and instead the window is often continuous with the wall as horizontal banding or, more alarmingly, it becomes the entire surface. The naming of the "window wall" is a prime example of the conflation or confusion of architectural elements.

Architectural elements require this distinction, one from another, in much the same way as language requires syntax; without variations among architectural elements, we will lose the anthropomorphic or figurative meaning. The elements of any

enclosure include wall, floor, ceiling, column, door, and window. It might be wondered why these elements, given their geometric similarity in some cases (for example, floor and ceiling) must be understood differently. It is essential in any symbolic construct to identify the thematic differences between various parts of the whole. If the floor as ground is regarded as distinct from the soffit as sky, then the material, textural, chromatic, and decorative inferences are dramatically different. Yet in a formal sense, these are both horizontal planes.

We as architects must be aware of the difficulties and the strengths of thematic and figural aspects of the work. If the external aspects of the composition, that part of our language which extends beyond internal technical requirements, can be thought of as the resonance of man and nature, we quickly sense an historical pattern of external language. All architecture before the Modern Movement sought to elaborate the themes of man and landscape. Understanding the building involves both association with natural phenomena (for example, the ground is like the floor), and anthropomorphic allusions (for example, a column is like a man). These two attitudes within the symbolic nature of building were probably originally in part ways of justifying the elements of architecture in a prescientific society. However, even today, the same metaphors are required for access to our own myths and rituals within the building narrative.

Although there are, of course, instances where the technical assemblage of buildings employs metaphors and forms from nature, there is also possibility for a larger, external natural text within the building narrative. The suggestion that the soffit is in some sense celestial, is certainly our cultural invention, and it becomes increasingly interesting as other elements of the building also reinforce such a narrative. This type of cultural association allows us "into" the full text or language of the architecture. This is in contrast to modern examples which commonly sacrifice the idea or theme in favor of a more abstract language. In these instances, the composition, while perhaps formally satisfying, is based only on internal references. A de Stijl composition is as satisfying turned upside down as it is right side up, and this is in part where its interest lies. We may admire it for its compositional unity, but as architecture, because of its lack of interest in nature and gravity, it dwells outside the reference systems of architectural themes. A de Stijl building has two internal systems, one technical and the other abstract.

In making a case for figurative architecture, we assume that the thematic character of the work is grounded in nature and is simultaneously read in a totemic or anthropomorphic manner. An example

The Humana Building, Michael Graves, architect. Louisville, Kentucky, Paschall/Taylor.

of this double reading might be had by analyzing the character of a wall. As the window helps us to understand our size and presence within the room, so the wall, though more abstract as a geometric plane, has over time accommodated both pragmatic and symbolic divisions. Once the wainscot or chair rail is understood as being similar in height to the window sill, associations between the base of the wall (which that division provides) and our own bodies are easily made. As we stand upright and are, in a sense, rooted in the ground, so the wall, through its wainscot division, is rooted relative to the floor. Another horizontal division takes place at the picture molding, where the soffit is dropped

from its horizontal position to a linear division at the upper reaches of the wall. Although this tripartite division of the wall into base, body, and head does not literally imitate man, it nevertheless stabilizes the wall relative to the room, an effect we take for granted in our bodily presence there.

The mimetic character that a wall offers the room, as the basic substance of its enclosure, is obviously distinct from the plan of the room. While we see and understand the wall in a face to face manner, we stand perpendicular to the plan. The wall contributes primarily to the character of the room because of its figurative possibilities. The plan, however, because it is seen perspectivally, is less capable

of expressing character and more involved with our spatial understanding of the room. While space can be appreciated on its own terms as amorphous, it is ultimately desirable to create a reciprocity between wall and plan, where the wall surfaces or enclosures are drawn taut around a spatial idea. The reciprocity of plan and wall is finally more interesting than the distinctions between them.

We can say that both wall and plan have a center and edges. The plan alone, however, has no top, middle and base, as does the wall. At this point, we must rely on the reciprocal action or volumetric continuity provided by both. Understanding that it is the volumetric idea that will be ultimately considered, we can analyze, with some isolation, how the plan itself contributes to a figurative architectural language.

For the purposes of this argument, a linear plan, three times as long as it is wide, might be compared to a square or centroidal plan. The square plan provides an obvious center, and at the same time emphasizes its edges or periphery. If the square plan is further divided, like tic-tac-toe, into nine squares, the result is an even greater definition of corners, edges, and a single center. If we continue to elaborate such a geometric proposition with freestanding artifacts such as furniture, the locations of tables and chairs will be not only pragmatic, but also symbolic of societal interactions. One can envision many compositions and configurations of the same pieces of furniture which would offer us different meanings within the room.

Predictably, the three-square composition will subdivide quite differently from the centroidal plan. While the rectangular composition will distinguish the middle third of the room as its center, and the outer thirds as its flanks, we are less conscious here of occupiable corners. The corners of the square composition contribute to our understanding of the center and are read as positive. In contrast, the corners of the rectangular plan are remote from its center and are seemingly residual. Our culture understands the geometric center as special and as the place of primary human occupation. We would not typically divide the rectangular room into two halves, but rather, more appropriately, would tend to place ourselves in the center, thereby precluding any reading of the room as a diptych. In analyzing room configurations, we sense a cultural bias to cer-

tain basic geometries. We habitually see ourselves, if not at the center of our "universe," at least at the center of the spaces we occupy. This assumption colors our understanding of the differences between center and edge.

If we compare the understanding of the exterior of the building to that of its interior volume, another dimension of figurative architecture arises. A freestanding building such as Palladio's Villa Rotunda, is comprehensible in its objecthood. Furthermore, its interior volume can be read similarly—not as a figural object, but as a figural void. A comparison between such an "object building" and a building of the Modern Movement, such as Mies van der Rohe's Barcelona Pavilion, allows us to see how the abstract character of space in Mies's building dissolves any reference to or understanding of figural void or space. We cannot charge Mies with failing to offer us figurative architecture, for this is clearly not his intention. However, we can say that, without the sense of enclosure that the Palladio example offers us, we have a much thinner palette than if we allow the possibility of both the ephemeral space of modern architecture and the enclosure of traditional architecture. It could be contended that amorphic or continuous space, as understood in the Barcelona Pavilion, is oblivious to bodily or totemic reference, and we therefore always find ourselves unable to feel centered in such space. This lack of figural reference ultimately contributes to a feeling of alienation in buildings based on such singular propositions.

In this discussion of wall and plan, an argument is made for the figural necessity of each particular element and, by extension, of architecture as a whole. While certain monuments of the Modern Movement have introduced new spatial configurations, the cumulative effect of nonfigurative architecture is the dismemberment of our former cultural language of architecture. This is not so much an historical problem as it is one of a cultural continuum. It may be glib to suggest that the Modern Movement be seen not so much as an historical break but as an appendage to the basic and continuing figurative mode of expression. However, it is nevertheless crucial that we re-establish the thematic associations invented by our culture in order to fully allow the culture of architecture to represent the mythic and ritual aspirations of society.

34

Art and Craft

R.G. COLLINGWOOD

§1. The Meaning of Craft

The first sense of the word 'art' to be distinguished from art proper is the obsolete sense in which it means what . . . I shall call craft. This is what *ars* means in ancient Latin, and what τέχνη means in Greek: the power to produce a preconceived result by means of consciously controlled and directed action. In order to take the first step towards a sound aesthetic, it is necessary to disentangle the notion of craft from that of art proper. In order to do this, again, we must first enumerate the chief characteristics of craft.

1. Craft always involves a distinction between means and end, each clearly conceived as something distinct from the other but related to it. The term 'means' is loosely applied to things that are used in order to reach the end, such as tools, machines, or fuel. Strictly, it applies not to the things but to the actions concerned with them: manipulating the tools, tending the machines, or burning the fuel. These actions (as implied by the literal sense of the word means) are passed through or traversed in order to reach the end, and are left behind when the end is reached. This may serve to distinguish the idea of means from two other ideas with which it is sometimes confused: that of part, and that of material. The relation of part to whole is like that of means to end, in that the part is indispensable to the whole, is what it is because of its relation to the whole, and may exist by itself before the whole

comes into existence; but when the whole exists the part exists too, whereas, when the end exists, the means have ceased to exist. As for the idea of material, we shall return to that in 4, below.

2. It involves a distinction between planning and execution. The result to be obtained is preconceived or thought out before being arrived at. The craftsman knows what he wants to make before he makes it. This foreknowledge is absolutely indispensable to craft: if something, for example stainless steel, is made without such foreknowledge, the making of it is not a case of craft but an accident. Moreover, this foreknowledge is not vague but precise. If a person sets out to make a table, but conceives the table only vaguely, as somewhere between two by four feet and three by six, and between two and three feet high, and so forth, he is no craftsman.

3. Means and end are related in one way in the process of planning; in the opposite way in the process of execution. In planning the end is prior to the means. The end is thought out first, and afterwards the means are thought out. In execution the means come first, and the end is reached through them.

4. There is a distinction between raw material and finished product or artifact. A craft is always exercised upon something, and aims at the transformation of this into something different. That upon which it works begins as raw material and ends as finished product. The raw material is found ready made before the special work of the craft begins.

From R. G. Collingwood, *The Principles of Art*. New York: Oxford University Press, 1938, pp. 15–41, 109–11, 121–22. Reprinted with permission of Oxford University Press.

5. There is a distinction between form and matter. The matter is what is identical in the raw material and the finished product; the form is what is different, what the exercise of the craft changes. To describe the raw material as raw is not to imply that it is formless, but only that it has not yet the form which it is to acquire through 'transformation' into finished product.

6. There is a hierarchical relation between various crafts, one supplying what another needs, one using what another provides. There are three kinds of hierarchy: of materials, of means, and of parts. (a) The raw material of one craft is the finished product of another. Thus the silviculturist propagates trees and looks after them as they grow, in order to provide raw material for the felling-men who transform them into logs; these are raw material for the saw-mill which transforms them into planks; and these, after a further process of selection and seasoning, become raw material for a joiner. (b) In the hierarchy of means, one craft supplies another with tools. Thus the timber-merchant supplies pit-props to the miner; the miner supplies coal to the blacksmith; the blacksmith supplies horse-shoes to the farmer; and so on. (c) In the hierarchy of parts, a complex operation like the manufacture of a motor-car is parcelled out among a number of trades: one firm makes the engine, another the gears, another the chassis, another the tyres, another the electrical equipment, and so on; the final assembling is not strictly the manufacture of the car but only the bringing together of these parts. In one or more of these ways every craft has a hierarchical character; either as hierarchically related to other crafts, or as itself consisting of various heterogeneous operations hierarchically related among themselves.

Without claiming that these features together exhaust the notion of craft, or that each of them separately is peculiar to it, we may claim with tolerable confidence that where most of them are absent from a certain activity that activity is not a craft, and, if it is called by that name, is so called either by mistake or in a vague and inaccurate way.

§2. The Technical Theory of Art

It was the Greek philosophers who worked out the idea of craft, and it is in their writings that the above distinctions have been expounded once for all. The philosophy of craft, in fact, was one of the greatest and most solid achievements of the Greek mind, or at any rate of that school, from Socrates to Aristotle, whose work happens to have been most completely preserved.

Great discoveries seem to their makers even greater than they are. A person who has solved one problem is inevitably led to apply that solution to others. Once the Socratic school had laid down the main lines of a theory of craft, they were bound to look for instances of craft in all sorts of likely and unlikely places. To show how they met this temptation, here yielding to it and there resisting it, or first yielding to it and then laboriously correcting their error, would need a long essay. Two brilliant cases of successful resistance may, however, be mentioned: Plato's demonstration (*Republic,* 330 D– 336 A) that justice is not a craft, with the pendant (336 E–354 A) that injustice is not one either; and Aristotle's rejection (*Metaphysics,* Λ) of the view stated in Plato's *Timaeus,* that the relation between God and the world is a case of the relation between craftsman and artifact.

When they came to deal with aesthetic problems, however, both Plato and Aristotle yielded to the temptation. They took it for granted that poetry, the only art which they discussed in detail, was a kind of craft, and spoke of this craft as ποιητική τέχνη, poet-craft. What kind of craft was this?

There are some crafts, like cobbling, carpentering, or weaving, whose end is to produce a certain type of artifact; others, like agriculture or stock-breeding or horse-breaking, whose end is to produce or improve certain non-human types of organism; others again, like medicine or education or warfare, whose end is to bring certain human beings into certain states of body or mind. But we need not ask which of these is the genus of which poet-craft is a species, because they are not mutually exclusive. The cobbler or carpenter or weaver is not simply trying to produce shoes or carts or cloth. He produces these because there is a demand for them; that is, they are not ends to him, but means to the end of satisfying a specific demand. What he is really aiming at is the production of a certain state of mind in his customers, the state of having these demands satisfied. The same analysis applies to the second group. Thus in the end these three kinds of craft reduce to one. They are all ways of bringing human beings into certain desired conditions.

The same description is true of poet-craft. The poet is a kind of skilled producer; he produces for consumers; and the effect of his skill is to bring about in them certain states of mind, which are conceived in advance as desirable states. The poet, like any other kind of craftsman, must know what effect he is aiming at, and must learn by experience and precept, which is only the imparted experience of others, how to produce it. This is poet-craft, as conceived by Plato and Aristotle and, following them, such writers as Horace in his *Ars Poetica.*

There will be analogous crafts of painting, sculpture, and so forth; music, at least for Plato, is not a separate art but is a constituent part of poetry.

I have gone back to the ancients, because their thought, in this matter as in so many others, has left permanent traces on our own, both for good and for ill. There are suggestions in some of them, especially in Plato, of a quite different view; but this is the one which they have made familiar, and upon which both the theory and the practice of the arts has for the most part rested down to the present time. Present-day fashions of thought have in some ways even tended to reinforce it. We are apt nowadays to think about most problems, including those of art, in terms either of economics or of psychology; and both ways of thinking tend to subsume the philosophy of art under the philosophy of craft. To the economist, art presents the appearance of a specialized group of industries; the artist is a producer, his audience consumers who pay him for benefits ultimately definable in terms of the states of mind which his productivity enables them to enjoy. To the psychologist, the audience consists of persons reacting in certain ways to stimuli provided by the artist; and the artist's business is to know what reactions are desired or desirable, and to provide the stimuli which will elicit them.

The technical theory of art is thus by no means a matter of merely antiquarian interest. It is actually the way in which most people nowadays think of art; and especially economists and psychologists, the people to whom we look (sometimes in vain) for special guidance in the problems of modern life.

But this theory is simply a vulgar error, as anybody can see who looks at it with a critical eye. It does not matter what kind of craft in particular is identified with art. It does not matter what the benefits are which the artist is regarded as conferring on his audience, or what the reactions are which he is supposed to elicit. Irrespectively of such details, our question is whether art is any kind of craft at all. It is easily answered by keeping in mind the half-dozen characteristics of craft enumerated in the preceding section, and asking whether they fit the case of art. And there must be no chopping of toes or squeezing of heels; the fit must be immediate and convincing. It is better to have no theory of art at all, than to have one which irks us from the first.

§3. Break-down of the Theory

1. The first characteristic of craft is the distinction between means and end. Is this present in works of art? According to the technical theory, yes. A poem is means to the production of a certain state of mind in the audience, as a horseshoe is means to the production of a certain state of mind in the man whose horse is shod. And the poem in its turn will be an end to which other things are means. In the case of the horseshoe, this stage of the analysis is easy: we can enumerate lighting the forge, cutting a piece of iron off a bar, heating it, and so on. What is there analogous to these processes in the case of a poem? The poet may get paper and pen, fill the pen, sit down and square his elbows; but these actions are preparatory not to composition (which may go on in the poet's head) but to writing. Suppose the poem is a short one, and composed without the use of any writing materials; what are the means by which the poet composes it? I can think of no answer, unless comic answers are wanted, such as 'using a rhyming dictionary,' 'pounding his foot on the floor or wagging his head or hand to mark the metre,' or 'getting drunk.' If one looks at the matter seriously, one sees that the only factors in the situation are the poet, the poetic labour of his mind, and the poem. And if any supporter of the technical theory says 'Right: then the poetic labour is the means, the poem the end,' we shall ask him to find a blacksmith who can make a horseshoe by sheer labour, without forge, anvil, hammer, or tongs. It is because nothing corresponding to these exists in the case of the poem that the poem is not an end to which there are means.

Conversely, is a poem means to the production of a certain state of mind in an audience? Suppose a poet had read his verses to an audience, hoping that they would produce a certain result; and suppose the result were different; would that in itself prove the poem a bad one? It is a difficult question; some would say yes, others no. But if poetry were obviously a craft, the answer would be a prompt and unhesitating yes. The advocate of the technical theory must do a good deal of toe-chopping before he can get his facts to fit his theory at this point.

So far, the prospects of the technical theory are not too bright. Let us proceed.

2. The distinction between planning and executing certainly exists in some works of art, namely those which are also works of craft or artifacts; for there is, of course, an overlap between these two things, as may be seen by the example of a building or a jar, which is made to order for the satisfaction of a specific demand, to serve a useful purpose, but may none the less be a work of art. But suppose a poet were making up verses as he walked; suddenly finding a line in his head, and then another, and then dissatisfied with them and altering them until he had got them to his liking: what is the plan which he is executing? He may have had a vague idea that if he went for a walk he would be able to compose

poetry; but what were, so to speak, the measurements and specifications of the poem he planned to compose? He may, no doubt, have been hoping to compose a sonnet on a particular subject specified by the editor of a review; but the point is that he may not, and that he is none the less a poet for composing without having any definite plan in his head. Or suppose a sculptor were not making a Madonna and child, three feet high, in Hoptonwood stone, guaranteed to placate the chancellor of the diocese and obtain a faculty for placing it in the vacant niche over a certain church door; but were simply playing about with clay, and found the clay under his fingers turning into a little dancing man: is this not a work of art because it was done without being planned in advance?

All this is very familiar. There would be no need to insist upon it, but that the technical theory of art relies on our forgetting it. While we are thinking of it, let us note the importance of not over-emphasizing it. Art as such does not imply the distinction between planning and execution. But (a) this is a merely negative characteristic, not a positive one. We must not erect the absence of plan into a positive force and call it inspiration, or the unconscious, or the like. (b) It is a permissible characteristic of art, not a compulsory one. If unplanned works of art are possible, it does not follow that no planned work is a work of art. That is the logical fallacy[1] that underlies one, or some, of the various things called romanticism. It may very well be true that the only works of art which can be made altogether without a plan are trifling ones, and that the greatest and most serious ones always contain an element of planning and therefore an element of craft. But that would not justify the technical theory of art.

3. If neither means and end nor planning and execution can be distinguished in art proper, there obviously can be no reversal of order as between means and end, in planning and execution respectively.

4. We next come to the distinction between raw material and finished product. Does this exist in art proper? If so, a poem is made out of certain raw material. What is the raw material out of which Ben Jonson made *Queene and Huntresse, chaste, and faire?* Words, perhaps. Well, what words? A smith makes a horseshoe not out of all the iron there is, but out of a certain piece of iron, cut off a certain bar that he keeps in the corner of the smithy. If Ben Jonson did anything at all like that, he said: 'I want to make a nice little hymn to open Act v, Scene vi of *Cynthia's Revels.* Here is the English language, or as much of it as I know; I will use *thy* five times, *to* four times, *and, bright, excellently,* and *goddesse* three times each, and so on.' He did nothing like this. The words which occur in the poem were

never before his mind as a whole in an order different from that of the poem, out of which he shuffled them till the poem, as we have it, appeared. I do not deny that by sorting out the words, or the vowel sounds, or the consonant sounds, in a poem like this, we can make interesting and (I believe) important discoveries about the way in which Ben Jonson's mind worked when he made the poem; and I am willing to allow that the technical theory of art is doing good service if it leads people to explore these matters; but if it can only express what it is trying to do by calling these words or sounds the materials out of which the poem is made, it is talking nonsense.

But perhaps there is a raw material of another kind: a feeling or emotion, for example, which is present to the poet's mind at the commencement of his labour, and which that labour converts into the poem. 'Aus meinem grossen Schmerzen mach' ich die kleinen Lieder,' said Heine; and he was doubtless right; the poet's labour can be justly described as converting emotions into poems. But this conversion is a very different kind of thing from the conversion of iron into horseshoes. If the two kinds of conversion were the same, a blacksmith could make horseshoes out of his desire to pay the rent. The something more, over and above that desire, which he must have in order to make horseshoes out of it, is the iron which is their raw material. In the poet's case that something more does not exist.

5. In every work of art there is something which, in some sense of the word, may be called form. There is, to be rather more precise, something in the nature of rhythm, pattern, organization, design, or structure. But it does not follow that there is a distinction between form and matter. Where that distinction does exist, namely, in artifacts, the matter was there in the shape of raw material before the form was imposed upon it, and the form was there in the shape of a preconceived plan before being imposed upon the matter; and as the two coexist in the finished product we can see how the matter might have accepted a different form, or the form have been imposed upon a different matter. None of these statements applies to a work of art. Something was no doubt there before a poem came into being; there was, for example, a confused excitement in the poet's mind; but, as we have seen, this was not the raw material of the poem. There was also, no doubt, the impulse to write; but this impulse was not the form of the unwritten poem. And when the poem is written, there is nothing in it of which we can say, 'this is a matter which might have taken on a different form,' or 'this is a form which might have been realized in a different matter.'

When people have spoken of matter and form in connexion with art, or of that strange hybrid dis-

tinction, form and content, they have in fact been doing one of two things, or both confusedly at once. Either they have been assimilating a work of art to an artifact, and the artist's work to the craftsman's; or else they have been using these terms in a vaguely metaphorical way as means of referring to distinctions which really do exist in art, but are of a different kind. There is always in art a distinction between what is expressed and that which expresses it; there is a distinction between the initial impulse to write or paint or compose and the finished poem or picture or music; there is a distinction between an emotional element in the artist's experience and what may be called an intellectual element. All these deserve investigation; but none of them is a case of the distinction between form and matter.

6. Finally, there is in art nothing which resembles the hierarchy of crafts, each dictating ends to the one below it, and providing either means or raw materials or parts to the one above. When a poet writes verses for a musician to set, these verses are not means to the musician's end, for they are incorporated in the song which is the musician's finished product, and it is characteristic of means, as we saw, to be left behind. But neither are they raw materials. The musician does not transform them into music; he set them to music; and if the music which he writes for them had a raw material (which it has not), that raw material could not consist of verses. What happens is rather that the poet and musician collaborate to produce a work of art which owes something to each of them; and this is true even if in the poet's case there was no intention of collaborating.

Aristotle extracted from the notion of a hierarchy of crafts the notion of a supreme craft, upon which all hierarchical series converged, so that the various 'goods' which all crafts produce played their part, in one way or another, in preparing for the work of this supreme craft, whose product could, therefore, be called the 'supreme good.'[2] At first sight, one might fancy an echo of this in Wagner's theory of opera as the supreme art, supreme because it combines the beauties of music and poetry and drama, the arts of time and the arts of space, into a single whole. But, quite apart from the question whether Wagner's opinion of opera as the greatest of the arts is justified, this opinion does not really rest on the idea of a hierarchy of arts. Words, gestures, music, scenery are not means to opera, nor yet raw materials of it, but parts of it; the hierarchies of means and materials may therefore be ruled out, and only that of parts remains. But even this does not apply. Wagner thought himself a supremely great artist because he wrote not only his music but his words, designed his scenery, and acted as his own producer. This is the exact opposite of a

system like that by which motorcars are made, which owes its hierarchical character to the fact that the various parts are all made by different firms, each specializing in work of one kind.

§4. Technique

As soon as we take the notion of craft seriously, it is perfectly obvious that art proper cannot be any kind of craft. Most people who write about art today seem to think that it is some kind of craft; and this is the main error against which a modern aesthetic theory must fight. Even those who do not openly embrace the error itself, embrace doctrines implying it. One such doctrine is that of artistic technique.

The doctrine may be stated as follows. The artist must have a certain specialized form of skill, which is called technique. He acquires his skill just as a craftsman does, partly through personal experience and partly through sharing in the experience of others who thus become his teachers. The technical skill which he thus acquires does not by itself make him an artist; for a technician is made, but an artist is born. Great artistic powers may produce fine works of art even though technique is defective; and even the most finished technique will not produce the finest sort of work in their absence; but all the same, no work of art whatever can be produced without some degree of technical skill, and, other things being equal, the better the technique the better will be the work of art. The greatest artistic powers, for their due and proper display, demand a technique as good in its kind as they are in their own.

All this, properly understood, is very true; and, as a criticism of the sentimental notion that works of art can be produced by any one, however little trouble he has taken to learn his job, provided his heart is in the right place, very salutary. And since a writer on art is for the most part addressing himself not to artists, but to amateurs of art, he does well to insist on what every artist knows, but most amateurs do not: the vast amount of intelligent and purposeful labour, the painful and conscientious self-discipline, that has gone to the making of a man who can write a line as Pope writes it, or knock a single chip off a single stone like Michelangelo. It is no less true, and no less important, that the skill here displayed (allowing the word skill to pass for the moment unchallenged), though a necessary condition of the best art, is not by itself sufficient to produce it. A high degree of such skill is shown in Ben Jonson's poem; and a critic might, not unfruitfully, display this skill by analysing the intricate and ingenious patterns of rhythm and rhyme, alliteration, assonance, and dissonance, which the poem con-

tains. But what makes Ben Jonson a poet, and a great one, is not his skill to construct such patterns but his imaginative vision of the goddess and her attendants, for whose expression it was worth his while to use that skill, and for whose enjoyment it is worth our while to study the patterns he has constructed. Miss Edith Sitwell, whose distinction both as poet and critic needs no commendation, and whose analyses of sound-pattern in poetry are as brilliant as her own verse, has analysed in this way the patterns constructed by Mr. T. S. Eliot, and has written warmly of the skill they exemplify; but when she wishes conclusively to compare his greatness with the littleness of certain other poets who are sometimes ridiculously fancied his equals, she ceases to praise his technique, and writes, 'here we have a man who has talked with fiery angels, and with angels of a clear light and holy peace, and who has "walked amongst the lowest of the dead."'[3] It is this experience, she would have us understand, that is the heart of his poetry; it is the 'enlargement of our experience' by his own (a favourite phrase of hers, and one never used without illumination to her readers) that tells us he is a true poet; and however necessary it may be that a poet should have technical skill, he is a poet only in so far as this skill is not identified with art, but with something used in the service of art.

This is not the old Greco-Roman theory of poet-craft, but a modified and restricted version of it. When we examine it, however, we shall find that although it has moved away from the old poet-craft theory in order to avoid its errors, it has not moved far enough.

When the poet is described as possessing technical skill, this means that he possesses something of the same nature as what goes by that name in the case of a technician proper or craftsman. It implies that the thing so called in the case of a poet stands to the production of his poem as the skill of a joiner stands to the production of a table. If it does not mean this, the words are being used in some obscure sense; either an esoteric sense which people who use them are deliberately concealing from their readers, or (more probably) a sense which remains obscure even to themselves. We will assume that the people who use this language take it seriously, and wish to abide by its implications.

The craftman's skill is his knowledge of the means necessary to realize a given end, and his mastery of these means. A joiner making a table shows his skill by knowing what materials and what tools are needed to make it, and being able to use these in such a way as to produce the table exactly as specified.

The theory of poetic technique implies that in the first place a poet has certain experiences which demand expression; then he conceives the possibility of a poem in which they might be expressed; then this poem, as an unachieved end, demands for its realization the exercise of certain powers or forms of skill, and these constitute the poet's technique. There is an element of truth in this. It is true that the making of a poem begins in the poet's having an experience which demands expression in the form of a poem. But the description of the unwritten poem as an end to which his technique is means is false; it implies that before he has written his poem he knows, and could state, the specification of it in the kind of way in which a joiner knows the specification of a table he is about to make. This is always true of a craftsman; it is therefore true of an artist in those cases where the work of art is also a work of craft. But it is wholly untrue of the artist in those cases where the work of art is not a work of craft; the poet extemporizing his verses, the sculptor playing with his clay, and so forth. In these cases (which after all are cases of art, even though possibly of art at a relatively humble level) the artist has no idea what the experience is which demands expression until he has expressed it. What he wants to say is not present to him as an end towards which means have to be devised; it becomes clear to him only as the poem takes shape in his mind, or the clay in his fingers. . . .

In describing the power by which an artist constructs patterns in words or notes or brush-marks by the name of technique, therefore, this theory is misdescribing it by assimilating it to the skill by which a craftsman constructs appropriate means to a preconceived end. The patterns are no doubt real; the power by which the artist constructs them is no doubt a thing worthy of our attention; but we are only frustrating our study of it in advance if we approach it in the determination to treat it as if it were the conscious working-out of means to the achievement of a conscious purpose, or in other words technique.

§5. Art as a Psychological Stimulus

The modern conception of artistic technique, as stated or implied in the writings of critics, may be unsuccessful; but it is a serious attempt to overcome the weaknesses of the old poet-craft theory, by admitting that a work of art as such is not an artifact, because its creation involves elements which cannot be subsumed under the conception of craft; while yet maintaining that there is a grain of truth in that theory, because among the elements involved in the creation of a work of art there is one which can be thus subsumed, namely, the artist's technique. We have seen that this will not do; but

at least the people who put it forward have been working at the subject.

The same cannot be said about another attempt to rehabilitate the technical theory of art, namely, that of a very large school of modern psychologists, and of critics who adopt their way of speaking. Here the entire work of art is conceived as an artifact, designed (when a sufficient degree of skill is present to justify the word) as means to the realization of an end beyond it, namely, a state of mind in the artist's audience. In order to affect his audience in a certain way, the artist addresses them in a certain manner, by placing before them a certain work of art. In so far as he is a competent artist, one condition at least is fulfilled: the work of art does affect them as he intends it should. There is a second condition which may be fulfilled: the state of mind thus aroused in them may be in one way or another a valuable state of mind; one that enriches their lives, and thus gives him a claim not only on their admiration but also on their gratitude.

The first thing to notice about this stimulus-and-reaction theory of art is that it is not new. It is the theory of the tenth book of Plato's *Republic,* of Aristotle's *Poetics,* and of Horace's *Ars Poetica.* The psychologists who make use of it have, knowingly or unknowingly, taken over the poet-craft doctrine bodily, with no suspicion of the devastating criticism it has received at the hands of aestheticians in the last few centuries.

This is not because their views have been based on a study of Plato and Aristotle, to the neglect of more modern authors. It is because, like good inductive scientists, they have kept their eye on the facts, but (a disaster against which inductive methods afford no protection) the wrong facts. Their theory of art is based on a study of art falsely so called.

There are numerous cases in which somebody claiming the title of artist deliberately sets himself to arouse certain states of mind in his audience. The funny man who lays himself out to get a laugh has at his command a number of well-tried methods for getting it; the purveyor of sob-stuff is in a similar case; the political or religious orator has a definite end before him and adopts definite means for achieving it, and so on. We might even attempt a rough classification of these ends.[4] First, the 'artist's' purpose may be to arouse a certain kind of emotion. The emotion may be of almost any kind; a more important distinction emerges according as it is aroused simply for its own sake, as an enjoyable experience, or for the sake of its value in the affairs of practical life. The funny man and the sob-stuff monger fall on one side in this division, the political and religious orator on the other. Secondly, the purpose may be to stimulate certain intellectual activities. These again may be of very various kinds, but

they may be stimulated with either of two motives: either because the objects upon which they are directed are thought of as worth understanding, or because the activities themselves are thought of as worth pursuing, even though they lead to nothing in the way of knowledge that is of importance. Thirdly, the purpose may be to stimulate a certain kind of action; here again with two kinds of motive: either because the action is conceived as expedient, or because it is conceived as right.

Here are six kinds of art falsely so called; called by that name because they are kinds of craft in which the practitioner can by the use of his skill evoke a desired psychological reaction in his audience, and hence they come under the obsolete, but not yet dead and buried, conception of poet-craft, painter-craft, and so forth; falsely so called, because the distinction of means and end, upon which every one of them rests, does not belong to art proper.

Let us give the six their right names. Where an emotion is aroused for its own sake, as an enjoyable experience, the craft of arousing it is amusement; where for the sake of its practical value, magic.... Where intellectual faculties are stimulated for the mere sake of their exercise, the work designed to stimulate them is a puzzle; where for the sake of knowing this or that thing, it is instruction. Where a certain practical activity is stimulated as expedient, that which stimulates it is advertisement or (in the current modern sense, not the old sense) propaganda; where it is stimulated as right, exhortation.

These six between them, singly or in combination, pretty well exhaust the function of whatever in the modern world wrongfully usurps the name of art. None of them has anything to do with art proper. This is not because (as Oscar Wilde said, with his curious talent for just missing a truth and then giving himself a prize for hitting it) 'all art is quite useless', for it is not; a work of art may very well amuse, instruct, puzzle, exhort, and so forth, without ceasing to be art, and in these ways it may be very useful indeed. It is because, as Oscar Wilde perhaps meant to say, what makes it art is not the same as what makes it useful. Deciding what psychological reaction a so-called work of art produces (for example, asking yourself how a certain poem 'makes you feel') has nothing whatever to do with deciding whether it is a real work of art or not. Equally irrelevant is the question what psychological reaction it is meant to produce.

The classification of psychological reactions produced by poems, pictures, music, or the like is thus not a classification of kinds of art. It is a classification of kinds of pseudo-art. But the term 'pseudo-art' means something that is not art but is mistaken for art; and something that is not art can be mistaken for it only if there is some ground for the mis-

take: if the thing mistaken for art is akin to art in such a way that the mistake easily arises. What must this kinship be? . . . There may be a combination of, for example, art with religion, of such a kind that the artistic motive, though genuinely present, is subordinated to the religious. To call the result of such a combination art, *tout court,* would be to invite the reply, 'it is not art but religion'; that is, the accusation that what is simply religion is being mistaken for art. But such a mistake could never in fact be made. What happens is that a combination of art and religion is elliptically called art, and then characteristics which it possesses not as art but as religion are mistakenly supposed to belong to it as art.

So here. These various kinds of pseudo-art are in reality various kinds of use to which art may be put. In order that any of these purposes may be realized, there must first be art, and then a subordination of art to some utilitarian end. Unless a man can write, he cannot write propaganda. Unless he can draw, he cannot become a comic draughtsman or an advertisement artist. These activities have in every case developed through a process having two phases. First, there is writing or drawing or whatever it may be, pursued as an art for its own sake, going its own way and developing its own proper nature, caring for none of these things. Then this independent and self-sufficient art is broken, as it were, to the plough, forced aside from its own original nature and enslaved to the service of an end not its own. Here lies the peculiar tragedy of the artist's position in the modern world. He is heir to a tradition from which he has learnt what art should be; or at least, what it cannot be. He has heard its call and devoted himself to its service. And then, when the time comes for him to demand of society that it should support him in return for his devotion to a purpose which, after all, is not his private purpose but one among the purposes of modern civilization, he finds that his living is guaranteed only on condition that he renounces his calling and uses the art which he has acquired in a way which negates its fundamental nature, by turning journalist or advertisement artist or the like; a degradation far more frightful than the prostitution or enslavement of the mere body.

Even in this denatured condition the arts are never mere means to the ends imposed upon them. For means rightly so called are devised in relation to the end aimed at; but here, there must first be literature, drawing, and so forth, before they can be turned to the purposes described. Hence it is a fundamental and fatal error to conceive art itself as a means to any of these ends, even when it is broken to their service. It is an error much encouraged by modern tendencies in psychology, and influentially

taught at the present day by persons in a position of academic authority; but after all, it is only a new version, tricked out in the borrowed plumage of modern science, of the ancient fallacy that the arts are kinds of craft.

If it can deceive even its own advocates, that is only because they waver from one horn of a dilemma to the other. Their theory admits of two alternatives. Either the stimulation of certain reactions in its audience is the essence of art, or it is a consequence arising out of its essence in certain circumstances. Take the first alternative. If art is art only so far as it stimulates certain reactions, the artist as such is simply a purveyor of drugs, noxious or wholesome; what we call works of art are nothing but a section of the Pharmacopoeia.[5] If we ask on what principle that branch can be distinguished from others, there can be no answer.

This is not a theory of art. It is not an aesthetic but an anti-aesthetic. If it is presented as a true account of its advocates' experience, we must accept it as such; but with the implication that its advocates have no aesthetic experience whatever, or at least none so robust as to leave a mark on their minds deep enough to be discernible when they turn their eyes inward and try to recognize its main features.[6] It is, of course, quite possible to look at pictures, listen to music, and read poetry without getting any aesthetic experience from these things; and the exposition of this psychological theory of art may be illustrated by a great deal of talk about particular works of art; but if this is really connected with the theory, it is no more to be called art-criticism or aesthetic theory than the annual strictures in *The Tailor and Cutter* on the ways in which Academy portrait-painters represent coats and trousers. If it attempts to develop itself as a method of art-criticism, it can only (except when it forgets its own principles) rely on anti-aesthetic standards, as when it tries to estimate the objective merits of a given poem by tabulating the 'reactions' to it of persons from whom the poet's name has been concealed, irrespective of their skill or experience in the difficult business of criticizing poetry; or by the number of emotions, separately capable of being recorded by the psychologist and severally regarded by him as valuable, which it evokes in a single hearer.

On this horn of the dilemma art disappears altogether. The alternative possibility is that the stimulating of certain reactions should be regarded not as the essence of art but as a consequence arising in certain conditions out of the nature of that essence. In that case, art survives the analysis, but only at the cost of making it irrelevant, as a pharmacologist's account of the effect of a hitherto unanalysed drug would be irrelevant to the question of its chemical

composition. Granted that works of art in certain conditions do stimulate certain reactions in their audience, which is a fact; and granted that they do so not because of something other than their nature as works of art, but because of that nature itself, which is an error; it will even so not follow that light is thrown on that nature itself by the study of these reactions.

Psychological science has in fact done nothing towards explaining the nature of art, however much it has done towards explaining the nature of certain elements of human experience with which it may from time to time be associated or confused. The contribution of psychology to pseudo-aesthetic is enormous; to aesthetic proper it is nil.

§6. Fine Art and Beauty

The abandonment of the technical theory of art involves the abandonment of a certain terminology, which consists in describing art proper by the name of 'fine art'. This terminology implies that there is a genus art, divided into two species, the 'useful arts' and the 'fine arts'. The 'useful arts' are crafts like metallurgy, weaving, pottery, and so forth; that is, the phrase means 'arts (i.e., crafts) devoted to making what is useful'. This implies that the genus art is conceived as craft, and that the phrase 'fine arts' means 'crafts devoted to making what is fine, i.e. beautiful.' That is to say, the terminology in question is intended to commit any one who uses it to the technical theory of art.

Happily, the term 'fine art', except in a few archaic phrases, is obsolete; but whether this is due to a general repudiation of the ideas it expresses, or only to the convenience of abbreviating it into 'art,' is not so clear. Some of those ideas, at any rate, do not seem to have died out; and it would be well to look into them here.

1. The phrase implies that art and manufacture, to use current modern equivalents for the old terms 'fine arts' and 'useful arts,' are species of one genus: both essentially activities productive of artifacts, but differing in the qualities which these artifacts are meant to possess. This is an error which must be eradicated from our minds with all possible care. In doing this we must disabuse ourselves of the notion that the business of an artist consists in producing a special kind of artifacts, so-called 'works of art' or *objets d'art*, which are bodily and perceptible things (painted canvasses, carved stones, and so forth). This notion is nothing more nor less than the technical theory of art itself. We shall have, later on, to consider in some detail what it is that the artist, as such and essentially, produces. We shall find that it is two things. Primarily, it is an 'internal' or 'men-

tal' thing, something (as we commonly say) 'existing in his head' and there only: something of the kind which we commonly call an experience. Secondarily, it is a bodily or perceptible thing (a picture, statue, &c.) whose exact relation to this 'mental' thing will need very careful definition. Of these two things, the first is obviously not anything that can be called a work of art, if work means something made in the sense in which a weaver makes cloth. But since it is the thing which the artist as such primarily produces, I shall argue that we are entitled to call it 'the work of art proper'. The second thing, the bodily and perceptible thing, I shall show to be only incidental to the first. The making of it is therefore not the activity in virtue of which a man is an artist, but only a subsidiary activity, incidental to that. And consequently this thing is a work of art, not in its own right, but only because of the relation in which it stands to the 'mental' thing or experience of which I spoke just now. There is no such thing as an *objet d'art* in itself; if we call any bodily and perceptible thing by that name or an equivalent we do so only because of the relation in which it stands to the aesthetic experience which is the 'work of art proper.'

2. The phrase 'fine art' further implies that the bodily or perceptible work of art has a peculiarity distinguishing it from the products of useful art, viz. beauty. This is a conception which has become very much distorted in the course of many centuries' speculation on aesthetic theory, and we must try to get it straight. The word does not belong to the English language as such, but to the common speech of European civilization (*le beau, il bello, bellum*; the last used as an equivalent of τὸ καλόν). If we go back to the Greek, we find that there is no connexion at all between beauty and art. Plato has a lot to say about beauty, in which he is only systematizing what we find implied in the ordinary Greek use of the word. The beauty of anything is, for him, that in it which compels us to admire and desire it: τὸ καλόν is the proper object of ἔρως, 'love.' The theory of beauty is thus, in Plato, connected not with the theory of poetry or any other art, but primarily with the theory of sexual love, secondly with the theory of morals (as that for the sake of which we act when action is at its highest potency; and Aristotle similarly, of a noble action, says that it is done 'for beauty's sake,' τοῦ καλοῦ ἕνεκα), and thirdly with the theory of knowledge, as that which lures us onward in the path of philosophy, the quest of truth. To call a thing beautiful in Greek, whether ordinary or philosophical Greek, is simply to call it admirable or excellent or desirable. A poem or painting may certainly receive the epithet, but only by the same kind of right as a boot or any other simple artifact. The sandals of Hermes, for example, are

regularly called beautiful by Homer, not because they are conceived as elegantly designed or decorated, but because they are conceived as jolly good sandals which enable him to fly as well as walk.

In modern times there has been a determined attempt on the part of aesthetic theorists to monopolize the word and make it stand for that quality in things in virtue of which when we contemplate them we enjoy what we recognize as an aesthetic experience. There is no such quality; and the word, which is a perfectly respectable word in current usage, means not what the aesthetic theorists want it to mean but something quite different and much more like what τὸ καλόν means in Greek. I shall deal with these points in the reverse order.

a. The words 'beauty,' 'beautiful,' as actually used, have no aesthetic implication. We speak of a beautiful painting or statue, but this only means an admirable or excellent one. Certainly the total phrase 'a beautiful statue' conveys an implication of aesthetic excellence, but the aesthetic part of this implication is conveyed not by the word 'beautiful' but by the word 'statue.' The word 'beautiful' is used in such a case no otherwise than as it is used in such phrases as 'a beautiful demonstration' in mathematics or 'a beautiful stroke' at billiards. These phrases do not express an aesthetic attitude in the person who uses them towards the stroke or the demonstration; they express an attitude of admiration for a thing well done, irrespective of whether that thing is an aesthetic activity, an intellectual activity, or a bodily activity.

We speak of things as beautiful, with no less frequency and no less accuracy, when their excellence is one that appeals only to our senses: a beautiful saddle of mutton or a beautiful claret. Or when their excellence is that of well-devised and well-made means to an end: a beautiful watch or a beautiful theodolite. When we speak of natural things as beautiful, it may, of course, be with reference to the aesthetic experiences which we sometimes enjoy in connexion with them; for we do enjoy such experiences in connexion with natural objects, as we enjoy them in connexion with *objets d'art,* and, I think, enjoy them in both cases in precisely the same way. But it need not be with reference to aesthetic experience; it may equally well be with reference to the satisfaction of some desire or the arousing of some emotion. A beautiful woman ordinarily means one whom we find sexually desirable; a beautiful day, one which gives us the kind of weather we need for some purpose or other, or just for some reason like; a beautiful sunset or a beautiful night, one that fills us with certain emotions, and we have seen that such emotional reactions have nothing to do with aesthetic merit. The question was acutely raised by Kant, how far our attitude towards the

song of a bird is an aesthetic one, and how far it is a feeling of sympathy towards a little fellow creature. Certainly we often call our fellow creatures beautiful by way of saying that we love them, and that not only sexually. The bright eyes of a mouse or the fragile vitality of a flower are things that touch us to the heart, but they touch us with the love that life feels for life, not with a judgement of their aesthetic excellence. A very great deal of what we express by calling natural things beautiful has nothing whatever to do with aesthetic experience. It has to do with that other kind of experience which Plato called ἔρως.

Modern aestheticians who want to connect the idea of beauty with the idea of art will say to all this either that the word is 'correctly' used when it is used in connexion with aesthetic experience and 'incorrectly' on other occasions, or that it is 'ambiguous', having both an aesthetic use and a non-aesthetic. Neither position is tenable. The first is one of those all too frequent attempts on the part of philosophers to justify their own misuse of a word by ordering others to misuse it in the same way. We ought not, they say, to call a grilled steak beautiful. But why not? Because they want us to let them monopolize the word for their own purposes. Well, it does not matter to anybody but themselves, because nobody will obey them. But it matters to themselves, because the purpose for which they want it, as we shall see in the next paragraph, is to talk nonsense. The second alternative is simply untrue. There is no ambiguity. The word 'beauty,' wherever and however it is used, connotes that in things by virtue of which we love them, admire them, or desire them.

b. When these aestheticians want to use the word as a name for the quality in things by virtue of which we enjoy an aesthetic experience in connexion with them, they want to use it as a name for something non-existent. There is no such quality. The aesthetic experience is an autonomous activity. It arises from within; it is not a specific reaction to a stimulus proceeding from a specific type of external object. Some of those who want to use the word 'beauty' in this way are quite aware of this, and indeed preach it as a doctrine under the name of the subjectivity of beauty; not realizing that if this doctrine is accepted their own motive for wresting the word 'beauty' from its proper sense disappears. For to say that beauty is subjective means that the aesthetic experiences which we enjoy in connexion with certain things arise not from any quality that they possess, which if they did possess it would be called beauty, but from our own aesthetic activity.

To sum up: aesthetic theory is the theory not of beauty but of art. The theory of beauty, if instead of being brought (as it rightly was by Plato) into con-

nexion with the theory of love it is brought into connexion with aesthetic theory, is merely an attempt to construct an aesthetic on a 'realistic' basis, that is, to explain away the aesthetic activity by appeal to a supposed quality of the things with which, in that experience, we are in contact; this supposed quality, invented to explain the activity, being in fact nothing but the activity itself, falsely located not in the agent but in his external world. . . .

Since the artist proper has something to do with emotion, and what he does with it is not to arouse it, what is it that he does? . . . [T]he kind of answer we expect to this question is an answer derived from what we all know and all habitually say; nothing original or recondite, but something entirely commonplace.

Nothing could be more entirely commonplace than to say he expresses them. The idea is familiar to every artist, and to every one else who has any acquaintance with the arts. To state it is not to state a philosophical theory or definition of art; it is to state a fact or supposed fact about which, when we have sufficiently identified it, we shall have later to theorize philosophically. For the present it does not matter whether the fact that is alleged, when it is said that the artist expresses emotion, is really a fact or only supposed to be one. Whichever it is, we have to identify it, that is, to decide what it is that people are saying when they use the phrase. Later on, we shall have to see whether it will fit into a coherent theory.

They are referring to a situation, real or supposed, of a definite kind. When a man is said to express emotion, what is being said about him comes to this. At first, he is conscious of having an emotion, but not conscious of what this emotion is. All he is conscious of is a perturbation or excitement, which he feels going on within him, but of whose nature he is ignorant. While in this state, all he can say about his emotion is: 'I feel . . . I don't know what I feel.' From this helpless and oppressed condition he extricates himself by doing something which we call expressing himself. This is an activity which has something to do with the thing we call language: he expresses himself by speaking. It has also something to do with consciousness: the emotion expressed is an emotion of whose nature the person who feels it is no longer unconscious. It has also something to do with the way in which he feels the emotion. As unexpressed, he feels it in what we have called a helpless and oppressed way; as expressed, he feels it in a way from which this sense of oppression has vanished. His mind is somehow lightened and eased.

This lightening of emotions which is somehow connected with the expression of them has a certain resemblance to the 'catharsis' by which emotions are earthed through being discharged into a make-believe situation; but the two things are not the same. Suppose the emotion is one of anger. If it is effectively earthed, for example by fancying oneself kicking some one down stairs, it is thereafter no longer present in the mind as anger at all: we have worked it off and are rid of it. If it is expressed, for example by putting it into hot and bitter words, it does not disappear from the mind; we remain angry; but instead of the sense of oppression which accompanies an emotion of anger not yet recognized as such, we have that sense of alleviation which comes when we are conscious of our own emotion as anger, instead of being conscious of it only as an unidentified perturbation. This is what we refer to when we say that it 'does us good' to express our emotions.

The expression of an emotion by speech may be addressed to some one; but if so it is not done with the intention of arousing a like emotion in him. If there is any effect which we wish to produce in the hearer, it is only the effect which we call making him understand how we feel. But, as we have already seen, this is just the effect which expressing our emotions has on ourselves. It makes us, as well as the people to whom we talk, understand how we feel. A person arousing emotion sets out to affect his audience in a way in which he himself is not necessarily affected. He and his audience stand in quite different relations to the act, very much as physician and patient stand in quite different relations towards a drug administered by the one and taken by the other. A person expressing emotion, on the contrary, is treating himself and his audience in the same kind of way; he is making his emotions clear to his audience, and that is what he is doing to himself.

It follows from this that the expression of emotion, simply as expression, is not addressed to any particular audience. It is addressed primarily to the speaker himself, and secondarily to any one who can understand. Here again, the speaker's attitude towards his audience is quite unlike that of a person desiring to arouse in his audience a certain emotion. If that is what he wishes to do, he must know the audience he is addressing. He must know what type of stimulus will produce the desired kind of reaction in people of that particular sort; and he must adapt his language to his audience in the sense of making sure that it contains stimuli appropriate to their peculiarities. If what he wishes to do is to express his emotions intelligibly, he has to express them in such a way as to be intelligible to himself; his audience is then in the position of persons who overhear[1] him doing this. Thus the stimulus-and-reaction terminology has no applicability to the situation.

The means-and-end, or technique, terminology too is inapplicable. Until a man has expressed his emotion, he does not yet know what emotion it is. The act of expressing it is therefore an exploration of his own emotions. He is trying to find out what these emotions are. There is certainly here a directed process: an effort, that is, directed upon a certain end; but the end is not something foreseen and preconceived, to which appropriate means can be thought out in the light of our knowledge of its special character. Expression is an activity of which there can be no technique. . . .

Finally, the expressing of emotion must not be confused with what may be called the betraying of it, that is, exhibiting symptoms of it. When it is said that the artist in the proper sense of that word is a person who expresses his emotions, this does not mean that if he is afraid he turns pale and stammers; if he is angry he turns red and bellows; and so forth. These things are no doubt called expressions; but just as we distinguish proper and improper senses of the word 'art', so we must distinguish proper and improper senses of the word 'expression,' and in the context of a discussion about art this sense of expression is an improper sense. The characteristic mark of expression proper is lucidity or intelligibility; a person who expresses something thereby becomes conscious of what it is that he is expressing, and enables others to become conscious of it in himself and in them.

Notes

1. It is an example of what I have elsewhere called the fallacy of precarious margins. Because art and craft overlap, the essence of art is sought not in the positive characteristics of all art, but in the characteristics of those works of art which are not works of craft. Thus the only things which are allowed to be works of art are those marginal examples which lie outside the overlap of art and craft. This is a precarious margin because further study may at any moment reveal the characteristics of craft in some of these examples. See *Essay on Philosophical Method.*

2. *Nicomachean Ethics,* beginning: 1094 a 1–b 10.

3. *Aspects of Modern Poetry,* chap. 5 and p. 251.

4. The reason why I call it a rough classification is because you cannot really 'stimulate intellectual activities', or 'stimulate certain kinds of action', in a man. Anybody who says you can, has not thought about the conditions under which alone these things can arise. Foremost among these conditions is this: that they must be absolutely spontaneous. Consequently they cannot be responses to stimulus.

5. Cf. D. G. James, *Scepticism and Poetry* (1937).

6. Dr. I. A. Richards is at present the most distinguished advocate of the theory I am attacking. I should never say of him that he has no aesthetic experience. But in his writings he does not discuss it; he only reveals it from time to time by things he lets slip.

35

The Aesthetic of the Antique

LEON ROSENSTEIN

I

The antique, as a category, and antiques, as objects which embody this characteristic, have gained considerable attention in the modern world. Little serious thought has yet been given on a philosophical level, however, to what this character is. This essay will therefore address the questions, what is "an antique" and "the antique"? Why is it worthy of critical analysis? How does it function within a broader range of aesthetic categories?

II

Let us deal with the second question above, in a preliminary way, by examining the current appeal of the antique. The source of this appeal and the function it serves are varied, to be sure. Economic investment as a hedge against inflation, acquisition of social status, and decorative service to fill empty spaces come to mind. But these are mainly extraneous to aesthetics. There does seem to be a psychological function as well—viz., escape from the reality of the present.

There is no doubt that a large body of contemporary aesthetic experience is devoted to the antique as the only alternative to nature itself in the struggle against the void of the contemporary fabricated environment. Here the antique is an antidote to the insipidity of mass-produced furnishings.

It is an antidote as well to modern anomic art, the art of "the they" *(das Man),* supported by attempts to elevate the undone (one cannot any longer employ the term "shocking" seriously) to the status of the highest criterion and at the same time everywhere to homogenize the already bland. To be sure, the antique has this antidotic function—the escape from vapid "they" art and its attendant "they" art criticism. But this can hardly be all. Certainly it would not be a sufficient explanation of the category itself. Nor would it be a unique means of escape from the inauthenticities of present reality: several stiff drinks would achieve the same end, after all. Yet there is some special significance to the deliberate preference for past reality that the antique satisfies, and certainly the consideration of this aspect of the antique has some respectable parentage.

The antique must be treated in any investigation of renaissances and revivals in style and taste, for instance. All such revivals deliberately choose to re-create the past by fashioning new objects imitating the old, or by incorporating certain traits of the old, or by collecting and analyzing actual old objects with appropriate veneration. Western civilization has seen such recollections often enough and at regular intervals in the past—though in each instance with a difference. The fortitudinous consciousness generated in the Italian Renaissance by reawakening the classicism of Greece and Rome, for example, was not the same as the consciousness generated

Leon Rosenstein, "The Aesthetic of the Antique," *The Journal of Aesthetics and Art Criticism,* 45, no. 4 (1987), pp. 393–402. Reprinted with permission of *The Journal of Aesthetics and Art Criticism* and the author.

subsequently by the revival of this past in late eighteenth and early nineteenth-century England and France. The latter revival was attended by attitudes of nostalgia for the old and the past; e.g., the cult of the ruin and associations with the picturesque, which were perhaps foreshadowings of the Romantic temperament, which Hegel would identify not with "fortitude" but with the "unhappy consciousness." Such references and revivals are not uniquely Western, of course. Japanese and Chinese instances occur. There is, even more appropriately for our present concern, the Japanese appreciation of *sabi*—their general preference for aged objects.

In themselves, revivals and renaissances may tell us where and under what circumstances "the antique" and "antiques" become relevant to a civilization's self-conception. But they cannot explain why and how the antique exerts its special appeal, or furnish appropriate criteria for distinguishing and establishing the antique as an aesthetic category.

III

For the purposes of this inquiry, an antique shall be defined as a primarily handcrafted object of rarity and beauty which, by means of its style and the durability of its materiality, has the capacity to evoke and preserve for us the image of a world now past.

Each component of this definition will be examined for the sake of clarity. This section and the next will deal with the issue of *what kind of thing* an antique is. Section V will address the *means* by which the antique achieves it aesthetic function. Section VI will provide a concluding analysis of the *end, or effect*, that antiques achieve for our aesthetic sensibility.

We begin by contrasting the antique with the "art object" in general so as to understand more clearly what kind of handcrafted article an antique is. Several years ago I argued in these pages[1] that the existentiality of an art object is unique. Art objects do not reside in the world like other objects, but captivate our attention through the sensuous vehicles of their media, and, tearing through the extra-artistic world of everyday concern, set up their own worked (i.e., "artistic," "artificial") worlds of meaning and reality. Such objects, I said, have ontological integrity (and thus are genuine art objects) insofar as their corporeal nature (i.e., their sensuous vehicle or material medium) exhibits the special property I called "translucence." To have this quality, the art object must avoid the two false and opposite extremes of "transparency" and "opacity." If too transparent in its medium, the art object becomes

merely an instrument for communication, as its corporeal nature dissolves and disappears from notice—a special problem often occurring with didactic art. If too opaque, the art object becomes so enmeshed in the reality of its corporeality that it becomes a mere curiosity inhabiting the extra-artistic world—a thing of fancy. It cannot construct or communicate any content, any *worked* world at all, because it is entirely a creature of this one. (This is a special problem which often occurs in contemporary non-representational art and in art objects whose media are incoherently blended into the material elements of the overall environment.) An art object that has ontological integrity is thus "translucent" in its materiality only insofar as we remain captivated by the corporeal structures of its medium and, at the same time, are continuously attuned by them to the forms of the unique worked world which it generates as its content—a world with its own objective givens and its own values and interpretations. This is the illusion of the art object—that it opens up it own space and time and "puts into play" there the creatures of its own reality.

Now certainly not all art objects are antiques and not all antiques are "art objects" as normally understood (i.e., as "fine art"). But each is an object of aesthetic experience. Their similarities and differences are therefore worth noting.

Art objects set up their own uniquely worked artistic world—a timeless and spaceless reality with its own arbitrary extra-artistic associations and its own interpretations—and thus they remain forever at the center of their own stage, referring ultimately to themselves by means of their translucence.

Antiques set up the image of a world of the past—a real world in space and time, with all the associations and interpretations appropriate to it (or at least as we best imagine it to have been). Thus, they are symbols for a context of past possibilities, and are icons potent in transubstantiating the past reality's presence by means of their style and by an appeal to the duration of their materiality. They do this (as we shall see in section V), by relying upon certain constants in the interrelatedness of their forms and contents which are art-historically isolable, and by relying in a certain fashion upon the corporeality of their media so as by both of these means to generate "an image of the past" as their message.

It is probably for these very differences between the two that we normally reserve the term "antique" for works we would classify as craft rather than fine art. Even while recognizing the antique qualities of a Rembrandt painting, we generally prefer to notice only its existence as a fine art object. (Rembrandt's bed or chamber pot we might call antiques—*faute de mieux*, as it were.) We seem

to experience some conflict in adjusting ourselves to the equal reality of the painting's fine-art-objectness on the one hand and its antiqueness on the other—or to their equal status. This is, I believe, a serious error, for it deprives us of an important aspect of the total aesthetic experience of art objects such as Rembrandt's paintings. If they contain properties which tell us they are also antiques and tell us they should also be experienced from that perspective, we should be fools to deny ourselves that pleasure simply from a prudish prejudice for experiental purity. As Nelson Goodman has correctly observed, rather: "The aesthetic properties of a picture plainly include not only those found by looking at it but also those that determine how it is to be looked at."[2] That we in fact usually do set aside antiqueness in favor of fine-art-ness is probably due, however, not merely to a sense of respect for the work's purely formal properties, but also to a genuine ambiguity (if not antinomy) regarding the "correct" attitude. This occurs, I submit, in great measure due to the conflict arising between the respective worlds they evoke: art objects erecting a new world of their own through the translucence of their media, antiques re-evoking an image of a past world. Crafts, having less (or no) self-subsistent ideational content, and constrained to exist entirely in their own material-ity (i.e., opacity), are naturally more disposed to the generation of the past world through the material-ity of their media. They can become antiques, then, more easily. They can do this both by displaying the appropriate modifications in the opacity of their media, and by the peculiar modifications, co-ordi-nations, and combinations of their corporeal ele-ments which we call "style" (see section V). More-over, it is precisely because of the divergent world-creating and world-referent characteristics of the art object and the antique respectively that antiques (like all crafts in general) invariably affirm the values of the world they evoke and preserve, and can never critique that world and its values, as can fine art.[3] So, for example, we say that Goya's *The Third of May, 1808* critiques the extra-artistic world of its creator; though perhaps it would be better to say that this painting *as* fine art evokes a worked world which in turn subjects the contemporary real world it represents to criticism, but *as* antique the painting evokes that past real world and seeks to preserve it.

Having developed a clearer notion of the "what-ness" of the antique, we shall need to determine *how* the antique functions to evoke an image of past reality. This can be accomplished by examining both *style* (the peculiar coordination of the object's corporeal and contentual elements which are con-stants discriminable by art-historical analysis) and the *durability of its materiality* (a modification of opacity which we will call "agedness").

First of all, however, two other issues suggested by the definition of antique require clarification. These are the references to rarity and beauty.

I V

While beauty is rare, not all rare things are beauti-ful. It is this quality of beauty above all others which *should* enable us to distinguish between the antique and other crafted articles which are often associated with it in practice—viz., artifacts, souvenirs, and collectibles. I say "should enable us" because beauty, appearing as a formal property of the object, must remain notoriously indefinable as a quality. We can only here adopt the ancient criterion that beauty is *quod visum placet*—that which is pleasing to the eye.

In view of the indecipherability of the quality of beauty, however, and the consequent absence of certainty in this regard, we may also rely on other appropriate differentia.

The antique is to be distinguished from the mere artifact. Objects encountered in archaeological and art-historical contexts are "artifacts." They are seen as examples, and evidences from among other such entities. Such proof objects have only antiquarian reality and a documentary and testimonial value. The stone door jamb, unglazed pot, and arrowhead sort of artifact, moreover, is usually neither suffi-ciently impressive, unique, or relevant to us so as to generate a *Lebenswelt* of the past—real or imag-ined. On the other hand, to oppose documentary value to the aesthetic experience of the antique would be a false antinomy, since, in the context of its appreciation, the past world it testifies to is its significant aspect. The only valid question is, "Is it *merely* documentary and thus *merely* an artifact?"

The antique is not a "souvenir," either. The sou-venir is an *aide-memoire* to personal experience. Natural objects, e.g., dried flowers pressed in books, may be souvenirs. For me, a Metropolitan Opera program for a performance of *Il Trovatore* would call to mind an event from my childhood when, at the age off four, I saw that performance as my first opera experience. That program, however, is not an antique; and my age alone has no bearing on that fact. Souvenirs have only subjective reality and autobiographical value. Souvenirs may *become* antiques—assuming they fulfill other requisite cri-teria—only if they obtain objective recognition as icons of the past. Nor is the antique to be identified with the collectible. Collectibles are comprised by a category of things whose forms are primarily dic-tated by practical function—e.g., Coca Cola signs, campaign buttons, bits of barbed wire, beer cans—which are invariably only one of a series of mass-

produced exemplars whose value resides entirely in the fact of their collectibility. Last year's limited edition of numbered plates or commemorative medals by a recognized maker may be instantly "collectible," but they are not antiques. Unlike artifacts which they may in some other respects resemble, collectibles are valued above all for their collectibility—and vice versa. For these reasons they have a tautological reality and economic values established by current peculiarities of their market or psychological values invested in them by the individual accumulator or collector, who himself has a unique mentality. Thus, other considerations, in *addition to beauty,* may serve to distinguish the "antique" from the "collectible," the "artifact," and the "souvenir."

In the antique, "rarity" is not only a function of beauty, for beauty is rare, as we have said. Rareness is also a function of original "fewness" or uniqueness—itself due to its handcraftedness. Thirdly, rareness is a function of the durability of its medium. These last factors are best understood in conjunction with "agedness."

Simply to define an "antique" legally as an "object over 100 years of age" is about as meaningful and reliable as establishing that a person is mature at the age of twenty-one. A somewhat more reasonable stipulation on time would be "pre-1830." This criterion places the antique object prior to the machine age and thus increases or guarantees both its rarity and uniqueness. Furthermore, as the iconic embodiment of the objective spirit of the creator and his age now past, the antique must move us out of our present reality. An unmachined object reflecting a pre-machine world is an assurance of that move to the past. But "pre-1830" is still a false criterion because it remains arbitrary and artificial. The term "machine" is itself vague and arbitrary (a potter's wheel is a machine of sorts) and there are many instances of objects we would call "antiques" without hesitation which are at least in part "machined." Moreover, the date is far too restrictive in practice. The Gallé vase, the Art Nouveau pewter charger, the Lalique bracelet, the Tiffany window—these are certainly antiques, though all were made c. 1900 and thus fail to meet either the pre-1830 or 100 year criterion. More significant than their years and dates, it is the beauty and rarity of these examples which is important. This is so because they capture our attention and tell us that they are uncommon, not everywhere to be encountered in the everyday world of the present, and hence not of this world.

Age is important. But it is important—as stated in our definition—as an appeal to style and to the durability of the object's materiality, and not as an enumeration of years. This brings us to a consideration of agedness.

V

We must now come to terms with the *how* of the antique's nature. This must be done in conformity with our definition's stipulations of "style" and "durability of materiality," both of which are references to age. It is this quality of the antique which evokes and preserves an image of the past.

An object's age is first of all recognized in style. While we cannot here set forth a fully developed theory of style, suffice it it to affirm, first and foremost, that style in art objects generally is a function of both form (the material vehicle) and content (the worked world erected by it).

For example, the Elizabethan style in tragedies is as much a creation of its vehicles of corporeal manifestation (i.e., the particular sounds and pronunciations of English words, sentence structure, method of acting, costumes and stage designs, metaphors, and imagery) as it is of its content, the structured, meaningful, worked world it generates for us (i.e., a world wherein power-driven kings are encountered, where tragic flaws and demonic forces work out their bloody solutions). Thus, the style of Elizabethan tragedy could not possibly be mistaken for ancient Greek or French neoclassical or modern tragedies. Similarly, in painting the Impressionist style is as much a matter of subject (peaceful landscapes and domestic scenes of bourgeois or Bohemian daily affairs—no Old Testament patriarchs and prophets, or kings receiving peace terms from the conquered or ensconced in their seraglios) as it is of medium (spectrum palette, optical mixing, avoidance of black "holes," quick brushstroke, mottled lighting effects, small easel canvases, etc.). One does not mistake such a work for a Holbein, a Delacroix, or a Caravaggio. Furthermore, the works of different masters within a given style can be distinguished by using these same two criteria. For example, van Gogh's heavy impasto, his bold, intense, contrasting colors and gash-like brushstrokes, his brooding interior subjects, crazed portraits, and incendiary landscapes distinguish his style from that of Monet.[4]

Moreover, differences in style result from the unique fine-tuning of these two factors—the material elements and world elements—both internally and externally, each with the other. Thus, internally, the material medium is composed of various subvehicles. In painting, for example, the subvehicles are surface texture, disposition of shapes, clarity of line, contrast and intensity of color, and thinness or type of paint—each of which must be adjusted to the others, some being more or less emphasized, actualized, balanced. Correspondingly, internally the worked world is composed of submeanings or subjects, e.g., the social status of the persons depicted (if any), the expressions and inten-

tions suggested by their dispositions and gestures, the action or the story being told, the emotional atmosphere generated or statements communicated; these, too, must be harmonized. And, finally, the various contents or submeanings of the worked world and the various components or subvehicles of the material medium must each be coordinated externally to the other. Thus, clear line, realistic modeling, formal balance, glassy surface texture may (Raphael) or may not (Dali)—depending upon the entire nexus of adjustments uniquely made on all levels and in all areas—generate a worked world of objective rationality and peaceful normality. Style in painting is the result of the totality of these separate factors and of the distinct manner in which the artist or epoch coordinates them.

Again, noticing differences between the art object per se and the antique will prove helpful. Since the antique exists primarily in the direction of the opacity of its medium, the appropriate modifications and coordination in its corporeal elements will surely determine the antique's particular style as well. But since antiques are usually weak in generating a contentual worked world of their own, but, rather, generate an image of the past world now gone by, we cannot speak here in the same sense of style as a function of an interior worked-world vision and of correspondingly coordinated cognitive elements.

Thus, we would say that we recognize the latter, the contentual or cognitive elements of an art object's worked world, as typical, e.g., of the "Elizabethan style," when, in experiencing a tragedy, we find ghosts crying out for vengeance, just as we would recognize the style's material presence in corpses strewn about the stage, or in its now "archaic" language. We recognize Botticelli's style, similarly, from both its Neo-Platonic images and the interrelative meanings of the idealized reality they construct (part pagan, part Christian, part Renaissance humanist—but uniquely Botticelli) and also recognize the style from the pure, clear, flowing, disembodied line which established itself in the sensuous vehicle through which this worked world shines.

But what of the bronze Ming dynasty temple bell or the Lalique pendant or the Georgian epergne? Surely one cannot speak of the unique worked world of cognitive meaning, independent of space and time, generated by the Georgian epergne. No. For, just as this sort of object is tied ineluctably to the real world in virtue of its corporeality, so this very corporeality evokes an image of the real world, though it is the image of a real world of the *past*.

The Ming dynasty temple bell of course evokes a world—an image of Imperial Ming China, of its long tradition of crafting in bronze, of its religious attitudes and ceremonial commitments. And in this generation of an historically and culturally conditioned image we note its style. Because of this style recognition, moreover, we should immediately detect any "errors"—either errors in our judgment of style or in the thing itself. So, for example, we might suddenly notice that the bell's metal is too thin ever to have been used for its presumed function, or that the manner of stylizing the cloud patterns in its surface decoration is of nineteenth-century origin. In either such instance of "error" we would be noting *stylistic* contradictions, either between material structure and past-world use or between material configuration of design and presumed age. This is also true in the case of the Georgian epergne: the image of the opulence of the dinner tables where it performed its service is evoked, the guests, their clothes and conversations, the flowers and fruits that it held, etc. But suppose, again, that we discover "errors" as we scrutinize it further: the unpolished bottoms of its ruby glass inserts are wrong for this period; however, the overall shape and design is exact for the period, and the sterling silver frame with its engraved and repoussé decoration is the correct material for that design; on the other hand, the size of the whole object seems a bit diminutive for the kind of dinner service we would expect for the society using that material and that design; still, the hallmarks on the silver are absolutely correct; we breathe lightly on the hallmarked area to test and a resulting line of condensation indicates solder has been used to "let in" a genuine hallmark cut from a Georgian spoon. At this point we conclude that it is a deliberate forgery. We have accomplished all this by combining and contrasting the material elements, first one with the next, then with those elements discovered (or not discovered) in the image of the past world that the object generates. In this process we have pursued a dialectic of its *style*.

Style is something we can (and which antique dealers and museum curators must) become keenly, even subconsciously, attuned to. Seeing the past in the antique through its style, by virtue of its consistencies and inconsistencies, is the prime means by which the appraiser/authenticator evaluates a piece. Thus, it is often noted as a truism in the field that deliberate fakes of antiques, hard to spot when they are new, become easy to detect after a generation or so. Whereas the style of the present or immediate past is always too transparent to notice, we can detect clearly, when enough time has passed, an incongruity between two styles of the past colliding in the same object.

In these various ways, then, style enables us to recognize age. Style, as we now see, is the result of a nexus of interrelated elements, of forms and contents which are art-historically isolable and sufficiently constant for us to recognize their congruity

and incongruity. By its style, the antique shows its age and thereby evokes the image of an historical world.[5]

There remains now the second consideration in the recognition of an object's age—the durability of its materiality. Age here relates to the modifications in the materiality of the sensuous vehicle noted in section III. It explains how, through this other mode, the antique becomes an icon for the image of a past reality. It also explains how antiques differ from certain artworks which may also be historical (or, better yet, which "exist historically"). Hence musical art objects (as opposed to their books or scores) cannot be antiques. My hearing of the art object called *Le nozze di Figaro*, an event of great "rarity" and "beauty," can certainly by its *style* evoke and preserve an image of a world now gone by. My reading of *War and Peace* re-creates nineteenth-century Russia and makes that world live again for me. But the novel, the literary masterpiece itself; the opera performance, the musical masterpiece itself: these cannot be antiques. These artworks cannot evoke a past world by "appealing to the durability of their own materiality," because their media cannot display that sort of material modification which we call "agedness."

All antiques, we say, should *show their age*. Agedness, however, is made apparent not only through style—as when we recognize that an object's beauty is not presently in vogue, is "old-fashioned," of "another time and place." Style is a formal trait of the object. There remains also the material or corporeal aspect of agedness. This appears in the form of dirt, wear, damage, discoloration, patina, and the like. This materially present agedness has two effects. First, it may increase or decrease the object's formal aesthetic appeal per se (i.e., making it more/less beautiful). Second, it increases the object's material aesthetic appeal (i.e., making us experience it as antique).

In the first instance, the purely formal aesthetic response may increase through the effects of agedness. This occurs either by (a) enabling the object's present appearance to coincide with current expectations of preferences, so that, for example, the colorlessness of Classical Greek marble statues now appeals to present taste as tasteful, whereas their original bright pigmentation would appear garish; or by (b) improving surface qualities: either making objects sometimes simpler, as when wear smooths and obscures irregularities, or patina blends and softens original sharp incongruities (hence, Ruskin: "whatever faults it may have are rapidly disguised ... whatever virtue it has still shines and steals out in the mellow light"[6]); or, more often, having the contrary effect in making these aged objects more complex, as when, for example, stains, small chips,

tiny cracks, or the disappearance of very minor parts creates irregularities and asymmetries which are, in their visual and tactile conditions, more interesting and stimulating to the imagination than uniform regularity (hence, Kant: "all stiff regularity ... has something in it repugnant to taste; for our entertainment in the contemplation of it last for no length of time, but it rather ... produces weariness"[7]).

But materially present (as opposed to formal, i.e., stylistically present) agedness (patina, and the like) has the second effect of increasing the object's material (as opposed to purely formal) aesthetic appeal. Materially present agedness denotes the object's historicality and stimulates the aesthetic response to its antiqueness. Patina becomes the peculiar modification of the object's corporeal structure (and, in the case of representational or fine art objects—as opposed to crafts—the peculiar modification of the opacity of their sensuous vehicles) in which we recognize the duration of the object's existence through the durability of its materiality. This objective manifestation of endurance in time—agedness—becomes an Ariadne's thread, conducting the mind to the image of a past world, an icon invoking a past reality into the present and preserving it in a transubstantial entity which stands before us (as shall be explained in section VI). Thus, for example, an Ancient Greek play or a Renaissance madrigal may evoke for us the spirit of their respective ages, but they have not sensuously materialized that time past. The play, the tune, are abstractions and can enjoy only the "intervality" of existence. But the antique wears time like a trophy—like Ahab's White Whale, bearing the scars of experience and the weight of history.

Hence, if it is true (and I think it is), as Trilling claims regarding literature of the past, that "its historicity is a fact in our aesthetic experience,"[8] then, a fortiori, antiques, as physically enduring objects which sensuously display their history in agedness, contribute a unique element in the totality of our aesthetic response.[9] It is one thing to know the age of the work, another to see and feel its palpable presence. In antiques, historicality is patently tactile—we feel, we can hold and caress, the age. The durability of its materiality, which marks of agedness prove, objectifies the duration of the antique's reality and so its "right" to speak for the past.

Hence, it is at least as much in the duration of its materiality, noted by physical signs of agedness we can "touch," as in style, noted by formal coordinations of material elements we observe, that we experience the aesthetic enjoyment of the antique. It is primarily in this corporeal and sensuous mode—in its historicality rather than in its mere history—that we appreciate authenticity in the antique.

Authenticity, as Walter Benjamin has noted, is not merely a matter of who made it and when and where; it is a function of the object's entire existence in the world. Authenticity, he writes, is "the essence of all that is transmissible from its beginning, ranging from its substantive duration to its testimony to the history which it has experienced." In the age of mechanical reproduction, therefore, the object's own "time and place" become irrelevant, the "aura" (as he calls it) of the object is eliminated, and consequently it loses its "authority."[10] Thus, to be told of a pocket watch that it was "made for Napoleon" does not serve merely to verify its antiqueness as to date and provenance, but to ascribe to it a life-world which it has lived through and which has earned it the right to speak for and evoke an image of the past.

V I

In addition to the pleasure deriving from any object of beauty, it is the evocation and preservation of a world now past that is the chief delight for lovers of antiques. In some respects this seems to be a human experience of relatively recent origin—perhaps only of the past 150 or 200 years. While it is true that the ancient Romans appreciated and coveted Greek statues, and that the taste for all things classical was revived by the Italians of the early Renaissance (Petrarch and a few solitary individuals at first in the early 1300s, but by the late 1400s already a fashion, even craze, manipulated by dealers), it was not really until the eighteenth century that "furnishings"—i.e., objets de virtu, decorative arts, glassware and porcelains, tables and chairs, etc., as opposed to paintings and statues—were actively pursued by those who could otherwise have afforded new things.

It was a pursuit fostered by a new attitude towards the self as the focus and end of civilization, a pursuit which was engaged in above all by the English gentleman of the mid-century. His virtu was incomplete without the grand tour which capped his education; and the grand tour was itself completed in the hundreds of trinkets and trophies shipped back home. Thus we find in Dean Tucker's popular Instruction for Travellers of 1757:

Persons who propose to Themselves a Scheme for Travelling generally do it with a view to obtain one or more of the following Ends; viz. First to make Curious Collections, as Natural Philosophers, Virtuosos or Antiquarians. Secondly to improve in Painting, Statuary, Architecture and Music. Thirdly to obtain the reputation of being Men of Vertu and of an elegant Taste.[11]

The pursuit was to some degree engaged in by the French as well. Though that process was disrupted by the Revolution, it was revived full force during the age of Napoleon.

Surely many such objects were purchased with social, economic, or political motives. But, I submit, it was the newly created awareness of the historicality of civilization and of the individual's own self-consciousness as a historical creature—as awareness . . . first inspired by such eighteenth-century thinkers as Vico, Winkelmann, Lessing, and Rousseau, but finalized by the likes of Hegel in the first quarter of the nineteenth century—that established the ground for this new type of aesthetic experience.[12]

It would not be difficult to locate a material or objective equivalent for the creation of this new subjective historical spirit (as Hegel would describe it). The spatial correlative of temporal recollection is the empire—world empires being constructed in the economic and political spheres at the time by the English (and, later, by the French and by other power centers of Western civilization). In order to view themselves as legitimate possessors and due inheritors of the greater world and its past, it became necessary to possess the objects materially embodying that world so as to be able to identify (or at least empathize) authentically with the image thus evoked. It was necessary in order to see oneself world-historically as the end and focus of that world-historical process. Consequently, it was in the eighteenth century that politically (as empire) and intellectually (as historical consciousness) the ground for a new type of aesthetic experience was laid. From these origins we may deduce the present appeal of the antique.

What was—is—the intellectual reward of such a new awareness? It is the ability to locate and to define ourselves within the entirety of human civilization. What was—is—the reason that the antique arouses our interest, and for the special delight it affords? It is to expand objectively and materially (beyond the immediate givens in the actually perceived everday world of the present) what subjectively and intellectually we have already assimilated, or wish to assimilate, as our own. Thus, it is not merely the present reality's inauthenticity or blandness that we wish to "escape" by means of the antique. It is not merely its "evil" or its "bad taste" but rather its limitations. It is its incompleteness and insufficiency for a consciousness sufficiently historical, sufficiently worldly—and sufficiently imaginative.

As possibility is freer than actuality, so imagination provides a more expansive world than perception. This is true of beautiful art objects in general. Art objects open up new relations of possibility in

imitation of the limited orders of reality and create new substantive worlds, like quasars glowing within the known sphere. Antiques are symbols for a context of past possibilities and are icons potent in transubstantiating past reality in the form of an image evoked by an object "yet present" from that time. It is because we want to own and assimilate ourselves in the universality—or some portion of the universality—of human civilization that we become attuned to the appeal of the antique. By surrounding myself with Georgean antiques I, too, can live in that world. The antiques serve my imagination, and it is in virtue of the operations of my imagination that antiques please.

Let us again for a moment compare the antique and the fine art object with respect to the aesthetic pleasure the imagination affords in their contemplation. Even so "formalist" a philosopher of art as Kant admits that "while the judgment of taste by which something is declared beautiful must have no interest *as its determining ground* . . . it does not follow that, after it has been given as a pure aesthetical judgment, no interest [and consequently no other pleasure or response] can be combined with it." The pleasure which beautiful art inspires in us is *not merely a function of the immediately apprehended form* of the art object we perceive before us. On the contrary, Kant claims that the pleasure we take in beautiful art "must be derived from reflection," from "the reflective judgment and not from sensation." It is for this reason—viz., to undermine the presumed primacy of the immediate object of sensation—that he emphasizes the role of the active and productive imagination which reflective judgment requires. That is why he can define "beauty in general" as the "expression of aesthetical ideas"

which are "representations of the imagination which occasion much thought, without any *definite* thought being capable of being adequate to it." It is therefore to reflection and to the "freedom and wealth" of the imagination that the primary roles in aesthetic experience are assigned. Hence, Kant says, "the imagination (as a productive faculty of cognition) is very powerful in creating another nature, as it were, out of the material that actual nature gives it. We entertain ourselves with it when experience becomes too commonplace." And thus he notes the "very common play of our fancy, which attributes to lifeless things a spirit suitable to their form by which they speak to us."[13]

It seems that the aesthetic experience is based upon the transformation of actuality into possibility by the imagination's generating a more expansive world than the mere perceptive faculty can provide. Antiques, being historical objects, establish a context in which the imagination can entertain us with images reflective of past possibilities. This explanation is entirely consistent with any aesthetic theory which admits of diverse sources for and varied aspects to the totality of the aesthetic experience.

The antique preserves and "holds as true"—in Heidegger's sense of *Wahrung*—an image of the past encapsulated *in nuce* in the present. The antique's form—its style and aged corporeality—enables us to fancy the subjective spirit hibernating there. Whether or not Kant's dictum is true—that "beauty is the symbol of the morally good"[14]—I trust we have now established the validity of the thesis that the antique is the symbol of materially immanent historicality.

Notes

1. "The Ontological Integrity of the Art Object from the Ludic Viewpoint," *Journal of Aesthetics and Art Criticism* 34, no. 3 (1976), 323–36.

2. Nelson Goodman, "Art and Authenticity," in *Forgery in Art,* ed. Dennis Dutton (University of California Press, 1983).

3. On this issue and related matters see Herbert Marcuse, *One Dimensional Man* (Boston, 1964), chap. 9; and *The Aesthetic Dimension* (Boston, 1978).

4. To be sure, Van Gogh is classed as a "Post-impressionist." But there is no "Post-impressionist" style per se: "Post-impressionist" masters like Van Gogh perform stylistic variations in an "impressionistic" manner.

5. Cf. Joseph Alsop's discussion in "The Faker's Art" (*New York Review of Books,* 33, no. 16:30) where he points out that we, as creatures of a self-consciously historical civilization, must adopt a purely aesthetic *and* an historical response to works of art; and that, in cases of proven inauthenticity (especially art fakery), the historical response "goes to war with" and "most often" subdues the aesthetic one.

6. John Ruskin, *Modern Painters* (London, n.d.), part 2, sec. 1, chap. 6, p. 97.

7. Immanuel Kant, *Critique of Aesthetic Judgement,* trans. J. H. Bernard (New York, 1953), sec. 22, p. 80.

8. Lionel Trilling, *The Liberal Imagination* (New York, 1953), p. 179.

9. I am indebted, for several of the ideas expressed in the above three paragraphs, to suggestions made by Yuriko Saito in the article "Why Restore Works of Art?" *Journal of Aesthetics and Art Criticism* 44, no. 2 (1985), 141–51.

10. Walter Benjamin, "The Work of Art in the Age of Mechanical Reproduction," in *Illuminations*, ed. Hanna Arendt, trans. Harry Zohn (1968; reprint, Huntington, N.Y., 1973), pp. 222–23.

11. Quoted by Wendell Garrett in *Antiques* 128, no. 6 (1985), 1173.

12. Of course I am *not* saying that to appreciate the aesthetic of the antique one must actually have read these philosophers themselves. The "trickle down" theory always applies in the realm of ideas, even if it doesn't in economic life.

13. Kant, quotations from sections 45, 49, and 51, respectively.

14. Ibid., sec. 59.

36

Use and Contemplation

OCTAVIO PAZ

Firmly planted. Not fallen from on high: sprung up from below. Ocher, the color of burnt honey. The color of a sun buried a thousand years ago and dug up only yesterday. Fresh green and orange stripes running across its still-warm body. Circles, Greek frets: scattered traces of a lost alphabet? The belly of a woman heavy with child, the neck of a bird. If you cover and uncover its mouth with the palm of your hand, it answers you with a deep murmur, the sound of bubbling water welling up from its depths; if you tap its sides with your knuckles, it gives a tinkling laugh of little silver coins falling on stones. It has many tongues: it speaks the language of clay and minerals, of air currents flowing between canyon walls, of washerwomen as they scrub, of angry skies, of rain. A vessel of baked clay: do not put it in a glass case alongside rare precious objects. It would look quite out of place. Its beauty is related to the liquid that it contains and to the thirst that it quenches. Its beauty is corporal: I see it, I touch it, I smell it, I hear it. If it is empty, it must be filled; if it is full, it must be emptied. I take it by the shaped handle as I would take a woman by the arm, I lift it up, I tip it over a pitcher into which I pour milk or pulque—lunar liquids that open and close the doors of dawn and dark, waking and sleeping. Not an object to contemplate: an object to use.

A glass jug, a wicker basket, a coarse muslin *huipil*, a wooden serving dish: beautiful objects, not despite their usefulness but because of it. Their beauty is simply an inherent part of them, like the perfume and the color of flowers. It is inseparable from their function: they are beautiful things because they are useful things. Handcrafts belong to a world antedating the separation of the useful and the beautiful. Such a separation is more recent that is generally supposed. Many of the artifacts that find their way into our museums and private collections once belonged to that world in which beauty was not an isolated and autonomous value. Society was divided into two great realms, the profane and the sacred. In both beauty was a subordinate quality: in the realm of the profane, it was dependent upon an object's usefulness, and in the realm of the sacred it was dependent upon an object's magic power. A utensil, a talisman, a symbol: beauty was the aura surrounding the object, the result—almost invariably an unintentional one—of the secret relation between its form and its meaning. Form: the way in which a thing is made; meaning: the purpose for which it is made.

Today all these objects, forcibly uprooted from their historical context, their specific function, and their original meaning, standing there before us in their glass display cases, strike our eye as enigmatic divinities and command our adoration. Their transfer from the cathedral, the palace, the nomad's tent, the courtesan's boudoir, and the witch's cavern to the museum was a magico-religious transmutation. Objects became icons. This idolatry began in the Renaissance and from the seventeenth century onward has been one of the religions of the

From Octavio Paz, *In Praise of Hands: Contemporary Crafts of the World,* trans. Helen R. Lane. New York: World Crafts Council, 1974, pp. 17–24. Reprinted with permission of Little, Brown and Company.

West (the other being politics). Long ago, at the height of the Baroque period, Sor Juana Inés de la Cruz coined a witty little phrase poking fun at aesthetics as superstitious awe: "A woman's hand is white and beautiful because it is made of flesh and bone, not of marble or silver; I esteem it not because it is a thing of splendor but because its grasp is firm."

The religion of art, like the religion of politics, sprang from the ruins of Christianity. Art inherited from the religion that had gone before the power of consecrating things and imparting a sort of eternity to them: museums are our places of worship and the objects exhibited in them are beyond history; politics—or to be more precise, Revolution—meanwhile co-opted the other function of religion: changing man and society. Art was a spiritual heroism; Revolution was the building of a universal church. The mission of the artist was to transmute the object; that of the revolutionary leader was to transform human nature. Picasso and Stalin. The process has been a twofold one: in the sphere of politics, ideas were converted into ideologies and ideologies into idolatries: art objects in turn were made idols, and these idols transformed into ideas. We gaze upon works of art with the same reverent awe—though with fewer spiritual rewards—with which the sage of antiquity contemplated the starry sky above: like celestial bodies, these paintings and sculptures are pure ideas. The religion of art is a neo-Platonism that dares not confess its name—when it is not a holy war against heretics and infidels. The history of modern art may be divided into two currents: the contemplative and the combative. Such schools as Cubism and Abstract Expressionism belong to the former; movements such as Futurism, Dadaism, and Surrealism to the latter. Mystics and crusaders.

Before the aesthetic revolution the value of works of art pointed to another value. That value was the interconnection between beauty and meaning: art objects were things that were perceptual forms that in turn were signs. The meaning of a work was multiple, but all its meanings had to do with an ultimate signifier, in which meaning and being fused in an indissoluble central node: the godhead. The modern transposition: for us the artistic object is an autonomous, self-sufficient reality, and its ultimate meaning does not lie beyond the work but within it, in and of itself. It is a meaning beyond meaning: it refers to nothing whatsoever outside of itself. Like the Christian divinity, Jackson Pollock's paintings do not *mean*: they *are*.

In modern works of art meaning dissolves into the sheer emanation of being. The act of seeing is transformed into an intellectual process that is also a magic rite: to see is to understand, and to understand is to partake of the sacrament of communion.

And along with the godhead and the true believers, the theologians: art critics. Their elaborate interpretations are not less abstruse than those of Medieval Scholastics and Byzantine scholars, though far less rigorously argued. The questions that Origen, Albertus Magnus, Abelard, and Saint Thomas Aquinas gravely pondered reappear in the quibbles of our art critics, though tricked out this time in fancy masquerade costumes or reduced to mere platitudes. The parallel can be extended even further: in the religion of art, we find not only divinities and their attributes and theologians who explicate them, but martyrs as well. In the twentieth century we have seen the Soviet State persecute poets and artists as mercilessly as the Dominicans extirpated the Albigensian heresy in the thirteenth.

Not unexpectedly, the exaltation and sanctification of the work of art has led to periodic rebellions and profanations. Snatching the fetish from its niche, daubing it with paint, pinning a donkey's ears and tail on it and parading it through the streets, dragging it in the mud, pinching it and proving that it is stuffed with sawdust, that it is nothing and no one and has no meaning at all—and then placing it back on its throne. The Dadaist Richard Huelsenbeck once exclaimed in a moment of exasperation: "Art should get a sound thrashing." He was right—except that the welts left on the body of the Dadaist object by this scourging were like military decorations on the chests of generals: they simply enhanced its respectability. Our museums are full to bursting with anti-works of art and works of anti-art. The religion of art has been more astute than Rome: it has assimilated every schism that came along.

I do not deny that the contemplation of three sardines on a plate or of one triangle and one rectangle can enrich us spiritually; I merely maintain that the repetition of this act soon degenerates into a boring ritual. For that very reason the Futurists, confronted with the neo-Platonism of the Cubists, urged a return to art with a message. The Futurists' reaction was a healthy one, but at the same time an ingenuous one. Being more perspicacious, the Surrealists insisted that the work of art should say something. Since they realized that it would be foolish to reduce the work of art to its content or its message, they resorted to a notion that Freud had made common currency: that of *latent content*. What the work of art says is not be to found in its manifest content, but rather in what it says without actually saying it: what is behind the forms, the colors, the words. This was a way of loosening the theological knot binding being and meaning together without undoing it altogether, so as to preserve, to the maximum extent possible, the ambiguous relation between the two terms.

The most radical of the avant-gardists was Marcel Duchamp: the work of art passes by way of the senses but its real goal lies farther on. It is not a thing: it is a fan of signs that as it opens and closes alternately reveals its meaning to us and conceals it from us. The work of art is an intelligible signal beamed back and forth between meaning and non-meaning. The danger of this approach—a danger that Duchamp did not always manage to avoid—is that it may lead too far in the opposite direction, leaving the artist with the concept and without the object, with the *trouvaille* and without the *thing*. This is the fate that has befallen his imitators. It should also be said that frequently they are left both without the object and without the concept. It scarcely bears repeating that art is not a concept: art is a thing of the senses. Speculation centered on a pseudo-concept is even more boring than contemplation of a still-life. The modern religion of art continually circles back upon itself without ever finding the path to salvation: it keeps shifting back and forth from the negation of meaning for the sake of the object to the negation of the object for the sake of meaning.

The industrial revolution was the other side of the coin of the artistic revolution. The ever-increasing production of ever-more-perfect, identical objects was the precise counterpart of the consecration of the work of art as a unique object. As our museums became crowded with art objects, our houses became filled with ingenious gadgets. Precise, obedient, mute, anonymous instruments. But it would be wrong to call them ugly. In the early days of the industrial revolution aesthetic considerations scarcely played any role at all in the production of useful objects. Or better put, these considerations produced results quite different from what manufacturers had expected. It is superimposition that is responsible for the ugliness of many objects dating from the prehistory of industrial design—an ugliness not without a certain charm: the "artistic" element, generally borrowed from the academic art of the period, is simply "added onto" the object properly speaking. The results were not always displeasing. Many of these objects—I am thinking in particular of those of the Victorian era and those in the so-called "Modern Style"—belong to the same family of mermaids and sphinxes. A family ruled by what might be called the aesthetics of incongruity. In general the evolution of the industrial object for everyday use followed that of artistic styles. It was almost always a borrowing—sometimes a caricature, sometimes a felicitous copy—from the most fashionable artistic trend of the moment. Industrial design consistently lagged behind the art of the period, and imitated artistic styles only after they had lost their initial freshness and were about to become aesthetic clichés.

Modern design has taken other paths—its own characteristic ones—in its search for a compromise between usefulness and aesthetics. At times it has achieved a successful compromise, but the result has been paradoxical. The aesthetic ideal of functional art is to increase the usefulness of the object in direct proportion to the amount by which its materiality can be decreased. The simplification of forms and the way in which they function becomes the formula: the maximum efficiency is to be achieved by the minimum of presence. An aesthetic mindful of the realm of mathematics, where the *elegance* of an equation is a function of the simplicity of its formulation and the inevitability of its solution. The ideal of modern design is invisibility: the less visible functional objects are, the more beautiful they are. A curious transposition of fairy tales and Arabic legends to a world governed by science and the notions of usefulness and efficiency: the designer dreams of objects which, like *jinni,* are mute and intangible servants. The precise opposite of craftwork: a physical presence which enters us by way of the senses and in which the principle of maximum utility is continually violated in favor of tradition, imagination, and even sheer caprice. The beauty of industrial design is conceptual in nature: if it expresses anything at all, it is the precise accuracy of a formula. It is the sign of a function. Its rationality confines it to one and only one alternative: either an object will work or it won't. In the second case it must be thrown into the trash barrel. It is not simply its usefulness that makes the handcrafted object so captivating. It lives in intimate connivance with our senses and that is why it is so difficult to part company with it. It is like throwing an old friend out into the street.

There comes a moment, however, when the industrial object finally turns into a presence with an aesthetic value: when it becomes useless. It is then transformed into a symbol or an emblem. The locomotive that Whitman sings of is a machine that has stopped running and no longer propels trainloads of passengers or freight: it is a motionless monument to speed. Whitman's disciples—Valéry Larbaud and the Italian Futurists—were sent into ecstasies by the beauty of locomotives and railroad tracks at precisely the point in time when other means of transportation—the airplane, the automobile—were beginning to replace the train. The locomotives of these poets are the equivalent of the fake ruins of the eighteenth century: they complement the landscape. The cult of the mechanical is nature-worship turned topsy-turvy: usefulness that is becoming useless beauty, an organ without a

function. Through ruins history again becomes an integral part of nature, whether we are contemplating the crumbled stone walls of Ninevah or a locomotive graveyard in Pennsylvania.

This affection of machines and contraptions that have fallen into disuse is not simply another proof of the incurable nostalgia that man feels for the past. It also reveals a blind spot in the modern sensibility: our inability to interrelate beauty and usefulness. Two things stand in our way: the religion of art forbids us to regard the useful as beautiful; the worship of usefulness leads us to conceive of beauty not as a presence but as a function. This may well be the reason for the extraordinary poverty of technology as a source of myths: aviation is the realization of an age-old dream that appears in every society, yet it has failed to create figures comparable to Icarus and Phaeton.

The industrial object tends to disappear as a form and to become indistinguishable from its function. Its being is its meaning and its meaning is to be useful. It is the diametrical opposite of the work of art. Craftwork is a mediation between these two poles: its forms are not governed by the principle of efficiency but of pleasure, which is always wasteful, and for which no rules exist. The industrial object allows the superfluous no place; craftwork delights in decoration. Its predilection for ornamentation is a violation of the principle of efficiency. The decorative patterns of the handcrafted object generally have no function whatsoever; hence they are ruthlessly eliminated by the industrial designer. The persistence and the proliferation of purely decorative motifs in craftwork reveal to us an intermediate zone between usefulness and aesthetic contemplation. In the work of handcraftsmen there is a constant shifting back and forth between usefulness and beauty. This continual interchange has a name: pleasure. Things are pleasing because they are useful *and* beautiful. This copulative conjunction defines craftwork, just as the disjunctive conjunction defines art and technology: usefulness *or* beauty. The handcrafted object satisfies a need no less imperative than hunger and thirst: the need to take delight in the things that we see and touch, whatever their everyday uses may be. This necessity is not reducible either to the mathematical ideal that acts as the norm for industrial design or to the strict rites of the religion of art. The pleasure that craftwork gives us is a twofold transgression: against the cult of usefulness and against the cult of art.

Since it is a thing made by human hands, the craft object preserves the fingerprints—be they real or metaphorical—of the artisan who fashioned it. These imprints are not the signature of the artist; they are not a name. Nor are they a trademark.

Rather, they are a sign: the scarcely visible, faded scar commemorating the original brotherhood of men and their separation. Being made *by* human hands, the craft object is made *for* human hands: we can not only see it but caress it with our fingers. We look at the work of art but we do not touch it. The religious taboo that forbids us to touch the statues of saints on an altar—"You'll burn your hands if you touch the Holy Tabernacle," we were told as children—also applies to paintings and sculptures. Our relation to the industrial object is functional; to the work of art, semi-religious; to the handcrafted object, corporal. The latter in fact is not a relation but a contact. The trans-personal nature of craftwork is expressed, directly and immediately, in sensation: the body is participation. To feel is first of all to be aware of something or someone not ourselves. And above all else: to feel *with* someone. To be able to feel itself, the body searches for another body. We feel *through* others. The physical, bodily ties that bind us to others are no less strong than the legal, economic, and religious ties that unite us. The handmade object is a sign that expresses human society in a way all its own: not as work (technology), not as symbol (art, religion), but as a mutually shared physical life.

The pitcher of water or wine in the center of the table is a point of confluence, a little sun that makes all those gathered together one. But this pitcher that serves to quench the thirst of all of us can also be transformed into a flower vase by my wife. A personal sensibility and fantasy divert the object from its usual function and shift its meaning: it is no longer a vessel used for containing a liquid but one for displaying a carnation. A diversion and a shift that connect the object with another region of human sensibility: imagination. This imagination is social: the carnation in the pitcher is also a metaphorical sun shared with everyone. In fiestas and celebrations the social radiation of the object is even more intense and all-embracing. In the fiesta a collectivity partakes of communion with itself and this communion takes place by way of ritual objects that almost invariably are handcrafted objects. If the fiesta is shared participation in primordial time—the collectivity literally shares among its members, like bread that has been blessed, the date being commemorated—handcraftsmanship is a sort of fiesta of the object: it transforms the everyday utensil into a sign of participation.

In bygone days, the artist was eager to be like his masters, to be worthy of them through his careful imitation of them. The modern artist wants to be different, and his homage to tradition takes the form of denying it. If he seeks a tradition, he searches for one somewhere outside the West, in the

art of primitive peoples or in that of other civilizations. Because they are negations of the Western tradition, the archaic quality of primitive craftsmanship or the antiquity of the Sumerian or Mayan object are, paradoxically, forms of novelty. The aesthetic of constant change demands that each work be new and totally different from those that have preceded it: and at the same time novelty implies the negation of the tradition closest at hand. Tradition is thus converted into a series of sharp breaks. The frenetic search for change also governs industrial production, though for different reasons: each new object, the result of a new process, drives off the market the object that has immediately preceded it. The history of craftwork, however, is not a succession of new inventions or of unique (or supposedly unique) new objects. In point of fact, craftwork has no history, if we view history as an uninterrupted series of changes. There is no sharp break, but rather continuity, between its past and its present. The modern artist has set out to conquer eternity, and the designer to conquer the future; the craftsman allows himself to be conquered by time. Traditional yet not historical, intimately linked to the past but not precisely datable, the handcrafted object refutes the mirages of history and the illusions of the future. The craftsman does not seek to win a victory over time, but to become one with its flow. By way of repetitions in the form of variations at once imperceptible and genuine, his works become part of an enduring tradition. And in so doing, they long outlive the up-to-date object that is the "latest thing."

Industrial design tends to be impersonal. It is subservient to the tyranny of function and its beauty lies in this subservience. But only in geometry is functional beauty completely realized, and only in this realm are truth and beauty one and the same thing; in the arts properly speaking, beauty is born of a necessary violation of norms. Beauty—or better put: art—is a violation of functionality. The sum of these transgressions constitutes what we call a style. If he followed his own logical principles to the limit, the designer's ideal would be the absence of any style whatsoever: forms reduced to their function, as the artist's style would be one that began and ended in each of his works. (Perhaps that is the goal that Mallarmé and Joyce set for themselves.) The one difficulty is that no work of art is its own beginning and its own end. Each is a language at once personal and collective: a style, a manner. Styles are a reflection of communal experiences, and every true work of art is both a departure from and a confirmation of the style of its own time and place. By violating that style, the work realizes all the potentialities of the latter. Craftwork, once again, lies squarely between these two poles: like industrial design, it is anonymous; like the work of art, it is a style. By comparison with industrial designs, however, the handcrafted object is anonymous but not impersonal; by comparison with the work of art, it emphasizes the collective nature of style and demonstrates to us that the prideful *I* of the artist is a *we*.

Technology is international. Its achievements, its methods, and its products are the same in every corner of the globe. By suppressing national and regional particularities and peculiarities, it has impoverished the world. Having spread from one end of the earth to the other, technology has become the most powerful agent of historical entropy. Its negative consequences can be summed up in one succinct phrase: it imposes uniformity without furthering unity. It levels the differences between distinctive national cultures and styles, but it fails to eradicate the rivalries and hatreds between peoples and States. After turning rivals into identical twins, it purveys the very same weapons to both. What is more, the danger of technology lies not only in the death-dealing power of many of its inventions but in the fact that it constitutes a grave threat to the very essence of the historical process. By doing away with the diversity of societies and cultures it does away with history itself. The marvelous variety of different societies is the real creator of history: encounters and conjunctions of dissimilar groups and cultures with widely divergent techniques and ideas. The historical process is undoubtedly analogous to the twofold phenomen that geneticists call *inbreeding* and *outbreeding*, and anthropologists *endogamy* and *exogamy*. The great world civilizations have been syntheses of different and diametrically opposed cultures. When a civilization has not been exposed to the threat and the stimulus of another civilization—as was the case with pre-Columbian America down to the sixteenth century—it is fated to mark time and wander round and round in circles. The experience of the *Other* is the secret of change. And of life as well.

Modern technology has brought about numerous and profound transformations. All of them, however, have had the same goal and the same import: the extirpation of the *Other*. By leaving the aggressive drives of humans intact and reducing all mankind to uniformity, it has strengthened the forces working toward the extinction of humanity. Craftwork, by contrast, is not even national: it is local. Indifferent to boundaries and systems of government, it has survived both republics and empires: the art of making the pottery, the woven baskets, and the musical instruments depicted in the frescoes of Bonampak has survived Mayan high priests, Aztec warriors, Spanish friars, and Mexican presidents. These arts will also survive Yankee tourists.

Craftsmen have no fatherland: their real roots are in their native village—or even in just one quarter of it, or within their own families. Craftsmen defend us from the artificial uniformity of technology and its geometrical wastelands: by preserving differences, they preserve the fecundity of history.

The craftsman does not define himself either in terms of his nationality or of his religion. He is not faithful to an idea, nor yet to an image, but to a practical discipline: his craft. His workshop is a social microcosm governed by its own special laws. His workday is not rigidly laid out for him by a time clock, but by a rhythm that has more to do with the body and its sensitivities than with the abstract necessities of producion. As he works, he can talk with others and may even burst into song. His boss is not an invisible executive, but a man advanced in years who is his revered master and almost always a relative, or at least a close neighbor. It is revealing to note that despite its markedly collectivist nature, the craftsman's workshop has never served as a model for any of the great utopias of the West. From Tommaso Campanella's *Civitas Solis* to Charles Fourier's phalansteries and on down to the Communist collectives of the industrial era, the prototypes of the perfect social man have never been craftsmen but priest-sages and gardener-philosophers and the universal worker in whom daily praxis and scientific knowledge are conjoined. I am naturally not maintaining that craftsmen's workshops are the very image of perfection. But I do believe that, precisely because of their imperfection, they can point to a way as to how we might humanize our society: their imperfection is that of men, not of systems. Because of its physical size and the number of people constituting it, a community of craftsmen favors democratic ways of living together; its organization is hierarchical but not authoritarian, being a hierarchy based not on power but on degrees of skill: masters, journeymen, apprentices; and finally, craftwork is labor that leaves room both for carefree diversion and for creativity. After having taught us a lesson in sensibility and the free play of the imagination, craftwork also teaches us a lesson in social organization.

Until only a few short years ago, it was generally thought that handcrafts were doomed to disappear and be replaced by industrial production. Today however, precisely the contrary is occurring: handmade artifacts are now playing an appreciable role in world trade. Handcrafted objects from Afghanistan and Sudan are being sold in the same department stores as the latest products from the design studios in Italian or Japanese factories. This rebirth is particularly noticeable in the highly industrialized countries, affecting producer and consumer alike. Where industrial concentration is heaviest—

as in Massachusetts, for instance—we are witnessing the resurrection of such time-hallowed trades as pottery making, carpentry, glass blowing. Many young people of both sexes who are fed up with and disgusted by modern society have returned to craftwork. And even in the underdeveloped countries, possessed by the fanatical (and untimely) desire to become industrialized as rapidly as possible, handcraft traditions have undergone a great revival recently. In many of these countries, the government itself is actively encouraging handcraft production. This phenomenon is somewhat disturbing, since government support is usually inspired by commercial considerations. The artisans who today are the object of the paternalism of official state planners were yesterday threatened by the projects for "modernization" dreamed up by the same bureaucrats, intoxicated by economic theories they have picked up in Moscow, London, or New York. Bureaucracies are the natural enemy of the craftsman, and each time that they attempt to "guide" him, they corrupt his sensibility, mutilate his imagination, and debase his handiwork.

The return to handcraftsmanship in the United States and in Western Europe is one of the symptoms of the great change that is taking place in our contemporary sensibility. We are confronting in this case yet another expression of the rebellion against the abstract religion of progress and the quantitative vision of man and nature. Admittedly, in order to feel disillusioned by progress, people must first have undergone the experience of progress. It is hardly likely that the underdeveloped countries have yet reached the point of sharing this disillusionment, even though the disastrous consequences of industrial super-productivity are becoming more and more evident. We learn only with our own thinking-caps, not other people's. Nonetheless, how can anyone fail to see where the faith in limitless progress has led? If every civilization ends in a heap of rubble—a jumble of broken statues, toppled columns, indecipherable graffiti—the ruins of industrial society are doubly impressive: because they are so enormous in scope and because they are so premature. Our ruins are beginning to overshadow our constructions, and are threatening to bury us alive. Hence the popularity of handcrafts is a sign of health—like the return to Thoreau and Blake, or the rediscovery of Fourier. Our senses, our instincts, our imagination always range far ahead of our reason. The critique of our civilization began with the Romantic poets, just as the industrial era was dawning. The poetry of the twentieth century carried on the Romantic revolt and rooted it even more deeply, but only very recently has this spiritual rebellion penetrated the minds and hearts of the vast majority of people. Modern society is begin-

ning to question the principles that served as its cornerstone two centuries ago, and is searching for other paths. We can only hope that it is not too late.

The destiny of the work of art is the air-conditioned eternity of the museum; the destiny of the industrial object is the trash barrel. The handcrafted object ordinarily escapes the museum and its glass display cases, and when it does happen to end up in one, it acquits itself honorably. It is not a unique object, merely a typical one. It is a captive example, not an idol. Handcrafted artifacts do not march in lockstep with time, nor do they attempt to overcome it. Experts periodically examine the inroads that death is making in works of art: cracks in paintings, fading outlines, changes in color, the leprosy eating away both the frescoes of Ajanta and Leonardo da Vinci's canvases. The work of art, as a material thing, is not eternal. And as an idea? Ideas too grow old and die. The work of art is not eternal. But artists often forget that their work is the possessor of the secret of the only real time: not an empty eternity but the sparkling instant, and the capacity to quicken the spirit and reappear, even if only as a negation, in the works that are its descen-

dants. For the industrial object no resurrection is possible: it disappears as rapidly as it first appeared. If it left no trace at all, it would be truly perfect; unfortunately, it has a body and once that body has ceased to be useful, it becomes mere refuse that is difficult to dispose of. The obscene indestructibility of trash is no less pathetic than the false eternity of the museum.

The thing that is handmade has no desire to last for thousands upon thousands of years, nor is it possessed by a frantic drive to die an early death. It follows the appointed round of days, it drifts with us as the current carries us along together, it wears away little by little, it neither seeks death nor denies it: it accepts it. Between the timeless time of the museum and the speeded-up time of technology, craftsmanship is the heartbeat of human time. A thing that is handmade is a useful object but also one that is beautiful; an object that lasts a long time but also one that slowly ages away and is resigned to so doing; an object that is not unique like the work of art and can be replaced by another object that is similar but not identical. The craftsman's handiwork teaches us to die and hence teaches us to live.

VI

Modern Developments

Michael Carin's novel, *The Neutron Picasso,* is a cautionary tale. In Carin's story, archaeologists, working more than a thousand years after a twentieth-century nuclear holocaust all but destroys human civilization, unearth a steel crate containing two artifacts which provide the first clues to the question why a society with a high level of technological achievement and wealth would allow itself to commit mass suicide. The two artifacts are testimony to a profound cultural disease among whose symptoms are a deliberate disregard for things human, a high regard for mental deformity, and a refusal to look reality in the face. The artifacts which disclose this tragic condition are two paintings.

The archaeologists decide that the first of these, Picasso's cubist work *Ma Jolie* (1911–1912), with its ambiguous mode of representation and its emphasis on color, form, and the process of painting itself, virtually turns its back on social and intellectual concerns. Instead of serving the proper functions of art—the creation of order and the celebration of humanity—the Picasso painting seems more like an exercise in the pathology of vision. The second painting, Jackson Pollock's "action painting" *Convergence* (1952) does not even attempt to represent the world; its retreat from figuration is complete. Indeed, it appears to be little more than a canvas covered with random paint drippings. It does not seem to be the result of disciplined creation at all. These are works that fail to communicate or, what is worse, deny that communication is desirable. In either case, the high esteem in which they were apparently held—as suitable objects for contemplation and adoration—clearly indicates the tragic inversion of values that led to the eventual collapse of pre-Bomb society.

To be sure, the critics of the future argue, these works were probably produced under the aegis of appropriate theories which placed a premium on technique, "art for itself alone," or perhaps (in the case of the Pollock) expression of the private, inner state of the artist. But such conceptual apparatus only attests more deeply to a radical retreat from human concerns. Those theories amount to an avowal of the view that anything is permitted. They represent a level of depravity so great that the near-obliteration of an

entire civilization becomes an intelligible phenomenon. Subsequent
archaeological discoveries of Henry Moore's *Three Piece Reclining Figure* and a
copy of Samuel Beckett's *Waiting for Godot* confirm the analysis: the art of the
twentieth century was both a symptom and a cause of a decadent society. One
would hardly be surprised to find that everyday objects—garbanzo beans, say—
were also exhibited as works of art.[1]

Carin's novel is a work of fiction, but its thinly disguised criticism of
twentieth-century art raises important questions about the contemporary art
scene. This century has seen a steady succession of developments in the
artworld which have seemed to challenge, if not subvert, prevailing notions and
attitudes about the meaning and purpose of art. This is nowhere more evident
than in the world of the visual arts. Of course, some of the actions of some
avant garde artists—such as the Vancouver artist who endeavored to squash a
rat to death between two canvases with a huge concrete block, or the English
artist who embalmed the corpse of a dead homeless person named Diogenes[2]—
are shocking or distasteful considered simply as human acts. But other less
ghastly developments in twentieth-century artistic practice have been no less
disturbing from an art-theoretical point of view. Whether we think of the
Cubists' explorations of nonillusionist modes of representation, the abstract
paintings of Kandinsky and his followers, the kinetic mobiles of Calder, the
minimalist sculptures of Donald Judd, Carl Andre, and Robert Morris, the
Brillo boxes and mass-produced silk screens of Andy Warhol, the urinal,
bottlerack, and other "readymades" of Marcel Duchamp, the benday dot
paintings of Roy Lichtenstein, the giant hamburgers, clothespins, and
toothpaste tubes of Claes Oldenburg, or the more recent activities of
conceptual, body, performance, and earth artists, we seem in the twentieth
century to have witnessed the proliferation of objects and events that drive us
to the question, "What is art?" Of course, aesthetic theories must be able to
take account of new and transformed styles and genres as well as new forms of
art. But developments in twentieth-century art, particularly visual art, have
caused philosophers not only to press their understanding of art but also to
reconsider how one philosophizes about the arts.

Arnold Berleant, for example, sees modern aesthetic theory as having
proceeded primarily from general philosophical doctrine rather than from
actual artistic practice, to the detriment of theory. In "Aesthetics and the
Contemporary Arts," Berleant argues that aesthetic theory should proceed
from the bottom up, so to speak, rather than from the top down. On Berleant's
own reading, the actual practices of the contemporary arts represent a retreat
from the notion of art as an autonomous activity rooted in a distinctive
"disinterested" attitude or experience and from a correlative "museum
mentality," which physically isolates works of art. What is offered in place of

1. Michael Carin, *The Neutron Picasso* (Toronto: Deneau/Gaudet Publishers, 1989). See especially pp. 53–71.
2. *The Guardian*, January 6, 1990.

these presumptions is a reaffirmation of the connection between art and extra-artistic forms of life, a change enabled by the introduction of new, technologically advanced artistic materials, objects, and techniques and by the increased democratization of the arts. The significance of these changes for aesthetic theory is profound. A fully developed aesthetic theory would have to allow for this increased range of artistic qualities, objects, and events, the new modes of appreciation appropriate to them, and the reintegration of art into the course of normal human activity which has characterized much contemporary art.

Arthur Danto also takes the emergence of what he calls "a whole new class of artworks" as grounds for a reassessment of aesthetic theory. Danto's initial target in his article "The Artworld" is the time-honored imitation theory of art, the view that art holds a mirror up to nature. Danto grants the power of the imitation theory. It explains much of what many artists have been doing for centuries and provides grounds for the evaluation of much of that art. But, Danto argues, we can no longer accept the claim that imitation is the essence of art. The invention of photography has put the lie to the claim that imitation could be regarded as a sufficient condition of art, and the tendency in contemporary art to completely abandon imitation as a concern, or at least to relegate it to a peripheral role, forces us to disavow even the claim that imitation is a necessary condition.

The acceptance of these contemporary practices as art is made possible only by a radical revision in art theory itself, specifically rejection of the strict opposition of artworks and real things on which the imitation theory insists, and acceptance of the view that art could consist, not in the imitation of real forms, but in the creation of new ones. This "reality theory" of art explains not only the work of postimpressionist painters but also the work of an artist like Robert Rauschenberg, who might use a real bed in the creation of a new artistic one, and of facsimiles of real objects such as Andy Warhol's Brillo boxes. But Danto's aim is not so much to offer a substitute for the imitation theory as to make a more fundamental point about definitions of art, the theories they undergird, and, ultimately, the ontology of art. To say that something "is" a work of art, Danto argues, is to invoke what he calls the "is of artistic identification," and this, he argues, appeals implicitly to a theory of art that, in a sense, makes the art possible. "To see something as art," Danto asserts, "requires something the eye cannot descry—an atmosphere of artistic theory, a knowledge of the history of art: an artworld."[3]

George Dickie, like Danto and Berleant, takes the emergence of nonrepresentational art, found art, and ready-mades to have great significance for art theory. In "What is Art?: An Institutional Analysis" Dickie rejects the claim that such developments point up what Morris Weitz characterized as the "openness" of the concept of art, that is, the claim that there are no common

3. For a further development of Danto's theory, see Arthur Danto, *The Transfiguration of the Commonplace* (Cambridge Harvard University Press, 1981).

characteristics that distinguish art from nonart. Dickie instead determines to fix a definition of "work of art" that identifies the essential characteristics of art but is broad enough to accommodate classical and contemporary developments in the history of art. But Dickie declines to center his definition on yet another "prominent but accidental" perceptual property or feature of art which might have characterized the art of a particular period. Instead, he offers an "institutional" definition that identifies two "nonexhibited" properties of works of art, both of which involve a relation between the work and institutions of the society in which the work is embedded. According to Dickie, "A work of art in the classificatory sense (1) is an artifact (2) a set of the aspects of which has had conferred upon it the status of candidate for appreciation by some person or persons acting on behalf of a certain social institution (the artworld).[4]

The question of the cultural embeddedness of works of art is also taken up by Joseph Margolis in a careful analysis of the ontological status of works of art. In his article "The Ontological Peculiarity of Works of Art," Margolis deploys the type/token distinction to show that, though works of art must have some perceptible physical properties, they cannot be said to be reducible to physical properties. Printings of Dürer's *Melancholia I*, for example, may differ with respect to their physical properties and yet be bona fide instances of *Melancholia I*. Works of art thus seem to be types, but types of a distinctive kind: types that must be instantiated by a (or some) token-instance(s) or for which a notation exists by which an admissible token-instance might be generated and which must be identified and understood in a cultural context. The artist makes a token and in doing so creates the type. This helps us understand the sense in which Duchamp's achievement was *artistic:* Duchamp may not have made (i.e., manufactured) the bottlerack, but he did make a token of *Bottlerack,* thereby creating a (type) work exhibiting both physical and intentional properties. Works of art, Margolis says, are "culturally emergent entities, tokens-of-a-type that exist embodied in physical objects."

In "Piece: Contra Aesthetics" Timothy Binkley also takes Duchamp seriously. Binkley argues that Duchamp's works *L.H.O.O.Q.* and *L.H.O.O.Q. Shaved,* cannot be properly understood in terms of "aesthetic experience," the notion that has dominated philosophical aesthetics since the eighteenth century, because the central meaning of these works does not depend fundamentally on the aesthetic qualities of their visual appearance. The artistic significance of these works—their critical statements about the practice of art—is a function of the sort of action Duchamp has taken with respect to reproductions of the *Mona Lisa,* including the titles attached to these works by Duchamp and the cultural environment in which Duchamp's jokes make sense.

4. This selection represents the version of Dickie's theory which has received most attention in the philosophical literature. Since the publication of the book from which this selection was taken, Dickie has modified his arguments considerably while still maintaining the institutional focus of the argument. See especially, George Dickie, *The Art Circle: A Theory of Art* (New York: Haven Publications: 1984).

On Binkley's showing, an artwork is "piece," an entity *indexed* as such within the conventions of artistic practice, a formulation that has some affinity with Dickie's institutional approach but is designed especially to avoid specifying as a necessary condition any connection with a capacity for aesthetic experience as well as to accommodate conceptual and perceptual entities.

Binkley thus joins forces with other philosophers who insist on understanding both contemporary and traditional works of art in their cultural context. The point of their reflections is not to disparage traditional works of art or philosophical theories that rely on the notion of aesthetic experience to explain aspects of them. It is rather to argue that traditional theories of the aesthetic do not exhaust the ways in which works of art may have meaning and significance. To that extent, contemporary artistic practice may be said to have contributed to and enlarged philosophical theory in a fundamental way.

37

Aesthetics and the Contemporary Arts

ARNOLD BERLEANT

I

Philosophers have long been fascinated by the strange power of the arts. Some, like Plato, have an uneasy suspicion of their elusive force and are concerned over the threat the arts seem to present to the rational stability of the social order. When they come to account for the arts, then, their ideas take the form of prescription and control. Others, like Tolstoy, attempt to harness the power of the arts to aid in expressing a religious vision and achieving a lofty social ideal. Still others, impressed by the unpredictable yet fruitful creativity of the arts, seek to allow them to flourish freely and to make their unique contribution to society in their own way. Control, cultivation, and encouragement constitute but several of the many philosophical reactions to the activity of art.

Despite such attention, however, the philosophy of art has lagged far behind philosophical thought in most other areas. It did not achieve an identity of its own until the mid-eighteenth century when Baumgarten published his *Aesthetica*. Yet even since that time, philosophical thought about art has remained encumbered by prior commitments to doctrines that were developed with little regard to the practice of the arts. Perhaps it is felt that, in dealing with the fruits of civilization, the theory of art can be expected to derive its full sustenance from the roots of philosophic thought.

This has not always been the case. Aristotle stands as one highly significant exception, basing the largest part of his *Poetics* on the empirical study of Greek tragedy. More recent instances are critics and philosophers like Roger Fry and Ortega y Gasset, who felt called upon to explain and defend the new face of the arts early in the twentieth century. But in the philosophical literature these remain the exception rather than the rule. In fact, a strong impulse in recent aesthetics has been generated by the interest in conceptual analysis. Here the limited area of discourse is staked out with attention confined to the meaning and significance of aesthetic concepts rather than to the materials and practices of the arts. This has led to self-defeating consequences for many since, as Morris Weitz claims to have shown, aesthetic theory is foredoomed to fail inasmuch as it is logically impossible to define the concept "art."[1]

In contrast with such pessimistic allegations, let us consider what may be a more promising alternative by taking an empirical tack rather than a conceptual one. After some brief reflections on the function of aesthetic theory, I shall develop two constructive responses to the challenge thrust upon aesthetics by new forms and movements in the contemporary arts. The first of these comes from the importance for aesthetics of recent artistic practices and concepts. The second responds to the need for developing fresh ideas in aesthetic theory. Any new

This is a revised version of Arnold Berleant's article "Aesthetics and the Contemporary Arts," *The Journal of Aesthetics and Art Criticism*, 29 (1970), pp. 155–68. Reprinted with permission of *The Journal of Aesthetics and Art Criticism* and the author.

notions must not only account for new art better; they must also explain the data of past art more effectively than the traditional principles which originated not so much from an examination of art as from philosophic theories and assumptions that developed independently of art.

II

What, to begin, is the point of aesthetic theory? What is its function in relation to the artistic activities in which people engage and the artistic products that they fashion? These questions can perhaps best be answered by turning first to the way in which theories are used in other areas. Once the typical function of theory becomes clearer, we can inquire into its proper use in connection with the arts.

In general, it is the task of any theory to account for phenomena and, by accounting for them, to make experience more understandable and therefore easier to achieve and control. Whether the phenomena are falling objects, planetary motions, the bending of light in interstellar space; whether they are fossil remains, homologous forms among organisms, or data about the distribution and modification of biological species, the theories offered to account for such phenomena are developed in creative interplay between the puzzlement that such data evoke and the need to comprehend, to function with, and perhaps to achieve control over these phenomena. Theorizing is not primarily an attempt to define concepts unambiguously and to construct coherent systems. It is rather an effort to identify, relate, and explain phenomena, an effort which proves itself by its success in assimilating new data and by its fruitful application. By first turning to those experiences that both attract and puzzle us, theory defines the limits of discussion by the relevance the phenomena have to our initial confusion. Thus the theorist develops concepts such as mass, force, motion, energy, organism, species, environment; discerns relationships, such as causality or natural selection; and elaborates the categories and structures that are most effective in dealing with the problems at hand, in acquiring and explaining the relevant data, and in accounting for and controlling experience. Thus it is to experience that we first must turn (and with which we finally must end), and it is experience which dictates the appropriate theoretical structures, meanings, and operation.

Aesthetic theory, in particular, must account for aesthetic phenomena. Its purpose is to render the experiences of art and the aesthetic perception of nature more understandable. Aesthetic theory can do this satisfactorily only by constructing concepts and principles which derive directly from the arts

and from aesthetic experience, and which return to clarify and enhance our future experience by helping us to recognize, order, and respond in ways that are appropriate to the phenomena.

Developing an effective theory of the arts might appear to be a task that could be undertaken in a straightforward fashion. Yet as philosophers are fond of observing, appearances are often deceptive, and in this case no less so theoretically than perceptually. Aesthetic theory has not been a particularly fruitful region of philosophical inquiry, in part because of its subjection to philosophical commitments unrelated to artistic practices, and in part because of the complexity of these data, themselves.

When we turn to the practices and experience of the arts, the fascination that we feel at first often turns into bafflement, for the arts confront us with a disconcerting array of materials and perceptual activities. And when we look at the contemporary arts, this variety seems to take on the character of a *mélange*. Aesthetics seems at a loss to account in any coherent and systematic way for the use of sharply new materials, such as plastic, acrylics, electronically produced sounds, for novels and plays without plots, and for the deliberate elimination of other devices of order from various arts. Even the distinctions among the arts have broken down, and we are often unable to decide where a new development belongs—whether, for example, environments are sculpture or architecture; assemblages paintings or sculptures; happenings and performance art theater, painting, or an entirely new art form synthesizing elements of theater, sculpture, dance, painting, and music. And within the arts, too, basic distinctions fail to hold, for we are no longer able to draw the line between design, decoration, and illustration and fine art, or between musical sound and noise.

With this plethora of data, how can aesthetic theory respond? Whatever its answer, one thing is certain: aesthetics cannot legislate these data away. The philosophy of art, if it is to fulfill its function as theory, must account for these developments, not discount them. Yet how are we to proceed? Perhaps we can discover a clue in the very source of our aesthetic confusion, the contemporary arts themselves. What are these arts trying to achieve? To what are they appealing? How do they confront us? What perceptual demands to they impose upon us?

III

A number of influences in the history of modern aesthetics have, until fairly recently, moved art steadily away from any close association with the objects, experiences, and appearances of the world that surrounds us. The romantic nineteenth cen-

tury expressed in many different ways a concern with individual sensibility: a proclamation of artistic independence, autonomy, and self-sufficiency, especially in music, in painting, and in poetry. And with the introduction into painting of a degree of abstraction approaching that of music, which spilled over into sculpture, dance, and some of the other arts and which found its theoretical expression in the doctrine known as formalism, that which is recognizable, realistic, and lifelike became on principle unessential and, indeed, distracting. Much recent theory and criticism might seem to support the view that art has gradually and steadily emancipated itself from features that can be seen as catering to the uncultivated observer. The need for special training, often long and technical, may seem unavoidable if one is to appreciate the intricacies of some of the more esoteric movements in the arts of our time, such as cubism and abstract expressionism in painting, serial and electronic music, and certain forms of experimental poetry.

Yet it may be possible to view such developments as somewhat more distant expressions of a quite different tendency, a constant dynamic in the direction of a remarkably intimate association of the artistic experience with the forces and interests of the world outside of art. For there is a thread which runs through the history of the arts since its earliest origins which must be taken with the utmost seriousness. This is the connection that objects and experiences of art have with the range of human activity outside the artistic, with the forms and qualities of the cultural environment. Perhaps by pursuing this strand we may be able to clarify the confusion and conflict that seem to prevail over the meaning and significance of the contemporary arts for the history of the arts and for aesthetic theory. For against the movement in recent times toward an ever greater autonomy and narrowing of the arts,[2] a trend has developed during the past several decades toward extending the range of what we have been willing to accept as art. This has happened too rapidly for us to have been able to reestablish clear lines and limits in understanding art.

With this extension of our aesthetic embrace has come the need to reappraise our relations to those objects we have come to call art and our ideas about these relationships. For cherished doctrines have come into question, and the validity of guiding principles has encountered serious challenges. A challenge has been laid down in particular to ideas and practices that codify the separation of art from life, like the disinterested attitude for regarding art, the removal of art from practical uses, and the deliberate deletion of all nonartistic associations from artistic products.

It has been observed[3] that the point in history at which the aesthetic attitude began to be characterized as disinterested, that is, the eighteenth century in England, coincided with the point in history when modern aesthetics first emerged. This is certainly a suggestive correspondence, for the identification of an aesthetic attitude seems to signify the point at which people first began to recognize aesthetic experience as a distinct kind and attempted to locate that feature which makes it distinctive. The recognition of aesthetic experience emerges historically as an important event in the development of human perception and awareness. And it was in the eighteenth century that aesthetic perception finally emancipated itself from a long tradition of subservience to ritualistic, utilitarian, and other nonaesthetic modes of experience.[4]

It is possible, in fact, to trace a gradual refinement and a clearer identity for aesthetics from that time forward, culminating in the early decades of the twentieth century with the development of the formalist aesthetic. Here the relevant features in the object are only the formal qualities which emerge out of the materials and techniques of the particular art involved, and the experience of art consists in an emotion peculiar to apprehending these formal qualities. Once aesthetics and the objects and experience it elucidates achieved an identity of their own, it might appear that the question of the connections of art with other human activities and interests had been answered in favor of aesthetic isolation. This development, moreover, carried an additional implication. This was that the perceptual distinctness of aesthetic experience required the removal of the objects of such perception from the other objects and activities which surround us. This belief finds concrete expression in what one might call the "museum mentality," the compulsion to isolate the objects of art physically in order to encourage us to isolate them perceptually.

This parallel between isolating the object and disengaging our perception of it from practical associations may in fact be an excessive reaction to the earlier subservience of the arts and the discovery of an aesthetic mode of experience. It may be that the presence of an aesthetic dimension in primitive artifacts and in religious ritual does not signify merely a stage in the development toward art unencumbered by extraneous uses and associations. Rather it may stand as an early phase of something that has always been present in the arts in one form or another—the expression of the major role that the arts play in the full range of human experience and of their function as integrative forces in that experience. Rather than assuming a strange and wonderful uniqueness, the object of art can be seen as a product of a dimension of human life that has always been important, although often obscured and unaware. That dimension includes a vital and vibrant sensitivity to what is direct and qualitative

in experience, a role art shares in its own way with serious human relationships and with objects of nature.

Moreover, assigning an identity to such experience does not require making it separate from other things and experiences, nor does it commit us to a particular formulation for expressing it. For aesthetic theory and its objects to have an identity does not mean that art must be ontologically discrete, set apart by its very nature from the rest of human experience. Distinctive though art is, its identity may persist within an underlying continuity of experience. It is here, in fact, than an examination of the contemporary arts has special significance. For the traditional separation of art from the other activities and interests that people exhibit cannot provide a convincing account of recent developments. Moreover, such common descriptions of the aesthetic attitude as contemplative, disinterested, employing psychical distance, and isolating the object all distort the experience of the traditional arts as well as obscure their human significance. Stated positively, the contemporary arts bring home to us the functional relation that holds between all the participants in the experience of art—the creative artist, the audience, the art object, and the performer—and they reaffirm the connections between this experience and the experiences and concerns of people outside the world of art. Let me suggest how this has come about.

The historian of the arts is often impressed by the ways in which the arts draw upon changes in the conditions and quality of life, and how they mirror these changes in the perceptual forms peculiar to the arts. Careful but suggestive studies have revealed important relationships, for example, between Greek sculpture of the fifth and fourth centuries B.C.E., Gothic architecture, Renaissance painting, and the characteristic qualities of experience that marked Hellenic humanism, medieval spiritual aspiration, and the rebirth of secularism, naturalism, and humanism in the fourteenth and fifteenth centuries.

The same can be done with many of the contemporary arts. Yet here the discontinuity with the past history of the arts is rather more acute. Of the many changes in cultural experience, two seem to have had special significance for the arts. The first is the rise of industrial production, which has transformed the characteristic features that objects possess and has led to the use of new materials, objects, and techniques in artistic practice. Second are the fundamental social changes that have come about through increasing democratization, in particular the emergence of population masses and a corresponding mass culture, generating new perceptual activities and reaffirming a social function for the

arts. Together, new artistic materials and objects and new perceptual activities have been embodied in some strikingly different forms and movements in the arts themselves, and it is these that present the challenge to aesthetics. In their negative consequences the contemporary arts insist on the rejection of aesthetic isolation; in their positive consequences they offer the opportunity for a renewal of aesthetic relevance and for the reintegration of the arts into the mainstream of contemporary culture.

Let us explore this functional exchange of the activities of art with the fuller context of human experience by examining two significant influences. The first of these is the ways in which new materials, objects, and techniques that arise out of the technology of industrial production have entered into the art world and have profoundly influenced the vocabulary and practice of artists. The other is how certain fundamental social changes in the modern world have come to reshape our perceptual activities in the arts into new and different forms. Finally, I shall try to assess the implications these developments carry for aesthetic theory that tries, as theory should, to account for these changes.

I V

It would be indeed strange to suppose that so sensitive a cultural barometer as the arts would not be affected by the industrial transformation of modern society. What is, in fact, most surprising is how traditional ways of making and enjoying art have been able to persist so long without serious change. But now that such changes are upon us, we find it as difficult to explain them in traditional terms as to account for the power of a nuclear generator by the principle of the lever. Industrialism has transfigured the object of art just as it has transformed the other articles of human inventions. Yet in what ways?

One can with little difficulty single out features that are typical of art objects of the past, features that arise in large measure from the fact that these articles were produced by skilled craftspersons using relatively simple hand tools.[5] Such objects combined workmanship that was intricate, a design unique to the object, and rarity and expensiveness that resulted from the large quantity of labor required to produce a small output. Because of their manner of production, traditional art objects possessed signs of human workmanship and fallibility, displaying irregularities and providing maximum opportunity for unstudied, intuitive decisions in the process of fashioning them. And since these art objects often performed a variety of functions, such as contributing to religious worship or recording people and events, artists were forced to accept

severe limitations on their choice of subject matter, in their freedom to abstract, and on the audience responses they could evoke. Yet at the same time, the celebratory character of the fine arts associated them with ritual and various forms of social privilege. This encouraged the development of a sharp distinction between the practical activities of people, which demanded a commitment to utility, and the artistic activities of aesthetic enjoyment, which were cut off from practical affairs and were regarded for their own intrinsic worth. Along with such regard went a sharply defined difference between objects of utility and objects of beauty. Unlike ordinary things, art objects were treated with special care. They were treasured, honored for their age and for the status they conferred on their patron or owner, and safeguarded as possessing value that was inherent and permanent. Moreover, these were not only descriptive features of past art; they carried in addition a powerful normative connotation: It was just such traits that art was expected to possess.

Industrialism changed all this. It has generated an entire set of new features in the things that surround us, and these traits are reflected in the objects that have emerged from the contemporary arts. In place of unique objects which possess an intricate structure and are produced in small numbers and at great cost, we now have uniform articles manufactured in enormous quantities, with simplicity of design and economy of price. The irregularity and fallibility and the intuitive manner by which they were formerly fashioned have given way to a flawless precision governed by careful calculation. And in place of objects treasured for their age and permanence, we value the newness of things that are expendable in the light of improvements and changes in taste.

Like the traits of traditionally produced art, these new features have also assumed the character of aesthetic standards and have given birth to new materials, objects, and techniques of artistic production. The emancipation of the arts from subservience to historical accuracy and religious devotion has encouraged their propensity to abstraction, while at the same time their integration into the traffic of daily life has replaced the isolated object of art with one integrated through its function into the course of ordinary human activity. Artists are making free use of materials from the new technology, like plastic, acrylics, machine parts, electronic sounds, and foam. They are taking up everyday articles and situations, like newspapers, kitchen utensils, factory work and assembly lines, and theater marquees. They are utilizing impermanent materials, like leaves, paper, light, balloons, and have appropriated features of mass culture produced by or taken from

this new technology, such as comic strips and street noises. They are drilling, welding, dripping and splashing, making and modifying electronically generated sounds, splicing tapes, and composing by computer.

Yet behind the use of the materials, objects, and techniques of an industrial culture lies the inspiration of the science and technology that produced it. This is hardly recent, and we sometimes overlook how responsive many of the arts have already been to the material transformation of the modern world. We forget how, in the last quarter of the nineteenth century, Georges Seurat, Paul Signac, and Henri-Edmond Cross developed *pointillisme* as a method of producing paintings, drawing from the mechanical techniques of technology, the analytic method of scientific inquiry, and the principles of optics. We fail to recall how Zola regarded the novel as the model of a scientific experiment and transformed the novelist into an observer and an experimentalist, and how the naturalistic novel at the same time responded to the ideas of evolutionary biology and revealed the conditions of an emerging industrial society.

Science and technology have continued to exercise a profound influence on theories of artistic production and on their results. Leger and the cubists went from the geometry of the machine to the geometrization of nature. Gropius and the Bauhaus discovered the modern medium and principles of design in the machine. More recently, painters have applied scientific concepts and terminology to their work, as with optical artists associated with the Nouvelle Tendance, who create uniform patterns of many small geometric units that they call "periodic structures" and speak of elements of their works as "information" and of their compositional arrangement as "programming." Composers, too, have responded in similar ways when they term the musical score "time-space" and make use of graphs, statistical charts, symbolic codings, and laws and formulas from mathematics and the physical sciences. Technological tools like the computer and the synthesizer are increasingly being used, and the tape recorder has rendered assistance to the performer and at times made any such person obsolete.

Recording techniques, in fact, have transformed the musical object by the variety of ways in which music can be manipulated, such as through the balance of microphones, echo chambers, and multi-track recordings. It can even be said that recording has turned music into a group product, the results of collaboration between the composer, the performer, and the engineer. As a result, the requirements of performance have changed, making recorded music a rather different art from live music. For example, while one can observe the play-

ers, during a pause in a live performance, preparing for what will follow, such a visual spectacle does not exist in a recording and this pause must be filled in by pushing ahead to the next notes. Tempos, therefore, are regularly taken faster in recordings to help eliminate dead spots. Moreover the technical excellence of recorded performances results from a mechanical achievement and conveys that fact. The music does not live and grow before one in a freshly re-creative act; it is run off instead like the machine product that it is.

Mechanical precision and standardization have also gained acceptance from other directions, as when minimal, optical, some pop artists use repeated patterns and mathematical exactness of line and arrangement. Even when contemporary art appears to deny some of these features, such as sometimes occurs with Happenings, pop art, and performance art, they are still most understandable as commentaries on and reactions to industrialism in the arts and the mass commercial culture that has accompanied it rather than as spontaneous developments.[6] The Industrial Revolution has finally reached the arts.

While it is true that the mechanization of the arts diminishes the personal creative element in certain respects, this is not a sign of the intrinsic failure of technology. It may rather suggest new forms and directions to creative imagination. Recording techniques and synthesizers, for instance, have led to new types of musical composition that develop out of sound textures and rhythmic complexities instead of melodic phrases and harmonic progressions. Sculpture has moved from a traditional craft technology in which the sculptor individually designs and executes an object from wood or stone, through the production of wax or clay models from which molds were made and bronze cast by artisans, to the point at which sculptors have others make sheet metal sculptures from small paper cut-outs (as Picasso did), build large constructions from designs and sketches (as was David Smith's practice), and utilize the prefabricated products of an industrial technology (as in the work of the dadaists, constructivists, and junk sculptors). Parallel examples of new forms of creative production have occurred in most of the other arts.

Yet probably the most striking and suggestive parallel is in the transformation given the dramatic arts by the advent of photography and the motion picture. While a traditional performing art has continued to function, albeit more weakly, with less influence, and to smaller audiences, technology has created a new and distinctive art in which the actual movement and discourse of people have been replaced by images fixed on a celluloid strip and shown in rapid succession so as to create the illusion of movement. The old rapport between actors and audience is replaced by a film audience which enters a new world, loses touch with its surroundings, and aided by superb mechanical contrivance is able to dispense with the conventional illusions and deliberate self-deceptions necessary to appreciation in traditional theater. It might even be claimed in the case of the film that technology has helped us achieve an art of greater immediacy and power.

V

This transformation of the materials and objects of art through the pervasive influence of industrialism has been paralleled by new perceptual activities that have resulted from fundamental social changes. Here the relationship is still somewhat obscure, although the different manner of aesthetic response is an established fact. Aristocratic art has had to react to increasing democratization; no longer is art fit only for kings. Demographic isolation has given way to enormous population masses, while local and regional cultures have retreated before the forces of a mass culture that has radically altered the size and type of audiences and the communication, production, distribution, and consumption of art.

Out of these changes a new mode of perceiving art has emerged. Both the type and range of perceptual qualities and the objects admitted to aesthetic perception have become vastly more inclusive. We are asked to appreciate the interaction of color areas arranged in stripes or panels and to discriminate among the subtle gradations of value in monochromatic canvases. We are confronted with sounds whose range of frequencies and timbres have expanded enormously through the use of synthesizers. We are blinded by lights, startled by mirrors, inflamed by dance, transported in fascinated absorption by film. We walk through sculptures, readjust our sense of spatial order in environments and in daring architectural structures, sit alongside the performers at a theatrical or dance event. We are made to view the sacrilegious, the obscene, the mundane, the commercial; to hear the sound of traffic or dripping water; to vibrate bodily from the impact of intense volumes or cringe before the physical force of high frequencies.

Not only have the contemporary arts vastly extended the range of the traditional aesthetic senses and objects; they are drawing upon sensory capacities never before allowed or at least recognized. Certainly the appeal to the tactile and kinesthetic senses represents a major shift in expanding the limits of aesthetic perception. Along with the enlargement of our sensory responsiveness has come the breakdown of aesthetic prohibitions, and none

is more significant than that against the sensual.[7] It is easier to be a visual spiritualist than a tactile one, and with the inclusion of the contact senses the presence of the erotic has been admitted and intensified in dance, sculpture, and the novel, as well as film.

This enlargement of aesthetic sensibility has produced at least two major shifts in the perceptual experience of the contemporary arts. First, there is the deliberate elimination of any perceptual separation between the principal factors in aesthetic experience. The art object, for example, has imposed itself inescapably upon the audience through the use of many new devices. These include electronically amplified music of deafening volume (as in the Joffrey Ballet's production of *Astarte*), the blinding flash of spotlights on the audience, the entrance of actors and dancers through the audience and at times from the audience, environments into which one enters or through which one passes, sculptures and assemblages containing mirrors or polished, reflecting surfaces which incorporate the viewer into the work both as image and as participant through the very act of perceiving it, direct addresses to the theater audience instead of mere asides, and optical art which twists the eyes into painfully futile conformity. In the case of plotless films, the visual movement alone does not give shape to the passage of time, and it is only through the participation of the viewer that a dramatic factor is introduced. In a similar way the creative artist and the object have been integrated, as in action painting and performance art; the creator and the perceiver have joined, as in some forms of modern and ethnic dance; and the performer has been assimilated with the creator, the perceiver, and the object, as in Happenings.

A second shift in perceptual experience consists in the deliberate integration of features from ordinary life into art. The relationship between life and art has always powered the novel,[8] but it has become one of the most persistent themes in the arts today. One of the most striking ways in which art is made to reflect these features is through the use of chance elements. Aleatoric music, action painting, literary works which require the reader to choose from among alternative endings, all incorporate the fortuitousness of ordinary experience in an artistic format.

Another way in which art and life are integrated lies in the use of everyday materials, such as prosaic events and commonplace objects. The forms this takes are almost too numerous to mention. There is the music of John Cage, who is responsive to sounds of all sorts and considers any kind of noise as musical material. Happenings were a passing mode of artistic activity which not only synthesized all the elements of the aesthetic field into a creative activity but deliberately drew their themes and materials from the ongoing course of ordinary life and from industrial objects and activities. Cage, himself an influence on this development, observed that "one could view everyday life itself as theater."[9] There are the *objets trouvés* used in collages and sculptures, which intentionally draw in associations from prosaic sources of the most unlikely sorts, leading to parody, satire, or direct criticism of social features as well as to an enhanced awareness of the daily environment. There is the contemporary dance of those who choreograph their work using the materials of ordinary activities and commonplace gestures, as in Cunningham's "How to Pass, Kick, Fall, and Run," which also happens to employ music written by Cage. This interplay with the conditions of daily experience has long been engaged in by film, and nowhere with such intensity as in much of the contemporary cinema, with its intimacy of ordinary detail. In portraying real surfaces with free movement in time and space, the film is an artistic medium that approaches the directness and randomness of life. Pop art, too, has seized on the intimate relation between art and life.[10] Robert Rauschenberg denies, for example, any division between "Sacred Art" and "Profane Life," and insists on working "in the gap between the two." Indeed, as he once remarked, "There is no reason not to consider the world one gigantic painting." Theater, too, has joined the other arts here. Everything is a fitting subject, and in the most candid, graphic terms, from liberalism and race relations to homosexuality, deformity, marital problems, deliberate suicide, and the sex act. The distancing logic of a plot has receded and in its place appear the ordinary details of life which we never trouble to notice, such as the series of movements by which a man sits in a chair or a woman handles a cup or moves her lips, or the understated verbal evocations of human relations of which Pinter is a master. Dramatic shape is replaced by the mystery of the mundane, and instead of resting on a structure that the playwright has provided, we must move on the crest of our own attention.[11] Performance art is the inheritor of many of these developments, using materials from everyday life and popular culture and intensifying the occasion through the intimate bond that is encouraged between the creator–performer and the audience.

All this illustrates what has become a motif in a good deal of twentieth-century art—a deliberate dethroning of art and its reintegration into the course of normal human activity, giving the contemporary arts both a more human and a more diabolical aspect. The childlike, the primitive, the fantastic and dreamlike, the utterly simple have

DIFFERENT FEATURES OF OBJECTS
UNDER INDUSTRIAL PRODUCTION

Pre-Industrial

intricacy
expensiveness
uniqueness
rarity

irregularity
human error, fallibility
intuition

age
permanence
treasuring

art and utility sharply distinguished
representation, realism

Industrial

simplicity
economy
uniformity
quantity

precision
flawlessness
calculation

newness
change, improvement
expendability

functionalism, art object "working"
geometric forms, abstractions

FUNDAMENTAL SOCIAL CHANGES

Pre-Industrial

aristocratic
demographic isolation
local, regional culture
individual production of goods by single craftsmen
hierarchical, tribal social model

Industrial

democratic
population masses
mass culture (audiences, communication,
 production, distribution, consumption)
group production in quantity by specialized labor
mechanical, electronic social model

NEW MATERIALS AND OBJECTS IN ART

the scientific model, scientific concepts and laws
the machine
materials from technology, machine products
standardized objects (repeated patterns)

electronic mechanisms and instruments
ordinary materials
ordinary objects

NEW PERCEPTUAL ACTIVITIES

extended range of perception
greater inclusiveness of objects
inclusion of other sensory receptors—tactile,
 kinesthetic
rejection of aesthetic prohibitions, e.g., erotic
elimination of distinctions between
 object and perceiver, spectator
 creator and object
 creator and perceiver
 performer, artist, and perceiver
integration of art with life
 chance
 prosaic events
 commonplace objects
 dethroning of art, inclusion of primitive,
 grotesque, brutal dreamlike
 functionalism, art as skill, technology
 social commentary

NEW FORMS AND MOVEMENTS IN ART

theater of cruelty
theater of the absurd

Happenings

photography

film

environments

functional architecture

kinetic sculpture

objects trouvée

assemblages

new movements in painting
 impressionism
 abstract expressionism
 futurism
 cubism
 dada
 surrealism
 pop art
 op art
 minimal art

modern dance

aleatoric music

serial music

electronic music

THE NEW AESTHETIC

Negative Features

1. Denial of importance of unity, harmony. These contribute to the isolation of the art object.

2. Rejection of the ideal (i.e., beauty) as the end of art.

3. Denial of distance and of the contemplative attitude.

4. Denial of disinterestedness.
 a. denial of separation of art object from life.
 b. denial of the uniqueness of art, of institutional arrangements that perpetuate this, i.e., museums.

Positive Features

1. Continuity between life and art.
 a. process, movement
 b. functionalism

2. Perceptual integration of elements in the aesthetic situation.

3. Artistic creation as a cooperatire enterprise.

Basic Concept: The Aesthetic Field

1. A more inclusive "general theory of aesthetics."

2. Integration of
 a. artist
 b. object
 c. perceiver
 d. performer

3. Functional relation between
 a. creator–perceiver–performer
 b. object working
 c. aesthetic experience as a functional activity

4. Inclusiveness
 a. materials
 b. events

5. Diffusion
 a. greater continuity between aesthetic and nonaesthetic
 b. closer connection of art with society, as commentary, satire, criticism

appeared in painting, sculpture, and film, accompanied by their obverse, the grotesque, the brutal, the perverted. Gone is the ideal of beauty and in its place appear the mundane and subterranean. Music, dance, and the plastic arts have joined the other arts in a kind of theater of life in which we are told nothing and presented everything.

There is yet another way in which art has become integrated with the lived environment, and nowhere is it more apparent than in the two arts which perhaps more than any others embody the artistic vitality of our age, architecture and the film. Renoir once commented that "Painting, like carpentry or iron work, is a craft and as such, subject to the same rules." That the arts are technology involving, with etymological literalness, a joining or fitting together is something that artists have always known. But it is in modern architecture and the film, artistic offspring of our industrial technology, that this integration has asserted itself most impressively. Both architecture and film embody an aesthetics of function, the one an explicit concourse for human activity,[12] the other an absorbing reflection and commentary on it. The steel and glass skyscraper is a mechanical building, a "machine pure and simple," as Frank Lloyd Wright called it, and it has a reflexive force as both the embodiment of industrial activity and a monument to industrial power. Gropius compares the low-ceilinged air-conditioned cells of the modern skyscraper with the low-ceilinged humid cells that form the understory of the Gothic cathedral. As the latter reminded man of his humble position before God, so the former reminds him of his humble condition before the dollar. By stressing the continuity between the technological aspect of production and the functional aspect of their social uses, the arts have again reaffirmed their filiation with the basic activities of human life. Thus in a multitude of ways the aristocratic diffidence of the traditional arts has given way to democratic acceptance and involvement.

V I

We come, finally, to the significance for aesthetics of these developments that have transformed the arts. As I noted at the beginning, these provide data we cannot ignore, however confusing or distressing they may be for our artistic comfort and our aesthetic tranquillity. Nor can we legislate them away by appealing to traditional concepts and principles. At the same time, by taking these changes into account we need make no commitment to their value in advance. Great achievements in the arts appear in the same modes as lesser ones, and at this

point in their history it is more important to explain than to judge them. Once we take these developments seriously, we must go still further and recognize the need for an aesthetic theory which has sufficient breadth and generality to account for the contemporary arts, while at the same time absorbing the traditional ones as more limited cases. Although it may be too soon to set forth such a full-fledged theory of the arts, its requirements and outlines are clear.

There is a need, first, to cast off the shackles of traditional restraints, and this takes the form of a series of denials. We must deny the importance of unity and harmony, at least as these are restricted to the art object. Such aesthetic standards of formal beauty contribute to the independence, indeed to the isolation, of the object. The relevance of these standards must now be extended to the entire aesthetic situation and to how the object functions in that situation, rather than to the art object taken alone.[13] Then we must reject the ideal as the end of art. Gone is the standard of beauty and in its place are characteristics that possess greater breadth and inclusiveness. The sense of distance and the contemplative attitude must also be set aside, for these thrive under conditions of aesthetic aloofness. But perhaps most significant is the denial of disinterestedness and of the consequences this notion has had in quarantining the art object from creative interplay with the ongoing concerns of human living. With this, too, must come a rejection of the notion that art is unique, dismissing the museum mentality and other such institutional attitudes and arrangements designed to safeguard that uniqueness.

Yet coupled with these denials of traditional restrictions have come some powerful affirmations. One of these, as we have seen, centers on the continuity between art and life. An aesthetics of func-

tion has emerged which draws sustenance from this connection. It extends the domain of artistic accomplishment with Greenough to the sailing ship and with Marinetti to the speeding automobile and beyond them to the skyscraper and the modern city. Along with functionalism has come the temporalizing of all the arts, seeing art as process rather than as stasis, so that even the so-called spatial arts have either adopted movement, as in the case of kinetic sculpture; have taken on the semblance of movement, as in optical art; or in one fashion or another have insinuated themselves into the dynamic course of experience.

This activity of the art object contributes to a second positive feature of the new aesthetics, the perceptual integration of all the elements in the aesthetic situation into the procession of a unified experience. Not only have the distinctions between the creator of art, the aesthetic perceiver, the art object, and the performer been obscured; their functions have tended to overlap and merge as well, becoming continuous in the course of aesthetic experience.

These observations suggest the need for new concepts, for a theoretical vision which is able to encompass the broader extension of the arts, their fuller integration into the other activities people engage in, and their greater generality and inclusiveness. Such a concept may perhaps be found in the notion of the aesthetic field, which delineates the functional relationship which holds among the participating factors in aesthetic events and which identifies the basic referent as a general field of experience, instead of the more restrictive object, perceiver, or artist. But this is really a subject for another study, and there is enough that is controversial here for one occasion.[14]

Notes

1. M. Weitz, "The Role of Theory in Aesthetics," *The Journal of Aesthetics and Art Criticism,* 15 (Sept. 1956), 27–33. This has been widely reprinted. *Problems in Criticism of the Arts,* ed. H. G. Duffield (San Francisco, 1968), includes the paper along with several replies, among them one of my own.

2. In the two decades since this essay was written, a major shift has occurred away from abstraction and toward styles that are more recognizable and graspable. These include minimalism and what some call the new romanticism in music, photorealism and neoexpressionism in painting, and postmodernism in architecture.

3. Jerome Stolnitz, "On the Origins of 'Aesthetic Disinterestedness,'" *The Journal of Aesthetics and Art Criticism,* 20 (Winter 1961), 131–44.

4. "Up to the time of Kant, a philosophy of beauty always meant an attempt to reduce our aesthetic experience to an alien principle and to subject art to an alien jurisdiction. Kant, in his *Critique of Judgment,* was the first to give a clear and convincing proof of the autonomy of art." Ernst Cassirer, *Essay on Man* (Garden City, 1956), p. 176.

5. This discussion derives in part from the highly suggestive observations of Lewis Mumford. See *Technics and Civilization* (New York, 1934), parts of which have been reprinted in M. Rader, ed., *A Modern Book of Esthetics,* 3rd ed. (New York, 1960), pp. 354–64.

6. See J. P. Hodin, "The Aesthetics of Modern Art," *The Journal of Aesthetics and Art Criticism,* 23 (Winter 1967), 184–85.

7. See my paper,"The Sensuous and the Sensual in Aesthetics," *The Journal of Aesthetics and Art Criticism,* 23 (Winter 1964), 185–92.

8. George Lukacs, for example, distinguishes between ecstasy, which involves a radical break with everyday life, and aesthetic catharsis, in which there is a "streaming back and forth". See V. Maslow, "Lukacs' Man-Centered Aesthetics," *Philosophy and Phenomenological Research,* 27 (June 1967), 545–46, and notes.

9. In Happenings the audience is a part of the work. The spectators are drawn into the action and, in one way or another, forced to respond to a new environment, to a strange adventure, to a parody of customary things and events. The Happening may have reached its fullest extension in Regis Debray, who regarded a revolution as a coordinated series of guerrilla Happenings. Some of his admirers, in fact, took part in Happenings, feeling that they were training for future happenings when they will use guns and grenades. One thinks here of Wilde's dictum of Life imitates Art.

10. John Cage has noted that pop art takes its style and subject matter from the world of commerce and advertising, a setting devoted to making one go out and buy, and disengages such material from this context. Still, the practical claim persists, and it is from this that pop art derives its satirical relevance. See "An Interview with John Cage," *Tulane Drama Review,* 10 (Winter 1965), 66. "More," Cage has observed, "the obligation—the mortality, if you wish—of all the arts today is to intensify, alter perceptual awareness and, hence, consciousness. Awareness and consciousness of what? Of the real material world. Of the things we see and hear and taste and touch." "We Don't Any Longer Know Who I Was," an interview with Cage, *New York Times,* March 16, 1968, p. D9.

11. See Walter Kerr, "The Theater of Say It! Show It! What Is It!" *The New York Times Magazine,* September 1, 1968, p. 1of.

12. A good discussion of this occurs in John Dewey's *Art as Experience* (New York, 1934), pp. 230–32.

13. See *Art as Experience* and D. W. Gotschalk, *Art and the Social Order* (New York, 1962), among other books.

14. A systematic attempt to develop a contextualist aesthetic along the lines sketched out in part V of this paper is the subject of my book *The Aesthetic Field* (Springfield, Ill.: Charles C Thomas, 1970). This approach is extended in my forthcoming *Art and Engagement* (Philadelphia: Temple University Press, 1990).

38

The Artworld

ARTHUR DANTO

> HAMLET: *Do you see nothing there?*
> THE QUEEN: *Nothing at all; yet all that is I see.*
>
> Shakespeare: *Hamlet*, act 3, scene 4

Hamlet and Socrates, though in praise and depreciation respectively, spoke of art as a mirror held up to nature. As with many disagreements in attitude, this one has a factual basis. Socrates saw mirrors as but reflecting what we can already see; so art, insofar as mirrorlike, yields idle accurate duplications of the appearances of things, and is of no cognitive benefit whatever. Hamlet, more acutely, recognized a remarkable feature of reflecting surfaces, namely that they show us what we could not otherwise perceive—our own face and form—and so art, insofar as it is mirrorlike, reveals us to ourselves, and is, even by Socratic criteria, of some cognitive utility after all. As a philosopher, however, I find Socrates' discussion defective on other, perhaps less profound grounds than these. If a mirror image of *o* is indeed an imitation of *o*, then, if art is imitation, mirror images are art. But in fact mirroring objects no more is art than returning weapons to a madman is justice; and reference to mirrorings would be just the sly sort of counterinstance we would expect Socrates to bring forward in rebuttal of the theory he instead uses them to illustrate. If that theory requires us to class *these* as art, it thereby shows its inadequacy: "is an imitation" will not do as a sufficient condition for "is art." Yet, perhaps because artists *were* engaged in imitation, in Socrates' time and after, the insufficiency of the theory was not noticed until the invention of photography. Once rejected as a sufficient condition, mimesis was quickly discarded as even a necessary one; and since the achievement of Kandinsky, mimetic features have been relegated to the periphery of critical concern, so much so that some works survive in spite of possessing those virtues, excellence in which was once celebrated as the essence of art, narrowly escaping demotion to mere illustrations.

It is, of course, indispensable in Socratic discussion that all participants be masters of the concept up for analysis, since the aim is to match a real defining expression to a term in active use, and the test for adequacy presumably consists in showing that the former analyzes and applies to all and only those things of which the latter is true. The popular disclaimer notwithstanding, then, Socrates' auditors purportedly knew what art was as well as what they liked; and a theory of art, regarded here as a real definition of 'Art', is accordingly not to be of great use in helping men to recognize instances of its application. Their antecedent ability to do this is precisely what the adequacy of the theory is to be tested against, the problem being only to make explicit what they already know. It is *our* use of the term that the theory allegedly means to capture, but we are supposed able, in the words of a recent writer, "to separate those objects which are works of art from those which are not, because . . . we know how correctly to use the word 'art' and to apply the phrase 'work of art'." Theories, on this account, are somewhat like mirror images on Soc-

Arthur Danto, "The Artworld," *The Journal of Philosophy*, 61 (1964), 571–84. Reprinted with permission of *The Journal of Philosophy* and the author.

rates' account, showing forth what we already know, wordy reflections of the actual linguistic practice we are masters in.

But telling artworks from other things is not so simple a matter, even for native speakers, and these days one might not be aware he was on artistic terrain without an artistic theory to tell him so. And part of the reason for this lies in the fact that terrain is constituted artistic in virtue of artistic theories, so that one use of theories, in addition to helping us discriminate art from the rest, consists in making art possible. Glaucon and the others could hardly have known what was art and what not: otherwise they would never have been taken in by mirror images.

I

Suppose one thinks of the discovery of a whole new class of artworks as something analogous to the discovery of a whole new class of facts anywhere, viz., as something for theoreticians to explain. In science, as elsewhere, we often accommodate new facts to old theories via auxiliary hypotheses, a pardonable enough conservatism when the theory in question is deemed too valuable to be jettisoned all at once. Now the Imitation Theory of Art (IT) is, if one but thinks it through, an exceedingly powerful theory, explaining a great many phenomena connected with the causation and evaluation of artworks, bringing a surprising unity into a complex domain. Moreover, it is a simple matter to shore it up against many purported counterinstances by such auxiliary hypotheses as that the artist who deviates from mimeticity is perverse, inept, or mad. Ineptitude, chicanery, or folly are, in fact, testable predications. Suppose, then, that tests reveal that these hypotheses fail to hold, that the theory, now beyond repair, must be replaced. And a new theory is worked out, capturing what it can of the old theory's competence, together with the heretofore recalcitrant facts. One might, thinking along these lines, represent certain episodes in the history of art as not dissimilar to certain episodes in the history of science, where a conceptual revolution is being effected and where refusal to countenance certain facts, while in part due to prejudice, inertia, and self-interest, is due also to the fact that a well-established, or at least widely credited theory is being threatened in such a way that all coherence goes.

Some such episode transpired with the advent of Postimpressionist paintings. In terms of the prevailing artistic theory (IT), it was impossible to accept these as art unless inept art: otherwise they could be discounted as hoaxes, self-advertisements, or the visual counterparts of madmen's ravings. So to get them accepted *as* art, on a footing with the *Transfiguration* (not to speak of a Landseer stag), required not so much a revolution in taste as a theoretical revision of rather considerable proportions, involving not only the artistic enfranchisement of these objects, but an emphasis upon newly significant features of accepted artworks, so that quite different accounts of their status as artworks would now have to be given. As a result of the new theory's acceptance, not only were Postimpressionist paintings taken up as art, but numbers of objects (masks, weapons, etc.) were transferred from anthropological museums (and heterogeneous other places) to *musées des beaux arts,* though, as we would expect from the fact that a criterion for the acceptance of a new theory is that it account for whatever the older one did, nothing had to be transferred out of the *musée des beaux arts*—even if there were internal rearrangements as between storage rooms and exhibition space. Countless native speakers hung upon suburban mantelpieces innumerable replicas of paradigm cases for teaching the expression 'work of art' that would have sent their Edwardian forebears into linguistic apoplexy.

To be sure, I distort by speaking of a theory: historically, there were several, all, interestingly enough, more or less defined in terms of the IT. Arthistorical complexities must yield before the exigencies of logical exposition, and I shall speak as though there were one replacing theory, partially compensating for historical falsity by choosing one which was actually enunciated. According to it, the artists in question were to be understood not as unsuccessfully imitating real forms but as successfully creating new ones, quite as real as the forms which the older art had been thought, in its best examples, to be creditably imitating. Art, after all, had long since been thought of as creative (Vasari says that God was the first artist), and the Postimpressionists were to be explained as genuinely creative, aiming, in Roger Fry's words, "not at illusion but reality." This theory (RT) furnished a whole new mode of looking at painting, old and new. Indeed, one might almost interpret the crude drawing in Van Gogh and Cézanne, the dislocation of form from contour in Rouault and Dufy, the arbitrary use of color planes in Gauguin and the Fauves, as so many ways of drawing attention to the fact that these were *non-imitations,* specifically intended not to deceive. Logically, this would be roughly like printing "Not Legal Tender" across a brilliantly counterfeited dollar bill, the resulting object (counterfeit *cum* inscription) rendered incapable of deceiving anyone. It is not an illusory dollar bill, but then, just because it is non-illusory it does not automatically become a real dollar bill either. It rather occupies a freshly opened area between real

objects and real facsimiles of real objects: it is a non-facsimile, if one requires a word, and a new contribution to the world. Thus, Van Gogh's *Potato Eaters,* as a consequence of certain unmistakable distortions, turns out to be a non-facsimile of real-life potato eaters; and inasmuch as these are not facsimiles of potato eaters, Van Gogh's picture, as a non-imitation, had as much right to be called a real object as did its putative subjects. By means of this theory (RT), artworks reentered the thick of things from which Socratic theory (IT) had sought to evict them: if no *more* real than what carpenters wrought, they were at least no *less* real. The Post-Impressionist won a victory in ontology.

It is in terms of RT that we must understand the artworks around us today. Thus Roy Lichtenstein paints comic-strip panels, though ten or twelve feet high. These are reasonably faithful projections onto a gigantesque scale of the homely frames from the daily tabloid, but it is precisely the scale that counts. A skilled engraver might incise *The Virgin and the Chancellor Rollin* on a pinhead, and it would be recognizable as such to the keen of sight, but an engraving of a Barnett Newman on a similar scale would be a blob, disappearing in the reduction. A *photograph* of a Lichtenstein is indiscernible from a photograph of a counterpart panel from *Steve Canyon;* but the photograph fails to capture the scale, and hence is as inaccurate a reproduction as a black-and-white engraving of Botticelli, scale being essential here as color there. Lichtensteins, then, are not imitations but *new entities,* as giant whelks would be. Jasper Johns, by contrast, paints objects with respect to which questions of scale are irrelevant. Yet his objects cannot be imitations, for they have the remarkable property that any intended copy of a member of this class of objects is automatically a member of the class itself, so that these objects are logically inimitable. Thus, a copy of a numeral just *is* that numeral: a painting of 3 is a 3 made of paint. Johns, in addition, paints targets, flags, and maps. Finally, in what I hope are not unwitting footnotes to Plato, two of our pioneers—Robert Rauschenberg and Claes Oldenburg—have made genuine beds.

Rauschenberg's bed hangs on a wall, and is streaked with some desultory housepaint. Oldenburg's bed is a rhomboid, narrower at one end than the other, with what one might speak of as a built-in perspective: ideal for small bedrooms. As beds, these sell at singularly inflated prices, but one *could* sleep in either of them: Rauschenberg has expressed the fear that someone might just climb into his bed and fall asleep. Imagine, now, a certain Testadura—a plain speaker and noted philistine—who is not aware that these are art, and who takes them to be reality simple and pure. He attributes the paint

streaks on Rauschenberg's bed to the slovenliness of the owner, and the bias in the Oldenburg bed to the ineptitude of the builder or the whimsy, perhaps, of whoever had it "custom-made." These would be mistakes, but mistakes of rather an odd kind, and not terribly different from that made by the stunned birds who pecked the sham grapes of Zeuxis. They mistook art for reality, and so has Testadura. But it was meant to *be* reality, according to RT. Can one have mistaken reality for reality? How shall we describe Testadura's error? What, after all, prevents Oldenburg's creation from being a misshapen bed? This is equivalent to asking what makes it art, and with this query we enter a domain of conceptual inquiry where native speakers are poor guides: *they* are lost themselves.

II

To mistake an artwork for a real object is no great feat when an artwork is the real object one mistakes it for. The problem is how to avoid such errors, or to remove them once they are made. The artwork is a bed, and not a bed-illusion; so there is nothing like the traumatic encounter against a flat surface that brought it home to the birds of Zeuxis that they had been duped. Except for the guard cautioning Testadura not to sleep on the artworks, he might never have discovered that this was an artwork and not a bed; and since, after all, one cannot discover that a bed is not a bed, how is Testadura to realize that he has made an error? A certain sort of explanation is required, for the error here is a curiously philosophical one, rather like, if we may assume as correct some well-known views of P. F. Strawson, mistaking a person for a material body when the truth is that a person *is* a material body in the sense that a whole class of predicates, sensibly applicable to material bodies, are sensibly, and by appeal to no different criteria, applicable to persons. So you cannot *discover* that a person is not a material body.

We begin by explaining, perhaps, that the paint streaks are not to be explained away, that they are *part* of the object, so the object is not a mere bed with—as it happens—streaks of paint spilled over it, but a complex object fabricated out of a bed and some paint streaks: a paint-bed. Similarly, a person is not a material body with—as it happens—some thoughts superadded, but is a complex entity made up of a body and some conscious states: a conscious-body. Persons, like artworks, must then be taken as irreducible to *parts* of themselves, and are in that sense primitive. Or, more accurately, the paint streaks are not part of the real object—the bed—which happens to be part of the artwork, but are, *like* the bed, part of the artwork as such. And this

might be generalized into a rough characterization of artworks that happen to contain real objects as parts of themselves: not every part of an artwork *A* is part of a real object *R* when *R* is part of *A* and can, moreover, be detached from *A* and seen *merely* as *R*. The mistake thus far will have been to mistake *A* for *part* of itself, namely *R*, even though it would not be incorrect to say that *A* is *R*, and the artwork is a bed. It is the 'is' which requires clarification here.

There is an *is* that figures prominently in statements concerning artworks which is not the *is* of either identity or predication; nor is it the *is* of existence, of identification, or some special *is* made up to serve a philosophic end. Nevertheless, it is in common usage, and is readily mastered by children. It is the sense of *is* in accordance with which a child, shown a circle and a triangle and asked which is him and which his sister, will point to the triangle saying "That is me"; or, in response to my question, the person next to me points to the man in purple and says "That one is Lear"; or in the gallery I point, for my companion's benefit, to a spot in the painting before us and say "That white dab is Icarus." We do not mean, in these instances, that whatever is pointed to stands for, or represents, what it is said to be, for the *word* 'Icarus' stands for or represents Icarus: yet I would not in the same sense of *is* point to the word and say "that is Icarus." The sentence "That *a* is *b*" is perfectly compatible with "That *a* is not *b*" when the first employs this sense of *is* and the second employs some other, though *A* and *B* are used nonambiguously throughout. Often, indeed, the truth of the first *requires* the truth of the second. The first, in fact, is incompatible with "That *a* is not *b*" only when the *is* is used nonambiguously throughout. For want of a word I shall designate this the *is of artistic identification;* in each case in which it is used, the *a* stands for some specific physical property of, or physical part of an object; and finally, it is a necessary condition for something to be an artwork that some part or property of it be designable by the subject of a sentence that employs this special *is*. It is an *is,* incidentally, which has near relatives in marginal and mythical pronouncements. (Thus, one *is* Quetzalcoatl; those *are* the Pillars of Hercules.)

Let me illustrate. Two painters are asked to decorate the east and west walls of a science library with frescoes to be respectively called *Newton's First Law* and *Newton's Third Law.* These paintings, when finally unveiled, look, scale apart, as follows:

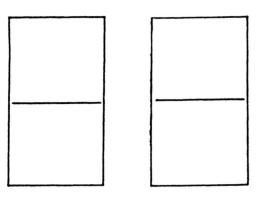

Figure A　　　　**Figure B**

As objects I shall suppose the works to be indiscernible: a black, horizontal line on a white ground, equally large in each dimension and element. *B* explains his work as follows: a mass, pressing downward, is met by a mass pressing upward: the lower mass reacts equally and oppositely to the upper one. *A* explains his work as follows: the line through the space is the path of an isolated particle. The path goes from edge to edge, to give the sense of its *going* beyond. If it ended or began within the space, the line would be curved: and it is parallel to the top and bottom edges, for if it were closer to one than to another, there would have to be a force accounting for it, and this is inconsistent with its being the path of an *isolated* particle.

Much follows from these artistic identifications. To regard the middle line as an edge (mass meeting mass) imposes the need to identify the top and bot-

tom half of the picture as rectangles, and as two distinct parts (not necessarily as two masses, for the line could be the edge of *one* mass jutting up—or down—into empty space). If it is an edge, we cannot thus take the entire area of the painting as a single space: it is rather composed of two forms, or one form and a non-form. We could take the entire area as a single space only by taking the middle horizontal as a *line* which is not an edge. But this almost requires a three-dimensional identification of the whole picture: the area can be a flat surface which the line is *above (Jet-flight)*, or *below (Submarine-path)*, or *on (Line)*, or *in (Fissure)*, or *through (Newton's First Law)*—though in this last case the area is not a flat surface but a transparent cross section of absolute space. We could make all these prepositional qualifications clear by imagining perpendicular cross sections to the picture plane. Then, depending upon the applicable prepositional clause, the area is (artistically) interrupted or not by the horizontal element. If we take the line as *through* space, the edges of the picture are not really the edges of the space: the space goes beyond the picture if the line itself does; and we are in the same space as the line is. As *B*, the edges of the picture can be *part* of the picture in case the masses go right to the edges, so that the edges of the picture are *their* edges. In that case, the vertices of the picture would be the vertices of the masses, except that the masses have four vertices more than the picture itself does: here four vertices would be part of the artwork which were not part of the real object. Again, the faces of the masses could be the face of the picture, and in looking at the picture, we are looking at these faces: but *space* has no face, and on the reading of *A* the work has to be read as faceless, and the face of the physical object would not be part of the artwork. Notice here how one artistic identification engenders another artistic identification, and how, consistently with a given identification, we are *required* to give others and *precluded* from still others: indeed, a given identification determines how many elements the work is to contain. These different identifications are incompatible with one another, or generally so, and each might be said to make a different artwork, even though each artwork contains the identical real object as part of itself—or at least parts of the identical real object as parts of itself. There are, of course, senseless identifications: no one could, I think, sensibly read the middle horizontal as *Love's Labour's Lost* or *The Ascendency of St. Erasmus*. Finally, notice how acceptance of one identification rather than another is in effect to exchange one *world* for another. We could, indeed, enter a quiet poetic world by identifying the upper area with a clear and cloudless sky, reflected in the still surface of the water below, whiteness kept from whiteness only by the unreal boundary of the horizon.

And now Testadura, having hovered in the wings throughout this discussion, protests that *all he sees is paint:* a white painted oblong with a black line painted across it. And how right he really is: that is all he sees or that anybody can, we aesthetes included. So, if he asks us to show him what there is further to see, to demonstrate through pointing that this is an artwork (*Sea and Sky*), we cannot comply, for he has overlooked nothing (and it would be absurd to suppose he had, that there was something tiny we could point to and he, peering closely, say "So it is! A work of art after all!"). We cannot help him until he has mastered the *is of artistic identification* and so *constitutes* it a work of art. If he cannot achieve this, he will never look upon artworks: he will be like a child who sees sticks as sticks.

But what about pure abstractions, say something that looks just like *A* but is entitled *No. 7?* The 10th Street abstractionist blankly insists that there is nothing here but white paint and black, and none of our literary identifications need apply. What then distinguishes him from Testadura, whose philistine utterances are indiscernible from his? And how can it be an artwork for him and not for Testadura, when they agree that there is nothing that does not meet the eye? The answer, unpopular as it is likely to be to purists of every variety, lies in the fact that this artist has returned to the physicality of paint through an atmosphere compounded of artistic theories and the history of recent and remote painting, elements of which he is trying to refine out of his own work; and as a consequence of this his work belongs in this atmosphere and is part of this history. He has achieved abstraction through rejection of artistic identifications, returning to the real world from which such identifications remove us (he thinks), somewhat in the mode of Ch'ing Yuan, who wrote:

> Before I had studied Zen for thirty years, I saw mountains as mountains and waters as waters. When I arrived at a more intimate knowledge, I came to the point where I saw that mountains are not mountains, and waters are not waters. But now that I have got the very substance I am at rest. For it is just that I see mountains once again as mountains, and waters once again as waters.

His identification of what he has made is logically dependent upon the theories and history he rejects. The difference between his utterance and Testadura's "This is black paint and white paint and nothing more" lies in the fact that he is still using the *is* of artistic identification, so that his use of "That black paint is black paint" is not a tautology.

Testadura is not at that stage. To see something as art requires something the eye cannot descry—an atmosphere of artistic theory, a knowledge of the history of art: an artworld.

III

Mr. Andy Warhol, the Pop artist, displays facsimiles of Brillo cartons, piled high, in neat stacks, as in the stockroom of the supermarket. They happen to be of wood, painted to look like cardboard, and why not? To paraphrase the critic of the *Times,* if one may make the facsimile of a human being out of bronze, why not the facsimile of a Brillo carton out of plywood? The cost of these boxes happens to be 2×10^3 that of their homely counterparts in real life—a differential hardly ascribable to their advantage in durability. In fact the Brillo people might, at some slight increase in cost, make their boxes out of plywood without these becoming artworks, and Warhol might make *his* out of cardboard without their ceasing to be art. So we may forget questions of intrinsic value, and ask why the Brillo people cannot manufacture art and why Warhol cannot *but* make artworks. Well, his are made by hand, to be sure. Which is like an insane reversal of Picasso's strategy in pasting the label from a bottle of Suze onto a drawing, saying as it were that the academic artist, concerned with exact imitation, must always fall short of the real thing: so why not just *use* the real thing? The Pop artist laboriously reproduces machine-made objects by hand, e.g., painting the labels on coffee cans (one can hear the familiar commendation "Entirely made by hand" falling painfully out of the guide's vocabulary when confronted by these objects). But the difference cannot consist in craft: a man who carved pebbles out of stones and carefully constructed a work called *Gravel Pile* might invoke the labor theory of value to account for the price he demands; but the question is, What makes it art? And why need Warhol *make* these things anyway? Why not just scrawl his signature across one? Or crush one up and display it as *Crushed Brillo Box* ("A protest against mechanization . . .") or simply display a Brillo carton as *Uncrushed Brillo Box* ("A bold affirmation of the plastic authenticity of industrial . . .")? Is this man a kind of Midas, turning whatever he touches into the gold of pure art? And the whole world consisting of latent artworks waiting, like the bread and wine of reality, to be transfigured, through some dark mystery, into the indiscernible flesh and blood of the sacrament? Never mind that the Brillo box may not be good, much less great art. The impressive thing is that it is art at all. But if it is, why are not the indiscernible Brillo boxes that are in the stockroom? Or *has* the whole distinction between art and reality broken down?

Suppose a man collects objects (readymades), including a Brillo carton; we praise the exhibit for variety, ingenuity, what you will. Next he exhibits nothing but Brillo cartons, and we criticize it as dull, repetitive, self-plagiarizing—or (more profoundly) claim that he is obsessed by regularity and repetition, as in *Marienbad.* Or he piles them high, leaving a narrow path; we tread our way through the smooth opaque stacks and find it an unsettling experience, and write it up as the closing in of consumer products, confining us as prisoners: or we say he is a modern pyramid builder. True, we don't say these things about the stockboy. But then a stockroom is not an art gallery, and we cannot readily separate the Brillo cartons from the gallery they are in, any more than we can separate the Rauschenberg bed from the paint upon it. Outside the gallery, they are pasteboard cartons. But then, scoured clean of paint, Rauschenberg's bed is a bed, just what it was before it was transformed into art. But then if we think this matter through, we discover that the artist has failed, really and of necessity, to produce a mere real object. He has produced an artwork, his use of real Brillo cartons being but an expansion of the resources available to artists, a contribution to *artists' materials,* as oil paint was, or *tuche.*

What in the end makes the difference between a Brillo box and a work of art consisting of a Brillo Box is a certain theory of art. It is the theory that takes it up into the world of art, and keeps it from collapsing into the real object which it is (in a sense of *is* other than that of artistic identification). Of course, without the theory, one is unlikely to see it as art, and in order to see it as part of the artworld, one must have mastered a good deal of artistic theory as well as a considerable amount of the history of recent New York painting. It could not have been art fifty years ago. But then there could not have been, everything being equal, flight insurance in the Middle Ages, or Etruscan typewriter erasers. The world has to be ready for certain things, the artworld no less than the real one. It is the role of artistic theories, these days as always, to make the artworld, and art, possible. It would, I should think, never have occurred to the painters of Lascaux that they were producing *art* on those walls. Not unless there were neolithic aestheticians.

IV

The artworld stands to the real world in something like the relationship in which the City of God stands to the Earthly City. Certain objects, like certain individuals, enjoy a double citizenship, but there

remains, the RT notwithstanding, a fundamental contrast between artworks and real objects. Perhaps this was already dimly sensed by the early framers of the IT who, inchoately realizing the nonreality of art, were perhaps limited only in supposing that the sole way objects had of being other than real is to be sham, so that artworks necessarily had to be imitations of real objects. This was too narrow. So Yeats saw in writing "Once out of nature I shall never take / My bodily form from any natural thing." It is but a matter of choice: and the Brillo box of the artworld may be just the Brillo box of the real one, separated and united by the *is* of artistic identification. But I should like to say some final words about the theories that make artworks possible, and their relationship to one another. In so doing, I shall beg some of the hardest philosophical questions I know.

I shall now think of pairs of predicates related to each other as "opposites," conceding straight off the vagueness of this *demodé* term. Contradictory predicates are not opposites, since one of each of them must apply to every object in the universe, and neither of a pair of opposites need apply to some objects in the universe. An object must first be of a certain kind before either of a pair of opposites applies to it, and then at most and at least one of the opposites must apply to it. So opposites are not contraries, for contraries may both be false of some objects in the universe, but opposites cannot both be false; for of some objects, neither of a pair of opposites *sensibly* applies, unless the object is of the right sort. Then, if the object is of the required kind, the opposites behave as contradictories. If F and non-F are opposites, and object o must be of a certain kind K before either of these sensibly applies; but if o is a member of K, then o either is F or non-F, to the exclusion of the other. The class of pairs of opposites that sensibly apply to the (\hat{o}) Ko I shall designate as the class of K-*relevant predicates*. And a necessary condition for an object to be of a kind K is that at least one pair of K-relevant opposites be sensibly applicable to it. But, in fact, if an object is of kind K, at least and at most one of each K-relevant pair of opposites applies to it.

I am now interested in the K-relevant predicates for the class K of artworks. And let F and non-F be an opposite pair of such predicates. Now it might happen that, throughout an entire period of time, every artwork is non-F. But since nothing thus far is both an artwork and F, it might never occur to anyone that non-F is an artistically relevant predicate. The non-F-ness of artworks goes unmarked. By contrast, all works up to a given time might be G, it never occurring to anyone until that time that something might be both an artwork and non-G;

indeed, it might have been thought that G was a *defining trait* of artworks when in fact something might first have to be an artwork before G is sensibly predicable of it—in which case non-G might also be predicable of artworks, and G itself then could not have been a defining trait of this class.

Let G be 'is representational' and let F be 'is expressionist'. At a given time, these and their opposites are perhaps the only art-relevant predicates in critical use. Now letting '+' stand for a given predicate P and '−' for its opposite non-P, we may construct a style matrix more or less as follows:

F	G
+	+
+	−
−	+
−	−

The rows determine available styles, given the active critical vocabulary: representational expressionistic (e.g., Fauvism); representational nonexpressionistic (Ingres); nonrepresentational expressionistic (Abstract Expressionism); nonrepresentational nonexpressionist (hard-edge abstraction). Plainly, as we add art-relevant predicates, we increase the number of available styles at the rate of 2^n. It is, of course, not easy to see in advance which predicates are going to be added or replaced by their opposites, but suppose an artist determines that H shall henceforth be artistically relevant for his paintings. Then, in fact, both H and non-H become artistically relevant for *all* painting, and if his is the first and only painting that is H, every other painting in existence becomes non-H, and the entire community of paintings is enriched, together with a doubling of the available style opportunities. It is this retroactive enrichment of the entities in the artworld that makes it possible to discuss Raphael and DeKooning together, or Lichtenstein and Michelangelo. The greater the variety of artistically relevant predicates, the more complex the individual members of the artworld become; and the more one knows of the entire population of the artworld, the richer one's experience with any of its members.

In this regard, notice that, if there are m artistically relevant predicates, there is always a bottom row with m minuses. This row is apt to be occupied by purists. Having scoured their canvases clear of what they regard as inessential, they credit themselves with having distilled out the essence of art. But this is just their fallacy: exactly as many artistically relevant predicates stand true of their square monochromes as stand true of any member of the Artworld, and they can *exist* as artworks only insofar as "impure" paintings exist. Strictly speaking, a

black square by Reinhardt is artistically as rich as Titian's *Sacred and Profane Love*. This explains how less is more.

Fashion, as it happens, favors certain rows of the style matrix: museums, connoisseurs, and others are makeweights in the Artworld. To insist, or seek to, that all artists become representational, perhaps to gain entry into a specially prestigious exhibition, cuts the available style matrix in half: there are then $2^n / 2$ ways of satisfying the requirement, and museums then can exhibit all these "approaches" to the topic they have set. But this is a matter of almost purely sociological interest: one row in the matrix is as legitimate as another. An artistic breakthrough consists, I suppose, in adding the possibility of a column to the matrix. Artists then, with greater or less alacrity, occupy the positions thus opened up: this is a remarkable feature of contemporary art, and for those unfamiliar with the matrix, it is hard, and perhaps impossible, to recognize certain positions as occupied by artworks. Nor would these things be artworks without the theories and the histories of the Artworld.

Brillo boxes enter the Artworld with that same tonic incongruity the *commedia dell'arte* characters bring into *Ariadne auf Naxos*. Whatever is the artistically relevant predicate in virtue of which they gain their entry, the rest of the Artworld becomes that much the richer in having the opposite predicate available and applicable to its members. And, to return to the views of Hamlet with which we began this discussion, Brillo boxes may reveal us to ourselves as well as anything might: as a mirror held up to nature, they might serve to catch the conscience of our kings.

39

What Is Art?
An Institutional Analysis

GEORGE DICKIE

The attempt to define "art" by specifying its necessary and sufficient conditions is an old endeavor. The first definition—the imitation theory—despite what now seem like obvious difficulties, more or less satisfied everyone until some time in the nineteenth century. After the expression theory of art broke the domination of the imitation theory, many definitions purporting to reveal the necessary and sufficient conditions of art appeared. In the mid-1950's, several philosophers, inspired by Wittgenstein's talk about concepts, began arguing that there are no necessary and sufficient conditions for art. Until recently, this argument had persuaded so many philosophers of the futility of trying to define art that the flow of definitions had all but ceased. Although I will ultimately try to show that "art" can be defined, the denial of that possibility has had the very great value of forcing us to look deeper into the concept of "art." The parade of dreary and superficial definitions that had been presented was, for a variety of reasons, eminently rejectable. The traditional attempts to define "art," from the imitation theory on, may be thought of as Phase I and the contention that "art" cannot be defined as Phase II. I want to supply Phase III by defining "art" in such a way as to avoid the difficulties of the traditional definitions and to incorporate the insights of the later analysis. I should note that the imitation theory of the fine arts seems to have been adopted by those who held it without much serious thought

and perhaps cannot be considered as a self-conscious theory of art in the way that the later theories can be.

The traditional attempts at definition have sometimes failed to see beyond prominent but accidental features of works of art, features that have characterized art at a particular stage in its historical development. For example, until quite recently the works of art clearly recognizable as such were either obviously representational or assumed to be representational. Paintings and sculptures were obviously so, and music was widely assumed in some sense also to be representational. Literature was representational in that it described familiar scenes of life. It was, then, easy enough to think that imitation must be the essence of art. The imitation theory focused on a readily evident relational property of works of art, namely, art's relation to subject matter. The development of nonobjective art showed that imitation is not even an always-accompanying property of art, much less an essential one.

The theory of art as the expression of emotion has focused on another relational property of works of art, the relation of a work to its creator. The expression theory also has proved inadequate, and no other subsequent definition has been satisfactory. Although not fully satisfying as definitions, the imitation and expression theories do provide a clue: both singled out *relational* properties of art as essential. As I shall try to show, the two defining

From George Dickie, *Art and the Aesthetic: An Institutional Analysis.* Ithaca: Cornell University Press, 1974, pp. 19–52. Reprinted with permission of Cornell University Press and the author.

characteristics of art are indeed relational properties, and one of them turns out to be exceedingly complex.

I

The best-known denial that "art" can be defined occurs in Morris Weitz's article "The Role of Theory in Aesthetics."[1] Weitz's conclusion depends upon two arguments which may be called his "generalization argument" and his "classification argument." In stating the "generalization argument" Weitz distinguishes, quite correctly, between the generic conception of "art" and the various subconcepts of art such as tragedy, the novel, painting, and the like. He then goes on to give an argument purporting to show that the subconcept "novel" is open, that is, that the members of the class of novels do not share any essential or defining characteristics. He then asserts without further argument that what is true of novels is true of all other subconcepts of art. The generalization from one subconcept to all subconcepts may or may not be justified, but I am not questioning it here. I do question, however, Weitz's additional contention, also asserted without argument, that the generic conception of "art" is open. The best that can be said of his conclusion about the generic sense is that it is unsupported. All or some of the subconcepts of art may be open and the generic conception of art still be closed. That is, it is possible that all or some of the subconcepts of art, such as novel, tragedy, sculpture, and painting, may lack necessary and sufficient conditions and at the same time that "work of art," which is the genus of all the subconcepts, can be defined in terms of necessary and sufficient conditions. Tragedies may not have any characteristics in common which would distinguish them from, say, comedies *within the domain of art*, but it may be that there are common characteristics that works of art have which distinguish them from nonart. Nothing prevents a "closed genus/open species" relationship. Weitz himself has recently cited what he takes to be a similar (although reversed) example of genus-species relationship. He argues that "game" (the genus) is open but that "major league baseball" (a species) is closed.[2]

His second argument, "the classification argument," claims to show that not even the characteristic of artifactuality is a necessary feature of art. Weitz's conclusion here is something of a surprise, because it has been widely assumed by philosophers and nonphilosophers alike that a work of art is necessarily an artifact. His argument is simply that we sometimes utter such statements as "This piece of driftwood is a lovely piece of sculpture," and since such utterances are perfectly intelligible, it follows that some nonartifacts such as certain pieces of driftwood are works of art (sculptures). In other words, something need not be an artifact in order to be correctly classified as a work of art. I will try to rebut this argument shortly.

Recently, Maurice Mandelbaum has raised a question about Wittgenstein's famous contention that "game" cannot be defined and Weitz's thesis about "art."[3] His challenge to both is based on the charge that they have been concerned only with what Mandelbaum calls "exhibited" characteristics and that consequently each has failed to take account of the nonexhibited, relational aspects of games and art. By "exhibited" characteristics Mandelbaum means easily perceived properties such as the fact that a ball is used in a certain kind of game, that a painting has a triangular composition, that an area in a painting is red, or that the plot of a tragedy contains a reversal of fortune. Mandelbaum concludes that when we consider the nonexhibited properties of games, we see that they have in common "the potentiality of . . . [an] . . . absorbing nonpractical interest to either participants or spectators."[4] Mandelbaum may or may not be right about "game," but what interests me is the application of his suggestion about nonexhibited properties to the discussion of the definition of art. Although he does not attempt a definition of "art," Mandelbaum does suggest that feature(s) common to all works of art may perhaps be discovered that will be a basis for the definition of "art," if the nonexhibited features of art are attended to.

Having noted Mandelbaum's invaluable suggestion about definition, I now return to Weitz's argument concerning artifactuality. In an earlier attempt to show Weitz wrong, I thought it sufficient to point out that there are two senses of "work of art," an evaluative sense and a classificatory one; Weitz himself distinguishes these in his article as the evaluative and the descriptive senses of art. My earlier argument was that if there is more than one sense of "work of art," then the fact that "This piece of driftwood is a lovely piece of sculpture" is intelligible does not prove what Weitz wants it to prove. Weitz would have to show that "sculpture" is being used in the sentence in question in the classificatory sense, and this he makes no attempt to do. My argument assumed that once the distinction is made, it is obvious that "sculpture" is here being used in the evaluative sense. Richard Sclafani has subsequently noted that my argument shows only that Weitz's argument is inconclusive and that Weitz might still be right, even though his argument does not prove his conclusion. Sclafani, however, has constructed a stronger argument against Weitz on this point.[5]

Sclafani shows that there is a third sense of "work of art'" and that "driftwood cases" (the nonartifact cases) fall under it. He begins by comparing a paradigm work of art, Brancusi's *Bird in Space*, with a piece of driftwood which looks very much like it. Sclafani says that it seems natural to say of the piece of driftwood that it is a work of art and that we do so because it has so many properties in common with the Brancusi piece. He then asks us to reflect on our characterization of the driftwood and the *direction* it has taken. We say the driftwood is art because of its resemblance to some paradigm work of art or because the driftwood shares properties with several paradigm works of art. The paradigm work or works are of course always artifacts; the direction of our move is from paradigmatic (artifactual) works of art to nonartifactual "art." Sclafani quite correctly takes this to indicate that there is a primary, paradigmatic sense of "work of art" (my classificatory sense) and a derivative or secondary sense into which the "driftwood cases" fall. Weitz is right in a way in saying that the driftwood is art, but wrong in concluding that artifactuality is unnecessary for (the primary sense of) art.

There are then at least three distinct senses of "work of art": the primary or classificatory sense, the secondary or derivative, and the evaluative. Perhaps in most uses of Weitz's driftwood sentence example, both the derivative and the evaluative senses would be involved: the derivative sense if the driftwood shared a number of properties with some paradigm work of art and the evaluative sense if the shared properties were found to be valuable by the speaker. Sclafani gives a case in which only the evaluative sense functions, when someone says, "Sally's cake is a work of art." In most uses of such a sentence "work of art" would simply mean that its referent has valuable qualities. Admittedly, one can imagine contexts in which the derivative sense would apply to cakes. (Given the situation in art today, one can easily imagine cakes to which the primary sense of art could be applied.) If, however, someone were to say, "This Rembrandt is a work of art," both the classificatory and the evaluative senses would be functioning. The expression "this Rembrandt" would convey the information that its referent is a work of art in the classificatory sense, and "is a work of art" could then only reasonably be understood in the evaluative sense. Finally, someone might say of a sea shell or other natural object which resembles a man's face but is otherwise uninteresting, "This shell (or other natural object) is a work of art." In this case, only the derivative sense would be used.

We utter sentences in which the expression "work of art" has the evaluative sense with considerable frequency, applying it to both natural objects and artifacts. We speak of works of art in the derived sense with somewhat less frequency. The classificatory sense of "work of art," which indicates simply that a thing belongs to a certain category of artifacts, occurs, however, very infrequently in our discourse. We rarely utter sentences in which we use the classificatory sense, because it is such a basic notion: we generally know immediately whether an object is a work of art, so that generally no one needs to say, by way of classification, "That is a work of art, " although recent developments in art such as junk sculpture and found art may occasionally force such remarks. Even if we do not often talk about art in this classificatory sense, however, it is a basic concept that structures and guides our thinking about our world and its contents.

II

It is now clear that artifactuality is a necessary condition (call it the genus) of the primary sense of art. This fact, however, does not seem very surprising and would not even be very interesting except that Weitz and others have denied it. Artifactuality alone, however, is not the whole story and another necessary condition (the differentia) has to be specified in order to have a satisfactory definition of "art." Like artifactuality, the second condition is a nonexhibited property, which turns out to be as complicated as artifactuality is simple. The attempt to discover and specify the second condition of art will involve an examination of the intricate complexities of the "artworld." W. E. Kennick, defending a view similar to Weitz's, contends that the kind of approach to be employed here, following Mandelbaum's lead, is futile. He concludes that "the attempt to define Art in terms of what we do with certain objects is as doomed as any other."[6] He tries to support this conclusion by referring to such things as the fact that the ancient Egyptians sealed up paintings and sculptures in tombs. There are two difficulties with Kennick's argument. First, that the Egyptians sealed up paintings and sculptures in tombs does not show that they regarded them differently from the way in which we regard them. They might have put them there for the dead to appreciate or simply because they belonged to the dead person. The Egyptian practice does not establish so radical a difference between their conception of art and ours that a definition subsuming both is impossible. Second, one need not assume that we and the ancient Egyptians share a common conception of art. It would be enough to be able to specify the necessary and sufficient conditions for the concept of art which we have (we present-day Americans, we present-day Westerners, we Westerners

since the organization of the system of the arts in or about the eighteenth century—I am not sure of the exact limits of the "we"). Kennick notwithstanding, we are most likely to discover the differentia of art by considering "what we do with certain objects." Of course, nothing guarantees that any given thing we might do or an ancient Egyptian might have done with a work of art will throw light on the concept of art. Not every "doing" will reveal what is required.

Although he does not attempt to formulate a definition, Arthur Danto in his provocative article, "The Artworld," has suggested the direction that must be taken by an attempt to define "art."[7] In reflecting on art and its history together with such present-day developments as Warhol's *Brillo Carton* and Rauschenberg's *Bed,* Danto writes, "To see something as art requires something the eye cannot descry—an atmosphere of artistic theory, a knowledge of history of art: an artworld."[8] Admittedly, this stimulating comment is in need of elucidation, but it is clear that in speaking of "something the eye cannot descry" Danto is agreeing with Mandelbaum that nonexhibited properties are of great importance in constituting something as art. In speaking of atmosphere and history, however, Danto's remark carries us a step further than Mandelbaum's analysis. Danto points to the rich structure in which particular works of art are embedded: he indicates *the institutional nature of art.*[9]

I shall use Danto's term "artworld" to refer to the broad social institution in which works of art have their place.[10] But is there such an institution? George Bernard Shaw speaks somewhere of the apostolic line of succession stretching from Aeschylus to himself. Shaw was no doubt speaking for effect and to draw attention to himself, as he often did, but there is an important truth implied by his remark. There is a long tradition or continuing institution of the theater having its origins in ancient Greek religion and other Greek institutions. That tradition has run very thin at times and perhaps even ceased to exist altogether during some periods, only to be reborn out of its memory and the need for art. The institutions associated with the theater have varied from time to time: in the beginning it was Greek religion and the Greek state; in medieval times, the church; more recently, private business and the state (national theater). What has remained constant with its own identity throughout its history is the theater itself as an established way of doing and behaving, what I call [elsewhere] the primary convention of the theater. This institutionalized behavior occurs on both sides of the "footlights": both the players and the audience are involved and go to make up the institution of the theater. The roles of the actors and the audience are

defined by the traditions of the theater. What the author, management, and players present is art, and it is art because it is presented within the theater-world framework. Plays are written to have a place in the theater system and they exist as plays, that is, as art, within that system. Of course, I do not wish to deny that plays also exist as literary works, that is, as art within the literary system: the theater system and the literary system overlap. Let me make clear what I mean by speaking of the artworld as an institution. Among the meanings of "institution" in *Webster's New Collegiate Dictionary* are the following: "3. That which is instituted as: a. An established practice, law, custom, etc. b. An established society or corporation." When I call the artworld an institution I am saying that it is an established practice. Some persons have thought that an institution must be an established society or corporation and, consequently, have misunderstood my claim about the artworld.

Theater is only one of the systems within the artworld. Each of the systems has had its own origins and historical development. We have some information about the later stages of these developments, but we have to guess about the origins of the basic art systems. I suppose that we have complete knowledge of certain recently developed subsystems or genres such as Dada and happenings. Even if our knowledge is not as complete as we wish it were, however, we do have substantial information about the systems of the artworld as they currently exist and as they have existed for some time. One central feature all of the systems have in common is that each is a framework for the *presenting* of particular works of art. Given the great variety of the systems of the artworld it is not surprising that works of art have not exhibited properties in common. If, however, we step back and view the works in their institutional setting, we will be able to see the essential properties they share.

Theater is a rich and instructive illustration of the institutional nature of art. But it is a development within the domain of painting and sculpture—Dadaism—that most easily reveals the institutional essence of art. Duchamp and friends conferred the status of art on "ready-mades"(urinals, hatracks, snow shovels, and the like), and when we reflect on their deeds we can take note of a kind of human action which has until now gone unnoticed and unappreciated—the action of conferring the status of art. Painters and sculptors, of course, have been engaging all along in the action of conferring this status on the objects they create. As long, however, as the created objects were conventional, given the paradigms of the times, the objects themselves and their fascinating exhibited properties were the focus of the attention

of not only spectators and critics but of philosophers of art as well. When an artist of an earlier era painted a picture, he did some or all of a number of things: depicted a human being, portrayed a certain man, fulfilled a commission, worked at his livelihood, and so on. In addition he also acted as an agent of the artworld and conferred the status of art on his creation. Philosophers of art attended to only some of the properties the created object acquired from these various actions, for example, to the representational or to the expressive features of the objects. They entirely ignored the nonexhibited property of status. When, however, the objects are bizarre, as those of the Dadaists are, our attention is forced away from the objects' obvious properties to a consideration of the objects in their social context. As works of art Duchamp's "ready-mades" may not be worth much, but as examples of art they are very valuable for art theory. I am not claiming that Duchamp and friends invented the conferring of the status of art; they simply used an existing institutional device in an unusual way. Duchamp did not invent the artworld, because it was there all along.

The artworld consists of a bundle of systems: theater, painting, sculpture, literature, music, and so on, each of which furnishes an institutional background for the conferring of the status on objects within its domain. No limit can be placed on the number of systems that can be brought under the generic conception of art, and each of the major systems contains further subsystems. These features of the artworld provide the elasticity whereby creativity of even the most radical sort can be accommodated. A whole new system comparable to the theater, for example, could be added in one fell swoop. What is more likely is that a new subsystem would be added within a system. For example, junk sculpture added within sculpture, happenings added within theater. Such additions might in time develop into full-blown systems. Thus, the radical creativity, adventuresomeness, and exuberance of art of which Weitz speaks is possible within the concept of art, even though it is closed by the necessary and sufficient conditions of artifactuality and conferred status.

Having now briefly described the artworld, I am in a position to specify a definition of "work of art." The definition will be given in terms of artifactuality and the conferred status of art or, more strictly speaking, the conferred status of candidate for appreciation. Once the definition has been stated, a great deal will still remain to be said by way of clarification: A work of art in the classificatory sense is (1) an artifact (2) a set of the aspects of which has had conferred upon it the status of candidate for appreciation by some person or persons acting on behalf of a certain social institution (the artworld).

The second condition of the definition makes use of four variously interconnected notions: (1) acting on behalf of an institution, (2) conferring of status, (3) being a candidate, and (4) appreciation. The first two of these are so closely related that they must be discussed together. I shall first describe paradigm cases of conferring status outside the artworld and then show how similar actions take place within the artworld. The most clear-cut examples of the conferring of status are certain legal actions of the state. A king's conferring of knighthood, a grand jury's indicting someone, the chairman of the election board certifying that someone is qualified to run for office, or a minister's pronouncing a couple man and wife are examples in which a person or persons acting on behalf of a social institution (the state) confer(s) *legal* status on persons. The congress or a legally constituted commission may confer the status of national park or monument on an area or thing. The examples given suggest that pomp and ceremony are required to establish legal status, but this is not so, although of course a legal system is presupposed. For example, in some jurisidictions common-law marriage is possible—a legal status acquired without ceremony. The conferring of a Ph.D degree on someone by a university, the election of someone as president of the Rotary, and the declaring of an object as a relic of the church are examples in which a person or persons confer(s) nonlegal status on persons or things. In such cases some social system or other must exist as the framework within which the conferring takes place, but, as before, ceremony is not required to establish status: for example, a person can acquire the status of wise man or village idiot within a community without ceremony.

Some may feel that the notion of conferring status within the artworld is excessively vague. Certainly this notion is not as clear-cut as the conferring of status within the legal system, where procedures and lines of authority are explicitly defined and incorporated into law. The counterparts in the artworld to specified procedures and lines of authority are nowhere codified, and the artworld carries on its business at the level of customary practice. Still there *is* a practice and this defines a social institution. A social institution need not have a formally established constitution, officers, and bylaws in order to exist and have the capacity to confer status—some social institutions are formal and some are informal. The artworld could become formalized, and perhaps has been to some extent in certain political contexts, but most people who are interested in art would probably consider this a bad thing. Such formality would threaten the freshness and exuberance of art. The core personnel of the artworld is a loosely orga-

nized, but nevertheless related, set of persons including artists (understood to refer to painters, writers, composers), producers, museum directors, museum-goers, theater-goers, reporters for newspapers, critics for publications of all sorts, art historians, art theorists, philosophers of art, and others. These are the people who keep the machinery of the artworld working and thereby provide for its continuing existence. In addition, every person who sees himself as a member of the artworld is thereby a member. Although I have called the persons just listed the core personnel of the artworld, there is a minimum core within that core without which the artworld would not exist. This essential core consists of artists who create the works, "presenters" to present the works, and "goers" who appreciate the works. This minimum core might be called "the presentation group," for it consists of artists whose activity is necessary if anything is to be presented, the presenters (actors, stage managers, and so on), and the goers whose presence and cooperation is necessary in order for anything to be presented. A given person might play more than one of these essential roles in the case of the presentation of a particular work. Critics, historians, and philosophers of art become members of the artworld at some time after the minimum core personnel of a particular art system get that system into operation. All of these roles are institutionalized and must be learned in one way or another by the participants. For example, a theater-goer is not just someone who happens to enter a theater; he is a person who enters with certain expectations and knowledge about what he will experience and an understanding of how he should behave in the face of what he will experience.

Assuming that the existence of the artworld has been established or at least made plausible, the problem is now to see how status is conferred by this institution. My thesis is that, in a way analogous to the way in which a person is certified as qualified for office, or two persons acquire the status of common-law marriage within a legal system, or a person is elected president of the Rotary, or a person acquires the status of wise man within a community, so an artifact can acquire the status of candidate for appreciation within the social system called "the artworld." How can one tell when the status has been conferred? An artifact's hanging in an art museum as part of a show and a performance at a theater are sure signs. There is, of course, no guarantee that one can always know whether something is a candidate for appreciation, just as one cannot always tell whether a given person is a knight or is married. When an object's status depends upon nonexhibited characteristics, a simple look at the object will not necessarily reveal that status. The

nonexhibited relation *may* be symbolized by some badge, for example, by a wedding ring, in which case a simple look will reveal the status.

The more important question is that of how the status of candidate for appreciation is conferred. The examples just mentioned, display in a museum and a performance in a theater, seem to suggest that a number of persons are required for the actual conferring of the status. In one sense a number of persons are required but in another sense only one person is required: a number of persons are required to make up the social institution of the artworld, but only one person is required to act on behalf of the artworld and to confer the status of candidate for appreciation. In fact, many works of art are seen only by one person—the one who creates them—but they are still art. The status in question may be acquired by a single person's acting on behalf of the artworld and *treating an artifact as a candidate for appreciation*. Of course, nothing prevents a group of persons from conferring the status, but it is usually conferred by a single person, the artist who creates the artifact. It may be helpful to compare and contrast the notion of conferring the status of candidate for appreciation with a case in which something is simply presented for appreciation: hopefully this will throw light on the notion of status of candidate. Consider the case of a salesman of plumbing supplies who spreads his wares before us. "Placing before" and "conferring the status of candidate for appreciation" are very different notions, and this difference can be brought out by comparing the salesman's action with the superficially similar act of Duchamp in entering a urinal which he christened *Fountain* in that now-famous art show. The difference is that Duchamp's action took place within the institutional setting of the artworld and the plumbing salesman's action took place outside of it. The salesman could do what Duchamp did, that is, convert a urinal into a work of art, but such a thing probably would not occur to him. Please remember that *Fountain's* being a work of art does not mean that it is a good one, nor does this qualification insinuate that it is a bad one either. The antics of a particular present-day artist serve to reinforce the point of the Duchamp case and also to emphasize a significance of the practice of naming works of art. Walter de Maria has in the case of one of his works even gone through the motions, no doubt as a burlesque, of using a procedure used by many legal and some nonlegal institutions—the procedure of licensing. His *High Energy Bar* (a stainless-steel bar) is accompanied by a certificate bearing the name of the work and stating that the bar is a work of art only when the certificate is present. In addition to highlighting the status of art by "certifying" it on a document, this example serves

to suggest a significance of the act of naming works of art. An object may acquire the status of art without ever being named but giving it a title makes clear to whomever is interested that an object is a work of art. Specific titles function in a variety of ways—as aids to understanding a work or as a convenient way of identifying it, for example—but any title at all (even *Untitled*) is a badge of status.[11]

The third notion involved in the second condition of the definition is candidacy: a member of the artworld confers the status of candidate for appreciation. The definition does not require that a work of art actually be appreciated, even by one person. The fact is that many, perhaps most, works of art go unappreciated. It is important not to build into the definition of the classificatory sense of "work of art" value properties such as actual appreciation: to do so would make it impossible to speak of unappreciated works of art. Building in value properties might even make it awkward to speak of bad works of art. A theory of art must preserve certain central features of the way in which we talk about art, and we do find it necessary sometimes to speak of unappreciated art and of bad art. Also, not every aspect of a work is included in the candidacy for appreciation; for example, the color of the back of a painting is not ordinarily considered to be something which someone might think it appropriate to appreciate. The problem of which aspects of a work of art are to be included within the candidacy for appreciation is a question I pursue [elsewhere] in trying to give an analysis of the notion of aesthetic object. The definition of "work of art" should not, therefore, be understood as asserting that every aspect of a work is included within the candidacy for appreciation.

The fourth notion involved in the second condition of the definition is appreciation itself. Some may assume that the definition is referring to a special kind of *aesthetic* appreciation. I argue [elsewhere] that there is no reason to think that there is a special kind of aesthetic consciousness, attention, or perception. Similarly, I do not think there is any reason to think that there is aesthetic appreciation. All that is meant by "appreciation" in the definition is something like "in experiencing the qualities of a thing one find them worthy or valuable," and this meaning applies quite generally both inside and outside the domain of art. Several persons have felt that my account of the institutional theory of art is incomplete because of what they see as my insufficient analysis of "appreciation." They have, I believe, thought that there are different kinds of appreciation and that the appreciation in the appreciation of art is somehow typically different from the appreciation in the appreciation of nonart. But the only sense in which there is a difference between the appreciation of art and the appreciation of nonart is that the appreciations have different *objects*. The institutional structure in which the art object is embedded, not different kinds of appreciation, makes the difference between the appreciation of art and the appreciation of nonart.

In a recent article[12] Ted Cohen has raised a question concerning (1) candidacy for appreciation and (2) appreciation as these two were treated in my original attempt to define "art."[13] He claims that in order for it to be possible for candidacy for appreciation to be conferred on something that it must be possible for that thing to be appreciated. Perhaps he is right about this; in any event, I cannot think of any reason to disagree with him on this point. The possibility of appreciation is one constraint on the definition: if something cannot be appreciated, it cannot become art. The questions that now arises is: is there anything which it is impossible to appreciate? Cohen claims many things cannot be appreciated; for example, "ordinary thumbtacks, cheap white envelopes, the plastic forks given at some drive-in restaurants."[14] But more importantly, he claims that *Fountain* cannot be appreciated. He says that *Fountain* has a point which can be appreciated, but that it is Duchamp's gesture that has significance (can be appreciated) and not *Fountain* itself. I agree that *Fountain* has the significance Cohen attributes to it, namely, that it was a protest against the art of its day. But why cannot the ordinary qualities of *Fountain*—its gleaming white surface, the depth revealed when it reflects images of surrounding objects, its pleasing oval shape—be appreciated? It has qualities similar to those of works by Brancusi and Moore which many do not balk at saying they appreciate. Similarly, thumbtacks, envelopes, and plastic forks have qualities that can be appreciated if one makes the effort to focus attention on them. One of the values of photography is its ability to focus on and bring out the qualities of quite ordinary objects. And the same sort of thing can be done without the benefit of photography by just looking. In short, it seems unlikely to me that any object would not have some quality which is appreciatable and thus likely that the constraint Cohen suggests may well be vacuous. But even if there are some objects that cannot be appreciated, *Fountain* and the other Dadaist creations are not among them.

I should note that in accepting Cohen's claim I am saying that every work of art must have some minimal *potential* value or worthiness. This fact, however, does not collapse the distinction between the evaluative sense and the classificatory sense of "work of art." The evaluative sense is used when the object it is predicated of is deemed *to be* of substantial, actual value, and that object may be a natural object. I will further note that the appreciata-

bility of a work of art in the classificatory sense is *potential* value which in a given case may never be realized.[15]

The definition I have given contains a reference to the artworld. Consequently, some may have the uncomfortable feeling that my definition is viciously circular. Admittedly, in a sense the definition is circular, but it is not viciously so. If I had said something like "A work of art is an artifact on which a status has been conferred by the artworld" and then said of the artworld only that it confers the status of candidacy for appreciation, then the definition would be viciously circular because the circle would be so small and *uninformative*. I have, however, devoted a considerable amount of space in this chapter to describing and analyzing the historical, organizational, and functional intricacies of the artworld, and if this account is accurate the reader has received a considerable amount of *information* about the artworld. The circle I have run is not small and it is not uninformative. If, in the end, the artworld cannot be described independently of art, that is, if the description contains references to art historians, art reporters, plays, theaters, and so on, then the definition strictly speaking is circular. It is not, however, viciously so, because the whole account in which the definition is embedded contains a great deal of information about the artworld. One must not focus narrowly on the definition alone: for what is important to see is that art is an institutional concept and this requires seeing the definition in the context of the whole account. I suspect that the "problem" of circularity will arise frequently, perhaps always, when institutional concepts are dealt with.

III

The instances of Dadaist art and similar present-day developments which have served to bring the institutional nature of art to our attention suggest several questions. First, if Duchamp can convert such artifacts as a urinal, a snow shovel, and a hatrack into works of art, why can't natural objects such as driftwood also become works of art in the classificatory sense? Perhaps they can if any one of a number of things is done to them. One way in which this might happen would be for someone to pick up a natural object, take it home, and hang it on the wall. Another way would be to pick up a natural object and enter it in an exhibition. I was assuming earlier, by the way, that the piece of driftwood referred to in Weitz's sentence was in place on a beach and untouched by human hand or at least untouched by any human intention and therefore was art in the evaluative or derivative sense. Natu-ral objects which become works of art in the classificatory sense are artifactualized without the use of tools—artifactuality is conferred on the object rather than worked on it. This means that natural objects which become works of art acquire their artifactuality at the same time that the status of candidate for appreciation is conferred on them, although the act that confers artifactuality is not the same act that confers the status of candidate for appreciation. But perhaps a similar thing ordinarily happens with paintings and poems; they come to exist as artifacts at the same time that they have the status of candidate for appreciation conferred on them. Of course, being an artifact and being a candidate for appreciation are not the same thing—they are two properties which may be acquired at the same time. Many may find the notion of artifactuality being conferred rather than "worked" on an object too strange to accept and admittedly it is an unusual conception. It may be that a special account will have to be worked out for exhibited driftwood and similar cases.

Another question arising with some freqeuncy in connection with discussions of the concept of art and seeming especially relevant in the context of the institutional theory is "how are we to conceive of paintings done by individuals such as Betsy the chimpanzee from the Baltimore Zoo?" Calling Betsy's products paintings is not meant to prejudge that they are works of art, it is just that some word is needed to refer to them. The question of whether Betsy's paintings are art depends upon what is done with them. For example, a year or two ago the Field Museum of Natural History in Chicago exhibited some chimpanzee and gorilla paintings. We must say that these paintings are not works of art. If, however, they had been exhibited a few miles away at the Chicago Art Institute they would have been works of art—the paintings would have been art if the director of the Art Institute had been willing to go out on a limb for his fellow primates. A great deal depends upon the institutional setting: one institutional setting is congenial to conferring the status of art and the other is not. Please note that although paintings such as Betsy's would remain her paintings even if exhibited at an art museum, they would be the *art* of the person responsible for their being exhibited. Betsy would not (I assume) be able to conceive of herself in such a way as to be a member of the artworld and, hence, would not be able to confer the relevant status. Art is a concept which necessarily involves human intentionality. These last remarks are not intended to denigrate the value (including beauty) of the paintings of chimpanzees shown at natural history museums or the creations of bower birds, but as remarks about what falls under a particular concept.

Danto in "Art Works and Real Things" discusses defeating conditions of the ascriptivity of art.[16] He considers fake paintings, that is, copies of original paintings which are attributed to the creators of the original paintings. He argues that a painting's being a fake prevents it from being a work of art, maintaining that originality is an analytical requirement of being a work of art. That a work is derivative or imitative does not, however, he thinks, prevent it from being a work of art. I think Danto is right about fake paintings, and I can express this in terms of my own account by saying that originality in paintings is an antecedent requirement for the conferring of the candidacy for appreciation. Similar sorts of things would have to be said for similar cases in the arts other than painting. One consequence of this requirement is that there are many works of nonart which people take to be works of art, namely, those fake paintings which are not known to be fakes. When fakes are discovered to be fakes, they do not lose that status of art because they never had the status in the first place, despite what almost everyone had thought. There is some analogy here with patent law. Once an invention has been patented, one exactly like it cannot be patented—the patent for just that invention has been "used up." In the case of patenting, of course, whether the second device is a copy or independently derived is unimportant, but the copying aspect is crucial in the artistic case. The Van Meegeren painting that was not a copy of an actual Vermeer but a painting done in the manner of Vermeer with a forged signature is a somewhat more complicated case. The painting with the forged signature is not a work of art, but if Van Meegeren had signed his own name the painting would have been.

Strictly speaking, since originality is an analytic requirement for a painting to be a work of art, an originality clause should be incorporated into my definition of "work of art." But since I have not given any analysis of the originality requirement with respect to works other than paintings, I am not in a position to supplement the defintion in this way. All I can say at this time is what I said just above, namely, that originality in paintings is an antecedent requirement for the conferring of the candidacy for appreciation and that considerations of a similar sort probably apply in the other arts.

Weitz charges that the defining of "art" or its subconcepts forecloses on creativity. Some of the traditional definitions of "art" *may* have and some of the traditional definitions of its subconcepts probably *did* foreclose on creativity, but this danger is now past. At one time a playwright, for example, may have conceived of and wished to write a play with tragic features but lacking a defining characteristic as specified by, say, Aristotle's definition of "tragedy." Faced with this dilemma the playwright might have been intimidated into abandoning his project. With the present-day disregard for established genres, however, and the clamor for novelty in art, this obstacle to creativity no longer exists. Today, if a new and unusual work is created and it is similar to some members of an established type of art, it will usually be accommodated within that type, or if the new work is very unlike any existing works then a new subconcept will probably be created. Artists today are not easily intimidated, and they regard art genres as loose guidelines rather than rigid specifications. Even if a philosopher's remarks were to have an effect on what artists do today, the institutional conception of art would certainly not foreclose on creativity. The requirement of artifactuality cannot prevent creativity, since artifactuality is a necessary condition of creativity. There cannot be an instance of creativity without an artifact of some kind being produced. The second requirement involving the conferring of status could not inhibit creativity; in fact, it encourages it. Since under the definition anything whatever may become art, the definition imposes no restraints on creativity.

The institutional theory of art may sound like saying, "A work of art is an object of which someone has said, 'I christen this object a work of art.'" And it is rather like that, although this does not mean that the conferring of the status of art is a simple matter. Just as the christening of a child has as its background the history and structure of the church, conferring the status of art has as its background the Byzantine complexity of the artworld. Some may find it strange that in the nonart cases discussed, there are ways in which the conferring can go wrong, while that does not appear to be true in art. For example, an indictment might be improperly drawn up and the person charged would not actually be indicted, but nothing parallel seems possible in the case of art. This fact just reflects the differences between the artworld and legal institutions: the legal system deals with matters of grave personal consequences and its procedures must reflect this; the artworld deals with important matters also but they are of a different sort entirely. The artworld does not require rigid procedures; it admits and even encourages frivolity and caprice without losing its serious purpose. Please note that not all legal procedures are as rigid as court procedures and that mistakes made in conferring certain kinds of legal status are not fatal to that status. A minister may make mistakes in reading the marriage ceremony, but the couple that stands before him will still acquire the status of being married. If, however, a mistake cannot be made *in* conferring the status of art, a mistake can

be made *by* conferring it. In conferring the status of art on an object one assumes a certain kind of responsiblity for the object in its new status—presenting a candidate for appreciation always allows the possibility that no one will appreciate it and that the person who did the conferring will thereby lose face. One *can* make a work of art out of a sow's ear, but that does not necessarily make it a silk purse.

IV

Once the institutional nature of art is noted, the roles that such "theories of art" as the imitation and expression theories played in thinking about art can be seen in an interesting perspective. For example, as long as all art was imitative or thought to be imitative, imitation was thought to be a universal property of art. Not surprisingly, what was thought to be the only universal property of art was taken to be the defining property of art. What happened was that an assumed always-accompanying property was mistaken for an essential property, and this mistake led to a mistaken theory of art. Once the imitation theory was formulated, it tended to work in a normative way to encourage artists to be imitative. Of course, philosophical theories do not generally have much effect on the practices of men. The imitation theory in the past may, however, have had more than the usual slight impact, because it was based on a widespread feature of art and therefore reinforced an emphasis on an easily perceived characteristic and because the class of artists was relatively small and contained lines of communication.

The role played by the expression theory was quite different from that of the imitation theory. It was seen as a replacement for the imitation theory and served as its correction. Developments in art had shown that the imitation theory was incorrect and it was quite natural to seek a substitute that focused on another exhibited property of art, in this case its expressive qualities, interpreting them as expressions of the artists. I suspect that the expression theory had a normative role in a way that the imitation theory did not. That is, the expression theory was on the part of many of its proponents an attempt to "reform" art. Whether the expression theorists saw themselves as attempting to influence the creation of art with a certain kind of content or to separate art from something which pretended to be art, they aimed at reform.

From the point of view of the institutional theory, both the imitation theory and the expression theory are mistaken as theories of art. If, however, they are approached as attempts to focus attention on aspects of art (its representative and expressive qualities) which have been and continue to be of great importance, then they have served and continue to serve a valuable function. The institutional definition of "art" does not reveal everything that art can do. A great deal remains to be said about the kinds of thing that art can do, and the imitation and expression theories indicate what *some* of these things are, although not in a perfectly straightforward way.

Notes

1. *Journal of Aesthetics and Art Criticism*, (September 1956), 27–35. See also Paul Ziff's "The Task of Defining a Work of Art," *Philosophical Review* (January 1953), 58–78; and W. E. Kennick's "Does Traditional Aesthetics Rest on a Mistake?" *Mind* (July 1958), 317–34.

2. "Wittgenstein's Aesthetics," in *Language and Aesthetics*, Benjamin R. Tilghman, ed. (Lawrence, Kans., 1973), p. 14. This paper was read at a symposium at Kansas State University in April 1970. Monroe Beardsley has pointed out to me that the relationship between "game" and "major league baseball" is one of class and member rather than of genus and species.

3. "Family Resemblances and Generalizations Concerning the Arts," *American Philosophical Quarterly* (July 1965), 219–28; reprinted in *Problems in Aesthetics*, Morris Weitz, ed., 2d ed. (London, 1970), pp. 181–97.

4. Ibid., p. 185, in the Weitz anthology.

5. "'Art' and Artifactuality," *Southwestern Journal of Philosophy* (Fall 1970), 105–8.

6. "Does Traditional Aesthetics Rest on a Mistake?" p. 330.

7. *Journal of Philosophy* (October 15, 1964), 571–84.

8. Ibid., p. 580.

9. Danto does not develop an institutional account of art in his article nor in a subsequent related article entitled "Art Works and Real Things," *Theoria*, parts 1–3, 1973, pp. 1–17. In both articles Danto's primary concern is to discuss what he calls the Imitation Theory and the Real Theory of Art. Many of the things he says in these two articles are consistent with and can be incorporated into an institutional account, and his brief remarks in the later article about the ascriptivity of art are similar to the institutional theory. The institutional theory is one possible version of the ascriptivity theory.

10. This remark is not intended as a definition of the term "artworld," I am merely indicating what the expression is used to *refer* to. "Artworld" is nowhere defined in this book, although the referent of the expression is described in some detail.

11. Recently in an article entitled "The Republic of Art" in *British Journal of Aesthetics* (April 1969), 145–56, T. J. Diffey has talked about the status of art being conferred. He, however, is attempting to give an account of something like an evaluative sense of "work of art" rather than the classificatory sense, and consequently the scope of his theory is much narrower than mine.

12. "The Possibility of Art: Remarks on a Proposal by Dickie," *Philosophical Review* (January 1973), 69–82.

13. "Defining Art," *American Philosophical Quarterly* (July 1969), 253–56.

14. "The Possibility of Art," p. 78.

15. I realized that I must make the two points noted in this paragraph as the result of a conversation with Mark Venezia. I wish to thank him for the stimulation of his remarks.

16. Pages 12–14.

40

The Ontological Peculiarity
of Works of Art

JOSEPH MARGOLIS

In the context of discussing the nature of artistic creativity, Jack Glickman offers the intriguing comment, "Particulars are made, types created."[1] The remark is a strategic one, but it is either false or misleading; and its recovery illuminates in a most economical way some of the complexities of the creative process and of the ontology of art. Glickman offers as an instance of the distinction he has in mind, the following: "If the chef created a new soup, he created a new kind of soup, a new recipe; he may not have made the soup [that is, some particular pot of soup]."[2] If, by 'kind,' Glickman means to signify a universal of some sort, then, since universals are not created (or destroyed), it could not be the case that the chef "created" a new soup, a new kind of soup.[3] It must be the case that the chef, in making a particular (new) soup, created (to use Glickman's idiom) a kind of soup; otherwise, of course, that the chef created a new (kind of) soup may be evidenced by his having formulated a relevant recipe (which locution, in its own turn, shows the same ambiguity between type and token).

What is important, here, may not meet the eye at once. But if he can be said to create (to invent) a (new kind of) soup and if universals cannot be created or destroyed, then, in creating a kind of soup, a chef must be creating something other than a universal. The odd thing is that a kind of soup thus created is thought to be individuated among related creations; hence, it appears to be a particular of some sort. But it also seems to be an abstract entity

if it is a particular at all. Hence, although it may be possible to admit abstract particulars in principle,[4] it is difficult to concede that what the chef created is an abstract particular if one may be said to have tasted what the chef created. The analogy with art is plain. If Picasso created a new kind of painting, in painting Les Demoiselles d'Avignon, it would appear that he could not have done so by using oils.

There is only one solution if we mean to speak in this way. It must be possible to instantiate particulars (of a certain kind or of certain kinds) as well as to instantiate universals or properties. I suggest that the term 'type'—in all contexts in which the type/token ambiguity arises—signifies abstract particulars of a kind that can be instantiated. Let me offer a specimen instance. Printings properly pulled from Dürer's etching plate for Melancholia I are instances of that etching; but bona fide instances of Melancholia I need not have all their relevant properties in common, since later printings and printings that follow a touching up of the plate or printings that are themselves touched up may be genuine instances of Melancholia I and still differ markedly from one another—at least to the sensitive eye. Nothing, however, can instantiate a property without actually instantiating that property.[5] So to think of types as particulars (of a distinctive kind) accommodates the fact that we individuate works of art in unusual ways—performances of the same music, printings of the same etching, copies of the same novel—and that works of art may be created and

Joseph Margolis, "The Ontological Peculiarity of Works of Art," *The Journal of Aesthetics and Art Criticism*, 36 (1977), 45–50. Reprinted with permission of *The Journal of Aesthetics and Art Criticism* and the author.

destroyed. If, further, we grant that, in creating a new soup, a chef stirred the ingredients in his pot and that, in creating a new kind of painting, in painting *Les Demoiselles,* Picasso applied paint to canvas, we see that it is at least normally the case that one does not create a new kind of soup or a new kind of painting without (in Glickman's words) making a particular soup or a particular painting.

A great many questions intrude at this point. But we may bring this much at least to bear on an ingenious thesis of Glickman's. Glickman wishes to say that, though driftwood may be construed as a creation of "beach art," it remains true that driftwood was *made* by no one, is in fact a natural object, and hence that "the condition of artifactuality" so often claimed to be a necessary condition of being a work of art, is simply "superfluous."[6] I see no conclusive conceptual block, " says Glickman, "to allowing that the artwork [may] be a natural object."[7] Correspondingly, Duchamp's "ready-mades" are created out of artifacts, but the artist who created them did not actually make them. Glickman's thesis depends on the tenability of his distinction between making and creating; and as we have just seen, one does not, in the normal case at least, create a new kind of art (type) without making a particular work of that kind (that is, an instance of that particular, the type, not merely an instance of that kind, the universal). In other words, when an artist *creates* (allowing Glickman's terms) "beach art," a new kind of art, the artist *makes* a particular instance (or token) of a particular type—much as with wood sculpture, *this unique token of this driftwood composition.* He cannot create the universals that are newly instantiated since universals cannot be created. He can create a new type-particular, a particular of the kind "beach art" but he can do so only by making a token-particular of that type. What this shows is that we were unnecessarily tentative about the relation between types and tokens. We may credit an artist with having created a new type of art; but there are no types of art that are not instantiated by some token-instances or for which we lack a notation by reference to which (as in the performing arts) admissible token-instances of the particular type-work may be generated.

The reason for this strengthened conclusion has already been given. When an artist creates his work using the materials of his craft, the work he produces must have some perceptible physical properties at least; but it could not have such properties if the work were merely an abstract particular (or, of course, a universal). Hence, wherever an artist produces his work directly, even a new kind of work, he cannot be producing an abstract particular. Alternatively put, to credit an artist with having created a new *type* of art—a particular art-type—

we must (normally) be thus crediting him in virtue of the particular (token) work he has made. In wood sculpture, the particular piece an artist makes is normally the unique instance of his work; in bronzes, it is more usually true that, as in Rodin's peculiarly industrious way, there are several or numerous tokens of the very same (type) sculpture. But though we may credit the artist with having created the type, the type does not exist except instantiated in its proper tokens. We may, by a kind of courtesy, say that an artist who has produced the cast for a set of bronzes has created an artwork-type; but the fact is: (i) he has *made* a particular cast, and (ii) the cast he's made is not the work *created.* Similar considerations apply to an artist's preparing a musical notation for the sonata he has created: (i) the artist makes a token instance of a type notation; and (ii) all admissible instances of his sonata are so identified by reference to the notations. The result is that, insofar as he creates a type, an artist must make a token. A chef's assistant may actually make the first pot of soup—of the soup the chef has created, but the actual soup exists only when the pot is made. Credit to the chef in virtue of his recipe is partly an assurance that his authorship is to be acknowledged in each and every pot of soup that is properly an instance of his creation, whether he makes it or not; and it is partly a device for individuating proper token instances of particular type objects. But only the token instances *of* a type actually exist and aesthetic interest in the type is given point only in virtue of one's aesthetic interest in actual or possible tokens—as in actual or contemplated performances of a particular sonata.

But if these distinctions be granted, then, normally, an artist makes a token of the type he has created. He could not create the type unless he made a proper token or, by the courtesy intended in notations and the like, he provided a schema *for* making proper tokens of a particular type. Hence, what is normally made, in the relevant sense, is a token of a type. It must be the case, then, that when Duchamp created his *Bottlerack,* although he did not make a bottlerack—that is, although he did not manufacture a bottlerack, although he did not first bring it about that an object instantiate being a bottlerack—nevertheless, *he did make a token of the Bottlerack.* Similarly, although driftwood is not a manufactured thing, when an artist creates (if an artist can create) a piece of "beach art," *he makes a token of that piece of "beach art."* He need not have made the driftwood. But that shows (i) that artifactuality is not superfluous, though it is indeed puzzling (when displaying otherwise untouched driftwood in accord with the developed sensibilities of a society can count as the creation of an art-work); and (ii) it is not the case (contrary to Glickman's

claims) that a natural object can *be* a work of art or that a work can be created though *nothing* be made.

We may summarize the ontological peculiarities of the type/token distinction in the following way: (i) types and tokens are individuated as particulars; (ii) types and tokens are not separable and cannot exist separately from one another, (iii) types are instantiated by tokens and 'token' is an ellipsis for 'token-of-a-type'; (iv) types and tokens may be generated and destroyed in the sense that actual tokens of a novel type may be generated, the actual tokens of a given type may be destroyed, and whatever contingencies may be necessary to the generation of actual tokens may be destroyed or disabled; (v) types are actual abstract particulars in the sense only that a set of actual entities may be individuated as tokens of a particular type; (vi) it is incoherent to speak of comparing the properties of actual token- and type-particulars as opposed to comparing the properties of actual particular tokens-of-a-type; (vii) reference to types as particulars serves exclusively to facilitate reference to actual and possible tokens-of-a-type. These distinctions are sufficient to mark the type/token concept as different from the kind/instance concept and the set/member concept.

Here, a second ontological oddity must be conceded. The driftwood that is made by no one is not the (unique) token that is made of the "beach art" creation; and the artifact, the bottlerack, that Duchamp did not make is not identical with the (probably but not necessarily unique) token that Duchamp did make of the creation called *Bottlerack*. What Duchamp made was a token of *Bottlerack*; and what the manufacturer of bottleracks made was a particular bottlerack that served as the material out of which Duchamp created *Bottlerack* by making a (probably unique) instance of *Bottlerack*. For, consider that Duchamp made something when he created *Bottlerack* but he did not make a bottlerack; also, that no one made the driftwood though someone (on the thesis) made a particular composition of art using the driftwood. If the bottlerack were said to be identical with Duchamp's *Bottlerack*, (the token or the type), we should be contradicting ourselves; the same would be true of the driftwood case. Hence, in spite of appearances, there must be an ontological difference between tokens of artwork-types and such physical objects as bottleracks and driftwood that can serve as the materials out of which they are made.

My own suggestion is that (token) works of art are *embodied* in physical objects, not identical with them. I should argue, though this is not the place for it, that persons, similarly, are embodied in physical bodies but not identical with them.[8] The idea is that not only can one particular instantiate another particular in a certain way (tokens of types) but one particular can embody or be embodied in another particular with which it is (necessarily) not identical. The important point is that identity cannot work in the anomalous cases here considered (nor in the usual cases of art) and that what would otherwise be related by way of identity are, obviously, particulars. Furthermore, the embodiment relationship does not invite dualism though it does a require a distinction among kinds of things and among the kinds of properties of things of such kinds. For example, a particular printing of Dürer's *Melancholia I* has the property of being a particular token of *Melancholia I* (the artwork type), but the physical paper and physical print do not, on any familiar view, have the property of being a token of a type. Only objects having such intentional properties as that of "being created" or, as with words, having meaning or the like can have the property of being a token of a type.[9]

What is meant in saying that one particular is embodied in another is: (i) that the two particulars are not identical; (ii) that the existence of the embodied particular presupposes the existence of the embodying particular, (iii) that the embodied particular possess some of the properties of the embodying particular; (iv) that the embodied particular possesses properties that the embodying particular does not possess; (v) that the embodied particular possesses properties of a kind that the embodying particular cannot possess; (vi) that the individuation of the embodied particular presupposes the individuation of the embodying particular. The 'is' of embodiment, then, like the 'is' of identity and the 'is' of composition[10] is a logically distinctive use. On a theory, for instance a theory about the nature of a work of art, a particular physical object will be taken to embody a particular object of another kind in such a way that a certain systematic relationship will hold between them. Thus, for instance, a sculptor will be said to make a particular sculpture by cutting a block of marble: Michelangelo's *Pietà* will exhibit certain of the physical properties of the marble and certain representational and purposive properties as well; it will also have the property of being a unique token of the creation *Pietà*. The reason for theorizing thus is, quite simply, that works of art are the products of culturally informed labor and that physical objects are not. So seen, they must possess properties that physical objects, *qua* physical objects, do not and cannot possess. Hence, an identity thesis leads to palpable contradictions. Furthermore, the conception of embodiment promises to facilitate a non-reductive account of the relationship between physical nature and human culture, without dualistic assumptions. What this suggests is that the so-called mind/body problem is essentially a special form of

a more general culture/nature problem. But that is another story.

A work of art, then, is a particular. It cannot be a universal because it is created and can be destroyed; also, because it possesses physical and perceptual properties. But it is a peculiar sort of particular, unlike physical bodies, because (i) it can instantiate another particular; and (ii) it can be embodied in another particular. The suggestion here is that all and only culturally emergent or culturally produced entities exhibit these traits. So the ontological characteristics assigned are no more than the most generic characteristics of art: its distinctive nature remains unanalyzed. Nevertheless, we can discern an important difference between these two properties, as far as art is concerned. For, the first property, that of being able to instantiate another particular, has only to do with individuating works of art and whatever may, contingently, depend upon that; while the second property has to do with the ontologically dependent nature of actual works of art. This is the reason we may speak of type artworks as particulars. They are heuristically introduced for purposes of individuation, though they cannot exist except in the sense in which particular tokens of particular type artworks exist. So we can never properly *compare* the properties of a token work and a type work.[11] What we may compare are alternative tokens of the same type—different printings of the same etching or different performances of the same sonata. In short, every work of art is a token-of-a-type; there are no tokens or types *tout court*. Again, this is not to say that there are no types or that an artist cannot create a new kind of painting. It is only to say that so speaking is an ellipsis for saying that a certain set of particulars are tokens of a type and that the artist is credited with so working with the properties of things, instantiated by the members of that set, that they are construed as tokens of a particular type.

So the dependencies of the two ontological traits mentioned are quite different. There are no types that are separable from tokens because there are no tokens except tokens-of-a-type. The very process for individuating tokens entails individuating types, that is, entails individuating different sets of particulars as the alternative tokens of this or that type. There is nothing left over to discuss. What may mislead is this: the concept of different tokens of the same type is intended, in the arts, to accommodate the fact that the aesthetically often decisive differences among tokens of the same type (alternative performances of a sonata, for instance) need not matter as far as the individuation of the (type) work is concerned.[12] But particular works of art cannot exist except as embodied in physical objects. This is simply another way of saying that works of art are culturally emergent entities; that is, that works of art exhibit properties that physical objects cannot exhibit, but do so in a way that does not depend on the presence of any substance other than what may be ascribed to purely physical objects. Broadly speaking, those properties are what may be characterized as functional or intentional properties and include design, expressiveness, symbolism, representation, meaning, style, and the like. Without prejudice to the nature of either art or persons, this way of viewing art suggests a very convenient linkup with the functional theory of mental traits.[13] Be that as it may, a reasonable theory of art could hold that when physical materials are worked in accord with a certain artistic craft then there emerges, culturally, an object embodied in the former that possesses a certain orderly array of functional properties of the kind just mentioned. Any object so produced may be treated as an artifact. Hence, works of art exist as fully as physical objects but the condition on which they do so depends on the independent existence of some physical object itself. Works of art, then, are culturally emergent entities, tokens-of-a-type that exist embodied in physical objects.

Notes

1. Jack Glickman, "Creativity in the Arts," in Lars Aagaard-Mogensen, ed., *Culture and Art* (Nyborg and Atlantic Highlands, N.J.: F. Løkkes Forlag and Humanities Press, 1976), p. 140.

2. Loc. cit.

3. Difficulties of this sort undermine the recent thesis of Nicholas Wolterstorff's, namely, that works of art are in fact kinds. Cf. Nicholas Wolterstorff, "Toward an Ontology of Art Works," *Nous* 9 (1975), 115–42. Also, Joseph Margolis, *Art and Philosophy* (Atlantic Highlands, N.J.: Humanities Press, 1978), chap. 5.

4. Cf. Nelson Goodman, *The Structure of Appearance,* 2nd ed. (Indianapolis: Bobbs-Merrill, 1966).

5. The subleties of the type/token distinction are discussed at length in Margolis, loc. cit.

6. Op. cit., p. 144.

7. Ibid., p. 143.

8. A fuller account of the concept of embodiment with respect to art is given in *Art and Philosophy,* chap. 1. I have tried to apply the notion to all cultural entities—that is, persons, works of art, artifacts, words and sentences, machines, institutionalized actions, and the like—in *Persons and Minds* (Dordrecht: D. Reidel, 1977). Cf. also "On the Ontology of Persons," *New Scholasticism* 10 (1976), 73–84.

9. This is very close in spirit to Peirce's original distinction between types and tokens. Cf. *Collected Papers of Charles Sanders Peirce,* ed. Charles Hartshorne and Paul Weiss (Cambridge: Harvard University Press, 1939), vol. 4, par. 537.

10. Cf. David Wiggins, *Identity and Spatio-Temporal Continuity* (Oxford: Basil Blackwell, 1967).

11. This is one of the signal weaknesses of Wolterstorff's account, loc. cit., as well as of Richard Wollheim's account; cf. *Art and Its Objects* (New York: Harper, 1968).

12. This counts against Nelson Goodman's strictures on the individuation of artworks. Cf. *Languages of Art* (Indianapolis: Bobbs-Merrill, 1968) and Joseph Margolis, "Numerical Identity and Reference in the Arts," *British Journal of Aesthetics* 10 (1970), 138–46.

13. Cf. for instance Hilary Putnam, "Minds and Machines," in Sidney Hook, ed., *Dimensions of Mind* (Englewood Cliffs, N.J.: Prentice-Hall, 1960), and Jerry Fodor, *Psychological Explanation* (New York: Random House, 1968).

41

Piece: Contra Aesthetics

TIMOTHY BINKLEY

I. What Is This Piece?

1. The term "aesthetics" has a general meaning in which it refers to the philosophy of art. In this sense, any theoretical writing about art falls within the realm of aesthetics. There is also a more specific and more important sense of the term in which it refers to a particular type of theoretical inquiry which emerged in the eighteenth century when the "Faculty of Taste" was invented. In this latter sense, "aesthetics" is the study of a specific human activity involving the perception of aesthetic qualities such as beauty, repose, expressiveness, unity, liveliness. Although frequently purporting to be a (or even *the*) philosophy of art, aesthetics so understood is not exclusively about art; it investigates a type of human experience (aesthetic experience) which is elicited by artworks, but also by nature and by non-artistic artifacts. The discrepancy is generally thought to be unimportant and is brushed aside with the assumption that if aesthetics is not exclusively about art, at least art is primarily about the aesthetic. This assumption, however, also proves to be false, and it is the purpose of this piece to show why. Falling within the subject matter of aesthetics (in the second sense) is neither a necessary nor a sufficient condition for being art.

2. Robert Rauschenberg erases a DeKooning drawing and exhibits it as his own work, "Erased DeKooning Drawing." The aesthetic properties of the original work are wiped away, and the result is not a nonwork, but another work. No important information about Rauschenberg's piece is presented in the way it *looks*, except perhaps *this* fact, that looking at it is artistically inconsequential. It would be a mistake to search for aesthetically interesting smudges on the paper. The object may be bought and sold like an aesthetically lush Rubens, but unlike the Rubens it is only a souvenir or relic of its artistic meaning. The owner of the Rauschenberg has no privileged access to its artistic content in the way the owner of the Rubens does who hides the painting away in a private study. Yet the Rauschenberg piece is a work of art. Art in the twentieth century has emerged as a strongly self-critical discipline. It has freed itself of aesthetic parameters and sometimes creates directly with ideas unmediated by aesthetic qualities. An artwork is a piece; and a piece need not be an aesthetic object, or even an object at all.

3. This piece is occasioned by two works of art by Marcel Duchamp, L.H.O.O.Q. and L.H.O.O.Q. Shaved. How do I know they are works of art? For one thing, they are listed in catalogues. So I assume they are works of art. If you deny that they are, it is up to you to explain why the listings in a Renoir catalogue are artworks, but the listings in a Duchamp catalogue are not. And why the Renoir show is an exhibition of artworks, while the Duchamp show is not, and so forth. Anyway, whether the Duchamp pieces are works of art is ultimately inconsequential, as we shall see.

This piece is also, shall we say, about the philo-

Timothy Binkley, "Piece: Contra Aesthetics," *The Journal of Aesthetics and Art Criticism,* 35 (1970), pp. 265–77. Reprinted with permission of *The Journal of Aesthetics and Art Criticism* and the author.

sophical significance of Duchamp's art. This piece is primarily about the concept "piece" in art; and its purpose is to reformulate our understanding of what a "work of art" is.

II. What Is *L.H.O.O.Q.*?

These are Duchamp's words:

> This Mona Lisa with a moustache and a goatee is a combination readymade and iconoclastic Dadaism. The original, I mean the original readymade is a cheap chromo 8 x 5 on which I inscribed at the bottom four letters which pronounced like initials in French, made a very risque joke on the Gioconda.[1]

Imagine a similar description of the *Mona Lisa* itself. Leonardo took a canvas and some paint and put the paint on the canvas in such-and-such a way so that—presto—we have the renowned face and its environs. There is a big difference between this description and Duchamp's description. The difference is marked by the unspecified "such-and-such" left hanging in the description of Leonardo's painting. I could, of course, go on indefinitely describing the look of the *Mona Lisa,* and the fidelity with which your imagination reproduced this look would depend upon such things as how good my description is, how good your imagination is, and chance. Yet regardless of how precise and vivid my description is, one thing it will never do is acquaint you with the painting. You cannot claim to know that work of art on the basis of reading the most exquisite description of it, even though you may learn many interesting things *about* it. The way you come to know the *Mona Lisa* is by looking at it or by looking at a decent reproduction of it. The reason reproductions count is not that they faithfully reproduce the work of art, but rather because what the work of art is depends fundamentally upon how it looks. And reproductions can do a more or less acceptable job of duplicating (or replicating) the salient features of the appearance of a painting. This does not mean that a person is entitled to limit his or her aesthetic judgments to reproductions. What it means is that you can't say much about a painting until you know how it looks.

Now reconsider the description of Duchamp's piece: *L.H.O.O.Q.* is a reproduction of the *Mona Lisa* with a moustache, goatee, and letters added. There is no amorphous "such-and-such" standing for the most important thing. The description tells you what the work of art is; you now know the piece without actually having seen it (or a reproduction of it). When you do see the artwork there

are no surprises: Yes, there is the reproduction of the *Mona Lisa;* there is the moustache, the goatee; there are the five letters. When you look at the artwork you learn nothing of artistic consequence which you don't already know from the description Duchamp gives, and for this reason it would be pointless to spend time attending to the piece as a connoisseur would savor a Rembrandt. Just the opposite is true of the *Mona Lisa.* If I tell you it is a painting of a woman with an enigmatic smile, I have told you little about the work of art since the important thing is how it *looks;* and that I can only *show* you, I cannot tell you.

This difference can be elucidated by contrasting ideas and appearances. Some art (a great deal of what is considered traditional art) creates primarily with appearances. To know the art is to know the look of it; and to know that is to *experience* itself the look, to perceive the appearance. On the other hand, some art creates primarily with ideas.[2] To know the art is to know the idea; and to know an idea is not necessarily to experience a particular sensation, or even to have some particular experience. This is why you can know *L.H.O.O.Q.* either by looking at it or by having it described to you. (In fact, the piece might be better or more easily known by description than by perception.) The critical analysis of appearance, which is so useful in helping you come to know the *Mona Lisa,* bears little value in explaining *L.H.O.O.Q.* Excursions into the beauty with which the moustache was drawn or the delicacy with which the goatee was made to fit the contours of the face are fatuous attempts to say something meaningful about the work of art. If we do look at the piece, what is important to notice is *that* there is reproduction of the *Mona Lisa, that* a moustache has been added, etc. It hardly matters exactly *how* this was done, how it looks. One views the *Mona Lisa* to see what it looks like, but one approaches Duchamp's piece to obtain information, to gain access to the thought being expressed.

III. What Is *L.H.O.O.Q. SHAVED?*

Duchamp sent out invitations to preview the show called "Not Seen and/or Less Seen of/by Marcel Duchamp/Rrose Selavy 1904–64: Mary Sisler Collection." On the front of the invitation he pasted a playing card which bears a reproduction of the *Mona Lisa.* Below the card is inscribed, in French, "L.H.O.O.Q. Shaved." This piece looks like the *Mona Lisa* and the *Mona Lisa* looks like it: since one is a reproduction of the other, their aesthetic qualities are basically identical.[3] Differences in how they look have little, if any, artistic relevance. We do not establish the identity of one by pointing out

where it looks different from the other. This is due to the fact that Duchamp's piece does not articulate its artistic statement in the language of aesthetic qualities. Hence, its aesthetic properties are as much a part of *L.H.O.O.Q. Shaved* as a picture of a mathematician in an algebra book is part of the mathematics.

Appearances are insufficient for establishing the identity of a work of art if the point is not in the appearance. And if the point is in the appearance, how do we establish that? What is to keep a Duchamp from stealing the look for ulterior purposes? Here occurs the limit of the ability of aesthetics to cope with art, since aesthetics seeks out appearances. To see why and how, we need to examine the nature of aesthetics.

IV. What Is Aesthetics?

1. *The Word.* The term "aesthetics" has come to denote that branch of philosophy which deals with art. The word originated in the eighteenth century when Alexander Gottlieb Baumgarten adopted a Greek word for perception to name what he defined to be "the science of perception."[4] Relying upon a distinction familiar to "the Greek philosophers and the Church fathers," he contrasted things perceived (aesthetic entities) with things known (noetic entities), delegating to "aesthetics" the investigation of the former. Baumgarten then gathered the study of the arts under the aegis of aesthetics. The two were quickly identified and "aesthetics" became "the philosophy of art" in much the way "ethics" is the philosophy of morality.

2. *Aesthetics and Perception.* From the outset aesthetics has been devoted to the study of "things perceived," whether reasoning from the "aesthetic attitude" which defines a unique way of perceiving, or from the "aesthetic object" of perception. The commitment to perceptual experience was deepened with the invention of the Faculty of Taste by eighteenth-century philosophers anxious to account for the human response to Beauty and to other aesthetic qualities. The Faculty of Taste exercises powers of discrimination in aesthetic experiences. A refined person with highly developed taste is enabled to perceive and recognize sophisticated and subtle artistic expressions which are closed to the uncultured person with poorly developed taste. This new faculty was characterized by its operation in the context of a special "disinterested" perception, a perception severed from self interest and dissociated from so-called "practical concerns." The development of the concept of disinterestedness reinforced the perceptual focus of aesthetics, since removing "interest" from experience divests it of utility and invests its value in immediate awareness.

An aesthetic experience is something pursued "for its own sake." Eventually aesthetics came to treat the object of aesthetic perception as a kind of illusion since its "reality"—i.e., the reality of disinterested perception—stands disconnected from the reality of practical interest. The two realities are incommensurable: The cows in Turner's paintings can be seen, but not milked or heard.

It is important to note that aesthetics is an outgrowth of the ancient tradition of the philosophy of the Beautiful. Beauty is a property found in both art and nature. A man is beautiful; so is his house and the tapestries hung inside. Aesthetics has continued the tradition of investigating a type of experience which can be had in the presence of both natural and created objects. As a result, aesthetics has never been strictly a study of artistic phenomena. The scope of its inquiry is broader than art since aesthetic experience is not an experience unique to art. This fact has not always been sufficiently emphasized, and as a result aesthetics frequently appears in the guise of philosophy-of-art-in-general.

As aesthetics and the philosophy of art have become more closely identified, a much more serious confusion has arisen. The work of art has come to be construed as an aesthetic object, an object of perception. Hence the meaning and essence of all art is thought to inhere in appearances, in the looks and sounds of direct (though not necessarily unreflective) awareness. The first principle of philosophy of art has become: all art possesses aesthetic qualities, and the core of a work is its nest of aesthetic qualities. This is why "aesthetics" has become just another name for the philosophy of art. Although it is sometimes recognized that aesthetics is not identical to the philosophy of art, but rather a complementary study, it is still commonly assumed that all art is aesthetic in the sense that falling within the subject matter of aesthetics is at least a necessary (if not a sufficient) condition for being art.[5] Yet as we shall see, being aesthetic is neither a necessary nor a sufficient condition for being art.

Devotees of modern aesthetics may believe that Baumgarten's "science of perception" is a moribund enterprise befitting only pre-Modern aesthetes rapt in pursuit of ideal Beauty. Yet a survey of contemporary aesthetic theory will prove that this part of philosophy still accepts its raison d'être to be a perceptual entity—an appearance—and fails to recognize sufficiently the distinction between "aesthetics" in the narrow sense and the philosophy of art. In his essay "Aesthetic and Non-Aesthetic," Frank Sibley has articulated this commitment to perception:

It is of importance to note first that, broadly speaking, aesthetics deals with a kind of percep-

tion. People have to *see* the grace of unity of a work, *hear* the plaintiveness or frenzy in the music, *notice* the gaudiness of a color scheme, *feel* the power of a novel, its mood, or its uncertainty of tone . . . the crucial thing is to see, hear, or feel. To suppose indeed that one can make aesthetic judgements without aesthetic perception . . . is to misunderstand aesthetic judgement.[6]

Despite the many new directions taken by the philosophy of art in the twentieth century, it is still practised under the guidance of aesthetic inquiry, which assumes that the work of art is a thing perceived.

The reason asethetic qualities must be perceived in order to be judged is that they inhere in what Monroe Beardsley has called the "perceptual object": "A perceptual object is an object some of whose qualities, at least, are open to direct sensory awareness."[7] This he contrasts with the "physical basis" of aesthetic qualities, which "consists of things and events describable in the vocabulary of physics."[8] Hence the work of art turns out to be an entity possessed of two radically different aspects, one aesthetic and the other physical:

When a critic . . . says that Titian's later paintings have a strong atmospheric quality and vividness of color, he is talking about aesthetic objects. But when he says that Titian used a dark reddish underpainting over the whole canvas, and added transparent glazes to the painting after he laid down the pigment, he is talking about physical objects.[9]

This "aesthetic object" is taken by the philosophy of art to be its subject of study. Appearances are paramount, from expressionist theories which construe the artwork as an "imaginary object" through which the artist has articulated his or her "intuition," to formalist theories which venerate perceptual form.[10] Clive Bell's "significant form" is clearly a perceptual form since it must be perceived and arouse the "aesthetic emotion" before it functions artistically.[11] Susanne Langer has christened aesthetic appearances "semblances," and has undertaken what is probably the most extensive investigation of artistic semblance in her book *Feeling and Form*. Aesthetics perceives all the arts to be engaged in the creation of some kind of semblance or artistic "illusion" which presents itself to us for the sake of its appearance.

It has been difficult, however, to maintain a strictly perceptual interpretation of the aesthetic "appearance." Literature is the one major art form which does not easily accommodate the perceptual model of arthood. Although we perceive the printed words in a book, we do not actually perceive the literary *work* which is composed with intangible linguistic elements. Yet as Sibley points out, the reader will "feel the power of a novel, its mood, or its uncertainty of tone," so that its aesthetic qualities are at least *experienced* through reading if not actually perceived by one of the senses. There are various things we experience without perceiving them. Like an emotion, the power of a novel is "felt" without its being touched or heard or seen. Thus, although it will not be quite correct to say that one cannot know the aesthetic qualities of a novel without "direct perceptual access," it is true that one cannot know them without directly experiencing the novel by reading it. This rules out the possibility of coming to know a literary work by having it described to you (as one may very well come to know *L.H.O.O.Q.*). Just as you must look at the particular object constituting a painting, you must read the particular words comprising a novel in order to judge it aesthetically. Hence, although perception is the paradigm of aesthetic experience, an accurate aesthetic theory will locate aesthetic qualities more generally in a particular type of *experience* (aesthetic experience) so that literature can be included.

3. *The Theory of Media.* What does it mean to have the requisite "direct experience" of an aesthetic object? How do you specify *what* it is that one must experience in order to know a particular artwork? Here we encounter a problem. Aesthetic qualities cannot be communicated except through direct experience of them. So there is no way of saying just what the aesthetic qualities of a work are independently of experiencing them. As Isabel Hungerland puts it, there are no intersubjective criteria for testing the presence of aesthetic qualities.[12] This is why one cannot communicate the *Mona Lisa* by describing it. It is impossible to establish criteria for identifying artworks which are based on their aesthetic qualities. And this is the point where aesthetics needs the concept of a medium. Media are the basic categories of art for aesthetics, and each work is identified through its medium. Let's see how this is done.

In recent aesthetics, the problem of the relationship between the aesthetic and the non-aesthetic properties of an object has been much discussed. Whatever the particular analysis given, it is generally conceded that aesthetic qualities *depend* in some way upon non-aesthetic qualities.[13] There is no guarantee that a slight change in color or shape will leave the aesthetic qualities of a painting unaffected, and this is why reproductions often have aesthetic qualities different from those of the original.[14] Changing what Beardsley calls the "physical" properties, however slightly, can alter those features of a

work of art which are experienced in the "aesthetic experience" of the object. Aesthetic objects are vulnerable and fragile, and this is another reason why it is important to have identity criteria for them.

Since aesthetic qualities depend on nonaesthetic qualities, the identity of an aesthetic artwork can be located through conventions governing its non-aesthetic qualities. These conventions determine the non-aesthetic parameters which must remain invariant in identifying particular works. A medium is not simply a physical material, but rather a network of such conventions which delimits a realm over which physical materials and aesthetic qualities are mediated. For example, in the medium of painting there is a convention which says that the paint, but not the canvas, stretcher, or frame, must remain invariant in order to preserve the identity of the artwork. On the other hand, paint is not a conventional invariant in the art of architecture but is applied to buildings (at least on the inside) according to another art, interior decorating. The same architectural work could have white walls or pink walls, but a painting could not have its white clouds changed to pink and still remain the same painting. Similarly, the medium of painting is invariant through modifications of the frame holding a painting, while a building is not invariant through modifications in, say, the woodwork. Moving a Rubens from an elaborate Baroque frame into a modern Bauhaus frame will not change the work of art, but making a similar change in the woodwork of the building will change, however slightly, the architectural work.

In its network of conventions, each artistic medium establishes non-aesthetic criteria for identifying works of art. By being told which medium a work is in, we are given the parameters within which to search for and experience its aesthetic qualities. As we watch a dance, we heed how the dancers move their bodies. As we watch a play on the same stage, we concentrate instead on what is being acted out. Treating a piece of writing as a poem will make us focus on different non-aesthetic features than if we approach it as a short story: when the type is set for a poem the individual lines are preserved, as they are not in a short story. Thus Susanne Langer's characterization of media in terms of the particular type of semblance they create is pointed in the wrong direction. She holds that painting creates the illusion of space, music the illusion of the passage of time, etc. Yet it is not the "content" of an aesthetic illusion which determines the medium. Before we can tell whether something presents a semblance of space, we have to know where to look for the semblance; and this we know by understanding the conventions, i.e., the medium, within which the thing is proffered for aesthetic experience. Anything that can be seen can be seen aesthetically, i.e., it can be viewed for the sake of discerning its aesthetic qualities. The reason we know to look at the aesthetic qualities on the front of a painting is not because the back lacks aesthetic qualities, but rather because the conventions of painting tell us to look there. Even if the back of a painting looks more interesting than the front, the museum director is nevertheless required to hang the painting in the conventional way with the front out. The medium tells you what to experience in order to know the aesthetic artwork.

In the twentieth century we have witnessed a proliferation of new media. A medium seems to emerge when new conventions are instituted for isolating aesthetic qualities differently on the basis of new materials or machines. Film became an artistic medium when its unique physical structure was utilized to identify aesthetic qualities in a new way. The filmmaker became an artist when he or she stopped recording the creation of the playwright and discovered that film has resources for creation which theater lacks. The aesthetic qualities that can be presented by a film photographed from the orchestra and obedient to the temporal structure of the play are, basically, the aesthetic properties of the play itself. But when the camera photographs two different actions in two different places at two different times, and the images end up being seen at the same time and place, aesthetic properties can be realized which are inaccessible to theater. A new convention for specifying aesthetic properties has emerged. We say "See this film" instead of "See this play." In each case, what you look for is determined by the conventions of the medium.

The aesthetic theory of media has given rise to an analogy which seems to be gaining acceptance: a work of art is like a person. The dependence of aesthetic qualities on non-aesthetic ones is similar to the dependence of character traits on the bodily dispositions of persons. As Joseph Margolis has put it, works of art are *embodied* in a physical object (or physical event) in much the way a person is embodied in a human body:

> To say that a work of art is embodied in a physical object is to say that its identity is necessarily linked to the identity of the physical object in which it is embodied, though to identify the one is not to identify the other; it is also to say that, *qua* embodied, a work of art must possess properties other than those ascribed to the physical object in which it is embodied, though it may be said to possess (where relevant) the properties of that physical object as well. Also, *if* in being embodied, works of art are specifically, *emergent entities,* then the properties that a work of art

possesses will include properties *of a kind* that cannot appropriately be ascribed to the object in which it is embodied.[15]

The "emergent" entities of aesthetic art are aesthetic qualities which are accessible only through direct experience. The aesthetic and physical properties of the artwork fuse into a person-like whole, the former constituting the "mind,"the latter the "body" of the work. When we want to locate a person we look for his or her body—likewise, when we want to locate an artwork we look for its "body," namely the physical material in which it is embodied, as delimited by the conventions of media.

Although not universally accepted, this person analogy appears frequently in aesthetic theory because it provides a suitable model for understanding the artwork as a single entity appealing to two markedly different types of interest. It explains, for example, the basis of the connection between Beauty and Money.

The analogy has recently been carried to the extent of claiming that works of art, like persons, have rights.[16] To deface a canvas by Picasso or a sculpture by Michelangelo is not only to violate the rights of its owner, but also to violate certain rights of the work itself. The work is a person; to mar the canvas or marble is to harm this person. So we see that aesthetic works of art are also mortal. Like people, they age and are vulnerable to physical deterioration.

4. *Art and Works.* Aesthetics has used the conventions of media to classify and identify artworks, but its vision of the nature of art does not adequately recognize the thoroughly conventional structure within which artworks appear. This is because aesthetics tends to view a medium as a kind of substance (paint, wood, stone, sound, etc.) instead of as a network of conventions.

Its preoccupation with perceptual entities leads aesthetics to extol and examine the "work of art," while averting its attention almost entirely from the myriad other aspects of that complex cultural activity we call "art." In other words, art for aesthetics is fundamentally a class of things called works of art which are the sources of aesthetic experience. To talk about art is to talk about a set of objects. To define art is to explain membership in this class. Thus we frequently find aesthetic discussions of the question "What is art?" immediately turning to the question "What is a work of art?" as though the two questions are unquestionably identical. Yet they are not the same.

What counts as a work of art must be discovered by examining the practice of art. Art, like philosophy, is a cultural phenomenon, and any particular work of art must rely heavily upon its artistic and cultural context in communicating its meaning. *L.H.O.O.Q. Shaved* looks as much like the *Mona Lisa* as any reproduction of it does, but their artistic meanings could hardly be more different. Just as I cannot tell you what the word "rot" means unless you say whether it is English or German, I cannot explain the meaning of a painting without viewing it immersed in an artistic milieu. The shock value of Manet's *Olympia*, for example, is largely lost on modern audiences, although it can be recovered by studying the society in which the painting emerged. Even so simple a question as what a painting represents cannot be answered without some reference to the conventions of depiction which have been adopted. Whether a smaller patch of paint on the canvas is a smaller person or a person farther away—or something else—is determined by conventions of representation. The moribund prejudice against much of the "unrealistic" art of the past comes from misjudging it according to standards which are part of the alien culture of the present.

Thus trying to define "art" by defining "work of art" is a bit like trying to define philosophy by saying what constitutes a philosophy book. A work of art cannot stand alone as a member of a set. Set membership is not the structure of that human activity called art. To suppose we can examine the problem of defining art by trying to explain membership in a class of entities is simply a prejudice of aesthetics, which underplays the cultural structure of art for the sake of pursuing perceptual objects. Yet even as paradigmatic an aesthetic work as the *Mona Lisa* is a thoroughly cultural entity whose artistic and aesthetic meanings adhere to the painting by cultural forces, not by the chemical forces which keep the paint intact for a period of time.

As media proliferated, the aesthetic imperatives implied in their conventions weakened. Art has become increasingly non-aesthetic in the twentieth century, straining the conventions of media to the point where lines between them blur. Some works of art are presented in "multi-media," others (such as Duchamp's) cannot be placed within a medium at all. The concept of a medium was invented by aesthetics in order to explain the identity of artworks which articulate with aesthetic qualities. As art questions the dictates of aesthetics, it abandons the conventions of media. Let us see why.

V. Art Outside Aesthetics

Art need not be aesthetic. *L.H.O.O.Q. Shaved* makes the point graphic by duplicating the appearance of the *Mona Lisa* while depriving it of its aesthetic import. The two works look exactly the same but are completely different. As the risque joke is

compounded by *L.H.O.O.Q. Shaved*, the *Mona Lisa* is humiliated. Though restored to its original appearance, it is not restored to its original state. Duchamp added only the moustache and goatee, but when he removed them the sacred aura of aesthetic qualities vanished as well—it had been a conventional artistic covering which adhered to the moustache and goatee when they were removed, like paint stuck to tape. The original image is intact but literalized; its function in Duchamp's piece is just to denote the *Mona Lisa*. *L.H.O.O.Q.* looked naughty, graffiti on a masterpiece. It relies upon our seeing both the aesthetic aura and its impudent violation. But as its successor reinstates the appearance, the masterpiece is ironically ridiculed a second time with the disappearance of the dignity which made *L.H.O.O.Q.* a transgression. The first piece makes fun of the Gioconda, the second piece destroys it in the process of "restoring" it. *L.H.O.O.Q. Shaved* re-indexes Leonardo's artwork as a derivative of *L.H.O.O.Q.*, reversing the temporal sequence while literalizing the image, i.e., discharging its aesthetic delights. Seen as "*L.H.O.O.Q.* shaved," the image is sapped of its artistic/aesthetic strength—it seems almost vulgar as it tours the world defiled. This is because it is placed in a context where its aesthetic properties have no meaning and its artistic "person" is reduced to just another piece of painted canvas.

It has already been pointed out that one can know the work *L.H.O.O.Q.* without having any direct experience of it, and instead by having it described. This it shares with a great deal of recent art which eschews media. When Mel Bochner puts lines on a gallery wall to measure off the degrees of an arc, their purpose is to convey information, not to proffer aesthetic delights. The same is true of On Kawara's "I GOT UP" postcards, which simply note his time of rising each day.[17] What you need to see, to experience, in order to know this art is subject to intersubjective tests—unlike aesthetic art—and this is why description will sometimes be adequate in communicating the artwork.

When Duchamp wrote "*L.H.O.O.Q.*" beneath the image of the *Mona Lisa*, he was not demonstrating his penmanship. The beauty of a script depends upon aesthetic properties of its line. The meaning of a sentence written in the script, however, is a function of how the lines fit into the structure of an alphabet. Aesthetics assumes that artistic meaning must be construed according to the first type of relation between meaning and line, but not the second. It mistakes the experience of aesthetic qualities for the substance of art. Yet the remarkable thing about even aesthetic art is not its beauty (or any other of its aesthetic qualities), but the fact that it is human-created beauty *articulated* in a medium.

The flaw in aesthetics is this: how something looks is partly a function of what we bring to it, and art is too culturally dependent to survive in the mere look of things. The importance of Duchamp's titles is that they call attention to the culture environment which can either sustain or suffocate the aesthetic demeanor of an object. Duchamp's titles do not name objects; they put handles on things. They call attention to the artistic framework within which works of art are indexed by their titles and by other means. The culture infects the work.

A great deal of art has chosen to articulate in the medium of an aesthetic space, but there is no a priori reason why art must confine itself to the creation of aesthetic objects. It might opt for articulation in a semantic space instead of an aesthetic one so that artistic meaning is not embodied in a physical object or event according to the conventions of a medium. Duchamp has proven this by creating non-aesthetic art, i.e., art whose meaning is not borne by the appearance of an object. In particular, the role of line in *L.H.O.O.Q.* is more like its role in a sentence than in a drawing or painting.[18] This is why the appearance of the moustache and goatee are insignificant to the art. The first version of *L.H.O.O.Q.* was executed not by Duchamp, but by Picabia on Duchamp's instructions, and the goatee was left off. It would be an idle curiosity to speculate about whose version is better or more interesting on the basis of how each looks. The point of the artwork cannot be ascertained by scrutinizing its appearance. It is not a person-like union of physical and perceptual qualities. Its salient artistic features do not *depend* upon non-aesthetic qualities in the sense of being embodied in them. The aesthetic qualities of *L.H.O.O.Q.*, like the aesthetic qualities of Rauschenberg's erased DeKooning, are not offered up by the artist for aesthetic delectation, but rather are incidental features of work like its weight or its age. Line is perceived in Duchamp's piece just as it is in a sentence in a book, and in both cases we can descry the presence of aesthetic qualities. But the point of neither can be read off its physiognomy. The lines are used to convey information, not to conjure up appearances; consequently the relationship of meaning to material is similar to what it is in a drawing of a triangle in a geometry book.

If an artwork is a person, Duchamp has stripped her bare of aesthetic aura. *L.H.O.O.Q.* treats a person as an object by means of the joke produced by reading the letters in French. It also treats an artwork as a "mere thing." The presence of the moustache violates the *Mona Lisa*'s aesthetic rights and hence violates the artwork "person." In making fun of these persons, Duchamp's piece denies its own personhood.

Aesthetics is limited by reading the artwork on the model of a person. Some person-like entities are works of art, but not all artworks are persons. If not a person, what is an artwork?

VI. What Is an Artwork?

An artwork is a piece. The concept "work of art" does not isolate a class of peculiar aesthetic personages. The concept marks an indexical function in the artworld. To be a piece of art, an item need only be indexed as an artwork by an artist. Simply recategorizing an unsuspecting entity will suffice. Thus "Is it art?" is a question of little interest. The question is "So what if it is?" Art is an epiphenomenon over the class of its works.[19]

The conventions of titling works of art and publishing catalogues facilitate the practice of indexing art. However, it is important to distinguish between the artist's act of indexing by creating and the curator's act of indexing by publishing the catalogue. It is the former act which makes art; the latter act usually indexes what is already art under more specific headings, such as works by a certain artist, works in a particular show, works owned by a person or a museum, etc. To make art is, basically, to isolate something (an object, an idea, . . .) and say of it, "This is a work of art," thereby cataloguing it under "Artworks." This may seem to devolve responsibility for arthood upon the official creators of art called artists, and the question of determining arthood turns into a question of determining who the artists are. But this wrongly places emphasis upon entities again, overshadowing the practice of art. Anyone can be an artist. To be an artist is to utilize (or perhaps invent) artistic conventions to index a piece. These might be the conventions of a medium which provide for the indexing of an aesthetic piece by means of non-aesthetic materials. But even the aesthetic artist has to stand back from the painting or play at a certain point and say "That's it. It's done." This is the point where the artist relies upon the basic indexing conventions of art. The fundamental art-making (piece-making) act is the specification of a piece: "The piece is ———."Putting paint on canvas—or making any kind of product—is just one way of specifying what the work of art is. When Duchamp wrote "L.H.O.O.Q." below the reproduction, or when Rauschenberg erased the DeKooning, it was not the work (the labor) they did which made the art. A work of art is not necessarily something worked on; it is basically something conceived. To be an artist is not always to make something, but rather to engage in a cultural enterprise in which artistic pieces are proffered for consideration. Robert Barry

once had an exhibition in which nothing was exhibited:

> My exhibition at the Art & Project Gallery in Amsterdam in December, '69, will last two weeks. I asked them to lock the door and nail my announcement to it, reading: "For the exhibition the gallery will be closed."[20]

The fact that someone could be an artist by just christening his or her radio or anxiety to be an artwork may seem preposterous. However, the case of the Sunday Painter who rarely shows his or her paintings to anyone is not substantially different. We need to beware of confusing issues about arthood with issues about good or recognized arthood. The amateur indexer may index trivially, and the effortlessness of the task will only seem to compound the artistic inconsequence. But things are not so different when the Sunday Painter produces a few terrible watercolors which are artistically uninteresting. Despite their artistic failures, both the casual indexer and the casual painter are still artists, and the pieces they produce are works of art, just as the economics student's term paper is a piece of economics, however naive or poorly done. Simply by making a piece, a person makes an artistic "statement"; good art is distinguished by the interest or significance of what it says. Of course, interesting art, like interesting economics, is usually produced by people who, in some sense, are considered "professionals." Thus there are senses of "artist" and "economist" which refer to people who pursue their disciplines with special dedication. But what these "professionals" do is no different from what the amateurs do; it is just a difference in whether the activity is selected as a vocation. This shows that the question "Is that person an artist?" like the question "Is that thing an artwork?" is not a question with great artistic import.

A useful analogy is suggested. Art is a practised discipline of thought and action, like mathematics, economics, philosophy, or history. The major difference between art and the others is that doing art is simply employing indexing conventions defined by the practice. The reason for this is that the general focus of art is creation and conception for the sake of creation and conception, and consequently the discipline of art has devised a piece-making convention which places no limits on the content of what is created. In other words, art, unlike economics, has no general subject matter. The artworld develops and evolves through a complex network of interrelated interests, so it does have the general structure of a "discipline." But part of the recent history of art includes the loosening of conventions on what can be art until they are purely "formal." The wider use of the term "piece" instead of

"work" reflects this liberalization, as does the decreasing importance of media. "Work of art" suggest an object. "Piece" suggests an item indexed within a practice. There are many kinds of "pieces," differing according to the practices they are indexed within. A "piece" could be a piece of mathematics or economics or art; and some pieces may be addressed to several disciplines. An artwork is just a piece (of art), an entity specified by conventions of the practice of art.

This view of art has one very important point of difference with aesthetics. Media are set up to identify works extensionally. Joseph Margolis relies on this idea when he argues that the identity of an artwork depends upon the identity of the physical object in which it is embodied:

> So works of art are said to be the particular objects they are, *in intensional contexts*, although they may be identified, by the linkage of embodiment, through the identity of what may be identified *in extensional contexts*. That is, works of art are identified extensionally, in the sense that their identity (whatever they are) is controlled by the identity of what they are embodied in. . . .[21]

Some difficulties for this view are already suggested by Duchamp's "double painting," a single stretcher with *Paradise* painted on one side and *The King and Queen Surrounded by Swift Nudes* on the other. The decisive cases, however, are found among artworks which are produced merely by indexing, such as Duchamp's readymades. Indexes index their items intensionally: from the fact that "the morning star" occurs in an index, one cannot infer that "the evening star" occurs there also, even though the two expressions denote the same object. *L.H.O.O.Q. Shaved* could, for the sake of argument, be construed as residing in the same physical object as the *Mona Lisa* itself. Then there is one extensionally specified object, but two intensionally specified artworks. Rauschenberg has suggested this possibility since the only things of substance he changed by erasing the DeKooning drawing were aesthetic qualities. To complete the cycle in the way Duchamp did, Rauschenberg should buy a DeKooning painting and exhibit it in his next show: "Unerased DeKooning." The point is that artworks are identified intensionally, not extensionally. The reason *L.H.O.O.Q. Shaved* and the *Mona Lisa* are different artworks is not that they are different objects, but rather that they are different ideas. They are specified as different pieces in the art practice.

That an artwork is a piece and not a person was established by the Readymade. Duchamp selected several common objects and converted them into art simply by indexing them as artworks. Some-

times this was accomplished in conjunction with explicit indexing ceremonies, such as signing and dating a work, giving it a title, entering it in a show. But always what separates the readymade artwork from the "readymade" object it was ready-made from is a simple act of indexing. Duchamp says, "A point I want very much to establish is that the choice of these Readymades was never dictated by aesthetic delectation. The choice was based on a reaction of *visual indifference* with a total absence of good or bad taste."[22] The Readymade demonstrates the indexical nature of the concept "work of art" by showing that whether something is an artwork is not determined by its appearance but by how it is regarded in the artworld. The same shovel can be a mere hardware item at one time and an artwork at another depending upon how the artworld stands in relation to it. Even an old work of art can be converted into a new one without changing the appearance of the old work, but only "creating a new idea for it," as Duchamp has said of the urinal readymade called *Fountain*. The significance of the title of this piece has not been fully appreciated. A urinal is a fountain; that is, it is an object designed for discharging a stream of water. The reason most urinals are *not* fountains, despite their designs, is that their locations and use differ from similar devices we do consider fountains. The objects are structurally similar, but their cultural roles are very different. Putting a urinal in a gallery makes it visible as a "fountain" and as a work of art because the context has been changed. Cultural contexts endow objects with special meanings; and they determine arthood.[23]

It has been pointed out that *Fountain* was accepted as a work of art only because Duchamp had already established his status as an artist by producing works in traditional forms. This is probably true: not just anyone could have carried it off. You cannot revolutionize the accepted conventions for indexing unless you have some recognition in the artworld already. However, this does not mean that Duchamp's piece is only marginal art and that anyone desiring to follow his act of indexing has to become a painter first. When Duchamp made his first non-aesthetic work, the conventions for indexing artworks were more or less the media of aesthetics: to make an artwork was to articulate in a medium. Duchamp did not simply make an exception to these conventions, he instituted a new convention, the indexing convention which countenances non-aesthetic art, though perhaps it should be said rather that Duchamp *uncovered* the convention, since it lies behind even the use of media, which are specialized ways of indexing aesthetic qualities. In any event, once the new convention is instituted anyone can follow it as easily as he or she

can follow the indexing conventions of aesthetics. The Sunday Indexer can have just as good a time as the Sunday Painter.

VII. Duchamp's Legacy

Because of Duchamp's wit and humor, it was easy at first to dismiss his art, or maybe just to be confused by it. Yet it is not trivial because it is funny. With the art of Duchamp, art emerged openly as a practice. His *Large Glass,* whose meaning is inaccessible to anyone who merely examines the physical object, stands as the first monument to an art of the mind.

This kind of art developed historically; it is not an anomaly. Probably it originates in what Clement Greenberg calls "Modernism," whose characteristic feature is self-criticism. Like philosophy, art developed to the point where a critical act about the discipline (or part of it) could be part of the discipline itself. Once embarked on self-scrutiny, art came to realize that its scope could include much more than making aesthetic objects. It is a practice, which is why jokes about art can be art in the way jokes about philosophy can be philosophy. Art is a prac-

tice which can be characterized about as well and as usefully as philosophy can be. Defining art is not likely to be a very interesting pursuit. An artwork is a piece indexed within conventions of this practice, and its being an artwork is determined not by its properties, but by its location in the artworld. Its properties are used to say *what* the particular work is.

If art must be aesthetic, the tools of the art-indexer must be media, whether mixed or pure. To make a work of art is to use a medium to join together literal physical qualities and created aesthetic qualities. An aesthetic person is born in the intercourse.

Aesthetics treats aesthetic experience, not art. Anything, from music to mathematics, can be seen aesthetically. This is the basis for the traditional preoccupation of aesthetics with Beauty, a quality found in both art and nature. Aesthetics deals with art and other things under the heading of aesthetic experience. Conversely, not all art is aesthetic. Seeing its marriage to aesthetics as a forced union, art reaches out to find meaning beyond skin-deep looks. The indexers create with ideas. The tools of indexing are the languages of ideas, even when the ideas are aesthetic.

Notes

1. Quoted from *Marcel Duchamp,* catalogue for the show organized by the Museum of Modern Art and the Philadelphia Museum of Art, ed. Anne d'Harnoncourt and Kynaston McShine (New York: Museum of Modern Art; Philadelphia: Philadelphia Museum of Art, 1973), p. 289. When pronounced in French, the letters produce a sentence meaning "She has a hot ass."

2. For numerous examples see Lucy Lippard, *Six Years: The dematerialization of the art object from 1966 to 1972* (New York, 1973). There is no sharp dichotomy between idea art and appearance art. Most traditional art is concerned with ideas, even though they may be expressed visually.

3. One might even consider the *Mona Lisa* an instance of *L.H.O.O.Q. Shaved.* Duchamp refers to the earlier piece *L.H.O.O.Q.* as "*this Mona Lisa* with a moustache and goatee. . . ."

4. See Alexander Gottlieb Baumgarten *Reflections on Poetry,* Translated by Karl Aschenbrenner and William B. Holther (Berkeley, 1954), p. 78. The translators translate *scientia cognitionis sensitivae* as "the science of perception." Monroe Beardsley gives a somewhat more precise translation: "the science of sensory cognition." See his *Aesthetics from Classical Greece to the Present* (New York, 1966), p. 157. For useful discussions of the emergence of "aesthetics" in eighteenth-century philosophy, see Beardsley's history and also George Dickie, *Aesthetics: An Introduction* (New York, 1971).

5. George Dickie expresses what is occasionally realized: "The concept of art is certainly related in important ways to the concept of the aesthetic, but the aesthetic cannot completely absorb art." (See *Aesthetics: An Introduction,* p. 2.) However, it turns out that one way art is related to aesthetics is that both the philosophy of art and the philosophy of criticism, like aesthetics itself, are grounded in what Dickie calls "aesthetic experience." (See the diagram on p. 45 of *Aesthetics.*) It seems that for Dickie, what differentiates aesthetics from the other two is simply the manner in which each studies aesthetic experience. See also his *Art and the Aesthetic* (Ithaca, 1974). Dickie takes a very important first step in distinguishing the concepts "art" and "aesthetics," but his search for a definition of "work of art" seems to me to follow an aesthetic development based upon the notion of "appreciation." Dickie's views are discussed at greater length in my essay "Deciding About Art: A Polemic Against Aesthetics," in *Culture and Art,* ed. Lars Aagaard-Mogensen (Atlantic Highlands, N.J., 1976).

6. Frank Sibley, "Aesthetic and Non-Aesthetic," pp. 135–159. *The Philosophical Review,* 74

(1965), reprinted in Matthew Lipman, ed., *Contemporary Aesthetics* (Boston, 1973), p. 434. See also Sibley's "Aesthetic Concepts," *The Philosophical Review,* 68 (1959), 421–50

7. Monroe Beardsley, *Aesthetics: Problems in the Philosophy of Criticism* (New York, 1958), p. 31.

8. Ibid., p. 31.

9. Ibid., p. 33. George Dickie presents arguments against Beardsley's notion of the aesthetic object, but I do not find them very persuasive. See Dickie's *Art and the Aesthetic,* pp. 148 ff.

10. See Benedetto Croce, *Aesthetic* (New York, 1929), and R. G. Collingwood, *The Principles of Art* (New York, 1938). In the expression theory developed by Croce and Collingwood, it is not the concept of expression itself which is aesthetic, but rather the concept of intuition.

11. See Clive Bell, *Art* (New York, 1959). Formalist criticism has maintained its commitment to aesthetics. See, for example, Clement Greenberg, *Art and Culture* (Boston, 1961), and "Modernist Painting," *Art and Literature,* 4 (1965).

12. See Isabel Creed Hungerland, "The Logic of Aesthetic Concepts," *The Proceedings and Addresses of the American Philosophical Association,* 40 (1963), and "Once Again, Aesthetic and Non-Aesthetic," *The Journal of Aesthetic and Art Criticism,* 26 (1968), 285–95.

13. See Sibley, "Aesthetic and Non-Aesthetic," for a discussion of the dependency of aesthetic qualities on non-aesthetic qualities.

14. E. H. Gombrich, in *Art and Illusion* (New York, 1960), demonstrates how a simple change in contrast in a photograph can change its aesthetic properties.

15. Joseph Margolis, "Works of Art as Physically Embodied and Culturally Emergent Entities," *The British Journal of Aesthetics,* 15 (1975), 189.

16. See Alan Tormey, "Aesthetic Rights," *The Journal of Aesthetics and Art Criticism,* 32 (1973), 163–70.

17. See Ursula Meyer, *Conceptual Art* (New York, 1972).

18. It is interesting that Duchamp says there are *four* letters in the title *L.H.O.O.Q."* There are five letter tokens, each with its own particular appearance. But there are only four letter types, and a letter type does not have any particular appearance.

19. George Dickie develops a related notion in his "Institutional Theory of Art." See especially *Art and the Aesthetic.* His basic idea is that something is art which has been christened art. One difficulty with this view is that it does not provide for the intensional specification of a work of art. This point is discussed later on. The notion of indexing introduced here is discussed further in "Deciding About Art" (see above).

20. In Meyer, *Conceptual Art,* p. 41.

21. Margolis, "Works of Art As Physically Embodied and Culturally Emergent Entities," p. 191. An extensional context is one in which expressions denoting the same entity can replace one another without altering the truth of what is said.

George Dickie holds that making art involves a kind of status-conferral. This theory has insights to offer, but it does have the shortcoming that status-conferral is basically extensional. If it is true that Cicero has had the status of statesman conferred on him, the same is true of Tully, since the two names belong to the same person.

22. *Marcel Duchamp,* p. 89.

23. Cf. Arthur Danto, "The Artworld," *The Journal of Philosophy,* 61 (1964), where a similar point is made, pp. 571–84.

VII

Art History and Museums

When we reflect on the visual arts from a philosophical point of view, we often think, naturally enough, about the works themselves or perhaps about the artists who produce them and the processes which govern their immediate production. But the visual arts exist in a world of institutions, practices, and theories which help to determine the kind of significance we accord to artistic works and activities. In this section, we take up two central and related features of the artworld: the discipline of art history and the institution of the museum.

Consider art history. What kind of inquiry is art history? What is its object of study? What are its goals and methods? Is the task of the art historian primarily to authenticate and establish reliable attributions for works of art? to make aesthetic judgments about the works? to identify the stylistic development within an artist's ouevre or of works within a particular period? to situate works within the history of ideas? to explain works in terms of the social-historical circumstances of their time? And what is the relation between art history and art criticism?

In "The History of Art as a Humanistic Discipline" Erwin Panofsky argues, first of all, that art history *is* a discipline; that is, like science, it is a kind of inquiry involving specific rules and techniques. Beyond that, Panofsky argues, art history is humanistic in approach. Since many people see science and humanism as somehow antithetical, Panofsky's first challenge is therefore to show that the notion of a "humanistic discipline" is not an oxymoron.

Humanism, in Panofsky's view, centers on two sets of ideas. On the one hand, it concerns itself with certain values (notably rationality and freedom) which are thought to distinguish human beings from animals and barbarians. On the other hand, humanism emphasizes the limitations of human beings (especially human frailty, human fallibility, and human mortality), as compared with the idea of the divine. In the first case, humanism fosters an appreciation of the idea of responsibility, in the second tolerance. The object of humanistic inquiry is culture, as it can be studied through human records and artifacts.

The humanities are a branch of learning which, Panofsky writes, "enliven" the past.

Humanistic study, so conceived, turns out to have many affinities with the operations of natural science, according to Panofsky. Among other things, humanistic study involves a process of investigation which requires observation of phenomena ("the historical facts") selected in accordance with a preexisting conceptual (in this case, historical) framework. Humanistic study employs some of the same categories as science (e.g., space, time, and relativity) and it aims to integrate its results into some larger coherent system.

However, because the primary material of art historical study in particular is the work of art which "demands to be experienced aesthetically," the art historian must bring to his or her study an aesthetic sensitivity to artistic form, style, and motif, an interest in the human intention behind the work and its historical context—in short, in everything we associate with the human meaning or significance of works of art. (Panofsky elsewhere characterizes the study of art history as the identification and analysis of three levels of subject matter: (1) primary or natural subject matter, that is, objects, events, and expressive qualities represented in the work of art, the study of which is *pre-iconographical;* (2) secondary or conventional subject matter, that is, themes and concepts manifested in the images, stories and allegories of works of art, the study of which is *iconographical;* and (3) instrinsic meaning or content, that is, larger "symbolical" values of the civilization in which the work was created, the study of which is *iconological.*[1]) The art historian is therefore engaged in a re-creative activity which is, in part and of necessity, synthetic and subjective. At the same time, Panofsky argues, the art historian is involved in an archaeological inquiry and, armed with the appropriate "cultural equipment," he or she aims toward objectivity in the understanding of reality. Even here, then, art history, though differing in significant ways from scientific inquiry, shares certain of its goals and methodologies.

Jenefer Robinson, Kendall Walton, and Nelson Goodman each discuss concepts of great importance to art history and thus illuminate the relationship between our understanding and appreciation of works of visual art and their histories. In "Style and Significance in Art History and Art Criticism" Robinson takes up Panofsky's suggestion that the understanding of a work involves both archaeological research and intuitive aesthetic re-creation, to investigate the question of the relationship of art history to art criticism. Robinson rejects the view that the functions of art history and art criticism can be neatly delineated, on the grounds that the art historian deals mainly with facts (in questions of attribution and chronology, for instance) whereas the critic is concerned primarily with values (as embedded in aesthetic and

[1]See Erwin Panofsky, "Iconography and Iconology: An Introduction to the Study of Renaissance Art," in his *Meaning in the Visual Arts* (Chicago: University of Chicago Press, 1955).

interpretative judgments). Robinson points out that matters of attribution, for example, are typically debated by appeal to the style of the work in question, but the identification of style, requires reference to critical judgments about aesthetic significance—that is, the work's representational content and its formal and expressive qualities. Conversely, reasonable judgments about representational content and formal and expressive qualities can be made only if the work is placed historically, which is to say that we know what style the work is in. Judgments of style and judgments of significance are thus interdependent. They are as two halves of an arch, connected, as Panofsky says, in an "organic situation."

Kendall Walton, in "Categories of Art," takes up the question of the relationship between art history and our experience of works of art from a different perspective. Walton argues against the view that the only aesthetically relevant qualities of works of art are perceptual, which can be seen or (in the case of music) heard in the works themselves. On such view, one distinguishes sharply between the aesthetic and the historical. Walton, on the other hand, argues that knowledge about the origins of works of art is not only frequently illuminating, it is often *essential* to an aesthetic appreciation of the works. Properties are perceived as aesthetically relevant, Walton argues, precisely insofar as they are perceived to stand in certain ways in relation to particular categories, which are largely historically defined. Certain properties (e.g., the flatness or motionlessness of a painting) are apprehended as being standard with respect to a category; that is, they are relevant to the question whether a work belongs in a category. Other properties (the shapes or colors in a painting, say) are variable: their presence is irrelevant to the question whether a work belongs in a category. Still other properties (e.g., the electrically driven motion of a painting) are "contra-standard": their presence tends to disqualify works as belonging to a category. But the determination of the correct categories for a particular work frequently involves knowledge of the intention of the artist or of the categories established and recognized in a particular society. "The relevant historical facts are not merely useful aids to aesthetic judgment," Walton argues. "Rather, they help to *determine* what aesthetic properties a work has."

In "Art and Authenticity," Nelson Goodman addresses the knotty question of the aesthetic relevance of the distinction between an original work and a forgery. As Goodman points out, the determination of authenticity is a crucial practical matter for those, such as art historians, curators and collectors, who trade in the physical artifacts themselves. But Goodman is exercised by the philosophical problems. Suppose, Goodman suggests, that we have, side by side, two paintings, one which we know to be the original of Rembrandt's *Lucretia*, the other which appears to be a perfect fake, a copy so good that we cannot discern the original from the forgery merely by looking. We know that the distinction between original and copy has an enormous influence on the art

market, but would there be an *aesthetic* difference between the two paintings? Goodman, taking a position which many will find counterintuitive, argues that the knowledge that one is original and the other a copy is itself aesthetically significant. According to Goodman, knowledge of the authorship of a work contributes to our powers of aesthetic discrimination, a point which, he says, would be denied only by those who subscribe to the "tingle-immersion" theory of aesthetic experience. The fact that a painting *can* be faked is a consequence, in Goodman's view, of its being one-stage, "autographic" art. Unlike a musical performance which, Goodman argues, can be identified as an instance of a work in terms of its compliance with a musical score, a painting is identified as "the actual object . . . the product of the artist's hand." A forgery, Goodman says, is "an object falsely purporting to have the history of production requisite for the (or an) original of the work."

The concepts of style, aesthetic judgment, and authenticity each has a well-established place within the discipline of art history as traditionally conceived. Recently, however, the traditional notion of art history as a discipline concerned primarily with matters of authorship, date, iconography, and the development of period styles has come under attack by both practitioners and theorists of art history. Some contemporary art historians have placed increasing emphasis on questions concerning the role of gender, race, and class in what might be referred to as the social-historical constitution of the art world. There have also been attempts to introduce into art historical scholarship analytical methods and concepts derived from other disciplines, especially literary theory as well as efforts to pay greater attention to vernacular productions (quilts, carpets, barns, postcards, etc.) not normally included under the rubric of serious or high art. Whether or not these emphases constitute a radical transformation of the discipline of art history is an issue of much current debate. The subject was the topic of a symposium entitled "The New(?) Art History," held at the Vancouver meetings of The American Society for Aesthetics in October 1988, the papers from which are included in this part.

In the first of these, "What Is 'New' About the 'New Art History'?", Thomas DaCosta Kaufmann describes the work of traditional art historians in North America as having been concerned by and large with the "archaeological or positivistic recuperation and categorization of works of the past." Kaufmann characterizes the new trends as exemplifying an increasing theoretical self-awareness by art historians. But he argues, the "new" art historians are to a certain extent only doing what their European counterparts had been doing generations earlier. In fact, not only did the Europeans engage in theoretical discussions about their discipline, they also significantly expanded the canon by drawing attention to previously undiscovered or undiscussed artists, works, and periods, something the North Americans (with the notable exception of feminist writers) have not done. Nor have the "new" historians devoted much

energy to the question of canon formation itself. Indeed, Kaufmann argues, some of their descriptions of individual works seem very like those offered by the traditionalists. And yet, says Kaufmann, art history is far from suffering from the anemia attributed to it by Arthur Danto. The newer trends, Kaufmann says, are signs of the intellectual health of the discipline.

Michael Marrinan begins his contribution to the symposium ("Cultural Institutions and the Topography of Art History") with a discussion of a "sanitized" museum catalog description of Degas's *The Song of the Dog,* which studiously avoids reference to the social, sexual, and political readings of the sort advanced by art historians T.J. Clark and Robert Herbert. Why, Marrinan asks, might these readings have been suppressed? The answer has to do with the nature of art historical inquiry and what is to count as appropriate historical evidence. Drawing on the work of Michael Baxandall, Michel Foucault, Michel deCerteau, and others, Marrinan argues that historians have traditionally been involved in a process of "pointing to" in which the historian selects from the multiplicity of things certain objects or documents to fit into a narrative that (presumably) helps us make sense of past events. The "pointing" of the historian of art in particular is frequently a literal pointing: standing before the actual physical work of art lends authority to the narrative and to the enterprise of art history. This is why it is not in the interests of museums (or their catalog writers) to dwell on interpretations which undermine the authority of the "museum space" by repeated or extended reference to the social space of the work. But the art historian's primary concern, Marrinan argues, should be the "art event"—"the coming together, at a specific time and in a specific place, of the necessary agents to 'make art' "—rather than making a fetish of the art object or regarding the work as a mere placeholder in some previously established historical narrative. It is this concern with the art event that ensures a future for the new art history.

In "Old, New and Not So New Art History" Arthur Danto responds to the chapters by Kaufmann and Marrinan by first noting that fundamental concepts such as *art, artist, artwork, masterpiece,* and *art history* are under intense debate among art critics, historians, and other members of the artworld. Danto agrees with Kauffman that a "new" art history cannot be merely a matter of widening the canon to include discussion of works by previously disenfranchised groups such as women and minorities. On Danto's view, what would make new art history truly new would be a radical transformation of the discipline involving, among other things, a recasting of the notion of historical explanation. Danto then in effect offers a genealogy of art histories, described in terms of the relative sophistication of their notions of historical explanation. The key notion for traditional art history is the relationship of "influence" according to which art is explained in terms of art. Conceptually-conservative-new-art-history (of the sort practiced by Herbert and Clark) goes beyond traditional concerns with influence and iconography to probe the

social, economic, and political structures of the artworld surrounding the production of works of art. This sort of enterprise is conceptually conservative in the sense that it still fits into and preserves the discourse of the institutions of the artworld in which it is practiced. Conceptually-radical-new-art-history would engage in a redefinition or deconstruction of fundamental concepts pertaining to the artworld and its history and criticism of its institutions. But Danto is not sanguine about the possibility of such a goal being achieved, if for no other reason than that historians are not likely to commit institutional suicide in this way. "The armies of scholarship march on their pocketbooks," Danto remarks laconically. "Our limits make conservatives of us all." In the end, then, Danto, like Panofsky, links the scope of the discipline of art history to human limitations, but his sense of the nature of these limitations is radically at odds with Panofsky's.

Francis Sparshott looks further into the provenance and function of that important institution of the artworld, the art museum. Beginning his essay "Showing and Saying, Looking and Learning: An Outsider's View of Art Museums" with the observation that some things get collected and some collections get preserved, Sparshott argues that museums in general are not likely to serve any single function. The most we can say is that a museum is basically "a collection of collectables that is in some way officially in the public domain." Different sorts of collections serve different purposes, as tourist attractions, ethnic shrines, declarations of magnificence, emblems of civic or national pride or refinement, celebrations of a personal or cultural past, and so on, or some or all of these. Works of art may be contained in any such collection, and their presence there may be understood in the appropriate context.

When we have a collection consisting primarily of works of art, we have an art museum. What can we say of its function or functions? As museums, art museums can serve any of the purposes museums generally serve. But insofar as art museums are set up to enshrine and esteem the practice of art and works of art as "the product of creative imagination, the timeless and placeless condition of contemplability," the conservation and display of works of art would seem to be inescapable responsibilities (though, Sparshott is quick to point out, one might take issue with the set of "museum values" according to which art museums are set up in the first place).

The question of the educative function of museums is more complex. It seems obvious enough, Sparshott notes, that art museums have provided the means by which people acquire a knowledge and a love of art, but the exact nature and scope of that education is less evident. Art museums can indeed expose people to works of art, to their diversity and achievements, and to the worlds they inhabit. Museums can provide for us at least three kinds of artworks: the familiar, the ideal, and the serendipitous. On the other hand, Sparshott argues, art museums also introduce us to a specific practice of picture

seeing—the quick walk through the gallery—which neither permits nor encourages the kind of intimacy with works of art that enhances our appreciation of them or of life itself.

Hilde Hein, in "Exhibits and Artworks: From Art Museum to Science Center," also notes the diversity of roles museums play in society as well as the range of their exhibits ("anything from birth control devices to funerary practices, or from quasars to town meetings"). Hein, however, argues that all museums do share some functions: they "shelter material resources of more or less value . . . [and they] make selected objects (not excluding ideas) available to researchers and members of the public for their voluntary examination." One way of classifying museums, then, is according to the kinds of objects they exhibit. On this basis, Hein distinguishes five main types of museums: (1) museums of art, (2) museums of science (including museums of the history of science, museums of industry and technology, museums of natural history, zoos and botanical gardens, and science centers), (3) museums of anthropology, (4) museums of history, and (5) special interest museums.

The art museum cannot trace its lineage as far back as other kinds of museums, but it remains the norm in comparison with which other kinds of museums are understood. The modern art museum, Hein argues, contains objects "preeminently created for visual appreciation . . . removed from their utilitarian context and presented as purely aesthetic items." Like Sparshott, Hein sees art museums as celebrating the works and practices of art. In so doing, Hein argues, art museums function as legitimizing institutions, fostering and promoting particular cognitive and aesthetic attitudes. One might think this would distinguish art museums from, say, museums of science, but Hein argues that the parallels between museums of art and science are closer than one might at first think. The exhibits of both institutions have an aesthetic dimension. But, more profoundly, both sorts of institution decontextualize their objects and promote an air of authority and objectivity of judgment. According to Hein, "where art museums replace private taste with public excellence, science museums displace subjective opinion with a collective truth that appears to be the product, only and inexorably, of collaborative observation and experiment. Science museums canonize science as art museums valorize art.

There are, of course, significant differences between the two. Art museums are more likely to emphasize the particularity of their exhibited objects, science museums emphasizing instead scientific principles or the (allegedly) steady progress of the history of scientific inquiry to which the exhibited objects stand as representative examples. Science *centers,* which feature "hands-on" experiments and exhibits, place even less of a premium on the particularity of their exhibited objects: any old device will do if it illustrates the scientific principles in question. But even here, science centers are not far removed from museums of art. The great asset of science centers, Hein argues, is "the

immediacy of the felt experience, and through it they can bring to life connections that are hard to convey abstractly." To be sure, the art museum has traditionally placed a greater emphasis on the appreciation of unique objects and, consequently, on the conservation and restoration of objects in its collection. But science museums, science centers, and museums of art have this much in common: they are "dedicated to helping people to see" by providing interpretive schemes. In an age when the authority and accountability of both art and science are coming under intense and increasing scrutiny, the importance of museums of art and science will continue unabated.

42

The History of Art as a Humanistic Discipline

ERWIN PANOFSKY

I

Nine days before his death Immanuel Kant was visited by his physician. Old, ill and nearly blind, he rose from his chair and stood trembling with weakness and muttering unintelligible words. Finally his faithful companion realized that he would not sit down again until the visitor had taken a seat. This he did, and Kant then permitted himself to be helped to his chair and, after having regained some of his strength, said, "Das Gefühl für Humanität hat mich noch nicht verlassen"—"The sense of humanity has not yet left me."[1] The two men were moved almost to tears. For, though the word *Humanität* had come, in the eighteenth century, to mean little more than politeness or civility, it had, for Kant, a much deeper significance, which the circumstances of the moment served to emphasize: man's proud and tragic consciousness of self-approved and self-imposed principles, contrasting with his utter subjection to illness, decay and all that is implied in the word "mortality."

Historically the word *humanitas* has had two clearly distinguishable meanings, the first arising from a contrast between man and what is less than man; the second, between man and what is more. In the first case *humanitas* means a value, in the second a limitation.

The concept of *humanitas* as a value was formulated in the circle around the younger Scipio, with Cicero as its belated, yet most explicit spokesman.

It meant the quality which distinguishes man, not only from animals, but also, and even more so, from him who belongs to the species *homo* without deserving the name of *homo humanus;* from the barbarian or vulgarian who lack *pietas* and παιδεια—that is, respect for moral values and that gracious blend of learning and urbanity which we can only circumscribe by the discredited word "culture."

In the Middle Ages this concept was displaced by the consideration of humanity as being opposed to divinity rather than to animality or barbarism. The qualities commonly associated with it were therefore those of frailty and transience: *humanitas fragilis, humanitas caduca.*

Thus the Renaissance conception of *humanitas* had a two-fold aspect from the outset. The new interest in the human being was based both on a revival of the classical antithesis between *humanitas* and *barbaritas,* or *feritas,* and on a survival of the mediaeval antithesis between *humanitas* and *divinitas.* When Marsilio Ficino defines man as a "rational soul participating in the intellect of God, but operating in a body," he defines him as the one being that is both autonomous and finite. And Pico's famous "speech," "On the Dignity of Man," is anything but a document of paganism. Pico says that God placed man in the center of the universe so that he might be conscious of where he stands, and therefore free to decide "where to turn." He does not say that man *is* the center of the universe,

From Erwin Panofsky, *Meaning in the Visual Arts.* New York: Doubleday, 1956, pp. 1–25. Reprinted with permission of Doubleday.

not even in the sense commonly attributed to the classical phrase, "man the measure of all things."

It is from this ambivalent conception of *humanitas* that humanism was born. It is not so much a movement as an attitude which can be defined as the conviction of the dignity of man, based on both the insistence on human values (rationality and freedom) and the acceptance of human limitations (fallibility and frailty); from this two postulates result—responsibility and tolerance.

Small wonder that this attitude has been attacked from two opposite camps whose common aversion to the ideas of responsibility and tolerance has recently aligned them in a united front. Entrenched in one of these camps are those who deny human values: the determinists, whether they believe in divine, physical or social predestination, the authoritarians, and those "insectolatrists" who profess the all-importance of the hive, whether the hive be called group, class, nation or race. In the other camp are those who deny human limitations in favor of some sort of intellectual or political libertinism, such as aestheticists, vitalists, intuitionists and hero-worshipers. From the point of view of determinism, the humanist is either a lost soul or an ideologist. From the point of view of authoritarianism, he is either a heretic or a revolutionary (or a counterrevolutionary). From the point of view of "insectolatry," he is a useless individualist. And from the point of view of libertinism he is a timid bourgeois.

Erasmus of Rotterdam, the humanist *par excellence,* is a typical case in point. The church suspected and ultimately rejected the writings of this man who had said: "Perhaps the spirit of Christ is more largely diffused than we think, and there are many in the community of saints who are not in our calendar." The adventurer Ulrich von Hutten despised his ironical skepticism and his unheroic love of tranquillity. And Luther, who insisted that "no man has power to think anything good or evil, but everything occurs in him by absolute necessity," was incensed by a belief which manifested itself in the famous phrase: "What is the use of man as a totality [that is, of man endowed with both a body and a soul], if God would work in him as a sculptor works in clay, and might just as well work in stone?"[2]

II

The humanist, then, rejects authority. But he respects tradition. Not only does he respect it, he looks upon it as upon something real and objective which has to be studied and, if necessary, reinstated: "*nos vetera instauramus, nova non prodimus,*" as Erasmus puts it.

The Middle Ages accepted and developed rather than studied and restored the heritage of the past. They copied classical works of art and used Aristotle and Ovid much as they copied and used the works of contemporaries. They made no attempt to interpret them from an archaeological, philological or "critical," in short, from an historical, point of view. For, if human existence could be thought of as a means rather than an end, how much less could the records of human activity be considered as values in themselves.[3]

In mediaeval scholasticism there is, therefore, no basic distinction between natural science and what we call the humanities, *studia humaniora,* to quote again an Erasmian phrase. The practice of both, so far as it was carried on at all, remained within the framework of what was called philosophy. From the humanistic point of view, however, it became reasonable, and even inevitable, to distinguish, within the realm of creation, between the sphere of *nature* and the sphere of *culture,* and to define the former with reference to the latter, i.e., nature as the whole world accessible to the senses, except for the *records left by man.*

Man is indeed the only animal to leave records behind him, for he is the only animal whose products "recall to mind" an idea distinct from their material existence. Other animals use signs and contrive structures, but they use signs without "perceiving the relation of signification,"[4] and they contrive structures without perceiving the relation of construction.

To perceive the relation of signification is to separate the idea of the concept to be expressed from the means of expression. And to perceive the relation of construction is to separate the idea of the function to be fulfilled from the means of fulfilling it. A dog announces the approach of a stranger by a bark quite different from that by which he makes known his wish to go out. But he will not use this particular bark to convey the idea that a stranger *has* called during the absence of his master. Much less will an animal, even if it were physically able to do so, as apes indubitably are, ever attempt to represent anything in a picture. Beavers build dams. But they are unable, so far as we know, to separate the very complicated actions involved from a premeditated *plan* which might be laid down in a drawing instead of being materialized in logs and stones.

Man's signs and structures are records because, or rather in so far as, they express ideas separated from, yet realized by, the processes of signaling and building. These records have therefore the quality of emerging from the stream of time, and it is precisely in this respect that they are studied by the humanist. He is, fundamentally, an historian.

The scientist, too, deals with human records,

namely with the works of his predecessors. But he deals with them not as something to be investigated, but as something which helps him to investigate. In other words, he is interested in records not in so far as they emerge from the stream of time, but in so far as they are absorbed in it. If a modern scientist reads Newton or Leonardo da Vinci in the original, he does so not as a scientist, but as a man interested in the history of science and therefore of human civilization in general. In other words, he does it as a *humanist,* for whom the works of Newton or Leonardo da Vinci have an autonomous meaning and a lasting value. From the humanistic point of view, human records do not age.

Thus, while science endeavors to transform the chaotic variety of natural phenomena into what may be called a cosmos of nature, the humanities endeavor to transform the chaotic variety of human records into what may be called a cosmos of culture.

There are, in spite of all the differences in subject and procedure, some very striking analogies between the methodical problems to be coped with by the scientist, on the one hand, and by the humanist, on the other.[5]

In both cases the process of investigation seems to begin with observation. But both the observer of a natural phenomenon and the examiner of a record are not only confined to the limits of their range of vision and to the available material; in directing their attention to *certain* objects they obey, knowingly or not, a principle of pre-selection dictated by a theory in the case of the scientist and by a general historical conception in the case of the humanist. It may be true that "nothing is in the mind except what was in the senses"; but it is at least equally true that much is in the senses without ever penetrating into the mind. We are chiefly affected by that which we allow to affect us; and just as natural science involuntarily selects what it calls the phenomena, the humanities involuntarily select what they call the historical facts. Thus the humanities have gradually widened their cultural cosmos and in some measure have shifted the accents of their interests. Even he who instinctively sympathizes with the simple definition of the humanities as "Latin and Greek" and considers this definition as essentially valid as long as we use such ideas and expressions as, for instance, "idea" and "expression"—even he has to admit that it has become a trifle narrow.

Furthermore, the world of the humanities is determined by a cultural theory of relativity, comparable to that of the physicists; and since the cosmos of culture is so much smaller than the cosmos of nature, cultural relativity prevails within terrestrial dimensions, and was observed at a much earlier date.

Every historical concept is obviously based on the categories of space and time. The records, and what they imply, have to be dated and located. But it turns out that these two acts are in reality two aspects of one. If I date a picture about 1400, this statement would be meaningless if I could not indicate *where* it could have been produced at that date; conversely, if I ascribe a picture to the Florentine school, I must be able to tell *when* it could have been produced in that school. The cosmos of culture, like the cosmos of nature, is a spatio-temporal structure. The year 1400 means something different in Venice from what it means in Florence, to say nothing of Augsburg, or Russia, or Constantinople. Two historical phenomena are simultaneous, or have a determinable temporal relation to each other, only in so far as they can be related within one "frame of reference," in the absence of which the very concept of simultaneity would be as meaningless in history as it would in physics. If we knew by some concatenation of circumstances that a certain Negro sculpture had been executed in 1510, it would be meaningless to say that it was "contemporaneous" with Michelangelo's Sistine ceiling.[6]

Finally, the succession of steps by which the material is organized into a natural or cultural cosmos is analogous, and the same is true of the methodical problems implied by this process. The first step is, as has already been mentioned, the observation of natural phenomena and the examination of human records. Then the records have to be "decoded" and interpreted, as must the "messages from nature" received by the observer. Finally the results have to be classified and coordinated into a coherent system that "makes sense."

Now we have seen that even the selection of the material *for* observation and examination is predetermined, to some extent, by a theory, or by a general historical conception. This is even more evident in the procedure itself, as every step made towards the system that "makes sense" presupposes not only the preceding but also the succeeding ones.

When the scientist observes a phenomenon he uses *instruments* which are themselves subject to the laws of nature which he wants to explore. When the humanist examines a record he uses *documents* which are themselves produced in the course of the process which he wants to investigate.

Let us suppose that I find in the archives of a small town in the Rhineland a contract dated 1471, and complemented by records of payments, by which the local painter "Johannes *qui et* Frost" was commissioned to execute for the church of St. James in that town an altarpiece with the Nativity in the center and Saints Peter and Paul on the wings; and let us further suppose that I find in the Church of St. James an altarpiece corresponding to this contract. That would be a case of documentation as good and simple as we could possibly hope to encounter, much better and simpler than if we had to deal with

an "indirect" source such as a letter, or a description in a chronicle, biography, diary, or poem. Yet several questions would present themselves.

The document may be an original, a copy or a forgery. If it is a copy, it may be a faulty one, and even if it is an original, some of the data may be wrong. The altarpiece in turn may be the one referred to in the contract; but it is equally possible that the original monument was destroyed during the iconoclastic riots of 1535 and was replaced by an altarpiece showing the same subjects, but executed around 1550 by a painter from Antwerp.

To arrive at any degree of certainty we would have to "check" the document against other documents of similar date and provenance, and the altarpiece against other paintings executed in the Rhineland around 1470. But here two difficulties arise.

First, "checking" is obviously impossible without our knowing what to "check"; we would have to single out certain features or criteria such as some forms of script, or some technical terms used in the contract, or some formal or iconographic peculiarities manifested in the altarpiece. But since we cannot analyze what we do not understand, our examination turns out to presuppose decoding and interpretation.

Secondly, the material against which we check our problematic case is in itself no better authenticated than the problematic case in hand. Taken individually, any other signed and dated monument is just as doubtful as the altarpiece ordered from "Johannes *qui et* Frost" in 1471. (It is self-evident that a signature on a picture can be, and often is, just as unreliable as a document connected with a picture.) It is only on the basis of a whole group or class of data that we can decide whether our altarpiece was stylistically and iconographically "possible" in the Rhineland around 1470. But classification obviously presupposes the idea of a whole to which the classes belong—in other words, the general historical conception which we try to build up from our individual cases.

However we may look at it, the beginning of our investigation always seems to presuppose the end, and the documents which should explain the monuments are just as enigmatical as the monuments themselves. It is quite possible that a technical term in our contract is a ἅπαξ λεγόμενον which can only be explained by this one altarpiece; and what an artist has said about his own works must always be interpreted in the light of the works themselves. We are apparently faced with a hopeless vicious circle. Actually it is what the philosophers call an "organic situation."[7] Two legs without a body cannot walk, and a body without legs cannot walk either, yet a man can walk. It is true that the individual monuments and documents can only be examined, interpreted and classified in the light of a general historical concept, while at the same time this general historical concept can only be built up on individual monuments and documents; just as the understanding of natural phenomena and the use of scientific instruments depends on a general physical theory and vice versa. Yet this situation is by no means a permanent deadlock. Every discovery of an unknown historical fact, and every new interpretation of a known one, will either "fit in" with the prevalent general conception, and thereby corroborate and enrich it, or else it will entail a subtle, or even a fundamental change in the prevalent general conception, and thereby throw new light on all that has been known before. In both cases the "system that makes sense" operates as a consistent yet elastic organism comparable to a living animal as opposed to its single limbs; and what is true of the relationship between monuments, documents and a general historical concept in the humanities is evidently equally true of the relationship between phenomena, instruments and theory in the natural sciences.

III

I have referred to the altarpiece of 1471 as a "monument" and to the contract as a "document"; that is to say, I have considered the altarpiece as the object of investigation, or "primary material," and the contract as an instrument of investigation, or "secondary material." In doing this I have spoken as an art historian. For a palaeographer or an historian of law, the contract would be the "monument," or "primary material," and both may use pictures for documentation.

Unless a scholar is exclusively interested in what is called "events" (in which case he would consider all the available records as "secondary material" by means of which he might reconstruct the "events"), everyone's "monuments" are everyone else's "documents," and vice versa. In practical work we are even compelled actually to annex "monuments" rightfully belonging to our colleagues. Many a work of art has been interpreted by a philologist or by an historian of medicine; and many a text has been interpreted, and could only have been interpreted, by an historian of art.

An art historian, then, is a humanist whose "primary material" consists of those records which have come down to us in the form of works of art. But what is a work of art?

A work of art is not always created exclusively for the purpose of being enjoyed, or, to use a more scholarly expression, of being experienced aesthetically. Poussin's statement that "la fin de l'art est la

délectation" was quite a revolutionary one,[8] for earlier writers had always insisted that art, however enjoyable, was also, in some manner, useful. But a work of art always *has* aesthetic significance (not to be confused with aesthetic value): whether or not it serves some practical purpose, and whether it is good or bad, it demands to be experienced aesthetically.

It is possible to experience every object, natural or manmade, aesthetically. We do this, to express it as simply as possible, when we just look at it (or listen to it) without relating it, intellectually or emotionally, to anything outside of itself. When a man looks at a tree from the point of view of a carpenter, he will associate it with the various uses to which he might put the wood; and when he looks at it from the point of view of an ornithologist he will associate it with the birds that might nest in it. When a man at a horse race watches the animal on which he has put his money, he will associate its performance with his desire that it may win. Only he who simply and wholly abandons himself to the object of his perception will experience it aesthetically.[9]

Now, when confronted with a natural object, it is an exclusively personal matter whether or not we choose to experience it aesthetically. A man-made object, however, either demands or does not demand to be so experienced, for it has what the scholastics call an "intention." Should I choose, as I might well do, to experience the redness of a traffic light aesthetically, instead of associating it with the idea of stepping on my brakes, I should act against the "intention" of the traffic light.

Those man-made objects which do not demand to be experienced aesthetically, are commonly called "practical," and may be divided into two classes: vehicles of communication, and tools or apparatuses. A vehicle of communication is "intended" to transmit a concept. A tool or apparatus is "intended" to fulfill a function (which function, in turn, may be the production or transmission of communications, as is the case with a typewriter or with the previously mentioned traffic light).

Most of the objects which do demand to be experienced aesthetically, that is to say, works of art, also belong in one of these two classes. A poem or an historical painting is, in a sense, a vehicle of communication; the Pantheon and the Milan candlesticks are, in a sense, apparatuses; and Michelangelo's tombs of Lorenzo and Giuliano de' Medici are, in a sense, both. But I have to say "in a sense," because there is this difference: in the case of what might be called a "mere vehicle of communication" and a "mere apparatus," the intention is definitely fixed on the idea of the work, namely, on the meaning to be transmitted, or on the function to be fulfilled. In the case of a work of art, the interest in the idea is balanced, and may even be eclipsed, by an interest in form.

However, the element of "form" is present in every object without exception, for every object consists of matter and form; and there is no way of determining with scientific precision to what extent, in a given case, this element of form bears the emphasis. Therefore one cannot, and should not, attempt to define the precise moment at which a vehicle of communication or an apparatus begins to be a work of art. If I write to a friend to ask him to dinner, my letter is primarily a communication. But the more I shift the emphasis to the form of my script, the more nearly does it become a work of calligraphy; and the more I emphasize the form of my language (I could even go so far as to invite him by a sonnet), the more nearly does it become a work of literature or poetry.

Where the sphere of practical objects ends, and that of "art" begins, depends, then, on the "intention" of the creators. This "intention" cannot be absolutely determined. In the first place, "intentions" are, *per se*, incapable of being defined with scientific precision. In the second place, the "intentions" of those who produce objects are conditioned by the standards of their period and environment. Classical taste demanded that private letters, legal speeches and the shields of heroes should be "artistic" (with the possible result of what might be called fake beauty), while modern taste demands that architecture and ash trays should be "functional" (with the possible result of what might be called fake efficiency).[10] Finally our estimate of those "intentions" is inevitably influenced by our own attitude, which in turn depends on our individual experiences as well as on our historical situation. We have all seen with our own eyes the transference of spoons and fetishes of African tribes from the museums of ethnology into art exhibitions.

One thing, however, is certain: the more the proportion of emphasis on "idea" and "form" approaches a state of equilibrium, the more eloquently will the work reveal what is called "content." Content, as opposed to subject matter, may be described in the words of Peirce as that which a work betrays but does not parade. It is the basic attitude of a nation, a period, a class, a religious or philosophical persuasion—all this unconsciously qualified by one personality, and condensed into one work. It is obvious that such an involuntary revelation will be obscured in proportion as either one of the two elements, idea or form, is voluntarily emphasized or suppressed. A spinning machine is perhaps the most impressive manifestation of a functional idea, and an "abstract" painting is perhaps the most expressive manifestation of pure form, but both have a minimum of content.

IV

In defining a work of art as a "man-made object demanding to be experienced aesthetically" we encounter for the first time a basic difference between the humanities and natural science. The scientist, dealing as he does with natural phenomena, can at once proceed to analyze them. The humanist, dealing as he does with human actions and creations, has to engage in a mental process of a synthetic and subjective character: he has mentally to re-enact the actions and to re-create the creations. It is in fact by this process that the real objects of the humanities come into being. For it is obvious that historians of philosophy or sculpture are concerned with books and statues not in so far as these books and sculptures exist materially, but in so far as they have a meaning. And it is equally obvious that this meaning can only be apprehended by re-producing, and thereby, quite literally, "realizing," the thoughts that are expressed in the books and the artistic conceptions that manifest themselves in the statues.

Thus the art historian subjects his "material" to a rational archaeological analysis at times as meticulously exact, comprehensive and involved as any physical or astronomical research. But he constitutes his "material" by means of an intuitive aesthetic re-creation,[11] including the perception and appraisal of "quality," just as any "ordinary" person does when he or she looks at a picture or listens to a symphony.

How, then, is it possible to build up art history as a respectable scholarly discipline, if its very objects come into being by an irrational and subjective process?

This question cannot be answered, of course, by referring to the scientific methods which have been, or may be, introduced into art history. Devices such as chemical analysis of materials, X rays, ultraviolet rays, infrared rays and macrophotography are very helpful, but their use has nothing to do with the basic methodical problem. A statement to the effect that the pigments used in an allegedly mediaeval miniature were not invented before the nineteenth century may settle an art-historical question, but it is not an art-historical statement. Based as it is on chemical analysis plus the history of chemistry, it refers to the miniature not *qua* work of art but *qua* physical object, and may just as well refer to a forged will. The use of X rays, macrophotographs, etc., on the other hand, is methodically not different from the use of spectacles or of a magnifying glass. These devices enable the art historian to see more than he could see without them, but *what* he sees has to be interpreted "stylistically," like that which he perceives with the naked eye.

The real answer lies in the fact that intuitive aesthetic re-creation and archaeological research are interconnected so as to form, again, what we have called an "organic situation." It is not true that the art historian first constitutes his object by means of re-creative synthesis and then begins his archaeological investigation—as though first buying a ticket and then boarding a train. In reality the two processes do not succeed each other, they interpenetrate; not only does the re-creative synthesis serve as a basis for the archaeological investigation, the archaeological investigation in turn serves as a basis for the re-creative process; both mutually qualify and rectify one another.

Anyone confronted with a work of art, whether aesthetically re-creating or rationally investigating it, is affected by its three constituents: materialized form, idea (that is, in the plastic arts, subject matter) and content. The pseudo-impressionistic theory according to which "form and color tell us of form and color, that is all," is simply not true. It is the unity of those three elements which is realized in the aesthetic experience, and all of them enter into what is called aesthetic enjoyment of art.

The re-creative experience of a work of art depends, therefore, not only on the natural sensitivity and the visual training of the spectator, but also on his cultural equipment. There is no such thing as an entirely "naïve" beholder. The "naïve" beholder of the Middle Ages had a good deal to learn, and something to forget, before he could appreciate classical statuary and architecture, and the "naïve" beholder of the post-Renaissance period had a good deal to forget, and something to learn, before he could appreciate mediaeval, to say nothing of primitive, art. Thus the "naïve" beholder not only enjoys but also, unconsciously, appraises and interprets the work of art; and no one can blame him if he does this without caring whether his appraisal and interpretation are right or wrong, and without realizing that his own cultural equipment, such as it is, actually contributes to the object of his experience.

The "naïve" beholder differs from the art historian in that the latter is conscious of the situation. He *knows* that his cultural equipment, such as it is, would not be in harmony with that of people in another land and of a different period. He tries, therefore, to make adjustments by learning as much as he possibly can of the circumstances under which the objects of his studies were created. Not only will he collect and verify all the available factual information as to medium, condition, age, authorship, destination, etc., but he will also compare the work with others of its class, and will examine such writings as reflect the aesthetic standards of its country and age, in order to achieve a more "objective" appraisal of its quality. He will read old books on

theology or mythology in order to identify its subject matter, and he will further try to determine its historical locus, and to separate the individual contribution of its maker from that of forerunners and contemporaries. He will study the formal principles which control the rendering of the visible world, or, in architecture, the handling of what may be called the structural features, and thus build up a history of "motifs." He will observe the interplay between the influences of literary sources and the effect of self-dependent representational traditions, in order to establish a history of iconographic formulae or "types." And he will do his best to familiarize himself with the social, religious and philosophical attitudes of other periods and countries, in order to correct his own subjective feeling for content.[12] But when he does all this, his aesthetic perception as such will change accordingly, and will more and more adapt itself to the original "intention" of the works. Thus what the art historian, as opposed to the "naïve" art lover, does, is not to erect a rational superstructure on an irrational foundation, but to develop his re-creative experiences so as to conform with the results of his archaeological research, while continually checking the result of his archaeological research against the evidence of his re-creative experiences.[13]

Leonardo da Vinci has said: "Two weaknesses leaning against one another add up to one strength."[14] The halves of an arch cannot even stand upright; the whole arch supports a weight. Similarly, archaeological research is blind and empty without aesthetic re-creation, and aesthetic re-creation is irrational and often misguided without archaeological research. But, "leaning against one another," these two can support the "system that makes sense," that is, an historical synopsis.

As I have said before, no one can be blamed for enjoying works of art "naïvely"—for appraising and interpreting them according to his lights and not caring any further. But the humanist will look with suspicion upon what might be called "appreciationism." He who teaches innocent people to understand art without bothering about classical languages, boresome historical methods and dusty old documents, deprives naïveté of its charm without correcting its errors.

"Appreciationism" is not to be confused with "connoisseurship" and "art theory." The connoisseur is the collector, museum curator or expert who deliberately limits his contribution to scholarship to identifying works of art with respect to date, provenance and authorship, and to evaluating them with respect to quality and condition. The difference between him and the art historian is not so much a matter of principle as a matter of emphasis and explicitness, comparable to the difference

between a diagnostician and a researcher in medicine. The connoisseur tends to emphasize the re-creative aspect of the complex process which I have tried to describe, and considers the building up of an historical conception as secondary; the art historian in the narrower, or academic, sense is inclined to reverse these accents. But the simple diagnosis "cancer," if correct, implies everything which the researcher could tell us about cancer, and therefore claims to be verifiable by subsequent scientific analysis; similarly the simple diagnosis "Rembrandt around 1650," if correct, implies everything which the historian of art could tell us about the formal values of the picture, about the interpretation of the subject, about the way it reflects the cultural attitude of seventeenth-century Holland, and about the way it expresses Rembrandt's personality; and this diagnosis, too, claims to live up to the criticism of the art historian in the narrower sense. The connoisseur might thus be defined as a laconic art historian, and the art historian as a loquacious connoisseur. In point of fact the best representatives of both types have enormously contributed to what they themselves do not consider their proper business.[15]

Art theory, on the other hand—as opposed to the philosophy of art or aesthetics—is to art history as poetics and rhetoric are to the history of literature.

Because of the fact that the objects of art history come into being by a process of re-creative aesthetic synthesis, the art historian finds himself in a peculiar difficulty when trying to characterize what might be called the stylistic structure of the works with which he is concerned. Since he has to describe these works, not as physical bodies or as substitutes for physical bodies, but as objects of an inward experience, it would be useless—even if it were possible—to express shapes, colors, and features of construction in terms of geometrical formulae, wave lengths and statical equations, or to describe the postures of a human figure by way of anatomical analysis. On the other hand, since the inward experience of the art historian is not a free and subjective one, but has been outlined for him by the purposeful activities of an artist, he must not limit himself to describing his personal impressions of the work of art as a poet might describe his impressions of a landscape or of the song of a nightingale.

The objects of art history, then, can only be characterized in a terminology which is as re-constructive as the experience of the art historian is re-creative: it must describe the stylistic peculiarities, neither as measurable or otherwise determinable data, nor as stimuli of subjective reactions, but as that which bears witness to artistic "intentions." Now "intentions" can only be formulated in terms of alternatives: a situation has to be supposed in

which the maker of the work had more than one possibility of procedure, that is to say, in which he found himself confronted with a problem of choice between various modes of emphasis. Thus it appears that the terms used by the art historian interpret the stylistic peculiarities of the works as specific solutions of generic "artistic problems." This is not only the case with our modern terminology, but even with such expressions as *rilievo, sfumato,* etc., found in sixteenth-century writing.

When we call a figure in an Italian Renaissance picture "plastic," while describing a figure in a Chinese painting as "having volume but no mass" (owing to the absence of "modeling"), we interpret these figures as two different solutions of a problem which might be formulated as "volumetric units (bodies) vs. illimited expanse (space)." When we distinguish between a use of line as "contour" and, to quote Balzac, a use of line as "le moyen par lequel l'homme se rend compte de l'effet de la lumière sur les objets," we refer to the same problem, while placing special emphasis upon another one: "line vs. areas of color." Upon reflection it will turn out that there is a limited number of such primary problems, interrelated with each other, which on the one hand beget an infinity of secondary and tertiary ones, and on the other hand can be ultimately derived from one basic antithesis: differentiation vs. continuity.[16]

To formulate and to systematize the "artistic problems"—which are of course not limited to the sphere of purely formal values, but include the "stylistic structure" of subject matter and content as well—and thus to build up a system of *"Kunstwissenschaftliche Grundbegriffe"* is the objective of art theory and not of art history. But here we encounter, for the third time, what we have called an "organic situation." The art historian, as we have seen, cannot describe the objects of his re-creative experience without re-constructing artistic intentions in terms which imply generic theoretical concepts. In doing this, he will, consciously or unconsciously, contribute to the development of art theory, which, without historical exemplification, would remain a meager scheme of abstract universals. The art theorist, on other hand, whether he approaches the subject from the standpoint of Kant's *Critique,* of neo-scholastic epistemology, or of *Gestaltpsychologie,*[17] cannot build up a system of generic concepts without referring to works of art which have come into being under specific historical conditions; but in doing this he will, consciously or unconsciously, contribute to the development of art history, which, without theoretical orientation, would remain a congeries of unformulated particulars.

When we call the connoisseur a laconic art historian and the art historian a loquacious connoisseur, the relation between the art historian and the art theorist may be compared to that between two neighbors who have the right of shooting over the same district, while one of them owns the gun and the other all the ammunition. Both parties would be well advised if they realized this condition of their partnership. It has rightly been said that theory, if not received at the door of an empirical discipline, comes in through the chimney like a ghost and upsets the furniture. But it is no less true that history, if not received at the door of a theoretical discipline dealing with the same set of phenomena, creeps into the cellar like a horde of mice and undermines the groundwork.

V

It may be taken for granted that art history deserves to be counted among the humanities. But what is the use of the humanities as such? Admittedly they are not practical, and admittedly they concern themselves with the past. Why, it may be asked, should we engage in impractical investigations, and why should we be interested in the past?

The answer to the first question is: because we are interested in reality. Both the humanities and the natural sciences, as well as mathematics and philosophy, have the impractical outlook of what the ancients called *vita contemplativa* as opposed to *vita activa.* But is the contemplative life less real or, to be more precise, is its contribution to what we call reality less important, than that of the active life?

The man who takes a paper dollar in exchange for twenty-five apples commits an act of faith, and subjects himself to a theoretical doctrine, as did the mediaeval man who paid for indulgence. The man who is run over by an automobile is run over by mathematics, physics and chemistry. For he who leads the contemplative life cannot help influencing the active, just as he cannot prevent the active life from influencing his thought. Philosophical and psychological theories, historical doctrines and all sorts of speculations and discoveries, have changed, and keep changing, the lives of countless millions. Even he who merely transmits knowledge or learning participates, in his modest way, in the process of shaping reality—of which fact the enemies of humanism are perhaps more keenly aware than its friends.[18] It is impossible to conceive of our world in terms of action alone. Only in God is there a "Coincidence of Act and Thought" as the scholastics put it. Our reality can only be understood as an interpenetration of these two.

But even so, why should we be interested in the past? The answer is the same: because we are interested in reality. There is nothing less real than the

present. An hour ago, this lecture belonged to the future. In four minutes, it will belong to the past. When I said that the man who is run over by an automobile is run over by mathematics, physics and chemistry, I could just as well have said that he is run over by Euclid, Archimedes and Lavoisier.

To grasp reality we have to detach ourselves from the present. Philosophy and mathematics do this by building systems in a medium which is by definition not subject to time. Natural science and the humanities do it by creating those spatiotemporal structures which I have called the "cosmos of nature" and the "cosmos of culture." And here we touch upon what is perhaps the most fundamental difference between the humanities and the natural sciences. Natural science observes the time-bound processes of nature and tries to apprehend the timeless laws according to which they unfold. Physical observation is only possible where something "happens," that is, where a change occurs or is made to occur by way of experiment. And it is these changes which are finally symbolized by mathematical formulae. The humanities, on the other hand, are not faced by the task of arresting what otherwise would slip away, but of enlivening what otherwise would remain dead. Instead of dealing with temporal phenomena, and causing time to stop, they penetrate into a region where time has stopped of its own accord, and try to reactivate it. Gazing as they do at those frozen, stationary records of which I have said that they "emerge from the stream of time," the humanities endeavor to capture the processes in the course of which those records were produced and became what they are.[19]

In thus endowing static records with dynamic life, instead of reducing transitory events to static laws, the humanities do not conflict with, but complement, the natural sciences. In fact these two presuppose and demand each other. Science—here understood in the true sense of the term, namely, as a serene and self-dependent pursuit of knowledge, not as something subservient to "practical" ends—and the humanities are sisters, brought forth as they are by that movement which has rightly been called the discovery (or, in a large historical perspective, rediscovery) of both the world and man. And as they were born and reborn together, they will also die and be resurrected together if destiny so wills. If the anthropocratic civilization of the Renaissance is headed, as it seems to be, for a "Middle Ages in reverse"—a satanocracy as opposed to the mediaeval theocracy—not only the humanities but also the natural sciences, as we know them, will disappear, and nothing will be left but what serves the dictates of the subhuman. But even this will not mean the end of humanism. Prometheus could be bound and tortured, but the fire lit by his torch could not be extinguished.

A subtle difference exists in Latin between *scientia* and *eruditio*, and in English between knowledge and learning. *Scientia* and knowledge, denoting a mental possession rather than a mental process, can be identified with the natural sciences; *eruditio* and learning, denoting a process rather than a possession, with the humanities. The ideal aim of science would seem to be something like mastery, that of the humanities something like wisdom.

Marsilio Ficino wrote to the son of Poggio Bracciolini: "History is necessary, not only to make life agreeable, but also to endow it with a moral significance. What is mortal in itself, achieves immortality through history; what is absent becomes present; old things are rejuvenated; and young men soon equal the maturity of old ones. If a man of seventy is considered wise because of his experience, how much wiser he whose life fills a span of a thousand or three thousand years! For indeed, a man may be said to have *lived* as many millennia as are embraced by the span of his knowledge of history."[20]

Notes

1. E. A. C. Wasianski, *Immanuel Kant in seinen letzten Lebensjahren (Ueber Immanuel Kant,* 1804, Vol. 3), reprinted in *Immanuel Kant, Sein Leben in Darstellungen von Zeitgenossen* (Berlin: Deutsche Bibliothek, 1912), p. 298.

2. For the quotations from Luther and Erasmus of Rotterdam see the excellent monograph *Humanitas Erasmiana* by R. Pfeiffer, Studien der Bibliothek Warburg, 22, 1931. It is significant that Erasmus and Luther rejected judicial or fatalistic astrology for totally different reasons: Erasmus refused to believe that human destiny depends on the unalterable movements of the celestial bodies, because such a belief would amount to a denial of human free will and responsibility; Luther, because it would amount to a restriction of the omnipotence of God. Luther therefore believed in the significance of *terata*, such as eight-footed calves, etc., which God can cause to appear at irregular intervals.

3. Some historians seem to be unable to recognize continuities and distinctions at the same time. It is undeniable that humanism, and the entire Renaissance movement, did not spring forth like Athena from the head of Zeus. But the fact that Lupus of Ferrières emended classical texts, that Hil-

debert of Lavardin had a strong feeling for the ruins of Rome, that the French and English scholars
of the twelfth century revived classical philosophy and mythology, and that Marbod of Rennes wrote
a fine pastoral poem on his small country estate, does not mean that their outlook was identical with
that of Petrarch, let alone of Ficino or Erasmus. No mediaeval man could see the civilization of antiq-
uity as a phenomenon complete in itself and historically detached from the contemporary world; as
far as I know, mediaeval Latin has no equivalent to the humanistic *"antiquitas"* or *"sacrosancta vetus-
tas."* And just as it was impossible for the Middle Ages to elaborate a system of perspective based on
the realization of a fixed distance between the eye and the object, so it was equally impossible for this
period to evolve an idea of historical disciplines based on the realization of a fixed distance between
the present and the classical past. See E. Panofsky and F. Saxl, "Classical Mythology in Mediaeval
Art," *Studies of the Metropolitan Museum,* 4, no. 2 (1933), 228ff., particularly 263ff., and recently
the interesting article by W. S. Heckscher, "Relics of Pagan Antiquity in Mediaeval Settings," *Journal
of the Warburg Institute,* 1 (1937), 204ff.

4. See J. Maritain, "Sign and Symbol," *Journal of the Warburg Institute,* 1 (1937), 1ff.

5. See E. Wind, *Das Experiment und die Metaphysik* (Tübingen, 1934), and idem, "Some Points
of Contact Between History and Natural Science," *Philosophy and History, Essays Presented to Ernst
Cassirer* (Oxford, 1936), p. 255ff. (with a very instructive discussion of the relationship between phe-
nomena, instruments and the observer, on the one hand, and historical facts, documents and the his-
torian, on the other).

6. See, e. g., E. Panofsky, "Ueber die Reihenfolge der vier Meister von Reims" (Appendix), *Jahr-
buch für Kunstwissenschaft,* 2 (1927), 77ff.

7. I am indebted for this term to Professor T. M. Greene.

8. A. Blunt, "Poussin's Notes on Painting," *Journal of the Warburg Institute,* 1 (1937), 344ff.,
claims (p. 349) that Poussin's "La fin de l'art est la délectation" was more or less "mediaeval," because
"the theory of *delectatio* as the sign by which beauty is recognized is the key of all St. Bonaventura's
aesthetic, and it may well be from there, probably by means of some populariser, that Poussin drew
the definition." However, even if the wording of Poussin's phrase was influenced by a mediaeval
source, there is a great difference between the statement that *delectatio* is a *distinctive quality* of every-
thing *beautiful,* whether man-made or natural, and the statement that *delectatio* is the *end ("fin")* of
art.

9. See M. Geiger, "Beiträge zur Phänomenologie des aesthetischen Genusses," *Jahrbuch für Phi-
losophie,* 1, part 2 (1922), 567ff. Furthermore, E. Wind, *Aesthetischer und kunstwissenschaftlicher
Gegenstand,* Diss. phil. (Hamburg, 1923), partly reprinted as "Zur Systematik der künstlerischen
Probleme," *Zeitschrift für Aesthetik und allgemeine Kunstwissenschaft,* 18, (1925), 438ff.

10. "Functionalism" means, strictly speaking, not the introduction of a new aesthetic principle,
but a narrower delimitation of the aesthetic sphere. When we prefer the modern steel helmet to the
shield of Achilles, or feel that the "intention" of a legal speech should be definitely focused on the
subject matter and should not be shifted to the form ("more matter with less *art,"* as Queen Gertrude
rightly puts it), we merely demand that arms and legal speeches should not be treated as works of art,
that is, aesthetically, but as practical objects, that is, technically. However, we have come to think of
"functionalism" as a postulate instead of an interdict. The Classical and Renaissance civilizations, in
the belief that a merely useful thing could not be "beautiful" ("non può essere bellezza e utilità," as
Leonardo da Vinci puts it; see J. P. Richter, *The Literary Works of Leonardo da Vinci* [London,
1883], nr. 1445) are characterized by a tendency to extend the aesthetic attitude to such creations
as are "naturally" practical; we have extended the technical attitude to such creations as are "natu-
rally" artistic. This, too, is an infringement, and, in the case of "streamlining," art has taken its
revenge. "Streamlining" was, originally, a genuine functional principle based on the results of scien-
tific research on air resistance. Its legitimate sphere was therefore the field of fast-moving vehicles and
of structures exposed to wind pressure of an extraordinary intensity. But when this special and truly
technical device came to be interpreted as a general and aesthetic principle expressing the twentieth-
century ideal of "efficiency" ("streamline your mind!"), and was applied to arm chairs and cocktail
shakers, it was felt that the original scientific streamline had to be "beautified"; and it was finally
retransferred to where it rightfully belongs in a thoroughly non-functional form. As a result, we now
less often have houses and furniture functionalized by engineers, than automobiles and railroad trains
de-functionalized by designers.

11. However, when speaking of "re-creation" it is important to emphasize the prefix "re." Works
of art are both manifestations of artistic "intentions" and natural objects, sometimes difficult to isolate

from their physical surroundings and always subject to the physical processes of aging. Thus, in experiencing a work of art aesthetically we perform two entirely different acts which, however, psychologically merge with each other into one *Erlebnis:* we build up our aesthetic object both by re-creating the work of art according to the "intention" of its maker, and by freely creating a set of aesthetic values comparable to those with which we endow a tree or a sunset. When abandoning ourselves to the impression of the weathered sculptures of Chartres, we cannot help enjoying their lovely mellowness and patina as an aesthetic value; but this value, which implies both the sensual pleasure in a peculiar play of light and color and the more sentimental delight in "age" and "genuineness," has nothing to do with the objective, or artistic, value with which the sculptures were invested by their makers. From the point of view of the Gothic stone carvers the processes of aging were not merely irrelevant but positively undesirable: they tried to protect their statues by a coat of color which, had it been preserved in its original freshness, would probably spoil a good deal of our aesthetic enjoyment. As a private person, the art historian is entirely justified in not destroying the psychological unity of *Alters-und-Echtheits-Erlebnis* and *Kunst-Erlebnis*. But as a "professional man" he has to separate, as far as possible, the re-creative experience of the intentional values imparted to the statue by the artist from the creative experience of the accidental values imparted to a piece of aged stone by the action of nature. And this separation is often not as easy as it might seem.

1 2. For the technical terms used in this paragraph, see The Introduction to E. Panofsky, *Studies in Iconology.*

1 3. The same applies, of course, to the history of literature and of other forms of artistic expression. According to Dionysius Thrax (*Ars Grammatica*, ed. P. Uhlig, 30, 1 8 8 3, p. 5ff.; quoted in Gilbert Murray, *Religio Grammatici, The Religion of a Man of Letters* [Boston and New York, 1 9 1 8], p. 1 5), Γραμματική (history of literature, as we would say) is an ἐμπειρία (knowledge based on experience) of that which has been said by the poets and prose writers. He divides it into six parts, all of which can be paralleled in art history:

1. ἀνάγνωσις ἐντριβὴς κατὰ προσῳδίαν (expert reading aloud according to prosody): this is, in fact, the synthetic aesthetic recreation of a work of literature and is comparable to the visual "realization" of a work of art.
2. ἐξήγησις κατὰ τοὺς ἐνυπάρχοντας ποιητικοὺς τρόπους (explanation of such figures of speech as may occur): this would be comparable to the history of iconographic formulae or "types."
3. γλωσσῶν τε καὶ ἱστοριῶν πρόχειρος ἀπόδοσις (offhand rendering of obsolete words and themes): identification of iconographic subject matter.
4. ἐτυμνλογίας εὕρησις (discovery of etymologies): derivation of "motifs."
5. ἀναλογίας ἐκλογισμός (explanation of grammatical forms): analysis of compositional structure.
6. κρίσις ποιημάτων, ὃ δὴ κάλλιστόν ἐστι πάντων τῶν ἐν τῇ τέχνῃ (literary criticism, which is the most beautiful part of that which is comprised by Γραμματική: critical appraisal of works of art.

The expression "critical appraisal of works of art" raises an interesting question. If the history of art admits a scale of values, just as the history of literature or political history admits degrees of excellence or "greatness," how can we justify the fact that the methods here expounded do not seem to allow for a differentiation between first, second and third rate works of art? Now a scale of values is partly a matter of personal reactions and partly a matter of tradition. Both these standards, of which the second is the comparatively more objective one, have continually to be revised, and every investigation, however specialized, contributes to this process. But just for this reason the art historian cannot make an a priori distinction between his approach to a "masterpiece" and his approach to a "mediocre" or "inferior" work of art—just as a student of classical literature cannot investigate the tragedies by Sophocles in any other manner than the tragedies by Seneca. It is true that the methods of art history, *qua* methods, will prove as effective when applied to Dürer's *Melencolia* as when applied to an anonymous and rather unimportant woodcut. But when a "masterpiece" is compared and connected with as many "less important" works of art as turn out, in the course of investigation, to be comparable and connectable with it, the originality of its invention, the superiority of its composition and technique, and whatever other features make it "great," will automatically become evident—not in spite but because of the fact that the whole group of materials has been subjected to one and the same method of analysis and interpretation.

14. *Il codice atlantico di Leonardo da Vinci nella Biblioteca Ambrosiana di Milano*, ed. G. Piumati (Milan, 1894–1903), fol. 244 v.

15. See M. J. Friedländer, *Der Kenner* (Berlin, 1919), and E. Wind, *Aesthetischer und kunstwissenschaftlicher Gegenstand*, loc. cit. Friedländer justly states that a good art historian is, or at least develops into, *a Kenner wider Willen*. Conversely, a good connoisseur might be called an art historian *malgr'e lui*.

16. See E. Panofsky, "Ueber das Verhältnis der Kunstgeschichte zur Kunsttheorie," *Zeitschrift für Aesthetik und allgemeine Kunstwissenschaft*, 18 (1925), 129ff., and E. Wind, "Zur Systematik der künstlerischen Probleme," ibid., p. 438ff.

17. Cf. H. Sedlmayr, "Zu einer strengen Kunstwissenschaft," *Kunstwissenschaftliche Forschungen*, 1 (1931), 7ff.

18. In a letter to the *New Statesman and Nation*, 13 (1937), June 19, a Mr. Pat Sloan defends the dismissal of professors and teachers in Soviet Russia by stating that "a professor who advocates an antiquated pre-scientific philosophy as against a scientific one may be as powerful a reactionary force as a soldier in an army of intervention." And it turns out that by "advocating" he means also the mere transmission of what he calls "pre-scientific" philosophy, for he continues as follows: "How many minds in Britain today are being kept from ever establishing contact with Marxism by the simple process of loading them to capacity with the works of Plato and other philosophers? These works play not a neutral, but an anti-Marxist role in such circumstances, and Marxists recognize this fact." Needless to say, the works of "Plato and other philosophers" also play an anti-Fascist role "in such circumstances," and Fascists, too, "recognize this fact."

19. For the humanities it is not a romantic ideal but a methodological necessity to "enliven" the past. They can express the fact that the records A, B and C are "connected" with each other only in statements to the effect that the man who produced the record A must have been acquainted with the records B and C, or with records of the type B and C, or with a record X which was in turn the source of B and C, or that he must have been acquainted with B while the maker of B must have been acquainted with C, etc. It is just as inevitable for the humanities to think and to express themselves in terms of "influences," "lines of evolution," etc., as it is for the natural sciences to think and to express themselves in terms of mathematical equations.

20. Marsilio Ficino, Letter to Giacomo Bracciolini (*Marsilii Ficini Opera omnia* [Leyden, 1676], 1, p. 658): "res ipsa [*scil.*, historia] est ad vitam non modo oblectandam, verumtamen moribus instituendam summopere necessaria. Si quidem per se mortalia sunt, immortalitatem ab historia consequuntur, quae absentia, per eam praesentia fiunt, vetera iuvenescunt, iuvenes cito maturitatem senis adaequant. Ac si senex septuaginta annorum ob ipsarum rerum experientiam prudens habetur, quanto prudentior, qui annorum mille, et trium milium implet aetatem! Tot vero annorum milia vixisse quisque videtur quot annorum acta didicit ab historia."

43

Style and Significance in Art History and Art Criticism

JENEFER M. ROBINSON

I. Facts and Values

> Leonardo de Vinci has said: "Two weaknesses
> leaning against one another add up to one
> strength." The halves of an arch cannot even
> stand upright; the whole arch supports a
> weight. Similarly, archaeological research is
> blind and empty without aesthetic re-creation,
> and aesthetic re-creation is irrational and
> often misguided without archaeological
> research. But, "leaning against one another,"
> these two can support the "system that makes
> sense," that is, an historical synopsis.[1]

In this essay I should like to pursue this theme of
Panofsky's: how the art historian and the art critic
whose methods, interests, and aims seem markedly
different nevertheless depend essentially upon each
other in the proper performance of their respective
tasks.

What is the difference between the art historian
and the art critic? Of course one person may per-
form both functions, so our question should perhaps
be rephrased, although it remains at heart the same
question: what is the difference between the func-
tion of the art historian and the function of the art
critic? One neat and—at first glance—plausible
answer to this question is that the art historian is a
purveyor of facts, whereas the art critic deals chiefly
in values. The art historian seeks to know who pro-
duced a particular work, when and where it was
produced, and under what circumstances. The art
critic, on the other hand, attempts to discover such
things as the formal and expressive features of an art
work and whether and in what way it is a successful
or an unsuccessful work. The art historian seems to
be in pursuit of matters of fact: either a certain *Ado-
ration of the Magi* is by Gentile da Fabriano or it
isn't; either it was produced in Florence or it wasn't;
either it was completed in 1423 or it wasn't; either
it was commissioned by the Strozzi family or it
wasn't. And so on. The art critic, on the other hand,
sets out to discover things which do not seem to be
straightforwardly factual. It may be a matter of fact
that Gentile's *Adoration* contains many bright col-
ors but it is not a matter of fact that it is *too* brightly
colored, that it is carefully and fastidiously colored,
or that the color is designed to produce a pleasing,
decorative whole. It may be a matter of fact that
there are many figures represented in the painting,
but it is not a matter of fact that the painting is over-
crowded, that it expresses a sense of bustle or that it
lacks balance and harmony. It may be a matter of
fact (although I am not sure about this) that the
painting represents the Wise Men worshipping the
newly born Christ, but it certainly is not a matter of
fact that the main emphasis of the design is focused
on the Virgin and Child.

The distinction between facts and values is deeply
entrenched in the philosophical tradition. In ethics,
for example, there is said to be a big difference
between the statement of fact that people dislike to

From *The Journal of Aesthetics and Art Criticism*, 40 (1981), pp. 6–14. Reprinted with permission of *The Journal of
Aesthetics and Art Criticism* and the author.

be murdered, and the evaluative statements that murdering people is morally wrong and that we ought not to murder people. Thus while it may be true or false that most people dislike to be murdered, the value judgment that murder is morally wrong is not true or false in the same straightforward way. People disagree about what is or is not morally wrong, yet there is no clearcut way in such cases of deciding who is correct and who is incorrect. One reason for this is that one cannot verify a value judgment in the way that one verifies a statement of fact. If we want to know whether people genuinely dislike to be murdered, we can perform some empirical research in order to find out, but there is no program of empirical research which will tell us whether murder is morally wrong. Nor can we deduce the truth of a value judgment from any set of statements of fact. Thus from the fact that people dislike to be murdered, it does not follow logically that murder is morally wrong.

In philosophical aesthetics we find a similar dichotomy between facts and values. While it is a statement of fact that Gentile's *Adoration* was produced in Florence under commission by the Strozzi, it is not—or not simply—a statement of fact that it is fastidiously colored or overcrowded or expressive of a sense of bustle. All these judgments are aesthetic judgments or interpretative judgments and they are like moral judgments in that it is not always possible to determine whether they are true or false by appeal to any set of facts. The judgment that a picture is overcrowded cannot be verified by counting the number of people represented in it. You and I may agree on the number of people in the picture, yet disagree about whether the picture is overcrowded. And similarly with questions about the formal and expressive qualities of a work and questions about its success or failure as a work. Now it is precisely these questions which typically exercise the art critic: his chief concern is with interpretative and evaluative judgments about an art work.

In his search for historical facts about art works, the art historian relies on various kinds of data, ranging from documents contemporary with the art work to the results of present-day chemical analysis. One of the most important pieces of data which he considers, however, is the style of the work in question. It is largely in virtue of the style of a work that the art historian is able to "place" it in history. Thus in placing the Uffizi *Madonna with Child and St. Anne,* art historians inevitably pay attention to the differences in style within the painting. It is largely on stylistic grounds that parts of the painting are attributed to Masolino and other parts to Masaccio. However, what style a work is in is an interpretative question; it is not a matter of fact which can be determined by solely empirical means.

This is because the style of a work cannot be determined independently of its "meaning" or "significance," and what a work means is, in turn, an irreducibly interpretative question. Thus although it is a fact (I take it) that Masaccio painted the Holy Child in the Uffizi painting, this fact is grounded upon an evaluative judgment. In identifying who painted the Holy Child, a task which is clearly within the art historian's province, the art historian necessarily relies upon information gleaned from the art critic, or from that part of himself which is functioning as the art critic.

But this is not all. In determining what a painting means, the art critic is in turn dependent upon the work of the art historian, since frequently it is impossible to determine what a painting expresses or what it represents unless one knows something about the history of the painting and in particular its place in the history of style (who painted it, where and when). For example, as Ernst Gombrich has pointed out, unless one knows an artist's expressive "vocabulary," which is a function of the historical style in which he paints, one cannot understand the expressive significance of his work. In short, interpretative judgments, which have an irreducibly evaluative component, nevertheless rely upon judgments of historical fact. Thus the art historian in his turn provides information that is essential to the proper functioning of the art critic.

As Panofsky says, "Intuitive aesthetic re-creation and archaeological research are interconnected so as to form . . . an 'organic situation.'"[2] The art historian and the art critic, the two halves of the arch, need and support each other.

II. Style as a Function of Significance

The art historian is in pursuit of matters of fact. One would suppose, therefore, that the data he collects are also matters of fact. Certain of his data are indeed factual: the chemical composition of varnishes and dyes, the pattern of cracks on a treated canvas, the X-rays of sinopia (preliminary drawings underlying a finished canvas). This scientific evidence all helps to provide the correct attribution of the work to a period, a school, or a particular artist. This sort of evidence, however, is not peculiar to historians of art works. If we were trying to date a document which is not a work of art at all but a will, inscribed on parchment, we might use very similar scientific techniques in the attempt to locate its origin in time and place. When dealing with paintings, however, we have other sources of information, derived from looking at the painting *as* a painting, that is, as an art work rather than merely as a historical document. One of the most important of

these sources is the *style* of a painting. It is very often largely by reference to its style that we can tell when, where, and by whom a painting was painted. Indeed, style is sometimes *defined* as being all those characteristics of a work of art qua work of art which serve to identify when, where, and by whom it was produced.[3]

Now the question arises: is it a matter of fact what the stylistic features of a painting are? At first glance it seems as if it is. Surely it is a matter of fact that Holbein is a linear painter and Rembrandt a painterly painter, that Simone Martini's *Annunciation* does not respect the laws of perspective, whereas Leonardo's does. Looking nearer to our own time, it seems to be matter of fact that Mondrian's style is severely geometric whereas Kupka's involves the use of circular shapes, that Nolde's style is characterized by coarse brushwork, and Matisse's by broad, flat areas of unmixed color, and that central to Seurat's style is the use of tiny points of color juxtaposed. In all these cases it seems as if we can verify just by looking whether or not the painter's style is as described. It seems as if when consulting the style of a work in order to determine its history (when, where, and by whom it was composed) what the art historian has to do is to consult a kind of checklist of stylistic features: is the painting in question linear or painterly, is it in perspective, is the brushwork coarse, is it composed of tiny dots of color? Once the presence or absence of the various stylistic features has been determined, the style of the work will be apparent and the historian will have acquired valuable information for identifying the work.

This, however, is a highly unrealistic picture of what actually goes on. This is because in the first place we cannot tell that a painting has a style at all unless we know that it has what I shall call "meaning" or "significance" of an aesthetic sort. Secondly, even if we do know that a painting has a style we still cannot tell which of its elements are important stylistically until we know what the aesthetic significance of the work is. Finally, even if we suppose that some elements in a picture are always stylistically important (such as the absence or presence of perspective in paintings of the western tradition, perhaps), yet we cannot tell what importance they have unless we know how they contribute to the picture's aesthetic significance. What this implies, of course, is that the art historian, who wishes to determine the style of a work, has to rely upon the art critic whose job it is to determine the work's significance.

As I use the phrase, the term "aesthetic significance" encompasses what the work represents (if anything), both literally and metaphorically, what it expresses and what formal features it emphasizes.[4]

For example, Piero della Francesca's *Flagellation* literally *represents* three figures in the foreground and the flagellation of Christ in the background. Its figurative meaning is something of a mystery.

> The likeliest explanation of the three figures—so much more prominent than the actual subject— is that they are witnesses, like the three voices singing the Passion on Good Friday, or the commentators in a Passion Play. . . .[5]

If this is right, then the painting can be said to *express* a sense of man's responsibility and remorse for Christ's suffering. Finally the painting has certain interesting *formal* features such as the symmetrical composition, the careful use of perspective and the "consistent use of frontality."[6] All of these various remarks bear upon the aesthetic significance of the painting. Incidentally, "significance" in my sense subsumes all that Panofsky calls "subject-matter" or "content": what Panofsky calls the pre-iconographic description of a painting tells us what it represents (literally), and iconographical analysis and iconological interpretation tell us respectively what it represents symbolically and what in one sense it expresses.[7]

Why is it that the style of a work depends upon its aesthetic significance? One reason, as I have said, is that we cannot tell whether a painting has a style at all unless we know that it has some aesthetic significance or other.[8] Imagine two painted canvases, perceptually indistinguishable, which consist of a field of red crossed vertically by three thin black or white bands. One of these is a painting by Barnett Newman and has Barnett Newman's style. The other was produced by me and is the unfinished design for my new open-plan living-room, the thin bands marking the positions in the room where I wish to place, respectively, a Japanese screen, a long sofa, and an étagère. Ex hypothesi we cannot tell the two works apart just by looking at them, yet Barnett Newman's painting has Barnett Newman's distinctive style, whereas mine has no style at all. Why is this? The reason is that Newman's work has aesthetic significance whereas mine does not. In Newman's work, the position of the three lines which divide the canvas, the nature of the lines themselves (whether they are straight, as if ruled, or slightly wavy) and the exact hue of the four zones of red created by the three lines all have aesthetic significance and all were created with a specific aesthetic intention. In my work the positioning of the lines has a practical but no aesthetic significance, while the nature of the lines and the exact hue of the background is a purely accidental feature of the design. My work, I suppose, can be looked at *as if* it were a Barnett Newman, but the fact remains that it was not created with any aesthetic intention

and does not have any aesthetic status. It would therefore be absurd to talk of it as a painting with a place in the history of style as the Barnett Newman is.

What this shows is that in order to be in a style at all, a painting must have aesthetic status, that is, significance or meaning of an aesthetic sort. Now suppose that we know that some particular painting does indeed have a style. What I want to demonstrate next is that we cannot tell which elements in that painting are important stylistically until we know what its aesthetic significance is (what it represents, expresses, and so forth). When Edward Lucie-Smith describes the aesthetic significance of Newman's most characteristic works, he explains that Newman

> wanted to articulate the surface of the painting as a 'field', rather than as a composition—an ambition which went considerably beyond Pollock. [His] way of achieving the effect he wanted was to allow the rectangle of the canvas to determine the pictorial structure. The canvas is divided, either horizontally or vertically, by a band, or bands. This line of division is used to activate the field, which is of intense colour, with some small variations of hue from one area to another.[9]

Once we know what Newman is up to, we can begin to pick out those elements in his work which are stylistically important: the positioning of the vertical lines, the way the lines are drawn, the slight variations in hue and so on. The stylistically important elements in a Newman are "visible," as it were, only when we know its aesthetic significance.

But why should this be so? Why can't we simply pick out the stylistic elements in a painting by consulting our checklist of stylistic elements? One reason is that we may simply not notice the stylistic elements unless we know what to look for. Once Lucie-Smith has explained the aesthetic significance of a Barnett Newman, we may now notice the wavy vertical lines and the variations in hue where before we simply did not. Perceptual psychology has taught us that one can "look at" something—one's eyes can be open and directed towards the object—without ever "seeing" it, that is, without seeing its structure, for example, or the relative size of its parts.[10] This regularly occurs when we do not know what the object is, when we do not understand it. Similarly, when we do not understand Newman we do not see his work aright. Not only do we miss the wavy lines, but we also most certainly fail to see more complex stylistic features of his work, such as its stylistic relationship to the work of Jackson Pollock.

A second reason why we cannot pick out the stylistic features of a painting independently of its aesthetic significance is that the very same pictorial feature may be a vital stylistic element in the work of one painter but insignificant stylistically in the work of another. No doubt the painter Ingres drew his exquisite lines and did not use a ruler, but whereas the use of unruled lines is a vital stylistic element in Barnett Newman, it is not one we would mention in connection with Ingres. Why is this? It is because Newman has introduced those unruled lines with a special formal effect in mind, and this formal effect forms a large part of the aesthetic significance of a Newman canvas. Ingres presumably did not ever consider the use of a ruler: no aesthetically significant choice was involved in his use of unruled lines. Similarly, the use of geometrical shapes is a crucial stylistic feature of Mondrian's most characteristic work; it is central to their aesthetic significance. Now, in the work of the modern British painter L. S. Lowry, we also find many geometrical shapes—the outline of buildings drawn in a naive childlike way—but these shapes in themselves have no special aesthetic significance in Lowry's work. A final example. Many artists employ pastel shades from time to time, although we would not necessarily want to say that the use of pastel shades was essential to their style. Yet in the work of Monet pastel shades play a fundamental stylistic role, and this is precisely because Monet uses pastel shades to achieve his most important aesthetic aims: to convey the effects in nature of different kinds of light falling on different kinds of surface. No description of Monet's style could omit a reference to his pastel palette. In short, whether or not some feature in a painting is stylistically important depends upon how it contributes to the painting's aesthetic significance.

This brings me to my final point on this topic. Someone might say that certain features of a painting are *always* stylistically noteworthy, such as the observance or avoidance of the laws of perspective in painting of the western tradition. If this were true, then these features could be put on a checklist, since they are always stylistically important regardless of the aesthetic significance of the work in which they appear. There is indeed a sense in which this is true. Faced with a fifteenth-century Italian painting, we can be pretty sure that its treatment of perspective is one of its stylistically noteworthy features, even if we have very little understanding of its aesthetic significance. However, what we should notice is that we cannot tell *what* stylistic importance the treatment of perspective has unless we do understand the aesthetic significance of the painting. Paolo Uccello, Leonardo, and Raffaelo all made use of perspective but to say that this is a stylistic feature which they have in common is more than a

trifle misleading. What matters to the style of a
painter is not the mere fact that he employs per-
spective but the way in which he uses it and the way
in which it contributes to the aesthetic significance
of his work. In Uccello's *Rout of San Romano* the
use of perspective and foreshortening does not help
to create a sense of spacious distance such as we find
in Leonardo's *Annunciation*. Again, in the Uccello
work, perspective does not play a central role in
determining the composition, which remains essen-
tially decorative, whereas the composition of Raf-
faelo's *School of Athens* depends essentially on
where the figures are located in space which in turn
is determined very precisely, in part by Raffaelo's
use of perspective.

Now we are in a position to see why it is so mis-
leading to suppose that we can characterize a paint-
ing's style by checking off a list of stylistic features,
for style ultimately cannot be defined as a list of pic-
torial elements but rather as a way of doing certain
things, of manipulating pictorial elements. Flat
color planes are not in themselves stylistically sig-
nificant, but the way in which Gauguin or Matisse
uses flat color planes is. Why? Because Matisse and
Gauguin in their different ways use flat color planes
to achieve certain representational, formal, and
expressive goals. Again, vivid colors are not in
themselves a stylistic feature, but the way in which
Van Gogh uses vivid colors for his aesthetic ends is
a stylistic feature of Van Gogh's work, and the com-
pletely different way in which Van Eyck uses vivid
colors for his aesthetic ends is a stylistic feature—
but a very different one—of Van Eyck's work.

To summarize. It is impossible to figure out the
style of a painting unless we know that it has aes-
thetic significance and what that significance is.
Insofar, therefore, as the art historian seeks to know
the style of a work, he relies essentially upon the art
critic whose job it is to analyze its significance.

III. Significance as a Function of Style

If it is true that the art historian depends upon the
services of the art critic, it is equally true that the
art critic cannot act without the help and resources
of the art historian. The two halves of the arch
remain upright only if they give mutual support. I
have tried to show that figuring out the style of a
painting depends upon figuring out its aesthetic sig-
nificance. Now, paradoxically, I shall argue that fig-
uring out its aesthetic significance depends upon
figuring out its style and, in particular, its place in
the history of style. As I use the term, the "aesthetic
significance" of a painting encompasses its represen-
tational content, its expressive and its formal qual-
ities. I now want to demonstrate how figuring out

any one of these three things presupposes knowing
something about the painting's place in the history
of style. It is likely that other kinds of historical
knowledge are necessary too, but I shall not argue
this point here.

To begin with the representational element in
painting. Panofsky has shown that we cannot tell
what the "primary" or literal subject-matter of a
painting is unless we know what style it is in.[11] He
argues that the ability to give a pre-iconographical
description of a painting requires "familiarity with
objects and events" or "practical experience," pre-
sumably of the way things look and behave. This,
however, is not enough to ensure a correct descrip-
tion. Consider, for example, what appears to be a
quite unproblematic painting, Roger van der Wey-
den's *The Vision of the Three Magi*. A correct pre-
iconographical description of the picture would
state that it is a picture of three men contemplating
the apparition of a small child in the sky. But how
is it that we know the picture depicts an apparition?
Panofsky argues that the only good grounds for this
conclusion are that the child "is depicted in space
with no visible means of support": he "hovers in
mid-air." However, as he goes on to point out, there
are many pictures in which objects appear to hang
in mid-air without being apparitions. One such
example is a miniature from around 1000 A.D. in
the *Gospels of Otto III* in the Munich Staatsbi-
bliothek, which depicts in the foreground the res-
urrection of a youth and in the background, with
no visible means of support, the city of Nain where
the resurrection took place. Why is it that we read
The Three Magi as depicting an apparition whereas
the miniature clearly depicts a real city? Panofsky
explains that it is because the early miniature is in
an "unrealistic" pre-Renaissance style whereas Van
der Weyden's work, four centuries later, has highly
"realistic" qualities.

> But that we grasp these qualities in the fraction
> of a second and almost automatically must not
> induce us to believe that we could ever give a cor-
> rect pre-iconographical description of a work of
> art without having divined, as we're, its histor-
> ical "locus." While we believe that we are iden-
> tifying the motifs on the basis of our practical
> experience pure and simple, we really are reading
> "what we see" according to the manner in which
> objects and events are expressed by forms under
> varying historical conditions. In doing this, we
> subject our practical experience to a corrective
> principle which may be called the history of
> style.[12]

In short, before the art critic can determine even
what a painting represents at a literal level, he must
know where the painting occurs in the history of

style: he must be able to "place" it historically before he can adduce its aesthetic significance.

Like Panofsky, Ernst Gombrich recognizes the important role played by the history of style in the interpretation of a work of art. In particular Gombrich argues that we cannot understand the expressive qualities in a painting unless we understand what style it is in. Richard Wollheim has aptly characterized Gombrich's theory of expression in terms of three propositions:

> First of all, the painter's emotion does not naturally or spontaneously overflow into the particular painting or drawing which, as we say, "express" the emotion. On the contrary, we must see the painter as specifically choosing a form or colour which will correspond to or reflect the emotional state that he wishes his work to convey. Secondly, this choice, whether consciously or unconsciously made, always occurs within a set of alternatives that could, to a greater or lesser degree of completeness, be enumerated. These alternatives, which are provided by the style either of the age or of the individual artist, constitute the structure within which alone the conveying of emotion can occur. "No emotion however strong or however complex can be transposed into an unstructured medium." Thirdly, it is only when we are acquainted with these alternatives that we as spectators can understand what emotion the picture is intended to convey. "We cannot judge expression without an awareness of the choice situation."[13]

For our purposes, the essential point that Gombrich makes is that we cannot understand what emotion (or other state of mind) a painting expresses unless we know what style the work is in, either the individual style of the artist involved or the general style of his period or school. Gombrich illustrates the point with reference to Mondrian's *Broadway Boogie-Woogie*, which, given Mondrian's severely geometric style, can correctly be said to express "gay abandon."[14] In the context of a different style, such as Severini's, however, the picture would express much greater severity. In other words, what appears to be "the same painting" has, paradoxically, quite different expressive qualities depending upon the style in which it is painted. Other examples are not hard to find. Thus we might find a Giotto madonna wooden and stiff and expressive of a remote dignity if we did not know where Giotto occurs in the history of style, but once we see him as reacting against the Byzantine style we can also *see* the warmly compassionate realism which characterizes his work.[15]

It seems as if Panofsky and Gombrich between them have shown that understanding the style of an art work is essential to determining at least two aspects of its "meaning," what it represents and what it expresses. What about the formal or compositional features of a painting? At first glance it may seem unlikely that we need to understand a painting's style before we can grasp its form. Surely if a painting can wear anything on its face, so to speak, it is the face itself—the design of its surface? Any pictorial design, however, is necessarily in a style and cannot be picked out independently of the style in which it is couched. If, as Clive Bell suggests, the form of a painting were something which could be detected by the sensitive eye of the critic quite independently of any knowledge he might have of the painting's historical style, then it would be a mystery why a critic could be sensitive to the form of a Poussin while remaining blind to the form of a Matisse.[16] One would think that if he is sensitive to form, he would be sensitive to form wherever it is to be found. In fact, of course, it is not mysterious at all. A person may understand the form of a Poussin because he understands Poussin's style—how he manipulates space, treats the human figure, and so on—while remaining blind to the form of a Matisse because he fails to grasp Matisse's style; perhaps he even tries to look at a Matisse as if it were a Poussin. What this suggests is that even the form or design of a painting cannot be understood unless we know its place in the history of style. The form of a work in the international gothic style will not be appreciated by one who looks at it as if it were by Michelangelo. The form of a Monet is a closed book to one who expects a Claude Lorraine.

IV. The Dilemma Resolved

We are now in a position to see the full scope of the dilemma which I am trying to present here. On the one hand, identifying the stylistic features of a work of art depends upon understanding its aesthetic significance, and on the other hand, understanding the aesthetic significance of a work of art (its subject-matter, its form, its expression) depends upon identifying its style. The art historian requires the art critic. The art critic in turn requires the art historian. But as Leonardo tells us, two weaknesses leaning against one another add up to one strength. The art historian and the art critic lean against each other like the two halves of an arch which together support a weight.

Suppose we are faced with an unfamiliar painting: we do not know what style it is in and we do not understand its aesthetic significance. How do the art historian and the art critic cooperate to figure out such a painting? I should like to outline two possible scenarios. Given the space available, they will both necessarily be somewhat schematic, but I

hope that they will also be in the main correct. If the painting itself is indecipherable, then the art historian needs to seek information about it elsewhere. There are two things that he can do: he can search for clues about its meaning and then attempt to deduce the style of the work, or he can search for clues about its style and from that attempt to deduce its meaning. In both scenarios, however, it is the art historian who takes the first step; the art critic's role comes later.

In the first scenario, the art historian consults outside sources which bear upon the intended meaning of the work: the artist or one of his contemporaries may have left letters, diaries, or other documents setting forth the intended meaning of the work; there may be conventional iconography in the work which can be figured out from contemporary sources; the artist may have had a theory of space or color expounded elsewhere which is exemplified in the work, and so on. Now it is the turn of the art critic. By perusing the work itself he can corroborate or deny that the apparently intended meaning is in fact a possible meaning, that is, that on this reading of it the painting makes sense aesthetically and has some degree of aesthetic value. The art critic in thus "interpreting" the painting also performs another vital task: he figures out what the stylistically important features of the painting must be in order for his reading of it to be correct.

Suppose, for example, that the critic is faced for the first time with an Analytical Cubist work, such as Picasso's *Portrait of Kahnweiler*. From studying external sources the historian has been able to tell him that Picasso intended this to be a portrait of a certain man, intended its composition to be highly structured, and intended that expressively it be "cool" and "classical." Now the critic attempts to figure out what style would make this reading of the picture possible. Clearly the painting is not "classical" in the same way as a Poussin. Here there is very little recession into the picture plane and certainly no sense of vast distances within the picture. On the other hand, the colors are "cool" and the emphasis of the picture seems to be on its structure of lines and planes. As a portrait, it makes sense only if we conceive of it as giving a fragmented, three-dimensional version of Kahnweiler in which he becomes a set of planes rearranged in such a way as to form a highly structured and self-conscious work of art. There is none of the psychological realism we find in Rembrandt or Titian, and none of the flamboyant expressionism we find in Kokoschka.

What the critic has done here is to tease out the artistic attitudes and interests which are exemplified in the painting: Picasso's interest in a shallow space, in a structure of planes rather than colors, in three-dimensional representation, and so on, and

his lack of interest in psychological realism, flamboyant expressionism, and so on. What this amounts to, however, is nothing but a truncated account of Picasso's analytical cubist *style*, how he treats space, line, color, the human figure, etc. The critic has picked out those elements which are stylistically important in the Kahnweiler portrait. Now the art historian can reenter the scene, for once the stylistically important elements in the work have been identified, it can be placed in the history of style. Once the historian has identified the general style of the work (analytical cubism) he can recognize its relationship to Cézanne, to Braque, and to all those who were influenced by the style, and once he has identified the individual style of the work, he can place it correctly in Picasso's individual development.

We have discovered one way in which the art historian and the art critic can cooperate in deciphering a painting. To me, however, there is something a little improbable about this way of proceeding. For surely one can be told that the *Portrait of Kahnweiler* is intended to be a portrait of a man, that it is "cool" and classical and that its composition is highly organized without having the least idea *how* these assertions can be true. Even when the critic has been told what the aesthetic significance of the picture is supposed to be, he may simply remain baffled by the picture. Alternatively, in his bafflement, he might discern two or three equally possible, stylistic explanations of the painting, only one of which (or none) is the correct one. If we try hard enough, we can surely find a set of artistic interests and attitudes which it is plausible to find exemplified in the Picasso portrait (an interest in the decorative, the flat, the geometric) but which in fact are not, or not preeminently.

On the whole, therefore, I think the second scenario occurs more frequently. In this scenario the art historian again begins the process but this time he searches not for the meaning but for clues as to the style of the work. This way of proceeding provides the art critic with a great deal more information than on the first scenario. The meaning of a work of art is unique to that work, whereas its style is not: its general style will be shared by other works of the same period or school and its individual style will be shared by other works by the same painter. A reliable tract which describes the artistic aims of the analytical cubists will at once explain the whole range of analytical cubist work. The subject-matter, form, or expression of a particular painting in that style will not be hard to decipher once we have grasped how the analytical cubists treated space, line, color, figures, and so on, in short, once we know what the stylistically important elements in the painting are.

Frequently, however, external sources provide less direct information about style. Suppose that all the art historian knows about a painting is that it was painted in Siena in around 1300. Even this scant information will give him a good clue as to the place occupied by the painting in the history of style: he knows what went before, what came after and roughly what was going on at that time. If in addition he knows that an early source attributes the work to Duccio, then he has even more precise information about the style, since there is a body of work known to be by Duccio which presumably is in the same individual style. Now the art critic comes to the aid of the art historian. The art critic is familiar with the *meaning* of the work of Duccio and his contemporaries and hence has a grasp of the artistic interests and attitudes exemplified in their works. In other words he can figure out the stylistically important elements in this body of work. Faced with a new work, apparently by Duccio, he can infer that its stylistically important elements will be similar to other paintings by Duccio from the same period.[17] Once he has a grasp of *how* the painting treats space, color, line, and so forth, he can arrive at the meaning of the work: what it represents, expresses, and so forth.

It is true that this process relies upon the fact that the art critic already knows the meaning and the stylistically important elements of works other than the one he is considering. Can we not ask now how he figures out the meaning of these other works? Perhaps, but the process is not normally as limitless as this suggests. Frequently there is historical evidence external to the art works themselves which tells us the artistic interests and attitudes they are designed to embody; subsequent paintings may implicitly contain a "reading" of the style and

intentions of earlier work; and finally it may sometimes happen, contrary to what I have argued in the main body of this paper, that a group of paintings has a style that is exceptionally lucid and accessible. (Perhaps Duccio's is even an example of this.) In this case we can perhaps figure out the artistic interests and attitudes that lie behind a body of work before we perform any detailed critical analysis of the meaning of individual paintings in that style.

At any rate we do know—or think we know—the style and meaning of countless works in the history of art and both critics and historians rely on this knowledge in interpreting newly discovered, unfamiliar works. We can see how much they rely upon it if in conclusion we consider an art historical science fiction case. Suppose that a painting is discovered in a barn in Upper Bavaria. Further suppose that for some reason chemical tests, X-rays, and so on fail to reveal either the time or place of its origin. Finally, suppose that both its style and its meaning are mysterious to us. Perhaps it is a painting dropped by a U.F.O. In these circumstances neither the art critic nor the art historian is in a position to explain the work. There might be a number of alternative hypotheses explaining the style and thus the meaning of the work but we would be quite unable to choose among them. Alternatively, no hypotheses might suggest themselves and the painting would remain silent and uncommunicative. In short, if we cannot link a painting to other paintings in history then neither the art critic nor the art historian can decipher it. If, however, the art historian can give us some indication of its origin, then critic and historian can cooperate in discovering the style and significance of the work. Their tasks are "interconnected," as Panofsky says, "so as to form an organic situation."[18]

Notes

1. Erwin Panofsky, "The History of Art as a Humanistic Discipline," in *Meaning in the Visual Arts* (Garden City, N.Y., 1955), p. 19.

2. Ibid., p. 16.

3. Nelson Goodman, for example, argues that style "consists of those features of the symbolic functioning of a work that are characteristic of author, period, place, or school." See "The Status of Style" in *Ways of Worldmaking* (Indianapolis, 1978).

4. Cf. Goodman's emphasis on what a work represents, exemplifies, and expresses. Nelson Goodman, *Languages of Art,* (Indianapolis, 1968), especially chapts. 1 and 2.

5. Peter and Linda Murray, *The Art of the Renaissance* (London, 1963), p. 129.

6. Ibid., p. 129.

7. See Erwin Panofsky, "Iconography and Iconology: an Introduction to the Study of Renaissance Art" in *Meaning in the Visual Arts,* pp. 40–41.

8. As Richard Wollheim puts it, we are interested only in the paintings of painters. See "Style Now" in *Concerning Contemporary Art,* ed. B. Smith (Oxford, 1975), pp. 135–37.

9. Edward Lucie-Smith, *Late Modern,* 2nd ed. (New York, 1975), p. 103.

10. See Gombrich's comments on schemata, Ernst Gombrich, *Art and Illusion* (London, 1960), p. 64 and elsewhere.

11. Panofsky, "Iconography and Iconology," pp. 33–35.

12. Ibid., pp. 34–35.

13. Richard Wollheim, "On Expression and Expressionism," *Revue Internationale de Philosophie*, 18 (1964), 275. The first passage he quotes is from Ernst Gombrich, *Meditations on a Hobby Horse* (London, 1963), p. 57. The second passage he quotes is from Gombrich, *Art and Illusion*, p. 86.

14. Gombrich, *Art and Illusion*, p. 313.

15. Cf. Gombrich, *Art and Illusion*, p. 54.

16. "To those who have and hold a sense of the significance of form what does it matter whether the forms that move them were created in Paris the day before yesterday or in Babylon fifty centuries ago?" Clive Bell, *Art* (London, 1914). p. 37.

17. Although this inference is legitimate in the case of Duccio and of most other artists, it is not true of artists in whom we find radical shifts in style, such as Picasso.

18. Panofsky, "The History of Art as a Humanistic Discipline," p. 16.

44

Categories of Art

KENDALL L. WALTON

I. Introduction

*False judgments enter art history if we judge
from the impression which pictures of
different epochs, placed side by side, make on
us. . . . They speak a different language.*[1]

Paintings and sculptures are to be looked at; sonatas
and songs are to be heard. What is important about
these works of art, as works of art, is what can be
seen or heard in them.[2] Inspired partly by apparent
commonplaces such as these, many recent aesthetic
theorists have attempted to purge from criticism of
works of art supposedly extraneous excursions into
matters not (or not "directly") available to inspec-
tion of the works, and to focus attention on the
works themselves. Circumstances connected with a
work's origin, in particular, are frequently held to
have no essential bearing on an assessment of its aes-
thetic nature—for example, who created the work,
how, and when; the artist's intentions and expec-
tations concerning it, his philosphical views, psy-
chological state, and love life; the artistic traditions
and intellectual atmosphere of his society. Once
produced (it is argued) the work must stand or fall
on its own; it must be judged for what it is, regard-
less of how it came to be as it is.

Arguments for the irrelevance of such historical
circumstances to aesthetic judgments about works
of art may, but need not, involve the claim that
these circumstances are not of "aesthetic" interest
or importance, though obviously they are often
important in biographical, historical, psychological,
or sociological researches. One might consider an
artist's action in producing a work to be aestheti-
cally interesting, an "aesthetic object" in its own
right, while vehemently maintaining its irrelevance
to an aesthetic investigation of the work. Robert
Rauschenberg once carefully obliterated a drawing
by de Kooning, titled the bare canvas "Erased De
Kooning Drawing", framed it, and exhibited it.[3]
His doing this might be taken as symbolic or expres-
sive (of an attitude toward art, or toward life in gen-
eral, or whatever) in an "aesthetically" significant
manner, perhaps somewhat as an action of a char-
acter in a play might be, and yet thought to have no
bearing whatever on the aesthetic nature of the fin-
ished product. The issue I am here concerned with
is how far critical questions about works of art can
be *separated* from questions about their histories.[4]

One who wants to make this separation quite
sharp may regard the basic facts of art along the fol-
lowing lines. Works of art are simply objects with
various properties, of which we are primarily inter-
ested in perceptual ones—visual properties of paint-
ings, audible properties of music, and so forth.[5] A
work's perceptual properties include "aesthetic" as
well as "non-aesthetic" ones—the sense of mystery
and tension of a painting as well as its dark color-
ing and diagonal composition; the energy, exuber-
ance, and coherence of a sonata, as well as its
meters, rhythms, pitches, timbres, and so forth; the

From *The Philosophical Review*, 79 (1970), p. 334–67. Reprinted with permission of *The Philosophical Review* and the
author.

balance and serenity of a Gothic cathedral as well as its dimensions, lines, and symmetries.[6] Aesthetic properties are features or characteristics of works of art just as much as non-aesthetic ones are.[7] They are *in* the works, to be seen, heard, or otherwise perceived there. Seeing a painting's sense of mystery or hearing a sonata's coherence might require looking or listening longer or harder than does perceiving colors and shapes, rhythms and pitches; it may even require special training or a special kind of sensitivity. But these qualities must be discoverable simply by examining the works themselves if they are discoverable at all. It is never even partly *in virtue of* the circumstances of a work's origin that it has a sense of mystery or is coherent or serene. Such circumstances sometimes provide hints concerning what to look for in a work, what we might reasonably expect to find by examining it. But these hints are always theoretically dispensable; a work's aesthetic properties must "in principle" be ascertainable without their help. Surely (it seems) a Rembrandt portrait does not have (or lack) a sense of mystery in virtue of the fact that Rembrandt intended it to have (or to lack) that quality, any more than a contractor's intention to make a roof leakproof makes it so; nor is the portrait mysterious in virtue of any other facts about what Rembrandt thought or how he went about painting the portrait or what his society happened to be like. Such circumstances are important to the result only in so far as they had an effect on the pattern of paint splotches that became attached to the canvas, and the canvas can be examined without in any way considering how the splotches got there. It would not matter in the least to the aesthetic properties of the portrait if the paint had been applied to the canvas not by Rembrandt at all, but by a chimpanzee or a cyclone in a paint shop.

The view sketched above can easily seem very persuasive. But the tendency of critics to discuss the histories of works of art in the course of justifying aesthetic judgments about them has been remarkably persistent. This is partly because hints derived from facts about a work's history, however dispensable they may be "in principle," are often crucially important in practice. (One might simply not think to listen for a recurring series of intervals in a piece of music, until he learns that the composer meant the work to be structured around it.) No doubt it is partly due also to genuine confusions on the part of critics. But I will argue that (some) facts about the origins of works of art have an *essential* role in criticism, that aesthetic judgments rest on them in an absolutely fundamental way. For this reason, and for another as well, the view that works of art should be judged simply by what can be perceived in them is seriously misleading, though there is

something right in the idea that what matters aesthetically about a painting or a sonata is just how it looks or sounds.

II. Standard, Variable, and Contra-Standard Properties

I will continue to call tension, mystery, energy, coherence, balance, serenity, sentimentality, pallidness, disunity, grotesqueness, and so forth, as well as colors and shapes, pitches and timbres *properties* of works of art, though "property" is to be construed broadly enough not to beg any important questions. I will also, following Sibley, call properties of the former sort "aesthetic" properties, but purely for reasons of convenience I will include in this category "representational" and "resemblance" properties, which Sibley excludes—for example, the property of representing or being a picture of Napoleon, that of depicting an old man (as) stooping over a fire, that of resembling, or merely suggesting, a human face, claws (the petals of Van Gogh's sunflowers), or (in music) footsteps or conversation. It is not essential for my purposes to delimit with any exactness the class of aesthetic properties (if indeed any such delimitation is possible), for I am more interested in discussing particular examples of such properties than in making generalizations about the class as a whole. It will be obvious, however, that what I say about the examples I deal with is also applicable to a great many other properties we would want to call aesthetic.

Sibley points out that a work's aesthetic properties depend on its nonaesthetic properties; the former are "emergent" or *Gestalt* properties based on the latter.[8] I take this to be true of all the examples of aesthetic properties we will be dealing with, including representational and resemblance ones. It is because of the configuration of colors and shapes on a painting, perhaps in particular its dark colors and diagonal composition, that it has a sense of mystery and tension, if it does. The colors and shapes of a portrait are responsible for its resembling an old man and (perhaps with its title) its depicting an old man. The coherence or unity of a piece of music (for example, Beethoven's *Fifth Symphony*) may be largely due to the frequent recurrence of a rhythmic motive, and the regular meter of a song plus the absence of harmonic modulation and of large intervals in the voice part may make it serene or peaceful.

Moreover, a work *seems* or *appears* to us to have certain aesthetic properties because we observe in it, or it appears to us to have, certain nonaesthetic features (though it may not be necessary to notice consciously all the relevant nonaesthetic features). A

painting depicting an old man may not look like an old man to someone who is color-blind, or when it is seen from an extreme angle or in bad lighting conditions so that its colors or shapes are distorted or obscured. Beethoven's *Fifth Symphony* performed in such a sloppy manner that many occurrences of the four-note rhythmic motive do not sound similar may seem incoherent or disunified.

I will argue, however, that a work's aesthetic properties depend not only on its nonaesthetic ones, but also on which of its nonaesthetic properties are "standard," which "variable," and which "contra-standard," in senses to be explained. I will approach this thesis by way of the psychological point that what aesthetic properties a work seems to us to have depends not only on what nonaesthetic features we perceive in it, but also on which of them are standard, which variable, and which contra-standard *for us* (in a sense also to be explained).

It is necessary to introduce first a distinction between standard, variable, and contra-standard properties relative to perceptually distinguishable categories of works of art. Such categories include media, genre, styles, forms, and so forth—for example, the categories of paintings, cubist paintings, Gothic architecture, classical sonatas, paintings in the style of Cézanne, and music in the style of late Beethoven—if they are interpreted in such a way that membership is determined solely by features that can be perceived in a work when it is experienced in the normal manner. Thus whether or not a piece of music was written in the eighteenth century is irrelevant to whether it belongs to the category of classical sonatas (interpreted in this way), and whether a work was produced by Cézanne or Beethoven has nothing essential to do with whether it is in the style of Cézanne or late Beethoven. The category of etchings as normally construed is not perceptually distinguishable in the requisite sense, for to be an etching is, I take it, simply to have been produced in a particular manner. But the category of *apparent* etchings, works which *look* like etchings from the quality of their lines, whether they are etchings or not, is perceptually distinguishable. A category will not count as "perceptually distinguishable" in my sense if in order to determine perceptually whether something belongs to it, it is necessary (in some or all cases) to determine which categories it is correctly perceived in partly or wholly on the basis of nonperceptual considerations. (See Section IV below.) This prevents, for example, the category of serene things from being perceptually distinguishable in this sense.

A feature of a work of art is *standard* with respect to a (perceptually distinguishable) category just in case it is among those in virtue of which works in that category belong to that category—

that is, just in case the lack of that feature would disqualify, or tend to disqualify, a work from that category. A feature is *variable* with respect to a category just in case it has nothing to do with works' belonging to that category; the possession or lack of the feature is irrelevant to whether a work qualifies for the category. Finally, a *contra-standard* feature with respect to a category is the absence of a standard feature with respect to that category—that is, a feature whose presence tends to *disqualify* works as members of the category. Needless to say, it will not be clear in *all* cases whether a feature of a work is standard, variable, or contra-standard relative to a given category, since the criteria for classifying works of art are far from precise. But clear examples are abundant. The flatness of a painting and the motionlessness of its markings are standard, and its particular shapes and colors are variable, relative to the category of painting. A protruding three-dimensional object or an electrically driven twitching of the canvas would be contra-standard relative to this category. The straight lines in stick-figure drawings and squarish shapes in cubist paintings are standard with respect to those categories respectively, though they are variable with respect to the categories of drawing and painting. The exposition–development–recapitulation form of a classical sonata is standard, and its thematic material is variable, relative to the category of sonatas.

In order to explain what I mean by features being standard, variable, or contra-standard *for a person on a particular occasion,* I must introduce the notion of perceiving a work in, or as belonging to, a certain (perceptually distinguishable) category.[9] To perceive a work in a certain category is to perceive the *"Gestalt"* of that category in the work. This needs some explanation. People familiar with Brahmsian music—that is, music in the style of Brahms (notably, works of Johannes Brahms)—or impressionist paintings can frequently recognize members of these categories by recognizing the Brahmsian or impressionist *Gestalt* qualities. Such recognition is dependent on perception of particular features that are standard relative to these categories, but it is not a matter of *inferring* from the presence of such features that a work is Brahmsian or impressionist. One may not notice many of the relevant features, and he may be very vague about which ones are relevant. If I recognize a work as Brahmsian by first noting its lush textures, its basically traditional harmonic and formal structure, its superimposition and alternation of duple and triple meters, and so forth, and recalling that these characteristics are typical of Brahmsian works, I have not recognized it by hearing the Brahmsian *Gestalt*. To do that is simply to recognize it by its Brahmsian *sound,* without necessarily paying attention to the

features ("cues") responsible for it. Similarly, recognizing an impressionist painting by its impressionist *Gestalt,* is recognizing the impressionist *look* about it, which we are familiar with from other impressionist paintings; not applying a rule we have learned for recognizing it from its features.

To *perceive* a *Gestalt* quality in a work—that is, to perceive it in a certain category—is not, or not merely, to *recognize* that *Gestalt* quality. Recognition is a momentary occurrence, whereas perceiving a quality is a continuous state which may last for a short or long time. (For the same reason, seeing the ambiguous duck–rabbit figure as a duck is not, or not merely, recognizing a property of it.) We perceive the Brahmsian or impressionist *Gestalt* in a work when, and as long as, it *sounds (looks)* Brahmsian or impressionst to us. This involves perceiving (not necessarily being aware of) features standard relative to that category. But it is not *just* this, nor this plus the intellectual realization that these features make the work Brahmsian, or impressionist. These features are perceived combined into a single *Gestalt* quality.

We can of course perceive a work in several or many different categories at once. A Brahms sonata might be heard simultaneously as a piece of music, a sonata, a romantic work, and a Brahmsian work. Some pairs of categories, however, seem to be such that one cannot perceive a work as belonging to both at once, much as one cannot see the duck–rabbit both as a duck and as a rabbit simultaneously. One cannot see a photographic image simultaneously as a still photograph and as (part of) a film, nor can one see something both in the category of paintings and at the same time in the category (to be explained shortly) of *guernicas.*

It will be useful to point out some of the *causes* of our perceiving works in certain categories. (*a*) In which categories we perceive a work depends in part, of course, on what other works we are familiar with. The more works of a certain sort we have experienced, the more likely it is that we will perceive a particular work in that category. (*b*) What we have heard critics and others say about works we have experienced, how they have categorized them, and what resemblances they have pointed out to us is also important. If no one has ever explained to me what is distinctive about Schubert's style (as opposed to the styles of, say, Schumann, Mendelssohn, Beethoven, Brahms, Hugo Wolf), or even pointed out that there is such a distinctive style, I may never have learned to hear the Schubertian *Gestalt* quality, even if I have heard many of Schubert's works, and so I may not hear his works as Schubertian. (*c*) How we are introduced to the particular work in question may be involved. If a Cézanne painting is exhibited in a collection of

French Impressionist works, or if before seeing it we are told that it is French Impressionist, we are more likely to see it as French Impressionist than if it is exhibited in a random collection and we are not told anything about it beforehand.

I will say that a feature of a work is standard for a particular person on a particular occasion when, and only when, it is standard relative to some category in which he perceives it, and is not contra-standard relative to any category in which he perceives it. A feature is variable for a person on an occasion just when it is variable relative to *all* of the categories in which he perceives it. And a feature is contra-standard for a person on an occasion just when it is contra-standard relative to *any* of the categories in which he perceives it.[10]

III. A Point About Perception

I turn now to my psychological thesis that what aesthetic properties a work seems to have, what aesthetic effect it has on us, how it strikes us aesthetically often depends (in part) on which of its features are standard, which variable, and which contra-standard for us. I offer a series of examples in support of this thesis.

(*a*) Representational and resemblance properties provide perhaps the most obvious illustration of this thesis. Many works of art look like or resemble other objects—people, buildings, mountains, bowls of fruit, and so forth. Rembrandt's "Titus Reading" looks like a boy, and in particular like Rembrandt's son; Picasso's "Les Demoiselles d'Avignon" looks like five women, four standing and one sitting (though not *especially* like any particular women). A portrait may even be said to be a *perfect* likeness of the sitter, or to capture his image *exactly.*

An important consideration in determining whether a work *depicts* or *represents* a particular object, or an object of a certain sort (for example, Rembrandt's son, or simply *a* boy), in the sense of being a picture, sculpture, or whatever of it[11] is whether the work resembles that object, or objects of that kind. A significant degree of resemblance is, I suggest, a necessary condition in most contexts for such representation or depiction,[12] though the resemblance need not be obvious at first glance. If we are unable to see a similarity between a painting purportedly of a woman and women, I think we would have to suppose either that there is such a similarity which we have not yet discovered (as one might fail to see a face in a maze of lines), or that it simply is not a picture of a woman. Resemblance is of course not a *sufficient* condition for representation, since a portrait (containing only one figure) might resemble both the sitter and his twin brother

equally but is not a portrait of both of them. (The title might determine which of them it depicts.)[13]

It takes only a touch of perversity, however, to find much of our talk about resemblances between works of art and other things preposterous. Paintings and people are *very* different sorts of things. Paintings are pieces of canvas supporting splotches of paint, while people are live, three-dimensional, flesh-and-blood animals. Moreover, except rarely and under special conditions of observation (probably including bad lighting) paintings and people *look* very different. Paintings look like pieces of canvas (or anyway flat surfaces) covered with paint and people look like flesh-and-blood animals. There is practically no danger of confusing them. How, then, can anyone seriously hold that a portrait resembles the sitter to any significant extent, let alone that it is a perfect likeness of him? Yet it remains true that many paintings strike us as resembling people, sometimes very much or even exactly—despite the fact that they look so very different!

To resolve this paradox we must recognize that the resemblances we perceive between, for example, portraits and people, those that are relevant in determining what works of art depict or represent, are resemblances of a somewhat special sort, tied up with the categories in which we perceive such works. The properties of a work which are standard for us are ordinarily irrelevant to what we take it to look like or resemble in the relevant sense, and hence to what we take it to depict or represent. The properties of a portrait which make it *so* different from, so easily distinguishable from, a person—such as its flatness and its *painted* look—are standard for us. Hence these properties just do not count with regard to what (or whom) it looks like. It is only the properties which are variable for us, the colors and shapes on the work's surface, that make it look to us like what it does. And these are the ones which are taken as relevant in determining what (if anything) the work represents.[14]

Other examples will reinforce this point. A marble bust of a Roman emperor seems to us to resemble a man with, say, an aquiline nose, a wrinkled brow, and an expression of grim determination, and we take it to represent a man with, or as having, those characteristics. But why don't we say that it resembles and represents a perpetually motionless man, of uniform (marble) color, who is severed at the chest? It is similar to such a man, it seems, and much more so than to a normally colored, mobile, and whole man. But we are not struck by the former similarity when we see the bust, obvious though it is on reflection. The bust's uniform color, motionlessness, and abrupt ending at the chest are standard properties relative to the category of busts, and since we see it

as a bust they are standard for us. Similarly, black-and-white drawings do not look to us like colorless scenes and we do not take them to depict things as being colorless, nor do we regard stick-figure drawings as resembling and depicting only very thin people. A cubist work might look like a person with a cubical head to someone not familiar with the cubist style. But the standardness of such cubical shapes for people who see it as a cubist work prevents them from making that comparison.

The shapes of a painting or a still photograph of a high jumper in action are motionless, but these pictures do not look to us like a high jumper frozen in midair. Indeed, depending on features of the pictures which are variable for us (for example, the exact positions of the figures, swirling brush strokes in the painting, slight blurrings of the photographic image) the athlete may seem in a frenzy of activity; the pictures may convey a vivid sense of movement. But if static images exactly like those of the two pictures occur in a motion picture, and we see it as a motion picture, they probably would strike us as resembling a static athlete. This is because the immobility of the images is standard relative to the category of still pictures and variable relative to that of motion pictures. (Since we are so familiar with still pictures it might be difficult to see the static images as motion pictures for very long, rather than as [filmed] still pictures. But we could not help seeing them that way if we had no acquaintance at all with the medium of still pictures.) My point here is brought out by the tremendous aesthetic difference we are likely to experience between a film of a dancer moving *very* slowly and a still picture of him, even if "objectively" the two images are very nearly identical. We might well find the former studied, calm, deliberate, laborious, and the latter dynamic, energetic, flowing, or frenzied.

In general, then, what we regard a work as resembling, and as representing, depends on the properties of the work which are variable, and not on those which are standard for us.[15] The latter properties serve to determine what *kind* of a representation the work is, rather than what it represents or resembles. We take them for granted, as it were, in representations of that kind. This principle helps to explain also how clouds can look like elephants, how diatonic orchestral music can suggest a conversation or a person crying or laughing, and how a twelve-year-old boy can look like his middle-aged father.

We can now see how a portrait can be an *exact* likeness of the sitter, despite the huge differences between the two. The differences, in so far as they involve properties standard for us, simply do not count against likeness, and hence not against exact likeness. Similarly, a boy not only can resemble his father but can be his "spitting image," despite the

boy's relative youthfulness. It is clear that the notions of resemblance and exact resemblance that we are concerned with are not even cousins of the notion of perceptual indistinguishability.

(b) The importance of the distinction between standard and variable properties is by no means limited to cases involving representation or resemblance. Imagine a society which does not have an established medium of painting, but does produce a kind of work of art called *guernicas*. *Guernicas* are like versions of Picasso's "Guernica" done in various bas-relief dimensions. All of them are surfaces with the colors and shapes of Picasso's "Guernica," but the surfaces are molded to protrude from the wall like relief maps of different kinds of terrain. Some *guernicas* have rolling surfaces, others are sharp and jagged, still others contain several relatively flat planes at various angles to each other, and so forth. Picasso's "Guernica" would be counted as a *guernica* in this society—a perfectly flat one— rather than as a painting. Its flatness is variable and the figures on its surface are standard relative to the category of *guernicas*. Thus the flatness, which is standard for us, would be variable for members of the other society (if they should come across "Guernica") and the figures on the surface, which are variable for us, would be standard for them. This would make for a profound difference between our aesthetic reaction to "Guernica" and theirs. It seems violent, dynamic, vital, disturbing to us. But I imagine it would strike them as cold, stark, lifeless, or serene and restful, or perhaps bland, dull, boring— but in any case *not* violent, dynamic, and vital. We do not pay attention to or take note of "Guernica"'s flatness; this is a feature we take for granted in paintings, as it were. But for the other society this is "Guernica"'s most striking and noteworthy characteristic—what is *expressive* about it. Conversely, "Guernica"'s color patches, which we find noteworthy and expressive, are insignificant to them.

It is important to notice that this difference in aesthetic response is not due *solely* to the fact that we are much more familiar with flat works of art than they are, and they are more familiar with "Guernica"'s colors and shapes. Someone equally familiar with paintings and *guernicas* might, I think, see Picasso's "Guernica" as a painting on some occasions, and as a *guernica* on others. On the former occasions it will probably look dynamic, violent, and so forth to him, and on the latter cold, serene, bland, or lifeless. Whether he sees the work in a museum of paintings or a museum of *guernicas,* or whether he has been told that it is a painting or a *guernica,* may influence how he sees it. But I think he might be able to shift at will from one way of seeing it to the other, somewhat as one shifts between seeing the duck–rabbit as a duck and seeing it as a rabbit.

This example and the previous ones might give the impression that in general only features of a work that are variable for us are aesthetically important—that these are the expressive, aesthetically active properties, as far as we are concerned, whereas features standard for us are aesthetically inert. But this notion is quite mistaken, as the following examples will demonstrate. Properties standard for us are not aesthetically lifeless, though the life that they have, the aesthetic effect they have on us, is typically very different from what it would be if they were variable for us.

(c) Because of the very fact that features standard for us do not seem striking or noteworthy, that they are somehow expected or taken for granted, they can contribute to a work a sense of order, inevitability, stability, correctness. This is perhaps most notably true of large-scale structural properties in the time arts. The exposition–development–recapitulation form (including the typical key and thematic relationships) of the first movements of classical sonatas, symphonies, and string quartets is standard with respect to the category of works in sonata–allegro form, and standard for listeners, including most of us, who hear them as belonging to that category. So proceeding along the lines of sonata–allegro form seems *right* to us; to our ears that is how sonatas are *supposed* to behave. We feel that we know where we are and where we are going throughout the work—more so, I suggest, than we would if we were not familiar with sonata-allegro form, if following the strictures of that form were variable rather than standard for us.[16] Properties standard for us do not always have this sort of unifying effect, however. The fact that a piano sonata contains only piano sounds, or uses the Western system of harmony throughout, does not make it seem unified to us. The reason, I think, is that these properties are *too* standard for us in a sense that needs explicating (cf. note 10). Nevertheless, sonata form is unifying partly because it is standard rather than variable for us.

(d) That a work (or part of it) has a certain determinate characteristic (for example, of size, speed, length, volume) is often variable relative to a particular category, when it is nevertheless standard for that category that the variable characteristic falls within a certain range. In such cases the aesthetic effect of the determinate variable property may be colored by the standard limits of the range. Hence these limits function as an aesthetic catalyst, even if not as an active ingredient.

Piano music is frequently marked *sostenuto, cantabile, legato,* or *lyrical.* But how can the pianist possibly carry out such instructions? Piano tones

diminish in volume drastically immediately after the key is struck, becoming inaudible relatively promptly, and there is no way the player can prevent this. If a singer or violinist should produce sounds even approaching a piano's in suddenness of demise, they would be nerve-wrackingly sharp and percussive—anything but *cantabile* or lyrical! Yet piano music *can* be *cantabile, legato,* or lyrical nevertheless; sometimes it is extraordinarily so (for example, a good performance of the *Adagio Cantabile* movement of Beethoven's *Pathétique* sonata). What makes this possible is the very fact that the drastic diminution of piano tones cannot be prevented, and hence never is. It is a standard feature for piano music. A pianist can, however, by a variety of devices, control a tone's rate of diminution and length within the limits dictated by the nature of the instrument.[17] Piano tones may thus be *more or less* sustained within these limits, and *how* sustained they are, how quickly or slowly they diminish and how long they last, within the range of possibilities, is variable for piano music. A piano passage that sounds lyrical or *cantabile* to us is one in which the individual tones are *relatively* sustained, given the capabilities of the instrument. Such a passage sounds lyrical only because piano music is limited as it is, and we hear it as piano music; that is, the limitations are standard properties for us. The character of the passage is determined not merely by the "absolute" nature of the sounds, but by that in relation to the standard property of what piano tones can be like.[18]

This principle helps to explain the lack of energy and brilliance that we sometimes find even in very fast passages of electronic music. The energy and brilliance of a fast violin or piano passage derives not merely from the absolute speed of the music (together with accents, rhythmic characteristics, and so forth), but from the fact that it is fast *for that particular medium.* In electronic music different pitches can succeed one another at any frequency up to and including that at which they are no longer separately distinguishable. Because of this it is difficult to make electronic music *sound* fast (energetic, violent). For when we have heard enough electronic music to be aware of the possibilities we do not feel that the speed of a passage approaches a limit, no matter how fast it is.[19]

There are also visual correlates of these musical examples. A small elephant, one which is smaller than most elephants with which we are familiar, might impress us as charming, cute, delicate, or puny. This is not simply because of its (absolute) size, but because it is small *for an elephant.* To people who are familiar not with our elephants but with a race of mini-elephants, the same animal may look massive, strong, dominant, threatening, lumbering, if it is large for a mini-elephant. The size of elephants is variable relative to the class of elephants, but it varies only with a certain (not precisely specifiable) range. It is a standard property of elephants that they do fall within this range. How an elephant's size affects us aesthetically depends, since we see it as an elephant, on whether it falls in the upper, middle, or lower part of the range.

(*e*) Properties standard for a certain category which do not derive from physical limitations of the medium can be regarded as results of more or less conventional "rules" for producing works in the given category (for example, the "rules" of sixteenth-century counterpoint, or those for twelve-tone music). These rules may combine to create a dilemma for the artist which, if he is talented, he may resolve ingeniously and gracefully. The result may be a work with an aesthetic character very different from what it would have had if it had not been for those rules. Suppose that the first movement of a sonata in G major modulates to C-sharp major by the end of the development section. A rule of sonata form decrees that it must return to G for the recapitulation. But the keys of G and C-sharp are as unrelated as any two keys can be; it is difficult to modulate smoothly and quickly from one to the other. Suppose also that while the sonata is in C-sharp there are signs that, given other rules of sonata form, indicate that the recapitulation is imminent (for example, motivic hints of the return, an emotional climax, or a cadenza). Listeners who hear it as a work in sonata form are likely to have a distinct feeling of unease, tension, uncertainty, as the time for the recapitulation approaches. If the composer with a stroke of ingenuity accomplishes the necessary modulation quickly, efficiently, and naturally, this will give them a feeling of relief—one might say of deliverance. The movement to C-sharp (which may have seemed alien and brashly adventurous) will have proven to be quite appropriate, and the entire sequence will in retrospect have a sense of correctness and perfection about it. Our impression of it is likely, I think, to be very much like our impression of a "beautiful" or "elegant" proof in mathematics. (Indeed the composer's task in this example is not unlike that of producing such a proof.)

But suppose that the rule for sonatas were that the recapitulation must be *either* in the original key *or* in the key one half-step below it. Thus in the example above the recapitulation could have been in F-sharp major rather than G major. This possibility removes the sense of tension from the occurrence of C-sharp major in the development section, for a modulation from C-sharp to F-sharp is as easy as any modulation is (since C-sharp is the dominant of F-sharp). Of course, there would also be no special

release of tension when the modulation to G is effected, there being no tension to be released. In fact, that modulation probably would be rather surprising, since the permissible modulation to F-sharp would be much more natural.

Thus the effect that the sonata has on us depends on which of its properties are dictated by "rules," which ones are standard relative to the category of sonatas and hence standard for us.

(*f*) I turn now to features which are contra-standard for us—that is, ones which have a tendency to disqualify a work from a category in which we nevertheless perceive it. We are likely to find such features shocking, or disconcerting, or startling, or upsetting, just because they are contra-standard for us. Their presence may be so obtrusive that they obscure the work's variable properties. Three-dimensional objects protruding from a canvas and movement in a sculpture are contra-standard relative to the categories of painting and (traditional) sculpture respectively. These features are contra-standard for us, and probably shocking, if despite them we perceive the works possessing them in the mentioned categories. The monochromatic paintings of Yves Klein are disturbing to us (at least at first) for this reason: we see them as paintings, though they contain the feature contra-standard for paintings of being one solid color. Notice that we find other similarly monochromatic surfaces—for example, walls of living rooms—not in the least disturbing, and indeed quite unnoteworthy.

If we are exposed frequently to works containing a certain kind of feature which is contra-standard for us, we ordinarily adjust our categories to accommodate it, making it contra-standard for us no longer. The first painting with a three-dimensional object glued to it was no doubt shocking. But now that the technique has become commonplace we are not shocked. This is because we no longer see these works as *paintings,* but rather as members of either (*a*) a new category—*collages*—in which case the offending feature has become standard rather than contra-standard for us, or (*b*) an expanded category which includes paintings both with and without attached objects, in which case that feature is variable for us.

But it is not just the rarity, unusualness, or unexpectedness of a feature that makes it shocking. If a work differs *too* significantly from the norms of a certain category we do not perceive it in that category and hence the difference is not contra-standard for us, even if we have not previously experienced works differing from that category in that way. A sculpture which is constantly and vigorously in motion would be so obviously and radically different from traditional sculptures that we probably would not perceive it as one even if it is the first

moving sculpture we have come across. We would either perceive it as a *kinetic* sculpture, or simply remain confused. In contrast, a sculptured bust which is traditional in every respect except that one ear twitches slightly every thirty seconds would be perceived as an ordinary sculpture. So the twitching ear would be contra-standard for us and would be considerably more unsettling than the much greater movement of the other kinetic sculpture. Similarly, a very small colored area of an otherwise entirely black-and-white drawing would be very disconcerting. But if enough additional color is added to it we will see it as a colored rather than a black-and-white drawing, and the shock will vanish.

This point helps to explain a difference between the harmonic aberrations of Wagner's *Tristan and Isolde* on the one hand and on the other Debussy's *Pelléas et Mélisande* and *Jeux* and Schoenberg's *Pierrot Lunaire* as well as his later twelve-tone works. The latter are not merely *more* aberrant, *less* tonal, than *Tristan.* They differ from traditional tonal music in such respects and to such an extent that they are not heard as tonal at all. *Tristan,* however, retains enough of the apparatus of tonality, despite its deviations, to be heard as a tonal work. For this reason its lesser deviations are often the more shocking.[20] *Tristan* plays on harmonic traditions by selectively following and flaunting them, while *Pierrot Lunaire* and the others simply ignore them.

Shock then arises from features that are not just rare or unique, but ones that are contra-standard relative to categories in which objects possessing them are perceived. But it must be emphasized that to be contra-standard relative to a certain category is not merely to be rare or unique *among things of that category.* The melodic line of Schubert's song, *"Im Walde,"* is probably unique; it probably does not occur in any other songs, or other works of any sort. But it is not contra-standard relative to the category of songs, because it does not tend to disqualify the work from that category. Nor is it contra-standard relative to any other category to which we hear the work as belonging. And clearly we do not find this melodic line at all upsetting. What is important is not the rarity of a feature, but its connection with the classification of the work. Features contra-standard for us are perceived as being misfits in a category which the work strikes us as belonging to, as doing *violence* to such a category, and being rare in a category is not the same thing as being a misfit in it.

It should be clear from the above examples that how a work affects us aesthetically—what aesthetic properties it seems to us to have and what ones we are inclined to attribute to it—depends in a variety of important ways on which of its features are standard, which variable, and which contra-standard

for us. Moreover, this is obviously not an isolated or exceptional phenomenon, but a pervasive characteristic of aesthetic perception. I should emphasize that my purpose has not been to establish general principles about how each of the three sorts of properties affects us. How any particular feature affects us depends also on many variables I have not discussed. The important point is that in many cases whether a feature is standard, variable, or contrastandard for us has a great deal to do with what effect it has on us. We must now begin to assess the theoretical consequences of this.

IV. Truth and Falsity

The fact that what aesthetic properties a thing seems to have may depend on what categories it is perceived in raises a question about how to determine what aesthetic properties it really does have. If "Guernica" appears dynamic when seen as a painting, and not dynamic when seen as a *guernica,* is it dynamic or not? Can one way of seeing it be ruled correct, and the other incorrect? One way of approaching this problem is to deny that the apparently conflicting aesthetic judgments of people who perceive a work in different categories actually do conflict.[21]

Judgments that works of art have certain aesthetic properties, it might be suggested, implicitly involve reference to some particular set of categories. Thus our claim that "Guernica" is dynamic really amounts to the claim that it is (as we might say) dynamic *as a painting,* or for people who see it as a painting. The judgment that it is not dynamic made by people who see it as a *guernica* amounts simply to the judgment that it is not dynamic *as a guernica.* Interpreted in these ways, the two judgments are of course quite compatible. Terms like "large" and "small" provide a convenient model for this interpretation. An elephant might be both small as an elephant and large as a mini-elephant, and hence it might be called truly either "large" or "small," depending on which category is implicitly referred to.

I think that aesthetic judgments are in *some* contexts amenable to such category-relative interpretations, especially aesthetic judgments about natural objects (clouds, mountains, sunsets) rather than works of art. (It will be evident that the alternative account suggested below is not readily applicable to most judgments about natural objects.) But most of our aesthetic judgments can be forced into this mold only at the cost of distorting them beyond recognition.

My main objection is that category-relative inter-pretations do not allow aesthetic judgments to be mistaken often enough. It would certainly be natural to consider a person who calls "Guernica" stark, cold, or dull, because he sees it as a *guernica,* to be *mistaken:* he misunderstands the work because he is looking at it in the wrong way. Similarly, one who asserts that a good performance of the *Adagio Cantabile* of Beethoven's *Pathétique* is percussive, or that a Roman bust looks like a unicolored, immobile man severed at the chest and depicts him as such, is simply wrong, even if his judgment is a result of his perceiving the work in different categories from those in which we perceive it. Moreover, we do not accord a status any more privileged to our own aesthetic judgments. We are likely to regard, for example, cubist paintings, serial music, or Chinese music as formless, incoherent, or disturbing on our first contact with these forms largely because, I suggest, we would not be perceiving the works as cubist paintings, serial music, or Chinese music. But after becoming familiar with these kinds of art we would probably *retract* our previous judgments, admit that they were mistaken. It would be quite inappropriate to protest that what we meant previously was merely that the works were formless or disturbing for the categories in which we then perceived them, while admitting that they are not for the categories of cubist paintings, or serial, or Chinese music. The conflict between apparently incompatible aesthetic judgments made while perceiving a work in different categories does not simply evaporate when the difference of categories is pointed out, as does the conflict between the claims that an animal is large and that it is small, when it is made clear that the person making the first claim regarded it as a mini-elephant and the one making the second regarded it as an elephant. The latter judgments do not (necessarily) reflect a real disagreement about the size of the animal, but the former do reflect a real disagreement about the aesthetic nature of the work.

Thus it seems that, at least in some cases, it is *correct* to perceive a work in certain categories, and *incorrect* to perceive it in certain others; that is, our judgments of it when we perceive it in the former are likely to be true, and those we make when perceiving it in the latter false. This provides us with absolute senses of "standard," "variable," and "contra-standard": features of a work are standard, variable, or contra-standard absolutely just in case they are standard, variable, or contra-standard (respectively) for people who perceive the work correctly. (Thus an absolutely standard feature is standard relative to some category in which the work is correctly perceived and contra-standard relative to none, an absolutely variable feature is variable rel-

ative to all such categories, and an absolutely contra-standard feature is contra-standard relative to at least one such category.)

How is it to be determined in which categories a work is correctly perceived? There is certainly no very precise or well-defined procedure to be followed. Different criteria are emphasized by different people and in different situations. But there are several fairly definite considerations which typically figure in critical discussions and fit our intuitions reasonably well. I suggest that the following circumstances count toward its being correct to perceive a work, W, in a given category, C:

(i) The presence in W of a relatively large number of features standard with respect to C. The correct way of perceiving a work is likely to be that in which it has a minimum of contra-standard features for us. I take the relevance of this consideration to be obvious. It cannot be correct to perceive Rembrandt's "Titus Reading" as a kinetic sculpture, if this is possible, just because that work has too few of the features which make kinetic sculptures kinetic sculptures. But of course this does not get us very far, for "Guernica," for example, qualifies equally well on this count for being perceived as a painting and as a *guernica.*

(ii) The fact, if it is one, that W is better, or more interesting or pleasing aesthetically, or more worth experiencing when perceived in C than it is when perceived in alternative ways. The correct way of perceiving a work is likely to be the way in which it comes off best.

(iii) The fact, if it is one, that the artist who produced W intended or expected it to be perceived in C, or thought of it as a C.

(iv) The fact, if it is one, that C is well established in and recognized by the society in which W was produced. A category is well established in and recognized by a society if the members of the society are familiar with works in that category, consider a work's membership in it a fact worth mentioning, exhibit works of that category together, and so forth—that is, roughly if that category figures importantly in their way of classifying works of art. The categories of impressionist painting and Brahmsian music are well established and recognized in our society; those of *guernicas*, paintings with diagonal composition containing green crosses, and pieces of music containing between four and eight F-sharps and at least seventeen quarter notes every eight bars are not. The categories in which a work is correctly perceived, according to this condition, are generally the ones in which the artist's contemporaries did perceive or would have perceived it.

In certain cases I think the mechanical process by which a work was produced, or (for example, in architecture) the nonperceptible physical characteristics or internal structure of a work, is relevant. A work is probably correctly perceived as an apparent etching[22] rather than, say, an apparent woodcut or line drawing, if it was produced by the etching process. The strength of materials in a building, or the presence of steel girders inside wooded or plaster columns counts toward (not necessarily conclusively) the correctness of perceiving it in the category of buildings with visual characteristics typical of buildings constructed in that manner. Because of their limited applicability I will not discuss these considerations further here.

What can be said in support of the relevance of conditions (ii), (iii), and (iv)? In the examples mentioned above, the categories in which we consider a work correctly perceived seem to meet (to the best of our knowledge) each of these three conditions. I would suppose that "Guernica" is better seen as a painting than it would be seen as a *guernica* (though this would be hard to prove). In any case, Picasso certainly intended it to be seen as a painting rather than a *guernica,* and the category of paintings is, and that of *guernicas* is not, well established in his (that is, our) society. But this of course does not show that (ii), (iii), and (iv) *each* is relevant. It tends to indicate only that one or other of them, or some combination, is relevant. The difficulty of assessing each of the three conditions individually is complicated by the fact that by and large they can be expected to coincide, to yield identical conclusions. Since an artist usually intends his works for his contemporaries he is likely to intend them to be perceived in categories established in and recognized by his society. Moreover, it is reasonable to expect works to come off better when perceived in the intended categories than when perceived in others. An artist tries to produce works which are well worth experiencing when perceived in the intended way and, unless we have reason to think he is totally incompetent, there is some presumption that he succeeded at least to some extent. But it is more or less a matter of chance whether the work comes off well when perceived in some unintended way. The convergence of the three conditions, however, at the same time diminishes the *practical* importance of justifying them individually, since in most cases we can decide how to judge particular works of art without doing so. But the theoretical question remains.

I will begin with (ii). If we are faced with a choice between two ways of perceiving a work, and the work is very much better perceived in one way than it is perceived in the other, I think that, at least in the absence of contrary considerations, we would be

strongly inclined to settle on the former way of perceiving it as the *correct* way. The process of trying to determine what is in a work consists partly in casting around among otherwise plausible ways of perceiving it for one in which the work is good. We feel we are coming to a correct understanding of a work when we begin to like or enjoy it; we are finding what is really there when it seems to be worth experiencing.

But if (*ii*) is relevant, it is quite clearly not the *only* relevant consideration. Take any work of art we can agree is of fourth- or fifth- or tenth-rate quality. It is quite possible that if this work were perceived in some far-fetched set of categories that someone might dream up, it would appear to be first-rate, a masterpiece. Finding such ad hoc categories obviously would require talent and ingenuity on the order of that necessary to produce a masterpiece in the first place. But we can sketch how one might begin searching for them. (*a*) If the mediocre work suffers from some disturbingly prominent feature that distracts from whatever merits the work has, this feature might be toned down by choosing categories with respect to which it is standard, rather than variable or contra-standard. When the work is perceived in the new way the offending feature may be no more distracting than the flatness of a painting is to us. (*b*) If the work suffers from an overabundance of clichés it might be livened up by choosing categories with respect to which the clichés are variable or contra-standard rather than standard. (*c*) If it needs ingenuity we might devise a set of rules in terms of which the work finds itself in a dilemma and then ingeniously escapes from it, and build these rules into a set of categories. Surely, however, if there are categories waiting to be discovered which would transform a mediocre work into a masterpiece, it does not follow that the work really is a hitherto unrecognized masterpiece. The fact that when perceived in such categories it would appear exciting, ingenious, and so forth, rather than grating, cliché-ridden, pedestrian, does not make it so. It *cannot* be correct, I suggest, to perceive a work in categories which are totally foreign to the artist and his society, even if it comes across as a masterpiece in them.[23]

This brings us to the historical conditions (*iii*) and (*iv*). I see no way of avoiding the conclusion that one or the other of them at least is relevant in determining in what categories a work is correctly perceived. I consider both relevant, but will not argue here for the independent relevance of (*iv*). (*iii*) merits special attention in light of the recent prevalence of disputes about the importance of artists' intentions. To test the relevance of (*iii*) we must consider a case in which (*iii*) and (*iv*) diverge. One such instance occurred during the early days of the twelve-tone

movement in music. Schoenberg no doubt intended even his earliest twelve-tone works to be heard as such. But this category was certainly not then well established or recognized in his society: virtually none of his contemporaries (except close associates such as Berg and Webern), even musically sophisticated ones, would have (or could have) heard these works in that category. But it seems to me that even the very first twelve-tone compositions are correctly heard as such, that the judgments one who hears them otherwise would make of them (for example, that they are chaotic, formless) are mistaken. I think this would be so even if Schoenberg had been working entirely alone, if *none* of his contemporaries had any inkling of the twelve-tone system. No doubt the first twelve-tone compositions are much better when heard in the category of twelve-tone works than when they are heard in any other way people might be likely to hear them. But as we have seen this cannot *by itself* account for the correctness of hearing them in the former way. The only other feature of the situation which could be relevant, so far as I can see, is Schoenberg's intention.

The above example is unusual in that Schoenberg was extraordinarily self-conscious about what he was doing, having explicitly formulated rules—that is, specified standard properties—for twelve-tone composition. Artists are of course not often so self-conscious, even when producing revolutionary works of art. Their intentions as to which categories their works are to be perceived in are not nearly as clear as Schoenberg's were, and often they change their minds considerably during the process of creation. In such cases (as well as ones in which the artists' intentions are unknown) the question of what categories a work is correctly perceived in is, I think, left by default to condition (*iv*), together with (*i*) and (*ii*). But it seems to me that in almost all cases at least one of the historial conditions, (*iii*) and (*iv*), is of crucial importance.

My account of the rules governing decisions about what categories works are correctly perceived in leaves a lot undone. There are bound to be a large number of undecidable cases on my criteria. Artists' intentions are frequently unclear, variable, or undiscoverable. Many works belong to categories which are borderline cases of being well established in the artists' societies (perhaps, for example, the categories of rococo music—for instance, C.P.E. Bach—of music in the style of early Mozart, and of very thin metal sculptured figures of the kind that Giacometti made). Many works fall between well-established categories (for example, between impressionist and cubist paintings), possessing *some* of the standard features relative to each, and so neither clearly qualify nor clearly fail to qualify on the basis of condition (*i*) to be perceived in either. There

is, in addition, the question of what relative weights to accord the various conditions when they conflict.

It would be a mistake, however, to try to tighten up much further the rules for deciding how works are correctly perceived. To do so would be simply to legislate gratuitously, since the intuitions and precedents we have to go on are highly variable and often confused. But it is important to notice just where these intuitions and precedents are inconclusive, for doing so will expose the sources of many critical disputes. One such dispute might well arise concerning Giacometti's thin metal sculptures. To a critic who sees them simply as sculptures, or sculptures of people, they look frail, emaciated, wispy, or wiry. But that is not how they would strike a critic who sees them in the category of then metal sculptures of that sort (just as stick figures do not strike us as wispy or emaciated). He would be impressed not by the thinness of the sculptures, but by the expressive nature of the positions of their limbs, and so forth, and so no doubt would attribute very different aesthetic properties to them. Which of the two ways of seeing these works is correct is, I suspect, undecidable. It is not clear whether enough such works have been made and have been regarded sufficiently often as constituting a category for that category to be deemed well established in Giacometti's society. And I doubt whether any of the other conditions settle the issue conclusively. So perhaps the dispute between the two critics is essentially unresolvable. The most that we can do is to point out just what sort of a difference of perception underlies the dispute, and why it is unresolvable.

The occurrence of such impasses is by no means something to be regretted. Works may be fascinating precisely because of shifts between equally permissible ways of perceiving them. And the enormous richness of some works is due in part to the variety of permissible, and worthwhile, ways of perceiving them. But it should be emphasized that even when my criteria do not clearly specify a *single* set of categories in which a work is correctly perceived, there are bound to be possible ways of perceiving it (which we may or may not have thought of) that they definitely rule out.

The question posed at the outset of this section was how to determine what aesthetic properties a work has, given that which ones it seems to have depends on what categories it is perceived in, on which of its properties are standard, which variable, and which contra-standard for us. I have sketched in rough outline rules for deciding in what categories a work is *correctly* perceived (and hence which of its features are absolutely standard, variable, and contra-standard). The aesthetic properties it actually possesses are those that are to be found in it when it is perceived correctly.[24]

V. Conclusion

I return now to the issues raised in Section I. (I will adopt for the remainder of this paper the simplifying assumption that there is only one correct way of perceiving any work. Nothing important depends on this.) If a work's aesthetic properties are those that are to be found in it when it is perceived correctly, and the correct way to perceive it is determined partly by historical facts about the artist's intention and/or his society, no examination of the work itself, however thorough, will by itself reveal those properties.[25] If we are confronted by a work about whose origins we know absolutely nothing (for example, one lifted from the dust at an as yet unexcavated archaeological site on Mars), we would simply not be in a position to judge it aesthetically. We could not possibly tell by staring at it, no matter how intently and intelligently, whether it is coherent, or serene, or dynamic, for by staring we cannot tell whether it is to be seen as a sculpture, a *guernica*, or some other exotic or mundane kind of work of art. (We could attribute aesthetic properties to it in the way we do to natural objects, which of course does not involve consideration of historical facts about artists or their societies. But to do this would not be to treat the object as a *work* of art.)

It should be emphasized that the relevant historical facts are not merely useful aids to aesthetic judgment; they do not simply provide hints concerning what might be found in the work. Rather they help to *determine* what aesthetic properties a work has; they, together with the work's nonaesthetic features, *make* it coherent, serene, or whatever. If the origin of a work which is coherent and serene had been different in crucial respects, the work would not have had these qualities; we would not merely have lacked a means for *discovering* them. And of two works which differ *only* in respect of their origins—that is, which are perceptually indistinguishable—one might be coherent or serene, and the other not. Thus, since artists' intentions are among the relevant historical considerations, the "intentional fallacy" is not a fallacy at all. I have of course made no claims about the relevance of artists' intentions as to the aesthetic properties that their works should have, and these intentions are among those most discussed in writings on aesthetics. I am willing to agree that whether an artist intended his work to be coherent or serene has nothing essential to do with whether it is coherent or serene. But this must not be allowed to seduce us into thinking that *no* intentions are relevant.

Aesthetic properties, then, are not to be found in works themselves in the straightforward way that colors and shapes or pitches and rhythms are. But I

do not mean to deny that we perceive aesthetic properties in works of art. I see the serenity of a painting, and hear the coherence of a sonata, despite the fact that the presence of these qualities in the works depends partly on circumstances of their origin, which I cannot (now) perceive. Jones's marital status is part of what makes him a bachelor, if he is one, and we cannot tell his marital status just by looking at him, though we can thus ascertain his sex. Hence, I suppose, his bachelorhood is not a property we can be said to perceive in him. But the aesthetic properties of a work do not depend on historical facts about it in anything like the way Jones's bachelorhood depends on his marital status. The point is not that the historical facts (or in what categories the work is correctly perceived, or which of its properties are absolutely standard, variable, and contra-standard) function as *grounds* in any ordinary sense for aesthetic judgments. By themselves they do not, in general, count either for or against the presence of any particular aesthetic property. And they are not part of a larger body of information (also including data about the work derived from an examination of it) from which conclusions about the work's aesthetic properties are to be deduced or inferred. We must learn to *perceive* the work in the correct categories, as determined in part by the historical facts, and judge it by what we then perceive in it. The historical facts help to determine whether a painting is, for example, serene *only* (as far as my arguments go) by affecting what way of perceiving the painting must reveal this quality if it is truly attributable to the work.

We must not, however, expect to judge a work simply by setting ourselves to perceive it correctly, once it is determined what the correct way of perceiving it is. For one cannot, in general, perceive a work in a given set of categories simply by setting himself to do it. I could not possibly, merely by an act of will, see "Guernica" as a *guernica* rather than a painting, or hear a succession of street sounds in any arbitrary category one might dream up, even if the category has been explained to me in detail. (Nor can I imagine except in a rather vague way what it would be like, for example, to see "Guernica" as a *guernica*.) One cannot merely decide to respond appropriately to a work—to be shocked or unnerved or surprised by its (absolutely) contra-standard features, to find its standard features familiar or mundane, and to react to its variable features in other ways—once he knows the correct categories. Perceiving a work in a certain category or set of categories is a skill that must be acquired by training, and exposure to a great many other works of the category or categories in question is ordinarily, I believe, an essential part of this training. (But an effort of will may facilitate the training, and

once the skill is acquired one may be able to decide at will whether or not to perceive it in that or those categories.) This has important consequences concerning how best to approach works of art of kinds that are new to us—contemporary works in new idioms, works from foreign cultures, or newly resurrected works from the ancient past. It is no use just immersing ourselves in a particular work, even with the knowledge of what categories it is correctly perceived in, for that alone will not enable us to perceive it in those categories. We must become familiar with a considerable variety of works of similar sorts.

When dealing with works of more familiar kinds it is not generally necessary to undertake deliberately the task of training ourselves to be able to perceive them in the correct categories (expect perhaps when those categories include relatively subtle ones). But this is almost always, I think, only because we have been trained unwittingly. Even the ability to see paintings as paintings had to be acquired, it seems to me, by repeated exposure to a great many paintings. The critic must thus go beyond the work before him in order to judge it aesthetically, not only to discover what the correct categories are, but also to be able to perceive it in them. The latter does not require consideration of historical facts, or consideration of facts at all, but it requires directing one's attention nonetheless to things other than the work in question.

Probably no one would deny that *some* sort of perceptual training is necessary, in many if not all instances, for apprehending a work's serenity or coherence, or other aesthetic properties. And of course it is not only *aesthetic* properties whose apprehension by the senses requires training. But the kind of training required in the aesthetic cases (and perhaps some others as well) has not been properly appreciated. In order to learn how to recognize gulls of various kinds, or the sex of chicks, or a certain person's handwriting, one must usually have gulls of those kinds, or chicks of the two sexes, or examples of that person's handwriting pointed out to him, practice recognizing them himself, and be corrected when he makes mistakes. But the training important for discovering the serenity or coherence of a work of art that I have been discussing is not of this sort (though this sort of training might be important as well). Acquiring the ability to perceive a serene or coherent work in the correct categories is not a matter of having had serene or coherent things pointed out to one, or having practiced recognizing them. What is important is not (or not merely) experience with other serene and coherent things, but experience with other things of the appropriate categories.

Much of the argument in this paper has been

directed against the seemingly common-sense notion that aesthetic judgments about works of art are to be based solely on what can be perceived in them, how they look or sound. That notion is seriously misleading, I claim, on two quite different counts. I do not deny that paintings and sonatas are to be judged solely on what can be seen or heard in them—when they are perceived correctly. But examining a work with the senses can by itself reveal neither how it is correct to perceive it, nor how to perceive it that way.

Notes

1. Heinrich Wölfflin, *Principles of Art History,* 7th ed., trans. M. D. Hottinger (New York, 1929), p. 228.

2. "[W]e should all agree, I think, . . . that any quality that cannot even in principle be heard in it [a musical composition] does not belong to it as music." Monroe Beardsley, *Aesthetics: Problems in the Philosophy of Criticism* (New York, 1958), pp. 31–32.

3. Cf. Calvin Tompkins, *The Bride and the Bachelors* (New York, 1965), pp. 210–11.

4. Monroe Beardsley argues for a relatively strict separation (op. cit., pp. 17–34). Some of the strongest recent attempts to enforce this separation are to be found in discussions of the so-called "intentional fallacy," beginning with William Wimsatt and Beardsley, "The Intentional Fallacy," *Sewanee Review,* 54 (1946), which has been widely cited and reprinted. Despite the name of the "fallacy" these discussions are not limited to consideration of the relevance of artists' *intentions.*

5. The aesthetic properties of works of literature are not happily called "perceptual." For reasons connected with this it is sometimes awkward to treat literature together with the visual arts and music. (The notion of perceiving a work in a category, to be introduced shortly, is not straightforwardly applicable to literary works.) Hence in this paper I will concentrate on visual and musical works, though I believe that the central points I make concerning them hold, with suitable modifications, for novels, plays, and poems as well.

6. Frank Sibley distinguishes between "aesthetic" and "nonaesthetic" terms and concepts in "Aesthetic Concepts," *Philosophical Review,* 68 (1959).

7. Cf. Paul Ziff, "Art and the 'Object of Art,'" in Ziff, *Philosophic Turnings* (Ithaca, N.Y., 1966), pp. 12–16 (originally published in *Mind,* N. S. 60 [1951]).

8. "Aesthetic and Nonaesthetic," *Philosophical Review,* 72 (1965).

9. This is a very difficult notion to make precise, and I do not claim to have succeeded entirely. But the following comments seem to me to go in the right direction, and, together with the examples in the next section, they should clarify it sufficiently for my present purposes.

10. In order to avoid excessive complexity and length, I am ignoring some considerations that might be important at a later stage of investigation. In particular, I think it would be important at some point to distinguish between different *degrees* or *levels* of standardness, variableness, and contra-standardness for a person; to speak, e.g., of features being *more* or *less* standard for him. At least two distinct sorts of grounds for such differences of degree should be recognized. (*a*) Distinctions between perceiving a work in a certain category to a greater and lesser extent should be allowed for, with corresponding differences of degree in the standardness for the perceiver of properties relative to that category. (*b*) A feature which is standard relative to more, and/or more specific, categories in which a person perceives the work should thereby count as more standard for him. Thus, if we see something as a painting and also as a French Impressionist painting, features standard relative to both categories are more standard for us than features standard relative only to the latter.

11. This excludes, e.g., the sense of "represent" in which a picture might represent justice or courage, and probably other senses as well.

12. This does not hold for the special case of photography. A photograph is a photograph of a woman no matter what it looks like, I take it, if a woman was in front of the lens when it was produced.

13. Nelson Goodman denies that resemblance is necessary for representation—and obviously not merely because of isolated or marginal examples of non-resembling representations (p. 5). I cannot treat his arguments here, but rather than reject *en masse* the common-sense beliefs that pictures do resemble significantly what they depict and that they depict what they do partly because of such resemblances, if Goodman advocates rejecting them, I prefer to recognize a sense of "resemblance" in which these beliefs are true. My disagreement with him is perhaps less sharp than it appears since, as

will be evident, I am quite willing to grant that the relevant resemblances are "conventional." Cf. Goodman, *Languages of Art* (Indianapolis, 1968), p. 39, n. 31.

14. The connection between features variable for us and what the work looks like is by no means a straightforward or simple one, however. It may involve "rules" which are more or less "conventional" (e.g., the "laws" of perspective). Cf. E. H. Gombrich, *Art and Illusion* (New York, 1960) and Nelson Goodman, op cit.

15. There is at least one group of exceptions to this. Obviously features of a work which are standard for us because they are standard relative to some *representational* category which we see it in— e.g., the category of nudes, still lifes, or landscapes—do help determine what the work looks like to us and what we take it to depict.

16. The presence of clichés in a work sometimes allows it to contain drastically disorderly elements without becoming chaotic or incoherent. Cf. Anton Ehrenzweig, *The Hidden Order of Art* (London, 1967), pp. 114-16.

17. The timing of the release of the key affects the tone's length. Use of the sustaining pedal can lessen slightly a tone's diminuendo by reinforcing its overtones with sympathetic vibrations from other strings. The rate of diminuendo is affected somewhat more drastically by the force with which the key is struck. The more forcefully it is struck the greater is the tone's relative diminuendo. (Obviously the rate of diminuendo cannot be controlled in this way independently of the tone's initial volume.) The successive tones of a melody can be made to overlap so that each tone's sharp attack is partially obscured by the lingering end of the preceding tone. A melodic tone may also be reinforced after it begins by sympathetic vibrations from harmonically related accompanying figures, contributed by the composer.

18. "[T]he musical media we know thus far derive their whole character and their usefulness as musical media precisely from their limitations." Roger Sessions, "Problems and Issues Facing the Composer Today," in Paul Henry Lang, *Problems of Modern Music* (New York, 1960), p. 31.

19. One way to make electronic music sound fast would be to make it sound like some traditional instrument, thereby trading on the limitations of that instrument.

20. Cf. William W. Austin, *Music in the 20th Century* (New York, 1966), pp. 205-06; and Eric Salzman, *Twentieth-Century Music: An Introduction* (Englewood Cliffs, N.J., 1967), pp. 5, 8, 19.

21. I am ruling out the view that the notions of truth and falsity are not applicable to aesthetic judgments, on the ground that it would force us to reject so much of our normal discourse and common-sense intuitions about art that theoretical aesthetics, conceived as attempting to understand the institution of art, would hardly have left a recognizable subject matter to investigate. (Cf. the quotation from Wölfflin, above.)

22. Cf. p. 339.

23. To say that it is incorrect (in my sense) to perceive a work in certain categories is not necessarily to claim that one *ought not* to perceive it that way. I heartily recommend perceiving mediocre works in categories that make perceiving them worthwhile whenever possible. The point is that one is not likely to *judge* the work correctly when he perceives it incorrectly.

24. This is a considerable oversimplification. If there are two equally correct ways of perceiving a work, and it appears to have a certain aesthetic property perceived in one but not the other of them, does it actually possess this property or not? There is no easy general answer. Probably in some such cases the question is undecidable. But I think we would sometimes be willing to say that a work is, e.g., touching or serene if it seems so when perceived in one correct way (or, more hesitantly, that there is "something very touching, or serene, about it"), while allowing that it does not seem so when perceived in another way which we do not want to rule incorrect. In some cases works have aesthetic properties (e.g., intriguing, subtle, alive, interesting, deep) which are not apparent on perceiving it in any single acceptable way, but which depend on the multiplicity of acceptable ways of perceiving it and relations between them. None of these complications relieves the critic of the responsibility for determining in what way or ways it is correct to perceive a work.

25. But this, plus a general knowledge of what sorts of works were produced when and by whom, might.

45

Art and Authenticity

NELSON GOODMAN

*. . . the most tantalizing question of all: If a fake is so
expert that even after the most thorough and
trustworthy examination its authenticity is still open
to doubt, is it or is it not as satisfactory a work of art as
if it were unequivocally genuine?*

Aline B. Saarinen, *New York Times Book Review*

1. The Perfect Fake

Forgeries of works of art present a nasty practical
problem to the collector, the curator, and the art
historian, who must often expend taxing amounts
of time and energy in determining whether or not
particular objects are genuine. But the theoretical
problem raised is even more acute. The hardheaded
question why there is any aesthetic difference
between a deceptive forgery and an original work
challenges a basic premiss on which the very func-
tions of collector, museum, and art historian
depend. A philosopher of art caught without an
answer to this question is at least as badly off as a
curator of paintings caught taking a Van Meegeren
for a Vermeer.

The question is most strikingly illustrated by the
case of a given work and a forgery or copy or repro-
duction of it. Suppose we have before us, on the left,
Rembrandt's original painting *Lucretia* and, on the
right, a superlative imitation of it. We know from
a fully documented history that the painting on the
left is the original; and we know from X-ray pho-
tographs and microscopic examination and chemi-
cal analysis that the painting on the right is a recent
fake. Although there are many differences between
the two—e.g., in authorship, age, physical and
chemical characteristics, and market value—we
cannot see any difference between them; and if they
are moved while we sleep, we cannot then tell
which is which by merely looking at them. Now we

are pressed with the question whether there can be
any aesthetic difference between the two pictures;
and the questioner's tone often intimates that the
answer is plainly *no*, that the only differences here
are aesthetically irrelevant.

We must begin by inquiring whether the distinc-
tion between what can and what cannot be seen in
the pictures by 'merely looking them' is entirely
clear. We are looking at the pictures, but presum-
ably not 'merely looking' at them, when we exam-
ine them under a microscope or fluoroscope. Does
merely looking, then, mean looking without the use
of any instrument? This seems a little unfair to the
man who needs glasses to tell a painting from a hip-
popotamus. But if glasses are permitted at all, how
strong may they be, and can we consistently
exclude the magnifying glass and the microscope?
Again, if incandescent light is permitted, can violet-
ray light be ruled out? And even with incandescent
light, must it be of medium intensity and from a
normal angle, or is a strong raking light permitted?
All these cases might be covered by saying that
'merely looking' is looking at the pictures without
any use of instruments other than those customarily
used in looking at things in general. This will cause
trouble when we turn, say, to certain miniature illu-
minations or Assyrian cylinder seals that we can
hardly distinguish from the crudest copies without
using a strong glass. Furthermore, even in our case
of the two pictures, subtle differences of drawing or
painting discoverable only with a magnifying glass

From Nelson Goodman, *Languages of Art*, 2nd edition. Indianapolis: Hackett Publishing Company, 1976, pp. 99–123.
Reprinted with permission of Hackett Publishing Company.

may still, quite obviously, be aesthetic differences between the pictures. If a powerful microscope is used instead, this is no longer the case; but just how much magnification is permitted? To specify what is meant by merely looking at the pictures is thus far from easy; but for the sake of argument,[1] let us suppose that all these difficulties have been resolved and the notion of 'merely looking' made clear enough.

Then we must ask who is assumed to be doing the looking. Our questioner does not, I take it, mean to suggest that there is no aesthetic difference between two pictures if at least one person, say a cross-eyed wrestler, can see no difference. The more pertinent question is whether there can be any aesthetic difference if nobody, not even the most skilled expert, can ever tell the pictures apart by merely looking at them. *But notice now that no one can ever ascertain by merely looking at the pictures that no one ever has been or will be able to tell them apart by merely looking at them.* In other words, the question in its present form concedes that no one can ascertain by merely looking at the pictures that there is no aesthetic difference between them. This seems repugnant to our questioner's whole motivation. For if merely looking can never establish that two pictures are aesthetically the same, something that is beyond the reach of any given looking is admitted as constituting an aesthetic difference. And in that case, the reason for not admitting documents and the results of scientific tests becomes very obscure.

The real issue may be more accurately formulated as the question whether there is any aesthetic difference between the two pictures *for me* (or for *x*) if I (or *x*) cannot tell them apart by merely looking at them. But this is not quite right either. For I can never ascertain merely by looking at the pictures that even I shall never be able to see any difference between them. And to concede that something beyond any given looking at the pictures by me may constitute an aesthetic difference between them *for me* is, again, quite at odds with the tacit conviction or suspicion that activates the questioner.

Thus the critical question amounts finally to this: is there any aesthetic difference between the two pictures for *x* at *t*, where *t* is a suitable period of time, if *x* cannot tell them apart by merely looking at them at *t*? Or in other words, can anything that *x* does not discern by merely looking at the pictures at *t* constitute an aesthetic difference between them for *x* at *t*?

2. The Answer

In setting out to answer this question, we must bear clearly in mind that what one can distinguish at any given moment by merely looking depends not only upon native visual acuity but upon practice and training.[2] Americans look pretty much alike to a Chinese who has never looked at many of them. Twins may be indistinguishable to all but their closest relatives and acquaintances. Moreover, only through looking at them when someone has named them for us can we learn to tell Joe from Jim upon merely looking at them. Looking at people or things attentively, with the knowledge of certain presently invisible respects in which they differ, increases our ability to discriminate between them—and between other things or other people— upon merely looking at them. Thus pictures that look just alike to the newsboy come to look quite unlike to him by the time he has become a museum director.

Although I see no difference now between the two pictures in question, I may learn to see a difference between them. I cannot determine now by merely looking at them, or in any other way, that I *shall* be able to learn. But the information that they are very different, that the one is the original and the other the forgery, argues against any inference to the conclusion that I *shall not* be able to learn. And the fact that I may later be able to make a perceptual distinction between the pictures that I cannot make now constitutes an aesthetic difference between them that is important to me now.

Furthermore, to look at the pictures now with the knowledge that the left one is the original and the other the forgery may help develop the ability to tell which is which later by merely looking at them. Thus, with information not derived from the present or any past looking at the pictures, the present looking may have a quite different bearing upon future lookings from what it would otherwise have. The way the pictures in fact differ constitutes an aesthetic difference between them for me now because my knowledge of the way they differ bears upon the role of the present looking in training my perceptions to discriminate between these pictures, and between others.

But that is not all. My knowledge of the difference between the two pictures, just because it affects the relationship of the present to future lookings, informs the very character of my present looking. This knowledge instructs me to look at the two pictures differently now, even if what I see is the same. Beyond testifying that I may learn to see a difference, it also indicates to some extent the kind of scrutiny to be applied now, the comparisons and contrasts to be made in imagination, and the relevant associations to be brought to bear. It thereby guides the selection, from my past experience, of items and aspects for use in my present looking. Thus not only later but right now, the unperceived difference between the two pictures is a consideration pertinent to my visual experience with them.

In short, although I cannot tell the pictures apart

merely by looking at them now, the fact that the left-hand one is the original and the right-hand one a forgery constitutes an aesthetic difference between them for me now because knowledge of this fact (1) stands as evidence that there may be a difference between them that I can learn to perceive, (2) assigns the present looking a role as training toward such a perceptual discrimination, and (3) makes consequent demands that modify and differentiate my present experience in looking at the two pictures.[3]

Nothing depends here upon my ever actually perceiving or being able to perceive a difference between the two pictures. What informs the nature and use of my present visual experience is not the fact or the assurance that such a perceptual discrimination is within my reach, but evidence that it may be; and such evidence is provided by the known factual differences between the pictures. Thus the pictures differ aesthetically for me now even if no one will ever be able to tell them apart merely by looking at them.

But suppose it could be *proved* that no one ever will be able to see any difference? This is about as reasonable as asking whether, if it can be proved that the market value and yield of a given U.S. bond and one of a certain nearly bankrupt company will always be the same, there is any financial difference between the two bonds. For what sort of proof could be given? One might suppose that if nobody— not even the most skilled expert—has ever been able to see any difference between the pictures, then the conclusion that I shall never be able to is quite safe; but, as in the case of the Van Meegeren forgeries[4] (of which, more later), distinctions not visible to the expert up to a given time may later become manifest even to the observant layman. Or one might think of some delicate scanning device that compares the color of two pictures at every point and registers the slightest discrepancy. What, though, is meant here by "at every point"? At no mathematical point, of course, is there any color at all; and even some physical particles are too small to have color. The scanning device must thus cover at each instant a region big enough to have color but at least as small as any perceptible region. Just how to manage this is puzzling since "perceptible" in the present context means "discernible by merely looking", and thus the line between perceptible and nonperceptible regions seems to depend on the arbitrary line between a magnifying glass and a microscope. If some such line is drawn, we can never be sure that the delicacy of our instruments is superior to the maximal attainable acuity of unaided perception. Indeed, some experimental psychologists are inclined to conclude that every measurable difference in light can sometimes be detected by the naked eye.[5] And there is a further difficulty. Our

scanning device will examine color—that is, reflected light. Since reflected light depends partly upon incident light, illumination of every quality, of every intensity, and from every direction must be tried. And for each case, especially since the paintings do not have a plane surface, a complete scanning must be made from every angle. But of course we cannot cover every variation, or even determine a single absolute correspondence, in even one respect. Thus the search for a proof that I shall never be able to see any difference between the two pictures is futile for more than technological reasons.

Yet suppose we are nevertheless pressed with the question whether, if proof *were* given, there would then be any aesthetic difference for me between the pictures. And suppose we answer this farfetched question in the negative. This will still give our questioner no comfort. For the net result would be that if no difference between the pictures can in fact be perceived, then the existence of an aesthetic difference between them will rest entirely upon what is or is not proved by means other than merely looking at them. This hardly supports the contention that there can be no aesthetic difference without a perceptual difference.

Returning from the realm of the ultra-hypothetical, we may be faced with the protest that the vast aesthetic difference thought to obtain between the Rembrandt and the forgery cannot be accounted for in terms of the search for, or even the discovery of, perceptual differences so slight that they can be made out, if at all, only after much experience and long practice. This objection can be dismissed at once; for minute perceptual differences can bear enormous weight. The clues that tell me whether I have caught the eye of someone across the room are almost indiscernible. The actual differences in sound that distinguish a fine from a mediocre performance can be picked out only by the well-trained ear. Extremely subtle changes can alter the whole design, feeling, or expression of a painting. Indeed, the slightest perceptual differences sometimes matter the most aesthetically; gross physical damage to a fresco may be less consequential than slight but smug retouching.

All I have attempted to show, of course, is that the two pictures can differ aesthetically, not that the original is better than the forgery. In our example, the original probably is much the better picture, since Rembrandt paintings are in general much better than copies by unknown painters. But a copy of a Lastman by Rembrandt may well be better than the original. We are not called upon here to make such particular comparative judgments or to formulate canons of aesthetic evaluation. We have fully met the demands of our problem by showing that the fact that we cannot tell our two pictures apart merely by looking at them does not imply that

they are aesthetically the same—and thus does not force us to conclude that the forgery is as good as the original.

The example we have been using throughout illustrates a special case of a more general question concerning the aesthetic significance of authenticity. Quite aside from the occurrence of forged duplication, does it matter whether an original work is the product of one or another artist or school or period? Suppose that I can easily tell two pictures apart but cannot tell who painted either except by using some device like X-ray photography. Does the fact that the picture is or is not by Rembrandt make any aesthetic difference? What is involved here is the discrimination not of one picture from another but of the class of Rembrandt paintings from the class of other paintings. My chance of learning to make this discrimination correctly—of discovering projectible characteristics that differentiate Rembrandts in general from non-Rembrandts—depends heavily upon the set of examples available as a basis. Thus the fact that the given picture belongs to the one class or the other is important for me to know in learning how to tell Rembrandt paintings from others. In other words, my present (or future) inability to determine the authorship of the given picture without use of scientific apparatus does not imply that the authorship makes no aesthetic difference to me; for knowledge of the authorship, no matter how obtained, can contribute materially toward developing my ability to determine without such apparatus whether or not any picture, including this one on another occasion, is by Rembrandt.

Incidentally, one rather striking puzzle is readily solved in these terms. When Van Meegeren sold his pictures as Vermeers, he deceived most of the best-qualified experts; and only by his confession was the fraud revealed.[6] Nowadays even the fairly knowing layman is astonished that any competent judge could have taken a Van Meegeren for a Vermeer, so obvious are the differences. What has happened? The general level of aesthetic sensibility has hardly risen so fast that the layman of today sees more acutely than the expert of twenty years ago. Rather, the better information now at hand makes the discrimination easier. Presented with a single unfamiliar picture at a time, the expert had to decide whether it was enough like known Vermeers to be by the same artist. And every time a Van Meegeren was added to the corpus of pictures accepted as Vermeers, the criteria for acceptance were modified thereby; and the mistaking of further Van Meegerens for Vermeers became inevitable. Now, however, not only have the Van Meegerens been subtracted from the precedent-class for Vermeer, but also a precedent-class for Van Meegeren has been established. With these two precedent-classes

before us, the characteristic differences become so conspicuous that telling other Van Meegerens from Vermeers offers little difficulty. Yesterday's expert might well have avoided his errors if he had had a few known Van Meegerens handy for comparison. And today's layman who so cleverly spots a Van Meegeren may well be caught taking some quite inferior school-piece for a Vermeer.

In answering the questions raised above, I have not attempted the formidable task of defining "aesthetic" in general, but have simply argued that since the exercise, training, and development of our powers of discriminating among works of art are plainly aesthetic activities, the aesthetic properties of a picture include not only those found by looking at it but also those that determine how it is to be looked at. This rather obvious fact would hardly have needed underlining but for the prevalence of the time-honored Tingle-Immersion theory,[7] which tells us that the proper behavior on encountering a work of art is to strip ourselves of all the vestments of knowledge and experience (since they might blunt the immediacy of our enjoyment), then submerge ourselves completely and gauge the aesthetic potency of the work by the intensity and duration of the resulting tingle. The theory is absurd on the face of it and useless for dealing with any of the important problems of aesthetics; but it has become part of the fabric of our common nonsense.

3. The Unfakable

A second problem concerning authenticity is raised by the rather curious fact that in music, unlike painting, there is no such thing as a forgery of a known work. There are, indeed, compositions falsely purporting to be by Haydn as there are paintings falsely purporting to be by Rembrandt; but of the *London Symphony,* unlike the *Lucretia,* there can be no forgeries. Haydn's manuscript is no more genuine an instance of the score than is a printed copy off the press this morning, and last night's performance no less genuine than the premiere. Copies of the score may vary in accuracy, but all accurate copies, even if forgeries of Haydn's manuscript, are equally genuine instances of the score. Performances may vary in correctness and quality and even in 'authenticity' of a more esoteric kind; but all correct performances are equally genuine instances of the work.[8] In contrast, even the most exact copies of the Rembrandt painting are simply imitations or forgeries, not new instances, of the work. Why this difference between the two arts?

Let us speak of a work of art as *autographic* if and only if the distinction between original and forgery of it is significant; or better, if and only if even the

most exact duplication of it does not thereby count as genuine.[9] If a work of art is autographic, we may also call that art autographic. Thus painting is autographic, music nonautographic, or *allographic*. These terms are introduced purely for convenience; nothing is implied concerning the relative individuality of expression demanded by or attainable in these arts. Now the problem before us is to account for the fact that some arts but not others are autographic.

One notable difference between painting and music is that the composer's work is done when he has written the score, even though the performances are the end-products, while the painter has to finish the picture. No matter how many studies or revisions are made in either case, painting is in this sense a one-stage and music a two-stage art. Is an art autographic, then, if and only if it is one-stage? Counterexamples come readily in mind. In the first place, literature is not autographic though it is one-stage. There is no such thing as a forgery of Gray's *Elegy*. Any accurate copy of the text of a poem or novel is as much the original work as any other. Yet what the writer produces is ultimate; the text is not merely a means to oral readings as a score is a means to performances in music. An unrecited poem is not so forlorn as an unsung song; and most literary works are never read aloud at all. We might try to make literature into a two-stage art by considering the silent readings to be the end-products, or the instances of a work; but then the lookings at a picture and the listenings to a performance would qualify equally as end-products or instances, so that painting as well as literature would be two-stage and music three-stage. In the second place, printmaking is two-stage and yet autographic. The etcher, for example, makes a plate from which impressions are then taken on paper. These prints are the end-products; and although they may differ appreciably from one another, all are instances of the original work. But even the most exact copy produced otherwise than by printing from the plate counts not as an original but as an imitation or forgery.

So far, our results are negative: not all one-stage arts are autographic and not all autographic arts are one-stage. Furthermore, the example of printmaking refutes the unwary assumption that in every autographic art a particular work exists only as a unique object. The line between an autographic and an allographic art does not coincide with that between a singular and a multiple art. About the only positive conclusion we can draw here is that the autographic arts are those that are singular in the earliest stage; etching is singular in its first stage—the plate is unique—and painting in its only stage. But this hardly helps; for the problem of explaining why some arts are singular is much like the problem of explaining why they are autographic.

4. The Reason

Why, then, can I no more make a forgery of Haydn's symphony or of Gray's poem than I can make an original of Rembrandt's painting or of his etching *Tobit Blind*? Let us suppose that there are various handwritten copies and many editions of a given literary work. Differences between them in style and size of script or type, in color of ink, in kind of paper, in number and layout of pages, in condition, etc., do not matter. All that matters is what may be called *sameness of spelling*: exact correspondence as sequences of letters, spaces, and punctuation marks. Any sequence—even a forgery of the author's manuscript or of a given edition—that so corresponds to a correct copy is itself correct, and nothing is more the original work than is such a correct copy. And since whatever is not an original of the work must fail to meet such an explicit standard of correctness, there can be no deceptive imitation, no forgery, of that work. To verify the spelling or to spell correctly is all that is required to identify an instance of the work or to produce a new instance. In effect, the fact that a literary work is in a definite notation, consisting of certain signs or characters that are to be combined by concatenation, provides the means for distinguishing the properties constitutive of the work from all contingent properties—that is, for fixing the required features and the limits of permissible variation in each. Merely by determining that the copy before us is spelled correctly we can determine that it meets all requirements for the work in question. In painting, on the contrary, with no such alphabet of characters, none of the pictorial properties—none of the properties the picture has as such—is distinguished as constitutive; no such feature can be dismissed as contingent, and no deviation as insignificant. The only way of ascertaining that the *Lucretia* before us is genuine is thus to establish the historical fact that it is the actual object made by Rembrandt. Accordingly, physical identification of the product of the artist's hand, and consequently the conception of forgery of a particular work, assume a significance in painting that they do not have in literature.[10]

What has been said of literary texts obviously applies also to musical scores. The alphabet is different; and the characters in a score, rather than being strung one after the other as in a text, are disposed in a more complex array. Nevertheless, we have a limited set of characters and of positions for them;

and correct spelling, in only a slightly expanded sense, is still the sole requirement for a genuine instance of a work. Any false copy is wrongly spelled—has somewhere in place of the right character either another character or an illegible mark that is not a character of the notation in question at all.

But what of performances of music? Music is not autographic in this second stage either, yet a performance by no means consists of characters from an alphabet. Rather, the constitutive properties demanded of a performance of the symphony are those *prescribed in* the score; and performances that comply with the score may differ appreciably in such musical features as tempo, timbre, phrasing, and expressiveness. To determine compliance requires, indeed, something more than merely knowing the alphabet; it requires the ability to correlate appropriate sounds with the visible signs in the score—to recognize, so to speak, correct pronunciation though without necessarily understanding what is pronounced. The competence required to identify or produce sounds called for by a score increases with the complexity of the composition, but there is nevertheless a theoretically decisive test for compliance; and a performance, whatever its interpretative fidelity and independent merit, has or has not all the constitutive properties of a given work, and is or is not strictly a performance of that work, according as it does or does not pass this test. No historical information concerning the production of the performance can affect the result. Hence deception as to the facts of production is irrelevant, and the notion of a performance that is a forgery of the work is quite empty.

Yet there are forgeries of performances as there are of manuscripts and editions. What makes a performance an instance of a given work is not the same as what makes a performance a premiere, or played by a certain musician or upon a Stradivarius violin. Whether a performance has these latter properties is a matter of historical fact; and a performance falsely purporting to have any such property counts as a forgery, not of the musical composition but of a given performance or class of performances.

The comparison between printmaking and music is especially telling. We have already noted that etching, for example, is like music in having two stages and in being multiple in its second stage; but that whereas music is autographic in neither stage, printmaking is autographic in both. Now the situation with respect to the etched plate is clearly the same as with respect to a painting: assurance of genuineness can come only from identification of the actual object produced by the artist. But since the several prints from this plate are all genuine instances of the work, however much they differ in color and amount of ink, quality of impression, kind of paper, etc., one might expect here a full parallel between prints and musical performances. Yet there can be prints that are forgeries of the *Tobit Blind* but not performances that are forgeries of the *London Symphony*. The difference is that in the absence of a notation, not only is there no test of correctness of spelling for a plate but there is no test of compliance with a plate for a print. Comparison of a print with a plate, as of two plates, is no more conclusive than is comparison of two pictures. Minute discrepancies may always go unnoticed; and there is no basis for ruling out any of them as inessential. The only way of ascertaining whether a print is genuine is by finding out whether it was taken from a certain plate.[11] A print falsely purporting to have been so produced is in the full sense a forgery of the work.

Here, as earlier, we must be careful not to confuse genuineness with aesthetic merit. That the distinction between original and forgery is aesthetically important does not, we have seen, imply that the original is superior to the forgery. An original painting may be less rewarding than an inspired copy; a damaged original may have lost most of its former merit; an impression from a badly worn plate may be aesthetically much further removed from an early impression than is a good photographic reproduction. Likewise, an incorrect performance, though therefore not strictly an instance of a given quartet at all, may nevertheless—either because the changes improve what the composer wrote or because of sensitive interpretation—be better than a correct performance.[12] Again, several correct performances of about equal merit may exhibit very different specific aesthetic qualities—power, delicacy, tautness, stodginess, incoherence, etc. Thus even where the constitutive properties of a work are clearly distinguished by means of a notation, they cannot be identified with the aesthetic properties.

Among other arts, sculpture is autographic; cast sculpture is comparable to printmaking while carved sculpture is comparable to painting. Architecture and the drama, on the other hand, are more nearly comparable to music. Any building that conforms to the plans and specifications, any performance of the text of a play in accordance with the stage directions, is as original an instance of the work as any other. But architecture seems to differ from music in that testing for compliance of a building with the specifications requires not that these be pronounced, or transcribed into sound, but that their application be understood. This is true also for the stage directions, as contrasted with the dialogue, of a play. Does this make architecture and the drama less purely allographic arts? Again, an

architect's plans seem a good deal like a painter's sketches; and painting is an autographic art. On what grounds can we say that in the one case but not the other a veritable notation is involved? Such questions cannot be answered until we have carried through some rather painstaking analysis.

Since an art seems to be allographic just insofar as it is amenable to notation, the case of the dance is especially interesting. Here we have an art without a traditional notation; and an art where the ways, and even the possibility, of developing an adequate notation are still matters of controversy. Is the search for a notation reasonable in the case of the dance but not in the case of painting? Or, more generally, why is the use of notation appropriate in some arts but not in others? Very briefly and roughly, the answer may be somewhat as follows. Initially, perhaps, all arts are autographic. Where the works are transitory, as in singing and reciting, or require many persons for their production, as in architecture and symphonic music, a notation may be devised in order to transcend the limitations of time and the individual. This involves establishing a distinction between the constitutive and the contingent properties of a work (and in the case of literature, texts have even supplanted oral performances as the primary aesthetic objects). Of course, the notation does not dictate the distinction arbitrarily, but must follow generally—even though it may amend—lines antecedently drawn by the informal classification of performances into works and by practical decisions as to what is prescribed and what is optional. Amenability to notation depends upon a precedent practice that develops only if works of the art in question are commonly either ephemeral or not producible by one person. The dance, like the drama and symphonic and choral music, qualifies on both scores, while painting qualifies on neither.

The general answer to our somewhat slippery second problem of authenticity can be summarized in a few words. A forgery of a work of art is an object falsely purporting to have the history of production requisite for the (or an) original of the work. Where there is a theoretically decisive test for determining that an object has all the constitutive properties of the work in question without determining how or by whom the object was produced, there is no requisite history of production and hence no forgery of any given work. Such a test is provided by a suitable notational system with an articulate set of characters and of relative positions for them. For texts, scores, and perhaps plans, the test is correctness of spelling in this notation; for buildings and performances, the test is compliance with what is correctly spelled. Authority for a notation must be found in an antecedent classification of objects or events into works that cuts across, or admits of a legitimate projection that cuts across, classification by history of production; but definitive identification of works, fully freed from history of production, is achieved only when a notation is established. The allographic art has won its emancipation not by proclamation but by notation.

The two problems of authenticity I have been discussing are rather peripheral questions of aesthetics. Answers to them do not amount to an aesthetic theory or even the beginning of one. But failure to answer them can well be the end of one; and their exploration points the way to more basic problems and principles in the general theory of symbols.

Many matters touched upon here need much more careful study. So far, I have only vaguely described, rather than defined, the relations of compliance and of sameness of spelling. I have not examined the features that distinguish notations or notational languages from other languages and from nonlanguages. And I have not discussed the subtle differences between a score, a script, and a sketch. What is wanted now is a fundamental and thoroughgoing inquiry into the nature and function of notation in the arts. . . .

Notes

1. And only for the sake of argument—only in order not to obscure the central issue. All talk of mere looking in what follows is to be understood as occurring within the scope of this temporary concession, not as indicating any acceptance of the notion on my part.

2. Germans learning English often cannot, without repeated effort and concentrated attention, hear any difference at all between the vowel sounds in "cup" and "cop". Like effort may sometimes be needed by the native speaker of a language to discern differences in color, etc., that are not marked by his elementary vocabulary. Whether language affects actual sensory discrimination has long been debated among psychologists, anthropologists, and linguists; see the survey of experimentation and controversy in Segall, Campbell, and Herskovits, *The Influence of Culture on Visual Perception* (Indianapolis and New York: The Bobbs-Merrill Co., Inc., 1966), pp. 34–48. The issue is unlikely to be resolved without greater clarity in the use of "sensory," "perceptual," and "cognitive," and more care in distinguishing between what a person can do at a given time and what he can learn to do.

3. In saying that a difference *between the pictures* that is thus relevant to my present experience in looking at them constitutes an aesthetic difference between them, I am of course not saying that everything (e.g., drunkenness, snow blindness, twilight) that may cause my experiences of them to differ constitutes such an aesthetic difference. Not every difference in or arising from how the pictures happen to be looked at counts; only differences in our arising from how they are to be looked at. . . .

4. For a detailed and fully illustrated account, see P. B. Coremans, *Van Meegeren's Faked Vermeers and De Hooghs*, trans. A. Hardy and C. Hutt (Amsterdam: J. M. Meulenhoff, 1949). The story is outlined in Sepp Schüller, *Forgers, Dealers, Experts*, trans. J. Cleugh (New York: G. P. Putnam's Sons, 1960), pp. 95–105.

5. Not surprisingly, since a single quantum of light may excite a retinal receptor. See M. H. Pirenne and F. H. C. Marriott, "The Quantum Theory of Light and the Psycho-Physiology of Vision", in *Psychology*, ed. S. Koch (New York and London: McGraw-Hill Co., Inc., 1959), vol 1, p. 290; also Theodore C. Ruch, "Vision", in *Medical Psychology and Biophysics* (Philadelphia: W. B. Saunders Co., 1960), p. 426.

6. That the forgeries purported to have been painted during a period from which no Vermeers were known made detection more difficult but does not essentially alter the case. Some art historians, on the defensive for their profession, claim that the most perceptive critics suspected the forgeries very early; but actually some of the foremost recognized authorities were completely taken in and for some time even refused to believe Van Meegeren's confession. The reader has a more recent example now before him in the revelation that the famous bronze horse, long exhibited in the Metropolitan Museum and proclaimed as a masterpiece of classical Greek sculpture, is a modern forgery. An official of the museum noticed a seam that apparently neither he nor anyone else had ever seen before, and scientific testing followed. No expert has come forward to claim earlier doubts on aesthetic grounds.

7. Attributed to Immanuel Tingle and Joseph Immersion (*ca.* 1800).

8. There may indeed be forgeries of performances. Such forgeries are performances that purport to be by a certain musician, etc; but these, if in accordance with the score, are nevertheless genuine instances of the work. And what concerns me here is a distinction among the arts that depends upon whether there can be forgeries of works, not upon whether there can be forgeries of instances of works. . . .

9. This is to be taken as a preliminary version of a difference we must seek to formulate more precisely. . . .

10. Such identification does not guarantee that the object possesses the pictorial properties it had originally. Rather, reliance on physical or historical identification is transcended only where we have means of ascertaining that the requisite properties are present.

11. To be original a print must be from a certain plate but need not be printed by the artist. Furthermore, in the case of a woodcut, the artist sometimes only draws upon the block, leaving the cutting to someone else—Holbein's blocks, for example, were usually cut by Lützelberger. Authenticity in an autographic art always depends upon the object's having the requisite, sometimes rather complicated, history of production; but that history does not always include ultimate execution by the original artist.

12. Of course, I am not saying that a correct(ly spelled) performance is correct in any of a number of other usual senses. Nevertheless, the composer or musician is likely to protest indignantly at refusal to accept a performance with a few wrong notes as an instance of a work; and he surely has ordinary usage on his side. But ordinary usage here points the way to disaster for theory. . . .

The New Art History:
A Symposium

46

What Is "New" About the "New Art History"?

THOMAS DACOSTA KAUFMANN

The 1988 meeting of the College Art Association of America, the official North American organization of art historians and artists, included a number of sessions that seem to signal some important recent developments in the discipline of art history. Papers were delivered in sessions devoted to topics such as Feminism and art history ("Engendering Art"), the representation of the Other ("Discussing Otherness: Possessing the Outsider"), Marxism and art history ("Assessing the Marxist Tradition in U.S. Art History: Successes, Failures, Challenges"), and deconstruction and art ("What Use Is Deconstruction Anyway").[1] The consideration of the importance of gender in art, of the role of racial difference and sexual identity, of the social bases of art, and of the pertinence of recent literary theory to art history reflects the growing attention given to these issues.[2] While previously these sorts of subjects had been left to special interest groups or alternative meetings, they seem now to compete with what had been the usual fare of earlier years. At the 1988 College Art Association meeting older, established approaches to art history, such as the presentation of documentary discoveries, attributions of works of art (the determination of authorship and date), iconographic analyses (discussions of symbolism), and the formal typology of style (the characterization of visual forms as representative of a coherent "language" or demonstrative of a historical trend) seemed less in evidence. This altered program is symptomatic of a change in the field that introduces the theme of the "new art history."

Although much more could be said about the newer conceptualizations of art and its history that are represented by those trends identified, in a not entirely satisfactory manner, with the "new art history," rather than detailing all the varieties of approach that can be heard in public lectures or read in the copious recent writing that they exemplify, I would like to summarize and thus simplify matters. I would like to describe many of these new developments as representing an increased self-consciousness about method or approach to art historical topics. It is this theoretical self-awareness, that involves an openness to newer currents in other fields and the adaptation of many of their conceptualizations, that I think defines what is generally and rather vaguely described as the new art history. Traces of this kind of reflection are found not only in efforts to make broad framing generalizations, but in specific studies as well.

In order to understand, however, why these developments are supposed to represent something that might be considered "new," it may be helpful to describe some features of the discipline in which they have been received. What might the "old art history" be which leads us to speak of the "new"?

This leads to a consideration of certain aspects both of the history of the field, and of the traditional manners in which it has approached the objects to

Lecture delivered at the symposium "The New (?) Art History" of the American Society for Aesthetics, held in Vancouver, British Columbia, in October 1988. Published with permission of the author.

which it attends. In comparison with other similar discourses, art history is a relative newcomer, especially if it be considered in its prevalent form as an academic discipline. The oldest independent department on this continent, that at Princeton, is slightly over one hundred years old.[3] Most art history faculties, in fact the overwhelmingly majority, have been established or enlarged since the 1940s. A similar history may be told about public museums: the oldest in the United States (the Wadsworth Athenaeum) was founded in the 1830s, most date from the 1870s (the Metropolitan Museum of Art, the Boston Museum of Fine Arts) at the earliest, and many more have been founded quite recently.

Many art historians thus continue to occupy themselves with what may be called basic problems. Much seemingly archaeological activity goes on not only in the study of antiquity, but of the history of the visual arts in general before the nineteenth century. This activity still engages many scholars in the determination of the date, function, subject, and authorship of artifacts. As is the case with traditional archaeology, art historians can still find large masses of unstudied material. And just as important, major disagreements remain even about the authorship of famous works that are agreed to constitute the canon. Thus for art historians, issues—for example, about the attribution works by Raphael or Rembrandt—comparable to the question whether Shakespeare or Milton wrote *Paradise Lost* remain unsettled.[4]

Moreover the material existence of its objects of study has also long had a determining effect on art history. Obviously the recovery, or on the other hand destruction, of works of the past can have a determining influence on what is said about the history of art. The condition in which works are seen can also have an effect: here the highly publicized controversy that the cleaning of the ceiling of the Sistine Chapel has generated comes to mind. In such instances art historians are faced with issues comparable to those that might arise with the discovery of a new redaction of Vergil's poems. Many scholars have therefore tended to avoid speculation, staying rather close in their conceptualizations to the description and consideration of visual forms.

On the other hand, art historians, especially in Europe, and especially before the mid-1930s, have of course also developed framing conceptions to guide their interpretations, or to determine what works were to be recovered from the past. For this task they have long drawn from other disciplines. In this regard, art history has not remained isolated from intellectual developments outside the field. To mention just a few famous figures, Alois Riegl and Heinrich Wölfflin were informed by the psychology of perception, Aby Warburg constantly crossed boundaries, ranging from anthropology to astrology, Otto Pächt based his earlier theories on gestalt psychology and *Gesamtphilosophie,* and Erwin Panofsky was informed by neo-Kantian philosophy. Responses by art historians to recent intellectual trends such as semiotics, structuralism, and deconstruction is thus nothing unusual in itself.

There is, however, something special about the historical situation in North America that may well account for some of the furor that has been evinced not only within the field but even in newspaper accounts about the so-called new art history. Until the last decade or two art historians in North America have largely confined themselves to attending to the traditional projects I have described, the more archaeological or positivistic recuperation and categorization of works of the past. On this continent resistance has continued to theorizing about the methods that art historians use, about our assumptions, the objects that we study, and about the nature of the subject in general. It is significant that a figure of the stature of Erwin Panofsky, who had been a major contributor to theoretical discussions of art history in German, largely gave up writing about such subjects in English after the 1930s, as he adapted to his new environment in the United States. From his students in America one can learn that Panofsky rarely if ever discussed theoretical or methodological issues in his classes.[5]

Very few Americans of earlier generations paid much attention to these kinds of questions. Well-known writers such as James Ackerman, Meyer Schapiro, and George Kubler are perhaps all the more conspicuous in this regard because they are in fact so rare. Ackerman himself commented on this situation in an article published in 1973, when he noted that a gathering of the previous year was "the only theoretical symposium that I can recall involving American art historians on any general problem of method. Art history in this country has been a discipline without any avowed theoretical base; until quite recently, few of us have cared to reflect on the assumptions by which we work."

In 1973 Ackerman noticed that it was young scholars who responded to what he called "the need for a firmer philosophical foundation." It seems to me that what Ackerman described in the pages of a periodical devoted to new literary history has continued, and it is this response that I think we can identify with the new art history.[6] Even though debates may now tend to involve other realms of social interest than those that occupied many comparable earlier scholars, to my mind it is not specifically so much a gender-informed or social historical point of view, although these represent two

major categories of the "new art history"—but rather a more basic attitude that may said to be shared in common by much recent work in field. Whether they are talking about German limewood sculpture as the product of a "visual culture" determined by material, social, and other cultural considerations, or about Rembrandt's enterprise in the creation of the idea of art as a commodity, or about the structure of French eighteenth-century painting and its public, or about the New York's art market's connection of abstract expressionism to cold war ideology, many of the historians who have been regarded as the most prominent practitioners of the "new art history" in North America can instead well be compared to those historians of an earlier era in Europe, who had also reflected upon what they were doing, and placed their own endeavors in a larger intellectual context.[7]

What may have made work such as theirs seem so strikingly new is the exceedingly antagonistic reaction that it has evoked. Much resistance to this kind of approach has come from older American scholars, who have continued to resist self-reflection, or from those scholars of a younger generation who have otherwise remained more intellectually conservative, in that they are committed to older ways of dealing with material, or to older paradigms. I believe that it is the fury of this reaction that in part helped gain so much attention for supposedly newer ideas. After all, many figures who are identified with the so-called new art history have not taken on this mantle for themselves, but quite specifically renewed discussions that had been started by European scholars, or by a few Americans such as Schapiro.

Although in its theoretical self-consciousness the literature of the "new art history" may therefore be related to earlier traditions of discussion, there are, however, some fundamental differences that seem to distinguish recent work in art history both from that of earlier innovators in the field, as well as from advanced theoretical work in comparable discourses, such as literary theory. Major figures who were associated with the new art history of past eras, that is art historians who also contributed to the theoretical discussion within the field, also helped to broaden critical horizons. Scholars such as Wölfflin, Riegl, and others not only contributed to the theoretical underpinnings of the discipline, but added whole periods of study to the purview of art historians. Their new art history directly resulted in an expansion of the canon when they investigated works that had previously been neglected or disparaged. Wölfflin contributed to the recuperation of the baroque art of the seventeenth century, which his contemporary Bernard Berenson could simply dismiss as a period of decline.[8] Riegl's theories of Kunstwollen ("that which wills art") in part led to the recovery of the art of late antiquity, which had been regarded as a period of decadence, when he undertook to catalog the collection of "Spätrömische Kunstindustrie" in the imperial collections.[9] Max Dvorak provided a new definition of a "mannerist" art of the sixteenth century, which he related to the Geistesgeschichte of the time.[10] Along with their speculative and interpretive writings, other scholars such as Aby Warburg broadened the canon of artists of already well-regarded periods: Warburg helped add Botticelli to the constellation of stars of the Renaissance, when he tackled the question of what it was in antiquity that attracted artists of the quattrocento.[11]

With the notable exception of some feminist criticism, which has both enlarged the canon of works of art and, more fundamentally, our ways of looking at art, I do not find that such developments have much occurred within the trends describable as the "new art history." Much of the work that is identifiable with tendencies other than feminism has tended to reinforce the prominence of previously established movements or periods, such as impressionism or abstract expressionism. New interpretations have centered on canonical figures such as David, Rembrandt, Manet, and Degas, rather than illuminating previously obscure or despised artists. Debates have taken place within a critical context that has been already established. Some of the most intense countercriticism emanating from scholars who might be called proponents of the so-called new art history has been directed against those who would expand the canon.

Hence we can find a much praised and honored representative of newer tendencies in art history call the highly nationalist accounts of the sixteenth-century German art "classic" and uncritically accept their framing conceptions. It is instructive to compare his words with those to which he so positively refers. Both defend the same canon. Take, first, one text from 1980 defining the decline of German art after circa 1530:

[T]here were to be wars, and initiative in patronage as in other things was passing from the cities to modernized dukes and princes. Their new palazzi were decorated by second-rank Italians and half-Italian Netherlanders, while in the towns a rump of guildsmen subsided into a sort of pidgin Italianism: it was all provincial at best. For a time the dissociation between visual art and demotic modes of ordering visual experience was almost modern in its proportions, though this did not last.

Compare these comments to the highly nationalistic statement made at the time of the First World War by Georg Dehio:

> Therefore is it not to be argued and has never been argued that in the last two thirds of the sixteenth century art fell quickly, almost suddenly from the height that it had attained in the first third of the century. . . . [T]he art of the Renaissance came from another culture, only its external form, not the organic law bound to its *Himmelstrich, Volksart* and culture.[12]

The language, and what it reveals about method may be different, but the canon, and the defense for it, remain the same. In defending this approach, and his uncritical acceptance of earlier paradigms, the same "new art historian" has even boldly and publicly stated that he is a "great works man"[13]—as if in the writing of German art history by men such as Dehio nationalist ideology was not at play in the determination of what constituted a great work, and as if it remained settled what the "great works" might be. At a time when the notions of a "great work," and also that of an established canon, have come under attack in the fields of literary criticism, this statement indicates quite eloquently how what is called the new art history can be distinguished from related "new" developments in other fields of the humanities.

Furthermore, while the application of new approaches, or methods, may be said to determine a definition of the new art history, it is also not always the case that new ways of interpreting objects have resulted. Art historians continue to describe pictures or to make up stories in their accounts of famous works of art. A good example of the way that the proverbial old wine may have been packaged in new bottles may be found in two accounts of Rembrandt. In 1948 Jakob Rosenberg wrote:

> [I]n the portrait of Jan Six the coloristic splendor dominates over the chiaroscuro effect. The patrician wears a grey coat with gold buttons. A scarlet, gold-braided mantle is casually thrown over his shoulder. The greys form a beautiful contrast with this bright red, and the touches of golden yellow enliven the pictorial harmony. We observe a charm of texture which is due to Rembrandt's forceful and expressive brushwork, with bold impasto in the highlights and a rich play of values surrounding them.[14]

His words may be compared with those on the same picture in an account of 1988, regarded as revisonist:

> It is executed with a brilliance of brushwork achieved with an unaccustomed economy which must betoken an unaccustomed speed of completion. A sign of this is the consistent thinness of the paint surface. The series of horizontal brushstrokes which mark the fastenings of the coat are rendered in an almost transparent yellow ochre with a bit of pigment concentrated along an edge. Even the area which combines the most concentrated action and painterly attention—the hand which, having pulled on one glove, is gripping the other—lacks the characteristic thickness of paint build-up.[15]

While one might be called a thick and the other a thin description of paint, the point of the observations seems to be much the same.

What appears to be playing itself out therefore seems to my mind to resemble what happened in Germany and Austria in the 1930s and 1940s. Then as well the political and intellectual right within the discipline of art history reacted against the introduction of theoretical and interdisciplinary innovations within the field, in favor of a specifically archaeological approach.[16]

If we keep in mind the serious consequences that these reactionary responses had in the past—and the reciprocal effects of social and economic interests on considerations of art—I would thus neither want to belittle nor to underestimate the significance of the changes we refer to as the new art history, and their potential consequences. It may be that ultimately the flavor of the wine may become something quite different as a result of the methods in which the newer approaches have been casked. I would conclude that the new art history may result in major differences in the way things are stated, and in the outlook that scholars have. In any event, if we are not to measure recent developments in art history against the dream of a Hegelian *Kunstwissenschaft* (a "science of art" defined by Arthur Danto as "a sort of cultural philosophy of the sort he [Hegel] himself was working out") that preoccupied European art historians who represent the new art history of the past, and consider much current writing in the field in its own right, I think the recent upsurge in methodological and theoretical reflection and self-reflection gainsays the description, advanced not long ago by Danto, that art history is an anemic discipline.[17] Far from evincing the end or death of art or, to use the words of another scholar, the death of art history,[18] the vigorous theoretical self-reflection represented by the new art history demonstrates signs of intellectual health in the field.

Notes

1. A record of these papers can be obtained from the "Abstracts and Program Statements. 76th Annual Meeting. College Art Association of America. February 11–13, 1988, Houston." I am well aware that the choice of subjects for the program results in part from the determination of the art history chair, Dr. Thomas F. Reese, but I think that the selection and presentation of the materials in these meetings are nevertheless broadly representative of the trends I am describing in this essay.

2. These topics, as well as the development and discussion of many other newer issues, have by now generated a literature that has grown to such an extent that full citation is impossible in this brief essay. All that can be offered here are some suggestions for a preliminary orientation. For an introduction to the variety of feminist approaches to art history, the interested reader may consult Thalia Gouma-Peterson and Patricia Mathews, "The Feminist Critique of Art History," *The Art Bulletin*, vol. 69, no. 3 (September 1987), 320–57, and the ensuing "Exchange on the Feminist Critique of Art History, ibid., vol. 71, no. 1 (March 1989), 124–28. The theme of racial difference is that of the series on *The Image of the Black in Western Art*, most recently vol. 4, by Hugh Honour, *From the American Revolution to World War I* (Cambridge, Mass., 1988), and for the pertinence of "other" sorts of sexual identity to art is the subject of James Saslow, *Ganymede in the Renaissance. Homosexuality in Art and Society* (New Haven, 1986). The social history engages many writers, including perhaps most familiarly T. J. Clark, e.g., *The Image of the People*, 2nd ed. (Princeton, 1981). The writings of Norman Bryson, e.g. *Word and Image. French Painting of the Ancien Régime*, (Cambridge, 1981), exemplify the application of literary theory, structuralism, and semiotics to art history; see also Norman Bryson, *Calligram. Essays in New Art History from France,* ed. Norman Bryson (Cambridge, 1988). Besides these works, essays written by the other authors who presented abstracts and program statements mentioned in the previous note should obviously also be consulted.

3. A good comprehensive history of art history in the United States would be most useful. For the early history of the Princeton department, consult Marilyn Aronberg Lavin, "The Eye of the Tiger. The Founding and Development of the Department of Art and Archaeology, 1883–1923, Princeton University," Princeton, 1983.

4. I am reflecting here on some remarks that contrast the situation in literary and art historical studies made by J. A. Gere, "Some Observations on the Practical Utility of Connoisseurship," in *Drawings Defined,* ed. Walter Strauss and Tracie Felker, with a preface and commentary by Konrad Oberhuber (New York, 1987), p. 292.

5. Panofsky's earlier theoretical writings are collected in *Aufsätze zu Grundfragen der Kunstwissenschaft,* 2nd ed., ed. Hariolf Oberer and Egon Verheyen (Berlin, 1974). Information about the conduct of Panofsky's classes was gathered from conversations with some of his older former students in Princeton.

6. James S. Ackerman, "Toward a New Social Theory of Art," *New Literary History,* vol. 4, no. 3 (winter 1973), 315–30.

7. I am alluding to such works as Michael Baxandall, *The Limewood Sculptors of Renaissance Germany* (New Haven and London, 1980); Svetlana Alpers, *Rembrandt's Enterprise* (Chicago, 1988); Thomas E. Crow, *Painters and Public Life in Eighteenth-Century Paris* (New Haven and London, 1985); and Serge Guilbaut, *How New York Stole the Idea of Modern Art. Abstract Expressionism, Freedom and the Cold War,* trans. Arthur Goldhammer (Chicago and London, 1983).

8. I am here contrasting Wölfflin's *Renaissance and Baroque*, trans. Kathrin Simon (London, 1964), and *Principles of Art History*, trans. M. D. Hottinger (London, 1932), with Berenson's remarks on the "decline of art" (first published 1907) in *Italian Painters of the Renaissance* (Cleveland and New York, 1957).

9. The term *Kunstwollen* has caused a large amount of debate, and remains essentially untranslatable. Effectively, it refers to the internal development of formal change in artistic styles, conceived as voluntaristic notion. For a concise interpretation of some aspects of Riegl's *Spätrömische Kunstindustrie* see Margaret Olin, "Spätrömische Kunstindustrie: The Crisis of Knowledge in fin de siècle Vienna," in *Wien und die Entwicklung der kunsthistorischen Methode. (Akten des XXV. international Kongresses für Kunstgeschichte),* vol. 1, sect. 1, ed. Stefan Krenn and Marin Pippal (Vienna, Cologne, Graz, 1984), pp. 29–36.

10. This notion of art history as a history of the spirit *(Geistesgeschichte)* provided the title *(Kunstgeschichte als Geistesgeschichte)* for a collection of Dvorak's essays. The appropriateness of this title

as a description of Dvorak's work has, however, recently been criticized by Artur Rosenauer, "Das Rätsel der Kunst der Brüder Van Eyck—Max Dvorak und seine Stellung zu Wickhoff und Riegl," in *Wien und die Entwicklung der kunsthistorischen Methode,* pp. 45–52.

11. Like Riegl, Warburg has engendered an ever-expanding interpretive literature: Frank Kermode, *Forms of Attention* (Chicago and London, 1985), pp. 1–32, emphasizes Warburg's role in canon formation, the point made here.

12. These passages come from, respectively, Baxandall, *Limewood Sculptures of Renaissance Germany,* p. 216, and Georg Dehio, *Geschichte der deutschen Kunst,* vol. 3 (Berlin and Leipzig, 1926), pp. 171 and 175; my translation elides passages from these two pages.

I have commented on this situation in my "Introduction" to *Art and Architecture in Central Europe, 1550–1620. An Annotated Bibliography* (Boston, 1988), esp. pp. xxiii ff.

13. Baxandall's remarks to this effect were made in discussion at a symposium devoted significantly to the topic of the "New Art History" held at Princeton University, April 1985.

14. Jakob Rosenberg, *Rembrandt: Life & Work,* 3rd ed. (London and New York, 1964), pp. 79–80.

15. Svetlana Alpers, *Rembrandt's Enterprise,* 1988, p. 93.

16. For more on this situation see the illuminating account in Heinrich Dilly, *Deutsche Kunsthistoriker 1933–1945* (Munich, 1988).

17. See Arthur C. Danto, "The End of Art," in Berel Lang, ed., *The Death of Art* (New York, 1984), p. 34, for the contrast between his definition of Hegel's *Kunstwissenschaft,* used here, and current art history. Danto remarks that the Hegelian project is "hardly something art history as we know it attempts to do, though I am certain that the present rather anaemic discipline grew out of something as robust in its conception as Hegel meant for it to be."

The most thorough critique of earlier forms of Hegelian art history and cultural history is presented by E. H. Gombrich, most notably *In Search of Cultural History* (Oxford, 1969), reprinted in *Ideals and Idols. Essays on Values in History and in Art* (Oxford, 1979), pp. 24–59, in which book alternatives to Hegelianism are also offered.

18. See Hans Belting, *Das Ende der Kunstgeschichte?* (Munich, 1983) [trans. Christoper S. Wood, *The End of the History of Art?,* (Chicago and London, 1987)]. Belting means to raise the possibilities "that contemporary art indeed manifests an awareness of a history of art but no longer carries it forward; and that the academic discipline of art history no longer disposes of a compelling model of historical treatment" (trans., p. 3).

47

Cultural Institutions and the Topography of Art History

MICHAEL MARRINAN

For three days I've passed among this gathering, feeling a bit the outsider amidst philosophers, since a quick glance at the program shows that art historians are fairly rare birds. And then, while reading to prepare this talk, I was reminded that philosophers are sometimes a bit short with us: in a fairly famous essay, my colleague Arthur Danto remarked that he was certain "the present rather anaemic discipline grew out of something as robust in its conception as Hegel meant for it to be"; and then he added that perhaps the sorry state of art history is due to the fact that "art as we know it is finished."[1]

But to be fair, others have joined the fray. Norman Bryson, from the English Department at Cambridge, opened *Vision and Painting* with this lament: "It is a sad fact: art history lags behind the study of the other arts. . . . there has reigned a stagnant peace . . . in which monographs have been written, and more and more catalogues produced: but produced at an increasingly remote margin of the humanities, almost in the leisure sector of intellectual life."[2] Strong words, and perhaps not entirely just: there *has* been enough talk of a "new" art history to support this session in Vancouver, albeit flagged with a question mark in the program. But I'll be honest and say straight off that I will not spell out—not directly at any rate—what the "new" might be: frankly, I'm not sure; but I *am* sure that I'm not terribly interested to debate the pros and cons of various "methods" used by art historians. Rather, I will generally postpone the "new"

part and offer a few thoughts on the "history" part of our session's title.

I want to begin in the splendid exhibition now on view at the Metropolitan Museum and recently in Ottawa: I'm speaking of the Edgar Degas retrospective. One of the works in this show is a pastel done about 1877 called *The Song of the Dog*. The scene is a *café-concert*, probably one of several along the Champs-Élysées in Paris; the singer is probably Emma Valadon—known as Thérésa—who was a crowd favorite during these years. I want especially to draw attention to what is said about this work in the exhibition catalogue (a *very* large volume). The café-concert attracted "huge audiences," we are told, and "a good many prostitutes."[3] The material aspects of the work are described—for example, Degas pasted several strips of paper to enlarge the sheet for the background—and we are told that Degas described her voice as "the most natural, the most delicate, and the most vibrantly tender" instrument imaginable.[4] Further down we encounter a key paragraph worth reading at length:

In the *Song of the Dog*, or "La Chanson du Chien," as it is popularly known, much is contained in the artist's rendering of the physical presence of the singer—her pleasant face luridly lit by the footlights, her stout body securely encased in her tight dress, and her graphic paw-like gestures. Seen from the closest possible vantage point, she dominates her audience from the height of the stage: ridiculous but real, genuinely

Lecture delivered at the symposium "The New (?) Art History" of the American Society for Aesthetics, held in Vancouver, British Columbia, in October 1988. © Michael Marrinan. Published with permission of the author.

521

Edgar Degas: *The Song of the Dog*, c. 1876–77. Gouache and pastel over monotype on three pieces of paper joined. 57.5 × 45.4 cm. Private collection. Girandon.

absorbed in her song. The background, hazy with light from the globes scattered in the garden, is no less keenly observed. A mustachioed old man has fallen asleep, a young woman peers from behind a cluster of heads, a waiter takes an order, and in the background, a couple leaves during the performance.[5]

Now I first read this text with the vague memory of a rather different account of Degas's pastel, one which argued that café-concerts were important melting-pots of Paris society: men and women, rich

and poor, socially correct and not-so-correct could all be found in the audience.[6] And at the edges of the crowd, unable even to afford the *boisson* to merit a chair, would gather the poorest individuals and the street-smart *gamins* who were Thérésa's biggest fans. Cutting across this gathering were the lyrics of her song—often vulgar and sexually suggestive—such as these lines from a piece called "A bas les pattes, s'il vous plaît":

> HE How I like to see your white breasts
> Whose whiteness rivals that of milk

Its twin billows that swell and overflow
And seek to escape from the corset's
 confines.

SHE I know your refrain, come back on
 Sunday,
 Sir, paws down if you please![7]

We can imagine the kind of pantomime Thér-
ésa—in her tight dress—might add to such words.
"Go quick and hear Thérésa at the Alcazar," wrote
Degas to his friend Lerolle, "she opens her great
mouth and out comes the most grossly, delicately,
wittily tender voice imaginable. And feeling, and
taste, where could one find more? It's admirable."[8]
Do you remember this qutoe? When it appeared in
the exhibition catalogue, Degas's language—"great
mouth" and "grossly, delicately, wittily tender"—
was rendered "the most natural, the most delicate,
and the most vibrantly tender." Why, we might
ask, does one clean up a translation for the museum?
And how might we justify that sanitized translation
when Degas's sketches of Thérésa *show* that great
mouth and the energy he so admired? Where the
museum catalogue describes Thérésa's "pleasant
face luridly lit by the footlights" ("light" being a key
term of Impressionism), Degas seems to have been
interested in something quite different. Thérésa, to

judge from photographs, had fairly regular and
square features, yet Degas slanted her forehead,
extended her nose, and generally pushed her face
into a type we find in ethnographic treatises—such
as the plate (reproduced in the museum catalogue[9])
from Darwin's *Expression of Emotions,* published
in French translation in 1874—treatises which
attempt to correlate head shape and size to relative
stages of evolution and intelligence. An essay in the
exhibition catalogue claims this is evidence of
Degas's scientific interests, but one wonders—at
least I do—if Degas was exploring something *else.*
We could say, for example, that Thérésa's tight
dress, altered features, and specific gestures index
the carnal, physical passions coursing through the
crowd and overtly articulated by the singer's lyrics.

And finally, what *about* that crowd? It means
enough to Degas that he pasted extra paper for it:
was this only to enumerate characters sleeping,
looking, leaving, and waiting on tables? I believe
that Degas was perfectly aware that the "action" in
the crowd was *at least* as interesting as the stage
show and that—especially when Thérésa sang—it
offered a volatile cross-section of society. Robert
Herbert has recently described this crowd as some-
thing like today's rock-concert audiences: poten-
tially explosive gatherings.[10] Timothy Clark

Edgar Degas: *Studies of a Café-Concert Singer.* Page of a notebook used by Degas in
1877. Private collection, p. 11. Photograph taken from the facsimile edition published in
1949 by Quatre Chemins-Edittart. Paris. Bibliothèque Nationale.

Claude Reutlinger, *Carte de visite*,
photograph of Thérésa, c. 1867.
Bibliothèque Nationale, Paris,
Département des Estampes.

argued—in his 1984 book—that the café-concert
was a forum in which *class* and *sexual* values inter-
sected, merged, and clashed: a place where a new
kind of white-collar worker—with roots in the
working class but new bourgeois aspirations—
might feel at home while "slumming," might find
sexual partners, and ultimately an urban identity.[11]
Was Degas aware of this "scene" as we would call
it today? Surely he was, for it was often in the papers
and the topic of commentary or satire. Should it
enter a study of why he made *this* image, in the way
he did? Obviously the museum thinks not, for nei-
ther Clark nor Herbert are referenced in the bibli-

ography attached to this work: their readings were
not simply overlooked, they were rubbed out.[12]

My question is this: assuming that none of the
parties are charlatans, assuming that all are respon-
sible researchers and scholars, how might we
explain these *conflicting* readings of the image?
More important, how might we explain the sup-
pression of historical work? Indeed, if this is Art
History—and not simply interpretation and mean-
spiritedness—where is the *history* in all of this? I'm
not suggesting that I'm actually going to answer
this question today, but I do want to explore what
it means to *do* art history and to suggest some the-

oretical reasons for why certain kinds of readings are often suppressed. I will try to show that the crux of the matter depends upon a notion of what counts—or doesn't—as "appropriate evidence" in the history of art: but that's getting a bit ahead of ourselves.

To begin, a few words about how art historians talk to one another. Philosophers have frequently worried about the problem of "fit" between the words used to discuss a work of art and the work's appearance. Nelson Goodman describes the process as a bit like "measuring with no set tolerances," and he adds: "I am in no way claiming that the details of the pictorial system are before us for easy discovery; and I have offered no aid in deciding whether a given picture exemplifies a certain property."[13] More recently, Arthur Danto observed that there was "just a failure of perfect fit between the conceptual scheme and the vocabulary of the Greeks" so that they had no terms with which to distinguish art from artifact.[14] Danto suggests that we learn from the Greeks: insofar as they believed artists were "inspired," they felt no discomfort with this less-than-perfect fit.

The difference, I think, between such philosophical puzzles and the fact that art historians continue to talk and write has been best described by Michael Baxandall.[15] He points out that we art historians are actually *less* interested in "properties exemplified" (or not) than in what he calls "visual interest": we study works of art because they *are* visual and interest us on that level. Secondly, we art historians almost never talk about "generic" works of art, nor works we *have not seen.* Our language is less descriptive than *demonstrative*—by that is meant simply that we tend to *talk and point*—we point either to an original work of art or a mechanical reproduction of it. This pointing—and comparison—establishes a continuous system of checks and *limits* on what is possible or plausible to say. For complex objects, such as works of art, Baxandall admits that the "fit" between sense and reference can become "very loose," and that certain terms can be used only by assuming that the hearer will "interpret them in a sophisticated and specialized way: he must supply a great deal in the way of mental comparison with other works of art, of experience, of the previous use of such words in art criticism, and of general interpretive tact."[16] I suppose philosophers would say this sounds a bit like a "Blue and Brown Books" theory, although that's not my point.

Baxandall further observes that we use this demonstrative (or *ostensive*) language to argue *indirectly:* we use metaphoric comparisons to describe *what* we see (for example, a "rhythmic line"); we

use causal or inferential words to characterize the agents *responsible* for what we see (as when we say "a flashing stroke of red"); and we use subject or ego words to characterize the *feelings* created by what we see (such as "a moody landscape" or "an imposing vista"). Finally, Baxandall reminds us that all these observations are chained syntactically by the *language we speak,* in an order which has little or no connection to the pattern of fits and starts of eye movements with which we *see.* "The read text is majestically progressive," he writes, "the perception of a picture a rapid, irregular darting about and around on a field."[17] This problem can only be partially resolved by art historians and, despite any number of mediating strategies, some residual tension seems inevitable between the act of seeing and that of writing or saying.

Baxandall's characterization strikes me as a good, concrete, and practical one. I am struck, however, by a point he does *not* make: namely, that recent writing in the theory of history and its language settles on nearly identical issues. I have in mind here the work of Roland Barthes, Fernand Braudel, Michel de Certeau, Michel Foucault, and Gérard Genette, each of whom addresses aspects of the problem, and whom I mention only so you have an idea of where what follows is coming from.[18] Theorists of history worry a great deal about the relationship between their syntactically driven narratives and the supposed "objects" of their study: events of the past. They are sensitive to the fact that such events resist circumscription by language with as much tenacity as does the work of art; they too describe the language of history as demonstrative: a language of "pointing to" which links the historian, the audience or reader, and the material generated by the past event, but preserved in time as an object of study via the system of *archive.* Perhaps because they *are* historians, they have sensed that their process of pointing constructs a discursive *space,* describes a *social situation,* and establishes a relationship of *authority.* To point while speaking establishes the museum geometry required to articulate space: a triangulation of attention among speaker, hearer, and thing pointed out. Authority is established because the speaker who points to or cites the archive-object does so for people who cannot do it without guidance: if they could, the historian would be out of a job. Historical discourse is thus a *monologue,* consisting of a single voice which cites a plurality of archive-objects (documents) for someone unfamiliar with them. The act of citing—this gesturing to the archive—crosses and obfuscates the stubborn gap between the *time of narration* and that of the *past event* which is narrated. Knowledge of the archive is a mark of credibility

and establishes the historian's *authority* to instruct across this gap of time.

It seems to me that we might further our understanding of art history if we use this model to think about Baxandall's analysis of art-historical language. We could begin by asking: what might be an appropriate archive-object to which an art-historian's language will make reference? Suppose we adopt the systemic model of *archive* developed by Michel Foucault, by which he means neither the collection of all possible documents ever produced, nor even all those stored in various repositories around the world. Rather, he uses the term to refer to a kind fo filtering system operating *between* all the possible past acts (or statements) which—in the present case—we would call "artistic," and the objects of study we actually have on hand to which our art historical statements will make reference. "Between the *language* which defines the system of construction for all possible phrases, and the *corpus* which passively collects all the words said," observes Foucault, "the *archive* defines a particular level: that of an operation *(pratique)* which makes a very great number of event-traces *(énoncés)* appear to be a certain number of ordered events, a certain number of things susceptible to processing and manipulation."[19] We could say that the *archive* of art history has transferred through time to us today the evidence of past events which concern the art *historian* in the form of dense and compacted archive-objects usually called "works of art." (We will return to this formulation, and perhaps can debate it, for I do *not* mean to imply that a picture is merely a "document"—rather, I would say it is *itself* an "archiving system".) Art historians operate by gesturing to these objects and writing or speaking to a public. The *social space* of art history thus includes the work of art—or at least some replication of it. Unlike history proper, however, the social space of art history is *hierarchical*. Why? Because there is *one* configuration of it in which the art historian's authority is more intense than anywhere else: this is *before the actual object*. For example, I could show you two slightly different slides of Degas's pastel *The Song of the Dog,* and I could discuss Degas's use of color. But I might be obliged to say at some point: "you can't *exactly* see my point about color because these slides are slightly 'off' color—you would have to see the original in order to grasp my point."

I'm suggesting, of course, that if the authority of art historians is maximal before the original, it will *always be maximal* in those institutions where originals are stored, catalogued, and preserved—institutions we call *museums*. The museum space valorizes art-historical discourse in a way that the archive-institutions of history proper—such as the

Archives Nationales or Bibliothèque Nationale in Paris—do not. I can write the history of *payment* for a picture right here in Vancouver using a Xerox copy of a letter from the painter Jacques-Louis David to Napoléon's Minister of the Budget.[20] But if I want to maximize the authority of my comments about the *picture* in question, I *ought* to go to the museum at Versailles, stand in front of the canvas with my reader, and point out the validity of my observations.[21] Authority in the history of art seems not to be a question of aesthetic categories, but of physical *access* to the object-archive which is the work of art—an access usually controlled by the museum. My point is that museum institutions have been in a position to drive the agenda for the history of art and—as we have seen—to suppress more or less at will historical narratives which challenge the authority of the *museum space*. But how to argue against—and ultimately correct—this situation Here, I think, we touch upon at least the *possibility* of a "new" art history.

First of all, we need to clarify with *what* an art history might be concerned. Traditionally, art history has attempted to document and describe four kinds of events: the making of a single work of art; the life of a single artist; the contours of so-called "movements"; or the repetition of a theme cutting across all three of these. Thus, we have texts on Delacroix's *Death of Sardanapalus,* on the life of Rembrandt, on the movement called Impressionism, and on pictures which represent the Virgin Mary fondling and exposing the genitals of the Christ Child. Yet in each of these cases, the "events" described by the texts are pre-formed, a priori constructs, and objects are cited as "facts" until the pre-formed containers are "filled up" and the text "complete"—a condition which depends more on narrative closure than on an exhaustive enumeration of all the possible facts. I would say that insofar as the work of art becomes a "placeholder" in the unfolding narrative, it is impoverished.

The most glaring example of what I mean by "impoverished" can be found in the catalogues of museum exhibitions. Compare, for example, the Degas exhibition catalogue (supposedly designed to narrate his artistic biography) with that of the big exhibition called *The New Painting* held in 1986[22] (which supposedly narrated the Impressionist movement): despite the radically different historical purposes of each exhibition, both catalogues treat individual objects *in exactly the same way*. Individual entries in both catalogues reproduce the image, provide a description, a provenance, and a bibliography. Isn't this inflexible and insensitive "processing" a kind of impoverishment? I think so, and I attribute it to a positivist historical method which defines beforehand the event to be described, well

before any loan letters are sent out. And even if some owners refuse to lend their works, the exhibition generally happens anyway: first came the bucket, and whatever water fills it up would be fine.

The relationship between event and fact is much-discussed by theorists of history, for it cuts to the quick their main question: what *is* history? Not satisfied with the "bucket and water" theory, writers like Michel de Certeau suggest that we look closely at the *operation* of an historian's text. There we discover that as one multiplies citations—or to put it graphically, when the *act of pointing* increases—the narrative's semantic thread is increasingly threatened. Repeated gesturing across the text's social space confuses, diverts, and generally sows chaos among the narrative's linear order. "The discourse no longer *holds*," he writes, "if its structural organization collapses, but it is *historical* to the degree that its operation moves and corrodes the very conceptual frame needed to open up the space in which history-writing might occur."[23] An example would be the assassination of John Kennedy: *more* documentation—tons of it in this case—has *not* allowed us to say with certainty what happened in Dallas on that day. Long ago, the citations began to cancel out one another. Thus, historians recognize that the archive system will never "fully document" an event: that would be to have it more than once—a chronological impossibility.

Now let us ask: what kind of "event" might be the appropriate object of study for a *history* of art? I will suggest—again, I'm sure this needs debate—that art history, if *history* at all, should be concerned with "art events." I will also suggest that an "art event" be construed as the coming together, at a specific time and in a specific place, of the necessary agents to "make art": materials, a person to manipulate them, with the intention to do so, and so forth. And finally, I will suggest that the *art object* which comes down to us be considered (1) the product of a macro-archiving *system* appropriate to all "art events" and (2) *itself* a micro-archive of a single "art event." Like any archive, it is not complete, but it is *dense,* requires a concentrated *reading,* and *is* the object of our "pointing to" while speaking or writing art *history.*

Aestheticians will object strongly: doesn't this radically impoverish the art object? reduce it to mere document? Not really, provided that we think of *archive*—macro and micro—as an operating system rather than a static entity. "The archive is first of all the limit of what can be said," writes Foucault, "the system which regulates the visibility of event-traces [*énoncés*] as discrete entities. But the archive is also that which insures that not everything said [or done] piles up indefinitely into an amorphous mass; or is registered in an uninterrupted linearity; or disappears by accident. The archive groups these things said [or done] into distinct figures, combining them in multiple relationships, and preserving them or wiping them out according to specific patterns."[24] Adopting this formulation for the work of art positions it as the principal shaping force of art-historical discourse without ruling out the possibility that it might *also* generate an aesthetic interest. It *does* imply, however, that the work is *only one element*—albeit a dense one—of the potential archive-field of an "art event." In other words, *other* archive-objects *ought* to be referenced by our historical account of the "art event."

We are now in a position, I think, to see what's at stake in a "new" art history. The museum space has traditionally defined the social space of maximum art-historical authority. The museum institution has been, for the greater part of art history's *own* history, the discipline's principal archiving agent; its values have controlled the art-historian's available evidence: works hidden by curators in storerooms, for example, will *have no history.* The museum has wielded a tremendous cultural power, one which has been nearly unassailable insofar as museum institutions consciously seek links to other agents of cultural muscle: the wealthy, the privileged, and the politically empowered. To the extent that museum staffs are now—more than ever—trained art historians, the museum's institutional power and the authority of "old" art history have interlocked. Today, museums are virtually able to *dictate* (pace Arthur Danto) what *is* and is *not* a "work of art." The bulky catalogues of their block-buster exhibitions tend to replicate the museum space and the museum-defined archive. Authors like Clark and Herbert are "rubbed out" of the catalogue because their discussions assume a larger archive-field for an "art event" and thus implicitly challenge the museum's power.

If art historians recognize the dynamics and constraints of writing *history;* if they relinquish the lingering Romanticism which regards the work of art as fetish-object; if they fully explore the archive field; they *will* construct a new discursive space for the discipline—one cutting across the museum space, but not subject to its institutional interests. I personally predict that this "new" art history will be written in books, not museum catalogues, and that it will emerge from within historical institutes like those which nurtured the work of Aby Warburg and Erwin Panofsky. Yet it *will* be genuinely "new," for it will adopt a new object of attention, the "art event." In 1950, in his inaugural address to the Collège de France, Fernand Braudel compared the positivist, narrative-driven history of the nineteenth century to a painter before a landscape. These older historians believed, he wrote, "that

nothing must be left out, except—of course—that the painter must be overlooked. For the ideal was to suppress the observer as if reality were something to be surprised without frightening it off, as if history somehow existed outside our reconstructions, in a raw state of pure fact. The problem of history," Braudel continued, "is not to be found in the relationship between painter and painting, nor even—

though some have thought such a suggestion excessively daring—in the relationship between the painting and the landscape. The problem," he concluded, "is right *in* the landscape, in the heart of life itself."[25] The *new* art history, I would suggest, will find its subject in just that place, where living, thinking beings *make art:* in the heart of life itself.

Notes

1. Arthur Danto, "The End of Art," in *The Death of Art,* ed. Berel Lang (New York: Haven Publishing, 1984), p. 34.

2. Norman Bryson, *Vision and Painting: The Logic of the Gaze* (New Haven: Yale University Press, 1983), p. xi.

3. New York, The Metropolitan Museum of Art, *Degas,* exhibition catalogue (New York: The Metropolitan Museum, 1988), p. 290.

4. Ibid., p. 292.

5. Ibid.

6. T. J. Clark, *The Painting of Modern Life: Paris in the Art of Manet and His Followers* (Princeton: Princeton University Press, 1984), pp. 210-14.

7. Ibid., pp. 216-24.

8. The original French of Degas's letter to Lerolle, dated 4 December 1883, reads as follows:

> Mon cher Lerolle, allez vite entendre Thérésa à l'Alcazar, rue du Faubourg-Poissonnière. C'est près du Conservatoire et c'est mieux. On avait dit déjà, il y a longtemps,—je ne sais quel homme de goût, l'avait dit—que c'était à Gluck qu'il fallait l'appliquer. Vous êtes tous dans le Gluck en ce moment. C'est le moment d'aller entendre cette admirable artiste.
>
> Elle ouvre sa grande bouche et il en sort la voix la plus grossièrement, la plus délicatement, la plus spirituellement tendre qu'il soit. Et l'âme, et le goût, où peut-on en trouver de meilleur? C'est admirable. (*Lettres de Degas,* ed. Marcel Guérin [Paris: Grasset, 1931], p. 57).

9. *Degas,* exhibition catalogue, p. 206, fig. 100.

10. Robert L. Herbert, *Impressionism: Art, Leisure, and Parisian Society* (New Haven: Yale University Press, 1988), pp. 88-91.

11. Clark, pp. 214-16.

12. While one might reply that Herbert's book appeared too late for his findings to be included in the *Degas* exhibition catalogue, no such excuse can be found to justify the absence of Clark's text. The point here is not about the exclusion of individual authors but rather, as we shall see, the exclusion of certain kinds of historical evidence.

13. Nelson Goodman, *Languages of Art* (New York: Bobbs-Merril, 1968), pp. 235-36.

14. Arthur Danto, "Artifact and Art," in *ART/artifact* (New York: The Center for African Art, 1988), p. 27.

15. Michael Baxandall, "The Language of Art History," *New Literary History,* 10, no. 3 (Spring 1979), 453-65.

16. Ibid., p. 456.

17. Ibid., p. 460.

18. Roland Barthes, "Le Discours de l'histoire," *Information sur les Sciences Sociales,* 6, no. 4 (1967), 65-75; Fernand Braudel, *On History,* trans. Sarah Matthews (Chicago: The University of Chicago Press, 1980); Michel de Certeau, *L'Écriture de l'histoire* (Paris: Gallimard, 1975); Michel Foucault, *L'Archéologie du savoir* (Paris: Gallimard, 1969); Gérard Genette, "Frontières du récit," in *Figures,* vol. 2 (Paris: Éditions du Seuil, 1967), pp. 49-69.

19. Foucault, *L'Archéologie du savoir,* p. 171 [my translation].

20. *Archives Nationales,* AF[IV] 1049, dossier 2, p. 10. Letter from Jacques-Louis David to Estève, dated 13 floréal AN II.

21. *Bonaparte Crossing the Mont Saint-Bernard,* 1800. Signed "L. David." Versailles, Musée

National de Château (268 x 223 cm). Reproduced in The National Portrait Gallery, *Masterpieces from Versailles: Three Centuries of Portraiture,* exhibition catalogue (Washington, D.C.: Smithsonian Institution, 1983), p. 99.

22. San Francisco, The Fine Arts Museums, *The New Painting: Impressionism, 1874–1886,* exhibition catalogue (San Francisco: The Fine Arts Museums, 1986).

23. de Certeau, *L'Écriture de l'histoire,* p. 116 [my translation].

24. Foucault, *L'Archéologie du savoir,* p. 170 [my translation].

25. Braudel, "The Situation of History in 1950," in *On History,* p. 9.

48

Old, New and Not So New Art History

ARTHUR C. DANTO

We are living through times in which every concept that figures in the way we represent the practice of art, the meaning of "art" and "artist," and the institutional auspices under which art is taught, mastered, displayed, written about, paid for, and appreciated, is under intense and often angry discussion. Scarcely a term in those discourses, participation in which constitutes participation in the artworld at large, can be considered neutral or immune. Recently, for example, I wrote about a symposium on the concept of the masterpiece in which I took part. It was sponsored by a prestigious East Coast art museum, which had invited a number of hardly less prestigious art historians and curators to discuss a concept which each found some ingenious way of circumventing instead. Each wittily deplored the degradation of the concept, and each had a clever slide or two to demonstrate that the concept indeed has been degraded, and then, as if this gave them license to do so, each launched into a discussion of matters very distant indeed from anything one would have supposed relevant to understanding the idea we had been assembled to clarify. I was increasingly puzzled by this collective diffidence, for which an explanation came only with the final speaker—the only woman on the panel, and she well known as a feminist with somewhat radical views on the responsibilities of museums. Her first remark clarified everything: the concept, she said, sounded like "white male oppression." And she then went on to spoof the enterprise by showing works that she

admired and was prepared, on perhaps those grounds alone, to call masterpieces: works by women, Blacks, Hispanics, Orientals, or, if by white males, which made fun of high art. On the other hand, the other panelists—white, male—had also spoofed the concept by showing caricatures, depictions of monsters, fakes—that no one would have countenanced as masterpieces. And it became clear to me that as art historians and curators, indeed as privileged officials of central institutions of the artworld—departments of art history, major museums of art—these individuals must have by now been battle-weary veterans of such attacks, standardly targeted as oppressors; and their reticence on this occasion to discuss the concept directly, or perhaps any concept directly, reflected a defensive or evasive silence as the better part of valor. In truth, the concept of the masterpiece is a difficult one to analyze. But it is a mark of the present state of things that such inherent difficulties are augmented by the circumstance of having to address them under something like battlefield conditions.

To say that the masterpiece is a mode of white male oppression is in effect to say that the entire complex in which that concept has a place—the museum, the artistic genius, the entire apparatus of judging, grading, evaluating, and pricing—is a composite of privilege through which the white male is reinforced in his power through the systematic exclusion of other genders and other races. If the masterpiece, as a very concept, is an instrument

Lecture delivered at the symposium "The New (?) Art History" of the American Society for Aesthetics, held in Vancouver, British Columbia, in October 1988. © Arthur Danto. Published with permission of the author.

of power and oppression, and cannot be addressed save in terms of privilege and exclusion, it is then impossible to think of a concept pertaining to the institutional structures of art that will not be modified as part of this perception. The concept of the artist, for example, as someone to be judged in terms of a capacity to produce masterpieces, can hardly survive conceptual revision. But if "artist" is to undergo lexical transformation, so must "art," "artwork," and "art history." And if the words have their meanings modified, so must the practices, the institutions, society itself. Wittgenstein famously said that to imagine a language is to imagine a form of life. The activist corollary to this is: if you wish to change the form of life, change the language.

Against the background of this highly deconstructionist attitude, which defines so much of discourse and controversy in the humanities today, Thomas DaCosta Kaufmann's accommodation of what he perceives, but actually diminishes as "the new art history," is really a defense of a total discourse and a total form of life to which he contributes and from which he benefits. For it is the totality that is under attack. The issue is not to widen the canon to include works by women (for example), or to widen the curriculum to include courses in women's art—not even to appoint professors of women's art history to major departments in which they can supervise research and sponsor dissertations on women artists and women's art. Nor is it to open the agenda at professional meetings to include sessions on these topics. From the perspectives of deconstruction, all this is cooptation. So long as the discourse is left intact, the institutional structures, now making room for those who just recently stood outside as critics, in turn remains intact, and such measures as affirmative action and fair opportunity employment are but strategies for maintaining a status quo which remains insidiously oppressive if the larger criticisms are true. If they are true, then the adjunction of new courses, the modification of the canon, the waiving of requirements, leaves everything much as it was. And Kaufmann is absolutely correct in saying that there is little difference between the old and the new. The issue is not to enrich the discipline, but to change it.

The deconstructionist critique envisages a total transformation of art in every dimension, and virtually the emergence of a totally new structure even when the art is to be produced and described by men. Indeed, if women's art is discussed in the same terms used for the discussion of art in what we might just call "men's studies," nothing deep will have been changed at all. It will be truly new when, and only when, the way we think and talk about what men do is transformed. The new art history

envisaged, then, is one under which we bring to consciousness the power structures of the old, and the interpretations of works of art that those structures alone accept as licit. It is, in brief, a far more threatening challenge to the established order than any sense of the "new" would allow which can even in principle be assimilated to the "old."

Let me state this now in the light of what both panelists cite me as having written of art history as an "anaemic" discipline. I had in mind by this pretty much the sort of discipline which Professor Kaufmann characterizes near the beginning of his piece, descriptive of what art historians actually do: search for and discover documents; make and test attributions; analyze iconography; map styles in largely formalistic terms. These stand to the robust speculations Michael Podro presents in his important book, *The Critical Historians of Art,* in something like the way in which botany stands to biology—even or especially when botany is very refined and biology still pretty crude. Obviously this is unfair. "Critical history of art" was vague, sweeping, indifferent to detail, and embedded in metaphysics. But it really did set out to offer enough explanatory structure to quality as *Kunstwissenschaft* construed as an explanatory theory of art as art, to reveal what chiefly is wrong with "old art history:" the latter rarely thinks of art as something that needs explanation, and its practices act, institutionally, as a shield against speculation. To be sure, it is also a marvelous shield against hasty explanation. Someone anxious to explain El Greco's elongations as due to astygmatism might do well first to see to what extent some form of elongation might have been employed by artists in El Greco's milieu, not all of whom could reasonably be supposed afflicted by the postulated optical syndrome. Someone (I take the example from Leo Steinberg) anxious to use medical science to explain the represented symptoms of a sick woman in a Dutch painting of the seventeenth century might do well to see whether "sick" were not a euphemism for "pregnant," and investigate the extent to which there was an entire genre of ironic depictions of pregnant women feigning illness to conceal their true condition from trumped husbands or chaperons. Still, the nearest the old art history came to explanation was to seek for "influences"—a useful but limited causal concept. *New* art history undertakes to be explanatory.

Now there is, one might say, a distinction to be drawn between two sorts of New Art History, which we might think of as conceptually radical and conceptually conservative. The conservative variety is concerned with the explanation of art, as art is standardly understood. It seeks the causes of art in sources far more deeply present in the soci-

eties in which art is produced than the usual relationships of influence, which at best explains art in terms of art. Often, this will entail a widening of what old art history treats as iconography, namely, a widening of representational content. Thus the recent widely admired discussions of impressionism by R. L. Herbert and T. J. Clark go well beyond iconography in the usual sense, and deal less with symbols than with the attitudes toward common life of the people for whose sake the paintings were made. Or: the causes are reflected in the content. The stylistic analyses put forward by Michael Baxandall in his book on art in fifteenth-century Italy, refer us to the structures of patronage of that artworld, and the degree to which this is reflected in the work. In expanding causal explanation and thus expanding on the notion of content, the new art history expands upon and indeed enriches the domain within which the old art history was comfortable. And it can be assimilated with very little perturbation to the institutions in which the practice of art history has taken place in the past century. And this is so even if the practitioners of the new art history, so-called, are politically to the left, even by a considerable degree, of the old art historians, and see representations of class conflict and economic turmoil in works their colleagues analyze formalistically. A radical conservative like Hilton Kramer will see in the Marxist writings of T. J. Clark a threat to the public order, but, as is so often true of the Old Left, Clark fits easily into the institutions he criticizes. In any case, new and old, when new is considered in these terms, really are not more greatly different than Kaufmann says they are. New art history is conservative enough that it leaves the world of its practices intact.

But new art history in the wider or radical sense criticizes those very institutions in which old and new art history accommodate so easily to one another. I find Michael Marrinan's essay situated somewhere between the two versions of new art history. He tells us something about the causes and the content of Degas's work of cafe singers, and is in that sense explanatory rather than stylistic or attributional. But he is also engaged in something like the critique of institutions. Thus he cites Foucault on the archive as "the limit of what can be said," and as a device which "regulates the visibility of event traces" and hence how we conceive the history of art conceived of as composed of "art events." In controlling the archive, the museum in effect controls the past. Marrinan sees the museum as wielding "tremendous cultural power." Its power, indeed, is further strengthened through the links it has forged to "the wealthy, the privileged, and the politically empowered." The museum can in effect say (Marrinan uses the term *dictate*) "what a work of art is." Inevitably, it can "dictate" what "art history is" and who is an "art historian." So Marrinan sees old (and conceptually conservative new) art history as tied into the sort of complex a redefinition of the concept of the masterpiece must inevitably redefine. Art history is a form of power over the present, past, and future of art. There is something touchingly naive in Marrinan's faith that the "New art history will be written in historical institutes like those which nurtured Aby Warburg and Erwin Panofsky." Forgetting that the armies of scholarship march on their pocketbooks, this leaves untouched the question of how the very concept of history is itself up for deconstructive revision.

My own views are pessimistic or optimistic, depending upon where the reader stands. My sense is that the best the deconstructionist is going to get are changes in the curriculum, or in the canon, or in the employment profiles of the departments. Cooptation or not, it is human nature to take the bird in the hand. Moreover, it is one thing to use the rhetoric of deconstruction abusively and aggressively ("white male oppression") to get the bird into the hand. It is one thing, again, to talk about conceptual revision and another to achieve it. Our limits make conservatives of us all.

49

Showing and Saying, Looking and Learning: An Outsider's View of Art Museums

FRANCIS SPARSHOTT

Collectors sooner or later confront the problem of what to do with their collections. Even Queen Victoria, surely with more house-room than most, advised her daughter the Empress of Germany to go in for water-colors rather than oils because of the storage problem.[1] And for the heirs of collectors it is worse. What is one to do with all this junk? For it is highly unlikely that the legatee's taste in treasures will coincide with the legator's. It is equally unlikely that a purchaser can be found for a collection of objects that reflect one person's taste. On the other hand, it seems a pity to disperse what was painfully put together. And, as everyone knows, at any given time it may be impossible to find a purchaser for individual objects at anything like their appraised value. With collectables, buying and selling are clean different things.[2] Really the best solution is to preserve the collection for anyone who may be interested in it and, if possible, get some public body to take financial and curatorial responsibility for it. In this way, any cabinet of curiosities is a potential museum. And, since works of art are eminently collectable—it would be an exaggeration to say that eminently collectable objects are by definition works of art, but not a downright lie—museums generated in this way will often be, in whole or in part, art museums.

Historians and sociologists of museum culture often note that the word "museum" did not originally stand for any particular social, spiritual, educational, or other function, and still does not.[3] A museum is basically a collection of collectables that is in some way officially in the public domain. We have now seen part of the explanation of this: the collection comes first, its justification in public terms comes later. It will be one of my chief contentions in this meditation that that is just as it should be. There is absolutely no reason whatever why all museums should serve the same purpose, or why any one of them should serve any determinate purpose, so long as what is being done can be justified to whomever it has to be justified to. Of course, if governments, foundations, granting agencies, and other instruments under centralized control have to distribute limited funds among a lot of such institutions, and especially if their procedures are under review by watchdog committees and tax persons, they will need to establish a rationale of functions and priorities; and the people who first make a collection go public may (though they need not) ask themselves more or less explicitly what, other than disembarrassment, they are doing it for. But these ideological and bureaucratic necessities and conveniences do not in any way establish a hierarchy of purposes that all institutions called museums should be called on to serve, nor do they in any way support the notion that there is or should be a functionally defined institution, "The Museum," with a determinate part to play in public life.

What we have been talking about hitherto is an initially private collection that goes public. But some collections are, in a sense, public from the

From the *Journal of Aesthetic Education*, 19 (1985), pp. 63–78. Reprinted with permission of the *Journal of Aesthetic Education* and the author.

beginning. Already in ancient Greece the treasures and artworks dedicated at Delphi formed a tourist attraction as much as an ethnic shrine, a museum or set of minimuseums in which the rival cities presented to each other emblems of their glory. In modern times, nobles and kings housed their collections, in many cases their loot, in palaces and mansions that were from their origins in a sense public. From their very scale it was obvious that they were not to function as residences but in some public capacity: declarations of magnificence, local government offices, waystations on royal progressions, redoubts for or against banditry. And, from the beginning, it was understood that the treasures they contained were no more for the delectation of the proprietors than for display to the right sort of people, who might be fellow gentry, or connoisseurs and historians, or simply loyal subjects, depending on circumstances.

The massive rearrangements of collectables that accompanied Napoleon's success and his subsequent failure bring the foregoing notion into sharp focus. It becomes the notion of the national museum, in which the nation's loot and lootables are made available to everyone, to encourage nationals and impress foreigners. As before, much of this material is classified as art. The places where it is housed and displayed are, or replace, royal palaces and mansions. Especially in the United States, where one strong tradition of thought has always insisted that a democracy can do anything an aristocracy can do and do it better, art museums are "palaces for the people": the great civic and national museums of the world are palatial in style and significance, if not in origin, and this is part of their point.[4]

Our last paragraph casually added civic museums to national museums. Once the idea of the museum becomes established, every self-respecting city has to have one. It becomes part of the great sequence of signs of civic status, like a symphony orchestra or an opera company or (at the lower end of the scale) a speed limit and a traffic light.[5] As the traffic light symbolizes both enough prosperity to generate crosstraffic and enough sense of order to want to control it, so the symphony orchestra symbolizes both the passion to perform Beethoven and the ability to muster enough musicians to do so; and the civic art museum symbolizes enough culture to know what is collectable and enough money to collect it—or, perhaps, even better, the presence of citizens who combine such power and taste with enough civic sense to adorn their city with the proceeds. So it is that as American towns in the nineteenth century achieved a certain size and self-consciousness, each would establish its own art museum. And each art museum should contain a work by each of those painters by whom, at the time, the status of painting as a noble art was symbolized—notably Van Dyck (associated with King Charles I of England) and Raphael.

The sketch I have been presenting is of course a caricature, an "ideal type." As we read the accounts of these typical collections, each with its specimens of the Great Masters based on the most optimistic of attributions, we may be reminded of similar accounts of medieval ecclesiastical establishments, each of which would have its relics of the same few major saints, and of course a piece of the True Cross. What put an end to that business was documentation, the development of an overview of world holdings, which revealed just how much timber the True Cross would have had to contain and how many knuckles Saint Whatever would have had. Similarly, the development of catalogues of works of the great painters made it impossible for a painting to function as "our Veronese," since it had now to be related not only to the other locally available paintings (than which it was indubitably more Veronese-like) but to the paintings elsewhere that claimed the same origin with their own different degrees of historical and stylistic support. Thus the local art museums find themselves thrust ineluctably into a new context, the museum world.

People value things because they are good, or beautiful, or useful, or amusing; or because they are their own. The museums we have just described came into existence to lay claim to a past that was not their own by natural inheritance. But there is a quite different sort of museum of which the intention is simply to confirm the present of a community by laying hold of its past. Such museums are related to private keepsakes as the others are related to private collections. Their point is to lay hold of one's identity in changing times. An old lady once told me that the organ in her parlor ought to be in a museum—it had been the first organ in the county. Such museums are not art museums: if they contain any art at all, they do so incidentally, if for instance an artist lived in the neighborhood and left some residue.

But, after all, the museums that enshrine our old refrigerators are not so different from those set up to enshrine art. The practice of art, and the works of art that our civilization has agreed to esteem, are part of the heritage of the present dwellers of a western town no less authentically than the works of their own ancestors, and little less so than the exploits of their own youth. The suspect "Vandyke" stands for the tradition to which the citizens have a right. And it also stands for Art, the product of creative imagination, the timeless and placeless condition of contemplability.[6]

It appears from the foregoing that museums may

enshrine any or all of at least four quite different impulses and origins. There is the problem posed by the sheer existence of a collection that has lost its collector; there is the desire to display the opulence, acquisitive power, and magnanimity of the proprietor; there is the urge to lay hold of a personal past; and there is the urge to stake a claim in the values by which one's civilization purports to define itself. Three of these four urges lead directly to the formation not of museums in general but of art museums, or of museums largely devoted to art. None of them requires any direct interest in art objects for their own sakes, such as may animate some collectors. But we may suppose that unless such an interest did exist in a passionate and discriminating form, art museums could not serve the purposes they do serve.

The foregoing discussion suggests that art museums have their own dynamics. They come into being to respond to diverse needs and presumably continue to respond to changing needs. In a way, this is recognized; there are recognized taxonomies of art museums (Meyer in *The Art Museum* lists seven main types), depending on the nature and origin of their holdings and their relations to communities and organizations. But I am not sure that the usual treatments are adequate. They seem to suggest that there is a genus, the art museum, with species and subspecies. But is that quite right? It is true that, for instance, medical schools, and to a lesser extent universities, form genera within which differentiation represents variation on what has for very good reasons to be a single function or set of functions. It is not clear that anything like that is true of museums. It is not clear that, because the word "museum" has come to be applied to collections of collectables that are accessible to some public or other, the word should therefore be taken to designate a single type of institution with common standards and functions, of which certain standard demands are to be made, and of which it is accordingly relevant to ask whether what it does differs from what is done by other institutions of great wealth or power, or what is demanded by officials responsible for such collections. When we read that a certain great museum-minder has trained up others in his own likeness and sent them out across the country to Do Good to less enlightened museums elsewhere, we feel that in a way this is wonderful—how splendid that such taste and knowledge shall be available where hitherto the fads of someone's arty cousin prevailed. But there is something horrible about it too, as with slum clearance. The dirt and the overcrowding were shocking, but is it right to replace them with something unrelated to the real pressures of life, some high-minded official's idea of how people ought to behave? Art museums,

we may feel, are beginning to look more like each other than they have any need to. They look like the kinds of places the people who run art museums like and are liable to infestation by those singular pests, art-museum artists, who have discovered how to simulate the aroma of the preys that museum directors find especially delectable. Such doubts seem paranoid. But there was a case recently that was reported in the public press (rightly or wrongly) as follows. There was a well-established collection of paintings, established by a friend and sponsor of the artists who had painted them and kept in his family, though open to the public and now maintained through public financing. The member of the family who was now curator was not, however, a trained museologist and did not follow the approved conservation practices; so the government muscle-men moved in and decided to put things right, removing the family members in the process. On this occasion it was obvious to everyone that something very horrible indeed was being done, whatever the technical shortcomings of the museum, and the reformers had to back off a few inches. But that was because of the personal relationships involved. The priorities appealed to were not themselves challenged. Why not?

What we said about the diversity of art museums, the lack of any overriding concept of the museum as a functional institution, and the consequent absurdity of thinking in general terms about The Art Museum—an absurdity, by the way, that seems as characteristically and distinctively American as The High School Marching Band—seems plausible only while we think historically, that is, conservatively. If we think functionally, we see at once that the requirements of Art Museum practice are strict and not to be evaded.

We began with the notion that works of art are treasures, consigned to the museum for keeping and for sharing. Since the first requirement is that they be kept, conservation is the inescapable prime responsibility of the museum; hence the spiritual agonies surrounding the need for deaccessioning, a *rite de passage* consequent on the fact that not everything can be kept and what seems worth keeping varies from time to time. Hence, too, the embarrassments surrounding the acceptance of collections on condition that they be kept intact (a limitation the original collector would certainly not have imposed on himself), a condition that sets against the duty of conserving a treasure the rival duty of conserving a concept—a duty which nevertheless cannot be lightly rejected, since as we have seen the preservation of collections is one of the fundamental tasks for which museums are called into being. Conservation clearly requires control of light, temperature, humidity, airborne particles, physical con-

tact, and such other factors as from time to time may be found relevant.

But conservation of what, exactly? Is an object consigned to a museum to be preserved in the condition it was in when it came? Or allowed to continue the gradient of physical decline to which it was then committed (so that a picture from a club room must continue to be smoked at)? Or is it to be subjected to whatever curatorial processes history may from time to time bring into favor? These questions are not, as they look to be, idle or frivolous, but are of fundamental importance and difficulty. A defensible solution must be found, because a museum has actually to treat its holdings in some definite way. And the solution comes from the same quarter as the problem. Treasures are in museums to be preserved. But why? Why are they treasures? Perhaps because of their historical importance, in which case they should be treated in a way that respects that in them which was historically important (Ibsen's study as Ibsen left it, not as Ibsen found it); perhaps because of their technological significance, in which case they are to be kept in evident working order. But our present concern is with *art* museums. So the treasures are art treasures and must be conserved in their artistic significance. But what does that mean? The idea of art is both vague and complex, so that an art museum's proper interpretation of its curatorial function will change from time to time (and from director to director), but for present purposes it is enough to say that a work of art is considered and treasured as the visible expression of the creative act of a creative mind: as enshrining an artistic intention. The work must then be preserved in, or restored to, a condition as close as possible to what the artist must have intended. Except, of course, that the artist may not have intended his work for a museum, but for a church altar; but we get round that by saying that the specifically artistic or "aesthetic" intention was only for the work to be accessible to perception in a certain form. It may be objected that this supposed limited aesthetic intention is really nothing other than what the artist would have intended had he meant his work to go straight to a museum, so that in restoring and conserving the museum is actually doing something that can best be called making the work museum-worthy; but that is a bit harsh. We can easily suppose the artist passing aesthetic judgment on his altarpiece, showing it to his friends, and so on, before it left his studio (or as if it had been in his studio), and anecdotal art history is replete with such judgments (together with acknowledgment of their preemptive significance) from the earliest times.

The same argument that tells us that conservation is the prime function of the art museum shows that display is its secondary function.[7] Accessibility and visibility conflict with conservation, sometimes (as in the cave at Lascaux) drastically. Access for spectators may be access for vandals; light enough to see by may be too much light for delicate pigments. This raises practical problems rather than issues of principle: obviously there must be a trade-off, and various solutions and compromises will be tried. But what counts as visibility? Are works to be presented as in isolation or in groupings supposed historically or thematically relevant? Is a nineteenth-century Swedish expressionist watercolor portrait to be placed by period, by nationality, by medium, by genre (in the portrait room), by stylistic affinity, by its color scheme, by its immediate provenance (in the company of the rest of the collection it came with, or whatever), or simply wherever there is room, on the ground that as a pure creative achievement it must be considered in isolation from all else? Different interests in different spectators will call for different comparisons: which interests should be facilitated by collocation, which will require peregrination? No one answer, or set of answers, has preemptive force. Perhaps we can say at least that, whatever the context of display, the building itself should offer neither competition nor comment, since after all its sole function is housing and display: if it is pointedly palatial, its palatiality should be effective elsewhere than in the display galleries.

It seems, then, that our initial pluralism was wrong, that the diversity of reasons for there being art museums is overcome by the stringent and uniform demands of the museum situation itself. But is that really the case? Are these museum values, just because they are necessary, necessarily preemptive? There is no reason whatever to think so. There has been a tendency in recent years to speak and act as if it were socially and morally wrong for works of art to be treated otherwise than as objects for conservation and display in museumlike conditions. There should be no art where people live, it seems, because life can get rough. But even if we reject as a piece of typical twentieth-century bureaucratic humbug that all art should be in museums because only museums know how to look after it, we may want to say that at least it is obvious that museums should be governed by museum values. Well, in a way it is obvious; but in what way? It is like saying that every heir to a fortune should preserve and augment it: that's why it was left to him. But in fact we shrug our shoulders at spendthrift heirs.[8] Somewhat similarly, we might mitigate our indignation at those art museums that lose their holdings, fail to affix burglar alarms, let in the damp and the beetles, and in general commit every sin that museology defines. Fetishism and idolatry are wonderful

things, no doubt, but we may be surreptitiously grateful that casualness occasionally takes over.[9]

Thus far, we have said nothing about education and have seen nothing to suggest that art museums have anything to do with education. Why should they, indeed? The collocation of concepts is puzzling. Two things are indeed obvious. First, a knowledge and discriminating love of at least some art is a necessary condition of an educated person, and art museums are always among the chief and may often be the sole means to such knowledge. From this point of view, the connection is too obvious to be worth mentioning. The other obvious thing is that schools of art or of art history are likely to form collections of art as teaching aids or as byproducts of their work, so that we expect a flourishing art department to have what is in effect (and may be in name) an art museum attached to it. But that too is hardly worth mentioning. To see what makes it worthwhile to make a topic out of the relation between art museums and education we must go further.

Two things come at once to mind. First, we are raising this question in the context of the New World, in which, as we have seen, the materials of civilization are something to which a claim must be actively laid. Culture is something you do at school and, unless you are odd, nowhere else (but of course you are likely to be at school for a very long time).[10] Art museums are places that schools visit. Presumably, when things have settled down, if they ever do, the association of art with the student condition will weaken; but in the meantime we have to keep working at it. The other thing that leaps to mind is the curious situation that obtains, or used to obtain, in the United States, where (under the Tax Reform Act of 1969) the tax people distinguish between museums on the one hand and charitable and educational institutions on the other. The rationale must be that a museum, as such, is merely a place of recreation. Every responsible museum minder is therefore faced with the task of showing that his bailiwick is a bona fide educational institution within the meaning of the law; and, if necessary, making it become so, even if in the process it becomes something a museum never was before.

Contributors to this discussion who are not citizens of the great republic in question may be inclined to disavow this problem as a purely fiscal one, to be dealt with by subterfuge on the part of its victims rather than by rational argument on the part of the international scholarly community. But that would be short-sighted: tax people, like police forces and pornographers, are quick to pick up each other's most debased practices.

It has long been recognized that some public services are better provided by private choice. In modern societies with enormous tax loads, funds for benefactions to education, charity, art, and so on, are "tax exempt"—but part of what that means is that the taxes of the rich are paid in the form of "liturgies," public services. The system has much to be said for it. Our question now becomes: this being so, why should gifts to museums, in some jurisdictions, not be in the most favored class of liturgies? (It is useless to ask why they are not so in fact; governmental processes resist examination.) Four answers suggest themselves. First, the art market is a racket; art prices reflect speculative pressures in the light of rarity, not any social or aesthetic benefit, and the world of art dealing is as shady as that of financial manipulation. Second, no test of good faith or competence in artists or their clients exists or is possible, and the public purse cannot underwrite leaps of faith otherwise than through the approved procedures of its own agencies. Third, the kind of people who write tax laws (and, more notably, the kind of people who write and interpret the detailed regulations) know no values but those of accountancy, distrust and dislike art, see in it no ponderable good. And fourth, the elected people who are answerable for the tax laws expect the voters to object less vocally to public recognition of education and charity (which after all anyone might need) than to that of art (which no one needs).

The reasons given are doubtless sufficient. But what is to be the rationale? I have suggested that it must be that art merely entertains and does not enlighten; that making art available to the people has in itself no cognitive value. But that position is ludicrous. What other means have we for training perceptive discrimination?[11] The only tradition of thought in which appreciation of art is excluded from education and educational values is that which would equate education with vocational training; and that tradition, however powerfully it controls some practice, is not publicly viable.

One has to suppose that an educational institution, for tax purposes, is one in which things are done to people; in which people do not just look at pictures but are processed. They are hung about with cassettes; they are lectured at, in busloads, by earnest persons who tell them what they should look for and (especially) what they should not notice. Preferably, this should be done to school children in school hours; in that case, it is *certainly* educational. The test for education, then, is that what takes place should not respond to the individual's personal rhythm, should not be a matter of personal discovery, but should be imposed on the individual, preferably as part of a curriculum.

I am not suggesting that it is bad that a museum should do these things, grotesque as they are. They are as useful as they are grotesque. Like all school-

ing, they open doors through which the schooled may enter, even if very few of them will do so. One can, after all, go back to the museum, once it has been opened up to one, and follow one's own rhythms and hunches. One may even be encouraged to do so. And now we may say that an art museum is an educational institution in a special sense insofar as it offers active initiation into itself for those who feel themselves to be (or are felt to be) uninitiated. It would not be unreasonable for taxpersons (especially in such a society as we described when speaking of the rise of civic museums) to offer inducements to museums to undertake such initiatory functions, even if we believe that what the initiation should lead to is itself educational in a profounder sense, and even if we do not think such initiation is among the primary functions of an art museum as such.

I recently attended the oral examination of a Ph.D. candidate in psychology. His topic had been an aspect of aesthetic appreciation. His subjects had been seated in an environment as neutral as possible and confronted with slides of oil paintings, each exposed for five seconds with a few seconds interval. The candidate was asked if these conditions were not inimical to artistic appreciation. He replied, without a trace of irony, that these were in fact the conditions in which works of art are normally viewed. An art museum, like his lab, is a carefully neutral environment, with its oatmeal-colored walls; and in museums, which is where people mostly see paintings, what they mostly do is walk past them, looking at each one for a few seconds and taking a few seconds to move on to the next. The candidate, it must be emphasized, was not only an intelligent man and a good scientist with a good knowledge of painting, but himself a professionally trained and practicing painter. And what he said was, of course, entirely true. What it means is that the "educational" method of exposure to paintings is that into which we are indoctrinated: we are not just introduced to paintings in our museum tours, we are introduced to a specific practice of picture seeing. But the practice we are indoctrinated in is one that has little to do with that of people who live among treasures they have collected and preserved.

I spent an hour and a half in the Louvre, in 1949, on my only visit to Paris. It was that or nothing. What can one do, when one passes through a city once only? A quick walk round to see what there is, then go back to dwell on what caught the attention as probably rewarding, until time or visual energy runs out. One is necessarily a tourist in many more places than one inhabits, so that one sees what is in their museums as a tourist or not at all. Why, then, do persons of superior refinement, professionals of the art world, sneer at tourist methods of seeing?

What do they propose instead? If their own practices are different, what are they, and how are they financed?[12] The Ph.D. candidate was right, and right not to be ironical: most pictures must be seen in that way or not seen at all. One is, indeed, tempted to say that if one never sees any pictures in any other way, one might as well leave pictures alone altogether; but even that may not be true, though I will not argue the case here.

Almost everyone lives somewhere, and most people have places where they visit, so that for many people in a museum-forming culture there will be at least one museum to which they can return and with some of whose contents they can become familiar. In such a museum for such a person things have their cherished places. In my home museum (not an art museum, though I dimly recall dark portraits of defunct worthies on the walls), as a child, one revisited the tusk of the Upnor Elephant, and the Dickens memorabilia, and the mantraps in the tower room, and the objects and their places were bound together by a special scent (now lost forever) of polish and preservative. Some years later, the National Gallery in London (happily close to the station that took me home) became another such place, in which favorite paintings could be revisited where they belonged. For such a visitor, a museum becomes a sort of shrine, and the beloved paintings in their familiar niches acquire just such an aura as Walter Benjamin complained museums and reproductions deprived them of. Such a use of museums is not, presumably, "educational" in the narrow sense: the knowledge of painting and paintings that it brings is not sufficiently abstracted from the enhancement of life, the aesthetic and historical meanings of the art object not divorced from the deepening experience of getting to know the picture better as it greeted one from the place it had always occupied. Most of what I read by museum people suggests that they are not prepared to countenance such a use of the art museum. I don't know why not, unless they have learned all they know about museums from museology courses.

For such persons as we have been considering, there are at least three kinds of Art Museum: the local, the occasional, and the place of pilgrimage. They stand for three kinds of value: the familiar, the serendipitous, the ideal. (Cutting across these are the road-show exhibitions, which again are of three kinds with three values: the local son or daughter, the ad-hoc curiosity ["Quattrocento Precursors of Giacometti," and such like], the international blockbuster.) To put it another way: my local museum has examples of different sorts of paintings: if I want to know what painting is and has been, I can go there and get an idea. But if I want to know what the limits of achievement in painting

are, I must go to one of the great museums. I need not go to them all, unless I am in the trade; but I must go to some. However, if I confine myself to my hometown and the centers of pilgrimage, I miss something: the diversity, the surprisingness, even what has been called the goofiness, of art.[13] The little museums house all sorts of astonishing objects the big museums have no space for and the histories of art are too high-minded to mention. The pursuit of excellence is a noble pursuit, but quality can mean mainstream; good taste and orthodoxy can be favored to a point where the whole idea of art becomes radically corrupted. We learn from the diversity of museums, even though the exemplification of crankiness and oddity is not an objective that a museum director can well justify to his governing body.[14]

It now sufficiently appears that merely by displaying their normal holdings, art museums perform an intricate educational function in revealing the scope, the variety, the substantial nature, the rootedness, and the universality and possible achievement of the art of painting; and that an important part of this function is performed not by each museum severally but by the variety and distribution of museums and their probable relations to their visitors. An important supplementary function is performed by the ad hoc exhibitions to which art museums act as host and in the preparation of which they nowadays often collaborate. What these exhibitions do is display works in significant relationship. Illustrated books do the same thing, of course, but not always to the same effect. For instance, a retrospective exhibition of the work of Paul Nash revealed to me as a young man something that a book devoted to his work had not: the actual scope and real limits of Nash's work as a painter—and hence, more generally, the very idea of a painter's oeuvre, of what being a painter actually amounts to. Nothing replaces the confrontation with an individual artist's work as a simultaneous entirety. (The exhibition need not of course be temporary and travelling; it may be a permanent part, or even the whole, of a museum's holdings; but the temporary display is the norm.)

The fact that an art museum, by being what it is among other museums, performs an important and distinctive educational function does not mean that it is inappropriate for it to perform services more explicitly associated with education conceived as a schooling process. And the fact that education is neither the primary nor the secondary function of an art museum as such does not mean that it should not absorb much of a museum's energies and budget, regardless of the tax laws. It often happens that the most important things take least time and energy, because they are easy or self-regulatory or not under one's control. It is in principle possible that the basic tasks of conservation and display should need little attention, while quite peripheral tasks take up most of the staff's time and tax their ingenuity. It is certainly quite conceivable that a museum's energies should be properly concentrated on an educational program, acquisitions and temporary exhibitions being ruled out by current price and insurance levels and the problems of conservation and display being solved for the time being within the limits of available resources and brainpower. What such an educational program should actually consist of is something on which my opinions are worthless, since it is what education officers of art museums work on full time. A philosophical journalist can only, at best, suggest some ways of coming at the intelligible context within which their practice can be thought of as operating.

What, then, can I ask of my art museum? As soon as I ask the question I realize that such a museum is indeed a center of art education. Why? Because no place else is. The thesis that art education is not among the defining functions of a museum holds water only if some other institution is performing that function. But where else could I go to learn about the visual arts? If there is a local art college, or a university with an art department, I could go there, but such institutions are thinner on the ground than art museums and not oriented toward us members of the unmatriculated public. The public library will do what it can, but that will be little, since the library has to be all things to all people and consequently not much to anybody.[15]

First and foremost, I want my museum to show me what painting is—simply to have real paintings in it (I confine myself to painting just for brevity's sake: the same argument goes for engraving and sculpting, though building and bookbinding raise problems that are as easy to see as they are hard to explain). I hope it will show me examples of paintings of different times, places, and styles, so that if I read or hear about vorticism or whatnot I have at least some chance of seeing at first hand what sort of thing that is. I hope there will be at least some examples of really good painting, so that I can see not only what painting is, but why people take painting seriously (or so that, if I can't see that, I can be sure that there is something worth knowing about painting that I don't know yet; which I could not learn from a roomful of kitsch or dreck).

It is obvious that the function of providing examples of lots of sorts of paintings can be only imperfectly fulfilled by most museums, and more and more imperfectly as museums multiply and obtainable paintings get rarer and dearer. So I certainly hope that my museum will do the next best thing, maintain the biggest file it can of slides of represen-

tative works. Slides never look like paintings, of course, but at least since the invention of engraving almost everyone has known more paintings at second hand than at first hand: artists have always sought in the work of other artists a repertory of formal and thematic inventions no less than samples of painterly quality. One would think, then, that every art museum would maintain for examination by the public, as a natural extention of its holdings and with a content complementary to them, a large collection of slides. And perhaps they all do.

If I hope that my museum will show me examples of what I already want to have visual acquaintance with, it seems reasonable that it should also perform the converse function. When it confronts me with examples of something, it should help me to learn what the examples are examples of, what specific needs for visual cognition they would satisfy if I had those needs. So I do want catalogues, guided tours, and the rest; and, for the "good painting" requirement, which most museums can fulfill only in the sketchiest way, I hope there will be access to lectures, movies, books, and so on which will speak to the museum's aspirations as well as to its actualities, offering to tell me about what they would like to show me if they could get it.

If I am from out of town, there is something else I would like. My visual memory is very imperfect, and a week or two after seeing something that has impressed or moved me I retain only a vague recollection of its look. How nice it would be if I could be sure of easily and quickly getting, of any such object, some sort of photograph that would refresh my memory of its precise look. Museum people I meet at parties sneer at me when I say this, apparently because reproductions are for peasants (or for Serious Scholars, who can Arrange to have the Work Done).[16] But it surprises me that it is not a matter of course that such reproductions would be always available were it not for the expense and the storage space required.

Is there anything else I ask? Many things are possible, but nothing more seems to follow from the lines of thought started here. In particular, the relation between museums and the actual work of producing what they contain remains obscure. The museum as displayed collection really celebrates the transformation of works of art from operation to object, the divorce of the work from the worker. To associate the museum with the production of art is to confuse all relationships. And yet we know that some museums (especially, of course, museums of contemporary art) do enter into institutional relations with artists, and that artists often denounce museums for falsifying the nature of art by severing the vital link between painter and spectator. And if we follow our previous line of argument, according to which art museums take on complex educational and archival functions because there is nowhere else for people to go if they want to know about art, we can hardly deny that the "knowledge of what painting is" is principally knowledge of what painters have done, and hence of painters as they continue to do it. My sense of the matter is that painters and museums should deal at arm's length, if at all, and that a world in which museums exist for art that is made for museums is one in which both art and museums have lost much of the point they used to have. This is because the decision to conserve, originally fundamental, is not appropriate until the object on which it is directed has been produced, chosen, and considered at leisure. But the issue is not an easy one.

There is one more thing I ask of my art museum: that it shall appropriately welcome me in whatever appropriate capacity I come to it in. And this is something the management of a museum may have little control over. If too many people come, the staff becomes flustered and snappish; if too few, bored and resentful. But it is useless to go to a museum in which one will be too harried or too indignant to adopt whatever appreciative or inquiring stance is essential to one's proper business there. My only visit to one of the world's great museums was made at a bad hour of a bad day (but the only time I had) and left me bewildered by the snarling frustration of the exhausted personnel. Poor people, it was not entirely their fault.[17] But I will never go back.

Notes

1. "Amateurs never can paint in oils like artists and what can one do with all one's productions? Whereas water colours always are nice and pleasant to keep in books and portfolios. I hope, dear, you will not take to the one and neglect the other!" Roger Fulford, ed., *Dearest Child: Letters between Queen Victoria and the Princess Royal, 1858–1861* (London: Evans Bros., 1964), p. 178.

2. For many relevant examples, see Francis Haskell, *Rediscoveries in Art* (Ithaca, N.Y.: Cornell University Press, 1976).

3. Karl E. Meyer, *The Art Museum* (New York: William Morrow, 1979), p. 13, notes that in many cases a museum building has been begun and public funds committed without any consideration

of the purposes to be served. That may not be so bad a thing as it sounds, provided that the promoters are willing and able (in Meyer's words, ibid.) "to distinguish legitimate claims on the art museum from spurious and self-serving ones," a task that does not necessarily require that one be armed beforehand with a schedule of acceptable aims.

4. See Nathaniel Burt, *Palaces for the People* (Boston: Little, Brown, 1977). Burt's book was disparaged by reviewers as gossipy and trivial, but there is much to be learned from his sharp-etched treatment of the spread of art museums through America. The idea of a people's palace, by the way, seems to have its limits. The day I visited such a palace in Philadelphia, the only way in was through a mean little hole at the back—a Tradesman's Entrance if ever I saw one. I would like to think that repairs were taking place and that the populace is usually admitted through some more seemly portal.

5. For the rise of the symphony orchestra in America, the specific purpose of which was to play Beethoven as symbol of music greatness, see John H. Mueller, *The American Symphony Orchestra* (Bloomington: Indiana University Press, 1951).

6. Sherman E. Lee, *Past, Present, East and West* (New York: George Braziller, 1983), p. 22, claims that the development of the *Wunderkammer* into art museum as a place exclusively for pictures reflects the sense that paintings embody a superhuman skill. Germain Bazin, however, in *The Museum Age* (New York: Universe Books, 1967), p. 160, attributes this high valuation to a later development, the admission of the general public in the postrevolutionary era into galleries where only connoisseurs had been allowed before.

7. Lee, *Past, Present, East and West*, p. 24, gives the functions of the art museum as, first, preservation; second, exhibition; third, research and education.

8. Attitudes in these matters differ profoundly. Since writing the above, I find Isaac Disraeli writing in an article on "Whether allowable to Ruin Oneself?" (*Curiosities of Literature*, vol. 3 [London: Routledge, Warnes, and Routledge, 1859], pp. 400–408), protesting against this tolerant view of "that wastefulness, which a political economist would assure us was committing no injury to society! The moral evil goes for nothing in financial statements."

9. I have argued for this position elsewhere—"Why Artworks Have No Right to Have Rights," *Journal of Aesthetics and Art Criticism* (1983):5–15.

10. Remy G. Saisselin argues, in a preface to Lee's *Past, Present, East and West*, pp. 11–12, that it is only in America and not in Europe that art is thought of educationally rather than historically. The dominant males in America being managerial and bureaucratic rather than aristocratic, art becomes the province of women's organizations and the educational system, and its only natural habitat is the museum as part of the latter. With deference to Saisselin's authority, I would suggest that this attractive picture is supported neither by Burt's circumstantial account of the development of museums in America nor by Haskell's account of public debates about the function of art museums in Europe (*Rediscoveries in Art*, especially pp. 93–94). One does not need to be an aristocrat to see that the development and exercise of a taste for fine paintings (as of fine vintages, but more so) is proof positive of great wealth and sufficient leisure. The tendencies that Saisselin singles out are real and striking but not everywhere operative.

11. The point is made with characteristic trenchancy by Nelson Goodman in his "Foreward" to Lee's *Past, Present, East and West*, p. 17; that the significance of art is primarily cognitive has been one of Goodman's favorite themes for a long time.

12. What usually happens when a museum director wants to see something in a museum not his own? Does he walk through the public entrance like the rest of us? Or does he phone old so-and-so and drop in for a friendly chat? If he always does the latter, it may be a long time since he has seen a museum as the world sees it. But there is something very puzzling to the layman in the way experts talk about famous works of art, as if they had studied them closely. How did they manage to get even one good look at, for instance, the ceiling of the Sistine Chapel? Some viewers of Lord Clark's famous television series on "Civilization" were struck by three things: first, the splendor of the monuments; second, the way Lord Clark invariably walked onto the scene; and third, the fact that there was never anyone else around (except, of course, for the invisible technicians).

13. For this last quality, see Francis B. Randall, "The Goofy in Art," *British Journal of Aesthetics* 11 (1971):327–40.

14. On this issue there is at least a difference of emphasis, if not a downright disagreement, between my two chief witnesses, Francis Haskell and Sherman E. Lee. Lee writes (p. 24) that the museum's commitment must be to preserve the best of the past, on the basis of a developed connoisseurship. Francis Haskell, however, noting that the development of connoisseurship depends on expo-

sure to the relevant materials, complains (p. 94) that "the museums of the nineteenth century failed in their duty of giving the public an opportunity to make up its own mind about Taste" and adds that today's museums are similarly guilty when they keep in storage any pictures that do not meet textbook specifications. Lee might almost be interpreted as saying that it is the museum's duty to *prevent* the public from making up its own stupid mind about taste. Perhaps he means only that the developed connoisseurship should single out the works of finest "quality" in each genre and period (since one cannot keep everything); but the effect even of that apparently impeccable advice would be to distort our picture of art history by concealing the facts about what the painting profession was up to at a given time. I have suggested in the text that the apparent impasse is resolved if we say that it is appropriate for different sorts of art museum to assume different obligations. Lee and Haskell both write as if each museum severally had the duty of performing all the functions of "The Art Museum," so that what cannot properly be done by everybody should be done by nobody.

15. Sherman E. Lee (p. 63) warns that a museum that takes on too many functions risks merely dissipating its image and energy: in advanced societies, institutions should be differentiated. Who would deny it? But if in fact there is no one else to do the work Lee shrugs off, it won't get done, so hard choices may be forced on one.

16. I am not myself a Serious Scholar in the required sense, in that I am not a professional art historian. If I were one, I would certainly expect that a museum would offer me all needed facilities for my research insofar as that concerned its holdings, by allowing access and by making photographic documentation available. My impression is that art museums are good at this, since they are staffed by people who understand and share scholarly interests. But I am given to understand that there are exceptions to this rule.

17. Since this text was written, a friend no less devoted to museum-going than myself has spontaneously made, in conversation, the same complaint about the same institution, but without reference to the difficult season. He ended by advising me to avoid the place, despite its wealth, unless there was something special I needed to see. As the final sentence of this essay records, I had reached that conclusion for myself.

50

Exhibits and Artworks: From Art Museum to Science Center

HILDE HEIN

We used to hear that April is for lovers, but *The Boston Globe* (March 31, 1987) calls it "Museumgoers' month," a testimonial to the growing role of museums as popularizers of culture. The increase in museum attendance is well documented, and, more notably, everyone seems to be enjoying them: yet there is a certain unease, not least within the museum community itself, concerning what is or should be exhibited in museums and how properly to experience it.

As public institutions, museums are only two centuries old, but as this century draws to a close, we are coming to depend on them not only to preserve the inherited culture of the past, but to define the present and to articulate a sense of it that can be transmitted to generations of the future. We look to museums, as we do to television and other popular media, to collect and display the complex features of our own world and to make them accessible to a public that is both diverse and inextricably integrated.[1]

Once the domain of the private collector and the educated connoisseur, museums now draw the same crowds as department stores, amusement parks, and beaches, and for much the same reasons. People go there to get information, to be entertained, to shop, to eat, and to socialize with friends. They do not necessarily arrive with a specific agenda in mind, but they tend to expect an assortment of gratifications, including a secure recreational environment that accommodates all age groups, a degree of comfort that is refreshing, intel-

lectual stimulation that is not boringly didactic, and a sense of spiritual well-being. Museumgoers have set aside a few hours, on the average not more than two to three, to spend alone or with designated companions in a hospitable environment where they can be edified and experientially touched.[2]

Some people still approach museums with a sense of awe, regarding them as a sort of shrine to genius and high culture, but this attitude is rapidly disappearing as the halls of even the great palaces of art are filled with courting couples, troupes of boy scouts, baby strollers, weary tourists, and inspiration-hungry art students. Newer museums, following the "user-friendly" trend set by churches and banks, are striving for a nonintimidating atmosphere. They are now designed to offer smaller, more intimate spaces than the palaces of the past and greater tolerance for "hands-on" interaction with objects displayed, and they provide audiovisual aids and tour guides to make the work exhibited more accessible to its audience. The democratic spirit signaled by the opening of the Louvre to the general public in 1793 is finally beginning to be realized, although the price of entry that museums are increasingly forced to charge is still keeping out a large segment of the population.[3]

Another element in this "democratization" of the museum image is the proliferation of kinds of museums. Museums are not only more numerous and more widely dispersed than ever, making their collections available to more population centers,[4] but there is also a greater variety of things exhibited

Published with permission of the author.

in museums. Anything from birth control devices to funerary practices, or from quasars to town meetings can be shown in a museum format. What is needed is only a strategy for making the subject concrete enough to be perceptually accessible. Thus, museums are springing up to inspire local pride, to acquaint people with new and old technologies and industrial processes, to provide political education and health information, to warn of environmental hazards and the risks of self-abuse, to sensitize people to various private and public tragedies, as well as to carry out the more traditional purposes of glorifying works of art and celebrating great achievements.

Creating a museum or museum exhibition has become one of the conventional methods of bringing a subject to public attention. Private corporations advertise their product by telling its story in glass cases that line the walls of ever more impressive reception galleries. Universities maintain museums alongside their libraries, and high schools and even elementary schools display corridor educational exhibits that are sometimes museum loans. Towns and villages have chamber-of-commerce–sponsored historical and craft museums; and private citizens join in support of museums, much as they formerly subscribed to concert and lecture series as a form of personal enrichment and an expression of civic pride. What accounts for this shift in presentational style and the increased interest in museums? The answer, I believe, relates to a more pervasive trend away from purely literary and discursive educational forms that are essentially cognitive and successive, in favor of multilayered modes of expression that address their audience simultaneously, sensuously, and empathically. At the same time, museum professionals are confronting the problem of creating museum exhibits that will convey the complex cognitive and affective material or texts that a spectacle-hungry public demands.

I would like to examine how museums work in terms of their effectiveness as educational facilities, drawing out the characteristics that distinguish them from other educational institutions and that differentiate types of museums. All museums shelter material resources of more or less value. Common to all is their function to make selected objects (not excluding ideas) available to researchers and members of the public for their voluntary examination. No one is obliged to attend a museum (excepting organized school groups), and whoever does so is free to study selectively among the various objects that are presented.[5] No one takes attendance, and there are no prescribed curricula or final exams. Learning in a museum has been compared to reading a dictionary. It would be insane to cover the whole thing from beginning to end. One must make choices, but inexperienced visitors are sometimes puzzled by that necessity, and so learning to use a museum, unlike learning to follow instructions, is like learning to think. In principle, museums have the potential to appeal to an extraordinarily broad range of learners with diverse interests. Their ability to do so is as much a function of their social history as of the quality of their exhibits. Who is attracted to which type of museum is an interesting question of social psychology that I will not consider here. Nor is my aim to evaluate museums, but rather to assess their several genres and to begin thinking about how they do the job for which they are conceived.[6]

I

We may begin by discriminating between types of museums roughly in terms of their exhibit contents. There is no single correct classification system, but I propose the following: (1) *Art museums,* containing objects preeminently created for visual appreciation, sometimes including decorative art and crafts. While such things as furniture, costume, jewelry, and domestic articles are sometimes displayed here, they are generally removed from their utilitarian context and presented as purely aesthetic items. (2) *Science museums* fall into several distinct types: (a) *Historical* (or great moments in science) which chronicle outstanding achievements. These museums (or sections of museums) glorify individual scientists by depicting their life and work, sometimes by replicas of their laboratories, models of their inventions or discoveries, displays of notes and instruments, and often with elaborate wall panels that explain the work and its significance to history. (b) *Industry and Technology.* These museums celebrate procedures and systems over individual human designers. Often sponsored by the companies that use the procedures, they demonstrate the machines, their historical predecessors, and show them in productive operation. (c) *Natural History* collections are grounded in a theory of the natural world. Their aim originally was to display those objects found in nature that are not human artifacts. Following state-of-the-art typology, they strove for completeness and diversity. These goals have become diluted as the concept of nature has grown more complex and more inclusive and the strategies of classification have become divorced from ontology. (d) *Zoos and Botanical Gardens* are a type of living natural history museum. They contain and care for labeled specimens, preserved for their aesthetic and educational interest which are available for public observation and scholarly

research. (e) *Science Centers,* although not dedicated to collection and preservation, do display objects in order to demonstrate the scientific principles they embody. Their status as museum has been challenged, but they are now accredited within the museum community, which has adapted some of their characteristics for unambiguous museum purposes. (3) *Anthropology* museums, misidentified as museums of man, were conceived as the counterpart to the natural history museum, their mission to study and collect the artifacts of those beings whose quaint and curious customs resembled, but did not quite achieve, the level of human supremacy that white men allocated to themselves. (4) *History* museums are the most recent and hybridized spinoff of the art and science museum idea. They preserve tangible relics of the human past, (and now of the present) often displaying them in a reconstituted and interpreted setting. As written history is one-dimensional in its lack of material density, so history museums tend to freeze the flow of historical reality into spatial slices. (5) *Miscellaneous Special Interest* museums generally collect and display a limited variety of objects which may overlap and intersect with any of the preceding varieties. I make no claim for the exhaustiveness of this list or for the mutual exclusiveness of the items on it. I offer it merely as a provisional device to gain some analytic clarity on a subject that is undergoing rapid and radical transformations, both materially and conceptually. Actual museums are not as sharply distinct as my typology suggests. Many have multiple purposes, and their exhibits overlap.

Although they are not the most frequented type of museum nor the most historic, art museums are generally taken as the prototype of what a museum is supposed to be. The image that the word *museum* evokes for most people is of an imposing edifice in which valuable works of art are tightly guarded and displayed in splendid isolation, cut off from the world of lived experience and related only to one another or to their legendary proprietors. This image is changing under pressure of enormously expanded museum use and a deliberate effort on the part of museum personnel. But the paradigm remains normative, and so I will use it as a point of departure to compare types of museums. The ancestry of the science museum can actually be traced farther back in antiquity than that of the art museum to the collected spoils of conquerors and the cabinets of curiosities of private treasure hunters. But while the appreciation of beautiful things is ancient, the perception of them as works of art to be enshrined for that alone is a product of the modern sensibility.

Museums house collections of things, but one must learn to decipher their meaning and to appreciate an order among them that designates foreground and background, what takes priority and what does not. These are not fixed poles, but the visitor comes to know them by way of invisible suggestions. The unwritten rule of the art museum is that things are aestheticized, having no history and no identity except as art. As such they are atemporal, unnatural, and ecstatic. "In order to enter [the museum], an object must die. . . ."[7] This is the opposite of the rule for science museums, where the object is not an end in itself, but a means to transport the visitor to contemplation of truths about the world outside the museum. Yet one and the same object may evoke both responses. How are visitors to know where they are? How shall they select which rules to apply?

The intentions of most museums are not clear even to their creators, and visitors are legitimately bewildered as they wander among the collected objects. Like book-borrowers in a library, they may expect to find the objects identified, only to discover that the labels do not tell them what they need to know. Museums to an even greater degree than libraries are addressed to a dual audience. They speak first to the community of research scholars (or art historians) who traditionally define the order of arrangement in which the objects coexist. Though less visible than the public, the researchers are intellectually more powerful. Of late, however, and as a function of the democratization process, the public has played a more aggressive part in determining museum content and order. Especially where public funding is at stake, the will of the nonexpert visitor (or of their representative advocates) cannot be ignored, but deciding what that is requires considerable discretion. Some of the current confusion may be due to uncertainty on the part of administrators as to which way the wind is blowing: Which audience is to be gratified? And how compatible are their interests?[8]

II

The art museum arises out of a relatively recent bourgeois tradition that reveres works of original art by known or unknown individuals. The museum, in displaying the work, celebrates its creator and simultaneously promotes the particular product. At the same time, it places both in a continuum of other artists and other works with which it invites comparison. Whatever falls outside that stream is automatically excluded as art, notwithstanding whatever aesthetic merit it may possess. Art museums are thus legitimizing institutions which foster certain cognitive and aesthetic attitudes and nurture them among the public.

Although the values promoted adhere to aesthetic objects, they are akin to values endorsed by science.

Science museums arose out of a tradition of collecting curious objects, but like art museums, they have acquired an air of authority. Where art museums legislate value, the domain of the science museum is truth. Both types of institution profess objectivity of judgment. The museum, a purportedly impersonal and disinterested agent (with a timeless grandeur) presents to the attention of the visitor an object to be experienced without bias. The object is given without compromising context apart from that deemed relevant or conducive to clarify by the museum authority (e.g., animals may be depicted in a "natural habitat," minerals displayed in classificatory order, physical phenomena as exemplifying a theory—just as paintings are hung on blank walls, in lifeless space.) The visitor is invited to look and see for himself or herself. What is less evident is that, as with the art museum, the presentation of the object and its display in the science museum, carries an imperative weight that transcends the visitor's individual affection or judgment. Art museums thus help shape our ideas of what is important and what is to be cherished, while science museums do this in a parallel dimension by purporting to tell us what is real. Where art museums replace private taste with public excellence, science museums displace subjective opinion with a collective truth that appears to be the product, only and inexorably, of collaborative observation and experiment.[9]

Science museums canonize science as art museums valorize art. Sometimes the discoveries of science are treated as works of inspired genius, hardly distinguishable from works of art. But generally that impression will be counterbalanced by stressing the universality and inevitability of the scientific statement (Darwin and Wallace racing to the same conclusion, American and German physicists stalking the secret of the atom). Sooner or later the truth will out, and science brings us face-to-face with reality. Technology museums are drawn both ways. They frequently trace the history of a specific device such as the steam engine or the computer, expressed in terms of the accomplishment of a few outstanding geniuses, but they also place that achievement within a general and necessary logic. In the United States it is almost impossible not to tell the story of the atomic bomb as a wartime tale of intrigue and adventure that befell a group of young physicists and eventually the world, but strictly speaking their scientific contributions might have been made by others and could be rehearsed without personal anecdote. The personal stories are interesting and make science seem more human, but they have little to do with how nature works. The question of who

studies what and why might be explored by a history museum or a museum of the sociology of science.

We cannot always know what the creators of a science exhibit intended—whether to relate a unique historic event or to describe a generic process? The correct interpretation may not be discernible from the exhibit itself, but may be inferable from the general style of the museum. If the museum is mixed in its commitments, that may be confusing, but no more so than are some art exhibits that mix the history of movements with the foregrounding of individual artists or works.[10] The problem is that the physical exhibit is always a concrete, individual thing, even though its mission may be to stand as a token of a type. Who could guess that the forty freightcar loads of materials delivered to the Smithsonian by its curator, George Brown Goode, were simply *specimens* with the abstract task of illustrating the instructive labels they accompanied?

Art museums are no freer of ambiguity in their logic than science museums. Chiefly reputed for the housing and preservation of unique works of art, they also have the mission to teach what art is, and so have an interest in representing the generic. And with the current preoccupation with process, art museums are as likely to feature a show on printmaking, or the history of perspective or social criticism in art, as to mount exhibits of singular works by specific individuals. Obviously, individual works are shown, but they are illustrative of a technique or style, and their intrinsic quality as art is incidental. A critic who denounced such an exhibit for its poor taste in art or for its failure to include important artists contemporary to those shown would have missed the point of the exhibit. Similarly, a reviewer of a science exhibition on the history of microscopes who objected to displaying Leuwenhoek's original model because it is an inferior instrument to contemporary Bausch and Lomb models would fail to understand the intention of this show. In order to judge any type of museum exhibition, art or science, one must have some rationale for relating its separate contents. If none is made evident by the show itself, the visitor will have to invent one. Museum exhibits, even of the world's great masterpieces, never stand outside any context, and proper appreciation of them always entails sensing what that context is.

All museums, regardless of their type, also include an aesthetic dimension: museum people, however, even in art museums, do not agree on how fundamental a requirement this is. One of the attractions of natural history museums, as of aquaria, zoos, and botanical gardens, is the beauty of the organisms they contain. And audiences

become indignant, as much for aesthetic as for humanitarian reasons, if they are confronted with rows of cages or boring glass cases of specimens. They expect to be pleased as well as edified, and their enjoyment undoubtedly eases the path of instruction.

But by and large the beauty that science museums strive to reveal is not that of individual objects. In more reverential times it was the glory and diversity of the work of the Creator that was celebrated; and even now secular scientists can be transfixed by the beauty and order of the universe. One can easily be distracted by the clutter of things in a natural history museum or demoralized by the immensity of what one does not understand, but almost anyone can be overpowered, if only occasionally, by the wonder of some natural phenomenon or by the simplicity, or complexity, of the world.

III

Science centers display objects in a uniquely conceptual mode.[11] They are not ordinarily exhibited either for the sake of their intrinsic value (as works of art) or for their representative function as an example of something. They may be beautiful, and they are not uncommonly designed by artists. They may be working machines or laboratory instruments or parts or wholes of living organisms, but their essential function is to transmit ideas.

Science center exhibits are often fabricated in the museum or by specialized exhibit construction companies. On the other hand, they may be found or "collected" in a variety of unorthodox ways.[12] Their actual value is essentially the cost of the materials they contain and the labor represented by their design and production. This might be considerable, given that scientific equipment is often intricately engineered and that the modifications required to make it museum-accessible might entail a good deal of additional planning and research hours. But this is only to acknowledge that complex machinery and laboratory apparatus are expensive; it is not a measure of rarity or of accrued or symbolic value like that possessed by works of art or by some of the exhibits found in other types of museums. The value of science center exhibits, beyond their material worth, is primarily cognitive.

Science centers do receive "in-kind" donations, and these may be objects of aesthetic and historic interest—the original fire engine from the local volunteer fire department, a primitive sensing device from a captured submarine, the steam generator from a neighborhood hospital. Tax laws, the customs of philanthropy, and the comparative penury of science centers make it impossible to reject such

gifts, although they do add to the confusion between science centers and historical museums. These objects appear to be collectibles, refugees from the old cabinets of curiosities.[13] Science centers, however, are interested in revealing the principles by which these objects operate, rather than in the objects as such. If there are no legal constraints, the machines may be dismantled and their parts used to build other exhibits, or they may be displayed as part of a sequence of analytic exhibits meant to clarify a general scientific principle.[14]

It is always difficult to communicate abstract ideas, and a single symbol is almost sure to be misunderstood. To attempt to do so by means of concrete objects seems almost paradoxical, and yet that is exactly what museums strive to do. Furthermore, they hold that they are qualified to convey ideas with at least as great efficiency as conventional educational institutions by virtue of their use of those concrete objects. In order to do this effectively, science centers must use a number of interrelated exhibits that are meant, collectively, to amplify the intended abstract scientific concepts. The visitor may not succeed in grasping the concept from any one of these exhibits, experienced alone, but may get it disjunctively from several or as a result of their mutual reinforcement. The exhibits are not merely reiterative, but converge on the subject in conceptually distinct ways. A work of art or artifact may simply draw attention to the principle to be explored by exemplifying a situation where it is operative. Prisms that break up white light to make rainbows are a good phenomenological beginning to the study of optics. They are beautiful and appeal to visitors, but they do not explain anything. They need to be accompanied by a cluster of other exhibits that make refraction comprehensible—charts and diagrams, panels of explanatory description, simplified models, and simulations. In the museum setting there is, of course, no guarantee that visitors will linger about to examine all these interconnected exhibits and no way, apart from the inherently attractive power of the exhibits, to coerce them to do so. Thinking through how best to articulate a scientific concept so that it can be plainly grasped in a museum environment is a pedagogic challenge unlike that faced by the classroom teacher, but with a similar objective, to implant an idea that takes off from the immediate presentation, transcends it, and then reconnects it to real experience.[15]

The high school or college science teacher uses mainly verbal media, books, lectures, and occasionally films, assisted by classroom demonstrations. More important, the classroom teacher faces a relatively homogeneous group of students repeatedly and has the authority to demand that they attend

to her consecutive presentations. Moreover, the teacher can profit from feedback, waiting until there is evidence that a preliminary point has been grasped before moving on to the next one. Museum exhibits, by contrast, are addressed to a random and occasional audience that has not done its homework, and whose interest in the subject matter may be momentary and sporadic.[16] In these respects museumgoers are more like recreational shoppers than like matriculated students. Their interest must be captured by the provocative appearance of an exhibit and is held only as long as the exhibit continues to reward attention. Schoolteachers have a captive audience and can risk boring it, but museum visitors hold the power to walk away if exhibits are one-dimensional and unchallenging, or too diffuse, or too densely packed and confusing. Sometimes people register their negative response to an exhibit by vandalism or, more often, by ignoring it. Spending longer periods of time observing or operating an exhibit is a positive but not an infallible sign of an exhibit's success. The audience may be entertained by, but still fail to understand, an exhibit.[17]

There are now traveling science exhibits that resemble some of the itinerant artshows, and these have characteristic intellectual as well as practical problems. Some are modest assemblages of five or six conceptually linked mobile exhibits, while others approximate the blockbuster extravaganzas of the artworld. They may celebrate the technological or scientific achievements of a particular culture (traditional China or India), or explore a phenomenon such as weather or sleep. Like the big retrospective shows of single artists or movements that travel among art museums, they give historic insight into certain discoveries or scientific traditions, and one can learn something about art or science from studying them. But they tend to be self-contained and occasional diversions, spectacular devices to build audiences,. rather than exhibit-based science teaching instruments. One reason for this is that exhibits are inclined to be site-specific even when that is not their explicit design. Exhibits built by a local staff acquire a flavor appropriate to their space and clientele. They are not untransportable, but to change their venue requires a certain neutralization that involves more than battening down the hatches for easy trucking. The same exhibit will not "work" in all environments, and to translate well, one must adapt to the idioms of the target community.[18] Exhibits made for travel have a Campbell Soup uniformity and are often a bit pallid. Designed for easy packaging, they are very modular and include far too many wall panels. It is noteworthy that the Smithsonian SITE program, one of the earliest to develop the traveling exhibit market, is looking now to collaborative exhibit

design, where it will provide technical and promotional expertise but leave the actual exhibit-making to local museums. This strategy is only in part an economic measure. It turns out that communities differ radically in their preparedness to assimilate scientific information. Plate tektonics and seismic lore may be familiar in California, where inhabitants perch on the San Andreas fault, but not so in Washington D.C. where earthquakes rarely occur. Therefore an exhibit on volcanoes will reach audiences in these places very differently.[19]

A science center may set out, like a textbook author or curriculum planner, to demonstrate certain concepts such as wave motion or pattern recognition, or evolution, by breaking the topic into constituent parts and constructing a large number of exhibits to explain them. The staff confers with consultants who are expert in the field and frequently gets valuable exhibit ideas from them. But science centers are not three-dimensional, multimedia textbooks. Nor are they simply popularizers of research results. They cannot replace the traditional centers of learning, although they can be important adjuncts to them. They can stimulate people to make better use of conventional learning centers by arousing their curiosity about the things that can be studied there. Their asset is the immediacy of the felt experience, and through it they can bring to life connections that are hard to convey abstractly. Science centers can introduce visitors to phenomena that may be obscure for a variety of reasons—because they are too small, too big, too far away, too long ago, too widespread, too short-lived, too hidden in the profusion of our other experiences. Normally these things can be experienced or understood only with the help of tools and laboratory apparatus that is not available to the nonscientist. The science center can make such equipment available and show people how to use it. It thus expands the function of the natural history museum not only by displaying those phenomena that are exotic and interesting, but also by teaching people how to use the instruments that will enlarge their own ability to observe and know the world. In doing this the science center also plays a role that parallels that of the art museum, which is likewise dedicated to helping people to see.

I V

Apart from competition over funding, there is no reason why different types of museums or different centers of education should be in conflict. Science museums can give visitors some insight into scientific methodology, but they cannot do so rigorously. There is no substitute for actually working in a

research laboratory or library and learning how to pose problems, design experiments and research programs, take accurate measurements, and reason out solutions to problems. The discipline cannot be simulated. Nevertheless, a well-conceived series of exhibits can guide a visitor through a rational sequence of embodied questions and answers. Most visitors will also need written clues or the help of a museum guide or teacher, and many will prefer to enjoy the exhibits less didactically. There is no harm in simply enjoying a playful interaction with an exhibit. No one is forced to attend to business; or rather, having fun is as important a part of the business of science museums as aesthetic pleasure is of art museums. Their challenge is to make learning fun. As Frank Oppenheimer used to say of the Exploratorium, "No one flunks the museum." The essential is that the possibility of learning be there, and that visitors may avail themselves of it as they might use a library.

Museum exhibits also have other public obligations. They need to be safe and sturdy and to be manageable by people of all ages and abilities. They must be aesthetically inviting, yet cost-effective, and easily repairable. Since many museums receive in-kind donations or are subject to spatial and material restrictions dictated by local legislatures, fire laws, health ordinances, and industrial codes, exhibits will vary according to the available resources. Science centers are particularly dependent on electrical power facilities and susceptible to wave interferences. They must have adequate space and appropriate lighting.[20] Not least, their effectiveness is limited by the tools, intelligence, and skill of their exhibit constructors. No doubt the most important need of a science center is a well-equipped shop and skilled staff to run it.

Maintenance of exhibits is of unparalleled importance in a science center. An exhibit that does not work (unless that is clearly indicated) is a disaster. Nothing is more demoralizing to a potential exhibit-user than to be frustrated in her endeavor. Typically she will feel that it is her fault and that she is too stupid to understand science anyway. Visitors are commonly intimidated by machines and will take their unworkability as confirmation of the mystery of science.[21] This is the opposite of the message that the museum ought to convey. Exhibit failure in a science center is comparable to forgery in an art museum, for it undermines the reliability of the evidence on which all judgment must rest. A bad painting or a poorly conceived exhibit may be disappointing, but they can be ignored. The effect is straightforwardly negative. It does not threaten the foundations of anyone's aesthetic sensitivity or self-confidence. But a forgery sets up false expectations and deludes the perceiver. The same is true of an inoperable exhibit that appears to be in working order. The museumgoer, following the messages that the exhibit emits, does not know that she is being misled. Her legitimate response to the exhibit is thwarted and the visitor is taught to mistrust her own judgment, the very thing that the museum is committed to validate. Since constant mishandling of exhibits does bring about frequent dysfunction, it is absolutely essential that sufficient museum resources be devoted to full-time maintenance or at least that malfunctioning exhibits be immediately identified and, preferably, withdrawn from public view.

Art museums have a greater commitment to conservation and restoration than to maintenance as such.[22] The artwork leaves the hand of its creator as a finished item and convention forbids that anyone improve it. Even the creator gives up access to it once the work is sold, and tampering by anyone else is a legal offense. This is not the case in a science center, where staff members commonly find ways to improve on a science exhibit by making it run better or replacing a defective part with another one. Science exhibits, however ingenious their design, are supposed to convey concepts that are in the public domain, and so no one producer has a proprietary claim on them. Unlike works of art, science exhibits have a certain transparency. They are meant to project museumgoers' attention away from themselves, to the phenomena that they reveal or the principles they manifest. Artworks, too, by an infectious process, may carry their audience's imagination beyond themselves, to archetypes and ideals or to practices, but the works remain concretely present, not transparent. The mystique of the art museum requires that the visitor, on pain of being philistine, have an aesthetic experience *of the work* and not of whatever the work represents.[23] This fixation on the uniqueness and irreplaceability of works of art is surely one reason why art museums continue to emit an air of sanctity that science museums do not.[24]

V

Neither art nor science is impervious to change and, not surprisingly, the museums that exhibit them reflect their transformations. Environmental, aleatoric, and other contemporary participatory artforms defy understanding in terms of a single creative genius and require completion by perceivers. Less author-identified than traditional art, they also reject the reverential distance of the detached observer. Like science exhibits, they invite spectators to enter in, only to then project beyond the given stimulus to the world outside, though not

necessarily to a "universal" concept. Conceptual art fits this characterization, although its reference often is to the narrower sphere of the artworld. From the museum perspective, these trends suggest a movement ouf of the shrine and into the marketplace or onto the streets. For if art is no longer identified with a specific, value-laden object, then it becomes less imperative that it be housed in a tightly secured shelter.

Conversely, some science exhibits are becoming more artlike in their focus on a unique phenomenological experience that is offered up more or less as an end in itself. Significantly, the object remains secondary in importance to the experience evoked, and so the issue of genuineness or authenticity which plays such a major role in the art museum, applies not to the origin, accuracy, or provenance of the material thing that is displayed, but to the extent to which the museum is able to reproduce a psychologically persuasive experience of it.[25] Ironically, simulations and spectacles are often more effective at producing that theatrical effect than the slim shreds of evidence on which our interpretations of the world beyond the end of our noses is ordinarily based. The influence of Disneyland, Epcot, and their descendants on the growth of museum exhibits such as "Dinamation" should not be underestimated. There is no pretense here that we are looking at dinosaur bones as in a natural history museum reconstruction. Rather, the exhibit producers are trying to recreate an atmosphere—notably of a world in which no human beings would have been present—that captures the feeling of what coexistence with these prehistoric creatures would be like.[26]

While the evocation of thrills and chills may be harmless and benign, I have some doubts about its place in a science museum. Leaving aside the matter of their veracity or fraudulence (a question that we cannot answer with respect to living with dinosaurs), science exhibits bear a burden of expectation that they provide *explanations*. There is nothing wrong with identifying or calling attention to a phenomenon by causing the audience to experience it. Indeed that is often necessary in a world where pollution combined with the saturation of our senses has obscured such traditionally familiar experiences as the starry skies and the taste of fresh fruit. Introducing people to a phenomenon they may never have noticed is an excellent antecedent to any attempt to teach them about it. A person who has not observed the change in pitch of a passing train whistle or had some other personal consciousness of the Doppler effect is unlikely to benefit greatly from a museum exhibit (or school assignment) that explains how the sonar apparatus of bats and submarines makes use of this phenomenon. Science

museums that only offer explanation without giving visitors the opportunity to experience what is explained may lose their audience. But those that simply reproduce the experience are also failing their audience.[27]

A museum is not an amusement park, and yet, unless it gives pleasure, it will not survive and is not worth visiting. This is equally the case for art museums and science museums, and it does not interfere with the high seriousness of their mission. Both science and art represent reflective ways of organizing and making sense of our experience of the world, and both highlight patterns of perception that are personally gratifying and publicly expressible. To a greater or lesser degree both employ conventional interpretive schemes, in each case sanctioned by a historic community. Sometimes they merely reinforce what we already know, and then a museum visit is like calling on an old friend. But museums also issue invitations to the public to join with the appropriate community in applying and extending their interpretive schemes to what is as yet unexperienced and unknown.

There seems to be a convergence of art and science, as what we take to be truth has become more interpretational and therefore less exclusively the property of any single authority. Science has lost its innocence and is gradually being forced to assume a sense of responsibility for its consequences. The public will not accept its unvarnished truth without accountability. We have learned that art has consequences, too, possibly not unlike those of science, and here as well the authority but not the responsibility of the individual creator is diminished. Neither art nor science can any longer enjoy the status of superiority to ordinary moral and political discourse. In a sense, these spiritual giants have been cut down to size. As protectors and purveyors of art and science, museums cannot remain aloof from their fate; for they share in the process of constructing reality, and therefore in the responsibility for it. Thus museums too are accountable to their public in ways that their originators never imagined and that go far beyond fiscal responsibility.

Within the museum world there is unease about these new demands, which is producing an atmosphere of crisis.[28] Harassed at the same time by financial worries, museums are struggling to define themselves as well as their audience. Mindful of their tradition of serving the research community and the small circle of its connoisseurs, they are understandably reluctant to abandon the road of high scholarship. At the same time, they are eager to win applause from people who regard that scholarship with warranted suspicion. This is not an easy problem to resolve, and I will not attempt to do so here. I will close with what may appear a simple-

minded and naive exhortation. It is that the integrity of museums lies in the object-centeredness of their operation. No doubt museums exist to serve people, but unlike other educational institutions, they do this (like grocery stores) by bringing them face-to-face with those parts of the world that they cannot create or discover for themselves, and helping them enrich their lives by using that experience well. The nutritional value of the experience, the cost of procuring it, and how it is best distributed are matters that will require much more discussion.

Notes

1. Joel N. Bloom, Earl A. Powell, III, Ellen C. Hicks, and Mary Ellen Munley, *Museums for a New Century: A Report of the Commission on Museums for a New Century.* Washington, D.C.: American Association of Museums, 1984. The authors regard as one of the obligations of museums the preservation of the diversity of human culture. They recognize a changing attitude toward diversity as one of the forces for social change that is making an impact on museums. Museums are in the sometimes contradictory position of celebrating diversity by means of techniques that are increasingly universal and homogeneous.

2. Nelson H. H. Graburn, in "The Museum and the Visitor Experience," in Linda Draper, ed., *The Visitor and the Museum* (Washington, D.C.: American Association of Museums, 1974), describes museums as serving several functions: (1) satisfying a reverential need as a sacred space or secular form of worship as with a national shrine; (2) providing associational space, a congenial environment in which to court, converse with friends, cement family ties, or conduct other social transactions; (3) fulfill educational objectives. While these several objectives may sometimes come in conflict, they are not inherently incompatible and for some visitors may be simultaneously satisfied. Museum planners as well as scholars who study museums sometimes focus exclusively on one function or another, ignoring their dense interaction.

3. Appealing to wider audiences is a major endeavor of most museums in the United States, and it is closely related to the campaign to preserve cultural diversity. (See note 1, above.) The controversy over charging admissions fees is a factor in that effort because some people are obviously excluded by that condition. But while entry fees are an impediment, there are greater constraints on diversity. Audience surveys show overwhelmingly that, while their number has increased, the type of people who attend museums are middle class and well-educated. See also Robert Coles, "The Museum and the Pressures of Society," in Sherman E. Lee, ed., *On Understanding Art Museums* (Englewood Cliffs, N.J.: Prentice-Hall, 1975).

4. According to the 1984 American Association of Museums study, *Museums for a New Century,* there were 5000 museums in the United States alone.

5. Mindful that education is not the sole purpose of museums, I take it that it is a major one which is not necessarily in conflict with their other aims. Furthermore, I emphasize the role of objects, rather than collections as such, because the issues of how they are obtained and what the logical and ontological nature of these objects must be are themselves subject to dispute and vary with different types of museum. I believe that it is safe to say that even imaginary museums present (imaginary) objects to the attention of their audience in order that they may be better understood.

6. Evaluation as a measure of audience appreciation of museum exhibits began in the 1930s and has accelerated in the last decade, especially as funding agencies demand evidence of the merit of their investment. The payoff is identified in terms of measurable audience responses. Sometimes these are correlated with explicitly expressed intentions on the part of exhibit creators. Whether or not this correspondence or the anticipated audience behavior are true indices of the value of the exhibits is a question left untouched, and I will not deal with it here. My own interest is more abstract and concentrates more on the cognitive design of exhibits than on their reception, concerning which see Minda Borun, "Measuring the Immeasurable: A Pilot Study of Museum Effectiveness" (Washington, D.C.: Association of Science and Technology Centers, 1977); Ross Loomis, "Learning About the Denver Art Museum Audience, A Survey of Surveys" (Denver: Denver Art Museum, 1983); Chandler Screven, "The Measurement and Facilitation of Learning in the Museum Environment: An Experimental Analysis" (Washington, D.C.: Smithsonian Institution, Office of Museum Programs, 1974).

7. Robert Harbison, *Eccentric Spaces* (Boston: Nonpareil Books, 1988), p. 147.

8. Audience interest is but one of several factors that affect a museum's content. Most museums come by their exhibits by way of complex and largely fortuitous circumstances. Most are guided less

by abstract philosophical ideals than by specific obligations imposed on them by founders, legislators, donors, and boards of trustees. Even those museums that create their own exhibits in relative freedom are constrained by ad hoc and short-term considerations that impinge on their long-term objectives. (Cf. Spencer Crews and Jim Sims, "Locating Authenticity: An Intersection of Audience, Ideas and Objects," a paper presented at the Smithsonian Conference on "The Poetics and Politics of Representation," September 26–28, 1988).

9. The topic of objectivity and its deliberate betrayal lies outside the scope of this essay, but it cannot be ignored. The use of museums, as of all media, for promotional purposes by commercial enterprises is seriously distorting the public's capacity to acquire information, let alone to gain knowledge. Since museums depend on funding from private corporations, whose directors also serve on their boards of trustees, and from government agencies that cater to corporate interest, they are not free to select exhibit materials or to display it in a manner consistent with uninhibited inquiry. In a science museum especially, this amounts to a violation of trust because the public has a carefully nurtured expectation that, here at least, it is receiving the unvarnished truth. Epistemologically, this is a disaster that makes nonsense of the very notion of disinterested pursuit of truth. See Howard Learner, *White Paper on Science Museums*. (Washington, D.C.: Center for Science in the Public Interest, 1979).

10. Moreover the meaning of the works may change over time regardless of intentions. Manet's *Dejeuner sur l'Herbe* was presumably an act of defiance in the 1860s, "a reproach to the high-minded somnolence induced by museum reverence" (toward Giorgione's *Concert Champêtre*), but the fate of artistic sainthood has now befallen the Manet as well and it has ceased to shock audiences. Sometimes the death that museum installation imparts comes slowly. See Francis Haskell, "Museums and Their Enemies" in *Journal of Aesthetic Education*, 19, no. 2 (Summer 1985).

11. Perceived as not housing collections, they were until 1974 denied status as museums and were therefore ineligible for the funding and tax benefits that museums enjoy. The Association of Science and Technology Centers was therefore created as a lobbying agency, and it now has a membership of approximately two hundred, as well as commissioning and distributing exhibits. See Kay Davis and Richard Barker, *A Profile of Science-Technology Centres* (Washington, D.C.: Association of Science and Technology Centers, 1975).

12. It is unlikely that their collection will be a matter of international incident such as may be encountered in art collection or the procuring of ethnic artifacts. "Unorthodox" here refers only to the imaginative ways that intelligent people sometimes come upon to illustrate a phenomenon or explain how something happens. Such explanations rarely survive the editor's excision in science textbooks, but they do make it into museums—hence the yardsale or fleamarket atmosphere to be found in some of the best of them.

13. The Smithsonian Art and Industry Building is full of such relics, polished up for display and now gathering dust in Victorian halls. The same devices are featured across the mall in a different narrative in the Museum of American History's "Engines of Change" exhibit. Here they are presented generically as instruments that played a part in America's Industrial Revolution that changed the structure of our society. The science center would reveal them in yet another light.

14. An example of such a use is the Exploratorium's display on the "Stereo Map Projector," an obsolete aerial photography device that was donated to the museum by the U.S. Geological Survey. Another museum might have displayed the object as an antique surveying instrument (which is what it is), but the San Francisco museum made a few minor modifications and displayed it as one of a series of exhibits on binocular perception. It presents a model of stereoscopic vision where the observation points are at a distance of half a mile from each other. The object itself becomes dematerialized and serves more or less as a diagram.

15. This problem is not unique to science exhibits. Curators of exhibitions in art and history museums commonly complain that the public does not apprehend exhibits in the intended order. "Dropouts" constitute about half of the average population questioned in audience surveys. They are not necessarily displeased with the exhibits they visit, but most people are browsing randomly and do not care to follow the sequence that curators have laboriously contrived.

16. Museums are now experimenting with computer-assisted exhibits with a programmed text that does allow for the interactive use of feedback information. The manipulation of the computers, however, is under the control of the visitor, without teacher intervention. A crowded museum floor may not be the best environment for such protracted dialogue between a single person at a keyboard and (even an oversized) responsive screen. Moreover, it appears that those visitors who enjoy interacting with the computers are diverted from the actual exhibits. One wonders if machine learning

might not represent a third alternative that intercepts some of the didactic features of the classroom and some elements of the museum situation without fitting easily into either one.

17. This is hard to discern, and evaluative surveys often do not grasp the point. Since they tend to focus on the satisfaction of the audience they may take as evidence of an exhibit's success an (entirely legitimate) aesthetic or other pleasure that the audience is experiencing. From a cognitive perspective, however, the exhibit designer might do well to go back to the drawing board.

18. Where a single exhibit is extracted from a didactic sequence, it is obvious that the switch in context makes a difference; but even where that is not the case, the transplantation of a work (or works) exposes it to new associations. Anyone who has happened on a traveling exhibit in several cities may have experience of this shift. An interesting anticipation of that likelihood occurred when the Exploratorium duplicated a large group of its Vision exhibits for display in a Madison Avenue gallery space. The museum's funky San Francisco style would have been out of place in the posh New York scene, but worked very well in sleek cherry wood and uniform blue masonite, pleasing huge audiences that might have found the original exhibits ludicrous.

19. I am grateful to Myriam Springuel, of the Smithsonian SITE Program for giving me this example, and for discussing the complexities and policies of that program with me.

20. Obviously there are also concerns for art museums. Indeed, as art has become more kinetic in recent decades and more exploratory of new materials and technologies, it has shaken up the steeped-in-art-history curatorial staff of some art museums who sometimes do not know where the electrical outlets are located.

21. At the present time, and in consequence of various well-known technological catastrophes, science is not popularly held in high regard. Therefore another possibility is that people turn their irritation at an unworkable machine to an intensified dislike of science. There is also evidence from audience evaluations that exhibits on such problems as pollution and urban overcrowding tend to increase the public's hostility toward science.

22. Currently there are approximately five thousand professional conservators in the world, but the field is growing as demand increases and the technology becomes more refined. The J. Paul Getty Foundation has initiated a Conservation Training Program aimed at the prevention of further deterioration of precious cultural properties as well as the stabilization and restoration of work that is already damaged. Thus the artworld, too, is turning to maintenance in preference to repair. See J. Paul Getty Trust *Bulletin*, 3, no. 1 (Winter 1988).

23. Aestheticians since antiquity have puzzled about the immanence of the aesthetic experience. Aristotle acknowledged that our pleasure in the verisimilitude of an imitation might be enhanced by our appreciation of the object imitated, but he did so in context of questioning why we are pleased by a good imitation of something that displeases us. Pleasure objectified has been the byword of the Western aesthetic tradition. Often problematic, especially for those who honor the social value of art, it is nevertheless all but universally agreed (*pace* Malraux) that one cannot have the genuine aesthetic experience without experiencing the actual work of art. Whatever ecstasies it may stimulate, the work of art is not to be bypassed. It is the gateway of the aesthetic experience. This is not the case with a science exhibit, which serves rather as mnemonic device—Plato was right about the slaveboy's squares in the sand, but wrong in identifying these with squares by Joseph Albers.

24. In the continuing debate over who attends which museums, it has been suggested that the same well-educated, middle-class audience attends all of them. But when they go to an art museum, parents put on their good clothes and leave their children at home. I am indebted to Zahava Doering, of the Smithsonian Institutional Studies Office, for this observation. The data on science centers indicate that the average age of their audience is somewhat younger than that of other types of museums, which attract a preponderance of young adults with some college education.

25. Similar perplexities arise in museums of history, which have become more dramatically narrative in their interpretive approach. No longer confined to tableaux and reconstructed interiors, they stage morality tales and video-assisted reenactments that purport to draw the visitor into the climate of the times. Vintage artifacts are certainly helpful in obtaining a sense of authenticity, but these are generously supported by presentational technique that is informed on the one hand by skillful designers and, on the other, by social historians with a theory.

26. William H. Jordan, Jr., "They Move, They Roar: Dinosaurs Are Here Once More," *Smithsonian* 20, No. 5 (August 1989). The author stresses the serious educational purpose of Dinamation and the careful research that precedes the construction of the Cretaceous robots. But for all their lifelike magnificence, they are a product of contemporary imagination—an illusion of reality.

27. This is not to say that there is no place in the science museum or in life for the sheer, unadorned having-of-experience. Some things must ultimately be left unexplained (e.g., the pleasure of explanation) and perhaps that is where science and the aesthetic will never quite coalesce.

28. One symptom is the epidemic of self-studies and audience surveys that is sweeping the profession. Another is the agony of the anthropology museums as they struggle to demarcate the Otherness of their subject matter (other than what?—us?) and to legitimize their history of expropriation. The multidimensional negotiations of the Smithsonian with the Native American community as the Institute consummates its acquisition of the Heye collection of American Indian Art is a fascinating case study.

On the Borders of the Visual Arts

When we write and speak about the visual arts, we often assume a certain set of features or conditions that seem to be applicable to the category as a whole. In the case of the paradigmatic visual arts—painting, sculpture, and architecture—we are usually able to identify, among other things, (1) an artifact such as a painting, a building or a modeled object, which is (2) fashioned by one or more agents (painters, architects, sculptors) and is (3) usually produced with the intention of satisfying a specifically aesthetic interest (4) through primarily visual means. It does not seem unreasonable to take these conditions as defining the outlines of what we might call the "normal" view of what constitutes the visual arts.

There are, however, many practices which stand in close relation to the visual arts but which are not normally thought to be included in that group. They are on the "borders" of the visual arts in the sense that though they seem to have some affinity with the paradigm cases, they also seem to violate or at least fail to conform closely to one or another of the previously enumerated conditions or to some other value or state of affairs typically associated with the visual arts. Perhaps, as in the case of some conceptual and performance art, what is produced is something other than a finely crafted, relatively stable physical object or, perhaps, as in the case of the aesthetic appreciation of a natural vista, no artifact seems identifiable at all. Perhaps, as in certain kinds of kitsch, what is produced is a stable visible object that invites contemplation but whose properties seem at variance with traditional canons of taste. Or perhaps, as in the case of sport or circuses, though we may attend to aesthetic qualities of what is presented to us, what lies before us is a ritual or event whose primary function seems other than aesthetic. Of course, as the selections in Parts I, V, and VI make clear, the question of how we are to understand the notion of the "visual arts" is itself problematic, and has been especially so since the turn of the century. The essays in this section take up the question of the nature of the visual arts, this time from the standpoint of several practices which seem to some to be on the borderline of the visual arts. In each case, the prime

philosophical question to be addressed is how we are to understand the exact sense in which these practices are borderline.

Consider the art of dance. Given the importance of the sense of sight to the appreciation of dance, dance might quite reasonably be considered a visual art. But dance courses are rarely included in the curricula of departments of the visual arts or, for that matter, in university curricula generally. Indeed, until recently, even philosophers of art have not taken much notice of the dance. In general, dance has not received the attention in learned circles regularly accorded other visual arts such as painting, sculpture, architecture, and even the relatively young arts of photography and cinema. How are we to explain this disregard?

In "Why Philosophy Neglects the Dance," Francis Sparshott argues that the lack of philosophical attention given to dance cannot be explained on the grounds that dance lacks a tradition of notation or that it exists as a female art in a patriarchal society or even that dance is corporeal while philosophers "fear and hate the body." What is necessary for a developed philosophy of a particular art, Sparshott argues, is that "the art should occupy at the relevant time a culturally central position or that the ideology of the art could be integrated with a culturally prevalent ideology." In the case of dance, neither of these conditions has been satisfied. The reasons for this are various. For most of its history, the idea that rhythmically patterned movements of the human body could be seen as anything but a more or less transparent manifestation of human expression and communication has seemed an alien notion. The idea of a pure art of dance could gain credence only if it were possible to ascribe artistic meaning to such movement, but dance was not thought to occupy a specific place in either of the two major schemata of the arts which have dominated Western philosophical thought about the arts, the classically derived system of the "fine arts" of imitation or the Hegelian system of the arts of beauty. Dance, then, falls to the ground of its own weight. "Philosophers cannot invent or bestow seriousness," Sparshott says. "They can only explain it."

Another feature of modern life which might be thought to be at least tangentially related to the visual arts is what Kathleen Higgins in her essay calls "sweet kitsch"—items of the sort we associate with romantic greeting cards and posters of pretty landscapes with mottoes such as "Today Is the First Day of the Rest of Your Life." On Higgins's reading, sweet kitsch is characterized by representational imagery which evokes certain "touching" or "stirring" emotions. Sweet kitsch is generally valued by its devotees for its ability to sweeten the world by providing images of what is desirable and excluding what is intolerable, to facilitate easy catharsis, and to serve as a means of self-enjoyment. Sweet kitsch may therefore be understood on a relational model: it features a simple, attractive image which does not refer to something it actually depicts, but rather to a shared structure of beliefs and desires about the way things are or ought to be. Sweet kitsch thus functions as

an icon that makes symbolic reference to what Higgins calls a "cultural archetype." And therein lies another powerful appeal of kitsch: it holds out the promise of membership in a community of like-minded people.

But what about the common criticisms of sweet kitsch, that it is nothing but maudlin, gooey sentimentalism, that its facile nature debases aesthetic sensibility, that it encourages an attitude of mindless acceptance, and that its images of an innocent, careless world are too easily adopted by politicians, ad writers, and others for pernicious purposes? Higgins acknowledges the force of such complaints but argues that a wholesale elimination of sweet kitsch is unthinkable and would be inadvisable even if it were possible. The relational nature of kitsch is such that there exists no definitive set of objective constituent features by means of which we could confidently identify sweet kitsch objects or instances of the sweet kitsch appeal. Nor would the elimination of kitsch objects preclude a kitsch response to other sorts of objects. Moreover, the censorial tone of the eliminationist smacks of the same exclusivity which is presumed to be a feature of sweet kitsch. Finally, Higgins argues, sweet kitsch can have beneficial social effects, as the recipient of even the most saccharine greeting card knows full well.

The circus is another form of human creation not normally included in discussions of the visual arts. Of course, circuses are well-known for their brilliant visual displays. In some cases, such as the performances of the Ringling Brothers, Barnum and Bailey Circus, lively colors and visual patterns figure into the overall effects of clowns' antics, trapeze daredevilry, animal acts, and other staples of circus fare. In other cases, as in the dazzling performances of *Cirque du Soleil,* stunning visual effects are themselves foregrounded. But the circus may also provide aesthetic rewards which seem closer to those of theater or literary narrative.

In "Circus, Clowns and Culture," Paul Bouissac adopts a semiotic approach to circus, viewing it as an artistic instance of patterned communicative behavior in which visual features play an important part. Bouissac notes the ambivalent status of the circus: it is universally enjoyed and widely disparaged. This Bouissac attributes to its function as "metacultural discourse," as a "code that implicitly refers to the cultural codes." That is to say, while the circus does contain sights and events which are a source of immediate delight and titillation, it also employs items from within a cultural environment in order to represent, interpret, and characterize that culture. The circus clown, for example, is not adequately understood as the simple representation of a hapless figure who laughs through his or her misfortune. The clown act in a typical European circus, Bouissac argues, is a highly structured and intelligible performance whose message is communicated through visual and auditory means. The white-faced, thin-lipped, well-groomed clown or *auguste* is the epitome of culture and authority who confronts a gaudily colored, unkempt, tramplike clown with exaggerated features (the *faire-valoir*), the champion of nature. The way in which these opposing characters move, interact, and

conduct themselves with respect to established rules of social behavior constitutes a commentary on social custom. The audience appreciates and, more to the point, understands the meaning which the circus conveys, gratified in being able to grasp its import within the confines of a limited time and space. The circus, Bouissac says, is both a form of entertainment and a way of life.

Barbara Sandrisser's evocative essay "Rain" moves our attention from culture to nature, as it were, though the ultimate effect of her discussion is to bring the two together. Many of us regard rain as a phenomenon to be tolerated or lived through. Sandrisser argues that in Japanese culture, on the other hand, rain is often appreciated for its aesthetic qualities. This interest is manifested in many ways, from the rich Japanese vocabulary for myriad types and qualities of rain, to the frequent attention given to rain in Japanese nursery rhymes, proverbs, poems, stories, and works of visual art. Where rain is often taken in the West as a sign or metaphor for dreariness or sorrow, rain for many Japanese is seen as a thing of beauty, appreciated for its "ordinary yet gratifying pleasures." Rain, Sandrisser writes, "exemplifies intimate contact with the commonplace. . . . Rain hides the whole, creating nuance; it produces patinas of age, moss on rocks, and the soft sheen on Japanese roofs. It softens colors in the landscape. We smell it, feel it, touch, hear it, and see it. This sensory awareness is part of its aesthetic value."

Sandrisser's article highlights an important philosophical issue. There is no doubt, as Sandrisser's essay makes clear, that nature can be appreciated from an aesthetic point of view. The beauty and the sublimity of nature have long been subjects of artistic attention. On a more mundane level, we are all familiar with the Winnebago phenomenon: a line of tourist vehicles leading up to a location from which one may view what the Highway Department proclaims to be a "scenic" vista. It is not uncommon in such situations to hear uttered the sentiment that the scene is as "pretty as a picture." We frequently use much the same critical vocabulary to describe the natural environment that we use for works of art. The question arises, then, whether there is a particular sort of aesthetic appreciation appropriate to the natural environment and, if there is, how we would describe it.

In "Appreciation and the Natural Environment" Allen Carlson approaches these questions by examining first what aesthetic appreciation amounts to in the case of works of art. There, he argues, we can answer questions about (1) *what* there is to appreciate in works of art (aesthetic qualities such as the sound of the piano rather than the coughing, or the gracefulness of a painting rather than where it hangs) and questions about (2) *how* we ought to appreciate works of art (through pertinent acts of "aspection"). Can we ask and answer analogous questions about the aesthetic appreciation of the natural environment? According to a line of thinking which Carlson calls the "object" model of appreciation, one regards a natural object as if it were an aesthetic object or one appreciates the natural object as a natural object but savors it for its formal and expressive qualities. Many people do in fact adopt an object

model of appreciation when they put a natural object such as a piece of driftwood on display. The "what" and "how" questions are answered on this model, Carlson argues, but only in a way that unduly restricts the kinds of qualities which might be appreciated in nature. The "landscape" or "scenery" model of appreciation according to which nature is regarded as if it were a specific kind of art (such as a landscape painting) fares no better. This model, too, has been favored, not only by Winnebagoans, but by their eighteenth- and nineteenth-century predecessors. Carlson, however, rejects the model on both aesthetic and ethical grounds. Carlson himself favors an approach which he calls the "environmental" model according to which we attend to features we normally know only as background qualities in a natural setting. Such qualities need not be limited to the visual, and our appreciation of them may be enhanced by what we know about the particular environment in question, much in the way that art-historical knowledge can enrich our appreciation of works of art. Different natural environments will therefore promote different acts of aspection. Carlson thus develops a model of appreciation that leaves intact what he considers to be the basic structure of aesthetic appreciation, but one which does justice to the natural environment as nature and as environment.

Carlson's concern is with the natural environment as it occurs in a more or less pristine state. In "Nature and Art: Some Dialectical Relationships" Donald Crawford augments this discussion with a consideration of the conscious use and modification of nature for artistic purposes. Of course, nature has long been used as a subject matter by visual artists, especially in landscapes and seascapes. In the last several decades, however, artists have not merely *rendered* nature in their artwork but have used nature as *material* in new and interesting ways. Again, there is a sense in which art has always involved the use of natural materials and has relied on the exploitation of the forces and laws of nature for its effect. To that extent art and nature may be said to exist in a harmonious relationship. But Crawford argues that certain recent developments in the artworld have placed the natural and artifactual in more of a dialectical relationship. Crawford discusses three specific types of environmental sculpture: the display of natural objects (such as iron filings or a tree) in gallery settings, the modification or rearranging of natural components in a natural setting (Smithson's earthworks, for instance), and the construction of nonfunctional artifacts on natural sites (Christo's *Running Fence,* for example). In each case, Crawford argues, nature and natural forces are not to be construed as mere causal preconditions for the realization of a work (as in the case of the traditional use of natural materials or the use of nature as subject matter). Instead, nature and artifice are brought together into a relationship of conflicting interaction, and it is this relationship, rather than the perceived physical object as such, that becomes the object of aesthetic appreciation.

Crawford's analysis also leads him to some intriguing observations about the

aesthetic appreciation of ruins. Ruins partake in a dialectic between nature and artifice in a most interesting way. On the one hand, insofar as they are in a process of physical deterioration, ruins exemplify an ongoing movement from artifice to nature. On the other hand, ruins point to the past, prompting (on a classical interpretation of ruins) an imaginative reconstruction of past aesthetic unity or (on a romantic view) stirring a sense of the mystery of the past, if not of the passage of time itself. In both cases, the ruin (*qua* ruin) cannot be construed as either natural or artifactual. It occupies something of a transitional place, hovering between nature and artifice. In many cases, Crawford argues, the dialectic is quite subtle: "Our *perceptual* consciousness shifts back and forth between an awareness of the ruin as the human *resistance* to natural forces and consciousness of the forces of nature as the *destroyer* of the most carefully planned human monuments."

One is tempted to wonder how Crawford's remarks about ruins might apply to the visual appearance of one's own person, the potentially demoralizing effect of such a rumination notwithstanding. Curt Ducasse is not far from such a reflection. Ducasse begins his essay, "The Art of Personal Beauty," with the observation that human beings not only live their lives but observe themselves doing so. When one discovers that nature "has been both niggardly and clumsy in the appearance it has bestowed" and that the passage of time will take its own toll, one may engage in the art of cosmetics, that is, the art of improving the appearance of one's person. The art of personal beauty, as Ducasse calls it, is also a result of the desire to be fascinating and hence attractive to other people. Since youthfulness is one of the most powerful sorts of personal beauty, cosmetic art is often directed toward creating the appearance of the beauty of youth. This is especially so with the embellishment of the head and face. But decorative clothing, jewelry, perfume, and other adornments of the body may also serve to fascinate. In such cases, the wearer may "borrow" the beauty of the adornment, a borrowing which can go beyond visible beauty to include qualities associated with the adornment such as mystery, grandeur, and glamour. Indeed, one may cultivate manners, speech, talents, and even modes of thought and feeling, all as a kind of decoration of the person. But this sort of decoration should not be depreciated or shunned as mere vanity or deceit. The cosmetics of the person may result in the inculcation of morally praiseworthy habits. As Ducasse points out, "a part acted thoroughly and consistently soon becomes no longer a part, but truly oneself." Moreover, the adornment of the body and the improvement of character both evince a kind of idealism, a desire for perfection, which is reflected in the Greek root of the word "cosmetic," *cosmos,* one of whose original meanings is good order.

How far can we push the idea of an art of the person? The theme of the transformation of life through art is carried a step further by Oscar Wilde in the final selection in this part, "Life as the Imitation of Art," taken from Wilde's essay *On the Decay of Lying.* At one level, Wilde's essay can be seen as advancing a normative theory of art promoting a formalist brand of

aestheticism against the idea of art as the imitation of nature. According to
Wilde, artists should revel in their imaginative freedom to tell "beautiful
untrue things" rather than slavishly follow realist precepts. This normative
theory is based on a particular view of human understanding which grants to
artistic creation an important formative power. Even nature, on Wilde's view,
conforms to the created forms of the artist:

> Where, if not from the Impressionists, do we get those wonderful brown fogs
> that come creeping down on our streets, blurring the gaslamps and changing
> the houses into monstrous shadows? . . . Nature is no great mother who has
> borne us. She is our creation. It is in our brain that she quickens to life.
> Things are because we see them, and what we see, and how we see it,
> depends on the Arts that have influenced us. To look at a thing is very
> different from seeing a thing. One does not see anything until one sees its
> beauty. Then, and then only, does it come into existence. At present, people
> see fogs, not because there are fogs, but because poets and painters have
> taught them the mysterious loveliness of such effects. There may have been
> fogs for centuries in London. I dare say there were. But no one saw them.
> They did not exist till Art had invented them.

In Wilde's hands, the thesis that life imitates art has at times a decidedly
escapist strain. ("The highest art rejects the burden of the human spirit, and
gains more from a new medium or a fresh material than she does from any
enthusiasm for art, or from any lofty passion, or from any great awakening of
the human consciousness.") It would not be fair, however, to attribute to Wilde
the conceit that a life may be somehow construed as a work of art, visual or
otherwise. Aestheticist that he is, Wilde still acknowledges that, to the extent
that art is a means of shaping reality, the imaginative freedom of the artist
carries with it a heavy moral responsibility. It is for that reason that Wilde
offers his vaguely Aristotelian flourish:

> My own experience is that the more we study Art, the less we care for
> Nature. What Art really reveals to us is Nature's lack of design, her curious
> crudities, her extra-ordinary monotony, her absolutely unfinished condition.
> Nature has good intentions, of course, but, as Aristotle once said, she cannot
> carry them out. . . . Scientifically speaking, the basis of life—the energy of
> life, as Aristotle would call it—is simply the desire for expression, and Art is
> always presenting various forms through which the expression can be
> attained.

We cannot say, then, in a responsible way, that life should be understood as
art, but we might well say that if, as Wilde suggests, life holds the mirror up to
art, life is the richer for that. Art, in its own way, does not imitate reality as
much as help define it.

If we return, then, to the question of the borderline status of practices such

as dance, kitsch, the circus, cosmetics, the aesthetic appreciation of nature and the modification of nature for artistic purposes, we shall have to allow that, from a conceptual point of view, these practices may be relegated to the periphery of the visual arts insofar as they deviate from a norm established with respect to what have often been taken to be paradigm cases of the visual arts. There may also be a cultural and historical justification for consigning these practices to the borders of the visual arts, at least insofar as certain of these activities (e.g., cosmetics, dance, and kitsch) have not enjoyed the kind of serious attention from philosophers and others accorded to the paradigm cases. It would be a mistake to conclude, however, that for these reasons these arts are only marginally important. As we have seen, the significance of these borderline practices in human affairs (in some cases even with respect to the question of aesthetic value) is both substantial and beyond question.

Why Philosophy Neglects the Dance

FRANCIS SPARSHOTT

The 1960s saw an immense increase of interest in dance in the United States—an interest soon reflected in sociological and anthropological studies that now begin to be plentifully published. This situation drew attention to a strange state of affairs in aesthetics. A venerable tradition regards dance as one of the most basic of arts, and this tradition was strengthened in the early years of the present century by evolutionary notions that remarked the ubiquity of dance in primitive cultures and singled out dance-like behavior among primates as one of the principal animal antecedents of human art. But philosophers of art, contenting themselves with this lip-service, had done little work on the aesthetics of the art thus determined as fundamental. Examples of general points in aesthetics were and are seldom drawn from dance, and separate articles and monographs on dance aesthetics are few. Moreover, though there is an extensive early literature on dance, that literature is little known to the learned and literary worlds at large. One wonders why this should be so.

One suggestion is that dance is a female art, and our civilization has been patriarchal. But that is not so. World-wide, men dance as much as women do, and sometimes more. To assert that, despite this, dance is somehow an expression of the truly feminine aspects of the human psyche is to remove oneself from the domain of responsible discourse. And if dance here and now is in some respects institu-

tionally associated with femininity, that is a contingent phenomenon calling for historical explanation rather than itself an explanation for the larger currents of thought.

Another explanation is that dance is corporeal, and philosophers fear and hate the body. That may explain why philosophers are seldom athletes, but dance as an art or arts is not, from the standpoint of observer or critic, significantly more bodily and less spiritual than other arts tangibly embodied.

A third suggestion is that examples of dance have not until the advent of TV and videotape been generally accessible, so that few philosophers could acquaint themselves with much dance or rely on such acquaintance in their readers; and that the lack of a generally readable dance notation rendered dances themselves ephemeral. That is true, but does not explain what needs explaining, for aesthetics has never depended on a common stock of specific instances.

To be surprised that little has been written on the philosophy of dance is to be naive about the conditions in which philosophies of specific arts get written. That an art exists, and that admired works are created in it, has never sufficed to generate a philosophy of that art. It is necessary that the art should occupy at the relevant time a culturally central position, or that the ideology of the art could be integrated with a culturally prevalent ideology. Thus, theories of literature abound because poets have

been thought crucial figures in the culture of their times, and because vernacular literatures played key ideological roles in the rise of European nationalism. Philosophies of music reflect an era when music was allowed so central a role in education that its importance became not something to be established but a datum to be explained. Theories of cinema were developed in acknowledgement of the fact that the movies for some decades dominated even sophisticated imaginations, and this domination needed to be explored from within. But when we turn to dance we find, first, that for various reasons the ideologies available to the other arts have not been available to it, so that philosophers could not bring it into their general theories of the arts; and second, that dance has at no convenient time been a culturally central art. It may attain centrality in small non-literate ("primitive") societies, but their ways of doing things are not imaginatively accessible to us—nothing like them belongs anywhere in our imagined heritage. Dance was also a focus of interest in the personal monarchies of the sixteenth and seventeenth centuries, but this association with courts has itself sufficed to remove it from centrality in any contemporary western society. Attempts to find other contexts in which dance as an art might achieve the centrality one might expect it to possess have not yet succeeded. For instance, Isadora Duncan and others in the early years of this century thought dance might be the natural expression of Whitmanian democracy, the spirit of the healthy individual in open spaces; but the replacement of the frontier mentality by a disillusioned one-small-world-ism has woken us from that dream. Again, Diaghilev's Ballets Russes nearly succeeded in tearing ballet (still the only highly developed dance in the west) loose from its monarchical associations and making it a *Gesamtkunstwerk* that would rival Wagnerian opera, but in the end it did not come about. World War I shifted the balance of artistic acceptability towards less opulent forms; Wagner was in any case there first; and, perhaps most important, Diaghilev failed to establish a strong choreography at the core of his enterprise, which never fully established itself as dance rather than miscellaneous spectacle. Most recently, a new dance associated with such names as John Cage and Merce Cunningham has offered itself as the pure and necessary art in the moving body. But it turned out that there was no place for it to fill. As art for an alternative culture its place was preempted by the artistically unprecedented and unexpected outbursting of popular musics, a worldwide cultural revolution whose measure we have yet to take; and within its own solemn circle of art, as the name of John Cage reminds us, it did not establish a cultural presence and func-

tion separate from that of avant-garde music, para-theater, and "art" generally.

The upshot of the history summarized above is that there has been nothing for a philosophy of the dance to be about. Indeed, the very idea of an art of dance as such, distinct from mime and pageantry, is new and perhaps unstable. The prestigious court ballet of Louis XIV and his predecessors was less like anything we would call dance than like a pageant or a homecoming parade. The dances available from classical antiquity as imaginary exemplars for those who would dignify the dance were either pure mime, whose values were entirely those of expression and communication, or choric maneuverings whose value lay in the ceremony of which they formed part. The *ballet d'action* of Noverre and his contemporaries was again mimetic in its emphasis. Even Isadora Duncan at one time denounced the idea of a pure dance, saying that the value of her dances lay in their fidelity to the music for the sake of which they were created. Dance as dance, the rhythmically patterned movements of the body, was at all these times decried as a mere capering. The objection was not to its physicality but to its lack of meaning. Natural movements of the living body are motivated; unmotivated movements are mere swingings, jerkings, twitchings. The invention of a pure art of dance depends on the development of a characteristic system of motivation of its own, or something that will do duty for that. Till then, however many beautiful dances we have, there can be no philosophy of dance, because their significances remain indefeasibly miscellaneous. Only their beauty unites them. Beauty justifies dances, dancers, dancing, and the dance, but little can be said about it.

In order to vindicate a place for an art (such as dance) among the serious cultural concerns either of mankind or of our civilization, one must define a place that only it can fill, or that it fills in a distinctive way. To do that convincingly, it is advisable to construct a survey of real or possible arts among which the art in question is determinately located. Many such "systems of the arts" have been constructed. Some of these cover the whole range of human skills or a large part of that range, and others confine themselves to anatomizing the practices and skills that we lump together as "art" without relating art as a whole to any similarly articulated scheme for other areas of human activity. Many such systems, notably that of S. K. Langer, do make a place for dance. But only two such systems have been so widely accepted that our own spontaneous thinking still shows their influence, because they form part of the tradition within which our minds

work. And neither of these two preferred systems assigns a place to dance. Since philosophers of art, like other philosophers, spend most of their time (and most of them spend all their time) examining particular problems within unexamined frames of reference, these omissions go far to explain why philosophers neglect the dance. Of course, the prevalence of these two schematisms is not itself an ultimate datum, but demands explanation. Such explanation would include a demonstration of how each schema articulated the most pressing relevant concerns of the most influential ideologists of its age, and an explanation of that influence. No such explanation can even be sketched here; we will only note that the successful promulgation of a system of the arts from which dance was omitted shows either that dance was felt to lack significance at the relevant time or that its significance was not felt to lie within the proper scope of the system.

The two prevailing schemata of the arts to which I refer are the system of the "fine arts" as arts of imitation, derived via Aristotle from the Platonic *Epinomis* and developed in the sixteenth to early eighteenth century, and the system of the arts articulated by Hegel in his lectures on aesthetics and found at the basis of much nineteenth-century writing. Neither scheme commands the assent of serious thinkers today, but no other scheme of comparable mesmeric power has displaced them, so that they remain detectable as unquestioned operative assumptions in shaping the ways we still frame our questions.

The system of the "Fine Arts" is, for our purposes, best examined in the shallow but sophisticated version presented by D'Alembert in his "Preliminary Discourse" to Diderot's *Encyclopédie* (1751), where it forms part of a classification of the kinds of human knowledge.[1] "Another kind of reflective knowledge," he writes, ". . . consists of the ideas which we create for ourselves by imagining and putting together beings similar to those which are the object of our direct ideas" (p. 37). Among these arts of imitation painting and sculpture are primary because "it is in those arts above all that imitation best approximates the objects represented and speaks most directly to the senses" (ibid.); architecture does the same sort of thing only not so well; "Poetry, which comes after painting and sculpture, . . . speaks to the imagination rather than to the senses"; and music "holds the last place in the order of imitation" because it lacks a developed vocabulary, though it is nowadays evolving into a "kind of discourse" expressing the passions of the soul (p. 38). But, significantly from our point of view, "Any music that does not portray something is only noise" (p. 39). All these arts that "undertake the imitation of Nature" are called the Fine Arts "because they have pleasure for their principal object" (p. 43); they could all be included "under the general title of Painting" because they differ from that art only in their means (p. 55), or could be considered forms of poetry if "poetry" is taken in its old broad sense of "invention or creation." In the whole of this discussion, D'Alembert never mentions dance. Why not? Presumably because what he is classifying is forms of *knowledge*. Any dance which is not a variety of representational theater, and hence a form of "Painting," is mere movement in the same way that non-expressive music is "only noise," hence not a branch of knowledge and not to be included among the arts. What makes D'Alembert's exclusion of dance particularly remarkable is that his enumeration of great artists gives pride of place to those active at the court of that passionate practitioner and devotee of dance, Louis XIV; he even mentions Lully, Louis' great ballet impresario, but mentions him only as a musician. Yet the ballets of Louis' court were great public occasions, assigned high symbolic importance by their devisers and commentators. How could D'Alembert have overlooked them? A possible explanation is that opera (in which dance interludes were a normal component) was originally devised as a re-creation of Greek tragedy and inherited tragedy's traditional place among arts that "imitate Nature"; but the court ballet, in which Prince and nobility took part, found its ancestry in a different region of Platonic thought, in the choric dances in which the city expressed its unity and its symbolic equivalence with the hierarchy of the cosmos. Thus its strictly choreographic component (always subsidiary in the whole design) was as such below the level of art, its theatrical component is categorized as a continuation of painting by other means, and its inner significance lies in a mode of imitation radically other than that which the fine arts exemplify. There was thus no way in which the court ballet could be assigned a distinctive place among the fine arts, and its successors suffered the same difficulty.

In face of this exclusion it is easy to see what apologists of dance should do: they should say that dance stands alongside painting and poetry as an independent mode of imitation. And so they did. Noverre, among others, took just that line.[2] But the move never won general acceptance, because it was not as "imitation of Nature" that significant dance was significant.

The other schematism of arts that has dominated our minds is Hegel's. It goes like this. The fine arts are arts that produce beauty. Beauty is the adequation of a form to an idea, so that a fine art embodies

ideas in forms adequate to them. As civilization advances, arts become more refined. Symbolic arts in which spirit partly informs matter give way to classical arts in which spirit and matter are perfectly fused, and these in turn yield to romantic arts in which spirit dominates its material embodiment. After that, spirit assumes autonomous forms and art as a whole is superseded. The paradigm of a symbolic art is architecture; of a classical art, sculpture; the romantic arts are typically painting, music, and poetry. Sculpture is the central art, the most artistic of the arts; among romantic arts music is central, the most romantic, but poetry is the most spiritual and the most advanced.

One might have looked for dance in two places in Hegel's scheme. On the one hand, since the central place assigned to sculpture rests on the old thesis that of all natural forms only the human body, the favorite subject of sculpture, gives natural expression to "the Idea" because it is the body of the only theorizing animal, one might have expected dance, which sets actual human bodies in graceful motion, to join sculpture at the center. That place had been prepared for it by the Fine Arts schematism, but Hegel leaves it empty. On the other hand, dance might have been set alongside architecture as the primitive art, in which the actual materiality of the body is partly infused with formally significant properties in the same way that an architect gives a significant form to actual materials in all their solid strength. Why does Hegel refuse to make either of these obvious moves?

So far as Hegel knew, architecture of the appropriate heavy and symbolizing sort did dominate the early civilizations of Egypt and India; and sculpture, since Winckelmann, was taken to epitomize Greek civilization. But no civilized era had expressed its characteristic orientation in dance. Dance belonged to savages, and to primitive men whose expression was inarticulate. As a means of expression it is subhuman and pre-artistic. Apes and peacocks dance. Long after Hegel's death, as we have seen, such animal behavior would be assigned to the ancestry of art.

The supposed facts of history may have sufficed, but another thing that might make dance an unlikely partner for sculpture would be that the body made by God in His own image must already be expressive in the only way in which it can be expressive. The dancer as dancer can express no idea higher than the personality and full humanity his life should already more fully and perfectly show. An idealization of gesture could not be more eloquently expressive of humanity, but only an attenuation and trivialization.

What, then, of the analogy of architecture? The dancer's agility and grace imperfectly animate his real corporeal presence, the sweating and straining body, as an architect imparts an illusory lightness to the vault that sustains and is confirmed by the loads imposed on it. Even if no advanced civilization has taken dance as its central expression, should we not recognize that dance, like architecture, is an inevitable and basic art—that human beings will always build, and will always dance, and it will always matter to them how they do so? If the origins of dance are prehistoric and even prehuman, what is at the origin is not necessarily superseded, or if it is so is superseded only by losing its place at the focus of concern. It was in this sense that Hegel thought all art was superseded: science and philosophy must from now on always be more central to the concerns of humanity, but art has by no means completed its mission.

Hegel's relegation of architecture to the past corresponds to a historical fact. The architecture of his day was bankrupt, reduced to exploiting a repertory of forms of which the original significance was lost, in desperate search for any sort of authentic or persuasive style. Similarly, nothing in Hegel's day suggested any inevitable importance for an art of dance. The ballet d'action of Noverre and his contemporaries had quickly relapsed into the formalism they had protested against, and the dance of Hegel's day had nothing more significant to show than Vigano's choreodrammi at Milan—magnificent spectacle, but mere spectacle. In Hegel's terms, spectacle is not art. A modern art, a living art, had in Hegel's day to be a romantic art; and it was not until the year of Hegel's death (1831) that the dance of the nuns in Robert le Diable revealed the possibilities—quickly followed up—of a romantic art of dance.

Hegel will acknowledge no split between the rational and the real, and therefore always bases his schematizations on something very solid and closely observed in history. Dance in his place and time offered no such basis to observation, and to have claimed for it any systematic significance would have been pure ideology.

Dance as romantic art is born in the romantic ballet of Paris immediately after Hegel's death, and it is this ballet that still typifies the art of dance in the general mind. Such a dance, culturally prestigious and ideologically significant, might have won a posthumous place in the Hegelian system. But it did not. As Ivor Guest shows, the inner meaning of that ballet was a yearning for the unattainable as symbolized in a man's hopeless love for a fairy being, an etherealized woman.[3] But not only is that sort of "idealism" a weak escapism, incapable of bearing any but the most vapid symbolism; more seriously, the artistic fact it corresponded to was the cult of the ballerina, of Marie Taglioni and her rivals and

successors down to Pavlova—and of the ballerina as kept or keepable woman, whose body was central only as fetish for the Jockey Club. The idealization of the feminine is the degradation of the female. So far from vindicating for ballet a place among the arts in which the human spirit finds its defining form, this social attitude excludes ballet from art and confines it within the luxury trades. Association with ballet has meant the stigma of spiritual sickness, and for a whole it seemed that the only hope for a serious art of dance was to repudiate bal-let utterly. Unfortunately, no technique of comparable development, and no tradition of comparable weight, existed in the west or (because of the rigors of training, if nothing else) was importable from the east.

What this all amounts to is that there has not yet been any available basis for a philosophy of dance. Nor can such a basis be invented by philosophers. Philosophers cannot invent or bestow seriousness; they can only explain it.

Notes

1. Jean Le Rond D'Alembert, *Preliminary Discourse to the Encyclopedia of Diderot*, trans. Richard Schwab and Walter Rex (Indianapolis: Bobbs-Merrill, 1963).

2. Jean-Georges Noverre, *Letters on Dancing and Ballets* (1760), trans. Cyril Beaumont (New York: Dance Horizons, 1966).

3. Ivor Guest, *Romantic Ballet in Paris* (Middletown, Conn.: Wesleyan University Press, 1966).

52

Sweet Kitsch

KATHLEEN HIGGINS

Kitsch has provoked a deluge of commentary, much of which debates its definition. But despite the disparate assessments of what kitsch is, a surprising degree of agreement is reached when kitsch critics are presented with salient instances of kitsch. One species of these instances employs a foggy portrayal of a young couple in a beautiful natural setting. The depiction of the young man and young woman is rather shadowy; at least, one is not able to make out clear facial features or expressions. And the couple's postures, though affectionate, are not quite suggestive. Seemingly, it is not physical desire per se that causes them to occupy a world of their own. Nevertheless, they seem completely unaware of the beauty of their context, a geographically nonspecific landscape or beach. It could be anywhere, just as the couple could be any couple.

I take the greeting card that presents such an image and an accompanying romantic verse or statement to be a working example of "sweet" kitsch, or kitsch of the "saccharine type."[1] This "sweet" subcategory of kitsch is my focus. Starting with this romantic greeting card as an example, I consider the general question, "What does this kind of kitsch, *qua* kitsch, do to and/or for its observer?" An investigation of this general question easily leads to a number of others: How does kitsch of this sort affect us? Or how is it designed to affect us? Are the negative social and political effects that some have attributed to sweet kitsch inherent to all objects that can appropriately be labeled *sweet kitsch?* Does sweet kitsch ever have any socially desirable effects on those who like or use it? Does sweet kitsch prop-

erly designate objects that are characterized by a certain property or properties, or does it indicate something else? Could we eliminate sweet kitsch from modern life? Would we want to?

These questions are broad, and my discussion here cannot fully probe all of them. But I propose to reflect on some of these concerns. I begin in section I with a characterization of what I call sweet kitsch and consideration of some suggested accounts of the effects sweet kitsch has on the observer who appreciates it. I offer a model of the ways in which an instance of sweet kitsch functions to provoke a response, a model that integrates several of the suggested accounts of the sweet kitsch effect.

In section II I then discuss charges that have been raised against sweet kitsch as a social and political evil. I concur that at least some of these are important social concerns; but the remainder of the discussion indicates why I think it would be impossible to remedy these problems by attempting to reduce the presence or popularity of kitsch in modern American life.

In section III I consider the question of what makes kitsch-objects kitsch. I conclude that they are not kitsch because of some property or properties they have as objects. Instead, they are kitsch only in a relational context: they are kitsch because they provoke a certain response. This response is compatible with and encouraged in some cases by deliberate intent on the part of designers, purveryors, or users of kitsch; but it does not depend on deliberate manipulative intention. Instead it depends on the kitsch object's suitability to serve as what I call an

icon, a symbol that alludes (however quietly) to a structure of meaning that the kitsch audience can be assumed (prereflectively) to share. This suitability, though not independent of the object's nonrelational properties, is clearly bound to context. The consequence is that it is appropriate to speak of a "kitsch-object" only in the context of a situation, although the situation may be extremely common.

In section IV I contend that taking a witch-hunter's attitude toward kitsch would itself be socially harmful, and I defend the use of certain objects typically construed as sweet kitsch under certain circumstances. I conclude that the most interesting problems raised by the phenomenon of kitsch are questions about gestures and responses rather than objects; and I suggest that we should guard more against superficial understanding of sweet kitsch than against sweet kitsch itself.

I

As Calinescu has suggested, the meaning of the term *kitsch* is varyingly assessed. Even the effort to find a kind of family resemblance among the diverse characterizations of kitsch is hard to sustain in the face of the assortment one discovers. Kitsch is characterized as a form of "really bad taste";[2] an incarnation of evil;[3] an ironically designated "area of human achievement" that features "form at odds with functions" and incongruous juxtaposition;[4] an embellishment and enhancement of the day-to-day;[5] "a specifically aesthetic form of lying";[6] "art that is produced for immediate consumption";[7] "the expression of . . . the life style of the bourgeoise of the middle class";[8] and "the absolute denial of shit," of everything "which is essentially unacceptable in human existence."[9] Not surprisingly, Calinescu openly despairs of a clear-cut definition: "Kitsch cannot be defined from a single vantage point. . . . Kitsch refuses to lend itself even to negative definition, because it simply has no single compelling, distinct counterconcept."[10]

In my discussion I will limit myself to the subcategory of "sweet" kitsch. I believe that I can offer a working characterization of what I am calling sweet kitsch without arbitrating among the definitions that have been suggested. The advantage of this approach is twofold. First, it accords with Calinescu's point, which I believe is correct, that *kitsch* resists precise definition. Second, and more important, the analysis that I will develop from my working model of sweet kitsch suggests reasons why even the subcategory *sweet kitsch* evades definition. (Presumably, these reasons may be applicable to other varieties of kitsch as well.)

What, then, do I mean by sweet kitsch? I assume that an instance (here very broadly defined) of sweet kitsch evokes emotions of the "touching" or "stirring" sorts. Effective kitsch that commemorates motherhood evokes the former; effective kitsch that inspires patriotism evokes the latter. I will take both of these kinds of kitsch to be paradigmatic cases of what I am calling sweet kitsch.[11] (Sweet kitsch may be "cute," but it need not be. And not every "cute" object called kitsch is sweet kitsch as I understand it. What is crucial, in my view, is that an instance of sweet kitsch is suitably described as "touching" or "inspirational" by an appreciative observer.)

I assume also that sweet kitsch is representational, or in some way employs an image. I understand *image* in a broad sense. Usually the image is visual, but it may also be literary or even semiliterary, as in the case of kitsch song lyrics.[12] I take the representational image to be essential to ascribing sweetness or inspirational quality to the kitsch response. An abstract depiction might arguably be kitsch; but I do not see how one could see it as touching or inspiring.

What does sweet kitsch do for its audience? I suspect that it does a number of things. Several types of emotional benefit that have been associated with kitsch strike me as possibly applicable to the sweet subcategory. I consider four general types of alleged emotional benefits. In sequence, let us consider the following claims: (1) sweet kitsch makes the world sweeter and excludes what is intolerable; (2) sweet kitsch provides easy, effortless catharsis; (3) sweet kitsch serves as an aphrodisiac, a means of self-enjoyment; and (4) sweet kitsch reassures its audience.

Among the aims of kitsch that Lyell Henry describes, one seems particularly the province of sweet kitsch. Kitsch, Henry argues, aspires to "embellish the elemental sentiments," such as love of children, mother, spouse, country, God, and so on, and hatred of our country's enemies.[13] Henry's assessment of the way in which kitsch "enriches" our lives through these projects is tongue-in-cheek. But his tone suggests that kitsch is a rather light-hearted enterprise that tends to make our world somewhat more charming if we are not put off by its ridiculousness.

Kundera, too, sees the sweetening of life to be a fundamental aim of kitsch, as is clear from his suggestion that kitsch "excludes everything from its purview" that is unacceptable in human life.[14] Kundera's analysis of the sweet kitsch response reveals that he takes the achievement of this aim to have somewhat sinister ramifications.

Kitsch causes two tears to flow in quick succession. The first tear says: How nice to see children running on the grass!

The second tear says: How nice to be moved, together with all mankind, by children running on the grass!

It is the second tear that makes kitsch kitsch.

The brotherhood of man on earth will be possible only on a base of kitsch. . . .

And no one knows this better than politicians. Whenever a camera is in the offing, they immediately run to the nearest child, lift it in the air, kiss it on the cheek. Kitsch is the aesthetic ideal of all politicians and all political parties and movements.[15]

Kundera's dubiousness stems from his assessment of the propagandistic uses to which sweet kitsch can be put, a topic that I consider at length shortly. His analysis of the first and second tear, however, would seem to apply to cases of sweet kitsch whether or not they are employed for a propagandistic purpose. The romantic greeting card, for instance, might well evoke in its recipient a "second tear" response like "How nice it is to be young and in love!" Or for another example, consider a working woman's apartment that is decorated with posters of pretty, natural objects and cheering mottoes: "God Loves Us," "Today Is the First Day of the Rest of Your Life," and so forth. One can imagine the woman looking at the first of these posters and thinking not only "What a beautiful scene!," but also "How wonderful that God loves us!"

The first claim about the effect of sweet kitsch sounds plausible. In fact, it might even be construed as definitional. What would make sweet kitsch sweet if not the fact that it had a "sweetening" effect? The second, however, seems persuasive as well, particularly if we feel that Kundera is on to something with his analysis of "the second tear." What is perhaps most provocative about the described move from the first to the second tear is its easiness. We find something suspect in the facile shift from being charmed by children to being moved with all mankind. And yet Kundera argues that this is the essential move that constitutes kitsch.

Kundera is not alone in focusing on the facile aspect of kitsch; the untaxing character of kitsch has long been a focus of those who denounce it. In 1939 Clement Greenberg objected: "Kitsch is mechanical and operates by formulas. Kitsch is vicarious experience and faked sensations. Kitsch changes according to style, but remains always the same. Kitsch is the epitome of all that is spurious in the life of our times. Kitsch pretends to demand nothing of its customers except their money—not even their time."[16] Kitsch does, in Greenberg's view,

exact a price: it debases aesthetic sensibilities and facilitates propagandistic manipulation. But kitsch is easy, predigested. The example that Greenberg chooses, a painting by Repin, appeals to Russian peasants because it uses familiar elements. The audience is not required to reflect on what is presented. Instead, "the 'reflected' effect has already been included in the picture, ready for the spectator's unreflective enjoyment."[17]

The examples of sweet kitsch that we have considered do seem to offer touching emotion or inspiration without much effort on the part of the observer. One needn't reflect on the romantic greeting card image in order to be moved by it. One would suspect, in fact, that reflecting on the image would have a counterproductive effect on the "touched" response. The cheering and inspiring posters similarly require nothing like aesthetic reflection on the observer's part. They seem designed to bolster the spirits of someone whose energy is flagging. The sense of being moved along with all mankind in Kundera's example is hardly a reward for reflection; reflection would surely cast doubt on such an extreme generalization. (Presumably, reflection would also cause the articulation of this dubious thought in the first place.) Our first two claims, then—(1) that sweet kitsch makes the world sweeter and excludes what is intolerable and (2) that sweet kitsch provides easy, effortless catharsis—are not incompatible, and seem to be convincing descriptions of what the kitsch audience gets from sweet kitsch.

Our third claim is apt as well. It is not incompatible with claims 1 and 2; and its focus is on something different: it considers the internal mechanism involved in enjoying sweet kitsch. Sweet kitsch, it claims, offers the pleasures of an aphrodisiac. In enjoying sweet kitsch, one enjoys, not the object, but one's own state of mind. In arguing this point about kitsch in general, Karsten Harries contends that reflection occurs in response to kitsch, albeit not the reflection of aesthetic contemplation.

The need for Kitsch arises when genuine emotion has become rare, when desire lies dormant and needs artificial stimulation. . . . what is enjoyed or sought is not a certain object, but an emotion, a mood, even, or rather especially, if there is no encounter with an object which would warrant that emotion. Thus religious Kitsch seeks to elicit religious emotion without an encounter with God, and erotic Kitsch seeks to give the sensations of love without the presence of someone with whom one is in love. But even where such a person is present, love can itself be said to be Kitsch if that person is used only to stimulate a

feeling of love, if love has its center not in the beloved but within itself. Kitsch creates illusion for the sake of self-enjoyment.[18]

Harries concludes that kitsch is thus "more reflective than simple enjoyment in that it detaches itself from the original emotion in order to enjoy it."[19] His analysis is thus more psychologically complex than Greenberg's, in that the latter tends to underestimate the dynamic process and emotional effort that may be involved in enjoying kitsch. On the whole, Greenberg tends to focus on observable characteristics of kitsch-objects and to derive his assessment of observer responses from them, while Harries's analysis locates kitsch within the mind of the observer, allowing objects that we would not typically call kitsch to function as such. This is an important difference, and I consider it in greater detail later, ultimately siding with Harries.

Here, however, I wish only to consider the plausibility of claim 3 and its compatibility with the other claims suggested about the satisfactions derivable from sweet kitsch. Again, we have in effect assented to this claim if we have accepted Kundera's two-tear analysis. For the second tear—"How nice to be moved, together with all mankind, by children running on the grass!"—is a tear of self-enjoyment. The first tear, as Kundera described it, still focused on the object. But in the case of the second tear, one is enjoying nothing but the feeling inside and the illusion of universality that one ascribes to it.

Still, we should not be persuaded by Kundera unless his analysis seems apt for other examples of sweet kitsch. The example of the greeting card is a muddled example for our purposes here, for response to self or other surely depends on the recipient's relationship to the person that sent it. Let us consider, therefore, a similar depiction in the context of an advertisement, let us say an advertisement for champagne.

Presumably, if the advertisement is effective, we identify with the couple wandering in nature. What we enjoy is certainly not some other people having a lovely time in love, but our own potential lovely times in love. Perhaps at the time we see the ad, we are in love, and are immediately stimulated to think beyond the ad to practicality: "I'll buy some champagne before my date with Paul tomorrow night." But presumably this would be the aberrant case: the champagne company cannot aim its advertising campaign at those who might be accidentally (from its standpoint) in love at the moment. The advertisement must be aimed at a much larger audience. What designates one as a member of the audience the advertisement is aimed to effect? Surely it is the desire for lovely times while in love. And if this is

the characteristic that the advertisement appeals to, it is stimulating desire for a particular state of mind, independently of any relationship to anyone else. The ad's hook is, in this sense, aphrodisiac.

An aphrodisiac aspect can also be observed in the posters in the apartment described. Imagine our visiting the young working woman in her abode. We might well react to a barrage of such posters with a feeling of sadness, for they hint that something is lacking in the woman's life. The posters suggest a desire for companionship that they also help to assuage. But they do not offer the companionship of an ersatz relationship unless the woman is a peculiar adult. Instead, they offer a sense of belonging to a larger world in which God loves us all, and in which our lives are created anew everyday. This use of sweet kitsch as a stimulus to a sense of connection with a larger world is more depressing than decadent; but the enjoyment involved is self-enjoyment. Sweet kitsch, again in this example, acts an an aphrodisiac.

Claims 1, 2, and 3 are therefore not mutually contradictory. All three seem plausible interpretations of the response provoked in Kundera's example of the kitsch view of children. And each of them suggests something that is important to what the appreciative sweet kitsch observer gains from the experience. If we now turn to claim 4, that sweet kitsch reassures its audience, we can see that the same can be said of it. It does not contradict any of the other claims, and it points to something that may be important in an experience of sweet kitsch. The last example that we considered reveals this function of sweet kitsch. The woman turns to sweet kitsch posters as a means of fortifying her sense of belonging to a larger world, most likely, because she needs reassurance.

But on closer inspection, claim 4 does not seem as independent from claim 1 as the other claims seem from each other. Sweet kitsch can reassure because it makes the world appear somehow sweeter or more inspiring than it is. Claim 4 is not incompatible with claims 2 and 3—claims that kitsch provides easy catharsis and that it operates as a means of self-enjoyment. In fact, its effectiveness as a means of gaining reassurance seems related to these features. The reassurance it offers is acquired with little effort and without much assistance from anything outside one's own mind. Furthermore, although sweet kitsch may be appreciated because it is reassuring, I am not convinced that this is an essential capacity of sweet kitsch. A "patriotic" figurine of wide-eyed children, dressed in red, white, and blue and playing the fife and the marching drum, can be called "reassuring" only in a very strained sense of the term. I therefore concern

myself only with claims 1, 2, and 3 for the remainder of this discussion.[20]

Claims 1, 2, and 3 all seem plausible, and focusing as they do on different aspects of the experience of sweet kitsch, they are mutually consistent. How can we stimultaneously take all of these features into account while thinking about sweet kitsch? I now propose a model that I believe does this. In addition, it accounts for the general difficulty of giving a clear-cut definition of sweet kitsch, a definition that would provide the criteria for determining whether an object under scrutiny is or is not sweet kitsch.

Crucial to this model is the image that sweet kitsch, as I understand it, necessarily involves. The image involved in an instance of sweet kitsch, although it may be composed of multiple elements, is relatively uncomplicated. In keeping with the characterization that kitsch demands little in the way of aesthetic contemplation, the sweet kitsch image is simple, is recallable at will, and represents something attractive.

The simultaneous simplicity and attractiveness is crucial to the kitsch effect. It follows from this that the attractiveness of the kitsch image does not stem from the image's depiction of the details of an attractive situation. What, then, does its attractiveness depend on?

As I see it, the kitsch image appeals by making reference to something not depicted. This "something" not depicted does not share the simplicity of the kitsch image. Instead, it is a whole, complicated structure of beliefs about the way things are, and/or desires about the way things ought to be. In practice, the distinction between beliefs and desires of these sorts breaks down, for the "sweetness" involved in sweet kitsch images usually works to undercut any sense that the world is not (or could not be) as sweet or wonderful as what is presented. Kitsch idealizes. And it idealizes by means of what it can depend on its audience to provide: beliefs about the world and desires that their culture has presented to them as actual or attainable. How culture instills these notions is not my concern here; nor am I concerned to establish the limits of what constitutes a "culture." I will simply take as given the fact that cultures (however defined) do instill value-laden notions to their members about their situation in the world and the possibilities that are open to them. I will refer to these notions as cultural *archetypes*. I do not intend to suggest with this term anything about the origins of these notions or their potential for modification; nor do I mean to imply anything about whether or not cultures tend to develop similar notions with respect to common human situations (e.g., relationships between men and women). I use the term *archetype* to refer to culturally instilled beliefs and desires in order to emphasize their pervasiveness throughout a culture and their semiconscious status.

By means of its surface presentation, which I will call an *icon*, an instance of sweet kitsch makes symbolic reference to a cultural archetype. The sweet kitsch icon depicts a part or an instance of the larger structure of archetypal beliefs and desires. The icon, in other words, stands in a relationship of metonymy or synechdoche to the meaning–granting structure that constitutes the cultural archetype.

The greeting card motif I began with, certainly a case of sweet kitsch, can be used as an example of an icon in the sense that I use the term. A greeting card that employs such a motif calls to mind a whole structure of ideas that members of our culture are typically expected to have about love and its appropriate modes of expression. The depiction can function as an icon only if the person who sees it is previously aware of the archetypal structure to which it alludes. This is the case for all sweet kitsch icons, and for many other kinds of symbols as well.

This model can account for all of the effects of sweet kitsch that are alleged by claims 1, 2, and 3. In accordance with claim 1, sweet kitsch is able to make the world appear sweeter, and to exclude what is intolerable, by virtue of the icon's simplicity. The image is monodimensional; and being by definition a "sweet" image, it avoids any complication that would modify this sweetness. The simplicity of the icon also accounts for the effect alleged by claim 2. Because the overt presentation is simple, little exertion is required to digest the image. The satisfaction the kitsch-object provides is, therefore, effortless.

The aphrodisiac function of sweet kitsch, alleged by claim 3, is explained on my model by means of the archetypal structure. The archetypal structure to which the kitsch icon refers is provided by the observer, not by the icon itself. Enjoyment of one's heightened awareness of this background structure of beliefs and desires, occasioned by the kitsch icon, is doubly self-enjoyment. One enjoys feelings connected with pleasant beliefs and desires that one carries within oneself all the time, independently of the kitsch object. And one enjoys, as a result of observing the kitsch object, *heightened* (if not fully reflective) awareness of these desires and beliefs. One enjoys, in an unusually attentive way, feelings that one has brought to the experience oneself. Because the kitsch icon provides an image of uncomplicated sweetness or goodness, moreover, any stimulus toward complicating or modifying feelings is absent. The kitsch-object thus elicits an atmosphere of unsullied pleasure which takes its particular flavor from the generalized subject matter of the relevant archetype (e.g., romantic love or the family).

Having indicated the type of kitsch I want to consider, some of the effects it can have on an appreciative observer, and a model of its structural characteristics, I will proceed to consider the social and political dangers of sweet kitsch in both its propagandistic and its nonpropagandistic manifestations.

II

While the emotional response to sweet kitsch may occasion self-contained private enjoyment, sweet kitsch is also well-suited to propagandistic uses. This is one of Kundera's main points in his discussion of kitsch, as is evident in the previously cited passage about the two tears. Politicians mobilize kitsch sentiments for the purpose of getting elected. And, Kundera goes on to point out, totalitarian regimes are particularly prone to use kitsch as a means of solidifying feelings of group membership on the part of their citizens. How does this manipulation of kitsch for propagandistic ends work?

Consider again the self-enjoyment that is involved in the second tear that Kundera describes. The second tear ("How nice to be moved, together with all mankind, by children running on the grass!") involves a social reference. The mood stimulated by kitsch in this case, is experienced as being appropriately shared by everyone. The feeling that the world is wonderful (a generic formula for the feeling induced by sweet kitsch) does not involve awareness of any qualifications. The world in question is the whole social world, and those for whom it is wonderful are the whole spectrum of nonobjectionable fellow beings who inhabit it. This unanalyzed sense that one's mood of being moved is potentially universal gives one's response to sweet kitsch an aura of innocence.

The trick of the kitsch propagandist is to limit the scope of the social world with whom one (apparently) shares the sweet kitsch experience. By contextualizing the kitsch experience, the propagandist contextualizes the relevant social "world" as well. Where the propagandistic effort is successful, the audience is sufficiently located in its context that it does not differentiate between being moved "together with all mankind" and being moved "together with the whole party (or nation or interest group or religious group)." The effect is that the feeling of solidarity with other human beings, implicit in Kundera's "second tear," is translated into a feeling of solidarity with a partisan subset of humanity. Advertisements, political demonstrations, and religious rallies are among the contexts in which the observer's sense of the relevant "social world" can be manipulated in this fashion.

Kundera uses a communist May Day parade as a paradigm example of kitsch that is appropriated for a propagandistic purpose: "The unwritten, unsung motto of the parade was not 'Long live Communism!' but 'Long live life!' The power and cunning of Communist politics lay in the fact that it appropriated this slogan. For it was this idiotic tautology ('Long live life!') which attracted people indifferent to the theses of Communism to the Communist parade."[21] As Kundera's example indicates, the satisfied mood provoked by sweet kitsch does not, as such, involve differentiating between human beings that share one's experience and those who do not. It involves instead a sense of social feeling that is rather vague. The propagandistic exploitation of kitsch, however, suggests by the context in which kitsch is displayed that the true basis for this vaguely defined sense of social cohesiveness is the ideology being promoted. This sleight of hand is a cheap trick, but the enjoyment of the kitsch atmosphere pressures members of the audience to ignore the crudeness of the tactic. The pleasure of the experience is enough, for many people, to avoid formulating questions that would kill the mood. And the propagandistic display also provides "certainties and simple truths to make the multitudes understand,"[22] thereby placating minds that might otherwise be tempted to inconvenient reflection.

Another example of the propagandistic exploitation of sweet kitsch is forcefully depicted in Bob Fosse's film *Cabaret*. A conversation that we are observing in a *Biergarten* is abruptly interrupted by the seemingly spontaneous singing of a beautiful, blonde young man. His song is "Tomorrow Belongs to Me," and the sweetness of his voice and expression inspire a sentiment that might be described as: "How wonderful to feel touched by the ideals of innocent youth!" The propagandistic exploitation of this sentiment in the political context of the film transforms the vague sense of being moved by innocence to a more specific, though still emotive, thought: "How wonderful to be German in times such as these!" That the song has such an effect on the *Biergarten* patrons is indicated by the fact that many of them gradually rise and join in singing the song.

The *Cabaret* scene strikes us with the dangerous propagandistic potential of sweet kitsch. Before the song begins, we have been sympathetically attending to the condition of the personal lives of the main characters as it is reflected in their conversation. The intrusion of the singer, evidently a member of the Nazi party, into the context in which the characters can discuss personal matters symbolizes the threatening intrusion of the Nazi movement into a social order in which personal lives are still allowed to exist. His cloying song elicits affirmations of membership in and complicity with this movement

from many members of his audience. We, the film audience, are chilled by the observation that something as sinister as the spread of Nazism is being accomplished by means that appear so innocuous. Our horror is made greater by our awareness of the hideous extent of the evil that was supported by such seemingly innocent gestures of complicity as those made by the *Biergarten* patrons.

One can hardly see such a scene and fail to be impressed with the dangerous political power that kitsch of even the sweetest sort can represent. Sweet kitsch can be a political power because it exploits the human capacity to respond to an image as an icon, as a representation of a whole system of associations. This potential to exploit human responsiveness is not, of course, unique to kitsch. But the "sweetness" that characterizes the sweet kitsch appeal gives its political implementation a distinctive flavor among manipulative political devices. For when sweet kitsch is employed in a calculated manner for political purposes, the suggestion is made that such sweetness as we see in the presentation is a constant conjunct of the ideology which is offered as its context. The presentation being unobjectionable and harmless, the ideology, it is insinuated, is unobjectionable, too. The mood that Kundera calls "a categorical agreement with being" is provoked, and the implication is made that *the* ideological expression of this agreement with being is the ideology being promoted.[23]

Sweet kitsch can be used for propagandistic purposes. And because it can provide a sugar-coated hook for virtually any kind of ideology, it can be a tool of sinister propagandistic purpose. (I leave open the question of whether all propagandistic purposes are sinister. I assume that the use of kitsch by the Nazis makes it clear that some propagandistic purposes for which kitsch can be a tool are diabolical.) Some uses to which sweet kitsch has been and can be put, I conclude, are socially and politically dangerous.

But what of sweet kitsch that is not deliberately employed for propagandistic purpose? Is sweet kitsch itself socially and politically undesirable outside the context of its role in certain propaganda? Hermann Broch argues that it is. Even divorced from a propagandistic context, he maintains, kitsch (of all species, presumably) is a social and political evil.[24]

The producer of kitsch does not produce "bad" art, he is not an artist endowed with inferior creative faculties or no creative faculties at all. It is quite impossible to assess him according to aesthetic criteria; rather he should be judged as an ethically base being, a malefactor who profoundly desires evil. . . . Kitsch should be consid-

ered 'evil' not only by art but by every system of values that is not a system of imitation. The person who works for love of effect, who looks for nothing else except the emotional satisfaction that makes the moment he sighs with relief seem 'beautiful,' in other words the radical aesthete, considers himself entitled to use, and in fact uses, any means whatsoever to achieve the production of this type of beauty, with absolutely no restrictions. This is the gigantic kitsch, the 'sublime' spectacle staged by Nero in his imperial gardens, which enabled him to accompany the scene on his lute.[25]

Part of the evil of kitsch, in Broch's view, is its imperviousness to any restrictions that should limit the domain of what the viewer finds satisfying. Giving its audience pleasure by means of "effect" (in the sense meant in the expression "done for effect"), kitsch distracts them from any concern whatever with moral categories. But some means that can be employed for "effect" are immoral—some of Nero's stunts, for example.

This criticism may be apt for some kitsch; but the means employed by sweet kitsch do not seem particularly deserving of this complaint. The means involved in presentations of sweet kitsch are more or less innocuous, at least insofar as the presentation itself is concerned. (Perhaps a perfume acquired by means of torturing animals could be integrated into an instance of sweet kitsch—a cloying Maypole dance that uses artificial flowers and scents, for instance. The immortality of torturing animals, however, would not in this case be bound up with the production of kitsch, as such.) Broch's criticism here also seems relevant to a wide range of aesthetic phenomena besides what would normally be construed as kitsch. Some movies—Kubrick's *Clockwork Orange,* for example—might be criticized for giving an audience aesthetic pleasure by portraying immoral behavior, but not be instances of kitsch.

Broch has another reason for seeing kitsch as evil, however. Kitsch, he claims, "imposes a completely unreal convention on reality, thus imprisoning it in a false schema." This imposition amounts to a neurotic effort to transform human life into something that is absolutely false. The result is that those who are affected by kitsch feel pressured to obey "false commandments" and to construct their lives to accord with models of "universal hypocrisy."[26]

This criticism might apply to sweet kitsch, at least in some instances. An overly saccharine view of what romantic love is like could lead a member of a couple to have unrealistic expectations, expectations that impede understanding the other. An overly idealized view of the sweetness of motherhood, similarly, could lead a new mother to judge

her human limitations as proof that she is a bad mother, a view which, in itself, could easily make the performance of her role more difficult. In such cases, sweet kitsch may be instrumental in fostering unrealistic expectations that interfere with human interaction. I doubt that the sole responsibility for such unrealistic notions lies with sweet kitsch; indeed, if my analysis of the mechanism by which kitsch achieves its effects is correct, it would seem that beliefs and desires persisting without respect to realism are part of the archetypal inheritance of a culture. Nonetheless, sweet kitsch can reasonably be blamed for giving external approval to unrealistic beliefs that impede interpersonal interaction.

Mark Jefferson's analysis of sentimentality suggests a deeper danger in the distortion of reality promoted by sweet kitsch. A sentimentalized view of things can, Jefferson argues, lead beyond hypocrisy to outright brutality. He treats sentimentality as an emotional quality that is often not associated with the appeals of any propagandistic effort, thereby suggesting that such effort is not essential to sentimentality's adverse social effects. Sentimentality, he maintains, misrepresents the world by employing a particular kind of fiction, which he calls "the fiction of innocence." Sentimentality emphasizes

the sweetness, dearness, littleness, blamelessness, and vulnerability of the emotions' objects.... But this almost inevitably involves a gross simplification of the nature of the object. And it is a simplification of an overtly moral significance.... For the moral distortions of sentimentality are very difficult to contain just to its objects. Frequently these objects interrelate with other things and sentimentality may impair one's moral vision of these things too.... The unlikely creature and moral caricature that is someone unambiguously worthy of sympathetic response has it natural counterpart in a moral caricature of something unambiguously worthy of hatred.[27]

Sentimentality's dependence on moral caricature encourages a framework for formulating moral judgments that is overly simplistic and geared to extremes of approval and repudiation. The seemingly harmless illusion that some object is perfectly sweet depends on a larger illusory scheme which interprets other objects in the world as completely bad and deserving of brutality. Sentimentality, therefore, even when directed toward objects that are not utilized by any particular political or social movement, reinforces the kind of attitude that fuels lynch mobs.

The sentimental response provoked by sweet kitsch, outside propagandistic contexts, is a fair target for this criticism. This response, as we have observed, is understood as being experienced in common with others who might encounter the same stimulus. The woman who is touched by a bronze baby shoe, for instance, expects that others who see it would be moved similarly, and understands her own feeling as a universally shared appreciation of motherhood.[28] But implicit in such an expectation is a sense that one is justified in feeling that one who does not share this "universal" feeling is almost inhuman and deserves to be treated as such. If while cooing over the bronzed baby shoe the woman were made aware of someone who found the shoe silly or even repugnant, she would be likely to have an angry response: "Here is someone who doesn't even respect motherhood or the family!"

This reaction is not so dissimilar from the response of patriotic Americans who disparage "Godless communists." The move is easily made from sentimental appreciation of something one values, backed by a sense that others share this appreciation, to fury at the thought that some people think otherwise. This fury can easily be mobilized by a calculating political movement; but the history of lynch mobs indicates that this fury can be mobilized without such a movement. And even when this kind of fury never actually expresses itself in overt brutality, it is hard to doubt that its very existence has a damaging effect on the health of the social atmosphere of the people who feel it.

Sweet kitsch can, it seems, have pernicious social and political effects whether it is employed as a tool of a conscious propaganda campaign or not. The emotional responses that sweet kitsch provokes in themselves foster hostility toward those who seem not to share one's values or sentiments. It might appear, therefore, that sweet kitsch ought to be categorically shunned as a social and political danger.[29]

III

But there are problems with any attempt to avoid all instances of sweet kitsch, even if society at large banded together in this effort. The most obvious problem is that we are not sure how to find the class of sweet kitsch objects. In fact, we are unable to isolate those objects that are sweet kitsch from non-kitsch.

My model of the mechanism by which kitsch produces effects on the observer indicates why. This mechanism, as I have analyzed it, depends not only on what is objectively presented, but also on common cultural associations that are not directly presented or described. In order for an object to be experienced as kitsch, the object must somehow resonate with largely preconscious desires and beliefs; but an object's facility for doing this is not an inde-

pendent property of the object. Instead, this facility is a relational property that depends on the object's cultural context and its relationship to actual, if not fully conscious, beliefs and desires held by members of its audience.

If an object's nonrelational properties are not determinants of whether or not the object can function as kitsch, an investigation of such properties will do little to help us isolate the set of sweet kitsch objects from the objects that are not kitsch. In fact, it appears that there is little basis for talking of a set of sweet kitsch objects at all. If the kitsch-making property of a sweet kitsch object is a relational characteristic, as it appears, then audience *response* is crucial for an object's being sweet kitsch. And if response is what is crucial, then the range of sweet kitsch is relative to context and variable. There is no clearly definable "set" of kitsch objects.

Nonetheless, we usually take kitsch to be a description of something objective in ordinary uses of the term. The reason for this is that many objects seem clearly designed to provoke a kitsch response. I will call these "objects that make a kitsch appeal." In many cases, it seems that a kitsch response is likely to be the only nonironic appreciative response that an object such as this could produce. It is difficult to imagine nonkitsch enjoyment of the bronzed baby shoe, for example, which is also nonironic.[30]

I see no harm in our continued use of the term *kitsch* to refer primarily to objects that make a kitsch appeal. I think that the more interesting cases of kitsch are those that provoke a response without revealing any designed effort to stimulate it. But for the moment let us limit our consideration to those sweet kitsch objects that are so designed. It appears that if we can specify the objects that fall into this category, perhaps we will clarify at least a subcategory of objects that we ought to avoid in the name of political responsibility.

But the remainder of my discussion will explain why I think this an inappropriate tactic to use in response to the social and political accusations that have been made against the sweet kitsch response. The problems with this strategy are three. First, the kitsch appeal is not any more an independent property of an object than is "being a kitsch-object." One recognizes a kitsch appeal, in fact, by means of something negative: by one's sense that something is lacking in the communicative gesture being made. Thus, the category of objects that make a (sweet) kitsch appeal is as difficult to specify as the category of sweet kitsch objects; again, audience reaction is crucial to an object's belonging to the category. Second, the sweet kitsch response, which is the basis for viewing sweet kitsch as socially and politically pernicious, does not depend on anyone's

making a kitsch appeal. The consequences that one would want to avoid, therefore, might remain with us even if the objects that make a sweet kitsch appeal fell out of favor with the buying public. Third, the effort to avoid sweet kitsch as a category might itself have harmful social and political consequences.

In order to see why an object's "making a kitsch appeal" is not a clear objective property, let us consider again the character of the sweet kitsch object's surface presentation. The surface presentation consists of an icon, which conveys its resonance with the viewer's preconscious or semiconscious beliefs and desires *symbolically*.

Symbolic gestures can certainly be used as a means of communication. When such a gesture is used to communicate nondeceptively, sender and recipient of the gesture are both aware, and aware that the other is aware, of what the symbol means. Consider the conventional symbolic gesture of shaking hands, for instance. A mutual sense that the gesture is offered as a handshake, along with (not necessarily articulate) awareness of what a handshake means, is necessary for the gesture to function as an act of communication. A similar gesture of grasping another's hand would not be a handshake if one was unaware of the handshake convention or did not intend to use it.

Objects that make a kitsch appeal make a similar kind of symbolic gesture, but with an important gesture. Such objects do not inspire conviction that any particular background meaning is being alluded to. Background beliefs and desires concerning a particular matter are alluded to *in general*, without evidence of concern for their specific content. Crucial to the kitsch appeal is our lack of conviction that the maker of the kitsch-object intends to say anything in particular about its archetypal structure of meaning. The champagne advertisement with the couple in the natural setting, for example, communicates nothing specific about romantic love between men and women, nature, or even champagne. The advertiser can safely assume that the audience will add the missing beliefs and emotions to what is depicted.

Because nothing in particular is communicated about the contents of the archetypal structure behind the sweet kitsch icon, we have no reason to believe that the person who makes the kitsch appeal *understands* much of anything about the archetype. We are only led to believe that this person is aware that there is some such structure that his or her own gesture, made through the kitsch-object, refers to. We are given little ground for believing that consciousness informs the object's construction. In fact, we may not construe the sweet kitsch gesture as

performing an act of communication at all. The kitsch-object directs our attention not to meanings that are in any way bound up with the individual who makes it, but to meanings that masquerade as universal. Anyone might have made such a gesture, for anyone could potentially harbor the beliefs and desires that it awakens in its audience. The shared emotional content is not in any sense interactive. Instead, it is tacitly assumed to be common.

But what about a presentation would make us sense that consciousness informs it? Self-irony might contribute to our confidence; but surely it is not essential. And presumably self-irony can be a form of self-indulgence that impedes our sense of what its perpetrator thinks; the self-irony of Kierkegaard's seducer in *Either/Or,* volume I, for instance, leaves us doubtful as to what the seducer really thinks about anything. And how much awareness of the larger structure of meaning are we demanding from the author of a nonkitsch gesture? We do not expect the artist of a great work of art to be consciously aware of everything that his or her work can suggest to an observer in an appropriately aesthetic frame of mind.

Certainly, we should not look for a demonstration that a person employing an icon to refer to a larger structure of meaning is consciously articulate as to the intricacies of the structure in all parts. It is difficult even to know what such a degree of articulate consciousness would be in the case of cultural structures of archetypal and mythic meaning. But I think we can look for evidence that someone employs an icon with both awareness of and concern for its significance. What we are looking for is similar to what we count as evidence that someone who is speaking to us is speaking sincerely. We look simply for some clue that the words we hear are spoken with concern that communication be achieved. The absence of such a clue is more striking than its presence. When we feel that someone is trying to manipulate us, we feel a conspicuous lack of the kind of clue we expect; instead we sense a desire on the part of the other person to obfuscate his or her meaning.

An example of such a situation might help to clarify, indirectly, the absence of sense in the kitsch appeal. Let us consider the use of pleasantries that etiquette recommends in the context of social roles. When a person stands in certain clearly defined roles with respect to us, pleasant inquiries about our health and happiness strike us as quite appropriate. One such role is that of a person who is about to interview us for a job. We understand the inquiries as gestures that refer to the structure of social interaction that defines our formal relationship. So much do we understand inquiries of this sort with respect

to this structure that we might take it as an infraction of courtesy to respond with realistic answers to the surface questions asked, particularly when the responses would clearly be less pleasant than the tone of the questions. The inquiries function as icons in this context.

We expect here some indication that the gesture is supported by an appropriate mental disposition on the part of the person who makes it. In this case, we do not expect much thought or deep concern to motivate these inquiries; but we do expect to sense that they reflect a genuine sense of fellow-feeling on the part of the interviewer. When we sense the lack of the minimal level of concern that we associate with fellow-feeling, we are likely to feel resentment, or at least to reflect that there is something inhumane about the way the interview situation is being handled.

Kitsch appeals often provoke resentment; and the kind of resentment they provoke is structurally similar to that inspired by the interviewer who uses the gestures of politeness without conveying fellow-feeling. It is also similar to the resentment that Dewey describes as a common response to artworks that appear contrived without genuine emotional involvement or concern for the particular character of its materials.

If one examines into the reason why certain works of art offend us, one is likely to find that the cause is that there is no personally felt emotion guiding the selecting and assembling of the materials presented. We derive the impression that the artist, say the author of a novel, is trying to regulate by conscious intent the nature of the emotion aroused. We are irritated by a feeling that he is manipulating materials to secure an effect decided upon in advance. The facets of the work, the variety so indispensable to it, are held together by some external force. The movement of the parts and the conclusion disclose no logical necessity. The author, not the subject matter, is the arbiter.[31]

When we resent an instance of sweet kitsch, our resentment is a response to what is absent. A kitsch depiction of a baby, for instance, indicates no real concern for what babies are like beyond the concern to draw something that will recognizably pass as a baby. We sense that the person who constructed it aims at effect; we have no sense that he or she is concerned to say something in particular about the subject matter. But unlike Dewey's case, in which intellectually aggressive manipulation of materials is compatible with the emotional lack and insensitivity to materials that he criticizes, the kitsch depic-

tion is also void of any evidence of intellectual pur-
posiveness. We are thus unlikely to feel resentment
toward the artist, as such; as I have mentioned, we
hardly sense a person behind the presentation at all.

What we demand in any gesture of communica-
tion is some conscious awareness of and concern for
what the gesture implies. In the interviewer's uncar-
ing pleasantries, the inauthentic work of art, and
the kitsch appeal, this demand is unfulfilled. It is the
lack of something and not the presence of some-
thing, in each case, that makes the gesture objec-
tionable.

It follows from what has been said that the kitsch
appeal cannot be linked to a specific characteristic
or set of characteristics that appear in the kitsch
object. We recognize a kitsch appeal by means of
our reaction, not by means of observing objective
properties in the object; and the relevant reaction is
hard to define: it amounts to a sense that something
is missing in what lies behind the gesture. A defini-
tive characterization of objective features of objects
that make kitsch appeals is thus impossible.

There is a second problem with the strategy of
eliminating objects that make a sweet kitsch appeal
as a means of avoiding objectionable social and
political consequences. The elimination of objects
designed to provoke a kitsch response, even if we
could specify these clearly, would not eliminate the
kitsch response. The kitsch response does not
depend on a kitsch appeal. It is a state of mind that
can occur in the absence of any appeal whatsoever.

There are certainly natural objects that produce
a kitsch response. The popular middle class associ-
ation of Niagara Falls and honeymoons seems to be
built on precisely such an association of a natural
phenomenon and the response characteristically
provoked by sweet kitsch. At least the first of the
two tears that Kundera describes as being funda-
mental to the kitsch experience would seem to have
served as the precondition for the Niagara Falls–
honeymoon association: "How wonderful it is to be
at Niagara Falls and see something so beautiful!"
The conspicuous presence of many young couples
who perhaps have responded to the cultural associ-
ation facilitates the second tear: "How wonderful
young love and marriage are!"

This second tear may be a response of a nostalgic
observer. But one fears that it may also be the
response of some of the young couples themselves.
This response on the part of a member of a young
couple visiting Niagara Falls could reasonably be
interpreted as a kind of imposition of an unreal
schema of interpretation over the events of his or
her own life. The dangers involved in this imposi-
tion would be essentially the same as those that
Broch indicates in his criticism of kitsch. But in this

case a natural object has been the object that has
elicited the kitsch response.

It might be objected that the kitsch response to
Niagara Falls depends not on the natural wonder
but on the kitschification of its surroundings that
has been perpetrated by the tourist industry. Dis-
cussing the kitschification of the natural environ-
ment, Calinescu notes: "Less than a century ago,
nature used to imitate art, as Oscar Wilde put it in
his famous 'Decay of Lying.' Certain sunsets, Wilde
went on to say, had come to look like paintings by
Corot. Nowadays, nature has little choice but to
imitate mass-produced color reproductions, to be as
beautiful as a picture postcard."[32] No doubt the arti-
ficial tourist development facilitates the attitude of
aesthetic make-believe that Calinescu associates
with the phenomenon of kitsch. But the *object* that
elicits the kitsch response in this case, I would still
maintain, is a natural object—the falls themselves.
And I would suspect that less well-publicized natu-
ral objects would lend themselves to such a response
as well. The thought of going to Acapulco is per-
haps more likely to be a thought of visiting a world
of aesthetic make-believe than is the thought of
going to "the beach," in part because Acapulco has
a successful tourist industry. But "the beach," as
such, has surely been the occasion of kitsch experi-
ence even without the influence of the tourist indus-
try's propaganda.

The possibility of kitsch responses to natural
objects should not surprise us if we accept Kunder-
a's account of the figurative tears that are involved
in kitsch. The second tear, the tear that makes
kitsch kitsch, we should recall, says, "How nice to
be moved, together with all mankind, by children
running on the grass!" This tear, it should be noted,
depends on the experienced object only as an occa-
sion. Harries makes this point: "It is not that Kitsch
creates desire for an object.... The interest has
shifted from the object of desire to the desire itself.
What was originally an object of desire is trans-
formed by Kitsch to what, with Kierkegaard, we
may call a mere occasion which is used to stimulate
desire. The consciousness of the object is periph-
eral."[33]

The nature of the kitsch response, then, inher-
ently ensures the possibility of a kitsch response to
an object that is not designed to provoke one. Con-
versely, an object that is clearly designed to provoke
a kitsch response may not succeed. The kitsch greet-
ing card, for instance, may strike us as repulsively
sentimental. The feeling of repulsion may be com-
plicated, but the response it elicits is not the kitsch
response. Being on guard against kitsch appeals, we
can conclude, will not effectively arm us against
kitsch responses.

IV

The third problem I see in the tactic of shunning sweet kitsch is that the tactic itself may be socially harmful. This potential harm stems from the type of aesthetic that would underlie such a tactic. Such an aesthetic is necessarily exclusivistic, for it would condone the categorical rejection of certain sorts of objects, objects conducive to provoking a sweet kitsch response.

As we have seen, such a response does not depend directly on positive characteristics of the object. The decision of what sorts of objects to relegate to the shunned category, therefore, is a matter of the aesthetic observer's subjective judgment. Such a judgment, however, geared as it is to defending political righteousness in the case we have in mind, is likely to be parochial and self-congratulatory.

I suspect that exclusivistic aesthetics in general tend toward parochialism. The enterprise of the exclusivistic aesthetic always faces the problem of ensuring that its promoter's subjective preferences do not front themselves as "good taste" from an objective standpoint. But the exclusivistic judgment against sweet kitsch is not counterbalanced by appeal to objective characteristics, as some exclusivistic aesthetic judgments may be. The attitude fostered by the stance of repudiating sweet kitsch could thus come to resemble the self-congratulatory celebration of innocence or sweetness. In both cases one feels too easily justified in rejecting perspectives that are different from one's own.

In arguing for this position, I admit that there are situations in which sweet kitsch might have its place. Let me again take the saccharine greeting card as an example. My view is essentially that from a standpoint of concern for improved social relationships between people, even stylized, mass-produced, cliché gestures should be endorsed if they provide the only alternative to the promotion of a standardization of taste; and that the outright rejection of sweet greeting cards is, in effect, the promotion of such standardization.

As a case in point, consider the problem of communicating with a person who is two or more generations removed from oneself. The very real burdens that rapid change in the modern world impose on such a relationship are only heightened by an insistence that gestures more common as modes of social intercourse in the youth of senior citizens—including, perhaps, the recognition of birthdays with sentimentalized greetings through the mail—are outmoded and tasteless. It seems clear that birthday cards depicting cliché bouquets would for many people be an effective means of symbolically communicating affection to their grandmothers. Cards

that overtly showed some irony about themselves would, on the other hand, be less sensitive modes of emotional expression, even though they might strike most sophisticated, younger observers as more tasteful than cards with sentimental bouquets. The question of what is desirable, that is, appropriate, in the case of greeting cards is in such instances more a question of humanity—in the sense of what it means to be humane in the most positive sense—than it is a question of aesthetics.

This is not to say that I think my point here is unrelated to aesthetics. The aesthetic dimension of life is, I concur with Dewey, inappropriately placed in a realm unto itself. At the very least, the aesthetic dimension of life touches every social interaction that utilizes greeting cards, for better or for worse. It may well be that greeting cards often do more to discourage aesthetic sensitivy than to encourage it. But aesthetic sensitivis is not discontinuous with the kind of sensitivity on which humanity in social interaction depends. And if this is an accurate observation, it would seem that a rigidly exclusivistic aesthetic undercuts the kind of sensitivity that one would in general expect aesthetic experience to promote.

A rigidly exclusivistic aesthetic might reject mass-produced greeting cards outright because they display anesthetic reiterations of artistic clichés, usually presented in an inarticulate style. I take this assessment of the quality of the presentation of most greeting cards to be correct in essence. But a stance of rejecting greeting cards in general on grounds of taste strikes me as objectionable; for it justifies insensitivity to the fact that there may be situations in which a cliché gesture expresses more genuine concern for the emotional state of the person to whom it is addressed than would an effort to express one's own feeling directly. One need only think of the contexts in which sympathy cards are mailed to realize that there may be appropriate times for expressing only the gist, and not the detail, of one's own emotion. Sometimes the use of icons, even kitsch icons, is the most appropriate means of interacting with other human beings in a manner that is sensitive to their perspective, particularly when it significantly differs from one's own.

We may conclude, then, by allowing that the insight that grounds the claim that responses to sweet kitsch often have pernicious social and political consequences is the recognition that oversimplified interpretations of the world are socially harmful. To the extent that sweet kitsch promotes an understanding of the world that simplistically divides it into categories like "the innocent" and "the contemptible," it represents a serious social

danger. But we should realize that the categorical rejection of whole types of gestures, even when motivated by the most praiseworthy social concern, also reflects an oversimplified interpretation of the world. If oversimplified interpretations of the world are socially harmful as such, we should try to prevent our quest for insight into what should be val-

ued from becoming a search for platitudes that will make questions of value easy. Perhaps we should be most on guard in cases in which the platitudinous seems an almost undebatable truism. Such, I suggest, is the perspective that should be taken on the overview, "Sweet kitsch is bad."

Notes

I wish to thank Karsten Harries, Alexander Nehamas, David C. Ring, Garret Sokoloff, and Robert C. Solomon for their roles in helping me to formulate the ideas expressed in this paper.

1. Matei Calinescu, "The Benevolent Monster: Reflections on *Kitsch* as an Aesthetic Concept," *Clio* 6 (1976), 6.

2. See Gillo Dorfles, *Kitsch: The World of Bad Taste* (New York: Universe Books, 1968), p. 10.

3. See Hermann Broch, "Notes on the Problem of Kitsch," in Dorfles, ed., *Kitsch*, pp. 63–65.

4. Lyell D. Henry, Jr., "Fetched by Beauty: Confessions of a Kitsch Addict," *Journal of Popular Culture* 13 (1979), 198 and 207.

5. Henry, pp. 203–204.

6. Matei Calinescu, *The Faces of Modernity: Avant-Garde, Decadence, Kitsch* (Bloomington: Indiana University Press, 1977), p. 229.

7. Ibid., p. 240.

8. Ibid., p. 244. See also Calinescu's fascinating discussion of kitsch as a manifestation of the style of hedonism characteristic of the middle class, pp. 244–47.

9. Milan Kundera, *The Unbearable Lightness of Being* (New York: Harper & Row, 1984), p. 248.

10. Calinescu, *The Faces of Modernity*, p. 232.

11. Some analysts may question my inclusion of kitsch that stirs emotions of patriotism as instances of the sweet variety. Calinescu, for instance, suggests that there are "innumerable nuances" between the sweet and sour species of kitsch. (See Calinescu, *The Faces of Modernity*, p. 236.) I include kitsch that evokes patriotic feeling among instances of sweet kitsch because I am persuaded by Kundera that political kitsch often appeals to sentimentality of a straightforward and nonpolitical sort. I also think that effective political or patriotic kitsch in general activates a response mechanism that is essentially the same as that essential to effective nonpolitical sweet kitsch.

12. I do not exclude the possibility that wordless music may be kitsch. Background music used in advertisements around Christmas time that are not themselves Christmas carols but resemble them provide clear instances of this phenomenon, in my view. I suspect that an analysis of such musical kitsch would reveal that the kitsch quality of such examples depends on extramusical associations that the audience is likely to have, associations that would be directed toward what I would call an image. I am also not convinced that such musical kitsch could be sweet kitsch unless the overwhelmingly clear associations that it inspired had appropriately sweet content. But I believe that the special case of such musical kitsch deserves further treatment than I will provide here.

13. Henry, pp. 203–05.

14. Kundera, p. 248.

15. Ibid., p. 251.

16. Clement Greenberg, "Avant-Garde and Kitsch" (1939), in his *Art and Culture* (Boston: Beacon Press, 1965), p. 10.

17. Greenberg, p. 15. Greenberg later discovered that the painting by Repin was actually a product of his own imagination. See Greenberg, p. 21 n. For additional discussion of the "easy catharsis" offered by kitsch, see Calinescu, *The Faces of Modernity*, p. 228 and pp. 241–42. The latter discusses, in part, Adorno's definition of kitsch as the "parody of catharsis," an analysis which is also relevant to our discussion. See T.W. Adorno, *Aesthetische Theorie* (Frankfurt/Main: Suhrkamp, 1970), pp. 355ff.

18. Karsten Harries, *The Meaning of Modern Art* (Evanston: Northwestern University Press, 1968), pp. 79–80.

19. Ibid., p. 80.

20. Crick, while denouncing kitsch, cites this reassuring character as basic to all kitsch. "Kitsch is very much a by-product of social anxiety and tries very hard to reassure. It seeks to protect both its maker and its consumer from the rigour of the real." (Philip Crick, "Kitsch," *British Journal of Aesthetics*, 23, no. 1, 50.) It appears that Crick ties the reassuring character of kitsch to the ease with which it is digested. In the case of sweet kitsch I am inclined to think that reassurance, where derived, stems from the sweet aspect it lends to reality. But Crick's analysis would also provide grounds for limiting my further discussion to claims 1, 2, and 3, since claim 4 is derivative of claim 2 on his analysis.

21. Kundera, p. 249.

22. Ibid., p. 254.

23. Ibid., p. 248.

24. Broch, p. 65.

25. Ibid., p. 76.

26. Ibid., pp. 63–65.

27. Mark Jefferson, "What Is Wrong with Sentimentality?" *Mind* 92 (1983), 526–27.

28. There seems a certain incongruity in the idea that a man would own and display a bronzed baby shoe. I suspect that within the range of kitsch, for all its generic incongruities, a social notion of appropriate and inappropriate audiences for specific kitsch objects reigns. I suspect, furthermore, that the reigning sense of propriety in kitsch depends to a large extent on the stereotypes involved in the cultural myths on which kitsch gestures depend. A bronzed baby shoe is an allusion to a structure of associations about motherhood; therefore it seems appropriate that it is owned and displayed by a woman.

29. Sweet kitsch, and kitsch generally, might be viewed as a social and political evil for another reason as well. Kitsch has, I think aptly, been criticized for lowering aesthetic standards in society. This topic deserves further discussion, as does the question of whether the lowering of aesthetic standards contributes to more directly social and political ills.

30. I include treatment of kitsch objects as "camp" among the ironic appreciations of kitsch objects. I leave open the question of whether any object usually construed to be kitsch can be seen as camp, given an ironical perspective. The overlap between the set of objects often seen as kitsch and the set of objects presented (by means of context) as camp establishes, in my view, another reason for focusing on response as crucial to an object's being kitsch. But the relationship between the two categories is a topic that deserves further discussion elsewhere.

31. John Dewey, *Art as Experience*, excerpted in *Philosophies of Art and Beauty: Selected Readings in Aesthetics from Plato to Heidegger*, ed. Albert Hofstadter and Richard Kuhns (Chicago: University of Chicago Press, 1964), p. 610.

32. Calinescu, *The Faces of Modernity*, p. 229.

33. Harries, p. 79.

53

Circus, Clowns and Culture

PAUL BOUISSAC

The ethnologists, the students of cultures, consider as a relevant object for their investigations any organization through which goods or symbols are conveyed between the members of a given sociey. It is now widely accepted that most of the patterned exchanges and interactions that characterize a culture can be analyzed as codes, or metaphorically speaking, as languages.[1] From this point of view, the circus is a language. When a circus director puts a show together or when an artist creates and then performs an act, the audience is exposed to a sequence of audio-visual events that are in effect messages. The audience "consumes" these messages—that is, it understands what is performed in the ring—and gives signs of enjoyment and approval. This process of communication obviously can take place only because of the existence of a code shared by the performers and the public. It should also be obvious that this code is not restricted to a particular group, nation, or class, but is shared by people speaking various languages and experiencing various ways of life.

A circus artist can usually perform successfully in any country, without knowing the language or the specific culture. Although this does not necessarily mean that the code of the circus is completely universal, it definitely proves that it includes at least some of the elements that the cultures in question have in common. Furthermore, the fact that in going from one country to another, circus artists, primarily clowns, have to adjust some of the details of their acts to accommodate the specific culture of the area in which they are performing does not obviate the universality of this code, for such adjustments are part of the code.

What is the content of this code? It is sometimes claimed that even though the circus exists within many cultures it is not relevant to them. Some people think of the circus as a meaningless remnant of an ancient tradition. From that point of view, the circus' oddness would account for its attractiveness, and its survival would rest on its being a fascinating fossil: "Les débris d'un folklore où il n'y a rien à comprendre" [the meaningless remnants of an ancient folklore], as a historian of philosophy once said about Greek mythology.[2] On the contrary, I would like to defend the attitude expressed by Pierre Bost, a French essayist who wrote in the foreword of his book *Le Cirque et le Music-Hall* [Circus and Vaudeville]:

> Le cirque et le music-hall ne sont pas seulement des spectacles brillants et étourdissants, mais aussi et surtout des spectacles très précis et très clairs, derrière lesquels il y a certainement quelque chose à comprendre. C'est faire injure à nos plaisirs que de nous contenter de les subir.

> [Circus and vaudeville are not only brilliant and fascinating forms of spectacles but also, and above all, very precise and very lucid ones. They are very meaningful; to content ourselves with a passive enjoyment is to insult our intelligence.][3]

From Paul Bouissac, *Circus and Culture: A Semiotic Approach*. Lanham, Md.: University Press of America, 1985, pp. 5–9, 151–75. Reprinted with permission of University Press of America and the author.

It is my ambition to shed some light on our enjoyment, not of course to temper it, but if possible to enhance it.

Undoubtedly the circus enjoys a very peculiar status in our society. It appeals to all people, regardless of age, and generally captivates and gratifies them. However, its mention triggers ambivalent responses in which keen interest is mixed with derogatory laughter. Moreover, certain negative or unpleasant situations are commonly characterized as being circuslike. These indices suggest that the circus has a definite function in our culture, but its relation to it is not clear; it seems to be at the same time both "within" and "outside" culture. This impression is fully justified, since the circus can be defined as a metacultural code, i.e., as a code that implicitly refers to the cultural codes.

If we examine the components of some typical circus acts, we can identify elements coming from our cultural environment: objects, costumes, music, animals, patterned social behavior, and so on. By "cultural environment" I mean the totality of one's social experience and one's interpretation of the world; this includes not only material objects but also systems of relations between these objects, i.e., what some ethnologists call cultural units, units of world view, or folk ideas,[4] such as the compatibility or incompatibility of certain situations and certain behavior; zoological classifications like wild vs. domesticated animals, repulsive vs. attractive animals, humans vs. animals; or categories of styles such as exotic, primitive, historical, futuristic, and so on, each contrasting category being embodied in concrete signs that symbolize it. A circus performance tends to represent the totality of our popular system of the world, i.e., it actualizes in one way or another all the fundamental categories through which we perceive our universe as a meaningful system. According to this cosmological view of the circus, the constituents of the acts are symbols or tokens of their class, and their identification by the audience constitutes an important part of the decoding process. A circus performance is easily understood because, in a way, it is redundant with respect to our culture; and it is gratifying because it enables us to grasp its totality in a limited time and space.

But a circus performance is more than just a representation of the contextual culture; it is also a metacultural discourse. Some of the cultural elements are combined differently in the system of the circus than in the corresponding everyday instances. The rules of compatibility are transformed and often even inverted: at the level of the decoding process, a horse makes a fool of his trainer; a tiger rides an elephant (supposedly incompatible animals, predators and prey, or irreconcilable enemies are presented in immediate conjunction); an elephant uses the telephone, plays music, or, like man, eats dinner at a table; a clown produces incongruous sequences of objects and behavior. Even the basic rules of balance are seemingly defied or denied.

The circus freely manipulates a cultural system to such an extent that it leaves the audience contemplating a demonstration of humanity freed from the constraints of the culture within which the performance takes place. Circus tradition, contrary to what many assume, is not an invariable repetition of the same tricks but a set of rules for cultural transformations, displayed in a ritualistic manner that tempers this transgressive aspect. The liberty taken with myths, in the ethnological sense of the word, accounts for the ambivalent response to the circus, namely, repression and fascination—enthusiasm produced by contact with freedom from culture, accompanied by the fear that this potential subversion may be generalized. That is to say, it is this very relevance of the circus to culture that accounts for the semirejection of the circus by the culture. Apparently, then, the stereotyped association of the circus with childhood is less a matter of fact than of cultural compulsion. Furthermore, individuals who have not been fully integrated into a culture find it more acceptable to enjoy this type of performance, as do individuals with a marginal or unique status, such as poets and artists. As a matter of fact, if only children and poets had patronized the circus, it could not have been such a financial success for such a long time!

Others have magnificently extolled the moral and aesthetic qualities of circus performances, i.e., what the circus has in common with art and literature.[5] Maybe it is not useless to try to analyze its specificity in order to clarify the relationship between circus and culture—a situation often obscured by hasty judgment and limited experience. The precise and detailed study of the functioning of the circus has been undertaken only recently, but there is a growing feeling that more scholarly attention should be given to the institution and productions of the circus, as major achievements of mankind, both societal and individual. Other institutions may serve more or less the same function, but the circus does it in a most superb way. It is a kind of mirror in which the culture is reflected, condensed and at the same time transcended; perhaps the circus seems to stand outside the culture only because it is at its very center. . . .

Although circus clowns, as Western civilization has known them for the last two centuries, have attained the status of mythical figures through art, literature, and films, their performances themselves have received very little scientific attention. This is surprising, considering that clowns have always

been numerous, productive, and popular. Their proven ability to provoke emotions, particularly mirth, makes the study of clowns very relevant for any investigation of Western cultures, current or of the recent past. In earlier times, however, not many traces of what clowns did in the ring could be kept for future research. Most of their techniques and "secrets" were and still are transmitted orally. Moreover, their activities seem always to have been held in suspicion, if not openly repressed, and therefore not considered worthy of preservation. Ever since technology has made the recording of ephemeral events possible, some clown performances have been stored in archives. But such recordings (television tapes, for instance) are sporadic and not systematically undertaken. The purpose of this [section] is to formulate a tentative theory that would account for all aspects of clown acts, so that relevant descriptions and analyses of these acts will be possible.

The subject of clowns has inspired many writers. The Toole-Stott bibliography of the circus and allied arts[6] provides an impressive list of books dealing with the history of clowns and clowning, and numerous references to novels, poems, memoirs, and paintings using the clown as a model or as a theme.[7] However, these two kinds of works are very frustrating for a student of earlier clown performances. The historical literature generally deals with biographical and chronological data and their interpretation, and offers little information on the precise behavior of clowns as performers. A trick may be mentioned out of its immediate context, or part of a costume may be described, but the circumstances in which they were used are not given. The lack of useful information and the abundance of peripheral data might be explained by an attitude found in event-oriented cultures: a phenomenon considered important normally results in the feeling that its *history,* rather than a precise description of its manifestations and functions, should be written. Historians tend to emphasize variables, while anthropologists and semioticians are more concerned with the constants that can be isolated in a given synchrony. Even from a diachronic point of view, the latter focus their attention more on systematic than on incidental changes.

Both literary and iconographic works about clowns have a theme, mainly as a development of the Romantic approach, that is totally inaccurate with respect to actual performances. A recent essay[8] as well as a recent film[9] superbly orchestrate the image of the clown as a pathetic figure—the solitary outcast, rejected lover, unlucky tramp—who transcends his sorrow by making a show of it or by compelling himself to laugh uproariously. Viewing clowns through this archetypal filter is especially misleading; for centuries clowns have been entertaining thousands of people daily—they have spread mirth and created ingenious jokes, and quite often, they have been financial successes. Why the interpretation of circus clowns by painters and writers is so much out of touch with reality is an interesting semiotic problem. Cathartic repression against the transgressors (the clowns) might account for this stereotyped attitude.

Ethnologists and psychologists have shown an occasional interest in clowns. The former have identified some particular modes of behavior observed in primitive tribes as "ritual clowning."[10] The latter have been concerned with motivations that might account for an audience's enjoyment when watching clown acts. Unfortunately, both approaches seem to be characterized by a general impression, if not merely secondhand knowledge, of what a clown act consists of. Ethnologists refer to "the clowns of our circuses" as a familiar experience, but none of them have ever described a performance with the same methods they apply to their own field studies; instead they proceed through allusions. Psychologists usually isolate some features without taking into consideration that a clown act is not simply an accumulation of unrelated gags but a tightly structured performance, regardless of its length. A good example of psychologists' treatment is in S. Tarachow's *Circuses and Clowns:*[11]

> The clown does incredibly stupid things and never seems to learn; even in the judgment of the child he is stupid. Equipped with a broom, he tries to sweep away a circle of light cast by a spotlight, but never succeeds. He follows a bauble suspended from his own headdress. He engages in endless bickering or problems with another clown, problems and quarrels that could be settled in a moment if either clown showed an ounce of intelligence. Other clowns act out the most fantastic childish indulgences. One might endlessly break dishes, another eat enormous amounts of pie. Another is abysmally dirty. Sometimes the dirty clown creates a comic situation in which the superego is gratified. The clown removes a fantastic number of dirty shirts and finally arrives at a spotlessly clean one. They are absolutely undisciplined, in a childish way. There is a good deal of aggression as well as masochism. They strike each other, quarrel, fall, trip. The slapstick and bladder are prominent.

All of these statements are true, but their sum total is a very poor account of observable sequences, even sequences in an American circus, where, for technical reasons, clown performances tend to be somewhat less sophisticated than in European circuses. American clowns must adjust to the drastic increase

in the distance between the ring and the audience; they have to rely on large visual devices rather than on a subtle combination of speech, facial expressions, miming, and physical objects. This concern with the decoding capacities of the receivers of their messages modifies the form of their messages but not the basic content.

Rather than present a loose and allusive discourse about clowns, I will focus on the specific behavior of one individual (or a group of individuals under the leadership of one of them). This may help to avoid the usual confusion between the clown as an artist and the clown as a character. In view of the cultural connotations of "clown," it is important to point out that his outward appearance is neither the result of a curse nor the sign of a degraded life; it is a set of elements that he himself has selected and combined within the framework of circus tradition. The same is true of his behavior as a whole in the ring (gait, speech, gestures) and of the situations in which he gets involved. The production of a clown act consists of creating a dynamic situation that includes people and/or animals and/or objects, and is developed dramatically before coming to a conclusion. Clown acts may vary in length and complexity, but the creation of an act is always based on the same principles. It seems obvious, therefore, that the artist's behavior is that of a user of a language, or code. He is definitely engaged in an act of communciation.

The message transmitted by a clown involves two channels—optical and acoustic—and several codes that are actualized through both channels. This view is based on the assumption that the specificity of natural language is the specificity of its medium, not of its expressive, representative, or predicative capacity. Accordingly, language here is to be understood metaphorically, in the broad sense of semiotics: given a number of media that can be perceived as conveying discrete elements, and given the possibility of contrasting these elements in some respect and controlling them in one way or another, there is a human capacity for producing meaningful combinations independent of the character of each medium. As a result, multimedia or multilinear communication must not be taken to mean parallel messages (this would satisfy the definition of *noise*), but transmedia messages. When music, for example, is perceived as contributing to the atmosphere of a dramatic situation, it functions as a qualifier of the situation. Any significant change in intensity, key, or melody will modify the decoding of the situation presented. Meaningful transmedia syntagms are produced through co-actualization and immediate succession of occurrences.

The next step is to define the set of multimedia messages forming a clown act as a text. A clown act is not an indefinite event. It is actualized within time and space boundaries and can be easily identified and isolated. It repeats itself day after day without significant change, thanks to the physical permanence of the accessories and the memory of the actors. It is structured and intelligible in its details and in its totality, since it is obviously understood and appreciated by audiences. Such texts can be observed in contemporary circus shows or reconstructed from information scattered in existing documents. An observation of the immediate constituents of a clown act will indicate the following elements:

1. Human performers. The image of a solitary clown is the result of a transformation in an interpretative process cut off from the context of an actual clown act. A clown act always has at least two participants, or, more to the point, a basic dichotomy in the status of the participants. Two strings of signs symbolize, respectively, the cultural norm and the absence of that norm, either as nature or as anticulture. This dichotomy can be actualized, for example, by the contrast between the equestrian director or the master of ceremonies (MC) and the tramplike clowns. The MC usually has well-groomed hair, a moustache, and a serious, self-confident face. He wears either a well-cut uniform or a formal suit. He acts and talks with authority. He is the warden of a set order. The clown, on the other hand, is ill shaven, ill combed, ill behaved, a slovenly tatterdemalion, sloppy, inarticulate.

The basic dichotomy in clown acts is even more obvious in the traditional act that consists of a white-faced clown and a clown proper, often called the "auguste."[12] The former is the epitome of culture. He is qualified by an accumulation of overdetermined signs: his natural color and facial features disappear under white makeup; lines are drawn to form thin lips and asymmetrical eyebrows; his hair is inconspicuous, if not totally absent; his perfectly fitting costume is made of rich fabric and embroidered with glittering thread; and his shoes are those of a dancer. The white-faced clown behaves elegantly and authoritatively. He knows how to play the most sophisticated musical instruments. He talks well, and knows the solution to every riddle.

In contrast to the white-faced clown, with all his suave attributes, the ugly clown (clown proper) has a mask that accentuates natural protuberances and colors, enlarges his mouth, and emphasizes the natural symmetry of the human face; his wig is usually abundant and undisciplined; his suit is either too large or too small, of an extravagant color, and eccentric in other respects; and his shoes often are immense. His way of walking and talking differs strikingly from his companion's demeanor. He embodies the inverse of all the features of the white-

faced clown, who, significantly, in French circus jargon, is called the *faire-valoir* (literally: emphasizing by contrast the other's qualities). Since he is the antithesis of the white-faced clown (i.e., is anticulture), he could be considered the champion of nature. The basic dichotomy of clown acts, the participants, and the relationship of outward appearances to this dichotomy are summarized in Figure 1, which shows that the initial situation built up by the clowns symbolizes redundantly (and in a noiseless transmission) the opposition between cultural norms and cultural 'ab-norms'. This fundamental opposition is carried out dramatically by the accessories and social behavior of the clowns. Indeed, a culture can be defined by, among other things, its artifacts and the patterned body movements through which people interact symbolically.

2. Physical objects. The system of objects, in all cultures, is governed by rules of shape and proportion, collocation, use and function.[13] The white-faced clown knows and practices these rules, whereas the other clown lightheartedly violates them; e.g., he makes music with a rubber glove, after having pretended it was a cow's udder; he extracts a tooth as big as the patient's head from another clown's mouth; he uses a comb as long as his arm; he opens an umbrella containing a built-in device that produces rain *under* the umbrella.[14]

Almost all clowns carry tools in their luggage to fabricate new objects or somehow transform normal artifacts. Some clowns have permanent workshops for this purpose.

3. Social behavior. Patterned body movements are used similarly. Clowns manipulate inappropriately but not indiscriminately the contextual culture's system of accepted violence (verbal and physical) between age groups, the sexes, and social classes. First, they use highly institutionalized types of violent behavior. Second, their social interactions are governed by different rules, such as generalization of a highly specialized act (e.g., beheading), reciprocal use of what is supposed to be a one-directional action (e.g., pedagogical sanctions like slapping a student), and reversal of aggression (e.g., exhaustion of the kicker). (See last two rows of Fig. 2.)

Since the initial relation posited in a traditional clown act is very general ("cultural polarization"), the two participants can represent any type of social situation by adding to their basic outfits some attributes that symbolize the social functions selected (hats, instruments, tools) or simply by "quoting" a typical gesture or intonation associated with the social role they wish to portray. The instruction of a young recruit by an officer has been a popular act for some time. The white-faced clown wears an offi-

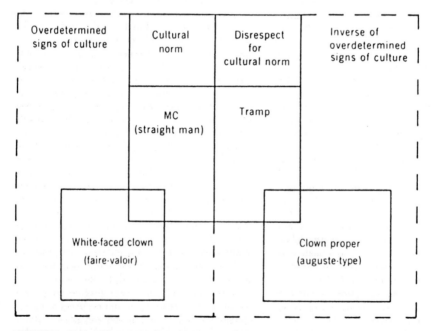

FIGURE 1. Basic dichotomy of a traditional clown act.

Natural quantity / Cultural quality	Verbal violence	Visual violence (gestures)	Physical violence	Killing
Weakly patterned	Raising the voice	Angry behavior	Chasing and wrestling	Murderous attack
Mildly patterned	Words and intonation of command and constraint	Threatening gestures	Slapping, boxing, wrestling	Crimes of passion
Strongly patterned	Stereotyped insults	Specific miming of patterned physical violence, or symbolic gesture	Teacher's slap, patterned limitation of freedom, outraged lady's slap	All forms of legal execution

FIGURE 2.

cer's cap; the clown proper has a wooden gun. The sequence of one such act is as follows:

1. The recruit makes a mistake.
2. The officer says, "I will teach you how to address me," and calls the recruit an insulting name.
3. The recruit pretends that the insulting name is the officer's and answers, "Pretty name!" Then, in a very urbane manner, he introduces himself in return.
4. The officer is taken aback for a moment (this allows time for the audience to laugh). Then he reacts, with physical violence.
5. The recruit gives his gun back to the officer and declares that he is quitting the game because the officer lacks a sense of humor.

In such a sequence, two types of patterned interactions, which are mutually exclusive in the cultural context, are mixed: superiority-inferiority in the military hierarchy; and first meeting between peers, who introduce themselves. The referent of both patterns is a social code that is actualized in the act as an indiscriminate generalization.

Our elementary examination of some aspects of clown performances hints at the fact that tradition, for clowns, is not a set of ready-made tricks but a set of rules that operates on the constitutive rules of the contextual culture. As a result, and in contrast to other circus acts, clown acts cannot be performed everywhere without some modification. Truly international clowns are rare, and clowns commonly talk about the adjustments they must make to the particular countries (actually, cultures) in which they perform. But the changes are paradigmatic, not syntactic. For example, for a period of several months, I observed an act that had the following beginning: The clown proper rushes through the ring, loaded with luggage. He is stopped by the white-faced clown, who asks where he is going. The answer is, "To the airport." Then he is asked where he is flying to. The verbal response is the name of a small suburb of the city in which the performance is taking place. At the same time the clown points in the opposite direction. Every time this clown arrived in a new city, he found out which suburb was looked down upon by the people there and its direction with respect to the circus ring. In this simple example, the relationships between escapism and exoticism and between means and goals are reversed. Furthermore, the clown's pointing in the opposite direction is very consistent, despite his verbal response, since it indicates that all his behavior is a mirror image, displaying a sort of inverse symmetry.

If the "reality" of a given culture can indeed be considered a semiotic text (a macrotext) satisfying the definition stated earlier, then the specific activity of clowns can be considered a metacultural text. In fact, the referent of clown activity is the code itself, or rather the various codes that constitute the contextual culture. The following examples illustrate the techniques clowns use:

1. Linguistic realization often plays an important role in clown acts. One attribute of the white-faced clown is a perfect mastery of natural language, whereas the clown proper plays with the phonological and grammatical systems of language. Not only do clowns demonstrate that modification of a very small part of a word can change its meaning but they select, as the modification, contrastive features of words that are diametrically opposed in the contextual sociosemantic system. Cooke's *The Circus Has No Home* contains a good example of this—in a quotation from the circus director's wife, Mrs. Rosaire:[15]

Some of the best circus jokes are 300 years old; I would say "clown!" and he'd peep around the tent flap; "Come out here and address the people!" I would shout, and he would make a rush to go in among them. "What are you doing?" I'd ask him, "I told you to *address* the people!"— "O, I thought you said *undress* the people!"

2. In London, during the early nineteenth century, the famous clown Grimaldi presented, among other "jokes of construction," the character of a hussar:[16]

His hat: a lady's muff, a watch-pocket pinned to the side of it, a table brush stuck out of the crown; his cords and tassels are contrived with a bellrope; boots: a pair of coal scuttles (handles like spurs); the sword: a poker.

The accessories selected by Grimaldi were very similar in shape and material to the uniform of a real hussar but as different as possible with respect to the existing cultural system. The trappings of a woman and a hearth were transformed into the paraphernalia of a warrior (one who is defined as virile and remote from the hearth). Significantly, in another instance, Grimaldi pretended he was a boxer and substituted loaves of bread for boxing gloves. Obviously, the elements of "jokes of construction" are not combined at random; they are the result of a systematic operation within a structure that becomes evident as such during the process.

3. An analysis of a clown sequence known as "the violin" in Europe helps to define what I mean by metacultural texts. The following versions of this act have been in the repertoire for some time:

a. A white-faced clown announces that a violin recital will be performed by a famous virtuoso. The clown proper, wearing a formal tailcoat over his outfit, enters the ring carrying a violin case. He bows ceremoniously to the audience, opens the case and extracts from it first a napkin, which he ties around his neck, then a bottle of cheap wine. He drinks noisily from the bottle, wipes his mouth, and puts the bottle and the napkin back in the case. He bows again to the audience—and is driven out of the ring by his outraged partner.

b. Same initial situation as in *a* except that the clown enters with a violin. As he starts playing, an explosion occurs in the violin. It falls apart and its contents spill out: strings of thick red sausages. Same conclusion as in *a*.[17]

c. Same beginning as in *b*, except that a horn is attached to the neck of the violin. Instead of playing the violin, the clown blows the horn. Same conclusion.[18]

In the first two versions the texts of the clown act juxtapose two categories of noise (in the acoustic sense) that are definitely disjoined in Western cultures: noises associated with nutrition (ingestion, digestion, excretion) and music. In certain circumstances, these two categories (nutritional and musical) may be combined in an accepted way (e.g., a formal or intimate dinner accompanied by light music). But, in these acts, they co-occur in a highly dramatic opposition: on the one hand, noisy ingestion and explosion (very unsophisticated behavior with regard to food) or, in a Parisian context (these performances were observed in Paris), cheap red wine and sausages and, on the other hand, a musical instrument that symbolizes the most sublime and sophisticated music. Although the third version seems very different, it exploits the same relationship but in a milder way, by restricting the operation to the musical code: a violin, the most elaborate stringed instrument, is physically linked to a honking horn, the most unsophisticated wind instrument. The transgressive conjunctions of the two categories of noise are performed through "rhetorical" devices applied to a system of artifacts: a "semiotic statement" is produced in the first two versions by manipulating the relationship between the whole and a part. Moreover, some objects are used as the causes of effects that they signify (bottle, sausages). Figure 3 attempts to place all the elements used in these three versions of the same basic operation with respect to one another.

4. The same rule of transformation can often

Codes	Sounds	Food	Behavior
Culture	Violin Honking horn	Sophisticated dinner Cheap wine and sausages	Formal behavior associated with a recital Bad table manners
Nature	"Glug-glug" ingestion (digestion) Excretion (explosion)	Food Excrement	Animal behavior

FIGURE 3.

result in performances that are seemingly very different, e.g., in the very popular act called "the mirror":[19]

The white-faced clown needs a mirror for something that has to do with his outward appearance or his gestures (e.g., an unexpected invitation to a formal party, his acting as a replacement for a famous actor, preparation for a ceremony). He sends the clown proper to get the mirror and leaves the ring for a moment.

During the white-faced clown's absence, the other clown inadvertently breaks the mirror. He is so afraid of how angry the white-faced clown will be if he discovers the deed that he pretends to be his reflection.

The white-faced clown returns to the ring and starts examining his appearance. Looking at himself in the mirror, he gestures. The clown proper imitates, as well as he can, whatever his partner does, until he makes a mistake and is discovered and punished.

The initial situation posits a strong contrast between two identities. The decoding of this situation depends on a fundamental rule of Western culture: the identity of an individual is based on his outward appearance (e.g., a passport photograph).

Mirrors, as a cultural artifact, play an important role in the formation of an individual's self-image and can be considered guardians of the stability of appearance. (In this sense, photographs are permanently imprinted mirrors.) In his attempt to establish two radically different individuals as the same person, the clown has modified the cultural rule of identity.

Another inversion of the cultural rule of identity is enacted by the following performance. After a beautiful female equestrian has left the ring, the clown proper starts crying. The MC asks him why he is sad. The clown says, "Me, too, I used to be a beautiful little girl!" The MC laughs at him and says that that is impossible. The clown goes on, "How do you know? Were you present when I was born? I was present! Then I must know better than you. One day the maid put me in my carriage and took me to the park. As she was talking to her lover, a witch came, took me—the nice little girl—away and put in my place, me—the ugly little boy. From that day to this I have been an ugly little boy."[20] Here the logical operation consists of establishing one identity for two different appearances, instead of two identities for one appearance, as in "the mirror." Both acts change the cultural rule that one appearance equals one identity.

Of course, since there are no systematic records

of clown performances,[21] the theory that has been tentatively presented here on the basis of an analysis of only a few sequences is highly speculative. Such an embryonic model seems necessary, however, to encourage researchers to gather relevant data from the past and to make accurate descriptions possible in the future.

The process we have been engaging in here, elementary as it is, could be called a *meta-meta-semiotic* one, since the referent of the discourse in question is a text whose referent consists of cultural codes. In conclusion, I suggest that linguistic expression proper is not a *sine qua non* of meta-semiotic processes. More often than not, clowns cannot articulate how the system they practice functions. Audiences (representing various cultures) definitely sense that clown behavior is significantly different from the actions and attitudes normally expected of individuals that have been integrated into a given society. The status of clowns is comparable to that of musicians and painters, whose works are truly metasemiotic (i.e., they refer to a code as such) quite apart from the question of whether their "discourses" can be translated into a linguistic code. . . .[22]

In everyone's experience, a circus appears periodically among the profusion of signs that form his sociocultural environment. It is immediately identifiable because the signs that indicate its presence are strongly marked with respect to all the other signs that it strives to transform into mere background for its temporary prominence in that location. It must be clear to the reader that by signs I mean not only the posters but all the elements that are put together to make up a circus show and that create meaningful sequences for its appreciative audience. The symbolic impact of circus performances is indeed so powerful in our culture that it tends to color whatever is connected with it—people, animals, objects—to the extent that trivial backstage activities, as long as they belong to the circus, are viewed somewhat differently from other similar activities commonly performed in everyday life. All these signs are so tightly clustered within a coherent system that the circus, both as a form of entertainment and as a way of life, is perceived as if it were a universe of its own. There exist thousands of circuses in the world, each one different from the others in size, importance, appearance, and program; however, to the rural or urban community in which a circus performs, it is always *the circus*, i.e., a unique manner of dealing with human physical possibilities, animals both domesticated and "wild," and objects of all sorts.

Some of us love it; others dislike it intensely or even fear its presence. In any case it is always difficult, if at all possible, to account for the circus' effect on our emotions. Literary imagery through which it is often described is strikingly poor when compared with the reality it tries to represent, for it is almost impossible to articulate exactly what is happening in and around the ring at the very moment a spectacle is being performed and enjoyed. It was the purpose of this [essay] to attempt such an articulation, awkward as it may seem, without reducing the experience of the circus to a marginal, irrational, or insignificant phenomenon.

I have contended that the circus is, so to speak, a semiotic crucible in which our cultural reality is systematically and significantly transformed for the length of the performance. Of course, I have tentatively set forth only a few of the many rules that have to be assumed in order to explain how every circus act and all circus programs make sense to us even though they are so much at odds with the principles that regulate our "normal" behavior and pattern our sociocultural life. Many questions still have to be answered before we can fully come to grips with the total phenomenon of the circus. The few answers I have proposed may help in formulating the questions more precisely. It is my hope that admirers of the circus will have found in these pages not only an homage to this unique art but also a way to understand better the intricate symbolic processes that occur in all circus acts. It is also my hope that detractors of the circus will have found some reasons for going to see, in order to check if it is at all as I have described it, the circus that will not fail, some day, to cross their paths.

Notes

1. Claude Lévi-Strauss, *Anthropologie structurale* (Paris: Plon, 1958).

2. L. Robin, La Pensée hellénique des origines à Epicure (Paris, 1942), p.35.

3. P. Bost, *Le Cirque et le Music Hall* [Circus and vaudeville] (Paris, 1931).

4. J. Laude, "Le Monde du cirque et ses jeux dans la peinture" [The circus world and its performances in painting], *Revue d'esthétique* 6 (1953).

5. A Dundes, "Folk Ideas as Unity of World-View," *Journal of American Folklore* 84 (1971).

6. R. Toole-Stott, *Circus and Allied Arts: A World Bibliography,* 4 vols. (Derby, England: Harpur and Sons, 1958–71).

7. E.g., V. Leathers, *British Entertainers in France* (Toronto: University of Toronto Press, 1959), or T. Rémy, *Les Clowns* (Paris: Grasset, 1945).

8. J. Starobinski, *Portrait de l'artiste en saltimbanque* (Geneva: Skira, 1970).

9. F. Fellini, *The Clowns.*

10. L. Makarius, "Ritual Clowns and Symbolic Behaviour" (with a bibliography), *Diogenes* 69 (1970), 44–73.

11. S. Tarachow, "Circuses and Clowns" (with a bibliography), in *Psychoanalysis and the Social Sciences,* ed. G. Rôheim (New York: International Universities Press, 1951), pp.171–85.

12. In this examination we shall restrict ourselves to the synchronic data produced in Europe during the last fifty years; it is an accepted view that for the reasons mentioned above American clown acts are adapted transformations of their European counterparts. "Auguste" is the name traditionally given to this function. There are several explanations for its origin; see Rémy, pp. 64–82.

13. See *Communications 13 (Les objets)* (Paris: Seuil) (1969).

14. O. Popov, *Russian Clown,* trans. M. Koenig (London: Macdonald, 1970), p.145.

15. Rupert Croft Cooke, *The Circus Has No Home* (London: Methuen, 1941).

16. Disher M. Willson, *Clowns and Pantomimes* (London: Constable, 1925), pp.104, 111.

17. Personal observation.

18. R. Gomez de la Serna, *Le Cirque,* trans. Simon Kra, Falgairolle (Paris, 1927), p.31.

19. Rémy, *Entrées clownesques* (Paris: L'Arche, 1962), p. 239.

20. H. Le Roux, *Les Jeux de cirque et la vie foraine* (Paris, 1889), chapter 7.

21. An exception should be made for *Entrées clownesques* by Rémy, who recorded the dialogues of sixty different acts. However the book gives no detail whatsoever about the makeup and costumes of the characters and limits itself to only one version of each act.

22. E.g., Ravel's *Bolero,* Stravinski's *Petrouchka,* Britten's *The Young Person's Guide to the Orchestra.*

54

Appreciation and the Natural Environment

ALLEN CARLSON

I

With art objects there is a straightforward sense in which we know both what and how to aesthetically appreciate. We know *what* to appreciate in that, first, we can distinguish a work and its parts from that which is not it nor a part of it. And, second, we can distinguish its aesthetically relevant aspects from its aspects without such relevance. We know that we are to appreciate the sound of the piano in the concert hall and not the coughing which interrupts it; we know that we are to appreciate that a painting is graceful, but not that it happens to hang in the Louvre. In a similar vein, we know *how* to appreciate in that we know what "acts of aspection" to perform in regard to different works. Ziff says:

> ... to contemplate a painting is to perform one act of aspection; to scan it is to perform another; to study, observe, survey, inspect, examine, scrutinise, etc., are still other acts of aspection.
> ... I survey a Tintoretto, while I scan an H. Bosch. Thus I step back to look at the Tintoretto, up to look at the Bosch. Different actions are involved. Do you drink brandy in the way you drink beer?[1]

It is clear that we have such knowledge of what and how to aesthetically appreciate. It is, I believe, also clear what the grounds are for this knowledge.

Works of art are our own creations; it is for this reason that we know what is and what is not a part of a work, which of its aspects are of aesthetic significance, and how to appreciate them. We have made them for the purpose of aesthetic appreciation; in order for them to fulfill this purpose this knowledge must be accessible. In making an object we know what we make and thus its parts and its purpose. Hence in knowing what we make we know what to do with that which we make. In the more general cases the point is clear enough: In creating a painting, we know that what we make is a painting. In knowing this we know that it ends at its frame, that its colors are aesthetically important, but where it hangs is not, and that we are to look at it rather than, say, listen to it. All this is involved in what it is to be a painting. Moreover, this point holds for more particular cases as well. Works of different particular types have different kinds of boundaries, have different foci of aesthetic significance, and perhaps most important demand different acts of aspection. In knowing the type we know what and how to appreciate. Ziff again:

> Generally speaking, a different act of aspection is performed in connection with works belonging to different schools of art, which is why the classification of style is of the essence. Venetian paintings lend themselves to an act of aspection involving attention to balanced masses: contours are of no importance, for they are scarcely to be

From *The Journal of Aesthetics and Art Criticism*, 37 (1979), 267–75. Reprinted with permission of *The Journal of Aesthetics and Art Criticism* and the author.

found. The Florentine school demands attention to contours, the linear style predominates. Look for light in a Claude, for color in a Bonnard, for contoured volume in a Signorelli.[2]

I take the above to be essentially beyond serious dispute, except as to the details of the complete account. If it were not the case, our complementary institutions of art and of the aesthetic appreciation of art would not be as they are. We would not have the artworld which we do. But the subject of this paper is not art nor the artworld. Rather: it is the aesthetic appreciation of nature. The question I wish to investigate is the question of what and how to aesthetically appreciate in respect to natural environment. It is of interest since the account which is implicit in the above remarks and which I believe to be the correct account for art cannot be applied to the natural environment without at least some modification. Thus initially the questions of what and how to appreciate in respect to nature appear to be open questions.

II

In this section I consider some paradigms of aesthetic appreciation which prima facie seem applicable as models for the appreciation of the natural environment. In this I follow tradition to some extent in that these paradigms are ones which have been offered as or assumed to be appropriate models for the appreciation of nature. However, I think we will discover that these models are not as promising as they may initially appear to be.

The first such paradigm I call the object model. In the artworld non-representational sculpture best fits this model of appreciation. When we appreciate such sculpture we appreciate it as the actual physical object which it is. The qualities to be aesthetically appreciated are the sensuous and design qualities of the actual object and perhaps certain abstract expressive qualities. The sculpture need not represent anything external to itself; it need not lead the appreciator beyond itself: it may be a self-contained aesthetic unit. Consider a Brancusi sculpture, for example, the famous *Bird In Space* (1919). It has no representational connections with the rest of reality and no relational connections with its immediate surroundings and yet it has significant aesthetic qualities. It glistens, has balance and grace, and expresses flight itself.

Clearly it is possible to aesthetically appreciate an object of nature in the way indicated by this model. For example, we may appreciate a rock or a piece of driftwood in the same way as we appreciate a Brancusi sculpture: we actually or contemplatively remove the object from its surroundings and dwell on its sensuous and design qualities and its possible expressive qualities. Moreover, there are considerations which support the plausibility of this model for appreciation of the natural environment. First, natural objects are in fact often appreciated in precisely this way: mantel pieces are littered with pieces of rock and driftwood. Second, the model fits well with one feature of natural objects: such objects, like the Brancusi sculpture, do not have representational ties to the rest of reality. Third and most important, the model involves an accepted, traditional aesthetic approach. As Sparshott notes, "When one talks of the aesthetic this or that, one is usually thinking of it as entering into a subject/object relation."[3]

In spite of these considerations, however, I think there are aspects of the object model which make it inappropriate for nature. Santayana, in discussing the aesthetic appreciation of nature (which he calls the love of nature) notes that certain problems arise because the natural landscape has "indeterminate form." He then observes that although the landscape contains many objects which have determinate forms, "if the attention is directed specifically to them, we have no longer what, by a curious limitation of the word, is called the love of nature."[4] I think this limitation is not as curious as Santayana seems to think it is. The limitation marks the distinction between appreciating nature and appreciating the objects of nature. The importance of this distinction is seen by realizing the difficulty of appreciating nature by means of the object model. For example, on one understanding of the object model, the objects of nature when so appreciated become "ready-mades" or "found art." The artworld grants "artistic enfranchisement" to a piece of driftwood just as it has to Duchamp's urinal or to the real Brillo cartons discussed by Danto.[5] If this magic is successful the result is art. Questions of what and how to aesthetically appreciate are answered, of course, but in respect to art rather than nature; the appreciation of nature is lost in the shuffle. Appreciating sculpture which was once driftwood is no closer to appreciating nature than is appreciating a totem pole which was once a tree or a purse which was once a sow's ear. In all such cases the conversion from nature to art (or artifact) is complete; only the means of conversion are different.

There is, however, another understanding of how the object model applies to the objects of nature. On this understanding natural objects are simply (actually or contemplatively) removed from their surroundings, but they do not become art, they remain natural objects. Here we do not appreciate the objects *qua* art objects, but rather *qua* nat-

ural objects. We do not consider the rock on our mantel a ready-made sculpture, we consider it only an aesthetically pleasing rock. In such a case, as the example of non-representational sculpture suggests, our appreciation is limited to the sensuous and design qualities of the natural object and perhaps a few abstract expressive qualities: Our rock has a wonderfully smooth and gracefully curved surface and expresses solidity.

The above suggests that, even when it does not require natural objects to be seen as art objects, the object model imposes a certain limitation on our appreciation of natural objects. The limitation is the result of the removal of the object from its surroundings which the object model requires in order even to begin to provide answers to questions of what and how to appreciate. But in requiring such a removal the object model becomes problematic. The object model is most appropriate for those art objects which are self-contained aesthetic units. These objects are such that neither the environment of their creation nor the environment of their display are aesthetically relevant: the removal of a self-contained art object from its environment of creation will not vary its aesthetic qualities and the environment of display of such an object should not affect its aesthetic qualities. However, natural objects possess what we might call an organic unity with their environment of creation: such objects are a part of and have developed out of the elements of their environments by means of the forces at work within those environments. Thus the environments of creation are aesthetically relevant to natural objects. And for this reason the environments of display are equally relevant in virtue of the fact that these environments will be either the same as or different from the environments of creation. In either case the aesthetic qualities of natural objects will be affected. Consider again our rock: on the mantel it may seem wonderfully smooth and gracefully curved and expressive of solidity, but in its environment of creation it will have more and different aesthetic qualities—qualities which are the product of the relationship between it and its environment. It is here expressive of the particular forces which shaped and continue to shape it and displays for aesthetic appreciation its place in and its relation to its environment. Moreover, depending upon its place in that environment it may not express many of those qualities, for example, solidity, which it appears to express when on the mantel.

I conclude that the object model, even without changing nature into art, faces a problem as a paradigm for the aesthetic appreciation of nature. The problem is a dilemma: either we remove the object from its environment or we leave it where it is. If the object is removed, the model applies to the object and suggests answers to the questions of what and how to appreciate. But the result is the appreciation of a comparatively limited set of aesthetic qualities. On the other hand if the object is not removed, the model seemingly does not constitute an adequate model for a very large part of the appreciation which is possible. Thus it makes little headway with the what and how questions. In either case the object model does not provide a successful paradigm for the aesthetic appreciation of nature. It appears after all not a very "curious limitation" that when our attention is directed specifically toward the objects in the environment it is not called the love of nature.

The second paradigm for the aesthetic appreciation of nature I call the scenery or landscape model. In the artworld this model of appreciation is illustrated by landscape painting; in fact the model probably owes its existence to this art form. In one of its favored senses "landscape" means a prospect—usually a grandiose prospect—seen from a specific standpoint and distance; a landscape painting is traditionally a representation of such a prospect.[6] When aesthetically appreciating landscape paintings (or any representative paintings, for that matter) the emphasis is not on the actual object (the painting) nor on the object represented (the actual prospect); rather it is on the representation of the object and its represented features. Thus in landscape painting the appreciative emphasis is on those qualities which play an essential role in representing a prospect: visual qualities related to coloration and overall design. These are the qualities which are traditionally significant in landscape painting and which are the focus of the landscape model of appreciation. We thus have a model of appreciation which encourages perceiving and appreciating nature as if it were a landscape painting, as a grandiose prospect seen from a specific standpoint and distance. It is a model which centers attention on those aesthetic qualities of color and design which are seen and seen at a distance.

It is quite evident that the scenery or landscape model has been historically significant in our aesthetic appreciation of nature.[7] For example, this model was evident in the eighteenth and nineteenth centuries in the use of the "Claude-glass," a small, tinted, convex mirror with which tourists viewed the landscape. Thomas West's popular guidebook to the Lake District (first published in 1778) says of the glass:

> . . . where the objects are great and near, it removes them to a due distance, and shews them in the soft colours of nature, and most regular perspective the eye can perceive, art teach, or science demonstrate . . . to the glass is reserved the

finished picture, in highest colouring, and just perspective.[8]

In a somewhat similar fashion, the modern tourist reveals his preference for this model of appreciation by frequenting "scenic viewpoints" where the actual space between the tourist and the prescribed "view" often constitutes "a due distance" which aids the impression of "soft colours of nature, and the most regular perspective the eye can perceive, art teach, or science demonstrate." And the "regularity" of the perspective is often enhanced by the positioning of the viewpoint itself. Moreover, the modern tourist also desires "the finished picture, in highest colouring, and just perspective"; whether this be the "scene" framed and balanced in his camera's viewfinder, the result of this in the form of a kodachrome slide, and/or the "artistically" composed postcard and calendar reproductions of the "scene" which often attract more appreciation than that which they "reproduce." R. Rees has described the situation as follows:

> . . . the taste has been for a view, for scenery, not for landscape in the original Dutch—and present geographical—meaning of the term, which denotes our ordinary, everyday surroundings. The average modern sightseer, unlike many of the Romantic poets and painters who were accomplished naturalists, is interested *not* in natural forms and processes, but in a prospect.[9]

It is clear that in addition to being historically important, the landscape model, like the object model, gives us at least initial guidelines as to what and how to appreciate in regard to nature. We appreciate the natural environment as if it were a landscape painting. The model requires dividing the environment into scenes or blocks of scenery, each of which is to be viewed from a particular point by a viewer who is separated by the appropriate spatial (and emotional?) distance. A drive through the country is not unlike a walk through a gallery of landscape paintings. When seen in this light, this model of appreciation causes a certain uneasiness in a number of thinkers. Some, such as ecologist Paul Shepard, seemingly believe this kind of appreciation of the natural environment so misguided that they entertain doubts about the wisdom of *any* aesthetic approach to nature.[10] Others find the model to be ethically suspect. For example, after pointing out that the modern sightseer is interested only in a prospect, Rees concludes:

> In this respect the Romantic Movement was a mixed blessing. In certain phases of its development it stimulated the movement for the protec-

tion of nature, but in its picturesque phase it simply confirmed our anthropocentism by suggesting that nature exists to please as well as to serve us. Our ethics, if the word can be used to describe our attitudes and behaviour toward the environment, have lagged behind our aesthetics. It is an unfortunate lapse which allows us to abuse our local environments and venerate the Alps and the Rockies.[11]

What has not been as generally noted, however, is that this model of appreciation is suspect not only on ethical grounds, but also on aesthetic grounds. The model requires us to view the environment as if it were a static representation which is essentially "two dimensional." It requires the reduction of the environment to a scene or view. But what must be kept in mind is that the environment is not a scene, not a representation, not static, and not two dimensional. The point is that the model requires the appreciation of the environment not as what it is and with the qualities it has, but rather as something which it is not and with qualities it does not have. The model is in fact inappropriate to the actual nature of the object of appreciation. Consequently it not only, as the object model, unduly limits our appreciation—in this case to visual qualities related to coloration and overall design, it also misleads it. Hepburn puts this point in a general way:

> Supposing that a person's aesthetic education . . . instills in him the attitudes, the tactics of approach, the expectations proper to the appreciation of art works only, such a person will either pay very little aesthetic heed to natural objects or else heed them in the wrong way. He will look—and of course look in vain—for what can be found and enjoyed only in art.[12]

III

I conclude that the landscape model, as the object model, is inadequate as a paradigm for the aesthetic appreciation of nature. However, the reason for its inadequacy is instructive. The landscape model is inadequate because it is inappropriate to the nature of the natural environment. Perhaps to see what and how to appreciate in respect to the natural environment, we must consider the nature of that environment more carefully. In this regard there are two rather obvious points which I wish to emphasize. The first is that the natural environment is an environment; the second is that it is natural.

When we conceptualize the natural environment as "nature" I think we are tempted to think of it as an object. When we conceptualize it as "landscape"

we are certainly led to thinking of it as scenery. Consequently perhaps the concept of the "natural environment" is somewhat preferable. At least it makes explicit that it is an environment which is under consideration. The object model and the landscape model each in its own way fail to take account of this. But what is involved in taking this into account? Here I wish initially to follow up some remarks made by Sparshott. He suggests that to consider something environmentally is primarily to consider it in regard to the relation of "self to setting," rather than "subject to object" or "traveler to scene."[13] An environment is the setting in which we exist as a "sentient part"; it is our surroundings. Sparshott points out that, as our surroundings, our setting, the environment is that which we take for granted, that which we hardly notice—it is necessarily unobtrusive. If any one part of it becomes obtrusive, it is in danger of being seen as an object or a scene, not as our environment. As Sparshott says, "When a man starts talking about 'environmental values' we usually take him to be talking about aesthetic values of a background sort."[14]

The aesthetic values of the environment being primarily background values has obvious ramifications for the questions of what and how to appreciate. In regard to what to appreciate this suggests the answer "everything," for in an essentially unobtrusive setting there seems little basis for including and excluding. I will return to this shortly. In regard to how to appreciate, the answer suggested is in terms of all those ways in which we normally are aware of and experience our surroundings. Sparshott notes that "if environmental aspects are background aspects, eye and ear lose part of their privilege" and goes on to mention smell, touch, and taste, and even warmth and coolness, barometric pressure and humidity as possibly relevant.[15] This points in the right direction, but as Sparshott also notes, it seems to involve a difficulty: that "the concept of the aesthetic tugs in a different direction"— the direction of the subject/object relation involving primarily the visual scrutiny of an aesthetic object.[16] However, I do not think this difficulty need be as serious as Sparshott seems to think. I suspect the apparent tension here is not due to the concept of the aesthetic being necessarily tied to the subject/object relation or to the visual, but rather is due to its being antithetical to the appreciation of anything only as unobtrusive background. To confirm this we need to consider the concept of the aesthetic as it is elaborated by John Dewey in *Art as Experience*.[17] Dewey's concept is such that anything which is aesthetically appreciated must be obtrusive, it must be foreground, but it need not be an object and it need not be seen (or only seen). Moreover, to assume that that which is aesthetically appreciated

need be an object or only seen is to confine aesthetic appreciation to either the object model or the landscape model, which, as we have noted, impose unacceptable limitations on the aesthetic appreciation of the natural environment.

I suggest then that the beginning of an answer to the question of *how* to aesthetically appreciate an environment is something like the following: We must experience our background setting in all those ways in which we normally experience it, by sight, smell, touch, and whatever. However, we must experience it not as unobtrusive background, but as obtrusive foreground! What is involved in such an "act of aspection" is not completely clear. Dewey gives us an idea in remarks such as:

> To grasp the sources of esthetic experience it is ... necessary to have recourse to animal life below the human scale.... The live animal is fully present, all there, in all of its actions: in its wary glances, its sharp sniffing, its abrupt cocking of ears. All senses are equally on the *qui vive*.[18]

And perhaps the following description by Yi-Fu Tuan gives some further indication:

> An adult must learn to be yielding and careless like a child if he were to enjoy nature polymorphously. He needs to slip into old clothes so that he could feel free to stretch out on the hay beside the brook and bathe in a meld of physical sensations: the smell of the hay and of horse dung; the warmth of the ground, its hard and soft contours; the warmth of the sun tempered by breeze; the tickling of an ant making its way up the calf of his leg; the play of shifting leaf shadows on his face; the sound of water over the pebbles and boulders, the sound of cicadas and distant traffic. Such an environment might break all the formal rules of euphony and aesthetics, substituting confusion for order, and yet be wholly satisfying.[19]

Tuan's account as to how to appreciate fits well with our earlier answer to the question of what to appreciate, viz. everything. This answer, of course, will not do. We cannot appreciate everything; there must be limits and emphasis in our aesthetic appreciation of nature as there are in our appreciation of art. Without such limits and emphases our experience of the natural environment would be *only* "a meld of physical sensations" without any meaning or significance. It would be a Jamesian "blooming buzzing confusion" which truly substituted "confusion for order" and which, I suspect contra to Tuan, would not be wholly satisfying. Such experience would be too far removed from our aesthetic appreciation of art to merit the label "aesthetic" or even the label "appreciation." Consider again the case of art. In this case, as noted in Section I, the

boundaries and foci of aesthetic significance of works of art are a function of the type of art in question, e.g., paintings end at their frames and their colors are significant. Moreover, I suggested that our knowledge of such matters is due to art works being our creations. Here it is relevant to note the second point which I wish to emphasize about natural environments: they are natural. The natural environment is not a work of art. As such it has no boundaries or foci of aesthetic significance which are given as a result of our creation nor of which we have knowledge because of our involvement in such creation.

The fact that nature is natural—not our creation—does not mean, however, that we must be without knowledge of it. Natural objects are such that we can discover things about them which are independent of any involvement by us in their creation. Thus although we have not created nature, we yet know a great deal about it. This knowledge, essentially common sense/scientific knowledge, seems to me the only viable candidate for playing the role in regard to the appreciation of nature which our knowledge of types of art, artistic traditions, and the like plays in regard to the appreciation of art. Consider the aesthetic appreciation of an environment such as that described by Tuan. We experience the environment as obtrusive foreground—the smell of the hay and of the horse dung, the feel of the ant, the sound of the cicadas and of the distant traffic all force themselves upon us. We experience a "meld of sensations" but, as noted, if our state is to be aesthetic appreciation rather than just the having of raw experience, the meld cannot be simply a "blooming buzzing confusion." Rather it must be what Dewey called a consummatory experience: one in which knowledge and intelligence transform raw experience by making it determinate, harmonious, and meaningful. For example, in order for there to be aesthetic appreciation we must recognize the smell of the hay and that of the horse dung and perhaps distinguish between them; we must feel the ant at least as an insect rather than as, say, a twitch. Such recognizing and distinguishing results in certain aspects of the obtrusive foreground becoming foci of aesthetic significance. Moreover, they are natural foci appropriate to the particular natural environment we are appreciating. Likewise our knowledge of the environment may yield certain appropriate boundaries or limits to the experience. For example, since we are aesthetically appreciating a certain kind of environment, the sound of cicadas may be appreciated as a proper part of the setting, while the sound of the distant traffic is excluded much as we ignore the coughing in the concert hall.

What I am suggesting is that the question of *what* to aesthetically appreciate in the natural environment is to be answered in a way analogous to the similar question about art. The difference is that in the case of the natural environment the relevant knowledge is the common sense/scientific knowledge which we have discovered about the environment in question. This knowledge gives us the appropriate foci of aesthetic significance and the appropriate boundaries of the setting so that our experience becomes one of aesthetic appreciation. If to aesthetically appreciate art we must have knowledge of artistic traditions and styles within those traditions, to aesthetically appreciate nature we must have knowledge of the different environments of nature and of the systems and elements within those environments. In the way in which the art critic and the art historian are well equipped to aesthetically appreciate art, the naturalist and the ecologist are well equipped to aesthetically appreciate nature.[20]

The point I have now made about what to appreciate in nature also has ramifications for how to appreciate nature. When discussing the nature of an environment, I suggested that Tuan's description seems to indicate a general act of aspection appropriate for any environment. However, since natural environments differ in type it seems that within this general act of aspection there might be differences which should be noted. To aesthetically appreciate an environment we experience our surroundings as obtrusive foreground allowing our knowledge of that environment to select certain foci of aesthetic significance and perhaps exclude others, thereby limiting the experience. But certainly there are also different kinds of appropriate acts of aspection which can likewise be selected by our knowledge of environments. Ziff tells us to look for contours in the Florentine school and for color in a Bonnard, to survey a Tintoretto and to scan a Bosch. Consider different natural environments. It seems that we must survey a prairie environment, looking at the subtle contours of the land, feeling the wind blowing across the open space, and smelling the mix of prairie grasses and flowers. But such an act of aspection has little place in a dense forest environment. Here we must examine and scrutinize, inspecting the detail of the forest floor, listening carefully for the sounds of birds and smelling carefully for the scent of spruce and pine. Likewise, the description of environmental appreciation given by Tuan, in addition to being a model for environmental acts of aspection in general, is also a description of the act of aspection appropriate for a particular kind of environment—one perhaps best described as pastoral. Different natural environments require different acts of aspection; and as in the case of what to appreciate, our knowledge of the environment in

question indicates how to appreciate, that is, indicates the appropriate act of aspection.

The model I am thus presenting for the aesthetic appreciation of nature might be termed the environmental model. It involves recognizing that nature is an environment and thus a setting within which we exist and which we normally experience with our complete range of senses as our unobtrusive background. But our experience being aesthetic requires unobtrusive background to be experienced as obtrusive foreground. The result is the experience of a "blooming, buzzing confusion" which in order to be appreciated must be tempered by the knowledge which we have discovered about the natural environment so experienced. Our knowledge of the nature of the particular environments yields the appropriate boundaries of appreciation, the particular foci of aesthetic significance, and the relevant act or acts of aspection for that type of environment. We thus have a model which begins to give answers to the questions of what and how to appreciate in respect to the natural environment and which seems to do so with due regard for the nature of that environment. And this is important not only for aesthetic but also for moral and ecological reasons.

IV

In this paper I have attempted to open discussion on the questions of what and how to aesthetically appreciate in regard to nature. In doing so I have argued that two traditional approaches, each of which more or less assimilates the appreciation of nature to the appreciation of certain art forms, leave much to be desired. However, the approach which I have suggested, the environmental model, yet follows closely the general structure of our aesthetic appreciation of art. This approach does not depend on an assimilation of natural objects to art objects or of landscapes to scenery, but rather on an application of the general structure of aesthetic appreciation of art to something which is not art. What is important is to recognize that nature is an environment and is natural, and to make that recognition central to our aesthetic appreciation. Thereby we will aesthetically appreciate nature for what it is and for the qualities it has. And we will avoid being the person described by Hepburn who "will either pay very little aesthetic heed to natural objects or else heed them in the wrong way," who "will look—and of course look in vain—for what can be found and enjoyed only in art."[21]

Notes

1. Paul Ziff, "Reasons in Art Criticism," *Philosophy and Education*, ed., I. Scheffler (Boston, 1958). Reprinted in *Art and Philosophy*, ed., W. E. Kennick (New York, 1964). p. 620.

2. Ibid. Ziff is mainly concerned with the way in which knowledge of types yields different acts of aspection. For an elaboration of this point and its ramifications concerning what is and is not aesthetically significant in a work, see K. Walton, "Categories of Art," *Philosophical Review* (1970), 334–67. How our knowledge of art (and the artworld) yields the boundaries between art and the rest of reality is interestingly discussed in A. Danto, "The Artistic Enfranchisement of Real Objects: the Artworld," *Journal of Philosophy* (1964), 571–84.

3. F. E. Sparshott, "Figuring the Ground: Notes on Some Theoretical Problems of the Aesthetic Environment," *Journal of Aesthetic Education* (1972), 13.

4. George Santayana, *The Sense of Beauty* (New York, 1961), p. 100.

5. Danto, op. cit., p. 579.

6. This favored sense of "landscape" is brought out by Yi-Fu Tuan. See *Topophilia: A Study of Environmental Perception, Attitudes, and Values* (Englewood Cliffs, 1974), pp. 132–33, or "Man and Nature: An Eclectic Reading," *Landscape*, 15 (1966), 30.

7. For a good, brief discussion of this point, see R. Rees, "The Scenery Cult: Changing Landscape Tastes over Three Centuries," *Landscape*, 19 (1975). Note the following remarks by E. H. Gombrich in "The Renaissance Theory of Art and the Rise of Landscape," *Norm and Form: Studies in the Art of the Renaissance* (London, 1971), pp. 117–18: ". . . I believe that the idea of natural beauty as an inspiration of art . . . is, to say the least, a very dangerous oversimplification. Perhaps it even reverses the actual process by which man discovers the beauty of nature. We call a scenery 'picturesque' . . . if it reminds us of paintings we have see. . . . Similarly, so it seems, the discovery of Alpine scenery does not precede but follows the spread of prints and paintings with mountain panoramas."

8. Thomas West, *Guide to the Lakes* (London: 1778) as quoted in J. T. Ogden, "From Spatial to Aesthetic Distance in the Eighteenth Century," *Journal of the History of Ideas*, 35 (1974), 66–67.

9. R. Rees, "The Taste for Mountain Scenery," *History Today*, 25 (1975), 312.

10. Paul Shepard, *The Tender Carnivore and the Sacred Game* (New York, 1973), pp. 147–48. Shepard made this position more explicit at a lecture at Athabasca University, Edmonton, Alberta, November 16, 1974.

11. Rees, "Mountain Scenery," op. cit., p. 312. Ethical worries are also expressed by Tuan, *Topophilia*, op. cit., Chapter 8, and R. A. Smith and C. M. Smith, "Aesthetics and Environmental Education," *Journal of Aesthetic Education* (1970), 131–32. Smith and Smith put the point as follows: "Perhaps there is a special form of arrogance in experiencing nature strictly in the categories of art, for the attitude involved here implies an acceptance, though perhaps only momentarily, of the notion that natural elements have been arranged for the sake of the man's aesthetic pleasure. It is possible that this is what Kant had in mind when he said that in the appreciation of natural beauty one ought not assume that nature has fashioned its forms for our delight and that, instead, 'it is we who receive nature with favour, and not nature that does us a favour.'"

12. R. W. Hepburn, "Aesthetic Appreciation of Nature," *Aesthetics and the Modern World*, ed. H. Osborne (London, 1968), p. 53. Hepburn implicitly argues that our aesthetic appreciation of nature is enhanced by our "realizing" that an object is what it is and has the qualities which it has. See pp. 60–65.

13. Sparshott, op. cit., pp. 12–13. Sparshott also considers other possible relations which are not directly relevant here. Moreover, I suspect he considers the "traveler to scene" relation to be more significant than I do.

14. Ibid., pp. 17–18.

15. Ibid., p. 21.

16. Ibid., pp. 13–14, 21.

17. John Dewey, *Art as Experience* (New York, 1958), especially chapters 1–3.

18. Ibid., pp. 18–19.

19. Tuan, *Topophilia*, op. cit., p. 96.

20. I have in mind here individuals such as John Muir and Aldo Leopold. See, for example, Leopold's *A Sand County Almanac*.

21. Hepburn, op. cit., p. 53.

55

Nature and Art:
Some Dialectical Relationships

DONALD CRAWFORD

Recent discussions of the aesthetics of nature have focused on the appreciation of natural objects, scenes and environments considered apart from human modification and from their interaction with artistic creations.[1] In many if not most cases, however, we experience nature as modified by human beings or in conjunction with artifacts. Power lines, roads and plowed fields form part of the landscape: there are people on the beaches, to say nothing of the litter, and fishing boats offshore; flowers are planted in gardens and arranged in vases. Pure nature is hard to find, and the aesthetic appreciation of nature is not limited to nature in its pristine form. Nature and artifacts commonly appear together, and not infrequently artistic constructions are intentionally placed in natural settings. In a variety of ways, then, the appreciation of nature often involves the artifactual.

This essay explores one general type of relationship between the natural and the artifactual that manifests itself in diverse, aesthetically significant contexts. I believe this relationship is best described as "dialectical," and I shall use that term even though I realize that this raises issues concerning the historical uses of that concept which cannot be fully dealt with here. Let us begin, therefore, with what is a very general and I hope non-controversial concept of the dialectical. In a dialectical relationship, the two terms of the relation designate conflicting forces. It is common, in addition, to apply this relation to cases in which the conflicting interaction

brings into being some third object. In the applications we shall consider, this third object is identified with the object of aesthetic attention or appreciation. Thus the two terms designate forces whose conflicting interaction is a determining factor in the constitution of the object of appreciation. In other words, the aesthetic appreciation can be seen as relating to both natural and artifactual elements interacting in other than purely harmonious or straight-forwardly causal ways. I hope the examples provided will make the thesis clearer.

I

In classical and neoclassical aesthetics, there is nothing dialectical in the relationship between art and nature, nature provides the model for artistic composition and there is, presumably, a harmonious relationship between the two. Conversely, some have suggested that in the aesthetic appreciation of scenery for its pictorial or compositional values, art (especially painting) is the model for an aesthetics of nature, and from the aesthetic standpoint nature is following art.[2] But here, too, nature and art would be in a harmonious relationship, reenforcing one another in a process that leads to a stable, non-dialectical object of aesthetic appreciation.

It might be suggested that these models fail to involve a dialectical relationship between art and nature *not* because of the presence of *harmony,*

From *The Journal of Aesthetics and Art Criticism*, 42 (1983), 49–58. Reprinted with permission of *The Journal of Aesthetics and Art Criticism* and the author.

since the harmony itself might be a resultant of opposing forces, but rather just because these are not cases of art and nature *interacting*. These concepts may not be precise enough to be definitive, but an examination of some varied examples of contemporary environmental sculpture might help determine what is involved in an interactive or dynamic relationship between the natural and the artifactual. At least three distinct forms of environmental sculpture appear relevant here.[3] In the first, relatively self-contained natural objects or environments are displayed within a traditional gallery setting: a living tree, a box of dirt, a patch of grass, an atmospheric chamber. In the second and third forms, the artist moves entirely outside the gallery to manipulate a natural site, either by modifying or rearranging the natural components (as in earthworks), or by constructing a non-functional artifact on the site (as in Christo's constructions).[4]

Consider the following two examples of the first type of environmental sculpture. Both clearly and essentially involve the dynamic interaction of natural forces and artifactual constructions.

Winter Vision. A clear plexiglass rectangular box, two feet square on each end and four feet long on each side, top and bottom. A single pane of plexiglass divides the inside of the box into two equal chambers. One chamber is filled with warm humid air and sealed. The other is connected to a cooling apparatus, which allows the air in the chamber to be chilled well below freezing; it is filled with cool dry air and sealed. When exhibited, automatic controls cycle the cooling system on and off every thirty minutes. During the On cycle, elaborate patterns of ice form on the humid air side of the central pane: they melt and evaporate during the Off cycle. This portable iced-window art work has received particular acclaim upon being displayed in museums in the equatorial regions of the world.[5]

Dancing Iron. A plexiglass box, the top portion of which is a two foot square cube with clear plexiglass top and sides and an opaque black base. The cube contains brightly colored iron filings. An electromagnetic mechanism under the base connects to knobs which allow the spectator to control the intensity of the magnetic field as well as the position of the magnet under the base, thereby creating changing patterns of iron filings on the black base of the viewing area.

Although *Dancing Iron* involves spectator participation while *Winter Vision* does not (though it could easily have been made to do so), both of these works are dynamic. And each essentially involves the creation and dissolution of formal patterns caused by natural forces under artistically con-

trolled conditions. Their design enables the viewer to be aware that the patterns are caused by natural forces. In effect, in each work our attention is drawn to a natural force operating on something created by human effort, resulting in an interesting dynamic visual display. What artistry there is consists in setting up the conditions under which these effects are visible and visibly caused by the natural forces.

Are there significant differences between these examples and the simpler, more established art form of the mobile? A mobile presents a dynamic display of moving three-dimensional forms, and the motion can draw our attention to the air currents causing these effects. But there are some differences. Mobiles usually continue to be aesthetically interesting while stationary. And it is not clear that mobiles always draw our attention to the air movement or that an electrically rotated mobile would be a significantly different work of art. *Dancing Iron* and *Winter Vision*, by contrast, would be mere objects of curiosity without electrical power setting their dynamic processes in motion. They require the engagement of natural forces for their minimal realization as works of art.[6] And they clearly involve the dynamic interaction of nature and artifact in the process of creating an aesthetic object.

Let me anticipate an objection. "The forces of nature," someone might observe, "are partially responsible for every aesthetic object, natural or artistic. A painting would not be the kind of object it is were it not for natural laws governing the transmission, absorption and reflection of light. So of course natural forces are aesthetically relevant in that they partially determine the properties of the object of appreciation. But in what other sense are natural forces engaged in the examples presented above?" I think they are engaged in the stronger sense of being *referred to* in the works themselves: the natural forces are not merely the *causal preconditions* for the realization of the work of art. Thus the interaction between the natural and the artifactual is part of the *aesthetics* of these works.

Artistic representation, as Nelson Goodman has emphasized, requires denotation or reference, but even in the visual arts denotation may be used in ways that differ from or go beyond mere representation. Consider the artistic use of fragments of a natural site to refer to that site, as in Robert Smithson's "non-sites" of the mid-1960's. Smithson exhibited aerial photographs and maps of a site together with containers of rocks collected from the site, which he placed in the gallery in positions isomorphic with their original locations. He considered this "a kind of deep three-dimensional abstract map that points to a specific site on the surface of the earth,"[7] thereby bringing into question the rela-

tionships between open and closed space, raw physicality and refined artifact, nature and gallery art, and nature and the artist. The intent is clear from Smithson's writings, but the formal sculptural and sensuous qualities of his well-crafted containers to some extent detracted from the intended dialectic, and one was left with a physical work in the gallery referring, albeit in a complex way, to something else—hardly a revolutionary dialectical relationship between art and nature.

For a working dialectic between art and nature, it seems, one must move outside the physical confines and artistic conventions of the gallery to more obviously environmental creations, such as Dennis Oppenheim's *Canceled Crops* (1969), in which two diagonal swaths were cut through a rectangular field of grain. The contrast between the cut and uncut grain draws attention to the fact that the grain is growing and, as such, is part of nature. But since we see a rectangular, planted field we are also visually aware that it is a *crop* and that the normal course of events—that combination of natural forces and human activity known as farming—will leave no trace of Oppenheim's swaths. Another example is Oppenheim's *Annual Rings* (1968), in which semicircular concentric paths were plowed in the snow and ice on either side of a river.[8] Both works were temporary because of nature's course, while only their documentation has been retained; they were executed and presented so that reference to their transience and to the interaction of the artifactual with natural forces was unmistakable.

From the standpoint of artistic intentions, one of the clearest examples of a dialectical interaction between nature and artifact is Smithson's on-site (as opposed to "non-site") earth-work creations, particularly *Spiral Jetty* (1970), a 1500 foot long, 15 foot wide mound of rocks and earth spiraling out into the Great Salt Lake in Utah. Not nearly so transitory as *Canceled Crop,* the dynamic interaction of artifactual construction with natural forces was truly dialectical, at least in Smithson's judgment: "You are confronted not only with an abstraction but also with physicality of the here and now, and these two things interact in a dialectical method and it's what I call a dialectics of place."[9]

Spiral Jetty emerges as an especially powerful and complicated earthwork even for those not familiar with Smithson's theoretical writings. The site is intentionally inaccessible to the public and the landscape does not fit the paradigms of scenic beauty; it is instead of wasteland site, an expansive backwater portion of a dead sea in the desert adjacent to an abandoned oil drilling operation—useless land and water.[10] Freed from utilitarian and scenic meaning, the present and past natural forces, both geological and climatological, influencing and shaping the site are all the more evident, especially given the incursion of the earthwork artifact:

> It's like the Spiral Jetty is physical enough to be able to withstand all these climate changes, yet it's intimately involved with those climate changes and natural disturbances. That's why I'm not really interested in conceptual art because that seems to avoid physical mass. You're left mainly with an idea. Somehow to have something physical that generates ideas is more interesting to me than just an idea that might generate something physical.[11]

Not all earthworks share this dialectical characteristic. Michael Heizer's monumental earth moving projects appear to be such assertively permanent modifications of the earth's surface that they lack this interactive, dynamic dimension, but they add another—an emphasis on the tremendous difficulty of modifying physical nature on a grand artistic scale, thus drawing attention to the forceful resistance of the earth to our manipulative artistic endeavors. In *Fragmented-Depressed-Replaced Mass* (1969), Heizer had a crane move three blocks of solid rock (30, 52 and 72 tons) sixty miles; in *Double Negative* (1969–70), 240,000 tons of earth were removed by cutting into a desert mesa. Neither of these works were accessible to spectators; elaborate documentation was provided and later displayed.

The role of documentation in environmental works is far from simple. It accentuates the temporary nature of the construction, compounds the issue of what exactly is the *work* or art, and may express an attitude toward the complex artistic/economic institution of the professional artist, gallery and collector. And it uses multiple referential devices to make clear that the intentional object goes beyond the merely physical manipulation of nature or artifacts in becoming conceptual, almost theoretical, in its aesthetic expression.[12]

II

Ruins similarly involve an interaction between the artifactual and the natural, but differ from earthworks in two important ways. Except in very unusual cases, ruins are aesthetically unintended, even though the partial destruction of the original structure may have been intentional. Second, ruins have a past history usually rich in meaning and associations, while earthworks have no past greatness from which they are in the process of decline, although in some cases attention may be drawn to the natural history of their sites.

Some may find it difficult to take the aesthetics of ruins seriously today, associating it with the Romantic self-indulgent fascination with the past and its decay. This may be especially true for Americans, whose relatively short cultural history has been future-oriented from the beginning, permeated with a sense of the ever-moving frontier and ideas of progress that, until very recently, left little room for nostalgia. Consciousness of the past has recently increased, revealing itself in many forms, including popular culture. In the environmental arts, the focus has been on restoration and preservation of historic structures and environments, with many attempts to slow down or reverse the hand of time. Within this context, the aesthetic appreciation of a ruined or crumbling structure may be viewed as an inappropriate, if not perverse, anachronism.[13] Most sincerely believe that we must preserve our historic and vernacular architecture, that it would be wrong to allow those structures to decay even if the resulting ruins provided more aesthetic enjoyment than the originals. If aesthetic values here conflict with the cultural and historic, many argue, the aesthetic must give way. We nonetheless must recognize that there is an aesthetic appreciation of fallen and crumbling edifices. Something of their power and fascination is revealed in terms of the dialectical model discussed above.

Ruins, in terms of their material, are only incompletely ruined; they are remains, remnants. This, of course, is a truism, but it has some important implications: first, ruins are material remnants of something past, whose form or material or function has been severely modified. Thus ruins differ from vestiges, tracks and spoors, which provide evidence of something that has passed through without themselves being part of it. An example of an architectural vestige is a foundation depression, without any trace of the foundation itself remaining. Ruins are more than indications of a past structure; they are themselves parts or fragments of the structure itself.

In terms of what we appreciate, however, reference to the past structure is ambiguous. A ruin is not necessarily a fragment of a past *aesthetic* unity, for it may be only a nonaesthetic remnant of the previous structure. For example, the brick ruins now evident at Roman sites originally were plastered and painted; the bricks themselves were not originally visible. Hence we now have only fragments of the material structure but nothing of the aesthetic surface of that structure. Of course, the brick structure is usually the basis of the *form* of the original, so in these cases one can say that we now have a remnant of the aesthetic form. But this is not always the case. We may have only a structural remnant that was never apparent and never meant to be perceived in the original, such as the exposed brick heating systems in Roman baths. Never intended as aesthetic focal points, these are still quite successful as ruins today (e.g., in Trier, West Germany; Bath, England). An aesthetically successful ruin is not necessarily the remnant of an aesthetically successful original.

The exposed material of a ruin may provide one focus for aesthetic interest, but it does not exhaust that interest. The exposed material lacks the naturalness of a natural form, and it does not exhibit the intentionality of a finished artifact. It does not fit comfortably into the natural world, nor does it seem to belong to the world of art or even to the artifactual. It may even lack the compositional unity we usually demand of artistic accomplishments and natural scenery. It hangs suspended, in a state of becoming (as some philosophers might put it), in transition between the artifactual and the natural. The exposed materials reveal the direction of the change implicit in that state of becoming, especially when the ruination of the structure is the result (at least in part) of the incursion of nature (through wind, weather, growth of vegetation, etc.). Ruins possess, for aesthetic perception, an inherent reference to the future, arousing expectations of their continued dissolution, further removal from the artifactual, closer to being absorbed into nature.

We can stop this process of physical decay in some cases if we choose, or slow it down. We can gird up the structure with supports, spray the surfaces with polyurethane, or even remove the peristyle to the interior of an atmospherically controlled environment such as a museum. But the object, the ruin, still exemplifies a stage in a process of change, however attenuated the actual change may have become. The appreciation of ruins thus involves awareness of a future state toward which the object is perceived to be moving. Patina appears on the copper, a glaze forms on previously shining surfaces, a wall begins to crumble, weeds start growing in crevices—and the artifact begins to appear more like a thing, untended. This is the forward-leaning aspect of ruins: toward a merging with nature and away from the artifactual.

But ruins simultaneously lean toward the past, since a ruin is literally something that has fallen or crumbled and thus has lost the original structural integrity of the whole.[14] Partial disintegration of structure, material, asthetic surface, etc. is thus necessary for something to be a ruin.[15] Often the partial disintegration brings with it the severance of the functioning of the original. A Roman forum is no longer a forum; a Cistercian abbey is no longer an

abbey. But this is not a requirement of ruins. A partially ruined Roman aqueduct may still serve as an aqueduct; a ruined ampitheatre may still be used today for performances.

Some might suggest that what is required is a discontinuity in function resulting from the partial disintegration of structure. Thus it might be said that a Greek theatre, if considered a ruin, may once again be used for performance but only by another culture at a different time, only after the Greeks ceased to use it as such. But even if one believes that a period of disuse is required, it is important to note that the disuse need not be *caused by* the partial disintegration, even in cases of functional discontinuity. Suppose an obsolete lighthouse is simply abandoned and thus falls into disuse and that at some later time it is damaged by an earthquake. We now have a ruin and will continue to have a ruin even if the damage is not severe enough to prevent its subsequent reuse as a lighthouse. But a natural disaster may cause such tragic destruction of human lives and property that we cannot contemporaneously view the remnants without seeing mere devastation. In such cases we might not be able to appreciate the remains aesthetically, either because the destruction is too extensive or because we cannot look at the devastation without becoming occupied with the tragic nature of the specific catastrophe. These considerations allow us to understand the efficacy of the passage of time and the discontinuous use of the ruined structure in the creation of ruins as *actual* objects of aesthetic interest.

In the limited recent literature on the aesthetics of ruins, the distinction has been drawn between the classical and the romantic conception of ruins.[16] On the classical theory, the ruin embodies the past by presenting a fragment of a missing whole, which we then imaginatively reconstruct. The aesthetic enjoyment is said to be in the imaginative apprehension of the past aesthetic unity. As a corollary to the classical view, although I have not found this point in the literature, one might suggest that part of the pleasure arises from the imaginative *activity* of reconstruction and not simply from the imaginative apprehension and contemplation of the original. In any case, the classical conception links the aesthetics of ruins to architectural and archeological interests in the original construction and site. It is unclear whether the classical view precludes acquiring information through scientific techniques (carbon dating, chemical testing, etc.), but the process of imaginative reconstruction is guided largely by what meets the eye: the physical ruin as perceived by the aesthetic observer.

On the *romantic* conception, the ruin stirs the perceiver's sense of the past and awakens associations of mystery. We are thrilled as we "glimpse the

unknown" and as we imaginatively live for a moment in the irretrievable past while simultaneously aware of the power of time to negate the present. The romantic theory may seem a bit old-fashioned and melodramatic, but initially it does appear to provide a moderately plausible explanation of the importance of visible effects of the forces of nature on the ruin. Another wall may fall, lichen appear on the stones, trees begin to grow in the crevices, all making the ruin even more interesting. Since these modifications make the construction of a past unity more difficult, it is initially hard to see how the classical view can accommodate this aesthetic aspect of ruins—the importance of the visible incursion of nature. On the romantic conception, however, incursions of nature serve to emphasize the transience of the present and thus add to the mystery and sense of irretrievability of the past. As dust returns to dust, we are touched by a glimpse backward as the past slips ever further away. As Robert Ginsberg aptly puts the romantic viewpoint, "we stroll about the Acropolis not trying to figure out what stood where or what its exact structure was, but rather glorying in being at the center of Greek greatness."[17]

Common to both conceptions of ruins is the importance of personally apprehending the eroding monuments of the past, exploring their many facets. The experience is thus clearly aesthetic in the sense of direct perceptual satisfaction, and it is environmental by involving a sense of place, of really being at the site and personally exploring it, from the initial approach to being at the site and personally exploring it, from the initial approach to being beside and in front of, within and on top of, and walking through and around it. At the same time, one's attention is not confined to the properties of the material fragments but expands to the ideational level. (Hence, historically, the experience of ruins was linked to that of the sublime, to the reflections on the greatness of the past and the power of natural forces.)[18]

Some suggest that there are new ruins as well. A new highway leaves the old road going nowhere and it quickly falls into ruin after a harsh winter or two. Although usually not raising the issue of past monumentality, one still has a case of the visible effect of nature making incursions on the artifactual, as if reclaiming the materials of the road from their prior status. Ruins can be caused intentionally and found to be interesting immediately without the passage of time or the incursion of nature. The demolition of buildings as it sometimes occurs in urban "renewal" may leave short term ruins which may yield picturesque views or reveal materials and structural forms that provide aesthetic satisfaction for some of the same reasons as classical ruins. They

may provide the occasion for the same fascination with decay that is part of the romantic view, a pleasure in perceiving the results of the destruction of mortal edifices. But in most cases the experience does not include an admiration for the original structure itself or projecting oneself into the past.

Returning to the issue of dialectical relationships, on what basis can it be said that the ruin in situ, as an object of aesthetic appreciation, is a product of *dialectically* interacting forces?

> Since brass, nor stone, nor earth, nor boundless
> sea,
> But sad mortality o'ersways their power,
> How with this rage shall beauty hold a plea,
> Whose action is no stronger than a flower?
> (Shakespeare Sonnet #65)

Intuitively, Shakespeare's ordered set seems appropriate. A flower is an excellent token of the transience of the present moment, but a poor symbol for resistance to "Time's injurious hand" (Sonnet #63). Tarnished brass, eroded stone, the cliffs of Dover and the sea's boundless shape are better, and in that order. Here is where the dialectical model comes into play. The perceived resistance of ruins to forces of time is the counterpoise to the visible effects of natural forces destroying architectural order and beauty.[19] Resistance is provided not simply by the material of the ruin, but also by its structure; that is, the ruin retains some of its architectural power to withstand nature, while nature's ability ultimately to conquer artifacts is simultaneously evident. Once again, Shakespeare expresses this thought magnificently:

> When I have seen by Time's fell hand defaced
> The rich proud cost of outworn buried age,
> When sometime lofty towers I see down razed
> And brass eternal slave to mortal rage;
>
> . . .
>
> Ruin hath taught me thus to ruminate,
> That Time will come and take my love away.
> (Sonnet #64)

That thought might arise in the experience of ruins. But many times, it seems to me, the experience is more complex, that our *perceptual* consciousness shifts back and forth between an awareness of the ruin as the human *resistance* to natural forces and consciousness of the forces of nature as the *destroyer* of the most carefully planned human monuments.

The ruin in situ is the dialectical product of this interaction and becomes aesthetically symbolic appropriate to these generalities. Other things being equal, the more monumental the original structure (or what can be imaginatively envisioned of it given the remnants), the better the ruin serves this expressive function. At the same time, both the classical and romantic pleasures in ruins seem dependent upon an awareness of this dialectical process. We experience a peculiar sense of urgency to seize the opportunity to get a glimpse of the past (a variation of carpe diem) and feel privileged to be participating in its imaginative reconstruction through personally exploring the remnants. The experience of ruins thus includes affective states based on the complex of physical/temporal status of the ruin as perceived. Ruins have a richly layered aesthetic.

III

We now turn to the third type of environmental sculpture referred to earlier: non-functional artifacts constructed on scenic sites, as best represented in recent works and projects by Christo (Javacheff), particularly *Valley Curtain, Running Fence,* and *Surrounded Islands.*[20] In these works synthetic fabric is placed or suspended by structural supports on or over a natural setting. As in the case of ruins, the specific qualities of the materials constitute one focal point; the texture, color and formal qualities of the fabric in place are aesthetically important. But there are several additional points of similarity to the aesthetics of ruins which are worth noting.

First, in both conception and design Christo's works are monumental in scale. We are continually reminded, visually as well as by documentation, of the extensive dimensions and costs of the materials and labor, as well as of the engineering complexity and sometimes the real danger in actual construction. Scale is relative to the comparison class, of course, but in the class of *non-functional* artistic creations, the physicality of these works of Christo are intentionally non-pareil. Just as the monumentality of ruins increases their expressiveness, so the scale of Christo's projects is essential to their heightened visual appeal and to the complex social context of their realization. They are extremely forceful appendages to, if not incursions upon, their natural settings.

Second, there is the similarity with ruins of the importance of the site. A ruin moved inside a museum may retain all of its material properties, but will lose some of its associational and, hence, expressive properties (although it may gain new ones—imagine Tintern Abbey moved to Central Park). Christo, like Smithson, has selected relatively undisturbed sites not already popular as scenic focal points for his projects, although Christo's settings are more accessible to public view given his desire to include an interested (or even antagonistic) public in the realization of his projects. But even more in

Christo's work than in Smithson's, the specifics of the construction are influenced by the natural setting, just as the setting itself may have been selected in terms of a vague idea of a type of project. Leaving aside the specifics of the creative process, however, what one perceives is a specific, dynamic interaction between the artifactual and the natural.

Third, Christo's constructions are temporary in nature, not meant to remain in place for more than a week or two; afterwards, their existence is reduced to their extensive documentation (which is intentional and well-planned). In part, legal and economic constraints determine their duration, since the necessary permits to construct the projects have been contingent upon a fixed short lifespan. In addition, the materials themselves partially influence the time period, for the fabric components would deteriorate if exposed to the elements for very long. Christo is well aware of the expressive component to these materials.

> I love [fabric] because it creates temporary, and not permanent relations between things. It is very ephemeral. . . . The fabric lends dynamic form to my projects, because you know very well it's not going to remain forever, and that it will be removed.[21]

It must be remembered, however, that Christo himself *chooses* to design projects that inherently raise the issue of how long they can physically or legally survive. Although Christo promises that the sites will be faithfully restored to their natural condition at the conclusion of the "exhibit," the transience of their physical realization is well publicized and itself becomes an aesthetic aspect of these works. (When this writer recently asked Christo whether he thought that the canyon at Rifle Gap remained unaffected by having hosted *Valley Curtain*, he replied: "Perhaps not. Was Mont-Saint-Victoire ever the same after Cézanne?")

Fourth, the transience of the physical construction is a factor in the transformation of Christo's works into something like public performances, which get attention both prior to their physical realization and after their physical demise. The artifacts and the natural site are but two elements in this larger work. The work ceases to be the mere physical construction on a natural site, but a project with extended temporal boundaries, whereby the social context of its realization takes on aesthetic import. Christo's projects generate intense controversy and involve legal and political institutions from their earliest planning stages through final construction, maintenance and dismantling. There is no doubt that the public hearings, legal contracts, etc. are part of Christo's intentions. "He insists that the work of art is not merely the physical object finally attained, but the whole process—the sur-

veys, the engineering, the leasing, the fabricating, the assembling, the hearings and the rest of it."[22] If Christo is successful then the experience of the realized work is similar to the experience of ruins in important ways. It can incorporate an awareness of the past (the planning stages and the social interactions required by the developing work, the difficulties in construction and realization), and the object can then be visually apprehended as a stage in an evolving process. At the same time, the experience can incorporate an awareness of the future disintegration of the artifactual components of the construction, after which the work will exist only in imaginative reconstruction on the basis of documentation.

The aesthetic status of Christo's work and his conception of the extended project as a work of art may be theoretically controversial, but in fact the actual controversies surrounding these projects have been confined largely to the environmental implications of the constructions, viewed as incursions on relatively pristine natural settings.[23] Although objections usually take the form of legal recourse through challenging the environmental impact of the construction itself, one cannot help but think that these critics believe Christo is engaged in an *aesthetic* affront to nature that goes deeper than the scientific assessment of environmental implications. This raises the question of whether they are destructive of the natural setting within the aesthetic context. It must be admitted that Christo's constructions are not merely peacefully coexistent artifactual appendages to their sites, living in aesthetic symbiosis with nature (as Frank Lloyd Wright conceived his "natural house"). Christo's artifacts forcibly assert their artifactuality over against nature, by their size, their engineering complexity and their synthetic components. Those who believe he has succeeded aesthetically, however, could argue that he has selected natural sites in which nature is up to the challenge and expresses its own grandeur and power. A dialectics of nature and art is achieved through a synthesis of opposing forces, artifactual and natural, but at the same time both forces retain their identity as separately identifiable components of the completed work.[24]

I V

These are just some of the aesthetically significant interactions of the natural and the artifactual. If I am correct in my analysis, the object of aesthetic appreciation in such cases is quite complex and goes well beyond the perceived physical object. It is in part a product of a dialectic between nature and art, the experience of which incorporates time past and time future into present awareness, but without

either the natural or the artifactual losing their identity. Although I cannot endorse the full implications of John Dewey's generalization, his remark in *Art as Experience* seems applicable to the range of examples discussed in this paper: Art celebrates with peculiar intensity the moments in which the past reenforces the present and in which the future is a quickening of what now is.[25]

Notes

An earlier, condensed version of this essay was presented at the meetings of the Pacific Division of the American Society for Aesthetics in April, 1983. I wish to thank those present, and especially the commentator, Gary Shapiro, for helpful comments and suggestions.

1. Ronald W. Hepburn, "Aesthetic Appreciation of Nature," in *Aesthetics and the Modern World*, H. Osborne, ed. (London, 1968), pp. 49–66; Mary Carmen Rose, "Nature as Aesthetic Object," *British Journal of Aesthetics*, 16 (1976), 3–12; Allen Carlson, "Appreciation and the Natural Environment," *Journal of Aesthetics and Art Criticism*, 37 (1979), 267–75.

2. For example, Carlson, "Appreciation."

3. Still another form of environmental sculpture has been important in recent art, but since it does not involve nature in any significant way I do not consider it here. It is "sculpture-in-place," which involves the interaction of the sculpture with the gallery environment, or even the transformation of the entire gallery room into a quasi-environment.

4. To better focus issues in the present essay, I shall underplay the issues of idea art, conceptual art and anti-art that may be involved in many of these works of environmental sculpture, nor for the most part shall I be concerned with their aesthetic merit as distinct from understanding how they work. An excellent discussion of some of these issues can be found in William Fowkes, "A Hegelian Critique of Found Art and Conceptual Art," *Journal of Aesthetics and Art Criticism*, 37 (1978), 157–68.

5. *Winter Vision* is derivative from some of Hans Haacke's sealed atmospheric constructions, such as *Condensation Cube* (1963–65). Haacke was attempting to disassociate himself from formalist concerns with color, line, shape and texture, as well as to draw attention to natural systems as self-sustaining, functioning entities. *See* Jack Burnham, "Steps in the Formulation of Real-Time Political Art," in Hans Haacke, *Framing and Being Framed* (The Press of the Nova Scotia College of Art and Design; New York University Press, 1975), pp. 131–34. Because of the additional anti-formalist issues Haacke's work raises, I have chosen not to discuss it here.

6. Wind chimes might be compared to environmental sculpture on this basis. Why they, along with toy windmills, are not part of the artworld despite their more established history and complete nonfunctionality lends support, I believe, to my view that the intentional reference to natural forces interacting with the artifactual is an essential aspect of the environmental art works being discussed.

7. *The Writings of Robert Smithson*, ed. Nancy Holt, (New York University Press, 1979), p. 155 (interview with Paul Cummings, 1972); See also p. 90.

8. That these "snow-works" were constructed on either side of the St. John River, which forms the boundary between Canada and the United States, adds still another dimension to their aesthetic significance.

9. Smithson, *The Writings* p. 166 (symposium at White Museum, Cornell University, 1970).

10. "I think you have to find a site that is free of scenic meaning. Scenery has too many built-in meanings that relate to stagey isolated views. I prefer views that are expansive, that include everything.... I can't really work in towns. I have to work in the outskirts or in the fringe areas, in the backwaters.... I'm interested in bringing a landscape with low profile up, rather than bringing one with high profile down. The macro aggression that goes into certain earthworks doesn't interest me." Ibid., p. 187; interview with G. Pettena, 1972.

11. Ibid., p. 187.

12. Ibid., pp. 115, 188. The exhibition (if not the sale) of the documentation also tends to bring environmental works within some of the more central conventions of the art world. Furthermore, it perhaps neutralizes one of the common criticisms of self-contained environmental systems sculptures (such as Haacke's condensation boxes): "... few of them create more than a fleeting aesthetic experience. Once seen, such works have exhausted their charm.... Moreover, the artistic affect is usually a copy of a natural effect instead of a retranslation of nature into artistic terms. Originals are always more stimulating then copies." Carla Gottlieb, *Beyond Modern Art* (New York, 1976), p. 316.

13. Cf. Henry James, in *The Italian Hours:* "To delight in the aspects of sentient ruin might appear a heartless pastime, and the pleasure, I confess, shows a note of perversity." Quoted in Rose Macauley, *Pleasure of Ruins* (London, 1953).

14. Latin, *ruina* (fall), *ruere* (to fall or crumble).

15. To test this condition, suppose a perfectly preserved ancient building were revealed by the recession of a melting glacier. Would it be a ruin? My intuition is that it would not, unless the glacier had partially destroyed it, marred its surface, twisted its form, or some such thing. Partial disintegration seems necessary for something to be a ruin.

16. Macauley, *Pleasure,* p. 378; Robert Ginsberg, "The Aesthetics of Ruins," *Bucknell Review,* 18 (1970), 89–102. Other recent discussions of the aesthetics of ruins include Paul Zucker, *Fascination of Decay* (Ridgewood, N.J., 1968), Walter Kaufmann, *Time Is an Artist* (New York, 1978), J. B. Jackson, "The Necessity for Ruins," in *The Necessity for Ruins and Other Topics* (University of Massachusetts Press, 1980), pp. 89–102, and Florence Hetzler, "The Aesthetics of Ruins: A New Category of Being," *Journal of Aesthetic Education,* 16 (1982), 105–8.

17. Ginsberg, "Aesthetics," p. 90.

18. For example, Schopenhauer declares: "Some objects of our perception excite in us the feeling of the sublime because, not only on account of their spatial vastness, but also of their great age, that is, their temporal duration, we feel ourselves dwarfed to insignificance in their presence, and yet revel in the pleasure of contemplating them: of this kind are very high mountains, the Egyptian pyramids, and colossal ruins of great antiquity." (*The World as Will and Idea,* Third Book, sect. 40).

19. Frederick Turner, *Shakespeare and the Nature of Time* (Oxford, 1971), p. 18; *See also* J. B. Leishman, *Themes and Variations in Shakespeare's Sonnets* (London, 1961), pp. 100–01.

20. *Valley Curtain* (realized October 10–11, 1972), Rifle, Colorado: fabric curtain 185–365 feet in height, 1,250–1,368 feet in width; 200,000 square feet of nylon polyamide; 110,000 pounds of steel cables; 800 tons of concrete.

Running Fence (realized September 8–22, 1976), Marin and Sonoma Counties, California: fabric fence 18 feet in height, 24½ miles in length; 2,000,000 square feet of woven nylon fabric, 90 miles of steel cables, 2,050 steel poles (each 3½ inches in diameter, 21 feet in length).

Surrounded Islands, (realized May 3–17, 1983) Biscayne Bay, Greater Miami, Florida; woven polypropylene fabric surrounding eleven islands, floating on the surface of the water and extending into the bay 200 feet by being laced to long booms.

21. *Christo: Oceanfront* (The Art Museum, Princeton University, 1975), p. 27.

22. Alfred Frankenstein, "Christo's 'Fence', Beauty or Betrayal?," *Art in America,* 64 (1976), 58.

23. Christo is also known for a slightly different type of artistic construction, architectural and monumental wrappings, such as: *Wrapped Monument to Vittorio Emanuele* (Piazza Duomo, Milan, 1970); *The Wall,* wrapped Roman wall, Via Veneto and Villa Borghese, Rome, 1974. His current projects include *The Pont Neuf Wrapped,* a project for Paris, and *Wrapped Reichstag,* a project for West Berlin. My analysis of his on-site constructions can be applied to these works as well, with minor alterations. They too are monumental in scope and design, temporary, and involve a complex social/ political context. But instead of an intimate relation to a natural setting, they create an intimate relation to an existing edifice: the wrapped statue or architectural structure itself. The wrapping draws attention to the building's formal qualities, especially its spatial dimensions. But attention is also drawn to qualities that are no longer visible; we think about what is wrapped that we cannot see. Also, the wrapping involves a negation of the function of the building, by displacing it or diminishing it during the period of its being wrapped. However, by doing so, the function of the building is conceptually highlighted, by visually being interfered with. The artistic treatment (or use) of the building for wrapping contrasts with the normal functional use of it (or, in the case of a monument, with one's normal relationship to it). The past and the future are thus brought fully into play here as well, even though nature is left out.

24. Gary Shapiro has suggested to me that my position thus stated is closer to the "left" than to the "right" Hegelians' notion of dialectic, insofar as I resist the view that the conflicting forces are negated in the dialectical process and subsumed under a higher unity. It may be that the extended aesthetic object in the cases discussed above can be described as a unity of interacting forces, but it does not seem that they thereby dissolve; nor does the notion of an evolutionary dialectical process seem applicable here.

25. John Dewey, *Art as Experience* (New York, 1934), p. 18.

56

Rain

BARBARA SANDRISSER

An old Japanese tale concerns the well-known twelfth-century Buddhist priest Saigyō, who once requested a night's lodging in the simple cottage of an old Shinto priest and his wife. As he approached the house he could hear them quarreling about whether to put a roof over their veranda. The wife was against the idea; she wanted to see the moon from inside their cottage. Her husband, on the other hand, loved the rain. He wished to hear the sound of the drops splashing against the roof while sitting comfortably on the veranda. The story is told somewhat differently in a Nō song: the roof needs repairing but the elderly couple are reluctant to do it, for the experience of the moon and the rain would no longer be immediate.[1]

Naturally, the point of this tale is not who won the argument. Since ancient times, these small drops of moisture which habitually fall from the sky profoundly influenced Japanese aesthetic notions. How Japanese people perceive and appreciate every nuance of rain is unique. It deserves some attention from those who, while conceding that it helps the farmers, look at a rainy day as a personal inconvenience. Appreciating the aesthetic quality of rain seems amusing and frivolous to many Westerns, and our patronizing attitude does not escape Japanese notice. In his essay on rain published in 1964, Iwao Matsuhara reminds us that many Japanese continue to believe that "anyone who does not appreciate the beauty of nature, particularly that of the moon and rain, should not be trusted in all

things, for such is likely to have a 'heart of stone' which knows neither pity nor tears in life. . . ."[2]

Matsuhara's suggestion merits our attention, for he touches upon a sensitive issue. We take pride in our incessant penchant for distancing ourselves from our environment, thereby diminishing aesthetic appreciation of nature's influence. Kenkō, an early fourteenth century Buddhist priest, discusses rain and the aesthetic relationship between rain and the moon.[3] He longs to see the moon while looking at the beauty of the rain but he does not wish the rain to stop. Kenkō perceives the moon behind the clouds and thus, he cherishes both the moment and the inevitable passing of time. Surely the rain will end and he—and we—will see the beauty of the moon once again.

Matsuhara, Kenkō, and others repeatedly tell us what we think we already know. Their seeming obviousness only reinforces our desire not to value the significance of their words. Consequently, we oftentimes belittle the notion that to be devoted to the ordinary yet gratifying pleasures of rain is an important aspect of life. Matsuhara brings us to the "heart" of the matter by suggesting that a purely rational mind is not necessarily a superior mind nor is it a reliable one. Rain exemplifies intimate contact with the commonplace. It is the essence of understatement. The impermanent, transient qualities of rain lead us to perceive nature, time, and space in an atypical manner. Rain hides the whole, creating nuance; it produces patinas of age, moss on rocks,

This revised version of Barbara Sandrisser's article "Fine Weather—The Japanese View of Rain" (*Landscape,* 36 [1982], 42–47) is published with permission of *Landscape* and the author.

609

Outside Kyoto. Barbara Sandrisser.

and the soft sheen on Japanese roofs. It softens colors in the landscape. We smell it, feel it, touch it, hear it, and see it. This sensory awareness is part of its aesthetic value.

From a Japanese perspective the idea of rain is particularly suited to the arts. Their appreciation of rain as aesthetic nourishment transcends our view of nature which we are taught must be controlled and manipulated. Rain is an integral part of Japanese life, perceived as a positive rather than a negative force. It affects the daily life of virtually everyone in the country. There are practical reasons for this but, more important, the aesthetic awareness of nature continues to be strong and binding among the Japanese people. Rain is rarely equated with sadness. Late fall is a more appropriate metaphor for sadness, used most frequently in love poems.

In Japan it rains primarily during the spring, summer, and fall. Within this time frame two rainy seasons occur, each lasting approximately six weeks, when rain seems to fail incessantly. Occasional typhoons strike during the late summer and early fall. Despite frequent rain, the sun appears often. The Japanese attribute the balance of sun and rain to their gentle sun goddess or *kami*, Amaterasu, who, during ancient times we are told, was constantly at odds with her brother, Susano-o the storm *kami*. She felt so intimidated by her brother's domineering and rough behavior that in despair she fled into a dark cave. The other *kami*, fearing that perennial darkness and ceaseless storms would overtake Japan, finally convinced Amaterasu to emerge to help maintain a harmonious climate.

Harmony and balance are key concepts in Japanese thought. Both rain and sun are needed for a pleasant environment. Thus both the sun *kami* and her brother must try to cooperate with each other to create a balanced climate. Ancient Shinto and

Buddhist traditions encouraged people to seek harmony and balance within their environment, not by force or coersion but through an awareness and appreciation of the intrinsic harmony and balance found in the natural world. Water becomes a purifying element, enhancing the landscape both physically and aesthetically.[4] The harmony of rain and sun created an agreeable balance without symmetry or uniformity.

Symmetry and uniformity are Western definitions of balance, not Japanese ones. Both words suggest human control, human authority, and finally human supremacy. We cannot control rain and thus we tend to ignore or avoid it. Western writers occasionally resort to it in order to evoke feelings of misery, fear, despondency, or desolation. The question arises as to why we harbor such negative feelings toward a phenomenon the Japanese find so full of beauty.

Our lingering frustration and crankiness with rain run deep in our heritage. In "Genesis," the first book of the *Old Testament*, we learn that God had second thoughts about having created humans.[5] Anger seemed just cause for destruction: ". . . in seven days, I will send rain upon the earth forty days and forty nights; and every living thing that I have made I will blot out from the face of the ground."[6] Rain is used to punish, to destroy and to kill. Understandably, then, it continues to make us somewhat anxious.

As children we are taught to dislike rain. We chant our nursery rhyme: "Rain, rain, go away/ Come again another day." We recognize that rain is a necessary evil. We tolerate it, but we'd be much happier if it didn't rain today. Maybe tomorrow, or next week, but not today, please. Children live in a world of todays; tomorrow is always tomorrow, and rain is perceived as bothersome.

Japanese children sing a totally different rhyme: "Rain, please rain/Mother will/come to get (me) with an umbrella/isn't that nice!/skip, skip, hop, hop/fa la la, la la."[7] What a cheerful, affectionate view of rain. Rain is accepted as a matter of course, as a positive element in the daily lives of children. Of course children are sometimes disappointed if it rains on special occasions, such as outdoor festivals, but in general they learn to perceive rain as a natural happening. Instead of rain, it is the thunder god who instills fear into the hearts of Japanese children due to his peculiar penchant for *okoso* or human navels. He enjoys eating them so much that occasionally he accidently falls from the sky with anticipated desire. Belly buttons appear to be his only vice but this is enough to ensure that on very hot summer days children put their clothes on quickly and run inside during a sudden cloudburst.[8]

The rain and wind of typhoons in late August and September are frequently destructive, prompting farmers to try to predict the impact of the storm in their district by carefully observing nature. If the leaves of mulberry trees are tightly curled, a typhoon will hit during the harvesting season. If oranges do not appear on the ends of branches, the trees sense a typhoon coming.[9] Farmers tend to take these and other observations seriously, caring little for scientific weather data collection. Old proverbs also play a role. When cats wash their faces, rain will fall; when children romp about during the evening, rain will soon appear, and it usually does, since the habits of cats, children, and rain typify certain predictable characteristics.

Rain falls, sprinkles, spits, pours, pelts, drizzles, and pitter patters, suggesting different qualities of descent from sky to earth. Rain is not simply rain in Japan. It depends on the type of rain, the time of year, whether it is soft or hard, day or night. Summer rain is sometimes called white rain (*hakusame*), not to be confused with a summer evening thunderstorm (*yudachi*). During spring there is seasonal rain (*harusame*), misty rain (*kirisame*), and May rain (*samidare*). Autumn brings a different seasonal rain (*akisame*), torrential rain (*oame*), not to mention sudden rain (*niwakaame*), and passing rain (*toriame*).[10] Bunsho Jugaku, professor of literature at Kyoto University, notes the variety of words used a century ago for winter rain. The inhabitants of the area around the Hakone mountains, for example, called it "my own rain" (*watakushi-ame*) suggesting, perhaps, that it was snowing elsewhere. The same kind of rain was called "mountain tripper" (*yama-meguri*) in parts of Gifu Prefecture, undoubedtly because it caused slush and ice.[11]

The importance of describing the subtleties of rain is not to label and categorize the various types, but to articulate their poetic qualities. Thus rain in Japan is not simply heavy or light. Each moment rain falls it merges with the environment, creating an atmosphere Japanese try to capture in their art forms. Indeed, many Japanese still believe that their intellectual and creative pursuits blossom during a rainy day. Rain is considered beneficial for contemplation, creating an atmosphere conducive to producing works of art. The Japanese novelist Junichiro Tanizaki elaborates:

As I have said there are certain prerequisites: a degree of dimness, absolute cleanliness, and quiet so complete one can hear the hum of a mosquito. I love to listen from such a toilet to the sound of softly falling rain, especially if it is a toilet of the Kanto region, with its long, narrow windows at floor level; there one can listen with such a sense of intimacy to the raindrops falling from the eaves and the trees, seeping into the earth as they wash over the base of a stone lantern and freshen the moss about the stepping stones. And the toilet

Near Kyoto. Barbara Sandrisser.

is the perfect place to listen to the chirping of insects or the song of the birds, to view the moon, or to enjoy any of those poignant moments that mark the change of the seasons. Here, I suspect, is where haiku poets over the ages have come by a great many of their ideas.[12]

Japanese poets from the earliest times appreciated rain. During the Heian period (794–1184), when women wrote much of the poetry, Lady Ise, mistress of Prince Atsuyoshi, composed an exquisite poem about rain:

The spring rain
Which hangs to the branches
Of the green willow
Looks like pearls
Threaded on a string.[13]

The elegance of her words are as clear as a twentieth-century photograph. Another poem about clinging raindrops written a century later in the Kamakura period (1192–1333) by the Buddhist priest Jakuren, suggests the evening chill of fall.

The hanging raindrops
Have not dried from the needles
Of the fir forest
Before the evening mist
Of autumn rises.[14]

The spring rain in Lady Ise's poem feels warm while the rain in Jakuren's poem is cooler, denser. We can easily imagine the cool mist and occasional droplets caressing our skin. Both poems seem to radiate sensuousness and sensuality. They exceed the merely descriptive depiction of raindrops in the landscape

by focusing on intimacy and immediacy, encouraging us to smell the rain in the pine forest and on the willow branches.

Jakuren was not above using the same idea over again:

The drops of pattering rain
Are not dry on the cypress leaves
Before trailing mists swirl
On an autumn evening.[15]

The aroma of wet cypress is different from the aroma of wet pine. In this poem, a breeze seems to engage the mist in a gentle dance. Jakuren shares with us the specialness of this moment in time.

We hear the sounds of rain as gravity propels each drop toward the earth yet, on occasion we mistake it for something else. Two poems again from the early Kamakura period, the first by the Buddhist priest Saigyō, the second by Yorizani Minamoto, depict this delightful deception:

Is it a shower of rain?
I thought as I listened
From my bed, just awake.
But it was failing leaves
Which could not stand the wind.[16]

The leaves of the trees are falling
In the house one cannot hear
anything,—
Both nights when showers fall
And nights when showers do not fall.[17]

Occasionally the rain will stop for a moment, enabling us to hear outher sounds, as suggested in this poem by Yoshitsune Fugiwara:

The irises
Their petals damp, are fragrant.
Listen! The cuckoos
Are calling now, this rainy
Evening in May.[18]

If we consider poems about rain written during the Heian and Kamakura periods as beautiful images similar to photographs that capture a moment in time, then Edo period (1603–1868) poetry about rain might be seen as moving pictures of landscape:

Winter blast—
Rain-storm even
Not reaching the ground.
 Kyorai Mukai[19]

Spring rain:
Telling a tale as they go,
Straw cape, umbrella.
 Buson Yosa[20]

Rain of a winter storm
Horns locked as they jostle,
Oxen in the meadow.
 Rankō Takakuwa[21]

Movement and activity dominate each poem, whether it is nature's kinetic force, people walking in the rain, or oxen butting, yet they illustrate simple, ordinary events with elegance and wit. Merely recording the image is insufficient. Instead, every nuance of rain and its effects of these poets to become part of their surroundings culminates in the act of creating a poem.

Gentle humor oftentimes elicits an unanticipated smile. The Buddhist priest Rikyu, Hideyoshi's famous tea master during the Momoyama period (1573–1603), wrote:

Such a pleasant, gentle spring rain.
Why don't you nightingales,
come out and with a hat,
enjoy the rain with me?[22]

Wit, charm and elegance, in concert with exceptional acuity, enabled many traditional Japanese poets to create persuasive and satisfying poetry using rain as a positive element. However, as the twentieth century neared, Western notions influenced Japanese perception of nature's benevolent forces. Particularly horrifying was the "black rain" that fell on Hiroshima after the atomic bomb blast. Taro Kitamura's poem expresses the sad reality of the event:

Spring imitates the shadow of a street
in every heavy window.

 The rain
keeps falling on the town,
and the place of our coming death
steams as well.

On the hill, the cemetery.
 The graves
brand crosses on our eyes,
mete out a limited enjoyment.

The rain between graves and window
falls on the town set with geraniums.

The sound of wheels
dies out in soft rain, and the rain
dies out in the brush of tyres.

We scrutinize our graves
hunt death beneath each stone.

Everything's there. All pain, all joy.
We're tethered there by every passing moment.

On the hill, the cemetery.

Acrid smells issue from the baker's shop,
emphasize our pettiness
and satisfy the town
with comfortable illusions.

What's gained, and why
are we inevitably confined,
existence like a tube?
The blond stream under the bridge,
everything streaming,
death streaming into our bowels.

Eleven a.m.

 The rain
dies out in the brush of tyres,
and the sound of wheels
dies out in soft rain.

The rain keeps falling on the town
and we move our sprawled limbs
behind heavy glass.[23]

Kitamura's drenching rain seems to soak into our innermost recesses, bringing feelings of despair and inevitability. Despite his grim view of rain, he seems reluctant to portray it as villainous. His rain is subtle, endless, and unclean, without drama or artifice.

With rare exception rain in Western poetry is replete with drama, melancholy and darkness. The witches in Shakespeare's *Macbeth* debate whether they should meet in thunder, lightning or in rain.[24] In *Venus and Adonis* the sun's comforting rays become a metaphor for love. "Love comforteth like sunshine after the rain."[25] Imagine, instead, "Love comforteth like rain after the sun shines."

To us rain is "useful trouble" as Alfred Lord Tennyson suggests.[26] Longfellow unintentionally provides us with two gloomy poetic phrases which today are virtual cliches: "Into each life some rain must fall/Some days must be dark and dreary."[27] Rain and unhappiness are synonymous, as Matthew Arnold suggests in his diary entry upon the death of his third and favorite child:

Hard rain
Rain
Rain
Rain in the morning
Rain in the morning
Rain in the evening
Rain
Rain in the evening
Rain all day
Rain all night
Rain[28]

In *All Quiet on the Western Front,* Erich Maria Remarque conveys fellings of anguish, misery, and despair: "Monotonously the lorries sway, monotonously come the calls, monotonously falls the rain. It falls on our heads and on the heads of the dead up the line, on the body of the little recruit with the wound that is much too big for his hip; it falls on Kemmerich's grave; it falls in our hearts."[29]

Twentieth-century Japanese writers still seem to prefer to depict rain as nature's gift rather than as a metaphor for sorrow. Poems, such as the one by Junzaburo Nishiwaki, showers our imagination with sensual delight:

With the south wind a gentle goddess came.
She soaked the bronze, she soaked the fountain,
She soaked the swallow's belly and its feathers
 of gold.
She hugged the tide, lapped the sand, drank
 the fish.
Secretly she soaked the temple, the bath-house,
 the theatre,
The confusion of her platinum lyre—
 the tongue of the goddess-secretly.
Soaked my tongue.[30]

Rain permeates the work of many well-known twentieth-century Japanese writers. Kawabata often begins his chapters with a sentence about rain to create the appropriate atmosphere for that particular moment in time: "It began raining on New Year's eve, and New Year's day was rainy," he writes in *The Sound of The Mountain.*[31] In *A Thousand Cranes* he writes about a telephone conversation in which Kikuji says, "It was raining so hard here that you must have heard it over the telephone." "Can you hear rain over the telephone?" "But I wasn't listening." She responds, "Could you hear the rain in my garden?"[32] In their next telephone conversation he refers to it again "... The last time—remember—I heard rain over the telephone."[33] Kawabata's language is straightforward; he depicts rain as a fact of life, not as a metaphor for an emotion.

In *Beauty and Sadness,* Kawabata integrates rain into a bantering interchange between husband and wife over breakfast, much like the couple who, centuries ago, argued about fixing the roof:

"Now the rain's leaking in! Right into the kitchen. Can you hear it, dear?" It was raining when he woke up, but now it had become a heavy downpour. The wind that swayed the pines and bamboos on the hill had veered around to the east and was driving the rain in from that side.
"How could I, with all the rain and wind?"
"Won't you come and look?"

"Mmm."

"Those poor little raindrops—hurled against the roof tiles, and squeezed through cracks, like teardrops seeping in on us . . ."

"You'll have me crying too."

"Let's set the wire trap tonight. I think it's up on the closet shelf. Will you get it down for me later, please?"

"Are you sure you want to catch Mrs. Mouse and her sweet little offspring in a trap?" said Oki mildly, without looking up from his newspaper. "And what about the leak?"

"How bad is it? Isn't that just the way the wind is blowing? Tomorrow I'll get up on the roof and see."

"That's dangerous for an old man. I can have Taichiro climb up."

"Who's an old man?"[34]

To set a trap for the mice, to fix a leaky roof, when to retire, or the aroma of miso soup—these plus rain are only a few of the matters raised in the first few paragraphs. Then Kawabata returns to the subject of rain once again to note the passage of time during their conversation: "The rain had slackened, though as yet there were no rifts in the clouds."[35] The reality of Kawabata's landscape appears in our mind's eye. Through his words we sense the continuing interplay between inside and outside. His imaginary characters and the constantly changing landscape seem inexorably intertwined.

The visual impact of rain in Japanese literature is reinforced by the visual quality of the character for rain (雨), which is a pictograph illustrating its descent from heaven to earth. The character inspired Seiichi Niikuni to compose a poem that is actually a visual essay on rain:[36]

Rain

雨＝rain Rain. Seiichi Niikuni.

Rain is common in ink sketches and woodblock prints generally appearing as black lines slashed diagonally across the landscape. Both Hokusai (1760–1849) and Hiroshige (1797–1858) incorporated rain into their work. Depicting rain entails considerable risk since the artist must first paint or, if making a woodblock, cut and print the entire scene—grass moving in a gust of wind, umbrellas open, and people in straw capes moving along in response to the raindrops. At this stage of completion, the ink sketch or woodcut seems infused with rain before the actual rain is added. Then the slashes are either painted over the sketch or, for the woodcut a separate block is cut, inked and pressed onto the existing scene.

Finishing touches may entail still more wood blocks. Carefully comparing Hiroshige's "Sudden shower at Ohashi" woodcuts in the second and completed stages reveals that darker clouds at the very top of the print may have been added after the rain block, but this is impossible to verify since very print is slightly different. A copy managed to find its way to France whereupon Van Gogh, perhaps inspired by the literal quality of the rain, replicated Hiroshigi's scene using oil paint. His attempt was a dismal failure, in part because oil paint and raindrops do not mix either practically or artistically. A Western-style oil painting brush, no matter what size, is a deterrent rather than an asset, for it leaves clumsy streaks of paint on the canvas.

The difficulties of depicting rain should not be underestimated. It can ruin composition, change colors, and obliterate detail. Why then is falling rain considered necessary in a painting, woodcut or other visual arts? The Japanese seem to prefer portraying weather conditions as they exist in nature. Each raindrop need not be represented. Still, essential qualities of the environment, particularly those which produce change and are themselves transient, become significant visual features. The art of the delicate line is the climax of this achievement.

Rain is there for all to see. It is neither before or after the storm but during it. Light and form appear diffused. Colors are exquisitely subtle, muted to the point of gray on gray. Rocks, and roof tiles shine with wetness. Trees and plants drip. The ground is soaked, heavy with moisture. We perceive the rain actually falling plus its effect on the environment.

In the West, paintings depicting rain are rare. The few that exist today, such as Van Gogh's, were directly influenced by Japanese woodcuts.[37] Many nineteenth-century artists, notably Constable and Caspar David Friedrich, painted dour days. Turner's painting glowed with light even when the sun hid behind clouds and Corot's soft gray-green landscapes only hinted at cloudy weather. Others painted ominous clouds on the horizon, immense

ocean waves, boats pitching to-and-fro, with dramatic titles like "After the Storm" or "Oncoming Storm."

Claude Monet painted all seasons at all times of day in all weather conditions except rain. In his paintings we see haze, mist, fog, sunsets, sunrises, snow, clouds, water, shadows and reflections, yet no rain. Perhaps nature's colors were too gray during rain, less vibrant than he wished. Yet he loved water, painting innumerable waterlilies and reflections observed in his private pond in Giverny. Nevertheless he avoided painting rain.

Unlike the Japanese, we prefer to avoid rain because we cannot dominate it. Indeed it seems to dominate us. Monet was forced to move his easel inside during an unexpected summer shower. On numerous occasions we, too, are forced to rearrange our lives, seemingly encumbered by the petty annoyances which may accompany a sudden rain storm. It drenches our clothing, pours down our eye-glasses, soaks our feet, leaving us dishevelled, wet and grumpy. Rain provokes in us a surprising amount of hostility. It talks too much, and few, other than Thomas Merton, wish to hear it. "Nobody started it, nobody is going to stop it. It will talk as long as it wants, this rain." As long as it talks Merton will listen, for the ". . . festival of rain cannot be stopped." Technology is helpless in the face of rain. Rain ". . . not being planned, not being fabricated, is an impertinence, a wen on the visage of progress."[38]

Rain envelops the Japanese environment. The continuing impact of rain on a rice culture such as Japan is significant in that it suggests appreciation of rain's sensuous and aesthetic value, rather than mere acknowledgment of its practical benefits. We know that all primitive cultures relate to their immediate surroundings, yet the Japanese have carried their animism into a postindustrial society. Rain is prevalent in every art form, including those of popular culture. Television advertisements use rain as a backdrop; soap operas and samurai films incorporate rain into their stories; magazine ads, comic books, fashion magazines and department stores all include rain as an integral part of their respective images.

Japanese music sometimes evokes sounds of rain that are enhanced by ancient Japanese instruments. Songs played on the koto and on the samisen often sound like falling rain. The musical sounds of geta (wooden thong sandal creatively designed to lift feet above mud and puddles,) on cobblestones and earth remind Japanese of the sounds of the tsuzumi or hand drum. The contemporary composer Toru Takemitsu acknowledges his debt to rain in "Rain Coming," one of his four compositions entitled "Waterscape," all of which recall a different aspect

of rain. Takemitsu suggests that his work enters "various metamorphoses aiming at the sea of tonality just like water which circulates in the universe."[39]

Rain appears and disappears. The experiences of rain, although similar, are never the same. The Japanese appreciation of rice, moss, and tea, all requiring abundant rain to develop and prosper, reflects their understanding and love of rain. Sitting on the wood veranda of a Japanese vernacular dwelling, watching the rain fall, provokes thoughts on the "way of tea" or *Chado*, as preparing, serving and drinking tea becomes an aesthetic event encompassing all our senses. The four basic principles of *Chado*

might also be applicable to the appreciation of rain. Purity, or *sei*, can suggest the spiritual cleanliness of rain. Respect and gratitude for rain can be defined as *kei*. The idea of harmony, or *wa*, permeates rain. Once we understand these principles, peace of mind, or *jaku*, ensues, and true creativity emerges.

The tea master pours the thick, green tea into an irregularily shaped, pottery bowl which sits comfortably in our curved palms. Before drinking the tea we gaze at the beauty of the old bowl, weathered by age. We see a glaze pattern called rain-drip named for the glaze that, when fired, spread until the appearance of falling rain appeared.

The source of the inspiration was rain.

Notes

1. *Ugetsu,* a famous Nō song meaning "rainy month."

2. Matsuhara, Iwao, *On Life and Nature in Japan* (N.p.: The Hokuseido Press, 1964), p. 145.

3. Kenkō, *Essays in Idleness,* trans. Donald Keene (New York: Columbia University press, 1967), p. 115.

4. Even today Japanese prevent one from photographing a particular rock in their garden by first rushing inside to obtain a bucket of water, pouring it over the rock in order to enhance the color and pattern.

5. Genesis 6:6.

6. Genesis 7:4.

7. Translated by Yoshie Zorn.

8. Joya, Mock *Quaint Customs and Manners of Japan* (Tokyo News Service, Ltd., 1951), pp. 160–61.

9. Joya, Mock, pp. 163–64.

10. There are dozens of Japanese words used today to describe specific characteristics of rain which are found in any thesaurus or dictionary.

11. Jugaku, Bunsho, "The Sound of Rain," *Chanoyu Quarterly,* 1, no. 3 (Autumn 1970), 64.

12. Tanizaki, Junichiro, *In Praise of Shadows,* trans. Thomas J. Harper and Edward G. Seidensticker (New Haven, Conn.: Leet's Island Books,), p. 4.

13. *Japanese Poetry, The "Uta",* trans. Arthur Waley (London: Lund Humphries, 1965), p. 94.

14. *Anthology of Japanese Literature,* ed. Donald Keene (New York: Grove Press, 1956), p. 192. The poem is translated by Kenneth Rexroth.

15. *The Penguin Book of Japanese Verse,* trans. Geoffrey Bownas and Anthony Thwaite (Baltimore: Penguin Books, 1964), p. 102.

16. *The Penguin Book of Japanese Verse,* p. 100.

17. *Japanese Poetry, The "Uta,"* p. 86.

18. *Anthology of Japanese Literature,* p. 194. The poem is translated by Donald Keene.

19. *The Penguin Book of Japanese Verse,* p. 113.

20. Ibid., p. 119.

21. Ibid., p. 121.

22. Kida, Taiichi, "Science of Tea, Part III," *Chanoyu Quarterly,* 1, no. 4 (Winter 1970), 70.

23. *Post-War Japanese Poetry,* trans. Harry and Lynn Guest and Shozo Kajima (Baltimore: Penguin Books, 1972), p. 81.

24. *William Shakespeare, The Complete Works,* ed. G. B. Harrison, (New York: Harcourt Brace and World, Inc., 1952), p. 1189.

25. Ibid., p. 1155.

26. Tennyson, Alfred Lord, *Idylls of the King* (New York: The Heritage Press, 1939), p. 102.

27. *The Complete Poetical Works of Henry Wadsworth Longfellow,* Household Edition, (New York: Houghton Mifflin Co., 1902), p. 20.

28. *Smithsonian Magazine* (Aug. 1981), 126.

29. Remarque, Erich Maria *All Quiet on the Western Front* (New York: Fawcett Crest Books, 1979), p. 70.

30. *The Penguin Book of Japanese Verse*, p. 200.

31. Kawabata, Yasunari, *The Sound of the Mountain,* trans. Edward Seidensticker (New York: Berkley Medallion Books, 1971), p. 80.

32. Kawabata, Yasunari, *A Thousand Cranes,* trans. Edward G. Seidensticker (New York: Berkley Medallion Books, 1958), p. 102.

33. Ibid., p. 123.

34. Kawabata, Yasunari, *Beauty and Sadness,* trans. Edward Seidensticker (New York: Berkley Medallion Books, 1971), pp. 130–31.

35. *Beauty and Sadness,* p. 135.

36. *Post-War Japanese Poetry,* p. 96.

37. An excellent example is Martin Lewis, an Australian–American printmaker, who, as a young man, traveled to Japan. Returning to New York during the 1920s, Lewis created etchings of New York City in rain and in other weather conditions. The influence of Hisoshigi is evident. See *American Etchers, Martin Lewis,* vol. 11, (New York: The Craftonn Collection, 1931).

38. Merton, Thomas, *Raids on the Unspeakable* (New York: New Directions Press, 1964), pp. 10–12.

39. From the program notes of the Saint Paul Chamber Orchestra (1985–86, Fall I, September 13–October 19), p. 29.

57

The Art of Personal Beauty

CURT J. DUCASSE

Man is the animal who is not satisfied with merely living his life, but who is capable of—and insists upon—watching himself doing it. He not only is, acts, feels, and knows; but, unlike any other animal, he is insatiably curious to observe his body, his actions, his feelings, and his thoughts.

When he does this, however, he is seldom wholly satisfied with what he finds. Nature, he discovers, has been both niggardly and clumsy in the appearance it bestowed upon him, and likewise in the talents, virtues, and powers with which it equipped him. Therefore, no sooner does he get a good look at himself than he takes steps to effect, as best he can, changes for the better.

This process of self-editing or self-improvement may, as we emphasized, be directed not only to man's person but also to his personality, in any or all of its various aspects. By the mental activity called reflection, man is able to behold more or less objectively his own manners, modes of speech, conduct, feelings, motives, and thoughts; and when he thus beholds them, he is in position to judge and appraise them, and to do something to mold them to a pattern more to his liking than the one they have at the moment.

Reflection upon what we are and the attempt to transform that into what we should like to be is thus a process closely analogous to that of sitting in front of a mirror and applying to our lips and cheeks the lustrous glow that nature forgot, begrudged, or eventually took away. In both cases, however, the appearance is often much easier to improve than the

reality. The kindliness, magnanimity, or patience that we find we lack but would like to possess genuinely does not, alas, come to dwell with us at the mere wish. But the appearance of these qualities is not so hard to put on as the reality. Even when ill will, pettiness, or impatience stirs within us, it is possible, with a little effort, to speak and act the part of good will, nobility, and equanimity.

Shallow criticism will say that to do this is to be a hypocrite and a sham. But although someone has said that "shams are the illegitimate offspring of idealism," we may say with equal justice that the legitimate first-born of idealism makes its appearance at the surface of our personality. For the surface is the easiest part to alter; and, being the place where our contacts with other persons are made, is of much more immediate importance to them than our psychological interior decorations.

Absorption in our inner selves to the neglect of the surface with which others have to deal betrays a degree of self-centeredness verging on what has been called spiritual selfishness. Moreover, it should be noted that a part acted thoroughly and consistently soon becomes no longer a part, but truly oneself. As a man thinks and feels, so indeed does he tend to act and speak; but it is equally true, and perhaps even more useful to remember, that as a man acts and speaks, so likewise does he tend to feel and think. Although, as we shall see, no very sharp line separates the improvement or adornment of our character from that of our person, and in a way both are decorative arts, yet the two are in a mea-

Reprinted from Curt J. Ducasse, *Art, the Critics and You*. New York: The Liberal Arts Press, 1944, pp. 151–70.

sure distinguishable. Evidently, it is with the second that a philosophy of the cosmetic art is primarily concerned.

The sort of picture of ourselves that we attempt to realize when we engage in the embellishment of our person is determined by several factors. One of them, obviously, is the foundation of inalterable fact that nature has wished upon us; for, after all, there are limits to the transformations of our appearance that can be accomplished, even by our best efforts and with the help of beauty doctors, plastic surgeons, and other high priests of the cosmetic art. It would have been hopeless for the late Marie Dressler to attempt to make herself look like Greta Garbo, or for either Laurel or Hardy to try to transform himself into a replica of Rudolph Valentino.

Another factor that determines what we attempt to make ourselves look like is the resources of our imagination. There are persons who have many ideas and others who have practically none, at least in certain directions. The ideas relevant in the present connection are pictorial ideas; and the fact that the pictorial imagination of most persons is limited is the reason why most women do not attempt to design their own clothes, but let fashion designers do it for them. They wisely limit the exercise of their taste to choice from a variety of available designs and to modest attempts to adapt either the fashion to themselves or themselves to the fashion, according as the one or the other seems more feasible.

Lack of pictorial imagination is an equally good reason why most of us really need an expert to design our faces as well as our clothes. But the design of faces is much more haphazard than the design of clothing. The design of men's faces, which is almost entirely a matter of beard and haircut, is traditionally set by the collar advertisements in the streetcars; and any man knows that it is hardly worth while to attempt to dissuade the average barber from denuding completely the sides of his head, even if the top is as barren and naked as the bad lands of Wyoming. If one forbids the use of clippers, the conscientious barber, thinking it is because of nervousness, will sprain a wrist if need be to attain the same results with the scissors—and will expect an extra tip for his trouble! The design of women's faces, on the other hand, is, especially among the young, largely a matter of imitating as far as nature will tolerate the design used by some favorite motion-picture star. Only once in a while do we see a young woman whose head gives any evidence that she has taken objective stock of its basic features, and then intelligently attempted to make the most of them.

The other two factors that determine what we attempt to make ourselves look like are the reactions we observe in others to certain sorts of human appearance and our own taste. The two are closely connected; indeed, it has even been maintained that our taste is wholly determined by the approvals and disapprovals of the persons who constitute our environment. For these approvals and disapprovals not only tend to be imitated by us and used as standards, but determine also the sorts of appearance that we see constantly about us. These, by force of habit, we soon come to consider normal; whereas the sorts of appearance seen only rarely tend to strike us as queer, shocking, freakish, or funny.

There can be no doubt that the individual's taste is in this way influenced considerably by what the members of his set approve or disapprove. But this can hardly be the whole story. A person's inborn nature, as well as his subsequent nurture, counts for something in determining his taste. This is shown, in the realm of the fine arts and elsewhere, by the fact that occasionally one man, instead of yielding to the pressure to fall in step with the taste or ideas of his contemporaries, succeeds in convincing them or their successors that not he but they are out of step; so that eventually they adopt his taste, ideas, or practices.

As regards our person, however, it is doubtless true that the appearance we attempt to bestow upon it is determined very largely by the impression we think it will make on others. The expression of our taste is thereby instinctively confined within the limits of what we conceive others will regard as appropriate and attractive. For the fact need hardly be stressed that our personal happiness and prosperity depend, throughout life, very considerably upon the attitude of the persons with whom we come in contact. Moreover, the contact we have with many of those who can affect our fortunes is often very brief and superficial; and the briefer and more superficial it is, the greater is the importance of the surface we exhibit, since it is then all they have to go by.

To be attractive to others, then, is something of great moment to practically all of us; and, roughly speaking, there are two ways to attract people. One is to be likeable, and the other is to be fascinating. The two are not entirely independent, but they are nevertheless distinguishable. Likeableness, on the whole, depends more on realities than on appearances; it is more a matter of disposition and character than of looks, except insofar as the latter may be taken as evidence of the former. Fascination, on the other hand, is a phenomenon much less closely connected with the real worth of its object. It depends very largely upon appearances and upon the effect they have on our imagination. The lover beholds the beloved, not with eyes, but with dreams;

and dreams also it is out of which fascination is born in every instance, for fascination is not confined to the experience of people in love. Persons of our own sex, children, animals, and even inanimate things can be fascinating. For some persons cats, for instance, have an intense fascination not possessed by any dog, no matter how well liked; whereas for others the reverse will be the case. For some the ocean, or the desert, or the arctic regions have a similarly quite unreasoned magic.

Fascination, then, has evidently nothing to do with reason and everything to do with imagination. It is the attraction anything has for us when it seems to promise realization of something we half-consciously have been longing to find. And fascination it is, rather than likeableness, that our attempts at self-embellishment serve, even if we are often not clearly aware of the fact. Let us now consider some of the means whereby we seek to make ourselves physically attractive.

Although the phenomenon known as falling in love is only one instance where fascination occurs, it is among the most striking and is doubtless the one that looms largest in the consciousness of mankind. And, although being physically fascinated is by no means all of which the state of being in love consists, it is nevertheless normally a very important—some would even say, indispensable—part of it. It is therefore but natural that physical fascination should be an aim figuring conspicuously in our attempts at self-embellishment.

The most obvious determinant of physical attraction is beauty of person; therefore to become or at least to appear beautiful is the most elementary step in the attempt to make ourselves physically fascinating. Of course, beauty of person is something that is variously conceived by different people; and there is probably no one who has not often been dumbfounded by the outlandish tastes of his or her friends in the matter of beauty in the opposite sex.

But no matter whether we prefer blondes or brunettes, a nose that turns up or one that is straight, a statuesque or a dainty figure, there is nevertheless one thing that practically all of us agree upon as contributing most powerfully to beauty of person. That magically effective ingredient is, of course, youthfulness. And the beauty characteristic of the years of youthful bloom is traceable to such familiar factors as a clear, smooth skin, bright eyes, abundant and glossy hair, sound teeth, rosy color of lips and cheeks, and smooth outlines of limbs and figure, without either obesity or emaciation. It is of such stuff that the beauty of young manhood and womanhood is made, and there is no doubt that upon it very largely depends the greatest physical fascination. Its natural foundation is vigorous health and a good frame; but unfortunately these are not to be

had for the asking nor even by hard work, and persons who lack them or who lack the normal appearance of them nevertheless wish and need to be personally fascinating just as much as those who possess such appearances.

Devices that Stimulate the Beauty of Youth

This, naturally, is the place where the resources of the cosmetic art are drawn upon. Powders and creams skillfully applied may, to some extent, endow the most unpromising surface with the appearance of the famous "skin you love to touch." Unbelievable things can be done to the eyes, making them seem larger, brighter, and more umbrous than nature ever thought of creating them. Shampoos, dyes, washes, and assiduous brushing can impart to the hair the gloss and color it lacks; and permanent waves, switches, wigs, toupées, and rats help to simulate the luxuriant growth that is not there. Teeth can be bought better looking and more serviceable than those we grow ourselves. The healthy color not brought to our lips and cheeks by swift-coursing red blood comes in a little box. Firmness and elasticity can, in some degree, be restored to the flesh by patronizing a beauty parlor or reducing salon, where we pay somebody to pinch us and slap our faces; and the outlines of our figure can be rounded out by the wearing of judiciously designed upholstery, or rounded by means of obesity belts, braces, foundation garments, straitjackets, or other instruments of torture.

The sometimes deadly effectiveness of such artifices in simulating the appearances of the beauty of youthfulness is well known to all those who use them, and may further be attested by a law that was passed by the English Parliament in 1774. This law stated that:

> All women, of whatever age, rank, profession or degree, whether virgins, maids or widows, that shall from and after this act impose upon, seduce and betray into matrimony any of His Majesty's subjects by the use of scents, paints, cosmetics, washes, artificial teeth, false hair, Spanish wool (impregnated with carmine and used as a rouge), iron stays, hoops, high-heeled shoes or bolstered hips, shall incur the penalty of the law now in force against witchcraft and like misdemeanors, and that the marriage, upon conviction, shall stand null and void.

The prohibition by law of such devices was, of course, due to the fact that they constitued a form of deceit or fraud—a species of false pretenses by means of which such benefits as reward fascination

could be obtained by unscrupulous chiselers, in violation of an unwritten code of fair competition. And this element of fraud or deceit, together with the fact that mere physical fascination is too flimsy a foundation for married life, is doubtless the reason why, until relatively recent years, the use of such cosmetic resources has been considered vulgar or even immoral by persons of refinement. As we all know, however, a decided change in this attitude has taken place in our generation. It would be interesting to inquire into the nature of the transformations in the structure of society that were responsible for this change, but this would take us too far afield. Let us consider rather the possible influence of the advent and growing popularity of certain means of fascination, the philosophy of which is quite different from that of the means just considered.

Self-Adornment Distinguished from Self-Edital

It should be remarked first that, to be successful, the various means of bestowing upon oneself the appearance of youthful beauty must be used with skill. Thus, as regards cosmetic art at least, Kant's assertion that to be good, art must look like nature, is completely true. For if it is obvious to the beholder that the complexion he sees on a woman's face is her own only in the sense that she paid for it, or that the red of her lips came to them not from the inside but from the outside, then her looks, far from creating in him the impression that she is the possessor of youthful health and beauty, on the contrary shout to him from afar that she does *not* possess these. Thus, unless such devices manage really to deceive, what they do is aggressively to defeat their own purpose—advertising, as they then do, at once our deficiencies, our wish to deceive, and our lack of skill. This is so evident that one is forced to wonder how so many of the persons who use cosmetics can be clumsy enough so to overdo their make-up that its effects have no chance whatever of being mistaken for the reality.

It is when we face this question that we begin to realize that make-up can be an effective instrument of fascination quite otherwise than by attempting to imitate the appearance of young beauty. Let it be noted first that our heads and faces are not the only parts of our persons whose appearance we deliberately alter, for clothing fundamentally transforms the appearance of the body as a whole. And, bearing in mind the distinction between clothing and upholstery, it is evident that the transformation clothing effects is not at all of the nature of make-believe. Although we do occasionally find a man of whom it is hard to believe that he was not born with a brown derby or in spats and morning coat, nevertheless we normally run no risk whatever of mistaking clothing for the appearance of the human body or of mistaking the beauty of clothing may possess for beauty of the human form. Of course, there are various reasons why human beings wear clothes: protection from the weather—for example, sheer stockings in winter; modesty—exemplified by the constantly diminishing bathing suits of recent years; and so on. But even when the function of clothing is to hide the human form, there is no more possibility of mistaking the one for the other than there is of mistaking a bush behind which a man hides for the man himself.

Clothing, then, aside from serving as the mask of the body that modesty or the climate or the desire for mystery may require, essentially constitutes *adornment*. Clothing is fundamentally for us today an ornamental mask for the human form, and whatever manages to serve as such constitutes clothing. A completely tattooed man, for example, can hardly any longer be called naked, since a whole picture gallery always trusts itself between his skin and the beholder's attention.

Now there is no reason why the human head and face should not be dealt with according to the same system as the rest of the body—covered, that is to say, with an ornamental mask. Such a mask—whether tied on or only painted on—constitutes, not embellishment, as did the deceiving devices already considered, but adornment. And although adornment, as we now perceive, is quite different from embellishment, it may nevertheless also be an effective means of fascination. In all probability, many of the instances of make-up that would have to be called unbelievably clumsy if they were intended to simulate the beauty of youthfulness are to be understood as attempts, not at deception, but at ornamentation. When, for instance, a lady stains her fingernails to resemble the claws of a tiger ripping up a sheep, we cannot plausibly suppose that she intends to make anyone believe that the bright crimson color is just the result of vigorous good health; but rather, as in a string of beads, we must assume that it is intended to provide decorative spots of contrasting or harmonizing color.

It is clear, then, that women who proceed in this way are for the most part not as yet wholly conscious of the fact that the alterations they make in the appearance of their hands and faces are no longer based upon the philosophy of traditional make-up. For if they were fully conscious of this, they would make a much fuller use than they do of the resources actually at their disposal. If the reason for staining the fingernails, for instance, is that they may provide decorative spots of bright color, why

then confine oneself to stains within the range of reds? That the hitherto unused resources provided by stains of other colors are nevertheless beginning to be realized as indicated by a report in the papers some time ago that a certain woman of prominence actually stained her fingernails green to harmonize with her gown. And if green or blue or golden fingernails, why then not likewise green or blue or golden lips, eyebrows, cheeks, and ears? Especially with colored wigs to match, some wonderful effects could undoubtedly be achieved.

Again, the shape of such a feature as the eyebrow is widely modified today by depilation; and more than one cinema star, we read, shaves off her eyebrows entirely and paints on another pair more beautifully designed. But there is no reason for designing eyebrows in a shape that is even plausible if decoration, rather than simulation of nature, is the aim. Double eyebrows, or forked or serpentine eyebrows might on occasion be more appropriate to the arrangement of the hair, or to the lines or fabric of a gown. Indeed, lines or shapes having no likeness to or connection with the features of the human face might well be introduced with most ornamental effect.

A step in this direction, which fashion has at times taken, is that of sticking upon the face a small black patch, sometimes round or diamond-shaped, or in the shape of a butterfly or flower. And of course the people whom we call savages, but whose sense of design is often quite as good as ours and is not hampered by the same set of conventions, do not hesitate to paint upon the face a variety of lines or patterns. It is true that the object here is not so much ornamentation as magical effect, perhaps to ward off evil spirits; but whether these patterns be magical or not, the draughtsman's sense of design makes them decorative. On the other hand, many civilized women are well aware the adornment of the human face is a magic that may effectively fascinate good spirits of the opposite sex not yet disembodied.

The Borrowing of Beauty and Other Qualities

Decorative clothing, whether for the body or the face, buttoned on or painted on, is something the beauty of which is easily susceptible of being borrowed by the wearer. The borrowing of beauty, interest, glamor, or other qualities by one thing from another is a very common phenomenon. It depends upon a certain psychological principle, an understanding of which illuminates for us a great many facts that otherwise would be puzzling. It is simply that when a given thing is intimately associated with another, then any noteworthy quality of that other tends to diffuse itself over the given thing and to be regarded as belonging to it.

Jewelers, for example, apply this principle when they give to an inferior or small diamond an ornate mounting. The mounting is intimately associated with the diamond, and the notable beauty that really belongs to the mounting tends to be regarded as inherent in the stone. The stone borrows beauty from the mounting if we do not stop to analyze, and usually we do not analyze so long as we are pleased. A jewel of outstanding beauty, on the other hand, is properly given the least conspicuous mounting possible, in order that the attention may not be distracted from its self-sufficient beauty.

Again, we easily think that the importance, might, intelligence, glamor, lowliness, or evilness of individual men are almost visible qualities; but take away from the man his clothing, his usual setting, and his typical occupations, and those normally almost visible qualities fade from sight. In a Turkish bath, rich man, poor man, beggar man, thief look very much alike.

The fact then that beauty, mystery, interest, grandeur, glamor, or other qualities that fascinate can be borrowed by a person from things possessing them that are closely associated with him is what explains the effectiveness of beautiful, exotic, ingenious, rich, or symbolic clothing as a means of fascination. And it explains also the fascinating effects of adornments other than clothing—such as jewelry, perfume, manners, and mode of speech—especially if we note that this borrowing and lending of qualities closely resembles the borrowing and lending of money. The quality or money that is lent is not always the lender's very own, but often has been borrowed from another lender. This means that, in considering the fascinating qualities that clothing, jewelry, perfumes, and the like tend to a person, we can distinguish between the qualities that such adjuncts themselves literally exhibit and the qualities that they only signify and suggest. With this in mind, let us now examine in detail some of these other instruments of fascination.

In the case of clothing, the qualities susceptible of being literally exhibited by it would include beauty of color, fabric, and design; whereas the qualities that clothing may represent and put us in mind of, rather than literally present, would include the rank, wealth, and office of the wearer. The fascination with which a military uniform is said to invest the wearer in the eyes of women is thus due in part to its picturesqueness; but probably fully as much to the romance, bravery, and adventure that it manages to connote. And, analogously, the fascination with which a nurse is endowed in the eyes of men by her uniform largely arises from the neat-

ness, sympathy, dependability, and gentleness it plausibly suggests.

The fascination jewelry may bestow on the wearer is similarly in part a matter of the beauty of its color, fire, or design. But that this is only a part of the source of its effect, and among us the lesser part, is shown by the importance commonly attached to the preciousness of the jewels worn. For, so far as actual, visible beauty is concerned, an inexpensive but indistinguishable imitation is precisely as good as the real thing. If known imitations of precious stones are not esteemed, even when faithful, it is therefore only because, although they look the same, they do not mean the same. They do not connote the wealth, power, position, or high birth that alone permit the possession of truly precious gems. And they do not, therefore, single out the possessor as a person unique among thousands, as do rare stones, paintings, and porcelain, or indeed titles, memberships in exclusive organizations, medals for heroism, championship belts, Ph.D. degrees, or six-inch fingernails.

In the case of perfume also, which lends pleasantness to the user, we find ourselves forced to distinguish between the pleasantness of the odor itself and the pleasantness of what the odor calls to mind. The odor of roast beef, for instance, is a pleasant odor; yet a woman who perfumed herself with it would hardly become more fascinating. The same would be true of the odors of freshly ground coffee, pineapple, fried onions, or pleasant food odors in general. Such odors, because of their associations, stimulate us, not to love and dream, but to bite or swallow. To perfume oneself with them would be to provoke hunger in others and tempt them to treat us as food—a mode of attraction very different indeed from that which we call fascination.

It would seem, then, that the only pleasant odors that can lend fascination to the person who uses them as perfume are of two sorts. One would include odors that do not make us think of the object that produces them—for example, musk, patchouli, ambergris, and coumarin. There is no temptation to view or treat the wearer of these perfumes as we would the objects from which they are extracted, because most of us do not even know what those objects are. The other sort of pleasant odors fit to serve as perfumes are mostly flower odors; for the objects from which they are extracted, although familiar, are things of beauty that are themselves able to serve as ornaments of the person and to lend it fascination.

But beside clothing, jewelry, perfumes, or even manners and modes of speech, there are certain other more subtle, non-sensuous things from which our person may borrow fascination. I refer to the moral, spiritual, or intellectual traits that together make up our personality as distinguished from our person. Evidently to describe such traits as decorations of the person is to invert what we regard as the normal order of importance, as did the barber who congratulated a customer upon having a large brain, because that meant lots of blood in the head, which in turn made the hair grow. Yet that was the important thing from the barber's point of view, and there is such a point of view. Likewise there is the point of view of the cosmetic art—the art concerned with making our *person* pleasing to contemplate—from which musical talent, a poetic mind, wit, resourcefulness, a courageous heart, a brilliant intellect, and a kind soul are all decorations of the person; for they do serve to adorn it and lend it fascination, notwithstanding that this is not their chief importance.

The word "cosmetic" is derived from the Greek *"cosmos,"* which has been borrowed by modern languages to mean specifically the ordered universe, but which originally means simply order or good order. This derivation of its name would be enough to suggest that the cosmetic art, although often regarded with scant tolerance as but a catering to human vanity, nevertheless has noble connections. As we have seen, it is after all one of the manifestations of the incurable perfectionism that marks off mankind from the animal tribes; since man's ideals are but traits, whether of soul or body, that he would like to see but fails to find when he observes himself. A more philosophical and fairer perspective on the cosmetic art is thus obtained if, in appraising it, we remember that the aspirant who in meditation beholds his soul and strives to improve it, and the worldling who in the mirror beholds his face and likewise strives to improve it, are in truth both engaged in "making up." Both, that is to say, are idealists trying to make up for defects they discover in themselves.

58

The Decay of Lying: An Observation

OSCAR WILDE

A Dialogue

Persons: Cyril and Vivian.

Scene: the library of a country house in Nottinghamshire.

CYRIL *(coming in through the open window from the terrace):* My dear Vivian, don't coop yourself up all day in the library. . . . Let us . . . enjoy nature.

VIVIAN: Enjoy Nature! I am glad to say that I have entirely lost that faculty. People tell us that Art makes us love Nature more than we loved her before; that it reveals her secrets to us; and that after a careful study of Corot and Constable we see things in her that had escaped our observation. My own experience is that the more we study Art, the less we care for Nature. What Art really reveals to us is Nature's lack of design, her curious crudities, her extraordinary monotony, her absolutely unfinished condition. Nature has good intentions, of course, but, as Aristotle once said, she cannot carry them out. When I look at a landscape I cannot help seeing all its defects. It is fortunate for us, however, that Nature is so imperfect, as otherwise we should have had no art at all. Art is our spirited protest, our gallant attempt to teach Nature her proper place. As for the infinite variety of Nature, that is a pure myth. It is not to be found in Nature herself. It resides in the imagination, or fancy, or cultivated blindness of the man who looks at her. . . .

Now, if you promise not to interrupt too often, I will read you my article.

CYRIL: You will find me all attention.

VIVIAN *(reading in a very clear voice):* "THE DECAY OF LYING: A PROTEST.—One of the chief causes that can be assigned for the curiously commonplace character of most of the literature of our age is undoubtedly the decay of Lying as an art, a science, and a social pleasure. The ancient historians gave us delightful fiction in the form of fact; the modern novelist presents us with dull facts under the guise of fiction. The Blue-Book is rapidly becoming his ideal both for method and manner. He has his tedious *document humain*, his miserable little *coin de la création* into which he peers with his microscope. He is to be found at the Librairie Nationale, or at the British Museum, shamelessly reading up his subject. He has not even the courage of other people's ideas, but insists on going directly to life for everything, and ultimately, between encyclopaedias and personal experience, he comes to the ground, having drawn his types from the family circle or from the weekly washerwoman, and having acquired an amount of useful information from which never, even in his most meditative moments, can he thoroughly free himself.

"The loss that results to literature in general from this false ideal of our time can hardly be overestimated. People have a careless way of talking about a 'born liar,' just as they talk about a 'born poet.' But

From Oscar Wilde, "The Decay of Lying: An Observation," in S. Weintraub ed., *Literary Criticism of Oscar Wilde.* Lincoln: University of Nebraska Press, 1968, pp. 165–66, 168–69, 174–76, 178, 180–84, 186–92, 194–95. Reprinted with permission of the University of Nebraska Press.

in both cases they are wrong. Lying and poetry are arts—arts, as Plato saw, not unconnected with each other—and they require the most careful study, the most disinterested devotion. Indeed, they have their technique, just as the more material arts of painting and sculpture have their subtle secrets of form and colour, their craft-mysteries, their deliberate artistic methods. As one knows the poet by his fine music, so one can recognise the liar by his rich rhythmic utterance, and in neither case will the casual inspiration of the moment suffice. Here, as elsewhere, practice must precede perfection. But in modern days while the fashion of writing poetry has become far too common, and should, if possible, be discouraged, the fashion of lying has almost fallen into disrepute. Many a young man starts in life with a natural gift for exaggeration which, if nurtured in congenial and sympathetic surroundings, or by the imitation of the best models, might grow into something really great and wonderful. But, as a rule, he comes to nothing. He either falls into careless habits of accuracy————"

CYRIL: My dear fellow!

VIVIAN: Please don't interrupt in the middle of a sentence. "He either falls into careless habits of accuracy, or takes to frequenting the society of the aged and the well-informed. Both things are equally fatal to his imagination, as indeed they would be fatal to the imagination of anybody, and in a short time he develops a morbid and unhealthy faculty of truth-telling, begins to verify all statements made in his presence, has no hesitation in contradicting people who are much younger than himself, and often ends by writing novels which are so life-like that no one can possibly believe in their probability. This is no isolated instance that we are giving. It is simply one example out of many; and if something cannot be done to check, or at least to modify, our monstrous worship of facts, Art will become sterile and beauty will pass away from the land. . . .

"The public imagine that, because they are interested in their immediate surroundings, Art should be interested in them also, and should take them as her subject-matter. But the mere fact that they are interested in these things makes them unsuitable subjects for Art. The only beautiful things, as somebody once said, are the things that do not concern us. As long as a thing is useful or necessary to us, or affects us in any way, either for pain or for pleasure, or appeals strongly to our sympathies, or is a vital part of the environment in which we live, it is outside the proper sphere of art. To art's subject-matter we should be more or less indifferent. . . ."

CYRIL: But what do you say about the return to Life and Nature? This is the panacea that is always being recommended to us.

VIVIAN: I will read you what I say on the subject. The passage comes later on in the article, but I may as well give it to you now:—

"The popular cry of our time is 'Let us return to Life and Nature; they will recreate Art for us, and send the red blood coursing through her veins; they will shoe her feet with swiftness and make her hand strong.' But, alas! we are mistaken in our amiable and well-meaning efforts. Nature is always behind the age. And as for Life, she is the solvent that breaks up Art, the enemy that lays waste her house."

CYRIL: What do you mean by saying that Nature is always behind the age?

VIVIAN: Well, perhaps that is rather cryptic. What I mean is this. If we take Nature to mean natural simple instinct as opposed to self-conscious culture, the work produced under this influence is always old-fashioned, antiquated, and out of date. One touch of Nature may make the whole world kin, but two touches of Nature will destroy any work of Art. If, on the other hand, we regard Nature as the collection of phenomena external to man, people only discover in her what they bring to her. She has no suggestions of her own. Wordsworth went to the lakes, but he was never a lake poet. He found in stones the sermons he had already hidden there. He went moralising about the district, but his good work was produced when he returned, not to Nature but to poetry. Poetry gave him "Laodamia," and the fine sonnets, and the great Ode such as it is. Nature gave him "Martha Ray" and "Peter Bell," and the address to Mr. Wilkinson's spade.

CYRIL: I think that view might be questioned. I am rather inclined to believe in "the impulse from a vernal wood," though of course the artistic value of such an impulse depends entirely on the kind of temperament that receives it, so that the return to Nature would come to mean simply the advance to a great personality. You would agree with that, I fancy. However, proceed with your article.

VIVIAN (*reading*): "Art begins with abstract decoration, with purely imaginative and pleasurable work dealing with what is unreal and non-existent. This is the first stage. Then Life becomes fascinated with this new wonder, and asks to be admitted into the charmed circle. Art takes life as part of her rough material, recreates it, and refashions it in fresh forms, is absolutely indifferent to fact, invents, imagines, dreams, and keeps between herself and reality the impenetrable barrier of beautiful style, of decorative or ideal treatment. The third stage is when Life gets the upper hand, and drives Art out into the wilderness. This is the true decadence, and it is from this that we are now suffering. . . .

"The whole history of the [decorative] arts in Europe is the record of the struggle between Orientalism, with its frank rejection of imitation, its love of artistic convention, its dislike to the actual representation of any object in Nature, and our own imitative spirit. Wherever the former has been paramount, as in Byzantium, Sicily and Spain, by actual contact or in the rest of Europe by the influence of the Crusades, we have had beautiful and imaginative work in which the visible things of life are transmuted into artistic conventions, and the things that Life has not are invented and fashioned for her delight. But wherever we have returned to Life and Nature, our work has always become vulgar, common and uninteresting.

"Art finds her own perfection within, and not outside of, herself. She is not to be judged by any external standard of resemblance. She is a veil, rather than a mirror. She has flowers that no forests know of, birds that no woodland possesses. She makes and unmakes many worlds, and can draw the moon from heaven with a scarlet thread. Hers are the 'forms more real than living man,' and hers the great archetypes of which things that have existence are but unfinished copies."

CYRIL: What do you mean by saying that life, "poor, probable, uninteresting human life," will try to reproduce the marvels of art? I can quite understand your objection to art being treated as a mirror. You think it would reduce genius to the position of a cracked looking-glass. But you don't mean to say that you seriously believe that Life imitates Art, that Life in fact is the mirror, and Art the reality?

VIVIAN: Certainly I do. Paradox though it may seem—and paradoxes are always dangerous things—it is none that less true that Life imitates art far more than Art imitates life. We have all seen in our own day in England how a certain curious and fascinating type of beauty, invented and emphasised by two imaginative painters, has so influenced Life that whenever one goes to a private view or to an artistic salon one sees, here the mystic eyes of Rossetti's dream, the long ivory throat, the strange square-cut jaw, the loosened shadowy hair that he so ardently loved, there the sweet maidenhood of "The Golden Stair," the blossom-like mouth and weary loveliness of the "Laus Amoris," the passion-pale face of Andromeda, the thin hands and lithe beauty of the Vivian in "Merlin's Dream." And it has always been so. A great artist invents a type, and Life tries to copy it, to reproduce it in a popular form, like an enterprising publisher. Neither Holbein nor Vandyck found in England what they have given us. They brought their types with them, and Life with her keen imitative faculty set herself to supply the master with models. The Greeks, with their quick artistic instinct, understood this, and set in the bride's chamber the statue of Hermes or of Apollo, that she might bear children as lovely as the works of art that she looked at in her rapture or her pain. They knew that Life gains from art not merely spirituality, depth of thought and feeling, soul-turmoil or soul-peace, but that she can form herself on the very lines and colours of art, and can reproduce the dignity of Pheidias as well as the grace of Praxiteles. Hence came their objection to realism. They disliked it on purely social grounds. They felt that it inevitably makes people ugly, and they were perfectly right. We try to improve the conditions of the race by means of good air, free sunlight, wholesome water, and hideous, bare buildings for the better housing of the lower orders. But these things merely produce health, they do not produce beauty. For this, Art is required, and the true disciples of the great artist are not his studio-imitators, but those who become like his works of art, be they plastic as in Greek days, or pictorial as in modern times; in a word, Life is Art's best, Art's only pupil.

As it is with the visible arts, so it is with literature. The most obvious and the vulgarest form in which this is shown is in the case of the silly boys who, after reading the adventures of Jack Sheppard or Dick Turpin, pillage the stalls of unfortunate apple-women, break into sweet-shops at night, and alarm old gentlemen who are returning home from the city by leaping out on them in suburban lanes, with black masks and unloaded revolvers. This interesting phenomenon, which always occurs after the appearance of a new edition of either of the books I have alluded to, is usually attributed to the influence of literature on the imagination. But this is a mistake. The imagination is essentially creative, and always seeks for a new form. The boy-burglar is simply the inevitable result of life's imitative instinct. He is Fact, occupied as Fact usually is, with trying to reproduce Fiction, and what we see in him is repeated on an extended scale throughout the whole of life. Schopenhauer has analysed the pessimism that characterises modern thought, but Hamlet invented it. The world has become sad because a puppet was once melancholy. . . .

Life holds the mirror up to Art, and either reproduces some strange type imagined by painter or sculptor, or realises in fact what has been dreamed in fiction. Scientifically speaking, the basis of life—the energy of life, as Aristotle would call it—is simply the desire for expression, and Art is always presenting various forms through which the expression can be attained. Life seizes on them and uses them, even if they be to her own hurt. Young men have committed suicide because Rolla did so, have died by their own hand because by his own hand Werther died. Think of what we owe to the imita-

tion of Christ, of what we owe to the imitation of Caesar.

CYRIL: The theory is certainly a very curious one, but to make it complete you must show that Nature, no less than Life, is an imitation of Art. Are you prepared to prove that?

VIVIAN: My dear fellow, I am prepared to prove anything.

CYRIL: Nature follows the landscape painter, then, and takes her effects from him?

VIVIAN: Certainly. Where, if not from the Impressionists, do we get those wonderful brown fogs that come creeping down our streets, blurring the gaslamps and changing the houses into monstrous shadows? To whom, if not to them and their master, do we owe the lovely silver mists that brood over our river, and turn to faint forms of fading grace curved bridge and swaying barge? The extraordinary change that has taken place in the climate of London during the last ten years is entirely due to a particular school of Art. You smile. Consider the matter from a scientific or a metaphysical point of view, and you will find that I am right. For what is Nature? Nature is no great mother who has borne us. She is our creation. It is in our brain that she quickens to life. Things are because we see them, and what we see, and how we see it, depends on the Arts that have influenced us. To look at a thing is very different from seeing a thing. One does not see anything until one sees its beauty. Then, and then only, does it come into existence. At present, people see fogs, not because there are fogs, but because poets and painters have taught them the mysterious loveliness of such effects. There may have been fogs for centuries in London. I dare say there were. They did not exist till Art had invented them. Now, it must be admitted, fogs are carried to excess. They have become the mere mannerism of a clique, and the exaggerated realism of their method gives dull people bronchitis. Where the cultured catch an effect, the uncultured catch cold. And so, let us be humane, and invite Art to turn her wonderful eyes elsewhere. She has done so already, indeed. That white quivering sunlight that one sees now in France, with its strange blotches of mauve, and its restless violet shadows, is her latest fancy, and, on the whole, Nature reproduces it quite admirably. Where she used to give us Corots and Daubignys, she gives us now exquisite Monets and entrancing Pissaros. Indeed, there are moments, rare, it is true, but still to be observed from time to time, when Nature becomes absolutely modern. Of course she is not always to be relied upon. The fact is that she is in this unfortunate position. Art creates an incomparable and unique effect, and, having done so, passes on to other things. Nature, upon the other hand, forgetting that imitation can be made the sincerest form of insult, keeps on repeating this effect until we all become absolutely wearied of it. Nobody of any real culture, for instance, ever talks nowadays about the beauty of a sunset. Sunsets are quite old-fashioned. They belong to the time when Turner was the last note in art. To admire them is a distinct sign of provincialism of temperament. Upon the other hand they go on. Yesterday evening Mrs. Arundel insisted on my going to the window and looking at the glorious sky, as she called it. Of course I had to look at it. She is one of those absurdly pretty Philistines to whom one can deny nothing. And what was it? It was simply a very second-rate Turner, a Turner of a bad period, with all the painter's worst faults exaggerated and over-emphasized. Of course I am quite ready to admit that Life very often commits the same error. . . . but then, when Art is more varied, Nature will, no doubt, be more varied also. That she imitates Art, I don't think even her worst enemy would deny now. It is the one thing that keeps her in touch with civilised man. But have I proved my theory to your satisfaction?

CYRIL: You have proved it to my dissatisfaction, which is better. But even admitting this strange imitative instinct in Life and Nature, surely you would acknowledge that Art expresses the temper of its age, the spirit of its time, the moral and social conditions that surround it, and under whose influence it is produced.

VIVIAN: Certainly not! Art never expresses anything but itself. This is the principle of my new aesthetics; and it is this, more than that vital connection between form and substance, on which Mr. Pater dwells, that makes music the type of all the arts. Of course, nations and individuals, with that healthy natural vanity which is the secret of existence, are always under the impression that it is of them that the Muses are talking, always trying to find in the calm dignity of imaginative art some mirror of their own turbid passions, always forgetting that the singer of life is not Apollo but Marsyas. Remote from reality and with her eyes turned away from the shadows of the cave, Art reveals her own perfection, and the wondering crowd that watches the opening of the marvellous many-petalled rose fancies that it is its own history that is being told to it, its own spirit that is finding expression in a new form. But it is not so. The highest art rejects the burden of the human spirit, and gains more from a new medium or a fresh material than she does from any enthusiasm for art, or from any lofty passion, or from any great awakening of the human conscious-

ness. She develops purely on her own lines. She is not symbolic of any age. It is the ages that are her symbols.

Even those who hold that Art is representative of time and place and people cannot help admitting that the more imitative an art is the less it represents to us the spirit of its age. The evil faces of the Roman emperors look out at us from the foul porphyry and spotted jasper in which the realistic artists of the day delighted to work and we fancy that in those cruel lips and heavy sensual jaws we can find the secret of the ruin of the Empire. But it was not so. The vices of Tiberius could not destroy that supreme civilisation, any more than the virtues of the Antonines could save it. It fell for other, for less interesting reasons. The sibyls and prophets of the Sistine may indeed serve to interpret for some that new birth of the emancipated spirit that we call the Renaissance; but what do the drunken boors and brawling peasants of Dutch art tell us about the great soul of Holland? The more abstract, the more ideal an art is the more it reveals to us the temper of its age. If we wish to understand a nation by means of its art, let us look at its architecture or its music.

CYRIL: I quite agree with you there. The spirit of an age may be best expressed in the abstract ideal arts, for the spirit itself is abstract and ideal. Upon the other hand, for the visible aspect of an age, for its look, as the phrase goes, we must of course go to the arts of imitation.

VIVIAN: I don't think so. After all, what the imitative arts really give us are merely the various styles of particular artists, or of certain schools of artists. Surely you don't imagine that the people of the Middle Ages bore any resemblance at all to the figures on mediaeval stained glass, or in mediaeval stone and wood carving, or on mediaeval metalwork, or tapestries, or illuminated MSS. They were probably very ordinary-looking people, with nothing grotesque, or remarkable, or fantastic in their appearance. The Middle Ages, as we know them in art, are simply a definite form of style, and there is no reason at all why an artist with this style should not be produced in the nineteenth century. No great artist ever sees things as they really are. If he did he would cease to be an artist. Take an example from our own day. I know that you are fond of Japanese things. Now, do you really imagine that the Japanese people, as they are presented to us in art, have any existence? If you do, you have never understood Japanese art at all. The Japanese people are the deliberate self-conscious creation of certain individual artists. If you set a picture by Hokusai, or Hokkei, or any of the great native painters, beside a real Japanese gentleman or lady, you will see that there is not the slightest resemblance between them. The actual people who live in Japan are not unlike the general run of English people; that is to say, they are extremely commonplace, and have nothing curious or extraordinary about them. In fact, the whole of Japan is a pure invention. There is no such country, there are no such people. One of our most charming painters went recently to the Land of the Chrysanthemum in the foolish hope of seeing the Japanese. All he saw, all he had the chance of painting, were a few lanterns and some fans. He was quite unable to discover the inhabitants, as his delightful exhibition at Messrs. Dowdeswell's Gallery showed only too well. He did not know that the Japanese people are, as I have said, simply a mode of style, an exquisite fancy of art. And so, if you desire to see a Japanese effect, you will not behave like a tourist and go to Tokio. On the contrary, you will stay at home and steep yourself in the work of certain Japanese artists, and then, when you have absorbed the spirit of their style, and caught their imaginative manner of vision, you will go some afternoon and sit in the Park or stroll down Piccadilly, and if you cannot see an absolutely Japanese effect there, you will not see it anywhere. Or, to return again to the past, take as another instance the ancient Greeks. Do you think that Greek art ever tells us what the Greek people were like? Do you believe that the Athenian women were like the stately dignified figures of the Parthenon frieze, or like those marvellous goddesses who sat in the triangular pediments of the same building? If you judge from the art, they certainly were so. But read an authority like Aristophanes, for instance. You will find that the Athenian ladies laced tightly, wore high-heeled shoes, dyed their hair yellow, painted and rouged their faces, and were exactly like any silly fashionable or fallen creature of our own day. The fact is that we look back on the ages entirely through the medium or art, and art, very fortunately, has never once told us the truth.

CYRIL: But modern portraits by English painters, what of them? Surely they are like the people they pretend to represent?

VIVIAN: Quite so. They are so like them that a hundred years from now no one will believe in them. The only portraits in which one believes are portraits where there is very little of the sitter and a very great deal of the artist. Holbein's drawings of the men and women of his time impress us with a sense of their absolute reality. But this is simply because Holbein compelled life to accept his conditions, to restrain itself within his limitations, to reproduce his type and to appear as he wished it to appear. It is style that makes us believe in a thing—nothing but style. Most of our modern portrait painters are doomed to absolute oblivion. They

never paint what they see. They paint what the public sees, and the public never sees anything. . . .

But in order to avoid making any error I want you to tell me briefly the doctrines of the new aesthetics.

VIVIAN: Briefly, then, they are these. Art never expresses anything but itself. It has an independent life, just as Thought has, and develops purely on its own lines. It is not necessarily realistic in an age of realism, nor spiritual in an age of faith. So far from being the creation of its time, it is usually in direct opposition to it, and the only history that it preserves for us is the history of its own progress. Sometimes it returns upon its footsteps, and revives some antique form, as happened in the archaistic movement of late Greek Art, and in the pre-Raphaelite movement of our own day. At other times it entirely anticipates its age, and produces in one century work that it takes another century to understand, to appreciate, and to enjoy. In no case does it reproduce its age. To pass from the art of a time to the time itself is the great mistake that all historians commit.

The second doctrine is this. All bad art comes from returning to Life and Nature, and elevating them into ideals. Life and Nature may sometimes be used as part of Art's rough material, but before they are of any real service to Art they must be translated into artistic conventions. The moment Art surrenders its imaginative medium it surrenders everything. As a method Realism is a complete failure,

and the two things that every artist should avoid are modernity of form and modernity of subject-matter. To us, who live in the nineteenth century, any century is a suitable subject for art except our own. The only beautiful things are the things that do not concern us. It is, to have the pleasure of quoting myself, exactly because Hecuba is nothing to us that her sorrows are so suitable a motive for a tragedy. Besides, it is only the modern that ever becomes old-fashioned. M. Zola sits down to give us a picture of the Second Empire. Who cares for the Second Empire now? It is out of date. Life goes faster than Realism, but Romanticism is always in front of Life.

The third doctrine is that Life imitates Art far more than Art imitates Life. This results not merely from Life's imitative instinct, but from the fact that the self-conscious aim of Life is to find expression, and that Art offers it certain beautiful forms through which it may realise that energy. It is a theory that has never been put forward before, but it is extremely fruitful, and throws an entirely new light upon the history of Art.

It follows, as a corollary from this, that external Nature also imitates Art. The only effects that she can show us are effects that we have already seen through poetry, or in paintings. This is the secret of Nature's charm, as well as the explanation of Nature's weakness.

The final revelation is that Lying, the telling of beautiful untrue things, is the proper aim of Art. But of this I think I have spoken at sufficient length.

Lightning Source UK Ltd.
Milton Keynes UK
08 February 2010

149760UK00007B/1/P